ROBERT INDIANA

BEYOND LOVE

WHITNEY MUSEUM OF AMERICAN ART, NEW YORK

DISTRIBUTED BY YALE UNIVERSITY PRESS, NEW HAVEN AND LONDON

ROBERT INDIANA

BEYOND LOVE

BARBARA HASKELL WITH CONTRIBUTIONS BY RENÉ PAUL BARILLEAUX SASHA NICHOLAS

FIG. 1 Robert Indiana in his Coenties Slip studio, 1964.
Photograph by Robert Walker

FOREWORD

Sometimes the role of a museum is to make accessible the work of artists who are lesser known or to make artwork that is seemingly esoteric more comprehensible. Other times, our job is to make accessible art that is hidden in plain sight.

In 1966, Robert Indiana created an image that would come to symbolize a generation: *LOVE*. While its fundamental composition was relatively staid (a symmetrical quartered layout, each quadrant containing a single letter of the word), Indiana injected a kind of electric dynamism and subtle destabilization to the work by tilting the "O" and selecting an optically abrasive color palette of red, blue, and green. Indeed, when the work first appeared, "[n]obody could read 'L-O-V-E.' It looked completely abstract to people . . . it took awhile before people could actually read the word 'love' and didn't see abstract shapes,"[1] as Indiana's studio assistant at the time and long-time friend Bill Katz points out in the first of two insightful roundtable discussions in this catalogue.

That initial sense of the work—of seeing an all-too-familiar (and often clichéd) word in a fresh, new, and destabilizing context—quickly faded, as Indiana's image was pirated and pressed into service as an emblem of the late-1960s counterculture. That the American public, and the world, would embrace Indiana's art with a gusto that seemed to reflect something of the essence of the very word at the center of the image itself would suggest unmitigated success, particularly for an artist who once proclaimed that he wanted to be "a people's artist as well as an artist's artist." By utilizing the strategies of design and the "elementary poetry" of advertising, and with his interest in high-impact imagery rather than "things that are delicate or soft or subtly nuanced," Indiana had created an image that no doubt spoke to people, but within a few years, the runaway success of *LOVE* had obfuscated— even eclipsed—the artist, his other work, and the aesthetic and social context from which it arose.

The appearance and almost immediate popularization of *LOVE* in 1966 was, at the time, the firework burst that capped the rocket-like trajectory of Indiana's early success in New York. Five years earlier, Alfred H. Barr, Jr., the admired founding director of the Museum of Modern Art and the museum's director of collections, had essentially launched Indiana's career by purchasing Indiana's *The American Dream, I* (1961) for MoMA's collection; the painting was then featured in MoMA's *Recent Acquisitions* exhibition that same year. The museum would include Indiana's construction *Moon* (1960) in its international survey *The Art of Assemblage* and devote an entire gallery to Indiana's art in its celebrated *Americans 1963* exhibition. The artist's reputation was further cemented when his work was

included in the historic 1962 exhibition *New Realists* at Sidney Janis Gallery, and in the Whitney Museum of American Art's *Annual of Contemporary Painting* in 1963. Somewhat to his consternation, Indiana was immediately identified with other Pop artists emerging at the time, such as Andy Warhol, James Rosenquist, and Roy Lichtenstein. In some ways, Indiana's inclusion made sense. His art was bold, hard-edged, graphic, and often brightly colored. It made use of numbers and of seemingly direct, simple words, typically of three or four letters. Its imagery was rooted in America's omnipresent signs and the visuals of highway culture. It seemed accessible to all.

But just as the nuances inherent in *LOVE* would be ultimately obscured by the work's ubiquity, so too would the aspects of Indiana that differentiated him from his peers be elided by his summary characterization as a Pop artist. Perhaps more than any of his cohorts, Robert Indiana has grounded his identity as an artist in being an American. Born in 1928 in the country's heartland, he changed his name in 1958 in a radical act of self-identification with his home state, just as his career was about to take off in New York. As a young art student in Indianapolis, he had admired and emulated the art of such American masters as Winslow Homer, Thomas Hart Benton, Edward Hopper, and Reginald Marsh, and as a mature artist, he would continue his engagement with the work of his modernist American forebears by paying direct homage to Charles Demuth, Joseph Stella, and Marsden Hartley. Although his art was not altogether devoid of European influences (in the mid-1950s he briefly experimented with the "art brut" style of the Jean Dubuffet paintings he had seen while studying at the Art Institute of Chicago), the primary sources for the development in the late 1950s of his signature hard-edge style were the colleagues he found in New York, Ellsworth Kelly principal among them. For subject matter, he plumbed not only the visual iconography of the American highways and roadside diners that marked the country's landscape of transience, but the American literary canon as well, employing the words of such quintessentially American writers as Walt Whitman, Herman Melville, and Henry Wadsworth Longfellow to both celebrate and critique his native country.

That both celebration and critique of contemporary American culture were always part of Indiana's ambition for his art was evident from the outset. *The American Dream, I*, the painting that first brought the artist critical acclaim, was a manifesto of sorts. The words "Tilt" and "Take All," the off-kilter horizontal bands, the somber and sober brownish ground, the stars with possible militaristic overtones, and the impenetrable use of numbers—all suggest something amiss in the

American Dream and that there is, indeed, a dark side to the bright and colorful surfaces of American culture as depicted in films, commercial products, and advertising, even as the painting's visual effect communicates something vibrant, even seductive.

This intrepid layering of meaning was apparent as well in Indiana's early "herms"—constructions he made from wood beams and iron wheels that he scavenged from his Coenties Slip neighborhood in New York, artifacts in and of themselves of another chapter in the history of American enterprise. Featuring choice monosyllabic words with myriad interpretations ("mate," "bar," "hub," and "chief" among them), these works are both object and subject (the pieces assume distinct anthropomorphic qualities), word and image, constructed and found, painted and assembled, sexual and ascetic. The artist called them herms because they resembled the columnar road markers and milestones of ancient Greece, which were themselves associated with Hermes, the messenger god and the god of transitions, who brought the dead from the world of the living to the afterlife. This derivation further suggests that Indiana's herms are not as straightforward, declarative, jaunty, and upbeat as they might first appear. Indeed, the bright colors are often offset by black grounds (as are the colors of many of the artist's paintings), the wheels are rusted, the timber is raw, and the meaning mercurial. This enigmatic and contradictory side of Indiana's art is even more explicit in his various *Eat/Die* paintings, the meanings and associations of which are much explored in this volume.

Yet all this—the richness and complexity, the Pandora's box of interpretation and an appreciation of the virtuoso mastery of technique inherent in Indiana's oeuvre—would ultimately be marginalized by the dominance of *LOVE*. As art critic and historian Thomas Crow remarks in the second roundtable discussion in this book: "Popular culture took on the attributes of Pop. And the only Pop artist who leapt into this and participated in it was Indiana, and he paid a price."[2] Derided by critics, Indiana found himself an outcast of the same art world that had once fervently embraced him, his work dismissed as clichéd or simply "graphic design." It is long past time that we stop to see Indiana's work anew, to seek the underbelly of Indiana's art history. The purpose of this exhibition is not to single out or reify *LOVE* but to re-contextualize its power and, most importantly, to reassess and appreciate the power and importance of Indiana's larger body of work.

My great congratulations to Barbara Haskell for grappling with the myths and misapprehensions of Indiana's art. While some in the art establishment have been dismissive of Indiana's accomplishments, Barbara has had the curiosity, courage, and persistence to assemble an exhibition that will, I suspect, surprise the artist's critics and cause them to reconsider their prejudices and Indiana's place in art history. Moreover, Barbara has devised this content to the richly layered catalogue that includes not only her perspicacious text and Sasha Nicholas's thoughtful

essay, which contextualizes Indiana's art in the American modernist tradition, but also René Paul Barilleaux's incisive commentary on Indiana's artistic legacy, as well as the transcripts of two dynamic roundtable discussions with the sometimes divergent opinions of seven Indiana specialists who represent multiple generations of scholarship. My thanks to Thomas Crow, Bill Katz, Robert Pincus-Witten, Susan Elizabeth Ryan, Robert Storr, Allison Unruh, and John Wilmerding for their frankness and generosity. I especially want to acknowledge Bill Katz and John Wilmerding for their wise council throughout this undertaking. My gratitude also extends to all the institutional and private lenders for their commitment and for understanding that this exhibition is a critical and long-overdue assessment of Indiana's art.

My sincere appreciation goes to the funders who made this endeavor possible and who helped to cover the very substantial costs of many international loans. Foremost among these is the Morgan Art Foundation and its chairman, Robert Gore. Without the foundation's support, the exhibition would have been substantially diminished and the scale of this historic catalogue significantly reduced. My profound thanks to Simon Salama-Caro, Marc Salama-Caro, and Emmy Salama-Caro for their encouragement, enthusiasm for Indiana's art, and their assistance regarding the complexity of loans and the organizational aspects of the exhibition. I would also like to express my appreciation to the other representatives of Indiana's work, including Galerie Gmurzynska, Zurich; Paul Kasmin and Clara Ha of the Paul Kasmin Gallery, New York; and Leslie Waddington of the Waddington Custot Galleries, London. It is fitting, and with great pleasure, that we share this exhibition with the McNay Art Museum in San Antonio, Texas, which has been stalwart in its support of Indiana's work.

To Robert Indiana: thank you for putting your trust in the Whitney Museum of American Art. Our association is a long one. Given the frequent misunderstanding surrounding your art, you have rightfully been cautious. Under the leadership of Barbara Haskell, we have done our utmost to clarify, rectify, and reconsider the complexities and contributions of your art. I hope you feel we have done you and your work the justice they deserve.

ADAM D. WEINBERG
Alice Pratt Brown Director

NOTES

1 See page 192 in this volume.

2 See page 199 in this volume.

BARBARA HASKELL

ROBERT INDIANA
The American Dream

Robert Indiana came to prominence on the wave of Pop art that engulfed the art world in the early 1960s. Along with Andy Warhol, James Rosenquist, Jim Dine, Claes Oldenburg, and Roy Lichtenstein, he was hailed for helping to puncture the seemingly impregnable metaphysics of Abstract Expressionism and bring art back in contact with the concrete and the everyday. Drawing on the vocabulary of vernacular highway signs and roadside entertainments, Indiana fashioned an art that was dazzlingly bold and visually kinetic. The optical punch and seemingly affirmative tone of his hard-edge, chromatically intense paintings suggested an America that was, in his words, "optimistic, generous, and naïve."[1] Yet even as his art was being extolled as celebratory, a few astute critics detected a psychologically disquieting subtext and questioned whether the surface dazzle of his canvases didn't veil something darker. These interpretations faded with the appearance in 1966 of what would become Indiana's most recognized and celebrated work—and the most troublesome for his reputation: *LOVE*. To the art world, *LOVE*'s conflation of word and image—its reductive simplicity and resemblance to the graphics and exhortations of advertising—was confounding. With Indiana's most perceptive champion, critic Gene Swenson, sidelined by mental illness, *LOVE* was mostly misunderstood by art-world tastemakers, who were put off by the public's valorization of the image as an emblem of countercultural sexual freedom.[2] In the ensuing years, the unauthorized appearance of *LOVE* on everything from paperweights to doormats further alienated critics, who faulted Indiana for the image's commercialized banality. What got lost was the work's unsettling message about the precariousness of relationships, as manifested by the slanting "O," which tacitly subverted the otherwise stable design, and its implicit critique of the often-hollow sentimentality associated with the word itself.[3] By 1978, the almost exclusive identification of Indiana with *LOVE* had muted recognition of the tension between celebration and alienation that had long been at the

FIG. 2 Robert Indiana in his Coenties Slip studio, 1964. Photograph by William John Kennedy

core of his art. That year, faced with eviction from his studio in New York, he relocated to the island of Vinalhaven, Maine, essentially exiling himself from an art world that had earlier acclaimed him as one of the groundbreaking artists of his generation.

The revisionist reassessment of Indiana's career that one might have predicted has begun. In recent decades, the poignancy and conceptual complexity of Indiana's art has once again become the focus of critical attention as critics and art historians have taken on the challenge of deciphering the multiple layers of autobiographical and cultural references embedded in his pioneering sculptural assemblages and paintings. Their work has revealed the enigmas of love, desire, time, and death that Indiana explores through the lens of memory and a keenly personal understanding of the aspirations and failures associated with the American Dream.

FIG. 3 Carmen Watters Clark, c. 1920s

Robert Indiana has claimed repeatedly that everything he makes is autobiographical, and he has spoken and written about his life more frequently than perhaps any other artist of his generation.[4] While his constructed narrative often hides as much as it reveals, and his significance as an artist transcends biography, an examination of his life yields important insights into an art that so often examines the complex interface between the personal and the cultural. He was born out of wedlock in 1928 and adopted within a year of his birth by Earl and Carmen Clark from Indianapolis, who named him Robert. He grew up knowing that the two were not his biological parents but, from all appearances, suppressed whatever anxiety this knowledge may have engendered.[5] Carmen was the more dominant figure in his life (fig. 3). Indiana describes her as warm and outgoing, though also uneducated and full of superstitions. The death from whooping cough of her son from a previous marriage (whose photograph she kept on her bureau) instilled in her an excessive phobia about death. During a brief period when the family lived next door to a cemetery, Indiana remembers her refusing to leave the house at night unaccompanied or to set foot in the back yard. Yet every Decoration Day, she insisted that the family drive from cemetery to cemetery around Indianapolis, placing flowers on the graves of the family's deceased relatives, of which there were many, according to Indiana. Under these circumstances, it comes as no surprise that her adopted son's childhood memories—and later dreams—were filled with graveyards and funerals.[6]

When Robert was five, Carmen seems to have concluded that his being nearsighted and underweight put him physically at risk. Fearing he was pre-tubercular, a condition both she and Earl incorrectly ascribed to fumes from the factory

located across the street from their house in Indianapolis, they delayed his entrance into first grade for a year and moved to a rural farm near the small town of Mooresville, twenty miles away.[7] It was but one of many moves. Carmen was "an absolute gypsy," Indiana would later say, constitutionally unable to remain in the same house for more than a year.[8] By Indiana's oft-told account, he moved twenty-one times before he was seventeen and once told an interviewer, "I never had a home."[9] Looking back, he remembers a popular family pastime was revisiting previous residences, each of which he referred to in shorthand by the number that corresponded to its place in the family's sequence of homes.

Years later, Indiana would write about his parents as members of the "lost generation."[10] Earl had worked at an oil refining company when the couple adopted Robert, but as the Depression began he lost his job, and the family's finances plummeted; from a child's perspective, they never fully recovered. Yet even as the Clarks moved from one seemingly shabby bungalow to another, both Earl and Carmen each often had their own cars. "It seemed that half my life was spent in the automobile," Indiana would recall.[11] Trips to both the Chicago World's Fair in 1933 and the Frontier Centennial Exhibition in Fort Worth, Texas, in 1937 introduced Robert to an idealized vision of America that was forward-looking, modern, and optimistic, reflecting a confidence that was implicit in the simple, bold, declarative road signage that emerged to advertise the country's increasingly consolidated and powerful companies. It would be an enormous lighted sign towering above Indianapolis for Phillips 66, the logo for the oil company where Earl ultimately found employment, that would become an enduring source of fascination for Indiana, one which seems to have encapsulated somehow the Clarks' own turbulent experience of trying to achieve some semblance of the American Dream only to fail miserably.

FIG. 4 Robert Clark (Robert Indiana), *The Hero*, c. 1936. Crayon and pencil on paper, 8⁷⁄₁₆ × 10¹⁵⁄₁₆ in. (21.4 × 27.8 cm). Collection of the artist

By Indiana's recollection, Earl left the family's home in rural Cumberland, a few miles east of Indianapolis, on July 4, 1938, abandoning his wife for another woman. Carmen pursued them in her car with the family revolver, threatening to shoot if she found them together.[12] Just a few months before, she had traveled to South Bend to testify for the defense at the trial of her sister-in-law, Ruby Watters, who had murdered Carmen's stepmother (Ruby's mother-in-law) in a dispute over custody of Ruby's two young children.[13] Family lore had it that Earl's adulterous relationship began while Carmen was away.[14] Robert's parents divorced soon thereafter, and both remarried within two years. Robert lived with Carmen and her new husband during the week near Cumberland and with Earl and his new wife and stepdaughter in Indianapolis on weekends.[15]

In the years immediately after the divorce, Carmen supported herself and her son by working at roadside cafes that offered "home-cooked" meals, but the jobs paid little, and Indiana later

recalled that many nights he went to bed hungry.[16] Looking back, he would remember thinking at an early age that his adoptive parents were inept and instinctively vowing to avoid duplicating their lives.[17] Neither athletic nor social as a young child—the latter owing to never settling long enough in one place to make friends—he turned to art as an activity he could control and which also garnered him praise (fig. 4). Already by age five or six, he had begun to fantasize about a life in art as something wonderfully remote from his own circumstances. He would later often credit the confirmation he received about his talent from his first-grade teacher, Ruth Coffman, as having inspired his later determination to become an artist.[18]

Cumberland was too small to hire art teachers for its schools, which made the four years Robert attended middle school there distressing to him.[19] Through his stepmother's father, a janitor at Arsenal Technical High School in Indianapolis, he learned of that school's extensive art program. Convinced that art offered a way to escape what he called the "bleak, cheap and tawdry" life of his adoptive parents, he enrolled as a freshman in 1942, which meant living with his father and his new family in Indianapolis in order to fulfill the school's residency requirement.[20] Not until his senior year, when Carmen relocated to the city, did he see her.[21] Soon after, Earl moved his family to California, and Robert Clark, as he was still known, would only see his adoptive father once more before Earl's death in 1965.

For Clark, the education he received at Arsenal Tech appeared to more than compensate for the flux and hardships he endured. He did extremely well academically, graduating in 1946 with high honors and awards in English and Latin.[22] But it was his experience with the school's twelve full-time art instructors that caused him to look back on his home state as "the place of most all of my most pleasant memories."[23] One teacher in particular stood out: Sara Bard, a watercolorist from Philadelphia, with whom he studied art history and painting. By his senior year, he was spending the majority of the school day in her class.[24] She introduced him to a wide range of twentieth-century artists, but her preference for Americans, particularly Winslow Homer, Edward Hopper, Charles Sheeler, and Reginald Marsh, was indelible. For the rest of his life, he would value American subjects and styles over European ones and proudly claim to "paint the American scene."[25] The art Clark produced in Bard's class and on weekend bicycle trips around Indianapolis evinces a precocious talent. Fascinated with architecture from an early age, he created a number of Hopper-esque watercolors of isolated buildings, but the subjects that most engaged him were genre scenes from everyday life (fig. 5). For these, Marsh was his guide. The older artist's exuberant, calligraphic brushstrokes and

swirling, linear rhythms became the model for Clark's high-school watercolors, one of which won a national Scholastic Art and Writing Award during his senior year.

Several months after graduating, Clark volunteered for the U.S. Army Air Corps (later the U.S. Air Force) in order to ultimately take advantage of the G.I. Bill, which had been passed by Congress two years earlier.[26] For a young man whose personality, interests, and incipient homosexuality were contrary to everything the Army represented, the decision was soul-wrenching. Yet in the end the prospect of getting "away from home" proved decisive: in September 1946, he began basic training.[27] The next three years were filled with illness, disappointment, a mental breakdown, and emotional isolation.[28] He took pride in managing the newspapers for the Air Corps bases in Hobbs, New Mexico, and in Anchorage, Alaska, but both assignments were relatively short.[29] Solace came primarily from the Christian Science Church, which he had attended as a boy.[30] A month before his twenty-first birthday and discharge from the Air Force, relatives obtained an emergency leave for him to visit Carmen, who was terminally ill with cancer.[31] When he arrived at her house, her body was so emaciated he barely recognized her and her vocal chords so damaged she had trouble speaking. Her last words to him before she died— "Have you had enough to eat?"—would resonate with her adopted son throughout his adult life.

Within a month, Carmen's husband died, too, leaving Clark, at twenty-one, bereft of his closest family. After selling his mother's and stepfather's possessions, he traveled to Chicago and enrolled under the G.I. Bill at the School of the Art Institute, where he studied for the next four years.[32] The school at that time was a bastion of figurative art, its teachers eschewing the abstraction that was burgeoning in New York. The leading local artist was Ivan Albright, whose semi-mystical themes and meticulously rendered images of decay and corruption intrigued Clark, as they did other students at the school who congregated around printmaker Vera Berdich, with whom Clark studied during his senior year. Having come of age artistically after the birth of the atomic bomb and the dawn of the Cold War, these young artists were particularly sensitive to the basic fragility and contingency of human life. For them, describing the terror and anxiety of the human condition meant working with figurative imagery. Although Clark did not socialize with Berdich's circle of artists, his student artwork, like theirs, bore witness to the unsettling realities of the time.[33]

At the end of his fourth year, Clark had a choice of where to complete his bachelor of fine arts:

FIG. 6 Untitled figurative composition in oil on canvas that won Clark (Indiana) a Foreign Traveling Fellowship from the School of the Art Institute of Chicago, 1953 (destroyed)

he could take the requisite academic classes at an accredited local college or university, or he could apply for one of the school's Foreign Traveling Fellowships and finish his degree abroad. He opted for the latter and submitted the mandatory multifigure composition to the faculty jury (fig. 6). His selection as one of seven fellowship recipients surprised the school's dean, who had been so certain that Clark's talent would not be recognized by the jury that he arranged for him to receive a compensatory scholarship to the nine-week summer residency at the Skowhegan School of Painting and Sculpture in Maine.[34] Opting to take advantage of both awards, Clark postponed going to Europe until the fall and left for Skowhegan in June.

In Maine, Clark elected to study fresco with Henry Varnum Poor rather than painting with the school's star teacher, Jack Levine, out of fear that Levine's strong personality would hinder his autonomy. But Skowhegan was small, and Clark interacted with Levine daily and attended his public lectures. As if by osmosis, the older artist's commitment to an art of social and political consciousness guided Clark, whose two frescoes that summer—*Pilate Washing His Hands* and a memorial to soldiers who had lost their lives in the Korean War (fig. 7)—dealt with redemption and sacrifice. Moral and political themes remained Clark's focus during his year abroad at the University of Edinburgh, where he augmented his academic classes by writing poetry, some of which he hand-set and illustrated in the print studios of the Edinburgh College of Art (fig. 8).[35] Yet other than these and a few expressionist heads he executed in London during the summer (fig. 9), his yearlong stay overseas had been "inhospitable to making art."[36] Even his exposure to Europe's centuries-long tradition of painting, architecture, and sculpture when he traveled to the continent during winter and spring breaks left him unmoved. "Those frescos and those cathedrals just aren't important in the way that they used to be," he later said.[37] In September 1954, he returned to the United States, unsure of whether to be a poet or a painter.

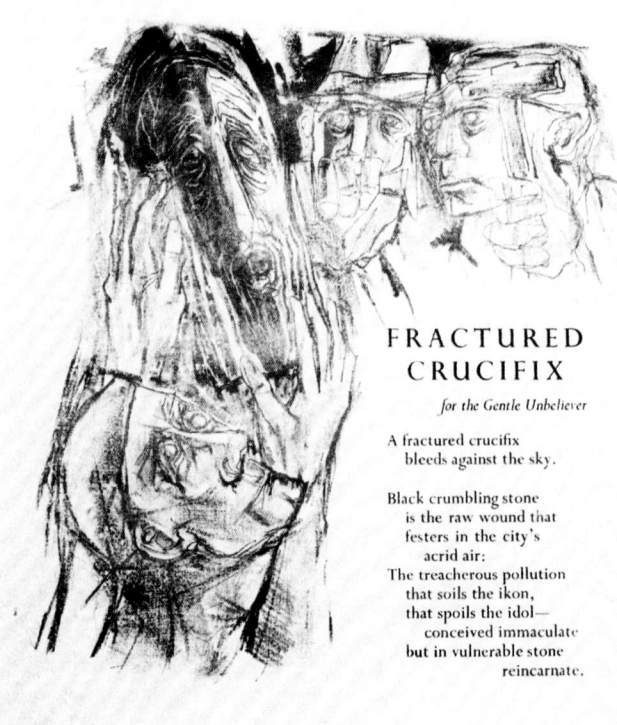

FRACTURED
CRUCIFIX

for the Gentle Unbeliever

A fractured crucifix
bleeds against the sky.

Black crumbling stone
is the raw wound that
festers in the city's
acrid air:
The treacherous pollution
that soils the ikon,
that spoils the idol—
conceived immaculate
but in vulnerable stone
reincarnate.

TOP
FIG. 7 Fresco mural Clark (Indiana) painted in Skowhegan, Maine, as a memorial to soldiers who died in the Korean War, 1953 (destroyed)

BOTTOM
FIG. 8 Robert Clark (Robert Indiana), "Fractured Crucifix," 1954. Lithography and typeset poem, 15⅛ × 13 in. (38.4 × 33 cm). Collection of the artist

Clark spent his first months in New York in utter poverty, abandoned by the friends he had counted on to help finance his return to Chicago. Even after he found a part-time job selling art supplies at Friedrichs on 57th Street, his twenty-dollar-a-week salary gave him barely enough money to room in a residential hotel in Hell's Kitchen. Not until June 1955, when he sublet the loft of Paul Sanasardo, a Chicago friend and professional dancer who was away on tour, did Clark have a studio where he could continue to pursue expressionist portraiture. His move to the East Village following Sanasardo's return thrust him into the heart of the Abstract Expressionist community, where he felt himself an outsider by virtue of temperament and finances. One visit to Cedar Tavern, a favorite haunt for many Abstract Expressionists, was enough for him to realize he did not belong in its world of heavy drinking and assertive masculinity. Finances prevented him from even trying: with barely enough money for rent, he could not afford the "buckets of paint" he later described these artists piling on their canvases.[38] Nevertheless, the community's pervasive belief in "tragic and timeless" subject matter, as Mark Rothko and Adolph Gottlieb put it, was inescapable; almost reflexively, Indiana moved his art further toward the mythic.[39] Guided by memories of the heavily

encrusted canvases of Jean Dubuffet that had impressed him as a student when they were exhibited at the Chicago Arts Club, he mixed sand, gravel, and paint to create black, elongated heads whose masklike immobility and occasional gilt backgrounds recalled Byzantine icons.[40] The heads' vacant, inscrutable expressions endowed them with a stoic detachment, made menacing by the stark whites of their eyes, which seemed to gaze into space as if transfixed by some unseen presence. Decades later Indiana made this foreboding quality explicit by inscribing on the paintings the words "*mene, mene, tekel, upharsin*," the biblical "writing on the wall" of Belshazzar's palace that Daniel interpreted to mean that God had doomed the Babylonian ruler's kingdom (figs. 17, 18).

Clark's life changed in June 1956 when Ellsworth Kelly came into Friedrichs to inquire about a Matisse postcard that Clark had displayed in the store's window. Recently returned from Paris where he had lived for six years, Kelly was already a successful artist, having just closed a show at New York's influential Betty Parsons Gallery the previous month. For Clark, five years Kelly's junior, the encounter was pivotal. The two artists discovered they were both looking for lofts—Clark because his lease had expired and Kelly because he wanted more space. Following Kelly's recommendation, Clark moved into 31 Coenties Slip a couple of weeks later; Kelly soon followed, taking a larger space nearby. Not long after, the two became lovers, spending their afternoons painting together, sketching the views outside Clark's window, and drawing one another.[41] Watching Kelly paint and listening to his discourses on art changed Clark's conception of his own work. "My painting life began with Ellsworth," he would later say. "Before Coenties Slip, I was aesthetically at sea. With Ellsworth, my whole life perspective changed. All of a sudden I was in the twentieth century."[42]

Clark and Kelly were not the only artists drawn to the Slip by its cheap rent: over the next few years, Jack Youngerman, Agnes Martin, Lenore Tawney, Ann Wilson, James Rosenquist, and Charles Hinman moved there, as well as the fashion designer John Kloss, with whom Indiana would later share his loft. Physically, Coenties Slip was one of several three-block-long, Y-shaped streets running to the East River in Lower Manhattan that had been used for docking cargo ships before the 1880s, when the inlets were paved over. Isolated from the city by the remnants of the elevated train, the Slip functioned like a "private little enclave," one whose lack of amenities bred a feeling of solidarity among the artists.[43] For Clark, who had never before had a circle of companions, it was "a life saver," as he later called it.[44] He compensated for the lack of heat and hot water in his loft by using a pot-belly stove and taking showers at Tawney's loft or at the nearby Seamen's Church Institute, where the cost to shower, do laundry, and eat was nominal. With the buildings on the Slip zoned for commercial use only, living in them was illegal, which kept the size of the community small and furthered its sense of cohesion and perceived detachment from the city. Martin likened it to living in the country. "Being down here reminds me of Taos," she once observed. "You feel as if you've

climbed a mountain above confusion . . . Everybody groans about going into the city and sings when he comes back home."[45] The isolation of Coenties Slip likewise protected it from the hegemonic pressures of Abstract Expressionism. It was, as Kelly put it, "a world apart, consciously leaving behind the heritage of de Kooning and Pollock."[46]

Most of the artists on Coenties Slip practiced either biomorphic or geometric abstraction, with the exception of Clark, who initially avoided Kelly's hard-edge approach as a matter of pride.[47] When he did venture into abstraction, in early 1957, it happened almost by accident. He had offered the use of his loft while he was working at Friedrichs to his neighbor, Cy Twombly, who needed additional space to prepare for his January 1957 show at the Stable Gallery. When Twombly departed, he left several canvases behind, whose images he obliterated by covering their still-wet paint with newspaper. Clark ripped most of the newsprint off Twombly's canvases and applied gestural brushstrokes to the torn-paper grounds (fig. 10), a brief experiment he ended after seeing Youngerman's similar paintings, which predated his. "I was kind of thrown and discouraged," Clark admitted, recognizing that it was impossible for him to continue in this vein. "[H]ere we'd be two neighbors who'd be working much, much too much alike."[48]

FIG. 10 Photograph of Clark (Indiana) at work featured in "Bohemia on the Waterfront," *Cue* magazine, March 22, 1958

Although Clark's initial plunge into abstraction had proved to be a dead end, the very act of taking it freed him. When he relocated to 25 Coenties Slip in the spring of 1957, in advance of the demolition of 31, he was more prepared to accept Kelly's influence and was "not so reluctant to experiment with the hard-edge approach."[49] Taking his cue from Kelly's technique of isolating and distilling fragments of the seen world until they lost their recognizability and identity (fig. 11), Clark chose as his subject the fan-shaped leaf of the ginkgo trees that grew in nearby Jeannette Park. Doubling the leaf at its stem to create a mirror image yielded a shape that resembled the ying-yang, making legitimate Indiana's later claim to have invested the symbol "with a new form" (fig. 12).[50] With his finances still precarious, Clark barely had enough money to survive, let alone to buy canvas and paint. As a result, he mostly painted his ginkgo images on paper or Homasote, a wall board made from compressed recycled paper, whose fragility meant that few works survived.

With these doubled-ginkgo-leaf paintings, the artist began a career-long pattern of making art whose content was simultaneously public and private. Objectively, these paintings were flat, hard-edge, biomorphic abstractions; subjectively, however, they contained private, coded meanings having to do with identity and partnership. According to friends, Clark associated the ginkgo tree with Kelly and with himself, likening his new life to the tree's casting off of its leaves in autumn.[51] The image of two joined leaves, touching at their stems to form an indivisible whole, metaphorically portrayed his relationship with Kelly. That the ginkgo is dioecious,

FIG. 11 Ellsworth Kelly (b. 1923), *Atlantic*, 1956. Oil on canvas on two panels, 80¾ × 115 in. (205.1 × 292.1 cm) overall. Whitney Museum of American Art, New York; purchase 57.9a-b

each tree being either exclusively female or exclusively male and thus "unable to have normal prehistoric sex," as Indiana later wrote, made the symbolism particularly apt.[52]

In January 1958, Clark answered an ad in *The New York Times* for a part-time secretarial position at the Cathedral Church of Saint John the Divine proofreading Canon Edward N. West's *The History of the Cross* and answering letters from parishioners angry over the recent appointment of the cathedral's divorced dean, James Pike, as bishop of California.[53] The combination of working at the cathedral and studying West's book inspired Indiana to begin an abstract portrait of the Crucifixion that spring. Still without funds to buy oil paint or canvas, he pieced together forty-four sheets of paper that had been left in his loft by a previous print-company occupant and began an epic portrait of Christ on the Cross that he titled *Stavrosis* (Greek for "crucifixion") (fig. 19). Using inexpensive printer's ink, he depicted Christ wearing a triangular loincloth and a crown of thorns, flanked by the two crucified thieves whose torsos he represented by a doubled ginkgo leaf and a doubled avocado seed. In accordance with West's description of the circle as the symbol of "divine potentiality," Clark drew twelve circles to the left of Christ symbolizing the twelve apostles and three to his right representing the Trinity.[54] Measuring nearly twenty feet long and taking almost a year to complete, *Stavrosis* was an aesthetic breakthrough for Clark. Feeling, in a way, reborn himself and hating the thought that "something nice" would happen to him as Robert Clark, a name he associated with everything he was trying to escape, he traded his surname for one that was at once archetypically American and deeply personal: Indiana.[55] It was a quintessential fusion of the public and the private that he later attributed to the "desire to have something unique and a name that was original and exclusive to my own use."[56] Critic Nathan Kernan described it as Indiana's first act as a Pop artist.[57]

The initial paintings Indiana made under his new name depicted an abstract avocado seed in a field of curving, vaguely organic forms that evoked the body and the processes of life, growth, and metamorphosis (fig. 20).[58] Executed in a hard-edge style, these biomorphic abstractions recalled the work of Jean Arp, whose retrospective at the Museum of Modern Art Indiana had recently seen with Kelly.[59] After completing only a few paintings, Indiana replaced the avocado motif with the circle, the image venerated by West and one the Christian Science Church

FIG. 12 Robert Indiana, *Ginkgo*, 1959.
Gesso on wood panel, 15½ × 9 in. (39.3 × 22.8 cm).
Private collection

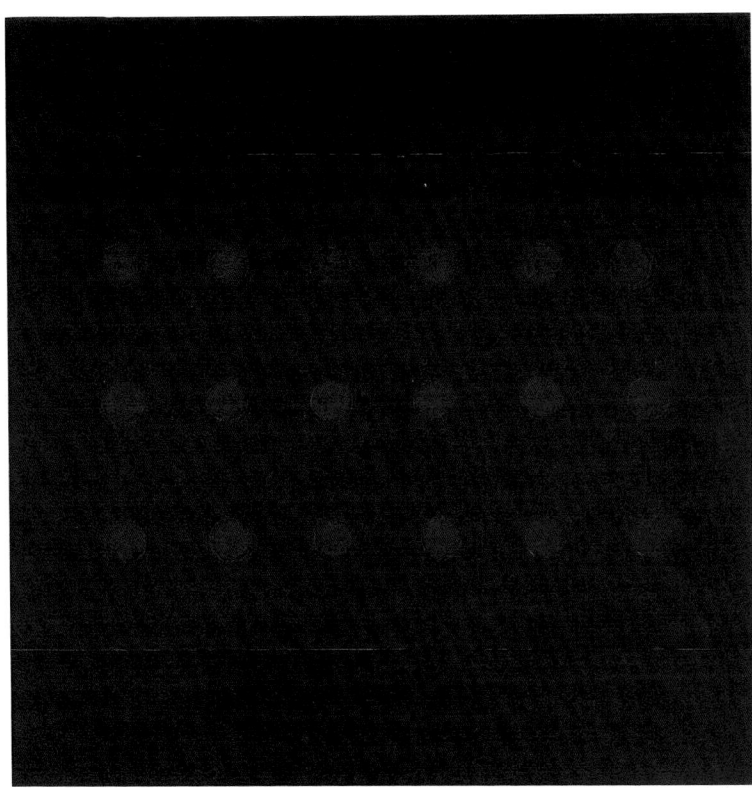

equated with man's eternal nature.[60] Adding to the motif's appeal for Indiana was its status as a classic geometric shape. Impelled by both metaphysical and formal considerations, he began painting uniformly spaced circles (orbs) with white gesso on the only material he could afford: weathered plywood, mostly using the grain of the board as his ground (fig. 13). Devoid of recognizable subject matter and illusionistic spatial recession, these modular compositions allied with the most advanced painting of the time.[61] Several months into the series, he experienced a moment of doubt when he saw the latest work of Agnes Martin, which utilized a similar modular layout of geometric shapes (fig. 14). "This begins to make it rather hard . . . [that] we should be using [the] same motif," he wrote in his journal. "Unfortunate for me, not for her."[62] Seeing Barnett Newman's show at French and Company soon after, in March 1959, reinvigorated him.[63] Inspired by how Newman activated the space of his compositions by bisecting his unified color fields with a narrow band of often-contrasting color, Indiana resolved to use vertical bands to elicit comparable pictorial tension.

A month later, he found Morris Louis's show even "more instructive and helpful." That Louis was able to achieve "a large, forceful image, magic and mysterious" by means of color reinforced the impact of Indiana's daily encounters with Kelly's high-keyed palette.[64] "I never thought about color until I knew Ellsworth," he would later say.[65]

Over the next year, Indiana's growing attraction to "the fuller harmonies of multicolor" led him to punctuate open fields of intense color with bent lines and triangular shapes in contrasting hues (fig. 15).[66] Yet even as he explored this Minimalist-inflected style, he once again began to embed his abstract compositions with deeply personal meanings, thereby casting them in opposition to the work of Kelly and such emerging Minimalist painters as Frank Stella, who denied that his paintings carried reference to anything beyond their own palpable physical reality. *Agadir* typified Indiana's approach. He identified the painting in a journal entry in March 1960 as a pictorial lament for the devastating earthquake in that Moroccan town that killed five thousand people in one night, but he simultaneously connected it to his breakup with a lover the year before: "a commemoration," he wrote, "of last year's event of [this] day, [the] madness of [the] two of us sharing a loft . . . a South Street fiasco for sure" (fig. 16).[67]

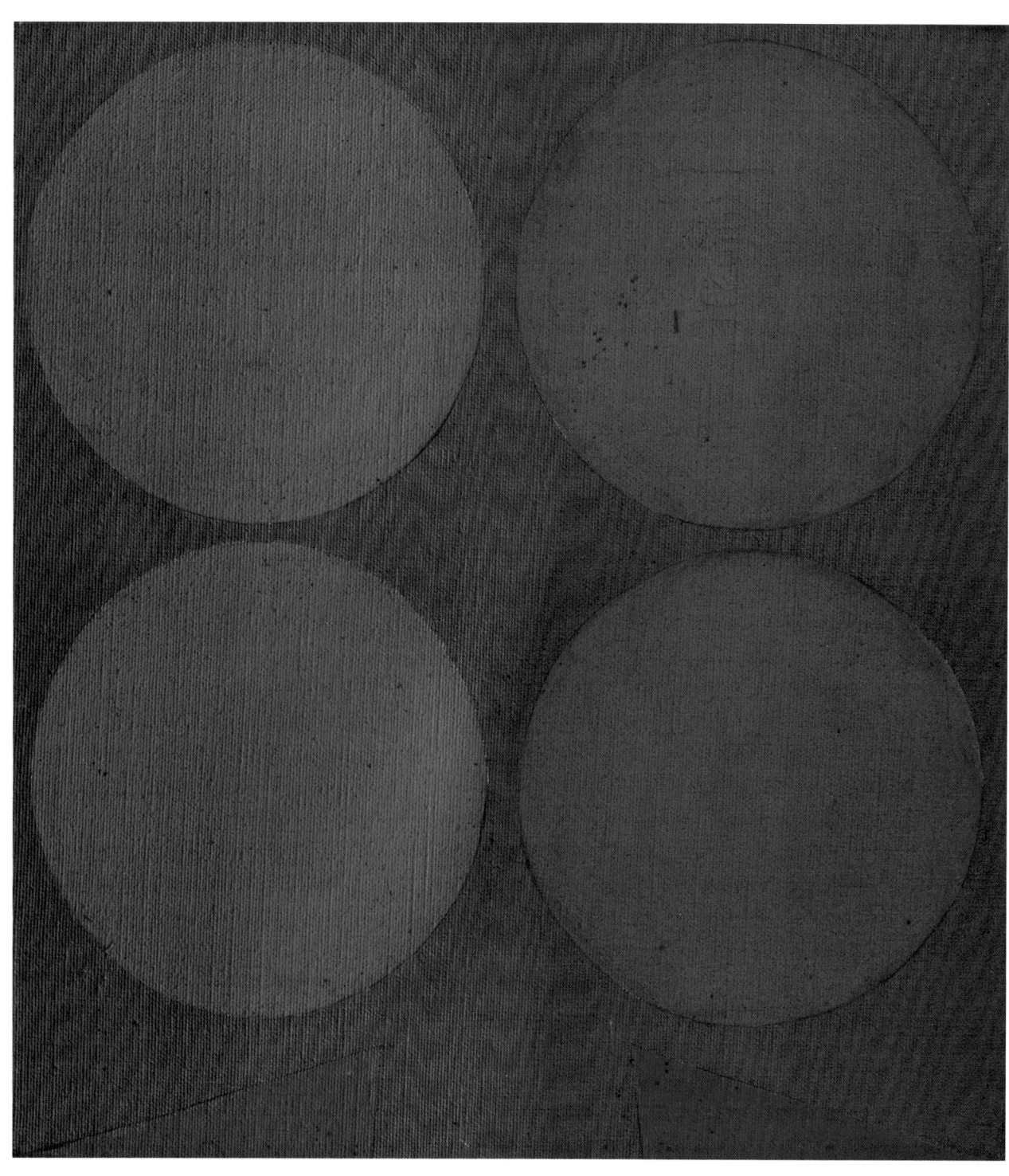

FIG. 15 Robert Indiana, right-hand panel of *Ra*,
1960 (triptych). Oil on canvas, 12 × 11 in.
(30.5 × 27.9 cm). Collection of the artist

FACING

FIG. 16 Indiana's journal, dated Wednesday/
Thursday, March 2–3, 1960, with sketch of the
painting *Agadir*, which the artist would eventually
over-paint to create *The American Dream, I* (1961).
Collection of the artist

CONT'D: WED/THUR: 2/3 /11
 '68

"AGADIR"

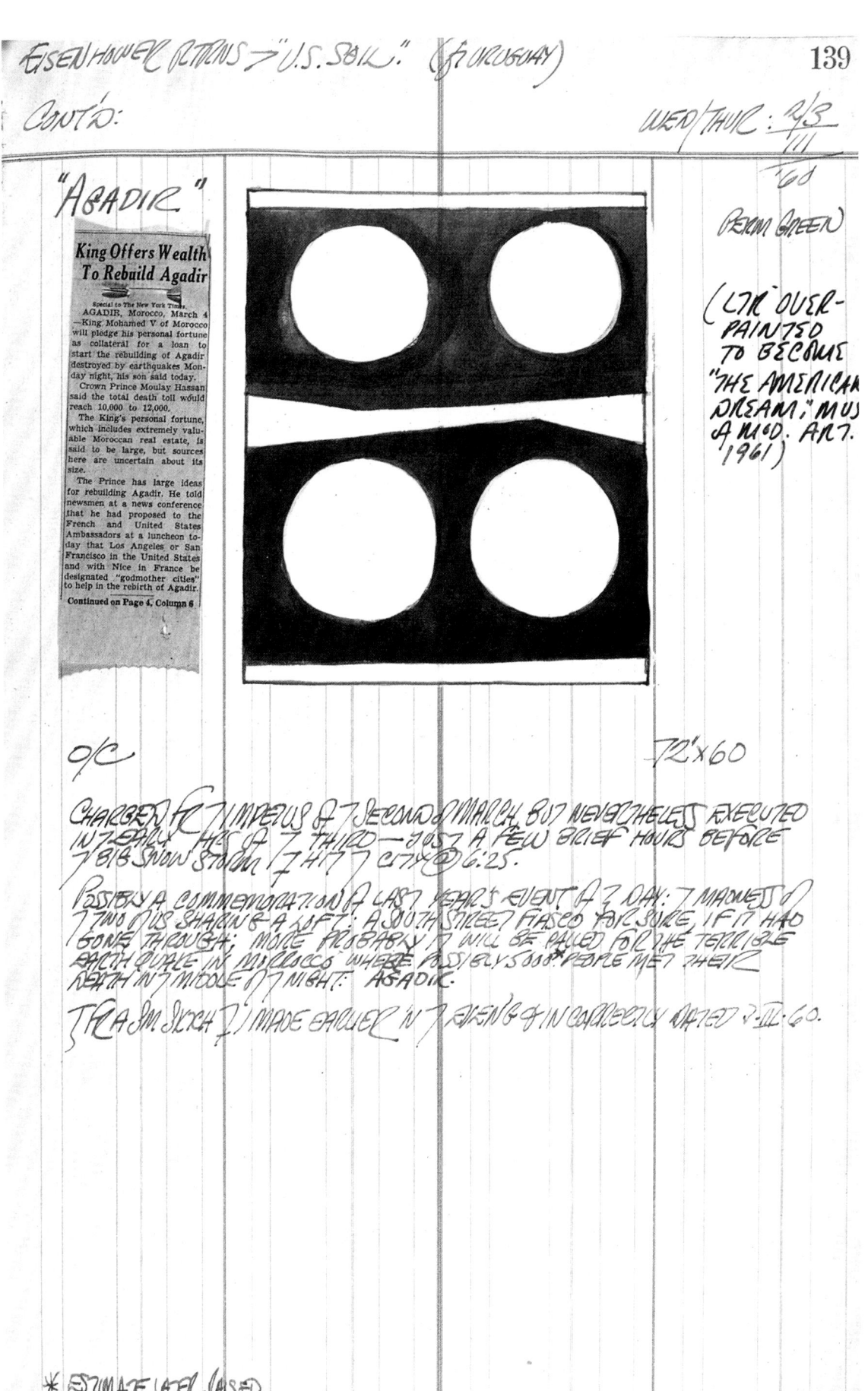

King Offers Wealth To Rebuild Agadir

Special to The New York Times.
AGADIR, Morocco, March 4 — King Mohamed V of Morocco will pledge his personal fortune as collateral for a loan to start the rebuilding of Agadir destroyed by earthquakes Monday night, his son said today.

Crown Prince Moulay Hassan said the total death toll would reach 10,000 to 12,000.

The King's personal fortune, which includes extremely valuable Moroccan real estate, is said to be large, but sources here are uncertain about its size.

The Prince has large ideas for rebuilding Agadir. He told newsmen at a news conference that he had proposed to the French and United States Ambassadors at a luncheon today that Los Angeles or San Francisco in the United States and with Nice in France be designated "godmother cities" to help in the rebirth of Agadir.

Continued on Page 4, Column 8

(FROM GREEN)

(LTR OVER-
PAINTED
TO BECOME
"THE AMERICAN
DREAM," MUS
OF MOD. ART.
1961)

O/C 72"X60

CHARGED FOR 1 INVOICE OF 1 SECOND OF MARCH, BUT NEVERTHELESS EXECUTED IN 1 EARLY HRS OF 1 THIRD — JUST A FEW BRIEF HOURS BEFORE 1 BIG SNOW STORM / 1 HIT 1 CITY @ 6:25.

POSSIBLY A COMMEMORATION OF LAST YEAR'S EVENT. OF 1 DAY: 1 MADNESS OF 1 TWO OF US SHARING A LOFT: A 50 TH STREET FIASCO FOR SURE, IF IT HAD GONE THROUGH: MORE PROBABLY IT WILL BE CALLED FOR 1 TERRIBLE EARTHQUAKE IN MOROCCO WHERE POSSIBLY 5000* PEOPLE MET THEIR DEATH IN 1 MIDDLE OF 1 NIGHT: AGADIR.

1 FOR A SM. SKETCH I MADE EARLIER IN 1 EVENING OF IN CORRECTLY DATED 3-III-60.

* ESTIMATE LATER RAISED

FIG. 17 Robert Clark (Robert Indiana), *Tekel*
(*"Brothers" Odd Fellows*), 1955–56/1989. Oil, gesso,
sand, and gold leaf on Homasote, 47¼ × 47¼ in.
(120 × 120 cm). Collection of the artist

FIG. 18 Robert Clark (Robert Indiana), *Mene Mene Tekel*, 1955–56/1989. Oil on Homasote with metal nails, 38½ × 57¾ in. (97.8 × 146.7 cm). Collection of the artist

FIG. 19 Robert Clark (Robert Indiana), *Stavrosis*,
1958. Ink on paper mounted on wood, 99¼ ×
229¼ in. (252 × 582.2 cm). Collection of the artist

FIG. 20 Robert Indiana, *Source I*, 1959. Oil on
Homasote, 46⅛ × 61½ in. (117.2 × 156.2 cm).
Collection of the artist

FIG. 21 Robert Indiana, *Twenty Golden Orbs*,
1959/2001. Oil on plywood, 96 × 48 in.
(243.8 × 121.9 cm). Galerie Gmurzynska,
Zurich, and private collection

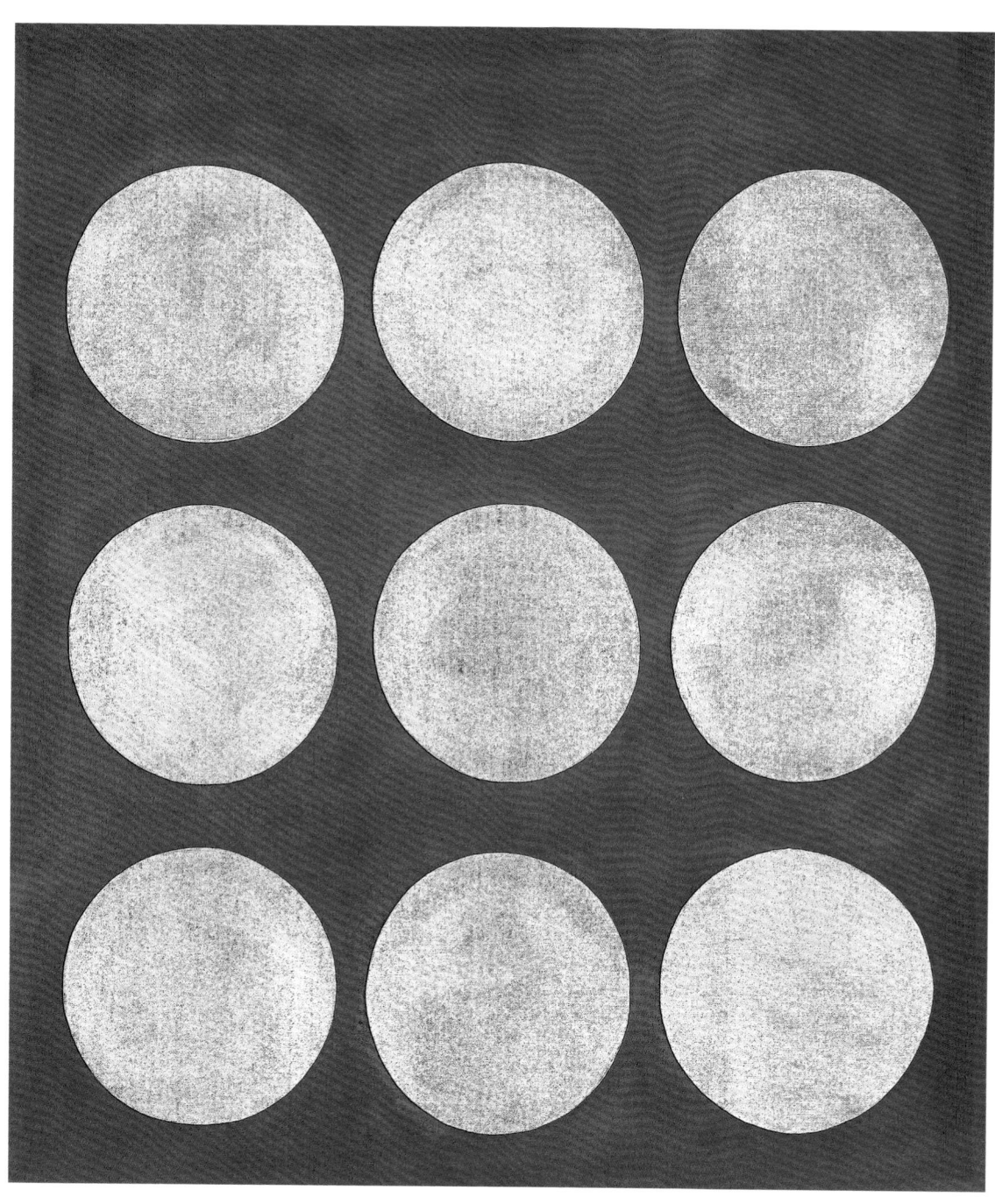

FIG. 22 Robert Indiana, *Nine Golden Orbs*, 1959.
Oil on canvas, 27³⁄₈ × 23⁵⁄₈ in. (70 × 60 cm).
Private collection

FIG. 23 Robert Indiana, *Jeanne d'Arc*, 1960–62.
Gesso, oil, iron, wood, and wheel, 83 × 24 × 6 in.
(210.8 × 61 × 15.2 cm). Collection of Guy and
Marion Naggar

Despite the advances Indiana was making in his painting, the artist spent the first half of 1960 mostly working on found-object constructions. "I thought of myself as a painter and a poet and became a sculptor because the potential raw materials were lying outside my studio door," he later said.[68] He had begun experimenting with assemblage in late 1959 after demonstrating the technique to children in the weekly art class he taught in a private home in Scarsdale, a suburb of New York. "As long as I haven't money enough for canvas and stretchers, perhaps it is just as well," he wrote.[69] He made his first constructions, all wall hangings—*Sun and Moon* (1959–60), *Wall of China* (fig. 33), *Marine Works* (fig. 28), and *Jeanne d'Arc* (fig. 23)—out of rusted metal objects, discarded bike wheels, and derelict pieces of wood he found lying around the neighborhood, using these materials as abstract forms to loosely reprise the circles, rectangles, and linear divisions that featured in his paintings. As he explained to an interviewer, "[T]he wheel is merely a physical projection of the circle."[70]

The explanation was only half true, as Indiana's journal entry describing his first construction reveals: "[F]rom an old piece of wood found on the loading platform of a long-vacated loft on Front Street, within sight of my front dormer, I made my first real construction . . . and in it I followed a theme already pursued in my paintings: the 'vision binoculaire' of the birds."[71] Indiana had encountered the concept while reading Cyril Connolly's *The Unquiet Grave*. Ophthalmologically, *vision binoculaire* describes the faculty of seeing with two eyes, each yielding a slightly different image of the same object, which the brain processes to produce depth perception. Connolly had embraced the phrase, along with the term "two-faced truth," as aptly describing the dialectical synthesis of two disparate things into a single entity that simultaneously maintained the integrity of its distinct parts. The process involved reconciling what he called "the Either, the Or" into the "Holy Both," a concept he equated with W. H. Auden's "double focus," though it accorded equally well with Christian "co-inherence," in which the two natures of Jesus—fully human and fully divine—are present in one form.[72] Connolly's assertion that "to attain two-faced truth we must be able . . . to see the mental side of the physical and the reverse . . . to be at the same time objective and subjective" held particular appeal to Indiana.[73] Adopting "double-focus" as an aesthetic strategy enabled him to create art that was private and autobiographical on the one hand, and objective and public on the other. He conceded that "any painting an artist does is possibly a self-portrait. He puts himself into it. It may not be the overt subject, but he's there, lurking in the shadows somewhere."[74] By providing a model to express "our inexorably divided self," *vision binoculaire* made it possible for Indiana to reconcile "the psychological conflict between self as subject and self as object."[75] He was aware that this involved ventriloquism: "[I]s an artist talking to himself, or is he trying to communicate to other people?" he later queried. "I suppose he's doing both."[76]

FIG. 24 Indiana's Coenties Slip studio, c. 1960, with herms, including *Star* (1960–62) in an early stage without wheels and *GE* (1960) in an early state without a peg. Photograph by John Ardoin

FIG. 25 The exterior of 25 Coenties Slip, where Indiana lived and worked, c. 1964

In the group of constructions that followed, made out of discarded wooden beams Indiana salvaged from the street or from the warehouses in Coenties Slip being razed for the widening of Water Street, he reveled in the multiple layers of public and private meanings that this expanded concept of *vision binoculaire* tacitly licensed him to encode in his work. Not only did his castoff materials contain traces of the area's history—and, by extension, his life on the Slip—his rescue of them metaphorically paralleled his shift in identity from Robert Clark to Robert Indiana. In both cases, his conversion involved transmuting "the Lost into the Found, Junk into Art, the Neglected into the Wanted, the Unloved into the Loved," as he described it.[77] He thought of his constructions as "phallic sentinels," their sexual connotations accentuated by their protruding (male) tenons, which carpenters had originally dovetailed into (female) mortises to make joints.[78] Yet at the same time, their rectangular shape and verticality recalled tombstones, and their wood material alluded to the Crucifixion, an idea reinforced by Indiana's proofreading of West's treatise. "The important thing . . . was the wood itself," West had written in describing Isaac carrying wood to the mountain for the sacrifice. "Wood always spoke of a cross."[79]

Indiana did not paint his purloined beams very much at first, preferring to keep their weathered patination and earthy color harmonies as "exercises in natural finishes."[80] The resemblance of his smaller constructions to stelae inspired him to title them—often retrospectively—after contemporary political events: France's explosion of a nuclear weapon in the Sahara (*French Atomic Bomb*; fig. 34);

FIG. 26 Island marble herm, Archaic Greek,
c. 520 BCE. National Archaeological Museum,
Athens, Greece

Fidel Castro's alliance with the U.S.S.R. (*Cuba*; 1960–62); and the downing of Francis Gary Power's spy plane over the Soviet Union (*U-2*; 1960). The larger size of subsequent pieces reminded Indiana of ancient herms, the stone or bronze rectangular pillars set at important intersections and along roads in the ancient world (fig. 26). Decorated with a head of Hermes, god of boundaries and travel, these ancient signposts often sported an erect phallus, which the Greeks believed averted evil. Indiana imagined a link between masturbation and herms, particularly the herm he remembered seeing at the Ashmolean Museum in Oxford during his year abroad.[81] Intrigued by these allusions, he began to fashion his constructions as modern-day versions of ancient *hermae*, attaching bicycle wheels to their sides to evoke the winged sandals of Hermes and suggesting the human body by painting paired circles at eye level, inserting phallic wooden pegs in the sculptures' lower registers, and once, filling the holes left by a removed wheel with studs to emulate nipples. So palpable was the suggestive human quality of these "herms," as Indiana called his constructions, he later confessed that they were a source of physic comfort during lonely times in the absence of a family.[82]

Indiana did not invent his herms in isolation. Even apart from the found-object experiments of his fellow downtown denizens Robert Rauschenberg and Agnes Martin, assemblage was a popular technique for those wishing to abandon the metaphysics of Abstract Expressionism and bring art into contact with the ordinary and the "real." The growing number of practitioners experimenting with the approach caught the attention of Martha Jackson, the owner of a highly respected eponymous gallery uptown. In June and September of 1960, in a two-part show called *New Forms–New Media*, Jackson assembled the work of seventy-one artists who constructed their work out of discarded materials.[83] Rolf Nelson, a resident of Coenties Slip and the gallery's director, included Indiana's *French Atomic Bomb* in the show's first installation and another herm, *GE* (fig. 41), in its second. Unlike most other works in the Jackson show, which depended compositionally on the hierarchical balance of parts, Indiana's herms were monolithic and symmetrical. Equally distinctive was his inclusion not only of "found materials" but also of "found images"—circles, stars, letters, and numbers—which he applied using die-cut stencils he had discovered in Lenore Tawney's loft.[84]

Indiana often modified existing herms sometimes months after their initial completion by changing the number or placement of their wheels and pegs.[85] By the time the first Martha Jackson show closed, he had begun stenciling complete words onto them.[86] Ever since moving to Coenties Slip, he had been impressed by the plethora of signs that surrounded him every day—they were everywhere, "more profuse than trees," he recalled (fig. 25).[87] Painting words, circles, hazard bars, bands, stars, and numbers in bright colors onto his herms was a way to connect them with everyday experience and thereby with the egalitarian populism characteristic of the American heartland. He approached the problem of adding words to his herms pragmatically, accepting that the width of the wooden beams restricted

LEFT

FIG. 29 Nineteenth-century crate stencil for
The American Hay Company. Collection of
the artist

RIGHT

FIG. 30 Robert Indiana, *Brow*, 1960–62. Oil on
wood and metal wheels, 44¾ × 18½ × 13¾ in.
(113.6 × 46.9 × 34.9 cm). Private collection,
courtesy Meredith Palmer Gallery, Ltd.,
New York

his choice to elementary words three or four letters long. Applied with stencils
that had been used in earlier times to affix trademarks and labels onto commercial
freight, the words possessed the immediacy of signs, but ones whose messages were
obscure. Simultaneously straightforward and unfathomable, they endowed Indi-
ana's herms with an "ominous presence," one critic remarked, as if reflecting
Hermes's role as guide to the underworld and mediator between the conscious and
unconscious mind.[88]

By October 1960, with almost twenty herms finished or underway, Indiana was
sufficiently confident about using words as an element in his art to begin applying
them to his existing ginkgo and orb paintings.[89] He proceeded cautiously at first,
limiting his choice of words to neutral but distinctly American nouns: female nick-
names in *The American Sweetheart* (fig. 48) and place names in *The Slips* (fig. 46) and
Terre Haute (fig. 47), the first painting he conceived with words already in mind. In
The Slips, he faced the challenge of how to accommodate words of more than three
or four letters. The circular format of a stencil for The American Hay Company
provided the solution, becoming in the process the template for much of his future
work (fig. 29). "[I]t was [that] one stencil in particular which has more or less cast

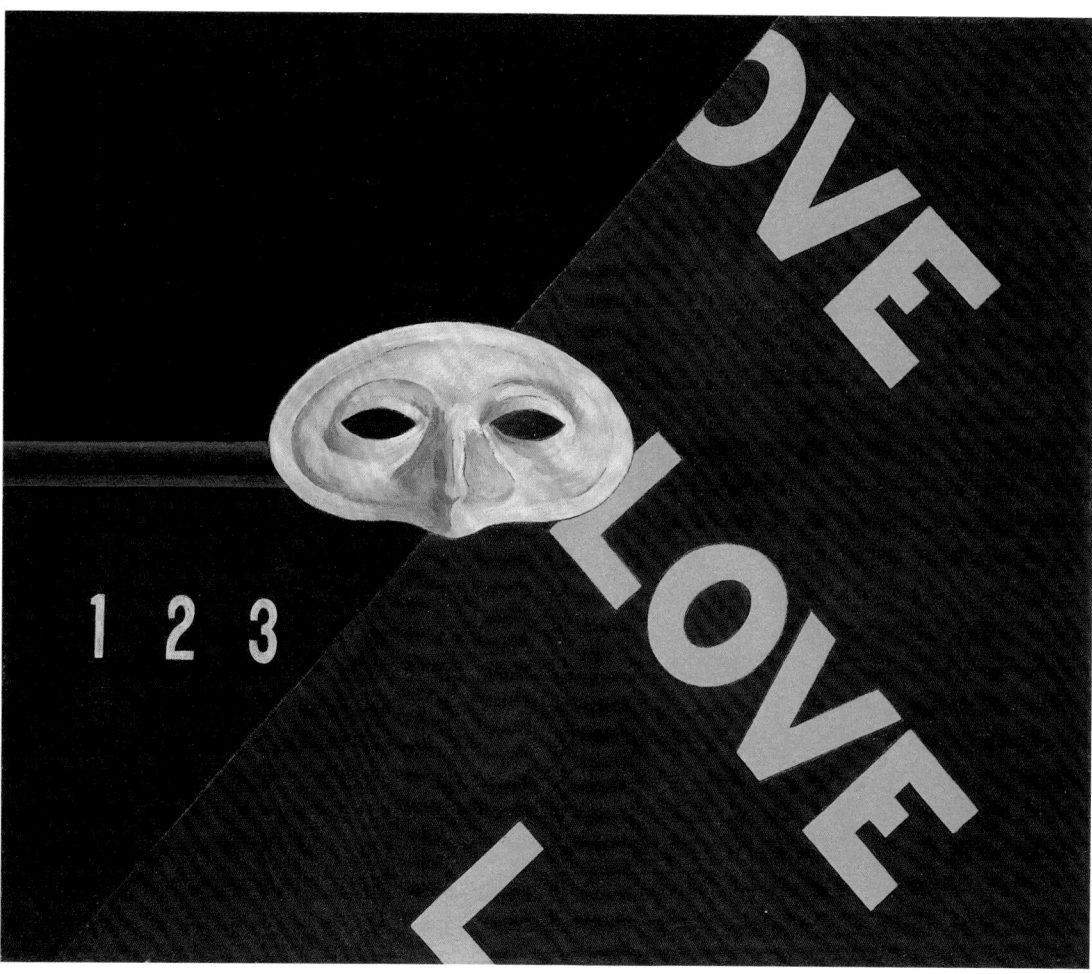

FIG. 31 Charles Demuth (1883–1935), *Love, Love, Love (Homage to Gertrude Stein)*, 1928. Oil on panel, 20 × 20⅞ in. (51 × 53 cm). Museo Thyssen-Bornemisza, Madrid, Spain

the die of my whole work," Indiana later said. "From that one stencil I derived my circular motif."[90]

Although initially tentative, Indiana's marriage of language and hard-edge abstraction was audacious—"miscegenatious," he called it.[91] It was one thing to insinuate words into an overall composition or to depict them with painterly brushstrokes, but to present them without mediation, in the style of advertisements, was unprecedented. One artist who had ventured in that direction earlier was Charles Demuth, whose "poster portraits" Indiana remembered seeing in Chicago.[92] Intended to symbolically convey their subjects' psychic and physical characteristics by means of recognizable images, Demuth's crisply demarcated paintings, emblazoned with numbers and words, resembled advertising placards. One painting in particular, Demuth's *Design for a Broadway Poster*, known now as *Love, Love, Love (Homage to Gertrude Stein)* (fig. 31), would later fascinate Indiana. The work's purported connection to Stein, its incorporation of the word "love," and its depiction of a mask, which Indiana acknowledged he had assumed when he changed his name, combined to make the work special to him.[93] He might have been even more intrigued had he known that the painting's association with Stein occurred only after Demuth's death. Its more credible subject was Robert Locher, the artist's lifelong friend and a fellow resident of Lancaster, Pennsylvania, with

GREENWICH STREET. *THURSDAY*

FIG. 32 Indiana's journal, dated Thursday, May 10, 1962, with sketch of the painting *The Sweet Mystery* (1959–62). Collection of the artist

whom Demuth likely had a clandestine sexual relationship that was in the process of dissolving during the period in which the artist executed the painting.[94]

Despite the precedent of Demuth, Indiana's newly charted path appalled Ellsworth Kelly, still a Coenties Slip neighbor, who had always taken care to exclude extrapictorial connotations from his art. Almost defiantly, Indiana persisted, convinced that elevating language to a dominant position in his work represented a modern step.[95] Because words were "already soaked with humanity," as the French poet Guillaume Apollinaire noted, using them in art forced a direct relationship between a work and its audience by transferring subjectivity to the viewer.[96] "[E]veryone drifts into some kind of projection from their own experience," Indiana would later say.[97] He enjoyed exploiting the narrative and allegorical possibilities of words to create what one critic called "a deliberately constructed labyrinth," the deciphering of which was akin to solving a puzzle.[98] He sometimes provided oblique clues, titling *The Sweet Mystery* (fig. 49), for example, after the well-known song about love from the turn-of-the-century operetta *Naughty Marietta* by Victor Herbert—a choice redolent with nostalgia.[99] To buttress the song's theme of love's pain and longing, Indiana painted red and black danger strips on the top and bottom of paired doubled ginkgo leaves, as if warning of the often bittersweet nature of intimacy—of its "hereness" and "nonhereness" as he described it in a 1968 text on the painting, in which he also interpreted the foul smell of the female ginkgo leaf as an "anguished protest" over its inability to have sex.[100]

Indiana's next word painting, *The Triumph of Tira* (fig. 50), contained an even greater kaleidoscope of meanings. He repeatedly called the work a companion to *The Sweet Mystery*, suggesting that it, too, addressed the paradoxes and volatility of intimacy and sexuality, but he also linked it to Mae West's performance as the carnival performer Tira in *I'm No Angel*.[101] The words "law," "cat," "sex," and "men" applied equally well to both readings, correlating loosely with the film's plot while also referencing the perils of homosexuality in an age when sodomy was illegal—an interpretation coinciding with West's status as a gay icon. In West, whom Indiana called "the *most* American bloom to have flowered on this 'scene,' which, in my case, is obviously A*M*E*R*I*C*A*N*," he found a model through which to express his belief in America and the "Americasm [*sic*] . . . that is sweeping every continent."[102] Having grown up at a time when "all eyes pointed toward Europe,"

he vowed "to help make that otherwise" by jettisoning what he regarded as European-based abstraction in favor of American subjects depicted with an archetypal American technique.[103] "I propose to be an American painter," he announced, "not an internationalist speaking some glib visual Esperanto."[104] Determined to "paint the American scene . . . in an American way," he embraced the "neon polychromy of Now America," asking rhetorically about his marriage of high-key color and sharp-edged forms: "How American can a technique get?"[105]

With his next word painting, *The American Dream, I* (fig. 51), Indiana broadened the thematic scope of his work to address what he felt was the shallow materialism in American "spiritual, economic, political, social, sexual and cultural" realms.[106] As he had done before, he over-painted an earlier work, in this case *Agadir*, retaining its angled lines and circles as if wishing to preserve the essence of his earlier romantic breakup, while recasting it as a more universal experience. Privately, jilted love remained a subtext, as suggested by his journal entry in which he called the work "my Mexicali Rose," a popular song about a man saying goodbye to his love.[107] To underscore the broader theme of unprincipled avarice in American culture, he introduced the words "TAKE ALL" and "TILT," associated with the greed of gambling and the fraud of "tilting" the pinball machine. Seeing Edward Albee's play *The American Dream* in January 1961 gave him a title for his painting. As with Albee, who called his play "a stand against the fiction that everything in this slipping land of ours is peachy-keen," Indiana viewed the American Dream as "broken . . . no longer in effect for us and for lots of others."[108] He equated the phrase with the grandiose ambitions of his adoptive father, whose dreams of "the big house on the hill" never materialized.[109] "'The American Dream' relates to something my father had," Indiana said. "He had an American dream that turned out to be hollow."[110] Just as Albee's play had drawn on the personal to portray "something [that has] to do with the anguish of us all," so too did Indiana's work encompass "every American's [dream] via the artist's personal experience."[111] Painted in flat, high-key colors against a dark ground, the painting's motifs produced an unsettling kinetic effect that evoked the flashing lights, raucous din, and neon glare of the pinball and slot machines in the "grubby bars and roadside cafes" that his adoptive parents frequented in their frantic efforts to distract themselves "from any meaningful aspects of life."[112] The painting was unnerving precisely because it was neither exclusively critical nor unabashedly celebratory; its message was dark, but its visual punch was exhilarating. It was a "Holy Both," uniting in one picture the pains and joys of American life. "Alienation and commitment might well describe both my work and life," Indiana admitted.[113] His genius was to openly portray what he called "all the meaner aspects of life," while simultaneously testifying to America as "the best of all possible worlds."[114]

FIG. 33 Robert Indiana, *Wall of China*, 1960–61.
Gesso, oil, and iron on wood, 48 × 54¾ × 8 in.
(121.9 × 139 × 20.3 cm). Private collection

FIG. 34 Robert Indiana, *French Atomic Bomb*, 1959–60. Painted wood and metal, 38⅝ × 11⅝ × 4⅞ in. (98 × 29.5 × 12.3 cm). Museum of Modern Art, New York; gift of Arne Ekstrom

LEFT

FIG. 35 Robert Indiana, *Moon*, 1960. Painted wood, concrete, and iron wheels, 78 × 17⅛ × 10¼ in. (198.1 × 43.5 × 26 cm) including base. Museum of Modern Art, New York; Philip Johnson Fund

RIGHT

FIG. 36 Robert Indiana, *Moon*, 1960 (reverse)

FACING

FIG. 37 Indiana's journal, dated Wednesday, August 3, 1960, with sketch of *Moon* (1960). Collection of the artist

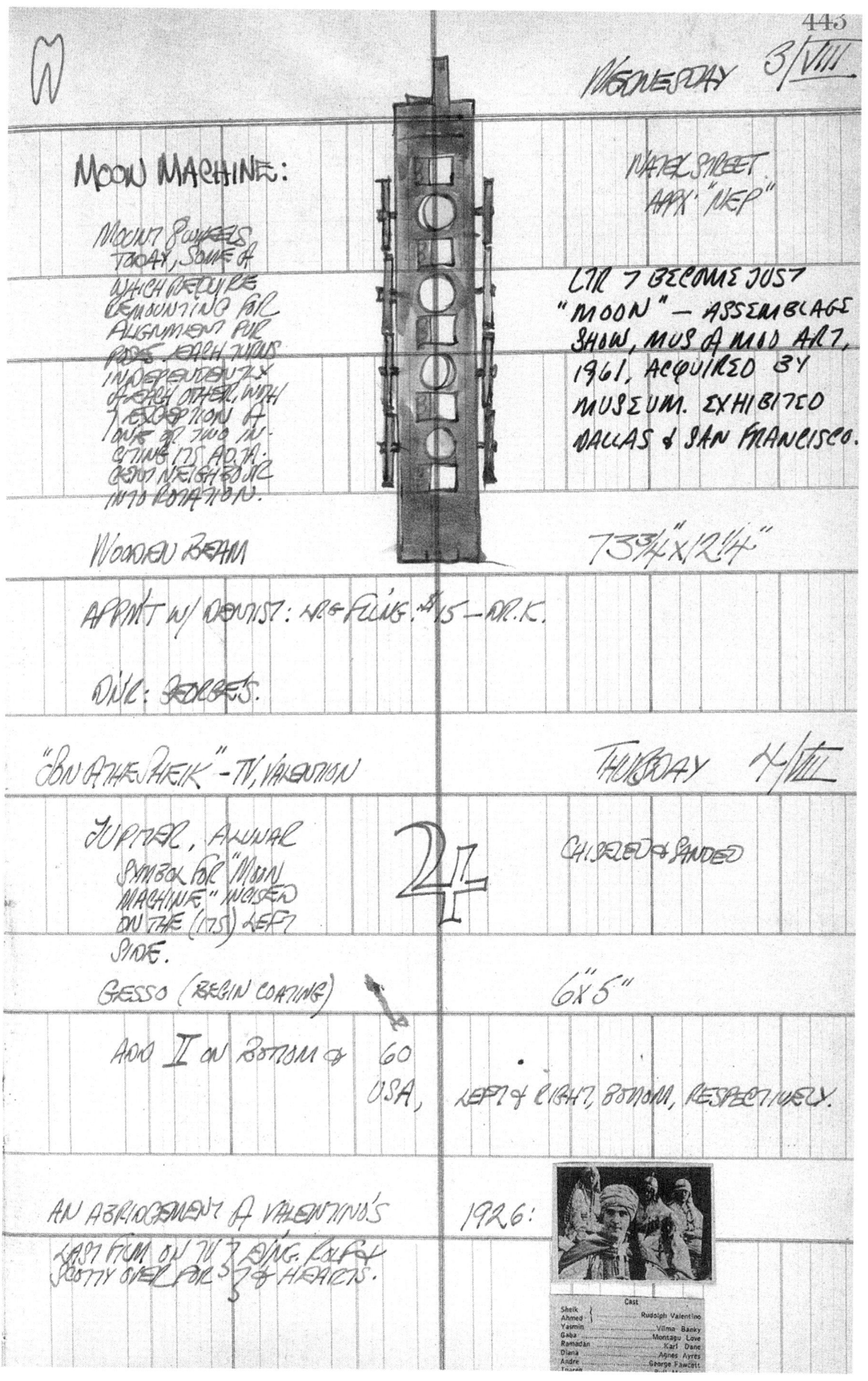

Ⓜ

MOON MACHINE:

MOUNT 8 WHEELS TODAY, SOME OF WHICH REQUIRE REMOUNTING FOR ALIGNMENT FOR PROPER EACH TURNS INDEPENDENTLY OF EACH OTHER, WITH THE EXCEPTION OF ONE OR TWO IN-CITING ITS ADJ. GEAR NEIGHBOR INTO ROTATION.

WATER STREET APPX "NEP"

LTR 7 BECOME JUST "MOON" — ASSEMBLAGE SHOW, MUS A MOD ART, 1961, ACQUIRED BY MUSEUM. EXHIBITED DALLAS & SAN FRANCISCO.

WOODEN BEAM

73¾" X 12¼"

APPMT W/ DENTIST: NRG FILLS. #15 — DR. K.

DENT: FORBES.

"SON OF THE SHEIK" — TV, VALENTINO

JUPITER, ALWAYS SYMBOL FOR "MOON MACHINE" INCISED ON THE (ITS) LEFT SIDE.

♃

CHISELED & SANDED

GESSO (BEGIN COATING)

6" 5"

ADD ⚢ ON BOTTOM & 60 USA,

LEFT & RIGHT, BOTTOM, RESPECTIVELY.

AN ABRIDGEMENT OF VALENTINO'S LAST FILM ON TV TONIGHT. PLAY SPOTTY OVER FIRST 3/4 HEARTS.

1926:

Cast	
Sheik Ahmed	Rudolph Valentino
Yasmin	Vilma Banky
Gaba	Montagu Love
Ramadan	Karl Dane
Diana	Agnes Ayres
Andre	George Fawcett

FIG. 38 Indiana's journal, dated Thursday, April 20, 1961, with sketch of *Womb* (1960). Collection of the artist

FIG. 39 Robert Indiana, *Law*, 1960–62. Painted wood and metal wheel, 44⅛ × 10⅞ × 3⅛ in. (111.9 × 27.6 × 7.8 cm). Museum of Modern Art, New York; gift of Philip Johnson

FIG. 40 Robert Indiana, *Star*, 1960–62. Oil and gesso on wood and iron wheels, 76 × 18 × 13 in. (193 × 45.7 × 33 cm) overall. Albright-Knox Art Gallery, Buffalo, New York; gift of Seymour H. Knox, Jr., 1963

FACING, LEFT

FIG. 41 Robert Indiana, *GE*, 1960. Gesso and oil on wood and iron-and-wood wheels, 58½ × 12 × 14 in. (148.6 × 30.5 × 35.6 cm). Private collection

FACING, RIGHT

FIG. 42 Robert Indiana, *Hole*, 1960. Oil on wood and iron wheels, 45 × 19 × 13 in. (114.3 × 48.3 × 33 cm). Private collection

RIGHT

FIG. 43 Robert Indiana, *Orb*, 1960. Oil and iron on wood and iron wheels, 62 × 19½ × 19 in. (157.5 × 49.5 × 48.3 cm). Private collection

FIG. 44 Indiana's journal, dated Friday, April 27, 1962, with sketch of *Cuba* (1960–62). Collection of the artist

FACING

FIG. 45 Robert Indiana, *Zig*, 1960. Oil on wood, wire, and metal wheels, 65 × 17¾ × 16⅛ in. (165.1 × 45 × 41 cm). Museum Ludwig, Cologne

FIG. 46 Robert Indiana, *The Slips*, 1959–60.
Oil on Homasote, 96 × 48 in. (243.8 × 121.9 cm).
Private collection

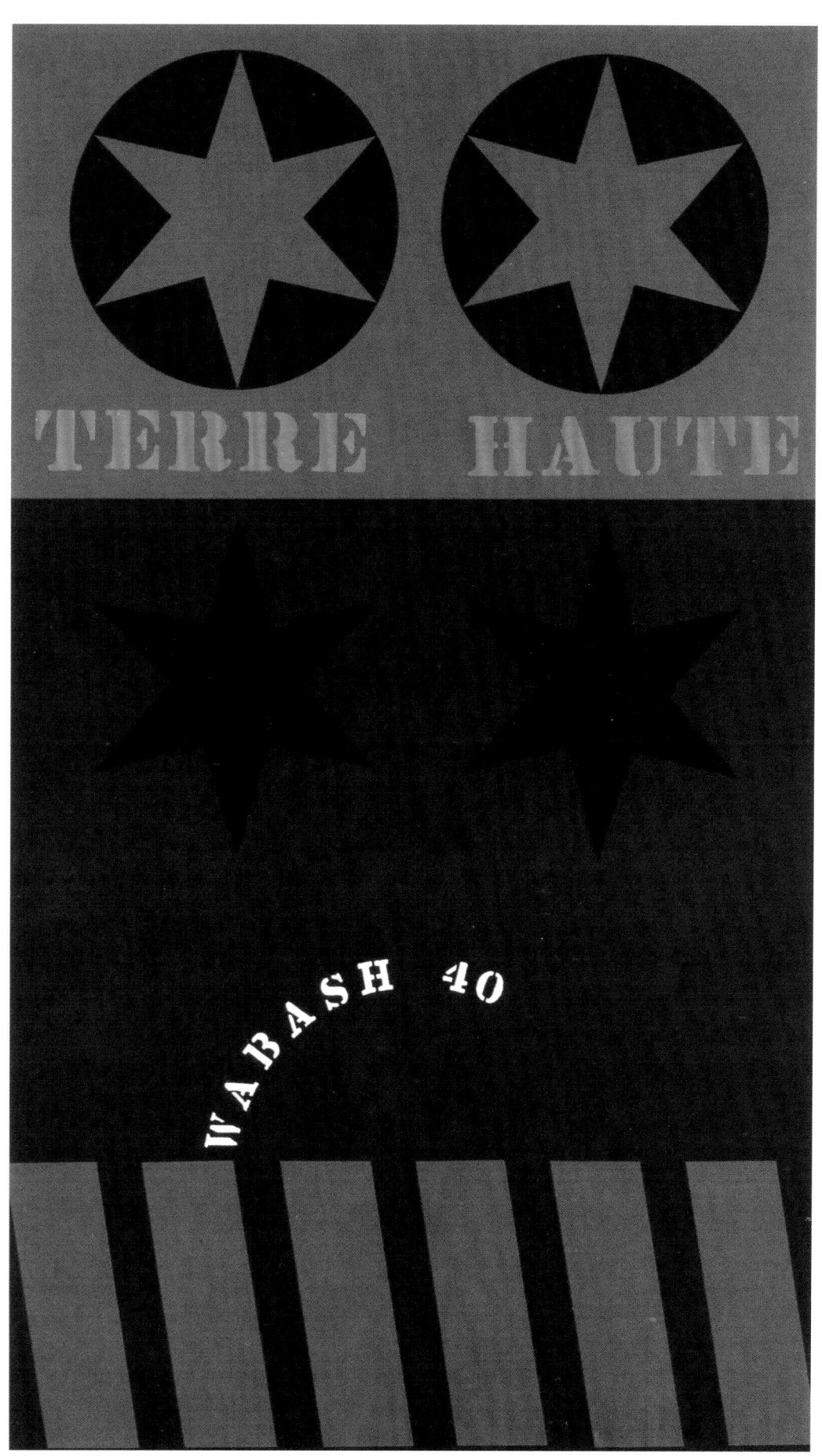

FIG. 47 Robert Indiana, *Terre Haute*, 1960.
Oil on canvas, 60 × 36 in. (152.4 × 91.4 cm).
Indiana State Museum, Indianapolis

FIG. 48 Robert Indiana, *The American Sweetheart*, 1959–61. Oil on Homasote, 96 × 48 in. (243.8 × 121.9 cm). Cari and Michael J. Sacks

FACING

FIG. 49 Robert Indiana, *The Sweet Mystery*, 1959–62. Oil on canvas, 72 × 60 in. (182.9 × 152.4 cm). Private collection

THE SWEET MYSTERY

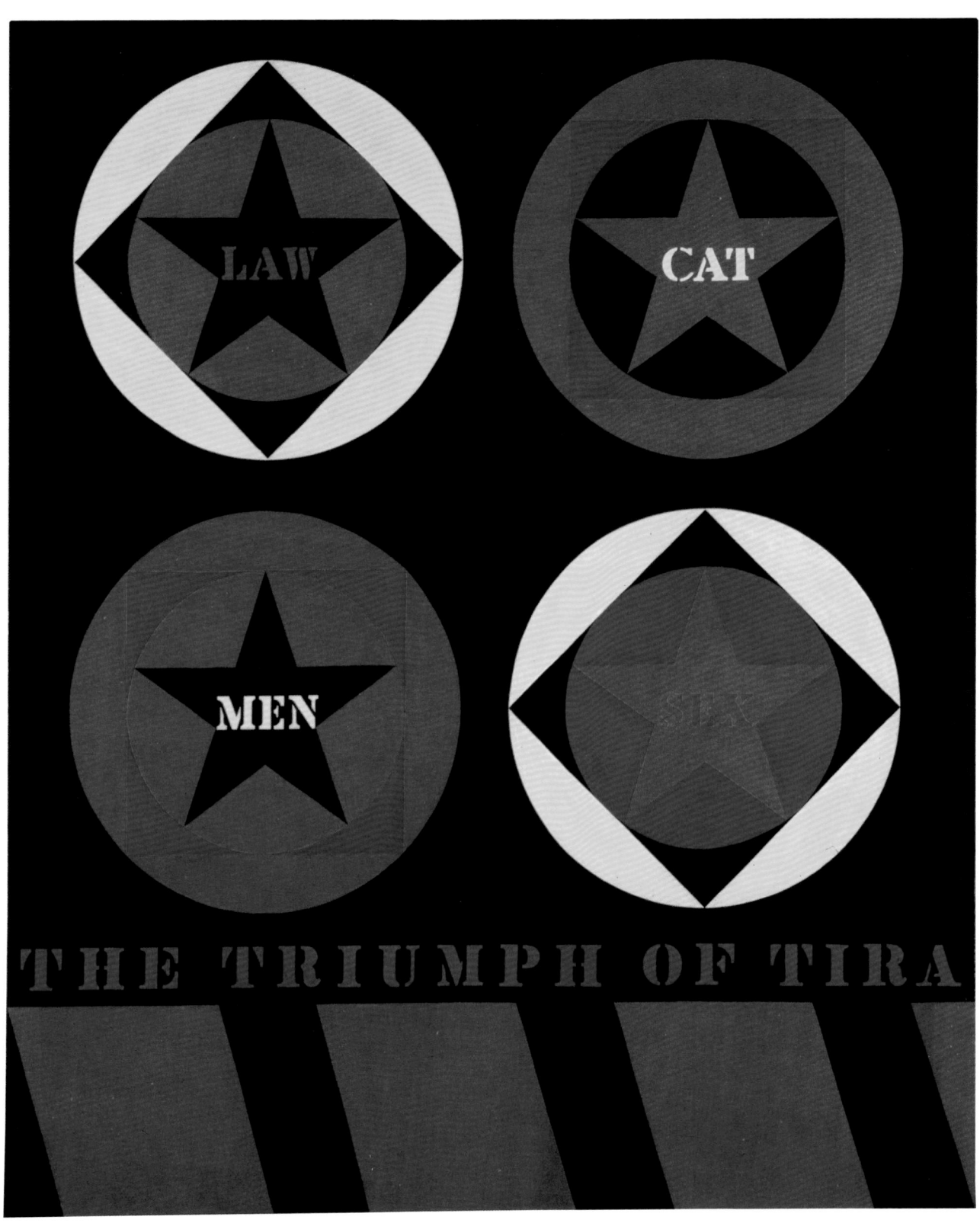

FIG. 50 Robert Indiana, *The Triumph of Tira*, 1960–61. Oil on canvas, 72 × 60 in. (182.9 × 152.4 cm). Sheldon Museum of Art, University of Nebraska–Lincoln; NAA-Nelle Cochrane Woods Memorial

FIG. 51 Robert Indiana, *The American Dream, I*,
1961. Oil on canvas, 72 × 60⅛ in. (183 × 152.7 cm).
Museum of Modern Art, New York; Larry Aldrich
Foundation Fund

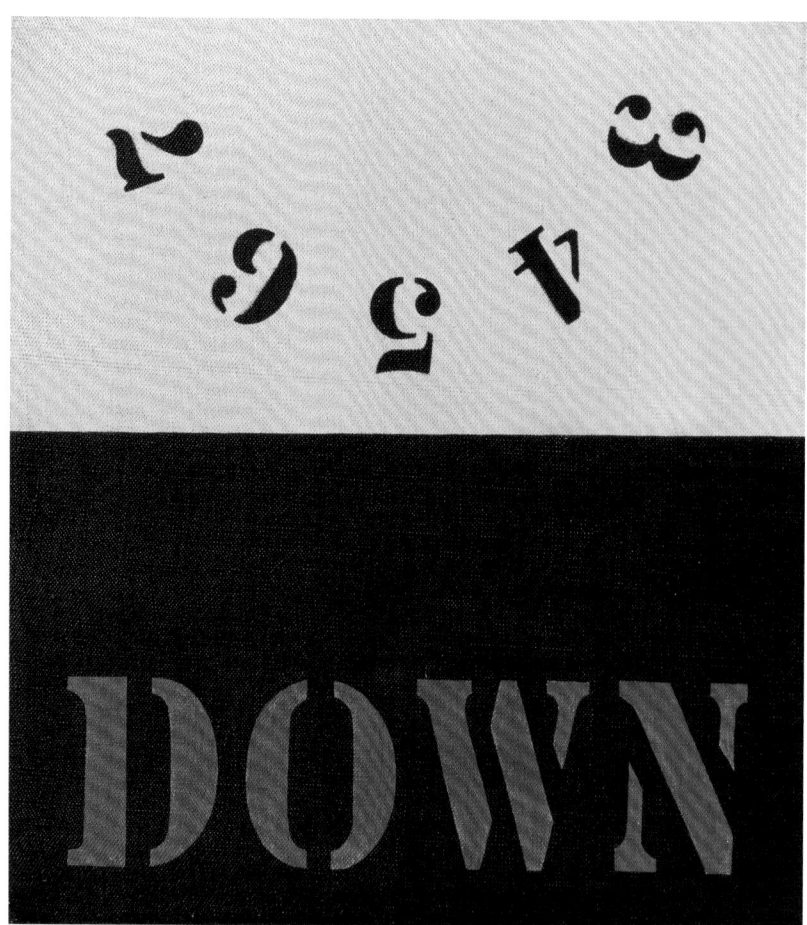

FIG. 52 Robert Indiana, *Down*, 1962. Oil on canvas, 12 × 12 in. (30.5 × 30.5 cm). Collection of Shirley and William Lehman

Indiana had introduced language into his work in the belief that it was fundamental to human existence.[115] The popular writings of linguist Noam Chomsky had persuaded him that language is, in Indiana's words, "an inherited process . . . it is simply not a learned thing but is something which the human species is peculiarly not only adapted to but inclined toward."[116] In Chomsky's view, all human thought, including visual data, is structured by means of innate linguistic rules that determine how information is organized and how meaning is assigned. For Indiana, the idea that language shapes all human cognition, including the visual, meant that it was inaccurate to divide language, idea, and visual experience into separate spheres.[117] He vowed to "undo" their compartmentalization by locking them into indivisible "verbal-visual" wholes, on which viewers would concentrate so intently that they would lose "conscious grasp" of the words and images as distinct.[118] "I should like . . . this to be part of my work," he said.[119]

To test his hypothesis about the interconnection between language, thought, and visual perception, Indiana created a series of paintings in 1961 and 1962 in which he placed single words—"HUG," "LOVE," "FUN," "UP," "GRASS"—in one half of the canvas and, in the other, a recognizable image or field of pure color (figs. 52, 53). Seen as a unit, the two halves created a verbal-visual riddle, much like the koans Zen Buddhists use to focus the mind during meditation. The works' small size, most measuring twelve inches square, lent them the intimacy of books.

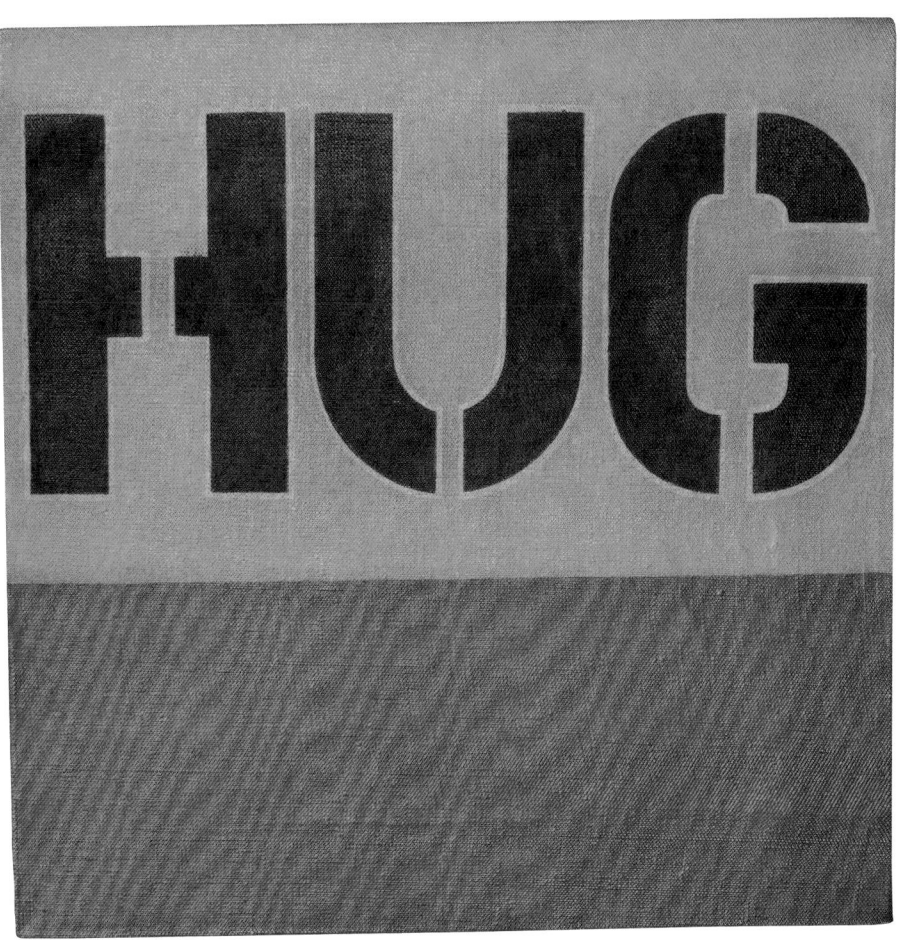

Indiana liked how the paintings' two quadrants demanded to be read as interdependent, and he debuted one of these works in New York in March 1961 in a show with Steve Durkee and Richard Smith at Paul Sanasardo's dance studio, and premiered more than a dozen in a small gallery in Mamaroneck, north of the city, the following year.[120]

Over the next twelve months, Indiana introduced more emotionally charged words into his work, in particular "eat" and "die," both of which had deeply personal associations for him—from his adoptive mother's obsession with death and the ubiquitous "EAT" signs that adorned the diners where she worked, to the last words she spoke to him before she died.[121] He would later say the two words were "my whole [life] . . . my whole childhood."[122] Privately, he associated "eat" with love and "eat/die" with the Last Supper, aligning the words with notions of affection, human fallibility, and forgiveness.[123] But the pairing also expressed something so fundamental about the human condition that the words themselves needed no interpretation. In contrast to sixteenth- and seventeenth-century Dutch and Flemish *vanitas* paintings, whose symbolism required explication, *Eat/Die* (fig. 85) conveyed its message with an authoritative immediacy. Executed in bold colors and block letters, the words' shouts of rage, triumph, fear, and warning possessed a directness and universality that Indiana likened to the Ten Commandments.[124] It was as if Indiana had been primed by his training in Christian Science to view

The text within the image (as drawn labels):
— TOGETHER · ON THE MOUNTAINS OF THE PRAIRIE —
THE TRIBES OF MEN
THE MIGHTY GITCHE MANITO
DELEWARE
MOHAWKS
HURONS
OJIBWAYS
CHOCTAWS
CAMANCHES
MANDANS
PAWNEES
KUNANA
THE CALUMET
SHOSHONIES
BLACKFEET
OMAHAS

"THE CALUMET"
AS IT WAS PUSHED → COMPLETION
A FINAL DESIGN, WITH STARS NOT
DECIDED UPON AT FIRST.

words as sacred. In Genesis, God *speaks* creation into existence; by the Gospel of John, the sanctity of words has become a centerpiece of Christianity: "In the beginning was the Word, and the Word was with God, and the Word was God . . . the Word became Flesh." Although Indiana had long before abandoned the Christian Science church, such scriptural references to the importance of words had been indelibly ingrained.

Eager to see how far he could go in creating indivisible "verbal-visual" wholes, Indiana stenciled entire sentences from American literature into triangular and circular formats that rendered comprehension of the texts almost subliminal. The choice of writers was significant: by focusing exclusively on canonical American literature, he declared his bond with the nation's literary past and proclaimed his identity as an American. Tellingly, his first completed literary painting used the opening stanzas of one of the country's most iconically nationalistic poems, Henry Wadsworth Longfellow's *The Song of Hiawatha*, in which warriors from various Native American tribes are called together and admonished to put aside their discord and find strength in their union (fig. 59). Myriad interpretations have been advanced about Indiana's selection of this text, from Susan Ryan's claim that the artist's choice owed to the phonetic similarity between "Indians" and "Indiana" to Jonathan Katz's speculation that the "calumet" (peace pipe) alluded to homosexuality.[125] Indiana's empathy for victims of social injustice would have sensitized him to the country's mistreatment of Native Americans and, indeed, he often spoke of the painting as an "homage to the American Indian."[126] Nevertheless, his particular choice of lines from the poem strongly suggests that brotherhood and peace were his message. Indeed, the construction of the Berlin Wall, which escalated tensions between the Soviet Union and Western Bloc countries in the months just prior to his commencement of *The Calumet,* would have made the harmony of nations a logical subject for him to address. Yet apart from specific lines, choosing Longfellow was, in itself, noteworthy. The poet was the most popular American writer of his day; by 1960, however, he had fallen into critical disrepute among the elite as a nostalgic sentimentalist. Indiana's choice of *The Song of Hiawatha* as subject matter testified not only to his self-conscious identification with American myths and history but also to his faith in American populism.

Indiana's engagement with American literature led him from Longfellow to another iconic American writer: Herman Melville. Inspired by the coincidence of living in the same neighborhood as the one inventoried in the opening chapter of *Moby Dick*, which he had first read with his close friend and former Chicago classmate John Curtis, Indiana turned to Melville's epic novel as a subject, stenciling the names of the sites mentioned by the narrator along with the writer's descriptive phrases of them onto three canvases.[127] *The Melville Triptych* (fig. 60), with its cartographic diagrams of Corlears Hook, Coenties Slip, and Whitehall, is more an homage to Indiana's neighborhood than either to sexuality, as some critics have suggested, or to what Melville called the "heartless voids and immensities of the

FIG. 54 Indiana's journal, dated Thursday, July 13, 1961, with sketch of *The Calumet* (1961). Collection of the artist

universe."[128] Not until Indiana painted *Melville* (fig. 61) a few months later did he address the novel's metaphysical aspects, placing lines from its twentieth chapter within a color scheme of red, blue, and green, around the void the artist associated with the "immense, fearful, terrible sea."[129]

After Longfellow and Melville, the third most important American writer in Indiana's pantheon was Walt Whitman. Indiana admired the poet for his democratic subject matter and style, for blurring the boundaries between his private and public self, and for the primacy he gave the body and sexual intimacy, particularly between men. Not surprisingly, Indiana's *Year of Meteors* (fig. 62), drawn from Whitman's poem of the same name, which telescopes the tumultuous events of 1859–60 into a single narrative, has lent itself to analysis as a coded reference to homosexuality; the very act of selecting a poem that Whitman addressed to "the youth I love" would eventually situate Indiana's painting squarely within a discourse on gay identity.[130] Growing up in the Midwest, in an era when homosexual activity was outlawed and "un-American," it is hard to imagine that Indiana could have escaped feeling marginalized, leading a number of critics to link the estrangement they have perceived in his art with what critic and art historian Robert Storr has called "the anxiety of unaccepted longing."[131] Yet as an adult, Indiana does not seem to have been overly concerned about his sexual orientation. "I never think of that broader world," he said. "I just feel so removed from it that it doesn't even come into my thinking very much at all . . . A first condition for the artist [is that] he must be apart."[132] Indeed, what more likely drew Indiana to Whitman was the poet's insertion of himself as a participant in the cultural events taking place around him and his rhapsodic celebration of America as a multitudinous, contradictory democracy. Like Whitman, Indiana treated himself as both object and subject, positioning himself simultaneously as an actor in, and witness of, the culture that surrounded him, while never failing to make his art "sing of the wonder" of America, even in light of its shortcomings.[133] As did his literary role model, Indiana celebrated the country's unpretentious innocence—in such works as *God Is a Lily of the Valley* (fig. 55)—while also acknowledging its darker aspects, as in *Eidolons* (1961), which derived its title from Edgar Allen Poe's "Dream-Land" about a dream-voyager "haunted by ill angels only" who wanders between life and death.[134]

In May 1961, Rolf Nelson, who had become director of the David Anderson Gallery (owned by Martha Jackson's son), included Indiana's herms, assemblages, and early word paintings in a two-person exhibition with Peter Forakis. Viewers of the show were shocked. While Rauschenberg and Jasper Johns had incorporated found objects and images of everyday life into their art some years earlier, they had always done so with gestural paint handling. No painter had so openly challenged the boundary between fine art and commercial advertising; even Swenson, who would become Indiana's most ardent champion, admitted that "none of this work

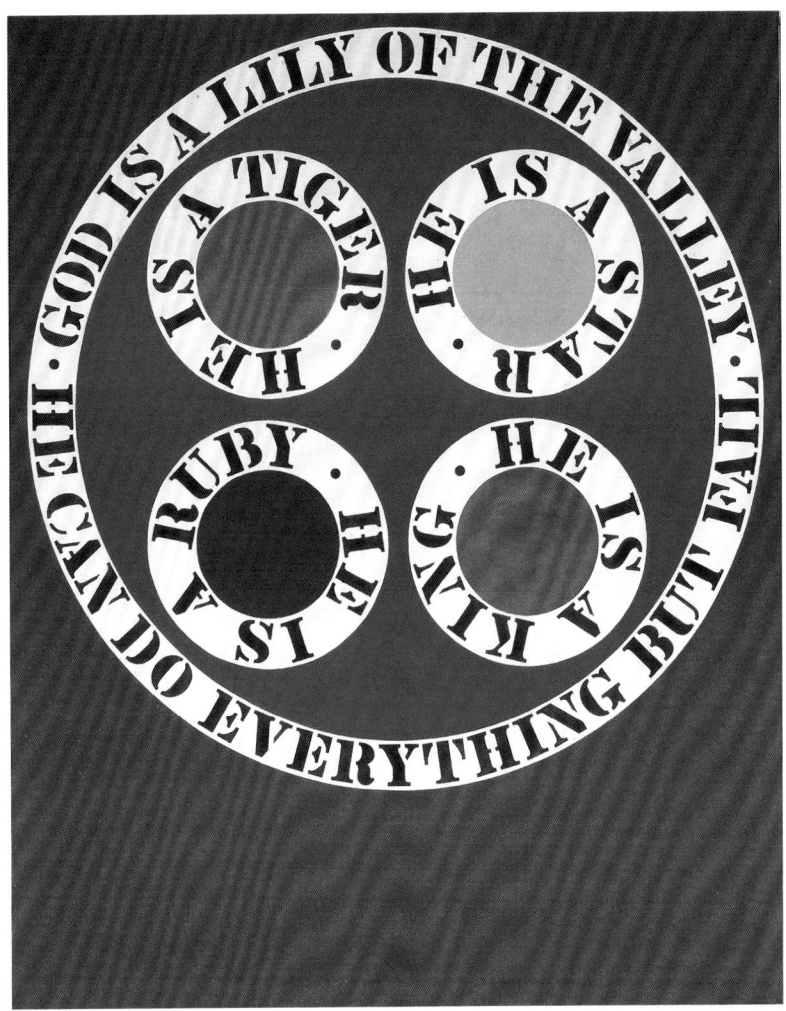

FIG. 55 Robert Indiana, *God Is a Lily of the Valley*, 1961–62. Oil on canvas, 60 × 48 in. (152.4 × 121.9 cm). Collection of Sylvio Perlstein

looks very much like Art."[135] To critic Mario Amaya, there was "something deep and troubling beneath their road-sign simplicity . . . [They] transmit a psychological and emotional jolt, and the artist appears to want them to gnaw into the subconscious and to come to terms with associations, past and present."[136] Not a single work sold during the run of the show, but after it closed, Alfred Barr, director of collections at the Museum of Modern Art, visited the gallery and was mesmerized by *The American Dream, I*, calling its effect "spellbinding."[137] As he had done after seeing Johns's encaustics at the Leo Castelli Gallery in 1958, Barr impulsively bought Indiana's *American Dream* painting for the museum's collection—a decision that instantly thrust the thirty-two-year-old artist into the top echelon of the New York art world. Indiana would later say that the painting "changed the entire course" of his life.[138] In October, Indiana's herm *Moon* (fig. 35) was featured in MoMA's exhibition *The Art of Assemblage*, and it, too, was acquired for the museum's collection. Two months later, when *The American Dream, I* was featured in MoMA's *Recent Acquisitions* show, Indiana's stature as a rising star was confirmed. Writing for *Art International*, Max Kozloff observed that the work was "the most blatantly 'American' painting exhibited," and that it "alone created a stir in this international potpourri."[139]

Despite Indiana's growing reputation on the art scene, Rolf Nelson's move to California in early 1962 had left the artist without a gallery, a situation that was soon remedied when Eleanor Ward chanced to see one of Indiana's herms in MoMA's lending gallery that spring and offered him a solo show at her Stable Gallery for October.[140] During the next eight months, Indiana completed several works already in progress and painted two more *American Dream* paintings, each saluting the heraldic symmetry, chromatic intensity, and emblematic geometries of mass-produced road signs and roulette wheels (figs. 66, 67). The exhibition immediately identified Indiana as one of the emerging artists crashing the gates of New York's art establishment, along with Jim Dine, James Rosenquist, Roy Lichtenstein, Claes Oldenburg, and Andy Warhol, each of whom also had solo shows in New York the same year. By fall, their work was being discussed as a cohesive style. With the opening of *The New Realists* exhibition at the Sidney Janis Gallery in October, Pop art, as it would soon be known, became the "most talked-about art movement of the moment."[141] Janis's stature in the art world, coupled with the show's size—so large that the gallerist was forced to rent a ground-floor storefront on 57th Street to accommodate the overflow from his gallery—implicitly proclaimed that "the New had arrived."[142] The survey's inclusion of Indiana's *Black Diamond American Dream #2* (fig. 66) tacitly nominated the artist as someone who "may already have proved to be the pacemaker of the 60s."[143] In reviews, exhibitions, and books during the next few years, critics and curators followed Janis's lead in aligning Indiana's work with Pop. By 1963, he was being called one of "the best-known Pop artists."[144] Based on his hard-edge vocabulary and engagement with matter-of-fact, comprehensible images, the alliance made sense. But it was always an uneasy pairing. Indiana celebrated what he called Pop's "re-enlistment in the world" and its "U-turn back to a representational visual communication," but his focus on words and numbers rather than on the common objects or media images depicted by many of his peers meant that he was never "hard-core" Pop, as he put it.[145] "I am the least Pop of Pop," he would later say. "I've always been on the outer edge . . . I was never considered a part of the inner circle."[146] Still, despite feeling that his work was more "hard-edge formalist" than Pop, he recognized the benefits of being aligned with a burgeoning movement.[147] Referring to his place in history, he later acknowledged, "I'm sitting here only because of my connection with Pop art."[148]

FIG. 57 Opening of the *Americans 1963* exhibition at the Museum of Modern Art, New York, with Indiana's *The Demuth American Dream #5* (1963) in the background. Photograph by William John Kennedy

Indiana's ascendancy as a leading artist of his generation was codified in May 1963 by his inclusion in Dorothy Miller's prestigious Museum of Modern Art exhibition *Americans 1963*, which presented the work of fifteen emerging contemporary artists, each in a separate gallery (figs. 56, 57). The show's other two Pop representatives, Oldenburg and Rosenquist, dealt with quotidian objects and images culled from the mass media that could be read as transnational. In contrast, Indiana's art forcefully asserted his identity as an American whose experiences derived from the country's heartland. Alone among his peers, he saw himself as an heir of nineteenth- and early-twentieth-century American painters and writers, respect for whom he saluted in works such as *The Demuth American Dream #5* (fig. 82), his dual homage to Charles Demuth and William Carlos Williams, whose poem "The Great Figure" Demuth had memorialized in *I Saw the Figure 5 in Gold* (fig. 154). To emphasize his continuity with America's literary and visual aesthetic heritage, Indiana inscribed "1928" and "1963" into his painting's central panel, denoting the years in which Demuth and he completed their respective canvases. Far from mechanically replicating Demuth's painting, Indiana's ode to it featured his by-now signature five-pointed star on five separate canvases, which he joined

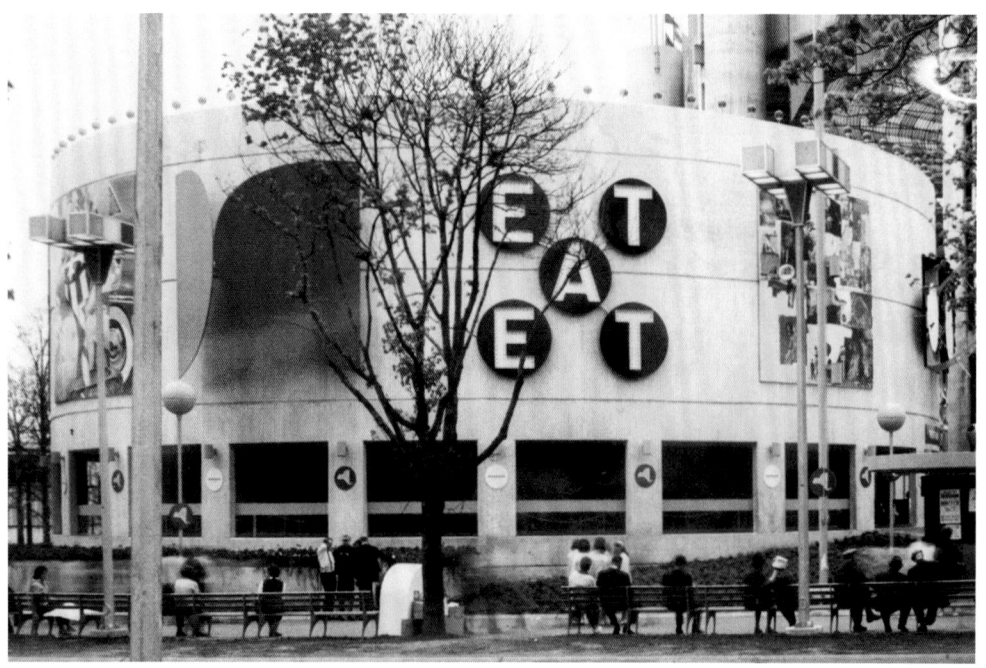

FIG. 58 Indiana's *EAT* (1964) on the Theaterama building of Philip Johnson's New York State Pavilion, New York World's Fair, 1964–65, flanked by works by Ellsworth Kelly and Robert Rauschenberg

together to form a Greek cross, its four traverse panels symbolizing the head, arms, and feet of the human body as well as the division of the world into four elements. Indiana identified these elements as "existence and love and survival and sin," which he conveyed by the words "DIE," "HUG," "EAT," and "ERR."[149]

Even before the conclusion of the eighteen-month nationwide tour of *Americans 1963*, Indiana was practically a household name, with sales of his work sufficiently strong to warrant his inclusion in *Life* magazine's September 1963 article "Sold Out Art." Shortly thereafter, Philip Johnson commissioned him and nine other artists to produce large-scale works to hang on the curved facade of the Theaterama, one of three structures Johnson designed for the New York State Pavilion complex at the 1964 New York World's Fair. Indiana's contribution was a twenty-foot-high illuminated electric sign with the word "EAT" spelled out twice on black circles, in a gigantic X. Programmed to light up sequentially and flash off and on, the electric *EAT* (fig. 58) came closer than anything Indiana had done previously to nearly obliterating the line between art and the signage of everyday life. Indeed, such was the confusion caused by the sign, with visitors lining up in front of the Theaterama looking for the restaurant they assumed was inside, that the fair's organizers turned off the artwork after the first day, rendering it "emasculated and tame," as Indiana would later write.[150] Still, Indiana's art fared better than another work installed on the pavilion's exterior facade: Warhol's *Thirteen Most Wanted Men* (1964), a painting whose presumed celebration of criminal deviance led to it being covered with aluminum house paint before the fair even opened.[151] Notwithstanding this interference, the Theaterama display was seen as a major moment in the public's reception of Pop art. Declaring in *The New York Times* that Pop "has arrived," art critic John Canaday likened the art on the Theaterama's exterior to "statues of saints on the exteriors of Gothic cathedrals."[152] To some, however, the fair's consumerist spectacle overwhelmed the art; as if in response, many of the Pop artists who had produced work for the pavilion began to shift in different directions.[153]

FACING

FIG. 59 Robert Indiana, *The Calumet*, 1961. Oil on canvas, 90 × 84 in. (228.6 × 213.4 cm). Rose Art Museum, Brandeis University, Waltham, Massachusetts; Gevirtz-Mnuchin Purchase Fund

FIG. 60 Robert Indiana, *The Melville Triptych*, 1961. Oil on canvas, three panels, 60 × 48 in. (152.4 × 121.9 cm) each. Private collection

COENTIES SLIP

WHITEHALL

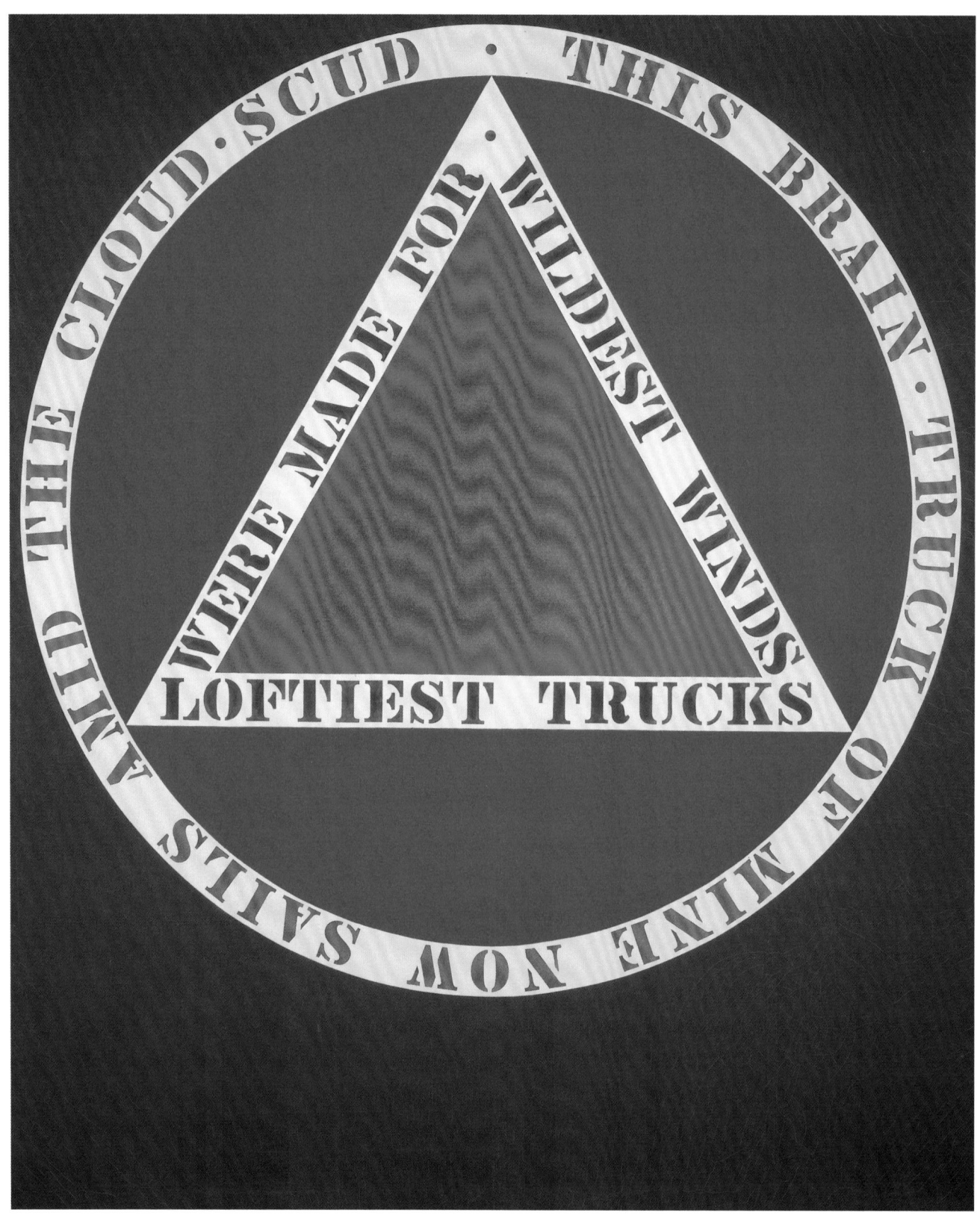

FIG. 61 Robert Indiana, *Melville*, 1961. Oil on
canvas, 72 × 60 in. (182.9 × 152.4 cm). Estate of
Mrs. Walter Netsch

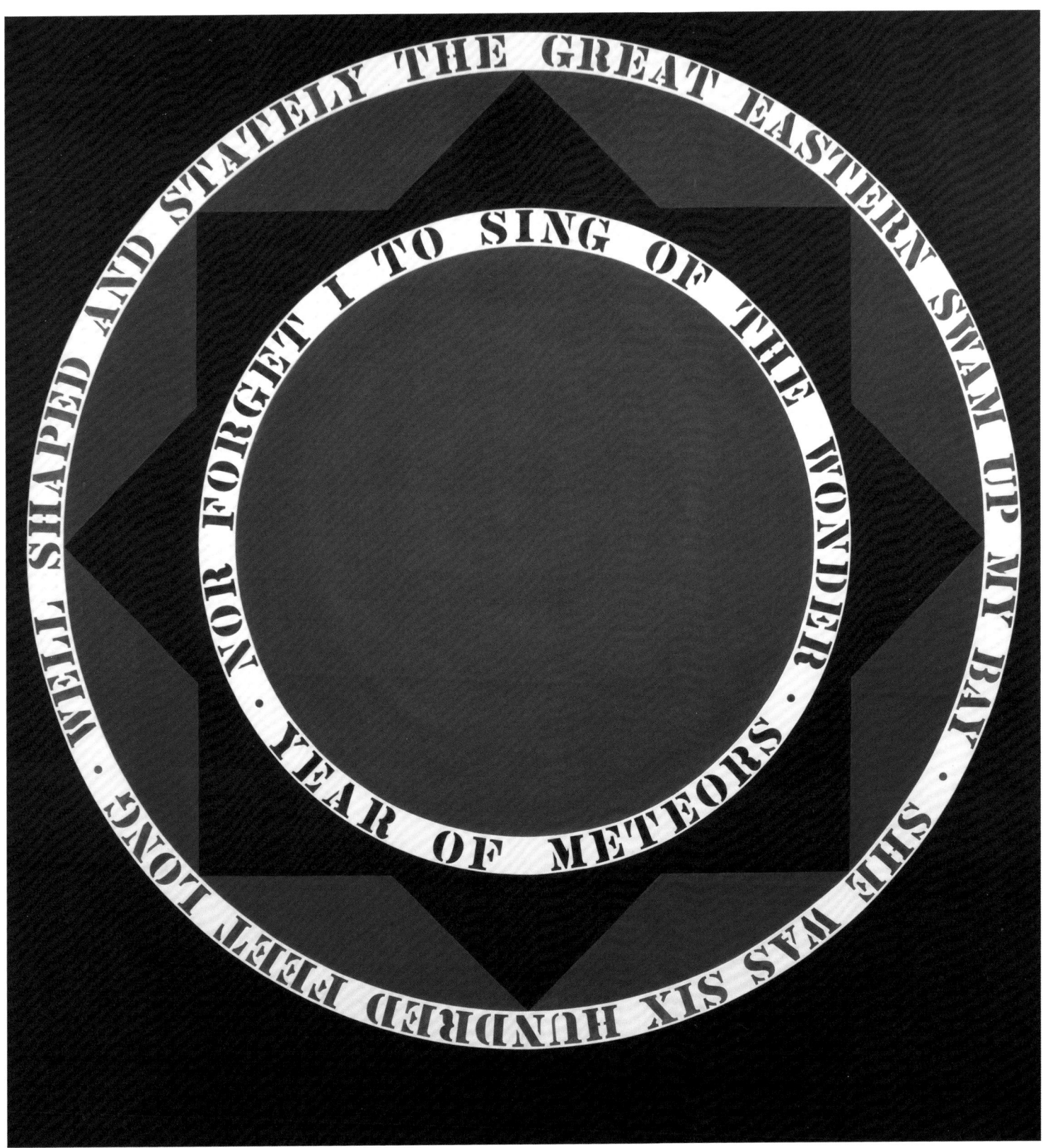

FIG. 62 Robert Indiana, *Year of Meteors*, 1961.
Oil on canvas, 90 × 84 in. (228.6 × 213.4 cm).
Albright-Knox Art Gallery, Buffalo, New York;
gift of Seymour H. Knox, Jr., 1962

The American Dream

FACING, LEFT

FIG. 63 Robert Indiana, *Chief*, 1962. Oil on wood, iron, and metal wheels, 64½ × 23½ × 18½ in. (163.8 × 59.4 × 47 cm). Private collection

FACING, RIGHT

FIG. 64 Robert Indiana, *Womb*, 1960. Oil on wood and iron wheels, 45 × 16¾ × 16 in. (114.3 × 42.5 × 40.6 cm). Private collection

RIGHT

FIG. 65 Robert Indiana, *Ahab*, 1962. Gesso and oil on wood and iron wheels, 61 × 18½ × 14 in. (154 × 47 × 35.6 cm). Private collection

FIG. 66 Robert Indiana, *The Black Diamond American Dream #2*, 1962. Oil on canvas, 85 × 85 in. (216 × 216 cm), diamond. Museu Colecção Berardo, Lisbon

FIG. 67 Robert Indiana, *The Red Diamond American Dream #3*, 1962. Oil on canvas, four panels, 102 × 102 in. (259 × 259 cm) overall, diamond. Van Abbemuseum, Eindhoven, The Netherlands

FIG. 68 Robert Indiana, *Beware-Danger American Dream #4*, 1963. Oil on canvas, four panels, 36⅛ × 36 in. (91.6 × 91.5 cm) each; 102¼ in. × 102¼ in. (259.5 × 259.5 cm) overall, diamond. Hirshhorn Museum and Sculpture Garden, Smithsonian Institution, Washington, D.C.; gift of the Joseph H. Hirshhorn Foundation, 1966

THE EATERIA

FIG. 72 Robert Indiana, *Two*, 1960–62. Oil on wood and iron wheels, 62½ × 19 × 20 in. (158.8 × 48.3 × 50.8 cm). Private collection

FACING, LEFT

FIG. 73 Robert Indiana, *Bar*, 1960–62. Oil on wood and iron wheels, 60½ × 19 × 13 in. (153.7 × 48.3 × 33 cm). Private collection

FACING, RIGHT

FIG. 74 Robert Indiana, *Four*, 1962. Oil and gesso on wood, wire, and iron wheels, 77¾ in. (197.5 cm), height. Private collection

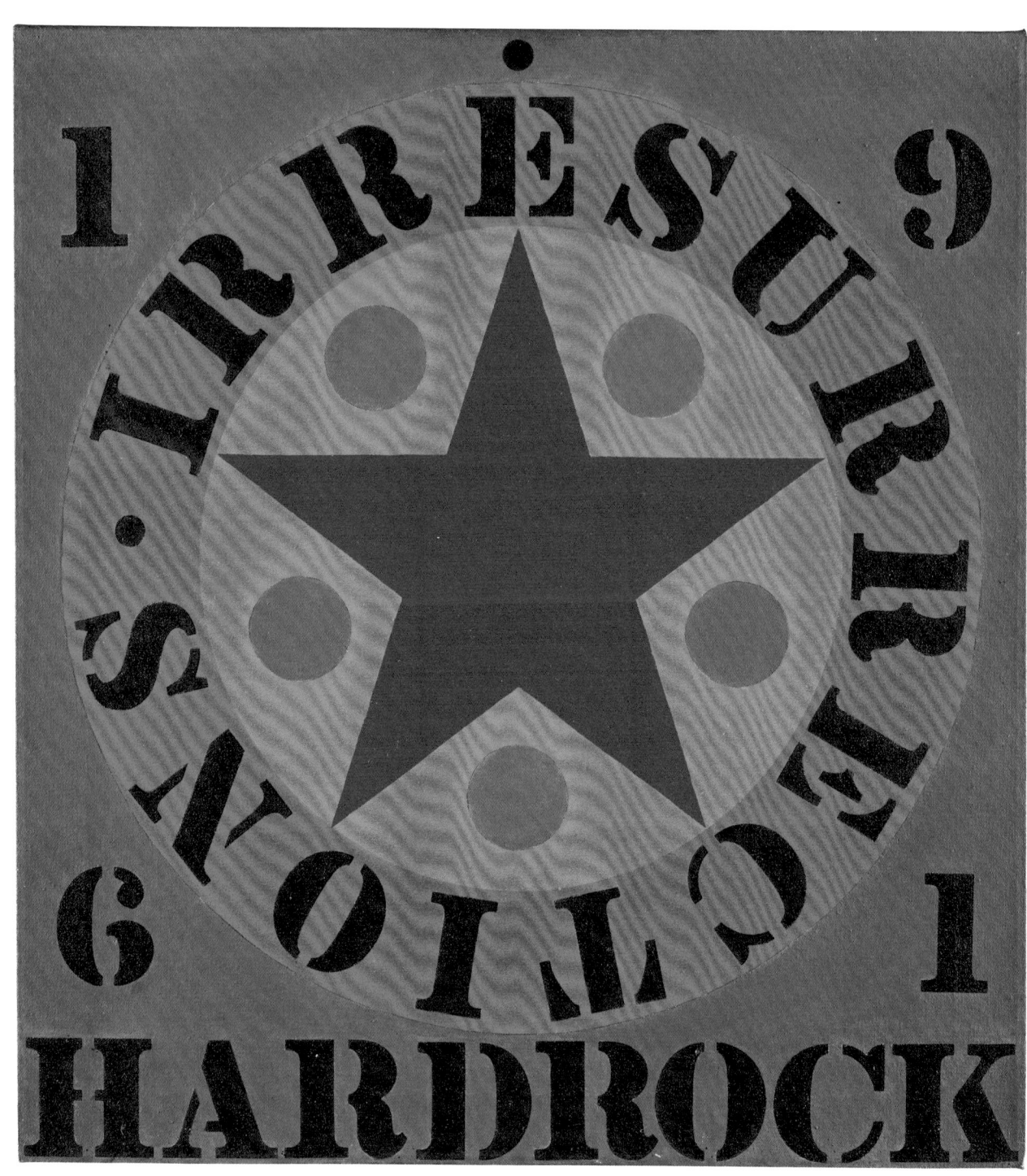

FIG. 75 Robert Indiana, *Hardrock*, 1961. Oil on
canvas, 24 × 22 in. (61 × 55.9 cm). Collection of
Gillian and Simon Salama-Caro

FIG. 79 Robert Indiana, *Five*, 1984. Painted wood
and metal wheels, 69⅛ × 26¾ × 18½ in. (175.6 ×
67.9 × 47 cm). Smithsonian American Art Museum,
Washington, D.C.; gift of the artist

FIG. 80 Group of twelve herms in Indiana's
Coenties Slip studio, New York, c. 1962

FIG. 81 Robert Indiana, *The Small Diamond Demuth Five*, 1963. Oil on canvas, 51¼ × 51¼ in. (130.2 × 130.2 cm), diamond. Private collection

FIG. 82 Robert Indiana, *The Demuth American
Dream #5*, 1963. Oil on canvas, five panels,
144 × 144 in. (365.8 × 365.8 cm) overall. Art Gallery
of Ontario, Toronto; gift from the Women's
Committee Fund, 1964

FIG. 83 Robert Indiana, *Eat*, 1962. Oil on wood
and iron wheels, 60 × 15½ × 17 in. (152.4 × 39.4 ×
43.2 cm). Private collection

FIG. 84 Robert Indiana, *The Electric EAT*,
1964/2007 (edition 3/5 plus 2 artist proofs).
Polychrome aluminum, stainless steel, and light-
bulbs, 78 in. (198.1 cm) (diameter) × 7 in. (17.8 cm).
Private collection

FOLLOWING SPREAD

FIG. 85 Robert Indiana, *Eat/Die*, 1962. Oil on
canvas, two panels, 72 × 60 in. (182.9 × 152.4 cm)
each. Private collection

FIG. 86 Robert Indiana, *The Green Diamond Eat/
The Red Diamond Die*, 1962. Oil on canvas, two
panels, 60¼ × 60¼ in. (153 × 153 cm) each,
diamonds. Walker Art Center, Minneapolis;
gift of the T. B. Walker Foundation, 1963

By the time the World's Fair opened, Indiana was pursuing a new aesthetic course,
having begun a diptych in early 1964 that realistically portrayed his adoptive
parents standing on either side of the family's Model-T Ford as if about to get
inside.[154] Several months earlier, Richard Brown Baker had conducted a series of
extensive interviews with Indiana about his life as Robert Clark. Memories of his
traumatic childhood had haunted him even after he fashioned his new identity,
but it was not until the Baker interviews that he appears to have consciously
begun to construct a mythology about his past. The aesthetic inspiration for his
diptych was Arshile Gorky's *The Artist and His Mother* (fig. 88), based on a photo-
graph Gorky's mother had sent to the artist's father who was living in America,
implicitly entreating him not to abandon the family during the Armenian geno-
cide. Stirred by Gorky's emotionally charged veneration of his mother, Indiana set
out to codify the mental image he had formed over the years of Carmen as vibrant
and of Earl as emotionally cold. Like Gorky, he based his depiction on a black-and-
white photograph, inserting himself into the composition as an invisible embryo
by presenting the couple in a partial state of undress and inscribing the license
plate on his mother's side of the car "Ind 27," as if implying that the painting
documented the place and year of his conception—an interpretation he reinforced
by drolly telling reporters he had "a notion that [he] was conceived in the back seat
of a tin lizzie."[155] Even without knowing Indiana was adopted (a fact that would
not emerge until later) critics acknowledged that the painting exuded an eerie
disquiet that "sets our teeth on edge," as Swenson put it.[156]

Indiana intended *Mother and Father* (fig. 94) to be one of four portraits depict-
ing Carmen and Earl in each of the four seasons, suggesting a relationship with
Thomas Cole's four-part series *The Voyage of Life* (1839–40), in which Cole associ-
ated the stages of human life with the seasons of the year.[157] Indiana had chosen

to begin his quartet with winter to correlate with his December conception. It was the only portrait he completed before the opening of his second solo exhibition at the Stable Gallery, in 1964. He installed it as the show's centerpiece and arranged for the opening to be held on Mother's Day to call attention to Carmen as the painting's lead performer. In preparing to send his paintings to the gallery, he noticed certain thematic parallels to the music of Virgil Thomson, especially the composer's *The Mother of Us All*, his operatic collaboration with Gertrude Stein.[158] Wishing to have a gala opening with music, Indiana arranged to have excerpts of Thomson's compositions performed at the opening, to which he invited the composer, whom he had recently met.[159] Shortly thereafter, Thomson commissioned Indiana to design the costumes for a workshop production of *The Mother of Us All*, scheduled to take place the following May at the University of California, Los Angeles.[160] The timing made it impossible for Indiana to do more than make preliminary drawings, but a year later, he used the sketches to collaborate with

Thomson on the opera's production at the Tyrone Guthrie Theater in Minneapolis. Indiana's enthusiasm for Stein, initially ignited by his high-school teacher Sara Bard, had been reawakened by Agnes Martin's devotion to the author, whose "strictness of style and manner" appealed to him.[161] Connections between Stein and Indiana abound: their shared use of laconic words, their insistence on their identity as Americans, and their interweaving of their autobiographies into their art. Nevertheless, it is a mistake to assume that Indiana was thinking of Stein when he painted *Mother and Father*. "I don't think my influence from Stein should be stressed too much," he would later say.[162] Indeed, it was not until 1966, two years after his Stable Gallery show, that he affixed the Stein-like legends "A Mother is a Mother" and "A Father is a Father" to his diptych. Deceptively simple, the words raised profound questions about culturally inscribed definitions of what it means to occupy these parental roles. From the evidence, Indiana's attitude accorded with that of Friedrich Nietzsche, who claimed that "what things *are called* is incomparably more important than what they are."[163]

FIG. 88 Arshile Gorky (1904–1948), *The Artist and His Mother*, c. 1926–36. Oil on canvas, 60 × 50¼ in. (152.4 × 127.6 cm). Whitney Museum of American Art, New York; gift of Julien Levy for Maro and Natasha Gorky in memory of their father 50.17

The thematic parallels Indiana recognized between his art and Thomson's music centered on their shared embrace of American popular culture. Just as Indiana's imagery spoke to everyday visual experience, so too did Thomson integrate folk melodies and popular and religious music into his compositions. One of the paintings in the Stable Gallery show that had struck Indiana as "touch[ing] upon" themes in Thomson's compositions was *The Brooklyn Bridge* (fig. 97), his synthesis of the respective portraits created by poet Hart Crane and painter Joseph Stella of one of America's seminal technological achievements, which Indiana saw daily from his Coenties Slip window.[164] For Crane and Stella—

FIG. 89 Indiana at his second solo
exhibition at the Stable Gallery,
New York, May 13, 1964. Photograph
by Fred W. McDarrah

and Whitman, too, whose "Crossing Brooklyn Ferry" had influenced them both—
the bridge symbolized redemption and mystic unity within the context of
modernity. Indiana approached the subject in a similarly exultant spirit, honoring
the painter's and poet's depictions of the bridge as emblematic of spiritual and
material union by juxtaposing the prominent Gothic arches and soaring cables in
Stella's painting with lines from the opening of Crane's poem, which delineated
the bridge as a symbol of transcendence unique to America: "How could mere
toil align thy choiring strings! / Thy cables breathe the north Atlantic still /
silver-paced as though the sun took step of thee."[165]

Indiana's skill in fusing dialectically opposing ideas into what Connolly had
called the "Holy Both" was evident in the group of wood sculptures he included
in his 1964 show at the Stable Gallery (figs. 89, 95). Made from discarded round
columns originally used as shipping masts in the nineteenth century then recycled
for use as construction materials in the Coenties Slip warehouses that were in the
process of being demolished, the sculptures celebrated humanity while also recog-
nizing its underlying pathos. Indiana had experimented with the round form once
before, in 1960, with a pole salvaged from Jack Youngerman's loft, which he had
stenciled with the names of places in the Coenties Slip neighborhood. Faced in
1964 with a dwindling supply of rectangular wood beams to make herms, he

turned to columns as a substitute. Rather than inscribe them with the nouns that had decorated his herms, he stenciled the verbs "HUG," "ERR," "EAT," and "DIE" in horizontal bands around the columns' circumferences, thereby investing the sculptures with multivalent metaphysical and personal meanings. The staccato repetition of the words, rendered in white gothic letters, registered as a visual incantation of human frailty and forgiveness.

Indiana had always taken seriously what he saw as the responsibility of the artist to comment on politics and the ethics of contemporary American life, describing himself as "a painter of signs, including the signs of the times."[166] Before 1962, however, his commentary had been nebulous. Indeed, even as the titles of his earliest stelae explicitly referenced current events, the works themselves contained no perceptible political critiques, despite his humorous claim that *French Atomic Bomb* was a "small protest against a pretentious small atomic bomb."[167] Although their titles alluded to potentially volatile international incidents, it is hard to see them as indictments, as one commentator wrote, of "the vicious cycle of fear and threat that bred Cold War American ideology" or as protests against the "cost" associated with the "ominous rise of the American 'military and industrial complex.'"[168]

Whatever reticence Indiana might have had in identifying specific political and ethical failures in American society changed in 1962 with *The Rebecca* (fig. 96), whose implicit denunciation of the trade associated with the titular cargo ship, which loaded provisions near Coenties Slip in the mid-nineteenth century after depositing African slaves in Cuba, was a clear indictment of America's legacy of racial injustice. The following year, in answer to an international request for donations to an exhibition benefitting Bertrand Russell's Peace Foundation, he made *Yield Brother*. Exploiting the formal resemblances among the cartographic layout of Coenties Slip, "yield" signs on American roadways, and the semaphore-based symbol for nuclear disarmament that would come to be adopted as the "peace sign," Indiana fashioned a work that suggested the universal need for compromise and respect—on highways, in politics, and in everyday life.[169] He described the painting's legend, from which the work took its name, as a "humble injunction—appropriate and pressing for the whole troubled world."[170] Calling upon the persuasive power of religion, he consciously structured the painting as a call and response, creating what he called a "visual catechism" for peace by juxtaposing the linguistic command to "yield" with four peace signs radiating out from the composition's center like a stained-glass rose window in a cathedral.[171]

Indiana extended his appeal for peace to all of humanity in the series' subsequent versions by inscribing the words "SISTER," "FATHER," "BROTHER," and "MOTHER" into circular bands within the composition's four circles (fig. 90). His claim that the bars bisecting these circles represented the North Star, used by escaping slaves to find their way to freedom, confirmed that his message was

about human brotherhood rather than about sibling relations, as one scholar suggested.[172] Indeed, in his 1968 text on *Yield*, he lamented how little the ubiquitous "yield" traffic sign had impacted "the national conscience . . . particularly in our least yielding region entrenched as it is in the doctrine of White Supremacy."[173] With the aim of rebuking this "recalcitrance," as he called it, he began one of the most audacious series of political paintings produced by any artist in the 1960s: *The Confederacy Series*.[174]

Indiana intended the series to encompass each of the Confederate states, "whose citizens were willing to die for the perpetuation of human slavery."[175] The four paintings he completed targeted Alabama, Mississippi, Louisiana, and Florida (figs. 100–103), marking with stars the specific cities in those states that had witnessed egregious violence against African Americans and civil rights workers. His message was blunt and scathing: in concentric circles around maps of each of the selected states—depicted in pink tones to suggest Caucasian flesh—he inscribed the legend: "JUST AS IN THE ANATOMY OF MAN, EVERY NATION MUST HAVE ITS HIND PART." When installed side by side, the paintings' kinesthetic effect and candy colors recalled the numerous sequential Burma-Shave ads Indiana had seen as a child on signposts along rural roadways, their cheery rhymes replaced in Indiana's series by sobering messages of rage. What made Indiana's "moral cries . . . against the dangers of unrecognized narrowness" fundamentally different from the social paintings of other Pop artists was their brutal clarity.[176] Rosenquist's *F-111* (1964–65), named after the fighter jet used in the Vietnam War, critiqued the interconnection between military and consumer products, but the subordination of the painting's subject matter to stylized aesthetics muted whatever moral outrage it possessed. Likewise, the repetition of images in Warhol's *Race Riot* paintings of the early 1960s rendered them emotionally detached, as Warhol himself acknowledged: "[W]hen you see a gruesome picture over and over again, it doesn't really have any effect."[177] The condemnation in Indiana's *Confederacy Series*, on the other hand, brooked no ambiguity. "[T]he situation in the South affects everyone," he said. "I can't wake up in the morning and . . . see a newspaper or listen to the radio without becoming . . . perhaps ill at the news that comes through. I am sensitive to this."[178] Whether the depth of his antipathy to racial injustice was inspired by his encounters with homophobia or his exposure to the tenets of Christian Science, Indiana remained empathetic with those seeking justice and equality, as his multiple donations of art throughout the 1960s to CORE (Congress of Racial Equality) attest.

At his third Stable Gallery exhibition, in 1966, Indiana premiered his three completed Confederacy paintings, as well as multiple versions of an image that would soon engulf his career—*LOVE*—and *The Cardinal Numbers*. Numbers had appeared in Indiana's work even before words, functioning variously as the abstract "names" of his anthropomorphic herms, as metaphors for the passage of time, and as reminders of vernacular American culture, in particular pinball machines and highway signs. Subjectively, numbers carried biographical meaning as memorials to Indiana's childhood experience of constantly moving. "It was just one little Hoosier bungalow after the other, and they got kind of numbered in my mind," he said. "I became obsessed with which was the 8th and which was the 13th and that sort of thing."[179] Yet not until he happened on an executive calendar in early 1961 with numbers whose fleshy serifs and rounded forms possessed an anthropomorphic quality did he begin to treat numbers as subjects in and of

FIG. 91 Robert Indiana, *Nonending Nonagon*, 1962. Oil on canvas, 24 × 22 in. (60.9 × 55.9 cm). Yale University Art Gallery; Richard Brown Baker, B.A. 1935, Collection

themselves. "I simply discovered the businessman's calendar and thought that the numbers had a kind of robustness and a kind of . . . crude vigor . . . which I liked," he said. "I [made] certain refinements. It turns out that when you fit a given number in a circle, sometimes you have to tuck in a serif. And you have to squeeze in the bulge of a '5' . . . So, although I didn't want to, I found myself refining these numbers."[180] Indiana's first number paintings, his *Polygons*, were playful, in the vein of Gertrude Stein's children's book *Alphabets and Birthday*, in which the writer had ascribed names and birthdays to every letter of the alphabet.[181] Following Stein's admonition to "think of names . . . Names will do," Indiana paired numbers with their correlative geometric form and whimsical alliterative words, such as "Square, Quare, Quandrangel" with 4; "Octagon, Octavia, Octaroon" with 8; "Nonending, Nonagon" with 9 (fig. 91). His next series, *The Cardinal Numbers*, identified each number in a sequence of one to nine and ending with zero with its word equivalent, a redundancy that raised questions about what it means to "name" a number (fig. 92).

Indiana's initial elevation of numbers to prominence as independent subjects coincided with his involvement with the *I Ching*, whose predictions derived from counting yarrow sticks or throwing numbered coins to cast hexagrams. Although his engagement with the book, then making the rounds of the Coenties Slip group, had been short-lived, his experiences in divination through numbers had led him to identify them with specific people—the number six with Earl, who was born in June, the sixth month; the number eight with Carmen, who died in August, the eight month—and to associate them with the milestones of life. Accordingly, he partnered numbers with psychological characteristics related to human development: four, for instance, signaled adolescent unhappiness and sexual awakening; two, his favorite number, denoted a couple and sexual fulfillment.[182] He would find confirmation for his pairing of distinct mental and physical attributes with the phases of life in the Currier and Ives etching *The Life and Age of Man: Stages of a Man's Life from the Cradle to the Grave*, which he received as a gift in 1970 from a colleague at Dartmouth College where he taught for a semester that year.[183] Yet the potentially infinite expansion of numbers appealed as well to Indiana, who sequenced *The Cardinal Numbers* as a never-ending cycle, in accordance with the Christian Science church's denial of death, as symbolized by the circle, zero's visual analogue. Ultimately, his conviction that numbers held keys to life's hidden secrets

led him to invest numerical coincidences with an almost-Talmudic significance. In his text on *The Demuth American Dream #5*, for instance, he described how subtracting 1928 (the year he was born and the year Demuth executed his painting) from 1963 (the year he executed *his* homage to Demuth) yielded 35, the year Demuth died and, coincidentally, the number suggested by the succession of three fives in Demuth's original painting.[184]

Indiana installed *The Cardinal Numbers* in his Stable Gallery exhibition in one room and *The Confederacy Series* and *LOVE* in another, ensuring that the latter two series were in dialectical conversation with one another.[185] The effect, as critic and art historian Thomas Crow wrote, was one of "address and effect . . . After the consciousness-raising, then, comes the Sunday sermon, a King-like exhortation to human brotherhood."[186] Indiana had first depicted the word "love" in his small 1961 *Four-Star Love* (fig. 107). *Love Is God* (fig. 106) had followed in 1964 after a chance encounter with collector Larry Aldrich, who was in the process of converting a Christian Science church into a private museum. Indiana's childhood attendance at the church encouraged Aldrich to commission the artist to make a painting for the museum's opening in November.[187] The inscription "God is Love" was prominently emblazoned on the wall of Aldrich's soon-to-be renovated build-

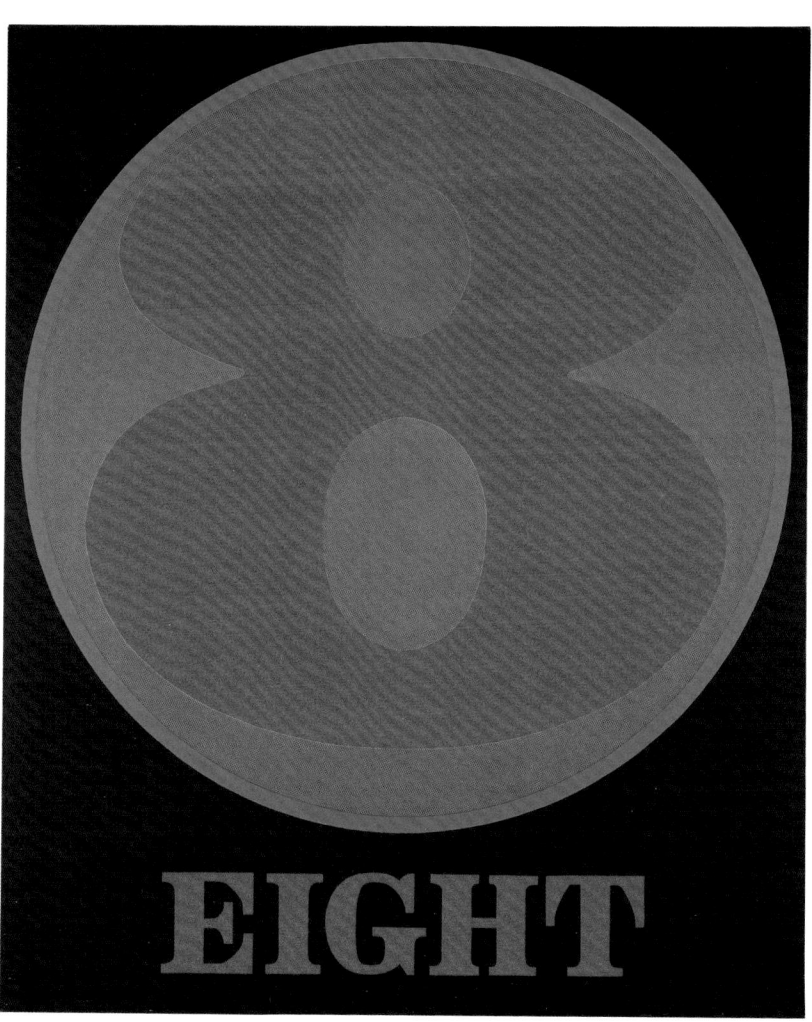

FIG. 92 Robert Indiana, *Eight*, 1965. Oil on canvas, 60 × 50 in. (152.4 × 127 cm). Stedelijk Museum, Amsterdam

ing, as it was on the walls of all Christian Science churches, including the ones Indiana had attended as a boy. Transposing the phrase into "Love is God," the artist proclaimed love as sacred and divine. "Know that the LOVE I am talking about is spiritual," Indiana would later say.[188]

A month after Aldrich's museum opened, the Free Speech Movement exploded at the University of California, Berkeley. Angered at being barred from staging protests despite the promises of Chancellor Clark Kerr of a "new era of freedom under the law," students began carrying banners that read "FUCK," an acronym for "Freedom under Clark Kerr" loaded with other connotations. The obscene humor of the abbreviation appealed to Indiana, who produced *FUCK* as a quartered field of stacked letters, which he inflected with spatial dynamism by tilting its "U." Pleased by his return to the four-quadrant layout of earlier work, he adopted the format a few weeks later for the Christmas cards he sent to friends of frottage rubbings of the word "love," its letters stacked and its "O" tilted, which called to mind Indiana's "dormant interest in the circle," as he described it.[189] He explained his

proclivity for the layout, saying, "I have a kind of passion about symmetry and the dividing of things into equal parts."[190] When, several months later, the Junior Council of the Museum of Modern Art commissioned him to design one of the museum's 1965 Christmas cards, he appropriated the composition, submitting four twelve-inch oil versions of *LOVE* in different color combinations.[191] The museum chose the most chromatically intense: red letters against a background of blue and green. The Christmas card was a sell-out success, reaching a mass market via an area of commerce pioneered by a company headquartered in Indiana's American Midwest: Hallmark.

Indiana recognized at once that *LOVE* possessed an uncanny allure, and he immediately adopted it as the template for a series of paintings. Words had long been important to his art, but prior to this he had always situated them within a larger composition. With *LOVE*, however, the image and word were coextensive—rendering it, in his words, a "one-word poem" (fig. 108).[192] Moreover, in distilling "to its bare bones" an abstract concept so symbolically freighted, Indiana explicitly shifted the responsibility for interpreting the image onto viewers, who projected back onto the work their own erotic, spiritual, or other personal associations and experiences.[193] Paradoxically, given the image's subsequent identification with the country's emerging countercultural and free love movement, Indiana's own associations with the word were ambiguous. His family had never used it, insisting instead on "hug." Nor had his adult relationships made him any less wary of the fragility and precariousness of the very concept for which his new image would become an icon. "Inevitably the embers go out," he said.[194] "Love is a dangerous commodity—fraught with peril."[195] *LOVE*'s tilted "O" implicitly critiqued the hollow sentimentality and facile abuse of the word in American usage, metaphorically suggesting unrequited longing, desire, and disappointment rather than saccharine affection. Yet what ultimately made the image so powerful was exactly its ability to contain all of these multiple, even contradictory meanings simultaneously.

Indiana painted more than eight versions of *LOVE* for his 1966 show at the Stable Gallery, some as quartered compositions, others as mirrored formats that evoked love's "narcissism," as he called it.[196] All were painted in red, blue, and green—colors he associated with his father, who had died shortly after the series began.[197] Just as Indiana had paid tribute to Carmen in his Stable Gallery show two years prior, so now did he choose to honor Earl. As he explained: "In the thirties, my father worked for Phillips 66, when all Phillips 66 gasoline stations were red and green: the pumps, the uniforms, the oil cans . . . [W]hen I was a kid, my mother used to drive my father to work in Indianapolis, and I would see, practically every day of my young life, a huge Phillips 66 sign. So it is the red and green of that sign against the blue Hoosier sky. The blue in the *LOVE* is cerulean. Therefore, my *LOVE* is [an] homage to my father."[198]

Indiana's *LOVE* appeared just as the counterculture's admonition to "make love not war" was garnering widespread media attention, and the work instantly

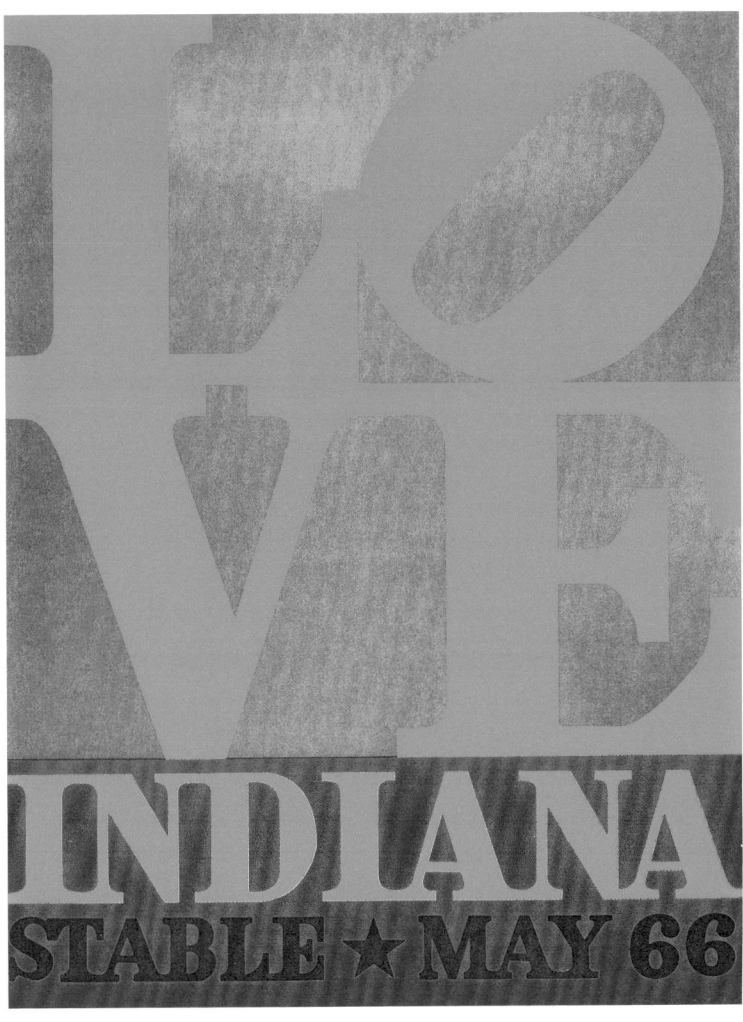

FIG. 93 Robert Indiana, poster for exhibition at the Stable Gallery, New York, May 1966. Silkscreen on paper, 32 × 24 in. (81.2 × 61 cm). Collection of the artist

became a talisman of the pacifism and sexual freedom associated with the cultural revolution and was reproduced in newspapers, magazines, and on television sets around the country. Earlier, Indiana had said that "the artist is often mainly talking to himself, and pleasing himself . . . not really addressing anyone at all." With *LOVE*, he found himself "addressing every, every person in America."[199] The public, young and old alike, embraced the design without often fully understanding why it moved them. Its formal sophistication, which sustained it as a work of fine art capable of eliciting myriad interpretations, registered on the majority of its legions of fans only subliminally. Paradoxically, it was precisely the image's formal quality that Indiana valued. "It's always been a matter of impact," he said. "[T]he relationship of color to color and word to shape and word to complete piece—both the literal and the visual aspects. I'm most concerned with the force of its impact."[200] Juxtaposing highly saturated complementary and near-complementary colors created an optical shimmer at the boundaries between hues, confusing figure and ground and bringing what Indiana called an "optical, near-electric quality" to *LOVE*.[201] The combination of flat, hard-edged compositions, chromatic intensity, and a recognizable word-image rendered *LOVE* neither exclusively Pop nor exclusively Op but something in between, a hybrid that was difficult for critics to assess.

At the time of his Stable Gallery show, Indiana registered the copyright neither for the *LOVE* poster he designed for the show (fig. 93) nor for the twelve-inch-high aluminum *LOVE* sculpture that Multiples, Inc. produced for the exhibition in an edition of six. He later explained that it had simply never occurred to him and that he had rejected attaching the copyright notice to the poster because it would have given it a "commercial look."[202] His failure to enforce his rights to the work in the 1960s resulted in the production of large numbers of unauthorized commercial products bearing the *LOVE* image. This made *LOVE* not only one of the most recognized images of its time but also a cliché, stripped of its "aura" as a unique work of fine art.

FIG. 94 Robert Indiana, *Mother and Father*, 1963–66.
Oil on canvas, two panels, 70 × 60 in. (177.8 × 152.4 cm)
each. Collection of the artist

FIG. 95 Robert Indiana, (left to right) *Column DIE*,
Column LOVE, *Column EAT/HUG/ERR*, *Column EAT*,
Column EAT/HUG/DIE, *Column HUG*, 1963–64
(with bases by Richard Artschwager). Gesso on
wood, dimensions variable. Private collection

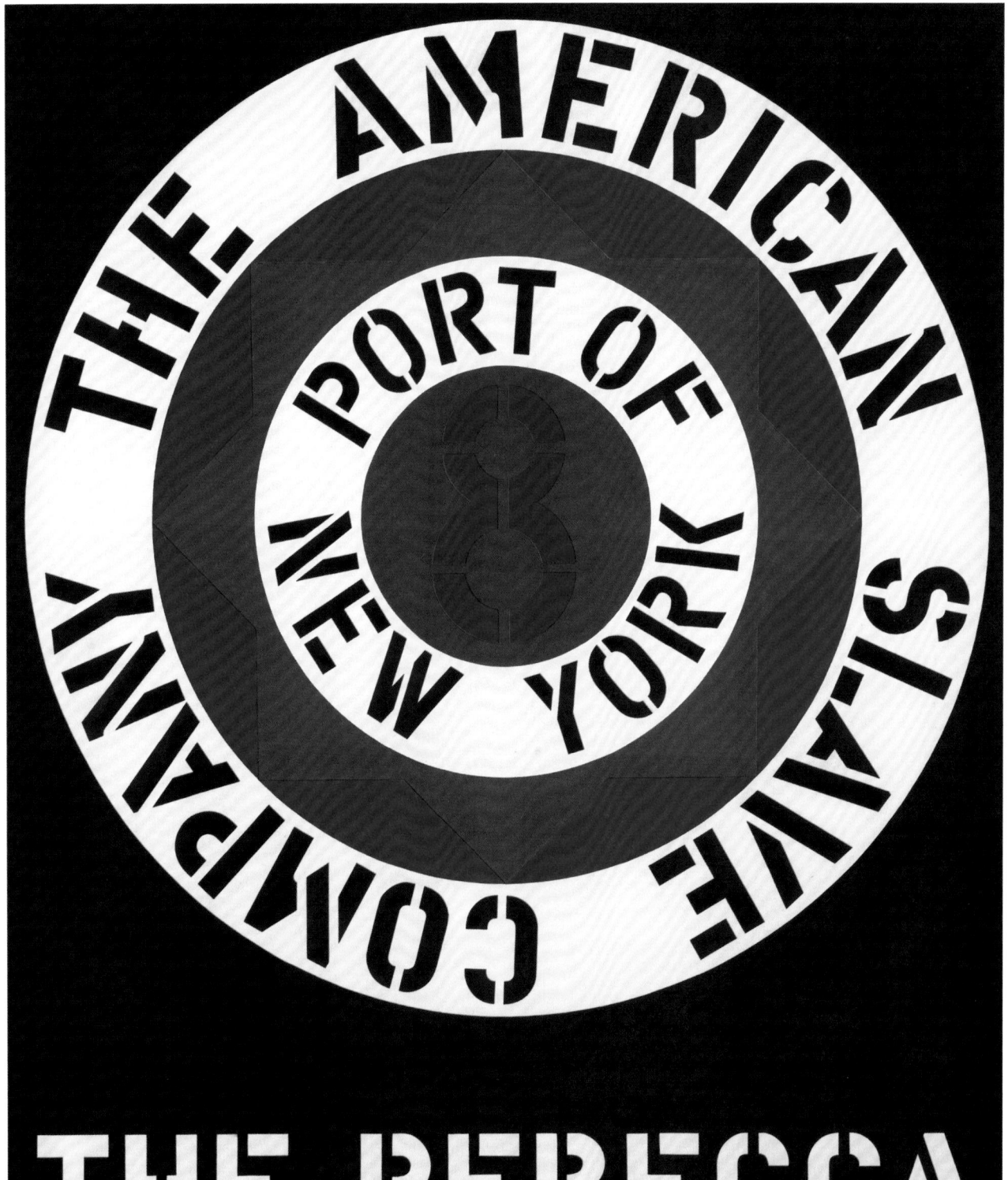

THE AMERICAN SLAVE. THE AMERICAN SLAVE COMPANY

PORT OF NEW YORK

THE REBECCA

FACING

FIG. 96 Robert Indiana, *The Rebecca*, 1962.
Oil on canvas, 60 × 48 in. (152.4 × 121.9 cm).
Courtesy of Morgan Art Foundation and
Galerie Gmurzynska, Zurich

ABOVE

FIG. 97 Robert Indiana, *The Brooklyn Bridge*, 1964.
Oil on canvas, four panels, 135 × 135 in. (343 ×
343 cm) overall, diamond. Detroit Institute
of Arts; Founders Society Purchase, Mr. and
Mrs. Walter Buhl Ford II Fund

FIG. 98 Robert Indiana, *The X-5*, 1963. Oil on canvas, five panels, 36 × 36 in. (91.4 × 91.4 cm) each; 108 × 108 in. (274.3 × 274.3 cm) overall. Whitney Museum of American Art, New York; purchase 64.9a-e

FIG. 99 Robert Indiana, *The Sixth American Dream (USA 666)*, 1964–66. Oil on canvas, five panels, 36 × 36 in. (91.4 × 91.4 cm) each; 102 × 102 in. (259 × 259 cm) overall. Courtesy of Morgan Art Foundation and Galerie Gmurzynska, Zurich

JUST AS ★ IN THE ANATOMY OF MAN EVERY NATION ★ MUST HAVE ★ ITS HIND PART

SELMA

ALABAMA

FIG. 100 Robert Indiana, *The Confederacy: Alabama*, 1965. Oil on canvas, 70 × 60 in. (177.8 × 152.4 cm). Miami University Art Museum, Oxford, Ohio; gift of Walter and Dawn Clark Netsch

FIG. 101 Robert Indiana, *The Confederacy: Mississippi*,
1965. Oil on canvas, 70 × 60 in. (177.8 × 152.4 cm).
The Robert B. Mayer Family Collection

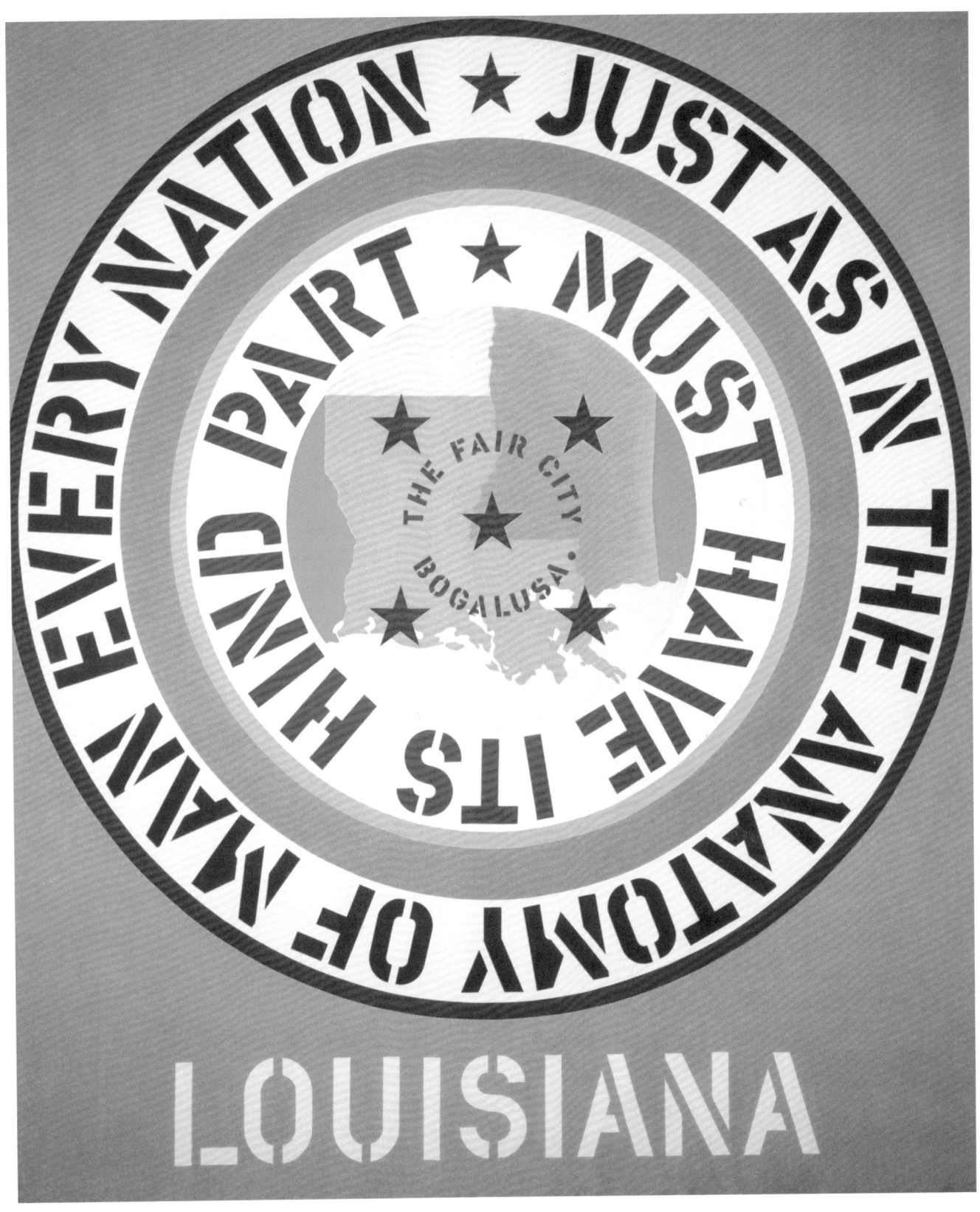

FIG. 102 Robert Indiana, *The Confederacy: Louisiana*,
1966. Oil on canvas, 70 × 60 in. (177.8 × 152.4 cm).
Krannert Art Museum and Kinkead Pavilion,
University of Illinois at Urbana-Champaign;
Contemporary Painting and Sculpture Exhibition
Purchase 1967-7-1

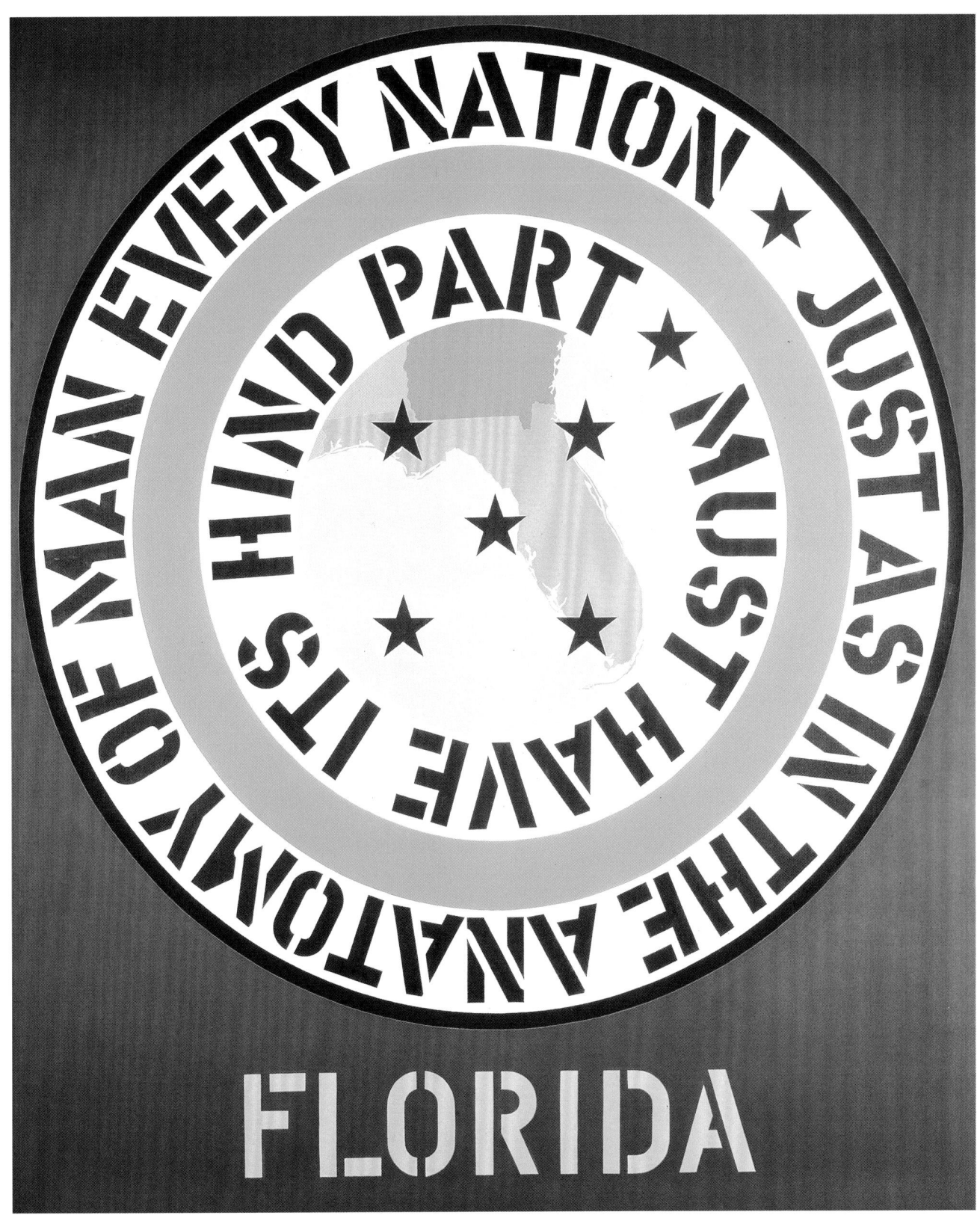

FIG. 103 Robert Indiana, *The Confederacy: Florida*,
1966. Oil on canvas, 70 × 60 in. (177.8 × 152.4 cm).
Collection of Shirley and William Lehman

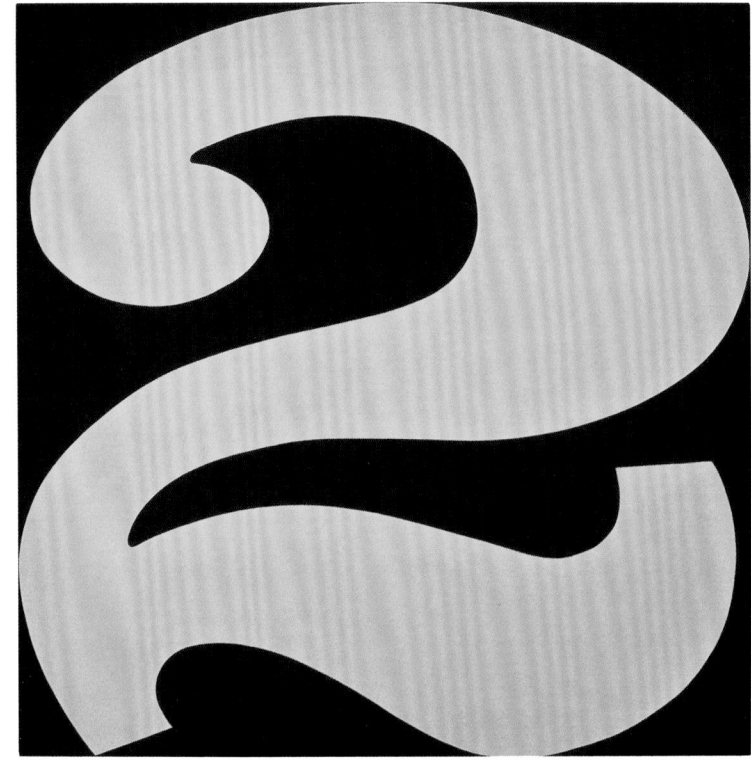

FIG. 104 Robert Indiana, *Exploding Numbers*,
1964–66. Oil on canvas, four panels, 12 × 12 in.
(30.5 × 30.5 cm); 24 × 24 in. (61 × 61 cm); 36 × 36 in.
(91.4 × 91.4 cm); and 48 × 48 in. (122 × 122 cm).
Private collection

FIG. 105 Robert Indiana, *The Big Four* (*Four Fours*),
1964. Oil on canvas, four panels, 24 × 24 in.
(61 × 61 cm) each, 48 × 48 in. (121.9 × 121.9 cm)
overall, diamond. Collection of the artist

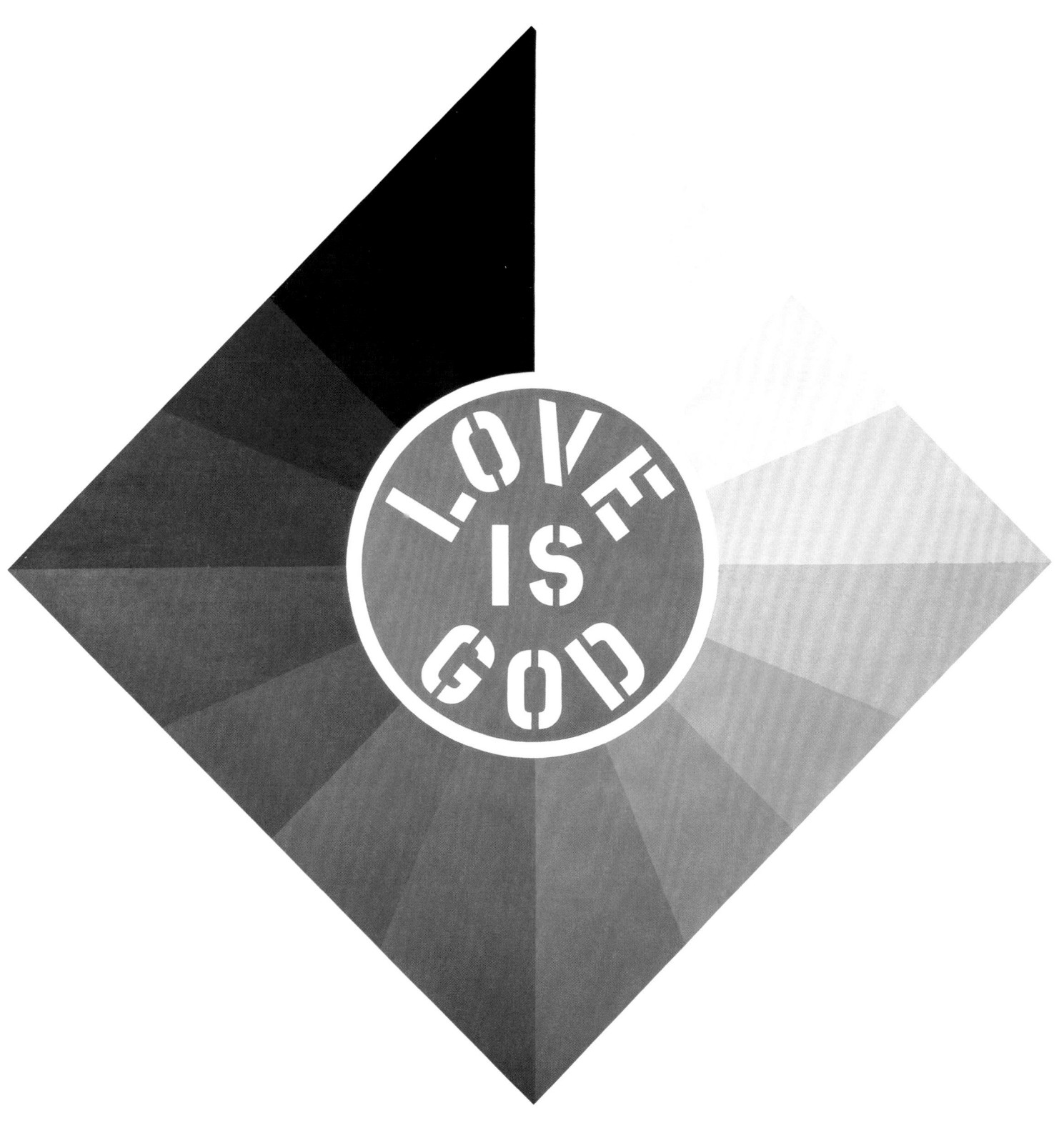

FIG. 106 Robert Indiana, *Love Is God*, 1964.
Oil on canvas, 68 × 68 in. (172.7 × 172.7 cm),
diamond. Private collection

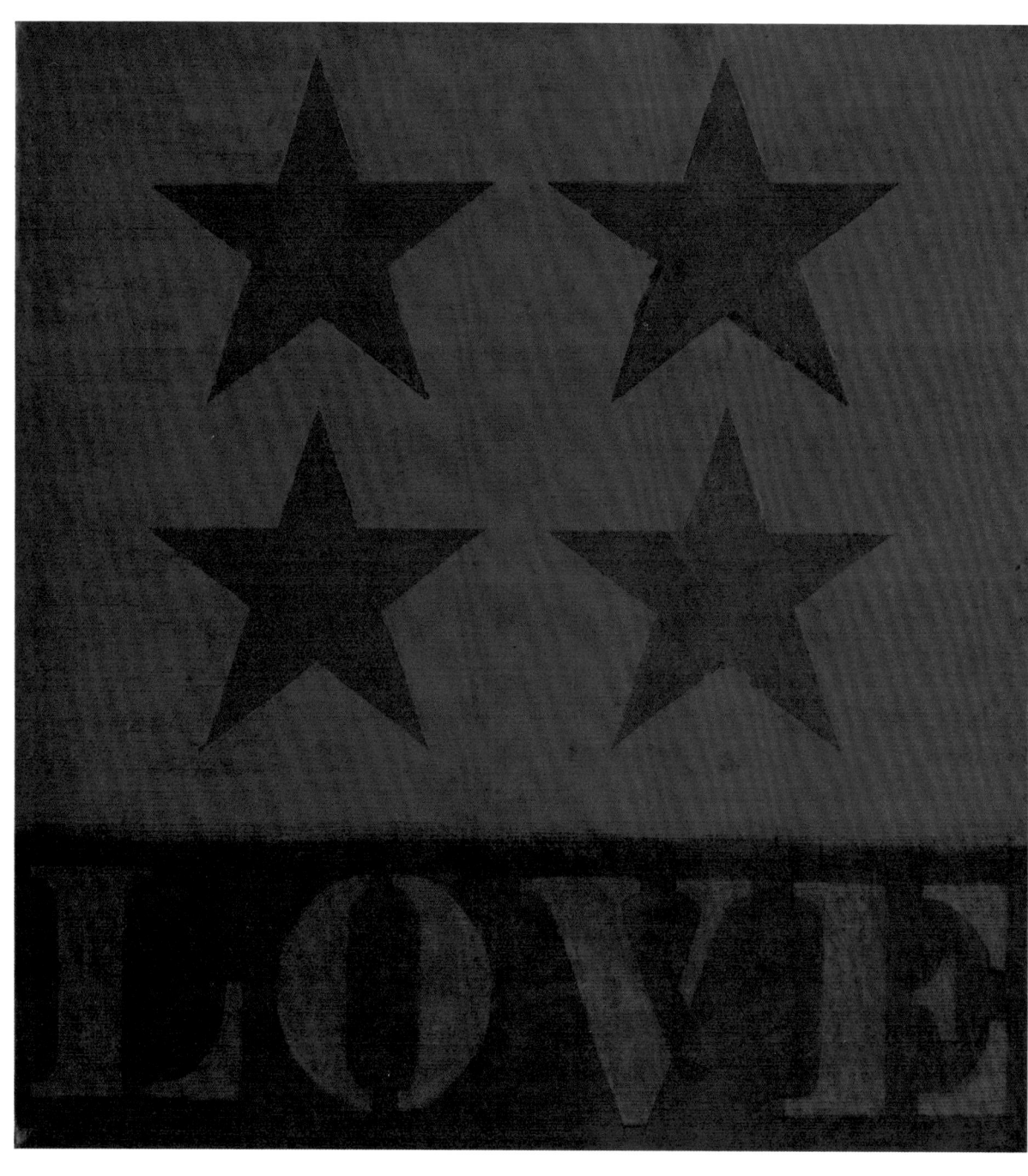

FIG. 107 Robert Indiana, *Four-Star Love*, 1961.
Oil on canvas, 12 × 11⅛ in. (30.5 × 28.3 cm).
Portland Museum of Art, Maine; gift of Todd
Brassner in memory of Doug Rosen, 1999.7

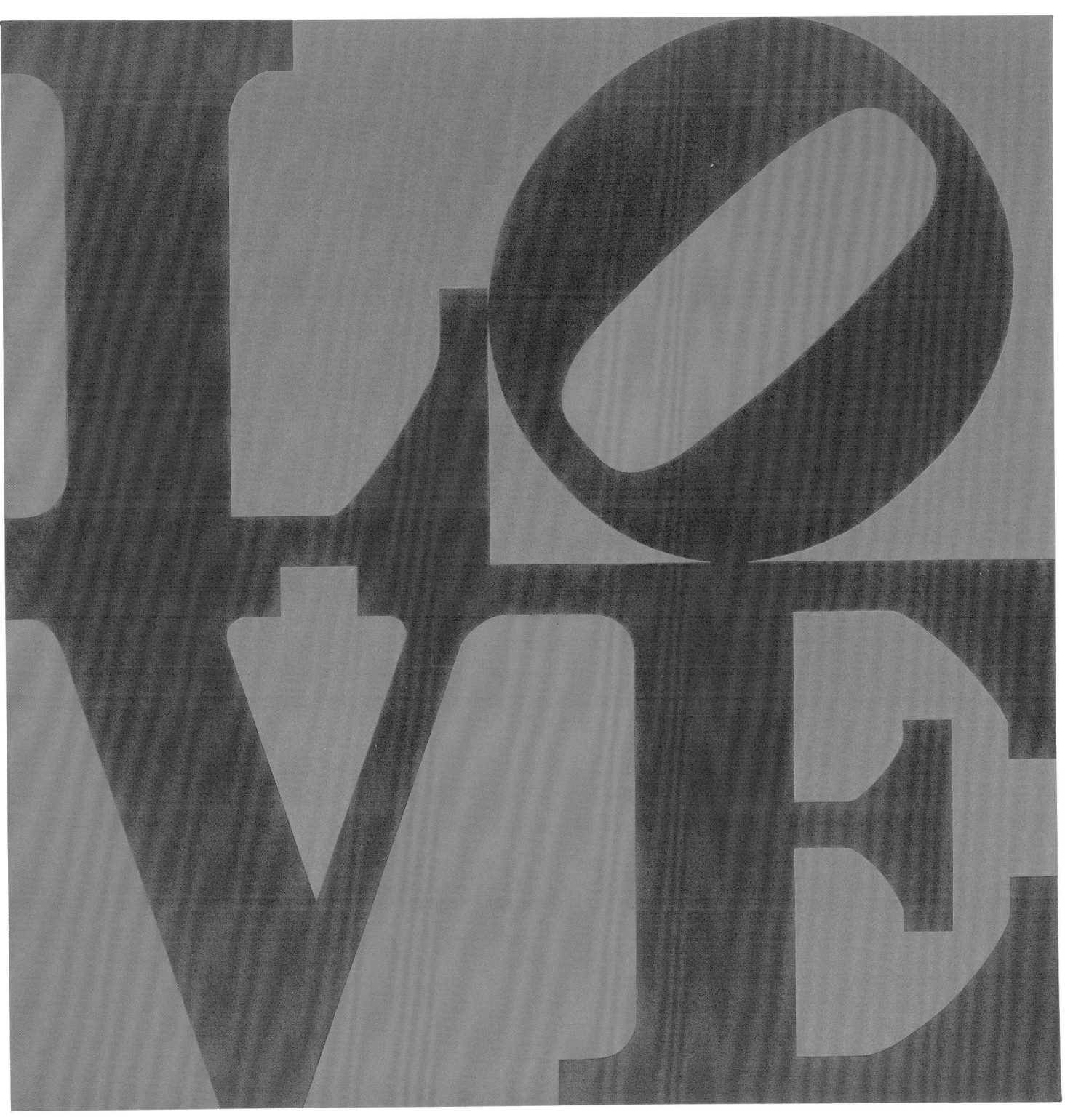

FIG. 108 Robert Indiana, *LOVE*, 1966. Oil on
canvas, 71⅞ × 71⅞ in. (182.6 × 182.6 cm).
Indianapolis Museum of Art; James E. Roberts
Fund 67.8

ABOVE AND FACING

FIGS. 109 AND 110 Stills from the Santa Fe Opera
Company's production of Virgil Thomson's and
Gertrude Stein's *The Mother of Us All*, with sets
and costumes designed by Indiana. Performed at
the Santa Fe Opera Company, August 7, 11, 20,
and 25, 1976. Photographs by Ken Howard

In retrospect, the years immediately following Indiana's 1966 show at the Stable
Gallery marked the high point in the critical reception of his art in the United
States. Immediately after the show, Walker Art Center curator Jan van der Marck
commissioned Indiana to design the costumes, set, and poster for the production
of *The Mother of Us All* scheduled to open at the Tyrone Guthrie Theater in January.
The opera's explicitly American themes—Susan B. Anthony's life and the women's
suffrage movement—appealed to Indiana, as did the name of its romantic lead:
Indiana Elliot. Stein's insertion of herself and Thomson into the opera as narrators
inspired Indiana to inject images from his own work into the production. Accord-
ingly, he designated the Model-T Ford from *Mother and Father* as the central prop
and gave each of the opera's thirty characters a sash bearing his or her name,
thereby solving the audience's problem of identifying the myriad performers while
also elevating words to the place of importance they occupied in his art. "Just as
my every painting or sculpture includes a word or words," he wrote, "I costumed
each of the thirty-odd characters . . . with his or her own individual name sash."[203]
Against the backdrop of red, white, and blue banners and signs, the profusion of
words was the opera's major scenic element. Adding them to what he called Stein's
"circus of Americana," with its host of fictional and nonfictional characters from

different periods of American history, lent the opera a "Pop" quality.[204] So, too, did Indiana's inclusion of a Model T, which he called the most "conspicuous element of that passing American parade . . . [It] has contributed far more to the liberation of the citizenry of this nation than all the legislation combined," noting that "if there's anything distinctively American, it's what's happened here with the automobile."[205] Indiana's decision to script a car into the narrative was practical as well as thematic: as a mobile prop physically moving characters around the stage, it solved the problems posed by the Guthrie Theater's amphitheater shape, which militated against set changes. That the Model T had been the favorite possession of Stein and Alice B. Toklas in France made its role as the opera's central scenic motif aptly symbolic "of those struggles that Gertrude Stein and Susan B. Anthony . . . shared (as this very autobiographical libretto suggests) in their separate battles, one for elective suffrage, the other for literary sufferance," as Indiana wrote.[206] Fittingly, during America's bicentennial nine years later, the Santa Fe Opera Company commissioned Indiana to design a full-scale production of the opera, held in conjunction with the company's twentieth

anniversary, again with costumes and sets (figs. 109, 110). The artist worked on the project for eight months in New York and Santa Fe, creating papier-collé designs out of color stock and Color-aid paper, which assistants translated into felt costumes and sixteen-foot-high felt floats that served as the production's sets (figs. 111–122).[207]

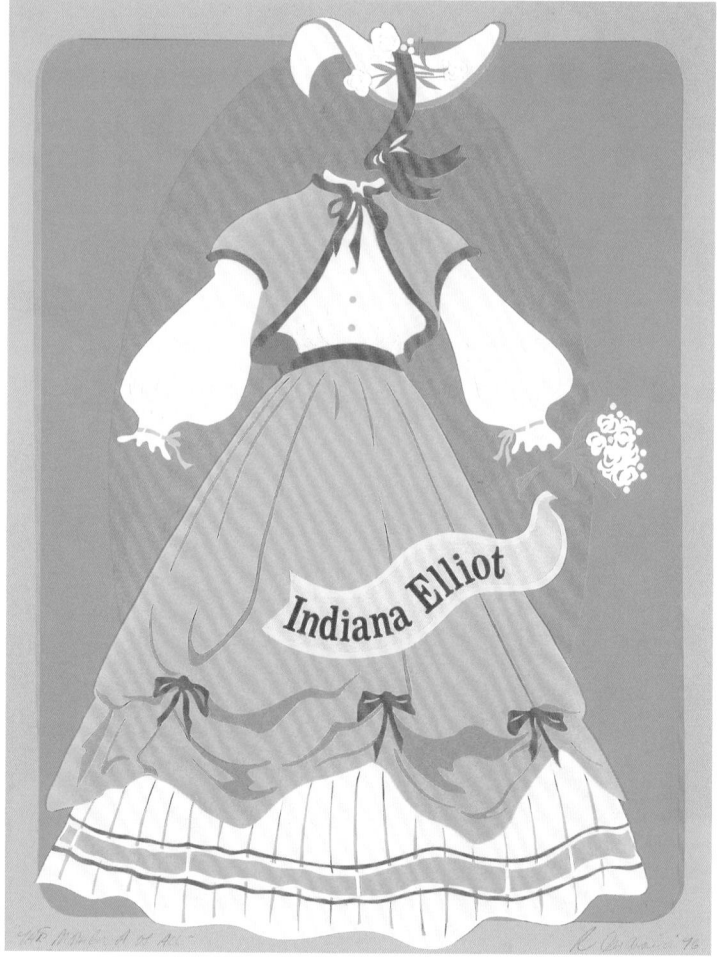

FIG. 111 Robert Indiana, costume design for
Susan B. Anthony in *The Mother of Us All*,
1966/76. Cut paper, 26 × 20 in. (66 × 50.8 cm).
McNay Art Museum, San Antonio, Texas; gift
of Robert L. B. Tobin

FIG. 112 Robert Indiana, costume design for
Indiana Elliot in *The Mother of Us All*, 1976.
Cut paper, 26 × 20 in. (66 × 50.8 cm). McNay
Art Museum, San Antonio, Texas; gift of
Robert L. B. Tobin

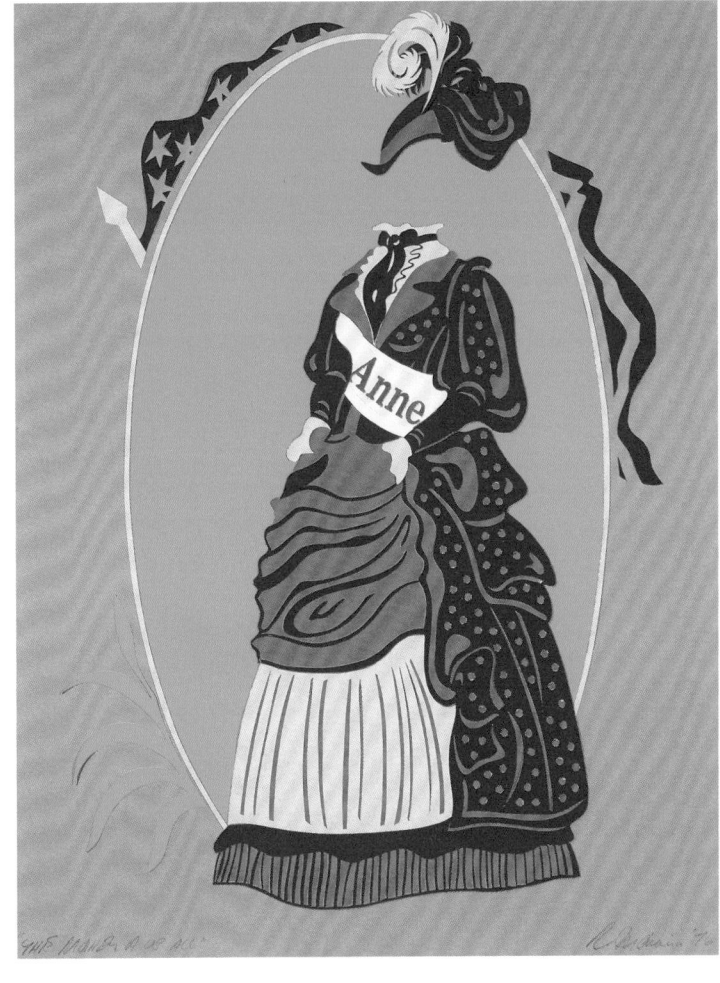

FIG. 113 Robert Indiana, costume design for
Gen. U. S. Grant in *The Mother of Us All*, 1966.
Cut paper, 25⅞ × 19¹³⁄₁₆ in. (65.7 × 50.3 cm).
McNay Art Museum, San Antonio, Texas; gift of
Robert L. B. Tobin

FIG. 114 Robert Indiana, costume design for
Anne in *The Mother of Us All*, 1976. Cut paper,
26⅛ × 20 in. (66.4 × 50.8 cm). McNay Art Museum,
San Antonio, Texas; gift of Robert L. B. Tobin

LEFT

FIG. 115 Robert Indiana, costume design for Virgil Thomson in *The Mother of Us All*, 1976. Cut paper, 26¹/₁₆ × 20 in. (66.2 × 50.8 cm). McNay Art Museum, San Antonio, Texas; gift of Robert L. B. Tobin

RIGHT

FIG. 116 Robert Indiana, costume design for Gertrude Stein in *The Mother of Us All*, 1966. Cut paper, 26¹/₁₆ × 20 in. (66.2 × 50.8 cm). McNay Art Museum, San Antonio, Texas; gift of Robert L. B. Tobin

LEFT

FIG. 117 Robert Indiana, costume design for Lillian Russell in *The Mother of Us All*, 1966. Cut paper, 26⁷/₈ × 19⁷/₈ in. (68.3 × 50.5 cm). McNay Art Museum, San Antonio, Texas; gift of Robert L. B. Tobin

RIGHT

FIG. 118 Robert Indiana, costume design for Jenny Reefer in *The Mother of Us All*, 1966. Cut paper, 25⁷/₈ × 19¾ in. (65.7 × 50.2 cm). McNay Art Museum, San Antonio, Texas; gift of Robert L. B. Tobin

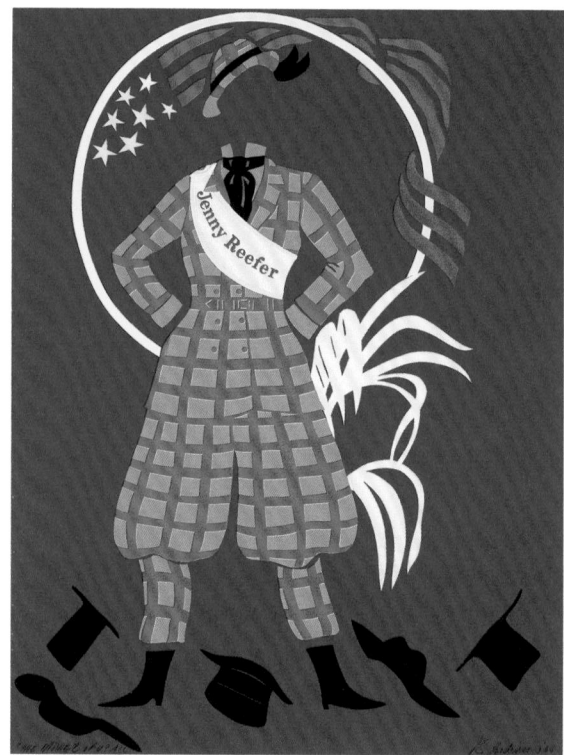

LEFT

FIG. 119 Robert Indiana, costume design for Daniel Webster in *The Mother of Us All*, 1966. Cut paper, 25¹⁵/₁₆ × 19¹³/₁₆ in. (65.9 × 50.3 cm). McNay Art Museum, San Antonio, Texas; gift of Robert L. B. Tobin

RIGHT

FIG. 120 Robert Indiana, costume design for Isabel Wentworth in *The Mother of Us All*, 1966. Cut paper, 26 × 20 in. (66 × 50.8 cm). McNay Art Museum, San Antonio, Texas; gift of Robert L. B. Tobin

LEFT

FIG. 121 Robert Indiana, costume design for Henrietta M. in *The Mother of Us All*, 1966. Cut paper, 25¹⁵/₁₆ × 19⁷/₈ in. (65.9 × 50.5 cm). McNay Art Museum, San Antonio, Texas; gift of Robert L. B. Tobin

RIGHT

FIG. 122 Robert Indiana, costume design for Jo the Loiterer in *The Mother of Us All*, 1966. Cut paper, 25¹³/₁₆ × 19⁵/₈ in. (65.6 × 49.8 cm). McNay Art Museum, San Antonio, Texas; gift of Robert L. B. Tobin

Indiana's escalating status as an art star led to numerous museum and gallery exhibitions and the acquisition of his work by major public institutions in Europe and America. Myriad book, print, and poster commissions, combined with the installation of work requiring his presence, left him little time to work in his studio, with the result that between 1966 and 1970, he created few new images other than *ART* (fig. 125). Mounting critical success and financial security began to shift his perception of his place in the world and, with it, his worldview. Celebration and commemoration inevitably edged out skepticism and alienation. His assignment in 1968 to author an "autochronology" along with texts on individual paintings for the catalogue that accompanied his retrospective that year at the Institute of Contemporary Art in Philadelphia gave him an opportunity to codify the narrative he had constructed of his life since assuming the name Robert Indiana. Three years later, he used his narrative as the basis for what ultimately would become a group of thirty self-portraits called *Decade: Autoportraits* that echoed the style of Demuth's "poster portraits." Taking six years to complete, the series existed in three different sizes, each consisting of ten panels documenting a different year of his life in the 1960s. Inspired by his experience designing costumes for *The Mother of Us All*, Indiana adopted an overlapping, quasi-Cubist format, stenciling signature words ("EAT," "DIE," "JACK," "JUKE") along with the names of people he had known and the places he had visited, lived, or worked during the decade onto canvases painted with five-pointed stars, numbers, and, in the two smaller series, a circle emblazoned with a diagonal "IND," suggestive of the identifying sashes worn by the performers in *The Mother of Us All* (figs. 136, 137).

Although the canvases that comprised *Decade: Autoportraits* contained many of Indiana's by-now familiar words and images, they no longer communicated the same sense of estrangement or disapproving commentary on American ethics that had marked his earlier work. Their brash forms and saturated colors were as visually immediate and bold as before, but their impact now was largely formal. Despite having long before rejected Kelly's insistence that art be free of recognizable images, Indiana had retained a vision of himself as heir to Kelly's formalist vocabulary. "I am a formalist," he insisted.[208] Indeed, in keeping with the lessons he had learned from his former mentor, he had always worked methodically, beginning with improvisatory sketches that he developed into full-size cartoons, which he then transferred in graphite to canvas. Once he began to apply paint, he made only minor changes, likening his approach to that of an architect who finalizes his blueprints before construction begins.[209] He had always relished the total control and serenity the method gave him. "[It's] just walking a slow, straight path," he said. "Virtuosity seems to me to be the other side of serenity."[210] The technique answered Indiana's personal desire for order and control, while also ensuring the smooth surfaces and crisp demarcations of form characteristic of contemporary American advertisements. His years of perfecting the approach served him well in his *Decade: Autoportraits*; if there was a message beyond their formal impact,

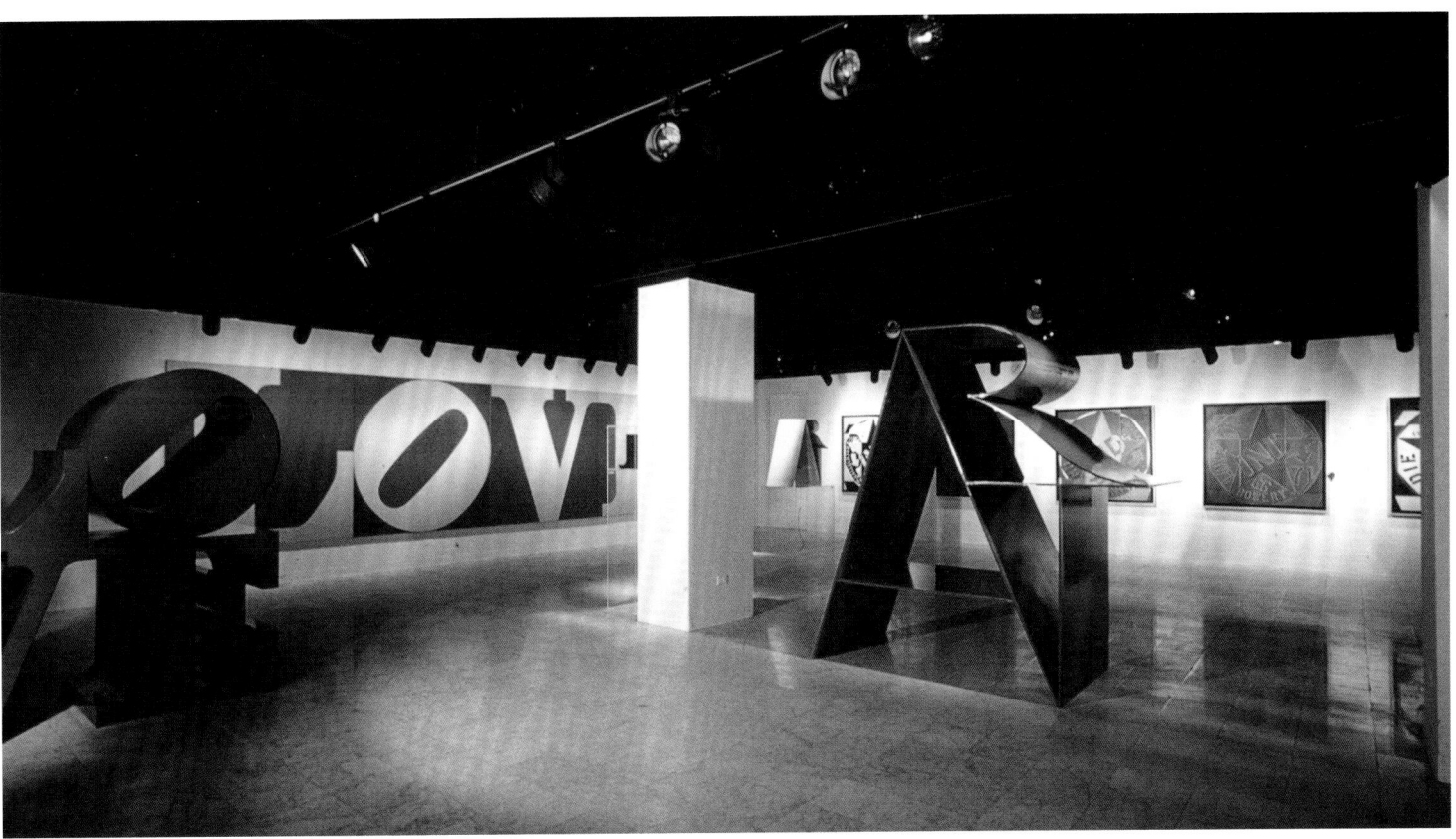

FIG. 123 Installation view of *Robert Indiana*, Galerie Denise René, New York, November 22–December 30, 1972. Photograph by Hans Namuth

it was one of unreserved optimism, modernity, and confidence—characteristics Indiana had come to identify with the American Dream in the wake of his own personal success.

Less than a year before Indiana began his *Decade: Autoportraits*, the Stable Gallery closed, leaving him without a dealer in New York. That changed when Denise René, who had operated a highly successful gallery in Paris, relocated to New York in 1971 and mounted an exhibition of his work the following November. For Indiana, who had not exhibited in New York since his 1966 *LOVE* show, it was an opportunity to reintroduce himself to a public that had come to associate his work exclusively with three images: *LOVE*, *ART*, and *The Cardinal Numbers*. Even Denise René had every reason to assume she would be premiering new work from the artist. But with the largest of his *Decade: Autoportraits* still unfinished, Indiana sent her only the series' two smaller versions, along with his twenty-four-foot red, blue, and white *LOVE* painting, several large polychrome *LOVE* sculptures, and *ART* in two and three dimensions (fig. 123). Installed in the gallery's cavernous main space, they reinforced the impression that his work had become repetitive. There was something touchingly innocent about Indiana's belief that *LOVE* was impervious to the cultural shifts that had occurred in the nation since 1966; he was, as he said of himself, "hopelessly sentimental and nostalgic."[211] But by 1972, with the assassinations of Martin Luther King, Jr., and Robert Kennedy three years earlier and the protests against the escalation of the Vietnam War having turned increasingly violent, the country's mood had darkened; its utopian vision

of revolution had yielded to cynicism and disillusion. In this context, Indiana's decision to include multiple versions of *LOVE* in his Denise René exhibition was a testament to his conviction that the image could overcome its association with trite sentimentality and communicate the "two-faced truth" of alienation and optimism he had originally intended. The problem was that *LOVE*'s appropriation by "trinket merchants" had "sheathed it in commonness for connoisseurs," rendering it "familiar to the point of nausea," as some critics wrote.[212] While acknowledging that "Indiana's 'love' predates the flower-power hoax," even as sympathetic a critic as John Perreault admitted that it was impossible "to divorce the design, even in massive three-dimensional, two-color form" from the "justifiable contempt" elicited by the ambiance of "meaningless sentiment" associated with it.[213] John Canaday was less forgiving, musing in *The New York Times* that all Indiana needed to do was print up a third image: MONEY.[214]

In the decades that followed, Indiana returned repeatedly to *LOVE*, making large-edition prints of the image and overseeing fabrication of a *LOVE* ring, a hologram, a tapestry, and, in 1973, a *LOVE* postage stamp.[215] Ultimately he would produce sculptural versions of the word in Hebrew (*AHAVA*; fig. 180) and Spanish (*AMOR*; fig. 140) and, in 1995, begin to pursue his idea from the 1960s of completing editions of *LOVE* sculptures in multiple sizes, each in as many as eight different colors. Given the poverty and traumas of his childhood, it is easy to understand his willingness to proliferate an image that made him beloved by millions of people. "My goal," he once optimistically proclaimed, "is that *LOVE* should cover the world."[216] Surrounded by adoring fans during the 1971 installation of his twelve-foot-high Cor-Ten steel *LOVE* at the entrance to Central Park, he had called it "one of the happiest occasions of my life"[217] (fig. 124). Nevertheless, it was difficult, even for him, to have it both ways— to be "a people's painter as well as a painter's painter."[218] When his second show at Denise René opened in 1975, few critics even bothered to review it. It would be fourteen years before he would have another exhibition in New York.

Contrary to all commonplace assumptions about the hegemony of the New York art world, the increasingly dismissive view of its insiders toward Indiana held little sway in the country's heartland or in Europe, where Indiana's art continued to be heralded as emblematic of America and American culture. Still, the absence of

recognition in the city he had adopted as his home was disheartening. Just prior to the demolition of 25 Coenties Slip in 1965, he had moved into a five-story building on the corner of Spring Street and the Bowery, which he soon was renting in its entirety, assigning different floors to painting, drawing, sculpture, and graphics, as well as living quarters. In 1975, his lease expired. He managed to resist eviction for three years until the building's sale forced his removal in 1978. That summer, on the eve of his fiftieth birthday, he relocated permanently to a tiny fishing village on the island of Vinalhaven, Maine, where he had had been spending the months of September and October for eight years. His romance with the island had begun in 1969 when he chanced to see the village's abandoned hundred-year-

FIG. 125 Robert Indiana, *ART*, 1972/2001. Polychrome aluminum, 144 × 144 × 72 in. (366 × 366 × 182 cm). Private collection

old Odd Fellows lodge, the "Star of Hope," while visiting *Life* magazine photographer Eliot Elisofon.[219] Indiana's enchantment with the building led Elisofon to purchase it and rent its top floors to the artist as a studio until 1977, when Indiana bought the building from the photographer's estate. It was a childhood dream come true for Indiana, an embodiment of the Midwestern Victorian mansions Carmen had always aspired to inhabit. He enjoyed occupying the former home of an association steeped in fraternal affection and coded ritual whose motto, "Friendship, Love, and Truth," was represented by three stars above the lodge's front door and whose very name, the Star of Hope, resonated with optimism. Yet for all of Vinalhaven's appeal, moving there was a "self-imposed exile," as he called it.[220] That he did so underscored his feeling of having been betrayed by the New York art world.

Indiana spent much of his first decade on Vinalhaven refurbishing the Star of Hope. Denuded of paint, its wooden decorative details in danger of disappearing, the building's splendor had faded; restoring it was akin to his earlier rescue of the masts, beams, and other cast-off materials he had salvaged on Coenties Slip. It had taken two vans, each making twelve trips, to move the thousands of artifacts Indiana had accumulated during his two decades in New York. "I'm a keeper," he explained. "I just don't discard things."[221] Situating these belongings in his new home occasioned a reassessment of his past, as did his production of *Decade: Autoportraits, Vinalhaven Suite*, a group of ten prints, each recapitulating a year of his life in the 1970s, which reprised the vocabulary of his earlier *Decade: Autoportraits* documenting the 1960s. Not until 1981 did he begin a new body of work, using the wooden beams he had brought with him from New York to create a fresh group of herms. While structurally akin

BELOW

FIG. 126 Robert Indiana, *Die*, 1962/84. Oil and gesso on wood, iron wheels, and animal skull, 79¾ in. (202.6 cm), height. Collection of the artist

FACING

FIG. 127 Robert Indiana, *Eve*, 1997. Oil on wood and iron wheels, 151 × 36 × 34½ in. (383.5 × 91.4 × 87.7 cm). Collection of Morgan Art Foundation

to his earlier totems, these new sculptures conveyed a more impish, homespun spirit appropriate to the objects he could scavenge on the island: animal skulls, pitchforks, shovels, harrowing discs, and other farming implements (fig. 126). Energized by making art once again, Indiana soon exhausted his imported supply of beams and turned to the island's abandoned driftwood as a substitute, often naming the finished herms after mythological figures: *Icarus*, *Mars*, *Zeus*, and *Eve* (fig. 127). Having once claimed that artists who live outside art centers atrophy, Indiana instead found that distance from New York freed him aesthetically.[222] He took advantage of the autonomy to introduce a playful, irreverent exuberance that accorded with the tradition of bricolage practiced by American folk artists, who used whatever heterogeneous materials were immediately available to invest their art with endlessly shifting interrelations and connections.

Yet despite this new burst of creativity, life on Vinalhaven was harsh, especially in the winter, when the island's population contracted to a core of just over a thousand permanent residents. The anomaly of being gay and an artist in a remote fishing village isolated Indiana psychologically and led to occasional vandalism to the Star of Hope and accusations of sexual impropriety.[223] By "the magic of coincidence," he discovered that the artist Marsden Hartley had summered on Vinalhaven in 1938 in a cottage near the building Indiana rented for storage.[224] "For me," Indiana once said, "the artist is probably about two or three times as interesting as his art. I'm fascinated by the lives of artists."[225] In researching the life of the Maine native, he discovered similarities: both were painter-poets and both felt exiled from the art world to an isolated island whose inhabitants treated them with hostility. "I am always moved by subject matter, and I simply was very moved by Hartley's tragic life," he explained of his decision to pay homage to the American modernist. "It seemed that he was simply plagued with misfortune. And in a sense, I feel that I have also been plagued by misfortune. Just my exile in Maine has been a misfortune."[226]

Initially, Indiana planned to focus on the archaic figure portraits Hartley had executed on Vinalhaven that memorialized the Mason family, whose sons Donny and Alty had drowned at sea during the period Hartley lived with the family. In studying the older artist's work, however, he came to feel more kinship with his predecessor's German military paintings. Like Indiana, Hartley employed symbolic numbers, letters, and stars in these works to code deeply personal information. He had started his *German Officer* series after the death, on October 7, 1914, of Karl von Freyburg, a young, handsome German officer with whom he was in love. His earliest paintings in the series paid direct homage to von Freyburg through imagery associated with him: 24, the age at which he died; K.v.F, his initials; 4, his regiment number; the

FIG. 128 Marsden Hartley (1877–1943), *Painting, Number 5*, 1914–15. Oil on linen, 39¼ × 32 in. (99.7 × 81.3 cm). Whitney Museum of American Art, New York; gift of an anonymous donor 58.65

Iron Cross that he was awarded shortly before his death; the white, feathered helmet of the Kaiser's Royal Guards; and the spurs and tassels of the Guards' dress uniform. On October 7, 1989, exactly seventy-five years after von Freyburg's death, Indiana commenced what he would call his *Hartley Elegies*, a series of eighteen paintings executed in three sequential formats: rectangles, diamonds, and tondos.

Indiana based his *Hartley Elegies* on reproductions in the catalogue that accompanied Hartley's 1980 retrospective at the Whitney Museum of American Art.[227] He began with the artist's *Portrait of a German Officer* (fig. 159), faithfully replicating Hartley's composition with the exception of a circle of words he added bearing Karl von Freyburg's name and "1914/7 October/1989." The older artist's memorial to von Freyburg had been covert; no one at the time questioned his claim that his iconography had "no hidden symbolism" or personal meaning.[228] Indiana changed that, overtly highlighting Hartley's relationship to the German officer by inserting references to the American painter into his homages: 1943 (the year of Hartley's death); 37 (his age when he painted his memorial portrait); 66 (his age when he died); 1938 (the year he summered in Vinalhaven).[229] All but one of Hartley's paintings have a black background, leading Indiana to interpret them as mourning pictures in the tradition of the nineteenth century. Given his own disappointing search for love, it is not surprising that Indiana empathized with his predecessor's anguish over the loss of "a great friendship which ended in grief," telling an interviewer that he "mourn[ed] the situation just as Hartley did at the time that he did [his paintings]."[230] Consequently, he went further than he had gone in *The Demuth American Dream #5* in inscribing personal information about himself into his *Hartley Elegies*: the date of his work, the year he first visited Vinalhaven, and "TvB," a Germanized version of the name of his companion at the time.

Notwithstanding Indiana's empathy for Hartley's grief over von Freyburg's death, he recognized that his predecessor's "tragedy," as he called it, was the deaths in 1936 of the two Mason sons, with whom Hartley had lived for two summers and may have been sexually intimate.[231] But however much Indiana might have wanted to use Hartley's *Archaic Portraits* as springboards for his own compositions, their figurative imagery dissuaded him. Only in Hartley's allegorical depiction of the Mason family at mealtime, *Fisherman's Last Supper* (fig. 129), did he find an iconography he could utilize. In this painting, Hartley had included eight-pointed stars above the heads of the two drowned sons, signifying their transcendence, and "mene, mene" on the tablecloth between the chairs they normally occupied at the dining table, indicating their "numbered" days. Earlier in his career, Indiana had often added words to paintings and sculptures months after completing them,

FIG. 129 Marsden Hartley (1877–1943), *Fisherman's Last Supper*, 1938. Oil on board, 22 × 28 in. (55.9 × 71.1 cm). Private collection

when he had "reason and space" to do so, as he had put it in 1963.[232] Now he returned to paintings he had made three decades before, applying words from the entire biblical passage predicting the demise of Belshazzar's kingdom to his three extant black portrait heads. Likewise, just as decades before he had transposed the Christian Science dictum "God is Love" into "Love is God," so now did he pictorially reorder the words over the door of the Star of Hope, converting the Odd Fellows' motto "Friendship, Love, Truth" into "Truth, Friendship, Love" (fig. 138). The sequence echoed the implied causality in the Delphic Oracle, whose inscription "*Korus, Hubris, Ate*" ("Gluttony, Pride, Destruction") announced death as the product of gluttony and pride. Similarly, by placing "love" as the final word in his sequence, Indiana asserted that it was "still the most important thing," despite all the resistance and hostility he had encountered in his years on Vinalhaven.[233]

By 1998, Indiana had lived on Vinalhaven for twenty years. Aside from his new herms and his *Hartley Elegies*, he had focused his creative energies primarily on producing sculptures of familiar images in different sizes and colors. That changed as recognition of his achievements began to shift in the wake of the reassessment of Pop art. Time had been on his side, as art historian Robert Pincus-Witten has noted.[234] Between 1998 and 2001, Indiana completed his final three *American Dream* canvases and embarked on a new series of works commemorating American cities and states. Then on September 11, 2001, while he was in New York en route to a show of his recent paintings based on Marilyn Monroe in Saint-Paul-de-Vence, France, he witnessed the destruction of the World Trade Center. Shaken, he returned immediately to Vinalhaven and painted *Afghanistan* (fig. 130),

adapting the format and scathing message from his 1965–66 *Confederacy Series*: "JUST AS IN THE ANATOMY OF EVERY MAN EVERY PLANET MUST HAVE ITS HIND PART." Sixteen months later, when the U.S.-led coalition of forces invaded Iraq, he begin a series of peace paintings, appropriating the encircled peace sign he had used in *Yield Brother* but replacing that series's gentle admonition to "yield" with anguished laments: "Where Oh Where Flees Peace"; "Peace Plunges in Despair"; "Whereabouts Hides Peace"; and "Peace Dives in Oblivion" (fig. 131). Indiana delivered his plea for peace with a vocabulary as dazzlingly bold as the one he had employed in his political paintings from decades before, creating hard-edge abstractions whose subtexts spoke of despair and disaffection. His Pop art peers had long before stopped addressing subjects associated with what Lichtenstein once called "the most brazen and threatening characteristics of our culture."[235] In contrast, Indiana had held fast to his commitment to record the cultural forces taking place around him, fusing into a "Holy Both" the alienation and celebration that marked his art and his life. As he said of himself, "I am stuck with an old-fashioned purpose. I haven't done a painting without a message."[236]

As scholars looked back on the 1960s, Indiana's commitment to delivering messages about the fundamental questions facing humanity—love, death, sin, and forgiveness—engendered a reevaluation of his place in art history. Probing the multiple layers of public and private references he embedded in his art exposed the dynamic synthesis of estrangement and commemoration, subjectivity and objectivity that made his painting and sculpture as visionary in its impact as the art of peers such as Warhol. Far from being unabashedly optimistic and celebratory, his work provided insight into the disappointments and failures of the American Dream. Unique among his colleagues, Indiana understood early on that language was integral to modern life. He had harnessed deceptively simple, declarative words to communicate

complicated ideas, using a style whose bold, hard-edge graphics was at once populist and singularly American. Not only was his embrace of language a precedent for contemporary text-based art, but *LOVE*, too, turned out to be prescient. Indiana had extracted a commonplace, often abused word from popular culture and transformed it into a powerfully resonate art object, successfully resisting the elitist equation between quality and scarcity and forcing a reexamination of the relationship between fine art and popular culture. With the rise in recent decades of revisionist views of Indiana's art, *LOVE* is being seen within the context of a body of work spanning more than half a century whose exploration of American identity, racial injustice, and the illusion and disillusion of love gives emotional poignancy and symbolic complexity to our ever-evolving understanding of the ambiguities of American democracy and the plight of the individual in the modern world.

FIG. 132 Robert Indiana, *LOVE*, 1966/93.
Polychrome aluminum, 144 × 144 × 72 in.
(365.8 × 365.8 × 182.9 cm). Shinjuku-I-Land
Public Art Project, Tokyo

FACING

FIG. 133 Robert Indiana, *LOVE Cross*, 1968.
Oil on canvas, five panels, 60 × 60 in. (152.4 ×
152.4 cm) each; 180 × 180 in. (457.2 × 457.2 cm)
overall. The Menil Collection, Houston

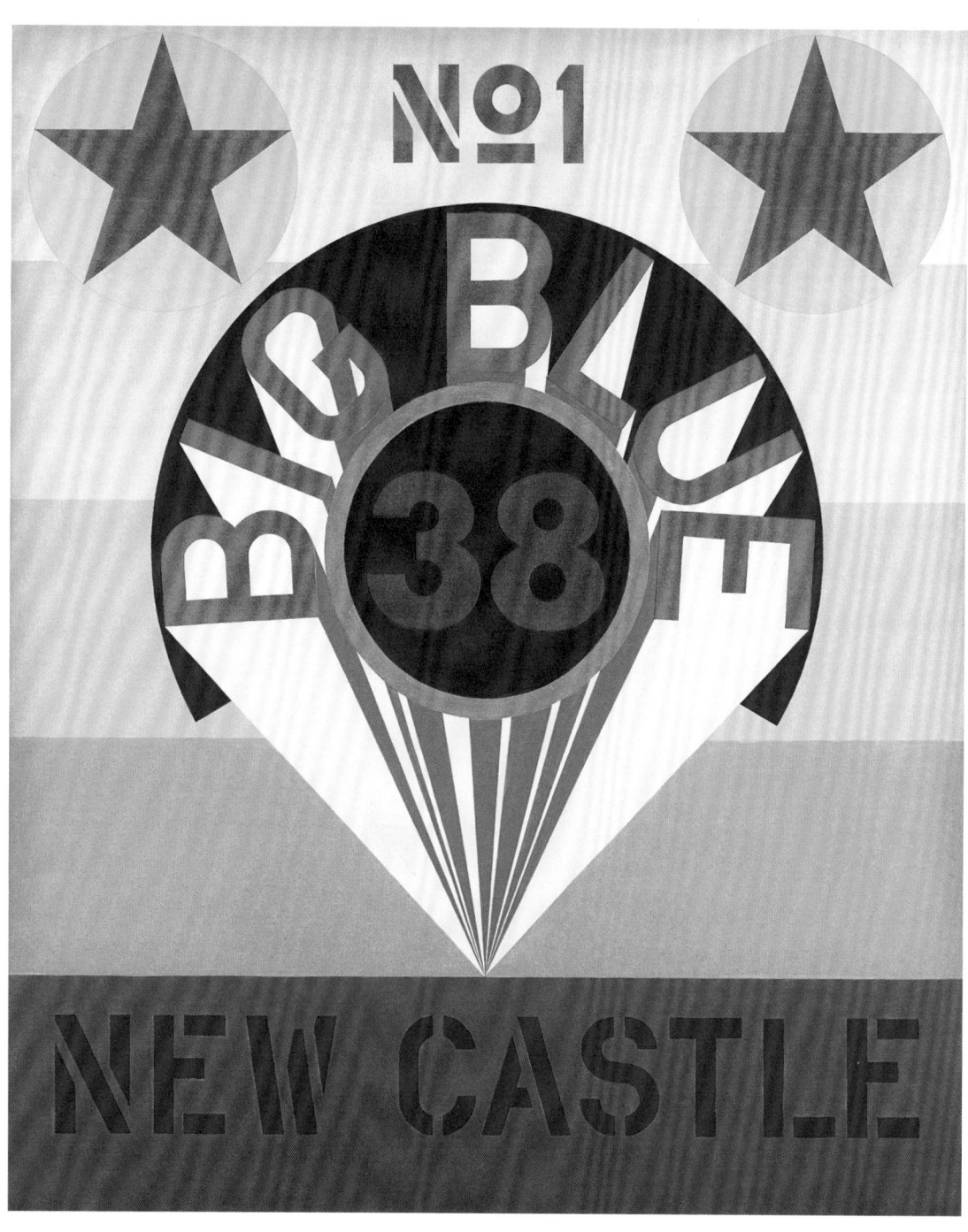

FIG. 134 Robert Indiana, *New Castle*, 1969.
Oil on canvas, 60 × 50 in. (152.4 × 127 cm).
Private collection

FIG. 135 Robert Indiana, *The Metamorphosis of Norma Jean Mortenson*, 1967. Oil on canvas, 102 × 102 in. (259.1 × 259.1 cm), diamond. McNay Art Museum, San Antonio, Texas; gift of Robert L. B. Tobin

FIG. 136 Robert Indiana, *Decade: Autoportrait 1961*,
1971. Oil on canvas, 24 × 24 in. (61 × 61 cm).
Private collection

FIG. 137 Robert Indiana, *Decade: Autoportrait 1961*, 1972–77. Oil on canvas, 72 × 72 in. (182.9 × 182.9 cm). McNay Art Museum, San Antonio, Texas; gift of Robert L. B. Tobin

FIG. 138 Robert Indiana, *KvF X (Hartley Elegy)*,
1989–94. Oil on canvas, 85 × 85 in. (215.9 ×
215.9 cm), diamond. Private collection

FACING

FIG. 139 Robert Indiana, *KvF IV (Hartley Elegy)*,
1989–94. Oil on canvas, 77 × 51 in. (195.6 ×
129.5 cm). Private collection

FIG. 140 Robert Indiana, *AMOR*, 1998/2006.
Polychrome aluminum, 96 × 96 × 48 in.
(244 × 244 × 122 cm). National Gallery of Art,
Washington, D.C.; gift of Simon and Gillian
Salama-Caro in memory of Ruth Klausner

FIG. 141 Robert Indiana, *The Electric LOVE*,
1966/2000. Polychrome aluminum with electric
lights, 72 × 72 × 36 in. (182.8 × 182.8 × 91.4 cm).
Private collection

FIG. 142 Robert Indiana, *Marilyn, Marilyn*, 1999.
Oil on canvas, 68 × 68 in. (172.7 × 172.7 cm),
diamond. Private collection

FIG. 143 Robert Indiana, *The American Dream 7*,
1998. Oil on canvas, four panels, 204 × 204 in.
(518.2 × 518.2 cm) overall, diamond. Collection
Fonds National d'Art Contemporain, on loan to
Musée d'Art Moderne et d'Art Contemporain, Nice

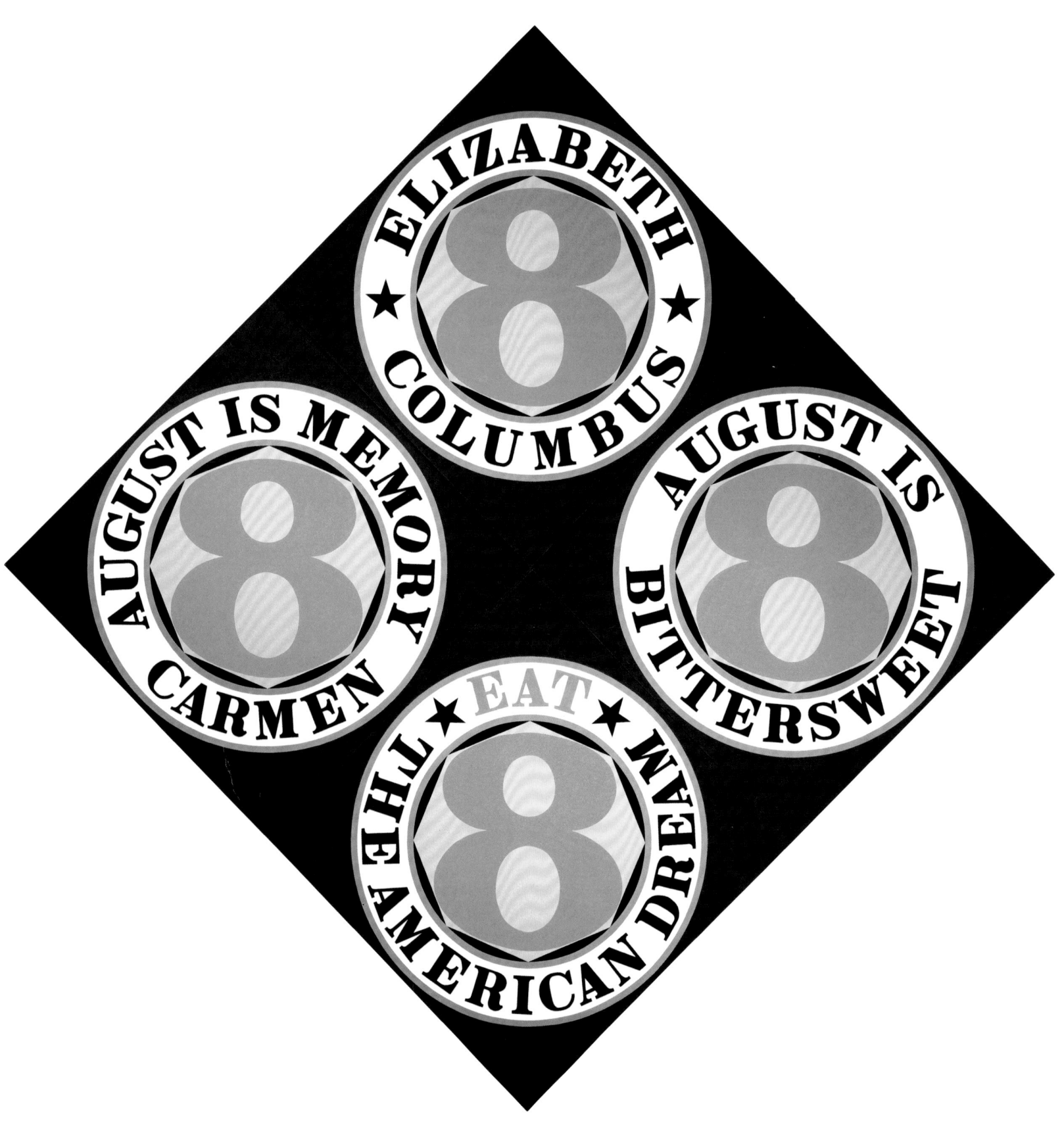

FIG. 144 Robert Indiana, *The Eighth American Dream*, 2000. Oil on canvas, four panels, 170 × 170 in. (431.8 × 431.8 cm) overall, diamond. Collection of the artist

FIG. 145 Robert Indiana, *The Ninth American Dream*, 2001. Oil on canvas, nine panels, 153 × 153 in. (388.6 × 388.6 cm) overall, diamond. Private collection

1 Robert Indiana, quoted in Gene R. Swenson, "What Is Pop Art? Answers from Eight Painters, Part I: Jim Dine, Robert Indiana, Roy Lichtenstein, Andy Warhol," *ARTnews* 62, no. 7 (November 1963): 27.

2 For a discussion of Swenson's life and career, see Scott Rothkopf, "On Gene Swenson: Banned and Determined," *Artforum* 40, no. 10 (Summer 2002): 142–45, 194; and also Charles C. Eldredge, et al., *Gene Swenson: Retrospective for a Critic*, exh. cat. (Lawrence, Kan.: University of Kansas Museum of Art, 1971).

3 For the design of *LOVE* communicating the fragility of relationships, see Joachim Pissarro's essay "Signs into Art," in Joachim Pissarro, John Wilmerding, and Robert Pincus-Witten, *Robert Indiana*, with autochronology by Robert Indiana (New York: Rizzoli International Publications, Inc., 2006), 72.

4 See, for example, "I consider my work primarily autobiographical . . . almost everything I've done has some relationship to something in my life . . . I am painting and writing my own history." Indiana, quoted in *A Visit to the Star of Hope: Conversations with Robert Indiana*, DVD, 2 discs, directed by Dale Schierholt (Rockland, Maine: Acadia Moving Pictures in association with The Farnsworth Art Museum, 2009), 17:23–17:40; hereafter cited as *A Visit to the Star of Hope*, timestamp. See also, "I think all of my work is basically autobiographical." Indiana, quoted in *Robert Indiana: American Dreamer*, DVD, directed by Eric Breitbart (New York: Eric Breitbart Productions, LLC, and Muse Film and Television, Inc., 2007), 6:08–6:14; hereafter cited as *Robert Indiana: American Dreamer*, timestamp.

5 Oddly, given the numerous interviews and statements Indiana has made about his life, the first printed mention that he was adopted was not until 1980, in the interviews conducted by Leah Carol Reichman printed in her "Robert Indiana and the Psychological Aspects of His Art" (master's thesis, Hunter College, The City University of New York, 1980). According to these interviews, Indiana's birth mother was underage and unmarried when she gave birth to him, and he was sent to live with an aunt before being adopted by the Clarks. Ibid., 99, 106, 114–15. Indiana retains to this day a photograph of himself at approximately nine months of age being held by the woman he describes as his "caretaker," who practiced Christian Science. According to Susan Elizabeth Ryan, Carmen never allowed Indiana to find his biological mother, although she told him from an early age that she and Earl were not his biological parents because she believed that children should know if they were adopted. See Ryan, *Robert Indiana: Figures of Speech* (New Haven, Conn.: Yale University Press, 2000), 19, 271n18.

6 For Indiana's recurrent dreams about death and funerals, see Arthur C. Carr, "The Reminiscences of Robert Indiana" (Arthur C. Carr Papers, Rare Book & Manuscript Library, Columbia University), 18, 22, 59–60. A psychologist and professor of medical psychology at Columbia University for several decades, Carr was interested in the psychology behind creativity, particularly among artists. In November 1965, he conducted six interviews with Indiana at the artist's Spring Street studio that he used as the basis for an unpublished manuscript, which includes numerous psychoanalytical interpretations regarding Indiana (see note 125).

7 Indiana recalled fumes from an International Harvester Plant across the street from the family's house as occasioning their move (see Ryan, *Robert Indiana: Figures of Speech*, 15), but this is incorrect; that particular factory was not built until 1937–38.

8 Robert Indiana, quoted in Richard Brown Baker, "Oral History Interview with Robert Indiana" (tape recording and transcript, Archives of American Art, Smithsonian Institution, Washington, D.C., September 12–November 7, 1963). Elsewhere Indiana writes that Carmen and Earl lived in over fifty different bungalows during their twenty-one years of marriage. Indiana, "A Mother Is a Mother, A Father Is a Father," in John W. McCoubrey, *Robert Indiana*, exh. cat. (Philadelphia: Institute of Contemporary Art, University of Pennsylvania, 1968), 36. Indiana told Carr that he cried uncontrollably upon seeing the dilapidated house into which the family was forced to move after Earl lost his job. Carr, "Reminiscences of Robert Indiana," 28. As an adult, Indiana looked back on his frequent moves

as having been "threatening to me," calling them collectively "that nightmare that I went through with my mother." First quote, conversation with the author, December 6, 2012. Second quote, in Donald B. Goodall, "Conversations with Robert Indiana," in Goodall, Robert L. B. Tobin, and William Katz, *Robert Indiana*, exh. cat. (Austin, Texas: University Art Museum, University of Texas at Austin, 1977), 31.

9 Indiana, quoted in Carr, "The Reminiscences of Robert Indiana," 145.

10 Indiana, "A Mother Is a Mother, A Father Is a Father," 36.

11 Indiana, quoted in Baker, "Oral History Interview with Robert Indiana."

12 Indiana, "A Mother Is a Mother, A Father Is a Father," 36. According to the artist, Carmen sat on the porch of their bungalow with the gun in her lap for months after Earl left. Indiana, in conversation with the author, December 5–6, 2012.

13 Indiana later wrote that Carmen's stepmother was "shot to death because she was so mean." Indiana, "A Mother Is a Mother, A Father Is a Father," 36. The Ruby Watters murder case made a lasting impression on the artist, who often mentioned it as an adult. The details of the murder are as follows: Roberta (Ruby) Watters returned to South Bend from New York, where she had been working as a nurse after separating from her husband, in order to regain custody of her two small children, ages four and nine, whom she had left with her mother-in-law, Martha Watters. When Martha refused to tell her where they were, Ruby accused her of kidnapping them and shot her. The trial ended in an acquittal based on a defense of temporary insanity. See "Pawns in Shooting: Young South Bend Mother May Be Charged with Murder of Mother-in-Law," *Logansport Pharos-Tribune*, April 29, 1938: 1; and "Will Plead Not Guilty: Young Mother Charged with Slaying of Her Mother-in-Law, April 26," *Logansport Pharos-Tribune*, May 12, 1938: 5.

14 Indiana attributed Earl's abandonment of the family to Carmen having gotten "fat and middle-aged." Indiana, "A Mother Is a Mother, A Father Is a Father," 36. But he also acknowledged that his adoptive mother's inability

"to live in one house for more than a year at a time . . . drove my father absolutely out of his mind." Robert Indiana, "A lecture by Robert Indiana sponsored by the National Museum of American Art in conjunction with the exhibition, *Wood Works: Constructions by Robert Indiana*" (transcribed sound recording, Archives of American Art, Smithsonian Institution, Washington, D.C., May 3, 1983). Hereafter cited as: Indiana, NMAA Lecture.

15 Carmen and Earl's marriage was the second for both. Indiana described Carmen's third husband, Foster Dickey, as uneducated and holding only menial jobs, and Earl's wife Sylvia as more educated and sophisticated than Carmen. See Baker, "Oral History Interview with Robert Indiana." The divorce was traumatic for Indiana, who later said, "My family was separated so that I don't remember anything about childhood experiences." Indiana, quoted in Carr, "Reminiscences of Robert Indiana," 89.

16 Indiana, quoted in Mario Amaya, *Pop Art . . . And After* (New York: The Viking Press, 1965), 85.

17 Carr, "Reminiscences of Robert Indiana," 144–45.

18 An annotated photograph in *A Visit to the Star of Hope* identifies Indiana's first-grade teacher as Ruth Kaufman (Haase), 12:01 and 12:55.

19 Indiana described Cumberland as "not much more than just a widening in the road." Indiana, quoted in Baker, "Oral History Interview with Robert Indiana." Minutes of the Cumberland town council meetings on November 7, 2007, and October 27, 2012, confirm that the town was without paved streets or curbs in the 1930s.

20 Indiana, quoted in Goodall, "Conversations with Robert Indiana," 29. According to Indiana, living with his father was stressful. Earl's new wife, Sylvia, had a daughter who was close in age to Indiana but not academically successful, which caused friction. In addition, Sylvia forbade Indiana to see his adoptive mother, perhaps because Carmen characterized Earl as the devil. Indiana contributed to the family income during high school by working various jobs after school: he delivered poultry and worked as a Western Union telegraph messenger and as a "copy boy" in the advertising

department of the *Indianapolis Star*. Baker, "Oral History Interview with Robert Indiana."

21 Carmen returned to Indianapolis with her husband after he lost his job at the Fort Benjamin Harrison Army Base in Lawrence. They moved into a small bungalow in a predominantly African American part of town, where Indiana moved in with them. Ibid., and Indiana, in conversation with the author, December 5–6, 2012.

22 In high school, Indiana was a member and ultimately captain of "The Tech Legion," an honor society for scholastically high-achieving students; a reporter for the school newspaper, the *Arsenal Canon*; the photography editor for the yearbook; and an officer in the Latin Club. Baker, "Oral History Interview with Robert Indiana."

23 Indiana, quoted in ibid.

24 In order to spend most of his senior year in Sara Bard's art class, Indiana attended summer school to fulfill his science credits required for graduation. Only in his last year was he permitted to work with oil paint. Ibid., and Indiana, in conversation with the author, October 6, 2012.

25 Robert Indiana, artist's statement, c. 1964, Stable Gallery Records, Archives of American Art, Smithsonian Institution, Washington, D.C.

26 The Scholastic Art and Writing Award gave Indiana a full-tuition scholarship to Indianapolis's John Herron Art Institute, where he had studied life-drawing on Saturdays during his senior year. He forfeited this when he joined the Army Air Corps. In Indiana's narratives about his life, he incorrectly attributes his decision to volunteer for the military to the imminent expiration of the G.I. Bill. (See, for example, Baker, "Oral History Interview with Robert Indiana"). In fact, the G.I. Bill had been passed only two years earlier, on June 22, 1944, and was not terminated until July 25, 1956.

27 Before Indiana enlisted, he went alone to Mammoth Cave, Kentucky, to ponder whether he had made the right decision to enter the Air Corps. He described the trip as a time of reflection in which he overcame his "fears and doubts." Ultimately, as he said, "I wanted to leave, I wanted to get away from home . . . I wanted to get away from Indianapolis." Indiana, quoted in Baker, "Oral History Interview with Robert Indiana."

28 See Indiana's interviews with Baker for his description of becoming ill upon arriving for training in San Antonio, Texas; feeling humiliated at being trained as a typist rather than as a photographer; his disappointment when his unit was assigned to Europe after he had requested an assignment in Alaska; and his mental breakdown in Alaska that required hospitalization. Ibid.

29 Indiana's assignment at the base in Hobbs lasted approximately three months. He served less than six months in Anchorage and was not assigned to run the newspaper there immediately upon arrival. Ibid.

30 "I was raised in Indiana as a Christian Scientist," Indiana told Ruth Bowman. Robert Indiana interview with Ruth Bowman, "Views on Art," WNYC (sound recording, Archives of American Art, Smithsonian Institution, Washington, D.C., December 2, 1971); see also Carr, "Reminiscences of Robert Indiana," 11–12, 17–18. The artist reconnected with the church while in the service. "Somehow or another this seemed very much to be filling an emptiness or need which probably being in the Army brought about in itself." Indiana, quoted in Baker, "Oral History Interview with Robert Indiana."

31 At the time of Carmen's death, she was living in a two-room house in Columbus, Indiana, with neither hot water nor a kitchen. Ryan, *Robert Indiana: Figures of Speech*, 18; also Indiana, in conversation with the author, December 5–6, 2012.

32 Indiana made a few friends while studying at the Art Institute but kept mostly to himself, partly as a result of having to supplement his stipend from the G.I. Bill with menial nighttime jobs. He worked at the Ryerson steel plant stocking inventory, as a stock boy in Marshall Field's department store, and as an assistant at the Ryerson Library at the Art Institute. One summer, he drew illustrations for the classified telephone directory. See Baker, "Oral History Interview with Robert Indiana," and also Susan Sheehan, *Robert Indiana Prints: A Catalogue Raisonné, 1951–1991*, with an interview of the artist by Poppy Gandler Orchier (New York: Susan Sheehan Gallery, 1991), 11. When asked to discuss these jobs, Indiana told Baker that they were "too painful" to remember.

33 The circle of artists around Berdich included June Leaf, George Cohen, Robert Barnes, and Leon Golub. In 1948, they joined with students from the Institute of Design to form an organization called Momentum, hoping to gain national recognition for their art by importing renowned art-world figures to jury their exhibitions. Indiana chose to join Momentum's more conservative competitor, the national honor art fraternity Delta Phi Delta, which promoted social and professional interactions among art students under the auspices of the school. The organization had a faculty sponsor and relied on faculty members to jury its shows, which were held in the Art Institute's Blackstone Gallery. Elected president of the fraternity in his senior year, Indiana organized a hugely popular student costume ball called "Death of a Mansion," which was held at Cyrus McCormick's abandoned mansion. Otherwise, Indiana's association with the fraternity was uneventful, save for a few sales he made out of the juried shows. Information on Delta Phi Delta can be found in various archives at the Art Institute of Chicago, including the 1950 student handbook as well as articles in *Symmetry*, the school newspaper. Indiana discussed the "Death of a Mansion" ball in Baker, "Oral History Interview with Robert Indiana."

34 Indiana's scholarship for the Foreign Traveling Fellowship was $1,250. "Foreign Traveling Fellowship Competition," *Symmetry* 1, no. 8 (June 1953). Indiana mentions the dean's Skowhegan offer in Baker, "Oral History Interview with Robert Indiana."

35 Indiana initially planned to study at Oxford or the University of London. Indiana, quoted in "Foreign Traveling Fellowship Competition." However, as he explained to Baker, "the quota was filled," and he could not attend. "My second choice was Edinburgh, and I was accepted in Edinburgh—very late—I might even have been in England before I knew just where I was going." Indiana, quoted in Baker, "Oral History Interview with Robert Indiana."

36 Indiana, in conversation with the author, December 5–6, 2012. "At the University of Edinburgh in Scotland there was no climate to do any art work . . . I just got involved with poetry . . . I got side-tracked altogether." Indiana, quoted in Goodall, "Conversations with Robert Indiana," 36.

37 Indiana, quoted in Baker, "Oral History Interview with Robert Indiana."

38 Indiana, quoted in Goodall, "Conversations with Robert Indiana," 37. Indiana continues: "I didn't have the means to become an abstract expressionist."

39 The phrase "tragic and timeless" appears in "A Letter from Mark Rothko and Adolph Gottlieb to the Editor of the New York Times," published in Edward Alden Jewell, "The Realm of Art: A New Platform and Other Matters: 'Globalism' Pops into View," *The New York Times*, June 13, 1943: X9.

40 Indiana told Baker that the Dubuffet exhibition was on the campus of Northwestern University in Evanston. Baker, "Oral History Interview with Robert Indiana." In fact, *Anticultural Positions*, as the show was called, was on view at the Arts Club of Chicago from December 18, 1951, through January 23, 1952.

41 Friends of both artists confirm that Indiana and Kelly's relationship was sexual. The lack of frankness about sexual orientation that existed at that time persists, however, leading to an understandable measure of discomfort for both artists about publically acknowledging the level of their intimacy. To this day, Indiana calls Kelly "the most important person in my life." *A Visit to the Star of Hope*, 13:32–13:38.

42 Indiana, in conversation with the author, October 6, 2012.

43 Indiana, quoted in *A Visit to the Star of Hope*, 15:29.

44 Indiana, quoted in *Robert Indiana: American Dreamer*, 9:30

45 Agnes Martin, quoted in Faye Hammel, "Bohemia on the Waterfront," *Cue*, March 22, 1958: 17.

46 Ellsworth Kelly, quoted in Hélène Depotte, "Towards an Immobile Voyage: Robert Indiana, the Reality-Dreamer," in Joachim Pissarro and Hélène Depotte, *Robert Indiana: Rétrospective 1958–1998*, exh. cat. (Nice, France: Musée d'Art Moderne et d'Art Contemporain, 1998), 38.

47 "I know I resisted [Kelly's] influence just out of a matter of pride, I suppose . . . it took two or three years before there was any really active influence on my work." Indiana, quoted in Baker, "Oral History Interview with Robert Indiana."

48 Indiana, quoted in Baker, "Oral History Interview with Robert Indiana."

49 Indiana, quoted in Baker, "Oral History Interview with Robert Indiana."

50 Indiana, "The Sweet Mystery," in McCoubrey, *Robert Indiana*, 15.

51 Indiana identifies himself with the ginkgo leaf in ibid. According to Tad Beck, the photographer and former studio assistant of Indiana's on Vinalhaven, the artist also identified the ginkgo leaf with Kelly. Tad Beck, in conversation with the author, December 10, 2012.

52 Indiana, "The Sweet Mystery," in McCoubrey, *Robert Indiana*, 15.

53 Edward N. West, *The History of the Cross* (New York: Macmillan, 1960). Indiana had almost no direct contact with Pike, as evidenced by the thank-you letter Pike sent to Indiana dated May 13, 1958. In it Pike writes, "I am sorry that you have been [at the Cathedral] at a time when I have been in the greatest 'rush' of my life, and hence we haven't had much chance to visit; but I do hope that our paths cross again sometime." Research files, Robert Indiana Catalogue Raisonné office, New York.

54 West, *History of the Cross*, 22.

55 "I could feel that something was going to be happening shortly, and I didn't want to have something nice happen with the burden of a name I didn't like." Indiana, quoted in Barbaralee Diamonstein, "Interview with Robert Indiana," in *Inside New York's Art World* (New York: Rizzoli International Publications, Inc., 1979), 156.

56 Indiana, quoted in Carr, "Reminiscences of Robert Indiana," 81. Indiana claimed that there were other artists in New York with the name Bob Clark. He may have been referring to Robert "Bob" Clarke, the comic book artist associated with *Mad Magazine*.

57 Nathan Kernan, *Robert Indiana* (New York: Assouline Publishing, 2003), 8.

58 Regarding *Source I* (fig. 20), Indiana wrote in his journal on December 31, 1959, "[T]his is, I feel, a very seminal painting, and if it bears great debt to [Jack] Youngerman's more tortured forms, it is possibly already repaid, or at least loses no great grace by that indebtedness; surely Jack is more graceful in his largesse than Ellsworth, who trembles lest anyone hard-edge." Indiana, quoted in Daniel O'Leary, "The Journals of Robert Indiana," in Daniel O'Leary, Aprile Gallant, and Susan Elizabeth

Ryan, *Love and the American Dream: The Art of Robert Indiana*, exh. cat. (Portland, Maine: Portland Museum of Art, 1999), 10.

59 The Jean Arp retrospective was held at the Museum of Modern Art from October 8 through November 30, 1958.

60 "Everything begins with the circle . . . As a child, I was hit over the head with this hammer which said that the circle is the symbolization of eternal life. So we start with eternal life, because we all just know it goes on and on forever." Indiana, quoted in Diamonstein, "Interview with Robert Indiana," 161.

61 To underscore the abstraction of his orb paintings, Indiana titled them according to the number of circles they contained. He did not correlate the numbers with aspects of his personal history as he would do later; his aim was to create abstract, geometric forms.

62 Robert Indiana, Journal Entry, February 12, 1959, Journal Collection 1959–1962, Collection of the artist, Vinalhaven, Maine. Hereafter cited as: Indiana, Journal Entry, date.

63 Indiana, Journal Entry, April 4, 1959.

64 Indiana, Journal Entry, April 22, 1959.

65 Indiana, quoted in Goodall, "Conversations with Robert Indiana," 27.

66 Indiana, Journal Entry, August 30, 1959.

67 Indiana, Journal Entry, March 2–3, 1960. The devastating Agadir earthquake took place on the night of February 29, 1960, and while the exact number of casualties will never be known, a reasonable estimate has indicated at least 12,000 killed and 12,000 wounded. Indiana's journal refers to the "possibly 5000 people [who] met their death in [the] middle of [the] night." He later discovered, and noted, that the death toll was higher than his previously stated figure, as described in a newspaper clipping he glued on the same page that read in part: "Crown Prince Maoulay Hassan said the total death toll would reach 10,000 to 12,000."

68 Indiana, quoted in Carl J. Weinhardt, Jr., *Robert Indiana* (New York: Harry N. Abrams, 1990), 57.

69 Indiana, journal entry, December 7, 1959, cited in O'Leary, "The Journals of Robert Indiana," 11.

70 Indiana, quoted in Baker, "Oral History Interview with Robert Indiana."

71 Indiana, Journal Entry, November 18, 1959.

72 Cyril Connolly, *The Unquiet Grave: A Word Cycle by Palinurus* (New York: Persea Books, 1981), 113.

73 Ibid., 114.

74 Indiana, interview with Susan Elizabeth Ryan, July 27, 1990, cited in Ryan, *Robert Indiana: Figures of Speech*, 165.

75 The phrase "our inexorably divided self" was used by Stephen Metcalf to describe W. H. Auden's poem "The New York Letter." See Stephen Metcalf, "Auden at 100," *Slate*, March 1, 2007: http://www.slate.com/articles/the_book_club/features/2007/auden_at_100/is_auden_the_honorary_american.html. For "psychological conflict," see W. H. Auden and Cecil Day-Lewis, preface to *Oxford Poetry 1927* (Oxford, United Kingdom: Basil Blackwell, 1927).

76 Indiana, quoted in Goodall, "Conversations with Robert Indiana," 26.

77 Robert Indiana, "Artist Questionnaire," December 11, 1961, Object Files, Department of Painting and Sculpture, Museum of Modern Art, New York.

78 Indiana, Journal Entry, August 2, 1960.

79 West, *History of the Cross*, 30. Indiana made an explicit connection to the Crucifixion in *Sun and Moon* (1959–60) by allowing the nails that secured the stove lid to the construction to project, suggesting what he described as a "crown of thorns." Indiana, interview with Susan Elizabeth Ryan, June 11, 1991, cited in Ryan, *Robert Indiana: Figures of Speech*, 63.

80 Indiana, quoted in Goodall, "Conversations with Robert Indiana," 25.

81 Indiana, in conversation with the author, December 5–6, 2012.

82 See Marius B. Péladeau and Martin Dibner, *Indiana's Indianas: A 20-Year Retrospective of Paintings and Sculpture from the Collection of Robert Indiana*, exh. cat. (Rockland, Maine: The William A. Farnsworth Library and Art Museum, 1982), 5.

83 The show initially was called *New Media–New Forms* and appeared under this title in Claes Oldenburg's illustration for the catalogue cover, in reviews, and in Martha Jackson's foreword. It was called *New Forms–New Media* on the cover of the catalogue, which was printed after the show opened. The show is mostly referred to by that title today.

84 Multiple journal entries refer to "Lenore's stencils." See, for example, January 11, 1961. Indiana also wrote that he found the stencils he used in the loft of someone he worked for. Tawney was one such person. Baker, "Oral History Interview."

85 Indiana attached a peg to *GE*, for example; added numbers and eight wheels to *Star*; crammed *Marine Works* with numbers, arrows, circles, and an "M" and "W"; and added a red "J" to *Jeanne d'Arc*.

86 Indiana told Baker that he felt his herms were incomplete without words and that he had applied words to counter what he felt was the herms' "decorative" quality. Indiana, quoted in Baker, "Oral History Interview with Robert Indiana."

87 Indiana, quoted in McCoubrey, introduction to *Robert Indiana*, 9.

88 G[ene] R. S[wenson], "Robert Indiana," *ARTnews* 63, no. 4 (Summer 1964): 13.

89 *The Sweet Mystery* was the first painting to which Indiana applied words, followed by *The Triumph of Tira*. See Baker, "Oral History Interview with Robert Indiana," and Indiana, "The Sweet Mystery," in McCoubrey, *Robert Indiana*, 15.

90 Indiana, quoted in Carr, "Reminiscences of Robert Indiana," 42–43.

91 Indiana, quoted in Ryan, *Robert Indiana: Figures of Speech*, 92.

92 Indiana claimed to have seen at least some of Charles Demuth's poster portraits at the Art Institute of Chicago. See Goodall, "Conversations with Robert Indiana," 27. In a later interview discussing Demuth's *I Saw the Figure 5 in Gold*, which would exert an exceptional influence on him, Indiana said that he "didn't see [the painting] in the flesh until I was well into my own series." Indiana, quoted in Jan van der Marck, "Interview of Robert Indiana and Richard Stankiewicz on occasion of the opening of *Richard Stankiewicz, Robert Indiana: An Exhibition of Recent Sculptures and Paintings*" (transcript, Walker Art Center, Minneapolis, October 21, 1963), http://www.walkerart.org/archive/5/A883710BAB4022C46169.htm.

93 In discussing this painting with Barbaralee Diamonstein, Indiana said: "There is a mask, and of course he who changes his name is wearing a mask." Diamonstein, "Interview with Robert Indiana," 163.

94 Like Indiana's work, Demuth's poster portraits included coded references to his own life. The numbers "1, 2, 3" on Demuth's *Love, Love, Love* refer to the address of Christine's, a restaurant frequented by Demuth, Eugene O'Neill, and others associated with the Provincetown Players. For analysis of this and the likely association of the painting with Locher, see Robin Jaffee Frank, *Charles Demuth: Poster Portraits 1923–1929* (New Haven, Conn.: Yale University Art Gallery, 1994), 101–6. For further arguments against the painting's association with Stein, see also Bruce Keller, *Letters of Charles Demuth, American Artist, 1883–1935* (Lancaster, Penn.: The Demuth Foundation, 2000), 126.

95 Indiana called Demuth's incorporation of words in his paintings "a modern step" in Goodall, "Conversations with Robert Indiana," 27.

96 Guillaume Apollinaire, quoted in William C. Seitz, *The Art of Assemblage*, exh. cat. (New York: Museum of Modern Art, 1961), 121.

97 Indiana, quoted in Phyllis Tuchman, "Pop! Interview with George Segal, Andy Warhol, Roy Lichtenstein, James Rosenquist, and Robert Indiana," *ARTnews* 73, no. 5 (May 1974): 29.

98 Robert L. B. Tobin, "Robert Indiana," in Goodall, et al., *Robert Indiana*, 17.

99 The lyrics for "Ah! Sweet Mystery of Life" in *Naughty Marietta* are: "Ah! Sweet mystery of life, at last I've found thee / Ah! I know at last the secret of it all; all the longing, seeking, striving, waiting, yearning / The burning hopes, the joy, and idle tears that fall! / For 'tis love, and love alone, the world is seeking / And 'tis love, and love alone, that can repay."

100 Indiana, "The Sweet Mystery," in McCoubrey, *Robert Indiana*, 15.

101 For *The Sweet Mystery* and *The Triumph of Tira* as companion paintings, see Baker, "Oral History Interview with Robert Indiana." According to Indiana, Mae West was the "model" for both paintings. Indiana, "Artist Questionnaire," May 19, 1965, Object Files, Museum of Modern Art, New York. As a child, Indiana was often put in movie theaters alone by his adoptive mother, who considered them babysitting surrogates. Indiana, in conversation with the author, December 6, 2012; see also Robert Indiana, "The Metamorphosis of Norma Jean Mortenson," in McCoubrey, *Robert Indiana*, 45.

102 For "the *most* American bloom," see Indiana, "Artist Questionnaire," May 19, 1965, MoMA. For "Americasm [*sic*]," see Indiana, quoted in Swenson, "What Is Pop Art?," 64.

103 Indiana, in conversation with the author, December 6, 2012. The artist makes a similar statement in Goodall, "Conversations with Robert Indiana," 40.

104 Indiana, "Artist Questionnaire," May 19, 1965, MoMA.

105 For "paint the American scene," see Indiana, artist's statement, c. 1964, Stable Gallery Records. For "neon polychromy," see Indiana, quoted in Weinhardt, *Robert Indiana*, 100. For "technique," see Indiana, "Artist Questionnaire," May 19, 1965, MoMA.

106 Indiana, "Artist Questionnaire," May 19, 1965, MoMA.

107 Indiana, Journal Entry, January 17, 1961.

108 For Albee quote, see Ryan, *Robert Indiana: Figures of Speech*, 93. For "broken" American Dream, see Indiana, quoted in Francine Koslow Miller, "Robert Indiana," *Tema Celeste* 20, no. 95 (January/February 2003): 70.

109 Indiana, "A Mother Is a Mother, A Father Is a Father," in McCoubrey, *Robert Indiana*, 36.

110 Indiana, quoted in Tuchman, "Pop!," 29.

111 For "anguish of us all," see Edward Albee, quoted in Ryan, *Robert Indiana: Figures of Speech*, 93. For "every American's [dream]," see Indiana, "Autochronology," in McCoubrey, *Robert Indiana*, 53.

112 For "grubby bars," see Indiana, "Artist Questionnaire," May 19, 1965, MoMA. For "meaningful aspects," see Indiana, "A Mother Is a Mother, A Father Is a Father," in McCoubrey, *Robert Indiana*, 36.

113 Indiana, quoted in Kalliopi Minioudaki, "From His Story to History: Robert Indiana's Patriotic Art of Social Engagement," in Robert Storr, Thomas Crow, Jonathan D. Katz, Kalliopi Minioudaki, and Allison Unruh, *Robert Indiana: New Perspectives*, ed. Allison Unruh (Ostfildern, Germany: Hatje Cantz Verlag, 2012), 99.

114 Indiana, quoted in Swenson, "What Is Pop Art?," 63, 64.

115 Carr, "Reminiscences of Robert Indiana," 121.

116 Indiana, quoted in Goodall, "Conversations with Robert Indiana," 29.

117 Indiana considered that language had "been so divided and compartmentalized by people who have split up human intelligence [that it had

obscured the fact] that language is a terribly important part of our being humans." Ibid.

118 For "undo," see ibid. For "conscious grasp," see Baker, "Oral History Interview with Robert Indiana." Indiana told Baker: "The very elementary part that language plays in man's thinking processes, and this includes his identification of anything visual . . . I'm sure that the word, the object, and the idea are almost inextricably [locked] in the mind, and to divide them and to break them down . . . it doesn't have to be done. The artist has usually done it in the past. I prefer not to." Most writers have assumed the word in the above quote was "lost"; given the meaning, it is most likely "locked" and was incorrectly transcribed as "lost."

119 Indiana, quoted in ibid.

120 Indiana remembered the Sanasardo show as only including constructions, but Swenson's review of the exhibition mentions *FUN*. G[ene] R. S[wenson], "Reviews and Previews: New names this month, Stephan Durkee, Robert Indiana, and Richard Smith," *ARTnews* 60, no. 4 (Summer 1961): 16. Indiana's second exhibition, in Mamaroneck, included these works as well. Susan Ryan wrote that the show took place in the winter of 1961–62, but according to a review, the show opened in March and closed on April 14, 1962. Ryan, *Robert Indiana: Figures of Speech*, 105. Noel Frackman, "Indiana, Natkin Display Avant-Garde Paintings," *The Scarsdale Inquirer*, March 29, 1962.

121 The death of Indiana's adoptive father immediately after a meal reinforced the association between "eat" and "die." Still, Indiana insisted the words referred primarily to Carmen. Robert Indiana, handwritten annotations to unpublished draft of Susan Elizabeth Ryan's Ph.D. dissertation, research files, Robert Indiana Catalogue Raisonné office, New York.

122 Indiana, quoted in van der Marck, "Interview of Robert Indiana and Richard Stankiewicz . . ."

123 For Indiana's association of "eat" with love, see Bill Katz's interview with Reichman: "[Carmen] loved to cook . . . eat is the same as love . . . he equated eating with . . . affection. Human affection in one's life." Katz, quoted in Reichman, "Robert Indiana and the Psychological Aspects of His Art," 115, 116. For Indiana's association between "eat/die" and the Last Supper, see Indiana's handwritten annotations

to unpublished draft of Ryan's Ph.D. dissertation, 38. As with all of Indiana's work, the compressed layers of meaning in *Eat/Die* have engendered multiple interpretations. See Robert Storr's association of the diptych with oral sex and orgasm. Robert Storr, "Preface: Robert Indiana, All-American" in Storr, et al., *Robert Indiana: New Perspectives*, 24. Allison Unruh sees *Eat/Die* as a "semiotic play with gender and family (as well as, perhaps, the larger conditions of existential polarization that typified the culture of the Cold War itself)." Allison Unruh, "Robert Indiana and the Politics of Family," in ibid., 192.

124 For Indiana's reference to the Ten Commandments, see Carr, "Reminiscences of Robert Indiana," 121.

125 Ryan, *Robert Indiana: Figures of Speech*, 135. Katz asserts that the fact that the calumet is "reserved for oral use among men, only amplifies the image's campy charge." Jonathan D. Katz, "Two-Faced Truths: Robert Indiana's Queer Semiotic," in Storr, et al., *Robert Indiana: New Perspectives*, 251. Similarly, Arthur Carr proposes that the calumet and Pukwana (meaning "brotherhood") are sexual references that represent "denial of the wish to fuse with the mother-figure." Arthur C. Carr, unpublished manuscript (Papers on Robert Indiana, 1952–1991, Rare Book & Manuscript Library, Columbia University, New York), 38.

126 Indiana, NMAA Lecture.

127 John (Jack) Curtis was one of Indiana's closest friends; the two met in Chicago where Curtis had gone after graduating from Yale in 1951. Curtis went to Skowhegan on Indiana's recommendation the summer Indiana was there, and they resumed their friendship when Indiana returned to New York after his yearlong study abroad. Based on Indiana's description of Curtis as wealthy, he was likely the friend Indiana had counted on to finance his return to Chicago. Curtis died on July 1, 1958. My thanks to Claes Oldenburg for sharing Curtis's obituary with me.

128 Herman Melville, *Moby Dick* (New York: Charles Scribner's Sons, 1902), 169. The opening lines of Melville's text read: "Circumambulate the city . . . Go from Corlears Hook to Coenties Slip thence northward by Whitehall." Indiana explained how this was the passage in the novel that "meant most to me" because of

its connection to the Slip. He described how he visually translated these sites into the painting's cartographic forms. "Just by chance Corlears Hook was a hook, Whitehall was a short straight street only a few blocks long. You combine Corlears Hook with Whitehall . . . you get that inverted Y configuration . . . that was the shape of Coenties Slip." Indiana, NMAA Lecture.

129 Indiana's handwritten annotations to unpublished draft of Ryan's Ph.D. dissertation, 43. Indiana's interpretation of *Moby Dick* may have derived from Jack Curtis, whom he described as "obsessed" with Ahab. Indiana, in conversation with the author, December 5–6, 2012.

130 The "youth I love" probably referred to Prince Edward, whom Whitman saw during the prince's visit to New York in 1860 and calls "sweet boy of England." Whitman, "Year of Meteors," in *The Poems of Walt Whitman (Leaves of Grass)* (New York: Thomas Y. Crowell Company Publishers, 1902), 404. The lines that Indiana quotes in *Year of Meteors* are: "Nor forget I to sing of the wonder," and, "Well-shaped and stately the Great Eastern swam up my bay, she was six hundred feet long." Jonathan Katz focuses on the lines surrounding these as proving the painting's homoerotic intent. Katz, "Two-Faced Truths: Robert Indiana's Queer Semiotic," 245–50. Likewise, Michael Plante argues that "in New York in the 1950s, references to Whitman conjured an association with homosexual identity" and that by quoting Whitman, Indiana "constructed a family tree of great American homosexual artists." For more of Plante's discussion of Indiana and homosexuality, see Plante, "Truth, Friendship, and Love: Sexuality and Tradition in Robert Indiana's Hartley Elegies," in Patricia McDonnell, *Dictated by Life: Marsden Hartley's German Paintings and Robert Indiana's Hartley Elegies*, exh. cat. (Minneapolis, Minn.: Frederick R. Weisman Art Museum, University of Minnesota, 1995), 73–75.

131 Storr, "Preface: Robert Indiana, All-American," 27. Homophobia was rampant in the 1950s, extending to President Dwight D. Eisenhower's 1953 Executive Order 10450 that excluded from government employment anyone who engaged in "sexual perversion." See Plante, "Truth, Friendship, and Love," 71. For a discussion of Whitman as central to gay identity,

see Jonathan Weinberg, *Speaking for Vice: Homosexuality in the Art of Charles Demuth, Marsden Hartley and the First American Avant-Garde* (New Haven, Conn.: Yale University Press, 1993), 133–40.

132 Indiana, quoted in Irma Jaffe, "Art News and Interviews, a panel discussion 'Alienation and Commitment,' including Robert Indiana, Martin Tucker, Robert Spector, Charles Hinman and Henry Pearson" (untranscribed sound recording, Archives of American Art, Smithsonian Institution, Washington, D.C., c. 1965–68). Hereafter cited as: Jaffe, "Art News and Interviews."

133 Phrase is from Walt Whitman's "Year of Meteors," quoted in G[ene] R. Swenson, "The Horizons of Robert Indiana," *ARTnews* 65, no. 3 (May 1966): 60.

134 Edgar Allan Poe, "Dream-Land," in *Complete Stories and Poems of Edgar Allen Poe* (New York: Doubleday Dell Publishing Group, 1984), 751. Indiana wrote Poe's name in his journal on February 14 and 21, 1961, next to a sketch of *Eidolons*. See O'Leary, "The Journals of Robert Indiana," in O'Leary, et al., *Love and the American Dream*, 17. Some scholars have mistakenly associated the work with Whitman's poem "Eidolons" from *Leaves of Grass*.

135 G[ene] R. S[wenson], "Reviews and Previews: New names this month, Peter Forakis and Robert Indiana," *ARTnews* 60, no. 3 (May 1961): 20.

136 Amaya, *Pop Art . . . And After*, 84.

137 Alfred Barr had been relieved of the directorship of the Museum of Modern Art in 1944 but had remained the heart and soul of the institution in his capacity as director of museum collections. In the 1961 MoMA bulletin on the museum's recent acquisitions show, he commented: "Because I do not understand why I like it so much, Robert Indiana's *The American Dream* is for me one of the two most spellbinding paintings in the show." Alfred H. Barr, Jr., "Comments," in Museum of Modern Art Recent Acquisitions bulletin, 1961, Archives of the Museum of Modern Art, New York.

138 Indiana, quoted in Péladeau and Dibner, *Indiana's Indianas*, 5.

139 Max Kozloff, "New York Letter," *Art International* 6, no. 2 (March 1962): 58.

140 Indiana received offers for two-person exhibitions from Alan Stone and David Anderson, but neither gallery seemed committed to his work. "The enthusiasm was somewhat lukewarm," Indiana explained in Baker, "Oral History Interview with Robert Indiana." Campbell Wylly organized exhibitions for the Museum of Modern Art's art-lending penthouse gallery. After Eleanor Ward expressed interest in one of Indiana's herms that she saw in Wylly's show, he arranged for her to visit Indiana's studio. Ibid.

141 Sidney Tillim, "Month in Review," *Arts Magazine* 37, no. 2 (November 1962): 36.

142 T[homas] B. H[ess], "Reviews and Previews: 'New Realists,'" *ARTnews* 61, no. 8 (December 1962): 12.

143 Sidney Janis, "On the Theme of the Exhibition," in *New Realists*, exh. cat. (New York: Sidney Janis Gallery, 1962), n.p.

144 Thomas B. Hess, "The Phony Crisis in American Art," *ARTnews* 62, no. 3 (Summer 1963): 27.

145 Indiana, quoted in Swenson, "What Is Pop Art?," 27.

146 For "least Pop" quote, see *A Visit to the Star of Hope*, 16:46; and Miller, "Robert Indiana," 70. For "outer edge" quote, see William Peterson and Bob Tomilson, "Robert Indiana" [interview], *Artspace* 1, no. 1 (Fall 1976): 5.

147 Indiana, quoted in Baker, "Oral History Interview with Robert Indiana."

148 Indiana, quoted in Marius B. Péladeau, "Preface, Robert Indiana: A Glimpse Today," in Péladeau and Dibner, *Indiana's Indianas*, v.

149 Indiana, quoted in Peterson and Tomilson, "Robert Indiana," 6.

150 Robert Indiana, "[Artist Statement, 1966]," in Frank Popper, *KunstLichtKunst*, exh. cat. (Eindhoven, The Netherlands: Stedelijk van Abbemuseum, 1966).

151 Andy Warhol's *Thirteen Most Wanted Men* would ultimately be draped with a large black fabric several months after the World's Fair opened. Richard Meyer has argued that censorship of the piece owed as much to its submerged homoeroticism as to its purported celebration of criminal deviance, suggesting that "wanted men" implies both male homoerotic desire as well as criminality. Richard Meyer, "Most Wanted Men: Homoeroticism and the Secret of Censorship in Early Warhol,"

in *Outlaw Representation: Censorship and Homosexuality in Twentieth-Century American Art* (New York: Oxford University Press, 2002), 137–40.

152 John Canaday, "Pop Art Sells On and On—Why?," *The New York Times*, May 31, 1964: SM7.

153 Katharine Kuh wrote that the examples of Pop art displayed at the fair were "unable to keep up with their vibrant, razzle-dazzle surroundings." Katharine Kuh, "The Day Pop Art Died," *The Saturday Review* 47, no. 21 (May 23, 1964): 24.

154 Some commentators have interpreted *Mother and Father* as depicting Carmen and Earl getting out of their car after having sex, an odd reading given the couple's poses. See Unruh, "Robert Indiana and the Politics of Family," in Storr, et al., *Robert Indiana: New Perspectives*, 154. Charles Hinman, Indiana's neighbor on both Coenties Slip and on Spring Street, described the painting as depicting Carmen and Earl returning from a picnic "where they have just made love and conceived Bob." Hinman, quoted in Reichman, "Robert Indiana and the Psychological Aspects of His Art," 103. Given the friendship of the two artists, the interpretation could well have been Indiana's.

155 Indiana, quoted in "Commanding Painter," *Time* 83, no. 21 (May 22, 1964): 72.

156 G[ene] R. S[wenson], "Reviews and Previews: Robert Indiana," *ARTnews* 63, no. 4 (Summer 1964): 13.

157 John Wilmerding has written about the correlation between Indiana's numbers as markers of the stages of human life and Cole's *The Voyage of Life*. John Wilmerding, "The Shape of Meaning," in Pissarro, et al., *Robert Indiana*, 161–62.

158 For Indiana's awareness of the thematic parallels between his work and Thomson's music, see Indiana, quoted in Diamonstein, "Interview with Robert Indiana," 164. Indiana also discussed his similarities to Thomson in his unpublished manuscript "The Route to *The Mother of Us All*" (research files, Robert Indiana Catalogue Raisonné office, New York). Hereafter cited as: Indiana, "Route to *The Mother of Us All*."

159 Indiana had first heard Thomson's music in Chicago, when a friend played a recording of *Four Saints in Three Acts*. Ryan, *Robert Indiana:*

Figures of Speech, 23. He met the composer though a mutual friend, the singer Anita Ellis, after expressing interest in having Thomson's music performed at his opening. Reichman, "Robert Indiana and the Psychological Aspects of His Art," 35.

160 Ibid., 136, 137.

161 Indiana, "Autochronology," in Goodall, et al., *Robert Indiana*, 54. Agnes Martin, a devoted Gertrude Stein fan, dedicated her first show at the Betty Parsons Gallery to Stein.

162 Indiana, quoted in Peterson and Tomilson, "Robert Indiana," 7. Thomson reiterated Indiana's claim not to have been inspired by Stein's writing, stating that Indiana "was never particularly involved with Gertrude Stein . . . I don't think he ever read anything by her." Thomson, quoted in Reichman, "Robert Indiana and the Psychological Aspects of His Art," 138.

163 Friedrich Nietzsche, quoted in James Rondeau and Douglas Druick, *Jasper Johns: Gray*, exh. cat. (Chicago: The Art Institute of Chicago, 2007), 130.

164 For Indiana's art "touch[ing] upon one or another theme that Mr. Thomson had set musically," see Indiana, "Route to *The Mother of Us All*." See also Diamonstein, "Interview with Robert Indiana," 164.

165 Hart Crane, "To Brooklyn Bridge," in *Writing New York: A Literary Anthology*, edited by Phillip Lopate (New York: Pocket Books, 2000), 485–86.

166 Indiana, in conversation with the author, October 6, 2012.

167 Robert Indiana, "Artist Questionnaire," May 19, 1965, MoMA.

168 Minioudaki, "From His Story to History," 117. Despite seeming to overreach in her interpretation here, Minioudaki deserves great credit for being the first scholar to focus on the political aspect of Indiana's work.

169 The peace symbol was originally designed for the British nuclear disarmament movement by Gerald Holtom in 1958, using the semaphore signals for the letters "N" and "D" to represent "nuclear disarmament." See Dan Stone, *The Oxford Handbook of Postwar European History* (Oxford, United Kingdom: Oxford University Press, 2012), 452–53.

170 Robert Indiana, "Yield," in McCoubrey, *Robert Indiana*, 20.

171 For "visual catechism," see ibid. For cathedral window analogy, see Baker, "Oral History Interview with Robert Indiana."

172 Ryan speculates that *Yield Brother*, "conjures sibling relations that the artist in fact never enjoyed" and "cautions against impending catastrophe, the fallacy of romanticizing the family." Ryan, *Robert Indiana: Figures of Speech*, 147.

173 Indiana, "Yield," in McCoubrey, *Robert Indiana*, 20.

174 Ibid.

175 Ibid. In his text, Indiana mistakenly writes of "13 Secessionist States" when, in fact, eleven states seceded from the Union, beginning with South Carolina on December 20, 1860, and ending with Tennessee on June 8, 1861.

176 Swenson, "Horizons of Robert Indiana," 49.

177 Andy Warhol, quoted in Irving Sandler, *American Art of the 1960s* (New York: Harper & Row, 1988), 154.

178 Indiana, quoted in Jaffe, "Art News and Interviews."

179 Indiana, quoted in Peterson and Tomilson, "Robert Indiana," 5.

180 Indiana, quoted in Goodall, "Conversations with Robert Indiana," 40.

181 Indiana records having seen Stein's book at Agnes Martin's loft. Indiana, Journal Entry, March 19, 1960.

182 Indiana's associations of the number 6 with his father went beyond the month of Earl's birth: "[My] father was born into a family of six members in the month of June, he worked for Phillips 66, and went west on Highway 66 when he left my mother, passing all those little signs on farmers' fences that say 'use 666,' which is also the sign of the devil—that's how my mother felt about him." Jan Garden Castro, "More Famous than John Dillinger: A Conversation with Robert Indiana," *Sculpture* 28, no. 2 (March 2009): 45. Indiana said of the number 2: "I'm particularly interested in two because it takes a couple of people to make love." Ibid. "Two is just my own personal number . . . the place that I lived at longest of all in New York was at 2 Spring Street on the Bowery, and it does require two for love, and love has been my greatest preoccupation." Indiana, NMAA Lecture.

183 For a discussion of the etching, see Wilmerding, "The Shape of Meaning," in Pissarro, et al., *Robert Indiana*, 161.

184 Indiana, "The Demuth American Dream No. 5," in McCoubrey, *Robert Indiana*, 27. Indiana's text on "The Metamorphosis of Norma Jean Mortenson" demonstrates his sometimes inconsistent factual information: he claims that Mortenson, who would become Marilyn Monroe, lived in twelve foster homes and was sexually abused at the age of six. Indiana, "The Metamorphosis of Norma Jean Mortenson," in McCoubrey, *Robert Indiana*, 45. However, according to an authoritative Monroe biography, she lived in eleven foster homes as a child and was sexually abused at the age of eight. Lois Banner, *Marilyn: The Passion and the Paradox* (New York: Bloomsbury, 2012), 48–49, 65. Similarly, Indiana incorrectly stated that *The Misfits* was Montgomery Clift's final film and that Monroe died on August 6. In fact, Clift went on to star in at least three more films, and Monroe died on August 5.

185 *LOVE* dominated Indiana's 1966 Stable Gallery show, causing him to call the exhibition his "LOVE Show." Indiana, "Autochronology," in Pissarro and Depotte, *Rétrospective*, 300.

186 Thomas Crow, "The Insistence of the Letter in the Art of Robert Indiana," in Storr, et al., *Robert Indiana: New Perspectives*, 94–95.

187 Both Indiana and Aldrich took credit for initiating the commission. Indiana's description of how it came about seems more plausible. He reports meeting Aldrich at a party and accusing him of not owning one of his paintings, which led to the commission. See Diamonstein, "Interview with Robert Indiana," 152. Conversely, Aldrich took credit for "persuading" Indiana to do the commission. Larry Aldrich, "Oral History Interview: Robert Indiana's *Love Series*" (sound recording and transcript, April 25–June 10, 1972, Archives of American Art, Smithsonian Institution, Washington, D.C.).

188 Indiana, quoted in Donald B. Goodall, "Introduction," in Goodall, et al., *Robert Indiana*, 12.

189 Indiana, quoted in Weinhardt, *Robert Indiana*, 157.

190 Indiana, quoted in Bowman, "Views on Art."

191 Indiana remembers submitting three one-foot paintings of *LOVE* to the Museum of Modern Art for its Christmas card. See Poppy Gandler Orchier, "Interview," in Sheehan, *Robert Indiana*

Prints, 13. Bill Katz, who was Indiana's studio assistant at the time, remembers the artist submitting four one-foot paintings: one in one color; one in black and white; one in blue and green; and one in red, blue, and green. Reichman, "Robert Indiana and the Psychological Aspects of His Art," 120.

192 Indiana, quoted in Miller, "Robert Indiana," 73.

193 Indiana, quoted in ibid., 70.

194 Indiana, in conversation with the author, December 5–6, 2012.

195 Indiana, quoted in American INSIGHT, "Robert Indiana: Full Circle," digital trailer of documentary-in-progress, 8:15, http://www.americaninsight.org/storyline/robert-indiana.

196 In describing the exhibition to Alfred Schmela Indiana wrote, "I was able to paint two 'Love Walls' and they dominate the main gallery. I have also a 'Narcissistic Love,' a diptych ten feet high, which is also the height of the 'Walls,' and a horizontal diptych, an 'Imperial Love,' which is six feet high and twelve feet wide. There is a five-foot tondo 'Eternal Love,' some smaller 'Loves' and the very beautiful sculptured 'Love' which is cut from solid aluminum and highly polished to a mirror finish." Indiana to Alfred Schmela, May 7, 1966, Galerie Schmela records, Box 4, Folder 3, The Getty Research Institute, Los Angeles.

197 Indiana's father died on December 19, 1965; Indiana received word of the death on December 30. Ryan, *Robert Indiana: Figures of Speech*, 206.

198 Indiana, quoted in Diamonstein, "Interview with Robert Indiana," 153.

199 Indiana, quoted in Jaffe, "Art News and Interviews."

200 Indiana, quoted in Tuchman, "Pop!," 29.

201 Robert Indiana, "USA 666," in McCoubrey, *Robert Indiana*, 29.

202 For "commercial look," see Indiana's handwritten annotations to unpublished draft of Ryan's Ph.D. dissertation, 28.

203 Indiana, "Route to *The Mother of Us All*," 4–5. See also Indiana, quoted in Weinhardt, *Robert Indiana*, 128–29.

204 Indiana, "Route to *The Mother of Us All*," 4.

205 For "passing American parade," see ibid., 5; for "distinctively American," see Peterson and Tomilson, "Robert Indiana," 4.

206 Indiana, "Route to *The Mother of Us All*," 6. See also Indiana, quoted in Weinhardt, *Robert Indiana*, 136.

207 Indiana's sets for the Santa Fe Opera production of *The Mother of Us All* were destroyed several months after the closing performance. Indiana blamed the owner of the company, who he claims put the sets on a mesa and burned them because they were too vanguard for his taste. *A Visit to the Star of Hope*, 33:56. According to Richard Gaddes, former director of the Santa Fe Opera, the sets were destroyed by nature. They were put on a flatbed truck and driven into Santa Fe as part of the city's annual Labor Day parade in which the opera company participated every year. A downpour encountered en route completely destroyed the felt Indiana had used for the costumes and sets. Gaddes, in conversation with the author, April 12, 2012.

208 Indiana, quoted in Marco Livingstone, "Robert Indiana Interviewed by Marco Livingstone" (transcribed sound recording, Research Files, Robert Indiana Catalogue Raisonné office, New York).

209 Goodall, "Conversations with Robert Indiana," 27.

210 Indiana, quoted in ibid., 25.

211 Indiana, quoted in Jon Loring, "*Architectural Digest* Visits: Robert Indiana," *Architectural Digest* 35, no. 9 (November 1978): 120.

212 For "trinket merchants" and "familiar to the point of nausea," see John Perreault, "Having a Word with the Painter," *Village Voice*, December 7, 1972: 34. For "sheathed it in commonness," see Richard Masheck, "Reviews: Robert Indiana," *Artforum* 11, no. 6 (February 1973): 80.

213 Perreault, "Having a Word with the Painter," 34.

214 John Canaday, "Aesop Revised, or the Luck of the Orthopterae," *The New York Times*, December 3, 1972: D21.

215 Already by 1973, Indiana had produced eight prints on the *LOVE* theme, most in editions of 250 and one in an unsigned edition of over 2,000. See Sheehan, *Robert Indiana Prints*, 28–30, 38, 48–49, 54, 72, 89.

216 Indiana, quoted in John Wilmerding, "Indiana and Maine: States of Play," in John Wilmerding and Michael K. Komanecky, *Robert Indiana and*

the Star of Hope, exh. cat. (Rockland, Maine: Farnsworth Art Museum, 2009), 30.

217 Indiana, NMAA Lecture.

218 Indiana, "Artist Questionnaire," December 11, 1961, MoMA.

219 Indiana had been coming to Maine in the summer for several years as a trustee of the Skowhegan School of Painting and Sculpture. He met Elisofon at the school in 1969, and the photographer invited him to Vinalhaven, where he had summered since 1940.

220 Indiana, quoted in Wilmerding, "Indiana and Maine," 52.

221 Indiana, quoted in Loring, "*Architectural Digest* Visits: Robert Indiana," 120.

222 See Indiana's discussion on artist Boris Anisfeld's career in Chicago in Baker, "Oral History Interview with Robert Indiana."

223 See Paul Taylor, "Love Story," *Connoisseur* 221, no. 955 (August 1991): 46–51, 94–97.

224 Indiana, quoted in Wilmerding, "Indiana and Maine," 53.

225 Indiana, quoted in Poppy Gandler Orchier, "Interview," 14.

226 Indiana, quoted in Plante, "Truth, Friendship, and Love," 57.

227 Barbara Haskell, *Marsden Hartley* (New York: Whitney Museum of American Art, 1980).

228 Marsden Hartley, quoted in ibid., 54.

229 For more analysis and explanation of these numbers, see Plante, "Truth, Friendship, and Love," 83.

230 Indiana, quoted in ibid., 84, 86.

231 For more on the deaths of the Mason sons and their impact on Hartley, see ibid., 81, 83.

232 Indiana, quoted in Baker, "Oral History Interview with Robert Indiana."

233 Indiana, quoted in Wilmerding, "Indiana and Maine," 30. Plante argues that Indiana's transposition of the Star of Hope's motto into "Truth, Friendship, Love" "mak[es] plain the terms of Hartley's love for von Freyburg [and] rewrite[s] history to reflect positively the emotional and possibly sexual relationship that the two men had and that was veiled for so long." Plante, "Truth, Friendship, and Love," 86.

234 See "Robert Indiana: Contemporary Perspectives, Part II," in this volume.

235 Roy Lichtenstein, quoted in Swenson, "What Is Pop Art?," 25.

236 Vivian Raynor, "The Man Who Invented Love," *ARTnews* 72, no. 2 (February 1973): 62.

FIG. 146 Robert Indiana on Vinalhaven, Maine,
with the catalogue for Marsden Hartley's 1980
retrospective at the Whitney Museum of American
Art. Photograph by Tad Beck, 1988

SASHA NICHOLAS

NATIVE LANGUAGE
Robert Indiana and American Modernism

Robert Indiana emerged at a moment when the conception of what it meant to be an American artist was in the midst of radical redefinition. If the Museum of Modern Art's trailblazing acquisition of Indiana's first *American Dream* painting (fig. 51) in 1961 had launched the artist into the spotlight, by 1963 his work was fully caught up in what he described as "the Pop explosion."[1] Although the Abstract Expressionist painters of the 1950s had ostensibly shifted the locus of the international avant-garde to the United States—in the now-familiar story of "how New York stole the idea of modern art," as Serge Guilbaut put it—Pop was, in many respects, the first distinctly American movement.[2] In contrast to Abstract Expressionism, whose engagement with formalist questions and existential themes remained fundamentally rooted in a European painterly tradition, Pop was devoted to American culture: specifically, to the nation's postwar consumerism, in all its sleek, seductive, and often vacuous incarnations. While artists such as Roy Lichtenstein embraced an international identity for Pop, the United States was indisputably the center of the movement and home to its most persuasive practitioners. By the mid-1960s, there was no question that Pop represented a powerful challenge to long-held convictions about European cultural hegemony; hence, the utter outrage of the French and Italian press when Robert Rauschenberg became the first American to win the grand prize at the Venice Biennale in 1964. ("In Venice, America Proclaims the End of the School of Paris and Launches Pop Art to Colonize Europe," fulminated one headline.)[3] Pop's audacious embrace of postwar American culture emboldened a generation of young American artists to reconsider their relationship to European modernism, even those who were forging their artistic identities well beyond Pop's distinct purview. In a joint 1964 interview, for example, Donald Judd and Frank Stella proclaimed their desire to reject "all the structures, values, feelings of the whole European tradition."[4] "It suits me fine if that's all down the drain," Judd added.[5]

FIG. 147 Robert Indiana at the *Americans 1963* exhibition at the Museum of Modern Art, New York, with *The American Dream, I* (1961) in the background. Photograph by William John Kennedy

FIG. 148 Reginald Marsh (1898–1954), *Death of Dillinger*, 1939. Watercolor on paper, 31¼ × 23½ in. (79.4 × 59.7 cm). Phoenix Art Museum; gift of Mr. and Mrs. Henry Luce 1960.12

Such a newfound spirit of liberation from longstanding insecurities about American provincialism fueled the work of many young artists coming of age in the early 1960s, yet Indiana took this sense of freedom in a unique and surprising direction. Unlike Andy Warhol, Lichtenstein, and other Pop figures who reveled in the nation's postwar amnesia, Indiana nurtured his art with subjects drawn from the American past. While Indiana shared Pop's desire to expose the dark underbelly of postwar culture through subverting the apparently cheerful and reassuring language of mass advertising, his references to American literary and artistic forebears separated him from his peers, launching him on an idiosyncratic, highly personal quest to link contemporary commercial culture with an earlier phase in the nation's modernity as well as to fashion his own creative identity. The work of other Pop artists was not devoid of connections to American aesthetic and cultural history; indeed, when Pop first emerged in the early 1960s, a number of scholars and critics observed a parallel between the movement and the crisp, geometric compositions and commercial themes that had characterized the paintings of many American modernists during the 1920s and 1930s. Writing in 1965, Robert Rosenblum likened this connection to family dynamics:

> In the case of the 1960's Pop artists, this rebellion against the parental generation [i.e., Abstract Expressionism] carried with it an espousal, both conscious and unconscious, of the grandparental one. In fact, any number of analogies can be made between the style and subject of Pop artists and of those modern masters active between the wars . . . artists like Charles Demuth, Joseph Stella, Stuart Davis, and the newly resuscitated Gerald Murphy all take on new historical contours as predecessors, when considered in the light of the 1960's.[6]

Indiana, however, was the only artist of his generation to adopt this pantheon of earlier American modernists as fundamental to his own artistic lineage and, in several key cases, as inspiration for his art. Indeed, it is almost impossible to imagine any of Indiana's contemporaries unabashedly situating their art within a trajectory of nineteenth- and twentieth-century American art, as Indiana himself did in 1961: "Not wishing at all to unsettle the shades of Homer, Eakins, Bellows, Sheeler, Hopper, Marin, et al.," he remarked, "I propose to be an American painter, not an internationalist speaking some glib visual Esperanto; possibly I intend to be a Yankee."[7] Indiana's rich engagement with American novelists and poets of the nineteenth and early twentieth centuries—among them Herman Melville, Henry Wadsworth Longfellow, and Gertrude Stein—has been extensively addressed by

scholars of his art.[8] While Indiana's engagement with a number of American painters from this period is also well known, a more thorough consideration of his early exposure to American modernism and his creative dialogue with these artists, most importantly Charles Demuth and Marsden Hartley, may offer new insights into Indiana's work, particularly its place in shifting postwar paradigms regarding American identity and cultural memory.

Indiana first became fascinated with American modernist painting during his childhood in the 1930s and 1940s growing up in the state he would ultimately choose as his namesake. Those years witnessed a burgeoning of Midwestern art, with American Scene painters such as Thomas Hart Benton, Grant Wood, and John Steuart Curry surging to prominence for their depictions of quaint rural life whose homespun values resonated with national audiences during the hardships of the Great Depression. These were among the first artists whose work Indiana was exposed to as a child. In *Life* magazine, which he avidly collected after its debut in November 1936, Indiana encountered paintings by American Scene artists from the Midwest as well as their urban counterparts, such as Reginald Marsh.[9] Having had no opportunities to see such works firsthand, the young Indiana was particularly taken with the full-color reproductions that appeared in the magazine—"I thought they were marvelous," he later recalled.[10] Marsh's painting *Death of Dillinger* (fig. 148), which appeared in *Life* in March 1940, may have carried particular resonance for Indiana, who lived for years in John Dillinger's hometown of Mooresville and recalled joining the crowd of onlookers to watch the body of America's most notorious bank robber as it was returned home for burial in July 1934.[11] During high school, Indiana would experiment with pastel drawings that closely emulated Marsh's model, featuring tawdry, voluptuous women on streets and in other public places (fig. 149). Though he did not remain interested in figuration, Indiana's mature art would retain the same fascination with creating a mythology around everyday life and capturing the aspirations and failures of ordinary Americans that occupied Marsh and many other American Scene painters of the 1930s. It was this connection, perhaps, that Indiana sought to affirm when he declared, "I paint the American scene" in the opening line of his statement accompanying one of his early exhibitions at the Stable Gallery.[12]

Indeed, Indiana claimed from the outset to have felt little attraction to European art ("Europe, Paris [were] far away," he wrote, "and never come very close . . ."),

yet he was drawn to a range of nineteenth- and twentieth-century American artists.[13] In first grade, Indiana's teacher, Ruth Coffman, showed him genre prints by the popular nineteenth-century lithography firm Currier and Ives; years later he would recall one in particular depicting a scene of ice skaters.[14] As a student at Arsenal Technical High School in Indianapolis, he encountered reproductions of watercolors by Winslow Homer, John Marin, and Edward Hopper, among others, in his art classes taught by Sara Bard. A number of Indiana's works from this period particularly reflect the influence of Hopper, whose lonely images of modest vernacular architecture offered ideas for depicting the young artist's own surroundings. Though Hopper's work was known to him largely through reproduction, Indiana likely saw the canvas *New York, New Haven and Hartford* (fig. 150) in the city's John Herron Art Institute (later the Indianapolis Museum of Art), an institution he frequented during the latter years of high school.[15] One of Indiana's watercolors of 1945–46, a view of a railroad signal station near his high school (fig. 151), shares Hopper's characteristic emphasis on a solitary building as well as his habit of portraying scenes from a low perspective and using railroad tracks to bisect his compositions.

The American modernists who would have the most powerful and enduring impact on Indiana, however, were the Precisionist painters—above all, Charles Sheeler and Charles Demuth. Growing up on what he described as "the other side of the tracks," Indiana felt a profound sense of kinship with these artists and the aesthetic potential they discovered in the rise of American industry following World War I.[16] Using a language of sharply delineated lines and flat, geometric planes of color, Precisionists such as Demuth, Sheeler, and Ralston Crawford—key early influences for Indiana—sought to modify European Cubism into a distinctly American aesthetic rooted in an optimistic embrace of technological progress.[17] The shared national experiences that they portrayed in the late 1920s and through the 1930s were, indeed, fundamental to Indiana's childhood, when the young artist

witnessed the flourishing of Indianapolis into a thriving industrial center, even as his family endured financial strain. The city's burgeoning automobile industry especially captured his imagination, and memories of his parents' cars as "venerated" emblems of optimism and achievement amid the economic hardships of the Depression would later become a wellspring for his art.[18] Indiana's identification with automobile production and his regular encounters with large-scale industrial operations such as Indianapolis's newly constructed International Harvester Plant (fig. 152), located across the street from one of his childhood homes, must have drawn him to Sheeler's industrial paintings, particularly his famous series of what was then the largest factory in the world, Ford Motor Company's colossal River Rouge Plant outside Detroit (fig. 153). The "things that fascinated me most," Indiana later recalled, were "factories, railroad crossings, grain elevators, things like that, and this was the influence of people like Sheeler."[19] Sheeler's and Demuth's images of architecture and industrial structures in the Pennsylvania towns where they lived might also have inspired the young Indiana to approach more modest

BELOW

FIG. 152 International Harvester Plant, Indianapolis, c. 1945

BOTTOM

FIG. 153 Charles Sheeler (1883–1965), *American Landscape*, 1930. Oil on canvas, 24 × 31 in. (61 × 78.8 cm). Museum of Modern Art, New York; gift of Abby Aldrich Rockefeller

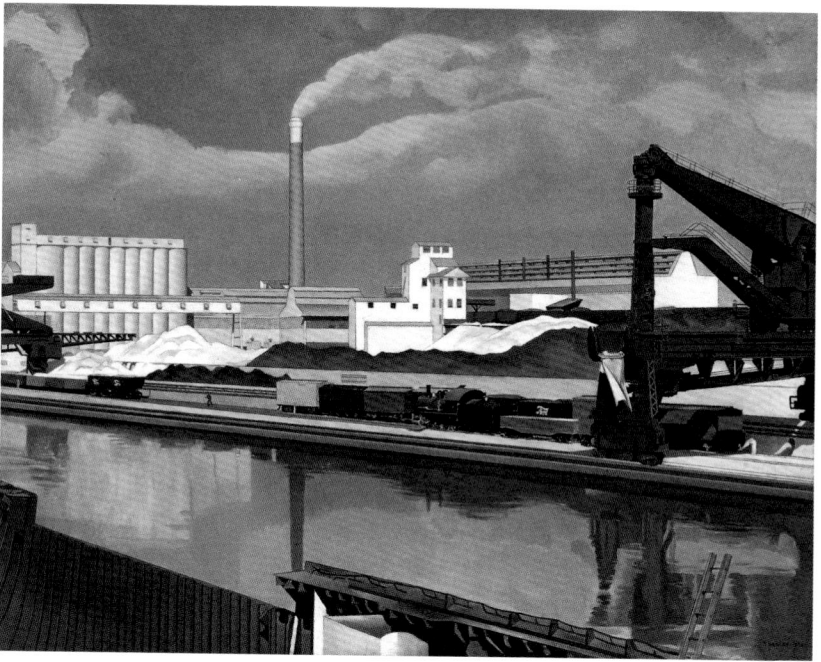

local sites as subject matter. Like Demuth's iconic oil painting *My Egypt* (1927), for example, the first work that Indiana sold in high school depicted a grain elevator—one that was located across the street from his grandmother's house in Mooresville.[20]

During the late 1950s and early 1960s, Indiana's fascination with early American modernist painting likely informed his transition to his mature artistic style. After moving into his studio on Coenties Slip in Lower Manhattan in 1956, he began producing works that alluded to the neighborhood's commercial history, such as his herm *Marine Works* (fig. 28) and the painting *Year of Meteors* (fig. 62), as well as the Slip's depiction by earlier American authors, including *The Melville Triptych* (fig. 60). The herms, which brought together salvaged wooden masts and beams, stenciled words, and antiquated machine parts, were particularly redolent of the American folk art traditions that had first been "discovered" in the 1920s by modernist painters, Sheeler prominent among them—objects like handmade signs, cigar store Indians and other carved figures, weather vanes, and Shaker furniture. Sheeler had exalted such vernacular objects for their simple, unadorned craftsmanship and practicality;

by featuring his collection of early American furnishings in his photographs and paintings of his homes in Doylestown, Pennsylvania, and South Salem, New York, he conveyed nostalgia for an era before the advent of technology and mass production.[21] John McCoubrey has noted the way in which Indiana's early herms and constructions similarly invoked a preindustrial tradition of hand-painted signs and folk Americana—"more expertly designed to begin with, more visually tolerable, more resistant to change and perhaps in everyday experience more truly seen than most of the material of the mass media."[22] Like Sheeler's images, Indiana's herms nostalgically celebrate the aesthetic of commercial traditions on the cusp of modern mass-production and the integrity of "found" utilitarian objects whose visual and tactile appeal often went unrecognized in their own time. Yet in Indiana's work these rescued objects of a fading past are not meticulously preserved—as in Sheeler's highly precise, almost fetishistic renderings. Rather, they are fragmentary and decaying, doing little to conceal their identity as part of an irretrievable past; their redemption arises only from creative intervention, reuse, and transformation. When asked in an interview, Indiana said he had not deliberately intended for his herms to invoke a link to the interests of earlier American modernists.[23] Although the same might be said for his conversion to a hard-edge style in the late 1950s—a shift that undoubtedly owed to his relationship with Ellsworth Kelly and the "lines of demarcation crisp and sure" he found in the Lower Manhattan landscape—it is difficult to imagine that the formal economies and unmodulated surfaces Indiana admired in Sheeler's and Demuth's art were not also an influence.[24]

If the art of the American modernists whom Indiana had revered during his childhood was lurking in the background of the earliest work he produced in New York, it became an explicit source of inspiration by 1963. That year, as he worked on his *American Dream* series, Indiana delved into an extended, self-described "homage" to Demuth's 1928 painting *I Saw the Figure 5 in Gold* (fig. 154).[25] Demuth's image, an abstracted Precisionist vision of a fire engine racing down a New York street, was inspired by a poem on the same subject by William Carlos Williams:

> Among the rain
> and lights
> I saw the figure 5
> in gold
> on a red
> fire truck
> moving
> tense
> unheeded
> to gong clangs
> siren howls
> and wheels rumbling
> through the dark city.[26]

With Williams's poem as his point of departure, Demuth placed the figure five at the center of his composition, rendering it three times and successively larger so that it appears to barrel toward the viewer like the onrushing fire engine. Demuth, who sought not only to capture the poem's terse dynamism but to create an abstract portrait of Williams as well, also inscribed his canvas with words and monograms alluding to the poet-doctor and their friendship. For Indiana, these elements presaged the "verbal-visual" symbiosis he sought to create through his own use of literary sources and the language of signs.[27] As he commented, *I Saw the Figure 5 in Gold* "seemed to be a modern step," since "not very many other American artists brought themselves to paint words or anything else that had much to do with the fact that the world was moving on."[28] Demuth's painting, moreover, was a product of the same era that Indiana was already grappling with in his *American Dream* series—the era of his childhood, when men like his father pursued prosperity and success with naïve optimism, before discovering that the dream, in Indiana's words, "turned out to be hollow."[29] While working on his *American Dream* paintings, which unfolded in numerical succession, Indiana seized upon Demuth's boldly articulated *Figure Five* as a springboard for the fifth suite of his series, including *The Demuth American Dream #5* (fig. 82), *The Figure Five* (fig. 155), and *The X-5* (fig. 98).

Many scholars have ascribed Indiana's adoption of Demuth's earlier composition to a sense of affinity with a predecessor who, like Indiana in the early years of his career, was fascinated by the creative possibilities of coded symbols and other complex allusive strategies, especially as a means for reinventing traditional portraiture.[30] Not only did Demuth's painting evoke a romantic modernity that Indiana associated with the origins of the American Dream and his childhood, but it also represented the apex of Demuth's innovative experiments with symbolic portraiture, a genre that Indiana similarly sought to explore by the early 1960s. With his poster portraits of artistic and literary figures such as Williams, Georgia O'Keeffe, John Marin, and others, Demuth pursued the radical objective of representing individuals not according to likeness but rather as a complex, often witty accumulation of signs, symbols, and everyday objects that conveyed the subject's key attributes. For Demuth as well as for other artists who engaged in experimental modes of portraiture—many of whom were associated, like Demuth, with the avant-garde photographer and gallerist Alfred Stieglitz—the result would be a truly modern portrait, one that communicated the artist's emotional connection to the sitter while acknowledging the fundamentally enigmatic and unknowable qualities of another person.[31] By the early 1960s, Indiana was pursuing a similar type of portraiture, using language and symbolic imagery in works such as *Melville* (fig. 61), a celebration of one of his literary idols, as well as in the mordant *Eat/Die* (fig. 85), which the artist associated with his mother.

In *The Demuth American Dream #5*, Indiana took his own experiments with symbolic portraiture a step further, for the first time using a complex set of

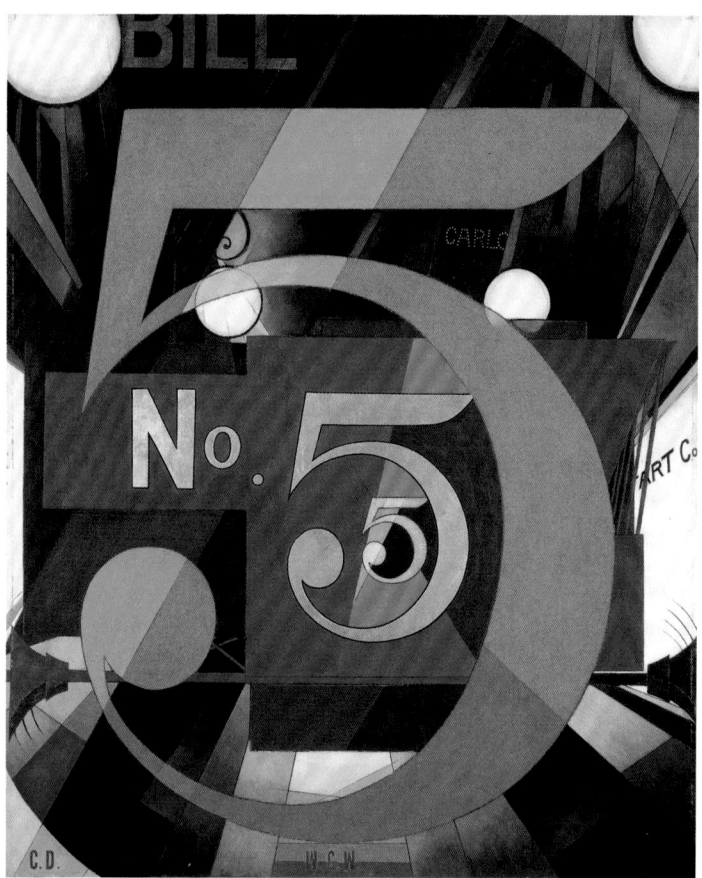

FIG. 154 Charles Demuth (1883–1935), *I Saw the Figure 5 in Gold*, 1928. Oil on cardboard, 35½ × 30 in. (90.2 × 76.2 cm). Metropolitan Museum of Art, New York; Alfred Stieglitz Collection, 1949 (49.59.1)

FACING

FIG. 155 Robert Indiana, *The Figure Five*, 1963. Oil on canvas, 60 × 50⅛ in. (152.4 × 127.2 cm). Smithsonian American Art Museum, Washington, D.C.; museum purchase

numerological and iconographic associations to fuse his own biography with references to figures and events from the past—a practice he would continue throughout the decades to follow. Using Demuth's bold composition as inspiration, Indiana thrust himself into the dialogue between Demuth and Williams that had taken place thirty-five years earlier, paying homage to both in a way that brought the past into the artist's own lived present. Though he initially worked from a reproduction, he soon went to visit Demuth's canvas at the Metropolitan Museum of Art, confirming his impression that it was "one of the loveliest paintings that has ever been painted in America."[32] If Indiana was attracted to Demuth's image because its dynamic vision of modern life expressed the same hopeful confidence that shaped his father's American dreams, seeing the work in person may have confirmed his fear that those dreams had atrophied. Demuth's once majestic painting, Indiana remarked in 1963, "is in terrible condition and looks like in a few years it won't be there."[33] As he investigated the history of *I Saw the Figure 5 in Gold*, Indiana discovered an intriguing chain of artistic and biographical associations, which he enumerated as follows:

> [In] 1928, the year of my birth, Demuth painted his "picture" inspired by his friend's poem "The Great Figure" . . . I did my painting in 1963, which when subtracted by 1928 leaves 35—a number suggested by the succession of three fives (5 5 5) describing the sudden progression of the fire truck in the poet's experience. In 1935 Demuth died . . . and then in 1963 the venerable doctor [Williams] died, completing the unpremeditated circle of numerical coincidence woven within the "Fifth Dream."[34]

The largest painting from the fifth *American Dream* suite, *The Demuth American Dream #5* vividly invokes this temporal circle of coincidence. By isolating the succession of three fives from Demuth's composition, Indiana abandoned what he described as the earlier image's "allusions to a Cubist cityscape" and prioritized the sensation of movement through abstract space.[35] As a symbol not only of physical progression but also of the triumvirate of Demuth, Williams, and Indiana, the three fives become isomorphic with an advancing trajectory of artistic exchange and cross-pollination. Indiana further binds himself to his two predecessors by surrounding the three figure fives with one of his favored emblems, the circle, which he has described as "the symbolization of eternal life."[36] Thematic allusions to memory, creative life cycles, and a collision of forces across time and space are

THE FIGURE 5

FIG. 156 Joseph Stella (1879–1946), *The Voice of the City of New York Interpreted: The Bridge*, 1920–22. Oil and tempera on canvas, 88½ × 54 in. (224.8 × 137.2 cm). The Newark Museum, 37.288e

conveyed by the phrase "American Dream 1928/1963" emblazoned on the circle in the central panel as well as the canvas' unusual cruciform shape, which Indiana described as a tool used "to set this particular painting most apart from all others given its theme and internal form in direct dialogue with the original inspiration."[37] The meaning of that dialogue is suggested, perhaps, by the dissonance between Indiana's emotional, almost poignant desire to connect with creative predecessors and the aggressive presence of his own signature three-letter words in the four panels surrounding the central canvas, which bluntly collapse the human life cycle into four directives: "EAT," "HUG," "ERR," and "DIE." In contrast to Demuth's early modern idealism, Indiana's words stand as emblems of the leveling out of experience into mindless, meaningless repetition, setting his empathetic communion with his artistic forebears within a cautionary, if also humorous, appraisal of postwar experience.

While the fifth *American Dream* suite represented Indiana's most extensive early engagement with an American modernist forebear, he continued to allude to other artistic predecessors during the years to follow. In a 1964 group of paintings, he used an iconographic representation of the Brooklyn Bridge drawn from the Precisionist-inflected images of the same subject by the Italian-born modernist Joseph Stella. Indiana's primary source was Stella's painting *The Voice of the City of New York Interpreted: The Bridge* (fig. 156), in which the artist used a Futurist formal language and the predella format of a Renaissance altarpiece to reimagine what was perhaps, at the time, the defining cultural monument of his adopted country within an art historical continuum originating in his native Italy. Indiana's decision to use Stella's image as a point of departure in his own series of bridge paintings—*To the Bridge* (1964), *The Brooklyn Bridge* (fig. 97), and *Fire Bridge* (1965)—suggests his affinity for a painter who used an iconic American form to telescope a sweeping historical dialogue, and also with one who felt personally bonded to the bridge as an emblem of artistic self-discovery (for his part, Indiana would gaze at the bridge during his formative years working in Coenties Slip from the window of his studio). Yet it is also clear that if Stella's work belongs to a singular moment in American history, so too does Indiana's. Indiana abandoned the geometric ray lines of Stella's composition (as he did in his homage to Demuth's *Figure Five*), simplifying the structure into an unmodulated, symmetrical form. As in the case of the *Demuth American Dream*, Indiana's series of Brooklyn Bridge paintings involve allusions not just to an artist but also to a poet: Hart Crane, one of Indiana's literary heroes. Excerpts from Crane's labyrinthine epic poem "The Bridge" (1930), which exalted the Brooklyn Bridge as a symbol of both the promises and the failures of the American experience, appear prominently in *The Brooklyn Bridge*.[38] Crane's shimmering lines ("And we have seen night lifted

FIG. 157 Stuart Davis (1892–1964), *Visa*, 1951. Oil on canvas, 40 × 52 in. (101.6 × 132.1 cm). Museum of Modern Art, New York; gift of Mrs. Gertrud A. Mellon

in thy arms / How could mere toil align thy choiring strings") evoke a feeling of elation, but the reduction of Stella's vibrant palette and pulsing ray lines into a flat, grisaille-toned icon, especially combined with the association of the poem to Crane's subsequent suicide by drowning, suggests immobility and loss.

Several of Indiana's paintings in the years following the fifth cycle of his *American Dream* series suggest his ongoing interest in the symbolic portraiture pioneered by Demuth and other American modernists. For example, the painting *Leaves* (1965), a remembrance of his formative relationship with Ellsworth Kelly and the last work he painted at Coenties Slip, recalls Demuth's poster portrait *Calla Lillies (Bert Savoy)* (1926), a memorial to the well-known female impersonator and nightclub performer Bert Savoy. Like the sinuous leaves, stems, and spadix of Demuth's image, the drooping, silhouetted leaves in Indiana's portrait—a reference to one of Kelly's signature subjects—hint at a phallic model of fertility, albeit a more ephemeral one.[39] In both, however, such allusions to homosexual creativity are subtle and coded; like visual puzzles, they disrupt a clear relationship between seeing and knowing. Indiana made extensive use of symbolic portraiture as well in his *Decade: Autoportraits*—a series of images that combine the artist's signature words, numbers, and personal symbology in a collective self-portrait of his experiences of the 1960s, which he felt was the most important decade in his life. In the portrait for the year 1964, Indiana included the word *champion*—a tribute to the proto-Pop painter Stuart Davis, who died that year and whose imaginative use of words, high-key colors, and crisp geometries drawn from advertising presaged Indiana's own innovations (fig. 157). For Indiana, Davis represented an artist who

led a long, "tremendously productive life" and yet by the time of his death was largely forgotten by the art world.[40] "He's rather unique in American art and . . . as far as I'm concerned, very unappreciated," Indiana observed in 1963.[41]

Indiana's most extensive engagement with an American modernist, however, would not occur until more than two-and-a-half decades following his Demuth suite of *American Dream* paintings. After moving to the small island of Vinalhaven, Maine, in 1978, Indiana became fascinated with Marsden Hartley, another painter in the Stieglitz circle and one who had spent the summer of 1938 on the island; like Indiana's retreat, Hartley's stemmed from disaffection with the New York art world.[42] In 1989, Indiana embarked on a series based on earlier compositions by Hartley. The *Hartley Elegies*, as they are known, would ultimately total eighteen in number and occupy Indiana until 1994. In these images, Indiana did not look to his predecessor's Maine landscapes of the 1930s but rather to the symbolic portraits Hartley made in 1914–15, a group of works that eulogized a young German cavalry officer and possible lover, Karl von Freyburg, whom Hartley met in Berlin just prior to the outbreak of World War I and who died in the war's initial months (fig. 159).[43] Indiana was fascinated by Hartley's use of signs, symbols, and letters—tightly knit layers of heraldic military imagery such as flags, the Iron Cross, epaulettes, and monograms—as a means for commemorating a beloved friend, much like the example of Demuth's *Figure Five*. In works such as *KvF I (Hartley Elegy)* (fig. 158), Indiana painted relatively faithful renditions of Hartley's brilliantly colored frontal compositions, only transforming his predecessor's coarse, expressionist brushwork into his own characteristic language of flat, sharply delineated forms. In several cases, Indiana encircled Hartley's imagery with his own signature mandala, as he had done previously with Demuth's 5's. For Indiana, the *Hartley Elegies* were not simply another homage to an artist whose innovative use of symbolic portraiture foretold his own, but a more forthright identification with a pictorial history of representing homosexual love and loss than had been possible in the early 1960s. What was once veiled and ambiguous in Indiana's work now surfaced amid the heated identity politics and AIDS crisis of the late 1980s—particularly with Indiana's decision to unite the names of Hartley and von Freyburg in the center of several canvases and to refer to his own past and present relationships through adding names and initials such as "Ellsworth" and "TvB," a Germanized allusion to his Vinalhaven friend and fellow artist Tad Beck. Within this cycle of representation beginning with Hartley and

FIG. 159 Marsden Hartley (1877–1943), *Portrait of a German Officer*, 1914. Oil on canvas, 68¼ × 41⅜ in. (173.4 × 105.1 cm). Metropolitan Museum of Art, New York; Alfred Stieglitz Collection, 1949 (49.70.42)

FACING

FIG. 158 Robert Indiana, *KvF I (Hartley Elegy)*, 1989–94. Oil on canvas, 77 × 51 in. (195.6 × 129.5 cm). Private collection

ending with his elegies, Indiana also subsumes a broader historical narrative. Several paintings in the series contain references to John F. Kennedy's 1963 "Ich bin ein Berliner" speech and the Berlin Wall that had recently fallen, thereby aligning nearly a century of political tumult, repression, and liberation with both personal history and a broader struggle to open the sexual closet.

Indiana's career-long dialogue with painters from the history of American modernism is inseparable from the artist's quest to fashion his own identity—a process that began in 1958 with the exchange of his surname "Clark" for the name of his home state in a bold proclamation of his American roots. Robert Storr has compared Indiana's self-invention to the Freudian concept of the "family romance," with Indiana seeking to alter his destiny by eschewing his familial ties in favor of ones that he selected for himself.[44] Without question, Indiana's embrace of his American modernist predecessors enabled him to forge a radically distinctive genealogy and trajectory for his own work. Some scholars have seen his selection of artistic forbears exclusively in terms of sexual identity—as indicating Indiana's desire to join "a family tree of great American homosexual artists who had also conflated their homosexuality and their nationalism."[45] Despite the contributions of such interpretations to an understanding of Indiana's art, however, there are additional, more far-reaching implications to his eschewal of the European tradition and adoption of a distinctly artistic American lineage, which allowed him to take his art in a different direction from virtually every other artist of his generation. Like other Pop artists, many of his early works were fueled by the tension between a flirtation with and a critique of postwar consumerism. At the same time, by initiating a rich creative exchange with American modernist predecessors who were at their peak during his childhood, Indiana nourished his art with their romantic ambitions and formal innovations, and with perceptive explorations of the historical cycles invoked by the conjunction of his work and theirs. Only by celebrating their ecstatic hopes for a modernity in which urban experience and industrial ingenuity would become, as Sheeler remarked, "our substitute for religious experience" could Indiana invoke the alienation and disillusionment that lay behind the blank facade of Pop—the failure, as he saw it, of the American Dream.[46]

In so doing, Indiana also answered stereotypes about the United States' lack of cultural memory—the perception that only Europe could offer an enduring wellspring for artistic creation, as voiced by British critic David Sylvester when he asked in 1963 whether America could "possibly provide a springboard for art in the way it has been provided in the past by religions which had transcendental aspirations and a tragic sense of life."[47] For Indiana, the American modernists to whom he turned represented precisely this union of transcendental aspirations and, from the vantage of the postwar present, tragic delusion. In the process of using their earlier meditations on modernity to explore contemporary American experience, he brought these artists out of the dusty confines of history. Sheeler,

Demuth, Stella, Hartley, and the other figures to whom Indiana turned were not fashionable or embraced within the art historical canon in the 1960s. Rather, as Indiana noted in 1963, "this particular school of American painters has been ignored and relegated to . . . a position which is much below what it deserves."[48] By viewing his American modernist past as something to be taken seriously, Indiana resuscitated a cultural history that was all but forgotten—performing the transformative act he once ascribed to a single work of art: "The technique, if successful, is that happy transmutation of the Lost into the Found, Junk into Art, the Neglected into the Wanted, the Unloved into the Loved, Dross into Gold."[49]

1 Robert Indiana, "Autochronology," in John McCoubrey, *Robert Indiana*, exh. cat. (Philadelphia: Institute of Contemporary Art, University of Pennsylvania, 1968), 54.

2 Serge Guilbaut, *How New York Stole the Idea of Modern Art* (Chicago: University of Chicago Press, 1985).

3 Pierre Cabanne, "A Venise, L'Amérique proclame la fin de l'Ecole de Paris et lance le 'Pop' Art pour coloniser l'Europe," *Arts*, June 24, 1964, quoted in Laurie J. Monahan, "Cultural Cartography: American Designs at the 1964 Venice Biennale," in Serge Guilbaut, ed., *Reconstructing Modernism: Art in New York, Paris and Montreal, 1945–1964* (Cambridge, Mass., and London: The MIT Press, 1995), 369.

4 Donald Judd, quoted in Bruce Glaser, "Questions to Stella and Judd," *ARTnews*, September 1966, reprinted in Kristine Stiles and Peter Selz, eds., *Theories and Documents of Contemporary Art: A Sourcebook of Artists' Writings* (Berkeley: University of California Press, 1996), 118.

5 Ibid.

6 Robert Rosenblum, "Pop Art and Non Pop Art," *Art and Literature*, Summer 1965, quoted in Steven Henry Madoff, ed., *Pop Art: A Critical History* (Berkeley: University of California Press, 1997), 133. Walker Art Center curator Jan van der Marck also made the comparison between Pop and earlier American modernism in a 1963 interview; see Jan van der Marck, "Interview of Robert Indiana and Richard Stankiewicz on occasion of the opening of *Richard Stankiewicz, Robert Indiana: An Exhibition of Recent Sculptures and Paintings*" (transcript, Walker Art Center, Minneapolis, October 21, 1963), http://www.walkerart.org/archive/5/A883710BAB4022C46169.htm.

7 Robert Indiana, quoted in Richard Brown Baker, "Oral History Interview with Robert Indiana" (tape recording and transcript, Archives of American Art, Smithsonian Institution, Washington, D.C., September 12–November 7, 1963).

8 See especially Susan Elizabeth Ryan, *Robert Indiana: Figures of Speech* (New Haven, Conn.: Yale University Press, 2000).

9 See Baker, "Oral History Interview with Robert Indiana."

10 Indiana, quoted in Baker, "Oral History Interview with Robert Indiana."

11 Marsh's *Death of Dillinger* was reproduced in *Life*, March 11, 1940, pp. 70–71. Indiana produced a herm titled *Dillinger* in 1964.

12 Robert Indiana, artist's statement, c. 1964, Stable Gallery Records, Archives of American Art, Smithsonian Institution, Washington, D.C.

13 Indiana, "Autochronology," in McCoubrey, *Robert Indiana*, 51.

14 Indiana, quoted in Baker, "Oral History Interview with Robert Indiana."

15 Ibid. Indiana frequented the museum and also attended Saturday life-drawing classes there during his senior year of high school.

16 Ibid.

17 For more, see van der Marck, "Interview of Robert Indiana and Richard Stankiewicz . . ."

18 Indiana, "Autochronology," in McCoubrey, *Robert Indiana*, 51.

19 Indiana, quoted in Baker, "Oral History Interview with Robert Indiana."

20 See Baker, "Oral History Interview with Robert Indiana."

21 For more on this subject, see Karen Lucic, *Charles Sheeler in Doylestown: American Modernism and the Pennsylvania Tradition* (Allentown, Penn.: Allentown Art Museum, 1997).

22 John McCoubrey, "Introduction," in McCoubrey, *Robert Indiana*, 23.

23 Indiana, quoted in van der Marck, "Interview of Robert Indiana and Richard Stankiewicz . . ."

24 Indiana, quoted in Carl J. Weinhardt, Jr., *Robert Indiana* (New York: Harry N. Abrams, 1990), 38.

25 Indiana, "The Demuth American Dream No. 5," in McCoubrey, *Robert Indiana*, 27.

26 William Carlos Williams, "The Great Figure," 1921, in *The Collected Poems of William Carlos Williams, Volume I, 1909–1939*, A. Walton Litz and Christopher MacGowan, eds. (New York: New Directions Books, 1991), 174.

27 Indiana, artist's statement, c. 1964, Stable Gallery Records.

28 Robert Indiana, quoted in Donald B. Goodall, Robert L. B. Tobin, and William Katz, *Robert Indiana*, exh. cat. (Austin, Texas: University Art Museum, University of Texas at Austin, 1977), 27.

29 Indiana, quoted in Phyllis Tuchman, "Pop! Interview with George Segal, Andy Warhol, Roy Lichtenstein, James Rosenquist, and

Robert Indiana," *ARTnews* 73, no. 5 (May 1974): 29.

30 Indiana's fascination with Demuth's strategy can also be linked to its use in evoking homosexual themes in a closeted era, which I will return to later in the essay. See especially Michael Plante, "Truth, Friendship, and Love: Sexuality and Tradition in Robert Indiana's Hartley Elegies," in Patricia McDonnell, *Dictated by Life: Marsden Hartley's German Paintings and Robert Indiana's Hartley Elegies* (Minneapolis, Minn.: Frederick R. Weisman Art Museum, University of Minnesota, 1995). For more on homosexual themes in Indiana's art, see Jonathan D. Katz, "Two-Faced Truths: Robert Indiana's Queer Semiotic," in Allison Unruh, ed., *Robert Indiana: New Perspectives* (Ostfildern, Germany: Hatje Cantz Verlag, 2012), 217–65.

31 Other artists in Stieglitz's circle who experimented with abstract and symbolic portraiture included Arthur Dove, Georgia O'Keeffe, Marsden Hartley, and Marius de Zayas. For a comparison of Indiana's work with abstract portraits by de Zayas, which were published in Stieglitz's magazine *Camera Work*, see Ryan, *Robert Indiana: Figures of Speech*, 125.

32 Indiana, quoted in van der Marck, "Interview of Robert Indiana and Richard Stankiewicz . . ."

33 Ibid.

34 Indiana, "The Demuth American Dream No. 5," in McCoubrey, *Robert Indiana*, 27.

35 Ibid.

36 Indiana, in Barbaralee Diamonstein, "Interview with Robert Indiana," in *Inside New York's Art World* (New York: Rizzoli International, 1979), 161.

37 Indiana, "The Demuth American Dream No. 5," in McCoubrey, *Robert Indiana*, 27. For more on Indiana and themes of cyclical time, see John Wilmerding, "The Shape of Meaning," in Joachim Pissarro, John Wilmerding, and Robert Pincus-Witten, *Robert Indiana* (New York: Rizzoli International, 2006), 139–67.

38 Indiana's bridge paintings and Jasper Johns's works such as *Diver* (1962–63) and *Periscope (Hart Crane)* (1963) are often compared for their contemporaneous use of Crane as a subject, especially for invoking themes of sexual identity. See, for example, Thomas Crow, "The Insistence of the Letter in the Art

of Robert Indiana," in Unruh, ed., *Robert Indiana: New Perspectives*, 75–76, and Plante, "Truth, Friendship, and Love," 76–78.

39 Another example of Indiana's engagement with symbolic portraiture during this period is his painting *Red Sails* (1963), a commemoration of his father. See Ryan, *Robert Indiana: Figures of Speech*, 172.

40 Indiana, quoted in van der Marck, "Interview of Robert Indiana and Richard Stankiewicz . . ."

41 Ibid.

42 Indiana soon discovered that Hartley not only spent time on Vinalhaven but also occupied a house near his own.

43 According to Michael Plante, Indiana initially intended to use Hartley's late Maine paintings, in which he grieved for the 1936 death of two young friends, Donny and Alty Mason. "Truth, Friendship, and Love," 81.

44 Robert Storr, "Robert Indiana, All-American," in Unruh, ed., *Robert Indiana: New Perspectives*, 13.

45 Plante, "Truth, Friendship, and Love," 73.

46 Charles Sheeler, quoted in *American Visionaries: Selections from the Whitney Museum of American Art* (New York: Whitney Museum of American Art, 2001), 277.

47 David Sylvester, *About Modern Art: Critical Essays, 1948–1997* (New York: Henry Holt and Co., 1997), 220–21.

48 Indiana, quoted in van der Marck, "Interview of Robert Indiana and Richard Stankiewicz . . ."

49 Robert Indiana, "Artist Questionnaire," December 11, 1961, Object Files, Department of Painting and Sculpture, Museum of Modern Art, New York.

RENÉ PAUL BARILLEAUX

ROBERT INDIANA AND THE LEGACY OF LANGUAGE

Just over fifty years ago, artists who ultimately came to be associated with Pop art exploited the visual impact and literal content of the written word, galvanizing the use of text in visual image-making. Pop artists employed language in diverse ways and for distinct purposes, often appropriating text from existing sources or using words inscribed on the canvas to label an image or physical object. In New York, Jasper Johns named—or purposely misnamed—the images in his painterly compositions using stenciled letters. Roy Lichtenstein borrowed dialogue and his Ben-Day dot technique from newspaper comic strips, while Andy Warhol looked to the world of advertising and product design. Jim Dine and Larry Rivers labeled elements in their compositions in the manner of captions or diagrams. Working on the West Coast, Ed Ruscha incorporated single words as key components of his paintings, often rendered in the typographical style of his source material.

Robert Indiana set himself apart from his Pop colleagues by the unique manner in which he fused idea, word, and image in his art into complete "verbal-visual" forms, as he called them.[1] Yet Indiana's use of seemingly commonplace and generally familiar words, names, dates, numbers, and symbols belies his work's deep underlying content and masks the artist's method of loading his art with hidden, coded messages. As a result, Indiana's approach to text became seminal to the work of artists who emerged in the wake of the Pop movement, and who themselves have become critical influences on artists who have emerged in the decades since. Individuals whose practices are as diverse as Bruce Nauman, Jenny Holzer, and Glenn Ligon are all part of Indiana's legacy of language.

FIG. 160 Indiana on Vinalhaven, Maine, sitting behind his four-handed chess board in front of a wall of portraits of him by Ellsworth Kelly. Photograph by Tad Beck, 1988

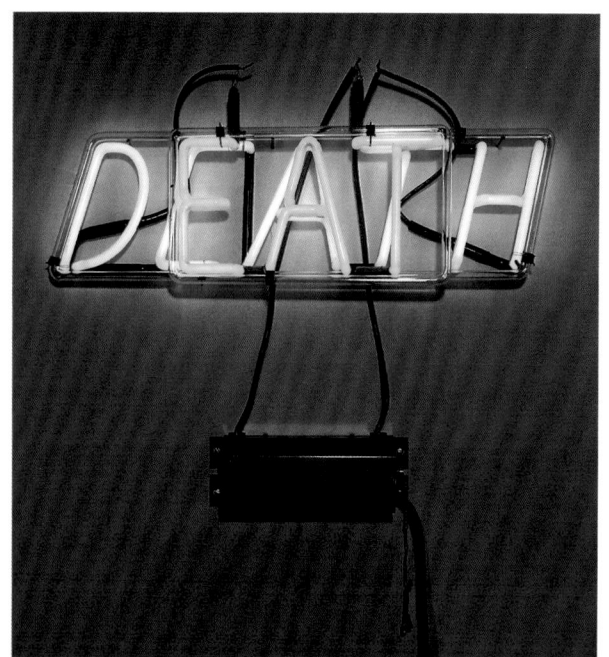

FIG. 161 Bruce Nauman (b. 1941), *Eat/Death*, 1972 (edition 2/6). Neon tubing with clear-glass-tubing suspension frame, 7½ × 25¼ × 2⅛ in. (19.1 × 64.1 × 5.4 cm). Collection of Angela Westwater

Robert Indiana's *Eat/Die* paintings from the early 1960s present the two words in a deadpan style, radically collapsing the opposing propositions of life and death (figs. 85, 86). A decade later Bruce Nauman went a step further with *Eat/Death* (fig. 161), merging the two titular words into a single neon-lit form. Just as Indiana relied on the stark graphics of roadside advertising—with its block lettering, geometric compositions, and bold, flat colors—so, too, does Nauman's sign beckon in the manner of a beer advertisement in a liquor store window. By presenting abstract, impersonal words using the visual ploys of advertising most familiar to contemporary viewers at the time, both artists subvert the traditionally optimistic and reassuring language of advertising, contracting the human life cycle into a single phrase that aggressively reminds viewers of their own mortality.

A generation after Nauman's *Eat/Death*, Jack Pierson's assemblages of individual cutout letters scavenged from old commercial signage recall Indiana's work as well. Whereas Indiana painted his "signs" and fabricated his word-sculptures, Pierson uses his purloined letters to spell out single words or short phrases as wall works or freestanding sculptures. As with Indiana's *Eat/Die*, Pierson's *Desire, Despair* (fig. 162) conflates two extremes of the human experience. Here, the playfulness of the various letterforms and their history as commercial signage undercut the serious tone and weighty contradictions of the text itself, even as the composition's cruciform shape invites multiple complex interpretations. Like Indiana, Pierson utilizes commercial signage to explore the pathos underlying the American Dream. In Pierson's work, this pathos is embodied not only by the mismatched metal, plastic, and wood letters but also by the elegiac tone of the collision between "desire" and "despair," which may allude to the AIDS epidemic that, by Pierson's time, had brought the sexual revolution of the 1960s to a tragic end.

FIG. 162 Jack Pierson (b. 1960), *Desire, Despair*, 1996. Metal, plastic, Plexiglas, and wood, 117½ × 56¼ in. (298.5 × 142.9 cm). Whitney Museum of American Art, New York; purchase, with funds from the Painting and Sculpture Committee 97.102.2a-l

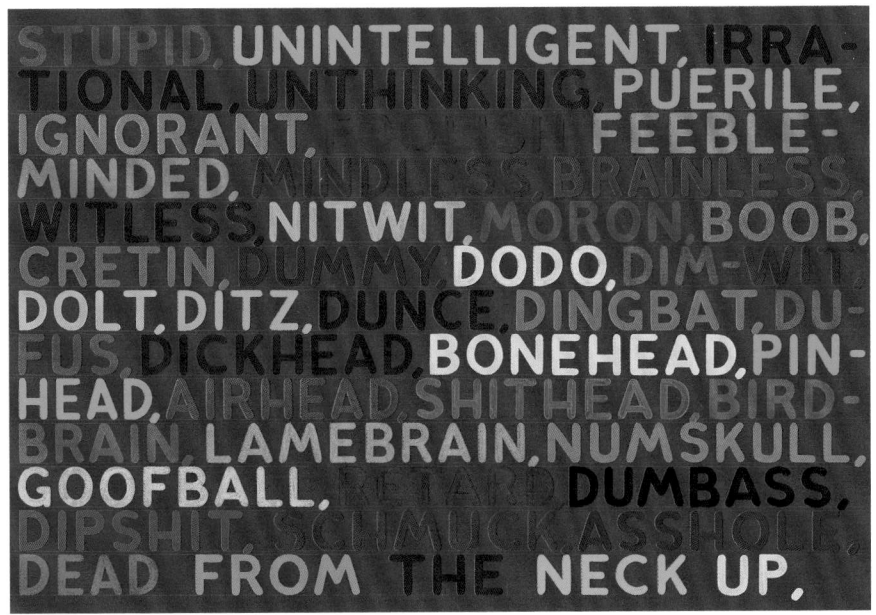

FIG. 163 Mel Bochner (b. 1940), *Stupid*, 2003.
Oil, acrylic, and fabricated chalk on canvas,
45 × 60 in. (114.3 × 152.4 cm). Whitney Museum
of American Art, New York; purchase, with funds
from the Painting and Sculpture Committee 2004.48

Multiplicity of meaning is critical to fully understanding Indiana's art, and the same holds true for the work of Mel Bochner. Bochner's early work from the 1960s features words, numbers, and diagrams in a highly conceptual approach. By the late 1970s, he had begun to make paintings using texts that range from strings of seemingly unrelated words to short phases to fields of a single word repeated across the canvas. A key Bochner phase emblazoned on various works—"language is not transparent"—leaves no uncertainty as to the artist's intended message while offering a window into his thinking and process. As with Indiana's art, Bochner's union of language and visually arresting surfaces, often combining stenciled words and high-key color (fig. 163), asks us to read and see at once, thereby calling attention to the cadences of language, especially the ambiguities that arise with the repetition of the most simple, laconic words in the American lexicon.

FIG. 164 Glenn Ligon (b. 1960), *Stranger in the Village #11*, 1998.
Acrylic, gesso, enamel, and coal dust on canvas, 96 × 72 in.
(243.8 × 182.9 cm). Linda Pace Foundation, San Antonio, Texas

Literature is a significant basis for Robert Indiana's art, and his interest in the writings of American literary forebears whose work both celebrated and challenged ideas at the heart of Americans' national self-image is well established. Glenn Ligon similarly draws his subjects from the country's literary past, as well as historical accounts, current news headlines, and in one series, excerpts from the incendiary stand-up comedy routines of Richard Pryor, using these to explore issues of identity, race, sexuality, and history. Indiana's strategy of selecting texts from writers with whom he felt a strong personal association, such as Walt Whitman and Herman Melville, presages Ligon's own selections, which have yielded paintings featuring the words of writers such as Zora Neale Hurston and James Baldwin (fig. 164). Ligon's selected texts typically correspond to his own identity as an African American gay man. Whereas Indiana masks his personal history and memories but paints the words in crisp lettering, Ligon's paintings record the process of veiling his message physically, with his texts becoming increasingly smudged and illegible due to the residue that adheres to his stencils as he works his way down his chosen support.

RUN
DOGR
UNDO
GRUN

Single words, short phrases, and appropriated text are central to Christopher Wool's paintings, which feature the artist's characteristically stenciled, upper-case, sans-serif lettering. This stenciled lettering, as evident in *Untitled* (fig. 165), represents what may be characterized as a hybrid of the approach of Indiana and Jasper Johns. As with Indiana's language-based paintings, the text in Wool's word pictures is both subject and image, while his use of stenciled letters, like Indiana's, recalls vernacular signage. But like the work of Johns, Wool's painterly approach also accommodates the individual letters' irregular edges, surface smearing, and dripping pigment, suggesting the artist's personal touch and affirming his immediate presence to the viewer.

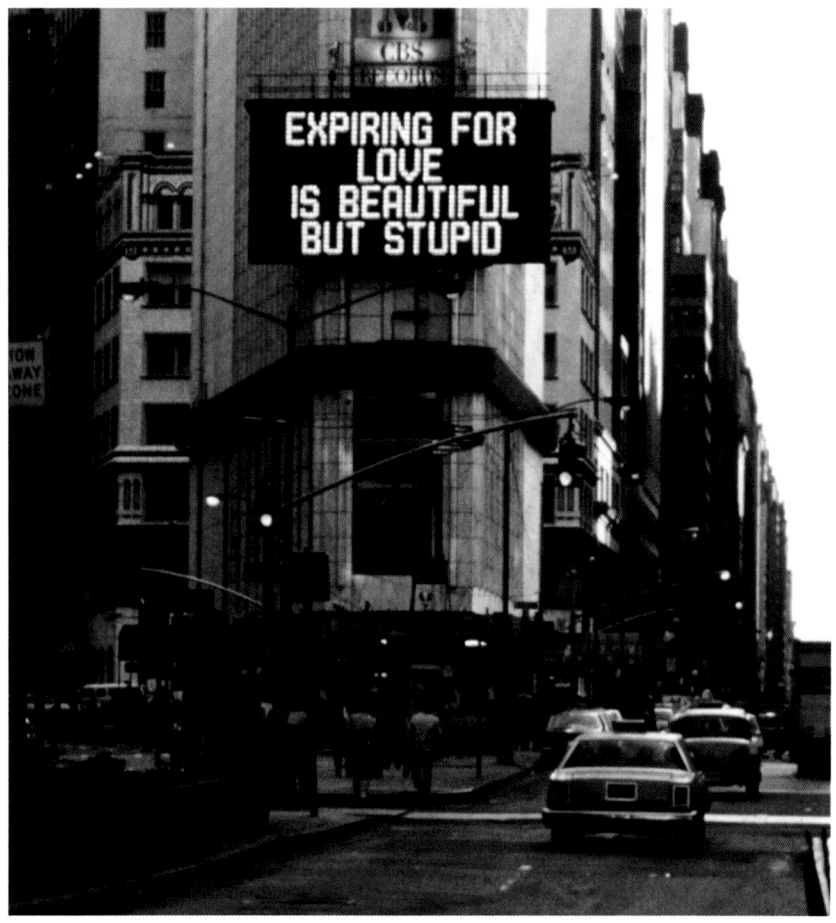

At first, the use of text may appear to be the only thing the work of Robert Indiana and Jenny Holzer has in common. Throughout much of her career, Holzer has employed texts written by herself that often appear as arresting, politically charged modern-day aphorisms, and while her earliest work took the form of simple printed handbills anonymously posted around New York, she quickly adopted more technologically advanced means. And it is here where the two artists' work intersect again. If Indiana manipulated the visual and linguistic iconography of American commerce in the postwar age of the highway and the automobile, Holzer updated this strategy at the dawn of the digital era. She employs highly sophisticated lighting and electronic technologies reflective of the information age to inject her texts seamlessly into the public sphere, often with words pulsing through space in a collision of text-based content and pure visual seduction.

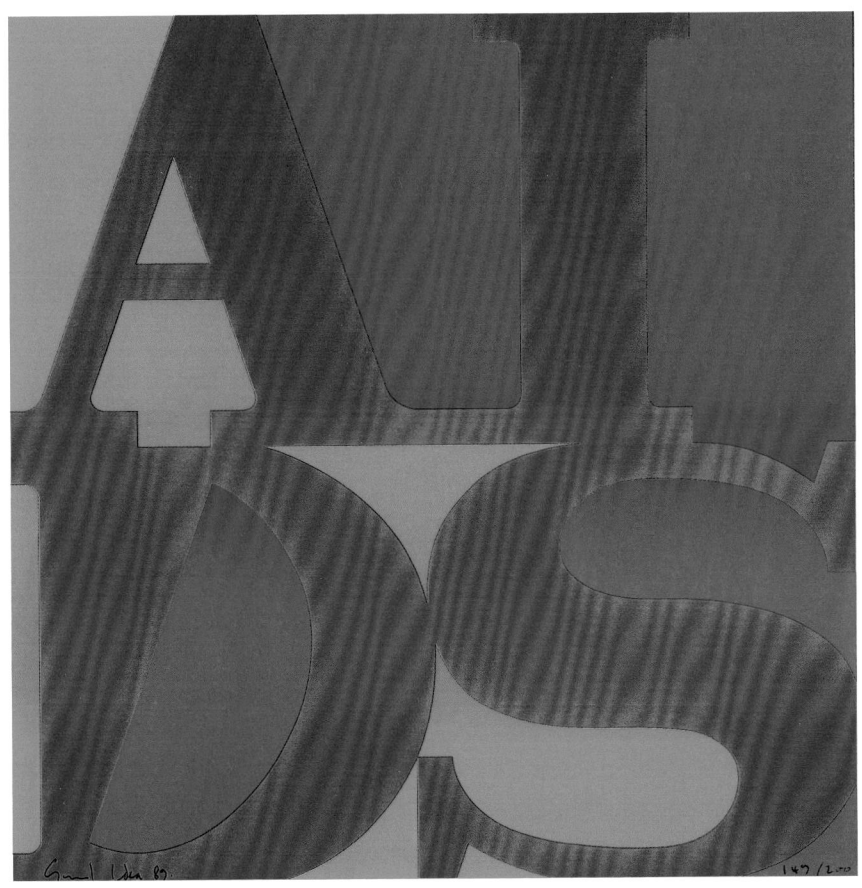

Perhaps it is in the work of the artist collective General Idea, comprised of AA Bronson, Felix Partz, and Jorge Zontal, where Indiana's influence is most immediately apparent. Because Indiana did not enforce his copyright in his *LOVE* image in the mid-1960s, many commercial products bearing the image were produced without his permission. By the 1980s, *LOVE* had become a clichéd icon in pop culture. Yet its ubiquity attracted General Idea, who sought to spread their *AIDS* image throughout the world, just as the disease itself had spread during the 1980s. "We wanted to make 'AIDS' a household word, something that anyone could get. And by spreading the image the way the *LOVE* logo was spread, we think we can deprive the disease of its exotic quality and depoliticize it," Bronson said. "If you can get AIDS to look completely normal, you can get normal medical gears into operation that can deal with the epidemic."[2] Just as *LOVE* had two decades before, the *AIDS* logo succeeded in reaching mass audiences around the world. First appearing in 1987 as the painting *AIDS*, the image exists as unique works of art as well as mass-produced multiples, viewed in both museums and in urban public spaces, under the series *Imagevirus* (fig. 167).[3] By consciously plagiarizing Indiana's *LOVE*, General Idea established an equivalency between the two words, endowing *AIDS* with an anguished poignancy that drove home the significance of the AIDS crisis as having abruptly ended the heady idealism of the sexual revolution of the 1960s.

FIG. 167 General Idea (1969–94), *AIDS*, 1989. From *Imagevirus* series, 1989–91. Offset lithograph, 22⅛ × 21⅛ in. (56.2 × 53.7 cm). Whitney Museum of American Art, New York; gift of David W. Kiehl, in memory of Felix Partz and Jorge Zontal 2003.160

NOTES

1 Robert Indiana, quoted in Richard Brown Baker, "Oral History Interview with Robert Indiana" (sound recording and transcript, September 12–November 7, 1963, Archives of American Art, Smithsonian Institution, Washington, D.C.).

2 AA Bronson, quoted in Paul Taylor, "Love Story," *Connoisseur* 221, no. 955 (August 1991): 50.

3 Gregg Bordowitz, *General Idea Imagevirus* (London: Afterall Books, 2010), 1.

ROBERT INDIANA
Contemporary Perspectives, Part I

A conversation moderated by Barbara Haskell, curator at the Whitney Museum of American Art, and including Bill Katz, architect, longtime friend of Robert Indiana, and former assistant in Indiana's studio; Susan Elizabeth Ryan, professor of art history at Louisiana State University and author of *Robert Indiana: Figures of Speech*; Allison Unruh, independent art historian and editor of *Robert Indiana: New Perspectives*; and John Wilmerding, professor of American art, emeritus, at Princeton University and author of numerous texts on Indiana.

Barbara Haskell I'd like to start with the question of biography. Given that so much of Indiana's work is autobiographical, is it legitimate to look at his life as a key to understanding his art?

John Wilmerding I think biography is absolutely important in understanding Indiana's work, but you have to understand the limits, and, in a sense, the embellishments.

Bill Katz You have to recognize that Robert Indiana is a construction—he wasn't born Robert Indiana. He was born Robert Clark, and not wanting to be stuck with what he thought was such an uninteresting name, he changed it.

Allison Unruh His self-mythology is one of his greatest creations. It's an epic story.

Haskell A number of critics have interpreted his art as coded expressions of homosexuality. How legitimate is that?

Katz I think that's overplayed. Indiana is a critic of the American Dream, and he believes in the social contract, but he never was involved in either hiding or openly expressing his homosexuality. I find the concentration on his homosexuality isn't really relevant to what he is about.

Haskell So the proposition made by Jonathan Katz and others that the peace pipe in *The Calumet* [fig. 59] alludes to homosexuality—[1]

Wilmerding I think that's a classic example of pushing it too far.

Unruh But in terms of Jonathan Katz's specific analysis, I think it's also coming from a different and important point of view in terms of art history, looking at a long-term social and cultural history of gay identity and different ways that it's mediated.

Susan Elizabeth Ryan Indiana's work has really become appreciated by a wider range of art historians than it was, say, in the 1980s, so it's logical that you get a lot of different points of view—art historians or curators with their own agendas bringing their own ideas to his work.

Katz *The Calumet* centers on Henry Wadsworth Longfellow's *The Song of Hiawatha*; it's part of a larger series of paintings in which Indiana was celebrating American authors, one after the other.

Unruh But it *is* an image of men coming together, a fellowship of men, friendship among men, and I think [Jonathan] Katz was reading that within the context of a larger dialogue about gay identity.

Haskell Was the painting about homosexuality or was it more about Coenties Slip, which was for Indiana the first community he felt a part of?

Katz He was making paintings that celebrated authors like Longfellow and Melville and Whitman, using lines from their work that had to do with the area around Coenties Slip. His use had nothing to do with the sexuality of the authors either one way or another.

Ryan But he did see these earlier American authors as forebears, as predecessors and alternatives to disappointing parents.

Katz I think that's a critic reading into it. I don't think he was thinking in terms of forebears or forefathers. Basically, he was celebrating America. When he took the name Indiana, he was celebrating being an American. And that's why he chose those authors, and why at that early period he used lines from many quintessentially American sources, from spirituals to the names of American companies and ships.

Unruh There's a play on the "Indian" tribes in relation to his adopted name, Indiana. Yet *The Calumet* also relates to issues that were very much in the public consciousness at the time—world peace, the potential for the United Nations, the potential for nations to come together. It has that large-scale international kind of resonance, in addition to its very particular American resonance. It's a perfect example of how there can be so many layered meanings in Indiana's work—of autobiography, of national history, poetry, and international implications of the Cold War.

Katz I would say your noticing the Indian tribes is much more important than the United Nations for Indiana. That's the kind of thing he likes.

Wilmerding It's the writer in him. He's writing almost throughout his career, and that's a largely overlooked part of his work. It's an admiration for the American Renaissance and the American past, but I think it's also deeply related to his own wish to write and to relate the American literature he admires to his own process of writing and talking.

Haskell Let's talk about an image that transcends the personal, that mixes the public and the private: *Eat/Die* [fig. 85]. Does knowing how the painting relates to Indiana's personal life give it greater impact?

Wilmerding Sure. Every chance he gets, he talks about "eat" or "ate," his mother's last words. He's talked about it, in my recollection, much more recently than earlier in his career, but it's deeply embedded in his self-mythology. On the one hand, it comes from the American highway, but on the other, it's intimately part of his own memory of his personal experiences.

Ryan His mother was overweight compared to his father. You can see that from pictures, and he often said that he associated "eat" with "mother," not just because of the last words.

Katz Indiana was dealing with three-letter words to begin with: "EAT," "DIE," "HUG," "ERR." He loved that kind of simplicity. His first herms had no words, then he put words onto their bases. That was his first use of words: three- or four-letter words that would fit on the bases. He reduced language to these essential, short, very American kinds of imperatives, and in reducing language, he abstracted and opened up all kinds of meanings. The personal is one of those meanings, which is one of the aspects that make his work so fascinating.

Haskell How did Indiana connect with Pop art, and how did he not? Was his success helped by riding its wave?

Katz It wasn't a matter of connecting. I think he stood apart. I think he thought of himself as an artist before he thought of himself as a Pop artist.

Wilmerding Like many of the people in that group who were linked together, almost none of them thought of themselves as a group. Many didn't want to be called Pop artists. To me, I think Indiana is very clearly linked to Pop and shares certain aspects. Yet he's also related to Minimalism and Op art and some of the other deep strains that are interested in pure design and pure surface, particularly when you consider the influence of Ellsworth Kelly. So to me, Indiana is extremely interesting in that he's both of Pop and apart. Pop art is not clean, unless you just say that Roy Lichtenstein and Andy Warhol are the only Pop artists. There are a number of artists who were on the periphery. Indiana is clearly one of them, but he staked out a middle ground that's totally unique, and that's why he's such a significant figure.

Katz I don't think he rode the wave at all. I think he could have if he had decided to, but he decided against it. In general, I don't think he feels that he is part of any group.

Unruh But he definitely was part of the critical formation of Pop in the early 1960s, as evident in writing by critics

such as Gene Swenson. Nineteen sixty-three was a banner year for Pop, and Indiana's statements in Swenson's "What Is Pop Art?" were so incredibly rich—he described Pop as "a re-enlistment in the world."[2] I actually think he has a very important role to play in understanding the history of Pop.

Katz His meeting Ellsworth Kelly brought the definitive change. When he met Kelly, it started a whole different way of thinking about art and about making art.

Wilmerding But isn't it also because he was in Coenties Slip, and Robert Rauschenberg, Jasper Johns, and other artists were in those warehouses, and they were picking up ephemera and junk materials? It seems to me so much of his interest in what we now call "popular culture" really comes out of that experience of being in New York at that time.

Ryan I remember looking very carefully at Indiana's journals in the years right around the period when he was doing the herms and some of his initial designs, and it seemed to me that he made connections between things that were happening in the world and things that were happening in his life—he was clipping things out of the newspaper and putting them right down next to something that happened to him that day.

Haskell What do you make of the fact that he was adopted—and knew it—but led critics and viewers to understand that Carmen and Earl Clark were his parents?

Katz To him, Carmen and Earl *were* his parents. That's why he wrote, "A Mother is a Mother" and "A Father is a Father" on *Mother and Father* [fig. 94].

Haskell Susan, your book was one of the first to discuss the fact that Indiana was adopted. How did you discover it?

Ryan I found out from someone who knew him on Vinalhaven, after I started going there to do my research. And so, of course, I asked him about it, and he acknowledged it, but he would never really give me any more information. I asked him, "Do you know who your real parents are?" Nothing. Not a word. But he did say to me, "My parents always told me that I was adopted. This was always something they were open about." That was the only shred of information I ever got out of him on the subject.

Wilmerding Don't you think anyone who was adopted thinks throughout their life about their biological parents and their relationship to their adoptive parents? And I think that's deeply ingrained.

Ryan Well, I think he may know much more than he would tell me.

Katz I don't think he does know more than he told you.

Unruh In his art, he's constantly asserting his identity and creating himself, again and again, in a constant rhythm. And so that tells you something in itself, that he's such a self-made person, in terms of the whole way in which he pulled himself up and pursued his education and all of the opportunities in his life. I think the *Mother and Father* diptych is one of the linchpins of Indiana's work—it's so different from the rest of his painting, but it's so connected to his self-mythology and the way in which he'd built up his identity to that point.

Wilmerding It's fascinating that he intended to do *Mother and Father* as a cycle of four.

Unruh The work isn't so well known now, so I think it will be one of the great revelations of this exhibition. It's an anomaly in terms of figural representation, which isn't typical of his work. But beyond that, it has so many deep, connected meanings, in terms of his larger body of work and making those kinds of narrative elements more explicit. And just in the history of artists' representations of their parents, it's such an unusual and special image.

Wilmerding In many ways, to me, that diptych is the great early masterpiece and the summary work of almost everything we've been talking about.

Unruh It's the first time he really put his autobiography center stage. I think it was connected to the way that, around 1963, he was becoming more self-conscious about having attained a kind of celebrity in the New York art world.

Haskell Indiana has described the first four paintings in his *American Dream* cycle as being critical, but he has also talked about his work as a whole as celebratory.

Wilmerding Just remember that when they were painted, in the early and mid-1960s, the whole country was in tension about the contrast between celebration and anguish, or failure. That was a national dialogue, beginning with the Kennedy assassination and through the escalation of the Vietnam War. It's not that he's making a direct link, but those larger tensions were there in American society, and Indiana is simply responding to, on the one hand, the wish for celebration and, on the other, the extermination, as it were, of Camelot. That's so deeply and powerfully part of the mid-1960s that, to me, it's the context for the ambivalence in these works.

Unruh Even if you go back to the early years of the Kennedy presidency, Indiana is already looking at both the positive and negative sides of the ideals of the country.

Haskell Does Indiana's work become more celebratory after he began to be successful?

Unruh I think it's essential in terms of the power of his work that he is consistently both celebratory and critical throughout his production.

Ryan If you don't have that tension, Robert Indiana's work would just be a bunch of words. There is that tension in almost all of the work, often between word and image, or between color and word.

Haskell So, then, is there no difference between his earlier work and the post-1965 work?

Wilmerding Well, yes, there's stylistic evolution, and the colors change, but no, the strain continues. I think his personality is like that. He has these moments of depression and these moments of exhilaration. However you diagnose it, the two are absolutely inseparable, and he keeps playing that way in his studio. It's partly what he is looking at. Is he looking at history, or is he thinking about the self? The same combination, the same tensions, continue. Sure, they may be reshaped in later work, but that's where he's a consistent artist.

Haskell Bill, you've talked about *The Demuth American Dream #5* [fig. 82] as being a watershed.

Katz I think it was the first time that he combined his admiration for both a painter and a poet—William Carlos Williams and Charles Demuth. Poetry is important to Indiana: Gertrude Stein was very important, William Carlos Williams was very important, Edith Sitwell was very important. Indiana said Demuth's *I Saw the Figure 5 in Gold* [fig. 154] was one of his favorite paintings in The Metropolitan Museum of Art.

Wilmerding It's one of the first that he writes about; he wrote a long statement about interpreting the Demuth *Figure Five* and the links he discovered about the birth and the death dates and the year in which it was painted. The Demuth *Figure Five* is the first work where Indiana discovers, it seems, the embellishments in the process of painting it—first it's an homage to the original source, then it becomes transformed into this elaborate infusion, if not imposition, of autobiography, and he starts discovering even more connections to Demuth because of the dates. And to me, it's a wonderful thing about his process: his best works come out of something, they get shaped in the moment, then he continues to keep imposing and, after the fact, starts interpreting things that I suspect were not there when he started. So they have a kind of afterlife.

Unruh The Demuth series was the turning point in terms of a greater interest and engagement with numbers.

Wilmerding Yes. But just to take one detail, the fives cross; I've linked that, of course, to Cimabue's *Crucifixion* [1287–88].

Unruh And to Indiana's own earlier *Stavrosis (Crucifixion)* [fig. 19].

Wilmerding And to the *LOVE Cross* [fig. 133]. And he said specifically that he was mindful of the devastating floods in Florence [in 1966] and so forth. So all of that starts to ripple out into contemporary history, in a way that was not there when he first decided to make his homage to the Demuth *Figure Five*.

Ryan I think he has a mind that makes connections, and those connections always come back to points in his own life. He looked at the Demuth and at the William Carlos Williams poem that Demuth was referencing, and then he made it into a Robert Indiana—a sort of lineage of voices.

Unruh It's a great example, too, of how he works in series, creating all of these incredible formal variations of a theme once he seizes on it. In the case of the Demuth *American Dream* series, it's five variations within the cycle, which are all so different, even though they all point to the Demuth.

Katz They're orchestrated. The earlier works in the *American Dream* series are like one movement, but the Demuth *Dream* is an orchestration.

Haskell Let's talk about *LOVE* for a moment and its proliferation.

Katz I was helping in the studio at the time he made the *LOVE* poster for his Stable Gallery show in 1966 [fig. 93], and I said, "Bob, you should copyright this." And he said, "Bill, artists don't do that. They don't put a copyright on top of an artwork."

Unruh Those rip-offs, which dispersed products that weren't under his control, had an enormous cost; they definitely had a negative effect. But at the same time, it's important to remember that Indiana *wanted LOVE* to proliferate, and he intentionally participated in forms such as the prints, felt banners, etcetera, that made the image more democratically accessible. I think the conceptual element of wanting *LOVE* to proliferate is an essential part of *LOVE*.

Katz But it doesn't have to do exclusively with *LOVE*, if you'll forgive me. He would be happy if every painting were made into a print—as long as it's done with his approval and under his supervision.

Haskell Can you comment on how the proliferation of *LOVE* sculptures has affected Indiana's career?

Katz The only *LOVE* sculpture Indiana did at the time of his Stable exhibition was the one that was cut out of solid aluminum, and then he did the *LOVE* ring shortly thereafter. Later he started working at the Lippincott Foundry, where he enjoyed making large sculptures.

The various sizes and colors came in a very natural way. The colors came from his paintings, and the sizes came from his paintings, too—one foot, two feet, three feet, six feet, twelve feet tall.

Wilmerding The irony is that *LOVE* created his reputation, for good or bad. Would he be as recognized or as famous without it?

Katz Before I came to New York, Indiana had been asked to design a Christmas card for the Museum of Modern Art. He submitted several possibilities of *LOVE*—in one color: black and white; in two colors: blue and green; three colors: red, blue, and green; and four colors. They chose the red, blue, and green version. Where I was working at the time, nobody could read "L-O-V-E." It looked completely abstract to people. It wasn't immediate—the card in the world of the Museum of Modern Art meant one thing, but in the world at large, it took a while before people could actually read the word "love" and didn't see abstract shapes.

Haskell Was there something so radical about his conflation of word and image that it challenged people?

Wilmerding Yes, I think there was. The idea of the block, the idea of the tilted letter, seemed most peculiar. And the optics of color, the vibration. It's a brilliant conception, even just from an optical standpoint.

Unruh And the six-foot painting [fig. 108] works so differently when encountered in person; its enveloping scale gives it a greater degree of abstraction, which in turn gives it a different kind of expressive power than when you see it reproduced, say, as a postage stamp or in other forms.

Haskell Do you think the way Indiana used words as signs affected the reception of works like *EAT* [fig. 58] and *LOVE*? He obscured the boundary between fine art and advertising more than any other artist.

Ryan I know when I started working with him in the mid-1980s, I would tell people, "I'm working on Robert Indiana. Do you like his work?" And a lot of people said, "It's a little too much like graphic design." So the graphic design aspect somehow did get in the way. People felt graphic design was commercial, and you didn't mix that with fine art. The work mystified people because Indiana unabashedly created these hard-edge images that were a little less obviously ironic than Warhol's work, for example, and people were confused. But times change.

Haskell Thomas Crow likened Indiana's over-painting of *Agadir* to create *The American Dream, I* [fig. 51] to Jackson Pollock's over-painting of *The Little King* to create *Galaxy* [1947]. He wrote of it as a turning point in 1960s art. Can you comment?

Unruh Indiana's unique vocabulary, which was branded "sign painting," becomes full-fledged in that image. So it really *was* a turning point in terms of his work. Previously, when he'd used text on things like the herms, it was in the vocabulary of assemblage, but [*The American Dream, I*] is a major creative turning point, both in terms of his own formal vocabulary and in terms of his enormous contribution to language-based art.

Wilmerding But do you attach it particularly to that work? That's what I'm not so sure of. To me, it's a bit of imposing a wish—which is what art historians do—for the "seminal moment." It's an interesting picture. It's an important one. But whether it was the *single* transformative work—I think there were other things going on at the time that were part of his evolution.

Haskell Can you compare how Indiana and Warhol depicted contemporary political events? In Warhol's case, I'm thinking of his *Tuna Fish Disaster, Car Crash*, and *Race Riot* series.

Wilmerding I don't take the Warhol works as political. In a way it's oversimplifying, but I see them as part of Warhol's discovery and burgeoning interest in everything graphic, namely the tabloids and magazine illustrations. To me, I don't think they're polemical in the way Indiana could be, and often wanted to be, polemical, in works like *The Confederacy Series* [figs. 100–103] and others.

Katz But Warhol's *Race Riot* works *are* political.

Wilmerding Yes, but in a way they're as visual as they are political. That is to say, the interest in the odd colors, the idea of the diptych—there are a lot of formal things going on in Warhol that we often don't give him credit for.

Haskell Do you feel that Indiana's involvement with themes of death and resurrection in his poetry and the early paintings he made under the name Robert Clark carry over in later work?

Unruh There's an iconic element in the early paintings of heads that carries over [figs. 17, 18]. He has also emphasized how his rendering of the word "love" has spiritual connotations. So there's definitely very much a spiritual dialogue in a lot of his work, which goes against the grain of our expectations and adds another dimension.

Wilmerding Let me relate this question to my thinking about the numbers, even though it requires a certain degree of oversimplification to make the point. In the case of the *Exploding Numbers* [fig. 104], for example, I think Indiana was interested in graphic design, the mathematics of design, and the relationship of how these canvases were going to be hung. I was at Dartmouth when a fellow member of the art department gave Indiana the Currier and Ives print of the ages of man. I think that print reaffirmed

a shifting interest from the optical, the graphic, to an idea of the cycle of numbers as a whole. Again, I'm oversimplifying to make the point, but in the late 1960s, early 1970s, Indiana becomes obsessed with the cycle of numbers. And it's interesting to me for two reasons. On the one hand, most of us think of numbers as beginning with zero and going to nine, but Indiana intentionally changed that and gives a new meaning to the zero by putting it at the *end* of the cycle. So that led me then to make this connection between the Currier and Ives print and Indiana's fascination with the idea of cyclical time. It's absolutely logical the way he thinks. So to pick up on your point: it's not resurrection in a specific Christian sense; it's a fascination with life and death, with aging, with mortality, which is on his mind more and more as his career progresses. I've made the parallel between Indiana's cyclic treatment of numbers and Thomas Cole's *The Voyage of Life* [1839–40]. That cycle is more national, more political, and relates to the cult of youth in the nineteenth century, especially after the Civil War, but Indiana belongs to that tradition. He turns it into something quite personal.

Unruh It's interesting because the zero has both the symbolic freight of signifying nothingness, the end of life, and the potential for rebirth. And it also visually relates to the circle, which is so important to him. He layers the allegorical meaning of numbers with the visual in such meaningful ways.

Haskell Can you talk about Indiana's relationship to American writers and early American modernists?

Ryan He told me that he started *The Brooklyn Bridge* [fig. 97] thinking about Joseph Stella, and he wasn't actually thrilled with Stella or his work, but then he started to think about Hart Crane. He associated *The Brooklyn Bridge* much more with Hart Crane than Joseph Stella.

Haskell What about Marsden Hartley?

Katz With Hartley, it came back to autobiography. Hartley's connection to Maine and to Vinalhaven in particular resonated with him. When Indiana realized that he was on the same island where Hartley once had a studio, he managed to acquire that studio. And the *Hartley Elegies*, which have to do with Hartley's love for a young German officer killed during the First World War, seem almost like Indiana's eulogy to his own *LOVE*.

Wilmerding I would argue that the *Hartley Elegies* are not as conscious an investigation as Indiana made in his writers series. I think his literary paintings will be one of his real contributions as an artist. He was one of the first to be interested in modern American letters and to investigate and bring them to the fore, long before art historians and cultural studies departments became

interested in many of these same writers. That's a terrifically important contribution. He was way ahead of his time, critically, in beginning to take those writers seriously.

Haskell How was Indiana's reputation affected by his decision to leave New York in 1978 and move permanently to Vinalhaven?

Unruh Dramatically, I think. He didn't have consistent representation in New York; he didn't have an anchor in terms of having a voice in the art scene here. I think that has had a powerful effect on the fact that he's not as well known now as he absolutely deserves to be.

Wilmerding He's used the word "exile," and for him I think that's apt. He's talked about how dealers were not interested—he had difficult relations with them, which was partly of his own doing. He was attracted by being in Skowhegan, being invited to be on the board of trustees. So it was as much a pursuit of something as it was an escape from something else. But yes, his leaving New York is a traumatic turning point.

Katz Indiana and I were up at Skowhegan—I think he was lecturing there—and Eliot Elisofon, the photographer, invited us to come to Vinalhaven. We had a wonderful several days with him and his two daughters. As we were leaving, I saw a beautiful building on Main Street—the Star of Hope, the old Odd Fellows Lodge. And I said to Eliot, rather casually, "Can you find out if maybe Bob could rent a floor and I could rent a floor?"—for the next summer. When Indiana left New York, he moved up there to the Star of Hope, where he still lives.

Ryan He just loved big houses. He often told me all about how the imagery of big houses came up in dreams.

Unruh He's turned the Star of Hope into, in a way, his greatest creation. It's a living work of art. He's constantly changing the arrangement of his furnishings and his artwork within it. It's incredibly unique, even in the history of other artist's studios.

Katz But I would hesitate to call it his greatest work of art, if you'll forgive me. It's a house. It's a house that an artist lives in, but it'll never be more than a house. Georgia O'Keeffe's greatest work isn't her house in Abiquiu. When he finished living at 2 Spring Street on the Bowery, Indiana had five floors including his own back gallery. You couldn't say that was a work of art. I just hesitate calling it that.

Haskell Robert Pincus-Witten has written that Indiana's work has been elevated to master status and is now being acknowledged on par with Johns, Rauschenberg, Warhol, Kelly, and Lichtenstein.

Wilmerding It's a very interesting moment in Indiana's reputation, no question. In part I think it has to do with the interest of contemporary art in lettering, in signage, in language, linguistics, etcetera. This isn't necessarily a direct result of Indiana's influence, but the fact that it's happening is sending a signal to more and more artists and to the public at large about the importance of his work for the current generation.

Ryan Also, people today are a lot less worried than they seemed to be in the 1970s and 1980s about art looking like graphic design. They don't think that way anymore.

Wilmerding There's a whole development from the 1960s, 1970s onward in the blurring of the traditional definitions of media—from painting to relief sculpture, to print-making and photography, which really traces back to Rauschenberg's Combines. The distinction between painting and printmaking, which used to be separate enterprises, each on a different level of aesthetic, critical, and monetary importance, has broken down now, and Indiana has been part of that. You could argue that the prints of the *Hartley Elegies* are as great as the paintings.

Haskell What is Indiana's place in American art?

Wilmerding For one, his prescience in reviving and establishing the early modernist writers and early modernist painters, before the art critics and before the literary critics—that's an oversimplification, but it is *one* major achievement that informs his art. It is a kind of personal investigation, whether haphazard or accidental, conscious or not. The second is the link he makes between that generation of modernist, experimental writing and contemporary artists' use of language. He is a critical father figure for much of that experimentation. While there's a lot of original work going on, in some ways you can say it's due to Robert Indiana. His legacy is in the making right now. Finally, the greatest of his artworks brilliantly balance graphic design and philosophical meaning. We look at his pictures from a visual point of view and from the polemical, the personal, and the narrative point of view. He's a writer in paint, which is unique with him.

Katz I love the idea that the Whitney Museum of American Art is having a show of Robert Indiana. I think he's a wonderful and a great artist, and his major works are all these things called "The Dream," the dream of America.

Ryan He brings the idea of being an American artist into a global art scene. Even when his work was less popular here, it was extremely popular in Germany and in France, for example. His work has had impact all around the world as an example of American art. I think that its importance is actually global. He's bringing the notion of America into the international.

Unruh The most important part of Indiana's legacy to
my mind is the way he provides this incredible connection
to the history of American modernism and then looks
forward to so many contemporary language-based prac-
tices. He is a pivotal figure who has created his own visual
language that melds word and images in a way that has
affected a much wider field of visual culture. And I think
the *American Dream* series is one of the deepest and most
meaningful meditations over the course of several decades
on an American experience from the point of view of
someone who is both a patriot and deeply critical.

Wilmerding One of the reasons that his reputation outside
the United States is so strong is that non-Americans see
Indiana's work, more than almost anybody else's, as an
embodiment of their idea of the American Dream—it
embraces the good, bad, ugly, and the indifferent. Indiana
also, to me, relates back to the American craft tradition.
His art is very much a modern expression of the American
folk tradition—of its crudeness and practicality. His art
is Pop in that it is the deeply ingrained idea of American
making and fabrication and so forth, and the bringing
together of high and low. Yet what's so distinctive about
his work is that it's deeply historical, going back almost
to a kind of Puritan tradition while at the same time,
it's ultimately international.

NOTES

1 Jonathan D. Katz, "Two-Faced Truths: Robert Indiana's Queer
 Semiotic," in Robert Storr, Thomas Crow, Jonathan D. Katz,
 Kalliopi Minioudaki, and Allison Unruh, *Robert Indiana:
 New Perspectives*, ed. Allison Unruh (Ostfildern, Germany:
 Hatje Cantz Verlag, 2012), 217–265.

2 Gene R. Swenson, "What Is Pop Art? Answers from Eight
 Painters, Part I: Jim Dine, Robert Indiana, Roy Lichtenstein,
 Andy Warhol," *ARTnews* 62, no. 7 (November 1963): 24–27,
 60–64.

ROBERT INDIANA
Contemporary Perspectives, Part II

A conversation moderated by Barbara Haskell, curator at the Whitney Museum of American Art, and including Thomas Crow, Provostial Fellow and the Rosalie Solow Professor of Modern Art at the Institute of Fine Arts, New York University; Robert Pincus-Witten, professor emeritus in the Doctoral Program in Art History at The Graduate Center, City University of New York, and contributing editor at *Artforum*; and Robert Storr, dean at the School of Art, Yale University.

Barbara Haskell Indiana has said that all his work is autobiographical. How legitimate is it to interpret his art through the lens of biography?

Thomas Crow Biography is a very underused resource for serious analysis. In our own lives we don't discount biographical details, so why would we discount them when we're talking about an artist? And Indiana's family background is astonishing. It could be a novel in itself.

Robert Pincus-Witten Regarding Indiana's coming out as gay when he got to New York, I think that biographical detail is critical and has been effective in valorizing Indiana's work in regard to gender identity politics. It hadn't been spoken of much until comparatively recently, but it's seriously changed the interpretation and acceptance of his work.

Robert Storr The biography is very important, but it's not the literal story that counts, and it's not necessarily the things Indiana has said about his life, be they somewhat true or entirely self-mythologizing. To be the kind of man he was—to be a gay man—and to be the kind of artist he was in America in the 1950s or 1960s was nigh on impossible. In order to be somebody in the world, you had to don a series of guises, although some were partially revelatory. Indiana never hid himself completely behind masks; rather, he was using them as filters so that the things that were important to him could come through. They would come through very clearly to people who understood and were sympathetic to his concerns, and they would come through in a slightly altered fashion but would be perceptible to people who were unsympathetic. To be a gay American artist in the 1950s was, in the minds of many, to be *un*-American. But to be a hyper-American artist in the 1950s was also something of an anomaly, a sort of counter-image to vanguard taste, which had left conservative American Scene art of the 1930s behind. Yet Indiana leapfrogged in reverse to the 1910s and 1920s—he was drawn to Gertrude Stein, Hart Crane, Charles Demuth.

Pincus-Witten The coded references attributed to Indiana's work are not an unfamiliar strategy. However, as interesting as all of that is (and because it's so interesting, it's

what gets written about), is that where the art is? Perhaps yes, perhaps no.

Storr I think it *is* partly where the art is, because Indiana is an artist of signs and appearances, rather than an artist of confessions and direct expression, so that the staging of these identities is part of what he's doing.

Haskell Indiana's selection of texts from Walt Whitman and Hart Crane, for example, have led some writers to assert that such choices are coded references to homosexuality. But these writers also are very American. How much does Indiana's choice of authors have to do with their homosexuality, and how much with their American-ness?

Pincus-Witten I don't want to suggest that he hasn't read these figures profoundly and absorbed their messages deeply. But in the end, I think it stays at the level of sign. And signs are meant to be decoded by the community to which they are addressed.

Crow Indiana's deep absorption of literature relates to his own idea of himself as an intellectual. But there weren't means by which he could translate learning and acculturation into the kind of art that was most esteemed at the time when he arrived in New York, because those artists were expected to be direct and intuitive and not stand on their pedigree or education. Ellsworth Kelly and Jack Youngerman were absolutely crucial to Indiana finding his way to a much more impersonal manner, and once he settled on that, then he could put into that style anything he wanted. Because it looked like a sign or it looked like "sign painting," it was in the idiom of his other self, the lower-class Midwesterner. So through those divergent aspects of himself, he was able to find a synthesis that really worked, from 1961 or so forward.

Haskell Tom, you have identified the stencil as a liberating tool for him.

Crow Yes, indeed, because of its impersonality and also its sense of history—he used old-fashioned stencils, the forms of which derive from the nineteenth century. It wasn't Jasper Johns's stencil from the local stationery store.

Storr It was not just American; it was *Americana.*

Crow It brought with it a sense of deep history. But it also brought the past into his work in a technical sense, rather than imposing it as a personal or idiosyncratic gesture.

Pincus-Witten The use of the stencil and the sign—the design issues of which we are so conscious—may very well be a major cause of the resistance to Indiana's acceptance into the pantheon.

Haskell How much of Indiana's critical resurgence has been impacted by a focus on his sexual orientation? There have been writers who have taken Indiana's homosexuality as one of the primary ways to understand his art.

Pincus-Witten Look at Gerald Murphy's work. He was gay, but do we look at his work as coded? Today we bring a special emphasis to a gender-based value system and, as a result, we valorize Indiana's work along these lines. But this valorization has not been given to Gerald Murphy, to cite but one example, though it certainly has been ceded to Jasper Johns and Robert Rauschenberg.

Storr I am sympathetic to what Robert says. To "out" everybody ex post facto and impose simplistic sexual and political messages tuned to the 1990s or the 2000s on their work, rather than to the moment in which the work was made, is a mistake. The important factors here have to do with the degrees of alienation from Main Street America—and the whys of that alienation vary—coupled with the degrees of identification with one's "own private America," to paraphrase Gus Van Sant. Indiana had plenty of reasons—from his family situation to the state of the country and so on—to be very, very alienated, and at the same time he defiantly embraced the United States and a certain vision of its history and traditions. That tension in his identity and his work is what really matters.

Haskell The joining of celebration and criticism is a primary aspect of Indiana's work.

Crow The founding work was [*The American Dream, I* (fig. 51)]. It's easy to slot this painting into a generic notion of identification with America and American aspiration. But the painting itself is quite mordant about all those things in its imagery, its associations, the legends and slogans that appear on it.

Haskell How would you characterize Indiana's relationship to Pop art?

Storr British Pop art was basically an embrace of American culture in a country that was comparatively antiquated and depressed. When Pop comes to the United States, and our artists transform British Pop into American Pop, they immediately bring into it many of the dark undercurrents left out by the Brits. It happens right away in the work of James Rosenquist, Andy Warhol, Claes Oldenburg, and, of course, Indiana. They shined a bright light in corners that were actually quite dark and sinister. They played with ambivalences and double messages that were more complex than the British had done at the beginning.

Pincus-Witten There was, in the mid-twentieth century, a dichotomy between a large progressive group of Abstract Expressionists who weren't particularly involved with nativism and who incorporated angst and tragedy into their work, and this very cool kind of art that was thought of as a boosterist style, which would ultimately coalesce into Pop. We've perhaps lost the sense of how repugnant the nationalist, chauvinistic, or patriotic aspect of culture in the 1950s was to liberal-minded, right-thinking people. And we also forget that, initially, there were a lot of artists associated with Pop who empathized with emotionalism and representationalism and softness, and they were dealing with a kind of inherited and rather overt social consciousness from the Great Depression. All that fell away, and it ended up just being cold, hard Pop art.

Crow They're *seen* as cold and hard and coolly indifferent to social and political passion, but that's a misreading of at least some Pop artists, and Indiana's one of them. Indiana dealt with the racial divide, for example, in a way that seems precise and somewhat impersonal, but as a general rule, you can be passionate in art, but you can't parade your passion—your passion has to be working against something that seems ostensibly contrary to it. Because every great work of art is based on a paradox, and attempts at art that contain no paradox are not works of art. Indiana sustained this.

Storr Part of what you are saying reflects the utter failure of the *New Images of Man* show in 1959 [at the Museum of Modern Art] and the near-complete obliteration of the art of moral outrage—no matter how good or bad the art actually was. It was a disaster, critically and commercially, even though some of the artists were good and important. Afterward, anybody who wanted to address issues of this nature knew they had to tack off the wind, because sailing straight into it was going to get them absolutely nowhere.

Haskell So to return to Indiana's relationship to Pop—

Storr Pop is an ambiguous term, which is a good thing critically, because nobody agrees on quite what it encompasses, and the debates clarify many issues. Look at the differences between Oldenburg and Indiana, for example: both had a considerable degree of social commitment or engagement, but they remain utterly different stylistically. Both started out with Jean Dubuffet's gritty expressionism and tried to morph it into something else, but Indiana jump cut to an entirely different clean, hard-edge aesthetic.

Crow If you asked someone in 1962 to name the big Pop artists, Indiana's might very well have been the first name to come up, and Warhol might've been forgotten. Indiana helped, as much as anyone, to create a collective consciousness that there was something called Pop, and that's something we ignore at our peril. It lives in the culture as something important that happened at a certain juncture that changed the scene in a decisive way, and Indiana was one of the drivers of that change.

Storr [*The American Dream, I*] was painted a year before Warhol broke cover.

Pincus-Witten At the beginning, the idea that there was this entity called Pop was very much negative, defined through the horror of a generation of artists—largely second-generation Abstract Expressionists—who suddenly felt that after the good struggle they were not getting their just dues. And spokespersons such as Dore Ashton and emerging younger critics were profoundly repelled by this new sensibility.

Storr In Britain, you didn't have the same kind of opposition, because you didn't have a successfully entrenched avant-garde. Instead there were a slew of relatively less-consolidated alternate tendencies. In France, meanwhile, there was New Realism, and the artists involved also had an attitude largely in sympathy with Pop. So you didn't get the same kind of pushback as you did here.

Haskell I want to get back to the issue of biography. *Eat/Die* [fig. 85] is clearly informed by biography, but how much knowledge of that does one need to appreciate the painting?

Pincus-Witten It doesn't help much. These three-letter commands are powerful in and of themselves. They have a kind of semaphoric power that assists in identifying the alignment of a certain group of works and also making them powerful and strong.

Storr That piece effectively collapses the lifecycle; it's a beyond-Zen koan version of existential philosophy. And it's important that Indiana understood that it was possible to do this with language. It's very important that he chose a particular graphic style. He seized on something very rich and was able to make something else out of that rich possibility. Indiana doesn't get credit for being a conceptual artist, but that's what he is.

Crow Or having been the first one to do it.

Haskell Let's talk about Indiana's reception. Early on he was considered a leading Pop artist; now he's somewhat marginalized. Was there something about his work that was difficult for the public—or critics—to accept?

Crow I think there's a one-word answer to that: *LOVE.* The *LOVE* phenomenon changed everybody's perception of Indiana.

Pincus-Witten Negatively.

Crow Yes, and the fact that he did not back away from the first negative responses. Pop art seems to me a kind of funneling down of a lot of things that were circulating in the culture that belonged to different sectors—to advertising, to movies, and so on. As it got funneled down, it accelerated with a kind of intensity that you couldn't

perceive when it was much more diffuse. What happened with Indiana was an anticipation of what was going to happen to Pop in general. It was going to expand back out again and enter into all those other sectors of the culture where it had come from—but transforming them in the process. Popular culture took on the attributes of Pop. And the only Pop artist who leapt into this and participated in it was Indiana, and he paid a price.

Storr There's a kind of sorcerer's apprentice dimension to this. I recently bought, for forty bucks, a copy of the original *LOVE* napkin. *LOVE* entered the popular culture in every way possible, even as it killed Indiana's career in the serious art world in many respects. Basically, *LOVE* is the predicate for Jeff Koons and Damien Hirst, where you go from the idea to the multiple, and from the multiple to global distribution of a metamorphic product.

Haskell How much was it the image itself, and how much was its proliferation responsible for the negative critical response?

Pincus-Witten Its sheer popularity removed it—it made it invisible. You simply didn't see it because it became so ubiquitous. This is the problem with popular arts: you don't think about them, which is why we sustain the elite arts. After that tightening through the sluice, there was this giant wave of embrace. I'm suggesting that the giant wave of embrace washed away any consciousness of the originality of the style.

Haskell But was there something about the work itself?

Crow I think the quality of the design is tremendous, and its long-term success would not have taken place were the design not so good. There is an empirical demonstration for the quality of any cultural object if it endures long past its moment. And *LOVE* is still alive, completely alive in the culture, and it wouldn't be if it were just ubiquitous for a moment but were now an object of nostalgia. It isn't. It stays current, and that's why the design is so good.

Pincus-Witten Ubiquity is not a demonstration of excellence. The point was that the logo's everywhereness rendered it anonymous as distinct from rendering it signaturized. To me, it would be worthwhile to make the comparison between something we see as profoundly abstract and something we see as legible.

Storr What happened was that this thing was embraced by mass culture at a very particular moment—it was not yet the Summer of Love, but not too far from it. It was a time of unbelievable optimism and of a romance of youth in the culture at large, but this gets "problematized" rather quickly. During the late 1960s and early 1970s, the dark side of love comes forward very strongly, and then, of course, there is the question of who loves whom? Here the question of Indiana's sexual identity does become

important, because what he means by this word, or may mean by it, or what other people in society might mean by it, may well not be the same thing. Thanks to that potential discrepancy, *LOVE* becomes a probe into the subjectivity of the viewer in relationship to the object.

Haskell Let's move on to Indiana's use of numbers and letters. Robert, in one of your texts you wrote that Indiana's work is as much a source as Jasper Johns's is for the period's ubiquitous letter, word, and number paintings. Can you expound on that a bit?

Pincus-Witten When you look back to the moment when such work entered into the world, one must remember the consternation this kind of imagery met. But once we got past the consternation, the work became a pool of reference for subsequent artists. The highly divergent Coenties Slip group, with Youngerman's 2-D consciousness of the edge and Kelly's consciousness of contour, goes back to epigraphic appreciation, the looking carefully at the formation of the history of Roman inscription—not for the *meaning* of the inscription but in terms of the beauty of the structural relationships. If there's a stylistic thread binding the Coenties Slip group together, it's the consciousness of contour, of edge, which came to embody an elect artistic sensibility.

Crow Even with the commonality of the use of stencils, the use of lettering in Johns and Indiana is as different as it can be. With Johns, stenciled letters are usually messily embedded in an atmospheric matrix of mark making, which was not Indiana's concern in the slightest. Johns's legends are often an enigmatic inclusion. The words are there to complicate, if not to confuse, the overall interaction of signs and gestures on the surface. In the case of Indiana, the use of lettering is, at least at one level, to make things as unambiguous as possible. And so the ambiguity and the layering of meaning happen as an unexpected outcome of what seems to be completely straightforward and declarative on the surface.

Storr The keen interest that Johns, Rauschenberg, and Oldenburg had towards Abstract Expressionism deeply permeates the work they made, and although, at the time, they were seen as a heretical counterforce producing dispassionate, mechanical art, their work doesn't look that way now. By contrast, Indiana took a full step away from Abstract Expressionism and became part of the community of artists who specialized in hard-edge and immaculate finishes. With Johns, not only are the words ambiguous, but their contours wobble; because they are stenciled, the ground receives them differently. Nothing is stable in a Johns painting.

Pincus-Witten So the obfuscation could be read in the context of the disguised personality. And the forthright

character of the formation of images in Indiana's work resist an obfuscation to which he may yet be alluding.

Storr The bold thrust of Abstract Expressionism, the declarative statement of Abstract Expressionism in Johns becomes erasure, effacement, whereas in Indiana's work an apparently declarative boldness is enhanced. You can't get away from it, even though, as I said before, the "messages" remain coded.

Crow Johns seems to have used stencils that you could get in the drugstore or the stationary store, and then, when they were worn out or covered with paint, he threw them away, as anybody would. Indiana's use of the brass stencils meant that they couldn't be treated like that; he would trace the letterforms and transfer them to the surface and then paint the transitions, the edges, with extraordinary facility that led to the impersonal effect of the works.

Haskell Can you talk about Indiana's use of numbers?

Pincus-Witten Both Indiana and Johns used serial sequences, but Indiana is not exploring abstruse numerical sequences. He uses pretty straightforward sequencing processes.

Storr One of the advantages to the numbers is that they are generally not loaded with symbolism, whereas letter forms carry meanings, or could carry meanings. In the case of the numbers you get to play with the form.

Haskell What about Indiana's involvement with numerology and his association of numbers with human characteristics or as symbols of the cycle of life?

Storr They may signify the things he worries about when he's alone with his work. But in terms of the public meaning—not just what the public *can* know, but what the public *needs* to know—I'm not sure that it's essential. With the exception of *The Demuth American Dream #5* [fig. 82].

Pincus-Witten Indiana replaces the numbers on the herms with the industrially forged big numbers that are made by industrial crafts production, a method highly distinct from the handmade, talismanic, and privately coded. Now when we think of Indiana's sculpture, it's *LOVE*. Or the numbers set along Park Avenue.

Haskell How did Indiana's herms compare with other work in the *New Forms–New Media* show [at New York's Martha Jackson Gallery in 1960]?

Storr Giacometti is there—*The Chariot* [1950], for example. Indeed, Indiana's work is a very interesting riff on an image that was highly visible in New York at the time. It's a transformation of the Franco-Etruscan into the all-American.

Pincus-Witten Yes, but it's also about Coenties Slip and the rafters and the beams and the waterfront pilings that began to be abandoned. It's about using found material. It's closer to the sensibility of Rauschenberg. It's much more about the found object, which is valorized by private association. In terms of the herms—think Hermaphroditus, child of Hermes and Aphrodite; think [Robert Rauschenberg's] *Gift for Apollo* [1959], which is a parallel in Rauschenberg's work, early Rauschenberg. It is coded in the private erotics of the period and is very different from the public character of the later work.

Crow The herms were Indiana's staging ground in a way, because he began embellishing them, first of all, with sequences of circles or other nonsignifying components that came from a much more abstract vocabulary: geometric formalism. Then he gradually sees that a sign is not only a designation of what this herm might be, it could be a sufficient formal exercise in and of itself, transferred to canvas.

Storr But let's also not leave out what herms are. How many erections are there in American art in this period? To be able to make a series of works featuring male erections, or to create posts with text on them that say "DIE," "LOVE," "HUG," "EAT" that transpose the no-longer horizontal erection to the straight-up vertical, with suggestive words on them—that is where the homoerotic play really occurs and gets interesting. To die, of course, is an orgasm as well. So "die" does not necessarily mean mortality always.

Haskell What is the perception of Indiana's work? Did the fact that it didn't fit into any one category— hard-edge abstraction, Pop—inhibit the recognition of his achievement?

Crow The short answer, yes.

Pincus-Witten I think the short answer is yes.

Storr But it's an indictment of the "art world" that it so insists on having such categories so rigidly inscribed.

Haskell Is Indiana's achievement seen as being of relatively short duration?

Storr Clement Greenberg had the catty habit of saying that every artist has ten years, and then whatever happens, happens. All that really matters is in the work of those ten years. I don't share his view. Ten good years *is* an awful lot, nonetheless. If somebody really does important work in that frame of reference and then proceeds to do other works out of that achievement that are valid and not simply commercial copies of the original, I don't see what we can hold against him or her.

Crow Indiana took a risk to change or broaden the definition of his art from the *LOVE* moment in 1966,

and from that time on, he was denied the kinds of interactions with the art world that his chief counterparts in the Pop movement continued to enjoy. But I'm not certain that others of them didn't carry on in what is almost as repetitive a way.

Storr I also want to come back to the political dimension of Indiana's work. Whatever claims one might make for the later work, the complexity belonging to the early phases of his career—the mixture of the personal, the political, the graphic, and the decorative, plus his resistance to the undertow in any one of them—made for really a very important body of work and thought and exercise of will. That's what we should focus on: what did it take to do that; what did he achieve doing that; and how many different ramifications did that have? I think the answers do accord him status as a major figure of that period and for a long while thereafter in widening but still reverberating circles.

Haskell How significant was his move to Maine in 1978?

Crow It was no doubt an extreme response, and it's had a huge consequence for his art. But the attitude of the New York art world toward him already by the end of the 1960s no doubt played a very large part in his decision, ultimately, to uproot himself.

Storr When we're talking about how one weighs reputations, we must keep in mind that people may go out of fashion for a host of complex reasons, and sometimes they stall. The crucial question is also whether and when the culture picks them up again—and why? The political and cultural bitterness and acrimony of the 1970s and 1980s made Indiana's critical but ultimately sanguine view of America pretty hard to understand, and maybe even unpalatable. I think now we're looking at a moment in which Indiana's mixed but essentially affirmative messages perhaps can be heard and paid attention to. It's a question of his agency and his overall ambition. If he doesn't want to be underestimated in the long run, he cannot play both sides of this game any longer. He has got to drive a very hard bargain on behalf of the basic meaning of his work, control production, and say no to most offers. He could still blow it if he isn't strict. There are many artists out there who have the deep respect of younger and middle generations, who are productive, have large ambitions and big personalities, and are regularly seen in the public, but they don't make a lot of work.

Haskell There is a whole generation of younger artists using language who see Indiana as a precursor. Is this a good time to be looking at Indiana's work?

Crow His high technical competence and the crispness of his edges and surfaces are just astonishing. When the show opens, I would anticipate that this is going to

accelerate a connection with the moment and with younger viewers and younger artists. That goes back to the long-term efficacy of his tools and techniques as an artist.

Storr Pop is the perfect style to be fresh in if you're a good technician. If you're a bad technician, nothing ages faster than new materials; if you're a good technician, the freshness factor can hold for a long period of time. And I think you're right about Indiana. People will walk into these rooms and say, "Damn!"

Haskell How would you characterize Indiana's legacy, his ultimate place in American art?

Crow My hope is that he'll find, largely as a result of this exhibition, a place where he's seen as decisive, important, and salient, at least in terms of the 1960s. But maybe it won't be under the aegis of Pop in the way that we've thought about it in the past—and that will be a good development, because that congealed idea of Pop was, and is now, an obstacle to understanding the period, rather than any kind of help.

Storr The interesting part is precisely the ways in which his work, if given its proper role in that time and place, will expand and complicate the discussion about what really was going on in the 1960s. Being American has been a pretty complicated business since 1945. Indiana complicates it in some exceedingly interesting ways, and he does it by means of visual devices that are very arresting and that tenaciously hold their own—devices that, if no longer seen as stylistic gambits or as a personal artistic brand but as a part of the larger cultural conversation, will stand him in good stead historically.

Pincus-Witten My assessment is that time is on his side, and that Vinalhaven is a redoubt. He was fortunate in his genes that he was able to wait out the long period of resistance, let alone rejection. Time has been on his side, and I think this will be a vindicatory exhibition.

FIG. 168 Robert Indiana in his Coenties Slip
studio with *Year of Meteors* (1961) in the
background, 1963. Photograph by William
John Kennedy

INTERVIEWS AND ARTIST'S STATEMENTS

COMPILED BY HEIDI HIRSCHL

What in your ancestry, nationality or background do you consider relevant to an understanding of your art?

Only that I am American. Only that I am of my generation, too young for regional realism, surrealism, magic realism, and abstract expressionism and too old to return to the figure. Only that for the last five years I have lived and worked on the Slip and the waterfront, where signs are much more profuse than trees (farewell, Nature), and much more colorful than the people of the city (farewell, Humanity), and the scene much too busy for calm plastic relationships (farewell, Pure Intellect). Not wishing at all to unsettle the shades of Homer, Eakins, Bellows, Sheeler, Hopper, Marin, et al., I propose to be an American painter, not an internationalist speaking some glib visual Esperanto; possibly I intend to be a Yankee. (Cuba, or no Cuba.)

A general statement about your program as an artist in relation to society.

I am an American painter of signs charting the course. I would be a people's painter as well as a painter's painter. I feel that I am at the front of a wave not over-dense with fish.

Was a specific model or scene used? Has the subject any special personal, topical or symbolic significance?

My "model" [for *The American Dream, I* (fig. 51)] was Mae West (appearing at the time of execution of this painting on the television Late Late Show in "Night After Night"—1952) who is the most American bloom to have flowered on this "scene" which, in my case, is obviously A*M*E*R*I*C*A*N, and loaded with "personal," "topical," and "symbolic" significance, namely all those dear and much-travelled U.S. Routes: #40, #99, #37 (on which I have lived) and #66 of U.S. Air Force days; those awful five bases of the American Game; the TILT of all those millions of Pin Ball Machines and Juke Boxes in all those hundreds of thousands of grubby bars and roadside cafes, alternate spiritual Houses of the American; and star-studded Take All: well established American ethic in all realms—spiritual, economic, political, social, sexual and cultural.

Has the work any special technical interest? Even if not, the Museum would be glad to have a description of the technique.

The use of stencil as an "art" technique. The technique stems from the craft of the sign-painter, particularly of that lowest breed who enhances the sides of crates, the cheapest shops, litter baskets, dust bins and steamer trunks. And most particularly the raiment of the American soldier. Otherwise, it is definitely "hard-edge" (how American can a technique get!), most assuredly not geometric, very unpure . . . positively not neo-Anything.

The Museum would like to have a better understanding of what you feel to be particularly important or interesting or valuable about this work.

It is interesting, in that this painting, by a totally unknown painter, though it be one of his major works to date, should be acquired by a major institution, before even his first one-man show—so in contrast to the Good Old Days, albeit the bean-soup-and-carrot story still holds true. Otherwise it might be significant in that it is one new shoot of a burgeoning field of new works smelling of a very different fragrance from those rather oily, messy jobs of the 1950s. Valuable: yes, but for posterity possible only if your institution stores its excess works in your [Rocky] Mountain Vaults.

Has the work [Moon (fig. 35)] any special technical interest? Even if not, the Museum would be glad to have a description of the technique.

The technique, if successful, is that happy transmutation of the Lost into the Found, Junk into Art, the Neglected into the Wanted, the Unloved into the Loved, Dross into Gold, hence: ALCHEMY, what Man has been looking for as long as for God, which—BEWARE—in Mr. Canaday's sagacious words is unmistakable Foolsgold. Otherwise, the technique might be described as "latter-day craft on early-day craft."

Do you feel that this work is a representative example of your work in this medium and of this period?

This piece is the major one of my constructions from the Winter of 1960–1961, although probably of parallel standing to "The Marine Works" from the same period and exhibited in the same initial show, and fully representative of a body of about twenty assemblages.

Excerpt from Robert Indiana, "Artist Questionnaire," December 11, 1961. Object Files, Department of Painting and Sculpture, Museum of Modern Art, New York.

INTERVIEW WITH RICHARD BROWN BAKER, 1963

Richard Brown Baker [The critic Sam Hunter says of your work], "The paintings of Ellsworth Kelly and Robert Indiana can also be linked to the movement toward a more rigorous formality." Now you would agree with that, would you not?

Robert Indiana I would agree . . . It is the formal aspect of my painting which fascinates me most . . . Ellsworth was probably my first artist friend in New York upon my

arrival here . . . he's been a neighbor ever since, and we have been very close friends.

Baker [Was] your painting before you knew Ellsworth Kelly . . . in any way hard-edge, or how [did] it differ from your present style?

Indiana The process of painting flat color and simple geometric edges all dates from my time here on Coenties Slip . . . I was always very concerned with a rather central image and one of a very fixed quality. When I was painting portraits and, shall we say, rather allegorical heads, which is the figurative work which immediately preceded the direction I have since gone, these images were always of a very fixed, rigid quality and, of course, my work still has this aspect . . . My work never had any element of movement, motion, compositional flux . . . [it is more similar to] the pre-art, before the Renaissance, [to] the Romanesque and the Byzantine—people were fixed. This is what my work would have been closer to.

Baker Have you ever used any other name? In your case, I think you are really not Robert Indiana by birth?

Indiana Robert Indiana is definitely a "nom de brush," shall we say . . . However, it is the only name that I use now, and the only name I care to use . . .

Baker When were you born?

Indiana September 13, 1928 . . . My whole life was very much affected and bound up with that phenomenon called the Depression, and at the time of my infancy . . . my father was connected with oil companies, worked for Phillips "66" a little later, and of course that Phillips "66" sign, which haunted most of my childhood . . . It was always an image which was very central in my whole life . . . I think it's pertinent to say that my mother suffered from wanderlust and that before I was seventeen years old I had lived in twenty-one different houses . . . Although I lived in all these different houses, the furniture and the paintings on the wall were consistent from the very beginning to the end . . . My parents were never able to afford anything else except that which we started with . . . My mother's name was Carmen Watters . . . She was named for the Carmen of Bizet's opera because that was her father's favorite opera.

[. . .]

Indiana [My paternal grandfather, Fred Clark, is] figured in one of my paintings—*The Highball on the Redball Manifest* . . . He was a locomotive driver on the Pennsylvania Railroad . . . I think my father's family had come from the West and had returned to Indiana because there were frequent references to places like Texas and Kansas and Alabama and things like that. As a youth I think that was where he spent his younger years. I know my

grandmother often spoke of setting type shortly after the Civil War period for a little Kansas newspaper . . . There was never very much proximity. They were always the people down on the farm that we went to visit on Sunday, and big chicken dinners and a heavy table with maybe twenty-five relatives all seated around it, or eating watermelons out under the trees by the pump.

Baker Then you had a lot of first cousins and things of that sort?

Indiana I did, and I've lost track of all of them . . . because of this business of moving around so much. Most of the time I didn't live very close to them.

Baker You are really the first artist in the family as far as you know?

Indiana The first artist, and all of my early ambitions, which started at the age of about five or six, were immensely discouraged. I was told before I even started into school that if I should persist in this ambition I'd be eating bean soup and living in a garret . . . Neither [my mother nor father were] sympathetic to art as a career. They were very sympathetic to my actual drawing and painting and encouraged me to do this, but they discouraged it as a possible profession.

Baker Well, were either of your parents interested in music [or literature]?

Indiana No. Very, very simple people with very simple interests . . .

Baker Did the process of moving and changing residence have any emotional effect on you as a child?

Indiana I was always very unhappy about leaving one school and going to another school. Frequently, it would be a country school where either art wasn't taught [or if it was taught, the teacher] was more interested in music than she was in art, which always made me very unhappy . . . I started school when I was seven . . . ordinarily a child in Indiana would have started at six, and it was decided that I . . . was not particularly strong at that time and that I should be held back for a year. And I was. So therefore I started when I was seven, but I later made that up by skipping an elementary grade.

Baker Before you went to school, how many homes did you have, do you think?

Indiana Oh, that probably would have been something like ten or twelve . . . The frequency tended to draw out a little bit as I got older. The more frequent moves . . . took place when I was a young child.

Baker You attributed this to your mother's wanderlust?

Indiana Yes, she couldn't bear to live in one house longer than a year.

Baker How did this affect your father's job-holding— whatever he was doing?

Indiana Very adversely. It made for a very bad situation and therefore the whole marital aspect was probably not good . . . The original company that he worked for when I was born went out of business because of the Depression, and immediately after that I think he did operate a filling station. But this was a very short period, and he was back in the administrative side shortly thereafter . . .

Baker To what would you attribute this curious tendency of your mother's to want to move constantly?

Indiana My mother was of a very easy, outgoing disposition, who made friends very easily. It would have been my father who was the antisocial one. I almost think my mother had a kind of fetish and a fascination about architecture or about domestic structures themselves . . . most of my childhood I can remember we would travel miles and miles in the country just to find empty houses and explore them . . . As a child I couldn't have been more delighted, and my mother loved to find an empty house and go poking through it . . . She loved new houses, she loved to explore them and get acquainted with them, and then after doing so she got bored very fast and was soon looking for the next one.

Baker You had a family car, I take it?

Indiana Always. The car, the car seemed to be another dominating and consistent aspect of my childhood, and it seemed that half my life was spent in the automobile. We were always driving some place for something. It was a very mobile childhood, that's for sure . . . At one time my father had his car and my mother had her car and, of course, this was very much going to [the] poorhouse in an automobile because that's exactly where they both were, but they still both had their own cars.

Baker To get back to these various houses. I take it they were rented, never owned?

Indiana My family did purchase, oh, I think several houses, but there again, that didn't stop my mother. She went tearing right ahead.

Baker But they took the same furniture from place to place?

Indiana Always it was the same furniture. It never changed, never changed. When my mother died I had the unhappy task of selling off some of whatever furniture was left and her washing machine, which she had had for twenty-one years, and which I remember all my life. It was a very wild and woolly primitive washing machine. It was auctioned off for twenty-five cents.

Baker What year was this?

Indiana This was '49, I think. The year that I was discharged from the Air Force was the year of her death, the death of my stepfather and my entry into art school in Chicago. So '49 was a pretty heavy year.

Baker Well, we'll leave that for the future. I am interested, though, still to try and get a conception of something of this artistic, or lack of artistic, quality in your immediate environment as a child.

Indiana My painting is that Phillips "66" sign which I saw all during my youth and which was the one most fascinating visual object in my entire youth because I saw that sign for years and years and years. This was a very large construction which probably was about ten stories high which towered over a Phillips "66" gasoline station. And it was illuminated at night with neon . . .

Baker Where was this?

Indiana In Indianapolis . . . Most of all these residences that I speak of were either in or near Indianapolis. I would never live too far away from the very center of Indianapolis . . . It did include a farm. There was always my grandparents' farm and my aunts' and uncles' farms. All my father's people were really farm people to begin with. When my grandfather retired from the railroad, he went to a farm. He had spent his youth as a farm boy. But I had a calf and animals and a garden when I was a young boy, and it was not a working farm but it had those things that farms have . . . I always had dogs and cats and, as I say, calves and chickens . . .

Baker I'm trying to imagine whether this fascination with the Phillips "66" sign was purely in terms of its design or whether the fact that your father was in the gasoline business carried an association that interested you, too . . . ?

Indiana Both of them . . . That's what fed me . . . It is, very vivid. That it should come out so much later is, of course, interesting, but subconsciously there it was all the time.

Baker Do you remember doing a lot of drawing as a small boy?

Indiana Yes, surely . . . I never had the exposure to techniques and so forth that children have today with art workshops, but I always had crayons and pencils and still have work going right back to when I was five or six years old.

Baker You kept that? Or your parents must have kept it?

Indiana No. I find that I was my own curator. My parents were never really quite that interested, and everything that I kept, I kept myself.

Baker What was the first school you entered?

Indiana My first school was this small town in central Indiana called Mooresville . . . [it's] about twenty miles below Indianapolis, and it was nearby that I lived on the farm that I spoke of . . . And it just so happened that Mooresville was the hometown of John Dillinger, who was Indiana's most notorious citizen.

Baker Do you recollect the first art instruction you had in school?

Indiana Oh, surely, very vividly. My first-grade teacher . . . was a very sympathetic teacher and taught all the subjects . . . She handled the art and music as well as arithmetic and reading and greatly encouraged me in my own art activities, and at the end of that first year [she] took some of my drawings and asked if she might keep them, that she wanted to hold these, so that one day when I became a famous artist, why she'd have them in her trunk . . . It was a great—I must say, a great incentive and a great spur . . .

Baker You mentioned your health. What was the trouble?

Indiana I'm not too sure myself except that I seemed to be underweight and a little scraggly, and the doctor felt it would be better if I was outside of the industrial smog of Indianapolis and moved to the country and postponed going to school for a year . . .

Baker Well now, you said you were upset over [moving from place to place]. Was this because of the difference in teaching or because you were separated from friends that you made in these schools?

Indiana As I remember, it was really more the appalling difference in instruction, and I really wanted to learn very badly and some of these schools were so bad I was aware of it, and I knew myself that I wasn't getting a very good education . . . [From] the third grade to the sixth grade was one of the few stable times of my childhood. My mother and father did buy a house and they did settle down a little bit more than they had theretofore. And I had those four years in one school, and this was Cumberland, Indiana.

Baker Since you have chosen to name yourself "Indiana," one infers that you have a very strong liking for Indiana, a very strong attachment to it. Is that correct?

Indiana I think I probably do. It's home, and it's the place of most all of my most pleasant memories. That's not really the reason that I chose the name. I chose it because it was my birthplace. Whether I had lived there for twenty-one years or . . . whether I lived there for less,

it wouldn't have made any difference. But I also liked the name . . .

Baker [If] a sentimental attachment to Indiana [exists], is it focused on the landscape or on the character of the people particularly?

Indiana Not the character of the people. I have divorced myself from Hoosiers pretty completely. People from Indiana have a peculiar way of talking which I lost . . . I don't know that I ever had it . . . but I lost it years and years ago. And, generally speaking, they're like my own family—most of them are rather simple people with uncomplicated lives, and I outgrew that a long, long time ago.

Baker I don't know that you've really said why you chose to abandon the name under which you were born and christened?

Indiana I suppose for one thing I was never particularly fond of the name, and one of the immediate reasons that I chose to make the change was that there were two or three artists practicing and exhibiting in New York with that name.

Baker I don't recall any named Clark myself.

Indiana These were not prominent people. But just seeing it upset me, that's all . . . I should like to be the only person with my own name, and I think at this point I am.

Baker Just to interrupt the youthful history we were discussing, would you like to say something about this studio we're in?

Indiana I provide my own heat with a potbelly stove . . . I've lived in New York for the last seven years without even so much as a shower, you see, which is very primitive for New York . . . [This building] was a ship chandlery for maybe half a century. It was at one time the marine works . . . Before that it was probably a warehouse. It's about a hundred and fifty years old. And it was on the busiest and the largest of all of Manhattan's slips.

Baker Did you find this place long ago, or . . . ?

Indiana I've been here for the past—oh, close to six, going on six years, Dick. When I first came to the slip I took . . . a top loft in [another] building that also had been the marine works. Just by coincidence both buildings on Coenties Slip were marine works shops and that building was torn down in less than a year after I came. It was demolished along with three neighboring buildings, one of which was the studio of Jack Youngerman.

Baker I'm asking some of these questions because this neighborhood, I think, has had its influence in a sense on your paintings like those which are named . . . or contain names that are rather picturesque, like Coenties Slip

and Corlears Hook and so on. You have utilized this environment in your work, haven't you?

Indiana Even more directly, say, for instance, my painting *Rebecca* [fig. 96] comes from a Civil War slaver which certainly would have passed by Coenties Slip in its own day, and this ship was captured by the British and the men were punished for their activities. The *Year of Meteors* [fig. 62] concerns the *Great Eastern*, another ship which would have sailed up the East River. These historical references are a part of those literary paintings.

Baker You must have read about those ships . . . You've brought in distinct historic reference through historical means, haven't you? I mean, you didn't see these ships?

Indiana They came down via American literature, Dick. The *Year of Meteors* is from a Whitman poem; *Rebecca* is strictly from historical reference; *The Melville Triptych* [fig. 60], which is a painting that includes those words you mentioned: Corlears Hook, Coenties Slip, and Whitehall— that comes from Melville's *Moby Dick*, the first chapter.

Baker Yes. And your interest in *Moby Dick* perhaps has been stimulated by living in this particular environment . . . ?

Indiana No, no. *Moby Dick* preceded the slip.

[. . .]

Baker I take it the conception of certain of your paintings grows up slowly in you—there's a certain edge of a notion of an idea lodged now in your mind . . .

Indiana A seed . . . Certain things happen while I'm in the process of painting. There is room for a certain amount of change and improvisation, but to compare it with Abstract Expressionism would be very difficult . . . I prefer to think of it as verbal-visual, not literary.

Baker Can you tell us a little about what you think about it—when you're thinking about verbal-visual?

Indiana What I am thinking about is the very elementary part that language plays in man's thinking processes, and this includes his identification of anything visual. I'm sure that the word, the object, and the idea are almost inextricably [locked] in the mind, and to divide them and to break them down is not really—it doesn't have to be done. The artist has usually done it in the past. I prefer not to.

Baker I look at [*The Demuth American Dream #5* (fig. 82)] a painting that hangs in front of me now. Am I supposed mentally to say to myself the figure 5 U.S.A.—things like that? Or am I just to look at it visually?

Indiana I have always been impressed how, with a little concentration and a little mental exercise, if one concentrates long enough on a word or figure, it's very easy to lose the conscious grasp of what that is, and one can look at a word, and after concentrating on it for a little while, one has almost forgotten what that word is. And I should like, in a way, for this to be a part of my work, too.

Baker Are there words that you would reject out of hand, and for what sort of reasons, if you did?

Indiana Well, first of all, my first preference is one-syllable words. I happen to prefer the verb to the noun. I use the simple command words first of all . . . I like short, terse words—I suppose I sometimes think of their visual pattern. I am intrigued with certain letters, and other letters I'm not very intrigued by. [But] this is not an important aspect of my work . . . One of my paintings is called *Le Premier Homme*, and this is a painting which was inspired by Gagarin's space flight, and I suppose subconsciously in order not to make it too sympathetic to the Communist propaganda, I decided to call the painting by its French title. And it came directly from the cover of a French magazine, and I liked the phrase.

Baker But I think it's one of the extremely individual features of your painting and probably important in some kind of analysis of your painting, your reaction, your verbal-visual responses, what you try to convey through them to a spectator . . . Now, which of these two reactions of these two individuals would you be most gratified by, [the purely formal or the conceptual]?

Indiana Well, I think I'd probably lean toward the person who appreciated its formal values first, Dick. However, obviously, I'm interested in the other aspect, too . . .

[. . .]

Baker In your youth, did you travel a lot by railroad train?

Indiana No, not very much because it concurred with the Depression. I remember as a child traveling to Chicago to see the 1933 Century of Progress exposition, and my mother and father and I went there by rail with some sort of half-fare pass or something from my grandfather. But because of the Depression, we just didn't do much of that kind of traveling at all.

Baker Do you recall being particularly impressed by any special type of exhibit or thing?

Indiana Again I remember some of the signs, and those were the things that impressed me most . . . I think it was a gasoline company; there was a large thermometer which towered stories and stories into the air.

Baker These memories of signs are always accompanied by approval in your recollection, aren't they? You remember these favorably?

Indiana Whenever riding with my parents in the car on, shall we say, Sunday drives or trips, those were the things I was always looking for.

Baker What recollections of seeing art do you have as you grew up?

Indiana I don't recall ever visiting a museum until I was in, probably, high school, Dick . . . Probably my first exposure to art besides the chromos in my mother's house was, oh, *Life* magazine and . . . the color reproductions of American regional painting . . . people like Thomas Hart Benton, Edward Hopper, Grant Wood, and works of this school . . . I thought they were marvelous.

Baker Do you recall the age at which you decided you would like to be an artist?

Indiana I decided when I was five or six years old that I wanted to be an artist . . . I had some alternative interest as a child, and I think in view of some of my more recent work, [it's] rather interesting. First of all, I had many old relatives at that time, aunts and uncles and grand-parents who were dying off, and it seems that half of my childhood was spent attending funerals. And now that I should be painting *Die* paintings, it's rather peculiar.

Baker Did attending funerals upset you, or . . . ?

Indiana No. I was very much impressed that during the Depression there was one profession which wasn't suffering at all, and that was funeral directors. And as a child I had an alternative ambition, and that was to have a funeral home, you see. But a very, very lavish gorgeous funeral home . . . [A funeral home had] a certain exotic flavor to it because it was, first of all, a subject, when broached to grownups, they didn't want to talk about it, and therefore it had a kind of forbidden quality which was very glamorous.

Baker Now, to get back to this determination to be an artist: did you think of it in terms of being an illustrator or a fine art artist, or commercial artist, or didn't you break it down to these alternatives?

Indiana Well, as far as I can remember, Dick, it had nothing to do with making it into any kind of commercial career because I probably didn't know anything about commercial art. When I was moved to desire to be an artist, I was looking at reproductions of paintings, not advertisements or anything of that nature . . . one of the things that my first-grade teacher kept was a scene from Currier and Ives of people skating on the ice.

Baker When you moved back and forth from these various schools, were the fundamental subjects more or less continuous?

Indiana All of my high school, luckily, was in one school. I was living in different houses, but I was able to stay at the same school . . . The high school was Arsenal Tech, which is essentially a tech school—technical—but it is also a very large school which offered a very wide range of subjects. In my last year—in my senior year in high school, I spent, oh, between two-thirds and four-fifths of my time in painting classes. This wouldn't have been possible in the average American high school.

Baker Can you remember some of your other painting teachers?

Indiana There were a number of years in grade school when the teachers all run together . . . they provided almost nothing. Then there were two years in junior high when I had no art instruction at all, which made me very desperate to get to this particular high school that I mentioned . . . I knew about the reputation of this school because I had relatives who were in contact with the school. And its advantages were well known to me. I knew that I could major in art in this school, and the last year was practically what you'd call pre-college.

Baker In other words, this was not a high school that you automatically, because you lived in a particular area, would have attended?

Indiana No. I made a personal sacrifice to attend this school, in that by that time . . . my mother and father had been separated and divorced and remarried [within a year or two], and in order to attend this school, I moved from a sympathetic home, which was my mother's and stepfather's [Foster Dickey's] to an unsympathetic home, which was my father's and stepmother's home . . . My father was sympathetic. However, I had a very unsympathetic stepmother . . .

Baker Well, so you made this sacrifice then. In the summers, for instance, did you go back to live with your own mother?

Indiana No, there was nothing like that. Part of the agreement—I had always seen my father on a basis of weekends, and that's how I got to know my stepmother, and on that basis my stepmother was always very friendly, and I had nothing but good times with her. But when I came to live with my father and stepmother, one of the stipulations was that I would cease to ever see my mother again. That was one of my stepmother's stipulations . . . So, therefore, immediately a bad condition existed, and as soon as my mother realized that she was never going to see me again unless she did something . . . she moved into the city of Indianapolis so that I might be encouraged to return to her household, and after two years of this unpleasantness with my father and stepmother, I returned to my mother's house and finished my high school . . .

[The situation was difficult, but] I'm afraid the schooling came first, you see.

Baker And since [your mother] didn't want you to be an artist, I don't suppose she was highly flattered by that motivation.

Indiana She didn't *not* want me to be an artist, but it's that I was always discouraged because they didn't understand that an artist could provide for himself . . .

Baker Well, now, tell us a little more about the high school experience itself.

Indiana I had a different instructor for the first two years each term, which meant two different instructors each year. Then the last two years were almost exclusively under the instruction of a little, marvelous old lady named Sara Bard . . . She was a watercolorist and won all kinds of prizes and so forth . . . we were all very much in awe of her, and I was very much in awe of her, and she was a great character and a terrifically inspiring instructor. And she alone was responsible for my decision to go to the Art Institute in Chicago . . . Winslow Homer was the figure she talked of mostly. To her he represented the ultimate in watercolor technique from the American standpoint. John Marin she held in the highest esteem. Much of my interest in art from the really serious standpoint was her discussions every day on the history of art and the current American scene at that time . . . Her special interest was from French Impressionism on up into the current scene, the modern French and the modern American.

[. . .]

Baker What are your recollections of the outbreak of war?

Indiana I was very much taken up with world events . . . and in high school toward the end of my junior year, I was very much caught up with the U.N. and the formation of the U.N.

Baker I was wondering if you had ambitions when you were sixteen, seventeen, to travel in Europe and things like that? . . . Would you say American or European art had the stronger . . . ?

Indiana At that time I think it was American. The American school of realism, as I said—Demuth, Grant Wood, Sheeler, Thomas Hart Benton, Curry—all these people I found very fascinating . . .

Baker Do you recollect your first visit to a museum, an art gallery?

Indiana It would have been during my high school years at Tech . . . I attended Saturday life-drawing classes [at the John Herron Art Institute] in my last year . . . I knew the museum very well . . . but my orientation, I must say, was American even then.

Baker Well, specifically of this group of then-contemporary painters like Sheeler and Benton, [whom did you most admire]?

Indiana Well, due to the influence of Miss Bard—yes, Winslow Homer. I never was very much exposed to his oil paintings, more just his watercolors, but other figures like Walt Kuhn and the Ashcan School and so forth, these became very familiar through reproduction and so on. Reginald Marsh . . .

Baker Can you say something about the character of the work you yourself were doing as a high-school painter?

Indiana Well, first of all, in high school at that time we were not allowed to work in oils unless it might have been the last year, and I did my first oil painting at the Art Institute in Chicago. Watercolor, I thought, was my medium, and I used to go out on weekends and paint landscapes around Indianapolis and even had a one-man show while I was still a senior in high school . . . There was a show in the high school; there was an exhibition area; and then there was a show at this local art store . . . The art department at this high school was big enough in itself that there would always be five or six people who would more or less, shall we say, rise to the top, and these people were fairly professional and . . . interested in exhibiting, and I was one of them.

Baker What, do you remember, were the themes?

Indiana I think I was influenced by much of the work that I mentioned just a little earlier, industrial aspects of Indianapolis were the things that fascinated me most—factories, railroad crossings, grain elevators, things like that. And this was the influence of people like Sheeler . . .

Baker These were primarily intended to be realistic [works] and have a kind of social message in the sense that they were industrial rather than . . . ?

Indiana I doubt if I thought they had any social message, and I doubt if I was putting any message into them. I was merely observing those things which fascinated me most and that is industrial scenes were more complicated and more intriguing to me than landscapes with trees . . . Living on the other side of the tracks may have had something to do with my preoccupation with industrial things in that we never lived very far away from the gas works and the railroad yards. We were not miles out in some pleasant residential community.

Baker You've given the impression of two one-man [shows]—one in the school and one in an art store?

Indiana Yes, [in 1946] I thought it was very exciting, which meant clippings in the newspaper and photographs and things like that . . . I had my first sale when I was in high school, and it was a watercolor rendition of an old

country—and this was Mooresville—grain elevator, which was situated right across the street from my grandmother's last house ... This painting was exhibited in *Scholastic*, which you know is a national society to show high school and grade school work ... It was exhibited in the Scholastic show, and one of the ladies in charge of the activity, I think, bought it for something like ten dollars ... it was very exhilarating.

Baker I take it you didn't have much money during high school. Did you have jobs?

Indiana Yes, I worked in the evening after school ... I started out delivering poultry, then I became a Western Union telegraph messenger. I became an advertising copy boy for a local newspaper, and ... just before I went into the Air Force, I was a dispatch boy for the morning newspaper ... In high school I became very interested in journalism, and for a very brief period even toyed with the idea of taking up journalism. I don't quite know, I think this was mainly because of the tremendous influence of the journalism teacher. She was a marvelous teacher and, shall we say, molder of young people, and her manner was infectious; she could get anyone interest in journalism. And so I fell under her sway ... But when things like scholarships came up, I won a scholarship to John Herron, and I didn't win a scholarship to a journalism school, so that my preference had already set me toward that ...

Baker This scholarship to John Herron was for an art class?

Indiana I had a life-drawing scholarship during my last year at Tech, but this would have meant the first year of my art school, which would have meant staying in Indianapolis, and I was very much opposed to that idea. I wanted to get away from home and I wanted to enlist in the Air Force, which I did, and become eligible for the G.I. Bill of Rights, which gave me five years of free schooling.

[...]

Baker I find I neglected to ask you whether, as a boy, you were interested in religion, whether you went to Sunday school, whether religion played any particular part in your upbringing?

Indiana My parents, Richard, I would say, were a rather typical, non-religious American family ... They didn't go to church. However, for some reason or another, I was put into Sunday school at about the same time I started to school ...

Baker What church, what denomination?

Indiana Well, that's the peculiar thing—it was the Christian Science church, and for a few years of my life I fell under some influence of this particular church ... It wasn't of any tremendous scope; I suppose it's

probably more—was more in the area of just, shall we say, moral living than anything else. I mean, nothing of a spectacularly religious aspect at all ...

Baker I wanted to ask if you wrote poetry at any time in your childhood?

Indiana I wrote poetry particularly in high school. One of those poems, as I remember, called "October," was published on the front page of one of the issues of the school paper ... When I went to England, [I did] much more writing than painting, and then upon my return to New York or to America, when I lived in New York, I continued to write a great deal.

Baker You chose to volunteer for military service [after you graduated from high school]?

Indiana Yes. It required the signature of my mother because I was under age ... This was before Korea, so that there was no immediate threat of [war]. Still, that whole thing was hanging in the air. But the real deciding factor was the G.I. Bill of Rights, which was going to be discontinued within just a period of weeks or days ...

Baker But when you enlisted, weren't you committing yourself for quite a few years?

Indiana Three years in the Army Air [Corps], which during my enlistment became the United States Air Force.

Baker Did your mother raise any objection?

Indiana She wasn't terribly happy, but she saw the wisdom of my decision because she and her husband were economically unable to see me through college, or art school rather. I would have had to have worked my way through. As it was, I did anyway. But she saw the reason that I made this decision and certainly went along with it ... I wanted to leave, I wanted to get away from home, I wanted to get away from Indianapolis. I probably wanted to go to a school which had a little bit more appeal to me than John Herron did.

Baker Now could you describe the process—once you went up and enlisted?

Indiana It was very quick. You enlist, and you're taken to a preliminary examination, and you're put in a bus, and that evening I was at Camp Atterbury ... near Columbus, Indiana ... I went to San Antonio, Texas, for Air Force basic, which would have been a relatively short time, something like six weeks. But during the course of my training I became ill and was set back and went into a different so-called flight, putting me out of contact with the servicemen of my own region and throwing me into a barracks of men from the South, from Georgia, which proved to be a very unpleasant experience and made my basic training end with a very bad taste actually.

Baker [Regarding] your personal exposure to great art, because as far as I know, except [for your experience at] John Herron . . . you still haven't encountered [examples of fine art] . . .

Indiana Only on a trip to New York City while I was still in the Air Force. During my second year I was stationed at Rome, New York, and I came down to New York City on a visit and I visited the Metropolitan and the Museum of Modern Art, and that would have been my first contact with [fine art]—that came probably even before [the Art Institute of] Chicago . . .

In my impatience, I volunteered for Alaska and left Rome, left my outfit, and went to Alaska. And two weeks later the outfit that I had been with received orders to go to England.

Baker Now I was wondering whether you ever got home during this period at all.

Indiana Just infrequently . . . for brief times [to visit my mother]. My father had since moved to California . . . I traveled [to Alaska] by train to the West Coast, and I took the opportunity to make a detour. I stopped off in Los Angeles to see my father [and also went to San Francisco] . . . I particularly remember the Palace of the Legion of Fine Arts.

Baker Did you finish up what you were doing in your journalistic work [in Alaska]?

Indiana I was very close to the end of my Army career in Alaska, Richard, when I was called home on an emergency basis. My mother was dying, and I returned to Indiana, and therefore my overseas service was abruptly terminated, and I finished the last month or two that I had remaining at a base in Dayton, Ohio.

Baker Your mother was stricken with some prolonged illness?

Indiana Yes, my mother had been dying of cancer, and she did expire at the very end of my Air Force career . . . I returned home on emergency leave to attend my mother, and she died about one hour after I got back to see her . . . She had been living only—had only been waiting to see me, and then she expired.

Baker This was in Columbus?

Indiana Columbus, Indiana, yes . . . She had been living there with my stepfather for, oh, a couple of years. They had moved there while I was in the Air Force, you see . . . I knew that she was ill, but it didn't reach—you see, the difficulty was, I was trying to postpone returning until my service was over, but it just didn't work out that way, so that when I did go back it was a great, great emergency . . .

Then, once back in the country, and due to the fact that it would have been nonsense to go back to Alaska, I was assigned on a temporary basis to . . . Dayton, and just killed time there until my formal discharge. And during the course of that time my stepfather died, too.

Baker I wanted to find out about how you came to go to the Art Institute of Chicago [in 1949] . . . presumably through Miss Bard. Did you see her after . . . ? She had planted in your mind the ambition to go to the Art Institute of Chicago school while you were at Arsenal Tech in Indianapolis?

Indiana That's right . . . It was a goal, but I did explore the possibility of other schools.

Baker Backed, I presume, by G.I. Bill of Rights income? . . . How substantial were those payments?

Indiana It was good. My tuition, of course, was paid for, and I had a monthly allotment. But I found upon arriving in Chicago and discovering the cost of living that it was not sufficient to meet everything, so even during my first year I got a part-time job in the evening, and subsequently every year that I was in Chicago, except for the last, I did work at night in addition to school . . . I took, shared an apartment that was advertised in the paper, and for the first year lived in Austin, the last suburb next to Oak Park, which was a great mistake, but due to my inexperience, I didn't know any better.

Baker I hope you will be able to give some sort of a picture of what the atmosphere was like at the Art Institute, and what kind of instruction you had.

Indiana Well, I think my first impression or reaction was a kind of being overwhelmed by the immensity and the complexity of the place, Richard. I didn't really know what I was getting myself into when I enrolled. It's really an art-student factory, and they have hundreds and hundreds of students there, and I would say that it wasn't really what I thought it was going to be at all . . . the first year is very rigid. Every first-year student regardless of his future desire or commitment takes a basic first-year course which included still-life painting, figure drawing, things like that . . . Each class was probably forty to fifty students, and there were probably six classes . . . The first year, there were very bright people, and it seemed that during the course of the four years those people tended to drop out . . .

During the first year, Richard, one had almost no exposure to the upper classmen at all. One was very much thrown in constantly with one's own classmates. Now, upon the second year, one began to have contact with older students. But still the progress, the plan of advancement and so forth, was so rigid that there was very little opportunity for that kind of thing unless one joined the

student activities, the organizations. Which I did do, and therefore I did have contact with older students . . . I became very disillusioned very soon with the whole organization of the school.

Baker [What kind of] personalities had influenced you at the Art Institute?

Indiana This is one of the aspects about the Art Institute which is part of the whole gray reaction that I have toward it. Actually, there was no one single instructor who really provided the inspiration or the enthusiasm that I encountered in those two instructors in high school . . . Considering the great number of years the Art Institute has been in operation and the thousands and thousands of students that have gone through the doors, the number of illustrious graduates has been very small . . . There were no students with whom I could say I was affiliated or close to as far as painting was concerned . . .

Baker Do you recall any special change in curriculum or in your own activities in the second year in Chicago?

Indiana The program at the Art Institute was a rather formal one. The first year was standardized. Everyone entering the school, whether they were going to become painters or ceramicists or dress designers or architectural designers, they all took the same first-year course, which is a little bit of a kind of soupy idea. And then the following three years, with each succeeding year you had more opportunity to choose the particular instructor that you wanted, and during my last two I had a former faculty member, or student—I really don't know which—at the Bauhaus, Mr. Weigar . . . And he taught there for years and years and probably was one of the little more inspiring instructors, certainly one of those whose ideas were a little more contemporary than the average instructor. The most illustrious instructor in my time was Boris Anisfeld, who had come over with the Russian Ballet with Diaghilev and had been one of his stage designers. And in fact did, for instance, *The Love of Three Oranges*—the Chicago Opera production . . .

Baker I can't remember to what extent we discussed what you saw in the way of art, for example, on exhibit in Chicago while you were a student.

Indiana There were three or four major exhibitions, not each one of which influenced me equally by any means, but I was tremendously impressed by them. First of all, there was a large Léger exhibit. The whole top floor of the Art Institute was filled with Léger paintings, including his largest and biggest canvases, and of course now I feel very influenced by Léger. There were many, many years when I felt no particular influence at all. As time has passed, I've grown more and more fond of his work. Another show was a large retrospective for Edvard Munch, and this had

a fantastic impact on the general, the whole decade of students at the Art Institute. That influence seemed to linger on just for years, and I think this is partly due to the fact that the people in Chicago were susceptible perhaps to that kind of expressionism, whereas Léger had absolutely no effect on the student body at all . . . The third, and it was not at the Art Institute, it was at Evanston, the campus of Northwestern University, and this was an early exhibit of Dubuffet—a large, beautiful show of Dubuffet. And it was he who was really my most active influence, not while I was at the Art Institute, really, because I never felt free to develop in that direction, but as soon as I left the institute—during the time that I was in England and my first year or two in New York, I was actively under Dubuffet's influence.

Baker Frankly, I can't see on the spur of the moment any relation between Dubuffet's work, as I know it, and your current production.

Indiana No, it's not there now. That was cut off abruptly and very cleanly, and there's a definite terminal date for that . . .

Baker Have you any recollections of shows in ordinary galleries?

Indiana Well, in '53 and '54 when I was in Chicago, Richard, there were really only one or two or three commercial galleries that could even be considered to be representative, and to tell you the truth, I don't remember a single show at any one of these galleries.

Baker I believe I was told that you were the leader of a student group while you were at the Art Institute, a club of some sort.

Indiana There were two student organizations active within the walls of the Art Institute itself . . . There was the Art Students League, which was called ASL, and which was primarily painters in the painting department, and there was Delta Phi Delta, which is a kind of national art fraternity whose activity takes place mostly on academic college campuses where there is some art activity going on . . . Its goal, obviously, is to promote even a greater interest in painting and exhibiting and professional activities among art students . . . I was a member of that, and I became (probably in my third year) president.

Baker What influence, if any, does the job of president of this organization carry?

Indiana The thing that interested me in both organizations primarily was the opportunity to promote and take part in student exhibits. And at that time, that was the only way for a student's work to be publicly seen.

Baker Were these exhibits organized by the student members themselves, or did faculty members have a [role]?

Indiana They were organized under the auspices of the Art Institute, but it was almost completely student [run]. There was always a faculty sponsor who really didn't do very much [and three faculty members who served as jurors]. The students took over the whole operation usually . . . The shows didn't really mean very much. The work was for sale, and I would say during the course of my four years there, I probably sold maybe half a dozen to a dozen pieces of work. But it meant something to me at the time . . . It was an encouragement, yes, and it was great fun . . . A certain group of students usually were doing both all the work on these exhibits, and they were doing the exhibiting and they were active. The majority of the student body wasn't.

Baker Were there any particular social events that you participated in, in connection with these organizations?

Indiana [Part of the role of Delta Phi Delta] was to sponsor student recreation and social activities. The time I was there, about the only thing that ever happened was a yearly art students ball, and the first two that I saw, or knew about, were pretty drab affairs. But in my third year, when I was president and when I was responsible for promoting this particular activity, a kind of windfall came down on us, and that is, someone learned that the old Cyrus McCormick mansion, which had been standing deserted for several years, could be available for such a party. And by just somehow coming in contact with the right people, we rented that mansion . . . It was something like four hundred dollars rent for one night, which seemed exorbitant, but considering the impact that this had on people, it was more than worth it. We [didn't make] a large amount of money from this dance. But it turned out to be a tremendous ball, and from all the people who had been in Chicago for years, it was one of the best that had ever been thrown in Chicago. This was called "Death of a Mansion." That was the theme. And one of the requirements was that everyone had to come in costume. It was a costume ball. And that costume had to be either black or white. There could be no color at all. And it was faithfully observed.

[. . .]

Baker I think you have intimated you got a scholarship and went abroad?

Indiana It's a program at the Art Institute; the last year for the painting department is dominated by the competition for the traveling fellowships, Richard, and each year about six or seven fellowships ranging from, oh, a thousand to twenty-five hundred dollars are given in open competitions . . . All the final-year students who are eligible submit drawings, or submit paintings . . . Sometimes there is a theme, and sometimes a certain composition is required. I know that in the *final* competition a set picture was a

figure competition with at least three figures, or something like that, and then sometimes in the preliminaries there's a theme. The year that I was there I don't recall that there was a theme. It was judged on the basis of classroom work that was submitted probably to a faculty jury . . . The finalists go before a board of trustees, an examining group, Richard. And always, of course, almost inevitably the wrong people get the fellowships. The really deserving, the really talented painters almost inevitably fail. My dean was so convinced that I wasn't going to get a fellowship that he had more or less arranged that I might get a kind of sop, a summer scholarship to Skowhegan, which I was given, and then I did win a fellowship, despite his fears. So that actually I had two prizes at the end of the four years.

Baker You did go to Skowhegan?

Indiana I went to Skowhegan the summer after the Art Institute.

Baker Have you more things that you can think about to say about your Chicago experience?

Indiana The fellowship competition itself: One of my first-year instructors at the Art Institute—still-life, general painting instructor, a Rumanian painter by the name of Ursulescu—warned his little first-year students that the fellowship was a deadly thing, and that it was a terrible waste of time and you exhaust your energies for this and then you go to Europe and it takes you five years to recover after you come back from Europe, and for me it pretty much turned out that way . . . As I found out, travel in Europe meant very little to my own artistic development. It was a nice vacation, but, you know, those frescos and those cathedrals just aren't important in the way that they used to be.

Baker Before we go abroad with you, let us go to Skowhegan . . . It's situated in Maine?

Indiana Skowhegan, Maine, which is in the heart of Maine. It is not near the sea. Next to a lovely lake called Wesserunsett.

Baker You went almost immediately after getting a—does one get a certificate or something at the conclusion of the Art Institute course?

Indiana Well, I was working on a degree program, Richard. The reason that I went to the University of Edinburgh on my fellowship was to finish academic work for a B.F.A. from the Art Institute of Chicago . . . My degree came at the completion of my academic year in Edinburgh . . . The real reason for pursuing the program was that it enabled me to have the fifth and final year of my G.I. Bill. If I had been taking merely a four-year certificate course, I would have automatically lost my fifth year. And after sacrificing

three years of my life for the Air Force, I felt I wanted my money, my reward in return . . . And it did give me a fuller and more interesting year abroad.

Baker Tell me more about Skowhegan.

Indiana The summer that I was there, Jack Levine was the painting instructor. I didn't take his class. I became very intrigued with fresco, so that I worked with Henry Varnum Poor and did one of the large frescos in the old barn that for several years had stood there. Now that barn has since burned down, and all the student frescos, including my own, were destroyed in about five minutes. But I think two or three prizes were given that summer for the frescos. And I won one of those.

Baker Could you describe the fresco that you did?

Indiana Oh, yes, I could, but it's a little embarrassing now. This was during, I think, the Korean War, and I did a kind of, I don't know whether you call it a—it was in memoriam, I suppose, to the men who were losing their lives in the Korean War. And then a smaller one of a religious nature, a small panel under a tier of windows, which was Pilate washing his feet.

Baker I think I'm accurate in saying, though, that [Henry Varnum Poor] . . . had the biggest name as an artist of any of the teachers you have yet mentioned that you've had?

Indiana Oh, probably so, yes. Well, Jack Levine . . . I didn't study under Levine, but I did go to his discussions and I saw him every day, and I knew what he was teaching and so forth. His particular style of American realism definitely did not appeal to me, and he demanded— at least I thought he demanded—a kind of allegiance from his students. And I didn't care to begin that kind of painting.

Baker Is the character of the student group at Skowhegan largely anti-abstract?

Indiana The general, the prevailing philosophy is very conservative, Richard, and it's the one thing that rather marred what was otherwise probably one of the most beautiful summers of my life. It's a beautiful place; it's a well-run school. On the whole you have freedom of choice—you may do what you want; you can work abstractly if you like. You're not going to be exactly encouraged, but they're really very liberal. But the prevailing mood is, here we are in the heart of nature, and artists have always drawn from nature, therefore, let's experience nature, and so on. And to a certain extent I did, I enjoyed this, but it's very conservative.

Baker Up to this point were you very much aware of painters like de Kooning, Pollock, Newman, Gorky, all these?

Indiana I wasn't . . . First of all, a lot of the students at Skowhegan were from the Boston area, and . . . Boston has its own group of painters, and a lot of discussion was about these artists who—this includes Levine and his associates, Hyman Bloom and so on—names which meant something to me then, which mean very little now. And in Chicago, I don't think that the New York School had made too much of a dent at that time. Chicago is of that provincial nature; the faculty is very large, and they have to, in some way, preserve their own integrity, and there was always a kind of guardedness about what was going on in New York and what wasn't going on in Chicago.

Baker What is your evaluation of [Levine] as an artist today?

Indiana During my youth I was intrigued by his work and, as I said, he seemed to be a major American figure. His whole period in this era seems to be a little eclipsed now, that's all . . . I think his impact on the bulk of the student body was at that time very great. His class was the most populous and most well attended, and people were right at his feet . . .

When I [got to Skowhegan] and found that Jack Levine was the principal teacher, I gravitated to Henry Varnum Poor because under him, probably the instruction was less arbitrary, and there the medium dominated the course, not the instructor's personality . . . The challenge of a new medium like fresco really was the primary reason.

[. . .]

Baker When did you really become a reader in a serious way?

Indiana Probably more in England and at the university than at any other period of my life. I was orientated toward books and literature more then than during any other period . . . The University of Edinburgh, in a way, Richard, is run very much on the American plan, and a comprehensive literature course there would be very similar to one given in America, at an American college, which made a very easy transition for me.

Baker As far as your life as an art appreciator might be concerned, I'm not quite clear that Edinburgh would contribute very much.

Indiana Very little. Very little.

Baker When had you begun writing poetry? Just then, or had you done some in Chicago before?

Indiana No. It was mainly a Scottish experience, and English, and I then did write when I returned to New York for the first year or two . . . [But the] climate of the university and Scotland and England and so forth [was literary]. It's a climate much more suited to writing than it is to painting.

Baker Did you become a member of any sort of little literary clubs in Edinburgh?

Indiana Yes, the poetry society . . . They put out a small anthology of their work while I was there, and I designed the cover for that particular magazine . . .

It came about through my interest in seeing my own poetry in print [illustrated poems] . . . I might have become [a bookman] if I had stayed in England or Scotland, and I did try, but I couldn't seem to find any way of prolonging my visit there . . . [In the summer] I enrolled at the University of London again in order to draw out my G.I. Bill benefits to the very end . . . Next to the summer in Maine, which of course was completely pastoral . . . it was certainly one of the most pleasant summers of my life . . . It was in September of 1954 that I returned to America and to New York to live for the first time.

Baker When you returned to New York, your future was completely indistinct, wasn't it?

Indiana Oh, very much so, yes. First of all, I had left all my paintings, possessions and so forth, art materials, in Chicago with friends, and rather anticipated returning to Chicago, but the friends that I—I remember I returned broke—I had overstayed myself in London.

Baker How many months were you actually abroad?

Indiana About thirteen. And even to get back and pay my passage, I had to borrow money from the U.S. Embassy, you see. And the friends that I was more or less counting on for help to get back to Chicago and get reorganized, they failed to come through, so I was more or less marooned in New York, had absolutely no contacts or friends here that I felt I could count on. I found one former Chicago friend who had been a model at the Art Institute, who found me a cheap room and a job and so forth . . . This was October.

Baker Where was this cheap room—what part of New York?

Indiana The Hell's Kitchen area. The West Side. I was just there for a short time, and through another former Chicago classmate who had since settled in New York—he had been an art student in Chicago, but he later became a dancer in New York, a dancer named Paul Sanasardo—I took his loft for the following summer while he was away, and that was my first loft.

Baker You had nothing, so you had to find some money. So you went to work.

Indiana One of my first jobs was in an art store here in New York, and I was there for, oh, a couple of years, I think, part-time job . . . Friedrichs [on 57th street] . . . as a clerk [selling] art supplies . . .

It wasn't a bad job. It enabled me to buy art supplies at half cost, and it put me kind of in contact with other artists. I actually met Jim Rosenquist, who has since become a close friend and a neighbor—he was a student at the Art Students League at that time, and I met him just because I was working at the art store. And I met Ellsworth Kelly because I was working at the art store . . . My second loft was on Fourth Avenue, immediately contingent to de Kooning's studio . . . I could look out my back window and look right into de Kooning's studio and watch him paint, you know . . . At this point I was still under the influence of Dubuffet. I was still painting these heads which had been set off by him [figs. 17, 18] . . . They were thick-textured. I mixed sand with my pigment and— yes, maybe they were rather grotesque. They don't look like Dubuffet, but as I say, they had been influenced, particularly texture-wise . . . I was a wing—still a wing, maybe, of the [Chicago] monster school . . .

The most significant thing that occurred to me in New York, I suppose, took place at Friedrichs. One day I was— I took care of one of the windows; I dressed the window with art postcards and reproductions, and I had put a Matisse postcard in the window. And Ellsworth Kelly was passing by on 57th Street and saw it and came in and asked for that particular postcard . . . That's how I met Ellsworth Kelly. And at that very time I was very desperately in need of a new loft, a new studio, because I was—my sublease was terminated on the one I had been living in. And it just so happened that at that time Ellsworth, who had been for a few months in a loft on Broad Street, was also thinking about—he wanted a larger loft, so he was thinking in terms of lofts and moving and actually needed some help just in the sheer physical process of moving. And so it all came about as a matter of convenience. He encouraged me to look on Coenties Slip.

Baker Had he already been down in that area, is that it?

Indiana No. [He was on] Broad Street. Which is just a block from Coenties Slip. So I came and took the corner loft at 31 Coenties Slip, which was my first. And just a few days, or a week or so later, Ellsworth took another loft on Coenties Slip, which I had looked at myself. But it was something like forty-five dollars a month, and mine was thirty dollars a month. So that fifteen dollars made quite a bit of difference in those days . . . So I took the cheaper [loft] and let Ellsworth have the more expensive one, and we've been in similar physical places ever since . . . My loft at 31 had originally been Fred Mitchell's loft . . . and he had used this loft as his school. I think he called it his Battery School, something like that. But he had left and had taken up residence and a job at Cranbrook in Detroit . . . [The loft] was in a pretty bad state. First of all, a lot of the refuse of Fred's art school was still there. There were still stacks of drawings that his students had done

and so forth. But that really was no problem. The problem was that he had been gone for some time and . . . the loft had been used by derelicts in the neighborhood, and it was piled high with refuse just from these waterfront characters and so forth. After all, South Street is a kind of an extension of the Bowery, and you get that type of person . . . I doubt very much if I would have faced [cleaning it up] by myself, Richard. But having Ellsworth as a neighbor made it much, much simpler. We did these things together. He helped me with mine, and I helped him with his loft . . . [The building] was owned by a man who was more interested in the parking lot potential of the building than the rental of the building itself. And when he lost his liquor license for his bar downstairs, he decided to tear the building down. And then I moved two doors away to 25 . . . Upon meeting Ellsworth Kelly, this was my first head-on contact with painting of any geometric or clean, hard-edge style. I had never been introduced to it personally, never knew a painter who worked in this manner, and had never very seriously thought of this kind of painting . . . He had just had his first show at Betty Parsons, after having exhibited in Paris.

Baker Most of the New York scene painting was not of this flat and hard-edge character. [Kelly] really represented, anyway, a kind of innovation, didn't he? By not having straight lines in his flat painting to some extent. I think he was not preceded directly by anybody, was he? In that approach.

Indiana I didn't know Leon [Polk Smith]'s work until I knew Ellsworth. Ellsworth was a friend of Leon's, and through him I met Leon socially and saw his painting. But it seemed that their two works had developed very independently, and that neither had exerted an influence.

Baker You would have really found Ellsworth's work a rather fresh experience.

Indiana It was. I had never seen anything [like it] . . . I didn't see that first show. I saw his second show at Betty Parsons. But then by that time I had become his friend . . .

It took two or three years before there was any really active influence on my work. I continued to work on the heads that I had started in the loft on 63rd Street and had worked on on Fourth Avenue, and I was working on them when I met Ellsworth . . . As I said, they were painted with thick pigment, with gravel, with sand, and they later became gilded. I used gold leaf for the backgrounds, which must have been some sort of a reference to Byzantium, I'm not sure.

But another influence, a very indirect influence, occurred, and that was my meeting Cy Twombly. He had a very, very small place in an area that has now been totally razed, over by City Hall. And his quarters were so small that he didn't have room to paint, and one day he heard about my loft and knew that I had a part-time job and was not there all the time . . . He came by and asked if he might share my studio in order to paint a show that was going to be at the Stable Gallery, the old Stable Gallery. And since the possibility of splitting a month's rent, and since I didn't use my loft all day anyway, I welcomed the idea. And he painted this show, many of the paintings for the show, in my loft. And as a kind of gesture and partial return for this, he gave me several of his old canvases, which he more or less was scrapping, and told me that I could use them and paint over them. Since I was painting with thick-textured paint, it wouldn't make any difference what kind of ground it was . . . by that time I had exhausted—I had lost all interest in the heads . . .

In the process of just getting the canvases ready, I began to tear this newspaper off. Much of it would pull off easily, but then in other sections it would not where the paint had really adhered or had made the paper adhere. And I suddenly found myself in possession of a rather beautiful collage technique, and I worked into and on top of those paintings, totally obscuring his configuration and so forth but making use of the torn newspaper that had been put on top. And I did just two canvases that way. I worked on them for some time, though, and was very happy. I liked very much what I had found. And then Jack Youngerman arrived on the scene from Paris with his wife and child. When I saw Jack's work for the first time, these collages were so close to what Jack had already been doing for so long and with great accomplishment that I was kind of thrown and discouraged, and so stopped that whole direction of effort . . . They weren't greatly alike, but they were close enough alike that I was discouraged from going on—well, here we'd be two neighbors who'd be working much, much too much alike. So therefore I was jarred out of that direction.

And at this time then I moved into the new loft at 25 . . . and really started fresh. And by that time I was not so reluctant to experiment with the hard-edge approach, and I began my experiments right then . . . Stencils were not found in my own loft but in a loft which I worked on for someone else . . . And that came later . . . Well, then, in searching for some, you know, personal expression, I went through several experiments. I came upon the ginkgo leaf, which is the tree which grows in the park in front of my loft, and I took it and made it into a—I doubled it and made it into a yin-and-yang form and spent, oh, many months working on a large number of variations of this form, coming then into direct contact with hard-edge and flat color and working, however still not having money enough for canvases. Almost all of these paintings are on paper and have since practically disintegrated . . . I worked for a year on the ginkgo form . . . It's a fan shape, which in a combination, when it's doubled, resembles a kidney form, and so this enabled me to work in two colors only.

Baker And this is what you said more or less [disintegrated]?

Indiana There is an exception. There are two smaller canvases which have a ginkgo, one being gilded with gold leaf, which is an immediate hangover from the heads. Another, larger work has become—has gone into the permanent, into what I call my permanent repertoire of works, and that is *The Sweet Mystery* [fig. 49] . . . Then when I decided to start using words, my first word painting was *Terre Haute* [fig. 47], a kind of homage to my home state. I found there was a reason and space to add words to this painting, and it became *The Sweet Mystery*, and with *The Triumph of Tira* [fig. 50], which is a companion painting and which had also existed previously without words—these became two of the very first word paintings.

Baker What was the year that the word painting started?

Indiana That started in 1960 . . . But they had existed as paintings before that, you see. The major, the principal format of the painting had been developed before the words were added. Then, after that, my paintings were all conceived with words in mind . . .

Baker When did you start working on these columns of wood?

Indiana They came first. They came before the word paintings. The constructions came into being because many of the old warehouses were being razed in the neighborhood for the widening of Water Street, and the wood was just lying around waiting to be picked up. And I brought it into my studio, and, as you know, at that time assemblage was kind of in the air . . . The constructions, too, were first used without words, but the words appeared on them first.

Baker I was just checking on the date of our [first] meeting there in December 1959, because my recollection is that, at the time, you were not an exhibiting artist, [you were] presenting yourself as a person who had not yet, wasn't ready, shall we say, to exhibit. Is that correct?

Indiana I think my main goal was just to develop or to acquire a body of work, Richard. I felt that it was very necessary to be able to work consistently in a given style for a given period of time. And that was my main preoccupation. It was very easy to zig and zag, to change from one piece to another, and I knew that I could not feel that I had found my own expression until I could cover a body of time with a given style and a given direction . . . Jack Youngerman had become my immediate next door neighbor, and I would see Jack much more than I would see Ellsworth, and Jack and I even went into a little venture together. We had figure-drawing classes in our studio . . . Many painters from uptown came down and took the opportunity of being able to draw from the figure. This didn't work out very well . . . We probably spent as much getting it ready and paying for models.

Baker [From '57 to '59] abstraction was certainly dominant, and I'm just curious that you did find a few people really wanting to draw from the figure almost.

Indiana This was mainly Jack's idea. And it turned out that there were people interested, but what defeated us more than anything else was cold weather. We couldn't really provide—we couldn't keep the lofts warm enough for a model during the winter . . . And it collapsed because of the, to most peoples' minds, the inaccessibility of the Slip, plus bad weather, plus inadequate heating, plus a freezing model. It just collapsed.

Baker Let's get back to your wooden structures. I'm not sure when you first did those.

Indiana Started in '59 . . . Not all of them have wheels. Most of them did. The wheels came about because of meeting Steve Durkee. He knew of a place where there were a number of old wheels that had been abandoned and provided me with a great number of uniform wooden and iron wheels that had been probably for baby carriages or something. And he himself was working in this form at that time. And we often competed for the wood that was in these demolition sites . . . [For me,] it wasn't an unnatural assimilation because I had become very interested in the circle and used—and have used—the circle consistently in my paintings. And after all, the wheel is merely a physical projection of the circle. So it was just a natural find and one which I could put to use with complete ease and relevancy . . . My new constructions, my new pieces of wood are—I've had these columns for some time; they were originally the masts of old sailing ships, and you can still see the worn areas where the iron rings that held them together were once fitted onto. Then they became columns for these warehouses that were built after the fire of 1835. And then as the buildings were demolished, I acquired several of these columns. I had to, unfortunately, had to cut them in half to get them into my loft; they were once nine feet tall. And I'm working now almost exclusively on them. They will not be assemblages in that there is nothing—there is no other material being added to them except words painted around the perimeter of the columns . . . The weathered wood was so beautiful that I was just reluctant [to stain or paint them] . . . To be consistent with my painting, my constructions probably should be made of brand new wood, which has no patina or age whatsoever . . . I think there's validity in the "foundness" of the object.

Baker Your style seems to have emerged almost, shall we say, fully matured? I think there must have been stages that you haven't spoken of tonight before you reached the

phase when you produced the first paintings that were exhibited.

Indiana There were. One particular phase which I spent, oh, a good part of a year on, Richard, was a coming out of that ginkgo period that I told you about. In fact, this particular work, it's a large mural-size work; it covers one whole side of my studio [*Stavrosis* (fig. 19)]. And, again, due to lack of funds, it's only on heavy paper, and a heavy paper which I found on the floor of my loft. The loft had at one time been used as a print shop. And so I found this great stack of . . . paper, and so I made a mural out of it using forty-four sheets. And at that time, as a part-time job, I was working at the Cathedral of St. John the Divine . . . It was a kind of semi-secretarial capacity . . . By this time I had become very wearied of working in the art store, and I was trying to get away from it.

Baker But you left that before you started exhibiting, before you had any kind of success?

Indiana I suppose there was some sort of influence just by being so close to the Cathedral that I decided that I'd do a Crucifixion, and the technique was dry brush. I used printer's ink with brush and did a lot of this rather large work, and it was the first thing that I did in New York that brought me to the attention of a gallery . . . [Harold Rubin and Robert Kayser] came down and invited me to show this work, but I declined. It just dawned on me that this was not a very good idea, and so I didn't, and it's never been exhibited. But it made use in two places of those ginkgo forms. And it also brought me into a very biomorphic phase whereby I still felt an affinity for the heads that I had been doing. There was the element of man in this work, but it was also becoming more geometric and less what I had been doing before. It was a very transitional thing. So the work became harder and more geometric, and then when I did start using words in. 1960 and these were, as I said, first on the constructions, because the constructions just needed the words; they did not look complete without them. And they were only decorative until they had their words. This was the beginning of my present work.

Baker The words on the constructions were usually one word only.

Indiana Yes. That's right. And very brief, usually three letters or four letters . . . They always said something from the very beginning.

Baker In the last few years more people have been using words, haven't they?

Indiana It seems that everybody was using them . . . Again, just like assemblages were in the air—everybody was making assemblages—everybody was beginning to use words. Remember that Rauschenberg and Jasper Johns,

who I knew (Ellsworth introduced me to them the very first year on the Slip)—and at that time they were still doing department store windows. They were still doing their display work. I even worked for them once on one of their display jobs . . . But you see they were only two blocks away. Now I never became personal friends of Jasper Johns or Robert Rauschenberg, but they were both, particularly Rauschenberg, they were very concerned with assemblages. And Steve Durkee was making assemblages, and then, of course, it all culminated in Martha Jackson's *New Media–New Forms* [exhibition] and eventually in the assemblage show at the Modern.

Baker How did you become known to the Martha Jackson Gallery?

Indiana It came about solely just through good luck. One of my neighbors on the Slip who had once wanted to be a painter himself and has now long since given up that ambition . . . This was Rolf Nelson. He was on the Slip, oh, for a good two or three years just as a struggling artist like myself . . . In order to make ends meet, he took a job as gallery assistant to Martha Jackson, and when their idea came up for an assemblage show, he, of course, knew of the things that I had been making and invited me to participate. In other words, he was responsible for bringing Martha down to the Slip, and she saw the pieces and said okay, and I was in the assemblage show . . . From there [Nelson] became the director of the David Anderson Gallery, which was Martha's son's gallery . . . So that then the next stop was a two-man show at the David Anderson Gallery with Peter Forakis.

Baker Was it a show which contained just two or three of your paintings?

Indiana No. Six [paintings] . . . And many constructions . . . Nothing happened during the course of the show. Not a single thing of Peter's or a single thing of mine was sold, and it was very disappointing. When [*The American Dream, I*] was called to the Modern to be looked at [and they accepted it], that was the real beginning of—

Baker [It] was a boost to your career, as any purchase by the Modern Museum is apt to be for any artist's career in this country.

Indiana Tremendous. But it still didn't have any particular immediate effect. I still was without a permanent gallery. There was a kind of a promise of an invitation for another show at the Anderson Gallery, which I really wasn't too enthusiastic about, because it had such a secondary aspect . . . For myself, there was the complication in that Rolf Nelson left the employ of the Jacksons and the Andersons, so that my patronage from this standpoint . . . no longer existed. I don't mean that there still was no interest in my work. I did receive an invitation from the Anderson

Gallery to have my first one-man show there, this being again more from an outside source—it was Marge Turan, who is now gallery assistant at the Tibor de Nagy Gallery. She saw my work and believed in it and urged that they invite me, and they did, but I think it was primarily upon her enthusiasm that this came about. However, by that time the picture had become more complicated. I had also received an invitation from Allan Stone, and this again (all these things happened indirectly to me), this came about because of Steve Durkee. Durkee had been taken on by Allan Stone, and Durkee had recommended me to Allan, so I had received an invitation to show from Stone. But the enthusiasm was somewhat lukewarm . . .

And then a third situation appeared, and this was an invitation from Eleanor Ward to show at the Stable Gallery. It meant waiting a whole summer and not being able to show till the following fall, whereas I could have shown at either the Anderson Gallery or the Stone Gallery in the spring. And I was ready to show. I had had paintings hanging which I was beginning to worry about because they were hanging in my loft for so long.

Baker How did Eleanor Ward happen to come [to know your work]?

Indiana I had nothing to do with it, Richard. It so happened that one of my pieces was being shown in the penthouse at the Museum of Modern Art. The curator of the penthouse, Campbell Wylly, knew my work and had selected this piece, and one day Eleanor Ward, I think, was just visiting the penthouse, and she remarked that she liked my work very much but was sorry that I was tied up. And Campbell merely let her know that I was not so committed as people thought, and that it might be very possible that I could be invited to show with her. And as it turned out, that was all arranged in one weekend. It just happened like that . . .

Well, I did have a three-man show which I didn't mention. I think on a previous tape I said something about my first loft being that of a former friend and classmate from Chicago, Paul Sanasardo, and in—oh, by '59 or '58, he had his own dance studio where he taught. And he had a foyer, and he thought it would be very nice if he presented some small showcase exhibits in this foyer for the benefit of his dance students. And so he invited me to form a three-man show, and I asked Steve Durkee and Dick Smith, an English painter who had taken a loft just a few blocks away from Coenties Slip on the waterfront, on Whitehall. They joined in with me, and we had a three-man show which was roughly simultaneous to the two-man show at the David Anderson Gallery . . . I had just constructions [at Sanasardo's studio]. I didn't show any paintings in that show . . .

[Leo] Castelli came [down to the Slip to see the work of a neighbor of mine, who] was gracious enough to ask me to hang one of my paintings in his studio so that Castelli might see it . . . And that's the first painting of mine that Castelli saw. And Castelli later came to visit my studio at the very time when people were becoming interested in—shall we say, a number of people were becoming interested. But it was Eleanor Ward's invitation which came through first and became final . . .

The next most important thing that occurred was that inclusion [in MoMA's *Americans 1963* exhibition], and that came very quickly, very quickly after my becoming affiliated with the Stable Gallery . . . Oh, it was, I think, six or seven [paintings were selected for the MoMA show].

[. . .]

Baker [During this interview,] I sometimes have a feeling you weren't being entirely revealing . . .

Indiana I think that possibly the things that didn't come out which probably are very important are childhood things which linger in one's mind and one never escapes.

Excerpts from Richard Brown Baker, "Oral History Interview with Robert Indiana, 1963, September 12–November 7," Archives of American Art, Smithsonian Institution, Washington, D.C.

INTERVIEW WITH GENE SWENSON, 1963

Gene Swenson What is Pop?

Robert Indiana Pop is everything art hasn't been for the last two decades. It is basically a U-turn back to a representational visual communication, moving at a break-away speed in several sharp late models. It is an abrupt return to Father after an abstract 15-year exploration of the Womb. Pop is a re-enlistment in the world. It is shuck the Bomb. It is the American Dream, optimistic, generous and naïve . . .

It springs newborn out of a boredom with the finality and over-saturation of Abstract-Expressionism which, by its own esthetic logic, is the END of art, the glorious pinnacle of the long pyramidal creative process. Stifled by this rarefied atmosphere, some young painters turn back to some less exalted things, like Coca-Cola, ice-cream sodas, big hamburgers, super-markets and "EAT" signs. They are eye-hungry; they pop . . .

Pure Pop culls its techniques from all the present-day communicative processes; it is Wesselmann's TV set and food ad, Warhol's newspaper and silkscreen, Lichtenstein's comic and Ben Day; it is my road signs. It is straight-to-the-point, severely blunt, with as little "artistic" transformation and delectation as possible. The self-conscious brush stroke and the even more self-conscious drip are not central to its generation. Impasto is visual indigestion.

Swenson Are you Pop?

Indiana No. If A-E [Abstract Expressionism] dies, the abstractionists will bury themselves under the weight of their own success and acceptance; they are battlers, and the battle is won; they are theoreticians, and their theories are respected in the staidest institutions; they seem by nature to be teachers and inseminators, and their students and followers are legion around the world; they are inundated by their own fecundity. They need birth control.

Swenson Is Pop death?

Indiana Yes, death to smuggery and the Preconcieved-Notion-of-What-Art-Is diehards. More to the heart of the question, yes, Pop does admit Death in inevitable dialogue as Art has not for some centuries; it is willing to face the reality of its own and life's mortality. Art is really alive only for its own time; that eternally-vital proposition is the bookman's delusion. Warhol's auto-death transfixes us; DIE is equal to EAT.

Swenson Is Pop easy art?

Indiana Yes, as opposed to one eminent critic's dictum that great art must necessarily be difficult art. Pop is Instant Art . . . Its comprehension can be as immediate as a Crucifixion. Its appeal may be as broad as its range; it is the wide-screen of the Late Show. It is not the Latin of the hierarchy; it is vulgar.

Swenson Is Pop complacent?

Indiana Yes, to the extent that Pop is not burdened with that self-consciousness of A-E, which writhes tortuously in its anxiety over whether or not it has fulfilled Monet's Water-Lily-Quest-for-Absolute/Ambiguous-Form-of-Tomorrow theory; it walks young for the moment without the weight of four thousand years of art history on its shoulders, though the grey brains in high places are well arrayed and hot for the Kill.

Swenson Is Pop cynical?

Indiana Pop does tend to convey the artist's superb intuition that modern man, with his loss of identity, submersion in mass culture, beset by mass destruction, is man's greatest problem, and that Art, Pop or otherwise, hardly provides the Solution—some optimistic, glowing, harmonious, humanitarian, plastically perfect Lost Chord of Life.

Swenson Is Pop pre-sold?

Indiana Maybe so. It isn't the Popster's fault that the A-Eers fought and won the bloody Battle of the Public-Press-Pantheon; they did it superbly, and now there is an art-accepting public and body of collectors and institutions that are willing to take risks lest they make another Artistic-Oversight-of-the-Century. This situation is mutually advantageous and perilous alike to all painters, Popsters and non-Popsters. The new sign of the Art Scene is BEWARE—Thin Ice. Some sun-dazed Californians have already plunged recklessly through.

Swenson Is Pop love?

Indiana Pop is love in that it accepts all . . . all the meaner aspects of life, which, for various esthetic and moral considerations, other schools of painting have rejected or ignored. Everything is possible in Pop. Pop is still pro-art, but surely not art for art's sake. Nor is it any Neo-Dada anti-art manifestation. Its participants are not intellectual, social and artistic malcontents with furrowed brows and fur-lined skulls.

Swenson Is Pop America?

Indiana Yes. America is very much at the core of every Pop work. British Pop, the first-born, came about due to the influence of America. The generating issue is Americasm [sic], that phenomenon that is sweeping every continent. French Pop is only slightly Frenchified; Asiatic Pop is sure to come (remember Hong Kong). The pattern will not be far from the Coke, the Car, the Hamburger, the Jukebox. It is the American Myth. For this is the best of all possible worlds.

Excerpts from Gene R. Swenson, "What Is Pop Art? Answers from Eight Painters, Part I: Jim Dine, Robert Indiana, Roy Lichtenstein, Andy Warhol," ARTnews 62, no. 7 (November 1963): 24–27, 60–64.

ARTIST STATEMENT, WALKER ART CENTER, 1964

Coenties Slip

Some years ago—it was in the spring of 1956, the last week of June precisely—having little or no money in my purse, and no particular interest in the wave of abstract expressionism that had inundated the middle part of Manhattan, I came to the tip end of the island where the hard edge of the city confronts the watery part.

There in that fringe of derelict warehouses that have stood since the Fire of 1835, facing the harbor between Whitehall and Corlears Hook, I rented a top-floor loft on Coenties Slip. Out of necessity it was a cheap accommodation, and it was necessary to put in the windows myself before it was habitable, but there were six of them and they overlooked the East River, Brooklyn Heights, the abandoned piers 5, 6, 7 and 8, the sycamores (as Hoosier as a tree can be) and ginkgoes of the small park called Jeannette, and the far side of the Brooklyn Bridge, through whose antique cables the sun rises each morning, while at night the Titanic memorial lighthouse of the nearby seamen's hostel illuminates the skylights of my studio whether the moon shines or not.

Coenties, of the dozen or so slips of Manhattan, is the oldest, largest and busiest of the lot, and the last to be filled in (circa 1880), all of which are relics of the wooden ship days of sail and mast. Its origin goes back directly to the Dutch days of Nieuw Amsterdam and a landowner named Coenach Ten Eyck. (The good Yankee slaver REBECCA may well have taken on provision here, and the GREAT EASTERN that Whitman celebrated in YEAR OF METEORS, as I did myself re-celebrate, certainly did steam and sail past the Slip.) Cartographically it describes a Y—a funnel drawing in the commerce of the port in its day, sadly now paved over with asphalt and granite brick, through which poke the fifteen ginkgoes, whose leaf form doubled provides the motif of THE SWEET MYSTERY— but a Y rounded out so as to describe a partial circle. This from the windows of 31 and now from the neighboring 25 (since the demolition of the first in 1957), both buildings by coincidence once the MARINE WORKS, ship chandlers at the turn of the century.

Also, from my windows, if one looks landward instead of seaward, there is that solid cliff of stone that Wall Street makes, meeting the sky as sharply as the piers do the water, all lines of demarcation crisp and sure. Here this heady confluence of all elements, the rock, the river, the sky and the fire of ship and commerce causes a natural magnetism that has drawn a dozen artists since to the Slip.

It is 25 which is emblazoned with signs of words over its entire facade that paradoxically became a daily confrontation with the format my work has assumed. Not only this, but every ship that passed on the river, every tug, every barge, every railroad car on every flatboat, every truck that passes below—on the Slip, on South, on Front, on Water and on Pearl Streets—and every helicopter that now lands at the heliport a stone's throw from my building—for progress pushes its way onto the obsolete waterfront, as sure to go as the artists collected by its rotting piers—carries those marks and legends that have set the style of my painting. The commercial brass stencils found in the deserted lofts—of numbers, of sail names, of the names of 19th-century companies (THE AMERICAN GAS WORKS) became matrix and substance for my painting and drawing. So then did all things weave together.

Excerpt from Jan Van der Marck, Richard Stankiewicz, Robert Indiana: An Exhibition of Recent Sculptures and Paintings, *exhibition catalogue (Minneapolis, Minn.: Walker Art Center, 1963).*

ARTIST STATEMENT, STABLE GALLERY, C. 1964

I paint the American scene (a non-provincialism, for, in truth, this has become in large part the world reality) in an American way (automatically & perforce this reads new) which is a style characterized by high color

(combustible polychromy), high relief (the hard-edged rationale), high poetry (the sharp-focus metaphor), high refinement (a classical idealization) & high endeavor (commensurate with the best and the most awful American tradition of lofty purpose), or, in more Hoosier-graphic words: my art is a disciplined high dive—high soar, simultaneous & polychromous, an exaltation of the verbal-visual . . . my dialogue.

Robert Indiana, artist statement, c. 1964, Stable Gallery Records, Archives of American Art, Smithsonian Institution, Washington, D.C..

ARTIST QUESTIONNAIRE: *MATE* (1960–62), WHITNEY MUSEUM OF AMERICAN ART, 1966

Mate [fig. 69] was done in those days on the Coenties Slip when I didn't have money for stretchers and canvas of the scale that I wanted to work on, and so instead plundered the nearby demolition sites for those choice pieces of beams that included the "haunched tenons" or the locking devices hand-cut mainly for stair and shaft openings, which I would scout for during the day and return at night to drag away, hoping that Steve Durkee or Mark di Suvero had not spotted the same piece, for us three were in hot competition for those pieces in those years and often lost out to each other. Most of the beams were too heavy to handle alone, requiring an accomplice to carry them back to 25 and up five flights of stairs, for at that time I occupied only one floor of the building, and my painting and constructing were done in the same small loft at the hard top, and so "mate" had special meaning for the accomplishment of everything. *And* it was the waterfront, and across the park from my loft was the Seaman's Institute where I took my meals and took my baths, as my building was really cold water and where the designation "mate" was common usage.

Excerpt from Robert Indiana, "Artist Questionnaire," February 17, 1966. Object Files, Whitney Museum of American Art, New York.

ARTIST STATEMENT, STEDELIJK VAN ABBEMUSEUM, 1966

Signs loomed large throughout my whole life. First there was the huge round Phillips 66 sign that rose high above the flat skyline of my hometown. I saw it and felt it every year of my youth there for it happened to stand, perched on two girders, on the very route that my father took to work each day for many years. It also just happened that he worked for the very company that it announced, red and green, against the blue sky. His sign: my sign. And it was about the highest thing (in my imagination) in town save the spectacularly ugly war monument that dominates the center of Indianapolis, surrounded as it is by a circular

street called the "Circle," the city being elaborately laid in freshly hewn forests according to a European plan.

Not long after came EAT signs. Ubiquitous in that part of America, they signal all the roadside diners (no DINE signs) that were originally old converted railway cars, taken off their wheels and mounted on blocks amid zinnias and petunias when the motor bus displaced the railroad in the '30s, and the cheap cafes (rivaled by CAFE signs). Some of the latter were operated with strict "homecooking" by my mother when she had to support herself and her son during the Depression when Father disappeared behind the gasoline sign (66) in a westerly direction, leaving home and family for other signs. The son, burning to be an artist from the age of six, painted the window signs of those establishments. It was fitting that the very last word that she uttered to him at her death was "eat."

Then, some years later, amid the lighted splendors of Times Square and the millions of signs in New York, a few which covered the front of my studio building in the old Dutch section of Manhattan, came the architect Philip Johnson and the New York World's Fair and his commission to do a work for his New York State Pavilion there—along with friends and neighbors, Kelly, Rosenquist, Rauschenberg—on the side of a circular building, part of the tallest and most prominent complex in the exposition. A black EAT came to mind, and in order to elevate it to the spirit of the occasion, it became an electric EAT, flashing its imperative with real energy [fig. 58]. Too much so for the Fair officials, who turned it off the very first day it was lit, and there it hung for two summers viewed by millions of people, but emasculated and tame. Too many people had reacted, that first day, to the imperative.

Originally published in Frank Popper, KunstLichtKunst, *exhibition catalogue (Eindhoven, The Netherlands: Stedelijk Van Abbemuseum, 1966).*

ARTIST STATEMENTS, INSTITUTE OF CONTEMPORARY ART, UNIVERSITY OF PENNSYLVANIA, 1968

The Sweet Mystery

The Sweet Mystery came from these things:

1. My first *I Ching* reading: this occurred early on Coenties Slip with Ellsworth Kelly and his newly arrived friend from Paris days, the Kentuckian Jack Youngerman, in this first loft on the waterfront which, curiously, was the site of a Chinese laundry at the time of my birth.

2. Yin and Yang: a wish to invest them with a new form.

3. The ginkgo leaf: the new form though of prehistoric Oriental botanic origin, not of a tree, but a fern, which—in the not-humid-enough climate of New York—unable to

have normal prehistoric sex, the female specimen throws off a foul-smelling seed as if in anguished protest (sour/sweet Mystery with Chatham Square and Chinatown the next El stop away from Hanover Square when the Slip was transversed by the famous snake-curve of the recently vanished Third Avenue Elevated downtown).

4. One year of painting: various mutations of the doubled ginkgo leaf shape—my Yin and Yang—but very Westernly and dangerously in oil on paper, a medium claiming no permanency . . . perhaps thinking of myself as a tree casting off leaves at autumn.

5. The cycle: from Spring's Permanent Green Light to Fall's golden leaves on the blue-black asphalt of Jeanette Park, even up to my own stoop next to the Rincon de España downstairs where a handsome, dark-eyed barmaid named Carmen—like my "Mother"—worked those eight years I lived above and sent Spanish music welling up the hoist shaft—but never the "Habeñera."

6. Yellow: my color, particularly in its darkened aspects, the browns and earths (my "Father'"s last property in Indiana was on Greasy Creek in Brown County).

7. "Vision binoculaire": a phrase from Cyril Connolly's *The Unquiet Grave*, a book I was reading at the time with a friend, who, ironically, was destined to commit suicide later while living at 3-5, since the book is fixed on the character of Palinurus.

8. The Sweet Mystery: life and death. The hereness and non-hereness.

9. The words: among my first cautious uses of them on canvas, here muted and restrained.

10. THE SWEET MYSTERY: song breaking through the darkness.

Yield

Arrogant admonition of the American highway, by far the most provocative of all road signs, emblazoned too on that unexpected shape: the descending triangle. Wildly indecorous for a humorless Highway Department that never follows "Soft Shoulders" with "Supple Hips." However, Yield—as humble injunction—appropriate and pressing for the whole troubled world. So when Bertrand Russell's plea for worldwide support for his peace program went out a few years ago, I respond with my first *Yield Brother*, transforming certain of the cartographic forms that I had used to describe early Manhattan streets mentioned in "Moby Dick" in the *Melville Triptych* into his "ban the bomb" symbol, four times over—visual catechism, so to speak. Ironically enough when it was presented there in a benefit exhibition at Woburn Abbey, it found no takers in swinging, with-it England, drawing the non-reaction instead that one might expect from her

old Puritannic Majesty's realm, and was returned to America for sale here. Perhaps there has been too much yielding for the British; in Stand-Firm-America there is more need. That the countryside is peppered with "Yield" signs hasn't affected the national conscience much—particularly in our least yielding region entrenched as it is in the doctrine of White Supremacy. Against the recalcitrance of the South I have aimed the salt of the Confederacy Series, *Florida* in this exhibition, but *Mississippi*, too, and *Alabama* and *Louisiana*, and eventually I mean to encompass all 13 of the Secessionist States whose citizens were willing to die for the perpetuation of human slavery, indicated here with "JUST AS IN THE ANATOMY OF MAN EVERY NATION MUST HAVE ITS HIND PART."[1]

The Demuth American Dream No. 5

I Saw the Figure 5 in Gold by Charles Henry Demuth [fig. 154] is my favorite American painting in New York City's Metropolitan Museum. *The Demuth American Dream No. 5* [fig. 82], the central painting of the five in my "Fifth Dream" suite, is in homage to Demuth and in direct reference to the same painting which his own object of acclamation, the American poet William Carlos Williams, thought one of his best works.

For in 1928, the year of my birth, Demuth painted his "picture" inspired by his friend's poem "The Great Figure." It was on a hot summer day in New York early in this century that William Carlos Williams, on his way to visit the studio of another American artist of the time, Marsden Hartley, on Fifteenth Street, that he heard "a great clatter of bells and the roar of a fire engine passing the end of the street down Ninth Avenue." He turned just in time to see a golden figure 5 on a red background flash by. He was so impressed that he took out a piece of paper from his pocket and wrote the following poem on the spot: Among the rain / and lights / I saw the figure 5 / in gold / on a red / firetruck / moving / tense / unheeded / to gong clangs / siren howls / and wheels rumbling / through the dark city.

I did my painting in 1963, which when subtracted by 1928, leaves 35—a number suggested by the succession of three fives (5 5 5) describing the sudden progression of the firetruck in the poet's existence. In 1935 Demuth died, either from an overdose or an underdose of the insulin (he suffered for years from diabetes) according to Doctor Williams, the pediatrician-poet who birthed thousands of babies as well as hundreds of poems, and then in 1963 the venerable doctor died, completing the unpremeditated circle of numerical coincidence woven within the "Fifth Dream."

For the major painting of this "Dream," I chose the cruciform, a polyptych of unusual form in the history of painting if not sculpture—the obvious exception to this, of course, being Cimabue's *Crucifix*, so recently nearly destroyed—by the use of which I meant to set this particular painting most apart from all others given that its theme and internal form is in direct dialogue with the original inspiration. The head, the arms, the foot, or less particularly the surrounding members echo and reinforce Demuth's composition though somewhat simplified to fit the nature of my own work, stripped as it is of the allusions to a cubist cityscape.

A Mother Is a Mother, A Father Is a Father

Some painters have painted their mothers; some painters have painted their fathers. A very few are known to have committed both to canvas, and fewer still fixed them both in the same work. *A Mother Is a Mother* and *A Father Is a Father* [fig. 94] is a single work, a diptych in homage, and respect, too, to two people conspicuously crucial to my life and my becoming an artist, for, contrary to the custom of the times, I was half-encouraged toward this unthinkable occupation. Otherwise they were immensely unimportant in their world, leaving no other mark on the world. Born at the end of the nineteenth century, they helped to dissolve that era's social solidity—they were definitely of the "lost generation." They were lost, and they got there fast on wheels!

My mother's name was Carmen. Though warm and vibrant, she was not Latin but was so named because it was her father's favorite opera. An insurance salesman when that breed crisscrossed North America by rail and were away from home long intervals spending nights in many hotels and going to vaudeville palaces or opera houses—according to their likes—he preferred Bizet. Her mother died of dementia melancholia while he was on the road, and he took another wife who was shot to death because she was so mean. My mother's darkest hour came at the trial when the defense would not permit her to testify in behalf of her step-mother's murderess, a dark-haired ball-o'-fire named Ruby.

My father's name was Earl, and he was colorless as his name and the grays I have used to depict him, but he thought himself a chip off the American block, a true patriot who wanted to make the world safe for democracy in '18 but never got closer to France than Louisville, Kentucky. He wanted the big house on the hill, geared himself to make it—he was the American Dreamer (The American Dream: the No.'s 37, 29, 40 and 66 inscribed therein are the highways he rode in his quest) high in the seat of his ambitions, a Lindbergh of the Plains, who never quite got there. He loved all three of his wives, but with Carmen he was in his prime. He wooed her on wheels (LOVE), and she was crazy for it. That was until she became fat and middle-aged when he ditched her and went shopping for a newer model—built-in obsolescence Yankee-style: new wives, new cars, new art (regularly).

Mother and Father is part and parcel of my American Dream, a series of paintings begun in 1961. The First and Third were couched in the jargon of the pinball and slot machines, two of my parents' favorite devices second only to the very keystone of their "dream"—the chugging chariot carrying them on to greener pastures and redder passions, the arm-breaking magic carpet of escape from the confines of family (large), neighbors (encircling), and the small town (Alcatraz), Mr. Ford's answer to a national dilemma that liberated one generation, killed off another, and put distraction from any meaningful aspects of life—now ended for "Mother" in that same Indiana loam she stands on, in fact, in a country cemetery very similar to the wintry landscapes here, but the rutting road was paved over and became a busy highway with the smell of exhaust instead of myrtle; for "Father," who went on traveling to both ends of the American rainbow, California for a few years then Florida where, Eureka!, having solved the domesticability problem with a house trailer, he was eating breakfast one morning and dropped dead (EAT/DIE).

Sealed in time, here they stand fixed on this lonely rutted back road frozen hard in midwinter, but my father considered himself as hard as hickory as well as a bit of a dandy, and my mother was reveling in her very store-bought attirement and a burst of warm sunshine. Beyond them a hand-split rail fence (it was Lincoln as well as Dillinger territory) encloses a stand of hickory, and it is nutting time. They are young and flush, and they're happy with themselves and their Tin Lizzie—surely as proud of her as they would have been if she were a Dusenberg or a Stutz Eight that elusive prosperity or Indiana's crack coachmen might have afforded then. They are totally unaware of the sad trip ahead.

The Metamorphosis of Norma Jean Mortenson

The rise and fall of the Flesh Cult in Hollywood, the birth and demise of one more celluloid goddess only pall in an enormous way, having gone through the gamut in the '30's when going to the movies was a substitute for a baby-sitter, but Marilyn Monroe was cut above the ordinary and made the tired old money-making ritual worthwhile again—almost. It was probably her pathetically human, incredibly vulnerable image she exposed on the consciousness of America and the Americanized world. Jean Harlow might have received similar homage in her day if certain artists had been born a generation earlier. Or the Hoosier Carol Lombard whose tragic death during the Second World War—setting off from Indianapolis after a bond rally—affected me more personally, but her death didn't really become Americana, the Dream. The little California orphan girl whose role in "Misfits" was not only her final appearance on the screen but the vehicle of farewell for her costars Clark Gable and Montgomery Clift as well.

The last film for all three.[2] Six divided by two. '26 the year of her birth; '62 the year of her death. At two, baby Norma Jean was almost suffocated by a hysterical neighbor; at six, a member of her 12 (6x2) foster families tried to rape her. In '52 (26+26) when she was 26, her most cherished ambition of all was realized when she starred in a dramatic role and, in the first week at the Manhattan box office, the film grossed $26,000. Death came by her hand on the sixth day of August, the eighth month (6+2 for the last time).[3] This odd run of numerical coincidences only buttressed my fascination with the subject once I had become intrigued by the metamorphosis of her name itself.

From the letters of her original name someone drew—almost anagrammatically—those of her fame. Three were added; three were subtracted. Six again. In gray. Encircled by the telephone dial-like ring of her destiny and death (it was this instrument she was clutching), Marilyn is posed—in the cosmetic colors of her much-vaunted femininity—against the golden star of her dreams, though its tips, however, point to the letters I MOON [fig. 134]. Her stylized image comes, of course, from the famous nude calendar "Golden Dreams," which, upon finding by chance in a Greenwich Village shop called "The Tunnel of Love," I turned over and discovered that our last Goddess of Love had been printed in Indiana.

Excerpts from John W. McCoubrey, Robert Indiana, *exhibition catalogue (Philadelphia: Institute of Contemporary Art, University of Pennsylvania, 1968), 15, 20, 27, 36, 45.*

ARTIST STATEMENT, SÃO PAULO 9, 1967

USA 666 [fig. 99] is one of six paintings of the incomplete "Sixth American Dream" and it brings to the "Dreams" their starkest image: the unmistakable black and yellow high visibility reflex-making of the X-shaped railway crossing danger sign that punctuated the Indiana roads of my youth where instant death befell the occupants of stalled cars, school buses in foggy weather, or of autos racing into serious miscalculations before the onrushing always irresistible locomotive.

But *USA 666* actually comes from multiple sources: the single six of my father's birth month, June; the Philips 66 sign of the gasoline company he worked for—the one sign that loomed largest in my life, casting its shadow across the very route that my father took daily to and from his work and standing high in a blue sky, red and green as the company colors were at the time but changed upon the death of the founder of the company. (Which three colors make up half of the "Sixth Dream" series, as they are also predominant in the "LOVE" series, for they are the most charged colors of my palette, bringing an optical, near electric quality to my work.) It also conjures up Route 66, the highway west for Kerouac and other Americans for

whom "Go West" is a common imperative, whereas for the common cold it is "Use 666," the patent medicine that is the final referent and which on small metal plates affixed to farmers' fences—black and yellow—dotted the pastures and fields like black-eyed Susans in perennial bloom, alternating with even more ubiquitous Burma-Shave advertisements that brought elementary poetry as well to the farms and byways. In perhaps lesser profusion over the countryside bloomed the EAT signs that signaled the roadside diners that were usually originally converted railway cars of a now-disappeared electric interurban complex taken off their wheels and mounted on cement blocks when the motorbus ruined and put that system out of business in the thirties. In similar cheap cafes my Mother supported herself and son by offering "home-cooked" meals for 25 cents when Father disappeared behind the big 66 sign in a westerly direction out Route 66.

Originally published in São Paulo 9, *exhibition catalogue (Museu de Arte Moderna, São Paulo, 1967), 78–79.*

INTERVIEW WITH PHYLLIS TUCHMAN, 1974

Phyllis Tuchman Did you realize the image *Love* would be received differently than *Eat* or *Die* or *Hug*?

Robert Indiana When I did *Love*, I thought they were equal. I presumed it was one more word to fit into my visual vocabulary. I had no idea of what would happen. I've always been mystified that *Eat* and *Die* didn't catch on the way *Love* did. I find *Eat* and *Die* much more fun that *Love*.

Tuchman How do you determine whether an object works or doesn't work?

Indiana It's always been a matter of impact; the relationship of color to color and word to shape and word to complete piece—both the literal and the visual aspects. I'm most concerned with the force of its impact. I've never found attractive things that are delicate or soft or subtly nuanced. They're not unattractive to others, but I've never found them attractive myself.

Tuchman How did you arrive at your word constructions? Do you have models?

Indiana Material influenced content. The wooden beams were so narrow I could not have long words. So my visual vocabulary became terse and telegraphic. The constructions have three-letter words; once in a while, they go to four or five.

Tuchman Do you consider your word constructions sculptures?

Indiana Yes. Basically they're stelae. They're also herms. I had a great interest in classical art—the word forms are

based on the herm figure minus the heads. That came about gradually. They preceded my paintings. First the words appeared on the herms and then, as I began to be able to afford canvas and stretchers, the paintings happened—although they started out, as you can see, very small.

Tuchman Do you use a different strategy for sculpture than painting?

Indiana My polychrome sculptures are more of a challenge. There's more to do. My paintings are really rather simple and uncomplicated. Surfaces are easily arrived at. With my sculpture, I carved away relief letters; I bound the pieces in wires; I attached ropes and wheels. It's just a more involving medium.

Tuchman Do you still regard "the American Dream" as "optimistic, generous and naïve"?

Indiana The American Dream has gone enormously sour. It has become the American Nightmare. The phrase "The American Dream" relates to something my father had. He had an American dream that turned out to be hollow. Given the war and what's happening in Washington now, I think it is very difficult to be optimistic, innocent and naïve. The dream aspect of the American character is probably all washed under now.

Excerpts from Phyllis Tuchman, "Pop! Interviews with George Segal, Andy Warhol, Roy Lichtenstein, James Rosenquist, and Robert Indiana," ARTnews 73, no. 5 (May 1974): 24–29.

INTERVIEW WITH WILLIAM PETERSON AND BOB TOMILSON, 1976

Robert Indiana I became involved with *The Mother of Us All* because I've always liked Virgil Thomson. The opera, of course, that I knew was *Four Saints in Three Acts* because *The Mother of Us All* had never been recorded . . . The reason for the Model T Ford is another link. It goes back to the 1967 production in which, due to budget reasons and others, the only scenic prop was a Model T. The whole opera revolved around the Model T. But the Model T became associated with the work; it doesn't appear in the opera at all. A car is never mentioned. And Virgil is conservative enough as a composer and a man, he wouldn't put automobiles in his operas either. But it struck me that it was high time that opera caught up with the times, and an automobile can be there just as well as a knight with a sword or something.

William Peterson Did it have anything to do with suggesting the idea of using floats and movement in the settings?

Indiana Probably it did, because Peter Wood came to my studio and saw the Model T design from the '67 production at the Guthrie Theater. But I wanted to explain my

own link. I once did a realistic portrait of my mother and father which is hanging in the Philadelphia Museum right now. I used my family snapshots. Mother is standing in front of her Model T, and Father is in front of his. And [Gertrude] Stein's favorite possession in France was a Model T. So that was the link with the Model T, and to me if there's anything distinctively American, it's what happened here with the automobile. It's become a passion of our country. And if we're going to have an opera with passion, we are going to have some American passion. I've been involved with this opera for years. I would like to see it beautifully rendered musically and theatrically and everything else. And this production really works. It's the best that's ever been—that I've ever seen.

Peterson I was recently looking at the Gene Swenson interview with you back in 1963.

Indiana Gene was the first serious critic to both accept and be enthusiastic about my work. But, unfortunately, he got himself killed, so I lost my chief voice, and I've never developed any real critical support, which has been a great disadvantage actually. There have been very few articles or interviews of any depth since Swenson died. He wrote about three altogether.

Peterson I am also interested in Stein . . .

Indiana Well, my fascination with Stein is obviously that her tool was words, and in a sense—although I paint words—my tool is also words. All of my paintings contain words. And I come from a verbal background. As well as being interested in things from a plastic point of view, I have also been interested in writing.

Peterson You are also known as a concrete poet in many circles.

Indiana That's the way I would like for my work to be taken, but I don't think too many people are concerned about that. The main reaction is simply a put-down because of the relationship to Pop and so forth. Gene was very brave at the time—nobody liked Pop, everybody thought it was pure junk. And unfortunately, it simply turned the whole course of American painting.

[. . .]

Indiana I was an angry young man. And it was very depressing wanting to be an artist and finding the art world going in a direction which I couldn't follow. I never have been an Abstract Expressionist. And, of course, every young student was throwing paint around, and painting "In the manner of—." And that's what was so nice about Pop. All of those people just sort of sprang out of the terrain like new flowers. And you couldn't say: "Ah, Vermeer!" or "Rembrandt!" There wasn't a clear line, and it was really a new development. At one time it was going

to be called "New Realism." That title got dropped because "Pop" was too catchy. Unfortunately, I think the title did the work as much harm as it did good. It would have been better if the term hadn't been applied actually. First of all, Pop Art is not really very popular. It appeals to a wider audience than Abstract Expressionism, but then the Abstract Expressionists made a formidable dent in the establishment. But making people decide to put Pop over their fireplaces is another matter. A Monet *Water Lily* still looks better over a fireplace than a Coca-Cola bottle.

Peterson Would you prefer to be associated with a hard-edge attitude?

Indiana Surely, I'm a formalist. And the point is that I'm mainly concerned with the marriage of the visual and the verbal. So that makes working with an opera on the stage a natural. The only thing is, I don't want to cultivate it because it's exhausting, and it has taken an enormous hunk out of my life, and actually isn't a very profitable enterprise. I mean, it's far too much work for the return.

Bob Tomilson You seem to be an individual who is also rather sensitive to the political climate in the country.

Indiana Oh, yes. And the fun thing about that is that this opera is filled with it. Of course this is the struggle for women to acquire the vote. And 1920 on the statue is the year when the legislation was finally passed. Susan B. Anthony never lived to see it. But I've been asked by the Democratic Committee to do a poster or two for them, and since I'm Democratically inclined, I probably shall. The word "vote" is the most repeated word in this opera, and of course that's what [Jimmy] Carter's interest is—in getting out the vote. And he has asked me to design a poster for that purpose. I was going to sneak it into the opera, but common sense prevailed. It simply didn't look very 19th century.

Excerpt from William Peterson and Bob Tomilson, "Robert Indiana," Artspace 1, no. 1 (Fall 1976): 4–9.

INTERVIEW WITH DONALD B. GOODALL, 1976–77

Donald B. Goodall As we look around [at your paintings, we see that] you put yourself to a very substantial technical discipline.

Robert Indiana But that's more a conceptual discipline than it is an actual discipline. There's nothing virtuosic about my way of painting . . . Just walking a slow, straight path, I think. It might have something to do with serenity. Virtuosity seems to me to be the other side of serenity.

Goodall This series of sculpture pieces [referring to the herms in Indiana's living area] appeared fairly early in the sixties, right?

Indiana They started in the late fifties. Most all of them were begun in the late fifties—and when I say "late," that's really '59. They bear the dates of '60 or '61 or '62 because there was a process of change; that is, they only became what they are as time went on. They were not conceived either in polychrome or barren wood; they were found objects, and they were exercises in natural finishes like rust and patination of wood, and the harmonies were very close and very earthy.

I have always thought of my work as being celebratory. Let's say it's the three C's—commemorative, celebratory, and colorful.

Goodall Well, the found object in the herms—

Indiana It's archaeological. Oh, there're definite traces of our history and civilization. These pieces of wood served a very peculiar function on the waterfront in New York. Archaeologically they're very valid. They're a piece in a jigsaw puzzle, and nobody except di Suvero and myself decided to save them at first, and he's done so in a much different manner. These gorgeous pieces of wood were lying around for anybody to take and, as it turned out, very few people did.

Goodall You face out toward life . . . it seems to me you respond enough to what's going on around you that you adapt with really astonishing celerity to the things that you're interested in adapting to.

Indiana Well, I think that simply reveals a conflict . . . there is a conflict because it's like the role of an artist, period. That is, is an artist talking to himself, or is he trying to communicate to other people? I suppose he's doing both, but sometimes one doesn't know for sure which is more important. I really have tried to do both. And it also goes back to that kind of awkward statement about wanting to be a people's artist as well as an artist's artist. I think most of my peers, most of the serious artists that I've come into contact with, would be perfectly satisfied to be artists' artists and are really just plain disdainful of people and their lack of understanding and their prejudices. And I think I have a real desire to break through prejudice, if possible, not on the level of the popular artists, by meeting their requirements head on, but obliquely. The LOVE is certainly an exercise in that direction. It's had a frustrating aspect to it, but it never occurred to me that it would become the kind of popular thing that it is.

Goodall You said something yesterday about the transient exhibitions that you saw at the Art Institute [when you were a student].

Indiana There were just two—the Munch and the Léger. There was a third which, interestingly enough, actually had more of an influence on me, but it wasn't at the Art Institute. There was a show at the University of Chicago

at the Renaissance Society, and there was a show up in Evanston, probably at some gallery connected with Northwestern. This was Dubuffet. That was his period when he was working with sand; that really had a fascination for me. When I came back from Europe, where I did almost no painting at all, I was mixing sand in my paint and hammering nails into my canvas or my canvas board and doing all sorts of peculiar things, and that lasted for about a year.

Goodall On your move toward a hard-edge image: I would gather from what I've understood so far that artists who would lie behind that, if some do directly, would be Léger, Matisse, Calder, and Kelly. Is that fair?

Indiana Kelly, of course, played the most crucial role in that, being a personal friend, Kelly simply made me aware of the use of primary color and of hard edges . . . My paintings, I think, I approach from an architectural standpoint. My paintings are really built, and they're designed in the way an architect arrives at his buildings. My paintings are arrived at from patterns and (almost what you could call) blueprints much more than [those of] most other artists that I can think of, certainly more than Ellsworth Kelly. This has nothing to do with words; this is the other part of the painting.

Goodall It's the planning aspect.

Indiana Kelly is the [chief influence upon my] color. No one more impressed me with the use of primary color than Ellsworth. I never thought about color until I knew Ellsworth and heard his long discourses on the subject and watched his paintings being painted.

[. . .]

Goodall Tell me about The American Dream. This phrase—I associate it with your thematic concerns.

Indiana The phrase I knew all my life, and I certainly can't remember how I first heard it or whether it was something my mother and father referred to or simply whether it came via films or written things. But there's no question that the focus was brought into being with [Edward] Albee's play—my own first American Dream painting was done at the time of his play, for I saw the play and liked it very much; it was very much on my mind when I chose that particular topic . . .

The play certainly suggested that particular name for a painting. I had no idea that it was going to become the chief cycle of all of my work. It's become many, many paintings—when I did it, I didn't anticipate that at all.

Goodall How would you characterize the central thrust of this theme?

Indiana The first two or three Dreams I would say were cynical. I was really being very critical of certain aspects

of the American experience. "Dream" was used in an ironic sense. Then, as they progressed, they lost that irony; particularly with the fifth *Dream*, where I became involved with the imagery and the experience of Demuth. And the same is true of the sixth *Dream*. And, as the *Dreams* continue via the autobiographical series, negative aspects have pretty well disappeared. They really are all celebrations. It is a celebration of ten years of my life. [At first] they were, let's say, very caustic—that might be a better word than saying "cynical."

Goodall Well, they may well have been cynical at the time—

Indiana Well, [cynicism] came out of a life that had spent much of its time in the Depression, a broken home, and all kinds of difficulties—the war, etc. . . . But instead of being an idealistic thing, the "Dream" had been perverted into a very cheap, tawdry experience. And the whole Depression period was, from my standpoint as a child, bleak, cheap, and tawdry. My family was very badly affected by the Depression, and I was affected by it . . . life was so mean.

[. . .]

Goodall It seems to me you are actively engaged in ruminating over various aspects of your life and asking yourself about them.

Indiana Well, one thread that keeps very much alive is the fact that I've kept a journal ever since I was in high school, and I've always been interested in writing, and I suppose always in the back of my mind was [the idea that] one day I simply would put all those things together and there would be an Indiana book.

Goodall It seems to me that one of the things that draws people to your work is the coincidence of word and image.

Indiana Well, I think something that has come fairly recently and which I presume you might call a new theory about language in relation to man, is that language seems to be more of an inherited process than once was thought, that it is simply not a learned thing but is something which the human species is peculiarly not only adapted to but inclined toward and that there's some very special mechanical thing within our being which makes language part and parcel of being a man. I really think my preoccupation and my fascination with words and languages is geared to that thought: that is, that language is a terribly important part of our being humans and that its having been so divided and compartmentalized by people who have split up human intelligence has obscured the vital issue. And I think I would like in my work to undo that damage and to stress that aspect: [the feeling of] so many of my peers—other artists who really have absolutely no toleration for my work whatsoever—that the word is almost a nasty, dangerous, unlikely baggage for an artist. I find that overreaction not only bizarre but

distasteful, and I suppose it's been my endeavor to reverse that attitude. It's been a little bit of a private goal in my life, which goes a little bit beyond just being an artist. The world is so glutted with images and art and schools of painting and art history that it seems an appropriate time to approach the subject from a different aspect—that's all.

Goodall Does the thought begin to clarify itself as the image is shaped and the sounds of the word reverberate in your mind, or do you start in with a prefixed idea and then actualize it from there?

Indiana Well, the painting itself, the canvas and the paint and the stretchers and all that—by the time I'm ready to paint a painting it is prefixed. I have it all pretty well worked out in my mind. On some rare occasions I've made changes while painting, and this mainly occurs with color choices. I have changed colors on the canvas itself. It's desirable from just a technical standpoint not to be doing that if one is going to present the perfect kind of surface that I like to deal with. But from the standpoint of how the paintings come about: in the first place, I just suppose that we operate on a common cultural base. I'm always intrigued to study and know the reaction of people to my work—say, for instance, those who don't know English, and whether or not [that is] a disadvantage to appreciating my work. I've always felt that since I am a painter and since I've been trained as a painter and have a general artistic background, my paintings can stand on their plastic values as objects, which are intriguing enough for their own intrinsic color play, design, whatever; that the message, which I think is probably the easiest way to describe it, isn't absolutely necessary for appreciation of the painting itself. For me, the word—although it's central as far as I'm concerned—can simply be a reinforcement and isn't absolutely necessary for the viewer. After all, most of the people of the world don't speak English, and it would be a crippling kind of position to be in if it were that important.

[. . .]

Goodall Is it fair to say, or is it obvious to say, that pictures as different as *USA 666* [fig. 99], *The Melville Triptych* [fig. 60], *God Is a Lily of the Valley* [fig. 55], and *Terre Haute* [fig. 47] . . . all have narrative aspects?

Indiana They all have narrative aspects, but you hit upon a group of paintings which essentially are all different. *Terre Haute* is really what I would consider, for me, a landscape. *Terre Haute* is about geography. *Terre Haute* is probably one of my less autobiographical paintings. I've never lived in Terre Haute and never really had any particular Terre Haute experiences. The fascination there was simply the eccentricity of the fact that a little Indiana town would bear such a fancy name. But the *EAT/DIE*, of course, comes from a very private autobiographical situation,

and *USA 666* is very much involved with aspects of my family and my remembrances of my childhood. It really is part of the American scene. It is actually, of course, one of my paintings that I call *The American Dream. USA 666* is the Sixth Dream, and the Sixth Dream, since my father was born in June, is more or less involved with the memory of him. It was started after he had died, and six was a number that was very dominant in his life.

[. . .]

Goodall The words appear in your pictures at first, then, for their graphic value, or because you wished to bring in levels of suggestion.

Indiana No. No, they were very suggestive of important things in my life. It's a peculiar way to approach the subject and not one I would necessarily encourage, but it's still there, and that is [that] the brevity of my words was dictated by the shape of the wooden beams that I found, because that's where the words began. In other words, I couldn't use words of more than four or five letters. I think CHIEF was my lengthiest word. Those columns which I found in those demolished buildings around me on Coenties Slip—it's not something I invented; it's not a form that I particularly sought out; it was a form that was there for the taking. All I had to do was walk out and drag these things back into my studio. It was at a time when I was very, very low in the pocket, and this simply represented a raw material that I could use. Well, Donald, the fact that those beams come very, very close to the width of a tombstone and that I should have been early preoccupied with "Eat" and "Die" in that context isn't so unusual. And neither is it irrelevant that as a child I was fascinated with graveyards.

Goodall We're really [focusing] on the resources which your eye and mind were attracted to as a younger person.

Indiana In a sense I got down to the subject matter of my work, to its bare bones: the subject is defined by its expression in the word itself. I mean, *LOVE* is purely a skeleton of all that word has meant in all the erotic and religious aspects of the theme, and to bring it down to the actual structure of the calligraphy itself is like a skeleton. It's reducing it to the bare bones. It was really a matter of distillation.

Goodall Did your interest in poetry have anything to do with your [inclusion of words]?

Indiana That's another part of it. Not only poetry but also journalism—I was longer with journalism. And certainly with journalism one is faced with the problem of reducing something to its briefest form—in other words, to communicate. Poetry was like a frill. I became involved with poetry in Europe because at the University of Edinburgh in Scotland there was no climate to do any artwork. And I

just got involved with poetry. I pursued that when I came back to New York. In those first few years when I didn't have any money for either a proper studio or materials, I was writing more poetry than I was [doing] painting.

Goodall Well, the obvious question—did you feel that poetry was a temporary attribute of your interests and personality, or did you think of poetry as something you might turn to in the long run?

Indiana At the time, Donald, I was so discouraged with my own artistic activity. My four years at the Art Institute were very discouraging and disappointing, mainly because I did not find there an inspiring instructor. Obviously each instructor attracted people sympathetic to his own personality, but of all the instructors at the Art Institute, I didn't find one. It was very disappointing to me to feel that I had spent four years and didn't come out of it with the kind of experience I had expected. And it just didn't happen there. Neither did it happen in Europe, because there I got sidetracked altogether. I was working on academics to finish up a B.F.A. degree; it was only when I came to New York that just through personal friendships and so forth did I come into contact with people who really had an impact on my own development and [the] shaping of my own work.

Goodall Could you indicate the most important of those ideas and persons?

Indiana Only one such friendship and influence which was direct and complete . . . Ellsworth. Often his imagery was from his own private snapshots, photographs of shadows on buildings, of leafage and all kinds of natural things that occurred at different times of day in light and shade. He is essentially an abstract artist. I had a more literal mind and so, therefore, the influence cut off. I could never be happy—and I did many paintings influenced by Ellsworth—[but] I simply couldn't be happy with them. It wasn't enough for me. Many of those canvases got covered over with what has now become Indiana.

Goodall This suggests that there were levels of meaning which you were involved with which could not be communicated by a set of shapes or color relationships which you would want to explore.

Indiana It never excited me to that extent. There's endless play of color in my work. I'm as much concerned with color when I paint as I am with the word aspect, but when it comes to the play of forms, it's like my feeling about my own calligraphy. I early on decided I didn't want to be a letter designer. In other words, almost all my paintings are based on two basic fonts: one is a Gothic stencil and the other is a Roman stencil. And that came about because I found these brass stencils in my studio on Coenties Slip . . .

As a young man on Coenties Slip I was intimidated and affected adversely by that Europeanization. It was not only Ellsworth, but also Jack Youngerman . . . Remember [the Slip] just had three blocks, so I was sandwiched in between a very European, as far as I was concerned, mentality. This is one reason I connect Ellsworth with abstraction. To me, abstraction is not inherently American. Abstraction is much more European. I mean, after all, they've had time to work on these things longer than we have. And that's one reason why from Ellsworth I was really influenced technically only, and that is simply the flat application of paint and the use of hard-edge, the clear-cut delineation of color areas.

Goodall But didn't your color change, too?

Indiana That's when the sign manifested itself, because just by an incredible coincidence that is the way signs are, too. They're also flat with hard edges. A good sign is flat with hard edges. It doesn't have bumps and texture and all those subtle nuances one associated with European painting.

Goodall Would you think of the sign as essentially an American desideratum, since signs have been a part of our history since the 18th century?

Indiana I didn't think about it. I didn't sit down and work it out. But let's put it this way. If I was influenced by any signs, they were not European. They were certainly American.

Goodall Phillips 66 is closer . . .

Indiana It has more to do with my fascination with numbers which came out of a peculiar circumstance, and that is that my mother couldn't stand to live in one house for more than one year at a time. By the time I was seventeen years old, I had lived in twenty-one different houses. And so it got to be a kind of thing that this was house number 6 and this was house number 13. I was very concerned about it as a child, and I think that's where the fascination began.

Goodall What aspect of the number fascinates you most as you work with it?

Indiana Well, as I worked with the numbers, I grew away from the stencil. I made the statement earlier that all of my calligraphy is connected with either the Gothic or the Roman stencil. With the numbers that's not true. Now, I could have invented, I could have designed very fancy, handsome numbers myself. But again I chose not to. I simply found—I don't know if it was in the loft, but all I had to do was look in a stationery store—I simply discovered the businessman's calendar and thought that the numbers had a kind of robustness and a kind of, you know, crude vigor to them which I liked. And so all my

numbers paintings are based on the numbers from the businessman's calendar, a found object. I did, however, make certain refinements. It turns out that when you fit a given number in a circle, sometimes you have to tuck in a serif. And you have to squeeze in the bulge of a "5." So, although I didn't want to, I found myself refining these numbers. And, yes, I got fascinated with the play of the background against the foreground, of a "5" in particular. And that momentarily was fascinating, but that certainly is not what my number paintings are about. My number paintings are simply a celebration of the fact that we have something as marvelous as numbers and that they are an incredible invention and should be celebrated.

Excerpts from Donald B. Goodall, "Conversations with Robert Indiana," in Donald B. Goodall, Robert L. B. Tobin, and William Katz, Robert Indiana, exhibition catalogue (Austin, Texas: University Art Museum, University of Texas at Austin, 1977), 25–41.

INTERVIEW WITH BARBARALEE DIAMONSTEIN, 1978

Barbaralee Diamonstein Perhaps we should begin by your telling us how you happened to create *LOVE*.

Robert Indiana Well it all started, Barbaralee, a long, long time ago. And it, it comes from a, of course, a spiritual rather than erotic beginning. When I was a child I was exposed [to and] involved in the Christian Science church. And all Christian Science churches are very prim and pure. Most of them have no decoration whatsoever—no stained glass windows, no carvings, no paintings. And, in fact, only one thing appears in a Christian Science church, and that's a small, very tasteful inscription in gold, usually, over the platform where the readers conduct the service. And that inscription, of course, is "God Is Love."

Well a few years ago, in the mid-sixties [Larry Aldrich] . . . had the inspiration to expose his rather large private collection to a broader public. And there happened to be a building available which had been, oh, a grocery store [that] sometime in the twenties became a Christian Science church. Then the Christian Scientists wanted better facilities so built themselves a new church next door.

I was at a party at Andy Warhol's old Factory, when it was near the U.N., and Aldrich was there. I didn't know him very well, but well enough to confront him. I was a little piqued because he had no Indiana, and I thought he should. And I told him that an excellent opportunity was forthcoming for a special Indiana because, since he was making his museum in a former Christian Science church, I had an idea to do a special painting for him. And that was the reversal of the religious motto; I made a painting which read "Love Is God" instead.

Although the *Love Is God* canvas bears no relationship to what now has become a logo, it started me thinking

about the subject of *LOVE*. And I had been at one time employed, in the dark days when things weren't going so well, as a typist to the man who was to become the bishop of California. And that man, of course, is Dean [James A.] Pike, later Bishop Pike. He, of course, was greatly involved with the subject of love, particularly from an ecclesiastic standpoint.

All these things kind of came together. And since I like to work on a square canvas, and since the way I put the letters down it is the most economical, the most dynamic way to put four letters on a square canvas—

That is how the *LOVE* came about . . .

When I did the first *LOVE*, or the first *LOVE*s, no, I wasn't thinking at all about what would happen. However, just as I was tackling the subject, I was invited by the Museum of Modern Art to design a postcard to benefit the Junior Council and therefore the museum. And on my desk at that particular time, or on my painting table, were *LOVE*s that I was doing, and the thought occurred, What better subject for a Christmas card? That Christmas card at the Museum of Modern Art became the best-selling Christmas card that they were ever to commission.

Diamonstein Why did you tilt the *O* in *LOVE*?

Indiana That was part of the most dynamic arrangement, I believe. I never paint with stencils, but I design with stencils, nineteenth-century brass stencils. And when I was playing with the stencils, this was certainly the most effective and most dynamic way to arrange them. You can't really play with the other letters. The *O* is playable. However, that was not an invention of mine. The tilted *O* is a very common typographic device, and though I've never been per se interested in typography, I do know a little bit about it . . .

LOVE looks like a typographic exercise, but in most of my other paintings, I don't think that necessarily comes to mind, because in all of them except the *LOVE* there's more play of composition and forms and shapes. The words usually occupy a much less dominant position.

Diamonstein Have you benefited by this mass commercialization of *LOVE*? What royalties have accrued to you?

Indiana Well, most of the *LOVE*s that people see probably are rip-offs—hippie patches and wastepaper baskets and wallpaper, and what have you. Nothing of that ever comes to me. The postage stamp is obviously the biggest burden. Out of 333 million stamps [issued on Valentine's Day 1973], I collected a designer's fee of $1,000.

Diamonstein Obviously your work, that work was not copyrighted. Is that correct?

Indiana That was the initial problem. With the copyright laws, every single thing has to bear the copyright notice.

Well, when I first did my *LOVE*s, the thought never occurred to me. Then, when I tried to protect myself by putting the notice on things, it was already too late, because if one is in circulation, it already becomes public domain . . . I'm not a fighter, and I don't like to go to court about anything, so I just let it go.

Diamonstein How do you compare your life as Robert Indiana to that of Robert Clark?

Indiana Well, Robert Clark didn't really exist artistically. It happened at a psychological moment when, after struggling as a student, struggling for my own artistic identification, not for the main identity itself, things were just coming together. I could feel that something was going to be happening very shortly, and I didn't want to have something nice happen with the burden of a name that I didn't like. And it was just like going through a revolving door from night into day. The first thing that happened, of course, was simply the very first major painting that was sold in New York was sold to the Museum of Modern Art . . . it was a incredible stroke of luck. You know, there is a magic, there's a definite magic to names.

Diamonstein Can you tell us about that?

Indiana Picasso was a name changer, too, having started out in life as Pablo Ruiz. Some of his early canvases were signed Pablo Ruiz. I can't imagine that a man could have achieved what Picasso achieved with an unpronounceable name, at least for the English, and the change certainly was magical for him. It was also extra magical because the PP, Pablo Picasso, back to back, is a mirror monogram. And, just by coincidence, he was born in 1881, which is one of those rare mirror dates that anyone can be born on, so I would say somewhere up there the stars were fixed for him.

[. . .]

Indiana [I found beams from debris of old buildings that] had this peculiar shape on the top, which is called a haunched tenon, which is simply the key for fitting one beam into another beam. There would be the female piece, and there would be the male piece here, and the two would lock together thanks to some very skilled rudimentary carpentry provided by Scandinavians at that time. I set them upright, and they really did look like hermae, the classical marble sculptures which would be set at roadsides and so forth, as road markers to the next town. I'd studied Latin for four years in high school and was very interested in the classical period. I thought I was updating the herm, for in those days you had to really think hard, because everybody was doing something, and if you wanted to be original or contribute something fresh, you really had to scrape pretty hard.

Diamonstein Those hermae, or wood constructions, did you consider them sculpture?

Indiana They were not only sculpture in themselves . . . then the beam itself had the female indentations in it, into which the other part would fit. And then I myself took a knife, and I made extra carvings on these pieces. As I said, they were very beautiful pieces of wood. I used only rusted iron. I put rusted wheels on them and various other elements. I grew a little weary of that because, as you can see, I do like color.

And so, around 1959, color started to appear on these early constructions. Somehow, polychrome sculpture is not, or at that time wasn't, too abundant. That was rather a different approach. And the word appeared. Now, exactly why the word appeared, I'm not sure, but after all I was basing them on hermae, and hermae were the road signs of antiquity; my hybrid accepted the cross-fertilization of our own contemporary American road signs. Since columns are about this wide, the word couldn't get much longer than "love," but most of them were really three-letter words: "eat" and "die" were two of my favorite words at that time.

Diamonstein Did you ever expect the media to proclaim the adventures of that group that became known as Pop the way they did?

Indiana Actually, we were not a collective; we were all different artists. Some of us knew each other, and some of us didn't. And for a while, in the beginning, it was called "New Realism"; that was particularly the European name for it. In other words, people who were obviously rebelling against Abstract Expressionism. Here was the image again in art. This time blatant and abrasive and to most people, absolutely obnoxious. It just made them sick when they saw it, it was so awful. One young critic, Gene Swenson, who was my chief supporter, decided to call it "sign painting." *I* fit that perfectly. For someone like Lichtenstein, it wasn't such a good appellation, however. With Warhol and all his labels and so forth, it wasn't such a bad one.

Diamonstein Why don't we talk for a moment about the auto-portraiture that characterizes a great deal of your work, particularly that sequence known as *The American Dream*.

Indiana In an exhibit in 1972, there were ten paintings being exhibited called *Decade: Autoportraits*, and in a sense this series is an extension of my *American Dream*, and my *American Dream*s are, after all, *my* American dreams and how I relate to that whole business. The auto-portraits stem from that, mainly from a form aspect. How the canvas is devised is very close. The auto-portrait, the decade, is the ten years of the 1960s; probably for me, as for any person, a certain decade is the most meaningful

one in one's life. I don't think any other decade will mean the same thing to me as the sixties did.

Diamonstein In that particular series, there is an almost obsessive dovetailing of references, cross-references, all sorts of sequential symbols.

Indiana The first, of course, is the circle, and for some reason it goes back to the childhood experience with Christian Science. Everything begins with the circle.

Diamonstein Is there a circle in every work?

Indiana Almost every . . . As a child, I was hit over the head with this hammer which said that the circle is the symbolization of eternal life. So we start with eternal life, because we all just know it goes on and on forever, and of course, cast in the circle is a decagon, and I'm very fond of geometry. The decagon says decade. Within the decagon, hitting every other point, is the five-pointed star, which, I assume, is the American symbol. If one is going to be an American and talk about things American, one has to have a star someplace . . . Then, cast on top of those is the number one. I am absolutely intrigued with numerals, this coming from the fact that when I was a kid, before I was seventeen years old I had lived in twenty-one different houses. I had a mother who was an absolute gypsy. She couldn't bear to live in a house for more than a year at a time. So that was House Number Five, and this was House Number Seventeen, and I just got this thing about numbers. Number one is there because, after all, it is a self-portrait, and that is what one is all about.

Diamonstein Can we go through some of the sequences of [those ten years of the 1960s]? Beginning in 1961?

Indiana Well, 1961 is when it all really started to happen. In my own mind there's a great kind of jumble and confusion. I can pick out highlights. For instance, the word "die" does appear frequently, and it appears in a year, say, like 1963, when there was a major assassination. It might also appear in another suite the year that my father died. My red, blue, and green 1966 goes back to the *LOVE*. My *LOVE* show was in 1966. My father was born in June, the sixth month, into a family of six children. He worked for Phillips 66 and left my mother and went to California via Highway 66, passing all those little signs that said "Use 666," which was a cold remedy. I do get caught up with very commonplace, everyday visual things like that.

Diamonstein Why is death such a recurring theme in your paintings?

Indiana Remember, if you have any knowledge of Christian Science, that there is no death, and that made a rather odd impression on me, because I really couldn't quite buy that—it was difficult when all the members of my family were passing away like flies. So it was an irony

which was on my mind, you see. If you weren't raised as a Christian Scientist, it might not be so strange.

Diamonstein How do you paint, by the way?

Indiana I paint flat. I have a painting table. I do not use an easel. And my paints are mixed, so that they're the consistency of rather heavy cream. And I paint without masking tape or any devices like that. I don't use the stencils for painting. Each stroke is put down by hand . . . Both temperamentally and artistically, I'm hard-edge, with maybe some soft parts here and there . . . I'm a colorist. I'm not interested in gradations of tone. Color is what I consider my forte.

Diamonstein What is your most prized possession?

Indiana My most prized possession is probably my studio in Maine. It's a marvelous old nineteenth-century Odd Fellows hall on an island in Penobscot Bay, and that happens to be the island—Vinalhaven—where the granite towers of the Brooklyn Bridge come from. And since for eight years I used to look out of my window every day and see the Brooklyn Bridge, it's nice now to have a studio in the home of the Brooklyn Bridge. And [it's] an old Odd Fellows hall, which means three rings over the doorway, and the first ring is friendship and the third ring is truth and the middle ring is love.

The man who introduced me to Vinalhaven . . . was Eliot Elisofon. When I graduated from the Art Institute in Chicago, I received a scholarship to the Skowhegan School, a summer school in Maine. I went to dinner one evening at Skowhegan; Elisofon [invited me to come to the island he lived on, Vinalhaven,] and I saw this old wreck of a building . . . It turned out that in two weeks he had bought it for me so that I could use it as a studio . . . I finally have a home away from home.

Diamonstein Can you tell us about *The Mother of Us All*?

Indiana My involvement started with my 1964 show at the Stable Gallery—it was my second one-man show. I wanted to have a little bit more than a table with a few glasses of wine and cheese. I wanted to have a gala opening, and what I really wanted was a musical opening. That came to me because when I looked around at my work in the studio before it went to the gallery, I realized that by some peculiar chance, the theme of every painting for that 1964 show was a theme that Virgil Thompson had dealt with. Now I had known Virgil's music since my art school days in Chicago. So, in 1965, I started working on sets and costumes for *The Mother of Us All*, and I've done two productions, one at the Tyrone Guthrie in Minneapolis and finally the one in Santa Fe last summer . . . My work reached its culmination there.

Diamonstein Getting back to *LOVE*, how has it affected your life?

Indiana What has happened with the *LOVE* has been one of the tragedies of my life. It has caused me probably much more damage than it has done me good, and that is on the very top professional level.

In other words, if you can project yourself into the minds of other artists, people are human, they're envious, they're jealous. Everyone just assumed that I was an instant millionaire from *LOVE*, because everybody assumed that I was raking in incredible profits from all the dispersion of this image. That was not the case.

And on the top professional levels . . . it's very understandable that their reaction to something like this would be very dim and not approving at all. And that's exactly what the case was . . . Before the *LOVE* took place, almost all my major work went directly into museums. Now, I don't know why I was so lucky, but that's what happened. After the *LOVE*, that whole pattern changed. I feel that, because of the degrading things that took place with the subject I was most involved with, my reputation as an artist has suffered.

Diamonstein Do you feel you've gotten the kind of critical attention that your work deserves?

Indiana I personally have not One of my disadvantages is that the very first person who took my work seriously, [Gene Swenson], and he happened to be the first American critic who took Pop seriously, had to go and get himself killed. I should have had other critics interested in my work. Part of the problem is simply . . . how important is it to make contact with the art community? I am not a gregarious person. I spend most of my time at home in my studio . . . However, one had to find some kind of interlocking, professional human relationship just to get the cart moving, shall we say. One can fill up one's studio with X number of paintings, and then either they go someplace or you have to move.

Excerpts from Barbaralee Diamonstein, "Interview with Robert Indiana," in Inside New York's Art World *(New York: Rizzoli International Publications, Inc., 1979), 151–66.*

INDIANA'S ANSWERS TO QUESTIONS BY MARTIN DIBNER ON THEMES IN HIS ART, 1982

The American Dream The idea of the first *Dream* happened very early on. It's a pivotal canvas and a crucial one to me. It changed the entire course of my life and forms a bridge with my earlier work. My paintings now tend to be very bright and high-colored. The *Dream* is still dark and full of the blackness of the paintings I did when I was very depressed upon my arrival in New York. It's a comment on the superficiality of American life; its images are taken from pinball machines and the neon glare and the road signs of America. When I did that painting, I had no idea

its theme would occupy most of my life. The first *Dream* led into the second and the second into the third and so on. The work I'm doing now, my *Auto Portraits*, I regard as an extension of the *Dream* series—my own personal American Dream. In other words, they have become self-portraits. I think of myself first of all as an American, then as an American painter painting an American theme. And this will continue.

Numbers Numbers fill my life. They fill my life even more than love. We are immersed in numbers from the moment we're born. Love? Love is like the cherry on top of the whipped cream. Our very lives are structured on numbers. Birthdays, age, addresses, money—everywhere you turn, there are numbers. Your shirt has six buttons. The room has four walls. Numbers surround us. It's endless. Now you may not be intrigued by this, but look at those who are mathematically inclined. Take the astronomers. How many numbers have the astronomers got? My God, the universe is a veritable sky full of numbers for them. If you happen to feel that love is as equally important as numbers, then you're an idealist, a dreamer. Everything we do is reckoned by numbers. Every day, every minute of every day—here, look at my wrist watch. Every second is a different number. Numbers are seething around us. Don't you recognize them?

LOVE I had no idea *LOVE* would catch on the way it did. Oddly enough, I wasn't thinking at all about anticipating the Love generation and hippies. It was a spiritual concept. It isn't a sculpture of love any longer. It's become the very theme of love itself.

Mother and Father Well, I'm very interested in art history and the painting that inspired me to do *Mother and Father* was Arshile Gorky's beautiful, beautiful canvas at the Whitney Museum of American Art that shows him as a small boy with his mother [*The Artist and His Mother* (fig. 88)]. It occurred to me that artists have frequently done portraits of their fathers or their mothers, but very rarely in art history do you find a double portrait. Given that I am indulging myself in art history, it also occurred to me to revive the half-draped figure, and in a sense, my mother is simply a very classical half-draped lady. As to why, in the 17th and 18th centuries, ladies wanted to have their paintings painted with their bosoms exposed, I do not know, but I do know my mother was not very Victorian; she was more of a Restoration type. She was a very warm, sensuous and alive human being, whereas my father was kind of a cold fish. It's a very loving portrait. The main criticism against the *Mother* painting is that people suspect a lack of respect on my part. They believe a well-brought-up young person wouldn't depict his mother in such a way. Indeed, I have hoped to give her immortality.

Excerpts from Martin Dibner, "Introduction," in Marius B. Péladeau and Martin Dibner, Indiana's Indianas: A 20-Year Retrospective of Paintings and Sculpture from the Collection of Robert Indiana, *exhibition catalogue (Rockland, Maine: The William A. Farnsworth Library and Art Museum, 1982), 1–10.*

EDITOR'S NOTES

1 Indiana misstates the number of states that seceded from the Union; there were eleven.

2 While *The Misfits* was indeed the final film made by both Gable and Monroe, Clift would go on to appear in at least three more films before his death in 1966.

3 Monroe's celebrity and the subsequent public fascination with her death has led to numerous accounts of her life, many contradictory and some with the appearance of sensational embellishment. How many foster families she lived with and at what age she became the victim of sexual assault are subject to debate. Monroe's starring role in *Don't Bother to Knock* in 1952 was her first dramatic lead. She died on August 5, not August 6, 1962.

FIG. 169 Robert Indiana at his Coenties Slip
studio with *Eat/Die* (1962) on the wall, 1963.
Photograph by William John Kennedy

CHRONOLOGY

1928

September 13. Robert Earl Clark is born in New Castle,
Indiana; soon thereafter he is taken to Richmond,
Indiana, to live with caretakers until his adoption by
Earl Clark and Carmen Watters Clark, who reside in
Indianapolis, where Earl works as an executive for the
Western Oil Refining Company. Owing to what Indiana
would later call his mother's "wanderlust," the family
moves repeatedly; Indiana later says he lived in twenty-
one houses before he was seventeen.

1929

Shell Oil purchases Western Oil. A few years later,
Earl loses his job, and the family is forced to abandon
their home and move to a dilapidated farmhouse in
the country. Earl briefly finds work pumping gas at a
filling station.

1933

Earl secures an administrative job at Phillips Petroleum
Company, where he works for the next twelve years.
The family temporarily moves back to Indianapolis, but
they never recover financially.

Summer. Robert travels with his parents to the Chicago
World's Fair and, in subsequent summers, to Alabama to
visit paternal relatives (1936) and to Fort Worth, Texas,
to see the Frontier Centennial Exposition (1937), trips
that contribute to his memories of a childhood spent
in transit.

1934

Fall. Underweight and nearsighted, Robert is deemed
too ill to enter first grade. His parents attribute his poor
health to fumes from the city's automotive plants, and
the family moves to a farm near the small town of
Mooresville, twenty miles southwest of Indianapolis.

1935

September. Enters first grade in Mooresville where
recognition of his artistic talent by his teacher, Ruth
Coffman, reinforces his decision to become an artist.
Halfway through the school year, the family moves into
Mooresville proper, into a house on Lockerbie Street.

1936

September. Skips second grade; family moves three times
during the school year, causing Robert to relocate to three
different schools.

FIG. 170 Cumberland,
Indiana, c. 1912. Indiana
Historical Society, P0391

1937

Family moves near Cumberland, a rural town east
of Indianapolis where Robert attends school for
three years.

1938

April. Engaged in a custody dispute, Robert's maternal
aunt, Roberta (Ruby) Watters, murders her mother-in-law
in South Bend, Indiana, after accusing her of kidnapping
her two young children. Carmen travels to testify on
Ruby's behalf at the trial, which ends in an acquittal
based on a defense of temporary insanity. While Carmen
is away, Robert lives with his paternal aunt and uncle
on their Martinsville farm. With his family gone, Earl
becomes involved with a younger woman, Sylvia.

July. Earl leaves Carmen for Sylvia, who becomes his
third wife. For the next few years, Robert lives with his
mother near Cumberland during the week and sees Earl
and his new wife in Indianapolis on weekends; his mother
supports herself by working in small restaurants and
roadside cafes.

1940

Carmen marries Foster Dickey, a custodian at the
officers' club at Fort Benjamin Harrison Army base
in Lawrence.

September. Enters Lawrence Junior High; attends the
school for two years.

1941

Spring. Wins first prize in the Marion County seventh-
grade essay competition for "A Covered Bridge," a poetic
description of a local bridge.

1942

September. Moves to Indianapolis to live with his father and his new family in order to attend Arsenal Technical High School, known for its strong art department. He does not see his mother for the next three years. To contribute to the family income, he works after-school jobs throughout high school, first delivering poultry and then as a messenger for Western Union. In his junior year, he takes a job as a runner in the advertising department of the *Indianapolis Star*.

1944

Studies at Arsenal Tech with Sara Bard, an exhibiting watercolorist from Philadelphia, during his last two years in high school.

Summer. Attends summer school to partially fulfill his science requirements in order to spend more time in Bard's class during the school year.

1945

Carmen's husband loses his job, and they move to Indianapolis. Robert leaves his father's house and moves in with them in a small bungalow in a predominantly African American part of town.

Attends figure-drawing classes on Saturdays at Indianapolis's John Herron Art Institute on a scholarship from the institute.

ROBERT E. CLARK

FIG. 171 Yearbook portrait of Robert Clark (Robert Indiana), Arsenal Technical High School, 1946

1946

June. Graduates from Arsenal Tech: valedictorian, photographer and photo editor of the class yearbook, captain of the honor society (The Tech Legion), staff member of the school newspaper, and recipient of medals in Latin and English. He gifts the Latin department his five medieval-style parchment illustrations of the Second Chapter of Luke from the King James Bible.

Receives a Scholastic Art and Writing Award to attend the John Herron Art Institute; chooses instead to enlist in the U.S. Army Air Corps (which would become the U.S. Air Force the following year) at Camp Atterbury, Edinburgh, Indiana.

September. Begins a six-week basic training course at Lackland Air Corps Base, San Antonio, Texas; becomes ill after a few weeks and is reassigned to another unit after recovering.

Fall. Takes a ten-week technical training course in typing at Lowry Field, Denver, Colorado.

FIG. 172 Robert Clark (Robert Indiana), Second Chapter of Luke from the King James Bible, 1946. Watercolor on parchment, dimensions unknown. Latin Department, Arsenal Technical High School, Indianapolis

1947

Stationed at New Mexico's Hobbs Army Airfield, an aircraft storage facility since 1945; teaches typing and starts a mimeographed newspaper for the base to replace its previous newspaper, which had been suspended.

1948

May. Sent to Griffiths Air Force Base, Rome, New York, following the decommissioning of the Hobbs airfield; assigned to the Public Information Office while awaiting permanent assignment. Attends an evening class in Russian at the Utica branch of Syracuse University and art classes at the Munson-Williams-Proctor Institute, Utica.

1949

January. Volunteers for assignment to Fort Richardson, Anchorage, Alaska, the only post available at the time outside the contiguous forty-eight states. Stops in Los Angeles en route to see his father, who had moved there with Sylvia before Robert graduated from high school; it is their last visit before Earl's death in 1965 in Florida. While stationed at Fort Richardson, Robert edits the base's newspaper, the *Sourdough Sentinel*.

August. Receives an emergency leave to visit his dying mother, who had been living in Columbus, Indiana, in a house without a kitchen or hot water while running a bakery with her husband. Robert arrives minutes before her death. Finishes his last month of duty at Wright-Patterson Air Force Base, Dayton, Ohio; while he is there, his stepfather dies.

September. Discharged from the Air Force. Enters the School of the Art Institute of Chicago under the G.I. Bill, majoring in painting and graphics. Active in the Zeta chapter of Delta Phi Delta, a national honor art fraternity. During his four years at the school, he supplements his stipend from the G.I. Bill by working nights taking inventory at Ryerson Steel and later for the Marshall Field & Company department store, and working part time at the Ryerson Library at the Art Institute; spends one summer illustrating the classified section of the phone book published by the R. R. Donnelley Print Company.

FIG. 173 Indiana stationed at Hobbs Army Airfield, Hobbs, New Mexico, 1947

Fall. Elected president of the Zeta chapter of Delta Phi Delta.

1953

March. Exhibits figurative paintings in a three-person exhibition with Claes Oldenburg and George Yelich at Club St. Elmo, a restaurant on North State Street in Chicago's Near North neighborhood.

Spring. Organizes the annual Art Students Costume Ball, sponsored jointly by Delta Phi Delta and the Art Students League, at Cyrus McCormick's deserted mansion.

June. Wins a cash prize of $1,250 as the recipient of one of the Art Institute's seven Foreign Traveling Fellowships, along with a scholarship to attend summer classes at the Skowhegan School of Painting and Sculpture, Maine.

Summer. Studies at Skowhegan with Henry Varnum Poor, under whom he completes two frescos: *Pilate Washing His Hands* and a memorial to soldiers who died in the Korean War. Receives the school's Fresno Prize for the latter.

Fall. Sails on the S.S. *United States* for England, intending to enroll at Oxford or the University of London to fulfill academic requirements for his bachelor of fine arts; enrolls instead at the University of Edinburgh, where he augments his studies by writing poetry, which he illustrates and hand-sets at the Edinburgh College of Art.

December. Embarks on a four-week visit to Paris, punctuated by a trip to the cathedrals of northern France and Belgium with three post-graduate American art historians from the University of Chicago, one of whom, Bates Lowry, would later serve as director of the Museum of Modern Art.

1954

Spring. Takes a month-long trip around Italy.

June. Receives, in absentia, his B.F.A. from the School of the Art Institute of Chicago.

Summer. Attends a six-week, nonacademic seminar on English seventeenth- and eighteenth-century art, music, and literature at the University of London on the G.I. Bill.

September. Arrives in New York; without funds to return to Chicago, he rents a room in Floral Studios, a seven-story residential hotel at 325 West 56th Street that caters to artists. Concentrates on writing poetry.

1955

Finds a part-time job selling art supplies at E. H. & A. C. Friedrichs Company on West 57th Street for $20 a week; works there for three years.

Summer. Sublets West 64th Street loft of Paul Sanasardo, a dancer and former classmate from the Art Institute, while Sanasardo is on tour; executes expressionist portraits of friends.

Fall. Moves into studio at 61 Fourth Avenue in Greenwich Village, the center of Abstract Expressionism; executes dark, allegorical heads influenced by Jean Dubuffet.

1956

Mid-June. Meets Ellsworth Kelly.

June 30. On Kelly's recommendation, moves into a cold-water loft on the top floor of 31 Coenties Slip, a three-block-long area on the East River at the southern tip of Manhattan. A few weeks later, Kelly moves into a nearby loft at 35 Coenties Slip. Within the year, the area's cheap rents attract other artists: Agnes Martin, Lenore Tawney, Ann Wilson, fashion designer John Kloss, and Jack Youngerman along with his wife, Delphine Seyrig, and their son, Duncan. In 1960, James Rosenquist and Charles Hinman move to the area.

Fall. Cy Twombly uses Indiana's loft during the day to prepare for his upcoming show at the Stable Gallery; he leaves several canvases behind, covering their still-wet surfaces with newspaper. Indiana uses these as the ground for abstract, textured paintings.

1957

Spring. Facing the imminent demolition of his studio building, Indiana relocates to 25 Coenties Slip.

Begins oil paintings on paper of a doubled ginkgo leaf in hard-edge style; works on the series for ten months. Due to the paper's impermanency, few survive.

Winter. Offers life-drawing classes with Jack Youngerman on the first floor of Youngerman's building at 27 Coenties Slip under the auspices of the Coenties Slip Workshop; the classes fail due to the inaccessibility of the neighborhood and the inability to adequately heat the space.

1958

January. Takes a part-time secretarial job at the Cathedral of St. John the Divine typing the correspondence of the dean, James A. Pike, and proofing Edward N. West's *The History of the Cross*, illustrated by Norman Laliberte.

Spring. Pieces together forty-four sheets of paper that he found in his loft and begins work on a nineteen-foot-long painting, *Stavrosis* (Crucifixion).

Fall. Takes over Jack Youngerman's class teaching art to children in a private home in Scarsdale, a suburb of New York; the following year, he teaches adults.

Upon completion of *Stavrosis*, changes his name to Robert Indiana.

1959

January. Ceases working at the Cathedral of St. John the Divine.

Executes several biomorphic abstractions in three or four colors on Homasote.

Begins to paint circles (orbs) and rectangles on raw plywood using white gesso. Soon thereafter, begins a series of hard-edge, polychrome abstractions of orbs on Homasote.

November. Starts his first assemblage, *Sun and Moon* (1959–60), out of rusted metal and discarded wood salvaged from Coenties Slip; several more wall-hanging assemblages follow, after which he begins making freestanding constructions out of wooden beams salvaged from buildings on Coenties Slip being demolished. Indiana calls these sculptures "herms," after the ancient *hermae* pillars that marked boundaries and served as milestones in the ancient world, attaching discarded wheels and painting single letters and numbers on them using die-cut, brass stencils found in Lenore Tawney's loft.

June. Rolf Nelson, a Coenties Slip neighbor and director of the Martha Jackson Gallery, includes Indiana's herm *French Atomic Bomb* in the gallery's *New Forms–New Media* exhibition; the piece is purchased and later gifted to the Museum of Modern Art.

Begins to paint single words of three and four letters in bright colors on his extant and new herms.

Makes a single sculpture out of a round wooden column salvaged from Jack Youngerman's Coenties Slip building, which is being demolished; names the work *Duncan's Column* (1960/62) after Youngerman's son. In 1963, when rectangular wood beams become hard to find, Indiana will begin a second group of sculptures made out of other wooden columns he scavenges from the neighborhood.

October. Adds words and phrases to previously abstract, polychromatic orb and ginkgo paintings.

Executes his first single-word paintings; includes one of them, *FUN*, along with recent wood constructions in a three-person show with Steve Durkee and Richard Smith, two Coenties Slip neighbors, at Paul Sanasardo's dance studio in March.

May. Exhibits herms and six paintings in a two-artist exhibition with Peter Forakis at the David Anderson Gallery; after the show closes, Alfred Barr, director of the Museum of Modern Art, purchases *The American Dream, I* for the museum's permanent collection, launching Indiana's career.

July. Begins a series of paintings incorporating lines of texts from American writers Herman Melville, Walt Whitman, and Henry Wadsworth Longfellow.

October–November. The Museum of Modern Art includes Indiana's herm *Moon* in its exhibition *The Art of Assemblage;* the work is acquired by the museum out of its Philip Johnson Fund.

FIG. 175 Robert Indiana in his studio on Coenties Slip, New York, 1965. Photograph by John Ardoin

December. The Museum of Modern Art includes *American Dream, I* in its exhibition *Recent Acquisitions: Painting and Sculpture*; the work is prominently featured in press accounts of the show.

1962

October. Eleanor Ward holds Indiana's first solo exhibition at her Stable Gallery. That same month at his eponymous gallery, Sidney Janis includes *The Black Diamond American Dream #2* in his *New Realists* exhibition, which announces the arrival of Pop art as a movement; over the next several years, Indiana exhibits in most of the major Pop art exhibitions.

Indiana donates *Yield Brother* (1962) to the Bertrand Russell Peace Foundation in support of its anti-nuclear program, the first in a series of donations to the foundation.

1963

Designs costumes for James Waring's experimental dance "At the Hallelujah Gardens," performed by Fred Herko at the Hunter Playhouse, Hunter College, New York, on February 3.

May. The Museum of Modern Art devotes an entire room to Indiana's work in its exhibition *Americans 1963*, further solidifying his reputation.

October. The Walker Art Center, Minneapolis, becomes the first museum to present a full survey of Indiana's work, in a two-person show with Richard Stankiewicz; the show travels to the Institute of Contemporary Art, Boston.

December. Exhibits for the first time in the Whitney Museum of American Art's annual exhibition of contemporary American painting.

1964

Collaborates with Andy Warhol on *Eat*, a thirty-five-minute film of Indiana eating a single mushroom. Warhol's decision to assemble the film's rolls nonsequentially makes the action mysterious, as if the mushroom magically renews itself from time to time.

Donates *The Black Yield* (1963) to CORE (Congress on Racial Equality); donations of two other paintings follow in 1965 and 1966.

The Albert A. List Foundation commissions Indiana to design a poster for the April 23 opening of the New York State Theater, Lincoln Center.

April–October. Exhibits *EAT*, a twenty-foot-square electric sign commissioned by Phillip Johnson for the curved facade of the Theaterama, one of the three components of

FIG. 176 Indiana appearing in Andy Warhol's film *Eat*, 1964. Film stills. The Andy Warhol Museum, Pittsburgh

FIG. 177 Indiana (left) and Andy Warhol in Warhol's studio on East 47th Street in New York, 1964. Photograph by Bruce Davidson

the New York State Pavilion at the New York World's Fair. Nine other artists, including Roy Lichtenstein, Andy Warhol, Robert Rauschenberg, and James Rosenquist, exhibit works on the pavilion's curved facade as well. The installation marks a major moment in the public reception of Pop art.

May 12. The Stable Gallery opens its second solo Indiana exhibition on Mother's Day with a concert of Virgil Thomson's music; the show features *Mother and Father*.

1965

Virgil Thomson asks Indiana to design the costumes for the UCLA Opera Workshop production of *The Mother of Us All*, scheduled to open May 13 in Schoenberg Hall, University of California, Los Angeles; time constraints prevent Indiana from making more than preliminary sketches.

February. The Corcoran Gallery of Art, Washington, D.C., devotes an entire room to Indiana's paintings in its biennial survey of contemporary American painting.

May. Rolf Nelson opens Indiana's first exhibition on the West Coast in his eponymous Los Angeles gallery.

Faced with the impending demolition of 25 Coenties Slip, Indiana moves his studio to a former luggage factory on the corner of Spring Street and the Bowery; begins his Confederacy painting series commenting on racial injustice in the South.

Summer. The Museum of Modern Art commissions Indiana to design its Christmas card. He submits *LOVE* in four color possibilities; the museum selects the red, blue, and green version.

Bill Katz becomes Indiana's studio assistant; he continues to assist Indiana for more than a decade, initiating and arranging print projects for the artist, including *Numbers*, with poems by Robert Creeley.

1966

March. Galerie Schmela, Düsseldorf, Germany, holds Indiana's first exhibition in Europe and arranges shows in Holland and elsewhere in Germany; the gallery is instrumental in placing many of the artist's major paintings in European museums.

The Center Opera Company commissions Indiana to design the sets, costumes, and poster for its production of *The Mother of Us All*. Indiana revises the scenario, casting a Model-T Ford as a central scenic motif. Performances take place at the Tyrone Guthrie Theater, Minneapolis, from January 27 to February 18, 1967.

May. The Stable Gallery opens its third solo Indiana exhibition, featuring the artist's *Cardinal Numbers* and *LOVE* paintings in different colors and configurations, and his twelve-inch aluminum *LOVE* sculpture, published in an edition of six by Multiples, Inc. Embraced by the public as an emblem of countercultural freedom, *LOVE* proliferates on commercial products.

1967

February–March. Exhibits in the American section of the IX Bienal, São Paulo, Brazil.

April. Installs his *Cardinal Numbers* as a vertical column fifty feet high for the American Pavilion at Montreal's Expo '67.

Produces five serigraphs of *LOVE* and *LOVE Wall*—two in editions of 250 and an unsigned edition of 2,275. During the next two years, produces other serigraph variations on *LOVE*, with more following in 1972, 1973, 1975, 1982, and 1991.

October. Exhibits *The Great LOVE* (1966) in the triennial exhibition of international art at the Carnegie Museum, Pittsburgh; the museum acquires the piece.

1968

April. The Institute of Contemporary Art, University of Pennsylvania, Philadelphia, opens Indiana's first solo museum exhibition; the show travels to the Marion Koogler McNay Art Institute, San Antonio, Texas, and the John Herron Institute of Art, Indianapolis.

Edition Domberger and Galerie Schmela publish a port-folio of Indiana's *Numbers*; each serigraph is accompanied by a Robert Creeley poem inspired by Indiana's *Numbers* paintings of 1965.

June. Exhibits fifteen works in Documenta 4 in Kassel, Germany, including *The Cardinal Numbers* and *LOVE Wall*.

RCA reproduces *Imperial LOVE* (1966) on the album cover of Olivier Messiaen's *Turangalîla-Symphonie*.

1969

Summer. Visits photographer Eliot Elisofon on Vinalhaven, an island off the coast of Maine. Inspired by Indiana's enthusiasm for the island's abandoned hundred-year-old Odd Fellows lodge, the "Star of Hope," Elisofon purchases the building. For the next nine years, Indiana will rent the top floor for use as a studio every September and October.

December. Colby College Museum of Art, Waterville, Maine, opens a retrospective of Indiana's prints and posters; the show travels for two years to museums in the northeast United States and Europe.

1970

Initiates his *ART* series of paintings and sculpture after making *ART* posters for the exhibition *American Art since 1960* at the Princeton University Art Museum, Princeton, New Jersey, and the opening of the Indianapolis Museum of Art.

Lippincott Foundry produces a twelve-foot-high Cor-Ten steel *LOVE*, which is shown that fall in *Seven Outdoors* at the Indianapolis Museum of Art. Ten months later, the piece travels to Boston for installation in October in the plaza surrounding city hall as part of the exhibition *Monumental Sculpture for Public Places*. Lippincott remains Indiana's foundry until 1994, when it ceases operation.

December. Designs the poster and banner for the exhibition *Four Americans in Paris* at the Museum of Modern Art.

1971

Begins *Decade: Autoportraits*, a series of paintings in three sizes chronicling his life in the 1960s; he finishes the two smaller series by 1972 and the larger series by 1977. The complete series totals thirty paintings.

FIG. 178 Indiana (right) with studio assistant Bill Katz in Indiana's studio on Spring Street, New York, 1966. Photograph by Basil Langton

FIG. 179 Robert Indiana, poster for the opening exhibition of the Hirshhorn Museum and Sculpture Garden, 1974. Color serigraph on paper, 29 × 23 in. (73.7 × 58.4 cm). Hirshhorn Museum and Sculpture Garden, Smithsonian Institution, Washington, D.C.; gift of the Smithsonian Resident Associate Program, 1974

FIG. 179 Robert Indiana, poster for the opening exhibition of the Hirshhorn Museum and Sculpture Garden, 1974. Color serigraph on paper, 29 × 23 in. (73.7 × 58.4 cm). Hirshhorn Museum and Sculpture Garden, Smithsonian Institution, Washington, D.C.; gift of the Smithsonian Resident Associate Program, 1974

May. Multiples, Inc. publishes *Decade*, a portfolio of ten serigraphs of Indiana's most significant images; the serigraphs are exhibited simultaneously at Multiples, Inc. in New York and Los Angeles, and in twenty-four other galleries worldwide.

November. *LOVE* travels to New York, where Indiana installs it at the Fifth Avenue and 60th Street entrance to Central Park; the sculpture remains on view for six weeks before returning to the Indianapolis Museum of Art for permanent display.

1972

Designs the cover for Robert Creeley's *A Day Book*, published by Scribner, New York.

Galerie Denise René, New York, becomes Indiana's New York dealer; it holds its first Indiana exhibition in November, premiering the first two series of *Decade: Autoportraits* along with a twenty-foot *LOVE* painting and several *LOVE* and *ART* sculptures.

1973

February 14. The U.S. Postal Service issues an eight-cent *LOVE* stamp designed by Indiana; 330 million stamps are produced, for which the artist receives a flat fee of a thousand dollars.

John Huszar produces *Robert Indiana: Portrait*, a documentary film about the artist.

1974

Designs poster for the opening of the Hirshhorn Museum and Sculpture Garden, Washington, D.C.

1975

December. Galerie Denise René publishes a portfolio of seven serigraphs, based loosely on Indiana's *Polygon* paintings of 1962; the gallery premiers them in December along with *LOVE* and *ART* sculptures.

1976

The Santa Fe Opera Company commissions Indiana to design the sets and costumes for a fully staged production of *The Mother of Us All* as part of the company's twentieth anniversary; the opera is presented on August 7, 11, 20, and 25.

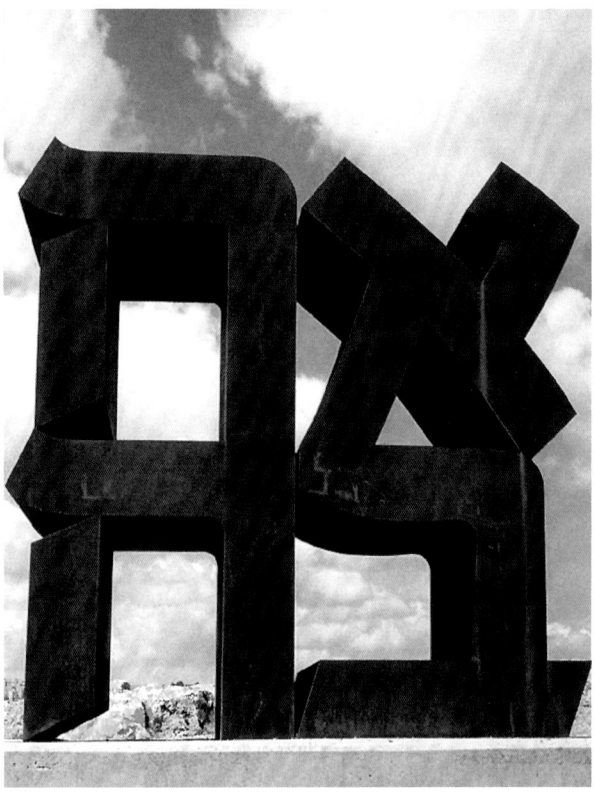

FIG. 180 Robert Indiana, *AHAVA*, 1977. Cor-Ten steel, 144 × 144 × 72 in. (365.8 × 365.8 × 182.9 cm). Israel Museum, Jerusalem

The State University of New York, Purchase, acquires and permanently installs one of Indiana's seven-foot-high red/blue *ART* sculptures on its campus.

Designs two serigraphs, *Liberty 76* and *The Golden Future of America*, for American bicentennial portfolios published by Lorillard and Transworld Art, respectively.

September. Installs a six-foot-high red/purple *LOVE* on the John F. Kennedy Plaza, Philadelphia, as part of the city's bicentennial celebration.

Summer. In response to a poster commission from the Democratic National Committee, Indiana designs *Vote;* in recognition of the artist's contribution to Jimmy Carter's election as thirty-ninth president of the United States, Indiana is invited to, and attends, the presidential inauguration in January 1977.

November. Indiana purchases the Star of Hope from the Elisofon estate.

1977

September. University Art Museum, University of Texas, Austin, opens a retrospective of Indiana's work; the show travels to museums in Norfolk, Virginia; Purchase, New York; Indianapolis; and South Bend, Indiana.

October. Installs his twelve-foot-high Cor-Ten steel *AHAVA* (the Hebrew word for "love"), produced by Lippincott Foundry, at the Fifth Avenue and 60th Street

entrance to New York's Central Park before sending it to the Israel Museum, Jerusalem, for permanent display.

Commissioned to design the floor of the MECCA Arena's basketball court, Milwaukee, Wisconsin.

1978

Loses lease on his Spring Street studio; moves permanently to Vinalhaven. Over the next ten years, Indiana restores the Star of Hope; it is listed on the National Register of Historic Places in 1982.

1980

The Indianapolis Museum of Art commissions the artist's monumental *Numbers*, becoming the largest institutional repository of Indiana's outdoor work.

Multiples, Inc. publishes *Decade: Autoportraits, Vinalhaven Suite*, a portfolio of ten serigraphs created by Indiana commemorating the events, places, and people of importance to him in the 1970s.

1981

Rents sail loft across from the Star of Hope to use as a sculpture studio; begins making a new series of herms out of driftwood he finds on Vinalhaven.

1982

July. The Farnsworth Art Museum, Rockland, Maine, across the Penobscot Bay from Vinalhaven, opens *Indiana's Indianas*, a twenty-year survey of work that Indiana has retained in his own collection; the show travels to five museums in Maine, Pennsylvania, Massachusetts, and New Hampshire.

1984

May. The National Museum of American Art, Washington, D.C., opens *Wood Works*, the first exhibition to survey Indiana's wood constructions; the show travels to the Portland Museum of Art, Maine.

1985

February. Indiana's work is included in *Pop Art, 1955–1970*, one of the first of many reexaminations of Pop art to take place over the next ten years that feature his art; sponsored by the International Council of the Museum of Modern Art, the show opens at the Art Gallery of New South Wales, Sydney, Australia, and travels to Melbourne and Brisbane.

1988

Salama-Caro Gallery, London, arranges to have eight of Indiana's early wood herms cast in bronze, each in an edition of eight, at the Empire Bronze Art Foundry, Long Island City, New York.

1989

Begins his series of paintings *Hartley Elegies*, inspired by the German Officer paintings of Marsden Hartley, who lived on Vinalhaven in the summer of 1938 in a house near the former grocery store Indiana rents for storage; Indiana works on the series, which ultimately comprises eighteen elegies, through 1994.

1990

Park Granada Editions publishes five serigraphs based on Indiana's *Hartley Elegies;* five more follow in a diamond format in 1991. Harry N. Abrams publishes *Robert Indiana* by Carl Weinhardt, Jr., the first hardcover monograph on the artist.

Late November–December. Marisa del Re Gallery becomes Indiana's New York dealer, showcasing his *Decade: Autoportraits* in an exhibition and commissioning two monumental sculptures over the next two years, a twelve-foot-high red/blue *LOVE* and a twelve-foot-high red/blue *ART*, which are shown in sculpture biennales in Monte Carlo, Monaco, in 1991 and 1993, respectively.

1991

May. Susan Sheehan Gallery, New York, holds a solo exhibition of Indiana's prints in conjunction with the gallery's publication of a catalogue raisonné of Indiana's prints.

September. The Salama-Caro Gallery, London, opens its first exhibition of Indiana's art with a show of the artist's early herms and paintings, and examples of bronze versions of his herms.

The Royal Academy of Arts, London, includes Indiana's work in its international survey *Pop Art*; the show travels to Museum Ludwig, Cologne; the Museo Nacional Centro de Arte Reina Sofía, Madrid; and the Montreal Museum of Fine Arts.

FIG. 181 Robert Indiana, *Numbers*, 1980–83. Polychrome aluminum, ten parts, 96 × 96 × 48 in. (243.8 × 243.8 × 121.9 cm) each. Indianapolis Museum of Art; gift of Melvin Simon and Associates 1988.241-250

1992

Susan Elizabeth Ryan completes the first Ph.D. dissertation on Robert Indiana at the University of Michigan, Ann Arbor; Yale University Press publishes it as *Robert Indiana: Figures of Speech* in 2000.

1993

One of Indiana's twelve-foot-high red/blue/green *LOVE* sculptures is acquired and permanently installed in front of the I-Land Tower in Tokyo's central business district, known as the Nishi-Shinjuku.

Lippincott produces a twelve-foot-high blue/green *LOVE* for permanent installation in front of Winsland House II, the headquarters of Wing Tai Holdings Limited, Singapore. It is the last Indiana sculpture the foundry produces before it closes.

1995

April. The Weisman Art Museum, University of Minnesota, Minneapolis, opens an exhibition of Marsden Hartley's German Officer paintings and Indiana's *Hartley Elegies*; the show travels to the Terra Museum of American Art, Chicago; the Frost Art Museum at Florida International University, Miami; and the Indianapolis Museum of Art, where only the *Hartley Elegies* are exhibited.

Simon Salama-Caro becomes Indiana's primary agent, organizing a program of gallery exhibitions and introducing Indiana to the Morgan Art Foundation, which undertakes to complete editions of the artist's monumental sculptures. Three years later, Salama-Caro will begin a project to catalogue all of Indiana's painting and sculpture.

1997

American Image Editions publishes *ROBERT INDIANA: The Book of Love*, a limited edition of twelve of Indiana's *LOVE* images and *LOVE*-related poems.

Indiana installs his monumental white/red *NUMBER 7*, among other works, in Monte Carlo for the 700th anniversary of the Grimaldi family's rule of Monaco.

1998

June. Indiana's first museum retrospective in Europe opens at the Musée d'Art Moderne et d'Art Contemporain, Nice, with the installation of a twelve-foot-high red/blue/green *LOVE* in the esplanade outside the museum. At the opening, Indiana is awarded Citoyen d'honor (honorary citizen of Nice) by the mayor.

Fall. Milgo/Bufkin produces Indiana's first *AMOR* sculpture. The foundry becomes Indiana's sculpture atelier.

The American Dream, a limited-edition book of thirty Indiana serigraphs with poems by Robert Creeley, is published by Marco Fine Arts Contemporary Atelier.

1999

June. The Portland Museum of Art, Maine, opens a retrospective of Indiana's art; the show travels to the Marietta/Cobb Museum of Art, Georgia.

2000

Milgo/Bufkin produces Indiana's monumental outdoor sculpture *2000* for the turn of the millennium; the piece is never installed.

February. One of Indiana's twelve-foot-high red/blue *LOVE* sculptures is installed on Sixth Avenue at 55th Street, New York.

PAX (now the Center to Prevent Youth Violence) commissions Indiana to design a poster for its campaign against gun violence; the poster, *LOVE 2000*, is displayed on the sides of buses and bus kiosks in cities across the United States.

2001

March. The Centre Georges Pompidou, Paris, installs a twelve-foot-high red/blue *LOVE* in its atrium to coincide with its survey of Pop art.

Indiana repaints the white gessoed areas of his 1959 orb paintings on plywood gold.

September 11. While in New York, en route to his show of recent *Marilyn* paintings at Galerie Guy Pieters, Saint-Paul-de-Vence, France, Indiana witnesses the destruction of the World Trade Center from his hotel window; he returns immediately to Vinalhaven and paints *Afghanistan*.

2002

In preparation for his first exhibition in China, Indiana embarks on three series of paintings with Chinese characters, one whose image is *ai* ("love" in Chinese), the second whose image is *ping* ("peace" in Chinese), and the third with the image of a doubled ginkgo leaf combined with *ai* and *ping*; he continues work on the three series through 2002, 2003, and 2006, respectively.

April 9. The Indiana State Museum, Indianapolis, installs the artist's fifty-nine-foot-high *INDIANA* obelisk in its atrium; Indiana governor Frank O'Bannon declares the day "Robert Indiana Day."

FIG. 182 Indiana's
studio, Vinalhaven,
Maine, 1998

July. The Shanghai Art Museum opens *Robert Indiana*,
a retrospective that introduces the artist's work to
Chinese audiences.

Fall. The Scottsdale Art Museum, Arizona, acquires one
of Indiana's twelve-foot-high red/blue *LOVE* sculptures
and places it on permanent loan on the city's Civic
Center Mall.

The state of Maine commissions Indiana to paint
The First State to Hail the Rising Sun to hang in the state
house in Augusta.

2003

February. Indiana's six-foot-high *NUMBERS ONE
THROUGH ZERO* are installed along Park Avenue,
New York, from 60th to 70th streets; they subsequently
travel to California for installation in front of Beverly
Hills City Hall. In conjunction with the New York
installation, two simultaneous exhibitions of Indiana's
work are held in the city: at C&M Arts and at Paul Kasmin
Gallery. The two galleries become Indiana's New York
dealers, in association with Simon Salama-Caro.

Following the American-led invasion of Iraq in March,
Indiana begins his series *Peace Paintings*.

2004

April. Paul Kasmin Gallery exhibits fifteen *Peace Paintings*.
Also that month, the Price Tower Arts Center, Bartlesville,
Oklahoma, opens a solo exhibition of Indiana's paintings
and sculpture; at the show's close in July, the center
purchases the artist's seventeen-foot-long *66* (2004) for
its plaza.

The Waddington Galleries becomes Indiana's London
dealer; its first exhibition of the artist's work opens in
September.

The Taipei Financial Center, Taiwan, commissions a
twelve-foot-high red/gold *LOVE* to be installed in front
of its tower, Taipei 101.

2006

May. Indiana's monumental sculptures *LOVE*, *Imperial
LOVE*, *AMOR*, *ART*, *LOVE Wall*, and *NUMBERS ONE
THROUGH ZERO* are installed outdoors in Madrid
between the Prado and Thyssen-Bornemisza museums;
the works travel to Valencia and Bilbao, Spain, and
Lisbon, Portugal.

Rizzoli publishes *Robert Indiana*, with essays by Joachim
Pissarro, John Wilmerding, and Robert Pincus-Witten.

FIG. 183 Robert Indiana, *LOVE Wall*, 1966/2006. Cor-Ten steel, 144 × 144 × 48 in. (366 × 366 × 122 cm). Private collection

2007

Eric Breitbart and MUSE Film and Television produce an hour-long documentary, *Robert Indiana: American Dreamer.*

November. Galerie Gmurzynska, Zurich, begins its association with Indiana by hosting a retrospective of his art.

2008

Summer. Indiana creates a six-foot-high stainless steel *HOPE*, which is placed outside the Pepsi Center during the Democratic National Convention in Denver. Indiana authorizes the printing of T-shirts, pins, bumper stickers, and posters adorned with the image, donating the proceeds to Barack Obama's presidential campaign.

July. The Padiglione d'Arte Contemporanea, Milan, presents the first solo show of Indiana's work in Italy, including an outdoor installation of Indiana's monumental sculptures *NUMBERS ONE THROUGH ZERO, LOVE, Imperial LOVE, AMOR,* and *LOVE Wall.*

September. Paul Kasmin Gallery opens *Robert Indiana: Hard Edge*, showcasing Indiana's large-scale metal sculptures and his electric *EAT*. A twelve-foot-high Cor-Ten steel *LOVE Wall* is installed at Park Avenue and 57th Street in conjunction with the exhibition.

2009

June. The Farnsworth Art Museum opens a survey of Indiana's art, accompanied by a documentary film directed by Dale Schierholt. In conjunction with the exhibition, the museum installs a twelve-foot-high Cor-Ten steel *LOVE Wall* on permanent display in its garden and the artist's twenty-foot electric *EAT*, in storage since the 1964 New York World's Fair, on its roof; *EAT* is reinstalled on the roof every subsequent year during the summer.

2011

Summer: Galerie Gmurzynska, Zurich, premiers Indiana's repainted 1959 orb paintings.

2012

Hatje Cantz publishes a collection of essays on Indiana's work in *Robert Indiana: New Perspectives.*

2013

September. The Whitney Museum of American Art opens Indiana's first ever New York retrospective, *Robert Indiana: Beyond LOVE.*

FIG. 184 Indiana in his studio, Vinalhaven, Maine, 1998.
Photograph by Diana and Dennis Griggs

SELECTED EXHIBITION HISTORY

COMPILED BY NATALIE MCCANN

Entries with an asterisk (*) indicate solo exhibitions. For group exhibitions, only reviews or articles that discuss the artist are listed.

1960

Martha Jackson Gallery, New York. *New Forms–New Media I.* June 6–24. Catalogue with texts by Lawrence Alloway and Allan Kaprow.

Martha Jackson Gallery, New York. *New Forms–New Media II.* September 27–October 22.

1961

Studio for Dance, New York. *Premiums.* March 25–April 22.

> G[ene] R. S[wenson]. "Reviews and Previews: New Names This Month: Stephen Durkee, Robert Indiana and Richard Smith." *ARTnews* 60, no. 4 (Summer 1961): 16.

David Anderson Gallery, New York. *Indiana/Forakis.* April. Catalogue.

> G[ene] R. S[wenson]. "Reviews and Previews: New Names This Month: Peter Forakis and Robert Indiana." *ARTnews* 60, no. 3 (May 1961): 20.

Museum of Modern Art, New York. *The Art of Assemblage.* October 2–November 12. Catalogue with text by William C. Seitz. Traveled to Dallas Museum for Contemporary Arts (January 9–February 11, 1962) and San Francisco Museum of Art (March 5–April 15, 1962).

Museum of Modern Art, New York. *Recent Acquisitions: Painting and Sculpture.* December 19, 1961–February 25, 1962. Museum bulletin with text by Alfred H. Barr, Jr.

> Kozloff, Max. "New York Letter." *Art International* 6, no. 2 (March 1962): 57–65.

1962

Stubing and Greenfield Gallery, Mamaroneck, New York. *Indiana/Natkin.* March 24–April 14.

> Frackman, Noel. "Indiana, Natkin Display Avant-Garde Paintings." *Scarsdale Inquirer*, March 29, 1962.

* Stable Gallery, New York. *Robert Indiana.* October 16–November 3. Brochure.

> G[ene] R. S[wenson]. "Reviews and Previews: Robert Indiana." *ARTnews* 61, no. 5 (October 1962): 14.

> Fried, Michael. "New York Letter." *Art International* 6, no. 9 (November 1962): 53–56.

> Tillim, Sidney. "In the Galleries: Robert Indiana." *Arts Magazine* 37, no. 3 (December 1962): 49.

Sidney Janis Gallery, New York. *The New Realists: An Exhibition of Factual Paintings and Sculpture from France, England, Italy, Sweden and the United States by the Artists.* October 31–December 1. Catalogue with texts by Sidney Janis and Pierre Restany.

> Genauer, Emily. "One for the Road Signs." *New York Herald Tribune*, October 21, 1962.

Dwan Gallery, Los Angeles. *My Country 'Tis of Thee.* November 18–December 15. Catalogue.

> Seldis, Henry J. "'New Realism' Comes in Humor, Cynicism." *Los Angeles Times*, December 2, 1962.

Museum of Modern Art, New York. *Recent Acquisitions.* November 20, 1962–January 13, 1963.

1963

Art Institute of Chicago. *66th Annual American Exhibition: Directions in Contemporary Painting and Sculpture.* January 11–February 10. Catalogue.

American Cultural Center, Paris. *De A à Z 1963: 31 peintres américains choisis par the Art Institute of Chicago [From A to Z 1963: 31 American painters selected by the Art Institute of Chicago].* May 10–June 20. Catalogue with texts by John Maxon and A. James Speyer. Organized by Art Institute of Chicago.

> Ashbery, John. "Paris Notes." *Art International* 7, no. 6 (June 1963): 76–78.

Museum of Modern Art, New York. *Americans 1963.* May 22–August 18. Catalogue edited by Dorothy C. Miller. Traveled to National Gallery of Canada, Ottawa (November 8–December 1); Artists' Guild of St. Louis (December 18, 1963–January 15, 1964); Toledo Museum of Art, Ohio (February 3–March 2, 1964); Ringling Museum of Art, Sarasota, Florida (March 18–April 15, 1964); Colorado Springs Fine Arts Center (May 1–29, 1964); San Francisco Museum of Art (June 16–August 9, 1964); Seattle Art Museum (September 9–October 11, 1964); and Detroit Institute of Arts (November 1–29, 1964).

> Canaday, John. "Art: 15 Exhibit at Modern: 'Americans 1963' Is Gadgety Collection of Current Painting and Sculpture." *New York Times*, May 22, 1963.

> Canaday, John. "Americans Once More: Museum of Modern Art Makes New Choices." *New York Times*, May 26, 1963.

> "'Americans 1963' at The Museum of Modern Art, New York." *Art International* 7, no. 6 (June 25, 1963): 71–75.

> Hess, Thomas B. "The Phony Crisis in American Art." *ARTnews* 62, no. 4 (Summer 1963): 24–28, 59–60.

> Baro, Gene. "A Gathering of Americans." *Arts Magazine* 37, no. 10 (September 1963): 28–33.

> Monte, James. "San Francisco: Americans, 1963, San Francisco Museum of Art." *Artforum* 3, no. 1 (September 1963): 43–44.

Washington Gallery of Modern Art, Washington, D.C. *Formalists.* June 6–July 7. Catalogue with text by Adelyn D. Breeskin.

> Ahlander, Leslie Judd. "'Formalists' Open Brilliant Exhibit." *Washington Post and Times-Herald*, June 16, 1963.

Beaverbrook Art Gallery, Fredericton, New Brunswick. *Dunn International: An Exhibition of Contemporary Painting.*

September 7–October 6. Catalogue with text by John Richardson. Traveled to Tate Gallery, London (November 15–December 22).

Oakland Art Museum and California College of Arts and Crafts, Oakland. *Pop Art USA.* September 7–29. Catalogue with text by John Coplans.

San Francisco Museum of Art. *Directions—American Painting.* September 20–October 20.

> J[ames] M[onte]. "Directions—American Painting, San Francisco Museum of Art." *Artforum* 2, no. 5 (November 1963): 43–44.

Walker Art Center, Minneapolis. *Richard Stankiewicz, Robert Indiana: An Exhibition of Recent Sculptures and Paintings.* October 22–November 24. Catalogue with text by Jan van der Marck. Traveled to Institute of Contemporary Art, Boston (December 14, 1963–January 26, 1964).

> "New Walker Show . . . Portrays 'American Environment.'" *Minnesota Daily*, October 23, 1963.

> Sherman, John K. "Metal Sculpture, 'Pop' Art Compete." *Minneapolis Sunday Tribune*, October 27, 1963.

> Driscoll, Edgar, Jr. "The Art World: 'Pop' and 'Junk' Art at Institute Showing." *Boston Globe*, December 15, 1963.

> Krauss, Rosalind. "Boston Letter." *Art International* 8, no. 1 (February 15, 1964): 32–34.

Albright-Knox Art Gallery, Buffalo, New York. *Mixed Media and Pop Art.* November 19–December 15. Catalogue.

Munson-Williams-Proctor Institute, Utica, New York. *New Directions in American Painting.* December 1, 1963–January 5, 1964. Catalogue with text by Sam Hunter. Traveled to Isaac Delgado Museum of Art, New Orleans (February 7–March 8, 1964); Atlanta Art Association (March 18–April 22, 1964); J. B. Speed Art Museum, Louisville, Kentucky (May 4–June 7, 1964); Art Museum of Indiana University, Bloomington (June 22–September 20, 1964); Washington University in St. Louis (October 5–30, 1964); and Detroit Institute of Arts (November 10–December 6, 1964). Organized by Poses Institute of Fine Arts, Brandeis University, Waltham, Massachusetts.

Whitney Museum of American Art, New York. *Annual Exhibition 1963: Contemporary American Painting.* December 11, 1963–February 2, 1964. Catalogue.

1964

Wadsworth Atheneum, Hartford, Connecticut. *Black, White, and Grey.* January 9–February 9.

University of British Columbia Fine Arts Gallery, Vancouver. *Art Becomes Reality.* January 29–February 8. Brochure.

> Lord, J. Barry. "Pop Art in Canada." *Artforum* 2, no. 9 (March 1964): 28–31.

Institute of Contemporary Arts, Washington, D.C. *American Paintings: A Selection of 40 Painters.* February 22–March 28. Catalogue with text by Robert Richman.

> Ahlander, Leslie Judd. "Institute Reopens with Humdinger." *Washington Post and Times-Herald*, February 23, 1964.

Davison Art Center, Wesleyan University, Middletown, Connecticut. *The New Art.* March 1–22. Catalogue with text by Lawrence Alloway.

Rose Art Museum, Brandeis University, Waltham, Massachusetts. *Recent American Drawings.* April 19–May 17. Catalogue.

> Krauss, Rosalind. "Boston Letter." *Art International* 8, no. 9 (November 25, 1964): 42–43.

Tate Gallery, London. *Painting and Sculpture of a Decade, 54–64.* April 22–June 28. Catalogue with text by Alison Smithson and Peter Smithson. Organized by the Calouste Gulbenkian Foundation, the Arts Council of Great Britain, and the Association française d'action artistique.

Theaterama, New York State Pavilion, New York World's Fair. April 22–October 18, 1964; April 21–October 17, 1965.

> "Avant-Garde Art Going to the Fair: Huge Works Commissioned to Adorn State Pavilion." *New York Times*, October 5, 1963.

> Glueck, Grace. "In Britain, What's a Government Budget without Art?" *New York Times*, July 19, 1964.

> Johnson, Phillip. "Young Artists at the Fair and at Lincoln Center." *Art in America* 62, no. 4 (August 1964): 112–27.

> Constantine, Mildred. "Visit New York, Visit New York: The World of Art." *Art in America* 52, no. 3 (June 1964): 124–29.

Gallery of the American Federation of Arts, New York. *Artists for CORE: Third Annual Art Exhibition and Sale.* May 6–16. Catalogue.

* Stable Gallery, New York. *Robert Indiana.* May.

> Gruen, John. "Curious Mismatch—Indiana, Thomson." *Herald Tribune*, May 11, 1964.

> "Upper Madison Av[enue]." *New York Herald Tribune*, May 16, 1964.

> Preston, Stuart. "Art Fresh Out of Past and Present." *New York Times*, May 17, 1964.

> "Uptown." *Time* 83, no. 21 (May 22, 1964).

> Willard, Charlotte. "In the Art Galleries." *New York Post*, May 24, 1964.

> G[ene] R. S[wenson]. "Reviews and Previews." *ARTnews* 63, no. 4 (Summer 1964): 13.

> Judd, Donald. "In the Galleries: Robert Indiana: Exhibition at Stable Gallery." *Arts Magazine* 38, no. 10 (September 1964): 61.

Gemeentemuseum Den Haag, The Hague, The Netherlands. *Nieuwe Realisten [New Realism].* June 24–August 30. Catalogue with texts by L. J. F. Wijsenbeek, Jasia Reichardt, Pierre Restany, and W. A. L. Beeren.

Museum des 20. Jahrhunderts, Vienna. *Pop, etc.* September 19–October 31. Catalogue with texts by Werner Hofmann and Otto A. Graf.

Institute of Contemporary Art, University of Pennsylvania, Philadelphia. *Group Zero.* October 30–December 11. Catalogue with text by Otto Piene.

> Glueck, Grace. "Art Notes: How to Build an Indoor Patio: Point of View." *New York Times*, November 29, 1964.

1965

Palais des Beaux-Arts, Brussels. *Pop Art, New Realism, etc.* February 5–March 1. Catalogue with text by Pierre Restany.

Worcester Art Museum, Massachusetts. *The New American Realism.* February 18–April 4. Catalogue.

> Driscoll, Edgar J., Jr. "The Art World: Should Pop Art Bring Laugh or Smile?" *Boston Globe*, February 21, 1965.

Finch College Museum of Art, New York. *Art in Process: The Visual Development of a Painting.* February 25–May 5. Catalogue with text by Elayne H. Varian.

> Genauer, Emily. "In the Works." *New York Herald Tribune*, March 21, 1965.

Corcoran Gallery of Art, Washington, D.C. *The Twenty-Ninth Biennial Exhibition of Contemporary American Painting.* February 26–April 18. Catalogue.

> Stevens, Elisabeth. "A Conscientious Cross-Section." *Washington Post and Times-Herald*, February 28, 1965.

Krannert Art Museum, University of Illinois at Urbana-Champaign. *Contemporary American Painting and Sculpture.* March 7–April 11. Catalogue.

Sheldon Memorial Art Gallery, University of Nebraska, Lincoln. *Nebraska Art Association LXXIII Annual Exhibition.* April 4–May 2. Catalogue.

Milwaukee Art Center. *Pop Art and the American Tradition.* April 9–May 9. Catalogue with text by Tracy Atkinson.

Whitney Museum of American Art, New York. *A Decade of American Drawings, 1955–1965.* April 28–June 6. Catalogue.

* Rolf Nelson Gallery, Los Angeles. *Robert Indiana.* May 10–June 5.

> Wilson, William. "In the Galleries: Sculpture Exhibit Impresses: Pop Artist Works Are Disappointing." *Los Angeles Times*, May 17, 1965.
>
> W[illiam] W[ilson]. "Come and See, Rolf Nelson Gallery." *Artforum* 4, no. 2 (October 1965): 13.

Guggenheim Museum, New York. *Word and Image.* December 8, 1965–January 2, 1966. Catalogue with text by Lawrence Alloway.

Whitney Museum of American Art, New York. *1965 Annual Exhibition: Contemporary American Painting.* December 8, 1965–January 30, 1966. Catalogue.

Institute of Contemporary Art, Boston. *Art Turned On.* December 10, 1965–January 30, 1966. Catalogue.

> Driscoll, Edgar J., Jr. "The Art World: 'Plugged In' Exhibit Electrifies Hub." *Boston Globe*, December 12, 1965.

Galería Colibrí, San Juan, Puerto Rico. *L'avant-garde.* December. Catalogue with texts by Luigi Marrozzini and Ernesto Ruiz de la Matz.

1966

Herron Museum of Art, Indianapolis. *Painting and Sculpture Today, 1966.* January 2–30. Catalogue.

Bianchini Gallery, New York. *Master Drawings: Pissarro to Lichtenstein.* January 15–February 5. Catalogue with text by William Albers Leonard. Traveled to Contemporary Arts Center, Cincinnati (February 7–26).

Corcoran Gallery of Art, Washington, D.C. *Op and Pop in Fabric.* January 21–February 20.

Pennsylvania Academy of the Fine Arts, Philadelphia. *161st Annual Exhibition of American Painting and Sculpture.* January 21–March 6. Catalogue.

Institute of Contemporary Art, University of Pennsylvania, Philadelphia. *The Other Tradition.* January 27–March 7. Catalogue with text by Gene R. Swenson.

* Galerie Schmela, Düsseldorf, Germany. *Robert Indiana.* March 4–31. Catalogue.

> Sommer, Ed. "Bericht aus Deutschland." *Art International* 10, no. 5 (May 20, 1966): 47–52.

Whitney Museum of American Art, New York. *Contemporary American Sculpture: Selection I.* April 5–May 15. Catalogue.

Grippi & Waddell Gallery, New York. *Artists for CORE: Fifth Annual Art Exhibition and Sale by Leading American Artists for the Benefit of CORE Scholarship, Education and Defense Fund.* April 27–May 7. Catalogue.

* Stable Gallery, New York. *Robert Indiana.* May 3–28.

> James, Ted, Jr. ". . . And Fine Living: Art: Pop-Op-Pop." *Women's Wear Daily*, May 6, 1966.
>
> Canaday, John. "Art: Shimmering Treasures of Peru; Hartford Gallery Puts on Spectacular Show; Robert Indiana." *New York Times*, May 7, 1966.
>
> Ashton, Dore. "The 'Anti-Compositional Attitude' in Sculpture: New York Commentary." *Studio International* 172 (July 1966): 44–47.
>
> Lippard, Lucy. "New York Letter." *Art International* 10, no. 6 (Summer 1966): 108–115.

* Museum Haus Lange Krefeld, Germany. *Robert Indiana, Number Paintings.* June 11–July 24. Catalogue with text by Johannes Cladders.

National Collection of Fine Arts, Washington, D.C. *Hard-Edge Trend.* July 13–September 18. Catalogue.

* Württembergischer Kunstverein Stuttgart, Germany. *Robert Indiana: Number Paintings at Studio 7.* August 5–28. Catalogue.

Stedelijk van Abbemuseum, Eindhoven, The Netherlands. *KunstLichtKunst [Art Light Art].* September 25–December 4. Catalogue.

* Dayton's Gallery 12, Minneapolis. *Robert Indiana.* September 27–October 22. Catalogue with text by G[ene] R. Swenson and Jan van der Marck.

> McConagha, Al. "Robert Indiana Exhibit to Open: 'Eat,' 'Die' Painter to Visit Gallery 12." *Minneapolis Tribune,* September 25, 1966.

Rijksmuseum Twenthe, Enschede, The Netherlands. *Kunst Na '45 [Art after '45].* October 8–November 6. Catalogue with text by L. Leering-van Moorsel.

Ball State University Art Gallery, Muncie, Indiana. *150 Years of Indiana Art.* October 9–December 31.

> "Hoosier-Born Robert Indiana Will Open Special Campus Art Show." *Ball State News,* October 5, 1966.

Stedelijk Museum, Amsterdam. *Vormen van de Kleur [New Shapes of Color].* November 20, 1966–January 16, 1967. Catalogue. Traveled as *Formen der Farbe* to Württembergischer Kunstverein, Kunstgebäude am Schlossplatz, Stuttgart, Germany (February 18–March 26, 1967) and Kunsthalle Bern, Switzerland (April 14–May 21, 1967).

Museum of Modern Art, New York. *Art in the Mirror.* November 22, 1966–February 5, 1967. Catalogue with text by Gene R. Swenson.

Whitney Museum of American Art, New York. *Annual Exhibition 1966: Contemporary Sculpture and Prints.* December 16, 1966–February 5, 1967. Catalogue.

1967

Krannert Art Museum, University of Illinois at Urbana-Champaign. *Contemporary American Painting and Sculpture, 1967.* March 5–April 9. Catalogue.

American Pavilion, International and Universal Exposition, Montreal. *American Painting Now.* April 27–October 29. Catalogue with texts by Claude Beaulieu, et al. Traveled to Horticultural Hall, Boston (December 15, 1967–January 10, 1968; catalogue with text by Alan Solomon).

> Driscoll, Edgar J., Jr. "The Art World: Expo Refugees." *Boston Globe,* December 24, 1967.

Mayfield Mall, Mountain View, California. *The American Poster.* July 24–August 20. Catalogue with text by Edgar Breitenbach, Margaret Cogswell, Caroline H. Backlund, and Frank R. Cawl, Jr. Traveled to Frye Art Museum, Seattle (September 3–24); University of Kentucky, College of Art and Science, Lexington (October 8–29); Everson Museum of Art, Syracuse, New York (November 12–December 3); State University College, Oswego, New York (January 21–February 11, 1968); Mount Holyoke College Art Department, South Hadley, Massachusetts (February 25–March 17, 1968); Clemson University School of Architecture, Clemson, South Carolina (March 31–April 21, 1968); Danbury Scott-Fanton Museum, Danbury, Connecticut (May 5–May 26, 1968); Roberson Center, Binghamton, New York (August 18–September 8, 1968); Hopkins Center, Dartmouth College, Hanover, New Hampshire (September 22–October 13, 1968);

Allen Memorial Art Museum, Oberlin College, Ohio (October 27–November 17, 1968); Brooks Memorial Art Gallery, Memphis, Tennessee (December 1–22, 1968); Southern Methodist University, School of Art, Dallas (February 9–March 2, 1969); and National Collection of Fine Arts, Smithsonian Institution, Washington, D.C. (April 20–June 15, 1969). Organized by American Federation of Arts, New York.

Museu de Arte Moderna, São Paulo. *São Paulo 9: Edward Hopper, Environment U.S.A.: 1957–1967 / Meio-Natural U.S.A.: 1957–1967.* September 22, 1967–January 8, 1968. Catalogue with texts by William C. Seitz and Lloyd Goodrich. Organized by the International Art Program, National Collection of Fine Arts, Smithsonian Institution, Washington, D.C.

Carnegie Museum of Art, Pittsburgh. *Pittsburgh International Exhibition of Contemporary Painting and Sculpture.* October 27, 1967–January 7, 1968. Catalogue.

Royal Dublin Society and National Museum of Ireland, Dublin. *ROSC '67, the Poetry of Vision: An International Exhibition of Modern Painting and Ancient Celtic Art.* November 13–December 30. Catalogue.

> McNay, M. G. "The Rosc Exhibition at the Royal Dublin Society." *The Guardian,* November 14, 1967.

Sidney Janis Gallery, New York. *Homage to Marilyn Monroe.* December 6–30. Catalogue.

> Kramer, Hilton. "Artists and Museum Pay Tribute to Frank O'Hara: Homage to Marilyn Monroe." *New York Times,* December 9, 1967.

Whitney Museum of American Art, New York. *1967 Annual Exhibition of Contemporary Painting.* December 13, 1967–February 4, 1968. Catalogue.

1968

Moore College of Art, Philadelphia. *American Drawing 1968.* January 13–February 16. Catalogue.

Museum of Modern Art, New York. *Word and Image: Posters and Typography from the Graphic Design Collection of The Museum of Modern Art 1879–1967.* January 25–March 10. Catalogue edited by Mildred Constantine with text by Alan M. Fern. Traveled to HemisFair, San Antonio, Texas (April 6–June 15).

> Bryant, Mavis. "Official HemisFair Poster Unveiled." *San Antonio Express,* March 8, 1968.

* Institute of Contemporary Art, University of Pennsylvania, Philadelphia. *Robert Indiana.* April 17–May 27. Catalogue with text by John W. McCoubrey and Robert Indiana. Traveled to Marion Koogler McNay Art Institute, San Antonio, Texas (July 1–August 15) and Herron Museum of Art, Indianapolis (September 1–29).

> "Evening with Indiana Set by Institute of Art." *Ardmore* (PA) *Main Line Times,* March 28, 1968.

> Donohoe, Victoria. "Philadelphia Art Scene: A Progress Report on Robert Indiana." *Philadelphia Inquirer,* April 21, 1968.

Neue Pinakothek, Haus der Kunst, Munich. *Sammlung 1968 Karl Ströher [Collection 1968: Karl Ströher].* June 14–August 9. Catalogue with texts by Karl Ströher, Six Friedrich, and Franz Dahlem. Traveled to Kunstverein Hamburg, Germany (August 24–October 6); Neue Nationalgalerie, Berlin (March 1–April 14, 1969); Städtische Kunsthalle Düsseldorf, Germany (April 25–June 17, 1969); and Kunsthalle Bern, Switzerland (July 12–August 17, August 23–September 28, 1969). Organized by Galerie Verein-München, Munich.

Museum Fridericianum, Orangerie, Karlsaue Park, and Galerie an der Schönen Aussicht, Kassel, Germany. *Documenta 4: International Exhibition.* June 27–October 6. Catalogue with text by Janni Müller-Hauck.

> Siegel, Jeanne. "Documenta IV: Homage to the Americans?" *Arts Magazine* 43, no. 1 (September/October 1968): 37–41.

Honolulu Academy of Arts, Hawaii. *Signals in the 'Sixties.* October 5–November 10. Catalogue with texts by James W. Foster, Jr., and James Johnson Sweeney.

Museum of Contemporary Art, Chicago. *Violence! in Recent American Art.* November 8, 1968–January 12, 1969. Catalogue with text by Robert Glauber.

Stephen Radich Gallery, New York. *American Tapestries.* November. Catalogue with texts by Mildred Constantine and Irma B. Jaffe. Traveled to more than thirty venues in the United States and Canada. Organized by Slatkin Galleries, New York.

> Canaday, John. "Art: The Pleasures of Everyday Life: American Tapestries." *New York Times*, November 2, 1968.

1969

Cedar Rapids Art Center, Iowa. *Patriotic Images in American Art.* January 19–February 9. Traveled to Decatur Art Center, Illinois (March 2–23) and Greenville County Museum of Art, Greenville, South Carolina (April 13–May 4). Organized by American Federation of Arts, New York.

> Willis, Thomas. "A Bit of Americana Down Decatur Way." *Chicago Tribune*, March 23, 1969.

* The Department of Art, Saint Mary's College, Notre Dame, Indiana. *Robert Indiana—Graphics.* June 12–July 6. Catalogue with text by Richard-Raymond Alasko.

Hayward Gallery, London. *Pop Art Redefined.* July 9–September 3. Catalogue with text by John Russell and Suzi Gablik.

> Gosling, Nigel. "Pop Art—the Birth of a New Literature." *The Observer*, July 13, 1969.

> Denvir, Bernard. "London Letter." *Art International* 13, no. 7 (September 1969): 66–69.

Georgia Museum of Art, University of Georgia, Athens. *American Painting: The 1960s.* September 22–November 8. Catalogue with text by Samuel Adams Green. Organized by American Federation of Arts, New York.

Moreau Art Gallery, Saint Mary's College, Notre Dame, Indiana. *Sign, Signal, Symbol.* November 7–December 23. Catalogue with text by R. P. Penkoff.

* Colby College Art Museum, Waterville, Maine. *The Prints and Posters of Robert Indiana: New England Tour.* December 1, 1969–January 3, 1970. Catalogue with text by William Katz. Traveled to Currier Gallery of Art, Manchester, New Hampshire (January 10–February 8, 1970); Hopkins Center, Dartmouth College, Hanover, New Hampshire (February 12–March 15, 1970); Bowdoin College Museum of Art, Brunswick, Maine (March 19–April 12, 1970); and Brandeis University, Waltham, Massachusetts (April 19–May 10, 1970).

1970

Institute of Contemporary Art, University of Pennsylvania, Philadelphia. *The Highway: An Exhibition.* January 14–February 25. Catalogue with text by John W. McCoubrey. Traveled to Institute for the Arts, Rice University, Houston (March 12–May 18) and Akron Art Institute, Ohio (June 5–July 26).

Princeton University Art Museum, Princeton, New Jersey. *American Art since 1960.* May 6–27. Catalogue edited by Sam Hunter with texts by John Hand, Michael D. Levin, and Peter P. Morrin.

Fondation Marguerite et Aimé Maeght, Saint-Paul-de-Vence, France. *L'art vivant aux Etats-Unis [Contemporary Art in the United States].* July 16–September 30. Catalogue with text by Dore Ashton.

Contemporary Arts Center, Cincinnati. *Monumental Art.* September 13–November 1. Catalogue with texts by William A. Leonard and Douglas MacAgy.

Indianapolis Museum of Art. *Seven Outdoors.* October 25, 1970–January 3, 1971. Catalogue. Traveled to City Hall Plaza, Boston (as *Monumental Sculptures for Public Places*, under the auspices of the Institute of Contemporary Art, Boston) (October 2–November 14, 1971) and Central Park, New York (November 29, 1971–January 5, 1972).

> Kay, Jane Holtz. "Architecture: The Shape of Things: Something New under the Sun." *Boston Globe*, October 10, 1971.

> Garmel, Marion Simon. "Indiana Has LOVE Affair with State." *Indianapolis Star*, February 14, 1972.

Mayfair Gallery, London. *Pop! '70.* November 26, 1970–January 16, 1971. Catalogue.

1971

* Galerie de Gestlo, Bremen, Germany. *Robert Indiana: Komplette Graphik [Robert Indiana: Complete Graphic Artwork].* February. Brochure.

> "Weltberühmt: Robert Indiana." *Graphik: Werbung und Formgebung*, May 5, 1971: 39–41.

Krannert Art Museum, University of Illinois at Urbana-Champaign. *American Paintings and Sculpture, 1948–1969.* March 7–April 11. Catalogue.

* Multiples, Inc., New York and Los Angeles. *Robert Indiana, Decade.* May 1–31. Catalogue. Traveled to twenty-four international galleries.

> Wilson, William. "A Critical Guide to the Galleries." *Los Angeles Times,* May 7, 1971.

> "Robert Indiana Serigraphs in Special 'Decade' Exhibit." *Baltimore Morning Sun,* May 20, 1971.

> Chapin, Louis. "The Home Forum: West Side, East Side." *Christian Science Monitor,* May 22, 1971.

> Wells, Daniel. "A Decade of 'Pop.'" *Chicago Tribune,* May 23, 1971.

> Domingo, Willis. "New York Galleries." *Arts Magazine* 45, no. 8 (Summer 1971): 52–54.

> Plagens, Peter. "Los Angeles: Robert Indiana." *Artforum* 10, no. 2 (October 1971): 86–90.

Museo de Arte Moderno La Tertulia, Cali, Colombia. *Primera Bienal Americana de Artes Gráficas: dibujo, grabado, diseño gráfico [First American Biennial of Graphic Arts: Drawing, Printmaking, Graphic Design].* July 24–August 30. Catalogue.

Museum of Art, University of Kansas, Lawrence. *Gene Swenson: Retrospective for a Critic.* October 24–December 5. Catalogue with texts by Charles C. Eldredge, et al.

Fendrick Gallery, Washington, D.C. *The Contemporary Art of Banners.* November 9–December 4.

> Allen, Henry. "A Banner Day for Modern Art." *Washington Post and Times-Herald,* November 28, 1971.

Philadelphia Museum of Art. *Silkscreen: History of a Medium.* December 17, 1971–February 27, 1972. Catalogue with text by Richard S. Field.

1972

High Museum of Art, Atlanta. *The Modern Image.* April 15–June 11. Catalogue with text by John Howett and Karl Nickel.

Indianapolis Museum of Art. *Painting and Sculpture Today, 1972.* April 26–June 4. Catalogue.

Neue Galerie der Stadt Aachen, Germany. *Kunst um 1970—Art around 1970.* June. Catalogue with text by Wolfgang Becker and Astrid Brock.

* Galerie Denise René, New York. *Robert Indiana.* November 22–December 30. Catalogue with text by Sam Hunter.

> Canaday, John. "Aesop Revised, or the Luck of the Orthopterae." *New York Times,* December 3, 1972.

> Perreault, John. "Having a Word with the Painter." *Village Voice,* December 7, 1972.

> Genauer, Emily. "Will Art Replace the Love Symbol?" *Arts,* December 8, 1972.

> Henry, Gerrit. "Reviews and Previews." *ARTnews* 72, no. 1 (January 1973): 19.

> Dyckes, William. "Galleries: Robert Indiana." *Arts Magazine* 47, no. 4 (February 1973): 76.

> Masheck, Joseph. "Reviews: Robert Indiana, Denise Rene Gallery." *Artforum* 11, no. 6 (February 1973): 79–81.

> Crimp, Douglas. "New York Letter." *Art International* 17, no. 6 (February 1973): 88–90.

1973

Kunstmuseum Düsseldorf, Germany. *Zero Raum [Zero Room].* June 8–August 23. Catalogue with text by Gerhard Storck.

Seattle Art Museum. *American Art: Third Quarter Century.* August 22–October 14. Catalogue with text by Jan van der Marck.

Rice Museum, Rice University, Houston. *Gray Is the Color: An Exhibition of Grisaille Painting XIII–XXth Centuries.* Organized by the Institute for the Arts, Rice University. October 19, 1973–January 19, 1974. Catalogue with texts by Dominique de Menil and J. Patrice Marendel.

1974

Williams College Museum of Art, Williamstown, Massachusetts. *Pop Art and After.* January 3–31. Catalogue.

Whitney Museum of American Art, Downtown Branch, New York. *Nine Artists/Coenties Slip.* January 10–February 14. Brochure.

> "Nine Artists/Coenties Slip." *Village Voice,* January 31, 1974.

> "Going Out Guide: Slippage." *New York Times,* February 5, 1974.

> Ritter, Walter. "Marine Art: A Document, a Mixture of Centuries." *South Street Reporter* (New York) 8, no. 1 (Spring 1974): 9.

Whitney Museum of American Art, New York. *American Pop Art.* April 6–June 16. Catalogue with text by Lawrence Alloway.

> Russell, John. "The Paintings Are Outliving Their Subjects: Persistent Pop." *New York Times,* July 21, 1974.

Indianapolis Museum of Art. *Painting and Sculpture Today, 1974.* May 22–July 14. Catalogue. Traveled to Contemporary Art Center and Taft Museum, Cincinnati (September 12–October 26).

Virginia Museum of Fine Arts, Richmond. *Twelve American Painters.* September 30–October 27. Catalogue with text by William Gaines.

Hirshhorn Museum and Sculpture Garden, Washington, D.C. *Inaugural Exhibition.* October 4, 1974–September 15, 1975.

Dallas Museum of Fine Arts and Pollock Galleries, Southern Methodist University, University Park, Texas. *Poets of the Cities of New York and San Francisco, 1950–1965.* November 20–December 29. Catalogue with texts by Neil A. Chassman, et al. Traveled to San Francisco Museum of Art (January 31–March 23, 1975) and Wadsworth Atheneum, Hartford, Connecticut (April 23–June 1, 1975).

1975

Corcoran Gallery of Art, Washington, D.C. *34th Biennial of Contemporary American Painting.* February 22–April 6. Catalogue with texts by Roy Slade and Linda Simmons.

Portland Art Museum, Oregon. *Masterworks in Wood: The Twentieth Century.* September 17–October 19. Catalogue with text by Jan van der Marck.

Worcester Art Museum, Massachusetts. *American Art since 1945 from the Collection of The Museum of Modern Art.* October 20–November 30. Catalogue with text by Alicia Legg. Traveled to Toledo Museum of Art, Ohio (January 10–February 22, 1976); Denver Art Museum (March 22–May 2, 1976); Fine Arts Gallery of San Diego (May 31–July 11, 1976); Dallas Museum of Fine Arts (August 19–October 3, 1976); Joslyn Art Museum, Omaha, Nebraska (October 25–December 5, 1976); Greenville County Museum, Greenville, South Carolina (January 8–February 20, 1977); and Virginia Museum of Fine Arts, Richmond (March 14–April 17, 1977). Organized by the Museum of Modern Art, New York.

Van Abbemuseum, Eindhoven, The Netherlands. *Grafiek 1960–1974: een tentoonstelling uit het bezit van het Van Abbe-museum [Graphic Art 1960–1974: An Exhibition from the Collection of the Van Abbemuseum].* October 24, 1975–November 24, 1976. Catalogue.

Corcoran Gallery of Art, Washington, D.C. *Images of an Era: The American Poster, 1945–75.* November 21, 1975–January 4, 1976. Traveled to Contemporary Art Museum, Houston (February 2–March 19, 1976); Museum of Science and Industry, Chicago (April 1–May 2, 1976); and Grey Art Gallery and Study Center, New York University (May 22–June 30, 1976). Organized by the National Collection of Fine Arts, Smithsonian Institution, Washington, D.C.

* Galerie Denise René, New York. *Robert Indiana.* December 12, 1975–January 10, 1976. Catalogue.

> André, Michael. "New York Reviews: Robert Indiana." *ARTnews* 75, no. 2 (February 1976): 108.

1976

The New Gallery of Contemporary Art, Cleveland. *American Pop Art and the Culture of the Sixties.* January 10–February 21. Catalogue with texts by Nina Sundell and Carol Nathanson.

National Collection of Fine Arts, Smithsonian Institution, Washington, D.C. *America as Art.* April 30–November 7. Catalogue with text by Joshua Charles Taylor.

Schleswig-Holsteinisches Landesmuseum, Germany. *Illustrationen zu Melvilles Moby-Dick [Illustrations to Melville's Moby Dick].* June 18–September 19. Catalogue with texts by Joachim Kruse, et al.

Art Galleries, California State University, Long Beach. *Beyond the Artist's Hand: Explorations of Change.* September 13–October 10. Catalogue with texts by Suzanne Paulson, J. Butterfield, and F. K. Fall.

Wildenstein & Co., New York. *Modern Portraits: The Self and Others.* October 20–November 28. Catalogue edited by J. Kirk T. Varnedoe. Organized by the Department of Art History and Archaeology, Columbia University, New York.

The Brooklyn Museum, New York. *30 Years of American Printmaking, Including the 20th National Print Exhibition.* November 20, 1976–January 30, 1977. Catalogue with text by Gene Baro.

1977

Indianapolis Museum of Art, Indiana. *Perceptions of the Spirit in Twentieth-Century American Art.* September 20–November 27. Catalogue with texts by Jane Dillenberger and John Dillenberger. Traveled to University Art Museum, University of California, Berkeley (December 20, 1977–February 12, 1978); Marion Koogler McNay Art Institute, San Antonio, Texas (March 5–April 16, 1978); and Columbus Gallery of Fine Arts, Ohio (May 10–June 19, 1978).

* University Art Museum, University of Texas at Austin. *Robert Indiana.* September 25–November 6. Catalogue with texts by Robert L. B. Tobin and William Katz and interview with the artist by Donald B. Goodall. Traveled to Chrysler Museum, Norfolk, Virginia (December 1, 1977–January 15, 1978); Indianapolis Museum of Art (February 21–April 2, 1978); Neuberger Museum, State University of New York, Purchase (April 23–May 21, 1978); and The Art Center, South Bend, Indiana (June 2–July 16, 1978).

> McIntyre, Mary. "Robert Indiana at Michener Gallery (U. of Texas, Austin)." *Art Voices/South* 1, no. 1 (January–February 1978): 31–32.
>
> Shirey, David L. "Slice of Americana by Robert Indiana." *New York Times*, May 7, 1978.
>
> Russell, John. "Gallery View: De-complication Is the Aim." *New York Times*, May 14, 1978.

Philadelphia College of Art. *Artists' Sets and Costumes: Recent Collaborations between Painters and Sculptors and Dance, Opera and Theater.* October 31–December 17. Catalogue with texts by Janet Kardon and Don McDonagh. Traveled to Performing Arts Center Gallery, Sarah Lawrence College, Bronxville, New York (January 24–February 19, 1978).

> McDonagh, Don. "Artists Take Center Stage." *New York Times*, January 29, 1978.

1978

Whitney Museum of American Art, New York. *Art about Art.* July 19–September 24. Catalogue with texts by Jean Lipman and Richard Marshall. Traveled to North Carolina Museum of Art, Raleigh (October 15–November 26); Frederick S. Wight Art Gallery, University of California, Los Angeles (December 17, 1978–February 11, 1979); and Portland Art Museum, Oregon (March 6–April 15, 1979).

> Wilson, William. "Art: An Exhibit That Parodies, Paraphrases and Ponders." *Los Angeles Times*, December 24, 1978.

1979

Museo de Arte Moderno de Bogotá, Colombia. *25 Años Despues: Robert Indiana, Ellsworth Kelly, Agnes Martin, Edgar Negret, Louise Nevelson, Jack Youngerman [25 Years Later: Robert Indiana, Ellsworth Kelly, Agnes Martin, Edgar Negret, Louise Nevelson, Jack Youngerman]*. September. Catalogue with texts by William Goodall, William Katz, John Stringer, and Robert L. B. Tobin.

1980

Museum of Modern Art, New York. *Printed Art: A View of Two Decades*. February 14–April 1. Catalogue with text by Riva Castleman.

Institute of Contemporary Art, University of Pennsylvania, Philadelphia. *Urban Encounters: Art, Architecture, Audience*. March 19–April 30. Catalogue with texts by Lawrence Alloway, et al.

1981

* Colby College Museum of Art, Waterville, Maine. *Decade: Autoportraits, Vinalhaven Suite*. May 10–June 14.

> Isaacson, Philip. "Arts/Books: Indiana's Maine Decade: The Medium without the Message." *Portland Press Herald*, May 24, 1981.

Neue Nationalgalerie, Berlin. *Druckgraphik: Wandlungen eines Mediums seit 1945 [Printmaking: Transformations of a Medium since 1945]*. June 17–August 16. Catalogue with texts by Alexander Dückers and Angela Schönberger.

1982

* William A. Farnsworth Library and Art Museum, Rockland, Maine. *Indiana's Indianas: A 20-Year Retrospective of Painting and Sculpture from the Collection of Robert Indiana*. July 16–September 26. Catalogue. Traveled to Colby College Museum of Art, Waterville, Maine (October 17–December 12); Reading Public Museum, Pennsylvania (January 16–March 20, 1983); Danforth Museum and School of Art, Framingham, Massachusetts (May 15–July 3, 1983); Currier Gallery of Art, Manchester, New Hampshire (October 25–November 27, 1983); and Berkshire Museum, Pittsfield, Massachusetts (December 12, 1983–January 29, 1984).

> Ouellette, Larry E. "Indiana Arrives Late at His Own Reception." *Portland* (ME) *Press Herald*, July 17, 1982.

> Beem, Edgar Allen. "Indiana Demonstrates the Power of the Painted Word." *Maine Times*, July 23, 1982.

> Patten, Bill. "Indiana: The American Sign Painter." *Camden* (ME) *Herald*, September 23, 1982.

> "Art Review: 'Indiana's Indianas.'" *Boston Globe*, June 8, 1983.

1983

Kyōto Kokuritsu Kindai Bijutsukan [National Museum of Modern Art, Kyoto]. *The Modern American Poster*. October 21–December 4. Catalogue with text by J. Stewart Johnson.

Traveled to Tōkyō Kokuritsu Kindai Bijutsukan [National Museum of Modern Art, Tokyo] (December 14, 1983–January 22, 1984). Organized by the Museum of Modern Art, New York.

1984

Whitney Museum of American Art at Champion, Stamford, Connecticut. *Autoscape: The Automobile in the American Landscape*. March 30–May 30. Catalogue with text by Pamela Gruninger Perkins.

> Hawes, Peter S. "Art Exhibit Traces Automobile's Alteration of America." *Hartford* (CT) *Courant*, April 28, 1984.

* National Museum of American Art, Smithsonian Institution, Washington, D.C. *Wood Works: Constructions by Robert Indiana*. May 1–September 3. Catalogue with text by Virginia M. Mecklenburg. Traveled to Portland Museum of Art, Maine (October 2–28).

> Kessler, Pamela. "Indiana, in Terms of Herms." *Washington Post*, May 4, 1984.

> Richard, Paul. "The 'LOVE' Man Turns to Wood." *Washington Post*, May 29, 1984.

> Fleming, Lee. "Robert Indiana: National Museum of American Art." *ARTnews* 83, no. 8 (October 1984), 160–61.

Marisa del Re Gallery, New York. *Masters of the Sixties: From New Realism to Pop Art*. November 7–December 31. Catalogue with text by Sam Hunter.

1985

Art Gallery of New South Wales, Sydney. *Pop Art, 1955–70*. February 27–April 14. Catalogue with texts by Henry Geldzahler and Edmund Capon. Traveled to Queensland Art Gallery, Brisbane (May 1–June 2) and National Gallery of Victoria, Melbourne (June 26–August 11). Organized by the International Council of the Museum of Modern Art, New York.

1986

Treasures from the National Museum of American Art. Organized by the National Museum of American Art, Smithsonian Institution, Washington, D.C. Catalogue with text by William Kloss. Traveled to Seattle Art Museum (February 20–April 13); Minneapolis Institute of Arts (May 17–July 13); Cleveland Museum of Art (August 13–October 5); Amon Carter Museum, Fort Worth, Texas (November 7, 1986–January 4, 1987); High Museum of Art, Atlanta (February 3–March 29, 1987); and National Museum of American Art, Smithsonian Institution, Washington, D.C. (May 8–June 7, 1987).

> Halpern, Sue M. "In Short: A Smithsonian Sampler." *New York Times*, April 27, 1986.

David Winton Bell Gallery, List Art Center, Brown University, Providence, Rhode Island. *Definitive Statements: American Art, 1964–66: An Exhibition by the Department of Art, Brown University*. March 1–30. Catalogue with texts by Christopher

Campbell, et al. Traveled to Parrish Art Museum, Southampton, New York (May 3–June 21).

> Harrison, Helen A. "Out of the 60's, a Meeting of History and Esthetics." *New York Times*, June 1, 1986.

Van Abbemuseum, Eindhoven, The Netherlands. *Ooghoogte: Stedelijk Van Abbemuseum, 1936–1986 [Eye Level: Stedelijk Van Abbemuseum, 1936–1986].* June 14–November 9. Catalogue with texts by Jan Debbaut, et al.

Holly Solomon Gallery, New York. *Text and Image: The Wording of American Art.* December.

> Smith, Roberta. "Art: 17 Early Paintings by Gerhard Richter." *New York Times*, January 2, 1987.

1987

Institute of Contemporary Art, University of Pennsylvania, Philadelphia. *1967: At the Crossroads.* March 13–April 26. Catalogue with text by Janet Kardon.

University Art Museum, University of California, Berkeley. *Made in U.S.A.: An Americanization in Modern Art, the '50s and '60s.* April 4–June 21. Catalogue with text by Sidra Stich. Traveled to Nelson-Atkins Museum of Art, Kansas City, Missouri (July 25–September 6) and Virginia Museum of Fine Arts, Richmond (October 7–December 7).

> Wilson, William. "Art: Made in the U.S.A." *Los Angeles Times*, May 24, 1987.

Clocktower Gallery, Institute for Contemporary Art, New York. *Modern Dreams: The Rise and Fall and Rise of Pop.* October 22, 1987–June 12, 1988. Catalogue with texts by Brian Wallis, et al.

Odakyu Grand Gallery, Tokyo. *Pop Art: U.S.A.–U.K.: American and British Art of the '60s in the '80s.* July 24–August 18. Catalogue with texts by Lawrence Alloway, Marco Livingstone, and Masataka Ogawa. Traveled to Daimaru Museum, Osaka (September 9–28); Funabashi Seibu Museum of Art, Funabashi (October 30–November 17); and Sogo Museum of Art, Yokohama (November 19–December 13).

1988

Museum of Modern Art, New York. *Committed to Print: Social and Political Themes in Recent American Printed Art.* January 31–April 19. Catalogue with text by Deborah Wye.

American Screenprints. Organized by National Academy of Design, New York. Federal Reserve Board Building, New York. May 17–September 2. Catalogue with text by Reba Williams and Dave Williams.

El Paso Museum of Art, Texas. *Pop Art: Works on Paper from the Collection of the Dayton Art Institute.* December 3–31. Traveled to Kerns Art Center, Eugene, Oregon (February 15–March 26, 1989); Art Center Waco, Texas (October 5–November 8, 1989); Turman Art Gallery, Indiana State University, Terre Haute (January 13–February 7, 1990); Art Center Gallery, College of DuPage, Glen Ellyn, Illinois (March 16–

April 30, 1990); Canton Art Institute, Ohio (June 1–August 15, 1990); and West Bend Gallery of Fine Art, Indiana (October 3–November 11, 1990).

1989

* Virginia Lust Gallery, New York. *Robert Indiana.* March.

> Russell, John. "Robert Indiana." *New York Times*, March 3, 1989.

Whitney Museum of American Art at Champion, Stamford, Connecticut. *The "Junk" Aesthetic: Assemblage of the 1950s and Early 1960s.* April 7–June 14. Catalogue with text by Roni Feinstein. Traveled to Whitney Museum of American Art at Equitable Center, New York (June 30–August 23).

> Karlins, N. F. "Arts/Entertainment: The Junk Aesthetic." *Westsider*, August 10–16, 1989.

Maine Coast Artists Gallery, Rockport. *The Vinalhaven Press: The First Five Years; Selected Prints, 1984–1989.* August 24–September 23. Catalogue. Traveled to Museum of Art, Olin Arts Center, Bates College, Lewiston, Maine (October 5–November 26).

* Galerie Natalie Seroussi, Paris. *Robert Indiana.* September 28–November 25. Catalogue with text by Herbert Lust.

1990

James Goodman Gallery, New York. *Pop on Paper.* May 4–June 15. Catalogue with texts by Timothy Bay, James Goodman, and Stuart Preston.

Nassau County Museum of Art, Roslyn Harbor, New York. *Two Decades of American Art: The 60's and 70's.* May 20–September 3. Catalogue with text by Leo Castelli.

> Harrison, Helen. "A Distorted View of 2 Decades." *New York Times*, July 1, 1990.

Milwaukee Art Museum. *Word as Image: American Art 1960–1990.* June 15–August 26. Catalogue with texts by Gerry Biller, Russell Bowman, and Dean Sobel. Traveled to Oklahoma City Art Museum (November 17, 1990–February 2, 1991) and Contemporary Arts Museum, Houston (February 23–May 12, 1991).

Montgomery Gallery, Pomona College, Claremont, California. *Crossing the Line: Word and Image in Art.* September 20–October 14. Catalogue with text by Mary Davis MacNaughton.

* Marisa del Re Gallery, New York. *Robert Indiana: Decade, Autoportrait.* November 27–December 31. Catalogue with text by Bill Maynes.

* Vinalhaven Press Gallery, New York. *Indiana.* November–December.

1991

IIIème Biennale de Sculpture Monte Carlo, Monaco. May–September 30. Catalogue with text by Pierre Restany.

* Susan Sheehan Gallery, New York. *Robert Indiana Prints: A Retrospective.* May–June 30. Catalogue with texts by Susan Sheehan and Poppy Gandler Orchier and interview with the artist by Poppy Gandler Orchier.

* Bates College Museum of Art, Olin Arts Center, Lewiston, Maine. *Robert Indiana: The Hartley Elegies.* August 30–December 20.

* Salama-Caro Gallery, London. *Robert Indiana: Early Sculpture, 1960–1962.* September 12–November 9. Catalogue with text by Robert Indiana.

Royal Academy of Arts, London. *The Pop Art Show.* September 13–December 15. Catalogue, *Pop Art: An International Perspective,* with texts by Marco Livingstone, et al. Traveled to Museum Ludwig, Cologne (January 23–April 19, 1992) and Centro de Arte Reina Sofía, Madrid (June 16–September 14, 1992).

1992

* Galería 57, Madrid. *Robert Indiana, Early Works.* June 8–September 12.

> Bonet, Juan Manuel. "ABC de las artes: Las letras 'pop' de Robert Indiana." *ABC,* July 3, 1992.

Musée d'Art Moderne et d'Art Contemporain, Nice. *Le portrait dans l'art contemporain, 1945–1992 [The Portrait in Contemporary Art, 1945–1992].* July 3–September 27. Catalogue with texts by Gilbert Perlain, et al.

Maine Coast Artists Gallery, Rockport. *On the Edge: Forty Years of Maine Painting, 1952–1992.* August 15–September 27. Catalogue with text by Theodore F. Wolff. Traveled to Reed Art Gallery, University of Maine at Presque Isle (October 3–December 20) and Portland Museum of Art, Maine (February 19–April 18, 1993).

Museum of Contemporary Art, Los Angeles. *Hand-Painted Pop: American Art in Transition, 1955–62.* December 6, 1992–March 7, 1993. Catalogue edited by Russell Ferguson with texts by Donna de Salvo, et al. Traveled to Museum of Contemporary Art, Chicago (April 3–June 20, 1993) and Whitney Museum of American Art, New York (July 16–October 3, 1993).

> Duncan, Michael. "Painterly Pop." *Art in America* 81, no. 7 (July 1993): 86–89, 117.

> Richard, Paul. "Snap, Crackle, Pop! Remember the Early '60s, When It Was Still Fun to Make Art?" *Washington Post,* August 8, 1993.

1993

The Pace Gallery, New York. *Indiana, Kelly, Martin, Rosenquist, Youngerman at Coenties Slip.* January 16–February 13. Catalogue with text by Mildred Glimcher.

> Smith, Roberta. "Art in Review: Coenties Slip." *New York Times,* February 12, 1993.

Espace lyonnais d'art contemporain, Lyon. *Autoportraits Contemporains / Here's Looking at Me.* January 29–April 30. Catalogue with text by Bernard Brunon.

* McNay Art Museum, San Antonio, Texas. *Robert Indiana's Hartley Elegies.* March 14–May 9.

> Goddard, Dan R. "Exhibit of Indiana Works." *San Antonio Express-News,* March 13, 1993.

IVème Biennale de Sculpture Monte Carlo, Monaco. May–September 30. Organized by Marisa del Re Gallery, New York, in collaboration with the Department of Cultural Affairs, La Société de Bains de Mer.

1994

Santa Barbara Museum of Art, California. *Printed Pop.* July 16–November 27.

> Wilson, William. "Art Review: 'Pop': Reminder of an Offbeat Generation." *Los Angeles Times,* July 29, 1994.

Institute of Contemporary Art, Boston. *Elvis + Marilyn 2X Immortal.* November 2, 1994–January 8, 1995. Catalogue edited by Geri De Paoli and Wendy McDavis with texts by John D. Baskerville, et al. Traveled to Contemporary Arts Museum, Houston (February 4–March 26, 1995); Mint Museum of Art, Charlotte, North Carolina (April 15–June 30, 1995); Cleveland Museum of Art (August 2–September 24, 1995); New-York Historical Society (October 15, 1995–January 8, 1996); Philbrook Museum of Art, Tulsa, Oklahoma (April 13–June 3, 1996); Columbus Museum of Art, Ohio (June 22–August 19, 1996); Tennessee State Museum, Nashville (September 7–November 3, 1996); San Jose Museum of Art, California (November 23, 1996–January 30, 1997); and Honolulu Academy of the Arts, Hawaii (April 17–June 8, 1997).

Marlborough Gallery, New York. *The Pop Image: Prints and Multiples.* November 9–December 3. Catalogue with text by Dore Ashton, et al.

1995

Museu de Arte Moderna, São Paulo. *Master American Contemporaries II.* January 17–February 28. Catalogue with text by Michael McKenzie.

Kunsthal Rotterdam, The Netherlands. *Pop Art.* April 8–October 29. Catalogue with text by Cees Straus.

Frederick R. Weisman Art Museum, University of Minnesota, Minneapolis. *Dictated by Life: Marsden Hartley's German Officer Paintings and Robert Indiana's Hartley Elegies.* April 14–June 18. Catalogue with texts by Patricia McDonnell and Michael Plante. Traveled to Terra Museum of American Art, Chicago (July 11–September 17) and The Art Museum at Florida International University, Miami (October 13–November 22).

> Abbe, Mary. "The LIFE and LOVEs of Robert Indiana: Weisman Show Explores the Coded Art of Maine Man." *Minneapolis Star Tribune,* April 9, 1995.

"Friendship, Love, Truth: Robert Indiana Pays Homage to Marsden Hartley." *Chicago Tribune*, August 13, 1995.

Casino de Monte Carlo, Monaco. *Vème Biennale de Sculpture Monte Carlo*. May–September 30. Catalogue. Organized by Marisa del Re Gallery, New York in collaboration with the Department of Cultural Affairs, La Société de Bains de Mer.

Vieux-Port de Montréal. *Skulptura Montréal 95: exposition internationale de sculptures extérieures [Skulptura Montreal 95: International Outdoor Sculpture Exhibition]*. June 15–September 17. Catalogue with text by Serge Fisette.

Marisa del Re Gallery and O'Hara Gallery, New York. *The Popular Image: Pop Art in America*. October 26–December 9. Catalogue with text by Sam Hunter. Traveled to Marisa del Re/O'Hara Gallery, Palm Beach, Florida (December 23, 1995–January 27, 1996).

1996

* Indianapolis Museum of Art. *Robert Indiana: The Hartley Elegies*. January 13–March 31. Catalogue with text by Holliday T. Day.

Elise Goodheart Fine Arts, Sag Harbor, New York. *Coenties Slip Artists: Now and Then*. June 22–July 14.

Braff, Phyllis. "Collages in Color and Black and White." *New York Times*, June 30, 1996.

Centre Georges Pompidou, Paris. *Face à l'Histoire, 1933–1996: l'artiste moderne devant l'événement historique [Facing History, 1933–1996: The Modern Artist before the Historical Event]*. December 18, 1996–April 7, 1997. Catalogue with text by Jean-Paul Ameline.

1997

* Portland Museum of Art, Maine. *Robert Indiana: Decade*. February 15–April 13.

Miller, Zoë. "Preview: Indiana on My Mind." *Casco Bay (ME) Weekly*, February 13, 1997.

Portland Museum of Art, Maine. *In Print: Contemporary Artists at the Vinalhaven Press*. April 13–June 4. Catalogue with texts by Aprile Gallant and David P. Becker. Traveled to McMullen Museum of Art, Boston College (June 19–September 14).

Temin, Christine. "Traditional Printing, Contemporary Images." *Boston Globe*, August 13, 1997.

VIème Biennale de Sculpture de Monte Carlo, Monaco. May–September. Catalogue. Organized by Marisa del Re Gallery in collaboration with the Department of Cultural Affairs, La Société des Bains de Mer.

University Art Museum, California State University, Long Beach. *The Great American Pop Art Store: Multiples of the Sixties*. August 26–October 26. Catalogue with texts by Constance W. Glenn, Karen L. Kleinfelder, and Dorothy Lichtenstein. Traveled to Jane Voorhees Zimmerli Art Museum, Rutgers University, New Brunswick, New Jersey (November 22, 1997–

February 22, 1998); Baltimore Museum of Art (March 25–May 31, 1998); Montgomery Museum of Fine Arts, Alabama (June 27–August 23, 1998); Frederick R. Weisman Art Museum, University of Minnesota, Minneapolis (October 3–December 6, 1998); McNay Art Museum, San Antonio, Texas (January 18–March 14, 1999); Wichita Art Museum, Kansas (April 11–June 6, 1999); Muskegon Museum of Art, Michigan (July 29–September 12, 1999); Joslyn Art Museum, Omaha, Nebraska (October 23, 1999–January 9, 2000); Lowe Art Museum, Coral Gables, Florida (February 3–March 26, 2000); and Toledo Museum of Art, Ohio (June 4–August 13, 2000).

* Murphy J. Foster Hall Art Gallery, Louisiana State University, Baton Rouge. *Dream-Work: Robert Indiana Prints*. September 15–October 15. Catalogue with text by Susan Elizabeth Ryan.

Musée d'Art Moderne et d'Art Contemporain, Nice. *De Klein à Warhol: Face-à-Face France/États-Unis: Collections du Musée National d'Art Moderne et du Musée d'Art Moderne et d'Art Contemporain de Nice [From Klein to Warhol: Face-to-Face France/United States: Collections from the Musée National d'Art Moderne and the Musée d'Art Moderne et d'Art Contemporain in Nice]*. November 14, 1997–March 16, 1998. Catalogue with texts by Sophie Duplaix and Gilbert Perlein.

1998

* Musée d'Art Moderne et d'Art Contemporain, Nice. *Robert Indiana: Rétrospective, 1959–1998*. June 26–November 22. Catalogue with texts by Joachim Pissarro and Hélène Depotte.

De Chassey, Eric. "Exposition: Indiana hors normes." *L'Oeil*, no. 498 (July/August 1998): 33.

Régnier, Philippe. "L'été indien de Nice: La ville offer une grande rétrospective à Robert Indiana." *Le Journal des Arts*, no. 66 (September 11, 1998).

High Museum of Art, Atlanta. *Pop Art: Selections from the Museum of Modern Art*. October 24, 1998–January 17, 1999. Catalogue with texts by Anne Umland, et al. Traveled to New York State Museum, Albany (February 26–May 2, 1999). Organized by the Museum of Modern Art, New York, in collaboration with the High Museum of Art.

1999

* Woodward Gallery, New York. *Robert Indiana: Prints*. January 14–March 6.

Cotter, Holland. "Changes Aside, SoHo Is Still Very Much SoHo." *New York Times*, February 12, 1999.

Museum of Modern Art, New York. *Pop Impressions: Europe/USA: Prints and Multiples from The Museum of Modern Art*. February 18–May 18. Catalogue with text by Wendy Weitman.

Glueck, Grace. "Art Review: Pop's 15 Minutes Keeps on Ticking." *New York Times*, April 23, 1999.

Castellani Art Museum, Niagra University, Lewiston, New York. *In Company: Robert Creeley's Collaborations.* April 12–June 12. Catalogue edited by Elizabeth Licata and Amy Cappellazzo. Traveled to New York Public Library, Humanities and Social Sciences Library, Edna Barnes Salomon Room (September 13, 1999–January 13, 2000); Weatherspoon Art Gallery, University of North Carolina at Greensboro (February 13–April 22, 2000); University of South Florida Contemporary Art Museum, Tampa (May 12–July 15, 2000); and Green Library, Stanford University, California (September 1, 2000–January 6, 2001).

> Midgette, Anne. "Words Worth a Thousand Pictures—Juxtaposing Poetry and Painting, Robert Creeley's Collaborations Give Art New Meaning." *Wall Street Journal*, September 22, 1999.

Nassau County Museum of Art, Roslyn Harbor, New York. *Contemporary American Masters: The 1960s.* June 13–September 12. Catalogue with texts by Constance Schwartz and Franklin Hill Perrell.

> Mills, Joan. "Ah, the Sexy Sixties: The Art Museum Brings Alive the Generation That Turned It Loose." *House* (May/June 1999): 82–83.

* Portland Museum of Art, Maine. *Love and the American Dream: The Art of Robert Indiana.* June 24–October 17. Catalogue with texts by Aprile Gallant, Daniel E. O'Leary, and Susan Elizabeth Ryan. Traveled to Marietta/Cobb Museum of Art, Marietta, Georgia (November 23, 1999–January 30, 2000).

> Sutherland, Amy. "For Better and Worse, It's the Love of His Life." *Maine Telegram*, June 20, 1999.

> Isaacson, Philip. "Indiana's 'American Dream' a Gift That Will Keep on Giving." *Maine Sunday Telegram*, July 4, 1999.

> Foshee, Rufus. "The Art of Robert Indiana: Seldom Seen or Appreciated, Always Unique." *Rockland* (ME) *Free Press*, July 22, 1999.

> Beem, Edgar Allen. "The Power of Love: Indiana Reconsidered." *Maine Times*, August 5, 1999.

> Palumbo, Mary Jo. "Rediscovering 'LOVE'—Retrospective Lets Robert Indiana Send His Message around the World." *Boston Herald*, August 12, 1999.

> Cotter, Holland. "Bountiful Boston." *New York Times*, August 20, 1999.

> Glueck, Grace. "Robert Indiana's Career: Love and American Style." *New York Times*, August 27, 1999.

> Temin, Christine. "The Real 'Love' of Robert Indiana." *Boston Globe*, August 29, 1999.

> Fox, Catherine. "Visual Arts: The 'Love' of Indiana Reconsidered." *Atlanta Journal-Constitution*, December 10, 1999.

Tehran Museum of Contemporary Art, Iran. *Pop Art.* August 16, 1999–January 22, 2000.

Whitney Museum of American Art, New York. *The American Century: Art & Culture 1900–2000, Part II, 1950–2000.* September 26, 1999–February 13, 2000. Catalogue with text by Lisa Phillips.

2000

Indianapolis Museum of Art. *Crossroads of American Sculpture.* October 14, 2000–January 21, 2001. Catalogue with texts by Holliday T. Day, Dore Ashton, and Lena Vigna. Traveled to New Orleans Museum of Art (June 30–September 2, 2001).

> McQuiston, Julie Pratt. "Indiana, Indianapolis: Crossroads of American Sculpture." *Dialogue* 24, no. 2 (March/April 2001): 47.

> McQuiston, Julie Pratt. "Indelicate Balance: Holly Day through the Crossroads." *New Art Examiner* 28, nos. 8/9 (May/June 2001): 77–81.

Museum Moderner Kunst Stiftung Ludwig Wien, Vienna. *Zwischenquartier [Interim Quarters].* October 26, 2000–March 11, 2001. Catalogue with text by Lóránd Hegyi.

2001

Centre Georges Pompidou, Paris. *Les Années Pop: 1956 à 1968 [The Pop Years: 1956 to 1968].* March 15–June 18. Catalogue with texts by Mark Francis, et al.

Centre Georges Pompidou, Paris. *Denise René, l'intrépide [Denise René, the Intrepid].* April 4–June 4. Catalogue with texts by Jean-Paul Ameline, Véronique Wiesinger, and Marion Hohlfeldt.

* Galerie Guy Pieters, Saint-Paul-de-Vence, France. *The Marilyn Paintings* and *Love-Art-Numbers.* September. Catalogue with text by Hélène Depotte.

Walker Art Center, Minneapolis. *American Tableaux.* November 10, 2001–June 16, 2002. Traveled to Miami Art Museum, Florida (June 20–September 7, 2003); Delaware Art Museum, Wilmington (October 10, 2003–January 4, 2004); University of Iowa Museum of Art, Iowa City (February 8–April 25, 2004); Winnipeg Art Gallery, Canada (September 8–December 5, 2004); and Plains Art Museum, Fargo, North Dakota (January 13–March 27, 2005).

> Abbe, Mary. "American Beauty: Walker Art Center Reshuffles Its Collection in Search of Defining American Narratives." *Minneapolis Star Tribune*, November 23, 2001.

2002

* Shanghai Art Museum. *Robert Indiana.* July 5–August 8. Catalogue with text by Stephen C. Foster.

2003

* *One Through Zero.* Organized by the City of New York Parks and Recreation Department as part of "Art in the Parks." Presented in collaboration with The Fund for Park Avenue. Park Avenue Malls, New York. February 3–May 3.

> Vogel, Carol. "Inside Art: Running Numbers." *New York Times*, December 27, 2002.

> Kinetz, Erika. "It Isn't Public Art Until They Say It Is." *New York Times*, February 16, 2003.

> Foshee, Rufus. "An Indiana Parade on Park." *The Free Press*, April 24, 2003.

* C&M Arts, New York. *Robert Indiana: Letters, Words and Numbers*. February 13–March 22. Catalogue with text by Robert Pincus-Witten. Presented in association with Simon Salama-Caro.

> Vogel, Carol. "Inside Art: Running Numbers." *New York Times*, December 27, 2002.

> MacAdam, Barbara A. "New York Reviews: Robert Indiana." *ARTnews* 102, no. 2 (February 2003): 124.

> Pollack, Barbara. "Datebook: Indiana, Pacer." *Art & Auction* 25, no. 3 (March 2003): 99–100.

> Tully, Judd. "Second Coming." *Art & Auction* 25, no. 6 (June 2003): 92–103.

* Paul Kasmin Gallery, New York. *Robert Indiana: Recent Paintings*. February 14–March 22. Catalogue with text by Nathan Kernan.

> "New Robert Indiana Work: What's Love Got to Do with It?" *Art Newsletter*, February 4, 2003.

> Pollack, Barbara. "Datebook: Indiana, Pacer." *Art & Auction* 25, no. 3 (March 2003): 99–100.

> Tully, Judd. "Second Coming." *Art & Auction* 25, no. 6 (June 2003): 92–103.

* Michael Kohn Gallery, Los Angeles. *Robert Indiana: Peace Paintings*. September 19–October 25. Catalogue.

* Scottsdale Museum of Contemporary Art, Arizona. *Robert Indiana: The Story of LOVE*. December 20, 2003–May 2, 2004. Catalogue with text by Valerie Vadala Homer.

2004

* Paul Kasmin Gallery, New York. *Robert Indiana: Peace Paintings*. April 21–May 29. Catalogue.

> La Rocco, Claudia. "Robert Indiana Creates Peace Paintings in Response to American Foreign Policy." *Associated Press Worldstream*, April 23, 2004.

> K[aren] R[osenberg]. "Retrospective: Tallying Cry: Robert Indiana, on His New Anti-War Work and the Fate of 'Love.'" *New York Magazine*, April 26, 2004.

> La Rocco, Claudia. "LOVE Artist Tackles Peace and Petroleum." *Seattle Times*, May 3, 2004.

> Andre, Mila. "An Artist Says His Peace." *New York Daily News*, May 7, 2004.

> Henry, Clare. "Pop Art Brings Peace, Where Once It Brought Love." *Financial Times*, May 11, 2004.

> Schoetzau, Barbara. "Creator of Love Symbol Celebrates 75th Birthday." *Voice of America*, May 12, 2004.

> Peterson, Oliver. "When in Manhattan . . . Peace and Love with Robert Indiana." *Dan's Papers*, May 14, 2004.

> Johnson, Ken. "Art in Review: Robert Indiana: 'Peace Paintings.'" *New York Times*, May 21, 2004.

> Leffingwell, Edward. "Robert Indiana at Paul Kasmin." *Art in America* 92, no. 10 (November 2004): 169.

* Price Tower Arts Center, Bartlesville, Oklahoma. *Robert Indiana 66: Paintings and Sculpture*. April 23–July 4. Catalogue with text by Adrian Dannatt.

> "Price Tower Exhibit Shows Artist's 'Love' of '66: Arts Center Explores the Great Plains Roots of Robert Indiana's Art." *Bartlesville (OK) Examiner-Enterprise*, April 23, 2004.

> Watts, James D., Jr. "Sign, Sign, Everywhere a Sign: Artist Robert Indiana Mines the 'Mother Road' for Inspiration." *Tulsa World*, April 25, 2004.

> "Price Tower Hosts Artist Robert Indiana." *Bartlesville (OK) Examiner-Enterprise*, April 30, 2004.

> "Indiana Exhibit." *Boston Sunday Globe*, May 2, 2004.

> La Rocco, Claudia. "LOVE Artist Tackles Peace and Petroleum." *Seattle Times*, May 3, 2004.

> Schoetzau, Barbara. "Creator of Love Symbol Celebrates 75th Birthday." *Voice of America*, May 12, 2004.

ARoS Aarhus Kunstmuseum, Denmark. *Pop Classics: Allan d'Arcangelo, Jim Dine, Robert Indiana, Jasper Johns, Allan Kaprow, Edward Kienholz, Yayoi Kusama, Roy Lichtenstein, Marisol, Claes Oldenburg, Robert Rauschenberg, James Rosenquist, Ed Ruscha, Wayne Thiebaud, Andy Warhol, Tom Wesselmann*. May 28–September 5. Catalogue with texts by Jens Erik Sørensen, et al. Co-organized by Museum Ludwig, Cologne.

* Waddington Galleries, London. *Robert Indiana: Paintings and Sculpture, 1961 to 2003*. September 29–October 23. Catalogue with text by Adrian Dannatt.

> Sumpter, Helen. "Robert Indiana." *Time Out London*, October 13, 2004.

* Galería Javier López, Madrid. *Robert Indiana: Obra Reciente [Robert Indiana: Recent Work]*. November 5–December 31.

> Ó[scar] A[lonso] M[olina]. "Robert Indiana." *Arte y Parte*, no. 53 (October–November 2004): 117.

> Navarro, Mariano. "Robert Indiana: Pelar la Bomba." *El Cultural–El Mundo*, November 11, 2004.

> "Robert Indiana." *Exit Express*, no. 8 (December 2004–January 2005): 20.

* Gallery Hyundai, Seoul. *Robert Indiana*. December 15, 2004–January 16, 2005. Catalogue with text by Jacob Robichaux.

2005

Tate Liverpool. *Summer of Love: Art of the Psychedelic Era*. May 27–September 25. Catalogue edited by Christoph Grunenberg. Traveled to Schirn Kunsthalle Frankfurt (November 2, 2005–February 12, 2006); Kunsthalle Wien, Vienna (May 5–September 3, 2006); and Whitney Museum of American Art, New York (May 24–September 16, 2007).

> Larsen, Lars Bang. "Summer of Love." *Artforum* 44, no. 6 (February 2006): 222.

> Pendle, George. "Summer of Love." *Frieze*, no. 111 (November–December 2007): 195.

* Paul Kasmin Gallery, New York. *Robert Indiana: Wood.* September 9–October 8. Catalogue with text by Adrian Dannatt.

> McGee, Celia. "A Big Wheel's Slip Service." *New York Daily News*, September 9, 2005.

> "Love Machine Robert Indiana." *New York Magazine*, September 19, 2005.

* Bates College Museum of Art, Olin Arts Center, Lewiston, Maine. *Robert Indiana: The Hartley Elegies.* October 1, 2004–December 17, 2005. Catalogue with text by Susan Elizabeth Ryan.

2006

* Seoul Museum of Art. *Robert Indiana: A Living Legend.* March 11–April 30. Catalogue with text by Adrian Dannatt.

* Paseo del Prado and Paseo de Recoletos, Madrid. *15 esculturas, 15 besos a Madrid [15 Sculptures, 15 Kisses for Madrid].* May 4–July 31. Catalogue. Organized by Aqualium Spain, Sociedad Limitada.

* Miami University Art Museum, Oxford, Ohio. *Social Justice: Robert Indiana.* August 29–December 16.

Fondation Beyeler, Riehen, Switzerland. *Eros in der Kunst der Moderne [Eros in Modern Art].* October 8, 2006–February 18, 2007. Catalogue edited by Delia Ciuha with Raphael Bouvier and Judith Rauser. Traveled to BA-CA Kunstforum, Vienna (March 1–July 22, 2007).

2007

* Gran Vía Marqués del Turia, Valencia, Spain. *14 esculturas por amor al arte. [14 Sculptures for the Love of Art].* January 8–February 25. Catalogue. Traveled to Gran Vía Don Diego López de Haro, Bilbao, Spain (March 29–June 27) and Praça Marqués do Pombal, Avenida da Liberdade, and Praça Rossio, Lisbon (November 30, 2007–February 29, 2008). Organized by Aqualium Spain, Sociedad Limitada.

Princeton University Art Museum, Princeton, New Jersey. *Pop Art at Princeton: Permanent and Promised.* March 24–August 12. Catalogue, *Pop Art: Contemporary Perspectives*, with texts by Suzanne Hudson, et al.

* Museum Kurhaus Kleve, Germany. *Robert Indiana: Der Amerikanische Maler der Zeichen [Robert Indiana: The American Sign Painter].* August 26, 2007–January 6, 2008. Catalogue with text by Roland Mönig. Traveled to Museum Wiesbaden, Germany (January 22–May 18, 2008; catalogue with text by Jörg Daur).

* *Art in the Parks: Robert Indiana, Love Wall.* Co-organized by City of New York Parks and Recreation Department, Fund for Park Avenue, and Paul Kasmin Gallery, New York. Park Avenue Malls, New York. October 1, 2007–May 15, 2008.

National Portrait Gallery, London. *Pop Art Portraits.* October 11, 2007–January 20, 2008. Catalogue with texts by Dominic Sandbrook and Paul Moorhouse. Traveled to Staatsgalerie Stuttgart, Germany (February 23–June 8, 2008).

Scuderie del Quirinale, Rome. *Pop Art! 1956–1968.* October 26, 2007–January 27, 2008. Catalogue with texts by Walter Guadagnini, Lóránd Hegyi, and Daniela Lancioni.

* Galerie Gmurzynska, Zurich. *Robert Indiana: A Retrospective.* November 20, 2007–January 31, 2008.

2008

Nassau County Museum of Art, Roslyn Harbor, New York. *Pop and Op.* February 17–May 4. Catalogue with texts by Franklin Hill Perrell and Constance Schwartz.

Van Abbemuseum, Eindhoven, The Netherlands. *Living Archive: Mixed Messages.* April 15–September 14. Catalogue.

* Padiglione di Arte Contemporanea, Piazzetta Reale, Piazza della Scala, and Corso Vittorio Emanuele II, Milan. *Robert Indiana a Milano [Robert Indiana in Milan].* June 21–September 14. Catalogue with text by Guido Comis. Co-organized by Galerie Gmurzynska, Zurich.

* Galerie Boisserée, Cologne. *Robert Indiana: The American Dream.* July 24–August 9.

Dialog:City (public program of the 2008 Democratic National Convention). Organized by the Denver Office of Cultural Affairs in conjunction with the Democratic National Committee. Pepsi Center, Denver. August 21–29.

> Canfield, Clarke. "Maine Artist Creates HOPE Image Decades after LOVE." *USA Today*, August 30, 2008.

> MacMillan, Kyle. "Fine Arts: Convention Helped Put Denver on the Art World's Radar; 'Dialogue:City,' Other Efforts during DNC Brought an Unexpected New York Vibe." *Denver Post*, August 31, 2008.

> Derakhshani, Tirdad. "With This Ring, Bada-Bing." *Philadelphia Inquirer*, September 1, 2008.

* Paul Kasmin Gallery, New York. *Robert Indiana: Hard Edge.* September 18–November 1. Catalogue with text by Adrian Dannatt.

2009

* Jim Kempner Fine Art, New York. *HOPE: Robert Indiana.* January 15–February 26.

* Galerie Boisserée, Cologne. *Robert Indiana: LOVE.* April 22–May 30.

* Farnsworth Art Museum, Rockland, Maine. *Robert Indiana and the Star of Hope.* June 20, 2009–January 10, 2010. Catalogue with texts by John Wilmerding and Michael Komanecky.

> McAvoy, Suzette. "Robert Indiana, Beyond Love." *Maine Home and Design*, April 2009, http://www.mainehomedesign.com/profiles/990-robert-indiana-beyond-love.html/.

> "Artist Robert Indiana Is on the Menu in Maine." *Los Angeles Times*, June 26, 2009.

Smee, Sebastian. "Indiana by Way of Maine; Exhibition Considers More than Pop Pieces." *Boston Globe*, August 21, 2009.

Hagan, Debbie. "Robert Indiana: Words as Medium." *Art New England* 30, no. 4 (August/September 2009): 16–18.

2010

Sheldon Museum of Art, Lincoln, Nebraska. *Messaging: Text and Visual Art*. May 7–August 1. Traveled to Chadron State College, Chadron, Nebraska (August 25–September 26); McKinley Education Center, North Platte, Nebraska (September 29–October 31); Museum of the High Plains, McCook, Nebraska (November 2–December 2); Gallery 92 West/Fremont Area Art Association, Nebraska (January 5–February 4, 2011); Columbus Art Gallery, Nebraska (February 5–March 7, 2011); Cornerstone Bank, York, Nebraska (March 9–April 11, 2011); and Library and Arts Center, Stalder Gallery, Falls City, Nebraska (May 15–June 15, 2011).

* Woodward Gallery, New York. *Robert Indiana: NOW*. November 20, 2010–January 22, 2011.

2011

* *Robert Indiana: The Four Seasons of Hope*. Organized by Woodward Gallery, New York. Four Seasons Restaurant, New York. January 13– December 31.

Vogel, Carol. "Inside Art: Metropolitan to Host Cézanne's 'Card Players'; Indiana in Four Seasons." *New York Times*, December 9, 2010.

Ebony, David. "Robert Indiana: A Man for All Seasons." *Art in America*, January 26, 2011, http://www.artinamericamagazine.com/news-opinion/news/2011-01-26/robert-indiana-hope-four-seasons/

* Galerie Gmurzynska, Zurich. *Robert Indiana: Rare Works from 1959 on Coenties Slip*. June 12–September 20. Catalogue with text by Joachim Pissarro.

2012

* Rosenbaum Contemporary, Boca Raton, Florida. *Robert Indiana: New and Classic Works*. February 9–March 2.

University Art Gallery, Indiana State University, Terre Haute. *Love and Fame: Works by Robert Indiana and Andy Warhol from Indiana State University's Permanent Art Collection*. September 24–October 26. Catalogue with texts by Barbara D. Räcker, Susan Elizabeth Ryan, and William V. Ganis.

* Waddington Custot Galleries, London. *Robert Indiana: Sculptures*. October 3–November 10. Catalogue.

* Galleria d'Arte Contini, Venice. *Robert Indiana "HOPE."* October 20, 2012–June 30, 2013.

2013

Acquavella Galleries, New York. *The Pop Object: The Still Life Tradition in Pop Art*. April 10–May 24. Catalogue with text by John Wilmerding.

Galerie Gmurzynska, Zurich. *Robert Indiana: The Monumental Woods*. June 8–mid-September. Catalogue with texts by Evgenia Perrova and Joachim Pissarro.

SELECTED BIBLIOGRAPHY

MONOGRAPHS AND SOLO EXHIBITION CATALOGUES

Celant, Germano. *Robert Indiana a Milano*. Exhibition catalogue. Milan: Padiglione d'Arte Contemporanea and Galerie Gmurzynska in association with Silvana Editoriale, 2008.

Creeley, Robert, and Robert Indiana. *Numbers*. New York: Poets Press, 1968.

Foster, Stephen C. *Robert Indiana*. Exhibition catalogue. With autochronology by Robert Indiana. Shanghai: Shanghai Art Museum, 2002.

Goodall, Donald B., Robert L. B. Tobin, and William Katz. *Robert Indiana*. Exhibition catalogue. With statements and autochronology by Robert Indiana and interview with the artist by Goodall. Austin, Texas: University Art Museum, University of Texas at Austin, 1977.

Kernan, Nathan. *Robert Indiana*. New York: Assouline Publishing, 2003.

Krause, Martin, and John Wilmerding. *The Essential Robert Indiana*. New York: Prestel, 2013.

McCoubrey, John W. *Robert Indiana*. Exhibition catalogue. With statements and autochronology by Robert Indiana. Philadelphia: Institute of Contemporary Art, University of Pennsylvania, 1968.

Mecklenburg, Virginia M. *Wood Works: Constructions by Robert Indiana*. Exhibition catalogue. Washington, D.C.: National Museum of American Art and the Smithsonian Institution Press, 1984.

Oh, Hyun-Mee, and Adrian Dannatt. *Robert Indiana: A Living Legend*. Exhibition catalogue. With autochronology by Robert Indiana. Seoul: Seoul Museum of Art, 2006.

O'Leary, Daniel, Aprile Gallant, and Susan Elizabeth Ryan. *Love and the American Dream: The Art of Robert Indiana*. Exhibition catalogue. Portland, Maine: Portland Museum of Art, 1999.

Péladeau, Marius B., and Martin Dibner. *Indiana's Indianas: A 20-Year Retrospective of Paintings and Sculpture from the Collection of Robert Indiana*. Exhibition catalogue. Rockland, Maine: The William A. Farnsworth Library and Art Museum, 1982.

Pissarro, Joachim, and Hélène Depotte. *Robert Indiana: Rétrospective 1958–1998*. Exhibition catalogue. Nice, France: Musée d'Art Moderne et d'Art Contemporain, 1998.

Pissarro, Joachim, John Wilmerding, and Robert Pincus-Witten. *Robert Indiana*. With autochronology by Robert Indiana. New York: Rizzoli International Publications, 2006.

Robert Indiana. Exhibiton catalogue. With introduction by Jan van der Marck and essay by Gene R. Swenson. Minneapolis, Minnesota: Dayton's Gallery 12, 1966.

Robert Indiana: Early Sculpture, 1960–1962. Exhibition catalogue. With essay by William Katz and artist statement and autochronology by Robert Indiana. London: Salama-Caro Gallery, 1991.

Robert Indiana: Hard Edge. Exhibition catalogue. With essay by Adrian Dannatt. New York: Paul Kasmin Gallery, 2008.

Robert Indiana: Letters, Words and Numbers. Exhibition catalogue. With essay by Robert Pincus-Witten. New York: C & M Arts, in association with Simon Salama-Caro, 2003.

Robert Indiana: Paintings and Sculpture, 1961 to 2003. Exhibition catalogue. With essay by Adrian Dannatt and autochronology by Robert Indiana. London: Waddington Galleries, 2004.

Robert Indiana: Peace Paintings. Exhibition catalogue. With essay by Adrian Dannatt and artist statement by Robert Indiana. New York: Paul Kasmin Gallery, 2004.

Robert Indiana: Rare Works from 1959 at Coenties Slip. Exhibition catalogue. With essay by Joachim Pissarro and Mara Hoberman, and interview of the artist by Pissarro. Zurich: Galerie Gmurzynska, 2011.

Robert Indiana: Recent Paintings. Exhibition catalogue. With essay by Nathan Kernan. New York: Paul Kasmin Gallery, 2003.

Robert Indiana: Wood. Exhibition catalogue. With essay by Adrian Dannatt. New York: Paul Kasmin Gallery, 2005.

Ryan, Susan Elizabeth. *Robert Indiana: Figures of Speech*. New Haven, Connecticut: Yale University Press, 2000.

Sheehan, Susan. *Robert Indiana Prints: A Catalogue Raisonné, 1951–1991*. With an interview of the artist by Poppy Gandler Orchier. New York: Susan Sheehan Gallery, 1991.

Sogbe, Beatriz. *Los Estados Unidos Bajo La Optica de Robert Indiana*. Exhibition catalogue. With autochronology by Robert Indiana. Caracas, Venezuela: Galeria Ateneo de Caracas, 2001.

Storr, Robert, Thomas Crow, Jonathan D. Katz, Kalliopi Minioudaki, and Allison Unruh. *Robert Indiana: New Perspectives*. Edited by Allison Unruh. Ostfildern, Germany: Hatje Cantz Verlag, 2012.

Weinhardt, Jr., Carl J. *Robert Indiana*. New York: Harry N. Abrams, 1990.

Wilmerding, John, and Michael K. Komanecky. *Robert Indiana and the Star of Hope*. Exhibition catalogue. Rockland, Maine: Farnsworth Art Museum, 2009.

GROUP EXHIBITION CATALOGUES AND GENERAL LITERATURE

Amaya, Mario. *Pop Art . . . And After*. New York: The Viking Press, 1965.

Brauer, David E., Jim Edwards, Christopher Finch, and Walter Hopps. *Pop Art: US/UK Connections, 1956–1966*. Exhibition catalogue. Houston, Texas: The Menil Collection, 2001.

Day, Holliday T. *Crossroads of American Sculpture: David Smith, George Rickey, John Chamberlain, Robert Indiana, William T. Wiley, Bruce Nauman*. Exhibition catalogue. With essays by Dore Ashton and Lena Vigna. Indianapolis, Indiana: Indianapolis Museum of Art, 2000.

Glimcher, Mildred. *Indiana, Kelly, Martin, Rosenquist, Youngerman at Coenties Slip*. Exhibition catalogue. New York: Pace Gallery, 1993.

Lippard, Lucy R. *Pop Art*. With contributions by Lawrence Alloway, Nancy Marmer, and Nicolas Calas. New York: Frederick A. Praeger, 1966.

Madoff, Steven Henry. *Pop Art: A Critical History*. Berkeley, California: University of California Press, 1997.

McDonnell, Patricia. *Dictated by Life: Marsden Hartley's German Paintings and Robert Indiana's Hartley Elegies*. Exhibition catalogue. With essay by Michael Plante. Minneapolis, Minnesota: Frederick R. Weisman Art Museum, University of Minnesota, 1995.

Russell, John, and Suzi Gablik. *Pop Art Redefined*. New York: Frederick A. Praeger, 1969.

São Paulo 9: Edward Hopper, Environment U.S.A.: 1957–1967 / Meio-Natural U.S.A.: 1957–1967. Exhibition catalogue. With essays by William C. Seitz and Lloyd Goodrich. Washington, D.C.: The Smithsonian Institution Press for the National Collection of Fine Arts, 1967.

Stringer, John. *25 Años Despues: Robert Indiana, Ellsworth Kelly, Agnes Martin, Edgar Negret, Louise Nevelson, Jack Youngerman*. Exhibition catalogue. Bogotá, Colombia: El Museo de Arte Moderno de Bogotá, 1979.

Umland, Anne. *Pop Art: Selections from The Museum of Modern Art*. Exhibition catalogue. With essays by Leslie Jones, Laura Hoptman, and Beth Handler. New York: The Museum of Modern Art in collaboration with the High Museum of Art, 1998.

ARTICLES, ESSAYS, AND INTERVIEWS

Alloway, Lawrence. "Notes on Five New York Painters." *Buffalo Fine Arts Academy, Albright-Knox Art Gallery, Gallery Notes* 26, no. 2 (Autumn 1963): 13–20.

Baker, Richard Brown. "Oral History Interview with Robert Indiana." Tape recording and transcript, September 12–November 7, 1963. Archives of American Art, Smithsonian Institution, Washington, D.C.

Calas, Nicholas, and Elena Calas. "Robert Indiana and His Injunctions." In *Icons and Images of the Sixties*, 139–44. New York: E. P. Dutton & Co., 1971.

Carr, Arthur C. "The Reminiscences of Robert Indiana." Unpublished interview with the artist, November 1965. Arthur C. Carr Papers, Rare Book and Manuscript Library, Columbia University, New York.

———. Unpublished manuscript. Papers on Robert Indiana, 1952–1991, Rare Book and Manuscript Library, Columbia University, New York.

Castro, Jan Garden. "More Famous than John Dillinger: A Conversation with Robert Indiana." *Sculpture* 28, no. 2 (March 2009): 44–45.

"Commanding Painter." *Time* 83, no. 21 (May 22, 1964): 72.

Dannatt, Adrian. "Artist Interview: LOVE, Pop, Words and More." *The Art Newspaper* 9, no. 133 (February 2003): 16.

Diamonstein, Barbaralee. "Interview with Robert Indiana." In *Inside New York's Art World*, 151–66. New York: Rizzoli International Publications, 1979.

Hagan, Debbie. "Robert Indiana: Words as Medium." *Art New England* 30, no. 5 (August–September 2009): 16–18.

Hudson, Suzanne. "Robert Indiana: 'A People's Painter.'" In Johanna Burton, et al. *Pop Art: Contemporary Perspectives*, 14–35. Exhibition catalogue. Princeton, New Jersey: Princeton University Art Museum, 2007.

Katz, William. "A Mother Is a Mother." *Arts Magazine* 41, no. 3 (December 1966–January 1967): 46–48.

Lemos, Peter. "Indiana in Maine." *ARTnews* 88, no. 8 (October 1989): 166–69.

Loring, Jon. "*Architectural Digest* Visits: Robert Indiana." *Architectural Digest* 35, no. 9 (November 1978): 112–21.

Messer, Thomas M. "Coins by Sculptors." *Art in America* 51, no. 2 (April 1963): 32–38.

Miller, Frances Koslow. "Robert Indiana." *Tema Celeste* 20, no. 95 (January/February 2003): 70–75.

Peterson, William, and Bob Tomilson. "Robert Indiana" [interview]. *Artspace* 1, no. 1 (Fall 1976): 4–9.

Raynor, Vivien. "The Man Who Invented LOVE." *ARTnews* 72, no. 2 (February 1973): 58–62.

Seckler, Dorothy Gees. "Folklore of the Banal." *Art in America* 50, no. 4 (Winter 1962): 56–61.

Sutherland, Scott. "Exiled in Maine, the Creator and Prisoner of Love." *The New York Times*, June 27, 1999.

Sverbeyeff, Elizabeth, and Sue Nirenberg. "Six in the Arts and How They Live: Robert Indiana." *House Beautiful* 112, no. 2 (February 1970): 52–55, 166.

Swenson, G. R. "The Horizons of Robert Indiana." *ARTnews* 65, no. 3 (May 1966): 48–49, 60–62.

———. "The New American 'Sign Painters.'" *ARTnews* 61, no. 5 (September 1962): 44–47, 60–62.

———. "What Is Pop Art? Answers from Eight Painters, Part I: Jim Dine, Robert Indiana, Roy Lichtenstein, Andy Warhol." *ARTnews* 62, no. 7 (November 1963): 24–27, 60–64.

Taylor, Paul. "Love Story." *Connoisseur* 221, no. 955 (August 1991): 46–51, 94–97.

Tuchman, Phyllis. "Pop! Interview with George Segal, Andy Warhol, Roy Lichtenstein, James Rosenquist, and Robert Indiana." *ARTnews* 73, no. 5 (May 1974): 24–29.

FILMS

Robert Indiana: American Dreamer. DVD. Directed by Eric Breitbart. New York: Eric Breitbart Productions and Muse Film and Television, 2007.

Robert Indiana Portrait. Directed by John Huszar. 1973. Film transferred to DVD. Chatham, New York: FilmAmerica, 2008.

A Visit to the Star of Hope: Conversations with Robert Indiana and Installing Indiana. DVD, 2 discs. Directed by Dale Schierholt. Rockland, Maine: Acadia Moving Pictures in association with the Farnsworth Art Museum, 2009.

ACKNOWLEDGMENTS

In 1958, on the eve of his thirtieth birthday, a relatively unknown artist named Robert Clark decided to adopt the name of his native state as his own, thereby inextricably tying his identity to the American heartland of his youth. Over the next few years, his radical vocabulary and bold, declarative painting style catapulted him to the forefront of a movement that would forever change the way Americans thought about art. By the late 1960s, the proliferation of unauthorized versions of his image *LOVE* had muted recognition of the multilayered, conceptual complexity of his fusions of word and image. That has changed in recent decades as critics and art historians have taken on the challenge of reassessing Indiana's contribution to mid-twentieth-century American art.

It has been an extraordinary privilege to channel this critical reconsideration of Indiana's work into this landmark exhibition and its accompanying monograph. I am deeply grateful to the scholars whose writings on Robert Indiana's art provided inspiration for my own assessment of his career, and in particular, to those individuals who lent their support to this project by participating in the roundtable discussions that appear in this volume: Thomas Crow, Bill Katz, Robert Pincus-Witten, Susan Elizabeth Ryan, Robert Storr, Allison Unruh, and John Wilmerding. Their insights are joined by those of Sasha Nicholas and René Paul Barilleaux, whose superb texts here provide new perspectives on Indiana's art and its relationship to twentieth- and twenty-first-century American painting and sculpture. I am grateful, too, to Jack Youngerman and Tad Beck, for sharing with me their recollections of Indiana; to Jason Best, for his wise and perceptive editing of the book; and to Leon Botstein, for his insightful reading of the manuscript.

The task of preparing this monograph and exhibition would not have been possible without the collective efforts of an exceptional team. No Indiana project can be realized at the highest degree of quality without the cooperation of Simon Salama-Caro, Indiana's longtime agent. I am most grateful for the unstinting assistance he and his children, Emeline Salama-Caro and Marc Salama-Caro, and their colleague in the catalogue raisonné office, Erin Barnes, have provided, including information and counsel about Indiana's art and its whereabouts as well as full access to their photographs and archives. I am indebted as well to Paul Kasmin, Mathias Rastofer, and Leslie Waddington for their enthusiastic endorsement and support of the show.

In bringing together the material for this catalogue, I have benefitted from the talents of a tremendous group of colleagues. First and foremost among them was project coordinator Sasha Nicholas, who oversaw the production of the book and the assembly of its myriad components. Heidi Hirschl, curatorial intern, researched archives and collected and edited the artist's interviews and statements. Natalie

McCann, curatorial intern, assiduously assembled the artist's extensive exhibition history and reviews; Katie Wright, curatorial assistant, collated the bibliography and handled loan correspondence; and Sarah Humphreville, curatorial assistant, brought the project to completion with enthusiasm, grace, and consummate skill. The staff at Marquand Books has created an intelligent design that wonderfully complements Indiana's art, a team that includes Donna Wingate, creative director in New York; Ryan Polich, design and production assistant; Jeff Wincapaw, design director; Melissa Duffes, managing editor; and Susan E. Kelly, designer.

In assembling the exhibition at the Whitney, I have been privileged to work with senior registrar Seth Fogelman, one of the finest registrars anywhere; Lauren DiLoreto, exhibitions manager, who coordinated the exhibition with tact and firmness along with Christy Putnam, associate director for exhibitions and collections management; Emily Russell, curatorial department manager, whose diplomacy and common sense were irreplaceable; Alexandra Wheeler, deputy director for development, and Stephanie Adams, director of planned giving, who succeeded in funding the exhibition despite the demands of an ongoing capital campaign; Beth Huseman, director of publications, who adroitly managed all aspects of the catalogue; Mark Steigelman and Anna Martin, who designed a sensitive and elegant installation; Anita Duquette, manager, rights and reproductions, who assisted with obtaining and preparing images; and my colleagues in the publicity and marketing department: Jeff Levine, chief marketing and communications officer; Stephen Soba, communications officer; and Rich Flood, marketing and communications manager. I am grateful to all of them. In particular I owe abiding gratitude to Adam D. Weinberg, Alice Pratt Brown Director of the Whitney Museum; Donna De Salvo, chief curator and deputy director for programs; and Scott Rothkopf, curator and associate director for programs. Their steadfast support, deft interventions at strategic moments, and humor created a spirit of collective unity that made implementation of this project a seamless pleasure.

Without funding, no exhibition of this scope and ambition could be realized. I am deeply grateful to the Morgan Art Foundation for its exceptionally generous support of this publication and exhibition. Other individuals, too, publically acknowledged the importance of this project for the reevaluation of Indiana's place in art history by providing critical financial assistance. My sincerest thanks go to them all. I am equally indebted to the many individuals and institutions who agreed to part with important works from their collections in order to ensure the success of this endeavor. Finally, I would like to thank Robert Indiana for his support of this project, for his openness over the years in granting interviews and authoring statements that have illuminated his life and his art, and most importantly, for the visually exhilarating and conceptually complex art he has produced during a career that now spans sixty years.

BARBARA HASKELL

LENDERS TO THE EXHIBITION

The Albright-Knox Art Gallery,
Buffalo, New York

Art Gallery of Ontario

Ruth and Ted Baum

Lisa Bialkin

Detroit Institute of Arts

Galerie Gmurzynska, Zurich

Hirshhorn Museum and Sculpture Garden,
Washington, D.C.

Robert Indiana

Indiana State Museum and Historic Sites,
Indianapolis

Indianapolis Museum of Art

Blanton Museum of Art,
The University of Texas at Austin

The JPMorgan Chase Art Collection

Krannert Art Museum and Kinkead Pavilion,
University of Illinois at Urbana-Champaign

Shirley and William Lehman

The Robert B. Mayer Family Collection

Debra E. Weese-Mayer and
Robert N. Mayer

McNay Art Museum, San Antonio, Texas

The Menil Collection, Houston, Texas

Martin Z. Margulies

Milwaukee Art Museum

Morgan Art Foundation,
Fribourg, Switzerland

Museu Colecção Berardo, Lisbon

Museum Ludwig, Cologne

The Museum of Modern Art, New York

Guy and Marion Naggar

Estate of Mrs. Walter Netsch

Sylvio Perlstein

Portland Museum of Art, Maine

The Rose Art Museum, Brandeis
University, Waltham, Massachusetts

Cari and Michael J. Sacks

Gillian and Simon Salama-Caro

Sheldon Museum of Art, University of
Nebraska–Lincoln

Smithsonian American Art Museum,
Washington, D.C.

Van Abbemuseum, Eindhoven,
The Netherlands

Walker Art Center, Minneapolis, Minnesota

Whitney Museum of American Art,
New York

Private collections

WHITNEY MUSEUM OF AMERICAN ART STAFF

Alison Abreu-Garcia
Jay Abu-Hamda
Stephanie Adams
Adrienne Alston
Martha Alvarez-LaRose
Amanda Angel
Marilou Aquino
Emily Arensman
Morgan Arenson
I. D. Aruede
Bernadette Baker
John Balestrieri
Wendy Barbee-Lowell
Courtney Bassett
Caroline Beasley
Justine Benith
Harry Benjamin
Nathalie Berger
Jeffrey Bergstrom
Caitlin Bermingham
Alberto Betancourt
Stephanie Birmingham
Ivy Blackman
Hillary Blass
Richard Bloes
Andrea Bonin
Leigh Brawer
Jeffrey Britton
Keri Bronk
Ethan Buchsbaum
Carda Burke
Douglas Burnham
Patrick Burns
Ron Burrell
Garfield Burton
Jocelyn Cabral
Pablo Caines
Margaret Cannie
Amanda Carrasco
Christina Cataldo
Inde Cheong
Ramon Cintron
Randy Clark
Ron Clark
Correna Cohen
Melissa Cohen
Arthur Conway
Heather Cox

Kenneth Cronan
Mia Curran
Donna De Salvo
Margo Delidow
Eduardo Diaz
Lauren DiLoreto
Lisa Dowd
Delano Dunn
Anita Duquette
Raquel Echanique
Alvin Eubanks
Eileen Farrell
Richard Fett
Rich Flood
Seth Fogelman
Meghan Forsyth
Carter Foster
Samuel Franks
Murlin Frederick
Annie French
Donald Garlington
John Gatti
Larissa Gentile
Robert Gerhardt
Hilary Greenbaum
Cassandra Guan
Peter Guss
Stewart Hacker
Kate Hahm
Jill Hamilton
Kiowa Hammons
Greta Hartenstein
Barbara Haskell
Maura Heffner
Dina Helal
Peter Henderson
Claire Henry
Jennifer Heslin
Ann Holcomb
Nicholas S. Holmes
Abigail Hoover
Jacob Horn
Sarah Hromack
Karen Huang
Sarah Humphreville
Wycliffe Husbands
Beth Huseman
Chrissie Iles

Jennifer Isaac
Carlos Jacobo
Julia Johnson
Dolores Joseph
Chris Ketchie
David Kiehl
Thomas Killie
Melissa Kim
Kathleen Koehler
Irene Koo
Tom Kraft
Amber LaCasse
Zoe Larkins
Eunice Lee
Sang Soo Lee
Kristen Leipert
Monica Leon
Jen Leventhal
Jeffrey Levine
Danielle Linzer
Kelley Loftus
Robert Lomblad
Sarah Lookofsky
Alison Lotto
Kevin Lu
Doug Madill
Elyse Mallouk
Carol Mancusi-Ungaro
Louis Manners
Joseph Mannino
Anna Martin
Meredith Martin
Heather Maxson
Madeline McGrath
Gene McHugh
Michael McQuilkin
Kate McWatters
Sandra Meadows
Sarah Meller
Bridget Mendoza
Graham Miles
Dana Miller
David Miller
Christa Molinaro
Becca Morgan
Victor Moscoso
Eleonora Nagy
Pablo Narvaez

Ruben Negron
Graham Newhall
Carlos Noboa
Thomas Nunes
Rose O'Neill-Suspitsyna
Brianna O'Brien Lowndes
Nelson Ortiz
Barbara Padolsky
Jane Panetta
Christiane Paul
Ailen Pedraza
Jessica Pepe
Laura Phipps
Angelo Pikoulas
Mary Potter
Kathryn Potts
Linda Priest
Frank Procaccini
Vincent Punch
Christy Putnam
Jessica Ragusa
Julie Rega
Natalee Reid
Gregory Reynolds
Emanuel Riley
Felix Rivera
Nicholas Robbins
Jeffrey Robinson
Georgianna Rodriguez
Gina Rogak
Justin Romeo
Adrienne Rooney
Joshua Rosenblatt
Jamie Rosenfeld
Amy Roth
Scott Rothkopf
Carol Rusk
Angelina Salerno
Leo Sanchez
Jay Sanders
Galina Sapozhnikova
Lynn Schatz
Arielle Schraeter
Peter Scott
Michelle Sealey
David Selimoski
Jason Senquiz
Ai Wee Seow

Amy Sharp
Elisabeth Sherman
Kasey Sherrick
Sasha Silcox
Matt Skopek
Michele Snyder
Joel Snyder
Stephen Soba
Barbi Spieler
Carrie Springer
John Stanley
Mark Steigelman
Minerva Stella
Betty Stolpen
Hillary Strong
Emilie Sullivan
Denis Suspitsyn
Elisabeth Sussman
Catherine Taft
Christine Taguines
Kean Tan
Ellen Tepfer
Latasha Thomas
Phyllis Thorpe
Mamie Tinkler
Ana Torres
Beth Turk
Lauren Turner
Ray Vega
Snigdha Verma
Eric Vermilion
Billie Rae Vinson
Farris Wahbeh
Morgan Watson
Cecil Weekes
Adam D. Weinberg
Alexandra Wheeler
Michelle Wilder
John Williams
Liza Zapol
Sefkia Zekiroski
Kayla Zemsky

As of July 19, 2013

INDEX

PHOTOGRAPHIC CREDITS

Copyrighted works appearing herein may not be reproduced in any form without the permission of the rights holder. In reproducing the images contained in this publication, the Museum obtained the permission of the rights holders whenever possible. The copyright holders, photographers, and sources of visual material other than those indicated in the captions are listed here. Every effort has been made to credit the copyright holders, photographers, and sources; if errors or omissions are identified, please contact the Whitney Museum of American Art so that corrections can be made in any subsequent edition.

All works of art by Robert Indiana in this publication are copyright © 2013 Morgan Art Foundation / Artists Rights Society (ARS), New York.

Boldface numerals indicate figure references.

1: © Robert Walker / The New York Times / Redux

2, 56, 57, 147, 168, 169: © 2010 William John Kennedy, kiwiartsgroup.com

11: © Ellsworth Kelly; Photograph by Jerry L. Thompson

12, 58, 87, 182: Photograph courtesy the artist

14: © 2013 Agnes Martin / Artists Rights Society (ARS), New York; Photograph by Ellen Page Wilson, courtesy Pace Gallery

26: © Vanni Archive / Art Resource, NY

28: Photograph by Brady / Behrens

31: Museo Thyssen-Bornemisza / Scala / Art Resource, NY

34, 35, 36, 39, 51, 153, 157: Digital Image © The Museum of Modern Art / Licensed by SCALA / Art Resource, NY

40, 62: Albright-Knox Art Gallery / Art Resource, NY

45, 77: Photograph © Rheinisches Bildarchiv Köln

50: Photograph © Sheldon Museum of Art

53: Diana Berrent Photography

61, 70, 101: Photograph by Michael Tropea

66: Courtesy Museu Colecção Berardo; Photograph by J. M. Costa Alves

67: Photograph by Peter Cox, Eindhoven, The Netherlands

68, 71: Photograph by Lee Stalsworth

76: Photograph by Peter Harholdt

78: Photograph by Rick Hall

79, 155: Smithsonian American Art Museum, Washington, D.C. / Art Resource, NY

80: Photograph courtesy The Schulhof Collection, LLC

82: Photograph © 2013 Art Gallery of Ontario, Toronto

88: © 2013 The Arshile Gorky Foundation / The Artists Rights Society (ARS), New York; Photograph by Sheldan C. Collins

89: Fred W. McDarrah / Premium Archive / Getty Images

92: Photograph courtesy Stedelijk Museum, Amsterdam

97: The Bridgeman Art Library

98, 128, 165: Photograph by Sheldan C. Collins

109, 110: Photograph courtesy The Santa Fe Opera

123: © 1991 Hans Namuth Estate; Courtesy Center for Creative Photography, University of Arizona

124: © Marvin W. Schwartz

129: Photograph by Jerry L. Thompson

133: Photograph by George Hixson, Houston

148: © 2013 Estate of Reginald Marsh / Art Students League, New York / Artists Rights Society (ARS), New York

152: Photograph courtesy the Irvington Historical Society, Indianapolis

154, 159: Image © The Metropolitan Museum of Art / Art Resource, NY

156: Newark Museum / Art Resource, NY

157: Art © Estate of Stuart Davis / Licensed by VAGA, New York, NY

161: © 2013 Bruce Nauman / Artists Rights Society (ARS), New York; Courtesy Sperone Westwater, New York

162: Courtesy Cheim & Read, New York; Photograph by Geoffrey Clements

163: © 2003 Mel Bochner; Digital Image © Whitney Museum of American Art, New York

164: Courtesy of the artist; Luhring Augustine, New York; and Regen Projects, Los Angeles

165: Courtesy of the artist and Luhring Augustine, New York

166: © 2013 Jenny Holzer / Artists Rights Society (ARS), New York. Photograph by Lisa Kahane; Courtesy: Jenny Holzer / Art Resource, NY

167: © General Idea, Inc. 1987; Digital Image © Whitney Museum of American Art, New York

171: Photograph courtesy Indianapolis Public Library

174: © 1991 Hans Namuth Estate; Photograph courtesy the artist

176: © 2013 The Andy Warhol Museum, Pittsburgh, PA, a museum of Carnegie Institute. All rights reserved.

177: © Magnum Photos

184: © Dennis and Diana Griggs

Back cover: Don Hogan Charles / The New York Times / Redux

...atalogue was published on the
...casion of the exhibition
Robert Indiana: Beyond LOVE
curated by Barbara Haskell, curator,
Whitney Museum of American Art,
New York

WHITNEY MUSEUM OF AMERICAN ART,
NEW YORK
September 26, 2013–January 5, 2014

MCNAY ART MUSEUM, SAN ANTONIO
February 5–May 25, 2014

Major support for the *Robert Indiana: Beyond
LOVE* exhibition and catalogue is provided by
Morgan Art Foundation.

Generous support for the exhibition is also
provided by Shirley and William Lehman,
The Lunder Foundation, and the Robert B.
Mayer Family.

Additional support is provided by
The Gage Fund, Inc., Virginia and Herbert
Lust, the Overbrook Foundation, and
Barbaralee Diamonstein-Spielvogel.

Whitney Museum of American Art
945 Madison Avenue
New York, NY 10021
whitney.org

DISTRIBUTED BY
Yale University Press
302 Temple Street
P.O. Box 209040
New Haven, CT 06520
yalebooks.com/art

PROJECT MANAGER Sasha Nicholas
EDITOR Jason Best

PRODUCED BY
Marquand Books, Inc., Seattle
www.marquand.com

DESIGNER AND TYPESETTER Susan E. Kelly
PROOFREADER Kerrie Maynes
INDEXER Katherine Jensen
COLOR MANAGEMENT iocolor, Seattle

SET IN Absara, Absara Sans, and Knockout
PRINTED ON 150gsm Perigord matte and
150gsm Munken Lynx

Library of Congress Cataloging-in-
Publication Data
Indiana, Robert, 1928–
 Robert Indiana: beyond Love / Barbara
Haskell ; with contributions by René Paul
Barilleaux, Sasha Nicholas.
 p. cm.
 Published on the occasion of the exhibition
Robert Indiana: Beyond LOVE, Whitney
Museum of American Art, New York,
September 26, 2013–January 5, 2014; McNay
Art Museum, San Antonio, February 5–
May 25, 2014.
 Includes bibliographical references and
index.
 ISBN 978-0-300-19686-3
 1. Indiana, Robert, 1928– —Exhibitions.
I. Haskell, Barbara. II. Barilleaux, René Paul.
III. Nicholas, Sasha. IV. Whitney Museum
of American Art. V. McNay Art Museum.
VI. Title.
 N6537.I53A4 2013
 709.2—dc23 2013026559

PRINTED AND BOUND IN ITALY BY GRAPHICOM

10 9 8 7 6 5 4 3 2 1

JACKET ILLUSTRATIONS
FRONT Robert Indiana, *The Red Diamond
American Dream #3*, 1962 (fig. 67)
BACK Installation of Robert Indiana's *LOVE*
sculpture at the southeast entrance to
New York's Central Park, November 1971.
Photograph by Don Hogan Charles

Y0-BEE-226

DAT®
PREP PLUS
2021-2022

Our 80 years' expertise = Your competitive advantage

2 PRACTICE TESTS + PROVEN STRATEGIES + ONLINE

Special thanks to the staff of Kaplan Test Prep who worked on this book.

TABLE OF CONTENTS

SECTION III: GENERAL CHEMISTRY

SECTION IV: ORGANIC CHEMISTRY

SECTION V: READING COMPREHENSION

SECTION VI: QUANTITATIVE REASONING

SECTION VII: PERCEPTUAL ABILITY

STUDY SHEETS

Getting Started Checklist ✔

☐ Tear out the perforated color "quick sheets" at the back of this book and staple them together so you can study even when you don't have your book.

☐ Resist temptation to skip straight to the science. Instead, start by reading the first three chapters (only 28 pgs!).

☐ As you finish a chapter (including the practice problems!), check it off on the Table of Contents.

☐ Obtain a DENTPIN (required to take the DAT and apply to Dental school) at ada.org/dentpin

☐ Register to take the DAT at ada.org/dat

☐ Contact Prometric (prometric.com) to arrange date, time and location for DAT administration.

☐ Take a moment to admire your completed checklist then get back to the business of prepping for this exam!

Late-Breaking Developments

kaptest.com/publishing

The material in this book is up to date at the time of publication. However, the test makers may release more information on test changes after this book is published. Be sure to read carefully the materials you receive when you register for the test. If there are any important late-breaking developments—or any changes or corrections to the Kaplan test preparation materials in this book—we will post that information online at **kaptest.com/publishing**.

Feedback and Comments

Email us: **booksupport@kaplan.com**

Ask us on Facebook: **facebook.com/KaplanDATOATPCAT**

Ask us on Twitter: **twitter.com/KaplanDATPrep**

We would appreciate your comments and suggestions about this book. Please provide any feedback you have for the improvements of this book to **booksupport@kaplan.com**. Your feedback is extremely helpful as we continue to develop high-quality resources to meet your needs.

NOTE TO STUDENTS APPLYING TO CANADIAN DENTAL SCHOOLS

The American Dental Association (ADA) and the Canadian Dental Association (CDA) offer different versions of the Dental Aptitude Test (DAT). The version of the DAT you should take is determined by where you plan to attend dental school and whether or not you are a Canadian resident. This book will prepare you for both exams, but understanding the differences between the two tests will allow you to tailor your preparation to your specific needs.

The American DAT is a computer-based test (CBT) and includes the Survey of Natural Sciences (with Biology, General Chemistry, and Organic Chemistry), Perceptual Ability, Reading Comprehension, and Quantitative Reasoning. In contrast, the English Canadian DAT is paper based and does *not* contain the Organic Chemistry subsection or Quantitative Reasoning section but *does* include an optional Manual Dexterity Test (soap carving). All other sections of the tests are identical with the exception of Reading Comprehension, which still contains three passages but allows for 10 fewer minutes. The CDA also offers a French Canadian DAT, which includes the same content as the English Canadian DAT but in French and without the Reading Comprehension section.

In the past, most Canadian schools required the Canadian DAT and the Manual Dexterity Test. However, several Canadian schools now accept American DAT results from applicants who are not Canadian residents, and many do not require the Manual Dexterity Test from any applicants.

If you are a resident of Canada and anticipate applying to Canadian dental schools: Plan to take the Canadian DAT, including the Manual Dexterity Test if any of your chosen schools require or encourage it. If you also plan to apply to U.S. dental schools, check the requirements at the schools that interest you. Your Canadian DAT results will be accepted by many U.S. schools, but you may also want to take the American DAT to maximize your options. If in doubt whether a school accepts Canadian DAT results or not, verify with that school in advance of applying.

If you are not a resident of Canada but plan to apply to Canadian dental schools: Research the specific requirements of each school you would like to attend, paying close attention to residency and standardized test requirements. American DAT results will be sufficient for some English-language Canadian dental schools, but some require the Canadian DAT, and a few of those also require the Manual Dexterity Test.

How to use this book: Since the American DAT includes more sections than the Canadian DAT (Organic Chemistry and Quantitative Reasoning) and many test takers, regardless of nationality, elect to take the American DAT, this book is formatted to follow the American DAT. However, if you will be taking the Canadian DAT, you can still use this book to prepare for your test since the sections the exams have in common test the same material in the same ways. If you are taking the Canadian DAT, you can safely skip Section IV: Organic Chemistry and Section VI: Quantitative Reasoning. However, these sections do contain strategies and information that may make learning the other sections easier, so you may still want to review parts of the sections, especially the first portion of each because it reviews basic concepts and approaches.

If you are planning to apply to one of the few English Canadian schools that requires the Manual Dexterity Test, then you may want to supplement your preparation with soap carving practice since that Test is not based on content knowledge or critical thinking like the sections covered in this book but rather your skilled use of soap, ruler, and blade.

For more information about the Canadian DAT, the Manual Dexterity Test, and Canadian dental school requirements, visit the CDA's website at **cda-adc.ca**.

NOTE TO INTERNATIONAL STUDENTS

If you are an international student hoping to attend a dental school in the United States, Kaplan can help you explore your options. Here are some things to think about.

- If English is not your first language, most dental schools will require you to take the TOEFL (Test of English as a Foreign Language) or provide some other evidence that you are proficient in English.
- Plan to take the DAT. All U.S. dental schools require it.
- Begin the process of applying to dental schools at least 12 months before the fall of the year you plan to start your studies. Some programs start as early as July.
- You will need to obtain an I-20 Certificate of Eligibility from the school you plan to attend if you intend to apply for an F-1 Student Visa to study in the United States.
- If you've already completed a dental degree outside the United States, get information from U.S. schools—some may have special programs for international graduates of dentistry.

Section I

DAT STRATEGIES

SECTION GOALS

Many DAT questions require the application of a strategic approach and critical thinking. The first portion of this book is designed to introduce you to the DAT, as well as the major Kaplan strategies for raising your score. This section is designed to help you achieve the following goals:

- Identify common themes within DAT test sections
- Recall the key content areas and timing guidelines for each section of the DAT
- Recognize opportunities for a strategic approach within test sections and questions
- Study and review the materials within this book using clear, effective rules that will assist with recall
- Troubleshoot problematic test questions with previously learned strategic techniques

CONTENT OVERVIEW

Test Day Format	Chapter 1: Introduction to the DAT
Strategy	Chapter 2: Studying Effectively Chapter 3: Test Strategies

KEY STUDY STRATEGIES

These chapters are designed to serve as both an introduction to the DAT and the Kaplan approach, and a resource that can be referred back to frequently. This section will remain useful throughout your studies, so refer back to these chapters as needed! Special focus should be given to the unique strategies detailed within Chapter 3. Make sure to apply the skills and strategies from this portion of the book across every relevant section of the DAT. In early practice, it may help to either flip back to this material, or to your notes on this material, every time you work through practice problems. In later practice, ensure you are using the Kaplan strategies on each practice problem. By the time you reach Test Day, these strategies and habits will be second nature for you. The DAT is a critical thinking test, and high scores are accomplished through a combination of content knowledge and effective strategy.

CHAPTER ONE

Introduction to the DAT

LEARNING OBJECTIVES

After this chapter, you will be able to:

- Recall the structure and function of a Computer-Based Test (CBT)
- Describe each section of the DAT
- Explain DAT scoring and what the exam is designed to test
- Apply the DAT mindset to build test awareness, stamina, and confidence

The Dental Admissions Test (DAT) is required for admission to most dental schools in the United States and Canada. The American Dental Association (ADA) Department of Testing Services administers the DAT at Prometric Test Centers. Your score is an important part of the dental school admissions process because it provides a universal factor for schools to use in comparing applicants. Your Kaplan program is designed to help you achieve your best score possible on the DAT.

The DAT is likely different from other tests you have encountered in your academic career. It is unlike the knowledge-based exams common in high school and college that emphasize memorizing information; dental schools can assess your academic prowess by looking at your transcript instead. Dental schools use DAT scores to assess whether you possess the foundational skills upon which to build a successful dental career. Though you certainly need to know the content to do well, the focus is on knowledge application. The DAT emphasizes reasoning, critical thinking, reading comprehension, data analysis, and problem-solving skills.

The DAT's power comes from its use as an indicator of your abilities: Good scores can open up many opportunities for you. Your power comes from preparation and mindset. The key to DAT success is knowing what you are up against. That's where this book helps. You'll learn the philosophy behind the test, review the sections one by one, attempt sample questions, master Kaplan's proven methods, and understand what the test makers really want. You'll get a handle on the process, find a confident perspective, and achieve your highest possible scores.

THE COMPUTER-BASED TEST

The DAT is conducted by the American Dental Association (ADA) and has been in operation on a national basis since 1950. The DAT is given year-round at test centers operated by Prometric. The official DAT website is **ada.org/dat** and is where you can begin the process of registering for the DAT. You will also find the DAT Guide and a PDF of Frequently Asked Questions as well as many other resources for DAT test takers.

To register for the DAT or apply for admission to dental school, you will need a DENTPIN. The DENTPIN is a standardized personal identifier used by the agencies responsible for the accreditation of dental school applicants. To obtain or retrieve a DENTPIN, visit **ada.org/dentpin.** Once you have a DENTPIN, you will be able to submit an electronic application at **ada.org** using a credit card. To request a paper application, call 1-800-232-2162.

After your application and fee are processed, you will receive instructions to contact Prometric (**prometric.com**) to arrange a date, time, and location for your test. Plan to register several weeks in advance of when you want to take the test so you can arrange the best time and location. Any corrections to your application must be completed at least two weeks prior to your test date, and rescheduling your test incurs a rescheduling fee that varies according to the advance notice you provide.

The American DAT is administered exclusively by computer and can be taken almost any day of the year. To check in for your testing session, you will need your admission ticket (emailed to you as confirmation of your registration) and two forms of valid, nonexpired identification with signature, one of which must be government-issued and contain a photograph of you, such as a driver's license, passport, state ID, or military ID. The first and last names on your admission ticket must match your personal IDs exactly; however, IDs with only middle initial or with no middle name included will be accepted. At the testing center, additional security procedures such as photos or digital fingerprints may be taken to confirm and record your identity.

During the test, there is a countdown timer in the corner of the screen. You will not be allowed to wear a watch and may not have access to a clock. One 30-minute rest break is scheduled for the middle of the test. You may take additional breaks with the permission of the proctor, but the test timer will continue running. Even if you are not at the computer, the test will continue to run itself, and successive sections will start automatically if time for the previous section has elapsed.

An on-screen periodic table is provided for the Survey of Natural Sciences section, and an on-screen calculator is provided for the Quantitative Reasoning section. The testing center provides a noteboard and marker to use for taking notes and writing out calculations. If you need to replace your noteboard or marker, you may ask the proctor for a new set any time during the test (although if this is during a section, your time will continue to elapse). You are not allowed to bring your own calculator, writing utensils, or paper.

CONTENT

The DAT is, among other things, an endurance test. It consists of four sections and 280 multiple-choice questions. Add in the administrative details at both ends of the testing experience plus the midtest break, and you can count on being in the test room for almost five hours. It can be a grueling experience, to say the least. If you do not approach the DAT with sufficient confidence and stamina, you may lose your composure on Test Day. That's why taking control of the test is so important.

The DAT consists of four timed sections: the Survey of Natural Sciences (including Biology, General Chemistry, and Organic Chemistry), Perceptual Ability, Reading Comprehension, and Quantitative Reasoning. In this book, we'll take an in-depth look at each DAT section with content review, sample questions, and specific, test-smart hints.

Survey of the Natural Sciences (Chapters 4–51)

Time: 90 minutes (54 seconds per question)

Format: 100 multiple-choice questions, subdivided into Biology, General Chemistry, and Organic Chemistry

What it tests: Knowledge of university-level sciences

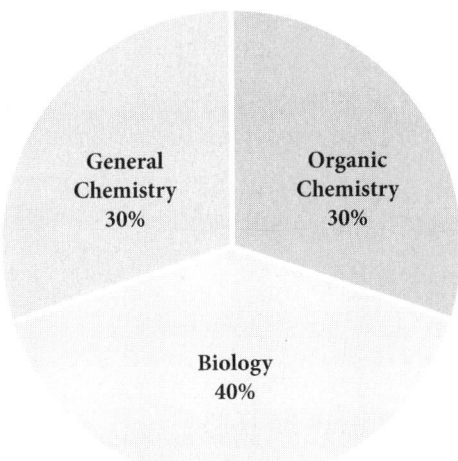

The distribution of Survey of
Natural Sciences questions

Figure 1.1

Biology (40 questions): Cellular and Molecular Biology, Diversity of Life, Structure and Function of Systems (Anatomy and Physiology), Developmental Biology, Genetics, and Evolution, Ecology, and Behavior.

General Chemistry (30 questions): Stoichiometry and General Concepts, Gases, Liquids and Solids, Solutions, Acids and Bases, Chemical Equilibria, Thermodynamics and Thermochemistry, Chemical Kinetics, Oxidation-Reduction Reactions, Atomic and Molecular Structure, Periodic Properties, Nuclear Reactions, and Laboratory Techniques.

Organic Chemistry (30 questions): Mechanisms, Chemical and Physical Properties of Molecules, Stereochemistry (structure evaluation), Nomenclature, Individual Reactions of the Major Functional Groups and Combinations of Reactions to Synthesize Compounds, Acid-Base Chemistry, and Aromatics and Bonding.

Perceptual Ability (Chapter 64)

Time: 60 minutes (40 seconds per question)

Format: 90 multiple-choice questions, subdivided into six sets of 15 questions each:

 Keyholes (Apertures)

 Top-Front-End (View Recognition)

 Angle Ranking

 Hole Punching (Paper Folding)

 Cube Counting

 Pattern Folding (3D Form Development)

What it tests: Ability to visualize and manipulate objects mentally in three dimensions; angle discrimination

Reading Comprehension (Chapters 52–54)

Time: 60 minutes (20 minutes per passage)

Format: 50 multiple-choice questions; three passages followed by 16–17 questions each

What it tests: Ability to comprehend, analyze, and interpret reading passages on scientific topics

Quantitative Reasoning (Chapters 55–63)

Time: 45 minutes (67.5 seconds per question)

Format: 40 multiple-choice questions

What it tests: Algebra (equations and expressions, inequalities, exponential notation, absolute value, ratios and proportions, and graphical analysis), Data Analysis, Interpretation, and Sufficiency, Quantitative Comparison, and Probability and Statistics

SCORING

The DAT is scored on a 1 to 30 scale. For each section of the test, the actual number of multiple-choice questions you answer correctly per section is your **raw score**. All multiple-choice questions are worth the same amount—one raw point—and there's no penalty for incorrect answers. That means you should always fill in an answer for every question whether you have time to fully invest in that question or not. Never let time run out on any section without filling in an answer for every question.

As mentioned above, your raw score is simply the number of questions you answered correctly in a given section. This score is not the indicator of your performance that schools receive because it doesn't reflect the relative performance of all test takers. So, on the official DAT score report, you (and the schools to which you are applying) will not receive raw scores, but will instead receive a scaled score, which is a score in the 1–30 range. Converting your score into this range allows each test to be calibrated for group performance and difficulty via equating procedures. In the scoring scale, a score of 17 is representative of approximately average performance. This allows scores from different tests, of potentially different difficulties, to be fairly compared to one another by dental schools.

When you receive your official score report, eight scores will appear: Biology, General Chemistry, Organic Chemistry, Perceptual Ability, Reading Comprehension, Quantitative Reasoning, Total Science, and Academic Average. The Total Science score is the sum of your initial, raw performance in Biology, General Chemistry, and Organic Chemistry, which is then standardized and converted into a score on the 1–30 scale, independent of your individual scores on these sections. To clarify, Total Science is not the average of your scaled scores in the Survey of Natural Sciences. The Academic Average is the average of the scores on all sections except for PAT: Biology, General Chemistry, Organic Chemistry, Quantitative Reasoning, and Reading Comprehension. For the purposes of looking at school admissions and matriculation statistics, Academic Average (AA), Total Science, and the PAT section score are the most commonly referenced measures of student DAT scores, and thus these should be the primary measures you use to determine if your score is potentially competitive for a given program.

Your score report will tell you—and dental schools—not only your scaled scores but also the **percentile** ranking that corresponds with your scaled score in each section. A percentile ranking reflects how many test takers scored at or below your level. For example, a percentile of 80 means that 80 percent of test takers did as well as or worse than you did, and only 20 percent did better.

What's a Good Score?

What defines a good score can vary significantly based on your personal situation. Much depends on the strength of the rest of your application (e.g., if your transcript is first-rate, then the pressure to do well on the DAT isn't as intense) and on where you want to go to school (e.g., different schools have different score expectations).

For each administration, the average scaled scores are approximately 17 for each section; this equates to the 50th percentile. To be considered competitive, you'll likely want to score above the 50th percentile. Highly competitive schools may want scores above the 70th percentile range. It's important to check score expectations for each individual school. One commonality is that most schools will consider scores that are evenly distributed across sections to be more favorable than a very high performance on one section offset by a very low performance on another. Performing consistently across the board is preferred.

Because all of your section scores factor into your cumulative score, maximizing your performance on every question is important. Just a few questions one way or the other can make a big difference in your scaled score. Make an extra effort to score well on a test section if you did poorly in a corresponding class; the best antidote for getting a C in chemistry class is acing the Chemistry section of the DAT!

WHAT THE DAT REALLY TESTS

It's important to grasp not only the nuts and bolts of the DAT (so you know what to do on Test Day) but also the underlying principles of the test (so you know why you're doing what you're doing). The straightforward facts tested by the DAT are covered throughout this book, but now it's time to examine the heart and soul of the exam to see what it's really about.

The Myth

Most people preparing for the DAT fall prey to the myth that the DAT is a straightforward science test. They think something like this:

The DAT covers the two years of science I had to take in school: biology, chemistry, and basic organic chemistry, plus math and something to do with perceptual ability. The important stuff is the science, though. After all, we're going to be dentists.

Remember: the DAT is not just a science test; it's also a critical thinking test. This means the test is designed to let you demonstrate your thought processes as well as your knowledge base. The implications are vast. Once you shift your test-taking paradigm to match the test makers', you'll find a new level of confidence and control over the test. You'll begin to work with the nature of the exam rather than against it. You'll be more efficient and insightful as you prepare for the test, and you'll be more relaxed on Test Day.

The Reality

Dental schools do not need the DAT to evaluate your content mastery; admission committees can assess your subject-area proficiency using your undergraduate coursework and grades. Schools are interested instead in your ability to solve problems. In recent years, many dental schools have shifted focus away from an information-heavy curriculum to a concept-based curriculum. Currently, more emphasis is placed on problem solving, holistic thinking, and cross-disciplinary integration. This trend is reflected in the DAT. Every good tool matches its task. In this case, the tool is the DAT, and the task is to predict how likely it is that you will succeed in dental school. In fact, research affirms that the DAT is correlated with success in dental school, and, together with undergraduate GPA, is powerful tool for schools to determine which applicants are likely to excel.

Therefore, your intellectual potential—how skillfully you absorb new information, how quickly you build connections between ideas, and how confidently and creatively you solve problems—is far more important to admission committees than your ability to recite the pK_a for every acid. Schools assume they can expand your knowledge base. They choose applicants carefully because expansive knowledge is not enough to succeed in dental school or in the profession. There's something more, and it's this something more that the test is trying to measure. Every section on the DAT tests essentially the same higher-order thinking skills: analytical reasoning, abstract thinking, and problem solving. Many test takers get trapped into thinking they are being tested strictly about their knowledge of science and math. Thus, they approach each section with a new outlook on what's expected. This constant mental shifting of gears can be exhausting and counterproductive. Instead of perceiving the DAT as parsed into radically different sections, maintain your focus on the underlying nature of the test; each section presents a variation on the same theme. The DAT is not just about what you know; it's also about how you think.

So, What About the Science?

With this perspective, you may be left asking questions: *What about the science? What about the content? Don't I need to know the basics?* The answer to each is a resounding *Yes!* You must be fluent in the different languages of the test. You cannot do well on the DAT if you don't know the basics of biology, general chemistry, organic chemistry, and mathematics. The best approach to learning that content is to take one year each of biology, general chemistry, and organic chemistry and then review the content in this book thoroughly before taking the DAT. However, knowing these basics is just the beginning of doing well on the DAT. That's a shock to most test takers. They presume that once they

relearn their undergraduate science they are ready to do battle against the DAT. Wrong! Test takers with only this minimum of knowledge merely have directions to the battlefield and lack what they need to actually beat the test: an understanding of the test makers' battle plans. You won't merely be drilled on facts and formulas on the DAT; you will need to demonstrate the ability to reason based on ideas and concepts. In other words, knowing the science is necessary, but not sufficient, to ace the DAT!

ADOPTING A DAT MINDSET

In addition to being a thinking test, the DAT is also a standardized test. As such, it has its own consistent patterns and features. This is the key to why test preparation works: You have the opportunity to familiarize yourself with those recurring aspects and adopt the proper test-taking mindset.

The DAT mindset is something to bring to every section, passage, and question you encounter. Being in the DAT mindset means reshaping the test-taking experience so you are in control. Answer questions in the order you want to; feel free to skip tough but doable passages and questions, coming back to them only after you've racked up points on easier ones. Answer questions *how* you want to; use Kaplan shortcuts and methods to get points quickly and confidently, even if those methods aren't exactly what the test makers had in mind when they wrote the test or the way your college professors taught you.

Some overriding principles of the DAT mindset that will be covered in-depth in the chapters to come are as follows:

- Read actively and critically.
- Translate prose into your own words.
- Save the toughest passages and questions for last.
- Know the test and its components inside and out.
- Practice! Do multiple DAT-style problems in each topic area after you've reviewed it.
- Allow your confidence to build on itself.
- Know that you are going to make mistakes and learn from those mistakes to get the most out of your practice.
- Stick with the new methods you'll be learning. Some might take more practice than others, but when mastered, all will pay off on Test Day by saving you valuable <u>time</u> and earning you more points.
- Complete full-length practice tests to break down the mystique of the real experience.
- Look at the DAT as a challenge and the first step in your new career rather than as an arbitrary obstacle.

The DAT mindset boils down to being positive, proactive and taking control of the testing experience so you can get as many points possible as quickly and as easily as you can. Keep this in mind as you read and work through the material in this book and as you face the challenge on Test Day.

The Four Basic Principles of Good Test Mentality

Knowing the test content arms you with the tools you need to do well on the DAT, but you must wield those tools with the right frame of mind and in the right spirit. Good test mentality involves taking a certain stance toward the entire test. Here's what's involved:

1. Test awareness

To do your best on the DAT, always keep in mind that the test is like no other test you've taken before, both in terms of content and in terms of the scoring system. If you took a test in high school or college and got a number of the questions wrong, you generally wouldn't receive a perfect grade. However, on the DAT, you can get a handful of questions wrong and still earn a fantastic—if not perfect—score. The test is geared so that only the very best test takers are able to finish every section, but even these people rarely get every question right.

What does this mean for you? Just as you shouldn't let one bad question ruin an entire section, you shouldn't let what you consider to be a subpar performance on one section ruin your performance on the entire test. Often when you think you did not do well you are mistaken. The questions you didn't know the answers to can cast an outsized shadow, obscuring the memory of all the questions you did know. If you allow a feeling of failure to rattle you, it can have a cumulative negative effect, setting in motion a downward spiral that can do serious damage to your score. Losing a few points won't ruin your cumulative score, but losing your cool will. If you feel you did poorly on a section, don't sweat it: Chances are it was just a difficult section, and that factor will already be figured into the scoring curve. The point is to remain calm and collected. Do your best on each section, and, once a section is over, forget about it and move on.

2. The right attitude

Those students who approach the DAT as an obstacle, rail against the necessity of taking it, or make light of its importance rarely fare as well as those who see the DAT as an opportunity to show off the reading and reasoning skills that dental schools are looking for. Don't waste time making value judgments about the DAT. It's not going away, so you have to deal with it. Those who look forward to doing battle with the DAT—or, at least, who enjoy the opportunity to distinguish themselves from the rest of the applicants—tend to score better than do those who resent or dread it.

3. Confidence

Confidence feeds on itself; unfortunately, so does the opposite of confidence: self-doubt. Confidence in your ability leads to quick, sure answers and a sense of well-being that translates into more points. If you lack confidence, you may end up reading the sentences and answer choices two, three, or four times until you confuse yourself. This leads to timing difficulties, which only perpetuate the downward spiral, causing anxiety and a rush to finish each section.

However, if you subscribe to the right DAT mindset, you'll gear all of your practice toward the major goal of taking control of the test. When you've achieved that goal, you'll be ready to face the test with supreme confidence—armed with the principles, techniques, strategies, and approaches set forth in this book—and that's the one sure way to score your best on Test Day.

4. Stamina

Improving your test-taking stamina can be just as beneficial as learning more content. Overall, the DAT can be a grueling experience, and some test takers simply run out of mental energy. This catches up to them on the last section, which happens to be one of the toughest in terms of timing and mental capacity required: Quantitative Reasoning. To avoid running out of steam, prepare by taking full-length practice tests in the weeks before your exam so that, on Test Day, completing all four sections will seem like a breeze. (Well, maybe not a breeze, but at least not a hurricane.) Taking online practice tests also ensures that you are comfortable with the computer-based format and allows you to review the explanations and assess your performance. Although the scores you earn on your Kaplan practice tests will be quite realistic, the scores are far less important than the practice itself.

It may sound a little dubious, but attitude adjustment is a proven test-taking technique. Just as a successful athlete prepares mentally and uses positive visualization before a big game, so too should you. Here are a few steps you can take to make sure you develop the right DAT attitude:

- Look at the DAT as a challenge but don't obsess over it; you certainly don't want to psych yourself out.
- Remember that, yes, the DAT is important, but this one test will not single-handedly determine the outcome of your life (contrary to what some students think).
- Practice makes permanent—the way you practice helps build the habits and skills you will use on Test Day. If you make sure to practice with the strategies you want to use on the real test, they will be second nature by the time you take the DAT.
- Have fun with the test. Learning how to match your wits against the test makers' can be a very satisfying experience, and the reading and thinking skills you'll acquire will benefit you in dental school as well as in your future dental career.
- Remember that you're more prepared than most other test-takers. You're training with Kaplan. You will have the tools you need and know how to use them.
- Get in shape; you wouldn't run a marathon without working on your stamina well in advance of the race, and the same goes for taking the DAT.

CHAPTER TWO

Studying Effectively

LEARNING OBJECTIVES

After this chapter, you will be able to:

- Build a personalized study plan utilizing guidelines and a sample calendar
- Apply principles of DAT studying to set goals and study efficiently
- Identify ideal study locations for your DAT prep

The first year of dental school is a frenzied experience for most students. To meet the requirements of a rigorous work schedule, students either learn to prioritize and budget their time or else fall hopelessly behind. It's no surprise, then, that the DAT, the test specifically designed to predict success in the first year of dental school, is a high-speed, time-intensive test. The DAT demands excellent time-management skills as well as grace under pressure, both during the test as well as while preparing for it. Having a solid plan of attack and sticking with it are key to giving you the confidence and structure you need to succeed.

CREATING A STUDY PLAN

Building a Calendar

The best time to create a study plan is at the beginning of your DAT preparation. If you don't already use a calendar, you will want to start. You can purchase a planner, print out a free calendar from the Internet, use a built-in calendar or app on of your smart devices, or keep track using an interactive online calendar. Pick the option that is most practical for you and that you are most likely to use consistently.

Once you have a calendar, write in all your school, extracurricular, and work obligations: class sessions, work shifts, meetings, etc. If you are taking a Kaplan course, be sure to include your class sessions in your calendar. Then add in personal obligations: appointments, lunch dates, family and social time, etc. As part of your personal obligations, schedule in specific time for family and friends, working out, or other hobbies. Making an appointment in your calendar for hanging out with friends or going to the movies may seem strange at first, but planning social activities in advance will help you cope with your busy schedule (soon to become even busier once you start dental school!) and will help you balance your personal and professional obligations. When life gets busy, social appointments are often the first to be sacrificed, but this can lead to strain in your personal life as well as burnout. Having a happy balance allows you to be more focused and productive when it comes time to study, so stay well-rounded and don't neglect anything important to you.

Once you have established your calendar's framework, add in study blocks around your obligations, keeping your study schedule as consistent as possible across days and across weeks. Studying at the same time of day as your official test is ideal for promoting the best recall, but if that's not possible, then fit in study blocks whenever you can.

Next, add in your full-length practice tests. Remember, these are located in your online assets (so as to best simulate this computer based test). Plan to take one test as a Diagnostic early in your prep. This can be one of the full-length tests in your online assets, or, if you are taking a Kaplan course, the designated Diagnostic exam. For the remainder of your tests, plan to take one full length test around half-way through your studies and then once per week until test day for the last 2-3 weeks ideally. Staggering your tests in this way allows you to form a baseline for comparison and to determine which areas to focus on right away, while also providing realistic feedback as to how you will perform on Test Day. For each test scheduled, set aside five hours to take the test and then another five hours the next day to thoroughly review the test (discussed more later in this chapter).

When planning your calendar, aim to finish your full-length practice tests and the majority of your studying by one week before Test Day, which will allow you to spend that final week completing a final, brief review of what you already know.

Your personal prep plan for studying for the DAT will need to be based around your commitments, your personal prep needs, and your time to Test Day. A sample week-by-week plan for the average student taking 8 weeks to prep can be seen on pages 16 and 17 as Figure 2.1. Note that this plan is not prescriptive of individual chapters: this is because you should be using a full-length test as a starting point, in combination with your own background knowledge, to determine the best order in which to start reviewing material. This calendar is also careful to recommend a variety of materials each week, as we do not recommend reading this book from front to back. Instead, you should work on a mix of materials each week, reviewing past information frequently via flashcards and your notes to ensure you retain all relevant testable information all the way to Test Day.

The sample calendar may include more focus than you need in some areas, and less in others, and it may not fit your timeline to Test Day. You will need to customize your study calendar in order to best suit your needs. For more sample calendars that follow different timelines or include typical Kaplan course schedules, for additional guidance on study planning, and for more information on the best ways to use this book to prepare for the DAT, make sure to check out the videos and resources in your online assets.

Study Blocks

To make studying as efficient as possible, block out short, frequent periods of study time throughout the week. From a learning perspective, studying one hour per day for six days per week is much more valuable than studying for six hours all at once one day per week (studying binges do not lead to success on the DAT!). Spacing out your preparation allows your brain time to consolidate its new memories, and seeing the material repeatedly over a longer period of time makes recalling the information on Test Day easier and faster. Specifically, Kaplan recommends studying for no longer than three hours in one sitting. In fact, three hours is an ideal length of time to study: It's long enough to build up your stamina for the five-hour Test Day but not so long that you become overwhelmed with too much information.

Within those three-hour blocks, also plan to take ten-minute breaks every hour. Use these breaks to get up from your seat, do some quick stretches, get a snack and a drink, and clear your mind. Although ten minutes of break for every 50 minutes of studying may sound like a lot, these breaks will allow you to deal with distractions and rest your brain so that, during the 50-minute study blocks, you can remain completely focused. Taking breaks more often than this, however, can be detrimental; research shows that becoming fully engaged in a mentally-taxing activity generally takes ten minutes, so if you stop to check your email or social media, talk with your roommates, or grab yet another

snack every ten minutes while studying, you will never be completely engaged and will not be using your time effectively.

If you would like to study for more than three hours in one day, space out your studying with a significant break in the middle. For example, you might study for three hours in the morning, take a two-hour break to have lunch with your friends, then study for another two hours in the afternoon.

If you are unable to study for a full three hours in one sitting, shorter amounts of time can work as well, but you'll get the most benefit from your studying if you immerse yourself in the material uninterrupted for at least one hour. For brief practice when you only have a few minutes, use the Study Sheets located at the back of this book. These sheets contain the most important information to memorize before Test Day, so take them with you wherever you go or put them where you'll see them frequently. These can be a great way to fit in extra studying when you wouldn't be doing anything productive otherwise, such as when waiting for the bus to arrive, or for a class or meeting to start. Even five or ten minutes per day quickly adds up to hours of additional studying over the course of a few weeks.

The total amount of time you spend studying each week will depend on your schedule, your starting content and critical thinking mastery, and your test date, but it is recommended that you spend somewhere in the range of 150–250 hours preparing before taking the official DAT. One way you could break this down is to study for three hours per day, five days per week, for three months. But this is just one approach. You might study six days per week (though avoid studying every day!) or for more than three hours per day. You might study over a longer period of time if you don't have as much time to study each week. Or you might find that you need more or fewer hours based on your personal performance and goal scores.

One way you could use this book is to complete at least one chapter per day. If you are taking a Kaplan course you should plan to follow the assigned order of chapters in your course syllabus. Note that the length of each chapter varies considerably, so only use this as a rough guideline, remembering each week to spend additional time practicing, memorizing vocabulary and formulas, and reviewing material previously covered. Furthermore, for best studying, don't just review all of the chapters in order; instead, start thinking about all of the sections of the test right away and reinforce long-term learning by staggering the interleaving material.

No matter what your plan is, ensure you complete enough practice to feel completely comfortable with the DAT and its content. A good sign you're ready for Test Day is when you begin to earn your goal score consistently in practice.

Time Off

Taking some time off can be just as important as studying. Just as you should take breaks during study blocks, take breaks during the week as well. Kaplan recommends taking at least one full day off per week, ideally from all of your study obligations but at minimum from studying for the DAT. Taking this time allows you to recharge mentally, and any fun or relaxing activities you plan for those days give you something to look forward to during the rest of the week.

Activity By Topic	Week 1	Week 2	Week 3	Week 4
Test Like Practice	Take Kaplan Free Practice Test			
Strategy + Review	Read Chapters 1–3; Review Free Practice Test			
Biology	Review + Practice from 3 Biology Chapters	Review + Practice from 3 Biology Chapters	Review + Practice from 3 Biology Chapters	Review + Practice from 3 Biology Chapters
General Chemistry	Review + Practice from 3 General Chemistry Chapters	Review + Practice from 3 General Chemistry Chapters	Review + Practice from 3 General Chemistry Chapters	Review + Practice from 3 General Chemistry Chapters
Organic Chemistry	Review + Practice from 2 Organic Chemistry Chapters	Review + Practice from 2 Organic Chemistry Chapters	Review + Practice from 2 Organic Chemistry Chapters	Review + Practice from 2 Organic Chemistry Chapters
Reading Comprehension	Read Chapter 52	Read Chapter 53	Practice with Outside Reading	Practice from Chapter 54
Quantitative Reasoning	Review + Practice from Chapters 55–56	Review + Practice from Chapters 57–59	Review + Practice from Chapter 60	Review + Practice from Chapter 61
PAT		Read Chapter 63	KH Problem Set A TFE Problem Set A	AR Problem Set A HP Problem Set A

Figure 2.1 Sample 8 Week Study Plan (*Continued*)

Activity By Topic	Week 5	Week 6	Week 7	Week 8
Test Like Practice	Take Full Length 1		Take Full Length 2	Complete any remaining practice
Strategy + Review	Review Full Length 1		Review Full Length 2	Final Review of Practice
Biology	Review + Practice from 3 Biology Chapters	Review + Practice from 3 Biology Chapters	Spot Check + Review of Problem Areas in Bio	Spot Check + Review of Problem Areas in Bio
General Chemistry	Review + Practice from 2 General Chemistry Chapters	Review + Practice from 2 General Chemistry Chapters	Spot Check + Review of Problem Areas in Gen Chem	Spot Check + Review of Problem Areas in Gen Chem
Organic Chemistry	Review + Practice from 2 Organic Chemistry Chapters	Review + Practice from 2 Organic Chemistry Chapters	Review + Practice from 2 Organic Chemistry Chapters	Spot Check + Review of Problem Areas in Orgo
Reading Comprehension	Practice with Outside Reading	Remainder of Practice from Chapter 54	Practice with Outside Reading	Practice with Outside Reading
Quantitative Reasoning	Review + Practice from Chapter 62	Review + Practice from Chapter 63	Spot Check + Review of Problem Areas in Quant	Spot Check + Review of Problem Areas in Quant
PAT	CC Problem Set A PF Problem Set A	KH Problem Set B TFE Problem Set B AR Problem Set B	HP Problem Set B CC Problem Set B PF Problem Set B	Final PAT Strategy Review

Figure 2.1 Sample 8 Week Study Plan

HOW TO STUDY

Goal Setting

The DAT covers a large amount of material, so studying for Test Day can initially seem daunting. To put studying more into your control, break the content down into specific goals for each day and each week instead of attempting to approach the test as a whole. A goal of "I want to increase my cumulative score by five points" is too big, abstract, and difficult to measure on the small scale. More reasonable goals are "I will read one chapter each day this week" or "I will be able to recite all the digestive enzymes by Friday." Goals like these are much less overwhelming and help break studying into manageable pieces. As you achieve these smaller goals, you may be surprised to see how quickly you begin achieving your bigger goals, too.

Once you've established your next short-term goals, you will want to achieve them as efficiently and effectively as possible, which means making the most of your study time. Always take notes when reading and practicing. Don't just passively read this book. Instead, read actively: Use the free margin spaces to jot down important ideas, draw diagrams, and make charts as you read. Highlighting can be an excellent tool, but use it sparingly: highlighting every sentence isn't active reading, it's coloring. Active participation increases your retention and makes rereading your notes at a later date a great way to refresh your memory.

Active Reading

As you go through this book, much of the information will be familiar to you. After all, you have probably seen most of the content before. However, be very careful: Familiarity with a subject does not necessarily translate to knowledge or mastery of that subject. Do not assume that if you recognize a concept you actually know it and can apply it quickly at an appropriate level. Frequently stop and ask yourself questions while you read (e.g., *What is the main point? How does this fit into the overall scheme of things? Could I thoroughly explain this to someone else?*). By making connections and focusing on the grander scheme, not only will you ensure you know the essential content, but you will also prepare yourself for the level of critical thinking required by the DAT.

Focus on Areas of Greatest Opportunity

If you are limited by only having a minimal amount of time to prepare before Test Day, focus on your biggest areas of opportunity first. Areas of opportunity are topic areas that are highly tested and that you have not yet mastered. You likely won't have time to take detailed notes for every page of this book; instead, use your results from practice materials to determine which areas are your biggest opportunities and seek those out. After you've taken a Full Length, make sure you are using your Smart Reports to best identify areas of opportunity. Skim over content matter for which you are already demonstrating proficiency, pausing to read more thoroughly when something looks unfamiliar or particularly difficult. If you are already feeling confident with the topic of a specific chapter, consider starting with the Review Problems at the end of the chapter. If you can get all of those questions correct within a reasonable amount of time, you may be able to quickly skim through that chapter, but if the questions prove to be more difficult, then you may need to spend time reading the chapter or certain subsections of that chapter more thoroughly, taking notes.

Practice, Review, and Tracking

Leave time to review your practice questions and your notes from previous chapters, too. You lead a busy life in addition to preparing for the DAT, and fitting in so much study time can often feel difficult. You may be tempted to push ahead and cover new material as quickly as possible, but failing

to schedule ample time for review will actually throw away your greatest opportunity to improve your performance. The brain rarely remembers anything it sees or does only once. When you build a connection in the brain and then don't follow up on it, that knowledge may still be in your memory somewhere but not in the accessible way you need it to be on Test Day. When you carefully review notes you've taken or problems you've solved (and the explanations for them), the process of retrieving that information reopens and reinforces the connections you've built in your brain. This builds long-term retention and repeatable skill sets—exactly what you need to beat the DAT!

While reviewing, take notes about the specific reasons why you missed questions you got wrong or had to guess on, perhaps by using a spreadsheet like the one below in Table 2.1. Keep adding to the same Why I Missed It Sheet (WIMIS) as you complete more practice, and periodically review your WIMIS to identify any patterns you see, such as consistently missing questions in certain content areas or falling for the same test-maker traps. For additional guidance on reviewing Full Length tests and other practice resources, check out your online resources.

Section	Q #	Topic or type	Wrong answer chosen	Why I missed it
Chemistry	42	Nuclear Chem.	Opposite	Confused electron absorption and emission
Chemistry	47	K_{eq}	Miscalculation	Need to memorize Kaplan steps
Reading Comp.	2	Detail	Opposite	Didn't read "not" in answer choice; slow down!
Reading Comp.	4	Inference	Out of Scope	Forgot to make a prediction

Table 2.1

As you move through your DAT program, adjust your study plan based on your available study time and the results of your practice questions. Your strengths and weaknesses are likely to change over the course of this program. Keep addressing the areas that are most important to your score, shifting your focus as those areas change.

Where to Study

One often-overlooked aspect of studying is the environment where the learning actually occurs. Although studying at home is many students' first choice, several problems can arise in this environment, chief of which are distractions. At home, many people have easy access to family, roommates, books, television, movies, food, the Internet, chores yet to be completed—the list goes on. Studying can be a mentally draining process, so as time passes these distractions become ever more tempting as escape routes. As discussed earlier, the moment you lose focus due to one of these distractions, you also lose the time it takes to return to the level of concentration you just had (not to mention any time clearly spent not studying!).

Although you may have considerable willpower, there's no reason to make staying focused harder than it needs to be. Instead of studying at home, head to a library, quiet coffee shop, or another new location whenever possible. This will eliminate many of the usual distractions and also promote efficient studying; instead of studying off and on at home over the course of an entire day, you can stay at the library for three hours of effective studying and enjoy the rest of the day off from the DAT. It

should also be noted that changing study locations is generally helpful; you will be most prepared for Test Day if you are used to studying and practicing in a wide variety of (relatively quiet) environments.

If you must study at home, consider ways to prevent distractions. Give copies of your schedule to family and friends and ask them not to interrupt your study blocks. Complete all the essential tasks you can before studying so they do not become distractions. If the Internet is a distraction for you, consider temporarily disabling your social media accounts or downloading an extension for your Internet browser that blocks certain websites while you are studying. Rather than fighting distractions with willpower alone, remove as many distractions as possible in advance to avoid the problem entirely.

An additional advantage of studying at libraries, however, is that their environments tend to be akin to those of the Prometric testing centers. Similar to a library, your testing center will be quiet but not completely silent. Not everyone at the test center will be taking the DAT, and not everyone will start at exactly the same time. While you are in the middle of a multiple choice section, other test takers may be entering the testing room to start their tests, taking breaks, typing essays, or talking with their proctors. Practicing in this type of environment (as opposed to in complete silence or while listening to music at home) means you will be less distracted in the actual testing center on Test Day.

Finally, no matter where you study, make your practice as much like Test Day as possible. Just as is required during the official test, don't have snacks or chew gum during your intense, 50-minute study blocks. Turn off your music, television, and phone. Practice on the computer with your online resources to simulate the computer-based test environment. When completing practice questions, do your work on scratch paper or noteboard sheets rather than writing directly on any printed materials since you won't have that option on Test Day. As Test Day approaches, study at the same time of day as your official test, especially on the same day of the week, to get in the habit of thinking about the test at those times. Because memory is tied to all of your senses, the more test-like you can make your studying environment, the easier it will be on Test Day to recall the information you're putting in so much work to learn.

In the end, you want to: 1. personalize your studying to be as effective as possible for you individually, 2. follow a specific calendar that contains your study blocks and breaks, and 3. make the most of those study blocks by focusing on your opportunity areas while simulating the testing environment. In this way, you'll learn more and at a faster rate than you could otherwise. Sticking with your efficient plan leads to effectively learning the material you need to ace the DAT—this way, you can do well the first time and not need to study for the test again. Being committed now will definitely pay off in the end.

CHAPTER THREE

Test Taking Strategies

LEARNING OBJECTIVES

After this chapter, you will be able to:

- Apply the Kaplan question strategy to DAT questions
- Integrate the four basic principles of test timing into your prep
- Organize your scratchwork using noteboard strategies
- Connect Kaplan's Top 10 DAT strategies to your own study

Even someone with perfect knowledge of all the science and math on the DAT is unlikely to achieve a top score without adequate test-taking strategies. Understanding the test question formats and having a clear plan for how to tackle each question while finishing every section on time can be just as important as content knowledge. In fact, using Kaplan's strategies allows you to use the test structure to your favor and determine correct answers even without complete knowledge of all the content. Specific strategies for each test section will be covered in the corresponding sections of this book, but this chapter will serve as an introduction to several overarching principles to apply throughout the DAT.

KAPLAN QUESTION STRATEGY

The DAT has only one question type: multiple choice. You won't find any fill-in-the-blank, matching, short response, or true/false problems on the test. Instead, every question will provide you with the option to select one of four or five answer choices. Every time. This means two important things. First, you won't need to prepare your knowledge in such a way that you can recite formulas, facts, or statistics from rote memory. Instead, all you'll need to do is recognize and apply those ideas using the choices provided. This means your focus when studying and answering questions should be on recognizing relationships and patterns more than on memorizing lists. Second, the fact that every question is multiple choice means you can identify patterns among the questions and answer choices to help you choose the correct answer even when you're not completely confident. Upcoming chapters in this book outline specific strategies for how to use question types and answer choices to your advantage in different subject areas of the test.

All the specific strategies for each section start with one key process: Stop-Think-Predict-Match. Although you will make slight modifications to this strategy depending on which question type you are tackling, the core ideas remain the same: Carefully analyze each question and determine what the correct answer will look like *before* reading the corresponding answer choices. This will allow you to use the question format to your advantage. You will quickly bypass wrong answer choices without needing to analyze them fully or falling for the test makers' trap choices. You will also leave yourself open to using alternative strategies, such as the process of elimination, when necessary. Each step of Stop-Think-Predict-Match is outlined in more detail below.

Stop

Your very first step when attempting any question is to Stop: Don't fully read the question or answer choices but instead **triage**: analyze the question's subject matter, length, and difficulty to determine if you should tackle it immediately, later, or not at all. For most questions, you will also use this opportunity to briefly characterize the answer choices (e.g., as vocabulary terms, sentences, equations, numbers with units, graphs, etc.).

As discussed later in this chapter, the Stop step allows you to make the most of the limited amount of time you have available. Determining each question's general characteristics before tackling it also allows you to get in the right mindset for that question. If you know you will need to calculate a specific value, you may list the variables you see on your noteboard as you read the question stem; if you know the answer will instead be a graph, you may sketch a quick plot of the variables instead of listing them.

Think

Once you've characterized the question stem and answer choices and decided to tackle a problem, the next step is to actually read the question stem—but don't read the answer choices yet. While reading the question, don't just read passively; instead, paraphrase as you read so you can determine what the question is really asking. You won't be able to answer the question correctly if you misunderstand what the question is asking you to do, so don't minimize the importance of this step. This step ensures that you do not rush through the question, potentially leading to additional work that is not needed. Establish what the correct answer will look like as specifically as possible (e.g., velocity on the *x*-axis in meters per second) while being careful to note any negative words, such as *not*, *except*, or *false*.

Predict

Once you have a clear idea of what the question is asking and have all the information you need to answer it, your next step is to formulate a framework of what the correct answer will look like. At this point, you still should not have thoroughly read the answer choices, so you are essentially treating the problem as a fill-in-the-blank question. A great prediction will answer the question as thoroughly as possible; however, if you're not certain what to expect from wordy answer choices or don't have strong content knowledge for the subject being tested, a simpler prediction could be nearly as useful and is always better than no prediction at all.

Although the Stop-Think-Predict-Match strategy may sound like a radical change to the way you approach a multiple-choice test, chances are it's not entirely different from what you normally do. The major difference is likely the order: Most test takers who are not Kaplan students start by reading the answer choices first and then determine what the correct answer will be. However, the advantages of predicting before reviewing the answer choices are many. First, making a prediction saves you time. Instead of analyzing all four answer choices, you can quickly skip the wrong choices that don't match your prediction without needing to disprove them specifically. Second, having a clear idea of what the correct answer will look like helps you avoid wrong answer choices that might otherwise be tempting. For example, although choice A of a hypothetical Reading Comprehension question might have sounded reasonable had you read it first, after making a prediction you instead realize it doesn't answer the question and in fact wasn't mentioned in the passage at all. In this way, you avoid the trap of "that sounds good" and hone in on the correct answer right away instead. Finally, you will

feel much more confident with your answer if you predict it and then find it among the choices. As discussed in Chapter 1, confidence builds upon itself, so this aspect of the Predict step is great for Test Day.

Match

After preparing a prediction, your last step is to select the answer choice that truly meets the requirements of your prediction. When matching, your goal is not to judge each answer choice based on its own merits but rather to identify if a choice corresponds with the framework you predicted. To that end, answer choices will fall into one of three categories:

- *The choice matches your prediction:* In this case, read the entire choice thoroughly to ensure all components of the choice are correct, paraphrasing as needed. If the choice looks completely correct, select it and move on to the next question.

- *The choice is clearly the opposite of your prediction or otherwise incorrect:* If at any point you realize a choice is definitely incorrect, stop reading that choice and use the strikethrough tool to eliminate it by right-clicking on the answer choice. If any component of a choice is incorrect, the entire choice must be incorrect, so there's no need to read the entire option.

- *The choice does not match your prediction:* When an answer choice is not obviously wrong but also doesn't align with what you were anticipating, skip that choice. Don't spend time at this point attempting to definitively prove the choice is incorrect; one of the other answer choices is likely to match your prediction instead, meaning you won't ever need to determine why this option is incorrect.

 Note that just because a choice doesn't match your prediction doesn't mean you should eliminate it right away. In some cases, you may find that no answer choice matches your original prediction. When this happens, you will need to return to the Think and Predict steps, incorporating more information to modify your prediction by making it more general or more specific as needed. Using this modified prediction, you can then complete the Match step again on the choices you did not already eliminate.

As you first start using the Stop-Think-Predict-Match strategy, you may find yourself moving through questions more slowly, especially when you need to modify your predictions, but don't give up! With practice, you will begin to perform these steps automatically and find both your speed and accuracy increased. Because mastery of all the DAT strategies does require practice, use them consistently throughout your practice tests and questions so you can use them effectively by Test Day.

TEST TIMING

For complete Test Day success, you must answer as many questions as possible correctly in the time allotted. Knowing the content and question strategies is important, but not enough; you also must hone your time-management skills so you have the opportunity to use those strategies on as many questions as possible. It's one thing to answer a Reading Comprehension question correctly; it's quite another to answer all of the questions in the section in the limited time allotted. The same applies for the other sections; it's a completely different experience to move from handling an individual passage or problem at leisure to handling a full section under timed conditions. Time is a factor that affects every test taker, and the good news is that you can easily improve your scores by adhering to the following basic principles.

The Four Basic Principles of Test Timing

On some tests, if a question seems particularly difficult, you can spend significantly more time on it because you are given more points for correctly answering hard questions. **This is not true on the DAT. Every DAT question, no matter how difficult, is worth the same amount**. There's no partial credit. Because there are so many questions to do in so little time, you can seriously hurt your score by spending five minutes earning one point for a hard question and then not having time to get several quick points from easier questions later in the section.

Given this combination—limited time and all questions equal in weight—you must manage the test sections to ensure you earn as many points possible as quickly and easily as you can.

1. Feel free to skip around

One of the most valuable strategies to help you finish sections in time is recognizing and dealing with the questions and passages that are easier and more familiar to you first. That means temporarily skipping those that promise to be more difficult and time-consuming. You can always come back to these at the end, and, if you run out of time, you're much better off having spent time on the questions that will definitely earn you points rather than those you might have gotten incorrect anyway. Because there's no guessing penalty, always fill in an answer to every question on the test whether you have time to fully attempt it or not.

This strategy is difficult for most test takers; we're conditioned to do things in order, but it just doesn't pay off on the DAT. Don't let your ego sabotage your score by wasting time on questions you can't do. Sometimes it isn't easy to give up on a tough, time-consuming question, but often it's better simply to move on. The computer won't be impressed if you get the toughest question right. If you dig in your heels on a tough question, refusing to move on until you've cracked it, you're letting your ego get in the way of your test score. A test section is too short to waste on lost causes. There's no point of honor at stake here, but there are DAT points at stake.

The test is actually built to help you with skipping around: the test interface will inform you on the review page which questions have and have not been answered. Furthermore, there is a marking functionality that will allow you to mark specific questions to return back to. This function adds a 'flag' to the question that reminds you to return to it when you are on the review page: practice with this feature in your full lengths so that you are fully comfortable with it by Test Day.

Give skipping around a try when you practice. Remember, if you do the test in the exact order given, you're letting the test makers control you. Be mindful of the clock, and don't get bogged down with the tough questions. On the computer-based test, you can skip around within a section but not among sections.

2. Seek out questions you can answer correctly

Being able to identify which questions will be most difficult for you personally is essential to making decisions about which ones to skip. Unlike items on some other standardized tests, questions and passages on the DAT are not presented in order of difficulty. There's no rule that says you have to work through the questions within a section in any particular order; in fact, the test makers scatter the easy and difficult questions throughout each section, in effect rewarding those who actually get to the end. Don't lose sight of what you're being tested for along with your reading and thinking skills: efficiency and cleverness. If general chemistry questions are your area of expertise, head straight for them when you first begin the Survey of Natural Sciences section and save the organic chemistry and biology questions until the end of that section.

With practice, you'll be able to determine if a question is easier or more difficult and time-consuming within the first five seconds. If you only realize a question is difficult after spending two minutes working on it, you've already lost time there and forfeited much of the advantage of skipping around.

When evaluating the difficulty of a question, consider factors such as length of question stem and answer choices, type of question, type of answer choices provided (e.g., numbers, expressions, terms, or sentences), vocabulary used, content area being tested, etc. Also consider how long a question will take you; even if you know exactly how to perform a calculation, if it involves multiple steps and will take you several minutes, you may want to skip that question initially. If you do decide you can't do a question or realize you won't get to it, guess! Fill in an answer—any answer—for every question. There's no penalty if you're wrong, but you increase your score if you're right. Note that no answer choice is more frequently correct on the DAT than any other, so avoid looking for big-picture patterns and instead make educated guesses based on logic and elimination.

3. Use the process of elimination judiciously

There are two ways to get a question right on the DAT: You either know the right answer, or you know all the wrong answers. Because there are four times as many wrong answers, you should be able to eliminate some, if not all, of them. Therefore, if you don't know the right answer, eliminate as many wrong answers as you can. By doing so, you either get to the correct response or increase your chances of guessing the correct response. You start out with a 20 percent chance of picking the right answer, and with each eliminated answer your odds go up. Eliminate one choice, and you have a 25 percent chance of picking the right answer; eliminate two choices, and you have a 33 percent chance; and so on. Remember to look for wrong-answer traps when eliminating. Some answers are designed to seduce you by distorting the correct answer and therefore can be quickly eliminated. For more information about common wrong answer pathologies in reading comprehension questions, see Chapter 53, Question Types.

However, note that using the process of elimination can be slow. If you attempt to use the process of elimination on every question, you undoubtedly will run out of time before getting to all the questions. Evaluating five choices is much more time-consuming than directly homing in on the correct answer and picking it without worrying about why all the wrong choices are incorrect. The process of elimination can be a powerful tool, but save it as a backup for when tackling the question directly with Stop-Think-Predict-Match method has not yielded a match.

Note that the DAT also helps you to use an elimination strategy by including a strikethrough feature. By right-clicking on an answer choice, you can strike it out. Make sure to practice with this and other computer-based test functionalities prior to taking the real DAT!

4. Keep track of time

While working on a section, maintain a general sense of your timing without constantly looking at the clock. For most multiple choice sections, you must average from 55 to 65 seconds per question in order to finish in time (the exception is Perceptual Ability, during which you have closer to 40 seconds per question!). These are averages, though; you will be able to answer some basic questions in 15 seconds, whereas other questions, such as those that involve lengthy calculations, may take over 60 seconds. Especially because of such discrepancies, constantly looking at the countdown timer after every question can be unnecessarily stressful and potentially misleading; you may have just tackled a particularly difficult question for which taking more time was perfectly acceptable, so trying to stick too closely to the average for every question can be counterproductive. Nevertheless, to ensure you finish each section, you still shouldn't spend a wildly disproportionate amount of time on any one question or group of questions.

A good strategy, therefore, is to look at the clock every five or ten minutes with a specific goal, such as "I should have more minutes than questions remaining in the Quantitative Reasoning section" (meaning there will be at least one minute for every remaining question). Having specific guidelines in mind helps to avoid spending time calculating how much time is left out of the total, which can use up valuable testing time.

When planning out your time, leave at least 30 seconds at the end of each section to review any questions you intended to come back to later and make quick educated guesses for questions you left blank (if any). The last thing you want to happen is for time to elapse for a particular section before you've gotten to half the questions. Therefore, it's essential that you pace yourself, keeping in mind the general guidelines for how long to spend on any individual question or passage. With practice, you will develop an innate sense of how long you have to complete each question so you'll know when you're exceeding the limit and should start to move faster.

Section-Specific Pacing

Let's now look at the section-specific timing requirements and some tips for meeting them. As described previously, keep in mind that the times per question or passage are only averages. Every question is of equal worth, so don't get hung up on any one. Think about it: If a question is so hard that it takes you a long time to answer it, chances are you may get it wrong anyway. In that case, you'd have nothing to show for your extra time but a lower score.

Reading Comprehension

Allow yourself approximately 20 minutes per passage set, which includes reading a passage and answering the associated questions. On average, give yourself 7–8 minutes to read a passage and 10–12 minutes to answer the corresponding questions. Some longer passages may take more time to read, but limit yourself to eight minutes as a maximum so you have time to answer the questions, which are what actually contribute to your overall score.

Do the easiest passages first. This may mean avoiding topics that are extremely unfamiliar or passages that seem to include a lot of challenging vocabulary. For passage-based questions, choose an answer **based only on the information given**. Be careful not to overthink the question by inserting too much of your own logic. Passages might generate their own data. Your answer choices must be consistent with the information in the passage, even if that means an answer choice is inconsistent with the science of ideal, theoretical situations.

The Survey of Natural Sciences

You hypothetically have about 55 seconds for each Biology, General Chemistry, or Organic Chemistry question in the Survey of Natural Sciences. However, Biology and Organic Chemistry questions typically take less time than complex General Chemistry calculations, so it's important to keep track of your overall progress. A good goal is to spend 30 seconds per Biology question, up to 75 seconds per General Chemistry question, and then 60 seconds per Organic Chemistry question. Completing the mostly fact-based Biology questions quickly will allow you to have plenty of time for the more time-consuming chemistry questions and set yourself up for success in the section as a whole.

Perceptual Ability and Quantitative Reasoning

Perceptual Ability averages 40 seconds per question, but different question types use far less or far more time. You have about 67 seconds for each Quantitative Reasoning question, but again, some will take more time and others less.

STRATEGIES

COMPUTER-BASED TESTING TOOLS

There are several tools available on the DAT testing interface that make the computer testing experience better for the student if used strategically. These tools include the onscreen timer, the 'Exhibit' button (in the Survey of Natural Sciences), the calculator (in Quantitative Reasoning), highlighting (in Reading Comprehension), and strikethrough. Refer to your online resources to see these features in the interface and practice with them in your Full Length exams.

Practice with these tools now will make use of them on Test Day simple and intuitive. Make sure to test out different levels of usage of the highlighter, mark button, and the strikethrough feature in order to find the method that is most successful for you. The periodic table is pulled up via the Exhibit button and does cover the entire screen when opened, so we suggest pulling it up only once per question, extracting the information you need, and closing it. In addition, we generally recommend highlighting no more than one phrase per paragraph of a passage, marking only about 1 in every 10 questions, and using strikethrough only when necessary in order to maximize efficiency on Test Day.

NOTEBOARD STRATEGIES

Other resources to maximize on Test Day are your noteboards and markers. Using the noteboards when you need them, but not so much that you waste your limited time, is important.

Write clearly on your noteboard. Conserve space by keeping all your work for a given problem in the same area. Number each question and box off its notes when you are finished so you can come back to it later, if needed, and so you do not confuse your work for one question with the work for another. When you finish a section, ask your proctor for a new noteboard (and a new marker if you sense yours is beginning to run out of ink). An example of how scratchwork can be organized is seen in the partial noteboard shown in Figure 3.1.

Figure 3.1

KAPLAN'S TOP TEN DAT STRATEGIES

1. **Relax!**

 Just by reading the first few chapters of this book you are already taking steps towards Test Day success. By the time Test Day arrives, you will have mastered the Kaplan strategies and DAT content needed to conquer the exam.

2. **Know what the DAT tests.**

 Never forget the purpose of the DAT: to test your powers of analytical reasoning. You need to know the content because each section has its own particular language, but the underlying DAT intention is consistent throughout the test.

3. **Develop the DAT mindset.**

 The DAT is designed to let you show off everything you've learned so far. Don't let your spirit fall, or your attitude will slow you down. Don't let yourself worry about a question or section once you've finished it; instead, change your mindset and tackle the next item as if you're just starting anew.

4. **Build your stamina.**

 Prepare your mind for Test Day by completing practice tests and studying in three-hour blocks while remembering to take breaks every hour and one day off per week.

5. **Master the art of predicting.**

 Kaplan's Stop-Think-Predict-Match strategy allows you to break up each question into manageable steps. Carefully determine what a question is really asking, then anticipate answers before you read the answer choices. This helps protect you from persuasive, tricky, and time-consuming incorrect choices.

6. **Skip around within each section by seeking out questions you can answer correctly.**

 Attack each section confidently. You're in charge. Since every question is worth the same amount, work your best areas first to maximize your opportunity for DAT points. Don't be a passive victim of the test structure, and don't let any one question drag you down!

7. **Use the process of elimination judiciously.**

 Most wrong answer choices are logical twists on the correct choice. Quickly move past any obvious traps to more easily match your prediction, but only use the full process of elimination when you cannot find a match.

8. **Keep track of time.**

 Pace yourself to avoid spending too much time on any individual question. Don't let the clock add stress to Test Day.

9. **Make the most of your noteboard and computer-based testing tools.**

 Keep track of all the notes you need on your noteboard by being neat and methodical. You aren't given many resources to use on Test Day, so take full advantage of those provided.

10. **Have the right attitude.**

 Your attitude toward the test really does affect your performance. You don't necessarily have to think nice thoughts about the DAT, but work to develop confidence and a positive mental stance toward the test. You can do this!

Section II

BIOLOGY

SECTION GOALS

Biology is a topic area integral to mastery of the Survey of Natural Sciences portion of the DAT. The biology strategies, content, and practice presented within this section are designed to help you accomplish the following goals:

- Recall key biology content terms and ideas
- Identify when and how Test Day questions are using biological concepts
- Distinguish key differences in similar answer choices using knowledge of biological concepts
- Connect new information given in a question to previously existing knowledge of biology
- Predict answers to DAT Biology questions accurately and quickly, using the Kaplan methods

CONTENT OVERVIEW

Cell and Molecular Biology	Chapter 5: Cellular Biology Chapter 6: Molecular Genetics* Chapter 7: Metabolism
Genetics	Chapter 6: Molecular Genetics* Chapter 8: Genetics
Structure and Function of Systems	Chapter 10: Integumentary and Immune Systems Chapter 11: Nervous System Chapter 12: Muscular and Skeletal Systems Chapter 13: Circulatory and Respiratory Systems Chapter 14: Digestive System Chapter 15: Urinary System Chapter 16: Endocrine System Chapter 17: Reproductive System
Developmental Biology	Chapter 18: Developmental Biology
Evolution, Ecology, and Behavior	Chapter 9: Evolution Chapter 19: Animal Behavior Chapter 20: Ecology
Diversity of Life	Chapter 21: Taxonomy

*Note: An understanding of Molecular Genetics is necessary for both Cellular and Molecular Biology and Genetics.

KEY STUDY STRATEGIES

The biology review in this book begins with a chapter on strategy that should be read thoroughly before any other chapters within the section. Once Chapter 4 has been read and internalized, this section can be used in a number of versatile ways. Most of the chapters can be perused in any order, but it is recommended that you prioritize the chapters of greatest need to your individual prep. Boldface vocabulary terms are likely to show up on Test Day. Make sure that you know not only the definitions of these bold terms, but also how they relate to other key terms within biology. Recognition of relevant terms, or "buzzwords," is one of the basic skills required for success on the DAT. Consider using Kaplan flashcards to review these terms, or build your own flashcard set. Use the table above, in combination with practice, to determine which chapters to prioritize in prep. After reviewing a chapter, use the associated quiz to test your knowledge of that content, and review the quiz to find any missing knowledge gaps.

CHAPTER FOUR

Biology Strategies

The biology knowledge you need for the DAT encompasses a wide variety of topics in the categories of cell and molecular biology, diversity of life, vertebrate anatomy and physiology, developmental biology, genetics and evolution, and ecology and behavior. Mastering biology on the DAT means not only memorizing biology vocabulary and facts but also learning to integrate your knowledge, make connections, and otherwise approach the multiple-choice questions in the Biology subtest and the entire Survey of Natural Sciences section in the best way possible.

THE SURVEY OF NATURAL SCIENCES

Biology content appears in the Survey of Natural Sciences section, which contains the Biology, General Chemistry, and Organic Chemistry subtests. The Survey of Natural Sciences has a total of 100 questions that must be completed in 90 minutes. Questions 1–40 are always related to biology, questions 41–70 are always related to general chemistry, and questions 71–100 are always related to organic chemistry. The content in each subtest does overlap in some areas (such as chemical bonding, which is tested in both General Chemistry and Organic Chemistry), but the questions always remain in three discrete groups, and you will receive separate scores for each subtest in addition to your cumulative Survey of Natural Sciences score. Therefore, when you first begin studying for the Survey of Natural Sciences, it's generally best to treat the section as three separate tests and master each content area separately, except for those topics that obviously overlap.

Survey of Natural Sciences Pacing

On Test Day you will be able to freely navigate among all 100 questions in the Survey of Natural Sciences section. Time is shared for all three subtests, giving you an average of 54 seconds per problem. Because the Survey of Natural Sciences is one long section, some test takers find themselves overwhelmed by the need to keep track of time, since there are so many questions yet less than one minute per question. Therefore, you should not only study each subtest separately but also consider each separately when managing the entire section.

Among the three subtests, you should complete Biology in the least amount of time since its questions are mostly fact based and require few calculations. Spend 30 seconds or less on each question to finish the Biology subtest within 20 minutes.

General Chemistry, which involves many more calculations and therefore more use of your scratch work, will take the most time. You should average 75 seconds for each General Chemistry question, which means the entire subtest will take you a total of 37.5 minutes.

Finally, Organic Chemistry will be somewhere in the middle, with some questions that involve drawing out reactions or complex figures taking longer and other questions that require just naming or identifying molecules taking less time. With 60 seconds per question, you will be able to complete this section in 30 minutes.

The Kaplan timing guidelines for the Survey of Natural Sciences are summarized below:

> Biology: 20 minutes (30 seconds per question)
>
> General Chemistry: 37.5 minutes (75 seconds per question)
>
> Organic Chemistry: 30 minutes (60 seconds per question)
>
> Review Marked Questions: 2.5 minutes
>
> Total: 90 minutes

Following these guidelines will allow you to break down the Survey of Natural Sciences into more reasonable pieces and give you a more realistic sense of how you're progressing through the section than if you were to use the overall average of 54 seconds per question. If you stick to the Kaplan guidelines closely, you'll also have 2.5 minutes left at the end of the section to review any questions that you marked to return to later because they involved lengthy calculations or otherwise would take too long to answer during your first pass through the section. The DAT rewards students who complete sections out of order, so work through the Biology questions in whatever order is best for you. By adhering to this Kaplan pacing strategy, using the Test Timing tips from Chapter 1 and the Test Strategies and Scratchwork Strategies from Chapter 3, and continually practicing, you undoubtedly will find the timing of the Survey of Natural Sciences much more reasonable than you previously thought.

BIOLOGY QUESTION STRATEGY

Kaplan's Stop-Think-Predict-Match strategy is useful for all sections of the test and is especially helpful for the Survey of Natural Sciences section due to the limited time given per question. Before spending a significant amount of time on any one question, *Stop* to consider what content area is being tested and whether you want to attempt that question right away or mark it for later. Each question within a section is worth the same number of points, so answer the easiest and fastest questions first to ensure you've earned as many points as possible before attempting the most difficult and time-consuming problems. Once you've committed to a question, *Think* about what is being asked by carefully reading and paraphrasing the question stem. Next, recall any pertinent outside information and apply that to the question to *Predict* the answer. Only when you have a strong prediction in mind should you read the answer choices, and even then, your goal should be to find a *Match* to your prediction rather than to analyze each answer choice on its own merits. Not reading the answer choices in advance is especially important for the Biology subtest because it contains many questions with lengthy trap answer choices that initially seem correct. For a more thorough review of Stop-Think-Predict-Match, see Chapter 3, Test Strategies.

STUDYING BIOLOGY CONTENT

The DAT assesses test takers' memories of discrete biological facts with particular focus on the molecular basis of life. However, the DAT also assesses test takers' proficiency with integrative questions that focus on biological systems as wholes, including the complex interactions within them. This means that the test rewards both breadth of knowledge and the ability to make connections. Learn both approaches; you'll still need to memorize a wide range of biology facts, but you'll also need to understand how those pieces work together.

To help you learn this wide range of material, it's important to use a wide range of methods while studying. The following chapters contain the biology content you need for Test Day, but you may still see questions on your official test about content that do not look familiar at first. That won't be a problem, though, because you'll be able to figure out the answers to those types of questions using critical thinking: bringing different ideas together to determine the correct answers and eliminate impossible choices. You may see a question about a particular enzyme you didn't study, but you can still use information in the question about where it is produced and your knowledge of other molecules with similar names to find the correct answer. For example, if a question asks you about carboxypeptidase formed in the pancreas but you can't remember its function, you can take what you do know to infer that coming from the pancreas means it acts in the small intestine. Since *peptid* refers to peptide bonds, carboxypeptidase must help digest proteins.

To ensure the facts you need come readily to mind, supplement your reading by memorizing flashcards as well as the science study sheets, which contain some of the most important content for Test Day, located at the end of this book. These study sheets are perforated and can be removed for easy reference. Once you have the basics down, use practice questions to evaluate your knowledge in a test-like setting, remembering to spend plenty of time reviewing the explanations for every question. Although it's unlikely you'll see the exact same questions on Test Day, carefully evaluating exactly why you answered correctly or incorrectly will allow you to apply the concepts to any similar questions you see in the future.

Finally, no matter how you're studying, don't neglect to keep a broad focus on the interactions within and among biological systems. It's important to know that aldosterone is produced by the adrenal cortex and increases salt reabsorption in the nephrons, but it's even more valuable to realize that damage to the adrenal glands (in the exocrine system) can cause low blood pressure (in the circulatory system). By making these connections, not only will you be prepared to answer challenging integrative questions on Test Day, but you'll also ensure you have a solid knowledge of the basics as well. Even if you come from a strong biology background, many of the other test takers do as well, and you might not be very familiar with every topic tested, so it's important to have very thorough knowledge to earn a higher score than your competition.

CHAPTER FIVE

Cellular Biology

LEARNING OBJECTIVES

After this chapter, you will be able to:

- Explain the key components of cell theory and cell structure
- Compare and contrast different methods of cellular transport
- Compare and contrast the steps of cell division via mitosis and meiosis

The cell is the fundamental unit of all living things. Every function in biology involves a process that occurs within cells or at the interface between cells. Therefore, to understand biology, you need to appreciate the structure and function of different parts of the cell.

CELL THEORY AND STRUCTURE

Cell Theory

The cell was not discovered or studied in detail until the development of the microscope in the 17th century. Since then, much more has been learned, and a unifying theory known as the Cell Theory has been proposed.

The Cell Theory may be summarized as follows:
- All living things are composed of cells.
- The cell is the basic functional unit of life.
- The chemical reactions of life take place inside the cell.
- Cells arise only from pre-existing cells.
- Cells carry genetic information in the form of **DNA**. This genetic material is passed from parent cell to daughter cell.

Cell Structure

There are millions of species of "living things" that can be divided into six kingdoms: **Bacteria, Archaea, Protista, Fungi, Plantae,** and **Animalia**. Within these six kingdoms are two major types of cells: **prokaryotic** and **eukaryotic**. Eukaryotes possess membrane-bound **organelles** and are generally considered more complex than prokaryotes. The word prokaryote means "before nucleus," which alludes to the structure of these organisms as a whole: they do not contain nuclei or membrane-bound organelles. While eukaryotes possess all the cellular structures mentioned in this chapter, prokaryotes only possess a cell membrane, cytoplasm,

genetic material, and ribosomes. Note that scientists formerly divided life into only five kingdoms but recently separated the kingdom of Monera (Prokaryota) into Bacteria and Archaea due to differing evolutionary origins.

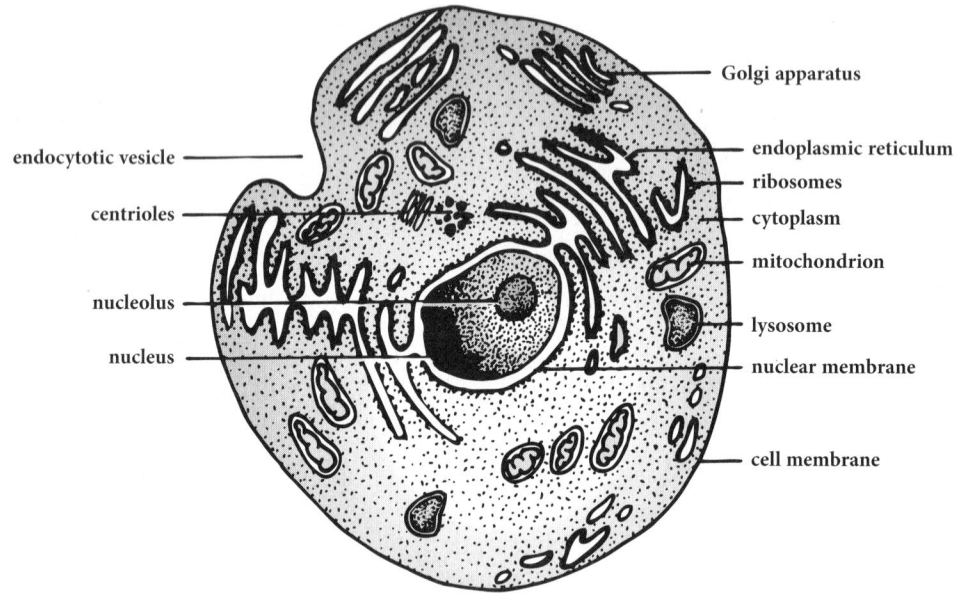

Figure 5.1

Cell membrane

The cell membrane (plasma membrane) encloses the cell and exhibits selective permeability; it regulates the passage of materials into and out of the cell. According to the generally accepted **fluid mosaic model**, the cell membrane consists of a phospholipid bilayer with proteins embedded throughout. The lipids and many of the proteins can move freely within the membrane.

The phospholipid bilayer has a specific structure that forms spontaneously. Phospholipid molecules are arranged such that the long, nonpolar, hydrophobic, "fatty" chains of carbon and hydrogen face each other, with the phosphorus-containing, polar, hydrophilic heads facing outward. The hydrophilic heads face the watery regions inside and outside the cell, while the hydrophobic tails face each other in a water-free region between the lipid layers.

As a result of its lipid bilayer structure, a plasma membrane is readily permeable to both small, nonpolar, hydrophobic molecules, such as oxygen, and small polar molecules, such as water. Small charged particles are usually able to cross the membrane through protein channels. However, charged ions and larger charged molecules cross the membrane with the assistance of **carrier proteins**.

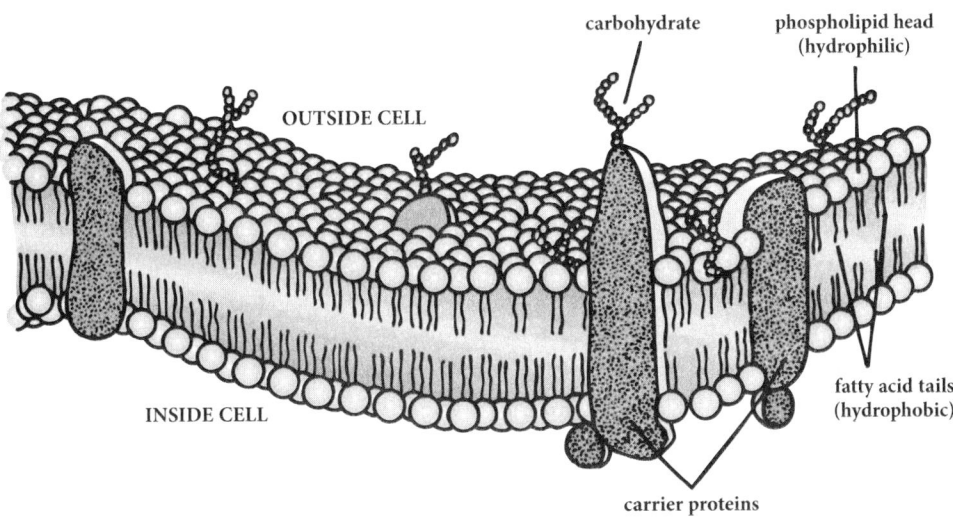

carbohydrate

phospholipid head
(hydrophilic)

OUTSIDE CELL

fatty acid tails
(hydrophobic)

INSIDE CELL

carrier proteins

Figure 5.2

Nucleus

Enclosed by the nuclear membrane, the nucleus contains DNA wound around structural proteins called histones. Depending on the activities of the cell, DNA can tighten or loosen its complexing with the histones. During DNA replication, DNA tightly winds around the histones, compacting chromatin (loose DNA) into chromosomes. During transcription, however, DNA unwinds itself from the histones, allowing for transcription to occur. In addition, the nucleus contains a dense structure called the nucleolus where ribosomal RNA (rRNA) synthesis occurs.

Prokaryotes do not have nuclei and therefore do not possess histones to organize their DNA into linear chromosomes. Instead, prokaryotic DNA is organized into small circular chromosomes located in a region of the cell termed the nucleoid.

Ribosome

Ribosomes facilitate protein production (see Chapter 6) and are made of two rRNA sequences, called ribosomal subunits. Although rRNA molecules are synthesized in the nucleolus of eukaryotes, they function either in the cytoplasm as unbound ribosomes or on the outer membrane of the rough endoplasmic reticulum as bound ribosomes. Note that in prokaryotes, while ribosomes are present, due to the lack of membrane-bound organelles both rRNA synthesis and ribosome function occurs in the cytoplasm.

Endoplasmic reticulum

The endoplasmic reticulum (ER) is a network of membrane-enclosed spaces involved in the transport of materials throughout the cell, particularly those materials destined to be secreted by the cell. There are two kinds of endoplasmic reticuli, rough ER and smooth ER. **Rough ER** contains ribosomes (which gives it a "rough" appearance under microscopy) and plays an important role in the production of proteins. **Smooth ER** does not contain ribosomes and so is not involved with protein synthesis but instead is involved with metabolism and the production of lipids.

Golgi apparatus

The Golgi apparatus is the primary site for cellular trafficking. It receives vesicles and their contents from the smooth ER and then modifies them (i.e., glycosylation), repackages them into vesicles, and distributes them to the cell surface for exocytosis.

Mitochondria

Mitochondria are the sites of aerobic respiration within the cell; they are responsible for the conversion of sugars, fats, and other sources of fuel into usable energy, specifically adenosine triphosphate (ATP). Each mitochondrion is composed of an outer and inner phospholipid bilayer. The outer membrane forms a barrier with the cytosol; the inner membrane is folded into cristae and contains enzymes for the electron transport chain (see Chapter 7). Between the two membranes is the intermembrane space. Finally, within the inner membrane is the mitochondrial matrix. Mitochondria also contain their own genome. Located within the matrix, this DNA is independent of the cell genome and resembles circular bacterial chromosomes. The presence of an independent genome allows mitochondria to divide independently of the nucleus via binary fission.

Cytoplasm

Most of the cell's metabolic activity occurs in the cytoplasm, which includes the **cytosol** (the cellular fluid contained within the cell membrane) and all the organelles of the cell. Transport within the cytoplasm occurs by **cyclosis** (streaming movement within the cell).

Vacuoles/Vesicles

Vacuoles and vesicles are membrane-bound sacs involved in the transport and storage of materials that are ingested, secreted, processed, or digested by the cell. Vacuoles are larger than vesicles and are more likely to be found in plant than in animal cells.

Centrioles

Centrioles are composed of microtubules and are involved in spindle organization during cell division. They are not bound by a membrane. Animal cells usually have a pair of centrioles oriented at right angles to each other that lie in a region of the cell called the centrosome. The centrosome organizes microtubules and helps regulate the progression of the cell cycle. Plant cells do not contain centrioles.

Lysosomes

Lysosomes are membrane-bound vesicles that contain **hydrolytic enzymes** involved in intracellular digestion. Lysosomes break down material ingested by the cell. An injured or dying cell may self-destruct by rupturing the lysosome membrane and releasing its hydrolytic enzymes; this process is called **autolysis**.

Cytoskeleton

The cytoskeleton supports the cell, maintains its shape, and aids in cell motility. It is composed of microtubules, microfilaments, and intermediate filaments.

Microtubules are hollow rods made up of polymerized **tubulin** that radiate throughout the cell and provide it with support. Microtubules provide a framework for organelle movement within the cell. Centrioles, which direct the separation of chromosomes during cell division, are composed of microtubules. **Cilia** and **flagella** are specialized arrangements of microtubules that extend from certain cells and are involved in cell motility and cytoplasmic movement.

Microfilaments are solid rods of **actin,** which are important in cell movement as well as support. Muscle contraction, for example, is based on the interaction of actin with myosin. Microfilaments move materials across the plasma membrane, for instance, in the contraction phase of cell division and in amoeboid movement.

Intermediate filaments are a diverse group of filamentous proteins, such as keratin. Intermediate filaments serve as the structural backbone of the cell, as they are able to withstand a tremendous amount of tension. Along with making the cell structure more rigid, intermediate filaments help anchor organelles to their respective places in the cell.

CELLULAR TRANSPORT

Substances can move into and out of cells in various ways. Some methods occur passively, without energy, whereas others are active and require energy expenditure (via hydrolysis of ATP).

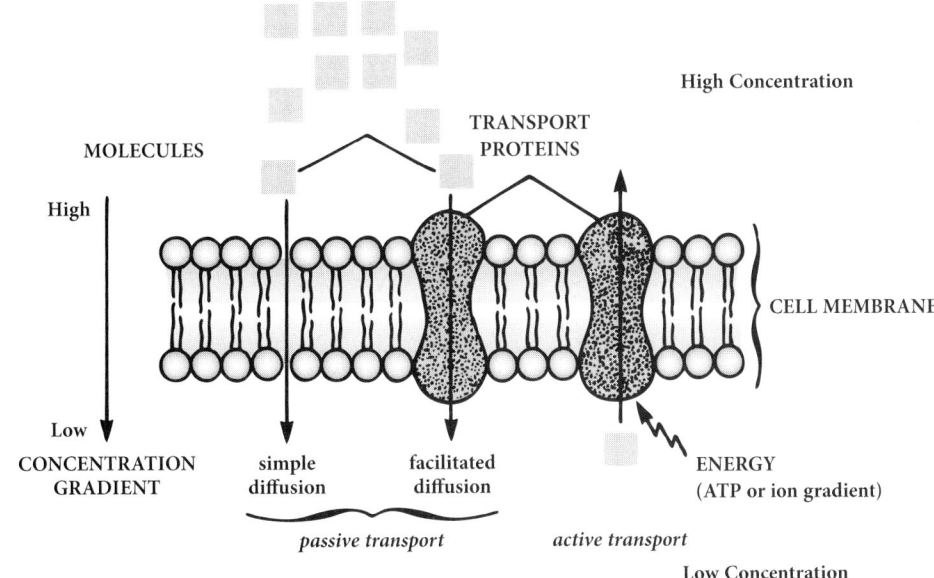

Figure 5.3

Simple Diffusion

Simple diffusion is the net movement of dissolved particles down their concentration gradients—from a region of higher concentration to a region of lower concentration. This is a passive process that requires no external source of energy.

BIO

Osmosis

Osmosis is the simple diffusion of water from a region of lower solute concentration to a region of higher solute concentration. When the cytoplasm of a cell has a lower solute concentration than the extracellular medium, the medium is said to be **hypertonic** to the cell, and water will flow out of the cell into the surrounding medium. This process, also called **plasmolysis**, will cause the cell to shrivel.

KEY CONCEPT

During osmosis, water moves toward isotonic equilibrium. In other words, water always moves in the direction that will make both solutions isotonic to one another.

If the extracellular environment is less concentrated than the cytoplasm of the cell, the extracellular medium is said to be **hypotonic** and water will flow into the cell, causing it to swell and **lyse** (burst). For example, red blood cells will burst if placed in distilled water. Freshwater protozoa have contractile vacuoles to pump out excess water and prevent bursting.

If the extracellular environment has the same concentration of solutes as the cell cytoplasm, the cell is said to be **isotonic** to the environment, and water will move back and forth in equal amounts across the cell membrane.

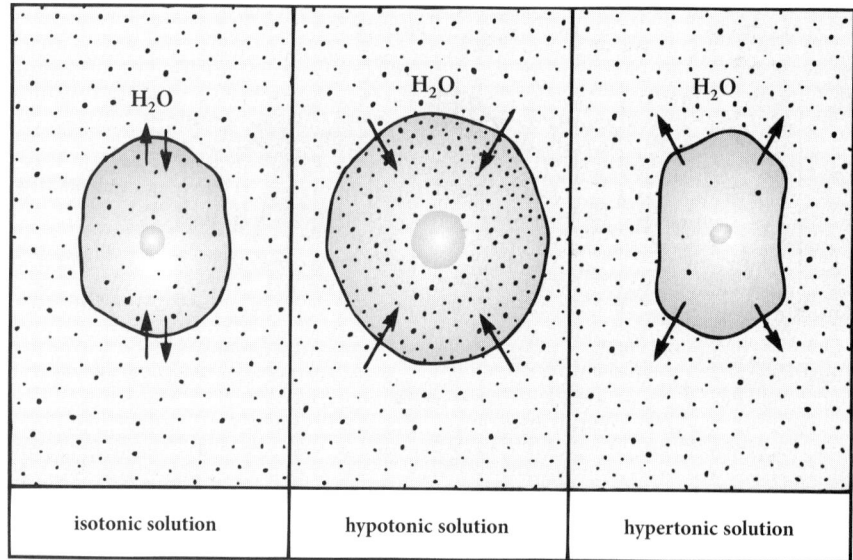

Figure 5.4

Facilitated Diffusion

Facilitated diffusion (passive transport) is the net movement of dissolved particles down their concentration gradient through special channels or carrier proteins in the cell membrane (see Figure 5.3). This process, like simple diffusion, does not require energy.

Active Transport

Active transport is the net movement of dissolved particles against their concentration gradients with the help of transport proteins. Unlike diffusion, active transport requires energy. These carrier molecules or transport proteins aid in the regulation of the cell's internal content of ions and large molecules. The passage of specific ions and molecules is facilitated by these carrier molecules, which include the following:

- **Symporters**: move two or more ions or molecules in the same direction across the membrane
- **Antiporters**: exchange one or more ions (or molecules) for another ion or molecule across the membrane
- **Pumps**: energy-dependent carriers (require ATP); e.g., sodium-potassium pump

Endocytosis

Endocytosis is a process in which the cell membrane invaginates, forming a vesicle that contains extracellular medium (see Figure 5.5). This allows the cell to bring large volumes of extracellular material inside the cell. **Pinocytosis** is the ingestion of fluids or small particles, and **phagocytosis** is the engulfing of large particles. Particles may bind to receptors on the cell membrane, triggering endocytosis.

Exocytosis

In exocytosis, a vesicle within the cell fuses with the cell membrane and releases a large volume of contents to the outside. Fusion of the vesicle with the cell membrane can play an important role in cell growth and intercellular signaling (see Figure 5.5). For example, neurotransmitters, which act as signals to neighboring cells, are often released from neurons in this manner. Note that in both endocytosis and exocytosis, material never actually passes through the cell membrane.

Figure 5.5

41

CELL DIVISION

Cell division is the process by which a cell doubles its organelles and cytoplasm, replicates its DNA, and then divides in two. For **unicellular organisms**, cell division is a means of reproduction, whereas for **multicellular organisms**, it is a method of growth, development, and replacement of worn-out cells. Cell division can follow two different courses, mitosis or meiosis, but each is preceded by interphase. The entire series of events leading to cellular replication constitutes the cell cycle.

Interphase

Interphase is a period of growth and chromosome replication. A cell normally spends at least 90 percent of its life in interphase. During this period, the cell performs its normal cellular functions, and each chromosome is replicated so that during division a complete copy of the genome can be distributed to both daughter cells. After replication, the chromosomes consist of two identical **sister chromatids** held together at a central region called the **centromere**. During interphase the individual chromosomes are not visible; the DNA is instead uncoiled and called **chromatin**.

Figure 5.6

Interphase consists of the following three parts:

1. **G1**: This phase initiates interphase. It is described as the active growth phase and can vary in length. The cell increases in size and synthesizes proteins. The length of the G1 phase determines the length of the entire cell cycle.

2. **S**: This is the period of DNA synthesis.

3. **G2**: The cell prepares to divide in G2. It grows and synthesizes proteins.

The last phase of the cell cycle is the M phase. During M phase mitosis or meiosis occurs, generally resulting in either two identical (mitosis) or four non-identical (meiosis) daughter cells.

Mitosis

Mitosis is the division and distribution of the cell's DNA to its two daughter cells such that each cell receives a complete copy of the original genome. This type of cell division takes place in somatic cells (as opposed to gametes). Nuclear division (**karyokinesis**) is followed by cell division (**cytokinesis**). This process is accomplished in four phases: prophase, metaphase, anaphase, and telophase, as shown in Figure 5.7.

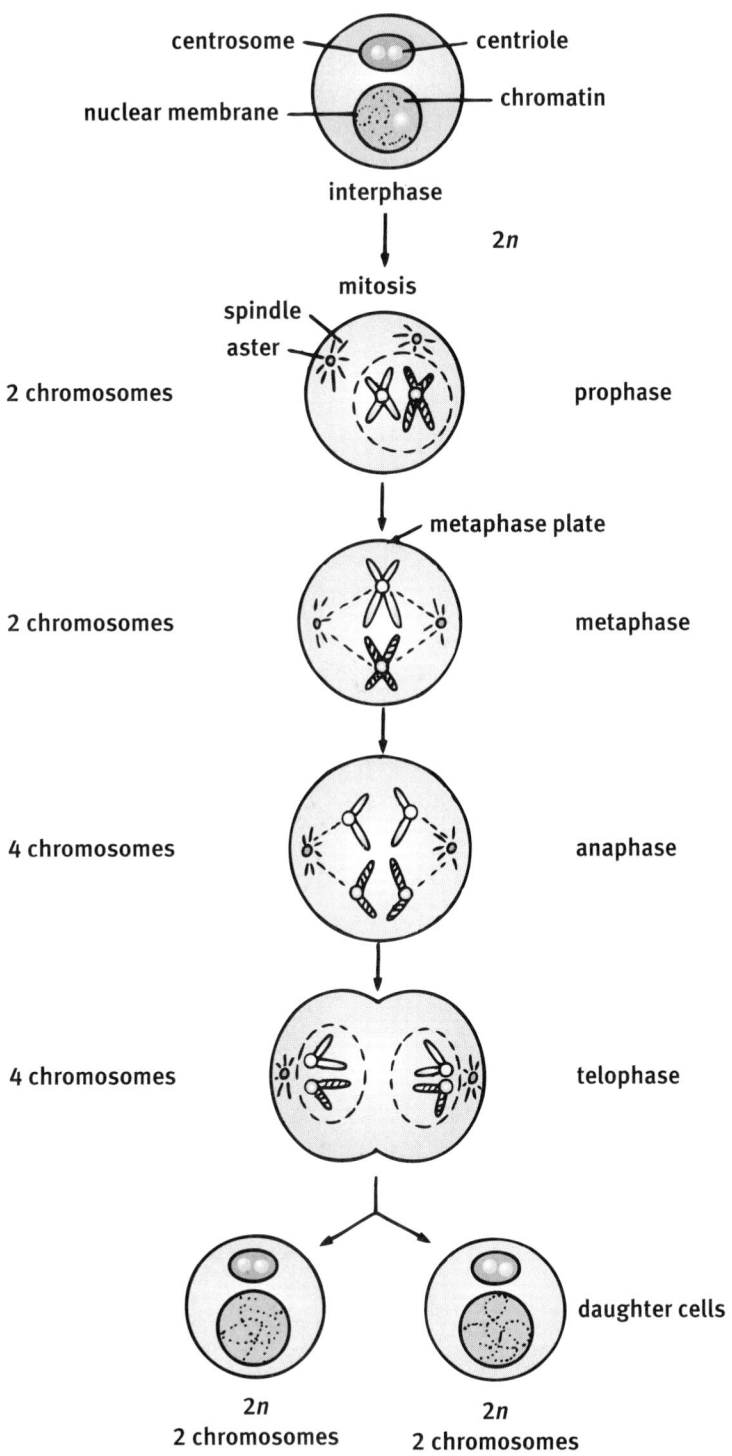

Figure 5.7

MNEMONIC

The phases of the cell cycle can be remembered as "**I** Party **M**ore **A**t **T**he **C**lub": **I**nterphase, **P**rophase, **M**etaphase, **A**naphase, **T**elophase, and **C**ytokinesis.

Prophase

Mitosis begins with prophase, which prepares the cell for karyokinesis (nuclear division). First, chromatin is condensed into clearly defined chromosomes. The nuclear membrane dissolves, which is necessary for nuclear division. Finally, the centriole pairs separate and move towards opposite poles of the cell. The centrioles will serve as anchoring points to pull and separate the chromosomes.

Metaphase

In metaphase, the centrioles are now at opposite poles of the cell and anchor themselves to the cell membrane through the formation of spindle fibers. Additional spindle fibers radiate outwards from the centriole towards the chromosomes and attach to each chromatid at the **kinetochore**, a protein located on the centromere of the chromosome. Once attached, the spindle fiber aligns the chromosomes along the **metaphase plate**.

Anaphase

Anaphase is marked by the separation of sister chromatids of each chromosome. First, the centromeres split so that that each chromatid has its own distinct centromere, thus allowing their separation. The sister chromatids are pulled toward the opposite poles of the cell by the shortening of the spindle fibers.

Telophase

The spindle apparatus disappears. A nuclear membrane forms around each set of newly formed chromosomes. Thus, each nucleus contains the same number of chromosomes (the **diploid** number, 2N) as the original or parent nucleus. The chromosomes uncoil, resuming their interphase form.

Cytokinesis

Near the end of telophase the cytoplasm divides into two daughter cells, each with a complete nucleus and its own set of organelles. In animal cells, a **cleavage furrow** forms, and the cell membrane indents along the equator of the cell, eventually pinching through the cell and separating the two nuclei. In plant cells a cell plate forms between the two nuclei, effectively splitting the plant cell in half and allowing the cell to divide.

Animal Cytokinesis

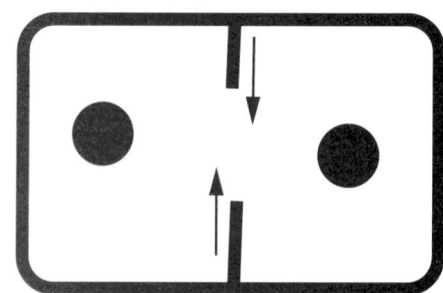

Plant Formation of Cell Plate

Figure 5.8

Meiosis

Sexual reproduction differs from asexual reproduction in that there are two parents involved. Sexual reproduction occurs via the fusion of two gametes—specialized sex cells produced by each parent. **Meiosis** is the process by which these sex cells are produced. Meiosis is similar to mitosis in that a cell duplicates its chromosomes before undergoing the process. However, whereas mitosis preserves the diploid number of the cell, meiosis produces **haploid** ($1N$) cells, halving the number of chromosomes. The haploid nature of sex cells is important, as it ensures that upon fertilization (sex cell fusion) the resulting cell is diploid.

Ploidy

Ploidy (i.e., haploid, diploid) refers to how many chromosomes an organism has in a homologous set. Homologous sets are chromosomes that share structure and gene locations, but can have different alleles. For example, humans are diploid, possessing two chromosomes in a homologous pair that will have a gene for hair color at the same location. However, one chromosome may contain an allele for brown hair while the other has the allele for blonde hair. Thus, one way to conceptualize ploidy number is to consider how many copies or versions of a chromosome a cell has (one copy is haploid; two copies is diploid; four copies is tetraploid).

Interphase

As in mitosis, the diploid parent cell goes through S phase, thereby replicating its DNA. Despite this replication, the result is still a diploid cell because the number of chromosomes remained the same. The change is that each chromosome now has two sister chromatids. Thus, each homologous pair has a total of four sister chromatids (see Figure 5.6).

First meiotic division

After replication of the parent cell genome, meiosis occurs. The first meiotic division yields two haploid (1N) daughter cells. Therefore, the first meiotic division separates the pair of homologous chromosomes, not chromatids.

Prophase I: Prophase I of meiosis shares similarities to prophase of mitosis: the chromatin condenses into chromosomes, the spindle apparatus forms, and the nucleoli and nuclear membrane disappear. The major difference in prophase I of meiosis is the occurrence of **crossing over** (see Figure 5.9). Crossing over is the genetic exchange between chromatids of homologous chromosomes and is vital for a species, as it increases genetic diversity.

The process of crossing over is as follows: First, homologous chromosomes come together and intertwine in a process called **synapsis**. This structure is often called a **tetrad**, as there is a total of four sister chromatids involved. The exact parts of the chromosomes where sister chromatids interact are called **chiasmata**. Once synapsis begins, chromatids of homologous chromosomes break at corresponding points and exchange equivalent pieces of DNA. Note that crossing over does not occur between sister chromatids on the same chromosomes, as these chromatids are identical and would not produce any genetic variation.

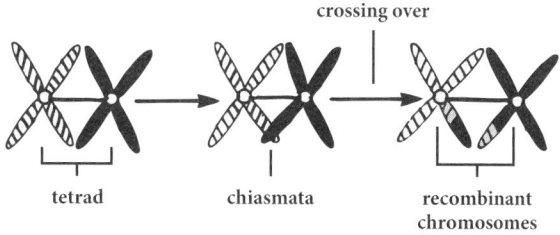

crossing over

tetrad chiasmata recombinant chromosomes

Figure 5.9

BIO

centrosome
centriole
nuclear
membrane
chromatin
2n

interphase

meiosis

prophase I 2 chromosomes

metaphase I 2 chromosomes

disjunction

anaphase I 2 chromosomes

telophase I 2 chromosomes

metaphase II 1 chromosome in
 each daughter cell

anaphase II 2 chromosomes in
 each daughter cell

telophase II

1 chromosome in each
daughter cell

n n n n

gametes

Figure 5.10

Metaphase I: Homologous pairs (tetrads) align at the equatorial plane and each pair attaches to a separate spindle fiber at the kinetochore.

Anaphase I: The homologous pairs separate and are pulled to opposite poles of the cell. This process is called **disjunction** and it accounts for the Mendelian law of segregation. During disjunction, each chromosome of paternal origin separates (or disjoins) from its homologue of maternal origin, and either chromosome can end up in either daughter cell. Thus, the distribution of homologous chromosomes to the two intermediate daughter cells is random with respect to parental origin. Each daughter cell will have a unique pool of genes from a random mixture of maternal and paternal origin.

Nondisjunction occurs when cells do not separate appropriately during meiosis (see Figure 5.11). This results in the daughter cells having an incorrect number of chromosomes and is discussed in greater detail in Chapter 8.

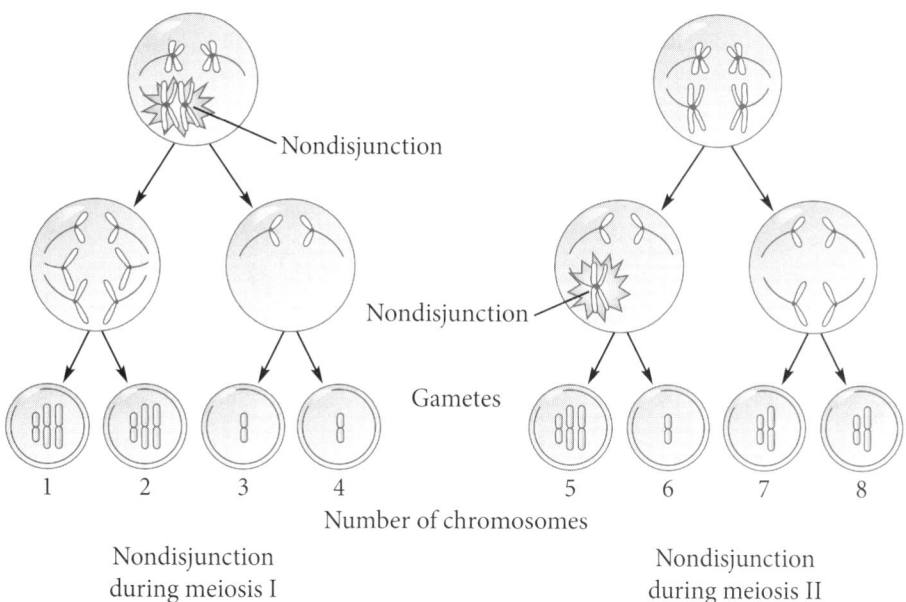

Figure 5.11

Telophase I: A nuclear membrane forms around each new nucleus, thereby forming two haploid cells (1N), in which each chromosome has two sister chromatids. These cells are often called **intermediate daughter cells**.

Second meiotic division

Meiosis II shares many similarities with mitosis, specifically that in both of these processes sister chromatids are separated. One major difference between the two processes is that in meiosis II both the parent (intermediate daughter cells) and daughter cells are haploid, while in mitosis all cells remain diploid.

Prophase II

During prophase II, the nuclear envelope dissolves, nucleoli disappear, the centrioles migrate to opposite poles, and the spindle apparatus begins to form.

Metaphase II

During metaphase II, the chromosomes line up on the metaphase plate.

Anaphase II

During anaphase II, the sister chromatids of the chromosomes are separated and are pulled apart by shortening spindle fibers. Each separated sister chromatid is now considered a chromosome itself.

Telophase II

During telophase II, a nuclear membrane forms around each new set of chromosomes. Cytokinesis follows and two haploid daughter cells are formed per intermediate daughter cell. Thus, by completion of meiosis II, up to four haploid daughter cells are produced per gametocyte (parent cell of meiosis II). We use the phrase *up* to because in oogenesis, female gametogenesis, two or three of the potential gametes become polar bodies and are absorbed by the body.

REVIEW PROBLEMS

1. All of the following are components of the Cell Theory EXCEPT the idea that
 A. all living things are composed of cells.
 B. all living things contain mitochondria.
 C. cooperation among cells allows for complex functioning in living things.
 D. all cells arise from preexisting cells.
 E. cells carry genetic information in the form of DNA.

2. A eukaryotic cell contains organelles specialized for various activities. Name the organelles involved and the role they play in the following activities.
 A. Ingestion
 B. Digestion
 C. Transport of proteins

3. Which of the following activities occurs in the Golgi apparatus?
 A. Synthesis of proteins
 B. Breakdown of lipids and carbohydrates
 C. Catalysis of various oxidative reactions
 D. Modification and packaging of proteins
 E. Aerobic respiration

4. Draw the fluid mosaic model of the cell membrane. How does this model account for the passage of materials across the membrane?

5. Prokaryotes and eukaryotes differ in a number of ways. Compare them in terms of the following characteristics.
 A. Organization of genetic material
 B. Site of cellular respiration
 C. Presence of membrane-bound organelles

6. A researcher treats a solution containing animal cells with ouabain, a substance that interferes with the Na^+/K^+ pump embedded in the cell membrane and causes the cell to lyse. Which of the following statements best explains ouabain's mechanism of action?
 A. Treatment with ouabain results in high levels of extracellular Ca_2^+.
 B. Treatment with ouabain results in high levels of extracellular K^+ and Na^+.
 C. Treatment with ouabain increases intracellular concentrations of Na^+.
 D. Treatment with ouabain decreases intracellular concentrations of Na^+.
 E. Treatment with ouabain results in high levels of extracellular Na^+ only.

7. Prokaryotic cells and eukaryotic animal cells both have
 A. DNA.
 B. ribosomes.
 C. cell walls.
 D. chloroplasts.
 E. A and B

8. What is the significance of the lysosomal membrane?

9. What roles do microtubules and microfilaments play in cell division?

10. If the haploid number of an organism is 13, what is its diploid number?

11. Fill in the blanks with the name of the appropriate stage of mitosis.
 A. During _____, the chromosomes separate and move to opposite poles of the cell.
 B. The nuclear membrane begins to dissolve during _____.
 C. The centromeres of the replicated chromosomes have completely split by _____.
 D. During _____, nucleoli disappear.
 E. Chromosomes condense, shorten, and coil during _____.
 F. Centromeres line up at the equatorial plate during _____.
 G. During _____, a cleavage furrow is formed.

12. How do metaphase and anaphase of mitosis differ from metaphase I and anaphase I of meiosis?

SOLUTIONS TO REVIEW PROBLEMS

1. **B** Prokaryotes do not possess membrane-bound organelles, including mitochondria. This is further discussed in cell theory section of this chapter.

2. **A** Cellular ingestion is a function of the cell membrane and vesicles. The cell membrane invaginates around a food particle and pinches off, enclosing the material in a vesicle that can travel freely in the cytoplasm. This is known as endocytosis.

 B The organelles involved in digestion are lysosomes, vesicles, and mitochondria. A lysosome is a membrane-bound sac containing hydrolytic enzymes. It fuses with a vesicle, allowing its enzymes to chemically degrade the ingested material. The products of lysosomal digestion are released into the cytoplasm, where they can be used by the cell. Glucose is metabolized in mitochondria via aerobic respiration.

 C The endoplasmic reticulum forms a long, interconnecting series of passageways through which proteins are transported. Rough ER secretes proteins into cytoplasmic vesicles that are transported to the Golgi apparatus. Microtubules are involved in the transport of proteins in some specialized cells, such as neurons.

3. **D** Discussed in cell structure section of this chapter.

4. According to the fluid mosaic model in Figure 5.2, the individual molecules of the lipid bilayer are in constant motion within the plane of the membrane. This fluidity allows ions and small molecules to diffuse directly across the cell membrane. However, large molecules cannot cross the membrane without the aid of special carrier protein molecules, which are embedded within the phospholipid bilayer. Some substances cannot cross the membrane at all. This selective permeability allows the cell membrane to tightly control the passage of materials into and out of the cell.

5. **A** In prokaryotes, the genetic material is composed of a single circular molecule, or chromosome, of DNA localized in a region of the cell called the nucleoid. Eukaryotes have highly coiled linear strands of DNA organized into chromosomes within a membrane-bound nucleus.

 B In prokaryotes, cellular respiration occurs directly at the cell membrane, whereas in eukaryotes, cellular respiration occurs across the mitochondrial membrane and within the mitochondrion itself.

 C Prokaryotes do not contain any membrane-bound organelles, whereas eukaryotes contain a number of membrane-bound organelles, such as the nucleus, lysosomes, vesicles, ER, and mitochondria.

6. **C** This question requires an understanding of osmosis and the action of the Na^+/K^+ pump, also known as Na^+/K^+ adenosine triphosphatase (ATPase). When a cell is placed in a hypertonic solution (a solution having a higher solute concentration than the cell), fluid will diffuse out of the cell into the solution, resulting in cell shrinkage. When a cell is placed in a hypotonic solution (a solution having a lower solute concentration than the cell), fluid will diffuse from the solution into the cell, causing the cell to expand and possibly lyse. Na^+/K^+ ATPase moves three sodium ions out for every two potassium ions it lets into the cell. Therefore, inhibition of Na^+/K^+ ATPase by ouabain will cause a net increase in the Na^+ concentration inside the cell, and water will diffuse down its concentration gradient and into the cell, causing the cell to swell and then lyse.

BIO

7. **E** Discussed in cell structure section of this chapter.

8. The lysosomal membrane serves an important function. It protects the cell from the hydrolytic actions of the enzymes it contains. If the membrane were to burst, these enzymes would digest cellular components and ultimately kill the cell.

9. Microtubules and microfilaments play important roles in cell division. Microtubules form the mitotic spindle, which is responsible for separating sister chromatids. During prophase, a radial array of microtubules forms around the centrioles. The microtubules "push" the centrioles to opposite poles of the cell, forming the bipolar spindle apparatus. When the chromosomes align at the metaphase plate, these spindle fibers attach to the centromeres. During anaphase, the fibers shorten and pull on the centromeres, separating the sister chromatids and moving them toward opposite poles of the cell.

 After anaphase, microfilaments (actin filaments) and myosin filaments under the cell membrane contract, leading to the indentation of the membrane at the metaphase plate and the subsequent division of the parent cell into two daughter cells.

10. Haploid gametes are produced by meiosis, a process in which the chromosome number of the parent cell is reduced by one half. Thus, if the haploid number (N) of a particular organism is 13, then the diploid number ($2N$) must be 26.

11. **A** anaphase

 B prophase

 C anaphase

 D prophase

 E prophase

 F metaphase

 G telophase

12. In metaphase of mitosis, replicated chromosomes line up in single file; during anaphase, sister chromatids separate and move to opposite poles of the cell. In metaphase I of meiosis, homologous pairs of replicated chromosomes line up; during anaphase I, the homologous chromosomes separate, but sister chromatids remain attached to each other.

CHAPTER SIX

Molecular Genetics

DNA is the molecule of life, the molecule of heredity, and a core tenet of the unifying cell theory (see Chapter 5). The importance of DNA stems from its ability to self-replicate (DNA replication) and its ability to store information. This information is vital as it can be transcribed into RNA (ribonucleic acid), then translated into a sequence of amino acids called a protein. This transmission of information through DNA, RNA, and proteins is called the **central dogma** of molecular biology.

This chapter will explore these processes of the central dogma (see Figure 6.1) and the roles of DNA, RNA, and proteins.

DEOXYRIBONUCLEIC ACID

Deoxyribonucleic acid (DNA) is the basis for heredity. Its ability to self-replicate makes sure that the coded DNA sequence will be passed on to future generations. DNA is **mutable** and can be altered under certain conditions. These changes alter the proteins produced and therefore the organism's characteristics. Changes in DNA are usually stable and are passed down from generation to generation. This provides the basis for evolution.

Figure 6.1

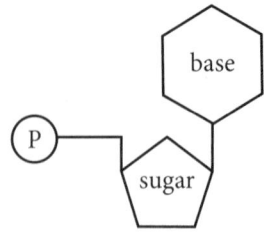

Figure 6.2

MNEMONIC

To remember the types and structures of the two classes of nitrogenous bases, remember to **CUT** the **PY**e (as C, U, and T are pyrimidines). You can also note that pie has one ring of crust, and pyrimidines have only one ring in their structure. You can also remember **PUR**e **A**s **G**old (as A and G are purines); think of gold wedding rings. It takes two gold rings at a wedding, just like purines have two rings in their structure.

DNA Structure

The basic unit of DNA is the **nucleotide**. A nucleotide is composed of deoxyribose (a sugar) bonded to both a phosphate group and a nitrogenous base (see Figure 6.2). There are two types of bases: **purines** and **pyrimidines**. Purines in DNA include **adenine** (A) and **guanine** (G); pyrimidines are **cytosine** (C) and **thymine** (T). RNA contains the pyrimidine **uracil** (U) instead of thymine. Purines are larger in structure than pyrimidines because they possess a two-ring nitrogenous base, whereas pyrimidines have a one-ring nitrogenous base. The phosphate and sugar form a chain with the bases arranged as side groups off the chain.

Figure 6.3

The directionality of DNA is designated by a 3′ (read as "three prime") and a 5′ (read as "five prime") end. This naming convention is based on which carbon of the sugar molecule of the DNA strand is the terminus of the helix. If the 5′ carbon is at the end of the DNA strand, then that end is referred to as the 5′ end. Similarly, if the 3′ carbon is at the end of the DNA strand, then that end is referred to as the 3′ end.

DNA is most commonly found in nature as double-stranded helices of complementary strands with the sugar-phosphate chains on the outside of the helix and the nitrogenous bases on the inside. These strands are held together by hydrogen bonds between the bases oriented toward the center. Purines pair with pyrimidines in the following pattern: T forms two hydrogen bonds with A, and G forms three hydrogen bonds with C. This pairing holds the two strands of the double helix together and links the polynucleotide chains. When arranged this way, one DNA strand has its 5′ end pointing up, and

the other strand has its 3′ end pointing up, resulting in an **antiparallel** arrangement. This structure was discovered by James Watson and Francis Crick with the help of Rosalind Franklin and others and is therefore known as the **Watson-Crick DNA model** (see Figure 6.4).

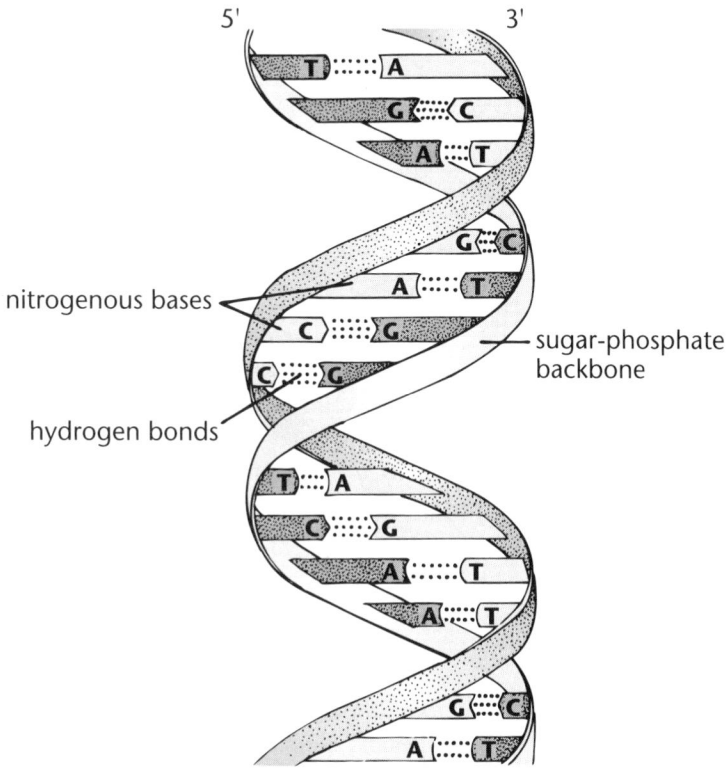

Figure 6.4

DNA Function

DNA replication

In order to replicate, the double-stranded DNA helix must unwind and separate into two single strands. This involves the breaking of hydrogen bonds between nitrogenous bases from each strand by **DNA helicase**. The opening in the DNA molecule created by DNA helicase is known as the **replication fork**. As DNA is replicated, the replication fork continues to travel up the DNA molecule, which could cause a buildup of torsional strain (due to twisting of the DNA molecule) upstream of the replication fork. However, **topoisomerase** removes this strain by cutting, twisting, and then rejoining the strands of DNA (see Figure 6.6).

Once the replication fork has passed a portion of DNA, the two strands are separated. This area is known as the replication bubble, in which each single strand can act as a template for complementary base-pairing. This allows for the synthesis of two new daughter strands. Each new daughter helix contains an intact strand from the parent helix and a newly synthesized strand; this type of replication is called **semiconservative**. The daughter strands of DNA formed from the parent strands are identical to the parent strands.

parent strands

daughter strands

Figure 6.5

Creation of these daughter strands is the result of **DNA polymerase**. DNA polymerase reads the parent DNA strand and creates a complementary, antiparallel daughter strand. DNA polymerase

KEY CONCEPT

With the exception of DNA polymerase's reading direction (and a few untested endonucleases), everything in molecular biology is 5′ to 3′. DNA polymerase reads 3′ to 5′, but the following processes occur 5′ to 3′:

- DNA synthesis
- DNA repair
- RNA transcription
- RNA translation (reading of codons)

always reads the parent strand in the $3' \rightarrow 5'$ direction, creating a new daughter strand in the $5' \rightarrow 3'$ direction. In other words, DNA polymerase can only add nucleotides to 3′ ends of DNA strands. This fixed directionality of DNA synthesis leads to an interesting difference between the two daughter strands, termed the **leading strand** and the **lagging strand**. The leading strand has its 3′ end facing towards the replication fork, thereby allowing DNA polymerase/DNA synthesis and the replication fork to travel in the same direction. This results in the leading strand being continually synthesized. In contrast, the lagging strand has its 3′ end facing away from the replication fork. Thus, the synthesis of the lagging strand and movement of the replication fork are opposite in direction. In order to replicate the entire lagging strand, additional DNA polymerase proteins must reattach to the parent strand near the continually moving replication fork. This discontinuous synthesis results in short fragments of synthesized DNA termed **Okazaki fragments**. As the lagging strand is formed, these fragments are joined together by **DNA ligase** (see Figure 6.6).

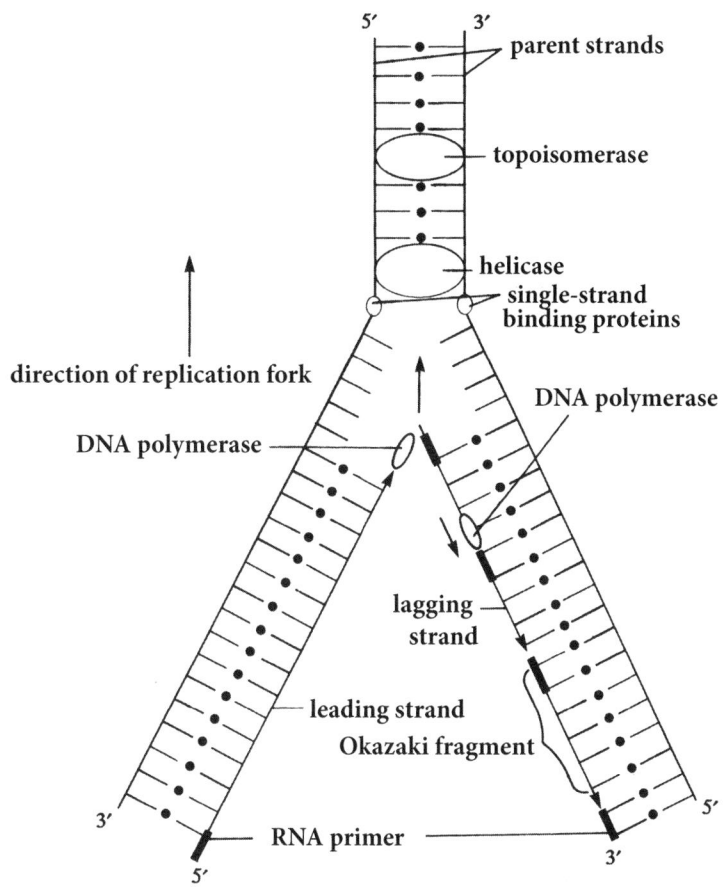

Figure 6.6

FLOW OF GENETIC INFORMATION

Classically, a gene is a unit of DNA that encodes a specific RNA molecule through the process of transcription and, through translation, that gene can be expressed as a protein. Although this sequence is now complicated by our increased knowledge of the ways in which genes and nucleic acids may be expressed, for Test Day you only need to understand the classical view of gene expression.

The relationship between the sequence found in double-stranded DNA, single-stranded RNA, and proteins is illustrated in Figure 6.7. Transcription is the process in which genetic information is passed from DNA to RNA. The RNA, specifically messenger RNA, is transcribed in the $5' \rightarrow 3'$ direction and is complementary and antiparallel to the DNA **template strand**. The **coding strand** of DNA is identical to the mRNA strand (with the exception that all thymine bases are exchanged for uracil). Translation is the process in which genetic information is passed from mRNA to protein. The ribosome translates the mRNA in the $5' \rightarrow 3'$ direction and the protein is synthesized from the amino terminus (N-terminus) to the carboxyl terminus (C-terminus).

Figure 6.7

RIBONUCLEIC ACID

RNA Structure

Ribonucleic acid (RNA) is a polynucleotide that is structurally similar to DNA but with three major exceptions:

- The sugar constituent is ribose (instead of deoxyribose).
- Uracil is used in place of thymine.
- Most RNA is single-stranded.

RNA can be found in both the nucleus and the cytoplasm of the cell. There are several types of RNA, all of which are involved in protein synthesis. The three major types are mRNA, tRNA, and rRNA.

Messenger RNA

Messenger RNA (mRNA) carries the complement of a DNA sequence. It then transports this information from the nucleus to the ribosomes for protein synthesis. mRNA is made from ribonucleotides complementary to the template strand of DNA. Eukaryotic mRNA is monocistronic, meaning that one mRNA strand codes for one polypeptide.

Transfer RNA

Transfer RNA (tRNA) is a small RNA molecule found in the cytoplasm. It assists in the translation of mRNA's nucleotide code into a sequence of amino acids by bringing the amino acids coded for in the mRNA sequence to the ribosomes during protein synthesis. tRNA recognizes both the mRNA codon and its corresponding amino acid. This dual function is reflected in its three-dimensional structure. One end contains a three-nucleotide sequence, the **anticodon**, which is complementary to one of the mRNA codons. The other end is the site of attachment of the corresponding amino acid. Each amino acid has its own aminoacyl-tRNA synthetase, which has an active site that binds to both the amino acid and its corresponding tRNA, catalyzing their attachment to form an aminoacyl-tRNA complex. When a tRNA is complexed with the appropriate amino acid, it is called a **charged tRNA**. There is at least one type of tRNA for each amino acid (there are approximately 40 known types of tRNA).

Ribosomal RNA

Ribosomal RNA (rRNA) is synthesized in the nucleolus of eukaryotes and in the cytoplasm of prokaryotes. rRNA functions as an integral part of the ribosomal machinery used during protein assembly in the cytoplasm. It is also the RNA type most abundant in the cell.

Transcription

Transcription is the process through which information coded in the sequence of DNA is used to direct the synthesis of a strand of RNA. After post-transcriptional modification, the RNA leaves the nucleus through nuclear pores.

The first step of transcription occurs when RNA polymerase binds to the DNA template strand at a promoter region, a short DNA sequence found upstream from the site where transcription of a specific RNA is going to take place. The most common promoter site in eukaryotes and prokaryotes, respectively, is the TATA box (approximately 30 bp upstream; sequence TATAAT) and the Pribnow box (approximately 10 bp upstream; sequence TTGACA). In order for RNA polymerase to bind to the promoter site, various transcription factors must assist. In a process very similar to DNA replication, the RNA polymerase surrounds the DNA molecule after it has been opened by the actions of DNA helicase and topoisomerase.

Once RNA polymerase has bound to the template DNA strand, it recruits and adds complementary RNA nucleotides, thereby transcribing a new RNA strand. As with DNA polymerase, RNA polymerase reads DNA in the $3' \rightarrow 5'$ direction and creates a new daughter strand of RNA in the $5' \rightarrow 3'$ direction. The RNA sequence is complementary to the original DNA sequence except that adenine (A) binds with uracil (U) rather than thymine (T).

Post-transcriptional processing

After transcription is complete, the RNA molecule undergoes post-transcriptional processing. RNA that has not yet been processed is known as hetero-nuclear RNA (hnRNA), or pre-RNA, and contains extra nucleotides that are not necessary to create the corresponding protein. These extra sequences are called **introns** and are subsequently spliced out (removed) by the spliceosome. In contrast, **exons** are the nucleotides necessary to make the protein and are kept during the post-transcriptional processing. In addition, before the spliced RNA can leave the nucleus it must gain a 5′ guanine cap and a series of adenines known as a 3′ poly-A tail. The function of these terminal structures is to provide protection from RNA-degrading enzymes within the cytosol. Once these three modifications are made to the RNA molecule, it is termed messenger RNA (mRNA) and can leave the nucleus.

> **MNEMONIC**
>
> **IN**trons stay **IN** the nucleus; **EX**ons will **EX**it the nucleus as part of the mRNA.

CODONS

While transcription from DNA to RNA relies on complementary base pair matching (A to U/T; C to G), translation is much more complex. In fact, this difference in complexity is found in the processes' names themselves. Transcription means to write or copy a document in the same language. In biology, transcription rewrites the DNA message in RNA using the same language, nitrogenous bases. Translation means to express the same idea in a different language. In biology, translation converts the nitrogenous base message of mRNA to the amino acid language of proteins. In this analogy, codons are the dictionary for this translation.

Codons are three nucleotide sequences on the mRNA that correspond to a specific amino acid. Because there are 4 possible nucleotides for each of the 3 positions in a codon, there are 64 possible codons (see Figure 6.8). Note that all codons are written in the $5' \rightarrow 3'$ direction, thus providing an unambiguous code where each codon codes for one and only one amino acid.

Second Base

	U	C	A	G	
U	UUU UUC } Phe UUA UUG } Leu	UCU UCC UCA UCG } Ser	UAU UAC } Tyr UAA UAG } *Stop*	UGU UGC } Cys UGA } *Stop* UGG } Trp	U C A G
C	CUU CUC CUA CUG } Leu	CCU CCC CCA CCG } Pro	CAU CAC } His CAA CAG } Gln	CGU CGC CGA CGG } Arg	U C A G
A	AUU AUC } Ile AUA AUG } *Start or Met*	ACU ACC ACA ACG } Thr	AAU AAC } Asn AAA AAG } Lys	AGU AGC } Ser AGA AGG } Arg	U C A G
G	GUU GUC GUA GUG } Val	GCU GCC GCA GCG } Ala	GAU GAC } Asp GAA GAG } Glu	GGU GGC GGA GGG } Gly	U C A G

First Base (5′) ... **Third Base (3′)**

Figure 6.8

The figure above is often cited as the "genetic code" because it can be used to decipher the message of genetic material (DNA/RNA) into amino acid sequences. This genetic code is universal across all species. While memorizing the table is unnecessary, there are a couple patterns that are worth pointing out.

MNEMONIC

Stop codons:

- **UAA**—**U A**re **A**nnoying
- **UGA**—**U G**o **A**way
- **UAG**—**U A**re **G**one

First, note that out of the total 64 codons only 61 code for amino acids. The remaining 3 codons are known as **stop codons** as they instruct the ribosome to stop translation, thereby ending the polypeptide. These codons are UAA, UGA, and UAG.

Second, the 61 amino acid codons only correspond to 20 different amino acids, thus there must be redundancy to the genetic code. In other words, multiple codons code for the same amino acid. The presence of this redundancy in the genetic code makes the code degenerate, meaning the mRNA sequence cannot be regenerated from the amino acid sequence.

Third, codons corresponding to the same amino acid are very similar. For instance, the four codons that code for Alanine are GCU, GCC, GCA, and GCG. Notice that the third nucleotide does not affect which amino acid the codon corresponds to. To clarify, if the first two nucleotides are GC, the codon corresponds to alanine. This phenomenon is known as the wobble position (3rd position) and is explained by the aminoacyl-tRNA complex's ability to bind to mRNA despite having non-complementary base pairs for the third nucleotide.

Translation

Translation is the process through which mRNA codons are translated into a sequence of amino acids. Translation occurs in the cytoplasm and involves ribosomes (rRNA), tRNA, mRNA, amino acids, enzymes, and other proteins. The process itself can be divided into four distinct stages: initiation, elongation, translocation, and termination (see Figure 6.9).

Initiation begins when the small ribosomal subunit binds to the mRNA near its 5′ end. The ribosome scans the mRNA until it binds to a **start codon** (AUG), which codes for methionine. The initiator aminoacyl-tRNA complex, methionine tRNA (with the anticodon 3′–UAC–5′), base pairs with the start codon. Once the mRNA, small ribosomal subunit, and the aminoacyl-tRNA complex is bound, the large ribosomal subunit binds, forming the completed initiation complex.

Elongation is a three-step cycle that is repeated for each amino acid added to the protein after the initiator methionine. During elongation, the ribosome moves in the 5′ to 3′ direction along the mRNA, synthesizing the protein from its amino (N-) to carboxyl (C-) terminus. The ribosome contains three very important binding sites:

- The **A site** holds the incoming aminoacyl-tRNA complex, which will be the next amino acid added to the growing chain. The incoming aminoacyl-tRNA complex is determined by mRNA codons.
- The **P site** holds the tRNA that carries the growing polypeptide chain and where the initiation complex formed (methionine). A **peptide bond** is formed as the polypeptide is passed from the tRNA in the P site to the tRNA in the A site. This action requires energy and is completed by the ribosome.
- The **E site** (not shown in Figure 6.9) is where the now uncharged tRNA briefly pauses before it is expelled from the ribosome, to be recharged.

Finally, this cycle is completed by **translocation**, in which the ribosome advances three nucleotides along the mRNA in the 5′ to 3′ direction. When the ribosome advances, the tRNA's position on the ribosome shifts. The charged tRNA (bound to the polypeptide) is transferred from the A site to the P site. The uncharged tRNA is transferred from the P site to the E site, where it is expelled. After translocation, the result is an empty A site ready for the entry of the aminoacyl-tRNA corresponding to the next codon. This cycling continues until a stop codon (UAA, UGA, or UAG) is encountered, triggering **termination**.

MNEMONIC

Order of sites in the ribosome during translation: **APE**

BIO

Figure 6.9

Post-translational modifications

Often, before a newly translated polypeptide chain is fully functional it must undergo modifications, termed **post-translational modifications**. Modification can include **cleavage**, where certain amino acid sequences are removed from the chain, or addition, where biomolecules are added to the peptide. Common addition processes include:

- **Phosphorylation:** Addition of a phosphate group.
- **Carboxylation:** Addition of carboxylic acid groups.
- **Glycosylation:** Addition of oligosaccharides (sugars), completed in the Golgi body.
- **Prenylation:** Addition of lipid groups, allowing for incorporation of the protein into membranes.

Prokaryotic vs. eukaryotic differences

Although the central dogma of molecular genetics is consistent between all forms of life, there are some key differences between the prokaryotic and eukaryotic processes.

In eukaryotes, transcription occurs in the nucleus; however, due to prokaryotes lacking membrane-bound organelles, transcription in these organisms occurs in the cytoplasm. In addition, since prokaryotes do not have a nucleus, posttranscriptional modification does not occur. Thus, prokaryotes are said to have **polycistronic** mRNA transcripts (while eukaryotes have **monocistronic** mRNA transcripts).

KEY CONCEPT

Monocistronic means one transcript translates to one protein. Polycistronic means one transcript translates to multiple proteins, often due to multiple start codons.

Although translation of mRNA is functionally the same between prokaryotic and eukaryotic cells, the ribosomes themselves have major structural differences. These structural differences have major implications in modern medicine as many antibiotic compounds target bacterial cells by targeting prokaryotic ribosomes.

In addition, due to the lack of membrane-bound organelles in prokaryotes, transcription and translation can occur at the same location in the cell. This results in transcription and translation occurring concurrently in prokaryotes.

Proteins

Formed by the culmination of transcription and translation, proteins are the functional units of life. The vast majority of all cellular functions are completed by proteins.

Protein structure

A protein's function is closely linked to its 3D structure, which has four levels of organization: primary (1°), secondary (2°), tertiary (3°), and quaternary (4°) structure.

The **primary structure** of a protein is the sequence of amino acids, determined by its mRNA strand. By convention, primary structure lists amino acids from the N-terminus to C-terminus. Peptide bonds, the bonds linking linear amino acids together, are central to a protein's primary structure.

The **secondary structure** of a protein is the local 3D structure of neighboring amino acids, which is determined by the primary structure of the protein. The most common secondary structures are α-helices (alpha helices) and β-sheets (beta-sheets). Secondary structure stability relies on hydrogen bond formation between amino acid side chains.

The **tertiary structure** of a protein refers to the folding of a polypeptide forming the 3D structure of the entire protein itself. This folding process is often assisted by **chaperones**, cellular proteins that stabilize transition states in the folding process. Tertiary structure relies on the hydrophobic and hydrophilic interactions of amino acid side groups, as well as **disulfide bonds**.

The **quaternary structure** of a protein describes the combining of polypeptides to form a complete protein complex. For example, hemoglobin is a tetramer formed by four separate subunits (polypeptides) complexing together. Quaternary structure stability relies on both hydrophobic and hydrophilic interactions and disulfide bonds. Note, all proteins have primary, secondary, and tertiary structure, but not all have quaternary structure.

Protein function

Almost all processes in the cell are reliant on the functioning of proteins; therefore, it is not surprising that they have a wide range of functions. Typically, a single protein will have a specific function; thus, proteins themselves can be categorized by their function, the two major categories being enzymatic and non-enzymatic.

Non-enzymatic functions are wide-reaching but generally fall into two major categories.

- Structural proteins, including cytoskeleton components and motor proteins, have the primary functions to fix cellular components in place or to move cellular components to their needed location.
- Binding proteins serve to transport, attach, or sequester molecules by directly adhering to the molecule. Common examples include hemoglobin, cell adhesion molecules, and immunoglobulins.

Enzymes

Enzymes are proteins that have a catalytic function; thus, enzymes are often called organic catalysts. A catalyst is any substance that affects the rate of a chemical reaction while remaining unchanged or being regenerated as a product. Typically, catalysts, and, therefore enzymes, increase the reaction rate through reduction of the activation energy of the reaction. Enzymes are crucial to living things, as all life relies on chemical reactions (metabolism).

Enzymes are proteins and thus, thousands of different enzymes can conceivably be formed. In addition, the variability of enzymes can be increased through conjugation. **Conjugated proteins** covalently bond to other groups (lipids, sugars, cations, etc.) that often serve as coenzymes or cofactors.

Enzymes are very selective, often only catalyzing one reaction or one specific class of closely related reactions. The molecule the enzyme acts on is called the **substrate**. There is an area on each enzyme to which the substrate binds, called the active site. There are two models that describe the specific binding process of the enzyme and the substrate, which will be explored below.

Most enzyme-catalyzed reactions are reversible. The product synthesized by an enzyme can be decomposed by the same enzyme. An enzyme that synthesizes maltose from glucose can also hydrolyze maltose back to glucose.

The following characteristics are true for all enzymes:

- Enzymes do NOT alter the equilibrium constant.
- Enzymes are NOT consumed in the reaction. This means that they will appear in both the reactants and the products.
- Enzymes lower the activation energy of a reaction, thereby speeding up the reaction.
- Enzymes are pH- and temperature-sensitive, with optimal activity at specific pH ranges and temperatures.

Lock and Key Theory

The Lock and Key Theory holds that the spatial structure of an enzyme's active site is exactly complementary to the spatial structure of its substrate (see Figure 6.10). The two fit together like a lock and key. For example, receptors are large proteins that contain a recognition site (lock) that is directly linked to transduction systems. When a drug or endogenous substance (key) binds to the receptor, a sequence of events is started. Although this theory has been largely discounted, it is still frequently used as a teaching tool when explaining drug interactions with receptors and enzymes.

Induced Fit Theory

This more widely accepted theory describes the active site as having flexibility of shape. When the appropriate substrate comes in contact with the active site, the conformation of the active site changes to fit the substrate (see Figure 6.10). It is this change in shape that begins the enzymatic process.

Figure 6.10



BIO

Enzyme Reaction Rates

Enzyme action and the reaction rate depend on several environmental factors including temperature, pH, and the concentration of enzyme and substrate.

In general, as the **temperature** increases, the rate of enzyme action increases until an optimum temperature is reached (usually around 37°C). Beyond optimal temperature, heat alters the shape of the active site of the enzyme molecule and deactivates it, leading to a rapid drop in rate of action.

For each enzyme, there is an optimal **pH**; above and below that, enzymatic activity declines. Maximal activity of many human enzymes occurs around pH 7.2, which is the pH of most body fluids. Exceptions include pepsin, which works best in the highly acidic conditions of the stomach (pH = 2), and pancreatic enzymes, which work optimally in the alkaline conditions of the small intestine (pH = 8.5). In most cases the optimal pH matches the conditions under which the enzyme operates (see Figure 6.11).

Figure 6.11

Enzyme Kinetics

The concentrations of substrate and enzyme greatly affect the reaction rate. When the concentrations of both enzyme and substrate are low, many of the active sites on the enzyme are unoccupied, and the reaction rate is low. Increasing the substrate concentration will increase the reaction rate until all of the active sites are occupied. After this point, further increase in substrate concentration will not increase the reaction rate, and the reaction is said to have reached the maximum velocity, V_{max} (see Figure 6.12). V_{max} is the reaction rate as substrate concentration goes to infinity. In order to change V_{max} more enzyme must be added.

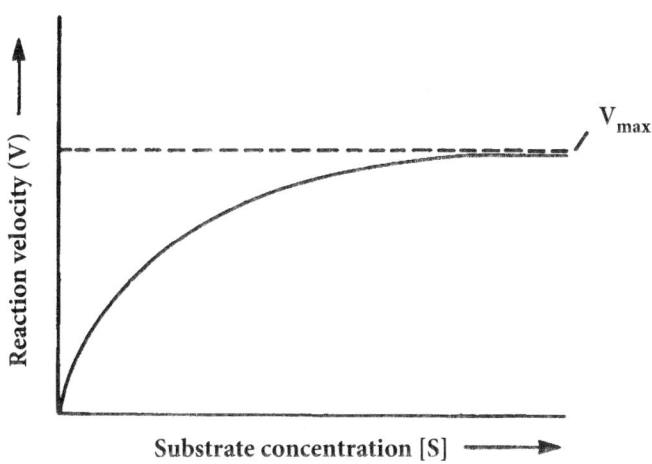

Figure 6.12

Another key point to the plot above is K_m, the **Michaelis constant**. K_m represents the substrate concentration needed to fill half of the enzyme's active sites. This is represented on the plot as the substrate concentration needed to reach $\frac{1}{2}$ V_{max}. K_m can be used to assess an enzyme's affinity for a substrate. Specifically, a higher K_m requires a higher concentration of substrate to reach $\frac{1}{2}$ V_{max}; therefore, the higher the K_m, the lower the enzyme's affinity for that substrate. Conversely, a lower K_m requires a lower concentration of substrate to reach $\frac{1}{2}$ V_{max}; therefore, the lower the K_m, the higher the enzyme's affinity for that substrate. In short, affinity and K_m are inversely related.

Enzyme Inhibition

Biological systems require tight control over biochemical reactions. As previously discussed, enzymes can accomplish part of this goal by increasing the rate of reactions. To truly control reactions, cells must be able to regulate the activity of enzymes, one method being enzyme inhibition. Enzyme inhibition is also a common mechanism of drug action in modern pharmacology.

Competitive inhibition

The active site of an enzyme is specific for a particular substrate or class of substrates. However, it is possible for molecules that are similar to the substrate to bind to the active site of the enzyme. If a similar molecule is present in a concentration comparable to the concentration of the substrate, it will compete with the substrate for binding sites on the enzyme and interfere with enzyme activity. This is known as **competitive inhibition** because the enzyme is inhibited by the inactive substrate, or competitor. If sufficient quantities of the substrate are introduced, however, the substrate can outcompete the competitor and will still be able to reach the V_{max}; however, this will require much higher concentrations of substrate than would be necessary without the competitor.

Noncompetitive inhibition

A **noncompetitive inhibitor** is a substance that that binds to an enzyme at a site other than the active site. The interaction of the noncompetitive inhibitor at an **allosteric site** (allosteric means "other site" or "other structure") changes the structure of the enzyme, resulting in a nonfunctional active site. The term noncompetitive stems from the concept that the inhibitor does not compete directly with the substrate for the enzyme's active site. Consequently, a noncompetitive inhibitor cannot be displaced by the addition of excess substrate and V_{max} must decrease. Noncompetitive inhibition is considered to be a type of **allosteric inhibition**.

Enzyme Classifications

Enzymes can be classified into six categories based on their function or mechanism. If you encounter an unfamiliar enzyme on Test Day, keep in mind that most enzymes have descriptive names ending in the suffix -ase: lactase, for example, breaks down lactose.

Ligases catalyze addition or synthesis reactions, generally between large, similar molecules, and often require ATP. Ligases are most likely to be encountered in nucleic acid synthesis and repair.

Isomerases catalyze the rearrangement of bonds within a molecule. Some isomerases can also be classified as oxidoreductases, transferases, or lyases, depending on the mechanism of the enzyme. Keep in mind that isomerases catalyze reactions between stereoisomers as well as constitutional isomers.

MNEMONIC

Major enzyme classifications: **LIL' HOT**

- **L**igase
- **I**somerase
- **L**yase
- **H**ydrolase
- **O**xidoreductase
- **T**ransferase

Lyases catalyze the cleavage of a single molecule into two products. They do not require water as a substrate and do not act as oxidoreductases. Because most enzymes can also catalyze the reverse of their specific reactions, the synthesis of two small molecules into a single molecule may also be catalyzed by a lyase. When fulfilling this function, it is common for them to be referred to as **synthases**.

Hydrolases catalyze the breaking of a compound into two molecules using the addition of water. In common usage, many hydrolases are named only for their substrate. For example, one of the most common hydrolases you will encounter on Test Day is a **phosphatase**, which cleaves a phosphate group from another molecule. Other hydrolases include peptidases, nucleases, and lipases, which break down proteins, nucleic acids, and lipids, respectively.

Oxidoreductases catalyze oxidation-reduction reactions, that is, the transfer of electrons between biological molecules. They often have a cofactor that acts as an electron carrier, such as NAD^+ or $NADP^+$. In reactions catalyzed by oxidoreductases, the electron donor is known as the reductant, and the electron acceptor is known as the oxidant. Enzymes with **dehydrogenase** or **reductase** in their names are usually oxidoreductases. Enzymes in which oxygen is the final electron acceptor often include **oxidase** in their names.

Transferases catalyze the movement of a functional group from one molecule to another. For example, in protein metabolism, an aminotransferase can convert aspartate and α-ketoglutarate. Most transferases will be straightforwardly named, but remember that kinases are also members of this class. **Kinases** catalyze the transfer of a phosphate group, generally from ATP to another molecule.

REVIEW PROBLEMS

1. What is the central dogma of molecular genetics?

2. Which of the following is NOT true about pyrimidines and purines?
 - A. Pyrimidines have a two-ring nitrogenous base.
 - B. Purines have a two-ring nitrogenous base.
 - C. Purines always bind to pyrimidines when a DNA helix is formed.
 - D. Purines and pyrimidines make up the "rungs" of the DNA ladder.
 - E. Purines and pyrimidines bind together using hydrogen bonds.

3. What is the difference between the 3′ and the 5′ ends of a DNA molecule?

4. Which model of DNA replication describes one parental strand and one new strand of DNA making up each new helix?
 - A. Semiconservative
 - B. Conservative
 - C. Dispersive
 - D. Redundancy
 - E. Degeneracy

5. Describe the process of DNA replication, including the roles of topoisomerase and DNA helicase, and the definitions of Okazaki fragments and the replication fork.

6. What is the redundancy of the genetic code?

7. What are the three major differences between RNA and DNA?

8. Distinguish between transcription and translation and describe the process that takes place within the ribosome during translation.

9. Describe the kinetic effects of increasing substrate concentration while enzyme concentration remains constant.

10. What determines enzyme specificity?

BIO

SOLUTIONS TO REVIEW PROBLEMS

1. The central dogma of molecular genetics states that genetic information goes from DNA to RNA to protein.

2. **A** Purines are larger molecules than pyrimidines and have a two-ring nitrogenous base, whereas pyrimidines only have a one-ring nitrogenous base. It is true that purines and pyrimidines bind to each other via hydrogen bonds when the DNA helix is formed and that they are on the inside of the helix ("rungs" of the DNA ladder) rather than the outside of the structure.

3. The $3'$ end of DNA is where the carbon on the sugar molecule at the farthest end of the DNA molecule is the $3'$ carbon within the ring structure. Similarly, the $5'$ end is where the carbon on the sugar molecule at the DNA terminus is the $5'$ carbon.

4. **A** Semiconservative replication produces two copies of DNA that each contain one parent strand and one new strand. In conservative replication there is one DNA copy with both parent strands and one with two new strands. In dispersive replication there are two copies of DNA that both have pairs of parent and new genetic material interspersed throughout the helix. Redundancy and degeneracy describe the multiple codons that code for the same amino acid in the genetic code.

5. DNA helicase "unzips" the DNA helix, exposing the two parent DNA strands. This opening is called the replication fork. DNA polymerase moves in a $3' \longrightarrow 5'$ direction along both parent DNA strands, recruiting complementary nucleotides and creating the daughter strands. The leading strand is made continuously, whereas the lagging strand is made discontinuously because DNA polymerase only moves in a $3' \longrightarrow 5'$ direction. This means that on the lagging strand DNA pieces are made in short sequences rather than one long strand. The short pieces of new DNA on the lagging strand are called Okazaki fragments. Topoisomerase prevents DNA from overcoiling during replication.

6. The genetic code is redundant because more than one codon (sequence of three base pairs) codes for many amino acids. Because there are four possible nucleotides for a codon consisting of a combination of three nucleotides, 64 possible combinations of nucleotides exist to make each codon. However, since only 20 amino acids are coded for, most amino acids can be coded for by more than one sequence of nucleotides. This is referred to as the redundancy of the genetic code.

7. Three major differences between RNA and DNA are that RNA (1) contains ribose instead of deoxyribose as its sugar, (2) contains uracil instead of thymine, and (3) is usually single-stranded.

8. Transcription is the process by which DNA is turned into RNA, whereas in translation RNA is turned into protein. In translation the ribosome locates a start codon near the $5'$ end of the mRNA. The ribosome then reads the mRNA sequence, codon by codon, and recruits the corresponding amino acid (attached to a tRNA) encoded by the mRNA. After each codon is read, the mRNA molecule translocates within the ribosome to make room for the next codon. Once a stop codon is reached, termination occurs, and the ribosome falls off the mRNA sequence. At this point the primary structure of the protein is complete, and it assumes its three-dimensional conformation based on its primary sequence.

9. When substrate concentration is low, the reaction proceeds slowly. Initial increases in substrate concentration greatly increase the reaction rate because of the binding of substrate to available active sites. Eventually, a point is reached at which all of the active sites are occupied, and the addition of more substrate will not hasten the reaction appreciably. Eventually, at very high levels of substrate, the reaction rate approaches a maximum, V_{max}.

10. Enzyme specificity is determined by the unique three-dimensional spatial structure of the active site. According to the induced fit hypothesis, an enzyme's active site is capable of undergoing a conformational change when the appropriate substrate comes into contact with it, such that the substrate is held in place to form an enzyme-substrate complex.

CHAPTER SEVEN

Metabolism

LEARNING OBJECTIVES

After this chapter, you will be able to:

- Recall terms related to energy use in living organisms
- Describe respiration, glucose catabolism, and alternate energy sources
- Relate the major components of photosynthesis

Energy is the currency of the universe. In order for any work, organization, or activity to occur, energy must be used. Organisms obtain energy from their environment (food, sunlight) and use it to power the basic activities of life. These processes fall under the definition of metabolism. **Metabolism** is the sum of all chemical reactions that occur in the body.

Metabolism can be divided into **catabolic** reactions, which break down chemicals and release energy, and **anabolic** reactions, which synthesize chemicals and require energy. Previous chapters have covered anabolic processes, such as DNA replication and protein synthesis. This chapter will primarily explore catabolic processes.

CELLULAR RESPIRATION

Cellular respiration describes the biochemical conversion of chemical energy stored in molecular bonds into usable energy (ATP), a catabolic process. Cellular respiration has two major pathways, aerobic and anaerobic respiration. **Aerobic respiration** occurs in the presence of oxygen, while **anaerobic respiration** occurs in the absence of oxygen. Closely related, yet distinct concepts, are external and internal respiration. **External respiration** refers to the inhaling and exhaling of air into and out of the lungs as well as the exchange of gas between the alveoli and the blood (see Chapter 13). **Internal respiration** refers to exchange of gas between individual cells and the extracellular fluid.

The bioenergetics of cellular respiration and metabolism in general should be considered as an example of conservation of energy. To clarify, if energy is released during a reaction, then the products must have less potential energy than the reactants.

Carbohydrates and fats are the favored fuel molecules in living cells due to their high number of energy-rich C-H bonds. Through metabolism, hydrogen is removed, and energy is made available. The end products of this process are always H_2O and CO_2, which contain low-energy bonds. Thus, the difference in potential energy between high-energy carbohydrates/fats and the low-energy H_2O and CO_2 is used directly for generation of ATP.

$$C_6H_{12}O_6 + 6\,O_2 \rightarrow 6\,H_2O + 6\,CO_2$$

Another way to look at the above reaction is through the lens of redox (reduction and oxidation) reactions. In the reactants, carbons are heavily reduced due to their bonds to hydrogen. During cellular respiration, those carbons are oxidized to CO_2. It is the oxidation of carbon that releases energy. The chemical reaction itself is very similar to that of combustion, the burning of fuel. The primary difference, however, is that cellular respiration releases this energy in a series of smaller steps, thereby allowing the cell to capture the energy for use rather than the energy being released to the environment as heat, as seen in combustion.

GLUCOSE CATABOLISM

Glucose catabolism is the classic cellular respiration pathway studied. The degradation of glucose by oxidation begins with glycolysis and then splits into two separate pathways, **aerobic** and **anaerobic**.

AEROBIC
1. Decarboxylation of pyruvate
2. Krebs cycle
3. Electron transport chain

GLYCOLYSIS

ANAEROBIC
1. Fermentation

Figure 7.1

Glycolysis

Glycolysis literally means "sugar breaking" and is a series of reactions that lead to the oxidative breakdown of glucose into two molecules of **pyruvate**, the production of ATP, and the reduction of NAD^+ into NADH. Recall that in a redox reaction there is always a compound that is oxidized and one that is reduced. In the case of glycolysis, glucose is oxidized and NAD^+ is reduced. The entirety of glycolysis occurs in the cytoplasm and, therefore, can be completed by both eukaryotic and prokaryotic cells.

The biochemical reactions of glycolysis can be divided into three stages: energy investment, cleavage, and energy payout (see Figure 7.2).

The **energy investment stage** (steps 1–3) gets its name from the fact that two ATPs are used to add two phosphate groups to glucose, producing fructose 1,6-biphosphate (6 carbon). These actions are completed by kinases.

The second stage of glycolysis (step 4), **cleavage**, splits fructose 1,6-biphosphate into glyceraldehyde 3-phosphate (PGAL) and dihydroxyacetone phosphate (DHAP), each being a 3 carbon compound with an added phosphate group. DHAP is then isomerized to form a second PGAL.

The third stage of glycolysis (steps 5–9), **energy payout**, results in the production of ATP. In addition, due to there being two PGAL molecules, steps 5–9 occur twice per glucose molecule. In this series of steps, PGAL is converted to pyruvate resulting in the reduction of NAD^+ to NADH (catalyzed by a dehydrogenase) and the production of two ATPs (catalyzed by kinases).

Glycolytic pathway

*Note: Steps 5–9 occur twice per molecule of glucose

Figure 7.2

BIO

In summary, from one molecule of glucose (6C), two molecules of pyruvate (3C) are obtained. During this sequence of reactions, two ATP are used (steps 1 and 3) and four ATP are generated (step 6 and 9, occurring twice each). Thus, there is a net production of two ATP per glucose molecule. This type of ATP production is called **substrate level phosphorylation** because ATP synthesis is directly coupled with the oxidation of glucose without participation of an intermediate molecule such as NADH or $FADH_2$. This is contrasted with **oxidative phosphorylation**, which does require an intermediate electron carrier such as NADH or $FADH_2$.

The net reaction for glycolysis is:

$$\text{Glucose} + 2\,\text{ADP} + 2\,P_i + 2\,NAD^+ \longrightarrow 2\,\text{Pyruvate} + 2\,\text{ATP} + 2\,\text{NADH} + 2\,H^+ + 2\,H_2O$$

At the end of glycolysis, much of the initial energy stored in the glucose molecule has not been released and is still present in the chemical bonds of pyruvate. Depending on the capabilities of the organism, pyruvate degradation can proceed in one of two directions. Under anaerobic conditions (in the absence of oxygen), pyruvate is reduced during the process of fermentation. Under aerobic conditions (in the presence of oxygen), pyruvate is further oxidized during cellular respiration in the mitochondria.

Anaerobic Respiration

NAD^+ must be regenerated for glycolysis to continue in the absence of O_2. This is accomplished by reducing pyruvate into ethanol or lactic acid via fermentation. Fermentation does not produce any ATP itself; therefore, glucose metabolized in the anaerobic pathway only produces the two ATP through glycolysis.

Alcohol fermentation occurs in yeast and some bacteria. The pyruvate produced in glycolysis is converted to ethanol. In this way, NAD^+ is regenerated, and glycolysis can continue.

Lactic acid fermentation occurs in certain fungi and bacteria and in human muscle cells during strenuous activity. When the oxygen supply to muscle cells lags behind the rate of glucose catabolism, the pyruvate generated is reduced to lactic acid. As in alcohol fermentation, the NAD^+ used in step 5 of glycolysis is regenerated when pyruvate is reduced.

Aerobic Respiration

Aerobic respiration is the most efficient catabolic pathway used by organisms to harvest the energy stored in glucose. Whereas anaerobic respiration yields only **2 ATP** per molecule of glucose from glycolysis, aerobic respiration can yield **36–38 ATP**. Aerobic respiration can be divided into three stages: pyruvate decarboxylation, the citric acid cycle, and the electron transport chain. All three of these stages occur in the mitochondria for eukaryotes and the cytoplasm for prokaryotes.

Mitochondria are membrane-bound organelles responsible for the aerobic production of ATP in eukaryotic cells. The function of the mitochondria is heavily reliant on its double membrane structure as seen in Figure 7.3. In general, the pyruvate produced from glycolysis is transported through both mitochondrial membranes into the mitochondrial matrix where it undergoes **pyruvate decarboxylation** to produce acetyl-CoA. Acetyl-CoA undergoes a cycle of reactions known as the **citric acid cycle** (sometimes called the TCA or Krebs cycle) producing **electron carriers** (NADH, $FADH_2$) and regenerating oxaloacatate, allowing the cycle to repeat. These electron carriers power the **electron transport chain** (**ETC**), located on the inner mitochondrial membrane, which transports protons (H^+) against their concentration gradient into the **intermembrane space**. This energy stored in this gradient is then used by ATP synthase, located on the inner membrane, to produce ATP. This method of ATP production is termed oxidative phosphorylation.

These processes will be expanded upon below.

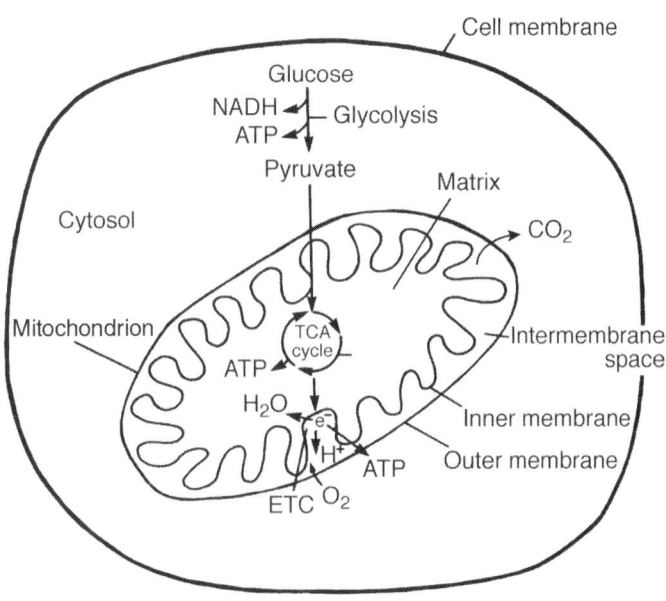

Figure 7.3

Although prokaryotes do not have mitochondria, aerobic bacteria are still able to partake in aerobic respiration, but the citric acid cycle occurs in the cytosol and the electron transport chain is located on the bacterial membrane itself.

Pyruvate decarboxylation

The pyruvate formed during glycolysis is transported from the cytoplasm into the mitochondrial matrix where it is decarboxylated (i.e., it loses a CO_2), and the acetyl group that remains is transferred to coenzyme A to form acetyl-CoA. In the process, NAD^+ is reduced to NADH.

Citric acid cycle

The citric acid cycle, also known as the **Krebs cycle**, can be understood by tracking the number of carbons in each intermediate. First consider the carbons count: the cycle begins when the two-carbon acetyl group from acetyl-CoA combines with oxaloacetate, a four-carbon molecule, to form the six-carbon citrate. Through a series of reactions, two CO_2 are released, and oxaloacetate, a four-carbon molecule, is regenerated for use in another turn of the cycle.

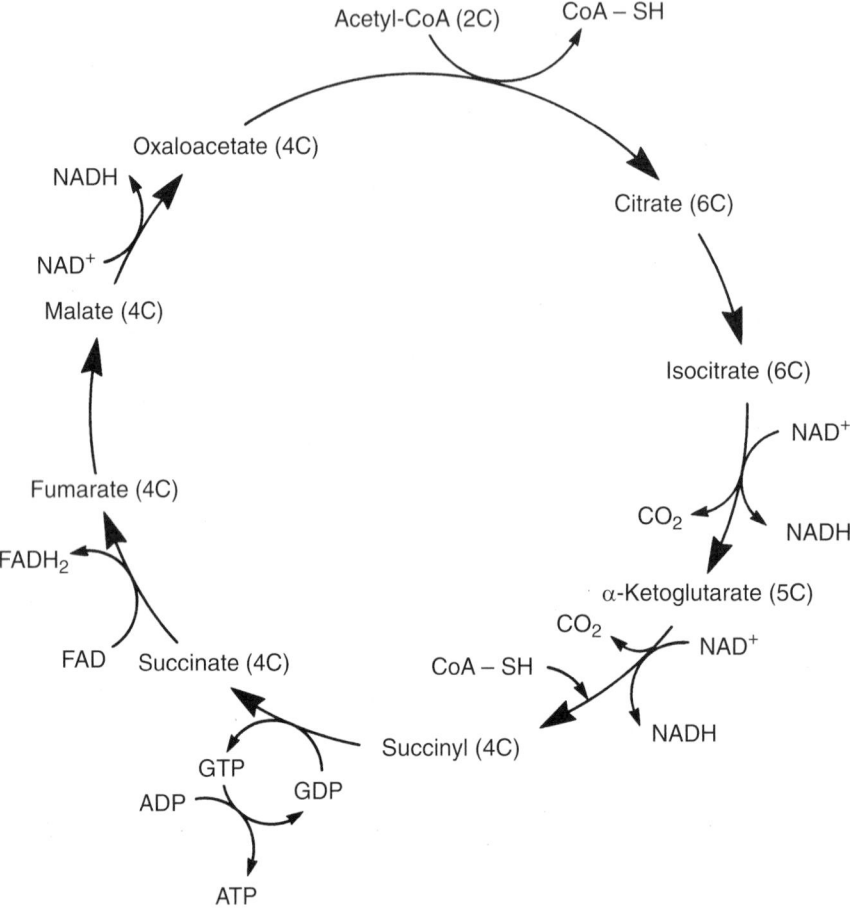

Figure 7.4

For each turn of the citric acid cycle, one ATP is produced by substrate-level phosphorylation via a GTP intermediate. In addition, electrons are transferred to NAD^+ and FAD, generating three NADH and one $FADH_2$, respectively. These reduction reactions are coupled with the oxidation of carbon, producing the two aforementioned CO_2. Studying the cycle, we can do some bookkeeping; keep in mind that for each molecule of glucose, two pyruvate are decarboxylated and channeled into the citric acid cycle. Therefore, two of each type of molecular product at this stage of the cycle are created for each glucose molecule.

$$2 \times 3 \text{ NADH} \quad \rightarrow \quad 6 \text{ NADH}$$
$$2 \times 1 \text{ FADH}_2 \quad \rightarrow \quad 2 \text{ FADH}_2$$
$$2 \times 1 \text{ GTP (ATP)} \quad \rightarrow \quad 2 \text{ ATP}$$

The net reaction of the citric acid cycle per glucose molecule is:

$$2 \text{ acetyl-CoA} + 6 \text{ NAD}^+ + 2 \text{ FAD} + 2 \text{ GDP} + 2 \text{ P}_i + 4 \text{ H}_2\text{O} \longrightarrow 4 \text{ CO}_2 + 6 \text{ NADH} + 2 \text{ FADH}_2 + 2 \text{ GTP} + 4 \text{ H}^+ + 2\text{CoA}$$

Electron transport chain

The electron transport chain (ETC) is a complex carrier mechanism located on the inside of the **inner mitochondrial membrane.** During oxidative phosphorylation, ATP is produced when high-energy potential electrons are transferred from NADH and FADH$_2$ to oxygen by a series of carrier molecules located in the inner mitochondrial membrane. As the electrons are transferred from carrier to carrier, free energy is released, which is then used to form ATP. Most molecules of the ETC are **cytochromes**, electron carriers that resemble hemoglobin in the structure of their active site. The functional unit contains a central iron atom that is capable of undergoing a reversible redox reaction (i.e., it can be alternatively reduced and oxidized). Sequential redox reactions continue to occur as the electrons are transferred from one carrier to the next; each carrier is reduced as it accepts an electron and is then oxidized when it passes it on to the next carrier. The last carrier of the ETC passes its electron to the final electron acceptor, O$_2$. In addition to the electrons, O$_2$ picks up a pair of hydrogen ions from the surrounding medium, forming water.

$$2 \text{ H}^+ + 2 \text{ e}^- + \frac{1}{2} \text{ O}_2 \longrightarrow \text{H}_2\text{O}$$

ATP Generation and the Proton Pump

As alluded to earlier, the electron transport chain (ETC) uses energy from redox reactions to generate ATP. The operating mechanism in this type of ATP production involves coupling the oxidation of NADH and FADH$_2$ to the phosphorylation of ADP. The coupling agent for these two processes is a **proton gradient** across the inner mitochondrial membrane, maintained by the ETC. As NADH and FADH$_2$ pass their electrons to the ETC, hydrogen ions (H$^+$) are pumped out of the matrix, across the inner mitochondrial membrane, and into the intermembrane space at each of the ETC protein complexes. The continuous translocation of H$^+$ creates a positively charged, acidic environment in the intermembrane space. This electrochemical gradient generates a proton-motive force, which drives H$^+$ back across the inner membrane and into the matrix. However, to pass through the membrane (which is impermeable to ions), the H$^+$ must flow through specialized channels provided by enzyme complexes called ATP synthases. As the H$^+$ pass through the **ATP synthases**, enough energy is released to allow for the phosphorylation of ADP to ATP. The coupling of the oxidation of NADH and FADH$_2$ with the phosphorylation of ADP is called **oxidative phosphorylation**.

Total Energy Production

To calculate the net amount of ATP produced per molecule of glucose, we need to tally the number of ATP produced by substrate-level phosphorylation and the number of ATP produced by oxidative phosphorylation.

Substrate-level phosphorylation

Degradation of one glucose molecule yields a net of two ATP from glycolysis and one ATP for each turn of the citric acid cycle. Thus, a total of four ATP are produced by substrate-level phosphorylation.

Oxidative phosphorylation

In order to calculate the amount of ATP generated through oxidative phosphorylation, NADH and $FADH_2$ must be counted, as shown below. Each NADH from the citric acid cycle generates three ATP. The two NADH that were reduced during glycolysis cannot cross the inner mitochondrial membrane and must use energy to be transferred into the mitochondria through a carrier protein, thus only yielding 2 ATP. $FADH_2$ generates two ATP per molecule.

All in all, the two NADH formed in glycolysis yield four ATP, the other eight NADH yield 24 ATP, and the two $FADH_2$ yield 4 ATP, for a total of 32 ATP produced in oxidative phosphorylation. For prokaryotes, the oxidative phosphorylation yield is 34 ATP because the two glycolytic NADH do not have any mitochondrial membranes to cross and, therefore, do not expend energy.

Eukaryotic ATP Production per Glucose Molecule	
Glycolysis	
2 ATP invested (steps 1 and 3)	– 2 ATP
4 ATP generated (steps 6 and 9)	+ 4 ATP (substrate)
2 NADH × 2 ATP/NADH (step 5)	+ 4 ATP (oxidative)
Pyruvate decarboxylation	
2 NADH × 3 ATP/NADH	+ 6 ATP (oxidative)
Citric acid cycle	
6 NADH × 3 ATP/NADH	+ 18 ATP (oxidative)
2 $FADH_2$ × 2 ATP/$FADH_2$	+ 4 ATP (oxidative)
2 GTP × 1 ATP/GTP	+ 2 ATP (substrate)
Total	+ 36 ATP

Table 7.1

ALTERNATE ENERGY SOURCES

When glucose supplies run low, the body uses other energy sources. These sources are used by the body in the following preferential order: other carbohydrates, fats, and proteins. These substances are first converted to either glucose or glucose intermediates, which can then be degraded in the glycolytic pathway and the citric acid cycle.

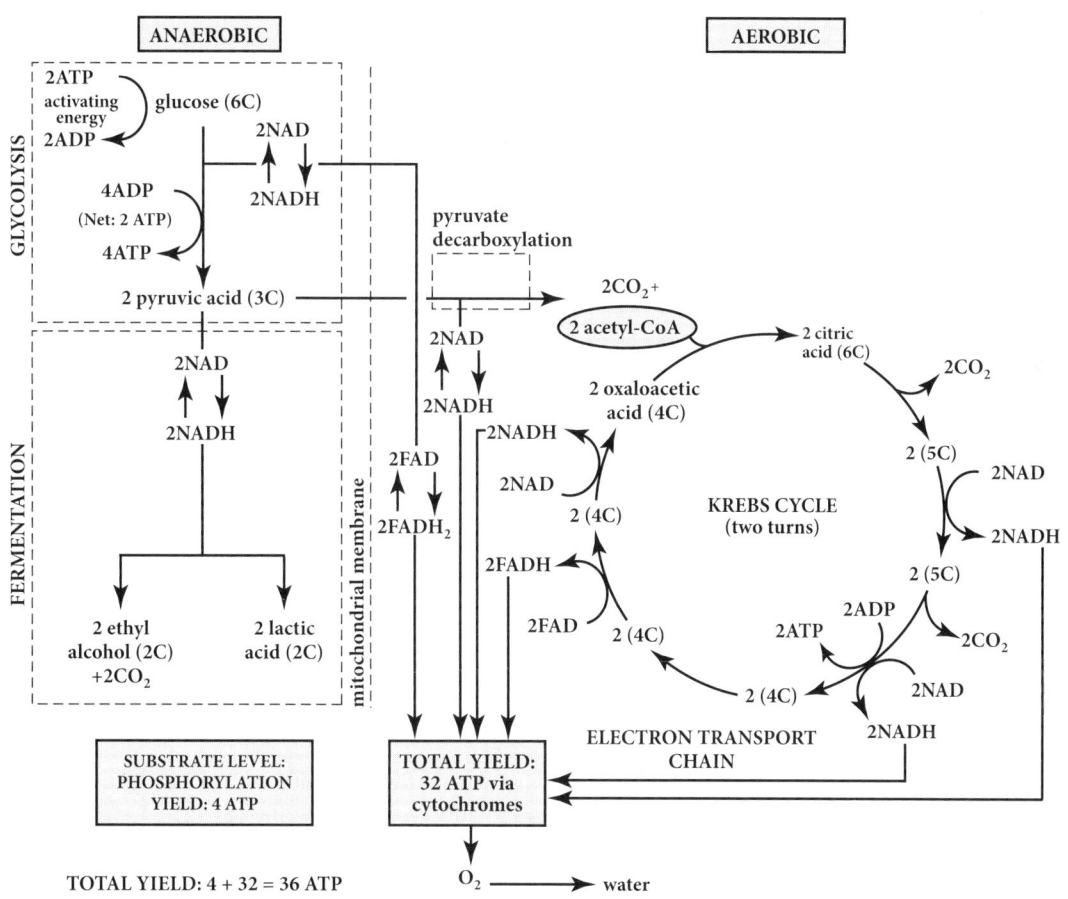

Figure 7.5

Carbohydrates

Disaccharides are hydrolyzed into monosaccharides, most of which can be converted into glucose or glycolytic intermediates. Glycogen stored in the liver can be converted, when needed, into a glycolytic intermediate.

Fats

Fat molecules are stored in adipose tissue in the form of triglycerides. When needed, they are hydrolyzed by **lipases** to **fatty acids** and **glycerol** and are carried by the blood to other tissues for oxidation. Glycerol can be converted into PGAL, a glycolytic intermediate. A fatty acid must first be "activated" in the cytoplasm; this process requires two ATP. Once activated, the fatty acid is transported into the mitochondrion and taken through a series of beta-oxidation cycles that convert it into two-carbon fragments, which are then converted into acetyl-CoA. Acetyl-CoA then enters the citric acid cycle. With each round of β-oxidation of a saturated fatty acid, one NADH and one $FADH_2$ are generated.

Of all the high-energy compounds used in cellular respiration, fats yield the greatest number of ATP per gram. This makes them extremely efficient energy storage molecules. Thus, while the amount of glycogen stored in humans is enough to meet short-term energy needs for about a day, the stored fat reserves can meet the long-term energy needs for about a month.

Proteins

The body degrades proteins only when not enough carbohydrate or fat is available. Most amino acids undergo a **transamination reaction** in which they lose an amino group to form an α-keto acid. The carbon atoms of most amino acids are converted into acetyl-CoA, pyruvate, or one of the intermediates of the citric acid cycle. These intermediates enter their respective metabolic pathways, allowing cells to produce fatty acids, glucose, or energy in the form of ATP.

Oxidative deamination removes an ammonia molecule directly from the amino acid. **Ammonia** is a toxic substance in vertebrates. Fish can excrete ammonia, whereas insects and birds convert it to uric acid, and mammals convert it to urea for excretion.

PHOTOSYNTHESIS

All green plants use **photosynthesis** to convert carbon dioxide and water into glucose and oxygen. Glucose can be stored as starch or used as an energy source. In plants, photosynthesis takes place in a specialized organelle called a chloroplast. Photosynthetic bacteria lack chloroplasts but have membranes that function in a similar manner.

Photosynthesis involves the reduction of CO_2 to carbohydrate accompanied by release of oxygen from water. The net reaction is the reverse of respiration—reduction occurs instead of oxidation. This net reaction is shown below:

$$6 \; CO_2 + 12 \; H_2O + \text{light energy} \longrightarrow C_6H_{12}O_6 + 6 \; O_2 + 6 \; H_2O$$

Perhaps the most surprising aspect of photosynthesis is the ability of photosynthetic proteins to split water molecules (H_2O). Once the water molecules have been split, the oxygen atoms are immediately released as O_2 and the hydrogen (H) atoms donate their electrons, which are used to form ATP and NADPH. The H atoms combine with the C and O atoms from CO_2 to form carbohydrates and more water. Sugars are used for energy storage, and O_2 is a waste product that other organisms use for respiration.

The process of photosynthesis itself can be divided into **light reactions**, which require sunlight, and **dark reactions**, which although coupled with the light reactions, do not require sunlight. The light reactions split H_2O and produce both ATP and NADPH. The dark reactions, also known as reduction synthesis, form sugar from CO_2 and the energy produced in the light reaction.

The Light Reactions

The light reactions, also called photolysis reactions, begin with the absorption of a photon of light by a chlorophyll molecule. When light strikes the special chlorophyll, a P700 molecule in photosystem I, it excites electrons to a higher energy level. These high energy electrons can flow along two pathways giving cyclic electron flow or noncyclic electron flow.

Cyclic electron flow

In cyclic electron flow, the excited electrons of P700 move along a chain of electron carriers. A series of redox reactions ultimately returns the electrons to P700. The reactions are harnessed using an electron transport chain, a proton gradient, and ATP synthase to produce ATP from ADP and P_i in a process called **cyclic photophosphorylation** (see Figure 7.6). Note that this process generates neither oxygen nor NADPH.

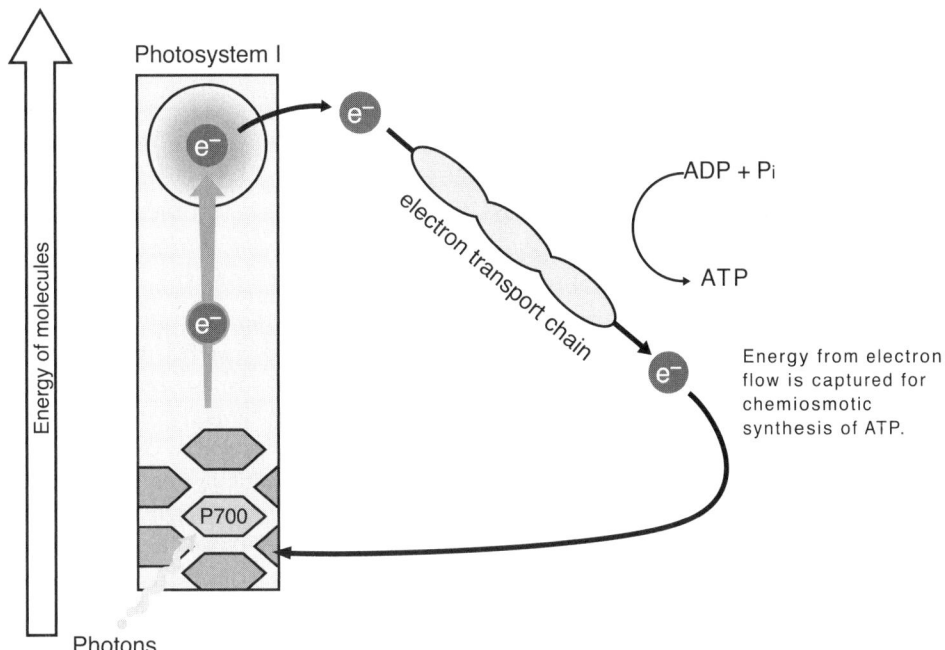

Figure 7.6

Noncyclic electron flow

This is the key pathway of the light reactions and involves reactions of both photosystems. Again, photons of light excite electrons in P700 in photosystem I. However, instead of returning to P700 along the carrier chain, the high-energy electrons are transferred to the electron acceptor $NADP^+$. $NADP^+$ is very similar to NAD^+, which functions in cellular respiration. $NADP^+$ accepts the high energy electrons and forms NADPH. P700 is left with electron "holes" and is thus a powerful oxidizing agent. When light strikes P680 in photosystem II, electrons are excited. These electrons travel down the same electron carrier chain used by cyclic electron flow until they reach P700 and fill the electron "holes." This cascade produces ATP by noncyclic photophosphorylation.

Now P680 has electron "holes." P680 is a strong enough oxidizing agent to oxidize water and fill its holes. Water is split into two hydrogen ions and an oxygen atom and the electrons produced reduce P680. Oxygen atoms combine to form O_2. The net result of noncyclic electron flow is the production of NADPH and ATP and the photolysis (breakdown) of water.

Figure 7.7

The Dark Reactions

The dark reactions use the ATP and NADPH produced by the light reactions to reduce CO_2 to carbohydrates. Although these reactions do not directly require light, they will only occur during the day, when the light reactions are replenishing the supply of ATP and NADPH. The dark reactions are also called carbon-fixation or reduction synthesis reactions. CO_2 is the source of carbon for carbohydrate production in the **Calvin cycle**. The product of the cycle is the three carbon sugar phosphoglyceraldehyde (PGAL). In order to produce a three carbon sugar from CO_2, the cycle must take place three times. The cycle begins with the addition of CO_2 to ribulose bisphosphate, a five carbon sugar, to produce an unstable six-carbon intermediate that immediately splits to give two three-carbon molecules of 3-phosphoglyceric acid. This acid is phosphorylated by ATP and reduced by NADPH to give glyceraldehyde-3-phosphate (PGAL). Two molecules of PGAL can be converted to glucose, which can then be oxidized to provide usable energy. The Calvin cycle is similar to the Krebs cycle in reverse: (1) carbon dioxide is fed into the cycle; in the Krebs cycle it was produced and released; (2) reducing power is utilized during the cycle (NADPH); in the Krebs cycle NADH was removed; (3) energy is used in the cycle (conversion of ATP to ADP); in the Krebs cycle, energy was produced when ATP was formed from ADP and inorganic phosphate.

Summary of the Calvin Cycle

Carbon dioxide is fixed to RBP (ribulose bisphosphate), a five carbon sugar. The resulting unstable six-carbon molecule splits to form two molecules of PGA (phosphoglyceric acid). PGA is then phosphorylated and reduced (by ATP and NADPH) to form PGAL. Most of the PGAL is recycled to RBP by a complex series of reactions. In six turns of the Calvin Cycle, 12 PGAL are formed from six carbon dioxide and six RBP. The 12 PGAL recombine to form six RBP and one molecule of glucose, the net product. PGAL is generally considered the prime end-product of photosynthesis and it can be used as an immediate food nutrient, combined and rearranged to form monosaccharide sugars (e.g. glucose) that can be transported to other cells, or packaged for storage as insoluble polysaccharides such as starch.

Figure 7.8

REVIEW PROBLEMS

1. What is the net reaction for glycolysis? For the citric acid cycle?

2. In glucose catabolism
 A. oxygen must be the final electron acceptor.
 B. oxygen is necessary for any ATP synthesis.
 C. inorganic phosphate is produced.
 D. ATP is generated.
 E. all of the above occur.

3. Fatty acids enter the degradative pathway in the form of
 A. glycerol.
 B. glucose.
 C. acetyl-CoA.
 D. brown adipose tissue.
 E. pyruvate.

4. How do ATP, NADH, and $FADH_2$ store energy?

5. How is NAD^+ regenerated and why is this important?

6. Describe the production of ATP via oxidative phosphorylation.

7. Which of the following is LEAST likely to occur during oxygen debt?
 A. Buildup of lactic acid
 B. Buildup of pyruvate
 C. Decrease in pH
 D. Fatigue
 E. Decrease in pO_2

8. Which of the following is true of the dark reactions of photosynthesis?
 A. They occur in the mitochondria.
 B. They occur at night.
 C. They do not require light directly but are linked to the light reactions.
 D. They require light in the UV range.
 E. They produce more energy than the light reactions.

9. What are the primary differences between cyclic electron flow and noncyclic electron flow?

SOLUTIONS TO REVIEW PROBLEMS

1. The net reaction for glycolysis is:

 Glucose + 2ATP + 4ADP + 2P_i + 2NAD^+ →
 2 Pyruvate + 2ADP + 4ATP + 2NADH + 2H^+ + 2H_2O

 The net reaction for the citric acid cycle is:

 2 Acetyl-CoA + 6NAD^+ + 2FAD + 2GDP + 2P_i + 4H_2O →
 4CO_2 + 6NADH + 2$FADH_2$ + 2GTP + 4H^+ + 2CoA

2. **D** Although oxygen is necessary as the final electron receptor for aerobic catabolism (respiration), anaerobic catabolism (fermentation) can occur in the absence of oxygen to still consume ADP and inorganic phosphate as reactants to create ATP.

3. **C** Discussed in alternate energy sources section of this chapter.

4. Energy is stored in ATP as high-energy bonds created by the covalent bonding of three phosphates to adenosine. The hydrolysis of ATP to ADP releases inorganic phosphate (P_i) and 7 kcal of energy. Hydrolysis of ADP to AMP releases an additional 7 kcal. Alternatively, ATP hydrolysis to AMP + PP_i releases 7 kcal.

 NADH and $FADH_2$ are reducing agents that carry chemical energy in the form of high-potential electrons, which can be transferred as hydride ions. In cellular respiration, these hydride ions are transferred to the electron transport chain, where energy release is coupled with ATP synthesis during a series of redox reactions.

5. Step 5 of glycolysis involves the reduction of NAD^+ to NADH. Because NAD^+ is necessary for glycolysis to continue, it must be regenerated in one of two ways. In the presence of oxygen, oxidative phosphorylation and the ETC can be used to oxidize NADH to NAD^+. Alternatively, alcohol or lactic acid fermentation can be used to regenerate NAD^+ under anaerobic conditions.

6. In the electron transport chain, the release of hydrogen ions is coupled with the transfer of electrons. H^+ ions accumulate in the mitochondrial matrix and are shuttled across the inner mitochondrial membrane, creating a proton gradient. To cross the inner membrane, the hydrogen ions must pass through ATP synthetases, which catalyze the phosphorylation of ADP into ATP.

7. **B** Discussed in fermentation section of this chapter.

8. **C** However, they depend on the ATP and NADPH that are generated by the light reactions, and so, occur only during the day.

9. Cyclic electron flow involves only photosystem I and leads to the production of ATP by cyclic photophosphorylation. Noncyclic electron flow is the key pathway of photosynthesis. Electrons are excited from P680 in photosystem II to P700 in photosystem I, leading to production of ATP by noncyclic photophosphorylation. Electrons are then removed from water to fill electron "holes" in P680. Water is split and oxygen is formed. This process leads to the formation of NADPH, which helps power the dark reactions.

CHAPTER EIGHT

Genetics

LEARNING OBJECTIVES

After this chapter, you will be able to:

- Apply the laws of Mendelian genetics
- Explain non-Mendelian inheritance patterns
- Identify genetic anomalies
- Recall key features of bacterial genetics and gene regulation

Genetics is the study of how traits are inherited from one generation to the next. The basic unit of heredity is the **gene**. Genes are composed of DNA and are located on **chromosomes**. When a gene exists in more than one form, the alternative forms are called **alleles**. The genetic makeup of an individual is the individual's **genotype**; the physical manifestation of the genetic makeup is the individual's **phenotype**. Some phenotypes correspond to a single genotype, whereas other phenotypes correspond to several different genotypes. Knowledge of genetics will help clarify the concepts of evolution by the process of natural selection.

MENDELIAN GENETICS

In the 1860s, Gregor Mendel developed the basic principles of genetics through his experiments with the garden pea. Mendel studied the inheritance of individual pea traits by performing **genetic crosses**. He took true-breeding individuals (which, if self-crossed, produce progeny only with the parental phenotype) with different traits, mated them, and statistically analyzed the inheritance of the traits in the progeny.

Mendel's First Law: Law of Segregation

Mendel postulated four principles of inheritance:

1. Genes exist in alternative forms (now referred to as alleles). A gene controls a specific trait in an organism.
2. An organism has two alleles for each inherited trait, one inherited from each parent.
3. The two alleles **segregate** during meiosis, resulting in gametes that carry only one allele for any given inherited trait.
4. If two alleles in an individual organism are different, only one will be fully expressed, and the other will be silent. A dominant allele only requires one copy present to be expressed whereas a recessive allele must have two copies present to be expressed. In genetics problems, dominant alleles are typically assigned capital letters, and recessive alleles are assigned lowercase letters. Organisms that contain two copies of the same allele are **homozygous** for that trait; organisms that carry two different alleles are **heterozygous**. The dominant allele is expressed in the phenotype. This is known as **Mendel's Law of Dominance**. For example, for the following genotypes, Yy and YY will both be yellow:

Genes	Genotype	Phenotype
YY	Homozygous	Yellow
Yy	Heterozygous	Yellow
yy	Homozygous	Green

Monohybrid cross

The Law of Segregation can be illustrated in a cross between two true-breeding, or homozygous, pea plants, one with purple flowers and the other with white flowers. Because only one trait is being studied in this particular mating, it is referred to as a **monohybrid cross**. The individuals being crossed are the **parental** or **P generation**; the progeny generations are the **filial** or **F generations**, with each generation numbered sequentially (e.g., F1, F2, etc.).

In Figure 8.1, the purple flower parent has the genotype PP (i.e., it has two dominant, P, alleles) and is homozygous dominant. The white flower parent has the genotype pp and is homozygous recessive. When these individuals are crossed, they produce F1 plants that are 100 percent heterozygous (genotype = Pp). Because purple is dominant to white, all the F1 progeny have the purple flower phenotype.

Punnett square

One way of predicting the genotypes expected from a cross is by drawing a **Punnett square diagram**. The parental genotypes are arranged around a grid. Because the genotype of each progeny will be the sum of the alleles donated by the parental gametes, their genotypes can be determined by looking at the intersections on the grid. A Punnett square indicates all the potential progeny genotypes, and the relative frequencies of the different genotypes and phenotypes can be easily calculated.

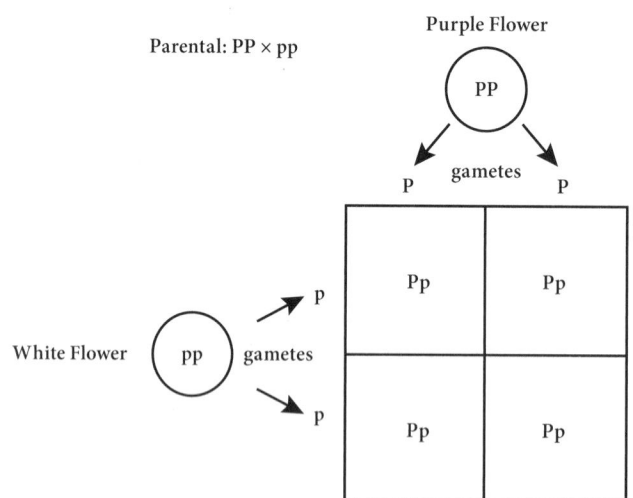

F_1 genotypes: 100% Pp (heterozygous)
F_1 phenotypes: 100% purple flowers

Figure 8.1

When the F1 generation from our monohybrid cross is self-crossed (i.e., Pp × Pp), the F2 progeny are more genotypically and phenotypically diverse than their parents. Because the F1 plants are heterozygous, they will donate a dominant, P, allele to half of their descendants and a recessive, p, allele to the other half. One-fourth (25 percent) of the F2 plants will have the homozygous dominant, PP, genotype, 50 percent will have the heterozygous, Pp, genotype, and 25 percent will have the homozygous recessive, pp, genotype. Because the homozygous dominant and heterozygous genotypes both produce the dominant phenotype purple flowers, 75 percent of the F2 plants will have purple flowers, and 25 percent will have white flowers.

This is a standard pattern of Mendelian inheritance. Its hallmarks are the disappearance of the silent (recessive) phenotype in the F1 generation and its subsequent reappearance in 25 percent of the individuals in the F2 generation. If we were to take a closer look at the physical characteristics of the plants themselves, we would find that the 1:2:1 genotypic ratio produces a 3:1 phenotypic ratio.

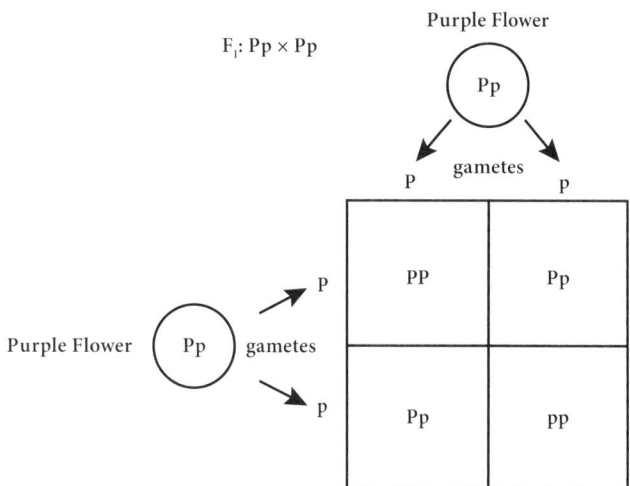

F_2 genotypes: 1:2:1; 1PP: 2Pp:1pp)
F_2 phenotypes: 3:1; 3 purple:1 white

Figure 8.2

Testcross

Mendel also developed the **testcross,** a diagnostic tool used to determine the genotype of an organism. Only with a recessive phenotype can genotype be predicted with 100 percent accuracy. If the dominant phenotype is expressed, the genotype can be either homozygous dominant or heterozygous. Thus, homozygous recessive organisms always breed true. This fact can be used to determine the unknown genotype of an organism with a dominant phenotype, such as when an organism with a dominant phenotype of unknown genotype (Ax) is crossed with a phenotypically recessive organism (genotype aa). Since the recessive parent is homozygous, it can donate only the recessive allele, a, to the progeny. If the dominant parent's genotype is AA, all of its gametes will carry an A, and all of the progeny will have genotype Aa. If the dominant parent's genotype is Aa, half of the progeny will be Aa and express the dominant phenotype, and half will be aa and express the recessive phenotype. In a testcross, the appearance of the recessive phenotype in the progeny indicates that the phenotypically dominant parent is genotypically heterozygous, as shown in Figure 8.3.

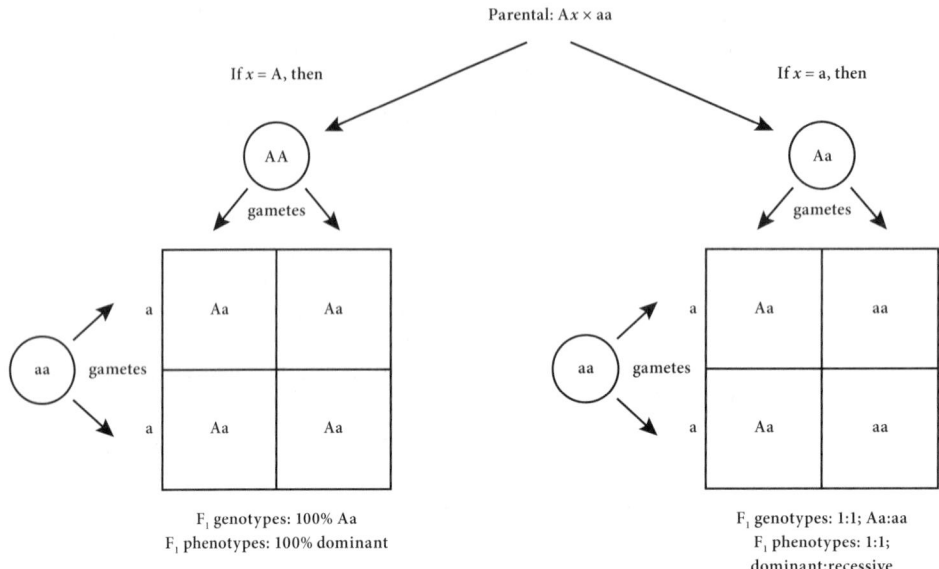

F$_1$ genotypes: 100% Aa
F$_1$ phenotypes: 100% dominant

F$_1$ genotypes: 1:1; Aa:aa
F$_1$ phenotypes: 1:1;
dominant:recessive

Figure 8.3

Mendel's Second Law: Law of Independent Assortment

Mendel's principle of segregation provides a satisfactory explanation for the inheritance of a single allele and also can be extended to a dihybrid cross, in which the parents differ in two traits, as long as the genes are on separate chromosomes and assort independently during meiosis. Mendel postulated that the inheritance of one such trait is completely independent of any other. In this way, a plant with purple flowers is no more likely to be a dwarf than a plant with white flowers (see the example below). This is known as **Mendel's Law of Independent Assortment**.

Note that according to modern, non-Mendelian genetics, genes on the same chromosome will not follow this rule and instead will stay together unless **crossing over** occurs (see Chapter 5, Cellular Biology). Nevertheless, crossing over exchanges information between chromosomes and may break the linkage of certain patterns. For example, red hair is usually linked with freckles, but some blondes and brunettes have freckles as well. Generally, the closer the genes are on the chromosome, the more likely they are to be inherited together.

Dihybrid cross

In Figure 8.4, a purple-flowered tall pea plant is crossed with a white-flowered dwarf pea plant; both plants are doubly homozygous (tall is dominant to dwarf, T = tall allele, t = dwarf allele; purple is dominant to white, P = purple allele, p = white allele). The purple parent's genotype is TTPP, and it thus produces only TP gametes; the white parent's genotype is ttpp and produces only tp gametes. The F1 progeny will all have the genotype TtPp and will be phenotypically dominant for both traits.

When the F1 generation is self-crossed (TtPp × TtPp), it produces four different phenotypes: tall purple, tall white, dwarf purple, and dwarf white, in the ratio 9:3:3:1, respectively. This is the typical pattern for Mendelian inheritance in a dihybrid cross between heterozygotes with independently assorting traits.

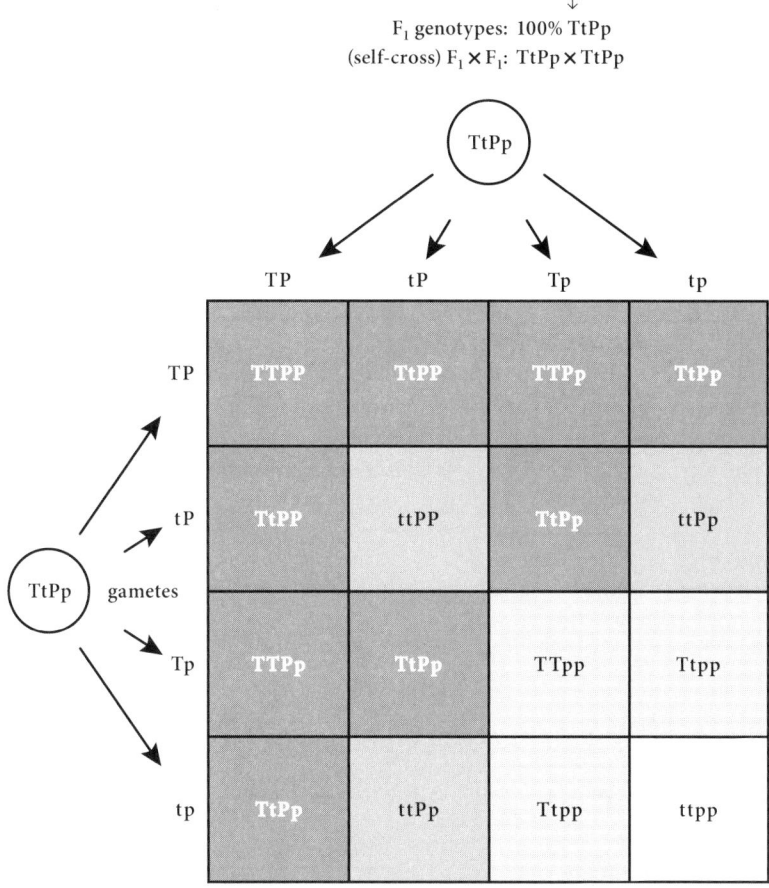

Parental: TTPP × ttpp
↓
F_1 genotypes: 100% TtPp
(self-cross) F_1 × F_1: TtPp × TtPp

F_2 phenotypes: 9:3:3:1
F_2 tall purple: 3 tall white:3 dwarf purple:1 dwarf white

Figure 8.4

Drosophila melanogaster

Modern work with the fruit fly (*Drosophila melanogaster*) helped to provide explanations for Mendelian genetic patterns. The fruit fly possesses several advantages for genetic research, including its large number of offspring and short life span. Drosophila has consequently been an important model organism for genetic research.

NON-MENDELIAN INHERITANCE PATTERNS

In most practical applications, inheritance patterns are often more complicated than Mendel would have hoped. One major source of complications is in the relationship between **phenotype** and **genotype**. In theory, 100 percent of individuals with the recessive phenotype have a homozygous recessive genotype, and 100 percent of individuals with the dominant phenotype have either homozygous or heterozygous genotypes. Such clean concordance between genotype and phenotype is not always the case.

Incomplete Dominance

Some progeny phenotypes are apparently **blends** of the parental phenotypes. The classic example is flower color in snapdragons: homozygous dominant red snapdragons, when crossed with homozygous recessive white snapdragons, produce 100 percent pink progeny in the F1 generation. When F1 progeny are self-crossed, they produce red, pink, and white progeny in the ratio of 1:2:1, respectively. The pink color is the result of the combined effects of the red and white genes in heterozygotes. An allele is incompletely dominant if the phenotype of the heterozygote is an intermediate of the phenotypes of the homozygotes.

R = allele for red flowers
r = allele for white flowers
Parental: RR × rr (red × white) F$_1$: Rr × Rr (pink × pink)

	R	R
r	Rr	Rr
r	Rr	Rr

	R	r
R	RR	Rr
r	Rr	rr

F$_1$ genotype ratio: 100% Rr F$_1$ genotype ratio: 1RR:2Rr:1rr
F$_1$ phenotype ratio: 100% pink F$_2$ phenotype ratio: 1 red:2 pink:1 white

Figure 8.5

Codominance

Codominance occurs when **multiple** alleles exist for a given gene and more than one of them is **dominant**. Each dominant allele is fully dominant when combined with a recessive allele, but when two dominant alleles are present, the phenotype is the result of the expression of both dominant alleles simultaneously.

The classic example of codominance and multiple alleles is the inheritance of **ABO blood groups** in humans. Blood type is determined by three different alleles: IA, IB, and i. IA codes for the A antigen, IB codes for the B antigen, and i indicates that no antigen is coded for and, thus, no antigen is expressed on blood cells. Only two alleles are present in any single individual, but the population contains all three alleles. IA and IB are both dominant to i. Individuals who are homozygous IA or heterozygous

I^Ai have blood type A; individuals who are homozygous I^B or heterozygous I^Bi have blood type B; and individuals who are homozygous ii have blood type O. However, I^A and I^B are codominant; individuals who are heterozygous I^AI^B have a distinct blood type, AB, which expresses both the A and B antigens. Chapter 13 discusses blood typing in more detail.

Codominance differs from incomplete dominance because in incomplete dominance the phenotype expressed is a blend of both genotypes. In codominance, however, both alleles in the genotype are expressed at the same time without a blending of phenotype.

Sex Determination

The two members of each of the chromosome pairs are identical in shape except for one pair: the sex chromosomes. Different species vary in their systems of sex determination. In sexually differentiated species, most chromosomes exist as pairs of homologues called **autosomes**, but sex is determined by a pair of sex chromosomes. All humans have 22 pairs of autosomes; additionally, women have a pair of homologous X chromosomes, and men have a pair of heterologous chromosomes, an X and a Y chromosome. The sex chromosomes pair during meiosis and segregate during the first meiotic division. Since females can produce only gametes containing the X chromosome, the gender of a zygote is determined by the genetic contribution of the male gamete. If the sperm carries a Y chromosome, the zygote will be male; if it carries an X chromosome, the zygote will be female. For every mating, there is a 50 percent chance that the zygote will be male and a 50 percent chance that it will be female.

Genes located on the X or Y chromosome are called **sex-linked**. In humans there is a considerable difference in the size of X and Y chromosomes. Thus, most sex-linked genes are located on the X chromosome, although some Y-linked traits have been found (e.g., hair on the outer ear).

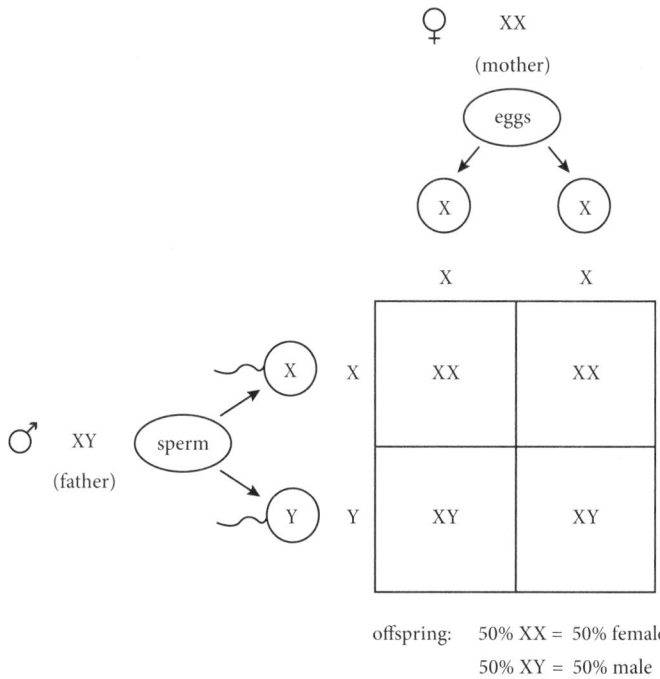

offspring: 50% XX = 50% female
50% XY = 50% male

Figure 8.6

Sex Linkage

In humans, women have two X chromosomes and men have only one. As a result, recessive genes carried on the X chromosome will produce the recessive phenotypes whenever they occur in men because no dominant allele is present to mask them. The recessive phenotype will thus be much more frequently found in men. Examples of sex-linked recessives in humans are the genes for **hemophilia** and **color-blindness**.

The pattern of inheritance for a sex-linked recessive trait is somewhat complicated. Because men pass the X chromosome only to their daughters and the gene is carried only on the X chromosome, affected men cannot pass the trait to their male offspring. Affected men will, however, pass the gene to all of their daughters. Nevertheless, unless the daughter also receives the gene from her mother, she will be a phenotypically normal carrier of the trait. It's important to note that carriers have a normal phenotype, but they do carry the trait and may pass it down to their offspring. Because all of the daughter's male children will receive their only X chromosome from her, half of her sons will receive the recessive sex-linked allele. Thus, sex-linked recessives generally affect only men; they cannot be passed from father to son, but they can be passed from grandfather to grandson via a daughter who is a carrier, thereby skipping a generation.

Environmental Factors

The environment can often affect the expression of a gene. Interaction between the environment and the genotype produces the phenotype. For example, *Drosophila* with a given set of genes have crooked wings at low temperatures but straight wings at higher temperatures. Temperature also influences the hair color of the Himalayan hare. The same genes for color result in white hair on the warmer parts of the body and black hair on colder parts. If the naturally warm portions are cooled (e.g., by the application of ice), the hair will grow in black.

Cytoplasmic Inheritance

Heredity systems exist outside the nucleus. For example, DNA is found in mitochondria and other cytoplasmic bodies. These cytoplasmic genes may interact with nuclear genes and are important in determining the characteristics of their organelles. Drug resistance in many microorganisms is regulated by cytoplasmic DNA, known as plasmids, that contain one or more genes. Plasmids can be passed from one bacterial cell to another via transformation (described below).

GENETIC PROBLEMS

Although genetic replication is very accurate, chromosome number and structure can be altered by abnormal cell division during meiosis or by mutagenic agents. This can result in the appearance of abnormal characteristics of the offspring in question.

Nondisjunction

Nondisjunction is either the failure of homologous chromosomes to separate properly during meiosis I or the failure of sister chromatids to separate properly during meiosis II. The resulting **zygote** might either have three copies of that chromosome, called **trisomy** (somatic cells will have $2N + 1$ chromosomes), or a single copy of that chromosome, called **monosomy** (somatic cells will have $2N - 1$ chromosomes). A classic case of trisomy is the birth defect **Down syndrome**, which is caused

by trisomy of chromosome 21. Most monosomies and trisomies are lethal, causing the embryo to spontaneously abort early in the pregnancy. Nondisjunction of the sex chromosomes may also occur, resulting in individuals with extra or missing copies of the X or Y chromosomes. The only viable monosomy is Turner's syndrome, which is a monosomy of the sex chromosomes resulting in the genotype XO.

Chromosomal Breakage

Chromosomal breakage may occur spontaneously or be induced by environmental factors, such as mutagenic agents and X-rays. The chromosome that loses a fragment is said to have a deficiency.

Mutations

Mutations are changes in the genetic information coded in the DNA of a cell. Mutations that occur in **somatic** cells can lead to tumors in the individual. Mutations that occur in the sex cells (**gametes**) will be passed down to the offspring. Most mutations occur in regions of DNA that do not code for proteins and are silent (not expressed in the phenotype). Mutations that do change the sequence of amino acids in proteins are most often recessive and deleterious.

Mutagenic agents

Mutagenic agents induce mutations. These include cosmic rays, X-rays, ultraviolet rays, and radioactivity, as well as some chemical compounds. Mutagenic agents are sometimes also **carcinogenic** (cancer-causing).

Mutation types

In a gene mutation, nitrogenous bases are **added**, **deleted**, or **substituted**, thus altering the amino acid sequence. When any of these occur, inappropriate amino acids may be inserted into polypeptide chains, and a mutated protein may be produced. Therefore, a mutation is a genetic "error" with the "wrong" base or a missing base in the DNA at any particular position.

In a **point mutation**, a nucleic acid is replaced by another nucleic acid. The number of nucleic acids substituted may vary, but generally point mutations involve between one and three nucleotides. There are three possible effects on the **codon**, the sequence of three nucleotides that determines the identity of the amino acid. First, the new codon may code for the same amino acid (a **silent mutation**), and no change in the resulting protein is seen. Second, the new codon may code for a different amino acid (a **missense mutation**). This may or may not lead to a problem with the resulting protein, depending on the role of that amino acid in determining the protein structure. Finally, the new codon may be a stop codon (a **nonsense mutation**). Nonsense mutations are often lethal or severely inhibit the functioning of the protein, which can lead to many different problems depending on the role of that protein in organism function. While these mutations may lead to proteins of a different length than the native protein, they do not affect the length of the genome itself as is seen with frameshift mutations.

In a **frameshift mutation**, nucleic acids are deleted or inserted into the genome sequence. This frequently is lethal. The insertion or deletion of nucleic acids throws off the entire sequence of codons from that point on because the genome is "read" in groups of three nucleic acids, or codons. Since nucleic acids are inserted or deleted, the length of the genome changes.

KEY CONCEPT

To visualize frameshift mutations, imagine an answer bubble sheet for a multiple choice test: If you forget to bubble an answer or bubble an answer on more than one row, then every answer after the mistake will be incorrect.

BIO

One example of a genetic disorder is **sickle-cell anemia**, a disease in which red blood cells become crescent-shaped because they contain defective hemoglobin. The sickle-cell hemoglobin carries less oxygen. This disease is caused by a substitution of valine (coded by GUA or GUG) for glutamic acid (coded by GAA or GAG) because of a single base-pair substitution in the gene coding for hemoglobin. While the decreased ability to carry oxygen can have negative effects on patients, these individuals do have less severe symptoms of malaria should they become infected, indicating a possible evolutionary advantage in regions where malaria infection is common.

BACTERIAL GENETICS

Bacterial Genome

The bacterial genome consists of a single circular chromosome located in the **nucleoid** region of the cell. Many bacteria also contain smaller circular rings of DNA called **plasmids**, which contain accessory genes. **Episomes** are plasmids that are capable of integration into the bacterial genome.

Replication

Replication of the bacterial chromosome begins at a unique origin of replication and proceeds in both directions simultaneously. DNA is synthesized in the 5′ to 3′ direction.

Genetic Variance

Bacterial cells reproduce by **binary fission** and proliferate very rapidly under favorable conditions. Although binary fission is an **asexual** process, bacteria have three mechanisms for increasing the genetic variance of a population: **transformation**, **conjugation**, and **transduction**.

Transformation

Transformation is the process by which a foreign chromosome fragment (**plasmid**) is incorporated into the bacterial chromosome via recombination, creating new inheritable genetic combinations.

Conjugation

Conjugation can be described as **sexual mating** in bacteria; it is the transfer of genetic material between two bacteria that are temporarily joined. A cytoplasmic conjugation bridge is formed between the two cells, and genetic material is transferred from the donor male (+) type to the recipient female (−) type. Only bacteria containing plasmids called sex factors are capable of conjugating. The best studied sex factor is the **F factor** in *E. coli*. Bacteria possessing this plasmid are termed F$^+$ cells; those without it are called F$^-$ cells. During conjugation between an F$^+$ and an F$^-$ cell, the F$^+$ cell replicates its F factor and donates the copy to the recipient, converting it to an F$^+$ cell. Genes that code for other characteristics, such as **antibody resistance**, may be found on the plasmids and transferred into recipient cells along with these factors.

Sometimes the sex factor becomes integrated into the bacterial genome. During conjugation, the entire bacterial chromosome replicates and begins to move from the donor cell into the recipient cell. The conjugation bridge usually breaks before the entire chromosome is transferred, but the bacterial genes that enter the recipient cell can easily recombine with the genes already present to form novel genetic combinations. These bacteria are called **Hfr** cells, meaning that they have a **high frequency of recombination**.

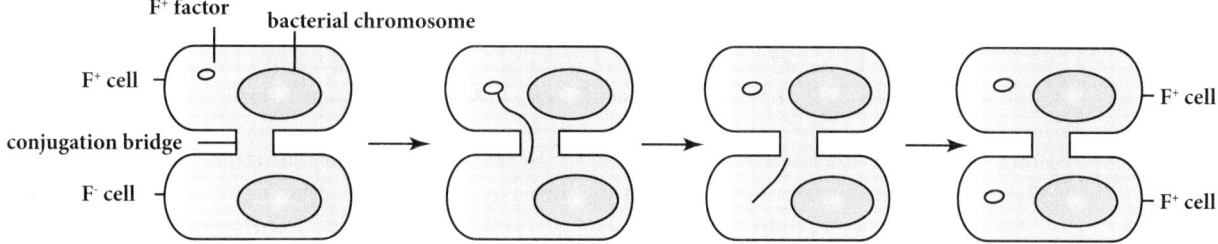

Figure 8.7

Transduction

A **bacteriophage** is a virus that infects its host bacterium by attaching to the bacterium, boring a hole through the bacterial cell wall, and injecting its viral DNA while its protein coat remains attached to the cell wall. Transduction occurs when fragments of the bacterial chromosome become packaged into the viral progeny produced during such a viral infection. These virions may infect other bacteria and introduce new genetic arrangements through recombination with the new host cell's DNA. The closer two genes are to one another on a chromosome, the more likely they will be to transduce together; this fact allows geneticists to map genes to a high degree of precision.

Transduction with DNA Fragment

Figure 8.8

Recombination

Recombination occurs when linked genes are separated. It occurs by breakage and rearrangement of adjacent regions of DNA when organisms carrying different genes or alleles for the same traits are crossed.

Gene Regulation

The regulation of **transcription,** one of the steps of gene expression, enables prokaryotes to control their metabolism. Regulation of transcription is based on the accessibility of **RNA polymerase** to the genes being transcribed and is directed by an **operon**, which consists of **structural** genes, an **operator** region, and a **promoter** region on the DNA before the protein coding genes. Structural genes contain sequences

of DNA that code for proteins. The operator is the sequence of nontranscribable DNA that is the **repressor** binding site. The promoter is the noncoding sequence of DNA that serves as the initial binding site for RNA polymerase. There is also a **regulator** gene, which codes for the synthesis of a repressor molecule that binds to the operator and blocks RNA polymerase from transcribing the structural genes.

RNA polymerase must also move past the operator to transcribe the structural genes. Regulatory systems function by preventing or permitting the RNA polymerase to pass on to the structural genes. Regulation may be via **inducible systems** or **repressible systems**. Inducible systems are those that require the presence of a substance, called an **inducer**, for transcription to occur. Repressible systems are in a constant state of transcription unless a **corepressor** is present to inhibit transcription.

Inducible systems

In an inducible system, the repressor binds to the operator, forming a barrier that prevents RNA polymerase from transcribing the structural genes. For transcription to occur, an inducer must bind to the repressor, forming an **inducer-repressor complex**. This complex cannot bind to the operator, thus removing it as a barrier and permitting transcription. The proteins synthesized are thus said to be inducible. The structural genes typically code for an enzyme, and the inducer is usually the substrate, or a derivative of the substrate, upon which the enzyme normally acts. When the substrate (inducer) is present, enzymes are synthesized; when it is absent, enzyme synthesis is negligible. In this manner, enzymes are transcribed only when they are actually needed.

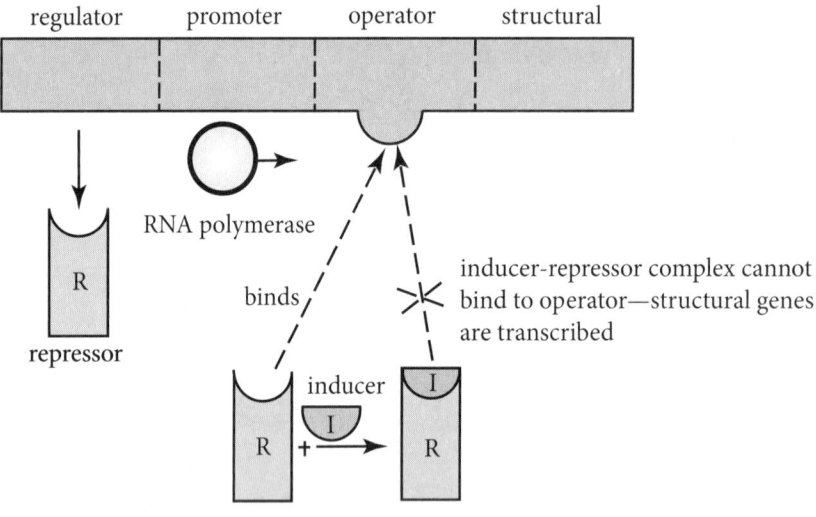

Figure 8.9

Repressible systems

In a repressible system, the repressor is inactive until it combines with the corepressor. The repressor can bind to the operator and prevent transcription only when it has formed a repressor-corepressor complex. Corepressors are often the **end products** of the biosynthetic pathways they control. The proteins produced (usually enzymes) are said to be repressible because they are normally being synthesized; transcription and translation occur until the corepressor is synthesized. Operons containing mutations, such as deletions, or whose regulator genes code for defective repressors are incapable of being turned off; their enzymes, which are always being synthesized, are referred to as **constitutive**.

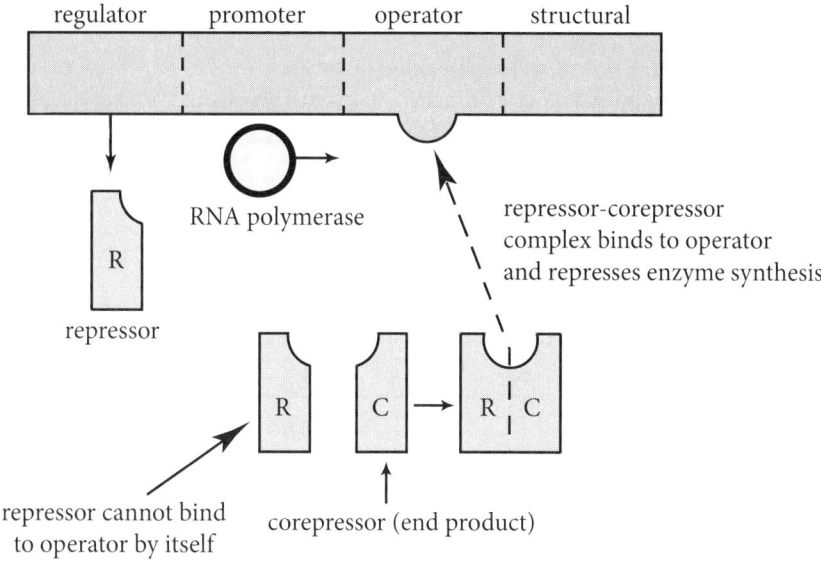

Figure 8.10

Pedigrees

Pedigrees are a tool used by geneticists to track one phenotype in a family across generations. In pedigrees, males are represented by squares and women by circles. **Affected** individuals (those who express a particular phenotype) are shaded in and **unaffected** are not. Rarely, known carriers of a recessive allele are half-filled in. Note that pedigrees track only one trait, which can be dominant or recessive. Often, your task on Test Day is to determine the inheritance pattern of a trait based on the pedigree. Also, remember that the traits in a pedigree may or may not be detrimental to an affected individual.

Autosomal Recessive Pedigree

If a trait is autosomal recessive, a person will only be affected if he or she possesses two copies of the recessive allele (homozygous recessive). Autosomal recessive traits affect roughly equal numbers of males and females and can skip generations due to dominant-phenotype carriers. Note that the presence of skipping definitively indicates a recessive trait, but the absence of skipping does not necessarily indicate dominance. Autosomal recessive patterns are most clearly identified when two unaffected individuals have offspring that are affected, which can only result from a recessive trait, as shown in Figure 8.11.

Figure 8.11

Autosomal Dominant Pedigree

If a trait is autosomal dominant, a person will be affected if he or she possesses one or more copies of the dominant allele (heterozygous or homozygous dominant). Autosomal dominant traits affect equal numbers of males and females and will appear in every generation. Only those individuals who are homozygous recessive will be unaffected. In order to prove an autosomal dominant pattern of inheritance, there must be two affected individuals who have an unaffected offspring, as shown in Figure 8.12.

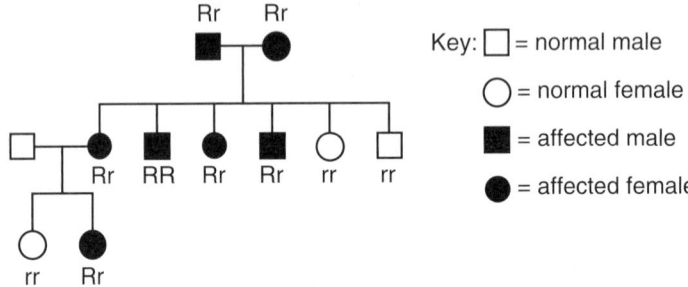

Figure 8.12

X-Linked Recessive Pedigree

When a trait is X-linked recessive, a person will be affected if he or she possesses only affected X chromosomes. Females have two X chromosomes and inherit these traits similar to those from other recessive alleles (must have two copies to express the trait). Males, however, have only one X chromosome, so these traits are inherited if they receive only one copy. Since males must receive their Y chromosome from their fathers, males can only inherit these disorders from their mothers. Thus, only mothers who are affected or carriers can pass these traits on to their sons. Since males cannot be carriers (only affected or unaffected), females who inherit these traits must have a father who is affected and a mother who is either a carrier or affected. Examples of X-linked traits include color-blindness and hemophilia. Besides these patterns, X-linked recessive can also skip generations like other recessive traits. If significantly more males are affected than females and two unaffected individuals produce an affected offspring, then a trait is likely X-linked recessive, as shown in Figure 8.13.

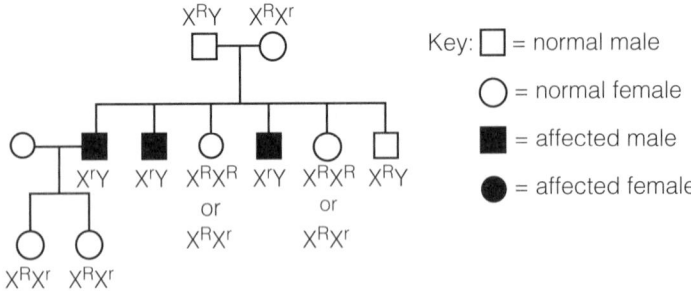

Figure 8.13

REVIEW PROBLEMS

1. A woman with blood genotype I^Ai and a man with blood genotype I^Bi have two children, both type AB. What is the probability that a third child will be blood type AB?

 A. 25%

 B. 33%

 C. 50%

 D. 66%

 E. 75%

2. In humans, the allele for black hair (B) is dominant to the allele to brown hair (b), and the allele for curly hair (C) is dominant to the allele for straight hair (c). When a person of unknown genotype is crossed against a straight- and brown-haired individual, the phenotypic ratio is:

 25% curly black hair

 25% straight black hair

 25% curly brown hair

 25% straight brown hair

 What is the genotype of the unknown parent?

 A. BBCC

 B. BbCC

 C. bbCc

 D. BbCc

 E. BBCc

3. Assuming classical Mendelian inheritance, how can one differentiate between a homozygous dominant individual and one who is heterozygous for the dominant trait?

 A. By crossing the individuals in question with one another

 B. By crossing each individual with a known homozygous recessive individual and examining the offspring

 C. By crossing each individual with a known heterozygote and examining the offspring

 D. By crossing each individual with a known homozygous dominant individual and examining the offspring

 E. Both B and C

4. If a male hemophiliac (X^hY) is crossed with a female carrier of both color blindness and hemophilia (X^cX^h), what is the probability that a female child will be phenotypically normal?

 A. 0%

 B. 25%

 C. 50%

 D. 75%

 E. Same as for a male child

BIO

5. Explain the concept of Mendel's law of segregation.

6. Why are lethal dominant alleles much less common than lethal recessive alleles?

7. Many point mutations do not have any effect on the gene product. What are two possible explanations for this observation?

SOLUTIONS TO REVIEW PROBLEMS

1. **A** This is a cross between two heterozygotes for a trait that has codominant alleles. The inheritance pattern for human blood groups is not a simple dominant/recessive pattern because the A and B alleles are both phenotypically expressed when the genotype is $I^A I^B$.

 This is a cross between a woman heterozygous for blood type A and a man heterozygous for blood type B: $I^A i \times I^B i$.

F1 genotypes:	25% $I^A I^B$	phenotypes:	25% type AB
	25% $I^B i$		25% type B
	25% $I^A i$		25% type A
	25% ii		25% type O

 The birth of each child is an independent event. Hence, the fact the first two children this couple had were type AB has no influence whatsoever on the probability that a third child will be AB. So there is a 25 percent chance that any child, not just the third, will be type AB.

2. **D** In this dihybrid problem, a doubly recessive individual is crossed with an individual of unknown genotype—this is known as a testcross. The straight- and brown-haired individual has the genotype bbcc and can thus produce only bc gametes. Looking at the F1 offspring, there is a 1:1:1:1 phenotypic ratio. The fact that both the recessive and dominant traits are present in the offspring means that the unknown parental genotype must contain both recessive alleles (b and c). The unknown parental genotype must therefore be BbCc. If you want to double-check the answer, you can work out the Punnett square for the cross BbCc × bbcc: BbCc can produce four different types of gametes, BC, Bc, bC, and bc, whereas bbcc can produce only bc gametes, as previously mentioned.

 So the unknown parental genotype is BbCc, choice (D).

3. **E** To differentiate between a homozygous dominant and a heterozygous dominant for a trait that exhibits classic dominant/recessive Mendelian inheritance, one must perform a cross that results in offspring that reveal the unknown parental genotype; this is known as a testcross. If we cross the homozygous dominant with a homozygous recessive, we will get 100 percent phenotypically dominant offspring; if we cross the heterozygous dominant with the homozygous recessive, we will get 50 percent phenotypically dominant and 50 percent phenotypically recessive offspring. Thus, using a homozygous recessive as a testcrosser will allow us to distinguish between the two. We can also use a known heterozygote as the testcrosser because when this is crossed with the homozygous dominant, 100 percent phenotypically dominant offspring are produced, and when it is crossed with the heterozygote, the phenotypic ratio of the offspring is 3:1 dominant:recessive. Hence, the correct answer is (E), because both (B) and (C) are viable options. Crossing the individuals in question with one another or with a homozygous dominant individual, as in (A) and (D), will result in 100 percent phenotypically dominant offspring and hence will not be helpful.

4. **C** In this problem, we are told that the female in this cross is a carrier of two sex-linked traits: color blindness and hemophilia. We are also told that the genes for these traits are not found on the same X chromosome, as indicated by her genotype, $X^c X^h$. So of the female offspring, half, or 50 percent, will be phenotypically normal.

5. The chromosomal basis for Mendel's Law of Segregation is as follows: For any given trait, all individuals have two alleles located on separate but homologous chromosomes, one inherited from each parent. During meiosis, or gamete formation, these homologous chromosomes pair and line up along the equatorial plate. As meiosis proceeds, the spindle fibers attached to the homologues move them toward opposite poles of the cell. Because the alleles are on different chromosomes, they segregate and wind up in different gametes. The paired condition of the alleles is restored with the fusion of egg and sperm during fertilization.

6. Lethal dominant alleles are much less common than lethal recessive alleles because a lethal dominant allele kills both heterozygotes and homozygotes, preventing the transmission of the allele to offspring (unless the gene is late-acting). Dominant lethals usually appear in an individual as a result of spontaneous mutations and die with that individual. Thus, the frequency with which dominant lethals appear in the gene pool always remains very low. Lethal recessive alleles only kill homozygotes; however, heterozygotes are phenotypically normal and will not die as a result of their single copy of the lethal recessive. Hence, heterozygotes are able to pass on the lethal allele to offspring and thus maintain the frequency of the allele in the gene pool.

7. A point mutation causes the substitution of one base pair for another. Sometimes, as in the case of sickle-cell anemia, it may have a very profound effect on the gene product (hemoglobin) because it changes the message carried by the gene. In some cases, however, a mutated gene codes for the same product. This can be explained by the redundancy of the genetic code: most amino acids have more than one triplet coding for them. The substitution of the third cytosine in the triplet CCC (proline) by any of the remaining bases (G, A, or U) will not change the amino acid sequence because the codons CCG, CCA, and CCU code for proline as well. In eukaryotes, a point mutation may occur in an intron (noncoding region) and thus will not affect the gene product because noncoding regions are excised after transcription.

CHAPTER NINE

Evolution

LEARNING OBJECTIVES

After this chapter, you will be able to:

- Compare and contrast theories of evolution
- Explain the components and evidence of evolution
- Describe the origin and early evolution of life

The change in the genetic makeup of a population with time is termed **evolution**. Evolution is explained by the constant propagation of new variations in the genes of a species, some of which impart an adaptive advantage. All living things (past and present) are descendents from a single common ancestor. Each of these organisms arose as a direct result of some genetic alteration in the species that lived before them, and this process is called evolution. Most evolutionary changes occur slowly over a long period of time.

THEORIES OF EVOLUTION

Lamarckian Evolution

This discredited theory proposed by Jean-Baptiste Lamarck held that new organs or changes in existing ones arose because of the needs of the organism. The amount of change was thought to be based on the **use or disuse** of the organ. The theory of use and disuse was based upon a fallacious understanding of genetics. Any useful characteristic acquired in one generation was thought to be transmitted to the next. An example of an **acquired characteristic** was the long necks of giraffes. Supposedly, early giraffes permanently stretched their necks to reach for leaves on higher branches of trees. The offspring were believed to inherit the valuable trait of longer necks as a result of this excessive use.

Modern genetics has disproved theories of acquired characteristics. In reality, only changes in the DNA of the sex cells can be inherited. In contrast, changes acquired during an individual's life are changes in somatic cells. August Weismann showed that these changes are not inherited in an experiment in which he cut off the tails of mice for 20 generations (somatic change) only to find that the 21st generation was born with tails.

Darwin's Theory of Natural Selection

In Charles Darwin's theory, pressures in the environment select for the organism most **fit** to survive and reproduce. In the evolutionary sense, **fitness** is the ability to survive and reproduce. Darwin essentially concluded that a member of a particular species that is equipped with beneficial traits, allowing it to cope effectively with the immediate environment, will produce more offspring than individuals with less favorable genetic traits. The genes of parents that are more fit are therefore passed down to more offspring and become increasingly prevalent in the gene pool. Darwin subsequently chose the words **natural selection** to describe his theory because nature selects the best set of parents for the next generation. Darwin outlined a number of basic agents leading to evolutionary change.

Overpopulation

More offspring are produced than can survive. Thus, the food, air, light, and space are insufficient to support the entire population.

Variations

Offspring naturally show differences (variations) in their characteristics compared to those of their parents. Darwin did not know the source of these differences. Hugo de Vries later suggested mutations as the cause of variations. Some mutations are beneficial, although many are harmful.

Competition

The developing population must compete for the necessities of life. Many young must die, and the number of adults in the population generally remains constant from generation to generation.

Natural selection

Some organisms in a species have variations that give them an advantage over other members of the species. In the struggle for existence, these organisms may have adaptations that are advantageous for survival. For example, a giraffe with a variation of a longer neck would be able to get more food from higher branches of a tree and therefore would be more fit. This principle is encapsulated in the phrase "survival of the fittest."

Inheritance of the variations

The individuals that survive (those with the favorable variations) live to adulthood to reproduce and thus **transmit** these favorable variations or adaptations to their offspring. These favored genes gradually dominate the gene pool.

Evolution of new species

Over many generations of natural selection, the favorable changes (adaptations) are perpetuated in the species. The accumulation of these favorable changes eventually results in such significant changes in the gene pool that we can say a new species has evolved. These physical changes in the gene pool were perpetuated or selected for by environmental conditions.

For example, the rapid evolution of DDT-resistant insects illustrates the theory of natural selection and speciation. A change in the environment such as the introduction of DDT (an insecticide) constitutes a favorable change for the DDT-resistant mutant flies. These mutants existed before the environmental change. Now, conditions select for survival of DDT-resistant mutants.

COMPONENTS OF EVOLUTION

Speciation

Speciation is the evolution of new species, which are groups of individuals that can interbreed freely with each other but not with members of other species. Gene flow is impossible between different species. Different selective pressures act upon the gene pools of each group, causing them to evolve independently. Genetic variation, changes in the environment, migration to new environments, adaptation to new environments, natural selection, genetic drift, and isolation are all factors that can lead to speciation.

Before speciation, small, local populations called **demes** often form within a species. For example, all the beavers along a specific portion of a river form a deme. There may be many demes belonging to a specific species. Members of a deme resemble one another more closely than they resemble members of other demes. They are closely related genetically since mating between members of the same deme occurs more frequently. They are also influenced by similar environmental factors and thus are subject to the same selection processes.

If these demes become **isolated**, speciation may occur. When groups are isolated from each other, there is no gene flow among them. Any difference arising from mutations or new combinations of genes will be maintained in the isolated population. Over time, these genetic differences may become significant enough to make mating impossible. If the gene pools within a species become sufficiently different so that two individuals cannot mate and produce fertile offspring, two different species have developed and one or more new species have formed. Genetic and eventually reproductive isolation often results from the geographic isolation of a population.

Evolutionary History

Biologists seek to understand the evolutionary relationships among species alive today. This evolutionary history is termed **phylogeny**. Evolutionary history may be visualized as a branching tree on which the common ancestor is found at the trunk and the modern species are found at the tips of the branches. All of the decendants from the common ancestor form what is known as a **clade** in phylogenies.

Convergent evolution

Groups among the branches often develop in similar ways when exposed to similar environments. When two species from different ancestors develop similar traits, this is known as **convergent evolution**. For example, sharks and dolphins have come to resemble one another physically despite belonging to different classes of vertebrates (sharks are members of Chondrichthyes, whereas dolphins are members of Mammalia). Despite different recent ancestors, they evolved certain similar features in adapting to the conditions of aquatic life.

Parallel evolution

Parallel evolution is similar to convergent evolution but occurs when a more recent ancestor can be identified. For example, marsupial (pouched) mammals and placental mammals are both in the class Mammalia but diverged due to geographic separation. Descendants of the ancestral marsupial mammal include the pouched wolf, anteater, mouse, and mole. These species have developed parallel to the placental wolf, anteater, mouse, and mole. Despite their geographic separation, the pouched mammals and their placental counterparts faced similar environments; thus, they developed similar adaptations.

BIO

Divergent evolution

In contrast, **divergent evolution** occurs when species with a shared ancestor develop differing traits due to dissimilarities between their environments. For example, bears of the family Ursidae within the class Mammalia share many similar traits but have diverged from a common ancestor to adapt to their specific environments. Polar bears have white coats to blend in with their arctic environment, whereas black bears have developed darker fur to blend in with their wet, forest environments. Over time, additional changes accumulated between these bears, resulting in the inability to cross-breed and eventual speciation.

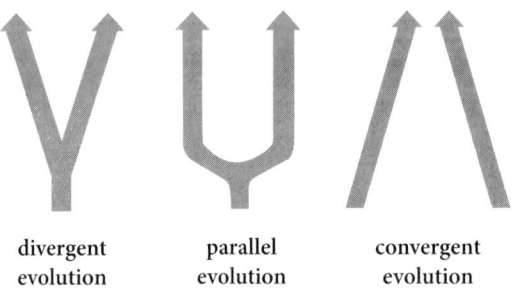

divergent parallel convergent
evolution evolution evolution

Figure 9.1

Adaptive radiation is the emergence of a number of lineages from a single ancestral species. A single species may diverge into a number of distinct species; the differences between them are those adaptive to a distinct lifestyle, or **niche**. A classic example is Darwin's finches of the Galápagos island chain. Over a comparatively short period of time, a single species of finch underwent adaptive radiation, resulting in 13 separate species of finches, some of them on the same island. Such adaptations minimized competition among the birds, enabling each emerging species to become firmly established in its own environmental niche.

Population Genetics

A **population** includes all members of a particular species inhabiting a given location. The **gene pool** of a population is the sum total of all the alleles for any given trait in the population. **Gene frequency** is the decimal fraction representing the presence of an allele for all members of a population that have this particular gene. In basic Mendelian genetics, only two alleles exist for a given trait: one dominant and one recessive. The letter p is used for the frequency of the dominant allele of a particular gene. The letter q represents the frequency of the recessive allele. Since by definition these are the only two alleles that can be present, for a given gene, $p + q = 1$.

The Hardy-Weinberg principle

Evolution can be viewed as a result of changing gene frequencies within a population. Gene frequency is the relative frequency of a particular allele. When the gene frequencies of a population are not changing, the gene pool is stable and the population is not evolving. However, this is true only in ideal situations in which the following conditions are met:

- The population is very large.
- No mutations affect the gene pool.

- Mating between individuals in the population is random.
- There is no net migration of individuals into or out of the population.
- The genes in the population are all equally successful at reproducing.

Under these idealized conditions, a certain equilibrium will exist among all of the genes in a gene pool, which is described by the **Hardy-Weinberg equation**.

For a gene with only two alleles, T and t, p = the frequency of allele T and q = the frequency of allele t. For that gene, $p + q = 1$, since the combined frequencies of the alleles must total 100 percent. Thus,

$$(p + q)^2 = (1)^2 \text{ , and}$$

$$p^2 + 2pq + q^2 = 1$$

where p^2 = frequency of TT (dominant homozygotes)

$2pq$ = frequency of Tt (heterozygotes)

q^2 = frequency of tt (recessive homozygotes)

The Hardy-Weinberg equation may be used to determine gene frequencies in a large population in the absence of microevolutionary change (defined by the five conditions given previously).

For a non-evolving population, Hardy-Weinberg helps to determine the allele frequencies, as well as phenotypic frequencies.

Take, for example, a population who has a gene frequency of 0.80 for the dominant Tall allele (T). Using $p + q = 1$ we can solve for the recessive allele's (t) gene frequency of 0.20. The Hardy-Weinberg equation, therefore, dictates the genotype frequencies of the population as shown below:

$$p^2 + 2pq + q^2 = 1$$

$$(0.80)^2 + 2(0.80)(0.20) + (0.20)^2 = 1$$

$$p^2 = (0.80)^2 = 0.64 \text{ or 64\% of the population is homozygous dominant (TT)}$$

$$2pq = 2(0.80)(0.20) = 0.32 \text{ or 32\% of the population is heterozygous (Tt)}$$

$$q^2 = (0.20)^2 = 0.04 \text{ or 4\% of the population is homozygous recessive (tt)}$$

Microevolution

No population can be represented indefinitely by the Hardy-Weinberg equilibrium because such idealized conditions do not exist in nature. Real populations have **unstable** gene pools and **migrating** populations. The agents of microevolutionary change—natural selection, mutation, assortive mating, genetic drift, and gene flow—are all deviations from the five conditions of a Hardy-Weinberg population.

BIO

Natural selection

Genotypes with favorable variations are selected through natural selection, and the frequency of favorable genes increases within the gene pool. Genotypes with low adaptive values tend to disappear.

Mutation

Gene mutations change allele frequencies in a population, shifting gene equilibria by introducing additional alleles. These gene mutations can either be favorable or detrimental for the offspring.

Assortive mating

If mates are not randomly chosen but rather selected according to criteria such as phenotype and proximity (**sexual selection**), the relative genotype ratios will be affected and will depart from the predictions of the Hardy-Weinberg equilibrium.

Genetic drift

Genetic drift refers to changes in the composition of the gene pool due to chance. Genetic drift tends to be more pronounced in small populations or new populations, where it is sometimes called the **founder effect**. Large die off events can also cause genetic drift and are called a genetic **bottleneck**.

Gene flow

Migration of individuals between populations will result in a loss or gain of genes, thus changing the composition of a population's gene pool.

EVIDENCE OF EVOLUTION

Fossil Record

Fossils are direct evidence of evolutionary change. They represent the preserved remains of an organism. Fossils are generally found in sedimentary rocks.

Types of fossils

Many types of fossils can provide information. Paleontologists can find actual remains, including teeth, bones, etc., in rock, tar pits, ice, and **amber** (the fossil resin of trees). **Petrification** is the process by which minerals replace the cells of an organism. **Imprints** are impressions left by an organism (e.g., footprints). **Molds** form hollow spaces in rocks as the organisms within decay. **Casts** are formed by minerals deposited in molds.

Significant fossil discoveries

The trilobite is a primitive arthropod (similar to lobsters and crabs), which was a dominant form of the early Paleozoic era. Dinosaurs were ancient animals related to both reptiles and birds. Various forms lived on all the ancient continents. They were a dominant form of the Mesozoic era. Eohippus, the dawn horse, was a primitive horse the size of a fox with four toes and short teeth with pointed cusps for feeding on soft leaves. Fossil evidence indicates a gradual evolution within the horse lineage to the modern horse, which has one toe (hoof) and two vestigial toes as side splints, flat teeth with ridges for grinding grain and tough prairie grass, and long legs for running. The woolly mammoth was a hairy elephant found in the Siberian ice. Saber-tooth tigers have been preserved in asphalt tar pits. Insects have been discovered preserved in amber. *Archaeopteryx* is a link between reptiles (it has teeth and scales) and birds (it also has feathers).

Comparative Anatomy

Homologous structures

Homologous structures have the same basic anatomical features and evolutionary origins. They demonstrate similar evolutionary patterns with late divergence of form due to differences in exposure to evolutionary forces. Although the origins and anatomical features of these structures are similar, their functions may not be. Examples of homologous structures include the wings of a bat, the flipper of a whale, the forelegs of horses, and the arms of humans. Note in these examples that while the structures are all similar, the functions of each structure are not the same.

Analogous structures

Analogous structures have similar functions but may have different evolutionary origins and entirely different patterns of development. The wings of a fly (membranous) and the wings of a bird (bony and covered with feathers) are analogous structures. Analogous organs demonstrate a superficial resemblance that cannot be used as a basis for classification.

Comparative Embryology

The **stages of development** of the embryo resemble the stages in an organism's evolutionary history. The human embryo passes through stages that demonstrate common ancestry with other organisms. The two-layer **gastrula** is similar to the structure of the hydra, a cnidarian. The three-layer gastrula is similar in structure to the flatworm. Gill slits in the embryo indicate a common ancestry with fish. The similarity of these stages suggests a common ancestry and development history.

The earlier the stage at which the development begins to diverge, the more dissimilar the adult organisms will be. For example, it is difficult to differentiate between the embryo of a human and that of a gorilla until relatively late in the development of each embryo.

Embryological development suggests other evidence of evolution from common ancestors. The avian embryo has teeth, suggesting shared ancestry with reptiles. The larvae of some mollusks resemble annelids. Human embryos possess a tail, like most other mammals.

Comparative Biochemistry (Physiology)

Most organisms demonstrate the same basic needs and metabolic processes. They require the same nutrients and contain similar cellular organelles and energy storage forms (ATP). For example, respiratory processes are very similar in most organisms. The similarity of the enzymes involved in these processes suggests that all organisms must contain some DNA sequences in common. The more recently organisms shared a common ancestor, the greater the similarity of their chemical constituents (enzymes, hormones, antibodies, blood) and genetic information. Thus, we can conclude that all organisms are descended from a single common ancestral form. The chemical similarity of the blood of different organisms very closely parallels the evolutionary pattern. A chimpanzee's blood shows close similarity to that of a human but is quite different from that of a rabbit or fish. Thus, the more time that has elapsed since the divergence of two species, the more different their biochemical characteristics.

Vestigial Structures

Vestigial structures have no known current function but apparently had some ancestral function. There are many examples of vestigial structures in humans, other animals, and plants:

- In humans, the appendix is small and useless. In herbivores, it assists in the digestion of cellulose.
- In humans, the tail is reduced to a few useless bones (coccyx) at the base of the spine.
- Splints on the legs of horses are the vestigial remains of the two side toes of more primitive horses.
- Python "legs" are reduced to useless bones embedded in the sides of the adult. The whale has similar hind-limb bones.

Geographic Barriers

Species multiplication is generally accompanied by **migration** to lessen **intraspecific competition**. Separation of a widely distributed population by emerging geographic barriers increases the likelihood of genetic adaptations on either side of the barrier. Each population may evolve specific adaptations to the environment in which it lives in addition to accumulating neutral (random, nonadaptive) changes. These adaptations will remain unique to the population in which they evolve—provided that interbreeding is prevented by the barrier. In time, genetic differences will reach the point where interbreeding becomes impossible between the populations and **reproductive isolation** would be maintained even if the barrier were removed. Following are two examples:

- **Marsupials:** A lineage of pouched mammals (marsupials) paralleling the development of placental mammals developed on the Australian side of a large water barrier. The geographic barrier protected the pouched mammals from competition and hybridization with modern placental mammals. This barrier resulted in the development of uniquely Australian marsupials, such as kangaroos and pouched wolves, as well as other Australian plants and animals, such as the eucalyptus tree and the duck-billed platypus.
- **Darwin's finches**: Over a comparatively short period of time, a single species of Galápagos finch underwent adaptive radiation to form 13 different species of finches. Slight variations in the beak, for example, favored ground or tree feeding. Such adaptations minimized the competition among the birds, enabling each emerging species to become firmly entrenched in its environmental niche. The evolution of these adaptations was helped by the geographic isolation of some of these species on different islands of the Galápagos island chain.

ORIGIN AND EARLY EVOLUTION OF LIFE

The Heterotroph Hypothesis

The first forms of life lacked the ability to synthesize their own nutrients; they required preformed molecules. These "organisms" were heterotrophs, which depended upon outside sources for food. The primitive seas contained simple inorganic and organic compounds such as salts, methane, ammonia, hydrogen, and water. Energy was present in the form of heat, electricity, solar radiation (including X-rays and ultraviolet light), cosmic rays, and radioactivity.

The presence of these building blocks and energy may have led to the synthesis of simple organic molecules such as sugars, amino acids, purines, and pyrimidines. These molecules dissolved in the "**primordial soup,**" and after many years, the simple monomeric molecules combined to form a supply of macromolecules.

Evidence of organic synthesis

In 1953, Stanley L. Miller set out to demonstrate that the application of ultraviolet radiation, heat, or a combination of these to a mixture of methane, hydrogen, ammonia, and water could result in the formation of complex organic compounds. Miller set up an apparatus in which the four gases were continuously circulated past electrical discharges from tungsten electrodes.

After circulating the gases for one week, Miller analyzed the liquid in the apparatus and found that an amazing variety of organic compounds, including urea, hydrogen cyanide, acetic acid, and lactic acid had been synthesized.

Formation of primitive cells

Colloidal protein molecules tend to clump together to form **coacervate droplets** (a cluster of colloidal molecules surrounded by a shell of water). These droplets tend to absorb and incorporate substances from the surrounding environment. In addition, the droplets tend to possess a definite internal structure. It is highly likely that such droplets developed on the early Earth. Although these coacervate droplets were not living, they did possess some properties normally associated with living organisms.

Most of these systems were unstable; however, a few systems may have arisen that were stable enough to survive. A small percentage of the droplets possessing favorable characteristics may have eventually developed into the first primitive cells. These first primitive cells probably possessed nucleic acid polymers and became capable of reproduction.

Development of Autotrophs

The primitive heterotrophs slowly evolved complex **biochemical pathways**, enabling them to use a wider variety of nutrients. They evolved anaerobic respiratory processes to convert nutrients into energy. However, these organisms required nutrients at a faster rate than they were being synthesized. Life would have ceased to exist if autotrophic nutrition had not developed. Autotrophs are able to produce organic compounds, including energy-containing molecules, from substances in their surroundings. The pioneer autotrophs developed primitive photosynthetic pathways, capturing solar energy and using it to synthesize carbohydrates from carbon dioxide and water.

Development of Aerobic Respiration

The primitive autotrophs fixed carbon dioxide during the synthesis of carbohydrates and released molecular oxygen as a waste product. The addition of molecular oxygen to the atmosphere converted the atmosphere from a **reducing** to an **oxidizing** one. Some molecular oxygen was converted to ozone, which functions in the atmosphere to block high-energy radiation. In this way, living organisms destroyed the conditions that made their development possible. Once molecular oxygen became a major component of the Earth's atmosphere, both heterotrophs and autotrophs evolved the biochemical pathways of aerobic respiration. Now equilibrium exists between oxygen-producing and oxygen-consuming organisms.

General Categories of Living Organisms

All living organisms can be divided into four basic categories. The **autotrophic anaerobes** include chemosynthetic bacteria. The **autotrophic aerobes** include the green plants and photoplankton. The **heterotrophic anaerobes** include yeasts. The **heterotrophic aerobes** include amoebas, earthworms, and humans.

Taxonomy

Scientists classify organisms based upon their common ancestors, as well as their structural similarities and differences. Organisms with recent common ancestors tend to have more structural similarities than organisms with distant common ancestors. Taxonomy is the system by which organisms are classified. Figure 9.2 shows a simplified phylogenetic tree showing how the major animal groups are broken down. Some phylogenetic trees also give a time scale for the evolutionary distance between the distinct branches.

Figure 9.2

Every organism fits into eight categories, or **taxa**, each one increasingly specific based on traits or common ancestors. The taxa, in order of increasing specificicty, are: Domain, Kingdom, Phylum, Class, Order, Family, Genus, and Species. There are also numerous subcategories within each of these taxa. This system of nomenclature helps scientists to order all organisms in an organized manner and differentiate between very closely related organisms. The final two taxa, Genus and Species, are commonly used to name organisms in a system of **binomial nomenclature**. See Chapter 21 for an in-depth discussion of taxonomy.

Cladograms

Another system of representing evolutionary hypotheses is cladograms, which demonstrate similarities between organisms due to a common ancestor. Cladograms do not represent the amount of change between ancestor and descendant. Similar to a phylogenetic tree, organisms on the same branch of a cladogram are more closely related than organisms on different branches. Take, for example, the cladogram in Figure 9.3:

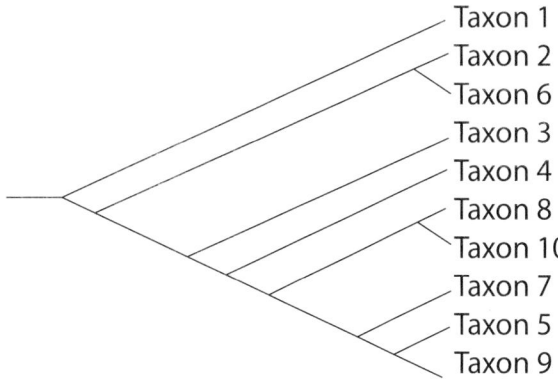

Figure 9.3

The above hypothetical cladogram shows relationships among ten taxa. A cladogram may or may not show a time scale. Taxon 7 may share a common ancestor, which isn't shown on the tree, with taxa 5 and 9. Taxon 7 is not the ancestor of taxa 5 and 9, nor does it necessarily have more characteristics in common with the ancestral taxon of taxa 7, 5, and 9 than taxa 5 or 9 do. It could have just as many anagenetic changes (evolutionary events without speciation) along its branch as cladogenetic changes (evolutionary events that lead to speciation). Taxon 4 is more closely related to taxa 8, 10, 7, 5, and 9 than it is to taxon 3. Even though taxon 3 is close to taxon 4 on the tree, it is not on the same branch that includes taxa 4, 8, 10, 7, 5, and 9. Likewise, taxon 2 is more closely related to taxon 6 than it is to taxon 1. Taxa 2 and 6 belong to the same branch that does not include taxon 1.

REVIEW PROBLEMS

1. Can the muscular strength that a weight lifter gains be inherited by the athlete's children?

2. Which organism has a greater evolutionary fitness: one that lives 70 years and has five fertile offspring or one that lives 40 years and has ten fertile offspring?

3. Homologous structures are
 A. similar in function but not in origin.
 B. similar in origin but not necessarily in function.
 C. completely dissimilar.
 D. found only in mammals.
 E. similar in function and origin.

4. Will chance variation have a greater effect in a large or a small population? What is this effect called?

5. As the climate got colder during the Ice Age, a particular species of mammal evolved a thicker layer of fur. This is an example of what kind of selection?

6. At what point are two populations descended from the same ancestral stock considered separate species?

7. In a nonevolving population, there are two alleles, R and r, which code for the same trait. The frequency of R is 30 percent. What are the frequencies of all the possible genotypes?

8. As the ocean became saltier, whales and fish independently evolved mechanisms to maintain the concentration of salt in their bodies. This can be explained by
 A. homologous evolution.
 B. analogous evolution.
 C. convergent evolution.
 D. parallel evolution.
 E. heterologous evolution.

9. In a particular Hardy-Weinberg population, there are only two eye colors: brown and blue. Thirty-six percent of the population has blue eyes, the recessive trait. What percentage of the population is heterozygous for brown eyes?

10. In a certain population, 64 percent of individuals are homozygous for curly hair (CC). The gene for curly hair is dominant to the gene for straight hair, c. Use the Hardy-Weinberg equation to determine what percentage of the population has curly hair.

11. Which of the following was NOT a belief of Darwin's?

 A. Evolution of species occurs gradually and evenly over time.

 B. There is a struggle for survival among organisms.

 C. Genetic mutation and recombination are the driving forces of evolution.

 D. Those individuals with fitter variants will survive and reproduce.

 E. More offspring are produced in a population than can survive.

12. The proposed "primordial soup" was composed of organic precursor molecules formed by interactions between all of the following elements EXCEPT

 A. oxygen.

 B. helium.

 C. nitrogen.

 D. hydrogen.

 E. carbon.

SOLUTIONS TO REVIEW PROBLEMS

1. No. The only characteristics that are inherited are those genetically coded for, not those acquired through the use or disuse of body parts. Therefore, the musculature of the weight lifter, an acquired characteristic, cannot be inherited by that athlete's children.

2. The organism that lives 40 years and has ten fertile offspring has the greater evolutionary fitness because it makes a greater genetic contribution to the next generation. It has twice as many direct descendants as the organism that lives 70 years and has five fertile offspring.

3. **B** Homologous structures are similar in origin but not necessarily similar in function. Analogous structures are similar in function but not in origin. Homologous structures are not limited to mammals; e.g., the forelimbs of crocodiles and birds are homologous structures.

4. Chance variation will have a greater effect in a small population because any one variant individual is a greater percentage of the whole population. This effect is called genetic drift.

5. This is an example of natural selection, the phenotypic norm of a particular species shifting to adapt to a selective pressure, such as an increasingly colder environment. Only those individuals with a thick layer of fur were able to survive during the Ice Age, thus that trait led to greater fitness (the production of more offspring, in this case due to living longer).

6. Two populations are considered separate species when they can no longer interbreed and produce viable, fertile offspring.

7. The frequency of R = 30%. Thus, $p = 0.30$. The frequency of recessive gene r = 100% − 30% = 70%. Thus, $q = 0.70$. Frequency of genotypes $= p^2 + 2pq + q^2 = 1$, where $p^2 = $ RR, $2pq = $ Rr, and $q^2 = $ rr.

p^2	=	$(0.3)^2$	=	0.09	=	9% RR	
$2pq$	=	$2(0.3)(0.7)$	=	0.42	=	42% Rr	
q^2	=	$(0.7)^2$	=	0.49	=	49% rr	

8. **C** Whales and fish have similar body structures (streamlined body with fins and tail), although they belong to different classes of vertebrates. When organisms that differ phylogenetically develop in similar ways when exposed to similar environments, the process is known as convergent evolution.

9. The percentage of the population with blue eyes (genotype = bb) = 36% = $q^2 = 0.36$; therefore, $q = 0.6$. Because $p + q = 1$, $p = 0.4$. The frequency of heterozygous brown eyes is $2pq = 2(0.4)(0.6) = 0.48$. So 48% of the population is heterozygous for brown eyes.

10. The variable p represents the frequency of the dominant allele (C), and q represents the frequency of the recessive allele (c). The CC frequency is 64%, which means that $p^2 = 0.64$, or $p = 0.8$. Because $p + q = 1$, $q = 1 − 0.8 = 0.2$.

 The problem asks for the percentage of the population with curly hair; this includes both homozygotes and heterozygotes (CC and Cc). The genotype frequencies can be found using the equation $p^2 + 2pq + q^2$.

CC	=	p^2	=	$(0.8)^2$	=	0.64	=	64% homozygous curly
Cc	=	$2pq$	=	$2(0.8)(0.2)$	=	0.32	=	32% heterozygous curly
cc	=	q^2	=	$(0.2)^2$	=	0.04	=	4% straight hair

Therefore, the percentage of the population with curly hair is 64% + 32% = 96%.

11. **C** Darwin believed the driving force behind evolution was the fitness of the organism for its particular environment.

12. **B** Helium, a noble gas, is inert and does not form molecules with other atoms.

BIO

CHAPTER TEN

Integumentary and Immune Systems

LEARNING OBJECTIVES

After this chapter, you will be able to:

- Describe the integumentary system
- Describe the features of immune system anatomy and explain their function

The body's ability to resist infection is highly dependent on both the integumentary and immune systems. The integument serves as the initial barrier to infection and prevents a large proportion of environmental microorganisms from entering the body. Should the organisms penetrate the integument, the immune system has several mechanisms to protect the body from infection and destroy the invading organisms.

THE INTEGUMENTARY SYSTEM

The **integument** provides a physical barrier to prevent the entrance of pathogens into the body. In humans, the integumentary system is composed of skin, hair, and nails, while in animals and plants it may also consist of fur, scales, feathers, hooves, shell, husk, and rind. Many microorganisms live on the surface of skin and make up the normal skin flora, also known as the **skin microbiome**. These microorganisms often participate in mutualism (relationships that benefit both the microorganisms and their host). By occupying the surface of the skin, these microorganisms prevent other, more harmful organisms from occupying that same space; in return, the microorganisms get a stable environment with access to nutrients. However, some of the normal flora can become pathogenic if they penetrate the integument.

The **skin** itself is also a nonspecific defense mechanism that protects against pathogenic invasion. For instance, sebaceous glands in the skin secrete oil onto the surface of the skin to keep its pH relatively acidic (a range of approximately 4–6 in humans), which decreases bacterial growth. These secretions also help keep the skin moist. **Sweat** is secreted from other glands and helps cool the skin by evaporative cooling. Sweat also contains enzymes that help destroy bacterial cell walls as well as pheromones used in chemical communication among humans.

The skin is divided into two different layers, the **dermis** and the **epidermis**, which are connected together by the **basement membrane**. The dermis contains the blood supply to the skin and most of the specialized cells, whereas the epidermis contains mainly keratinocytes, which differentiate into corneocytes: protective, waterproof cells that do not undergo further replication and are routinely sloughed off and replaced.

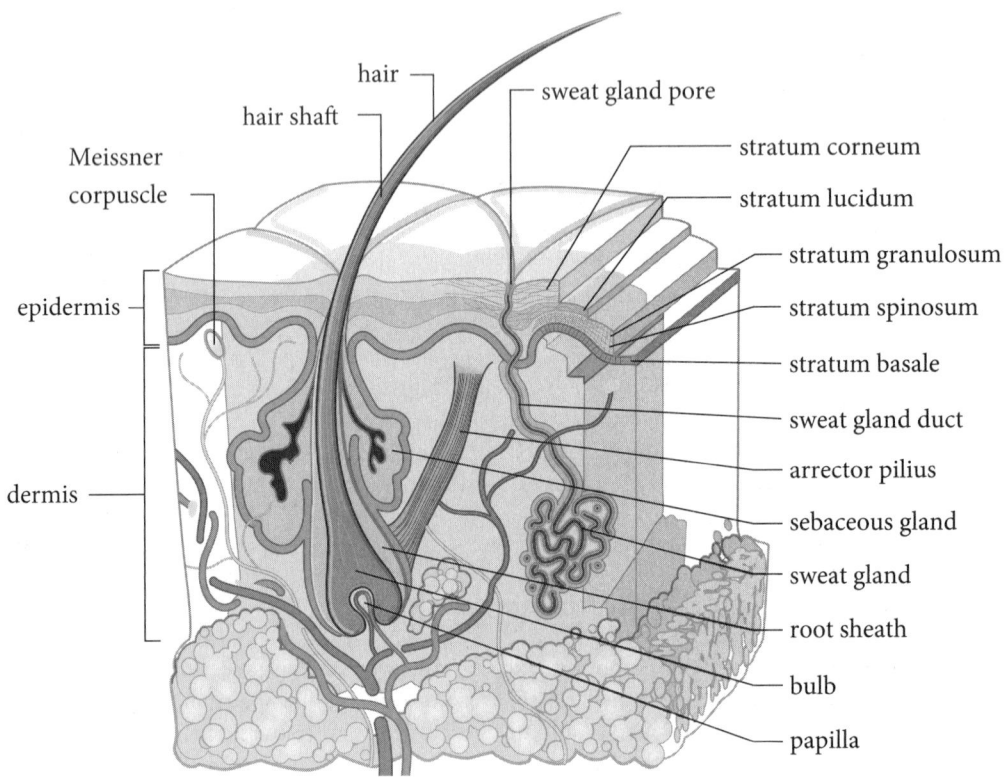

Figure 10.1

Parts of the skin are covered with **hair**, which aids the skin with the above functions. Hair serves to direct sweat and waste away from the skin, helping with evaporative cooling when the body is hot. Conversely, hair also traps heat, preventing the body from becoming too cool. Hair also serves as a sensory organ, allowing the detection of nearby motion.

Other components of the integument help prevent infection as well. **Mucous** secretions in the nose and aqueous secretions in the eyes help prevent foreign organisms from entering the body and resist infection. Similarly, **enzymes** in the mouth and throat break down many entering microorganisms and decrease their pathogenicity. Finally, **nails** protect the tips of the fingers and toes from physical injury and can be used as tools.

THE IMMUNE SYSTEM

The immune system has two major types of immunity: innate and adaptive.

Innate Immunity

Innate immunity is comprised of the body's initial, generalized defenses against pathogens. Nonspecific defense mechanisms include anatomic features (including the integument), inflammatory response (inflammation), physiologic response (temperature and pH change, enzymes), and phagocytic cells (neutrophils and macrophages). During inflammation, injured cells release chemicals, such as histamine, that dilate and increase the permeability of blood vessels. This increases the flow of white blood cells, or leukocytes, and other immune cells to the affected area, allowing the body to more effectively ward off infection. Inflammation is often accompanied by the rise in body temperature termed a **fever**, which in theory increases the ability to fight infection by killing temperature-dependent pathogens and speeding up healing processes. However, whether or not fever is practically beneficial is still a topic of scientific debate.

The immune system contains several varieties of leukocytes, each with a specific function.

Granulocytes

Granulocytes are attracted to the site of injury, where they phagocytize antigens and antigenic material.

Neutrophils, the most common type of granulocyte, are often the first responders to sites of inflammation. These cells are attracted to cytokines and, in turn, attract additional white blood cells once they arrive at the site of tissue damage. Although they can help moderate various infections and environmental trauma, neutrophils are particularly adapted to attack bacteria. Neutrophil counts are often elevated during the acute stages of inflammation and are the main component of pus.

Eosinophils are much less common and are responsible for immune responses, especially allergic and asthmatic responses. Elevated eosinophil counts on a complete blood count (CBC) often indicate an allergic response or infection by a parasite, including those that live on the surface of the skin (ectoparasites), such as fleas and ticks, and those that live in intercellular spaces (endoparasites), such as the parasitic worms known as helminths.

Basophils and the related **mast cells** are similarly involved in allergic responses and parasite infections, and often are responsible for the release of histamine, which stimulates blood vessel dilation as previously described.

Monocytes

Monocytes are large, long-lived immune cells that can differentiate into macrophages and dendritic cells. Macrophages and dendritic cells, along with B lymphocytes, belong to the antigen-presenting cells (APCs) family. APCs present antigens for recognition to mediate a cellular immune response.

BIO

The main role of **macrophages** is to phagocytize dead cells and pathogens. If a pathogen is ingested, its antigens are then presented on the surface of the macrophage to stimulate other immune cells to mount a specific immune response to the invading pathogen.

Dendritic cells are found in areas of the body where contact with the external environment is more common (e.g., the skin, intestine, and mucous membranes).

Dendritic cells are even more focused on processing antigens and presenting them to other immune cells and therefore serve as important links between the innate and adaptive immune systems.

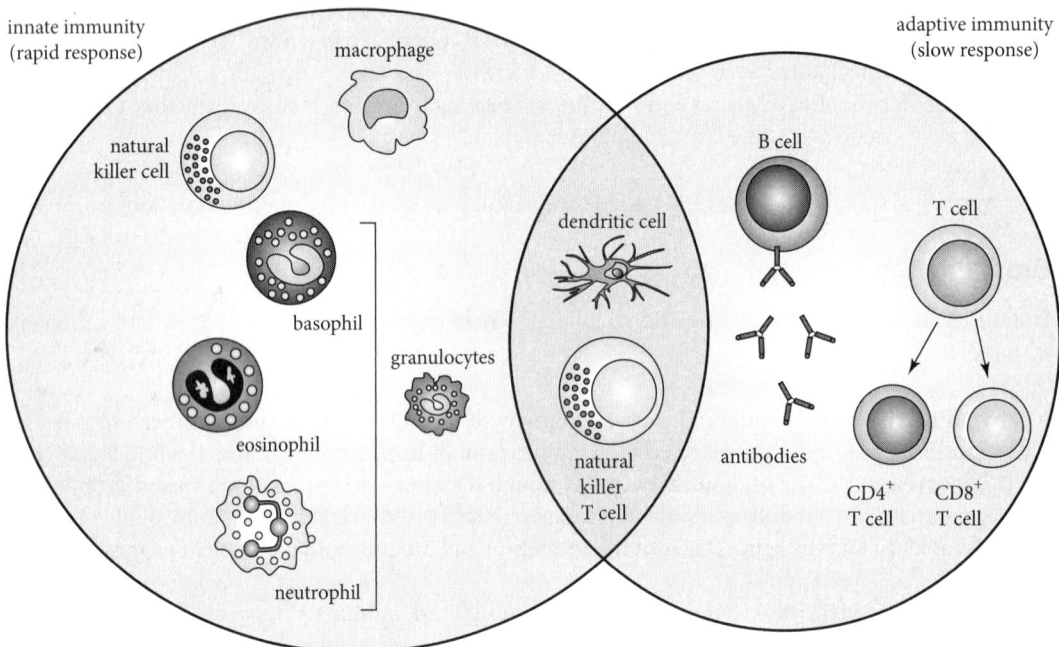

Figure 10.2

Adaptive Immunity

Adaptive or acquired immunity consists of cells capable of recognizing self versus nonself cells—for example, cells that can differentiate invading cells from host cells—and that are specific to a particular antigen. There are two types of adaptive immunity: cell-mediated, which is mediated by T lymphocytes, and humoral, which involves antibody production by B lymphocytes.

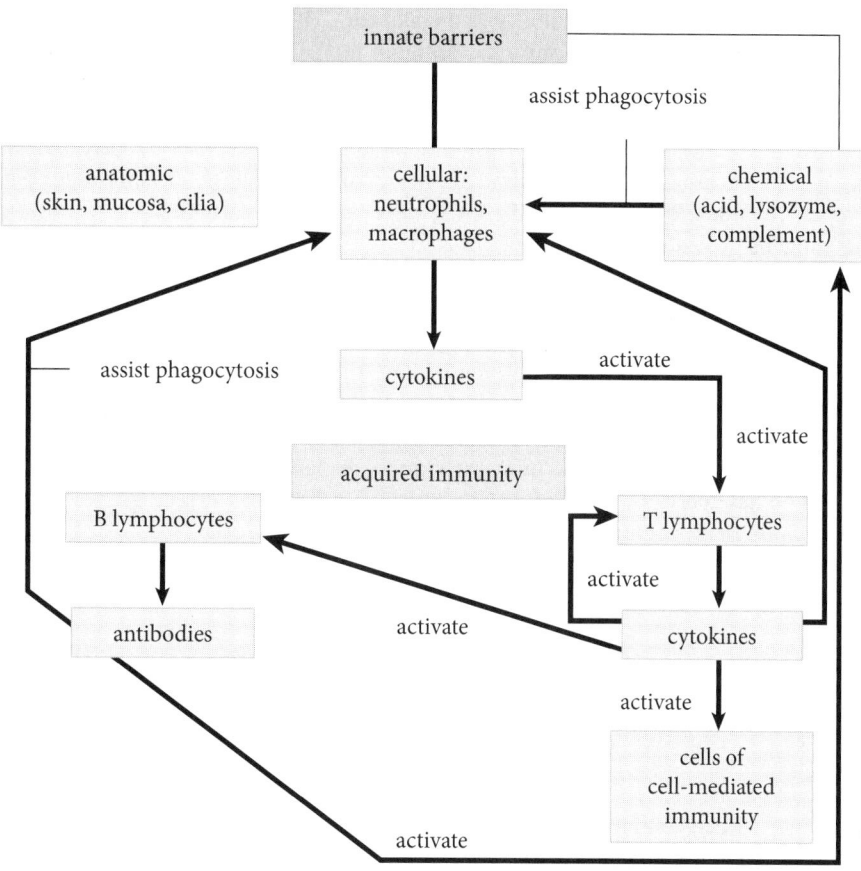

Figure 10.3

Cell-mediated immunity

T lymphocytes, or T cells, are an important component in cell-mediated immunity. They begin their development in the bone marrow, where T lymphocyte precursor cells are formed. Then, they travel via the bloodstream to the **thymus**, where they mature. It is because these cells mature in the thymus that they are referred to as T-cells. Once maturation is complete, the cells are released into the lymph to perform their immune function.

Through random rearrangement of gene sequences, each T cell becomes reactive to only one specific antigen. If infection with an organism that displays this antigen occurs, the antigen from the pathogen will be presented by a **major histocompatibility protein complex (MHC)** on the surface of an antigen-presenting cell, indicating that the corresponding T cell should perform its function. The vast majority of T cells created are deactivated and undergo apoptosis because they either will not react with the MHC or because they react too well and would attack self cells. Nevertheless, although each T cell can only respond to one specific antigen and many T cells are destroyed during development, a sufficient number of T cells exists to defend the body against nearly any pathogen.

The two major types of histocompatibility proteins are MHC I and MHC II. **Cytotoxic T (T_C) cells** (also known as **CD8+ T cells** because they contain the CD8 protein) recognize and respond to antigens presented by MHC I complexes. These complexes come from cells infected with viruses or developing tumors and signal T_C cells to destroy those cells. In contrast, **T helper (T_H) cells** (also known as CD4+ T cells) recognize and respond to antigens presented by MHC II complexes. Activated T_H cells release cytokines to stimulate the immune response, causing other white blood cells to mature and attack. **Natural killer T (NKT) cells** behave similarly to both T_C and T_H cells but respond to antigens presented by other types of cells.

Once a reaction has occurred, **memory T cells** reactive to the same antigens are formed and remain in circulation for long periods of time, allowing a quicker, more targeted response if the antigen reappears. **Regulatory** or **suppressor T (T_{reg}) cells** have the opposite function, serving to tone down T cell response to self cells or following an infection.

T cells are a vital component of the immune system. Patients with acquired immunodeficiency syndrome (AIDS) have very low levels of certain types of T cells and as a result are particularly subject to infection because their immune systems are so weakened by this loss.

The following table outlines the most important cells found in the immune system as well as their functions.

Cell Type	Function
Granulocytes	
Basophil	Least common of all the granulocytes (1%); fight parasites; mediate allergic response
Eosinophil	Much less common than neutrophils (5%); fight parasites; mediate allergic response
Neutrophils	Most common of the granulocytes (94%); phagocytic
Monocytes	
Macrophage	Phagocytic; secrete cytokines; present antigens
Dendritic cells	Present antigens; activate immune system
Lymphocytes	
B cells	Produce antigen-specific antibodies
T cells	Helper T (CD4+) cells activate other immune cells; cytotoxic T (CD8+) cells and natural killer T (NKT) cells destroy cells marked for destruction; memory T cells remain after an infection so a response can be mounted more quickly if infected again

Table 10.1

Humoral immunity

B lymphocytes or B cells, like T cells, begin their development in the bone marrow. However, unlike T cells, their development is completed there; they do not travel to other parts of the body to mature.

B cells, when stimulated, create and express **antibodies** (also known as **immunoglobulins**) that have a high affinity for antigens. Immunoglobulins have a very particular structure and utilize the specificity of this structure to aid in the targeted destruction of pathogens.

Several types of immunoglobulins exist within the immune system, and each plays a unique role in immunity. Nevertheless, the structure of all immunoglobulins is relatively consistent and resembles a "Y," with antigen binding sites at either end of the top of the "Y." Each side of the structure consists of two chains, a light chain and a heavy chain, which are held together with disulfide bonds. The variable portion of the structure is the antigen-binding region.

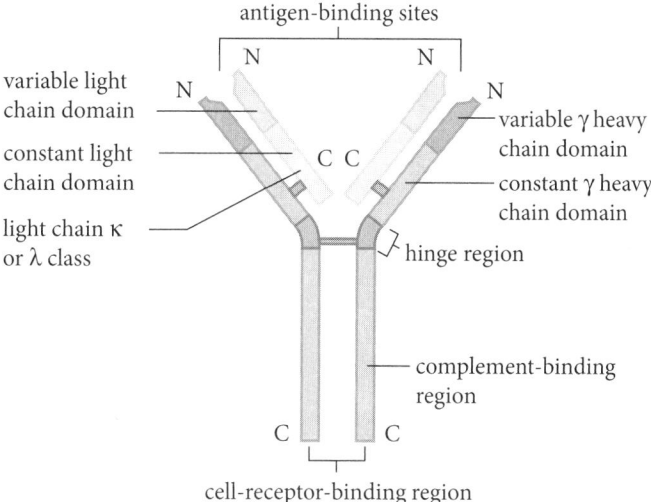

Figure 10.4

The antigen-binding region of the antibody is unique to each antigen and is the reason that specificity for a particular antigen exists. The immune system can generate millions of unique antigen-binding sites, which confers the ability to mount an immune response against any number of antigens. Like T cells, B cells can also stimulate the formation of memory cells.

Humoral immunity includes both active and passive immunity. **Active immunity** occurs as a result of an immune response. This can be due to exposure to a pathogen or antigen, such as during an infection. It can also be the result of **vaccination**, where an individual is deliberately exposed to a weakened, inactivated, or killed form of the antigen. This exposure stimulates the body's immune system to mount an immune response against the antigen presented. The features of this antigen are then stored in the "nonself" memory, allowing the body to mount a similar immune response should the antigen present itself again. This type of immune response, because it requires the development of cells specific to a particular antigen, can take weeks or months to build up.

Passive immunity, in contrast, is acquired by the transfer of antibodies from one individual to another. This can occur during pregnancy, for example, when maternal antibodies cross the placenta and enter fetal circulation. Injections of gamma globulin, which is the fraction of the blood containing antibodies, can also provide passive immunity by transferring antibodies to a particular illness to a given individual. While passive immunity is effective immediately upon transfer of antibodies, once the antibodies are no longer circulating in the immune system, the effect of the immunity is lost.

Innate and acquired immunity work together to protect the host and defend against invading pathogens. Phagocytic cells can stimulate production of specific T lymphocytes to assist in pathogen killing and destruction. T lymphocytes, in turn, can release cytokines, which increase the killing activities of phagocytes. Other examples of this type of cooperation exist, and they work to increase the function and efficacy of the immune system. Chemicals, hormones, and enzymes supplement the action of these cells and serve equally important roles.

Transplant rejection

Transplanted tissues or organs are detected as nonself by the recipient's immune system. This is because the antigens on the donated organ are those of the donor, not of the recipient. As a result, the recipient's immune system attacks the transplanted organ. This attack can lead to rejection of the organ, which can ultimately result in destruction of the organ or death of the patient. As a result, immunosuppressing drugs are used to lower the immune response to transplants and decrease the likelihood of rejection. This, however, also lowers the recipient's overall immune response. The recipient is then referred to as **immunocompromised** because his immune system is not functioning at its full capacity.

Lymphatic System

The **lymphatic system** is another important part of the immune system and is found in the extravascular space of most tissues. **Lymph** flows through the lymphatic vessels from lymph node to lymph node. The **lymph nodes** and **spleen** serve as reservoirs of white blood cells and filters for lymph, removing antigen-presenting cells and foreign matter and activating the immune system when necessary (see Chapter 13).

REVIEW PROBLEMS

1. What is the role of histamine in the immune response?
 A. To induce a fever
 B. To reduce inflammation
 C. To dilate the blood vessels
 D. To recruit immunoglobulin
 E. To increase inflammation

2. Describe the roles of the three types of granulocytes (basophils, eosinophils, and neutrophils) and the two types of monocytes (macrophages and dendritic cells).

3. What type of cell responds to activated MHC II complexes?
 A. Cytotoxic T cell
 B. Helper T cell
 C. Natural killer cell
 D. Plasma cell
 E. B cell

4. Which cells produce a memory-driven response to pathogens?
 A. Neutrophils
 B. Macrophages
 C. Cytokines
 D. B lymphocytes
 E. Basophils

5. Compare and contrast the maturation process of T lymphocytes and B lymphocytes.

6. Differentiate between active and passive immunity and give examples of each.

7. Where is the antigen-binding region found on the immunoglobulin structure?
 A. Heavy chain
 B. Light chain
 C. N-terminus
 D. Cytoplasmic tail
 E. Complement-binding region

SOLUTIONS TO REVIEW PROBLEMS

1. **C** Histamine triggers the inflammatory response and dilates blood vessels, thereby increasing blood flow to an injured area, which increases the number of immune cells that can reach the damaged tissue. In contrast, cytokines trigger the fever response and activate B lymphocytes, which in turn produce immunoglobulin.

2. Neutrophils are the first responders to inflammation and phagocytize pathogens. Eosinophils and basophils are involved in inflammation and the allergic response, and both are involved in combating parasites. Among other actions, basophils specifically stimulate histamine release. Macrophages phagocytize pathogens and dead or damaged cells. Dendritic cells present antigens to allow for a targeted immune response.

3. **B** The major histocompatibility complex (MHC) presents proteins to immune cells. MHC II in particular is found on antigen-presenting cells and B cells and presents to helper T lymphocytes, and these cells then activate other T cells and B cells. Cytotoxic T cells recognize and attack foreign antigens, natural killer cells similarly destroy tumor cells and cells infected with viruses, and plasma cells release large quantities of antibodies, but none of these types of cells interact with MHC.

4. **D** Macrophages are part of the general immune response and do not exert a targeted effect or retain memory of antigens. Cytokines activate B cells but do not themselves possess a memory for antigens. Neutrophils are phagocytic and also do not have a memory for specific antigens. Basophils stimulate histamine due to stimulation of an allergic reaction.

5. Both T lymphocytes and B lymphocytes begin development in the bone marrow. Immature T cells are released into the bloodstream and travel to the thymus. It is in the thymus that T cells complete the maturation process and develop their permanent characteristics. B cells, however, complete their maturation in the bone marrow. When B cells are released from the bone they are mature and ready to undertake their anti-pathogenic activities.

6. Active immunity is due to exposure to an antigen, for example during infection or vaccination. Passive immunity requires the transfer of antibodies from one individual to another, for example from a pregnant woman to her fetus.

7. **C** The heavy chain, light chain, complement-binding region, and cytoplasmic tail are all components of antibody structure, but none of them play a role in binding antigens. It is only the N-terminus that binds to antigens and thus determines the specificity of the antibody.

Nervous System

LEARNING OBJECTIVES

After this chapter, you will be able to:

- Describe the structure, function, and types of neurons
- Relate the organization of the human nervous system
- Identify the structure, function, and disorders of the eye and the ear

The **nervous system** is responsible for controlling most body functions, enabling organisms to receive and respond to **stimuli** from their external and internal environments. Signals from the nervous system travel quickly, reaching in excess of 100 meters per second in some cases, which results in transmission of information much more rapidly than through the endocrine system (see Chapter 16).

The nervous system is composed of both **neurons** (specialized nervous tissue) and **neuroglia** (cells that support and protect the neurons). These cells work together to form the major organs of the nervous system, which include the brain and spinal cord as well as complex sensory organs, such as the eye and ear. In turn, these organs can be grouped into two divisions: the **central nervous system (CNS)** and the **peripheral nervous system (PNS)**.

NEURON

Structure

Neurons are the functional units of the nervous system. Their primary function is to convert stimuli into electrochemical signals and conduct these signals throughout the body. Each neuron is generally an elongated cell consisting of dendrites, a cell body, and an axon (see Figure 11.1). **Dendrites** are cytoplasmic extensions that receive information and transmit it toward the cell body. The **cell body** (soma) contains the nucleus and controls the metabolic activity of the neuron. The **axon** is a long cellular process that transmits impulses, also known as action potentials, away from the cell body. Between the cell body and axon is the **axon hillock**, where the incoming signals (from the dendrites) are summed and, if great enough, trigger an action potential down the axon. The axons terminate in swellings known as **synaptic terminals** (also called boutons or knobs). When an action potential arrives at the synaptic terminal, neurotransmitters are released from these terminals into the **synapse** (or synaptic cleft), which is the gap between the axon terminals of one cell and the dendrites of the next cell. Through these cellular interactions multiple neurons can form systems, which can be as simple as a jellyfish central nervous system or as complex as a human brain.

Most mammalian axons are sheathed by an insulating substance known as **myelin**, which prevents leakage of signal from the axons and allows for faster conduction of impulses. The gaps between segments of myelin, the **nodes of Ranvier**, are where the action potential actually propagates; this occurs through a process known as **saltatory** ("hopping") **conduction**. Myelination is particularly important in neurons with longer axons, as their impulses must travel farther. For instance, the axon of a neuron traveling from the spinal cord to the tip of the foot can be over a meter long and must transmit the action potential along the entire distance to ensure proper function. Myelin itself is produced by glial cells known as **oligodendrocytes** in the central nervous system and by **Schwann cells** in the peripheral nervous system.

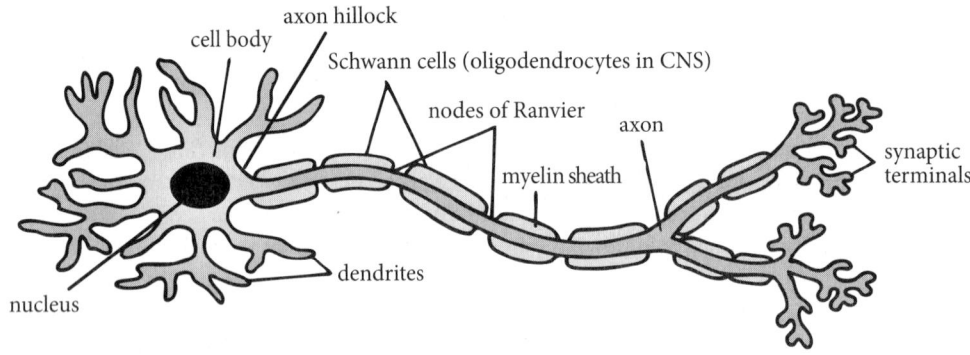

Figure 11.1

Function

The function of neurons is heavily reliant on their structure. Neurons receive information at the dendrites, process information at the axon hillock, and transmit information through the axon. The processing of the information is relatively straightforward: if sufficient depolarization occurs at the axon hillock, then an action potential is triggered down the axon. The action potential is an all or none signal, meaning it either fires or it does not. There are no partial action potentials and therefore no variation in the strength of an action potential. To understand the mechanics of the action potential, the resting potential must be discussed first.

Resting potential

Even at rest, a neuron is **polarized** due to an unequal distribution of ions between the inside and outside of the cell. The potential difference at rest between the extracellular space and the intracellular space is called the **resting potential**. A typical resting membrane potential is –70 millivolts (mV), which means the inside of the neuron is more negative than the outside. This difference is caused by selective ionic permeability of the neuronal cell membrane and is maintained by the active transport of ions by the **Na⁺/K⁺ pump** (also called the Na^+/K^+ ATPase), which pumps 3 Na^+ out of the cell for every 2 K^+ it transports into the cell. This uneven exchange results in one more positive charge leaving the cell than entering it, creating a negative internal environment. Furthermore, the cell membrane is more permeable to K^+ than to Na^+, allowing some of the K^+ that was pumped into the cell to move back out through facilitated diffusion, making the internal environment even more negative.

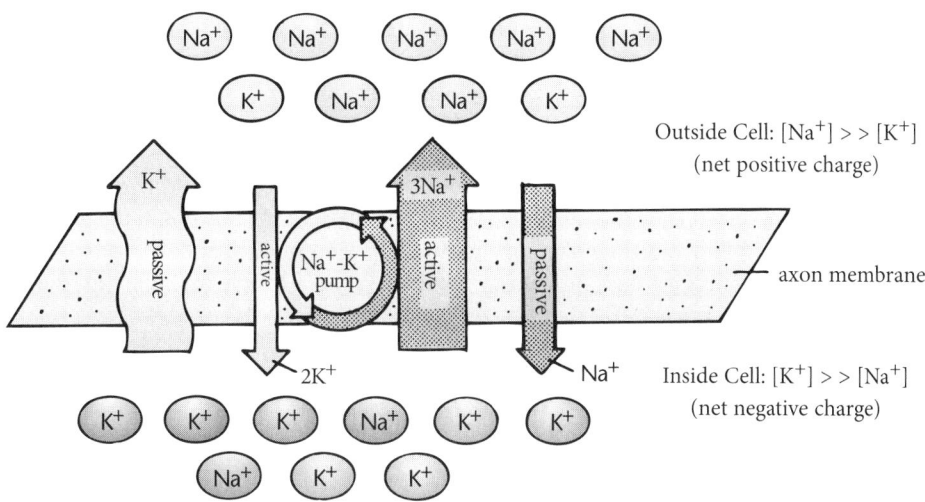

Outside Cell: $[Na^+] >> [K^+]$
(net positive charge)

axon membrane

Inside Cell: $[K^+] >> [Na^+]$
(net negative charge)

Figure 11.2

Action potential

As previously mentioned, the triggering of an action potential occurs at the axon hillock where signals from the dendrites are summed. These signals are actually electrochemical waves of depolarization, which are summed at the axon hillock, thereby shifting the membrane potential from −70 mV to a more positive state. If the membrane potential reaches the **threshold potential** of −55 mV, then **voltage-gated Na⁺ channels** open, triggering the action potential.

The action potential itself can be viewed as three separate phases: **depolarization**, **repolarization**, and **hyperpolarization**. Before jumping into the specifics of these three processes, exploring the etymology (word meaning) of these words can clarify the overarching concepts of the action potential. The term polarized means to separate, and, in the context of the neuron, it means to separate charges. The resting potential is −70 mV, which represents a separation of charge (negative interior, positive exterior); therefore, the resting potential is a polarized state. Depolarization means to lose this separation of charge; thus, after depolarization, membrane potential should be closer to 0 mV. In actuality, the membrane potential after depolarization is +35 mV. The term repolarization states that the charges should be re-separated during this process, and they are. After repolarization, the membrane potential is back to its original resting potential (−70 mV). Finally, hyperpolarization means to over-polarize the membrane. During hyperpolarization the membrane potential can range between −70 and −75 mV.

Depolarization, repolarization, and hyperpolarization

Depolarization occurs when a cell reaches threshold potential and voltage-gated Na⁺ channels open allowing the influx of Na⁺ into the neuron. The result of this influx is that the cell membrane potential reaches +35 mV and the cell is said to be depolarized.

At the peak potential of +35 mV, voltage-gated K$^+$ channels open. Since there is a high intracellular concentration of K$^+$, the opening of K$^+$ channels allows for the efflux (leaving) of K$^+$ down its concentration gradient. This efflux of positive charges is termed **repolarization** and results in the membrane potential decreasing to a negative value, thus repolarizing the membrane.

However, the opening and closing of K$^+$ is a slow process and, as a result, the efflux of K$^+$ causes the cell membrane to decrease to below the resting potential (<-70 mV). At this point, the cell is said to be **hyperpolarized**. This results in the **refractory period**: a period of time after the action potential in which new action potentials are very difficult to initiate. Within a couple milliseconds, the resting potential is reestablished by the Na$^+$/K$^+$ ATPase and Na$^+$ and K$^+$ leaky channels.

Figure 11.3

Notice that the values in Figure 11.3 are very specific: −70 mV, −55 mV, and +35 mV. In each and every action potential, for each and every neuron, these values are the same. Therefore, there is no variation in the "strength" of action potentials. Instead, stimulus intensity is coded by the frequency of action potentials and not their magnitude.

Impulse propagation

The propagation of the action potential along an axon relies on diffusion. To be clear, the process described in Figure 11.3 occurs at one segment of the axon over a short period of time. During depolarization, the influxed Na$^+$ diffuses and depolarizes its neighboring segment of the membrane, triggering subsequent voltage-gated Na$^+$ channels. This results in the action potential being renewed and continuing its propagation. Although axons can theoretically propagate action potentials bidirectionally, information transfer will occur only in one direction: from cell body to synaptic terminal. This is because synapses operate only in one direction and because refractory periods make the backward travel of action potentials impossible.

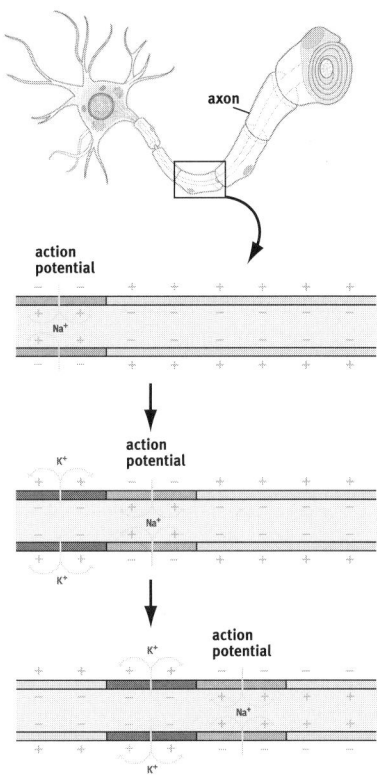

Figure 11.4

Conduction velocity of action potentials

Although all action potentials obey the all or none principle, different axons do propagate action potentials at different speeds. The greater the diameter of the axon and the greater its myelination, the faster the impulses travel. Larger diameter axons have a greater cross-sectional area and therefore provide less resistance to the diffusion of ions (Na^+ in particular). A classic example are giant squids: their reaction times are much quicker than that of humans due to their relative neuronal diameter, despite their large size and the fact that their action potentials must travel farther. The second factor affecting transmission speeds is myelination. Myelin increases the conduction velocity by insulating segments of the axon such that the membrane is permeable to ions only in the nodes of Ranvier. In this way, the action potential "hops" from node to node. Classic examples of myelinated and unmyelinated axons are white matter and grey matter of the brain. White matter has faster transmission times due to heavy myelination and is therefore used to transmit information across larger distances. Grey matter has slower transmission times due to less myelination and is used for processing information.

Synapse

The synapse is the gap between the axon terminal of one neuron (the **presynaptic neuron**) and the dendrites of the next neuron (the **postsynaptic neuron**). Neurons may also communicate with postsynaptic cells other than neurons, such as cells in muscles or glands; these are called **effector cells**.

The axon terminal contains thousands of membrane-bound vesicles full of chemical messengers known as **neurotransmitters**. When the action potential arrives at the axon terminal and depolarizes it, the synaptic vesicles fuse with the presynaptic membrane and release neurotransmitter into the synapse. The neurotransmitter diffuses across the synapse and acts on receptor proteins embedded in the postsynaptic membrane. The released neurotransmitter will lead to depolarization of the postsynaptic cell and consequent firing of an action potential.

Neurotransmitter is removed from the synapse in a variety of ways: it may be taken back up into the nerve terminal (via a protein known as an uptake carrier) where it may be reused or degraded; it may be degraded by enzymes located in the synapse (e.g., acetylcholinesterase inactivates the neurotransmitter acetylcholine); or it may simply diffuse out of the synapse.

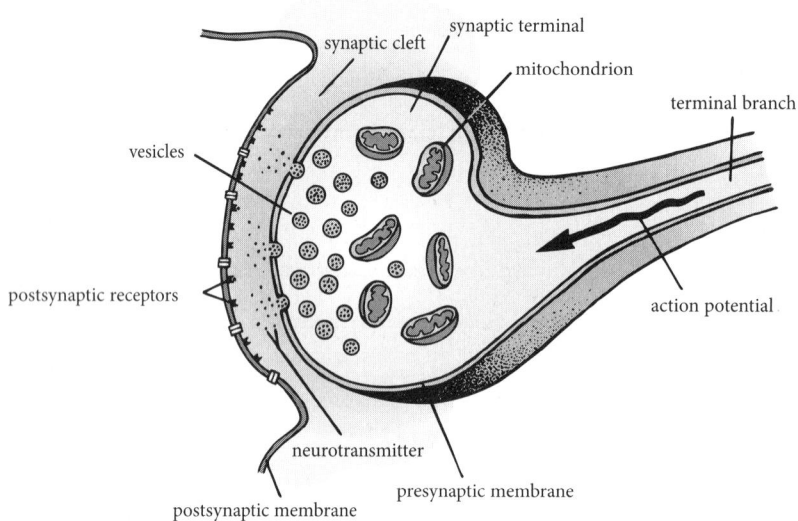

Figure 11.5

Neuron Types

Although their general characteristics remain the same, neurons can become specialized to perform specific tasks. Neurons that carry **sensory** information about the external or internal environment to the brain or spinal cord are called **afferent neurons**. Neurons that carry **motor** commands from the brain or spinal cord to various parts of the body (e.g., muscles or glands) are called **efferent neurons**. Some neurons (**interneurons**) participate only in local circuits, linking sensory and motor neurons in the brain and spinal cord; their cell bodies and their nerve terminals are in the same location.

Nerves are essentially bundles of axons covered with connective tissue. A network of nerve fibers is called a **plexus**. Neuronal cell bodies often cluster together: such clusters are called **ganglia** in the periphery; in the central nervous system, they are called **nuclei**.

Neuroglia

In addition to neurons, the nervous system contains neuroglia, which support and protect the specialized neuronal cells. The four major types of neuroglial cells in the central nervous system (CNS) and two major cell types in the peripheral nervous system (PNS) are summarized in Table 11.1.

Cells in the CNS and PNS	
Cell Type	**Cell Function**
CNS	
Astrocytes	Maintain the integrity of the blood–brain barrier, regulate nutrient and dissolved gas concentrations, and absorb and recycle neurotransmitters
Oligodendrocytes	Myelinate CNS axons as well as provide structural framework for the CNS
Microglia	Remove cellular debris and pathogens
Ependymal cells	Line the brain ventricles and aid in the production, circulation, and monitoring of cerebral spinal fluid
PNS	
Satellite cells	Surround the neuron cell bodies in the ganglia
Schwann cells	Enclose the axons in the PNS and aid in the myelination of some peripheral axons

Table 11.1

ORGANIZATION OF THE NERVOUS SYSTEM

The human nervous system can be viewed as having several different divisions, each with unique properties and functions:

Figure 11.6

Central Nervous System

The central nervous system (CNS) consists of the brain and spinal cord.

Brain

The brain is a mass of neurons that resides in the skull. Its functions include interpreting sensory information, forming motor plans, and cognitive function (thinking). The brain consists of an outer portion of cell bodies called the **gray matter** and an inner portion of myelinated axons called the **white matter**. The brain also can be divided into the forebrain, midbrain, and hindbrain.

Forebrain (Prosencephalon)

- The **forebrain** consists of the **telencephalon** and the **diencephalon**. A major component of the telencephalon is the **cerebral cortex**, which is the highly convoluted gray matter that can be seen on the surface of the brain. The cortex processes and integrates sensory input and motor responses and is important for memory and creative thought. The telencephalon also includes the **olfactory bulb**, the center for reception and integration of olfactory (smell-related) input.

- The diencephalon contains the thalamus and hypothalamus. The **thalamus** is a relay and integration center for the spinal cord and cerebral cortex. The **hypothalamus** controls visceral functions such as hunger, thirst, sex drive, water balance, blood pressure, and temperature regulation. It also plays an important role in the control of the endocrine system.

Midbrain (Mesencephalon)

- The **midbrain** is a relay center for visual and auditory impulses. It also plays an important role in motor control.

Hindbrain (Rhombencephalon)

- The **hindbrain** is the posterior part of the brain and consists of the cerebellum, the pons, and the medulla. The **cerebellum** helps to modulate motor impulses initiated by the cerebral cortex and is important in the maintenance of balance, hand-eye coordination, and the timing of rapid movements. One function of the **pons** is to act as a relay center to allow the cortex to communicate with the cerebellum. The **medulla** (also called the medulla oblongata) controls many vital functions such as breathing, heart rate, and gastrointestinal activity. Together, the midbrain, pons, and medulla constitute the **brainstem**.

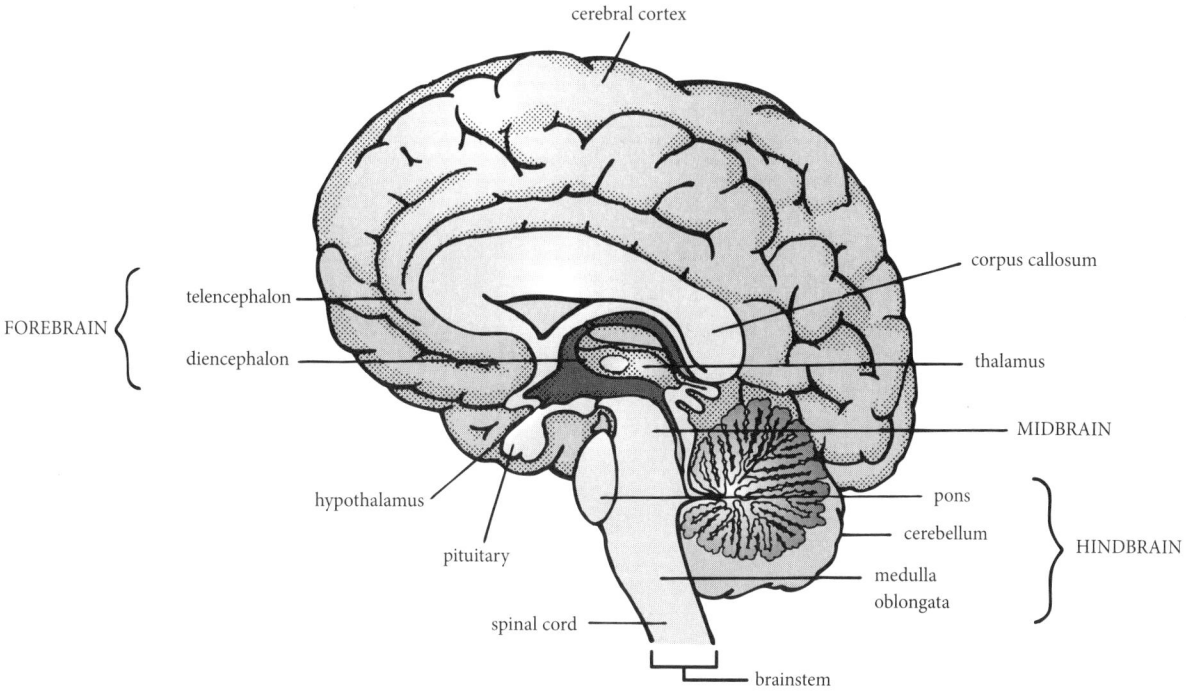

Figure 11.7

Spinal cord

The spinal cord is an elongated extension of the brain that acts as the conduit for sensory information to the brain and motor information from the brain. The spinal cord can also integrate simple motor responses (i.e., **reflexes**) by itself. A cross-section of the spinal cord reveals an outer white matter area containing motor and sensory axons and an inner gray matter area containing nerve cell bodies. Sensory information enters the spinal cord through the **dorsal horn**; the cell bodies of these sensory neurons are located in the dorsal root ganglia. All motor information exits the spinal cord through the **ventral horn**. For simple reflexes like the knee-jerk reflex, sensory fibers (entering through the dorsal root ganglion) synapse directly on ventral horn motor fibers. Other reflexes include interneurons between the sensory and motor fibers that allow for some processing in the spinal cord.

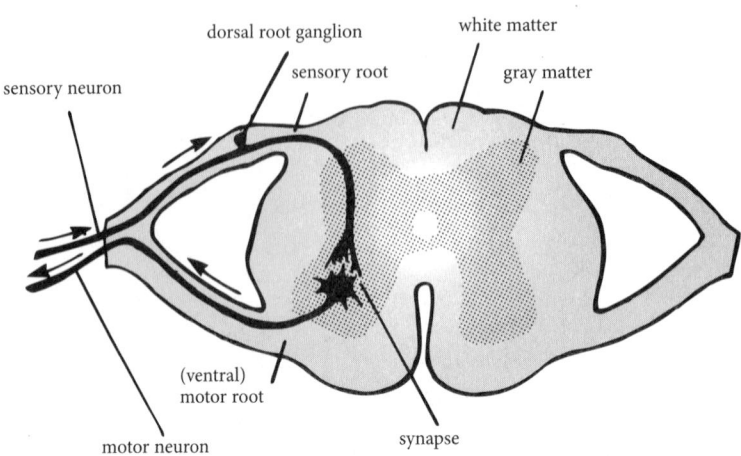

Figure 11.8

Peripheral Nervous System

The peripheral nervous system (PNS) consists of nerves and ganglia. The sensory nerves that enter the CNS and the motor nerves that leave the CNS are part of the peripheral nervous system. The PNS has two primary divisions: the **somatic** and the **autonomic** nervous systems, each of which has both motor and sensory components.

Somatic nervous system

The somatic nervous system (SNS) innervates skeletal muscles and is responsible for voluntary movement as well as reflex arcs (pathways that control motor reflexes).

Autonomic nervous system

The autonomic nervous system (ANS) is sometimes also called the **involuntary nervous system** because it regulates the body's internal environment without the aid of conscious control. The autonomic innervation of the body includes both sensory and motor fibers. The ANS innervates cardiac and smooth muscle. Smooth muscle is located in areas such as blood vessels, the digestive tract, the bladder, and bronchi (see Chapter 13), so the ANS is important in blood pressure control, gastrointestinal motility, excretion, respiration, and reproduction. The ANS is comprised of two subdivisions, the **sympathetic** and the **parasympathetic** nervous systems, which generally act in opposition to one another.

- **Sympathetic nervous system:** The sympathetic division is responsible for the "**flight or fight**" responses that ready the body for action in an emergency situation. It increases blood pressure and heart rate, increases blood flow to skeletal muscles, and decreases gut motility. It also dilates the bronchioles to increase gas exchange. The sympathetic nervous system uses **norepinephrine** as its primary neurotransmitter.

- **Parasympathetic nervous system:** The parasympathetic division acts to conserve energy and restore the body to resting activity levels after exertion ("**rest and digest**"). It acts to lower heart rate and increase gut motility. One very important parasympathetic nerve that innervates many of the thoracic and abdominal viscera is called the **vagus nerve**. It uses **acetylcholine** as its primary neurotransmitter.

Below is a summary table that lists the major functions of the parasympathetic and sympathetic nervous systems.

Comparison of Sympathetic and Parasympathetic Autonomic Functions		
Organ	**Sympathetic Effect**	**Parasympathetic Effect**
Lens	n/a	Accommodation
Iris	Dilates pupil	Constricts pupil
Salivary glands	Vasoconstriction	Secretion
Sweat glands	Secretion (specific)	Secretion (generalized)
Heart (force and rate)	Increases	Decreases
Peripheral blood vessels	Constriction	Dilation
Visceral blood vessels	Constriction	Dilation
Lungs	Bronchodilation	Bronchoconstriction
Gastrointestinal tract	Decreases peristalsis and secretion	Increases peristalsis and secretion
Rectum and anus	Inhibits smooth muscle in rectum and constricts sphincter	Increases smooth muscle tone and relaxes sphincter
Adrenal medulla	secretion	n/a
Bladder	Relaxation of the detrusor muscle and constriction of internal sphincter	Contraction of the detrusor muscle and inhibition of internal sphincter
Genitalia	Ejaculation	Penile erection / engorgement of clitoris and labia

Table 11.2

SPECIAL SENSES

The human body has a number of organs that are specialized receptors adapted to detect stimuli.

The Eye

The eye detects light energy (photons) and transmits information about intensity, color, and shape to the brain. The eyeball is covered by a thick, opaque layer known as the **sclera**, which is also known as the white of the eye. Beneath the sclera is the **choroid** layer, which helps to supply the retina with blood. The choroid is a dark, pigmented area that reduces reflection in the eye. The innermost layer of the eye is the **retina**, which contains the **photoreceptors** that sense light.

The transparent **cornea** at the front of the eye bends and focuses light rays. The rays then travel through an opening called the **pupil**, whose diameter is controlled by the pigmented, muscular **iris**. The iris responds to the intensity of light in the surroundings (light makes the pupil constrict). The light continues through the lens, which is suspended behind the pupil. The **lens**, the shape and focal length of which is controlled by the **ciliary muscles**, focuses the image onto the retina.

The eye also contains a jelly-like material called the **vitreous humor** that helps maintain its shape and optical properties. The **aqueous humor** is a more watery substance that fills the space between the lens and the cornea.

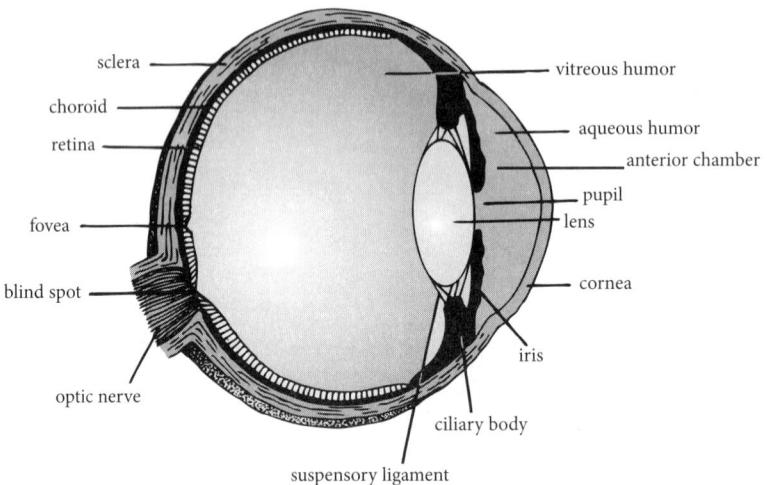

Figure 11.9

In the retina are **photoreceptors** that transduce light into action potentials. The two main types of photoreceptors are cones and rods. **Cones** respond to high-intensity illumination and are sensitive to color, whereas **rods** detect low-intensity illumination and are important in night vision. Cones and rods contain various pigments that absorb specific wavelengths of light. Cones contain three different pigments that absorb red, green, and blue wavelengths; the rod pigment, **rhodopsin**, only absorbs a single wavelength. While there are many more rods than cones in the human eye, the central section of the retina, called the **macula**, has a high concentration of cones. In fact, its centermost point, called the **fovea**, contains only cones. As one moves further away from the fovea, the concentration of rods increases while the concentration of cones decreases. Thus, visual acuity is best at the fovea.

The visual information gathered from the cones and rods must be transmitted to the brain's visual cortex for processing. In fact, processing of the visual stimulus begins in the eye itself. This process begins when the photoreceptor cells (which are a subtype of neuron) generate an action potential in response to light stimuli. The photoreceptor cells synapse onto **bipolar cells**, which in turn synapse onto **ganglion cells**, which group together to form the **optic nerve**, which transmits the visual information to the brain. While not directly in the visual pathway, **amacrine** and **horizontal cells**, also receive stimuli information from photoreceptors and process the information as well (see Figure 11.10).

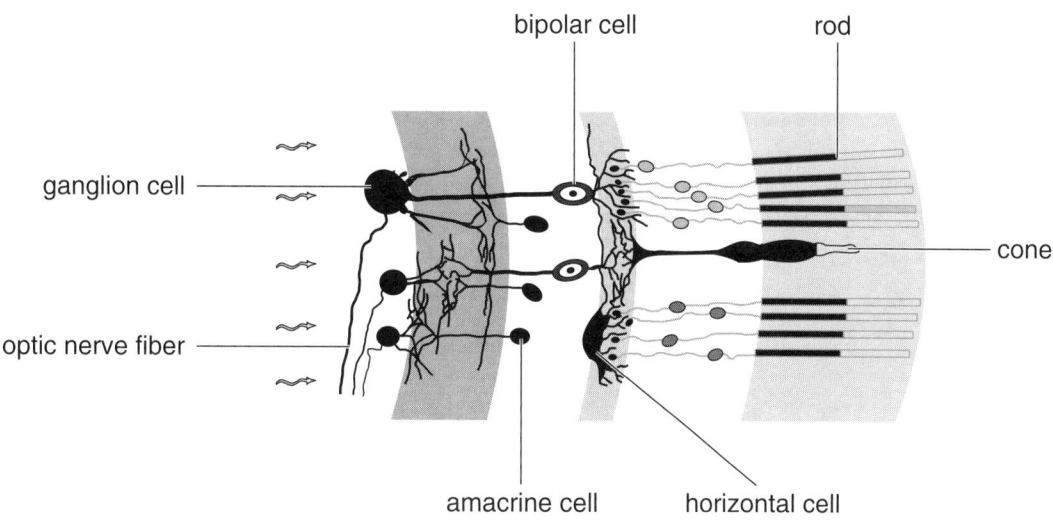

Figure 11.10

Disorders of the eye

- **Myopia (nearsightedness)** occurs when the image is focused in front of the retina.
- **Hyperopia (farsightedness)** occurs when the image is focused behind the retina.
- **Astigmatism** is caused by an irregularly shaped cornea.
- **Cataracts** develop when the lens becomes opaque; light cannot enter the eye, and blindness results.
- **Glaucoma** is an increase of pressure in the eye because of blocking of the outflow of the aqueous humor, which results in optic nerve damage.

THE EAR

The ear is divided into three parts: the outer, middle, and inner ear. **Sound**, which is vibration in the air/medium, is transmitted through this system. A sound wave first reaches the cartilaginous **pinna** (sometimes called **auricle**), the visible part of the ear. Here, sound is channeled into the **external auditory canal**, which focuses the sound wave toward the tympanic membrane (**eardrum**) located at the end of the external auditory canal. The tympanic membrane vibrates with the frequency and magnitude of the incoming soundwave, thereby transferring the vibrational energy from the air to itself.

The tympanic membrane is the boundary between the outer and **middle ear**. The middle ear contains three bones: the **malleus (hammer)**, **incus (anvil)**, and **stapes (stirrup)**. These bones are collectively called **ossicles**. The ossicles vibrate with the same frequency as the tympanic membrane and transfer the energy to another membrane, the **oval window**. The oval window is much smaller than the tympanic membrane; thus the transfer of energy between the two membranes amplifies the vibrations.

BIO

The inner ear, which begins after the oval window, contains **cochlea** and **vestibule**. The vibration of the oval window pushes against fluid (**perilymph**), resulting in pressure waves that travel through the fluid-filled cochlea. These pressure waves are detected by **hair cells**, which transform mechanical stimuli into action potentials that travel down the **auditory nerve**. The auditory nerve follows the auditory pathway until it reaches the **auditory cortex**, which is responsible for the processing of auditory information. The inner ear also contains the vestibule, which is a fluid-filled structure responsible for balance and acceleration detection of the organism.

Figure 11.11

REVIEW PROBLEMS

1. Which of the following statements best characterizes an axon?

 A. It is a long, slender process that fires every time neurotransmitters bind to the postsynaptic membrane.

 B. It transmits nonelectrical impulses.

 C. It transmits information from the cell body to the axon terminals.

 D. It releases neurotransmitter at the synaptic cleft.

 E. None of the above

2. Resting membrane potential is NOT dependent on

 A. the differential distribution of ions across the axon membrane.

 B. active transport.

 C. selective permeability.

 D. passive diffusion.

 E. pinocytosis.

3. All of the following are associated with the myelin sheath EXCEPT

 A. faster conduction of nervous impulses.

 B. nodes of Ranvier forming gaps along the axon.

 C. increased energy output for nervous impulse conduction.

 D. saltatory conduction of action potentials.

 E. insulation of axon segments.

4. The all-or-none law states that

 A. all hyperpolarizing stimuli will be carried to the axon terminal without a decrease in size.

 B. the size of the action potential is proportional to the size of the stimulus that produced it.

 C. increasing the intensity of the depolarization increases the size of the impulse.

 D. once an action potential is triggered, an impulse of a given magnitude and speed is produced.

 E. the greater the depolarization, the greater the impulse.

5. Discuss two major differences between the somatic and the autonomic divisions of the peripheral nervous system.

6. By increasing the intensity of the stimulus, the action potential will

 A. increase in amplitude.

 B. increase in frequency.

 C. increase in speed.

 D. increase in wavelength.

 E. increase in period.

BIO

7. Which of the following pairings is correct?

 A. Sensory nerves–Afferent
 B. Motor nerves–Afferent
 C. Sensory nerves–Efferent
 D. Sensory nerves–Ventral
 E. Motor nerves–Ventral

8. When a sensory receptor receives a threshold stimulus, it will do all of the following EXCEPT

 A. become depolarized.
 B. transduce the stimulus to an action potential.
 C. inhibit the spread of the action potential to sensory neurons.
 D. cause the sensory neuron to send action potentials to the central nervous system.
 E. have a more positive charge.

9. Which of the following structures is most important for focusing light on the retina?

 A. Cornea
 B. Aqueous humor
 C. Vitreous humor
 D. Sclera
 E. Lens

10. When the potential across the axon membrane is more negative than the normal resting potential, the neuron is said to be in a state of

 A. depolarization.
 B. hyperpolarization.
 C. repolarization.
 D. refraction.
 E. hypopolarization

11. Chemical X is found to denature all enzymes in the synaptic cleft. What are the effects on acetylcholine if chemical X is added to the cleft?

 A. Acetylcholine is not released from the presynaptic membrane.
 B. Acetylcholine does not bind to the postsynaptic membrane.
 C. Acetylcholine is not inactivated in the synaptic cleft.
 D. Acetylcholine is degraded before it acts on the postsynaptic membrane.
 E. Acetylcholine cannot be taken up into the axon terminal.

12. Which of the following statements concerning the somatic division of the peripheral nervous system is INCORRECT?

 A. Its pathways innervate skeletal muscles.
 B. Its pathways are usually voluntary.
 C. Some of its pathways are referred to as reflex arcs.
 D. It includes the vagus nerve.
 E. It controls motor reflexes.

13. In the ear, what structure transduces pressure waves to action potentials?

 A. Tympanic membrane
 B. Hair cells
 C. Oval window
 D. Semicircular canals
 E. Hammer, anvil, and stirrup

SOLUTIONS TO REVIEW PROBLEMS

1. **C** Axons carry information from the cell body of the neuron to the axon terminal by way of action potentials. From there, the impulse is transmitted to another neuron or to an effector. However, the axon does not fire unless the impulse is strong enough to depolarize the axon membrane to the threshold membrane potential.

2. **E** Resting membrane potential is a result of an unequal distribution of ions between the inside and the outside of the cell, and of all the other facets of cell structure listed. It is NOT dependent on pinocytosis, als known as "cellular drinking," which is a form of endocytosis by which the cell engulfs a portion of the extracellular fluid; this process requires much more ATP and would not be energetically efficient.

3. **C** Discussed in impulse propagation section of this chapter.

4. **D** Discussed in action potential section of this chapter.

5. First, the somatic nervous system regulates voluntary actions (except in the cases of monosynaptic and polysynaptic reflexes), whereas the autonomic nervous system regulates involuntary actions. Second, the somatic nervous system innervates skeletal muscle, whereas the autonomic nervous system innervates cardiac and smooth muscle.

6. **B** Discussed in action potential section of this chapter.

7. **A** Discussed in vertebrate nervous system section of this chapter.

8. **C** Discussed in vertebrate nervous system section of this chapter.

9. **E** Discussed in special senses section of this chapter.

10. **B** When the neuron goes past the resting potential and becomes even more negative inside than normal, this is termed hyperpolarization.

11. **C** Acetylcholine is inactivated in the synaptic cleft by the enzyme acetycholinesterase after it has acted upon the postsynaptic membrane. If chemical X denatures acetylcholinesterase, acetylcholinesterase will not be able to inactivate acetylcholine and prevent the continuous depolarization of the effector membrane.

12. **D** Discussed in peripheral nervous system section of this chapter.

13. **B** Discussed in special senses section of this chapter.

CHAPTER TWELVE

Muscular and Skeletal Systems

LEARNING OBJECTIVES

After this chapter, you will be able to:

- Describe the structural features and organization of the skeletal system
- Compare and contrast components of the muscular system

The musculoskeletal system forms the basic internal framework of the vertebrate body. Muscles and bones work in close coordination to produce voluntary movement. In addition, bone and muscle perform a number of other independent functions. Physical support and locomotion are the functions of animal skeletal systems, while the muscular system generates force.

SKELETAL SYSTEM

An endoskeleton serves as the framework within all vertebrate organisms. Muscles are attached to the bones, permitting movement. The endoskeleton also provides protection by surrounding delicate internal organs with bone. The rib cage protects the thoracic organs (heart and lungs), whereas the skull and vertebral column protect the brain and spinal cord. The two major components of the skeleton are cartilage and bone.

Structure of the Skeleton

Cartilage

Cartilage is a type of connective tissue that is softer and more flexible than bone. Cartilage is retained in adults in places where firmness and flexibility are needed. For example, in humans, the external ear, nose, walls of the larynx and trachea, and skeletal joints contain cartilage. **Chrondrocytes** are cells responsible for synthesizing cartilage.

Bone

Bone is a specialized type of mineralized connective tissue that has the ability to withstand physical stress. Ideally adapted for body support, bone tissue is hard and strong while at the same time somewhat elastic and lightweight. There are two basic types of bone: compact bone and spongy bone.

1. **Compact bone** is dense bone that does not appear to have any cavities when observed with the naked eye and makes up 80% of the skeleton. The bony matrix is deposited in structural units called **osteons** (Haversian systems). Each osteon consists of a central microscopic channel called a **Haversian canal**, surrounded by a number of concentric circles of bony matrix (calcium phosphate) called **lamellae**.

2. **Spongy bone,** which can be found at the ends of long bones, in the pelvic bones, skull, and vertebra, is much less dense and consists of an interconnecting lattice of bony **spicules** (trabeculae); the cavities between the spicules are filled with yellow or red bone marrow. **Yellow marrow** is inactive and infiltrated by adipose tissue; **red marrow** is involved in blood cell formation.

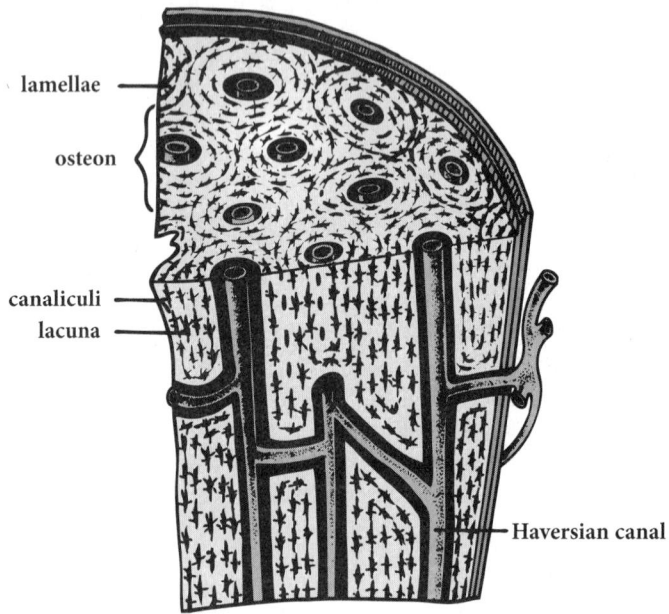

lamellae

osteon

canaliculi

lacuna

Haversian canal

Figure 12.1

Osteocytes

Two types of cells found in bone tissue are osteoblasts and osteoclasts. **Osteoblasts** synthesize and secrete the organic constituents of the bone matrix; once they have become surrounded by their matrix, they mature into osteocytes. **Osteoclasts** are large, multinucleated cells involved in bone reabsorption, wherein bone is broken down and minerals (namely Ca^{2+}) are released into the blood.

Bone formation

Bone formation occurs by either endochondral ossification or by intramembranous ossification. In **endochondral ossification**, existing cartilage is replaced by bone. Long bones arise primarily through endochondral ossification. In **intramembranous ossification**, mesenchymal (embryonic or undifferentiated) connective tissue is transformed into and replaced by bone. Both processes are essential to fetal development of the skeletal system in mammals.

Organization of the Skeleton

The **axial** skeleton is the basic framework of the body, consisting of the skull, vertebral column, and rib cage. It is the point of attachment of the **appendicular** skeleton, which includes the bones of the appendages (limbs) and the pectoral and pelvic girdles.

Bones are held together in a number of ways. Sutures or immovable joints hold the bones of the skull together. Bones that move relative to one another are held together by movable joints and are additionally supported and strengthened by ligaments. Ligaments serve as bone-to-bone connectors. Tendons attach skeletal muscle to bones and bend the skeleton at the movable joints.

The point of attachment of a muscle to a stationary bone (proximal end in limb muscles) is called the **origin**. The point of attachment of a muscle to the bone that moves (distal end in limb muscles) is called the **insertion**. **Extension** indicates a straightening of a joint, whereas **flexion** refers to a bending of a joint. Extension and flexion require the contraction of **antagonist** muscles.

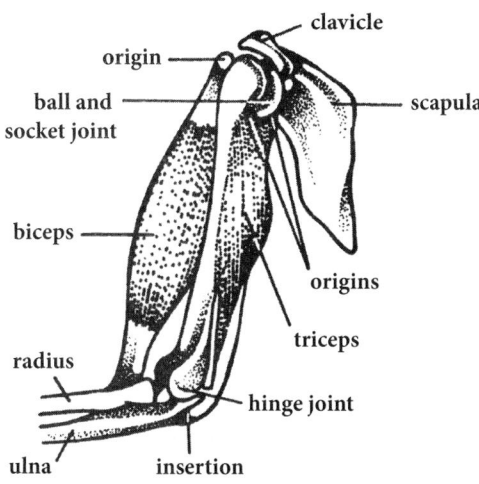

Figure 12.2

Some non-human vertebrates have special adaptations to their skeleton that make them particularly suited to their environment. For example, birds have bones that are fused and hollow so they are lightweight and allow for flight.

MUSCULAR SYSTEM

Muscle tissue consists of bundles of specialized contractile fibers held together by connective tissue. There are three morphologically and functionally distinct types of muscle in mammals: skeletal muscle, smooth muscle, and cardiac muscle.

Nervous control of the muscular system involves the axons of the pyramidal cells of the motor cortex, which descend from the brain to synapse on lower motor neurons in the brain stem and spinal cord. Because there are no intervening synapses, the **pyramidal system** is able to provide rapid commands to the skeletal muscles and various other organs. Several other centers can issue somatic motor commands as a result of processing performed at the unconscious, involuntary level. These centers and their associated tracts comprise the **extrapyramidal system**. The red nucleus, located in the mesencephalon, is the component of the extrapyramidal system primarily in control of skeletal muscle tone.

Skeletal Muscle

Skeletal muscle is responsible for voluntary movements and is innervated by the somatic nervous system. Each fiber is a multinucleated cell created by the fusion of several mononucleated embryonic cells. Embedded in the fibers are filaments called **myofibrils**, which are further divided into contractile units called **sarcomeres**. The myofibrils are enveloped by a modified endoplasmic reticulum that stores calcium ions and is called the **sarcoplasmic reticulum**. The cytoplasm of a muscle fiber is called sarcoplasm, and the cell membrane is called the sarcolemma. The **sarcolemma** is capable of propagating an action potential and is connected to a system of transverse tubules (T system) oriented perpendicularly to the myofibrils. The **T system** provides channels for ion flow throughout the muscle fibers and can also propagate an action potential. Because of the high-energy requirements of contraction, mitochondria are very abundant in muscle cells and are distributed along the myofibrils. Skeletal muscle has striations of light and dark bands and is therefore also referred to as **striated muscle**.

Figure 12.3

Sarcomeres

The sarcomere is composed of thin and thick filaments. The thin filaments are chains of actin molecules. The thick filaments are composed of organized bundles of myosin molecules.

Electron microscopy reveals that the sarcomere is organized as follows: **Z lines** define the boundaries of a single sarcomere and anchor the thin filaments. The **M line** runs down the center of the sarcomere. The **I band** is the region containing thin filaments only. The **H zone** is the region containing thick filaments only. The **A band** spans the entire length of the thick filaments and any overlapping portions of the thin filaments. When the muscles contract, the Z lines move toward each other. Note that during contraction, the A band is not reduced in size, whereas the H zone and I band are.

MNEMONIC

To remember which is the thin and thick filament, remember acthin: actin filaments are thin (while myosin filaments are thick).

Figure 12.4

MNEMONIC

- Z is the end of the alphabet and, therefore, the end of your sarcomeres.
- M is the middle and is attached to the mighty myosin filaments.
- I is the thinest letter so the I band has only thin filament.
- H (zone) is a thick letter and has only thick filaments.
- The A band is an in between sized letter and the A band includes the overlap of thick and thin.

Contraction

Muscle contraction is stimulated by a message from the somatic nervous system sent via a motor neuron. The link between the nerve terminal (synaptic bouton) and the sarcolemma of the muscle fiber is called the **neuromuscular junction**. The space between the two is known as the synapse, or synaptic cleft. Depolarization of the motor neuron results in the release of neurotransmitters (e.g., acetylcholine) from the nerve terminal. The neurotransmitter diffuses across the synaptic cleft and binds to special receptor sites on the sarcolemma. If enough of these receptors are stimulated, the permeability of the sarcolemma is altered and an action potential is generated.

Once an action potential is generated, it is conducted along the sarcolemma and the T system and into the interior of the muscle fiber. This causes the sarcoplasmic reticulum to release calcium ions into the sarcoplasm. Calcium ions initiate the contraction of the sarcomere by binding to troponin C on the actin filaments. Allosteric changes occur in the proteins that allow myosin heads to bind to these sites on the actin. Use of energy allows a power stroke to occur, pulling the Z bands closer together. Actin and myosin slide past each other, and the sarcomere contracts.

An interesting point is that several hours after death, all of the muscles in the body go into a state of **rigor mortis**. In this condition, the muscles contract and become rigid, even without action potentials. The rigidity is caused by an absence of adenosine triphosphate (ATP), which is required for the myosin heads to be released from the actin filaments. The muscles typically remain rigid for 12 to 24 hours after death until the muscle proteins degrade.

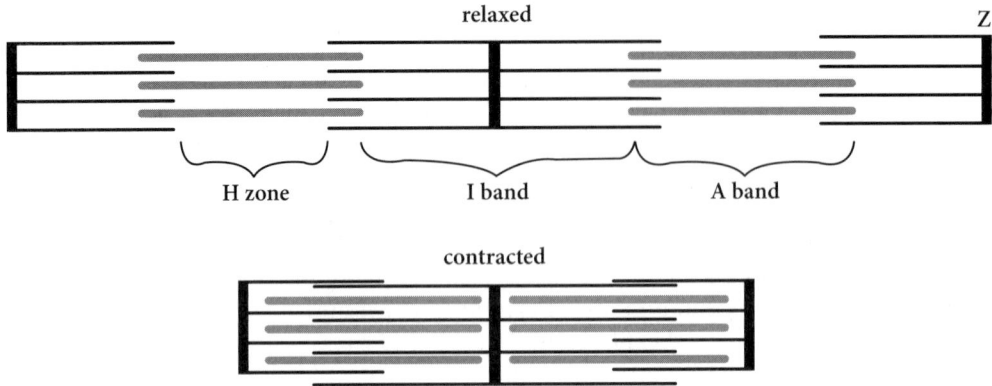

Figure 12.5

Stimulus and muscle response

Individual muscle fibers generally exhibit an all-or-none response; only a stimulus above a minimal value, called the threshold value, can elicit a contraction. The strength of the contraction of a single muscle fiber cannot be increased, regardless of the strength of the stimulus. However, the strength of contraction of the entire muscle can be increased by recruiting more muscle fibers. The different types of muscle responses are summarized as follows:

- A **simple twitch** is the response of a single muscle fiber to a brief stimulus at or above the threshold stimulus and consists of a latent period, a contraction period, and a relaxation period. The latent period is the time between stimulation and the onset of contraction. During this time lag, the action potential spreads along the sarcolemma, and Ca^{2+} ions are released. After the contraction period, there is a brief relaxation period during which the muscle is unresponsive to a stimulus; this period is known as the **absolute refractory period**.

- When the fibers of a muscle are exposed to very frequent stimuli, the muscle cannot fully relax. The contractions begin to combine, becoming stronger and more prolonged. This is known as **temporal summation**. The contractions become continuous when the stimuli are so frequent that the muscle cannot relax. This type of contraction is known as **tetanus** and is stronger than a simple twitch of a single fiber. If tetanus is maintained, the muscle will fatigue, and the contraction will weaken.

Figure 12.6

- **Tonus** is a state of partial contraction. Muscles are never completely relaxed and maintain a partially contracted state at all times.

During periods of strenuous activity, skeletal muscles convert glucose to pyruvic acid through the process of glycolysis. This process enables skeletal muscles to continue contracting even in the absence of oxygen. Lactic acid is generated when pyruvic acid reacts with the enzyme lactate dehydrogenase. This process allows the pyruvate to enter the citric acid (or Krebs) cycle.

Smooth Muscle

Smooth muscle is responsible for involuntary actions and is innervated by the autonomic nervous system. Smooth muscle is found in the digestive tract, bladder, uterus, and blood vessel walls, among other places. Smooth muscle cells possess one centrally located nucleus and lack the striations of skeletal muscle.

Cardiac Muscle

The muscle tissue of the heart is composed of cardiac muscle fibers. These fibers possess characteristics of both skeletal and smooth muscle fibers. As in skeletal muscle, actin and myosin filaments are arranged in sarcomeres, giving cardiac muscle a striated appearance. However, cardiac muscle cells generally have only one or two centrally located nuclei.

Comparison of Different Muscle Types		
Smooth Muscle	**Cardiac Muscle**	**Skeletal Muscle**
• Nonstriated • One nucleus per cell • Involuntary/autonomic nervous system • Smooth, continuous contractions	• Striated • One to two nuclei per cell • Involuntary/autonomic nervous system • Strong, forceful contractions	• Striated • Multinucleated cells • Voluntary/somatic nervous system • Strong, forceful contractions

Table 12.1

Energy Reserves

ATP is the primary source of energy for muscle contraction. Very little ATP is actually stored in the muscles, so other forms of energy must be stored and rapidly converted to ATP.

Creatine phosphate

In vertebrates, energy can be temporarily stored in a high-energy compound called creatine phosphate.

Myoglobin

Myoglobin is a hemoglobin-like protein found in muscle tissue. Myoglobin has a high oxygen affinity and maintains the oxygen supply in muscles by tightly binding to oxygen.

REVIEW PROBLEMS

Questions 1, 2, and 3 are based on the following diagram:

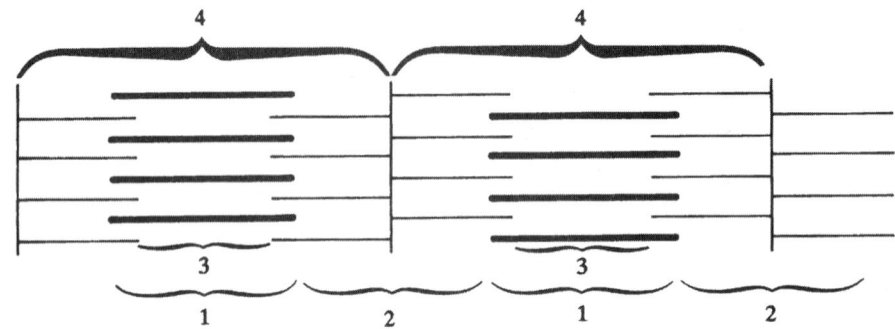

1. During muscle contraction, which of the following regions decrease(s) in length?

 A. 1 only
 B. 2 only
 C. 4 only
 D. 2, 3, and 4
 E. 2 and 3

2. Region 1 refers to

 A. the thick filaments only.
 B. the thin filaments only.
 C. the A band.
 D. the I band.
 E. the Z band.

3. Which of the following region(s) represents exactly one sarcomere?

 A. 1
 B. 2
 C. 3
 D. 4
 E. 1 and 2 together

4. Which of the following cells is correctly coupled with its definition?

 A. Osteoblasts—bone cells involved in the secretion of bone matrix
 B. Osteoclasts—immature bone cells
 C. Osteocytes—multinucleated cells actively involved in bone reabsorption
 D. Chondrocytes—undifferentiated bone marrow cells
 E. Chondrocytes—multinucleated cells actively involved in bone reabsorption

5. Describe the microscopic structure of compact bone. Include the following terms in your discussion: bone matrix, osteon, Haversian canal, lamellae, and osteocyte.

6. When a muscle fiber is subjected to very frequent stimuli
 A. an oxygen debt is incurred.
 B. a muscle tonus is generated.
 C. the threshold value is reached.
 D a simple twitch is repeatedly generated.
 E. tetanus occurs.

7. When a muscle is attached to two bones, usually only one of the bones moves. The part of the muscle attached to the stationary bone is referred to as
 A. proximal.
 B. distal.
 C. origin.
 D. insertion.
 E. ventral.

8. Two processes are involved in bone formation. How do they differ from one another?

Questions 9–11 refer to the following types of muscle:
 I. Cardiac muscle
 II. Skeletal muscle
 III. Smooth muscle

9. Which type of muscle is always multinucleated?
 A. I only
 B. II only
 C. III only
 D. Both I and II
 E. Both II and III

10. Which type of muscle has strong, forceful contractions?
 A. I only
 B. II only
 C. III only
 D. Both I and III
 E. Both I and II

11. Which type of muscle lacks sarcomeric striations?
 A. I only
 B. II only
 C. III only
 D. Both II and III
 E. None of the above

SOLUTIONS TO REVIEW PROBLEMS

1. **D** Discussed in the sarcomere section in this chapter.

2. **C** Discussed in the sarcomere section in this chapter.

3. **D** Discussed in the sarcomere section in this chapter.

4. **A** Discussed in structure of vertebrate skeleton section in this chapter.

5. Discussed in structure of vertebrate skeleton section in this chapter.

6. **E** Discussed in summation section of stimulus and muscle response in this chapter.

7. **C** Discussed in muscle/bone interactions section in this chapter.

8. The processes involved in bone formation are endochondral ossification and intramembranous ossification. In endochrondral ossification, cartilage is replaced with bone. In intramembranous ossification, mesenchyme, or undifferentiated cells, are transformed into bone cells.

9. **B** Discussed in skeletal muscle section in this chapter.

10. **E** Discussed in smooth muscle and cardiac muscle sections in this chapter.

11. **C** Discussed in smooth muscle section in this chapter.

CHAPTER THIRTEEN

Circulatory and Respiratory Systems

LEARNING OBJECTIVES

After this chapter, you will be able to:

- Analyze the flow of blood through the heart and circulatory system
- Distinguish between the components of blood
- Explain the functions of the circulatory and respiratory systems
- Describe the anatomy of the respiratory system

The human cardiovascular system is composed of a muscular, four-chambered heart, a network of blood vessels, and the blood itself. Blood is pumped into the **aorta**, which branches into a series of **arteries**. The arteries branch into **arterioles** and then into microscopic **capillaries**. Exchange of gases, nutrients, and cellular waste products occurs via diffusion across capillary walls. The capillaries then converge into **venules** and eventually into **veins**, which carry deoxygenated blood back toward the heart. From the heart, deoxygenated blood is pumped to the **lungs**, where CO_2 is exchanged for O_2, and this oxygenated blood returns to the heart to be pumped throughout the body once more.

BIO

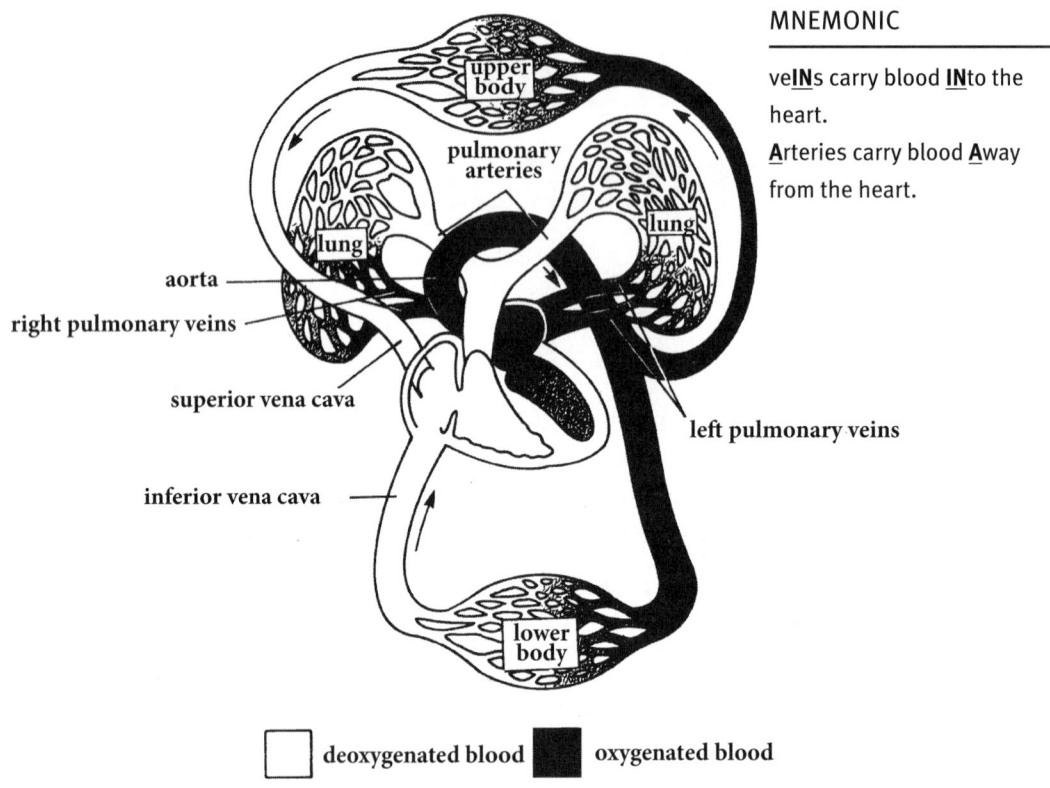

MNEMONIC

ve**IN**s carry blood **IN**to the heart.

Arteries carry blood **A**way from the heart.

deoxygenated blood ◼ oxygenated blood

Figure 13.1

THE HEART

The heart is the driving force of the circulatory system. The right and left halves can be viewed as two separate pumps: the right side of the heart pumps **deoxygenated** blood into **pulmonary** circulation (toward the lungs), whereas the left side pumps **oxygenated** blood into **systemic** circulation (throughout the body). The two upper chambers are called **atria**, and the two lower chambers are called **ventricles**. The atria are thin-walled, whereas the ventricles are extremely muscular and provide the force that drives the blood through the body. The left ventricle is more muscular than the right ventricle because it is responsible for generating the force that propels the systemic circulation and because it pumps against a higher resistance. As a result, in patients with increased systemic resistance, the left ventricle can become hypertrophied (enlarged), which over time can lead to congestive heart failure and other cardiovascular diseases.

Blood returning from the body first flows through the superior and inferior vena cava into the right atrium, then through the tricuspid valve into the right ventricle, and finally through the pulmonary semilunar valve into the pulmonary arteries to continue to the lungs. Blood returning from the lungs flows through the pulmonary veins into the left atrium, then through the bicuspid, or mitral, valve into the left ventricle, and finally out through the aortic semilunar valve into the systemic circulation through the **aorta**.

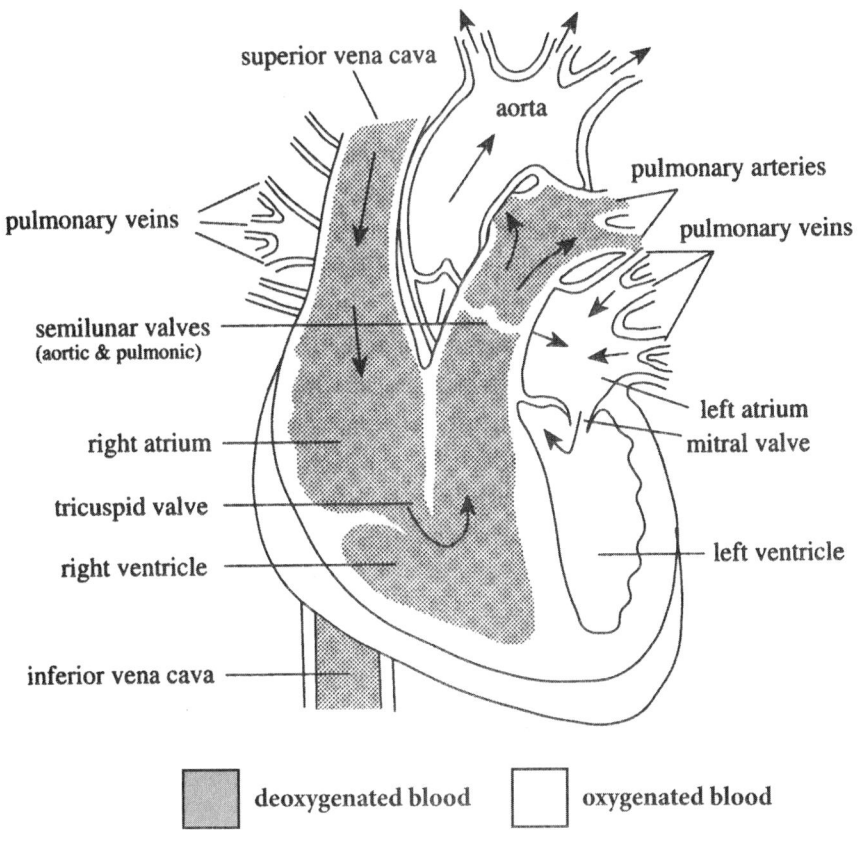

Figure 13.2

Valves

The **atrioventricular (AV) valves**, located between the atria and ventricles on both sides of the heart, prevent backflow of blood into the atria during ventricular contraction. The valve on the right side of the heart has three cusps and is called the **tricuspid valve**. The valve on the left side of the heart has two cusps and is called the **mitral (or bicuspid) valve**. The **semilunar valves** have three cusps and are located between the left ventricle and the aorta (the aortic valve) and between the right ventricle and the pulmonary artery (the pulmonic valve). The "lub-dub" sound of a heartbeat is made by the successive closing of the atrioventricular and semilunar valves.

MNEMONIC

Atrioventricular valves: **LAB RAT**

Left **A**trium = **B**icuspid
Right **A**trium = **T**ricuspid

Contraction

The heart's pumping cycle is divided into two alternating phases, **systole** and **diastole,** which together make up the **heartbeat.** Systole is the period during which the ventricles contract, forcing blood out of the heart into the pulmonary and systemic circulation. Diastole is the period of cardiac muscle relaxation during which blood drains into all four chambers. This is reflected in physiologic measurements such as blood pressure. Systolic blood pressure measures the pressure in a patient's blood vessels when the ventricles are contracting, and diastolic blood pressure measures the pressure

during cardiac relaxation. **Cardiac output** is defined as the total volume of blood the left ventricle pumps out per minute. Cardiac output = **heart rate** (number of beats per minute) × **stroke volume** (volume of blood pumped out of the left ventricle per contraction).

Control of heart rate

Cardiac muscle contracts rhythmically without stimulation from the nervous system, producing impulses that spread through its internal conducting system. An ordinary cardiac contraction originates in, and is regulated by, the **sinoatrial (SA) node** (the **pacemaker**), a small mass of specialized tissue located in the wall of the right atrium. The SA node spreads impulses through both atria, stimulating them to contract simultaneously and, thereby, filling the ventricles. The impulse arrives at the **atrioventricular (AV) node**, which slowly conducts impulses to the rest of the heart, allowing enough time for atrial contraction and for the ventricles to fill with blood. The impulse is then carried by the **bundle of His (AV bundle)**, which branches into the right and left bundle branches, and finally through the **Purkinje fibers** in the walls of both ventricles, stimulating a strong contraction. This contraction forces blood out of the heart into circulation. This process is shown in Figure 13.3.

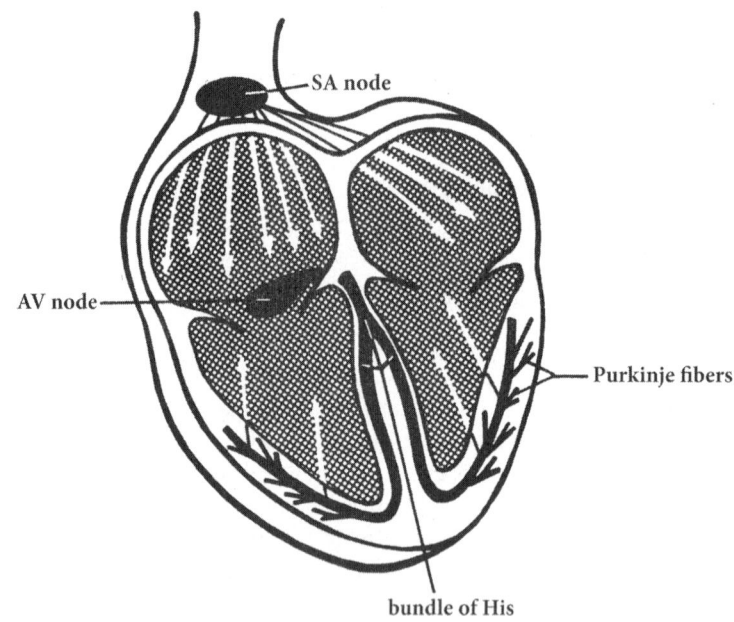

Figure 13.3

The **autonomic nervous system** modifies the rate of heart contraction. The parasympathetic nervous system innervates the heart via the **vagus nerve** and causes a decrease in heart rate. The sympathetic nervous system innervates the heart via the cervical and upper thoracic ganglia and causes an increase in heart rate. The adrenal medulla exerts hormonal control via epinephrine (adrenaline) secretion, which causes an increase in heart rate.

BLOOD VESSELS

The three types of blood vessels are arteries, veins, and capillaries. **Arteries** are thick-walled, muscular, elastic vessels that transport oxygenated blood away from the heart—except for the **pulmonary arteries**, which transport deoxygenated blood from the heart to the lungs. **Veins** are relatively thin-walled, inelastic vessels that conduct deoxygenated blood toward the heart—except for the **pulmonary veins**, which carry oxygenated blood from the lungs to the heart. Much of the blood flow in veins depends on their compression by skeletal muscles during movement rather than on the pumping of the heart. Venous circulation is often at odds with gravity; thus, larger veins, especially those in the legs, have valves that prevent backflow. Capillaries have very thin walls composed of a single layer of endothelial cells across which respiratory gases, nutrients, enzymes, hormones, and wastes can readily diffuse. **Capillaries** have the smallest diameter of all three types of vessels; red blood cells must often travel through them single file.

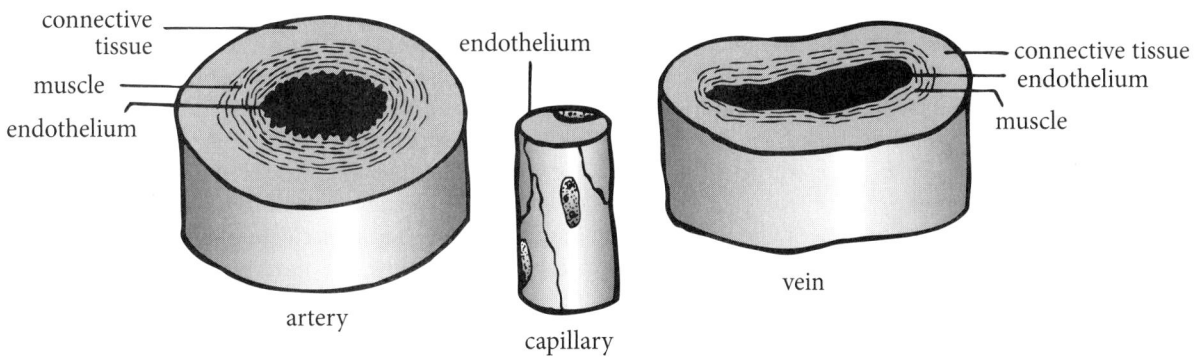

Figure 13.4

Lymph Vessels

The lymphatic system is a secondary circulatory system distinct from the cardiovascular circulation. Its vessels transport excess **interstitial fluid**, called **lymph**, to the cardiovascular system, thereby keeping **fluid** levels in the body constant. The smallest lymphatic vessels (**lacteals**) collect fats, in the form of chylomicrons, from the villi in the small intestine and deliver them into the bloodstream via the thoracic duct at the subclavian vein, bypassing the liver. **Lymph** nodes are swellings along lymph vessels containing phagocytic cells (**lymphocytes**) that filter the lymph, remove and destroy foreign particles and pathogens and, thus, play an important role in immunity (see Chapter 10).

BLOOD

On average, the human body contains four to six liters of blood. Blood has both liquid components (55 percent) and cellular components (45 percent). **Plasma** is the aqueous, non-cellular portion of the blood. It is an aqueous mixture of nutrients, salts, respiratory gases, wastes, hormones, and blood proteins (e.g., immunoglobulins, albumin, and fibrinogen). The cellular components of blood are erythrocytes, leukocytes, and platelets.

Leukocytes

Leukocytes (known as **white blood cells,** or WBCs) are larger than erythrocytes and serve protective functions. White blood cells are discussed further in the context of immunity in Chapter 10.

Platelets

Platelets are cell **fragments** that lack nuclei and are involved in clot formation. Many drugs inhibit platelet formation or adhesion to decrease clot development.

Erythrocytes

Erythrocytes (known as **red blood cells,** or RBCs) are the oxygen-carrying components of blood. An erythrocyte contains hemoglobin, which can bind up to four molecules of oxygen. When hemoglobin binds oxygen it is called **oxyhemoglobin**. This is the primary form of oxygen transport in the blood. Hemoglobin is also capable of binding to carbon dioxide. In this state it is referred to as **carbaminohemoglobin** and serves to remove carbon dioxide waste from the body. Erythrocytes have a distinct biconcave, disk-like shape that gives them both increased surface area for gas exchange and greater flexibility for movement through tiny capillaries. Erythrocytes are formed from stem cells in the **bone marrow**; their formation is stimulated by erythropoietin, a hormone made in the kidneys. In the bone marrow, erythrocytes lose their nuclei, mitochondria, and membranous organelles. Once mature, erythrocytes circulate in the blood for about 120 days, after which they are phagocytized by special cells in the spleen and liver. Finding immature erythrocytes circulating in the bloodstream—that is, before they have lost their organelles—can be an indicator of a number of disease states.

ABO blood types

Erythrocytes have characteristic cell-surface proteins (**antigens**). Antigens are macromolecules that are foreign to the host organism and trigger an immune response. The two major groups of red blood cell antigens are the **ABO group** and the **Rh factor**.

Characteristics of Human Blood Types				
Blood Type	**Antigen**	**Antibody**	**Can Donate To**	**Can Receive From**
A	A	anti-B	A and AB	A and O
B	B	anti-A	B and AB	B and O
AB	A and B	none	AB only	all (universal acceptor)
O	none	anti-A and anti-B	all (universal donor)	O only

Table 13.1

It is extremely important during blood transfusions that **donor** and **recipient** blood types be appropriately matched. The aim is to avoid transfusion of red blood cells that will be clumped ("rejected") by antibodies (proteins in the immune system that bind specifically to antigens) present in the recipient's plasma. For example, a person with blood type A has antigens for type A blood and antibodies for type B blood. This means that, if transfused with any blood containing type B antigens (type B or type AB blood), they will mount an immune response, and their anti-B antibodies will

clump and "reject" the transfusion. Therefore, to avoid rejection of the transfusion, the recipient must have a natural blood type with the same antigens as the blood type being transfused. For example, if a patient with type O blood is given blood of any type except type O, they will reject the transfusion because they do not have type A or type B antigens and as a result have anti-A and anti-B antibodies.

Type AB blood is termed the "**universal recipient**," as it has neither anti-A nor anti-B antibodies and therefore will not reject transfusions of any blood type. **Type O** blood is considered to be the "**universal donor**"; it will not elicit a response from the recipient's immune system because it does not possess any surface antigens.

Rh factor

The Rh factor is another antigen that may be present on the surface of red blood cells. Individuals may be Rh+, possessing the Rh antigen, or Rh−, lacking the Rh antigen. Consideration of the Rh factor is particularly important during **pregnancy**. An Rh− woman can be sensitized by an **Rh+ fetus** if fetal red blood cells (which will have the Rh factor) enter maternal circulation during birth. If this woman subsequently carries another Rh+ fetus, the anti-Rh antibodies she produced when sensitized by the first birth may cross the placenta and destroy fetal red blood cells. This results in a type of severe anemia in the fetus known as **erythroblastosis fetalis**. Erythroblastosis is not caused by ABO blood-type mismatches between mother and fetus because anti-A and anti-B antibodies cannot cross the placenta. Rhogam is a drug comprised of a mixture of antibodies given to mothers who are Rh− to prevent their immune systems from attacking the fetal red blood cells.

Rh factor is also an issue with blood transfusions. If patients who do not possess the Rh antigen (that is, who are Rh−) are given blood that is Rh+, their bodies can mount an immune response and reject the transfusion.

FUNCTIONS OF THE CIRCULATORY SYSTEM

Blood transports nutrients and O_2 to tissue and wastes and CO_2 from tissue. Platelets in the blood are involved in injury repair, and leukocytes in the blood are the main component of the immune system (see Chapter 10).

Transport of Gases

Erythrocytes transport O_2 throughout the circulatory system. The hemoglobin molecules in erythrocytes bind to O_2. Hemoglobin contains iron and each hemoglobin molecule is capable of binding to four molecules of O_2. Hemoglobin also binds to CO_2, in which case it is referred to as carbaminohemoglobin.

Transport of Nutrients and Waste

Amino acids and **simple sugars** are absorbed into the bloodstream at the intestinal capillaries. Throughout the body, metabolic **waste products** (e.g., water, urea, and carbon dioxide) diffuse into capillaries from surrounding cells; these wastes are then delivered to the appropriate excretory organs.

BIO

Clotting

When platelets come into contact with the exposed collagen of a damaged vessel, they release a chemical that causes neighboring platelets to adhere to one another, forming a **platelet plug**. Subsequently, both the platelets and the damaged tissue release the clotting factor thromboplastin. **Thromboplastin**, with the aid of its cofactors calcium and vitamin K, converts the inactive plasma protein **prothrombin** to its active form, **thrombin**. Thrombin then converts **fibrinogen** (another plasma protein) into fibrin. Threads of **fibrin** coat the damaged area and trap blood cells to form a clot. Clots prevent extensive blood loss while the damaged vessel heals itself. The fluid left after blood clotting is called **serum**. This complex series of reactions is called the **clotting cascade**. The clotting cascade also involves numerous other **factors** (namely Factor VIII), all of which are a potential sources of failure in the clotting cascade that can lead to a disorder known as hemophilia.

Warfarin, a commonly used anticoagulant, works by inhibiting the recycling of vitamin K. Without this essential cofactor, the clotting cycle is inhibited and patients are less likely to be able to form clots. Other types of anticoagulant medications work at other points along the clotting cascade.

Figure 13.5

THE RESPIRATORY SYSTEM

In the human respiratory system, air enters the **lungs** after traveling through a series of respiratory **airways**. The air passages consist of the nose, pharynx (throat), larynx, trachea, bronchi, bronchioles, and alveoli. Gas exchange between the lungs and the circulatory system occurs across the very thin walls of the **alveoli,** which are air-filled sacs at the terminals of the airway branches. Alveoli provide a moist respiratory surface for gas exchange. After gas exchange, air travels back through the respiratory pathway and is exhaled.

The respiratory system also provides a very large area for gas exchange, continually moving oxygenated air over this area and protecting the respiratory surface from infection, dehydration, and temperature changes. It moves air over the vocal cords for the production of sound and assists in the regulation of body pH by regulating the rate of carbon dioxide removal from the blood.

Figure 13.6

Ventilation

Ventilation of the lungs (breathing) is the process by which air is inhaled and exhaled. The purpose of ventilation is to take in oxygen from the atmosphere and eliminate carbon dioxide from the body.

During **inhalation**, the diaphragm contracts and flattens, and the external intercostal muscles contract, pushing the rib cage and chest wall up and out. The phrenic nerve innervates the diaphragm and causes it to contract and flatten. These actions cause the thoracic cavity to increase in volume. This volume increase reduces the pressure, causing the lungs to expand and fill with air.

Exhalation is generally a passive process. The lungs and chest wall are highly elastic and tend to recoil to their original positions after inhalation. The diaphragm and external intercostal muscles relax and the chest wall pushes inward. The consequent decrease in thoracic cavity volume causes the pressure to increase. This forces air out of the alveoli, causing the lungs to deflate.

Surfactant is a protein complex secreted by cells in the lungs. Surfactant keeps the lungs from collapsing by decreasing surface tension in the alveoli. Babies born prematurely do not always produce surfactant and must be given artificial surfactants until they can produce their own.

Control of ventilation

Ventilation is regulated by neurons (referred to as **respiratory centers**) located in the **medulla oblongata.** When the partial pressure of CO_2 in the blood rises, the medulla oblongata stimulates an increase in the rate of ventilation.

The primary goal of respiration is to maintain proper concentrations of oxygen, carbon dioxide, and hydrogen ions in tissues. Hence, respiratory activity is highly responsive to changes in the blood levels of these compounds. Excessive carbon dioxide and hydrogen ion levels are the primary stimuli for respiration. When carbon dioxide and hydrogen ion levels are increased, the respiratory center stimulates both the inspiratory and expiratory muscles of the lungs. Oxygen blood levels do not have a significant effect on the respiratory center. However, oxygen blood levels are monitored by peripheral **chemoreceptors**, which indirectly stimulate the respiratory center. Changes in acid-base chemistry due to kidney function can also influence ventilation (see Chapter 15, Urinary System).

Gas Exchange

A dense network of minute blood vessels called **pulmonary capillaries** surrounds the alveoli. Gas exchange occurs by diffusion across these capillary walls and those of the alveoli; gases move from regions of higher partial pressure to regions of lower partial pressure. Oxygen diffuses from the alveolar air into the blood, while carbon dioxide diffuses from the blood into the lungs.

Lung Capacities

The volume of air in the lungs changes throughout respiration. **Total lung capacity** represents the maximum volume of air the lungs can hold. The volume of air moved during a normal resting breath is known as the **tidal volume**, which is significantly less than the total lung capacity. The volume of air that could be additionally inhaled into the lungs at the end of a normal, resting inhalation is called the **inspiratory reserve volume**; you can think of this as the volume of "deep breath." The volume of air left in the lungs at the end of a normal, resting exhalation is called the **expiratory reserve volume**. The **vital capacity** is the volume of air moved during a maximum inhalation followed by a maximum exhalation. Even after maximum exhalation, there is always some air left in the lungs to keep the aveoli patent. This is known as the **residual volume**.

Figure 13.7

REVIEW PROBLEMS

1. Erythrocytes are anaerobic. Why is this advantageous for the organism?

2. The lymphatic system
 A. transports hormones throughout the body.
 B. transports absorbed chylomicrons to the circulatory system.
 C. filters the blood.
 D. contains vessels that are nearly identical to arteries.
 E. contains more erythrocytes than leukocytes.

3. Draw the reactions of the clotting process. Include all of the proteins and cofactors involved.

4. What role do the surface proteins on erythrocytes play in blood transfusions?

5. All of the following facilitate gas exchange in the lungs EXCEPT
 A. thin alveolar surfaces.
 B. moist alveolar surfaces.
 C. differences in the partial pressures of O_2 and CO_2.
 D. active transport.
 E. large surface areas.

6. What muscles play a role in ventilation? Compare the muscular motions involved in inhalation with those involved in exhalation.

7. Which is the correct sequence of the passages that air travels through during inhalation?
 A. Pharynx → Trachea → Bronchioles → Bronchi → Alveoli
 B. Pharynx → Trachea → Lungs → Bronchi → Alveoli
 C. Pharynx → Larynx → Bronchi → Trachea → Alveoli
 D. Pharynx → Larynx → Trachea → Bronchi → Alveoli
 E. Pharynx → Trachea → Larynx → Bronchi → Alveoli

8. Which of the following is generally an active process?
 A. Inhalation
 B. Exhalation
 C. Gas exchange
 D. Diffusion
 E. Osmosis

BIO

SOLUTIONS TO REVIEW PROBLEMS

1. If erythrocytes were aerobic, they would use some of the O_2 that they carry for their own energy requirements, thus decreasing the amount of O_2 transported to the rest of the body. Because they are anaerobic, they do not have any O_2 requirements of their own and can deliver all the O_2 they carry to other cells.

2. B The main function of the lymphatic system is to collect excess interstitial fluid and return it to the circulatory system, maintaining the balance of body fluids. However, this is not one of the answer choices. A second function of the lymphatic system is to absorb chylomicrons from the small intestine and deliver them to cardiovascular circulation; this is choice (B). The remaining answer choices describe the circulatory system but not the lymphatic system.

3. See Figure 13.5.

4. In a blood transfusion, the donor blood must be carefully matched with the blood of the recipient. If the erythrocytes in the donor blood have a different class of surface proteins (antigens) than the recipient's erythrocytes, the recipient's immune system might "attack" the surface protein of the donor, thus rejecting the donor blood. For example, if the donor blood is type A and the recipient blood is type B, the recipient's anti-A antibodies would attack the donor's erythrocytes, because type A blood has type A antigens.

5. D Discussed in gas exchange section of this chapter.

6. The muscles involved in ventilation are the diaphragm, which separates the thoracic cavity from the abdominal cavity, and the intercostal muscles of the rib cage. During inhalation, the diaphragm contracts and flattens while the external intercostals contract, pushing the rib cage up and out. These actions cause an overall increase in the volume of the thoracic cavity. During exhalation, both the diaphragm and the external intercostals relax, causing a decrease in the volume of the thoracic cavity. In forced expiration, the internal intercostals contract, pulling the rib cage down.

7. D Discussed in vertebrate respiratory system section of this chapter.

8. A Exhalation is generally a passive process involving elastic recoil of the lungs and relaxation of both the diaphragm and the external intercostal muscles. (However, during vigorous exercise, active muscular contraction assists in expiration.) Gas exchange, diffusion, and osmosis are also passive processes and involve molecules moving down their partial pressure gradients. Inhalation is an active process requiring contraction of the diaphragm and the external intercostals.

CHAPTER FOURTEEN

Digestive System

LEARNING OBJECTIVES

After this chapter, you will be able to:

- Analyze and correctly order the organs of the digestive tract
- Explain the functions of the organs of the digestive tract

Humans are **heterotrophic** and thus unable to synthesize all of their own nutrients. Instead, food provides the raw material for energy, repair, and growth of tissues. This food must first be **ingested** (eaten), after which **digestion** (breakdown) occurs. **Digestion** consists of the degradation of large molecules into smaller molecules that can be **absorbed** into the bloodstream and used directly by cells. **Intracellular** digestion occurs within the cell, usually in membrane-bound vesicles, discussed in Chapter 5. **Extracellular** digestion refers to a digestive process that occurs outside of the cell, within a lumen or tract, and will be the focus of this chapter.

DIGESTIVE TRACT

The human digestive tract begins with the **oral cavity** and continues with the **pharynx**, **esophagus**, **stomach**, **small intestine**, **large intestine**, and **anus.** Accessory organs, such as the salivary glands, pancreas, liver, and gallbladder, also play essential roles in digestion.

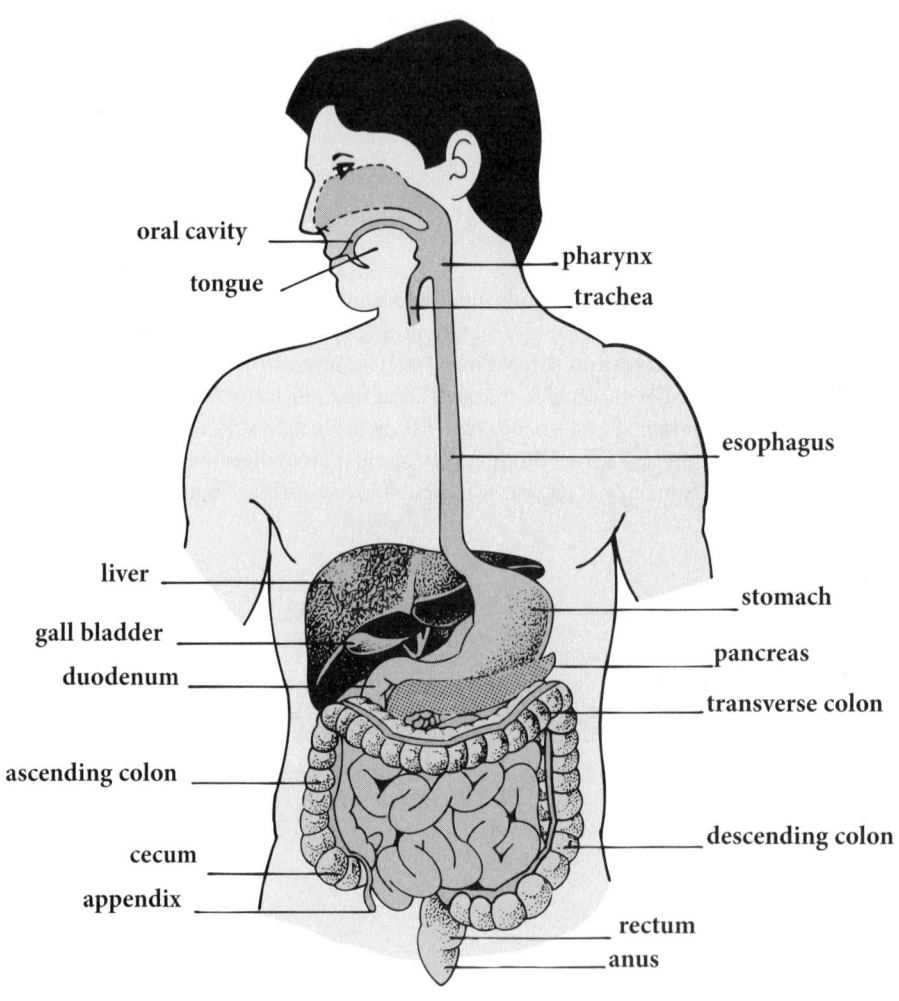

Figure 14.1

Oral Cavity

The oral cavity (the mouth) is where mechanical and chemical digestion of food begins. **Mechanical digestion** is the breakdown of large food particles into smaller particles through physical actions, such as the biting and chewing action of teeth (**mastication**) or the churning motion of the stomach. **Chemical digestion** refers to the enzymatic breakdown of macromolecules into smaller molecules and begins in the mouth when the salivary glands secrete **saliva**. Saliva is secreted in response to the presence of food in the mouth and serves to lubricate and begin digestion of food to facilitate swallowing. Specifically, saliva contains **salivary amylase (ptyalin)**, which hydrolyzes starch to maltose. Once food has been swallowed, it is referred to as a **bolus**.

BIO

Esophagus

The esophagus is the muscular tube responsible for transporting the bolus from the oral cavity to the stomach. The bolus is moved down the esophagus by rhythmic waves of involuntary muscular contractions called **peristalsis**. Note that, while the initiation of swallowing is voluntary, peristalsis is not. The esophagus is closed off from the stomach by contraction of a muscular structure called the **lower esophageal (cardiac) sphincter**.

The lower esophageal sphincter (LES) protects the esophagus from the acidic gastric contents. The esophagus lies within the thoracic cavity, which regularly is exposed to negative pressure as the person inhales. Contrastingly, the stomach is located in the abdominal cavity, which has a relative positive pressure. Therefore, without the actions of the lower esophageal sphincter, the pressure gradients favor a continual reflux of gastric content into the esophagus, resulting in a condition known as gastroesophageal reflux disease (GERD).

Stomach

The stomach, a large, muscular organ located in the upper abdomen, stores and partially digests food through both chemical and mechanical means. Chemical digestion relies on the **gastric mucosa**, which lines the walls of the stomach and contains the **gastric pits** and **gastric glands**. Various cell types in the gastric mucosa produce the chemicals responsible for chemical digestion.

- **Mucous cells**, in gastric pits, secrete mucus to protect the stomach lining from the harshly acidic juices (pH = 2) present in the stomach.
- **Chief cells**, in the gastric glands, synthesize pepsinogen, which is converted to pepsin upon contact with stomach acid and breaks down proteins.
- **Parietal cells**, also present within gastric glands, synthesize and release hydrochloric acid (HCl), which alters the pH of the stomach, kills bacteria, and produces intrinsic factor (IF), which is necessary for the absorption of vitamin B_{12}.

Finally, the churning of the stomach (mechanical digestion), combined with this enzymatic activity (chemical digestion), produces an acidic, semifluid mixture of partially digested food known as **chyme**. The chyme passes into the first segment of the small intestine, the **duodenum**, through the **pyloric sphincter**.

Small Intestine

The small intestine is divided into three sections and functions to digest and absorb nutrients. The three sections are the **duodenum, jejunum,** and **ileum**, with the duodenum being the primary site of digestion. Digestion in the small intestine is exclusively chemical and is facilitated by enzymatic secretions from the pancreas, liver, and local intestinal glands. These enzymes include **lipases, aminopeptidases,** and **disaccharidases**. In addition, the pancreatic secretions create a basic (high pH) environment in the small intestine.

MNEMONIC

Segments of the small intestine: **D**ow **J**ones **I**ndustrial

- **D**uodenum
- **J**ejunum
- **I**leum

The structure of the small intestine serves to increase the surface area of the intestinal walls, thereby increasing absorption. First, the small intestine is extremely long and coiling; if stretched out, it would span six meters. Second, the intestinal walls are lined with highly vascularized finger-like projections called **villi** (see Figure 14.2). The vast majority of absorption occurs through the villi. Note that some nutrients, such as glucose and amino acids, are actively absorbed (i.e., requiring energy), whereas others are passively absorbed.

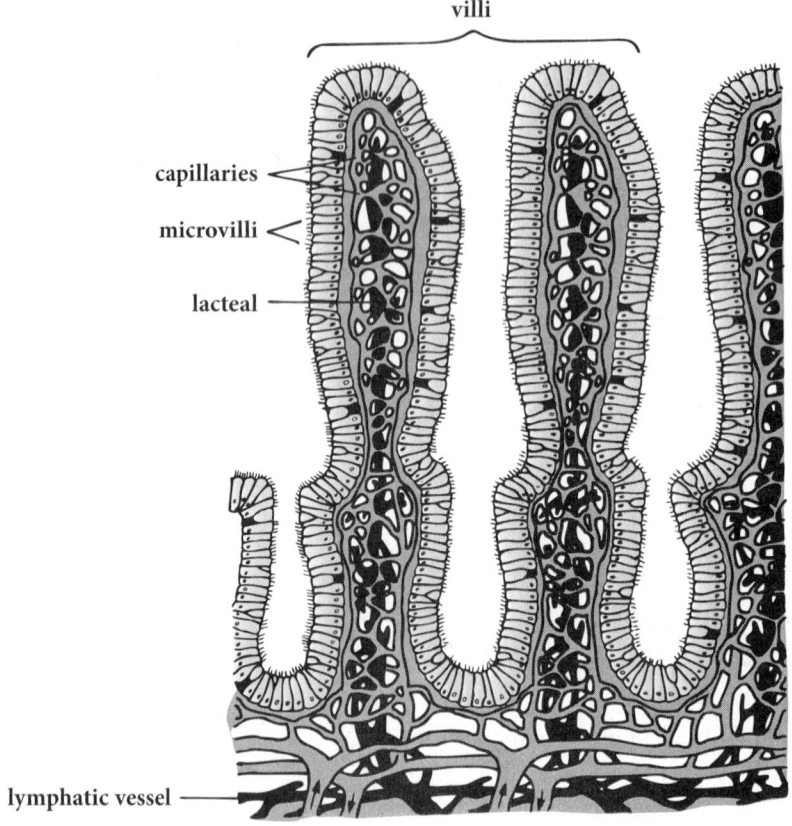

villi

capillaries

microvilli

lacteal

lymphatic vessel

Figure 14.2

Liver

The liver is an accessory digestive organ, meaning it is not part of the digestive tract, but instead secretes compounds into it. The liver produces **bile** that is stored in the **gallbladder** before being released into the small intestine. Bile functions to emulsify fats, breaking down large globules into small droplets. Emulsification increases the surface area of the fat, increasing the digestive actions of pancreatic enzymes. In the absence of bile, fats cannot be digested.

Although the liver continually detoxifies blood in the general circulation, the majority of detoxification is done via the **first pass effect**. Blood from the small intestine containing newly absorbed compounds is directly sent to the liver for detoxification before entrance into general circulation. The first pass effect serves to protect the body from ingested toxins. Finally, non-digestive functions of the liver include storage of glycogen, conversion of ammonia to urea, protein synthesis, and cholesterol metabolism.

Pancreas

Similar to the liver, the pancreas is an accessory digestive organ. Upon stimulation, the pancreas releases amylase, lipase, and **trypsinogen**. Trypsinogen is the precursor of **trypsin**, a powerful proteolytic enzyme, and is activated by **enterokinase**, which is produced in the small intestine. Thus, trypsin is only activated once it enters the small intestine. Trypsin then cleaves and activates the other zymogens (enzyme precursors). The pancreas also secretes a bicarbonate-rich juice that neutralizes the acidic chyme arriving from the stomach in the duodenum. The pancreatic enzymes operate optimally at this higher pH.

Large Intestine

The large intestine is approximately 1.5 m long and absorbs salts and any water not already absorbed by the small intestine. The large intestine also contains the **gut flora**, symbiotic bacteria that produce vitamins and digest nutrients that the host organism cannot. The distal portion of the large intestine is the rectum, which provides for transient storage of feces before elimination through the anus.

Digestive Hormones

The activity of the digestive system is regulated by several hormones, which allow for optimum flow of materials through the digestive tract and help regulate the hunger and satiation mechanisms. These hormones include:

- **Gastrin**: produced in the G cells of the duodenum, gastrin primarily functions to stimulate histamine and pepsinogen secretion, as well as increase gastric blood flow. Gastrin also stimulates the parietal cells to produce HCl, which denatures proteins and activates digestive enzymes.

MNEMONIC

"Gastric" refers to the stomach, thus gastrin regulates the function of the stomach.

- **Intrinsic factor**: a secretion of the parietal cells of the stomach that facilitates the absorption of vitamin B12 across the intestinal lining.
- **Cholecystokinin (CCK)**: produced and stored in the I cells of the duodenal and jejunal mucosa. It is involved in stimulation of pancreatic enzyme and somatostatin secretion as well as gallbladder contraction. CCK also acts as a hunger suppressant.
- **Secretin**: synthesized and stored in the S cells of the upper intestine. It stimulates the secretion of bicarbonate-containing substances from the pancreas and inhibits gastric emptying and gastric acid production.
- **Ghrelin**: synthesized both in the brain and the gut serves as the "hunger hormone." Increased levels of ghrelin in central circulation cause increased appetite and feeding behavior.
- **Leptin**: synthesized primarily in adipose tissue (fat cells) serves as an antagonist to ghrelin. Leptin acts on the brain to reduce hunger and provide a satiated state.

BIO

REVIEW PROBLEMS

1. Define extracellular digestion. How is the stomach specialized for extracellular digestion?

2. Where are proteins digested?
 A. Mouth and stomach
 B. Stomach and large intestine
 C. Small intestine and large intestine
 D. Mouth and small intestine
 E. Stomach and small intestine

3. All of the following processes occur in the mouth EXCEPT
 A. mechanical digestion.
 B. moistening of food.
 C. bolus formation.
 D. chemical digestion of proteins.
 E. saliva secretion.

4. The graphs below show the relative activities of pepsin and chymotrypsin in solutions of varying pH. Which graph refers to which enzyme?

 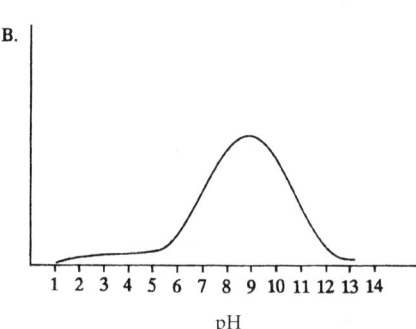

5. Outline the digestion of a piece of bread.

6. Why is pancreatic juice alkaline, and what would happen if its alkaline components were removed?

7. Starch is hydrolyzed into maltose by
 A. aminopeptidase.
 B. maltase.
 C. pancreatic amylase.
 D. sucrase.
 E. cholecystokinin.

8. The intestinal capillaries transport nutrients from the intestines to the
 A. large intestine.
 B. liver.
 C. kidney.
 D. heart.
 E. lungs.

SOLUTIONS TO REVIEW PROBLEMS

1. Digestion refers to a mechanical or chemical process whereby macromolecules are converted into smaller molecules that are more readily absorbed and used by cells. Extracellular digestion describes a process in which molecules are broken down outside of the cell. The stomach is a cavity perfectly adapted for extracellular digestion. Macromolecules are digested in an environment confined by the lower esophageal and pyloric sphincters. The cells lining the stomach walls are specialized for HCl and pepsinogen secretion by their ability to withstand acidic conditions. Muscular contractions aid in digestion by churning and crushing food. Little absorption occurs in the stomach; chyme is propelled into the small intestine, where further digestion and absorption occur.

2. **E** Protein digestion begins in the stomach with pepsin and continues in the small intestine.

3. **D** Chewing, the mechanical digestion of food, occurs in the mouth, as does moistening of food by saliva and bolus formation. In addition, salivary amylase begins digestion of complex carbohydrates.

4. Graph A refers to pepsin, whereas graph B refers to chymotrypsin. Pepsin is a gastric enzyme; it works best under the highly acidic conditions of the stomach. Chymotrypsin is an enzyme of the small intestine and thus operates optimally in alkaline environments.

5. In the mouth, teeth chew the bread into smaller particles, and salivary amylase digests some of the starch (the major component of bread) into maltose. The bread enters the stomach, where there is mechanical digestion of the bread into semiliquid chyme but no chemical digestion of starch. Chyme then enters the small intestine. In the small intestine, pancreatic amylase hydrolyzes starch into maltose while maltase, sucrase, and lactase hydrolyze various disaccharides into their respective monosaccharides. Most of the monosaccharides (e.g., glucose, fructose, and galactose) are absorbed into the circulatory system through the intestinal wall.

6. Pancreatic juice is an alkaline (basic) fluid that helps neutralize the acidity of the chyme entering the small intestine from the stomach. This is necessary because the small intestine enzymes work optimally at a neutral or alkaline pH. Also, the walls (mucosa) of the small intestine are not specialized for protection against acidic conditions. Therefore, without alkaline pancreatic juice, the intestinal enzymes would not function, and the intestinal walls would be damaged.

7. **C** Amylase, whether it is produced in the mouth or the pancreas, digests starch into maltose, a disaccharide.

8. **B** Intestinal capillaries transport amino acids and monosaccharides to the liver, where initial processing of many nutrients begins.

CHAPTER FIFTEEN

Urinary System

LEARNING OBJECTIVES

After this chapter, you will be able to:

- Recall the three functions of the kidney
- Explain the process of urine formation
- Apply the functions of the nephron to its structural regions
- Recall endocrine interactions with the kidney

Excretion refers to the removal of **metabolic wastes** produced in the body. Most of the body's activities produce metabolic wastes, including mineral salts, that must be removed. **Aerobic respiration** leads to the production of **carbon dioxide** and water. **Deamination** of amino acids in the liver leads to the production of **nitrogenous wastes,** such as urea and ammonia, both of which must be excreted. Excretion is distinguished from **elimination**, the removal of indigestible material, such as dietary fiber.

The principal organs of excretion in humans are the lungs, liver, skin, and kidneys. In the **lungs**, carbon dioxide and water vapor diffuse from the blood and are continually exhaled. Sweat glands in the **skin** excrete water and dissolved salts (and a small quantity of urea). Perspiration serves to regulate body temperature since the evaporation of sweat removes heat from the body. The **liver**, although not directly responsible for excretion, is responsible for transforming waste products into forms that can be excreted by other organs, primarily the kidney. For example, nitrogenous waste produced through deamination of proteins is converted to urea in the liver and then excreted by the kidneys. The kidneys function to maintain the osmolarity of the blood, excrete numerous waste products and toxic chemicals, and conserve glucose, salt, and water.

BIO

KIDNEYS

The kidneys regulate the concentration of salt and water in the blood through the formation and excretion of urine. The kidneys are bean-shaped and are located behind the stomach and liver. Each kidney is composed of approximately one million functional units called **nephrons**.

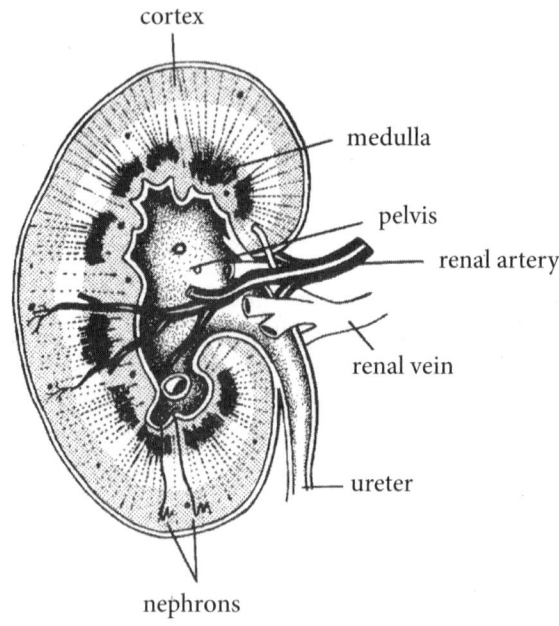

Figure 15.1

Structure

The kidney is divided into three regions: the outer **cortex**, the inner **medulla**, and the renal **pelvis**. A **nephron** consists of a bulb called **Bowman's capsule**, which embraces a special capillary bed called a **glomerulus**. Bowman's capsule leads to a long, coiled tubule divided into functionally distinct units: the **proximal convoluted tubule**, the **loop of Henle**, the **distal convoluted tubule**, and the **collecting duct**. The nephron is positioned such that the loop of Henle and collecting duct run through the medulla, while the convoluted tubules and Bowman's capsule are in the cortex (see Figure 15.2).

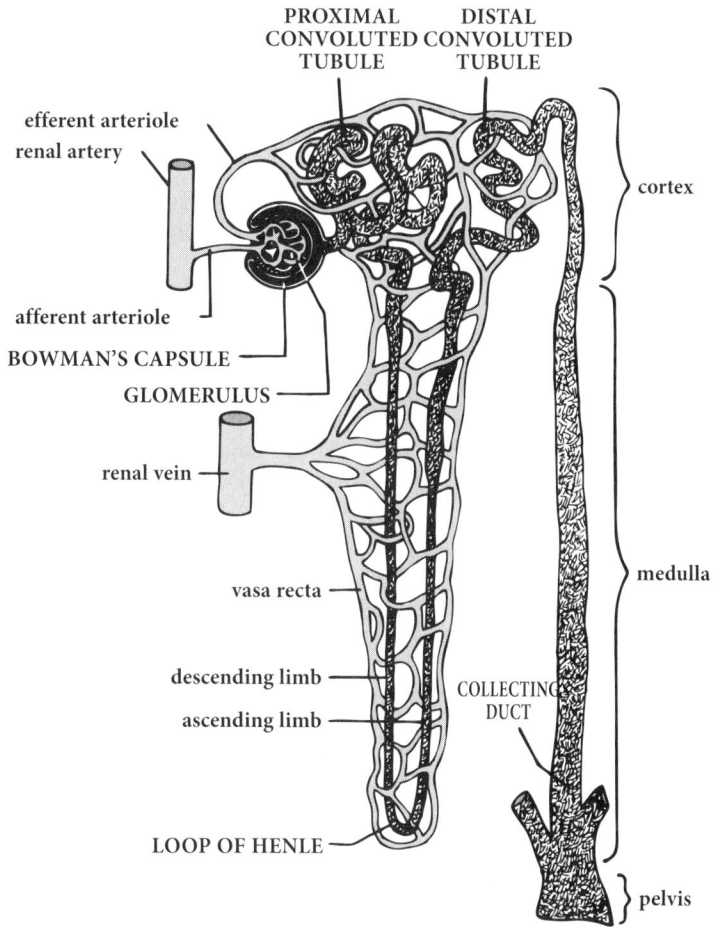

Figure 15.2

Urine Formation

Filtration, secretion, and reabsorption are the three processes that lead to urine formation.

- **Filtration**: Blood pressure forces 20 percent of the blood plasma entering the glomerulus through its capillary walls and into the surrounding Bowman's capsule. The fluid and small solutes entering the nephron are called the **filtrate**. The filtrate is isotonic with blood plasma. Particles too large to filter through the glomerulus, such as blood cells and albumin, remain in the circulatory system. Filtration is a passive process driven by the hydrostatic pressure of the blood. Thus, having high blood pressure results in an increased hydrostatic pressure, which exerts extra pressure on the kidney tissues and can lead to kidney damage over time.

- **Secretion**: The nephron secretes waste substances such as acids, ions, and other metabolites from the interstitial fluid into the filtrate by both **passive** and **active** transport.

- **Reabsorption**: Essential substances (**glucose**, **salts**, and **amino acids**) and water are reabsorbed from the filtrate and returned to the blood. Reabsorption occurs primarily in the proximal convoluted tubule and is an active process. Movement of these molecules is accompanied by the passive movement of water because water passively follows solute. This results in the formation of **concentrated urine**, which is hypertonic to the blood.

Once the filtrate is concentrated in the nephron, it flows into the **ureter** and is considered urine. The ureter brings the urine from the kidney to the **urinary bladder**, where urine collects until expelled via the **urethra**.

Nephron Function

As previously mentioned, the kidney uses mechanisms such as filtration, secretion, and reabsorption to produce urine and to regulate blood volume and osmolarity. However, the function of the nephron isn't quite that simple. In order to understand this complex organ, it is best to study the nephron piece-by-piece, discussing exactly what occurs in each segment (see Figure 15.3). As a theme, note that segments that are horizontal in Figure 15.3 (Bowman's capsule, the proximal convoluted tubule, and the distal convoluted tubule) are primarily focused on the identity of the particles in the urine. In contrast, the segments that are vertical in the diagram (loop of Henle and collecting duct) are primarily focused on the volume and concentration of urine.

Figure 15.3

Glomerulus

The **glomerulus** is the site of filtration; plasma and blood solutes are filtered and become the filtrate. Filtration is based on size exclusion; therefore, larger components of the blood, such as cells or proteins, do not enter the filtrate, while small compounds, like water, sugar, amino acids, and salts, do. Due to this lack of specificity, most compounds will have to be reabsorbed.

Proximal convoluted tubule

The filtrate first enters the **proximal convoluted tubule** (PCT). In this region, amino acids, glucose, water-soluble vitamins, and the majority of salts are reabsorbed along with water. In fact, almost 70 percent of filtered sodium will be reabsorbed. The nephron walls in the PCT are permeable to water; therefore, large amounts of water follow the sodium, thus being reabsorbed through osmosis. Reabsorbed solutes (taken from the nephron) re-enter circulation through the **peritubular capillaries**, which are part of the **vasa recta** (capillaries that surround the nephron). In addition to reabsorption, the PCT is also the site of secretion for waste products, such as hydrogen ions, potassium ions, ammonia, and urea.

MNEMONIC

Major waste products excreted in the urine: Dump the **HUNK**

H+
Urea
NH3
K+

Loop of Henle

Filtrate from the PCT then enters the **descending limb of the loop of Henle**, which dives deep into the medulla before turning around to become the ascending limb of the loop of Henle. The descending limb is permeable to only water, and because the osmolarity of the medulla increases deeper into the kidney, water leaves the filtrate (osmosis) as it goes deeper into the medulla. The **osmolarity gradient** in the medulla is crucial for the concentration of urine and will be discussed later in this chapter.

As the descending limb turns upwards to become the **ascending limb of the loop of Henle**, a change in permeability occurs. The ascending limb is only permeable to salts and is impermeable to water. Here the opposite process occurs: at the deeper parts of the medulla, salt concentrations are high, but decrease as the ascending limb rises. Thus, increasing amounts of salt are removed from the filtrate as it travels up the loop of Henle.

At the transition from the inner to outer medulla, the loop of Henle thickens, becoming the **thick ascending limb of the loop of Henle**. The thickening occurs due to the enlargement of the cells lining the tube, which is due to the increased number of mitochondria. This has a functional purpose, just as much as structural. The extra mitochondria produce additional ATP needed to power active transporters that pump out Na^+ and Cl^- from the filtrate. Thus, the thick ascending limb of the loop of Henle is also known as the **diluting segment**.

Throughout the loop of Henle, the filtrate has been concentrated and then diluted. It is easy to think that nothing of value happened as often the concentration of the filtrate is the same before and after the loop of Henle. However, the major change is filtrate volume. At the end of the loop of Henle large amounts of salts and water have been reabsorbed by the body.

Distal convoluted tubule

Next, the filtrate enters the **distal convoluted tubule** (DCT). Like the PCT, the DCT is also responsible for reabsorption and secretion. Specifically, the DCT responds to **aldosterone**, which promotes sodium reabsorption and, therefore, water reabsorption.

Collecting duct

The final concentration of the urine will depend largely on the permeability of the **collecting duct**, which is responsive to both **aldosterone** and **antidiuretic hormone** (ADH). Recall, the collecting duct extends down into the medulla and, therefore, areas of higher osmolarity. As permeability of the collecting duct increases, so too does water reabsorption, resulting in further concentration of the urine. The collecting duct almost always reabsorbs water, but the amount is variable. When the body is well hydrated, the collecting duct will be fairly impermeable to salt and water. When in water conservation mode, ADH and aldosterone will each act to increase reabsorption of water, thus, producing more concentrated urine. Once the filtrate leaves the collecting duct, it can then leave the kidney.

Osmolarity Gradient

As previously mentioned, the production of concentrated urine is made possible by the establishment of an osmolarity gradient between the tubules and the interstitial fluid that surrounds them. This gradient is created through the exiting and re-entry of solutes, such as Na^+ and Cl^-, at different segments of the nephron. The end result is an increase in osmolarity from the cortex to the inner medulla. This process is known as the **countercurrent multiplier system**, a system in which energy is used to create a concentration gradient.

The maximum osmolarity gradient in humans is 300 mOsm/L at the cortex and 1200 mOsm/L in the deep cortex. This state of maximum osmolarity graident is achieved during points of dehydration and results in maximal urine concentration. The general trend is that the greater the osmolarity gradient, the more concentrated the urine. This trend is exemplified when looking at animal species adapted to live in desert climates. For instance, the kangaroo rat, a small rodent, lives in areas with low rainfall and has a maximum urine concentration of 5500 mOsm/L. This is achieved through longer loops of Henle, which are able to build greater gradients via the countercurrent multiplier system.

Homeostasis

Through the processes facilitated by the nephron, the kidney is able to regulate blood osmolarity, blood volume, and blood pH. In addition, it's able to excrete waste products. These processes are under tight hormonal control.

Blood pressure and volume

Aldosterone is a steroid hormone that upregulates the active transport of sodium and potassium ions along the distal convoluted tubule and collecting duct, resulting in decreased excretion of sodium ions and increased excretion of potassium ions in the urine. Overall, more Na^+ ions are reabsorbed than K^+ ions that are excreted. Since water flows to the area of higher solute concentration through osmosis, this also causes additional water reabsorption.

Antidiuretic hormone (ADH) directly affects water reabsorption in the distal convoluted tubule and collecting ducts by opening additional aquaporins (water channels) in these structures. The opening of these channels allows water to leave the nephron and be reabsorbed more readily. Both ADH and

aldosterone cause a decrease in urine output and a corresponding increase in blood pressure, allowing the body to compensate for periods of dehydration or other causes of low blood pressure. However, one crucial difference between the two hormones is aldosterone does not affect the osmolarity of the blood, because it reabsorbs both salt and water; while ADH does affect the osmolarity of the blood, because it primarily acts to reabsorb water.

pH Maintenance

Body fluid pH remains relatively constant at 7.4. To maintain this pH, removal of carbon dioxide by the lungs and removal of hydrogen ions by the kidneys is tightly regulated. The key to understanding blood pH and its maintenance is the **bicarbonate buffer system**.

$$CO_2\ (g) + H_2O\ (l) \leftrightarrow H_2CO_3\ (aq) \leftrightarrow H^+\ (aq) + HCO_3^-\ (aq)$$

There are two categories of blood pH changes, **respiratory** and **metabolic**. **Respiratory** affects blood pH through changes in P_{CO_2} (partial pressure of CO_2). Increases in blood CO_2 result in a right shift of the bicarbonate buffer system (via the Le Châtelier Principle), thus increasing H^+ concentration and decreasing pH. Decreases in blood CO_2 do the opposite, resulting in an increased pH (more basic). Thus, an organism's respiratory rate can affect its blood pH. **Metabolic** regulation affects blood pH through changes in HCO_3^- and H^+, which is regulated in the kidney. Recall, the nephron secretes H^+ in both the PCT and DCT. As the kidney secretes more H^+ into the urine, the more basic (higher pH) the blood becomes and vice versa. Although HCO_3^- is not directly secreted by the nephron, it does enter the filtrate at the glomerulus and, therefore, HCO_3^- levels in the urine can be regulated through HCO_3^- reabsorption. The more HCO_3^- excreted (less reabsorbed) the more acidic the blood will become, due to the equilibrium shift of the bicarbonate buffering system.

Below is a summary of acid-base disorders and compensatory mechanisms by the human body:

	Condition	Defect	Blood pH	Compensation
Respiratory	Acidosis	Increased P_{CO_2}	Decreased	Increased HCO_3^-
	Alkalosis	Decreased P_{CO_2}	Increased	Decreased HCO_3^-
Metabolic	Acidosis	Decreased HCO_3^-	Decreased	Decreased P_{CO_2}
	Alkalosis	Increased HCO_3^-	Increased	Increased P_{CO_2}

Table 15.1

Compensation mechanisms that affect P_{CO_2} are performed by the respiratory system and can effect change quite quickly. However, compensation mechanisms that affect HCO_3^- are performed by the kidneys, and therefore the compensatory effect can take longer to manifest. These changes in acid-base chemistry within the body, as well as the cause of the change (respiratory or metabolic), dictate how a patient will be treated medically. For example, a change in pH due to a change in respiratory rate or function may be the result of airway obstruction or chronic obstructive pulmonary disease (COPD), whereas metabolic acidosis may be due to kidney dysfunction or volume loss, so these disorders must be treated accordingly.

BIO

REVIEW PROBLEMS

1. Which of the following would most likely filter through the glomerulus into Bowman's capsule?

 A. Erythrocytes

 B. Monosaccharides

 C. Leukocytes

 D. Platelets

 E. Monocytes

2. Draw a nephron and label all of its segments.

3. Which region of the kidney has the lowest solute concentration?

 A. Nephron

 B. Cortex

 C. Medulla

 D. Pelvis

 E. Glomerulus

4. In the nephron, amino acids enter the peritubular capillaries via

 A. filtration.

 B. secretion.

 C. reabsorption.

 D. osmoregulation.

 E. passive diffusion.

5. Glucose reabsorption in the nephron occurs in the

 A. loop of Henle.

 B. distal tubule.

 C. proximal tubule.

 D. collecting duct.

 E. Bowman's capsule.

6. Urine is

 A. hypotonic to the blood.

 B. hypertonic to the blood.

 C. hypertonic to the filtrate.

 D. hypotonic to the vasa recta.

 E. isotonic to the blood.

SOLUTIONS TO REVIEW PROBLEMS

1. **B** Monosaccharides would most likely filter through the glomerulus. Cells, cell fragments, and proteins remain on the circulatory side.

2. See Figure 15.2.

3. **B** Discussed in nephron function section in this chapter.

4. **C** Discussed in osmoregulation section in this chapter.

5. **C** Discussed in function of nephron section in this chapter.

6. **B** Discussed in function of nephron section in this chapter.

CHAPTER SIXTEEN

Endocrine System

LEARNING OBJECTIVES

After this chapter, you will be able to:

- Identify the major endocrine glands and hormones
- Recall the types and targets of endocrine hormones
- Contrast the different mechanisms of hormone action

The endocrine system acts as a means of internal communication, coordinating the activities of the organ systems. **Endocrine glands** synthesize and secrete chemical substances called **hormones** directly into the circulatory system. In contrast, **exocrine glands**, such as the gallbladder, secrete substances transported by ducts. The glands and hormones of the endocrine system are the focus of this chapter.

ENDOCRINE GLANDS

Glands or organs that synthesize or secrete hormones include the pituitary, hypothalamus, thyroid, parathyroids, adrenals, pancreas, testes, ovaries, pineal gland, kidneys, gastrointestinal glands, heart, and thymus. Some hormones regulate a single type of cell or organ, whereas others have more widespread effects. The specificity of hormonal action is determined by the presence of specific receptors on or in the target cells.

Hypothalamus

Any discussion of the endocrine system typically begins with the **hypothalamus**, the regulatory center of the endocrine system. The hypothalamus is part of the forebrain and is located directly above the **pituitary gland**. Receiving neural transmissions from other regulatory centers of the brain and peripheral nerves, the hypothalamus responds through secretions of hormones from its neurosecretory cells. The hypothalamic hormones regulate pituitary gland secretions via a negative feedback loop.

Interactions with the anterior pituitary

The releasing hormones of the hypothalamus stimulate or inhibit the secretions of the anterior pituitary. For example, **Gonadotropin releasing hormone (GnRH)** stimulates the anterior pituitary to secrete follicle stimulating hormone (FSH) and luteinizing hormone (LH). Releasing hormones are secreted into the hypophyseal portal system. In this circulatory pathway, blood from the capillary bed in the hypothalamus flows through a portal vein into the anterior pituitary (hypophyseal portal system), where it diverges into a second capillary network. In this way, releasing hormones can immediately reach the anterior pituitary without first entering the circulatory system.

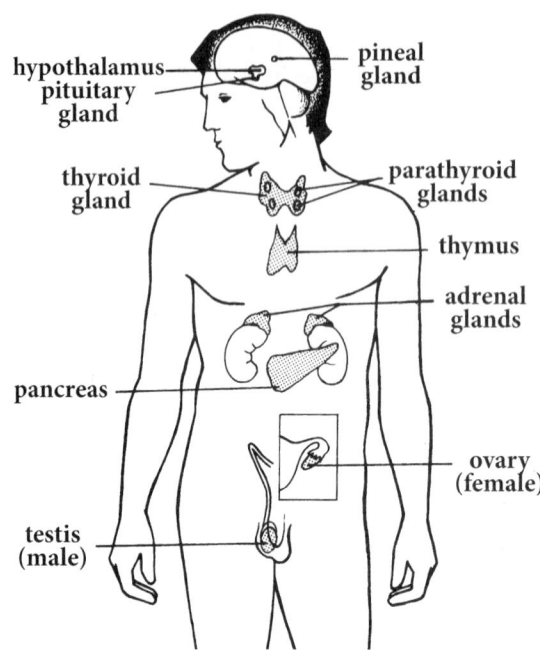

Figure 16.1

A complicated feedback system regulates the secretions of the endocrine system. The vast majority of feedback regulation is **negative feedback**, in which the product of the pathway inhibits its own production. For example, when the plasma levels of adrenal cortical hormones drop, hypothalamic cells release **corticotropin-releasing factor/hormone (CRF/CRH)** into the portal system, which signals the pituitary cells to release **ACTH**. ACTH then acts on the adrenal cortex to increase glucocorticoid levels. When the plasma concentration of corticosteroids exceeds the normal plasma level, the steroids themselves exert an inhibitory effect on the hypothalamus.

Additional noteworthy hormones that interact with the anterior pituitary gland are:

- **Thyrotropin-releasing hormone (TRH)** that stimulates the anterior pituitary to release thyroid hormones, T3 and T4.
- **Growth hormone-releasing hormone (GHRH)** that stimulates the anterior pituitary to release growth hormone.

Interactions with the posterior pituitary

Neurosecretory cells in the hypothalamus synthesize both oxytocin and ADH (antidiuretic hormone) and transport them via their axons into the posterior pituitary for storage and secretion. Due to this axonal interaction between the two glands, there is no need for a portal system to connect them.

Pituitary Gland

The pituitary gland (**hypophysis**) is a small, trilobed gland at the base of the brain. The two main lobes, anterior and posterior, are functionally distinct. The third lobe, the intermediate lobe, has varying functionality dependent on the species; in humans, it is rudimentary. The pituitary gland hangs below the hypothalamus and is connected to it by a slender cord known as the **infundibulum**. The infundibulum contains both the hypophyseal portal system and the neurosecretory axons, connecting the hypothalamus to the posterior pituitary gland.

Anterior pituitary

The **anterior pituitary** synthesizes both **direct hormones**, which directly act on their target organs, and **tropic hormones**, which stimulate other endocrine glands to release hormones. The hormonal secretions of the anterior pituitary are regulated by hypothalamic hormones called releasing/ inhibiting hormones or factors.

The **tropic hormones** of the anterior pituitary include:

- **Follicle-stimulating hormone** (**FSH**): In women, FSH causes maturation of ovarian follicles, which in turn secrete estrogen. In men, FSH stimulates maturation of the seminiferous tubules and sperm production.
- **Luteinizing hormone** (**LH**): In women, LH stimulates ovulation and maintenance of the corpus luteum. LH is also responsible for regulating progesterone secretion in women. In men, LH stimulates the interstitial cells of the testes to synthesize testosterone.
- **Adrenocorticotropic hormone** (**ACTH**): ACTH stimulates the adrenal cortex to synthesize and secrete glucocorticoids and is regulated by **corticotropin-releasing factor** (**CRF**).
- **Thyroid-stimulating hormone** (**TSH**): TSH stimulates the thyroid gland to synthesize and release thyroid hormones, thyroxine (T4) and triiodothyronine (T3).

The **direct hormones** of the anterior pituitary include:

- **Prolactin**: Prolactin stimulates milk production in female mammary glands.
- **Endorphins**: These are neurotransmitters that have pain-relieving properties.
- **Growth hormone** (GH, somatotropin): GH promotes bone and muscle growth. GH also promotes protein synthesis and lipid mobilization and catabolism.
- **Melanocyte-stimulating hormone** (MSH): MSH is secreted by the intermediate lobe of the pituitary. In mammals, MSH plays a role in the sun-induced darkening of skin (tanning). However, in amphibians the relationship between MSH and sunlight is reversed. When amphibians are in darker environments for long periods of time, MSH is released causing darkening of the skin in order to better camouflage with the environment.

Posterior pituitary

The posterior pituitary (neurohypophysis) does not synthesize hormones. Instead, it stores and releases the peptide hormones oxytocin and antidiuretic hormone, which are produced by the neurosecretory cells of the hypothalamus. Hormone secretion is stimulated by action potentials descending from the hypothalamus.

- **Oxytocin**, which is secreted during childbirth, increases the strength and frequency of uterine muscle contractions. During parturition (childbirth) oxytocin experiences a **positive feedback loop**, in which the product of a system increases its own synthesis. Specifically, oxytocin triggers uterine contractions that put pressure on the cervix, which triggers (through neuronal messages) additional release of oxytocin. Oxytocin secretion is also induced by suckling; oxytocin stimulates milk secretion in the mammary glands.

- **Antidiuretic hormone** (ADH) increases water permeability in the collecting duct of the nephron, thereby promoting water reabsorption and increasing blood volume, which subsequently increases blood pressure and decreases blood osmolarity. ADH is secreted when plasma osmolarity increases, as sensed by osmoreceptors in the hypothalamus, or when blood volume decreases, as sensed by baroreceptors in the circulatory system. Therefore, ADH is regulated in a negative feedback manner.

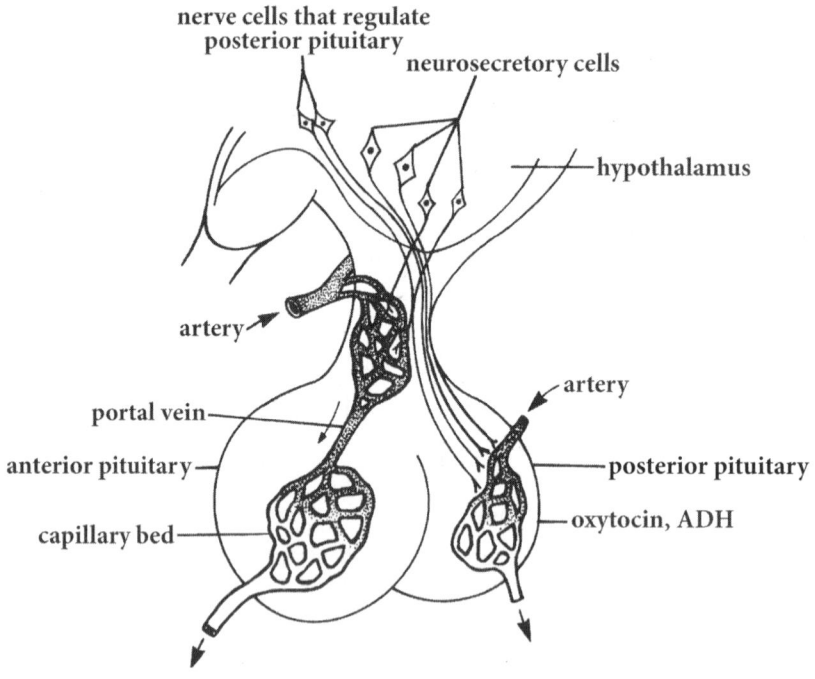

Figure 16.2

As previously described, the interactions between the hypothalamus and pituitary gland regulate the secretion of tropic hormones, which have downstream effects on the adrenal glands, thyroid, and gonads. These glands are the final part of their respective regulatory axes, specifically hypothalamic-pituitary-adrenal axis, hypothalamic-pituitary-thyroid axis, and hypothalamic-pituitary-gonadal axis.

Adrenal Glands

The adrenal glands are located on top of the kidneys and consist of the adrenal cortex and the adrenal medulla.

Adrenal cortex

In response to stress, **adrenocorticotropic hormone** (ACTH), which is produced by the anterior pituitary, stimulates the adrenal cortex to produce more than two dozen different steroid hormones, collectively known as **adrenocortical steroids**, or simply **corticosteroids**. In the bloodstream, these corticosteroids are bound to transport proteins called transcortins. Corticosteroids exert their action by determining which genes are transcribed in the nuclei of their target cells and at what rate. The subsequent changes in the nature and concentration of the proteins produced in the target cells will affect metabolism and other cellular functions. The three major classes of corticosteroids are described below:

- **Glucocorticoids**, such as cortisol and cortisone, are involved in glucose regulation and protein metabolism. Glucocorticoids raise blood glucose levels by promoting protein breakdown and gluconeogenesis and decreasing protein synthesis. Glucocorticoids are antagonistic to the effects of insulin and trigger the release of amino acids from skeletal muscle, as well as lipids from adipose tissue. They also promote the peripheral use of lipids and have anti-inflammatory effects.

- **Mineralocorticoids**, particularly **aldosterone**, regulate plasma levels of sodium and potassium and, consequently, the total extracellular fluid volume. Aldosterone causes active reabsorption of sodium and passive reabsorption of water in the nephron of the kidney. This results in an increase in both blood volume and blood pressure. The mineralocorticoids are stimulated by **angiotensin II** and inhibited by **ANP** (atrial natriuretic peptide). The production of angiotensin II is regulated by the lungs and kidney, which are sensitive to blood pressure changes. ANP is produced by the heart and serves as another regulator of blood pressure. See Chapter 15 for more information on the action of aldosterone.

- **Androgens** (male sex hormones) are secreted from the adrenal cortex in small quantities in both men and women. In men, most of the androgens are produced by the testes, so the physiologic effect of the adrenal androgens is quite small. In women, however, overproduction of the adrenal androgens may have masculinizing effects, such as excessive facial hair.

Adrenal medulla

The adrenal medulla produces **epinephrine (adrenaline)** and **norepinephrine (noradrenaline)**, both of which belong to a class of amino acid–derived compounds called catecholamines.

Epinephrine increases the conversion of glycogen to glucose in liver and muscle tissue, causing an increase in blood glucose levels and an increase in the basal metabolic rate. Both epinephrine and norepinephrine increase the rate and strength of the heartbeat and dilate and constrict blood vessels in such a way as to increase the blood supply to the skeletal muscles, heart, and brain, while decreasing the blood supply to the kidneys, skin, and digestive tract. Both epinephrine and norepinephrine will also promote the release of lipids by adipose tissue. These effects are known as the "fight or flight response" and are elicited by sympathetic nervous stimulation in response to stress.

Epinephrine will inhibit other functions, such as digestion, that are not immediately important for survival. Both of these hormones are also neurotransmitters, proteins used by neurons to transmit signals.

Thyroid

The thyroid is controlled by thyroid-stimulating hormone (TSH) from the anterior pituitary, which is in turn stimulated by thyroid-releasing hormone (TRH) from the hypothalamus. The thyroid is located in front of the trachea and has two major functions, the first being metabolism regulation (including growth for children) through the release of **triiodothyronine** (T3) and **thyroxine** (T4). The second function is regulation of blood calcium levels through the release of calcitonin, which has an antagonistic role with parathyroid hormone (produced in the parathyroid glands).

Thyroid hormones

The thyroid hormones, thyroxine (T4) and triiodothyronine (T3), are formed from the glycoprotein thyroglobulin, which is synthesized in thyroid cells. The numbers 3 and 4 refer to the number of iodine atoms attached to the hormone. Because of the specific tertiary structure of this glycoprotein, iodinated tyrosine residues present in thyroglobulin are able to bind together to form active thyroid hormones. The thyroid hormones possess the following characteristics:

- T3 is five times more potent than T4.
- T4 and T3 are transported via plasma proteins. Approximately 99.5% of these hormones are bound to proteins, but only an unbound hormone is able to enter a cell and elicit a cellular response.
- All of the T4 in the body is formed and secreted by the thyroid gland; however, only 20% of T3 is produced by the thyroid gland.
- The majority of T3 is produced by the conversion of T4 to T3 by the enzyme 5′-monodeiodase, found primarily in the peripheral tissues.

In **hypothyroidism**, thyroid hormones are under-secreted or not secreted at all. Common symptoms of hypothyroidism include a slowed heart rate and respiratory rate, fatigue, cold intolerance, and weight gain. Notice all symptoms can be explained by low levels of metabolism. In **hyperthyroidism**, the thyroid is overstimulated, resulting in the over secretion of thyroid hormones. Symptoms often include increased metabolic rate, feelings of excessive warmth, profuse sweating, palpitations, weight loss, and protruding eyes. In both disorders the thyroid often enlarges, forming a bulge in the neck called a goiter.

Hypothyroidism is often treated with supplementation of thyroid hormones via synthetic or animal-derived products. Hyperthyroidism can be treated by antithyroid medications that suppress the thyroid's release of excess hormone or ablation of the thyroid with radiation. After ablation, the thyroid no longer produces thyroid hormone, and the patient must take thyroid supplementation for the rest of his or her life.

Calcitonin

Calcitonin decreases plasma Ca^{2+} concentration by inhibiting the release of Ca^{2+} from bone and promoting the storage of Ca^{2+} in bones. Calcitonin secretion is regulated by plasma Ca^{2+} levels. Specifically, high blood Ca^{2+} levels stimulate calcitonin release. Calcitonin is antagonistic to parathyroid hormone. It is worth noting that calcitonin is not affected by the hypothalamus or the pituitary gland.

Gonads

Chapter 17 will cover the reproductive system in more detail; thus, this explanation will serve as a brief overview. Gonadotropin-releasing hormone (GnRH) from the hypothalamus acts on the anterior pituitary to release the **gonadotropins** (LH and FSH). In men, both LH and FSH act on the testes to produce testosterone and foster the maturation of sperm cells. In females, the gonadotropins cause the secretion of **estrogen** and **progesterone**.

Hypothalamic Releasing Hormone	Hormone(s) from Anterior Pituitary	Target Organ	Hormone(s) Released by Target Organ
Gonadotropin-releasing hormone (GnRH)	Follicle-stimulating hormone (FSH) and luteinizing hormone (LH)	Gonads (testes or ovaries)	Testosterone (testes) or estrogen and progesterone (ovaries)
Corticotropin-releasing factor (CRF)	Adrenocorticotropic hormone (ACTH)	Adrenal cortex	Glucocorticoids (cortisol and cortisone)
Thyroid-releasing hormone (TRH)	Thyroid-stimulating hormone (TSH)	Thyroid	Triiodothyronine (T_3), thyroxine (T_4)
Dopamine	Prolactin*	Breast tissue	N/A
Growth hormone–releasing hormone (GHRH)	Growth hormone	Bone, muscle	N/A

*Note that a *decrease* in dopamine from the hypothalamus promotes prolactin secretion.

Table 16.1

The upcoming glands are not directly regulated by the hypothalamus and pituitary, instead they are regulated by direct negative feedback from their products or the effects of their products.

Parathyroid Glands

The parathyroid glands are four small, pea-shaped structures embedded in the posterior surface of the thyroid. These glands synthesize and secrete **parathyroid hormone (PTH)**, which regulates plasma Ca^{2+} concentration. PTH raises the Ca^{2+} concentration in the blood by stimulating Ca^{2+} release from the bone and decreasing Ca^{2+} excretion in the kidneys. This is done in response to low Ca^{2+} levels in the blood. Calcium in bone is bonded to phosphate, and breakdown of the bone releases phosphate as well as calcium. Parathyroid hormone compensates for this by stimulating excretion of phosphate by the kidneys.

Pancreas

The pancreas is both an **exocrine** organ and an **endocrine** organ. The exocrine function is performed by the cells that secrete digestive enzymes into the small intestine via a series of ducts (see Chapter 14). The endocrine function is performed by small glandular structures called the **islets of Langerhans**, which are composed of alpha and beta cells. **Alpha cells** produce and secrete glucagon, while **beta cells** produce and secrete insulin. The endocrine hormones of the pancreas are regulated through negative feedback and are antagonistic to one another.

Glucagon, a peptide hormone, is released when blood glucose levels are low. Upon release, glucagon stimulates protein and fat degradation, the conversion of glycogen to glucose, and gluconeogenesis, all of which serve to increase blood glucose levels.

Insulin, a protein hormone, is secreted in response to a high blood glucose concentration. Insulin acts on glucose transporters on the cell membrane of liver, muscle, and adipose cells, resulting in the uptake of glucose. In addition, it also stimulates the synthesis of fats from glucose and the uptake of amino acids. In short, the effects of insulin all serve to lower blood glucose levels.

Underproduction of insulin, or insensitivity to insulin, leads to diabetes mellitus, which is characterized by hyperglycemia (high blood glucose levels). Diabetes is the most common endocrine disorder and, if not treated, can lead to long-term complications involving the eyes, nerves, kidneys, and blood vessels. Table 16.2 identifies the distinguishing characteristics of Type I and Type II diabetes.

Distinguishing Characteristics	Type I	Type II
% diabetics	10	90
Age of onset	Usually <30 years	Usually >30 years
Pathogenesis	Presence of islet cell antibodies Autoimmune Decreased insulin secretion	Resistance to insulin Increased hepatic glucose production
Plasma insulin	Usually none	Low, normal, or high Etiology dependent
Family history	Usually none	Strong
Obesity	Uncommon	Common

Table 16.2

Kidneys

The kidney plays a crucial role in the renin-angiotensin-aldosterone (RAA) system, which heavily regulates both blood volume and blood pressure. When blood volume falls, the kidneys produce **renin**—an enzyme that converts the plasma protein angiotensinogen to angiotensin I. Angiotensin I (produced by the liver) is converted to angiotensin II, which stimulates the adrenal cortex to secrete **aldosterone**. Aldosterone helps restore blood volume by increasing sodium reabsorption by the kidneys, leading to an increase in fluid retention. This removes the initial stimulus for renin production. The kidneys also produce **erythropoietin (EPO)**. EPO is a glycoprotein that stimulates red blood cell production; it is normally produced in the kidneys.

Gastrointestinal Hormones

Ingested food stimulates the stomach to release the hormone gastrin. **Gastrin** is carried to the gastric glands and stimulates the glands to secrete HCl in response to food in the stomach. Secretion of pancreatic juice, the exocrine product of the pancreas, is also under hormonal control. The hormone **secretin** is released by the small intestine when acidic chyme enters from the stomach. Secretin stimulates the secretion of an alkaline bicarbonate solution from the pancreas that neutralizes the acidity of the chyme. The hormone **cholecystokinin** is released by the small intestine in response to the presence of fats and causes the contraction of the gallbladder and release of bile into the small intestine. **Bile,** which is not a hormone, is involved in the emulsification and digestion of fats.

Pineal Gland

The pineal gland is a tiny structure at the base of the brain that secretes the hormone **melatonin**. The role of melatonin in humans is unclear, but it is believed to play a role in the regulation of **circadian rhythms**—physiological cycles lasting approximately 24 hours. Melatonin secretion is regulated by light and dark cycles in the environment. In primitive vertebrates, melatonin lightens the skin by concentrating pigment granules in melanophores (melatonin is an antagonist to MSH).

MECHANISM OF HORMONE ACTION

Hormones are classified on the basis of their chemical structure into two major groups: peptide hormones and steroid hormones. There are two ways in which hormones affect the activities of their target cells: via extracellular receptors or intracellular receptors.

Peptides

Peptide hormones range from simple short peptides (amino acid chains), such as ADH, to complex polypeptides, such as insulin. Peptide hormones act as **first messengers.** When they bind to **specific receptors** on the surface of their target cells, they trigger a series of enzymatic reactions within each cell, the first of which may be the conversion of ATP to cyclic adenosine monophosphate (cyclic AMP); this reaction is catalyzed by the membrane-bound enzyme adenylate cyclase. **Cyclic AMP** acts as a **second messenger**, relaying messages from the extracellular peptide hormone to cytoplasmic enzymes and initiating a series of reactions in the cell. This is an example of a **cascade effect**; with each step, the hormone's effects are amplified. Cyclic AMP activity is inactivated by the cytoplasmic enzyme phosphodiesterase.

Section II: Biology

Steroids

Steroid hormones, such as estrogen and aldosterone, belong to a class of cholesterol-derived molecules with a characteristic ring structure. They are produced by the testes, ovaries, placenta, and adrenal cortex. Because they are lipid soluble, steroid hormones cross the phospholipid bilayer and enter their target cells directly in order to bind to specific receptor proteins in the cytoplasm. This receptor-hormone complex enters the nucleus and directly activates the expression of specific genes by binding to receptors on the chromatin. This induces a change in mRNA transcription and protein synthesis.

Criterion	Peptide Hormones	Steroid Hormones
Chemical precursor	Amino acids (polypeptides)	Cholesterol
Location of receptor	Extracellular (cell membrane)	Intracellular or intranuclear
Mechanism of action	Stimulates a receptor (usually a G protein–coupled receptor), affecting levels of second messengers (commonly cAMP). Initiates a signal cascade	Binds to a receptor, induces conformational change, and regulates transcription at the level of the DNA
Method of travel in the bloodstream	Dissolves and travels freely	Binds to a carrier protein
Speed of onset	Quick	Slow
Duration of action	Short-lived	Long-lived

Table 16.3

REVIEW PROBLEMS

1. Name the different parts of the adrenal gland and the hormones secreted from each.

2. Discuss the relationship between the hypothalamus and the pituitary gland.

3. Increased activity of the parathyroid gland leads to
 A. a decrease in blood glucose levels.
 B. an increase in metabolic rate.
 C. a decrease in body temperature.
 D. an increase in blood Ca^{2+} concentrations.
 E. a decrease in blood phosphate concentrations.

4. Which of the following statements concerning growth hormone is NOT true?
 A. Overproduction of growth hormone in children results in gigantism.
 B. Overproduction of growth hormone in adults results in acromegaly.
 C. A deficiency of growth hormone results in dwarfism.
 D. Growth hormone is secreted by the hypothalamus.
 E. Growth hormone promotes protein synthesis.

5. Describe the regulation of plasma Ca^{2+} concentration. Include all of the hormones and organs involved.

6. Thyroid hormone deficiency may result in
 A. acromegaly.
 B. cretinism.
 C. gigantism.
 D. hyperthyroidism.
 E. ablation.

7. Match the following hormones with their respective functions.

 A. Growth hormone 1. Promotes growth of muscle
 B. ACTH 2. Stimulates the release of glucose into the blood
 C. Oxytocin 3. Prepares the uterus for implantation of a fertilized egg
 D. Progesterone 4. Stimulates the secretion of glucocorticoids
 E. Aldosterone 5. Increases the rate of metabolism
 F. Glucagon 6. Induces water reabsorption in the kidneys
 G. Thyroxine 7. Increases uterine contractions during childbirth

8. What is negative feedback?

9. Why is the level of blood glucose so important? What hormones are involved in the regulation of blood glucose levels?

BIO

10. Destruction of all beta cells in the pancreas would cause

 A. glucagon secretion to stop and a decrease in blood glucose.
 B. glucagon secretion to stop and an increase in blood glucose.
 C. insulin secretion to stop and an increase in blood glucose.
 D. insulin secretion to stop and a decrease in blood glucose.
 E. none of the above.

11. A man trapped for three days underneath the ruins of a collapsed building was rescued and rushed to the nearest hospital. He suffered from internal bleeding and was very dehydrated. Why was a high level of aldosterone found in his blood?

12. Oxytocin and vasopressin are

 A. produced and released by the hypothalamus.
 B. produced and released by the pituitary.
 C. produced by the hypothalamus and released by the pituitary.
 D. produced by the pituitary and released by the hypothalamus.
 E. produced by both the hypothalamus and pituitary but released by neither.

SOLUTIONS TO REVIEW PROBLEMS

1. The adrenal gland is divided into the adrenal cortex and the adrenal medulla. The adrenal cortex secretes steroid hormones called mineralocorticoids (e.g., aldosterone) as well as glucocorticoids (e.g., cortisol) and sex hormones (e.g., androstenedione). The adrenal medulla secretes the catecholamines norepinephrine and epinephrine, which are amino acid derivatives.

2. The posterior pituitary stores and secretes hormones produced by the neurosecretory cells of the hypothalamus. In contrast, the anterior pituitary produces hormones that are regulated by hypothalamic releasing hormones. Hypothalamic releasing hormones stimulate the anterior pituitary to secrete a particular hormone, whereas hypothalamic inhibiting hormones inhibit anterior pituitary secretions. The releasing and inhibiting hormones are secreted into a circulatory pathway known as the hypothalamic-hypophyseal portal system, which allows for high, localized concentrations of the various stimulating and inhibitory hormones and rapid, direct transport of these hormones to the pituitary.

3. **D** Discussed in section on parathyroid glands in this chapter.

4. **D** Discussed in section on hormones of the anterior pituitary in this chapter.

5. Calcium levels in the blood are regulated by two hormones: calcitonin and parathyroid hormone (PTH). Calcitonin is secreted by the thyroid gland when plasma Ca^{2+} levels are high and decreases the plasma Ca^{2+} concentration by inhibiting bone resorption (which releases Ca^{2+} into the blood). When plasma Ca^{2+} levels are low, PTH is secreted by the parathyroid glands. PTH increases plasma Ca^{2+} concentration by increasing bone resorption, increasing Ca^{2+} reabsorption in the kidney (thus reducing the amount of Ca^{2+} excreted in the urine), and stimulating the conversion of vitamin D into its active form (1,25-dihydroxycholecalciferol), which increases intestinal absorption of Ca^{2+}.

6. **B** Discussed in section on thyroid gland in this chapter.

7. **A** 1
 B 4
 C 7
 D 3
 E 6
 F 2
 G 5

8. Negative feedback is a means of regulation whereby an end product inhibits one or more of the earlier steps that lead to its production or secretion. For example, high plasma levels of thyroxine inhibit the pituitary gland from secreting TSH, thus removing the stimulus on the thyroid to secrete more thyroxine. Negative feedback mechanisms are also used by the body to regulate enzyme production and activity.

9. Glucose is the primary source of energy used by cells during aerobic respiration, so blood glucose levels determine the amount of energy available for cellular activity. Many

hormones involved in the regulation of blood glucose levels do so by stimulating the liver either to store or release glucose. When glucose levels are low, the adrenal medulla secretes epinephrine, which stimulates the liver to convert glycogen stores into glucose and release it into the blood. Epinephrine also acts on muscles, transforming their glycogen stores into lactic acid, which is transported to the liver and converted to glucose. The pancreas secretes glucagon, which also stimulates the liver to convert glycogen to glucose. When additional glucose is needed, the adrenal cortex secretes glucocorticoids, which stimulate the liver to synthesize glucose in a process called gluconeogenesis. Insulin is antagonistic to glucagon, epinephrine, and glucocorticoids; it lowers blood glucose levels by stimulating the uptake of glucose by adipose and muscle tissue and by promoting the conversion of glucose into glycogen in liver and muscle cells.

10. C Discussed in section on endocrine functions of the pancreas in this chapter.

11. Internal bleeding leads to a decrease in the volume of blood in the circulatory system. When blood volume falls, the kidney produces renin, which leads to an increase in aldosterone. Aldosterone causes increased water reabsorption in the nephrons, leading to an increase in blood volume. Thus, the man's body responded to the blood loss by secreting aldosterone.

12. C Discussed in section on anterior pituitary in this chapter.

CHAPTER SEVENTEEN

Reproductive System

LEARNING OBJECTIVES

After this chapter, you will be able to:

- Explain the steps of sexual reproduction
- Compare and contrast the male and female reproductive systems
- Explain the steps of the menstrual cycle

Reproduction in animals is a complex process involving the formation and fertilization of gametes and regulation of these processes by both parents. Upon fertilization, an embryo is formed, which continues to develop until parturition occurs. This chapter focuses on the formation and fertilization of gametes, while Chapter 18 will cover the development of the embryo.

SEXUAL REPRODUCTION

Sexual reproduction differs from asexual reproduction in that the genetic material of two organisms combines and results in a genetically unique offspring. Sexual reproduction occurs via the fusion of two gametes, the specialized sex cells produced by each parent. Sexual reproduction requires the following processes:

- The production of **functional sex cells** or **gametes** by adult organisms
- The union of these cells (**fertilization** or **conjugation**) to form a zygote
- The development of the zygote into another adult, completing the cycle

Gametogenesis

Gametogenesis, the production of gametes, occurs in specialized organs called **gonads**. The male gonads, the **testes**, produce **sperm** in the tightly coiled seminiferous tubules. The female gonads, the **ovaries**, produce **oocytes** (eggs). Some species are **hermaphrodites**, which possess both functional male and female gonads. These include the hydra and the earthworm.

Spermatogenesis, or sperm production, occurs in the seminiferous tubules of the testes. In females, the process is called **oogenesis**, or egg production, and occurs in the ovaries. Spermatogenesis and oogenesis will be discussed in more detail in the sections on the male and female reproductive systems, respectively.

Fertilization

Fertilization is the union of the egg and sperm nuclei to form a zygote with a diploid number of chromosomes. **Internal fertilization** is practiced by terrestrial vertebrates and provides a direct route for sperm to reach the egg cell. This increases the chance for fertilization success, and

BIO

females produce fewer eggs. The number of eggs produced is affected by other factors as well. If the early development of the offspring occurs outside of the mother's body, more eggs will be produced to increase the chances of offspring survival. The amount of parental care after birth is also related to the number of eggs produced. Species that care for their young produce fewer eggs.

MALE REPRODUCTIVE SYSTEM

The **testes** are located in the **scrotum**, an external pouch that maintains the testes' temperature at 2°C to 4°C lower than body temperature, a condition essential for sperm survival. Sperm production (spermatogenesis) occurs in the **seminiferous tubules** of the testes. The sperm cells mature in the **epididymis**, a structure resting atop of testes. Upon ejaculation, sperm cells pass through the **vas deferens** to the **ejaculatory duct** and then to the **urethra**. The urethra passes through the **penis** until it terminates with an external opening at the **glans** of the penis. In males, the urethra is a common passageway for both the reproductive and excretory systems (see Figure 17.1).

Male Sex Hormones

In males, the main sex hormones are follicle-stimulating hormone (FSH), luteinizing hormone (LH), and testosterone. Recall that the release of both FSH and LH from the anterior pituitary is induced by GnRH. FSH acts on the **Sertoli cells**, located in the seminiferous tubules, to support the development of maturing sperm cells. LH acts on **Leydig cells** to stimulate testosterone production in the testes. **Testosterone**, a steroid hormone, is produced in the testes and induces secondary male sex characteristics including facial and pubic hair, and voice changes. In embryogenesis, testosterone induces the male sexual differentiation.

MNEMONIC

Pathway of sperm through the male reproductive system: **SEVE(N) UP**

- **S**eminiferous tubules
- **E**pididymis
- **V**as deferens (also called the ductus deferens)
- **E**jaculatory duct
- **(N**ext)
- **U**rethra
- **P**enis

MNEMONIC

Remember "S n' L":

F**S**H acts on **S**ertoli cells to mature sperm.

LH acts on **L**eydig cells to produce testosterone.

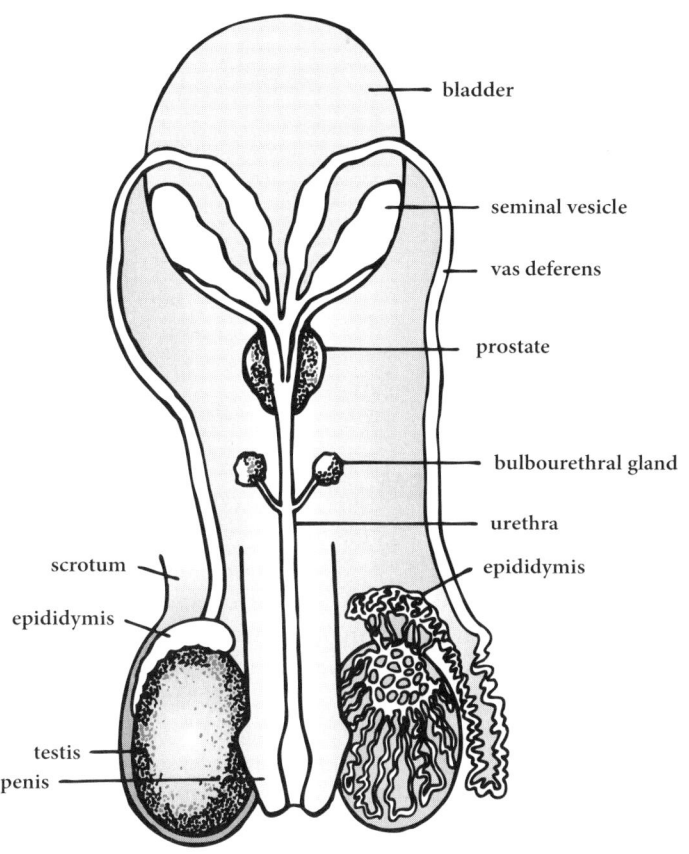

bladder

seminal vesicle

vas deferens

prostate

bulbourethral gland

urethra

scrotum epididymis

epididymis

testis

penis

Figure 17.1

Spermatogenesis

As previously mentioned, spermatogenesis, or sperm production, occurs in the seminiferous tubules. Here, diploid cells called **spermatogonia** differentiate into diploid cells called **primary spermatocytes**, which undergo a meiotic division to yield two haploid **secondary spermatocytes** of equal size; a second meiotic division produces four haploid **spermatids** of equal size (see Chapter 5). After meiosis, the spermatids undergo a final series of changes that increase their mobility, resulting in mature sperm, or **spermatozoa**. The mature sperm is an elongated cell with a head, neck, body, and tail. The head consists almost entirely of the nucleus. The tail (flagellum) propels the sperm, while mitochondria in the neck and body provide energy for locomotion. A caplike structure called the **acrosome**, derived from the Golgi apparatus, develops over the anterior half of the head. The acrosome contains enzymes needed to penetrate the tough outer covering of the ovum. After a male has reached sexual maturity, approximately 3 million primary spermatocytes begin to undergo spermatogenesis per day.

BIO

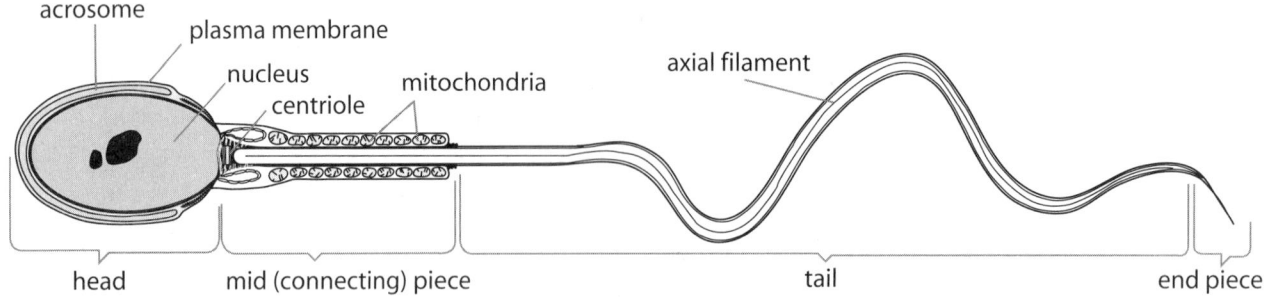

Figure 17.2

FEMALE REPRODUCTIVE SYSTEM

The female gonads, ovaries, are found in the abdominal cavity below the digestive system. The pair of ovaries each contain thousands of **follicles**. A follicle is a multilayered sac of cells that contains, nourishes, and protects an immature **ovum** (female gamete). It is actually the follicle cells that produce estrogen. Approximately once a month, an immature ovum is released (**ovulation**) from the ovary into the abdominal cavity and drawn by cilia into the nearby oviduct, also known as a **fallopian tube**. Each fallopian tube opens into the upper end of a muscular chamber called the **uterus**, the site of fetal development. The lower, narrow end of the uterus is called the **cervix**. The cervix connects with the vaginal canal, which is the site of sperm deposition during intercourse and is also the passageway through which a baby is expelled during childbirth. Both the development of follicles and ovulation are regulated by the **menstrual cycle**, which will be covered later in the chapter.

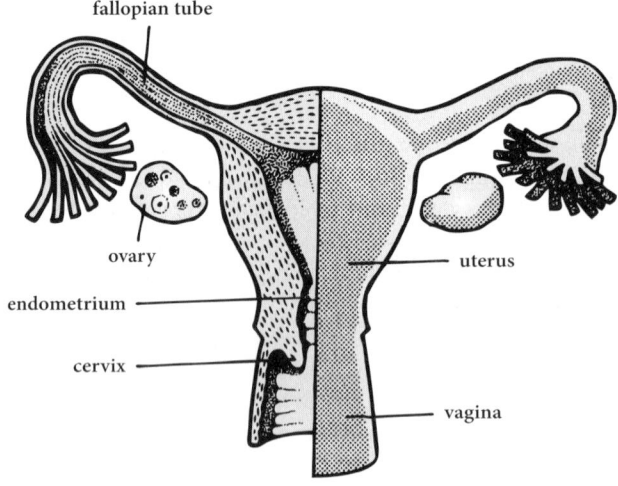

Figure 17.3

Oogenesis

Oogenesis, the production of female gametes, occurs in the ovarian follicles. At birth, most of the immature ova, known as **primary oocytes,** that a female will produce during her lifetime have already formed. Primary oocytes are diploid cells that form by mitosis in the ovary. After menarche (the first time a female menstruates), one primary oocyte per month completes meiosis I, yielding two daughter cells of unequal size—a **secondary oocyte** and a small cell known as a **polar body**. The secondary oocyte is expelled from the follicle during ovulation, while the polar body gets reabsorbed. Meiosis II does not occur until fertilization. The oocyte cell membrane is surrounded by two layers of cells; the inner **zona pellucida layer** and the outer **corona radiata layer**. Meiosis II is triggered when these layers are penetrated by a sperm cell, yielding two haploid cells—a mature ovum and another polar body. The mature ovum is a large cell containing cytoplasm, RNA, organelles, and nutrients needed by the developing embryo. When polar bodies are formed, they lack these resources and rapidly degenerate.

Female Sex Hormones

The ovaries synthesize and secrete female sex hormones, including estrogens and progesterone. The secretion of both estrogens and progesterone is regulated by **luteinizing hormone (LH)** and **follicle stimulating hormone (FSH)**, which, are regulated by gonadotropin-releasing hormone (GnRH).

Estrogens

Estrogens are steroid hormones necessary for normal female maturation. They stimulate the development of the female reproductive tract, contribute to the development of secondary sexual characteristics, and influence libido. Estrogens are also responsible for the thickening of the endometrium (the inner lining of the uterine wall). Estrogens are secreted by the ovarian follicles and the corpus luteum.

Progesterone

Progesterone is a steroid hormone secreted by the corpus luteum during the luteal phase of the menstrual cycle. Progesterone stimulates the development and maintenance of the endometrium in preparation for implantation.

The Menstrual Cycle

The hormonal secretions of the ovaries, hypothalamus, and anterior pituitary play important roles in the female reproductive cycle. From puberty through menopause, interactions between these hormones result in a monthly cyclical pattern known as the menstrual cycle. The menstrual cycle is divided into the follicular phase, ovulation, the luteal phase, and menstruation. Although Day 1 of the menstrual cycle is marked as the start of menstruation, conceptually it is best to consider the menstrual cycle to begin at the follicular phase and end with menstruation (see Figure 17.4).

Follicular phase

The **follicular phase** focuses on the follicle, specifically the growth of the follicle. The follicular phase begins with the cessation of **menses** (menstruation) from the previous cycle, which results in a decrease in progesterone. The decrease in progesterone results in the reduction of GnRH inhibition, thus increasing GnRH and FSH. The main hormone to consider in the follicular phase is follicle-stimulating hormone (FSH), which stimulates follicle growth. Recall follicles produce estrogen and as

they mature their estrogen production increases as well. Thus, throughout the follicular phase blood estrogen levels increase, eventually triggering the next phase, ovulation.

Ovulation

Midway through the cycle, ovulation occurs—a mature ovarian follicle bursts and releases an ovum into the fallopian tube. **Ovulation** is caused by a surge in LH that is preceded, and caused by, a peak in estrogen levels. As estrogen levels increase during the follicular phase, a concentration threshold is reached that causes a positive feedback loop with the anterior pituitary, inducing the LH surge (a smaller FSH surge also occurs). This surge causes the mature follicle to burst, releasing the ovum while the follicle exterior transforms into the **corpus luteum** (luteal body). The corpus luteum plays a crucial role in the luteal phase.

Although there are multiple follicles maturing during the follicular phase, one follicle typically outpaces the others and ovulates. Women ovulate approximately once every four weeks (except during pregnancy and, usually, lactation) until menopause, which typically occurs between the ages of 45 and 50. During menopause the ovaries become less sensitive to the hormones that stimulate follicle development (FSH and LH) and eventually atrophy. The remaining follicles disappear, estrogen and progesterone levels greatly decline, and ovulation stops. The profound changes in hormone levels are often accompanied by physiological and psychological changes that persist until a new balance is reached.

Luteal phase

After ovulation, LH levels are relatively high but begin to drop due to hormone interaction with the **corpus luteum**. LH maintains the corpus luteum, which secretes estrogen and progesterone. Recall estrogen and progesterone exert negative feedback regulation on both the hypothalamus and anterior pituitary, thus decreasing LH levels. In this way, the corpus luteum is on a biological timer, as it secretes more progesterone the less LH is present. This causes the degradation of the corpus luteum, triggering menstruation.

In addition, progesterone causes the glands of the endometrium to mature and produce secretions that prepare it for the implantation of an embryo. Progesterone and estrogen are essential for the maintenance of the endometrium.

Menstruation

If the ovum is not fertilized, the corpus luteum atrophies due to a decrease in LH. The resulting drop in progesterone and estrogen levels causes the endometrium (with its superficial blood vessels) to shed, giving rise to the menstrual flow (menses).

If fertilization occurs, menstruation is avoided as both the resulting zygote and the developing placenta produce **hCG (human chorionic gonadotropin)**. Human chorionic gonadotropin is a LH analog which maintains the corpus luteum, therefore ensuring a continuous supply of estrogen and progesterone needed to maintain the uterus. Eventually, the placenta will take over production of these hormones.

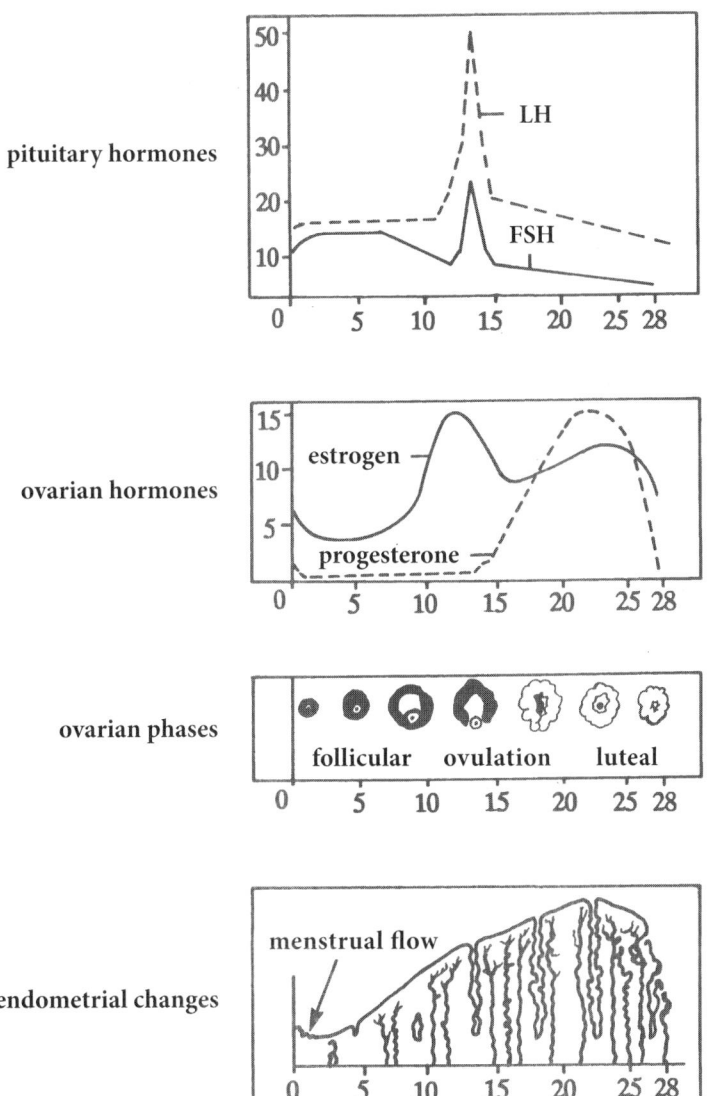

Figure 17.4

Fertilization

An egg can be fertilized during the 12–24 hours after ovulation. Fertilization most often occurs in the lateral, widest portion of the fallopian tube. Sperm must travel through the vaginal canal, cervix, uterus, and into the fallopian tubes to reach the ovum. Sperm remain viable and capable of fertilization for 1–2 days after intercourse.

The first barrier that the sperm must penetrate is the corona radiata. Enzymes secreted by the sperm aid in penetration of the corona radiata. The acrosome is responsible for penetrating the zona pellucida; it releases enzymes that digest this layer, thereby allowing the sperm to come into direct contact with the ovum cell membrane. Once in contact with the membrane, the sperm forms a

tubelike structure called the **acrosomal process,** which extends to the cell membrane and penetrates it, fusing the sperm cell membrane with that of the ovum. The sperm nucleus now enters the ovum's cytoplasm. It is at this stage of fertilization that the ovum completes meiosis II.

The acrosomal reaction triggers a **cortical reaction** in the ovum, causing calcium ions to be released into the cytoplasm; this initiates a series of reactions that result in the formation of the **fertilization membrane**. The fertilization membrane is a hard layer that surrounds the ovum cell membrane and prevents multiple fertilizations. The release of Ca^{2+} also stimulates metabolic changes within the ovum, greatly increasing its metabolic rate. This is followed by the fusion of the sperm nucleus with the ovum nucleus to form a diploid zygote. The first mitotic division of the zygote soon follows.

Multiple Births

Monozygotic (identical) twins

Monozygotic twins result when a single zygote splits into two embryos. Occasionally, the division is incomplete, resulting in the birth of "Siamese" (conjoined) twins, which are attached at some point on the body, often sharing limbs or organs. Monozygotic twins are genetically identical because they develop from the same zygote. Monozygotic twins are therefore of the same sex, blood type, and so on.

Dizygotic (fraternal) twins

Dizygotic twins result when two ova are released in one ovarian cycle and are fertilized by two different sperm. The two embryos implant in the uterine wall individually, and each develops its own placenta, amnion, and chorion (although the placentas may fuse if the embryos implant very close to each other). Fraternal twins share no more characteristics than any other siblings because they develop from two distinct zygotes.

In the animal kingdom, many species regularly have multiple births. For instance, dogs and cats regularly have litters sizes ranging from 5–8. This closely resembles the concept of fraternal twins, as each of the puppies/kittens in a litter develop from a unique fertilization and zygote.

REVIEW PROBLEMS

1. Upon ovulation, the oocyte is released into the

 A. fallopian tube.

 B. ovary.

 C. follicle.

 D. abdominal cavity.

 E. uterus.

2. Describe three ways in which sexual reproduction promotes genetic variability. How does genetic variability benefit a species?

3. All of the following describe glands in the male reproductive system EXCEPT

 A. prostate.

 B. bulbourethral.

 C. Cowper's.

 D. seminal vesicles.

 E. suprarenal.

4. Which of the following correctly describes the order of maturation of a sperm?

 A. spermatazoa → spermatogonia → primary spermatocyte → secondary spermatocyte → spermatid

 B. spermatogonia → spermatazoa → primary spermatocyte → secondary spermatocyte → spermatid

 C. spermatogonia → primary spermatocyte → secondary spermatocyte → spermatid → spermatazoa

 D. primary spermatocyte → secondary spermatocyte → spermatid → spermatazoa → spermatogonia

 E. spermatazoa → primary spermatocyte → secondary spermatocyte → spermatogonia

5. Ovulation is directly caused by

 A. a surge in estrogen.

 B. lack of inhibition from follicle-stimulating hormone.

 C. a decrease in progesterone.

 D. a sharp increase in luteinizing hormone.

 E. inhibition from gonadotropin-releasing hormone.

SOLUTIONS TO REVIEW PROBLEMS

1. **D** This subtle point about ovulation eludes most people and remains hard to believe until the organs are examined in anatomy class. The ruptured ovarian follicle releases an oocyte into the abdominal cavity, close to the entrance of the fallopian tube. With the aid of beating cilia, the oocyte is drawn into the fallopian tube, through which it travels until it reaches the uterus. If it is fertilized (in the fallopian tube), it will implant in the uterine wall; if it is not fertilized, it will be expelled along with the uterine lining during menstruation.

2. Sexual reproduction promotes genetic variability through the independent assortment of homologous chromosomes, the crossing over between homologous chromosomes during meiosis, and the random fertilization of an egg by a sperm.

 The independent assortment of chromosomes during gametogenesis allows for tremendous genetic variability by creating numerous possible combinations of chromosomes in a given gamete. During metaphase I, homologous chromosomes pair and randomly align at the metaphase plate. The random positioning of the homologous pairs determines which chromosomes are pulled toward each pole of the cell during anaphase. Thus, each resultant daughter cell has a random assortment of chromosomes, some of maternal origin and some of paternal origin.

 In addition to independent assortment, a random exchange of genes between chromosomes can occur via recombination. This allows for greater genetic variability by creating new combinations of genes on each chromosome. Recombination occurs during prophase I of meiosis, when homologous pairs of chromosomes align themselves side by side and exchange genetic information in a process called crossing over.

 Genetic variability is further enhanced by fertilization. An egg cell containing one of the millions of possible gene combinations fuses with a sperm cell containing another of the millions of possible combinations of different genes to create a zygote with a unique assortment of maternal and paternal genes.

 Genetic variability increases the chances of some members of a species surviving potential environmental stresses and conditions and promotes evolution over many generations.

3. **E** The suprarenal glands, also known as the adrenal glands, are located on the kidneys and are not part of the reproductive system, so (E) is the correct answer. The prostate, bulbourethral (Cowper's) gland, and seminal vesicles all contribute to the formation of semen in the male reproductive system.

4. **C** In spermatogenesis, a spermatogonia matures into a primary spermatocyte, which undergoes meiosis I to form two secondary spermatocytes, which in turn undergo meiosis II to form a total of four spermatid. These spermatid then undergo spermiogenesis to become spermatazoa.

5. **D** Ovulation occurs when luteinizing hormone (LH) spikes in response to a sharp increase in follicle-stimulating hormone (FSH), which in turn was caused by rising estrogen levels from the developing follicle. LH causes the follicle to rupture, releasing its ovum, and this is ovulation. The follicle leaves behind the corpus luteum, which is what gives LH its name.

CHAPTER EIGHTEEN

Developmental Biology

LEARNING OBJECTIVES

After this chapter, you will be able to:

- Explain the development of the embryo and fetus up to birth
- Recall the primary structures of plant embryology

Embryology is the study of the development of a unicellular zygote into a complete, multicellular organism. Over the course of nine months, a unicellular human zygote undergoes cell division, cellular differentiation, and morphogenesis in preparation for life outside the uterus.

Early Developmental Stages

Fertilization

In mammals, an egg can be fertilized within 12–24 hours after ovulation. Fertilization occurs in the lateral, widest portion of the oviduct where sperm traveling from the vagina encounter an egg. If more than one egg is fertilized, **fraternal (dizygotic) twins** may be conceived. **Identical (monozygotic) twins**, in contrast, occur when one zygote divides into two separate embryos.

Cleavage

Early embryonic development is characterized by a series of rapid mitotic divisions known as **cleavage**. These divisions lead to an increase in cell number without a corresponding growth in cell protoplasm (i.e., the total volume of cytoplasm remains constant). Thus, cleavage results in progressively smaller cells with an increasing ratio of nuclei to cytoplasm. Cleavage also increases the surface-area-to-volume ratio of each cell, thereby improving gas and nutrient exchange.

The first complete cleavage of a zygote occurs approximately 32 hours after fertilization. The second cleavage occurs after 60 hours, and the third cleavage after approximately 72 hours, at which point the eight-celled embryo reaches the uterus. As cell division continues, a solid ball of embryonic cells, known as the **morula**, is formed. **Blastulation** begins when the morula develops a fluid-filled cavity called the **blastocoel**, which by the fourth day becomes a hollow sphere of cells called the **blastula** (blastocyst in mammals).

Implantation

The outer layer of cells of the blastula, called the trophoblast, plays a role in the implantation of the blastula in the uterus. It also provides nutrients to the embryo and develops into part of the placenta. Emergency contraception works partially by inhibiting implantation of the blastula in the uterus, which is why it is most effective if taken within 72 hours of the time of potential fertilization.

In an ectopic pregnancy, the embryo implants outside the uterus, for example, in the fallopian tube. An embryo typically cannot be maintained for long outside of the uterus; it will usually abort spontaneously, and hemorrhaging may occur. Ectopic pregnancies can be fatal if not caught in time and managed appropriately.

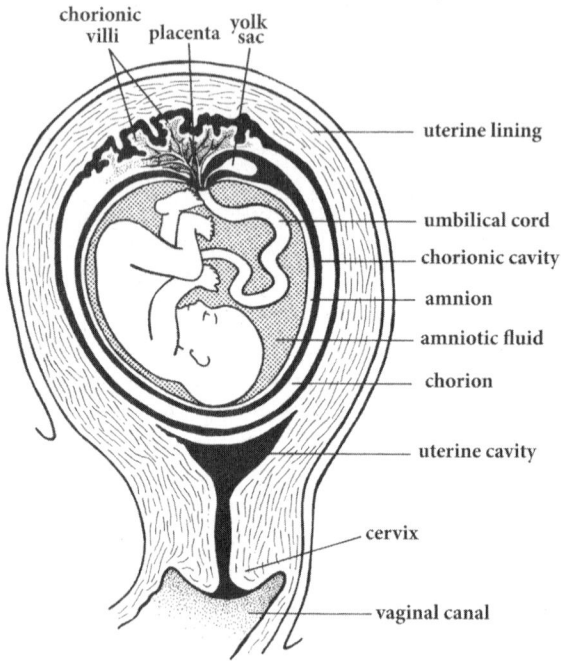

Figure 18.1

Placental development

The growing fetus receives oxygen directly from its mother through a specialized circulatory system. This system not only supplies oxygen and nutrients to the fetus but removes carbon dioxide and metabolic wastes as well. The two components of this system are the **placenta** and the **umbilical cord**, which begin to develop in the first few weeks after fertilization upon implantation.

The placenta and the umbilical cord are outgrowths of the four extra-embryonic membranes formed during development: the **amnion**, **chorion**, **allantois**, and **yolk sac**. The **amnion** is a thin, tough membrane containing a watery fluid called amniotic fluid. Amniotic fluid acts as a shock absorber of external pressure during gestation and localized pressure from uterine contractions during labor. Placenta formation begins with the **chorion**, a membrane that completely surrounds the amnion. The chorion assists with transfer of nutrients from the mother to the fetus. A third membrane, the **allantois**, develops as an outpocketing of the gut. The blood vessels of the allantoic wall enlarge and become the umbilical vessels, which will connect the fetus to the developing placenta. The **yolk sac**, the site of early development of blood vessels, becomes associated with the umbilical vessels.

Gastrulation

After week two, the embryo is fully implanted in the uterus and cell migrations transform the single cell layer of the blastula into a three-layered structure called a gastrula. These three primary germ layers give rise to specific structures:

- **Ectoderm** (outer layer): integumentary system (including the epidermis, hair, nails, and epithelium of the nose, mouth, and anal canal), the lens of the eye, the retina, and the nervous system
- **Mesoderm** (middle layer): musculoskeletal system, circulatory system, excretory system, gonads, connective tissue throughout the body, and portions of digestive and respiratory organs
- **Endoderm** (inner layer): epithelial linings of the digestive and respiratory tracts (including the lungs) and parts of the liver, pancreas, thyroid, and bladder lining

Figure 18.2

MNEMONIC

The primary germ layers:
- Ectoderm—"attracto" derm (things that attract us to others, such as cosmetic features and "smarts")
- Mesoderm—"means" oderm (the means of getting around as an organism, such as bones and muscle; the means of getting around in the body, such as the circulatory system; the means of getting around, such as the gonads)
- Endoderm—linings of "endernal" organs (the digestive and respiratory tract, and accessory organs attached to these systems)

Neurulation

By the end of gastrulation, regions of the germ layers begin to develop into a rudimentary nervous system; this process is known as **neurulation** and starts before week three. A rod of mesodermal cells called the **notochord** develops along the longitudinal axis of the embryo just under the dorsal layer of ectoderm. The notochord has an inductive effect on the overlying ectoderm, causing it to bend inward and form a groove along the dorsal surface of the embryo. The dorsal ectoderm folds on either side of the groove; these neural folds grow upward and finally fuse, forming a closed tube. This is the neural tube, which gives rise to the brain and spinal cord (central nervous system). Once the neural tube is formed, it detaches from the surface ectoderm.

The cells at the tip of each neural fold are called the **neural crest cells**. These cells migrate laterally and give rise to many components of the peripheral nervous system, including the **sensory ganglia**, **autonomic ganglia**, **adrenal medulla**, and **Schwann cells**.

Sometimes during development the neural tube does not close properly, resulting in a condition called spina bifida. The incidence of spina bifida can be decreased dramatically if the mother takes folic acid supplements during pregnancy.

Final Stages of Development

The final developmental processes can be divided into three different components that continue even after gestation (described below):

- **Organogenesis:** The body organs begin to form. In this process, the cells interact, differentiate, change physical shape, proliferate, and migrate.
- **Growth:** The organs increase in size, which is a continual process from infancy through childhood to adulthood.
- **Gametogenesis:** Eggs develop in women and sperm develop in men, which permits reproduction to occur.

Gestation

Human pregnancy, or gestation, is approximately nine months (266 days) long and can be subdivided into three **trimesters**. The primary developments that occur during each trimester are described below.

First trimester

During the first weeks the major organs begin to develop. The heart begins to beat at approximately 22 days, and soon afterward the eyes, gonads, limbs, and liver start to form. By five weeks the embryo is 10 mm in length; by six weeks the embryo has grown to 15 mm. The cartilaginous skeleton begins to turn into bone by the seventh week. By the end of eight weeks, most of the organs have formed, the brain is fairly developed, and the embryo is referred to as a fetus. At the end of the third month, the fetus is about 9 cm long.

Second trimester

During the second trimester the fetus does a tremendous amount of growing. It begins to move around in the amniotic fluid, its face appears human, and its toes and fingers elongate. By the end of the sixth month, the fetus is 30–36 cm long.

Third trimester

The seventh and eighth months are characterized by continued rapid growth and further brain development. During the ninth month, antibodies are transported by highly selective active transport from the mother to the fetus. The growth rate slows and the fetus becomes less active as it has less room to move about.

Birth and maturation

Childbirth is accomplished by **labor**, a series of strong uterine contractions. Labor can be divided into three distinct stages. In the first stage, the **cervix** thins and dilates, and the amniotic sac ruptures, releasing its fluids. During this time contractions are relatively mild. The second stage is characterized by rapid contractions, resulting in the birth of the baby (the umbilical cord is usually cut after this stage). During the final stage, the uterus contracts, expelling the placenta and the umbilical cord.

The embryo develops into an adult through the process of maturation, which involves cell division, growth, and differentiation. Differentiation of cells is complete when all organs reach adult form.

Congenital Disorders

In some cases, errors occur during fetal development, often because of deleterious genes or problems with the gestation environment. These **congenital disorders,** also known as birth defects, can present with a wide variety of symptoms, including death. Chemical and biological agents that cause such disorders are called **teratogens** and include some drugs, such as alcohol and tobacco, as well as some microorganisms, such as viruses and bacteria. When a mother passes on an infection directly to her developing offspring, this is called **vertical transmission** and can occur either during development or during birth. Other environmental factors that can lead to birth defects include poor nutrition, radiation, and physical trauma or restraint.

PLANT EMBROYOLOGY

Fertilization

In angiosperms (flowering plants), double fertilization occurs—one sperm cell fertilizes the egg cell, and the other fuses to form the endosperm, which provides nutrients to the developing embryo in the seed. In contrast, gymnosperms, such as the conifers, have "naked seeds"; they do not have endosperm. Some plants can produce seeds without fertilization or reproduce without the production of seeds by asexual reproduction, which gives rise to individuals genetically identical to the parent.

In the alternation of generations life cycle, plants can fluctuate between asexual diploid and sexual haploid stages, known as the sporophyte and gametophyte generations, respectively. The diploid sporophyte produces haploid spores via meiosis, which matures into a haploid gametophyte. This gametophyte goes on to produce gametes via mitosis. The gametes then fuse to produce a zygote.

Seed Formation

The zygote divides mitotically to form the mass of cells called the embryo. The embryo consists of the following parts:

- **Epicotyl:** precursor of the upper stem and leaves.
- **Cotyledons:** seed leaves; dicots have two seed leaves, while monocots have only one.
- **Hypocotyl:** the lower stem and root.
- **Endosperm:** feeds the embryo in angiosperms; in dicots, the cotyledon absorbs the endosperm.
- **Seed coat:** develops from the outer covering of the ovule; the embryo and its seed coat together comprise the seed.

Seed Dispersal

The fruit, in which most seeds develop, is formed from the ovary walls, the base of the flower, and other consolidated flower pistil components. The fruit may be fleshy like a tomato or dry like a nut. It serves as a means of seed dispersal. The fruit enables the seed to be carried more frequently or effectively by air, water, or animals (which in animals involves ingestion and subsequent elimination).

Seed Germination

Germination is the process of a seed sprouting into a seedling (young plant). A seed released from the ovary will germinate only if proper conditions are present (temperature, moisture, and oxygen).

Plant Development

Growth in higher plants is restricted to the embryonic (undifferentiated) cells called **meristem** cells. These tissues undergo active cell reproduction. Gradually, the cells elongate and differentiate into cell types characteristic of the species.

Apical meristem

The apical meristem is found in the tips of roots and stems. Growth in length occurs only at these points.

Lateral meristem

The lateral meristem or **cambium** is located between the xylem and phloem. This tissue permits growth in diameter and can differentiate into new xylem and phloem cells. It is not an active tissue in monocots (grasses) or herbaceous dicots (alfalfa) but is predominant in woody dicots like oaks.

EXPERIMENTAL EMBRYOLOGY

The field of **experimental embryology** aims to investigate factors affecting development. Experimental embryologists use genetic and molecular biology techniques, such as manipulation of genes, stem cells, and visualization of antigens using immunohistochemistry. By investigating embryos, scientists hope to identify risk factors for women who could become pregnant as well as treatments applicable throughout the human life cycle. In experimental plant embryology, scientists similarly examine processes involved in the control of fertilization, embryogenesis, and endosperm development to understand the functional, biochemical, and genetic nature of embryonic processes in plants.

REVIEW PROBLEMS

1. Which of the following developmental stages has the greatest nuclear-to-cytoplasmic material ratio?

 A. Four-celled zygote
 B. Eight-celled zygote
 C. Morula
 D. Blastula
 E. Neurula

2. Name the three embryonic germ layers. Identify the embryological origin of the following structures: nails, thyroid, lens, testes, aorta, peripheral nerves, and lung epithelium.

3. Describe the structure of a blastula.

4. What is cleavage? When does the embryo first differentiate into germ layers?

5. Describe the difference between the apical and lateral meristem.

6. What is the difference between dicots and monocots?

7. Which of the following is not a stage of cell cleavage?

 A. Morula
 B. Blastocoel
 C. Blastula
 D. Mesoderm
 E. Gastrula

8. Describe the function of the four extra-embryonic membranes formed during development.

BIO

SOLUTIONS TO REVIEW PROBLEMS

1. **D** Discussed in early development section of this chapter.

2. The three embryonic germ layers are the endoderm, mesoderm, and ectoderm. The thyroid and lung epithelium are of endodermal origin. The testes and the aorta are of mesodermal origin. The nails, lens, and peripheral nerves are of ectodermal origin.

3. The name *blastula* refers to an early stage of development in which the embryo consists of a hollow ball of cells surrounding a cavity called the blastocoel.

4. Cleavage is the rapid division of cells early in the embryo's development. A determinate cleavage results in cells whose differentiation pathways are clearly defined; these cells are incapable of individually developing into complete organisms. The appearance of the three primary germ layers—the endoderm, mesoderm, and ectoderm—from such processes occurs during gastrulation.

5. The apical meristem is in the tips of roots and stems, and growth occurs at these points. The lateral meristem is between the xylem and phloem and permits growth in diameter.

6. Dicots have two seed leaves (cotyledons), whereas monocots only have one.

7. **D** The mesoderm is a primary germ layer that differentiates into the musculoskeletal system, circulatory system, and other areas throughout the body.

8. The amnion contains the amniotic fluid, which is a shock absorber for external pressure and uterine contractions. The chorion completely surrounds the amnion. The allantois contains blood vessels that become the umbilical vessels and connect the fetus to the placenta. The yolk sac is the site of early development of blood vessels.

CHAPTER NINETEEN

Animal Behavior

LEARNING OBJECTIVES

After this chapter, you will be able to:

- Describe the patterns of animal behavior
- Describe the processes by which animals learn
- Explain how behavior affects intraspecific interactions

The preceding biology chapters focused mainly on vertebrate systems and plants. However, on Test Day you will see a few questions about non-vertebrate and non-plant systems. This chapter on Animal Behavior and the following two chapters on Ecology and Taxonomy contain the information you need to successfully answer questions about non-vertebrate systems on Test Day. However, as you are studying, keep in mind that these types of questions will likely be only a very small percentage of the Biology questions on your exam.

This chapter on animal behavior describes the individual and social activities of various organisms, how evolution has shaped those behaviors in the long term, and how learning can influence those behaviors in the short term.

PATTERNS OF ANIMAL BEHAVIOR

Simple Reflexes

Reflexes are automatic responses to simple stimuli and are recognized as reliable behavioral responses following a given environmental stimulus. A **simple reflex** is controlled at the **spinal cord,** connecting a two-neuron pathway from the **receptor** (afferent neuron) to the **motor** (efferent neuron). The efferent nerve innervates the effector (e.g., a muscle or gland). Reflex behavior is important in the behavioral response of lower animals. It is less important in the behavior in higher forms of life, such as vertebrates. A simple reflex arc is shown in Figure 19.1.

BIO

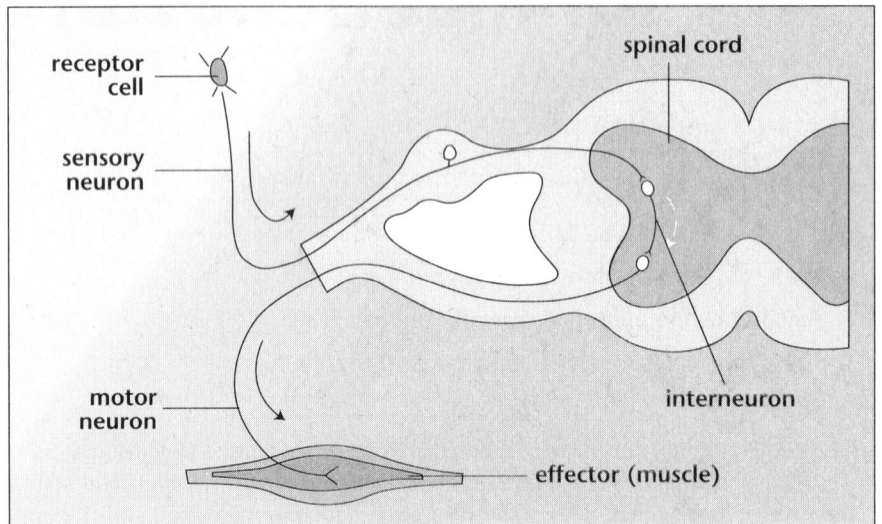

sensory neuron ⟶ interneuron ⟶ motor neuron
(contained in the spinal cord)

Figure 19.1

Complex Reflexes

More complex reflex patterns involve neural integration at a higher level of the **brainstem** or even the **cerebrum.** For example, the "**startle response**" alerts an animal to a significant stimulus. It can occur in response to potential danger or to hearing one's name called. The startle response involves the integration of many neurons in a system termed the **reticular activating system,** which is responsible for sleep–wake transitions and behavioral motivation.

Fixed-Action Pattern

Fixed-action patterns are complex, coordinated, **innate** behavioral responses to specific patterns of stimulation in the environment. The stimulus that elicits the behavior is referred to as the **releaser**. Since fixed-action patterns are innate, they are relatively unlikely to be modified by learning. An animal has a repertoire of fixed-action patterns and only a limited ability to develop new ones. The particular stimuli that trigger a fixed-action pattern are more readily modified, provided certain cues or elements of the stimuli are maintained. An example of a fixed-action pattern is the retrieval and maintenance response of many female birds to an egg of their species.

Certain kinds of stimuli are more effective than others in triggering a fixed-action pattern. For example, an egg with the characteristics of that species will be more effective than one that only crudely resembles the natural egg. Another type of fixed-action pattern is the characteristic movements made by animals that herd or flock together, such as the swimming actions of fish and the flying actions of locusts.

Behavior Cycles

Daily cycles of behavior are called **circadian rhythms**. Animals with such behavior cycles lose their exact 24-hour periodicity if they are isolated from the natural phases of light and dark. Cyclical

behavior, however, will continue with approximate day-to-day phasing. The cycle is thus initiated intrinsically but modified by external factors.

Daily cycles of eating, maintained by many animals, provide a good example of cycles with both internal and external control. The internal controls are the natural bodily rhythms of eating and satiation. External modulators include the elements of the environment that occur in familiar cyclic patterns, such as dinner bells and clocks.

Sleep and wakefulness are the most obvious examples of cyclic behavior. In fact, these behavior patterns have been associated with particular patterns of brain waves.

Environmental Rhythms

In many situations, patterns of behavior are established and maintained mainly by periodic **environmental stimuli**; a human example of this is the response to traffic light signals. Just as environmental stimuli influence many naturally occurring biological rhythms, biological factors influence behavior governed by periodic environmental stimuli.

LEARNING

Learned behavior involves **adaptive responses** to the environment. Learning is a complex phenomenon that occurs to some extent in all animals. In lower animals, instinctual or innate behaviors are the predominant determinants of behavior patterns, and learning plays a relatively minor role in the modification of these predetermined behaviors. In higher animals, learning plays a more significant role. The capacity for learning adaptive responses is closely correlated with the degree of **neurologic development** (i.e., the capacity of the nervous system, particularly the cerebral cortex, for flexibility and plasticity).

Habituation

Habituation is one of the simplest learning patterns involving the suppression of the normal start response to stimuli. In habituation, repeated stimulation results in decreased responsiveness to that stimulus. The normal autonomic response to that stimulus would serve no useful purpose since the stimulus becomes a part of the background environment; thus, the response to the stimulus is suppressed. If the stimulus is no longer regularly applied, the response tends to recover over time. This is referred to as **spontaneous recovery.** Recovery of the response can also occur with modification of the stimulus.

Classical Conditioning

Classical or **Pavlovian** conditioning involves the association of a normally **autonomic** or visceral response with an environmental stimulus. For this reason, the response learned through Pavlovian conditioning is sometimes called a **conditioned reflex.** In Pavlovian conditioning, the normal, innate stimulus for a reflex is replaced by one chosen by the experimenter. This is illustrated in Figure 19.2.

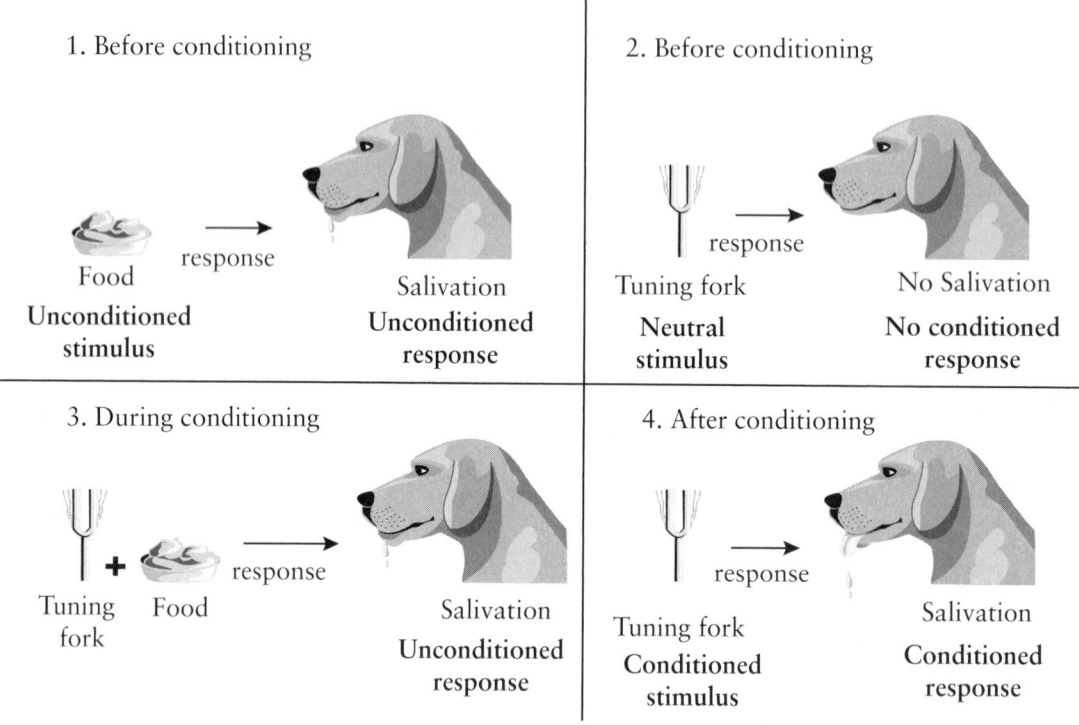

Figure 19.2

Pavlov's experiments

Ivan Pavlov, who won a Nobel Prize for his work on digestive physiology, studied the **salivation reflex** in dogs. In 1927, he discovered that if a dog was presented with an **arbitrary stimulus** (e.g., a bell) and then presented with food, it would eventually salivate on hearing the bell alone. The food elicited the unconditioned response of salivation. After repeated association of the bell with the food, the bell alone could elicit the salivation reflex. Thus, the innate or unconditioned response would occur with the selected stimulus. Pavlov's terminology, still used today, is described below:

- An established (innate) reflex consists of an **unconditioned stimulus** (e.g., food) and the response that is naturally elicited, termed the **unconditioned response** (e.g., salivation).

- A neutral stimulus is a stimulus that will not by itself elicit the response (prior to conditioning). During conditioning, the neutral stimulus (the bell) and the unconditioned stimulus (the food) are presented together. Eventually, the neutral stimulus is able to elicit the response in the absence of the unconditioned stimulus, and it is then called the conditioned stimulus. Pavlov's example of a conditioned stimulus is the sound of a bell for salivation.

- The product of the conditioning experience is termed the **conditioned reflex.** The conditioned reflex in Pavlov's experiment was salivation (the conditioned response) following a previously neutral stimulus (now the conditioned stimulus), such as the sound of a bell.

- Pavlov defined **conditioning** as the establishment of a new reflex (association of stimulus with response) by the addition of a new, previously neutral stimulus to the set of stimuli that are already capable of triggering the response.

Pseudoconditioning

Pseudoconditioning is a phenomenon that can be confused with true classical conditioning. A critical test of conditioning is the determination of whether the conditioning process is actually necessary for the production of a response by a previously "neutral" stimulus. In many cases, the "neutral" stimulus is able to elicit the response even before conditioning and, hence, is not really a neutral stimulus. Pseudoconditioning can be avoided by carefully evaluating all prospective stimuli before conditioning begins.

Operant or Instrumental Conditioning

Operant or instrumental conditioning involves conditioning responses to stimuli with the use of **reward** or **reinforcement.** When the organism exhibits a specific behavioral pattern that the experimenter would like to see repeated, the animal is rewarded. The reinforcement or reward increases the likelihood that the behavior will appear; it has been "reinforced." Although this instrumental conditioning was originally applied to conditioning responses under the voluntary control of the organism, it has been successfully applied more recently to the conditioning of visceral responses, such as changes in heartbeat.

Experiments of B. F. Skinner

B. F. Skinner first demonstrated the principles of operant conditioning and reinforcement. In the original operant conditioning experiments he used the well-known "Skinner box," which consists of a cage with a lever or key and a food dispenser. A food pellet was delivered whenever the animal pressed the lever. Thus, depression of the lever was the **operant response** under study. In later experiments, Skinner varied the type of reinforcement. Reinforcement fell into two categories: positive reinforcement and negative reinforcement.

Positive reinforcement

Positive reinforcement or reward includes providing food, light, or electrical stimulation of the animal's brain "pleasure centers." Following positive reinforcement, the animal was much more likely to repeat the desired behavioral response (e.g., to press the bar). In a sense, the animal has developed a positive connection between the action (response) and the reward (stimulus that followed). This type of conditioning is likely to be involved in normal habit formation.

Negative reinforcement

Negative reinforcement also involves stimulating the brain's pleasure centers. However, in contrast to positive reinforcement, negative reinforcement links a certain behavior to the removal of something unpleasant (e.g., a person learns that engaging the seatbelt removes a noise made by their car).

Thus, the animal has developed a *positive* connection between the action and the removal of something unpleasant, and the animal is more likely to repeat the behavioral response.

Punishment

Punishment involves conditioning an organism so that it will stop exhibiting a given behavior pattern. Punishment may involve painfully shocking the organism each time the chosen behavior appears. After punishment, the organism is less likely to repeat the behavioral response. The animal develops a negative connection between the stimulus and the response.

Habit family hierarchy

A stimulus is usually associated with several possible responses, each response having a different probability of occurrence. These stimulus–behavioral associations are believed to be ordered in a **habit family hierarchy.** For example, a chicken may respond to a light in many ways, but if one particular response is rewarded, the rewarded response will occur with a higher probability in the future. Reward strengthens a specific behavioral response and raises its order in the hierarchy. Punishment weakens a specific behavioral response and lowers its order in the hierarchy.

Modifications of Conditioned Behavior

Extinction

Extinction is the gradual **elimination** of conditioned responses in the absence of reinforcement (i.e., the "unlearning" of the response pattern). In **instrumental** and **operant conditioning,** the response is diminished and finally eliminated in the absence of reinforcement. The response is not completely unlearned but rather is inhibited in the absence of reinforcement. It will rapidly reappear if the reinforcement is returned. In **classical conditioning,** extinction occurs when the unconditioned stimulus is removed or was never sufficiently paired with the conditioned stimulus. The conditioned stimulus must be paired with the unconditioned stimulus, at least part of the time, for the maintenance of the conditioned response. After sufficient time elapses following extinction, the conditioned response may again be elicited by the conditioned stimulus. The recovery of the conditioned response after extinction is called **spontaneous recovery.**

Generalization and discrimination

Stimulus generalization is the ability of a conditioned organism to respond to stimuli that are similar, but not identical, to the original conditioned stimulus. The less similar the stimulus is to the original conditioned stimulus, the less the response will be. For example, an organism may be conditioned to respond to a stimulus of a 1,000 Hz tone, but it may respond to stimuli somewhat higher or lower in pitch as well. **Stimulus discrimination** involves the ability of the learning organism to respond differentially to slightly different stimuli. For example, if rewards are given during only a very narrow range of sound frequencies (such as a tone of 990 to 1,010 Hz) but not to stimuli outside this range, the organism will learn not to respond to stimuli that are different in tone. A **stimulus generalization gradient** is established after the organism has been conditioned, whereby stimuli further and further away from the original conditioned stimulus elicit responses with decreasing magnitude.

LIMITS OF BEHAVIORIAL CHANGE

Imprinting

Imprinting is a process in which environmental patterns or objects presented to a developing organism during a brief **critical period** in early life become accepted permanently as an element of its behavioral environment (i.e., "stamped in" and included in an animal's behavioral response). A duckling passes through a critical period in which it learns that the first large moving object it sees is its mother. However, other objects can be substituted during this period, and the duckling will follow anything that is substituted for its mother. This phenomenon was first identified by the ethologist Konrad Lorenz, who swam in a pond amongst newly hatched ducklings separated from their mother and found that they eventually followed him as if he was their mother.

Critical Period

Critical periods are specific time periods during an animal's early development when it is physiologically able to develop specific behavioral patterns. If the proper environmental pattern is not present during the critical period, the behavioral pattern will not develop properly. Some animals have a **visual critical period.** If light is not present during this period, visual effectors will not develop properly.

INTRASPECIFIC INTERACTIONS

Intraspecific interactions occur as a means of communication between members of a species.

Behavioral Displays

A display may be defined as an **innate behavior** that has evolved as a signal for **communication** between members of the same species. According to this definition, a song, call, or intentional change in an animal's physical characteristics is considered a display. Categories of displays include the following:

- **Reproductive displays** are specific behaviors found in all animals, including humans. Many animals have evolved a variety of complex actions that function as signals in preparation for mating.
- **Agonistic displays** are specific behaviors that function to reduce physical harm to the animal. They tend to be aggressive behaviors and are meant to intimidate rivals or predators. For example, some species of bird puff up their chest and raise their feathers to look larger and, thus, scare away predators.
- Other displays include various **dancing** procedures exhibited by **honeybees,** especially the scout honeybee, to convey information concerning the quality and location of food sources. Displays utilizing auditory, visual, chemical, and tactile elements are often used as a means of communication.

Pecking Order

The relationships among members of the same species living as a contained social group frequently become stable for a period of time. When food, mates, or territory are disputed, a **dominant** member of the species will prevail over a **subordinate** one. The social hierarchy is frequently referred to as the **pecking order.** It minimizes violent intraspecific aggressions by defining stable relationships among members of the group.

Territoriality

Members of most land-dwelling species defend a limited area or **territory** from intrusion by other members of the species. These territories are typically occupied by a male or a male–female pair and are frequently used for mating, nesting, and feeding. Territoriality serves the adaptive functions of distributing members of the species, so the environmental resources are not depleted in a small region, and reducing intraspecific competition. Although there is frequently a minimum size for any species' territory, the territory size varies with the population size and density. The larger the population, the smaller the territories are likely to be.

BIO

Response to Chemicals

The **olfactory sense** is immensely important as a means of communication in many animals. Many animals secrete substances called **pheromones,** which influence the behavior of other members of the same species. Pheromones can be classified as one of two types:

- Releaser pheromones trigger a reversible behavioral change in the recipient. For example, female silkworms secrete an attracting pheromone so powerful that a male responds to one ten-millionth of a gram from a distance of two miles or more. **Sex-attractant** pheromones are secreted by many animals, including cockroaches, queen honeybees, and gypsy moths. In addition to serving as sex attractants, releaser pheromones may also be secreted as **alarm** or **toxic defensive** substances.

- Primer pheromones produce long-term behavioral and physiological alterations in receiving animals. For example, pheromones from male mice may affect the estrous cycles of females. In areas of high animal density, pheromones have been shown to limit sexual reproduction. Primer pheromones are important in social insects such as ants, bees, and termites, where they regulate role determination and reproductive capacities.

REVIEW PROBLEMS

1. Explain the difference between a complex reflex and a fixed-action pattern.
2. How does pseudoconditioning differ from classical conditioning?
3. What is negative reinforcement?
4. Describe the critical period.
5. What is the difference between releaser pheromones and primer pheromones?

BIO

SOLUTIONS TO REVIEW PROBLEMS

1. A complex reflex involves neural integration at a high level, such as the brainstem or the cerebrum. It involves the neurons within the reticular activation system and as such has a more complex reflex arc than a simple reflex. Fixed-action patterns are coordinated behavioral responses to patterns of stimulation. They are innate, as with reflexes, and the triggers that stimulate a fixed-action pattern can be modified.

2. The determining factor is whether the conditioning process is necessary to get a response by a stimulus that previously did not evoke such a response. That is, often the stimulus being tested could elicit the response even without conditioning and therefore is not a "neutral stimulus." In pseudoconditioning, the stimulus that the animal has been conditioned to respond to can evoke the conditioned response without conditioning, therefore differentiating it from classical conditioning.

3. In contrast to positive reinforcement, where a reward is given following a desired behavior, in negative reinforcement the reward is given following a lack of a certain behavior. In both cases a reward is given, but in negative reinforcement it is rewarding a behavior the animal did not do rather than one it did do.

4. The critical period is a time in an animal's early development when it can develop specific behavior patterns. If the animal does not properly interact with the environment during this time, the behavioral pattern will not develop or will not develop properly.

5. Releaser pheromones trigger a reversible change in the recipient, whereas primer pheromones produce long-term behavioral and physiological changes in the recipient.

CHAPTER TWENTY

Ecology

LEARNING OBJECTIVES

After this chapter, you will be able to:

- Describe the levels of biological organization and environmental factors
- Explain the processes of interaction, relationships, and stability in an ecosystem
- Recall the features of world biomes

Ecology is the study of the interactions between organisms and their environment. The **environment** encompasses all that is external to the organism and is necessary for its existence. An organism's environment contains two components: the physical or nonliving (**abiotic**) environment, and the living (**biotic**) environment. The abiotic environment includes climate, temperature, availability of light and water, and the local topology. The biotic environment includes all living things that directly or indirectly influence the life of the organism, including the relationships that exist between organisms.

LEVELS OF BIOLOGICAL ORGANIZATION

Organism

The organism is the individual unit of an ecological system, but the organism itself is composed of smaller units. The organism contains many organ systems, which are made up of **organs.** Organs are formed from **tissues,** tissues from **cells,** cells from many different **molecules,** molecules from **atoms,** and atoms from subatomic particles.

Population

A **species** is any group of similar organisms that are capable of producing fertile offspring. A **population** is a group of organisms of the same species living in the same habitat. Examples of populations include dandelions on a lawn, flies in a barn, minnows of a certain species in a pond, and lions in a grassland. Environmental factors, such as nutrients, water, and sunlight limitations, aid in maintaining populations at relatively constant levels.

A **niche** defines the functional role of an organism or population. The niche is distinct from the **habitat**—the latter is the physical place where an organism lies. The characteristics of the habitat aid in defining the niche, but additional factors must also be considered. The niche describes what the organism eats, where and how it obtains its food, what climactic factors it can tolerate and which are optimal, the nature of its parasites and predators, where and how it reproduces, etc. The niche is so specific that a species can be identified by the niche it occupies. Thus, the concept of niche embodies every aspect of an organism's existence.

Communities

A community consists of populations of different plants and animal species interacting with each other in a given environment. The term **biotic community** is used to include only the population and not their physical environment. An **ecosystem** includes the community and the environment. Generally, a community contains populations from all six kingdoms (archea, eubacteria, protists, plants, fungi, and animals), all depending upon each other for survival. The following are examples of communities:

- A lawn contains dandelions, grasses, mushrooms, earthworms, nematodes, bacteria, etc.
- A pond contains dragonflies, algae, minnows, insect larva, etc.
- A forest contains moss, pine, bacteria, lichens, ferns, deer, chipmunks, spiders, foxes, etc.
- A sea contains fish, whales, plankton, etc.

Ecological Succession

Ecological succession is the orderly process by which the structure of an ecological community evolves over time. Primary succession occurs in areas uninfluenced by a pre-existing community, while secondary succession occurs in areas where a pre-existing community has been disrupted. Each community stage, or **sere**, in an ecological succession is identified by a **dominant** species—the one that exerts control over the other species that are present. Thus, in a grassland community, grass is the dominant species.

Changes occur because each community that establishes itself changes the environment, making it more unfavorable for itself and more favorable for the community that is to succeed it. Successive communities are composed of populations that are able to exist under the new conditions. Finally, a stage occurs in which a population alters the environment in such a way that the original conditions giving rise to that population are recreated. Replacement stops and the climax community is created, which is the final and most stable stage of ecological succession.

A climax community is the living (biotic) part of an ecosystem in which populations exist in balance with each other and with the environment. The type of climax community depends upon all the abiotic factors: rainfall, soil conditions, temperature, shade, etc. A climax community persists until a major climactic or geological change disturbs the abiotic factors or a major biotic change (disease, mutation, etc.) affects the populations. Once the equilibrium is upset, new climax conditions are produced and a new series of successions is initiated to establish new communities in the ecosystem.

- Primary succession example: A barren rocky area, perhaps as a result of a severe forest fire, in the northeastern United States.
 Step 1: Lichen may be the first or pioneer organism to resettle this area. Recall that lichen is an association between an algae and a fungus.
 Step 2: Acids produced by lichen attack the rocks and help to form bits of soil. Since lichens thrive only on a solid surface, conditions are now worse for the lichen but better for mosses.
 Step 3: Airborne spores of mosses land on the soil and germinate. The result is a new sere with the moss as the dominant species in the community.

Step 4: As the remains of the moss build up the soil still more, annual grasses and then perennial grasses with deeper roots become the dominant species.

Step 5: As time goes on, we find shrubs and trees. The first trees are the sun-loving gray birch and poplar. As more and more trees compete for the sun, these trees are replaced by white pine and finally maples and beeches, which grow in deep shade—the climax community. In the final maple beech community, are foxes, deer, chipmunks, and plant-eating insects, all of which would not have been found in the original barren rock terrain. However, one forest fire can kill the entire community. Ecological succession then starts all over again, commencing with lichen and bare rock.

It is important to note that the dominant species of the climax community depends on abiotic factors, so the dominant species in New York at higher elevations is hemlock-beech-maple, while at lower elevations is oak-hickory. The dominant species in cold Maine as well as in sandy New Jersey is pine; in the wet areas of Wisconsin, cypress; and on cold windy mountain tops, scrub oak.

- Secondary succession example: A pond.

Step 1: The pond contains plants such as algae and pondweed and animals such as protozoa, water insects, and small fish.

Step 2: Shallow pools form as the pond fills in, bringing reeds, cattails, and water lilies.

Step 3: Moist land brings grass, herbs, shrubs, willow trees, frogs, and snakes.

Step 4: Woodland brings the climax tree, perhaps pine or oak.

Ecosystem

An ecosystem or ecological community encompasses the interaction between living, biotic, communities and the nonliving, abiotic, environment. Therefore, in studying ecosystems, the biologist emphasizes the effects of the biotic community on the environment and the environment on the community. The examples listed previously for communities are also examples of ecosystems. An ecosystem can be referred to as self-sustaining and stable if three conditions are met:

1. The abiotic factors and biotic community are relatively stable.
2. There is a constant energy source and a biotic community incorporating this energy into organic compounds.
3. Materials are cycled between the abiotic factors and biotic community.

If nonnative (invasive) species are introduced into an ecosystem, the balance of the ecosystem can be disrupted and result in harm to the environment, the health of native species, or the local economy.

BIOMES

Ecosystems within a specific **geographic region** form **biomes**. The conditions in different geographic and climate regions select for plants and animals possessing suitable adaptations. The evolutionary origin of plants and animals can be traced to the seas. To colonize land, these organisms had to develop adaptations to face an environment with: (1) a relative lack of water; (2) a relative lack of food and supporting medium; (3) varying temperature (as compared to the oceans, which have a relatively constant temperature); and (4) varying composition of the soil as compared to the definite salt composition in the oceans.

Terrestrial Biomes

Land biomes are characterized and named according to the **climax vegetation** of the region. The climax vegetation is the vegetation that becomes dominant and stable after years of evolutionary development. Since plants are important as food producers, they determine the nature of the inhabiting animal population, and thus the climax vegetation determines the **climax animal population**. Some types of terrestrial biomes are as follows:

Desert biome

Deserts receive fewer than ten inches of rain each year; the rain is concentrated within a few heavy cloudbursts. The main growing season in the desert is restricted to those days after rainfalls. Generally, small plants and animals inhabit the desert. Most desert plants conserve water actively (cactus, sagebrush, and mesquite). Desert animals live in burrows (insects and lizards). Few birds and mammals are found in deserts except those that have developed adaptations for maintaining constant body temperatures. Examples of deserts include the Sahara in Africa and the Gobi in Asia.

Grassland biome

Grasslands are characterized by low rainfall (usually 10–30 inches per year), although this is considerably more than what desert biomes receive. Grasslands provide no shelter for **herbivorous mammals** (bison, antelope, cattle, and zebra) from carnivorous predators. Land animals that do inhabit the grasslands frequently have developed long legs, and many are hoofed. Examples of grasslands include the prairies east of the Rockies, the steppes of the Ukraine, and the pampas of Argentina.

Rainforest biome

Rainforests, sometimes known as jungles, are characterized by torrential rains. Tropical rainforests have high temperatures, whereas temperatures in rainforests are more moderate. They both include climax communities with dense growth of vegetation that does not shed its leaves. Vegetation, such as vines and **epiphytes** (plants growing on other plants), and animals, such as monkeys, lizards, snakes, and birds, inhabit rainforests. Trees grow closely together, and sunlight hardly reaches the forest floor. The floor is inhabited by **saprophytes,** which live off of dead organic matter. Tropical rainforests are found in Central Africa, Central America, the Amazon basin, and Southeast Asia. Temperate rainforests are much rarer but can be found in western North and South America, as well as on islands off of eastern Asian and Australian coasts.

Temperate deciduous forest biome

Temperate deciduous forests have cold winters, warm summers, and moderate rainfall. Inhabitants include beech, maple, oaks, and willow trees, which shed their leaves during the cold winter months. Animals in temperate deciduous forests include deer, foxes, woodchucks, squirrels, and birds. These biomes are found in the northeastern and central-eastern United States and in Central Europe.

Temperate coniferous forest biome

These forests are cold, dry, and inhabited mainly by trees that do not lose their leaves, such as fir, pine, and spruce trees. Much of the vegetation has evolved adaptations for water conservation, such as needle-shaped leaves. These forests are found in the extreme northern part of the United States and in southern Canada and contain the largest biomass of any terrestrial biome, in large part due to massive trees, such as the redwood. Animal inhabitants include beavers, bears, sheep, squirrels, and birds.

Taiga biome

Taigas receive less rainfall than temperate forests. They have long, cold winters and, like coniferous forests, are inhabited by trees that do not lose their leaves, especially the spruce. The forest floors in the taiga are characterized by thin soil covered in moss and lichens. The chief animal inhabitants are moose and deer; however, bears, wolves, rodents, and birds are also found there. Taigas exist in the extreme northern parts of Canada and Russia.

Tundra biome

The tundra is a treeless, frozen plain found between the taiga and the northern ice sheets. The ground is covered in snow and ice for much of the year and can be described as **permafrost.** There is only a very short summer and thus growing season, during when the ground becomes wet and marshy. Lichens, mosses, polar bears, musk oxen, and arctic hares are found in the tundra.

Polar region

Polar regions surround the **polar ice caps** and are frozen areas with no vegetation and few terrestrial animals. Animals that do inhabit polar regions generally live near the oceans and include penguins and polar bears. Although ice is present, there is little precipitation (falling rain or snow), so most polar regions can also be considered deserts.

Terrestrial Biomes and Altitude

The sequence of biomes between the equator and the poles is comparable to the sequence of regions on mountains. The nature of those regions is determined by the same decisive factors—temperature and rainfall. For example, the base of a mountain would resemble the biome of a temperate deciduous area. As one ascends the mountain, one would pass a coniferous-like biome, then taiga-like, tundralike, and polar-like biomes.

Aquatic Biomes

Aquatic biomes are classified according to criteria quite different from the criteria used to classify terrestrial biomes. Plants have little controlling influence on communities of aquatic biomes compared to their role in terrestrial biomes. Aquatic areas are the most stable ecosystems: the conditions affecting temperature, the amount of available oxygen and carbon dioxide, and the amount of suspended or dissolved materials are stable over very large areas with little tendency to change. Therefore, aquatic food webs and aquatic communities are balanced. There are two types of major aquatic biomes: **marine** and **freshwater**.

Marine biomes

The oceans connect to form one continuous body of water, which controls the Earth's temperature by absorbing solar heat. Water has the distinctive property of being able to absorb or utilize large amounts of heat without undergoing a great temperature change. Marine biomes contain a relatively constant amount of nutrient materials and dissolved salts. Although ocean conditions are more uniform than those on land, distinct zones in the marine biomes exist.

- **Intertidal zone:** The region exposed at low tides that undergoes variations in temperature and periods of dryness. Populations in the intertidal zones include algae, sponges, clams, snails, sea urchins, starfish, and crabs.

- **Neritic zone:** The region on the continental shelf that contains ocean with depths up to 600 feet and extends several hundred miles from the shores. Populations in neritic zone regions include algae, crabs, crustaceans, and many different species of fish.

- **Pelagic zone:** Typical of the open seas, this can be divided into photic and aphotic zones (see Figure 20.1).

- **Photic zone:** The sunlit layer of the open sea extending to a depth of 250–600 feet. It contains **plankton**, passively drifting masses of microscopic photosynthetic and heterotrophic organisms, and **nekton**, active swimmers such as fish, sharks, and whales that feed on plankton and smaller fish. The chief autotroph is the **diatom**, an alga.

- **Aphotic zone:** The region beneath the photic zone that receives no sunlight. There is no photosynthesis in the aphotic zone, and only heterotrophs exist here. Deep-sea organisms in this zone have adaptations enabling them to survive in very cold water with high pressures and in complete darkness. The zone contains nekton and **benthos** (the crawling and sessile organisms). Some are scavengers, and some are predators. The habitat of the aphotic zone is fiercely competitive.

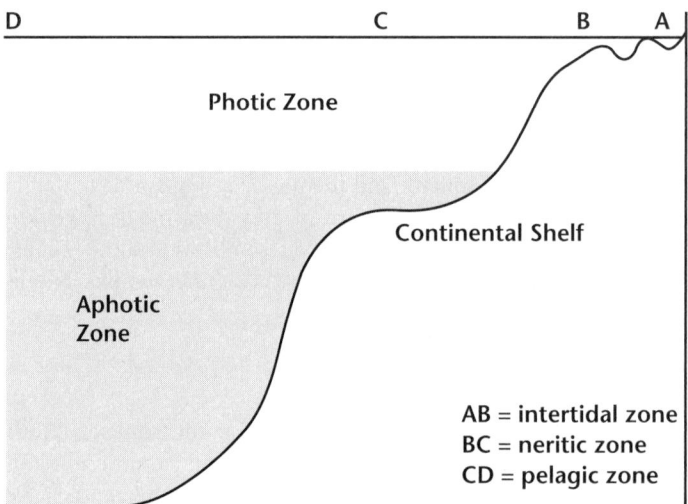

Figure 20.1

Freshwater biomes

Rivers, lakes, ponds, and marshes—the links between the oceans and land—contain freshwater. Rivers are the routes by which ancient marine organisms reached land and evolved terrestrial adaptations. Many forms failed to adapt to land and developed adaptations for freshwater. Others developed special adaptations suitable for both land and freshwater. As in marine biomes, factors affecting life in freshwater include temperature, transparency (suspended mud particles decrease illumination), depth of water, available carbon dioxide and oxygen, and most important, salt concentration. Freshwater biomes are different from saltwater biomes in following ways:

- In rivers and streams, strong, swift currents exist, and thus selection favored the survival of fish that developed strong muscles and plants with root-like **holdfasts**.

- Freshwater biomes, except very large lakes, are affected by variations in climate and water. The temperature of freshwater bodies may vary considerably; they may freeze or dry up; and mud from their floors may be stirred up by storms.

Biosphere

Together all ecosystems form a complex web that make up the biosphere. The biosphere includes all portions of the planet that support life: the **atmosphere,** the **lithosphere** (rock and soil surface), and the **hydrosphere** (the oceans). It is a relatively thin zone extending a few feet beneath the Earth's surface, several miles into the deepest sea, and several miles into the atmosphere.

ABIOTIC FACTORS

Water

More than 70 percent of the Earth's surface is covered by water—most of the Earth's plant and animal life is found in water. Additionally, water is the major component of the internal environment of all living things. As much as 90 percent of the Earth's food and oxygen production (photosynthesis) takes place in the water. Water may be readily available, or organisms may possess homeostatic mechanisms like osmoregulation to maintain their internal osmolarity and store and/or conserve water.

- Saltwater fish live in a hyperosmotic environment, which causes them to lose water and take in salt. They are constantly in danger of dehydration and must compensate by constant drinking and active secretion of salt across their gills.
- Freshwater fish live in a hypoosmotic environment, which causes intake of excess water and excessive salt loss. These fish correct this condition by seldom drinking, absorbing salt through the gills, and excreting dilute urine. In protozoa, contractile vacuoles regularly remove excess water to maintain water balance. Plant cells have rigid cell walls and thus build up cell pressure (cell **turgor**) as water flows in. This pressure counteracts the gradient pressure, stops the influx of water, and establishes water balance.
- Insects excrete solid uric acid crystals to conserve water.
- Desert animals possess adaptations for avoiding desiccation (drying up). The camel can tolerate a wide range of body temperatures and possesses fat layers in regions that are exposed to solar radiation. The horned toad has thick, scaly skin, which prevents water loss. Other desert animals burrow in the sand during the day and search for food at night, thereby avoiding the intense heat that causes water loss.
- Terrestrial plants possess adaptations for conservation of water. Nondesert plants possess waxy **cuticles** on leaf surfaces and stomata on the lower leaf surfaces only. They shed leaves in winter to avoid water loss. Desert plants have extensive root systems, fleshy stems to store water, spiny leaves to limit water loss, extra thick cuticles, and few stomata.

Temperature

The temperature of a geographic location depends upon its latitude and altitude. In fact, the same changes in habitat that occur as one approaches colder polar regions (changes in latitude) occur as one ascends toward the colder regions of a mountain top (changes in altitude). An organism's temperature must be maintained at an optimal temperature. Otherwise, for example, protoplasm is destroyed at temperatures below 0°C and at high temperatures. Organisms have adaptations necessary for protection against these extremes.

The vast majority of animals and plants are cold-blooded, or **poikilothermic**. Their body temperature is very close to that of their surroundings because most of their heat energy escapes to the environment. Cellular respiration only transfers a fraction of the energy derived from the oxidation of carbohydrates into the high-energy bonds of ATP. Roughly 60 percent of the total energy is given off as heat. Since an organism's metabolism is closely tied to its body temperature, the activity of poikilothermic animals is radically affected by environmental temperature changes. As the temperature rises, these organisms become more active. As temperatures fall, they become sluggish and lethargic.

Some animals, notably mammals and birds, are warm-blooded, or **homeothermic**. They have evolved physical mechanisms for thermoregulation that allow them to make use of the heat produced as a consequence of respiration. Physical adaptations like fat, hair, and feathers reduce heat loss. Homeotherms maintain constant body temperatures that are higher than the temperature of their environment. They are less dependent upon environmental temperature than poikilothermic animals and are able to inhabit a comparatively wider range of environments.

Sunlight

Sunlight is the ultimate source of energy for all organisms. Green plants must compete for sunlight in forests. They have adapted to capture as much sunlight as possible by growing broad leaves, branching, growing to greater height, or producing vine growths.

Oxygen

Air contains approximately 20 percent oxygen. This supply of oxygen is sufficient to support **terrestrial** life. Aquatic plants and animals, alternatively, utilize the small amount of oxygen dissolved in water. Pollution can significantly lower oxygen content in water and threaten aquatic life.

Substratum (soil or rock)

The substratum determines the nature of plant and animal life in the soil. Soil is affected by a number of factors:

- Soil **acidity**, or **pH**, may determine what types of plants grow in what types of soil. Some plants, such as rhododendrons and pines, are more suited for growth in acid soil. Acid rain may make soil pH too low for most plant growth.
- The **texture** of soil and its clay content determine the water-holding capacity of the soil. Most plants grow well in **loams**, which contain high percentages of each type of soil. Willows, for example, require moist soil.
- **Minerals**, including **nitrates** and **phosphates**, affect the type of vegetation that can be supported. Beach sand has been leached of all minerals and is generally unable to support plant life.
- **Humus** quantity is determined by the amount of decaying plant and animal life in the soil.

BIOTIC FACTORS

Modes of Nutrition

Autotrophs

Autotrophs are organisms that manufacture their own food. Phototrophs, such as green plants, utilize the energy of the sun to manufacture food. Chemotrophs, like chemosynthetic bacteria, obtain energy from the oxidation of inorganic sulfur, iron, and nitrogen compounds.

Heterotrophs

Heterotrophs cannot synthesize their own food and must depend upon autotrophs or other heterotrophs in the ecosystem to obtain food and energy.

Herbivores

These animals consume only plants or plant foods. The toughness of cellulose-containing plant tissues has led to the development of structures for crushing and grinding that can extract plant fluids. Herbivores have long digestive tracts that provide greater surface area and time for digestion. However, they cannot digest much of the food they consume. **Symbiotic bacteria** capable of digesting cellulose inhabit the digestive tracts of herbivores and allow the breakdown and utilization of cellulose.

Herbivores are more adept in defense than carnivores because they are often prey. Many herbivores, such as cows and horses, have hoofs instead of toes for faster movement on the grasslands. They have incisors adapted for cutting and molars adapted for grinding their food. Insects or other invertebrates can also be herbivores.

Carnivores

Carnivores are animals that eat only other animals. In general, carnivores, such as hyenas, possess pointed teeth and fanglike canine teeth for eating flesh. They have shorter digestive tracts due to the easier digestibility of animal food.

Omnivores

Omnivores, such as humans, are animals that eat both plants and animals.

Interspecific and Intraspecific Interactions

A community is not simply a collection of different species living within the same area. It is an integrated system of species that are dependent upon one another for survival. Relationships between species (interspecific) and between individuals within a species (intraspecific) are influenced by both disruptive and cohesive forces. Competition is the chief disruptive force, while cooperation is a cohesive force. The major types of interspecific interactions are symbiosis, predation, saprophytism, and scavenging.

Competition

Organisms occupying the same niche compete for the same limited resources: food, water, light, oxygen, space, minerals, and reproductive sites. Species occupying similar niches will utilize at least one resource in common. Therefore, they will compete for that resource. This competition can have a number of outcomes:

- One species may be competitively superior to another and drive the second to **extinction.**
- One species may be competitively superior in some regions, and the other may be superior in other regions under different environmental conditions. This would result in the elimination of one species in some places and the other in other places.
- The two species may rapidly evolve in **divergent** directions under the strong selection pressure resulting from intense competition. Thus, the two species would rapidly evolve greater differences in their niches.

It is implicit in the definition of niche that no two species can ever occupy the same niche in the same location. Competition is not restricted to interspecific interactions. Individuals belonging to the same species utilize the same resources; if a particular resource is limited, then these organisms compete with one another.

Cooperation

Species and members of the same species must also cooperate. Cooperative behavior within a population can provide protection from predators and destructive weather, acquisition of prey and resources, recognition of offspring, and transmission of learned responses. For instance, cooperation can be seen in schools of fish, in which living together decreases the chance of a predator attack, and among wolves in a pack, in which each wolf has a specific role in the pack's hunting strategy.

Symbiosis

Symbionts live together in an intimate, often permanent association, which may or may not be beneficial to both participants. Some symbiotic relationships are **obligatory**; that is, one or both organisms cannot survive without the other. Symbiotic relationships are classified according to the benefits the symbionts receive. The types of symbiotic relationships include commensalism, mutualism, and parasitism.

Commensalism (+/0)

One organism is benefited (+) by the association, and the other is not affected (0). The host neither discourages nor fosters the relationship. Some examples include the following:

- Remora and shark: The remora (suckerfish) attaches itself by a holdfast device on the underside of a shark. Through this association the remora obtains the food the shark discards, wide geographic dispersal, and protection from enemies. The shark is totally indifferent to the association.
- Barnacle and whale: The barnacle is a sessile crustacean that attaches to the whale and obtains wider feeding opportunities through the migrations of the whale.

Mutualism (+/+)

A symbiotic relationship from which both organisms derive some benefit (+). Some examples include the following:

- Tick bird and rhinoceros: The bird receives food in the form of ticks on the skin of the rhinoceros. The rhinoceros has its ticks removed and is warned of danger by the rapid departure of the bird.
- Fungi and algae: In a lichen, the green algae produces food for itself and the fungus by **photosynthesis**. The meshes of fungal threads support the algae and conserve rainwater. The fungus also provides carbon dioxide and nitrogenous wastes for the algae, all of which are needed for photosynthesis and protein synthesis.
- Nitrogen-fixing bacteria and legumes: Nitrogen-fixing bacteria invade the roots of legumes, and infected cells grow to form root nodules. In the nodule, the legume provides nutrients for the bacteria and the bacteria fixes nitrogen (by changing it into a soluble nitrate, a mineral essential for protein synthesis by the plant). These bacteria are a major source of usable nitrogen, which is needed by all plants and animals.
- Protozoa and termites: Termites chew and ingest wood but are unable to digest the cellulose. Protozoa in the digestive tract of the termite secrete an enzyme that digests the cellulose. Both organisms share the carbohydrates. Thus, the protozoan is guaranteed protection and a steady food supply, while the termites are able to obtain nourishment from the ingested wood.
- Intestinal bacteria and humans: Bacteria utilize some of the food material not fully digested by humans and manufacture vitamin K.

Parasitism (+/−)

A parasite benefits (+) at the expense (−) of the host. Parasitism exists when competition for food is most intense. Few autotrophs (green plants) exist as parasites (mistletoe is an exception). Parasitism instead flourishes among organisms such as bacteria, fungi, and animals. Some parasites cling to the exterior surface of the host (**ectoparasites**) using suckers or clamps. They may bore through the skin and suck out blood and nutrients. Leeches, ticks, and sea lampreys employ these techniques. Other parasites (**endoparasites**) live within the host. To gain entry, they must pass through defenses such as skin, digestive juices, antibodies, and white blood cells. Parasites possess special adaptations to overcome these defenses.

Parasitism is advantageous and efficient. The parasite lives with a minimum expenditure of energy. Parasites may even have parasites of their own. Thus, a mammal may have parasitic worms, which in turn are parasitized by bacteria, which in turn are victims of bacteriophages. It is interesting to note that successful parasites do not kill their hosts; this would lead to the death of the parasite. The more dangerous the parasite, the less the chance it will survive. Some examples are the following:

- Virus and host cell: All viruses are parasites. They contain nucleic acids surrounded by a protein and are nonfunctional outside the host. Upon entry of the viral nucleic acids into the host, the virus takes over the host cell functions and redirects them into replication of itself. The life functions of the bacterial cell slow down or cease in favor of viral replication.
- Disease bacteria and animals: Diphtheria is parasitic upon humans, anthrax is parasitic upon sheep, and tuberculosis is parasitic upon cows or humans.
- Disease fungi and animals: Most fungi are saprophytic. Ringworm is parasitic on humans.
- Worms and animals: An example is the parasitic relationship that exists between the tapeworm and humans.

Predation

Predators are free-living organisms that feed on other living organisms. This definition of predation includes both **carnivores** and **herbivores**. The effects of predators on their prey vary. The predator may severely limit the numbers or distribution of the prey, and the prey may become extinct. On the other hand, the predator may only slightly affect the prey because the predator is scarce or commonly utilizes another food source. In many cases, the predator aids in controlling the numbers of the prey but not so much as to endanger the existence of the prey population. Predator–prey relationships evolve toward a balance in which the predator is a regulatory influence on the prey but not a threat to its survival. Examples of predators include the hawk, lion, human, and Venus flytrap.

Saprophytism

Saprophytes include those protists and fungi that **decompose** (digest) dead organism matter externally by secreting digestive enzymes and then absorbing the nutrients; they constitute a vital link in the cycling of material within the ecosystem. Examples of saprophytes include mold, mushrooms, bacteria of decay, and slime molds.

Scavengers

Scavengers are animals that consume dead animals. They therefore require no adaptations for hunting and killing their prey. Decomposers, such as the bacteria of decay, may be considered scavengers. Examples of scavengers include the vulture and hyena. The snapping turtle is an organism that may be considered both a scavenger and a predator.

ENERGY FLOW

All living things require energy to carry on their life functions. The complex pathways involved in the transfer of energy through the living components of the ecosystem (biotic community) may be mapped in the form of a **food chain** or **food web**.

Food chain

A food chain is a single chain showing the transfer of energy. For example, energy from the sun enters living systems through the **photosynthetic** production of glucose by green plants. Within the food chain, energy is transferred from the original sources in green plants through a series of organisms, with repeated stages of consumption and finally decomposition. The levels of a food chain are called trophic levels and describe the number of steps an organism is from the start of the food chain. The levels are primary producers, primary consumers, secondary consumers, tertiary consumers, and decomposers.

Primary producers

The **autotrophic** green plants and **chemosynthetic** bacteria are the producers. They utilize the energy of the sun and simple raw materials (carbon dioxide, water, minerals), respectively, to manufacture carbohydrates, proteins, and lipids. The radiant energy of the sun is captured and stored in the C–H bond. Producers always form the initial step in any food chain. The wheat plant is a typical producer.

Primary consumers

Primary consumers are animals that consume green plants (herbivores). Examples include the cow, grasshopper, and elephant.

Secondary consumers

Secondary consumers are animals that consume the primary consumers (carnivores). These include frogs, tigers, and dragonflies.

Tertiary consumers

These are animals that feed on secondary consumers (also called carnivores).

Decomposers

Decomposers include saprophytic organisms (e.g., bacteria and fungi) and detritivores (e.g., earthworms, millipedes, and dung beetles). The producers and consumers, which concentrate and organize materials of the environment into complex living substances, give off wastes during their lifetimes and eventually die. Decomposers break down the organic wastes and dead tissues to simpler compounds, such as nitrates and phosphates, which are returned to the environment to be used again by living organisms. These processes are demonstrated in **food webs** and **material cycles** (nitrogen, carbon, and water).

Food web

The food web is not simply a linear chain but an intricate collection of interconnected food chains. Almost every species is consumed by one or more other species, some of which are on different food

chain levels. The result is a series of branches and cross-branches among all the food chains of a community to form a web. The greater the number of pathways in a community food web, the more stable the community. For example, owls eat rabbits. If rabbits died off because of disease, there would be more vegetation available to mice. Mice would provide substitute food for owls. Meanwhile, the decimated rabbit population would have a better chance of recovering while owls concentrated their predation on mice.

Food pyramid

A food pyramid, or ecological pyramid, graphically represents the feeding relationships between trophic levels. Organisms higher in the food chain derive their food energy from organisms at lower levels. A pyramid of energy shows the transfer of energy at each trophic level. Each level of the food chain utilizes some of the energy it obtains from food for its own metabolism (i.e., to support life functions) and loses some additional energy in the form of heat. Since this means a loss of energy at each feeding level, the producer organism at the base of the pyramid contains the greatest amount of energy. Less energy is available for the primary consumer and still less for secondary and tertiary consumers. The smallest amount of available energy is thus at the top of the pyramid. According to the second law of thermodynamics, since energy is lost at each trophic level, without a constant input of energy from the sun, an ecosystem would soon run down.

Additionally, because energy is lost from one level to the next, each level can support a successively smaller biomass (pyramid of biomass). For example, three hundred pounds of foliage (producer) may support 125 pounds of insects. This may support 50 pounds of insectivorous hens, which in turn may sustain 25 pounds of hawks. Consumer organisms that are highest in the food chain are usually larger and heavier than those further down. Thus, for the lower organism to have a greater total mass, there must be a greater number of lower-level organisms. (A large bass eats tiny minnows but eats many of them.) With the greatest number of organisms at the base (producer level) and the smallest number at the top (final consumer level), we have a pyramid of numbers.

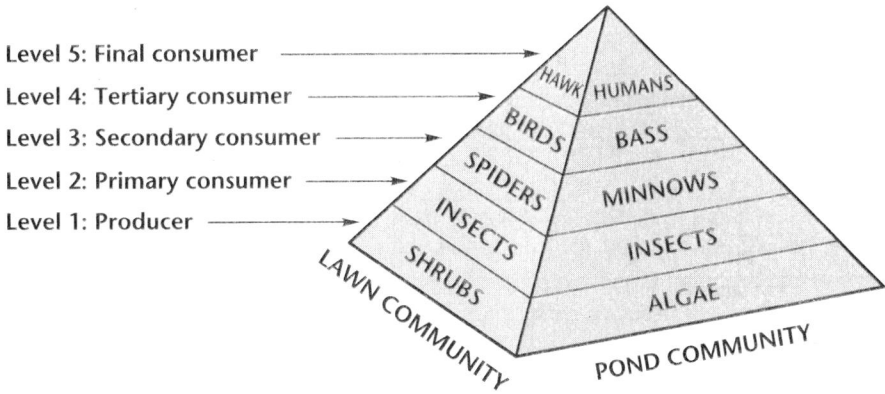

Level 5: Final consumer
Level 4: Tertiary consumer
Level 3: Secondary consumer
Level 2: Primary consumer
Level 1: Producer

HAWK HUMANS
BIRDS BASS
SPIDERS MINNOWS
INSECTS INSECTS
SHRUBS ALGAE
LAWN COMMUNITY POND COMMUNITY

Figure 20.2

In general, as the food pyramid is ascended, there is less energy content, less mass, and a fewer number of organisms. However, since other factors, such as the generation time of the size of the organisms must be considered, the pyramids of numbers and biomass do not apply to all levels at all times (unlike the pyramid of energy).

Material Cycles

Material is cycled and recycled between organisms and their environments, passing from inorganic forms to organic forms and then back to the inorganic forms. Many of these cycles are accomplished largely through the action of scavengers (such as hyenas and vultures) and decomposers (saprophytes such as bacteria and fungi).

Nitrogen cycle

Nitrogen is an essential component of amino acids and nucleic acids, which are the building blocks of all living things. Since there is a finite amount of nitrogen on the Earth, it is important that it be recovered and reused.

- Elemental nitrogen is chemically inert and cannot be used by most organisms. Lightning and nitrogen-fixing bacteria in the roots of legumes change the nitrogen to usable, soluble nitrates.
- The nitrates are absorbed by plants and are used to synthesize nucleic acids and plant proteins.
- Animals eat the plants and synthesize specific animal proteins from the plant proteins.
- Nitrogen locked up in waste and dead tissues is released by the action of bacteria of decay, which convert the proteins into ammonia (NH_3).
- Two fates await the ammonia. Some is nitrified to nitrites by chemosynthetic bacteria and then to usable nitrates by nitrifying bacteria. The rest is denitrified. This means the ammonia is broken down to release free nitrogen, which returns to the beginning of the cycle. Note the four kinds of bacteria that are involved in this cycle: **decay, nitrifying, denitrifying,** and **nitrogen fixing**. The bacteria have no use for the excretory ammonia, nitrites, nitrates, and nitrogen they produce. These materials are essential, however, for the existence of other living organisms.

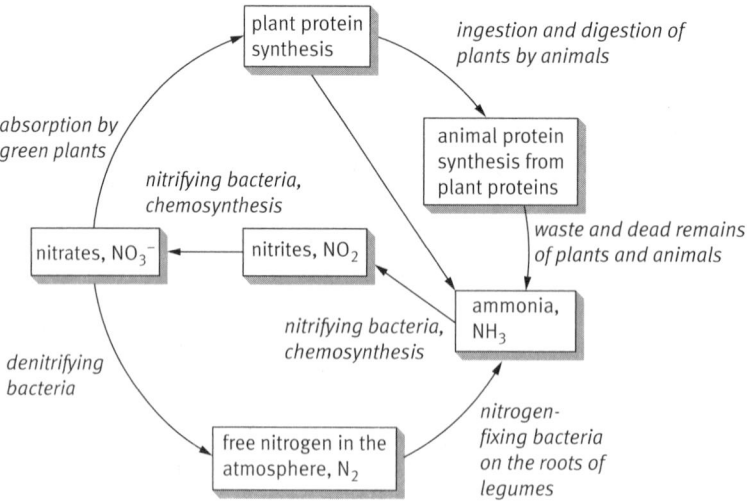

Figure 20.3

BIO

Carbon cycle

- **Gaseous CO$_2$** enters the living world when plants use it to produce glucose via photosynthesis. The carbon atoms from CO$_2$ are bonded to hydrogen and other carbon atoms. Plants use the glucose to make starch, proteins, and fats.

- Animals eat plants and use the digested nutrients to form carbohydrates, fats, and proteins characteristic of the species. A part of these organic compounds is used as fuel in respiration in both plants and animals.

- The metabolically produced CO$_2$ is released into the air. The rest of the organic carbon remains locked within an organism until its death (except for wastes given off), at which time decay processes by bacteria return CO$_2$ to the air.

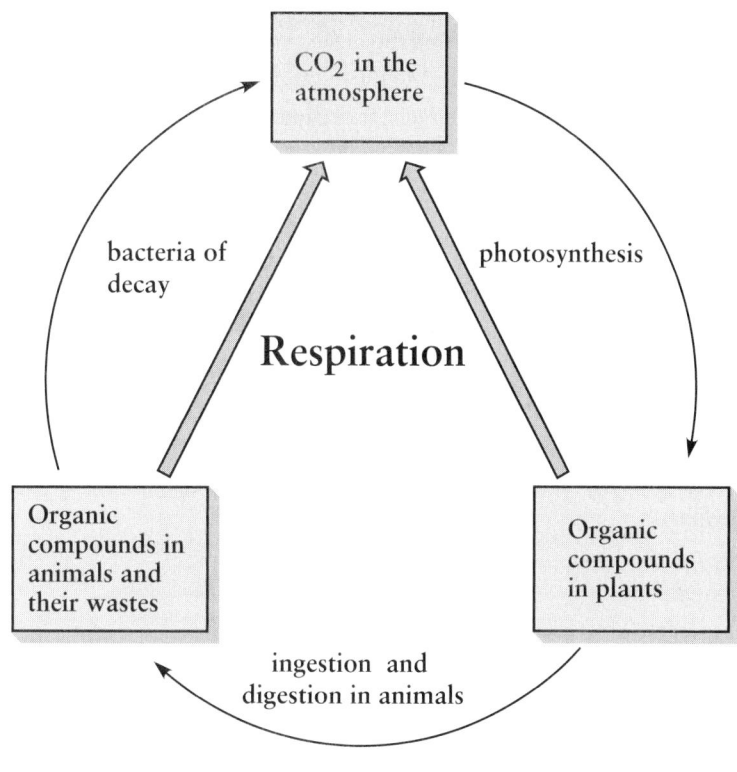

Figure 20.4

Other cycles

Other cycles recycle water, oxygen, and phosphorus. These substances are used by almost all living things and must be returned by the biotic community to the environment for reuse.

BIO

REVIEW PROBLEMS

1. Which of the following does not affect soil?

 A. Texture
 B. Nitrates
 C. Phosphates
 D. Loams
 E. Acidity

2. What is NOT true about niches?

 A. There may be many organisms of different species within the same niche.
 B. What the organism eats helps define the niche.
 C. Organisms in the same niche compete for resources.
 D. A species can be identified by the niche it occupies.
 E. Niches are different from habitats.

3. Which is an example of symbiosis?

 A. Predation
 B. Saprophytism
 C. Scavenging
 D. Commensalism
 E. Cooperation

4. Which is an example of a secondary consumer?

 A. Autotrophs
 B. Herbivores
 C. Carnivores
 D. Decomposers
 E. Bacteria

5. Which of the following is NOT true about the nitrogen cycle?

 A. Elemental nitrogen cannot be used by most organisms.
 B. Nitrates cannot be absorbed by plants.
 C. Bacteria of decay convert proteins into ammonia.
 D. Ammonia is broken down to release free nitrogen.
 E. Chemosynthetic bacteria turn ammonia intro nitrites.

6. Which is NOT a region of a marine biome?

 A. Intertidal zone
 B. Nekton zone
 C. Pelagic zone
 D. Aphotic zone
 E. Neritic zone

SOLUTIONS TO REVIEW PROBLEMS

1. **D** Loams contain high percentages of each type of soil, and most plants grow well in this type of environment. The other characteristics of soil affect the nature of plant and animal life that are able to live within the soil.

2. **A** No two species can ever occupy the same niche in the same location. All the other statements about niches are true.

3. **D** Symbionts live together in an association that may or may not be beneficial to both participants. In commensalism, one organism benefits from the association and the other is not affected. In predation, one free-living organism feeds on other living organisms. Saprophytes decompose dead organic matter to absorb the nutrients, and scavengers consume dead animals. Cooperation is an example of intraspecific interactions within members of the same species.

4. **C** Carnivores are secondary consumers because they consume primary consumers, which are herbivores. Autotrophs and bacteria are producers.

5. **B** Nitrates are in fact absorbed by plants and are used to synthesize nucleic acids and plant proteins. For a diagram of the nitrogen cycle, see Figure 20.3.

6. **B** Nekton are active swimmers such as fish and whales that feed on plankton and smaller fish. They are found in the photic zone.

CHAPTER TWENTY-ONE

Taxonomy

LEARNING OBJECTIVES

After this chapter, you will be able to:

- Recall the levels of taxonomic classification and features of organisms in each taxon

Billions of years of evolution have led to the great diversity of living organisms we see today. Scientists have tried to categorize relationships among the vast number of different organisms. The science of classification and the nomenclature used are known as **taxonomy**. The modern classification system seeks to group organisms on the basis of **evolutionary relationships**. In this system the bat, whale, horse, and humans are placed in the same class of animals because they have all descended from a common ancestor. Since much of early evolutionary history is not known, there is some disagreement among biologists as to the best classification system to employ, particularly with regard to groups of unicellular organisms. Taxonomy takes into account anatomical and structural characteristics; modes of excretion, movement, and digestion; genetic makeup; and biochemical capabilities. Taxonomic organization proceeds from the largest, broadest group to the smallest, most specific subgroups.

TAXONOMIC CLASSIFICATIONS

Biologists originally divided all living things into two categories: plants and animals. This division ignored a number of different organisms, and since then, several new systems have been proposed as additional knowledge is gained. The modern classification system used on the exam now separates the largest divisions of life by **domain** based on the degree of differences among them. The three domains are Archaea, Bacteria, and Eukarya. Within those domains are six **kingdoms**: Archaea, Eubacteria, Protista, Fungi, Plantae, and Animalia. Viruses fall somewhere outside of this system.

The modern scheme of taxonomy includes not only the three domains and six kingdoms but also further division. Each kingdom is divided into several major **phyla** (in the animal kingdom) or **divisions** (in other kingdoms). A phylum or division is further divided into **classes**. Each class includes multiple **orders**. Orders are subdivided into **families**, and each family is made up of many **genera** (singular *genus*). The **species** is the final major subdivision. Organisms of the same species can mate with one another to produce fertile offspring.

Each level also may have additional subdivisions, especially when many branching evolutionary paths are represented at one level. For example, humans can be classified as **Domain**: Eukarya, **Kingdom**: Animalia, **Phylum**: Chordata, **Subphylum**: Vertebrata, **Class**: Mammalia, **Order**: Primates, **Family**: Hominidae, **Tribe**: Homini, **Genus**: *Homo*, **Species**: *sapiens*.

BIO

All organisms are assigned a binomial name consisting of the genus and species name of that organism. Thus, humans are *Homo sapiens,* and the common housecat is *Felis domestica.*

The following sections outline specific information about the domains and kingdoms as well as examples of specific subdivisions within them. However, on Test Day, the entire field of taxonomy will only be a very small percentage of the Biology subtest. Since some (or all) of those questions may pertain to the broader ideas behind taxonomy listed above, the probability of seeing a specific species or even group is very low. Therefore, efficient use of your study time means not focusing on memorizing every phylum, class, and order but rather learning the general characteristics of the kingdoms and only quickly reviewing the more specific groupings. A good way to do this is to pick a model organism from each category that exemplifies the traits of that group. In that way, remembering one species will allow you to remember characteristics about all the members of that group. The following organisms will serve as great examples to memorize, or you can choose models of your own.

MONERA (ARCHAEA AND EUBACTERIA)

Monerans are **prokaryotes** (e.g., bacteria). They lack a nucleus or any membrane-bound organelles and are single-celled organisms that reproduce asexually. Monerans may exist as single cells or as aggregates of cells that stick together after division.

The kingdom Monera was part of the former, five-kingdom system but has since been divided into two separate kingdoms based on newly discovered differences among its members: the eubacteria and the archaea. Although both new kingdoms are composed of single-celled, prokaryotic organisms, they likely split down different evolutionary paths over three billion years ago.

Eubacteria

Bacteria are generally single-celled prokaryotes with a single double-stranded circular loop of DNA that is not enclosed by a nuclear membrane. Almost all forms have **cell walls**. They play active roles in **biogeochemical cycles**, recycling various chemicals such as carbon, nitrogen, phosphorus, and sulfur. Bacteria may be classified by their **morphological** appearances: **cocci** (round), **bacilli** (rods), and **spirilla** (spiral). Some forms are **duplexes** (diplo–), **clusters** (staph–), and **chains** (strepto–). Bacteria are ubiquitous, and many possess a wide variety of complex biochemical pathways.

Some common examples of these morphologies can be seen in bacteria that many of us are familiar with: *Streptococcus pneumoniae* (the bacteria that causes pneumonia) are diplococci; *Streptococcus pyogenes,* a common skin bacteria often referred to as group A strep, are streptococci; *Staphlococcus aureus,* another common pathogenic bacteria, are, as their name suggests, staphlococci; *Escheria Coli* (*E. coli*) is the most common example of a bacillus; and *Campylobacter jejuni,* a common cause of food poisoning, is spirillus.

Cyanobacteria

Cyanobacteria are types of bacteria that live primarily in fresh water but also exist in marine environments. They possess a cell wall and **photosynthetic pigments** but have no flagella, true nuclei, chloroplasts, or mitochondria. They can withstand extreme temperatures and are believed to be directly descended from the first organisms that developed photosynthetic capabilities. Cyanobacteria

are sometimes called blue-green algae, but be careful not to confuse them with other forms of algae, which are eukaryotic and members of the Protista kingdom instead.

Archaea

Archaea were formerly thought to be types of bacteria, but recent evidence shows that they are fundamentally different and in fact compose both their own domain and kingdom. Archaea are prokaryotes, like bacteria, and often have cell walls and flagella. However, they also exhibit several unique variations on the basic prokaryote plan, such as having cell membranes composed of glycerol-ether lipids, which is different from both Bacteria and Eukarya since they use glycerol-ester lipids instead. Further differences include changes to the molecules involved in basic biochemical processes, such as metabolism and translation; some of Archaea's enzymes correspond instead with Eukarya, and some are wholly unique. This may be due to the fact that Archaea inhabit a wide variety of environments, including extreme areas with high temperatures or high acidity (extremophiles). Scientists still have much to learn about Archaea, so having only a basic knowledge of their existence will be sufficient for Test Day.

PROTISTA

The Protist kingdom contains primitive eukaryotic organisms with membrane-bound nuclei and organelles. These organisms are either single cells or colonies of similar cells with no differentiation of specialized tissues. Each protist cell possesses the capability to carry out all of the life processes. The Protist kingdom contains all simple eukaryotes that cannot be classified as plants or animals. For example, the protists of the genus *Euglena* demonstrate the motility of animals and the photosynthetic capabilities of plants. The kingdom is divided into many phyla, which fall primarily into the categories of **protozoa** and **algae**.

Protozoa

Protozoa are single-celled organisms that are **heterotrophic** and in some ways are similar to little animals. This category of protists includes a number of different groups. The **rhizopods**, including amoebas, move with cellular extensions called pseudopods. The **ciliophors** have cilia that are used for feeding and locomotion.

Algae

Algae are primarily **photosynthetic** organisms. Blue, green, red, and brown algae all fit in this category. However, blue-green algae are not traditional algae and do *not* fit in this kingdom because they are prokaryotic rather than eukaryotic (see the Cyanobacteria section above). Examples of algae include the tiny **phytoplankton**, which are important sources of food for many marine organisms, as well as the **kelp**, which are large seaweeds of the brown algae family that can grow to be longer than 150 feet.

Slime Molds

The **slime molds** were formerly placed in the Fungi kingdom. However, they are now considered to belong to the Protist kingdom. They are arranged in a **coenocytic** (many nuclei) mass of **protoplasm**. The slime mold undergoes a unique life cycle containing animal-like and plant-like stages. These stages include fruiting bodies and unicellular flagellated spores. Slime molds reproduce asexually by sporulation.

FUNGI

Fungi may be considered nonphotosynthetic plants (i.e., they resemble plants in that they are eukaryotic, multicellular, differentiated, and nonmotile). However, their cell walls are composed of chitin and not cellulose, which is used by plants.

MNEMONIC

Saprophytic comes from the Greek words sapros, meaning "putrid," and phyton, meaning "plant."

Fungi are eukaryotes and primarily multicellular. All fungi are **heterotrophs**. This differentiates them from the plant kingdom. They may be **saprophytic,** decomposing dead organic material (e.g., bread mold), or parasitic, extracting nutrients from their hosts (e.g., the fungus that causes athlete's foot, *Epidermophyton floccosum*). In either case, fungi absorb food from their environment.

Fungi reproduce by asexual **sporulation** or by intricate sexual processes. Notable types are **mushrooms** (traditional macroscopic fungi), **yeast** (unicellular fungi), and **lichens** (fungi in symbiotic relationships with other, photosynthetic organisms).

PLANTAE

The plant kingdom includes multicellular organisms that exhibit differentiation of tissues and are **nonmotile photosynthetic**. Because plants are able to make their own energy rather than relying on consuming other organisms, they are known as **autotrophs**. Many plants also exhibit an alternation of generations and a distinct embryonic phase.

Plants have developed complex differentiated tissues to adapt to a terrestrial life. Photosynthetic tissue layers contain **chloroplasts** for the manufacture of carbohydrates. Supportive tissues provide mechanical support facilitating the typical upright radial construction of plants. Absorptive tissues, like specialized roots and simpler **rhizoids**, project into soil to absorb water and minerals. **Conducting** or **vascular** tissues include specialized tubes that transport water, minerals, and nutrients to all parts of the plant. Waxy **cuticles** on exposed surfaces minimize loss of water while permitting the transmittance of light. Cells are in direct contact with the external environment by means of air spaces called **stomata**, making elaborate respiratory and excretory systems unnecessary.

Bryophytes

The bryophyta, hepatophyta, and anthocerotophyta divisions (informally called **bryophytes** as a collective) are simple plants with few specialized organs and tissues. They lack the water-conducting woody material (**xylem**) that functions as support in tracheophytes and retain flagellated sperm cells that must swim to the eggs, which means they must live in moist places.

These types of plants undergo alternation of generations. The **gametophyte** is the dominant generation; it is the "main" plant and is larger and nutritionally independent. The **sporophyte** is smaller and shorter-lived, growing off the gametophyte from the **archegonium**. It resembles a heterotrophic parasite in that it obtains its organic and inorganic materials from the autotrophic gametophyte.

Mosses are classic bryophytes in which the sporophyte and gametophyte generations grow together. **Liverworts** are flat, horizontal, and leaf-like plants with differentiated dorsal and ventral surfaces.

Tracheophytes

Vascular plants (**tracheophytes**) are complex plants with a great degree of cell differentiation. They contain vascular tissues: **xylem** (water-conducting) and **phloem** (food-conducting). Tracheophytes have radial symmetry about a main vertical axis and are anchored by deep roots instead of rhizoids. Their extensive woody or nonwoody support systems allow them to grow to great heights. They have developed excellent provisions for water conservation (waxy surfaces) and gas exchange (stomata). Cellular water storage creates turgid cells.

Figure 21.1

In contrast to bryophytes, in vascular plants, the sporophyte generation is dominant. The gametophyte is short-lived and either independent (in primitive tracheophytes such as ferns) or small and parasitic (in more advanced tracheophytes such as seed plants).

Non-seed-bearing

There are two extant divisions of non-seed-bearing vascular plants: Pteriodphyta and Lycophyta. Those that remain are evidence of prior evolutionary linkage to the bryophytes.

Pterophytes, of the division Pteridophyta, include the familiar **fern**. They grow from an underground stem called the **rhizome** and contain large leaves (megaphylls) that possess many vascular bundles. Ferns grow lengthwise, not in diameter, and contain xylem with elongated **tracheid** cells that transport water and salts. They do not produce seeds, and their short-lived gametophyte generation possesses heart-shaped leaves; the fern's normal leaves are part of the sporophyte generation. Sporangium on the underside of the leaves produce monoploid spores, which germinate to form gametophytes.

Lycophytes belong to an ancient subdivision known as Lycopodiophyta. They have roots, are nonwoody, and contain microphyll leaves (e.g., **club mosses**).

Angiosperms

Angiosperms are members of the division Angiospermae, which contains the greatest number of different plant species of all the extant plant divisions. They have covered seeds and are the most abundant of all plants. Angiosperms have flowers, not cones, as their principal reproductive structures. The **anther** of the male **stamen** produces **microspores** (pollen grains), while the ovary of the female **pistil** produces **megaspores**. Successful pollination results in the germination of pollen tubes, which aid in fertilization of female eggs in the gametophyte. The embryo develops into a seed

within the ovary. The ovary eventually ripens into fruit, which is how the seeds are dispersed. Xylem-conducting cells are in the form of vessels as well as tracheids, allowing for better conduction of water.

Dicotyledons (dicots) are angiosperms with net-veined leaves and vascular bundles around a ring within the central cylinder. Dicotyledons contain two **cotyledons** (seed leaves) within the seed. Many have cambium and can be woody. They have flower parts in multiples of four or five. Some examples of dicotyledons are the maple and apple trees, potatoes, carrots, goldenrods, and buttercups.

Monocotyledons (monocots) are angiosperms that contain leaves with parallel veins, scattered vascular bundles, and seeds with single cotyledons. Most monocots do not possess cambium and therefore are nonwoody (herbaceous). They contain flower parts in multiples of three. Some examples are **grasses** such as wheat, corn, rye, and rice. Other monocots include sugar cane, pineapple, irises, bananas, orchids, and palms (woody monocots).

Gymnosperms

Gymnosperms are naked-seeded plants. The gametophyte stage of gymnosperms is short-lived and microscopic. The male microspore produces pollen that can be carried by the wind; thus, the requirement of a water environment for flagellated sperm is eliminated and the gymnosperms are truly terrestrial. Sperm nuclei fertilize the egg with the aid of a pollen tube, and the embryo develops within the exposed seed.

The presence of a specialized cambium tissue allows for secondary growth of secondary xylem (wood) and secondary phloem. Gymnosperms can grow in diameter as well as in length and are woody, not herbaceous (green with soft stems) plants. Most gymnosperms are evergreens (non-deciduous).

Conifers of the division Pinophyta make up the largest grouping of gymnosperms. They include pines, spruce, and firs. Conifers have cones, spiral clusters of modified leaves. There are two different types of cones: large female cones with sporangia that produce **megaspores** and small male cones with sporangia that produce microspores.

The remaining three divisions of gymnosperms contain fewer species and are Cycadophyta (**cycads**), Gnetophyta (**gnetophytes**), and Ginkgophyta (**ginkgo**). Cycads are stout, cylindrical trees with pinnate (feather-like) leaves. Gnetophytes have widely varying properties but tend to be vine like. Ginkgophyta only has one extant species: *Ginkgo biloba*, also known as the Ginkgo tree, which grows pungent seeds and is sometimes used in herbal medicine.

ANIMALIA

The animal kingdom contains **multicellular**, generally **motile**, **heterotrophic** organisms that have **differentiated** tissues (and organs in higher forms). With the exception of some parasites like the tapeworm, animals ingest bulk foods, digest them, and then eliminate the remains. Animals usually employ some form of locomotion to acquire nutrients, but some are **sessile** (stationary) and create currents to trap food. Nevertheless, locomotion can also be important for protection, mate selection, and reproduction.

Simple multicellular animals, such as sponges, coelenterates, and flatworms, have minimal differentiation. Most of their cells are in direct contact with the outside environment. In these organisms, only a few systems (such as the digestive and reproductive systems) are required to

support the life processes. In more advanced animals, specialized tissues and systems facilitate digestion, locomotion, circulation, message conduction (nervous system), and support.

Most animals also have right and left sides that are mirror images of one another, which is known as **bilateral symmetry**. However, some animals, such as the echinoderms and cnidarians, have **radial symmetry**.

Examples of Phyla

The **Porifera** phylum contains sea sponges, which have two layers of cells, pores, and a low degree of cellular specialization. Sponges are usually sessile, meaning they cannot move on their own during most of their life.

Cnidaria is a phylum with species that contain a digestive sac that is sealed at one end (gastrovascular cavity). Two layers of cells are present: the **ectoderm** and the **endoderm**. Cnidarians can have many specialized features, including tentacles, stinging cells, and nerve nets. Examples of cnidarians include hydra, jellyfish, sea anemones, and coral.

The **Platyhelminthes** phylum is characterized by flatworms with ribbon-like, **bilaterally symmetrical** bodies that possess three layers of cells, including a solid mesoderm. They do not have circulatory systems, and their nervous system consist of eyes, an anterior brain ganglion, and a pair of longitudinal nerve cords.

The **Nematoda** phylum contains roundworms that possess long digestive tubes and anuses. A solid mesoderm is present. Nematodes lack circulatory systems but possess nerve cords and an anterior nerve ring. Examples include hookworms, trichina, and free-living soil nematodes.

The phylum **Annelida** contains segmented worms that possess a **coelom** (true body cavity) contained in the mesoderm. Annelids have well-defined systems, including nervous, circulatory, and excretory systems. Examples of annelids include earthworms and leeches.

Members of the phylum **Mollusca** are soft-bodied and possess mantels that often secrete calcareous (calcium carbonate) exoskeletons. They breathe by gills and contain chambered hearts, blood sinuses, and a pair of ventral nerve cords. Examples include clams, snails, and squid.

Arthropoda species have jointed appendages, chitinous exoskeletons, and open circulatory systems (**sinuses**). The three most important classes of arthropods are insects, arachnids, and crustaceans. **Insects** possess spiracles and tracheal tubes designed for breathing outside of an aquatic environment. They also have three pairs of legs. **Arachnids** have four pairs of legs and book lungs. Examples include scorpions and spiders. **Crustaceans** have segmented bodies with a variable number of appendages and also possess gills. Examples include lobsters, crayfish, and shrimp.

Echinodermata members are spiny, radially symmetrical, contain a water-vascular system, and possess the capacity for regeneration of parts. There is evolutionary evidence suggesting a link between echinoderms and chordates. Echinoderms include the starfish and the sea urchin.

Members of the phylum **Chordata** are characterized by a stiff dorsal rod, called the **notochord**, present at some stage of embryologic development. They have paired gill slits and a tail extending beyond the anus at some point during development. The lancelets and tunicates (like amphioxus) are chordates but not **vertebrates.** This means they have notochords but no backbones.

Vertebrata is an important subphylum of Chordata. Vertebrates include **amphibians**, **reptiles**, **birds**, **fish**, and **mammals**. In addition to the chordate characteristics described above, vertebrates also possess bones, called vertebrae, which form the backbone. Bony vertebrae replace the notochord of the embryo and protect the nerve cord. A bony case (the skull) protects the brain.

Classes of Vertebrata

Jawless fish make up the superclass **Agnatha**. Jawless fish are eel-like, retain the notochord throughout life, and have a cartilaginous internal skeleton. They have no jaws and possess a sucking mouth. Examples include the lamprey and the hagfish.

Cartilaginous fish possess jaws and teeth and are in the **Chondrichthyes** class. A reduced notochord exists as segments between cartilaginous vertebrae. An example is the shark.

Bony fish are the most prevalent type of fish. They are in the **Osteichthyes** class, have scales, and lack a notochord in the adult form. During development, cartilage is replaced by a bony skeleton. Examples include the sturgeon, trout, and tuna.

Members of the **Amphibia** class have larval stages found in water but adult stages that live on land. Larvae possess gills and a tail with no legs, whereas adults have lungs, two pairs of legs, no tail, a three-chambered heart, and no scales. Amphibians utilize external fertilization; eggs are laid in water with a jellylike secretion and subsequently fertilized. Examples include the frog, salamander, toad, and newt.

Individuals in the class **Reptilia** are **terrestrial** animals since they live on land. They breathe air by means of lungs, lay leathery eggs, and utilize **internal fertilization**. Reptiles are cold-blooded (**poikilothermic**) and have scales and a three-chambered heart. Examples include the turtle, lizard, snake, and crocodile.

Birds, which are in the **Aves** class, possess four-chambered hearts. They are warm-blooded (**homoeothermic**), and their eggs are surrounded by shells. Examples include the hen and the eagle.

Finally, the **Mammalia** class includes animals that are warm-blooded and feed their offspring with milk produced in mammary glands. Members of the **Monotremata** order lay leathery eggs, have horny bills, and produce milk via mammary glands with numerous openings but no nipples. Examples of monotremes include the duck-billed platypus and echidna. Marsupials make up an infraclass of pouched mammals known as **Marsupialia**. The embryo begins development in the uterus and completes development while attached to nipples in the abdominal pouch. Examples include the kangaroo and opossum. Placental mammals of the infraclass **Placentalia** have embryos that develop fully in the uterus. The placenta attaches the embryo to the uterine wall and provides for the exchange of food, oxygen, and waste material. Examples include the bat, whale, mouse, and human.

VIRUSES

Viruses have not been placed in any of the six kingdoms because they do not carry out physiological or biochemical processes outside of a host. Although they are highly advanced parasites, they may be considered **nonliving**. Viruses are capable of taking over their host's cellular machinery and directing the replication of the viral genome and protein coat. Viruses have **lytic** and **lysogenic** life cycles. They contain either **DNA** or **RNA** and some essential enzymes surrounded by a protein coat. Viruses that exclusively infect bacteria are called **bacteriophages**. Chapter 8 covers bacterial genetics in more detail.

REVIEW PROBLEMS

1. Select the proper progression of the taxonomy classification system.

 A. Kingdom, order, phylum, class, genus, family, species
 B. Kingdom, phylum, class, order, family, genus, species
 C. Kingdom, order, phylum, class, family, genus, species
 D. Kingdom, phylum, order, class, family, genus, species
 E. Kingdom, phylum, order, class, genus, family, species

2. Which of the following is NOT true about viruses?

 A. They may be considered nonliving.
 B. They have lytic and lysogenic life cycles.
 C. They contain only DNA and not RNA.
 D. They are surrounded by protein coats.
 E. They cannot conduct physiological processes outside a host.

3. Which of the following does NOT belong to the kingdom Protista?

 A. Protozoa
 B. Cyanobacteria
 C. Algae
 D. Phytoplankton
 E. Rhizopods

4. Which contains the most number of different species of plants?

 A. Angiospermae
 B. Coniferophyta
 C. Tracheophyta
 D. Bryophyta
 E. Pterophyta

5. Which is NOT a type of worm?

 A. Platyhelminthes
 B. Nematoda
 C. Annelida
 D. Porifera
 E. None of the above

SOLUTIONS TO REVIEW PROBLEMS

1. **B** See the taxonomic classifications section within this chapter.

2. **C** Viruses can contain either DNA or RNA and also often contain some necessary enzymes within their protein coat.

3. **B** Cyanobacteria are part of the kingdom Monera. All other listed organisms belong to the kingdom Protista.

4. **A** Angiosperms have covered seeds and are the most abundant of all plants. They use flowers as their principal reproductive structures.

5. **D** Porifera are sponges and are not classified as worms. All the other classes of animals listed are types of worms.

Section III

GENERAL CHEMISTRY

SECTION GOALS

General Chemistry is a topic area integral to mastery of the Survey of Natural Sciences portion of the DAT. While it is not the predominant science in the section, general chemistry does account for 30% of the Survey, and is very important to a competitive score. The general chemistry strategies, content, and practice presented within this section are designed to help you to accomplish the following goals:

- Recall key general chemistry concepts, terms, and equations
- Calculate solutions efficiently without a calculator
- Apply previously memorized equations and concepts to new situations presented on the DAT
- Predict answers to DAT General Chemistry questions using the Kaplan methods

CONTENT OVERVIEW

Laboratory Techniques	Chapter 23: Laboratory Techniques
Atomic & Molecular Structure	Chapter 24: Atomic and Molecular Structure
Periodic Properties	Chapter 25: Periodic Properties
Stoichiometry & General Concepts	Chapter 26: Chemical Bonding Chapter 27: Stoichiometry
Chemical Equilibria	Chapter 28: Solutions Chapter 33: Chemical Equilibria
Oxidation-Reduction Reactions	Chapter 29: Reaction Types Chapter 30: Electrochemistry
Chemical Kinetics	Chapter 31: Chemical Kinetics
Thermodynamics and Thermochemistry	Chapter 32: Thermochemistry
Liquids and Solids	Chapter 34: Liquids and Solids
Gases	Chapter 35: Gases
Acids and Bases	Chapter 36: Acids and Bases
Nuclear Reactions	Chapter 37: Nuclear Reactions

KEY STUDY STRATEGIES

In general—especially during early review—study these chapters in order. In later review, skipping around to areas of weakness will be more efficient. The chapters within this section build upon each other to a substantial degree, so if you find a chapter is drawing on background knowledge you do not have, revisit previous chapters. Bolded vocabulary terms are concepts of great importance in the General Chemistry section, but in addition to those terms, there are equations given within the text. These equations will be tested on the DAT, so make sure to memorize them as part of your study. Note that the number of chapters devoted to a topic does not indicate the importance of that topic, but instead reflects the complexity of the topic area. Make sure to complete the associated practice problems. During practice refrain from using a calculator, and be sure to utilize the Kaplan methods. When possible, practice with scratch paper set up as it will be on Test Day. For more information on strategy and Test Day refer to Chapters 1–3 and 22.

CHAPTER TWENTY-TWO

General Chemistry Strategies

LEARNING OBJECTIVES

After this chapter, you will be able to:

- Apply Kaplan's question strategies to the General Chemistry section
- Use Kaplan's proven techniques to study DAT General Chemistry content effectively

General chemistry is an important subject for the DAT, not only because it is the main focus for an entire subtest, but also because a strong general chemistry foundation makes learning organic chemistry, which provides the basis for an entire additional subtest of the DAT, much more manageable. General chemistry provides the foundation for many other subjects within the field of chemistry, especially physical chemistry. On the DAT, General Chemistry questions cover stoichiometry; gases, liquids, and solids; solutions; acids and bases; equilibria; thermochemistry; kinetics; redox reactions; atomic and molecular structure; periodic properties; nuclear reactions; and laboratory techniques.

GENERAL CHEMISTRY QUESTION STRATEGY

The General Chemistry subtest of the Survey of Natural Sciences contains questions 41–70 and occurs after the Biology subtest but before the Organic Chemistry subtest. Like the other questions in the Survey of Natural Sciences, General Chemistry questions are susceptible to attack using the Kaplan Stop-Think-Predict-Match question strategy. In particular, the Stop step is extremely important for General Chemistry questions because it helps you decide which questions to attempt right away and which to mark for later. This allows you to better manage your time. In fact, since General Chemistry questions tend to involve many more calculations than the other science questions do, you will likely need to spend an average of 75 seconds per question. Note, however, that this is an average, and you should spend much less time on any fact-based questions so you have more time for the calculation-heavy questions. For more details about how to manage your time in the Survey of Natural Sciences, see Chapter 4, Biology Strategies.

STUDYING GENERAL CHEMISTRY CONTENT

The chemistry you will see on Test Day blends theoretical knowledge with practical application. For the DAT, knowing the reason why intermolecular bonds form is just as important as being able to calculate the energy required to break them. You may be tempted to study these two aspects of chemistry separately, but the best test takers are able to integrate their knowledge of different topics to answer even the most difficult chemistry questions. Therefore, when confronted with a new equation, don't focus only on how to perform each mathematical step. Instead, also consider what each variable truly represents, the proportionalities that are implied, and the reasons behind

those relationships. Having this conceptual understanding will not only help you answer questions but will also make memorizing equations easier and may even allow you to determine a mathematical relationship on Test Day if you can't recall the correct equation to use.

To facilitate learning the material this way, it's important to intersperse learning content with practicing questions. While reading, take breaks between topics to complete one or two practice questions from the end of the chapter, review relevant material from your online tests, or memorize the important equations from the study sheets at the back of this book. By utilizing a variety of resources, you'll see the material from different perspectives and gain a deeper understanding.

Furthermore, once you've finished a topic or chapter, take some time to reflect on how that knowledge connects to what you've already learned. If you form a narrative describing how an atom is formed, attaches to other atoms with intramolecular bonds to create a molecule, and connects with other molecules via intermolecular forces to determine its phase of matter, then you'll be much more likely to remember the material and apply it on Test Day. Once you've learned the material in the context of General Chemistry alone, you'll be able to apply it to other test sections, allowing you to truly master the DAT.

CHAPTER TWENTY-THREE

Laboratory Techniques

LEARNING OBJECTIVES

After this chapter, you will be able to:

- Describe how laboratories maintain a safe working environment
- Define precision and accuracy in laboratory measurements
- Identify types of laboratory equipment and the describe functions of that equipment

Laboratories can be dangerous places due to the chemicals often readily available. Laboratories may also have delicate experiments where contamination is a concern. For safety and accuracy there are a number of common protocols that are employed in laboratories to mitigate harm and increase statistical significance. Understanding the different applications of laboratory equipment allows for better technique and thus better results in executing experimental protocols.

SAFETY

One of the foremost considerations in working in a laboratory is maintaining a safe environment, both personally and for the laboratory as a whole. Although it is easy to become complacent when working in a laboratory on an ongoing basis, it is important to remember and follow simple rules, such as no eating or drinking in the lab.

Personal safety involves the consistent use of safety goggles, a laboratory coat or apron, and closed-toed shoes in any laboratory environment. Gloves may be appropriate when handling heated or toxic materials and the choice of glove should match the application (for example, some gloves may not be resistant to certain organic solvents). Volatile or dangerous chemicals should be handled in a hood, and a face mask or respirator may be needed as well.

All laboratories should have an eyewash station and shower station for rapid response to spills that contact the eyes or skin. Also, one or more fire extinguishers should always be present and in working condition. Finally, a laboratory should have more than one exit in the event of an emergency.

Disposal of laboratory waste should be done safely and appropriately, and containers should be set up for different types of waste. These include disposal containers for solvents and excess chemicals, biohazards, and broken glassware.

PRECISION VERSUS ACCURACY

Two important concepts in laboratory experiments are **accuracy** and **precision**. These terms do not mean the same thing and should not be used interchangeably.

Accuracy refers to a measurement giving the actual value for the sample with a limited deviation. For example, correctly determining the weight of a sample to be 1 gram plus or minus 0.001 gram is an accurate measurement.

Precision is the repeatability of a set of measurements on the same sample. For example, measuring the same 1 gram sample three times in a row and finding values of 1.001 g, 1.000 g, and 1.001 g is a precise series of measurements if this is within the limits of experimental error that the scientist wants to achieve.

It is possible to be accurate without being precise, and vice versa. For example, three measurements of the 1 gram sample as 0.9 g, 1.0 g, and 1.1 g give an accurate average value of 1 g for the sample, but are much less precise than the three samples determined to be 1.001 g, 1.000 g, and 1.001 g. Three determinations of the weight of a 1 g sample as 1.100 g, 1.1001 g, and 1.100 g may be precise but are not accurate.

Accuracy and precision are determined by a combination of using the correct laboratory apparatus and using that apparatus properly. In general, calibrated laboratory equipment will provide higher levels of both precision and accuracy than non-calibrated equipment, as long as the user is correctly trained and uses the equipment appropriately. Equipment that is calibrated generally has an acceptable temperature range and is specifically calibrated at one temperature (usually 25°C). All laboratories should have scheduled maintenance to keep the equipment accurately calibrated.

LABORATORY GLASSWARE

Laboratory glassware is a term that applies to a wide variety of vessels, not all of which are actually made of glass. Glass is generally preferred for chemistry applications because of its strength, inertness, transparency, and heat resistance. However, in some instances plastic may be a better choice if using chemicals that can interact with a glass surface. Plasticware also has the benefit of being lightweight and difficult to break.

Solvent compatibility with plastic and rubber labware needs to be considered and may not be obvious. For example, solvent fumes can compromise a pipet bulb, especially if the solvent is allowed to splash up into the bulb. Before using plasticware or rubber, check that no organic solvents will be used because components of the plastic can leach into organic solvents and contaminate the experiment. In some cases, plastic labware is made of Teflon to provide chemical inertness.

Non-Calibrated Glassware

A large number of items in the laboratory are uncalibrated because they are simply used for containing, mixing, and reacting without specifically measuring the experimental materials. These include test tubes, beakers, Erlenmeyer flasks, round-bottomed flasks, transfer (or Pasteur) pipets, watch glasses, bottles, jars and vials, etc. Although these pieces of glassware often have volume markings, they are approximate and should not be used for actual measurements. They are available in a wide range of sizes, as small as a few milliliters to several liters.

Test tubes, beakers, and Erlenmeyer flasks are used for many of the routine mixing and reaction tasks of the lab. **Test tubes** are relatively small and allow a large number of samples to be arrayed in a rack for easy processing. **Beakers** are wide-mouthed cylinders with a lip to allow pouring. **Erlenmeyer flasks** are tapered and therefore minimize accidental spills. The neck of an Erlenmeyer flask also allows it to be clamped in place either on the laboratory bench or above it on a stand. Some Erlenmeyer flasks have a side hose barb to allow connection to a vacuum apparatus. Erlenmeyer flasks can be sealed with rubber, cork, or ground glass stoppers. Both beakers and Erlenmeyer flasks have flat bottoms so they can stand on their own.

Round-bottom flasks are used for reaction, heating, or vacuum applications. The spherical shape and wall thickness of the flask provide extra strength and fit into a heating mantle, and the narrow neck allows the flask to be clamped into place. The top of the neck often has a ground glass joint to allow a stopper or glass tube to be connected to the flask. A **retort** is a round vacuum flask with a long neck that extends to the side. It is used for distillation and must be placed on a ring stand or heating mantle. These round-bottomed flasks are used frequently in experiments that require distillation to isolate product.

An **extraction flask,** also known as a **separatory funnel,** is a teardrop-shaped flask with a ground glass stopper at the top and a stopcock at the bottom. Two different solvents are mixed by shaking the flask, venting to prevent breakage, and are then allowed to separate by density; the lower layer is removed by draining through the stopcock. Since the flask cannot stand on its own, it is typically placed in ring stand to keep it vertical. This technique is often used to separate polar molecules from non-polar molecules. The two liquids in the separatory funnel must be immiscible to complete the separation.

Liquids are transferred using several different types of non-calibrated glassware. A funnel allows pouring from one vessel to another with minimal spillage. When small amounts are being transferred, a pipet is often used. **Transfer pipets** are often made of plastic and have an integral bulb at the top. **Pasteur pipets** are made of glass with a long tapered tip and require a separate rubber pipet bulb.

Bottles are containers with narrow openings generally used to store reagents or samples. Small bottles are called **vials**. **Jars** are cylindrical containers with wide openings that may be sealed. **Bell jars** are used to contain vacuums. Bottles, jars, and vials can be closed with stoppers or screw top lids. **Watch glasses**, also known as **evaporating dishes**, are shallow glass plates used as evaporating surfaces or to cover beakers.

Figure 23.1

From left to right, Figure 23.1 shows a test tube, Erlenmeyer flask, retort, round-bottom flask, and extraction flask.

Calibrated Glassware

Calibrated glassware should be used for any laboratory measurement that requires accuracy and precision. It is manufactured to provide exact volumes at a given temperature, which is usually 25°C. Calibrated glassware is available in a broad range of sizes, from a few milliliters or less to several liters.

A **graduated cylinder** is a tall, narrow tube with volume markings increasing from bottom to top and a lip at the top for pouring. A liquid is poured into the graduated cylinder to the approximate desired

level and then carefully added to or removed from the cylinder to reach the exact volume required. The fluid is then transferred to another vessel. Graduated cylinders have wide bases and often have protective plastic rings around the top of the cylinder to protect them from spilling and breaking. One important feature of using a graduated cylinder is reading the **meniscus**. The meniscus can be either concave or convex depending on the liquid being measured. If the liquid is attracted to the side of the cylinder, then the meniscus will be concave. This is common in most solvents. A convex meniscus occurs when the molecules of the liquid are more attracted to each other than the cylinder; mercury is one example. No matter the shape of the meniscus, volume is always read at the meniscus in the middle of the cylinder.

Burets and pipets are used to deliver exact volumes of liquids. A **buret** is a long tube that is clamped in place vertically with a stopcock at the bottom. The amount delivered is determined by the difference between the starting volume and the final volume in the buret. Burets are especially useful when liquids are to be dispensed slowly or dropwise. Burets are used to make solutions and to perform titrations. Chapter 36 covers titrations in detail.

A **graduated pipet** is hand-held and controlled by a pipet bulb that maintains a slight vacuum at the top of the pipet. Graduated pipets can deliver a variable amount of liquid, as either all of the fluid is dispensed or the stop and start volumes are measured. **Volumetric pipets** have a large bulge in the middle of the tube and deliver a single established volume of liquid with great accuracy and precision. Calibrated pipets are designed to take into account any liquid remaining in the pipet after the desired amount has been dispensed.

A **volumetric flask** is used to make solutions that require a specific volume of liquid, such as molar solutions. The components are added to the flask with less solvent than is required. The contents are mixed, and then a final amount of solvent is added to reach the volume marking on the neck of the flask. Volumetric flasks have flattened bottoms so that they can stand on a laboratory bench and narrow necks so that the volume mark can be easily read.

Figure 23.2

From left to right, Figure 23.2 shows a graduated cylinder, volumetric flask, graduated beaker, pipet, and buret.

pH DETERMINATION

The **pH meter** is an important piece of measurement equipment consisting of a glass probe and an electronic meter. Different pH meters can range from very simple to very complex, but all perform the same essential functions. A pH meter determines the acidity or basicity of a solution by comparing the voltage (electrical potential) produced by the solution compared to the voltage of a known standard solution and uses the difference in voltage (the potential difference) between them to calculate the pH.

The glass probe is first calibrated and then rinsed, dried, and quickly immersed in the solution to be measured. Calibration is done at an appropriate range of pH values to match the samples to be measured; the most commonly used range is pH 4.01 to pH 10.00, often with an initial calibration at pH 7. The sample must be at a known temperature, and the effect of temperature on pH must be compensated for (more complex pH meters can do this automatically).

Litmus paper can also be used to quickly determine pH, although it is less accurate than a pH meter. Traditional litmus paper is red under acidic conditions (below pH 4.5), blue under basic conditions (above 8.3), and purple at neutral pH. Modern litmus paper is available that is calibrated with different colors according to the pH range, typically with a different color at each integer pH value.

WEIGHT DETERMINATION

Laboratory balances are divided into two major categories: standard laboratory balances, and analytical balances. Standard laboratory balances (also called top-loading balances) are used when weights are in the milligram range and require accuracy to within plus or minus 0.5 mg. Analytical balances are used for much more sensitive weighing applications, with accuracy to plus or minus 0.01 mg. Analytical balances have glass sides and sliding doors to protect against slight movements due to drafts and must be used with particular care.

CALORIMETRY

Calorimetry is a way for chemists to measure the energy content of a substance. One of the most common versions of calorimetry is **bomb calorimetry**. There are many types of calorimeters; two of the most common are constant-pressure and constant-volume calorimetry. In a simple bomb calorimeter, the fuel (the sample being measured) is ignited, heating up the surrounding air. That air heats surrounding water. Using the specific heat of the water, it is possible to measure the heat content and thereby calculate the internal energy of the sample.

REVIEW PROBLEMS

1. Which of the following is appropriate to use for a procedure that involves simultaneously heating and distilling a reaction mixture?

 A. Erlenmeyer flask

 B. Erlenmeyer flask with a hose barb

 C. Volumetric flask

 D. Round-bottom flask

 E. Either A or B

2. What is the best piece of glassware to use to transfer exactly 50 mL of liquid?

 A. 50 mL beaker

 B. 50 mL Erlenmeyer flask

 C. 50 mL volumetric pipet

 D. 50 mL volumetric flask

 D. 500 mL graduated cylinder

3. What should be used to titrate 50 mL of 0.1 N HCl with 0.2 N NaOH?

 A. 10 mL buret

 B. 30 mL buret

 C. 30 mL graduated pipet

 D. 50 mL volumetric pipet

 E. 50 mL graduated cylinder

4. A scientist is setting up an experiment with 20 samples, each consisting of 0.5 g of a solid. He will pipet 2 mL of liquid into each sample, allow them to stand for 1 hour and then remove 1 mL for analysis. Which of the following is the best glassware to use?

 A. Erlenmeyer flasks

 B. Beakers

 C. Volumetric flasks

 D. Round-bottom flasks

 E. Test tubes

5. Which of the following will provide the most accurate and precise measurement of a sample at approximately pH 5?

 A. pH meter calibrated at pH 5.00

 B. pH meter calibrated at pH 4.01 and pH 10.00

 C. pH meter calibrated at pH 7.00

 D. pH meter calibrated at pH 7.00, pH 4.01, and pH 10.00

 E. Litmus paper

6. A scientist wants to prepare $AlCl_3$ by reacting a large excess of aluminum with exactly 3.0 moles of HCl dissolved in water. How should she measure the solid aluminum?

 A. Weigh 27.0 g of Al (*s*) on a standard laboratory balance.

 B. Weigh 27.00 g of Al (*s*) on an analytical balance.

 C. Weigh 50.0 g of Al (*s*) on a standard laboratory balance.

 D. Weigh 50.00 g of Al (*s*) on an analytical balance.

 E. Add the Al (*s*) by adding double the amount of NaCl by eye.

7. A scientist wants to make 50 mL of a 1.00 molal solution of sodium chloride in water. Which of the following should he use to measure the water to be added?

 A. Graduated cylinder

 B. Volumetric pipet

 C. Volumetric flask

 D. Buret

 E. Balance

8. Which of the following combinations is most suitable for titrating and measuring the pH of a solution with an endpoint of pH 4.4?

 A. Buret, beaker, and litmus paper

 B. Pipet, Erlenmeyer flask, and litmus paper

 C. Buret, volumetric flask, and pH meter

 D. Pipet, volumetric flask, and pH meter

 E. Pipet, Erlenmeyer flask, and pH meter

SOLUTIONS TO REVIEW PROBLEMS

1. **D** A round-bottom flask is best for a heating and distilling application because its round shape gives it extra strength to withstand heat and vacuum.

2. **C** A volumetric pipet is calibrated to deliver one volume with great accuracy. Although a volumetric flask is designed to hold an exact amount, it is not designed to transfer that amount, and some liquid may be left in the flask if it is not drained correctly. A graduated cylinder can be used to transfer liquid, but it will not be as accurate as a volumetric pipet.

3. **B** To solve this problem, the amount of NaOH solution must first be calculated using the formula $N_A V_A = N_B V_B$:

$$V_B = \frac{(50\,\text{mL})(0.1\,N)}{(0.2\,N)} = 25\,\text{mL of NaOH solution}$$

 Next, the appropriate glassware must be chosen for the titration. The best choice is a buret that allows gradual addition of the NaOH solution as the pH is monitored and that is of the right volume to hold all the solution required without refilling.

4. **E** The best choice is a rack of 20 test tubes, which will allow the scientist to rapidly process the set of samples in order. The test tubes are the correct shape to fit in a rack and allow the liquids to be readily added and removed.

5. **D** A pH meter is much more accurate and precise than litmus paper. For the best accuracy and precision, the three-point calibration is best.

6. **C** First, an appropriate amount of aluminum must be determined. Since the scientist wants to run the reaction with an excess of aluminum, she must have more than 1 mole to react according to the following equation:

$$\text{Al}\,(s) + 3\,\text{HCl}\,(aq) \rightarrow \text{AlCl}_3\,(s) + \frac{3}{2}\,\text{H}_2\,(g)$$

 Note that a balanced equation should normally have no fractions, but the above equation is more helpful because it shows the ratios with respect to the three moles of HCl added in this question.

 From the periodic table, the atomic mass of aluminum can be found to be 27 g/mol. Thus, weighing 50 g would only provide almost 2 moles, which is an excess. Because exact stoichiometric quantities are not being used, a standard laboratory balance is the correct equipment to use.

7. **E** A molal solution is defined as moles solute/kg of solvent. Since the solvent is measured by weight rather than volume, a balance is the correct measurement device.

8. **A** A buret is the preferred dispensing glassware for a titration since it allows the titrant to be gradually dispensed so the pH can be monitored. Although litmus paper is not as accurate as a pH meter, it will change color almost exactly at the desired pH endpoint, making it a good choice for this application. The use of a beaker as the receiving vessel allows the user to easily check the pH of the solution with the litmus paper.

CHAPTER TWENTY-FOUR

Atomic and Molecular Structure

LEARNING OBJECTIVES

After this chapter, you will be able to:

- Contrast the different subatomic particles
- Calculate the atomic weight of an element, given isotope abundance
- Describe the Bohr model of the atom
- Apply the quantum mechanical model to describe electrons of an element

Chemistry is the study of the nature and behavior of matter. The **atom** is the basic building block of matter, representing the smallest unit of a chemical element. An atom in turn is composed of subatomic particles called **protons**, **neutrons**, and **electrons**. The protons and neutrons in an atom form the **nucleus**, the core of the atom. The electrons exist outside the nucleus in characteristic regions of space called **orbitals**. All atoms of an **element** show similar chemical properties and cannot be further broken down by chemical means.

SUBATOMIC PARTICLES

In the early 1800s, an English scientist by the name of John Dalton formulated a specific theory of invisible building blocks of matter that are now called atoms. Dalton's atomic theory marks the beginning of the modern era of chemistry. Below is a summary of the key points of his hypothesis:

- All **elements** are composed of very small particles called atoms. All atoms of a given element are identical in size, mass, and chemical properties (although we now know **isotopes**, atoms of the same element with different masses due to different numbers of neutrons, also exist). The atoms of one element are different from atoms of all other elements.

- All **compounds** are composed of atoms of more than one element. For any given compound, the ratio of the numbers of atoms of any two of the elements present is either an integer or a simple fraction.

- A given **chemical reaction** involves only the separation, combination, or rearrangement of atoms; it does NOT result in the creation or destruction of atoms.

Protons

Protons carry a single positive charge and have a mass of approximately one **unified atomic mass unit** (**amu** or **u**), which is equivalent to one **dalton (Da)**. The **atomic number (Z)** of an element is equal to the number of protons found in an atom of that element. All atoms of a given element

GC

have the same atomic number. These positively charged particles carry the same quantity of charge as an electron; however, they have a mass that is approximately 1,840 times greater than that of an electron. Although the mass of the nucleus of an atom therefore comprises almost the entire weight of an atom, it occupies only 10^{-13} of the volume of the atom. Putting this in perspective, if the entire atom was the size of a football stadium that seats 100,000 people, the volume of the actual nucleus would be that of a small marble.

Neutrons

Neutrons carry no charge and have a mass only slightly larger than that of protons, so they can still be considered to have a mass of approximately 1 u. Different **isotopes** of one element have different numbers of neutrons but the same number of protons.

Electrons

Electrons carry a charge equal in magnitude but opposite in sign to that of protons. An electron has a very small mass, which is negligible for the purposes of the exam. The electrons in the electron shell farthest from the nucleus are known as **valence electrons**. The farther the valence electrons are from the nucleus, the weaker the attractive force of the positively charged nucleus and the more likely the valence electrons are to be influenced by other atoms. Generally, the valence electrons and their activity determine the reactivity of an atom. In a neutral atom, the numbers of protons and electrons are equal. Therefore, the atomic number indicates the number of electrons in a neutral atom. A positive or negative charge on an atom is due to a loss or gain of electrons; the result is called an **ion**. Note that a (+) charge indicates a *loss* of negatively-charged electrons, whereas a (−) charges indicates a *gain* of electrons.

Some basic features of the three subatomic particles are shown in the table below:

Subatomic Particle	Symbol	Relative Mass	Charge	Location
Proton	$_1^1H^+$	1	+1	Nucleus
Neutron	$_0^1n$	1	0	Nucleus
Electron	e^-	0	−1	Electron orbitals

Table 24.1

Example: Determine the number of protons, neutrons, and electrons in a nickel-58 atom and in a nickel-60^{2+} cation.

Solution: ^{58}Ni has an atomic number of 28 and a mass number of 58. Therefore, ^{58}Ni has 28 protons, 28 electrons, and (58 − 28), or 30, neutrons.

In the $^{60}Ni^{2+}$ species, the number of protons is the same as in the neutral ^{58}Ni atom (28 protons). However, $^{60}Ni^{2+}$ has a positive charge because it has lost two electrons, so Ni^{2+} has 26 electrons (as opposed to the 28 electrons in ^{58}Ni). Also, the mass number is two units higher than for the ^{58}Ni atom, and this difference in mass must be due to two extra neutrons; thus, it has a total of 32 neutrons (as opposed to 30 neutrons in ^{58}Ni).

MASS NUMBER AND ISOTOPES

Mass Number

The atomic **mass number (A)** of an atom is equal to the total number of nucleons (protons and neutrons). The convention $_Z^A X$ is used to show both the atomic number and mass number of an X atom, where Z is the atomic number and A is the mass number such that:

$$\text{mass number } (A) = \text{number of protons} + \text{number of neutrons}$$

On a larger scale, the **molecular weight** is the weight in grams per one mole (mol) of a given element (g/mol). A **mole** is a unit used to count particles and is represented by **Avogadro's number**, 6.02×10^{23} particles/mol, which is how many atoms of carbon are in 12.0 g of carbon-12. Avogadro's number is the conversion factor between amu and g such that, if one atom of nitrogen has a mass of 14 u, then one mole of nitrogen has a mass of 14 g (see Chapter 27, Stoichiometry).

Isotopes

For a given element, multiple species of atoms with the same number of protons (same atomic number, Z) but different numbers of neutrons (different mass numbers, A) exist; these are called **isotopes** of the element. Isotopes are referred to either by the convention described above or, more commonly, by the name of the element followed by the mass number. For example, carbon-12 $\left(_6^{12}C\right)$ is a carbon atom with six protons and six neutrons, while carbon-14 $\left(_6^{14}C\right)$ is a carbon atom with six protons and eight neutrons. Since isotopes have the same number of protons and electrons, they generally exhibit the same chemical properties.

In nature, almost all elements exist as a collection of two or more isotopes, and these isotopes are usually present in the same proportions in any sample of a naturally occurring element. Therefore, another common convention used to define the mass of an atom is **standard atomic weight**, which is a weighted average of all the isotopes of an element found naturally on Earth. The periodic table lists the atomic weight for the different elements, which accounts for the relative abundance of the various isotopes. The presence of these isotopes accounts for the fact that the accepted atomic weight for most elements is not a whole number. For example, nitrogen has two stable isotopes, ^{14}N and ^{15}N, but ^{14}N is much more common (99.6%), so the weighted average of the two is 14.007.

Example: Element Q consists of three different isotopes, A, B, and C. Isotope A has an atomic mass of 40 u and accounts for 60% of naturally occurring Q. The atomic mass of isotope B is 44 u and accounts for 25% of Q. Finally, isotope C has an atomic mass of 41 u and a natural abundance of 15%. What is the atomic weight of element Q?

Solution: $0.60(40 \text{ u}) + 0.25(44 \text{ u}) + 0.15(41 \text{ u}) = 24 \text{ u} + 11 \text{ u} + 6.15 \text{ u} = 41.15 \text{ u}$

The atomic weight of element Q is 41.15 g/mol.

BOHR'S MODEL OF THE HYDROGEN ATOM

In 1911, Ernest Rutherford provided experimental evidence that an atom has a dense, positively charged nucleus that accounts for only a small portion of the volume of the atom. In 1900, Max Planck developed the first **quantum theory**, proposing that energy emitted as electromagnetic radiation from matter comes in discrete bundles called **quanta**. The energy value of a quantum is given by the

equation $E = hf$, where h is a proportionality constant known as **Planck's constant**, equal to 6.626×10^{-34} J·s, and f (sometimes designated v) is the **frequency** of the radiation.

The Bohr Model

In 1913, Niels Bohr used the work of Rutherford and Planck to develop his model of the electronic structure of the hydrogen atom. Starting from Rutherford's findings, Bohr assumed that the hydrogen atom consisted of a central proton around which an electron traveled in a circular orbit, and that the centripetal force acting on the electron as it revolved around the nucleus was the electrical force between the positively charged proton and the negatively charged electron.

Bohr's model used the quantum theory of Planck in conjunction with concepts from classical physics. In classical mechanics, an object, such as an electron, revolving in a circle may assume an infinite number of values for its radius and velocity. Therefore, the **angular momentum** ($L = mvr$) and **kinetic energy** $\left(KE = \frac{mv^2}{2} \right)$ can take on any value. However, by incorporating Planck's quantum theory into his model, Bohr placed conditions on the value of the angular momentum. Like Planck's energy, the angular momentum (L) of an electron is quantized according to the following equation:

$$L = \frac{nh}{2\pi}$$

where h is Planck's constant and n is the principal quantum number, which can be any positive integer. Since h, 2, and π are constants, the angular momentum changes only in discrete amounts with respect to n.

Bohr then equated the allowed values of the angular momentum to the energy of the electron. He obtained the following equation:

$$E = -\frac{R_{\mathrm{H}}}{n^2}$$

where R_{H} is an experimentally determined constant (known as the **Rydberg energy**). Therefore, like angular momentum, the energy of the electron changes in discrete amounts with respect to n.

Applications of the Bohr Model

In his model of the structure of hydrogen, Bohr postulated that an electron can exist only in certain fixed-energy states. In terms of quantum theory, the energy of an electron is **quantized**. Using this model, certain generalizations concerning the characteristics of electrons can be made. The energy of the electron is related to its **orbital radius**: the smaller the radius, the lower the energy state of the electron. The smallest orbit (radius) an electron can have corresponds to $n = 1$, which is the ground state of the hydrogen electron. At the **ground state** level, the electron is in its lowest energy state. The Bohr model is also used to explain the atomic emission spectrum and atomic absorption spectrum of hydrogen, and it is helpful in interpretation of the spectra of other atoms.

Atomic emission spectra

At room temperature, the majority of atoms in a sample are in the ground state. However, electrons can be excited to higher energy levels by heat (or other) energy to yield the excited state of the atom. Because the lifetime of the excited state is brief, the electrons will return rapidly to the ground state

while emitting energy in the form of photons. The electromagnetic energy of these photons may be determined using the following equation:

$$E = \frac{hc}{\lambda}$$

where h is Planck's constant, c is the velocity of light in a vacuum (3.00×10^8 m/s), and λ is the wavelength of the radiation. This is a derivation of the equation $E = hf$, where $c = \lambda f$.

The different electrons in an atom will be excited to different energy levels. When these electrons return to their ground states, each will emit a photon with a wavelength characteristic of the specific transition it undergoes. The quantized energies of light emitted under these conditions do not produce a continuous spectrum (as expected from classical physics). Rather, the spectrum is composed of light at specific frequencies and is thus known as a **line spectrum**, where each line on the emission spectrum corresponds to a specific electronic transition. Because each element can have its electrons excited to different distinct energy levels, each element possesses a unique **atomic emission spectrum**, which can be used as a fingerprint. One particular application of atomic emissions spectroscopy is in the analysis of stars; although physical samples of the stars cannot be taken, the light from a star can be resolved into its component wavelengths, which are then matched to the known line spectra of the elements.

The Bohr model of the hydrogen atom explained the atomic emission spectrum of hydrogen, which is the simplest emission spectrum among all the elements. The group of hydrogen emission lines corresponding to transitions from upper levels $n > 2$ to $n = 2$ is known as the **Balmer series** (four wavelengths in the visible region), while the group corresponding to transitions between upper levels $n > 1$ to $n = 1$ is known as the **Lyman series** (higher energy transitions in the UV region). Below is a summary of various series in the hydrogen atomic emission spectrum where n_f and n_i are the final and initial states, respectively. Similarly, the **Paschen series** represents the infrared spectra that are released when $n > 3$.

Series	n_f	n_i	Spectrum region
Lyman	1	2, 3, 4 . . .	Ultraviolet
Balmer	2	3, 4, 5 . . .	Visible and Ultraviolet
Paschen	3	4, 5, 6 . . .	Infrared

Table 24.2

When the energy of each frequency of light observed in the emission spectrum of hydrogen was calculated according to Planck's quantum theory, the values obtained closely matched those expected from energy-level transitions in the Bohr model. That is, the energy associated with a change in the quantum number from an initial value n_i to a final value n_f is equal to the energy of Planck's emitted photon. Thus:

$$E = \frac{hc}{\lambda} = - R_H \left(\frac{1}{n_i^2} - \frac{1}{n_f^2} \right)$$

and the energy of the emitted photon corresponds to the precise difference in energy between the higher-energy initial state and the lower-energy final state.

Atomic absorption spectra

When an electron is excited to a higher energy level, it must absorb energy. The energy absorbed as an electron jumps from an orbital of low energy to one of higher energy is characteristic of that transition. This means that the excitation of electrons in a particular element results in energy absorptions at specific wavelengths. Thus, in addition to an emission spectrum, every element possesses a characteristic **absorption spectrum**. Not surprisingly, the wavelengths of absorption correspond directly to the wavelengths of emission since the energy difference between levels remains unchanged. Absorption spectra can thus be used in the identification of elements present in a gas phase sample.

QUANTUM MECHANICAL MODEL OF ATOMS

While the concepts put forth by Bohr offered a reasonable explanation for the structure of the hydrogen atom and ions containing only one electron (such as He^{1+} and Li^{2+}), they did not explain the structures of atoms containing more than one electron. This is because Bohr's model does not take into consideration the repulsion between multiple electrons surrounding one nucleus. Modern quantum mechanics has led to a more rigorous and generalized study of the electronic structure of atoms. The most important difference between the Bohr model and modern quantum mechanical models is that Bohr's assumption that electrons follow a circular orbit at a fixed distance from the nucleus is no longer considered valid. Rather, electrons are described as being in a state of rapid motion within regions of space around the nucleus called **orbitals**. An orbital is a representation of the probability of finding an electron within a given region. In the current quantum mechanical description of electrons, pinpointing both the exact location and momentum of an electron at any given point in time is impossible. This idea is best described by the **Heisenberg uncertainty principle**, which states that it is impossible to simultaneously determine, with perfect accuracy, the momentum (defined as mass times velocity) and the position of an electron. This means that if the momentum of the electron is being measured accurately, its position will not be certain, and vice versa.

KEY CONCEPT

Think of the quantum numbers as becoming more specific as one goes from n to ℓ to m_l to m_s. This is like a ticket for a sporting event or concert: n is the gate number, ℓ is the section number, m_l is the row number and m_s is the seat number. No two seats have the same four numbers, and, similarly, no electron has the same four numbers.

Quantum Numbers

Modern atomic theory states that any electron in an atom can be completely described by four **quantum numbers**: n, ℓ, m_ℓ, and m_s. Furthermore, according to the **Pauli exclusion principle**, no two electrons in a given atom can possess the same set of four quantum numbers. The position and energy of an electron described by its quantum numbers is known as its **energy state**. The value of n limits the values of ℓ, which in turn limit the values of m_ℓ. The values of three of the quantum numbers qualitatively give information about the orbitals: n about the size, ℓ about the shape, and m_ℓ about the orientation of the orbital. All four quantum numbers are discussed below.

Principal quantum number

The first quantum number is commonly known as the **principal quantum number** and is denoted by the letter n. This is the quantum number used in Bohr's model that can theoretically take on any positive integer value and represents the **shell** where an electron is present in an atom. The maximum n that can be used to describe the electrons of an element at its ground state corresponds with that element's period (row) in the periodic table. For example, nitrogen is in period

2, so neutral N in its ground state has electrons with n values of 1 and 2. The larger the integer value of n, the higher the energy level and radius of the electron's orbit. The maximum number of electrons in an electron shell n is $2n^2$.

The difference in energy between adjacent shells decreases as the distance from the nucleus increases. For example, the energy difference between the third and fourth shells ($n = 3$ and $n = 4$) is less than that between the second and third shells ($n = 2$ and $n = 3$).

Azimuthal quantum number

The second quantum number is called the **azimuthal (angular momentum) quantum number** and is designated by the letter ℓ. This number tells us the shape of the orbitals and refers to the **subshells** or **sublevels** that occur within each principal energy level. For any given n, the value of ℓ can be any integer in the range of 0 to $n - 1$. The four subshells corresponding to $\ell = 0$, 1, 2, and 3 are known as the sharp, principal, diffuse, and fundamental subshells, or s, p, d, and f subshells, respectively. The maximum number of electrons that can exist within a subshell is given by the equation $4\ell + 2$. The greater the value of ℓ, the greater the energy of the subshell. However, the energies of subshells from different principal energy levels may overlap. For example, the $4s$ subshell will have a lower energy than the $3d$ subshell because its average distance from the nucleus is smaller. The periodic table is arranged around these four subshells and can be helpful in determining the azimuthal quantum number. The first two columns show the atoms that have their valence electrons in the s subshell. The right "block" of the periodic table represents atoms that are filling the six spaces in the p subshell. Columns 3-12 represent the d block, and the Lanthanide and Actinide series are the f block. In this way the structure of the periodic table predicts the subshells a given atom's electrons will fill.

Magnetic quantum number

The third quantum number is the **magnetic quantum number** and is designated m_ℓ. This number describes the orientation of the **orbital** in space. An orbital is a specific region within a subshell that may contain no more than two electrons. The magnetic quantum number specifies the particular orbital within a subshell where an electron is highly likely to be found at a given point in time. The possible values of m_ℓ are all integers from ℓ to $-\ell$ including 0. Therefore, the s subshell ($\ell = 0$), has only one possible value of m_ℓ (0) and will contain one orbital; in contrast, the p subshell ($\ell = 1$) has three possible m_ℓ values (-1, 0, $+1$) and three orbitals. The d subshell ($\ell = 2$) has five possible m_ℓ values (-2, -1, 0, $+1$, $+2$) and five orbitals; the f subshell ($\ell = 3$) has seven possible m_ℓ values (-3, -2, -1, 0, $+1$, $+2$, $+3$) and contains seven orbitals. The shape and energy of each orbital are dependent upon the subshell in which the orbital is found. For example, a p subshell with its three possible m_ℓ values (-1, 0, $+1$) has three dumbbell-shaped orbitals that are oriented in space around the nucleus along the x, y, and z axes. These three orbitals are often referred to as p_x, p_y, and p_z.

Spin quantum number

The fourth quantum number is also called the **spin quantum number** and is denoted by m_s. The spin of a particle is its intrinsic angular momentum and is a characteristic of a particle. The two spin orientations are designated $+\frac{1}{2}$ and $-\frac{1}{2}$. Whenever two electrons are in the same orbital, they must have opposite spins due to the Pauli exclusion principle. Electrons in different orbitals (different m_ℓ values) with the same m_s values are said to have **parallel** spins. Electrons with opposite spins (different m_s values) in the same orbital (same m_ℓ value) are often referred to as **paired**.

Electron Configuration and Orbital Filling

For a given atom or ion, the pattern by which subshells are filled and the number of electrons within each principal level and subshell are designated by an **electron configuration**. In electron configuration notation, the first number denotes the principal energy level, the letter designates the subshell, and the superscript gives the number of electrons in that subshell. For example, $2p^4$ indicates that there are four electrons in the second subshell (p) of the second principal energy level ($n = 2$). Note that the third and fourth quantum numbers (m_ℓ and m_s) are not indicated in the electron configuration but can be determined for a given electron using the rules from earlier in this chapter if necessary.

When writing the electron configuration of an atom, it is necessary to remember the order in which subshells are filled. According to the **Aufbau principle**, subshells are filled from lowest to highest energy, and each subshell will fill completely before electrons begin to enter the next one. The $(n + \ell)$ **rule** is used to rank subshells by increasing energy. This rule states that the lower the sum of the first and second quantum numbers, the lower the energy of the subshell. If two subshells possess the same $(n + \ell)$ value, the subshell with the lower n value has a lower energy and will fill first. The order in which the subshells fill is shown in the following chart:

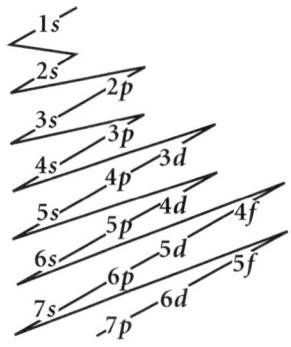

Figure 24.1

Example: Which will fill first, the $3d$ subshell or the $4s$ subshell?

Solution: For $3d$, $n = 3$ and $\ell = 2$, so $(n + \ell) = 5$. For $4s$, $n = 4$ and $\ell = 0$, so $(n + \ell) = 4$. Therefore, the $4s$ subshell has a lower energy and will fill first. This can also be determined from examining Figure 24.1.

KEY CONCEPT

You can remember Hund's Rule as the "GreyHund Bus" rule. As people board a bus, at first they will choose to sit in empty rows. Once all the rows are full then they will begin to pair up. Similarly, electrons will go to empty orbitals before pairing up.

To determine which subshells are filled, you must know the number of electrons in the atom. In the case of uncharged atoms, the number of electrons equals the atomic number. If the atom is charged, the number of electrons is equal to the atomic number plus the extra electrons if the atom is negative or the atomic number minus the missing electrons if the atom is positive.

In subshells that contain more than one orbital, such as the $2p$ subshell with its three orbitals, the orbitals will fill according to **Hund's Rule**. Hund's Rule states that, within a given subshell, orbitals are filled such that there are a maximum number of half-filled orbitals with parallel spins. Electrons "prefer" empty orbitals to half-filled ones because a

pairing energy must be overcome for two electrons carrying repulsive negative charges to exist in the same orbital.

Example: What are the written electron configurations for nitrogen (N) and iron (Fe) according to Hund's Rule?

Solution: Nitrogen has an atomic number of 7; thus, its electron configuration is $1s^2\ 2s^2\ 2p^3$. According to Hund's Rule, the two s orbitals will fill completely, while the three p orbitals will each contain one electron, all with parallel spins.

$$\frac{\uparrow\downarrow}{1s^2}\qquad \frac{\uparrow\downarrow}{2s^2}\qquad \frac{\uparrow\ \uparrow\ \uparrow}{2p^3}$$

Iron has an atomic number of 26, and its $4s$ subshell fills before the $3d$. Using Hund's Rule, the electron configuration will be:

$$\frac{\uparrow\downarrow}{1s^2}\qquad \frac{\uparrow\downarrow}{2s^2}\quad \frac{\uparrow\downarrow\ \uparrow\downarrow\ \uparrow\downarrow}{2p^6}\qquad \frac{\uparrow\downarrow}{3s^2}\quad \frac{\uparrow\downarrow\ \uparrow\downarrow\ \uparrow\downarrow}{3p^6}\qquad \frac{\uparrow\downarrow\ \uparrow\ \uparrow\ \uparrow\ \uparrow}{3d^6}\quad \frac{\uparrow\downarrow}{4s^2}$$

Iron's electron configuration is written as $1s^2\ 2s^2\ 2p^6\ 3s^2\ 3p^6\ 3d^6\ 4s^2$. Subshells may be listed either in the order in which they fill (e.g., $4s$ before $3d$) or with subshells of the same principal quantum number grouped together, as shown here. Both methods are correct.

The presence of paired or unpaired electrons affects the chemical and magnetic properties of an atom or molecule. If the material has unpaired electrons, a magnetic field will align the spins of these electrons and weakly attract the atom to the field. These materials are said to be **paramagnetic**. Materials that have no unpaired electrons and are slightly repelled by a magnetic field are said to be **diamagnetic**.

Valence Electrons

The valence electrons of an atom are those electrons that exist in its outer energy shell or that are available for chemical bonding. For elements in Groups IA and IIA, only the outermost s electrons are valence electrons. For elements in Groups IIIA through VIIIA, the outermost s and p electrons in the highest energy shell are valence electrons. For transition elements, the valence electrons are those in the outermost s subshell and in the d subshell of the next-to-outermost energy shell. For the inner transition elements (the lanthanide and actinide series), the valence electrons are those in the s subshell of the outermost energy shell, the d subshell of the next-to-outermost energy shell, and the f subshell of the energy shell two levels below the outermost shell.

There are some exceptions to these rules. Atoms with half-filled and fully-filled subshells are extremely stable. So much so that some molecules will move electrons from a lower energy subshell into a higher one to half fill the subshell. Take, for example, Chromium: it would be expected to have a valence shell configuration of $4s^2 3d^4$. However, if it moves one s electron into the d subshell, then both subshells will be half-filled. So, in reality, Cr exists as $4s^1 3d^5$. The same thing is true for all other elements in column 6. In a similar fashion, all atoms in column 11 will move one electron to complete the d subshell and, as a result, have a half-filled s subshell. Copper (Cu), for example, will exist as $4s^1 3d^{10}$.

Group IIIA–VIIA elements beyond Period 2 might, under some circumstances, accept electrons into their empty *d* subshells, which would give them more than eight valence electrons.

Example: Which are the valence electrons of elemental iron, elemental selenium, and the sulfur atom in a sulfate ion?

Solution: Iron has eight valence electrons: two in its 4*s* subshell and six in its 3*d* subshell.

Selenium has six valence electrons: two in its 4*s* subshell and four in its 4*p* subshell. Selenium's 3*d* electrons are not part of its valence shell.

Sulfur in a sulfate ion has 12 valence electrons: its original six plus six more from the oxygen to which it is bonded. Sulfur's 3*s* and 3*p* subshells can only contain eight of these electrons; the other four electrons have entered the sulfur atom's 3*d* subshell, which in elemental sulfur is empty.

REVIEW PROBLEMS

1. The Mg^{2+} ion has how many electrons?

 A. 12
 B. 10
 C. 14
 D. 15
 E. 24

2. It can be shown using mass spectrometry that the ratio of naturally occurring chlorine-35 to its isotope chlorine-37 is 3:1. Assuming no other isotopes exist, what is the standard atomic weight of chlorine?

3. A student represents electrons within the same orbital as having parallel spins. This goes against which of the following principles?

 A. Bohr's model of the hydrogen atom
 B. Pauli exclusion principle
 C. Heisenberg's uncertainty principle
 D. Planck's quantum theory
 E. Aufbau principle

4. What are the four quantum numbers? Discuss how they are related and to what each refers.

5. The maximum number of electrons in a shell with a principal quantum number of 4 is

 A. 2.
 B. 6.
 C. 10.
 D. 16.
 E. 32.

6. In Bohr's model of the hydrogen atom, the energy of an electron is directly dependent on

 A. the spin quantum number (m_s).
 B. Planck's constant (h).
 C. the principal quantum number (n).
 D. the angular momentum quantum number (ℓ).
 E. the magnetic quantum number (m_l).

7. Which of the following describes the excitation exhibited when an electron jumps from its ground state to a higher energy level?

 A. Balmer series
 B. Atomic absorption spectrum
 C. Lyman series
 D. Atomic emission spectrum
 E. Hund's rule

8. The Pauli exclusion principle states that
 A. no two electrons can have the same four quantum numbers.
 B. it is impossible to determine simultaneously the momentum and the position of an electron.
 C. energy is emitted from matter as quantized units.
 D. an electron will enter an empty orbital in a subshell before entering half-filled orbitals.
 E. the standard atomic weight is the most accurate measurement of the mass of atoms.

9. Atoms with the same atomic numbers but with different mass numbers are known as
 A. elements.
 B. isomers.
 C. ions.
 D. isotopes.
 E. compounds.

10. If the principal quantum number of a shell is equal to 2, what type(s) of orbitals will be present?
 A. s
 B. s and p
 C. s, p, and d
 D. s, p, d, and f
 E. s, p, d, f, and g

11. What quantity of energy is emitted when a hydrogen electron relaxes from $n = 3$ to $n = 2$? ($R_H = 2.18 \times 10^{-18}$ J)

12. What wavelength (in nm) corresponds to the energy calculated in Question 11? ($c = 3 \times 10^8$ m/s)

13. What is the total number of electrons that could be held in a subshell with an angular momentum number equal to 2?
 A. 2
 B. 6
 C. 8
 D. 10
 E. 12

14. An element with an atomic number of 26 has how many electrons in the $3d$ subshell?

 A. 0
 B. 2
 C. 6
 D. 8
 E. 10

15. If the energy associated with $n = 1$ is $-1{,}312$ kJ/mol, which principal energy level corresponds with an energy value of -328 kJ/mol?

 A. 1
 B. 2
 C. 3
 D. 4
 E. 5

16. In going from $1s^2\ 2s^2\ 2p^6\ 3s^2\ 3p^6\ 4s^1$ to $1s^2\ 2s^2\ 2p^6\ 3s^2\ 3p^5\ 4s^2$, an electron would

 A. absorb energy.
 B. emit energy.
 C. relax to the ground state.
 D. bind to another atom.
 E. become a proton.

17. The values of the spin quantum number are directly related to

 A. the principal quantum number.
 B. the angular momentum quantum number.
 C. the magnetic quantum number.
 D. none of the above.
 E. the atomic weight.

18. Which of the following orbitals has the lowest energy?

 A. $2p$
 B. $3s$
 C. $3d$
 D. $4s$
 E. $4d$

19. Which of the following correctly represents the excited state of scandium?

 A. $1s^2\ 2s^2\ 2p^6\ 3s^2\ 3p^6\ 3d^1\ 4s^2$
 B. $1s^2\ 2s^3\ 2p^5\ 3s^2\ 3p^6\ 3d^1\ 4s^2$
 C. $1s^2\ 2s^2\ 2p^6\ 3s^2\ 3p^6\ 3d^2\ 4s^1$
 D. $1s^2\ 2s^2\ 2p^6\ 3s^2\ 3p^6\ 3d^2\ 4s^2$
 E. $1s^2\ 2s^2\ 2p^5\ 3s^2\ 3p^6\ 3d^2\ 4s^1$

20. The photon frequency of red light is 4.51×10^{14} s^{-1}. If $R_H = 2.18 \times 10^{-18}$, what is the energy of the photon? Is this enough energy to cause a hydrogen electron to be excited from $n = 1$ to $n = 3$?

SOLUTIONS TO REVIEW PROBLEMS

1. **B** Magnesium has an atomic number of 12, meaning that it has 12 protons and 12 electrons. However, the Mg^{2+} ion has a positive charge because it has lost 2 electrons. Therefore, the Mg^{2+} ion has 10 electrons.

2. **35.5**

 Mass spectrometry shows that three out of every four chlorine atoms are Cl-35 and one is Cl-37. Thus, 75% of all chlorine atoms are Cl-35, and 25% are Cl-37. Using this information and the atomic weights of the isotopes (Cl-35 = 35 g/mol, Cl-37 = 37 g/mol), the atomic weight of chlorine can be determined as follows:

 (0.75)(35 g/mol) + (0.25)(37 g/mol)

 = (26.25 + 9.25) g/mol

 = 35.5 g/mol

3. **B** Discussed in the section on quantum numbers in this chapter.

4. Discussed in the section on quantum numbers in this chapter.

5. **E** The maximum number of electrons within a principal energy level can be calculated using the formula $2n^2$. Therefore, a shell with a principal quantum number equal to 4 will hold a maximum of 32 electrons.

6. **C** In the Bohr model for hydrogen, the energy of the electron is given by the equation
 $E = -\dfrac{R_H}{n^2}$ where R_H is a constant. Therefore, the energy of the electron is dependent only on n, the principal quantum number.

7. **B** For electrons to jump from ground state to higher energy levels, they must absorb energy. Therefore, the movements from ground state to excited state are characterized by an atomic absorption spectrum.

8. **A** Discussed in the section on quantum numbers in this chapter.

9. **D** Atomic weight equals the number of protons (atomic number) plus the number of neutrons. If two atoms have the same atomic number but different atomic weights, then the number of neutrons must be different. This is the definition of an isotope.

10. **B** When the principal quantum number is equal to 2, then the angular momentum quantum number will have values of $\ell = 0$ and 1. When $\ell = 0$, the subshell is an s subshell, and, when $\ell = 1$, the subshell is a p subshell. Therefore, the second principal energy level contains an s subshell and a p subshell.

11. **3.03×10^{-19} J**

To calculate the energy emitted when a hydrogen electron relaxes from $n = 3$ to $n = 2$, the

equation $E = -R_H\left(\dfrac{1}{n_i^2} - \dfrac{1}{n_f^2}\right)$ is used, where $R_H = 2.18 \times 10^{-18}$ J and n_i and n_f are

equal to 3 and 2, respectively. The calculation is performed as follows:

$$E = -2.18 \times 10^{-18} \text{ J}\left(\frac{1}{3^2} - \frac{1}{2^2}\right)$$

$$E = -2.18 \times 10^{-18} \text{ J}\left(\frac{1}{9} - \frac{1}{4}\right)$$

$$E = -2.18 \times 10^{-18} \text{ J}\left(\frac{4}{36} - \frac{9}{36}\right)$$

$$E = -2.18 \times 10^{-18} \text{ J}\left(-\frac{5}{36}\right)$$

$$E = 3.03 \times 10^{-19} \text{ J}$$

The value of the energy is positive because energy is released when an electron falls from an excited state back to the ground state.

12. **656 nm**

The wavelength in nm of a photon that carries the 3.03×10^{-19} J of energy found in Question 11 can be determined as follows:

$$E = \frac{hc}{\lambda}, \text{ thus, by rearrangement, } \lambda = \frac{hc}{E}$$

$$\lambda = \frac{\left(6.626 \times 10^{-34} \text{ J} \cdot \text{s}\right)\left(3 \times 10^8 \text{m/s}\right)}{3.03 \times 10^{-19} \text{ J}}$$

$$= 656 \text{ nm}$$

13. D The angular momentum number 2 corresponds to the d subshell, and d is capable of holding a maximum of $4(2) + 2 = 10$ electrons.

14. C An element with an atomic number of 26 will have six electrons in its $3d$ subshell. This can be determined by writing the electron configuration for the element: $1s^2\ 2s^2\ 2p^6\ 3s^2\ 3p^6\ 3d^6\ 4s^2$. The number of electrons must equal 26; recall that the $4s$ subshell must be filled before the $3d$ because it has the lower energy. Thus, $3d$ will carry six electrons.

15. B You can use the equation $E = -\dfrac{R_H}{n^2}$ to solve for different principle energy levels. However, since you know the value for $n = 1$, you don't need to plug in to the equation and can instead solve by comparing the numbers given. $-1{,}312$ is four times larger in magnitude than -328. Since the n in the denominator of the equation is squared, this means the values of n are only different by a factor of two. Therefore, since the original n was 1, the new n must be $1 \times 2 = 2$.

16. **A** The difference between the first and second electron configurations is that in the second configuration one electron has moved from the $3p$ subshell to the $4s$ subshell. Although the $3p$ and $4s$ subshells have the same $(n + \ell)$ value, the $3p$ subshell fills first because it is slightly lower in energy. For an electron to move from the $3p$ subshell to the $4s$ subshell, it must absorb energy.

17. **D** The spin quantum number is the intrinsic angular momentum of an electron in an orbital. The spin number can be either $+\frac{1}{2}$ or $-\frac{1}{2}$. These numbers are arbitrary and are not dependent on the other three quantum numbers.

18. **A** To determine which subshell has the lowest energy, the $(n + \ell)$ rule must be used. The values of the first and second quantum numbers are added together, and the subshell with the lowest $(n + \ell)$ value has the lowest energy. The sums of the five choices are $(2 + 1) = 3$, $(3 + 0) = 3$, $(3 + 2) = 5$, $(4 + 0) = 4$, $(3 + 1) = 4$. Choices (A) and (B) have the same $(n + \ell)$ value, so the subshell with the lower principal quantum number has the lower energy. This is the $2p$ subshell.

19. **C** Scandium has 21 electrons. Its ground-state electron configuration is $1s^2\ 2s^2\ 2p^6\ 3s^2\ 3p^6\ 3d^1\ 4s^2$. When it is in its excited state, one or more of the electrons will be present in a subshell with a higher energy than the one in which it is usually located. The number of electrons and ordering of subshells will not vary from the ground-state electron configuration of scandium. Choice (C) has one of the $4s$ electrons present in the $3d$ orbital. This represents an excited state because energy is required to cause an electron to jump from $4s$ to $3d$.

20. **2.988×10^{-19} J; No**

To determine the energy of a photon with a frequency (v) of 4.51×10^{14} s^{-1}, the following calculations are performed:

$E = hv$

$E = (6.626 \times 10^{-34} \text{ J} \cdot \text{s}) (4.51 \times 10^{14} \text{ s}^{-1})$

$E = 2.988 \times 10^{-19}$ J

The energy from red light will not be sufficient to excite a hydrogen electron from $n = 1$ to $n = 3$. This is because the energy necessary to perform that excitation is:

$$\Delta E = -R_\mathrm{H} \times \left(\frac{1}{n_\mathrm{i}^2} - \frac{1}{n_\mathrm{f}^2} \right)$$

$$\Delta E = -2.18 \times 10^{-18} \text{ J} \left(\frac{1}{1^2} - \frac{1}{3^2} \right)$$

$$\Delta E = -2.18 \times 10^{-18} \text{ J} \left(\frac{8}{9} \right)$$

$$\Delta E = -1.937 \times 10^{-18} \text{ J}$$

The magnitude of this energy is greater than the energy of red light.

CHAPTER TWENTY-FIVE

Periodic Properties

LEARNING OBJECTIVES

After this chapter, you will be able to:

- Use periodic trends to describe the properties of an element
- Distinguish between the periodic trends and types of elements
- Describe the chemical properties of ions and groups

In 1869, the Russian chemist Dmitri Mendeleev published the first version of his periodic table, in which he showed that ordering the elements according to atomic weight produced a pattern where similar properties periodically recurred. This table was later revised, using the work of the physicist Henry Moseley, to organize the elements on the basis of increasing atomic number. Using this revised table, the properties of certain elements that had not yet been discovered were predicted: A number of these predictions were later borne out by experimentation. The substance of this work is summarized in the **periodic law**, which states that the chemical properties of the elements are dependent, in a systematic way, upon their atomic numbers.

In the periodic table used today, the elements are arranged in **periods** (rows) and **groups** (columns). There are seven periods, representing the principal quantum numbers $n = 1$ to $n = 7$, and each period is filled sequentially. Groups represent elements that have the same electronic configuration in their **valence**, or outermost, shell. The electrons in this outermost shell are called **valence electrons**. These electrons are involved in chemical bonding and determine the chemical reactivity and properties of the element. Since they share the same valence electron configuration, elements within a group also share similar chemical properties. The Roman numeral above each group represents the number of valence electrons. There are two sets of groups, designated A and B. The A elements are the **representative elements**, which have either s or p sublevels as their outermost orbitals. These representative elements are those in Groups IA through VIIA, all of which have incompletely filled s or p subshells of the highest principal number. The B elements are the **nonrepresentative elements**, including the **transition elements**, which have partly filled d sublevels, and the **lanthanide** and **actinide** series, which have partly filled f sublevels. The position of an element on the periodic table can be used to determine the electron configuration of valence electrons. For example, an element in Group VA has a valence electron configuration of s^2p^3 ($2 + 3 = 5$ valence electrons).

PERIODIC PROPERTIES OF THE ELEMENTS

The properties of the elements exhibit certain trends that can be explained in terms of the electron configuration of the element. All elements seek to gain or lose valence electrons so as to achieve the stable, fully–filled formations possessed by the **inert** or **noble gases** of Group VIIIA. Two other important trends exist within the periodic table. First, from left to right across a period, protons

are added one at a time and the electrons of the outermost shell experience an increasing degree of nuclear attraction, becoming closer and more tightly bound to the nucleus. This net positive charge from the nucleus, as felt by an electron, is called the **effective nuclear charge** (Z_{eff}). Second, from top to bottom down a given column, the outermost electrons become less tightly bound to the nucleus. This is because the number of filled principal energy levels (which shield the outermost electrons from attraction by the nucleus) increases downward within each group. Taken together, these trends show that Z_{eff} is at a maximum for elements in the top-right of the table and at a minimum for those in the bottom-left and help explain elemental properties such as atomic radius, ionization potential, electron affinity, and electronegativity.

Atomic Radii

The atomic radius of an element is equal to one-half the distance between the centers of two atoms of that element that are just barely touching each other. In general, the atomic radius decreases across a period from left to right and increases down a given group; the atoms with the largest atomic radii will be located at the bottom of groups and toward the left of the table (Group IA).

As discussed in Chapter 24, Atomic and Molecular Structure, the electron cloud occupies the majority of the volume of an atom, whereas the nucleus takes up relatively little space. Therefore, something that affects the size of the electron cloud will change the radius of an atom, but altering the size of the nucleus will not directly affect the size of the atom.

From left to right across a period, electrons are added one at a time to the outer energy shell. Electrons within the same shell do not shield one another from the attractive pull of protons. Therefore, since the number of protons is also increasing from left to right across a period, the effective nuclear charge (Z_{eff}) increases as well. The greater the positive charge experienced by the valence electrons (the larger the Z_{eff}), the closer those electrons are pulled toward the nucleus and the smaller the atomic radius.

From top to bottom down a group, the number of electrons and filled electron shells increase. Although the number of valence electrons within a group remains the same, these valence electrons will be found farther from the nucleus as they are in progressively larger energy shells. Z_{eff} will become smaller with distance, so valence electrons in higher energy shells will feel less pull from the nucleus. Also, with more electrons comes increased repulsion from the additional negative (−) charges. Thus, the atomic radii will increase.

The **ionic radius** is the radius of a cation or an anion. The ionic radius will affect the physical and chemical properties of an ionic compound. In most situations, cations (positive ions) will be smaller than corresponding neutral atoms since possessing fewer electrons leads to less repulsion among the remaining electrons. Likewise, most anions (negative ions) will be larger than corresponding neutral atoms because having a greater number of electrons causes more repulsion, resulting in a greater distance between electrons and a larger atomic radius.

Ionization Energy

The ionization energy (IE) is the energy required to completely remove an electron from a gaseous atom or ion. Removing an electron from an atom always requires an input of energy and is endothermic. The closer and more tightly bound an electron is to the nucleus, the more difficult it will be to remove and the higher the ionization energy. The **first ionization energy** is the energy required to remove one valence electron from the parent atom, the **second ionization energy** is the energy needed to remove a second valence electron from the univalent ion to form the divalent ion, and so on. Successive

ionization energies often grow increasingly larger; i.e., the second ionization energy is usually greater than the first ionization energy. However, if the removal of a second electron from an element would give it a fully–filled or half–filled valence shell, then the second ionization energy would be lower than the first since atoms are more stable when the valence shell is fully or half–filled.

For example:

$$Mg(g) \quad \rightarrow \quad Mg^+(g) \quad + e^- \quad \text{First Ionization Energy} \quad = 7.646 \text{ eV}$$
$$Mg^+(g) \quad \rightarrow \quad Mg^{2+}(g) \quad + e^- \quad \text{Second Ionization Energy} = 15.035 \text{ eV}$$

Ionization energy increases from left to right across a period as Z_{eff} increases. Moving down a group, the ionization energy decreases as Z_{eff} decreases. Group IA elements have low ionization energies because the loss of an electron results in the formation of a stable, noble-gas configuration.

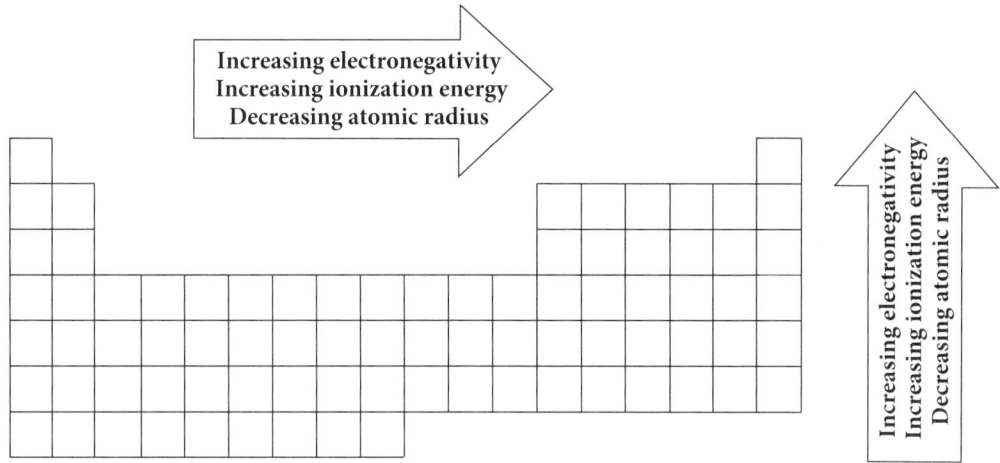

Figure 25.1

Electron Affinity

Electron affinity (EA) is the energy change that occurs when an electron is added to a gaseous atom, and it represents the ease with which the atom can accept an electron. The higher the Z_{eff}, the greater the electron affinity will be. In discussing electron affinities, two sign conventions may be used. The more common one states that a positive electron affinity value represents energy release when an electron is added to an atom; the other states that a negative electron affinity represents a release of energy. On Test Day, the first convention is more commonly used, but always read question stems carefully to determin-e if the less common convention is being used.

Electron affinity can be best represented by the following equation, where X is an atom of a given element in the gaseous state (*g*):

$$X(g) + e^- \rightarrow X^-(g)$$

Generalizations can be made about the electron affinities of particular groups in the periodic table. For example, the Group IIA elements, or **alkaline earth metals**, have low electron affinity values. These elements are relatively stable because their *s* subshell is filled. Group VIIA elements, or **halogens**, have high electron affinities because the addition of an electron to the atom results in a completely filled shell,

which represents a stable electron configuration. Achieving the stable octet involves a release of energy, and the strong attraction of the nucleus for the electron leads to a high change in energy. The Group VIIIA elements (**noble gases**) have electron affinities on the order of zero because they already possess full shells and cannot readily accept electrons. Elements of other groups generally have low values of electron affinity.

Electronegativity

Electronegativity is a measure of the attraction an atom has for electrons in a chemical bond. The greater an atom's electronegativity, the greater its attraction for bonding electrons. Electronegativity values are not determined directly. The most common electronegativity scale is the **Pauling electronegativity scale** where the values range from 0.7 for the most electropositive elements, like cesium, to 4.0 for the most electronegative element, fluorine. Electronegativities are related to effective nuclear charge: elements with low Z_{eff} will have low electronegativities because their nuclei do not attract electrons strongly, while elements with high Z_{eff} will have high electronegativities because of the strong pull the nucleus has on electrons. Therefore, electronegativity increases from left to right across periods and decreases from top to bottom down a group.

TYPES OF ELEMENTS

The elements of the periodic table may be classified into three categories: **metals**, located on the left side and in the middle of the periodic table; **nonmetals**, located on the right side of the table; and **metalloids** (**semimetals**), found along a diagonal line between the metals and nonmetals.

Metals

Metals are shiny solids (except for mercury) at room temperature and generally have high melting points and densities. Metals have the characteristic ability to be deformed without breaking. The ability of a metal to be hammered into shapes is called **malleability**, and the ability to be drawn into wires is called **ductility**. Many of the characteristic properties of metals, such as large atomic radius, low ionization energy, and low electronegativity, are due to the fact that the few electrons in the valence shell of a metal atom can easily be removed. Because the valence electrons can move freely, metals are good conductors of heat and electricity. Groups IA and IIA represent the most reactive metals and will be discussed below. The transition elements, also discussed later, are metals that have partially filled d orbitals.

Nonmetals

Nonmetals are generally brittle in the solid state and show little or no metallic luster. They have high ionization energies and electronegativities and are usually poor conductors of heat and electricity. Most nonmetals share the ability to gain electrons easily but otherwise display a wide range of chemical behaviors and reactivities. The nonmetals are located on the upper right side of the periodic table and are separated from the metals by a line cutting diagonally through the region of the periodic table containing elements with partially filled p orbitals.

Metalloids

The metalloids or semimetals are found along the line between the metals and nonmetals in the periodic table, and their properties vary considerably. Their densities, boiling points, and melting points fluctuate widely. The electronegativities and ionization energies of metalloids lie between those of metals and nonmetals; therefore, these elements possess characteristics of both those classes.

For example, silicon (Si) has a metallic luster, yet it is brittle and is not an efficient conductor. The reactivity of metalloids is dependent upon the element with which they are reacting. For example, boron (B) behaves as a nonmetal when reacting with sodium (Na) and as a metal when reacting with fluorine (F). The elements classified as metalloids are boron (B), silicon (Si), germanium (Ge), arsenic (As), antimony (Sb), and tellurium (Te).

Group →	1	2	3	4	5	6	7	8	9	10	11	12	13	14	15	16	17	18
Period																		
1	1 H											Metalloids			Nonmetals			2 He
2	3 Li	4 Be											5 B	6 C	7 N	8 O	9 F	10 Ne
3	11 Na	12 Mg			Metals								13 Al	14 Si	15 P	16 S	17 Cl	18 Ar
4	19 K	20 Ca	21 Sc	22 Ti	23 V	24 Cr	25 Mn	26 Fe	27 Co	28 Ni	29 Cu	30 Zn	31 Ga	32 Ge	33 As	34 Se	35 Br	36 Kr
5	37 Rb	38 Sr	39 Y	40 Zr	41 Nb	42 Mo	43 Tc	44 Ru	45 Rh	46 Pd	47 Ag	48 Cd	49 In	50 Sn	51 Sb	52 Te	53 I	54 Xe
6	55 Cs	56 Ba		72 Hf	73 Ta	74 W	75 Re	76 Os	77 Ir	78 Pt	79 Au	80 Hg	81 Tl	82 Pb	83 Bi	84 Po	85 At	86 Rn
7	87 Fr	88 Ra		104 Rf	105 Db	106 Sg	107 Bh	108 Hs	109 Mt	110 Ds	111 Rg	112 Cn	113 Nh	114 Fl	115 Mc	116 Lv	117 Ts	118 Og

Lanthanides	57 La	58 Ce	59 Pr	60 Nd	61 Pm	62 Sm	63 Eu	64 Gd	65 Tb	66 Dy	67 Ho	68 Er	69 Tm	70 Yb	71 Lu
Actinides	89 Ac	90 Th	91 Pa	92 U	93 Np	94 Pu	95 Am	96 Cm	97 Bk	98 Cf	99 Es	100 Fm	101 Md	102 No	103 Lr

Figure 25.2

IONS

Ionic solutions are of particular interest to chemists because certain important types of chemical interactions occur in them. For instance, acid-base reactions and oxidation-reduction reactions occur in ionic solutions. Ions and their properties in solution will be introduced here; the chemical reactions mentioned are discussed in detail in Chapter 29, Reaction Types, and Chapter 36, Acids and Bases.

Cations and Anions

Ionic compounds are made up of cations and anions, where a cation is a positive ion and an anion is a negative ion. The nomenclature of ionic compounds is based on the names of the component ions.

- For elements that can form more than one positive ion (usually transition metals), the charge is indicated by a Roman numeral in parentheses following the name of the element.

Fe^{2+} Iron (II) Cu^+ Copper (I)

Fe^{3+} Iron (III) Cu^{2+} Copper (II)

- An older, but still commonly used, method is to add the ending *-ous* or *-ic* to the root of the Latin name of the element to represent the ions with lesser or greater charge, respectively.

 Fe^{2+} Ferrous Cu^+ Cuprous
 Fe^{3+} Ferric Cu^{2+} Cupric

- Monatomic anions are named by dropping the ending of the elemental name and adding *-ide*.

 H^- Hydride S^{2-} Sulfide
 F^- Fluoride N^{3-} Nitride
 O^{2-} Oxide P^{3-} Phosphide

- Many polyatomic anions contain oxygen and are therefore called **oxyanions**. When an element forms two oxyanions, the name of the one with less oxygen ends in *-ite* and the one with more oxygen ends in *-ate*.

 NO_2^- Nitrite SO_3^{2-} Sulfite
 NO_3^- Nitrate SO_4^{2-} Sulfate

- When the series of oxyanions contains four oxyanions, prefixes are also used. *Hypo-* and *per-* are used to indicate less oxygen and more oxygen, respectively.

 ClO^- Hypochlorite
 ClO_2^- Chlorite
 ClO_3^- Chlorate
 ClO_4^- Perchlorate

- Polyatomic anions often gain one or more H^+ ions to form anions of lower charge. The resulting ions are named by adding the word hydrogen or dihydrogen to the front of the anion's name. An older method uses the prefix *bi-* to indicate the addition of a single hydrogen ion.

 HCO_3^- Hydrogen carbonate or bicarbonate

 HSO_4^- Hydrogen sulfate or bisulfate

 $H_2PO_4^-$ Dihydrogen phosphate

Ion Charges

Metals, which are found in the left part of the periodic table, generally form positive ions, whereas nonmetals, which are found in the right part of the periodic table, generally form negative ions. Note, however, that anions that contain metallic elements do exist; e.g., MnO_4^- (permanganate) and CrO_4^{2-} (chromate). All elements in a given group tend to form monatomic ions with the same charge. Thus, the alkali metals (Group IA) usually form cations with a single positive charge, the alkaline earth metals (Group IIA) form cations with a double positive charge, and the halogens (Group VIIA) form anions (halides) with a single negative charge. Though other main group elements follow this trend, the intermediate electronegativity of such elements (which makes them less likely to form ionic compounds) and the transition from metallic to nonmetallic character further complicates the picture.

THE CHEMISTRY OF GROUPS

Hydrogen

There is no suitable place for hydrogen in the periodic table. Hydrogen does resemble alkali metals because it has a single s valence electron and forms the H^+ ion, which is hydrated in solution. However, it can also form the hydride ion (H^-), which is far too reactive to exist in water. In this respect, hydrogen resembles the halogens in that it only requires one additional electron to reach the next noble gas configuration.

Alkali Metals

The alkali metals are the elements of **Group IA**. They possess most of the physical properties common to metals, yet their densities are lower than those of other metals. The alkali metals have only one loosely bound electron in their outermost shell, giving them the largest atomic radii of all the elements in their respective periods. Their metallic properties and high reactivity are due to their low ionization energies; they easily lose their valence electron to form univalent cations, allowing them to easily form +1 cations. Alkali metals have low electronegativities and react very readily with nonmetals, especially halogens.

Alkaline Earth Metals

The alkaline earth metals are the elements of **Group IIA** and also possess many characteristically metallic properties. Like the alkali metals, these properties are dependent on the ease with which they lose electrons. The alkaline earth metals have two electrons in their outer shell and have smaller atomic radii than the alkali metals. However, the two valence electrons are not held very tightly by the nucleus, so they can be removed to form divalent cations. Therefore, alkaline earth metals commonly form +2 cations. Alkaline earths have low electronegativities and positive electron affinities.

Carbon Group

The family containing carbon, **Group IVA**, exhibits a wide range of characteristics and includes a nonmetal (C), metalloids (Si and Ge), and metals (Sn and Pb). Although these elements do not share many physical properties, they do all have 2 electrons in their outermost p subshells, leading to a configuration that is distant from that of a noble gas. This explains why carbon tends not to form ions (which would need to be +4 or −4 to reach noble gas configuration) but rather participates in electron sharing; it usually is most stable with four covalent bonds (discussed further in Chapter 26, Chemical Bonding).

Pnictogens

Nitrogen and the elements below it in **Group VA** also display a wide variety of properties and include a mixture of nonmetals (N and P), metalloids (As and Sb), and a metal (Bi). Similar to carbon, nitrogen often forms covalent bonds but most commonly forms three per atom instead of carbon's four. Nitrogen also commonly holds a positive charge in organic reactions, making several nitrogen-containing compounds good bases.

Chalcogens

Group VIA, which contains oxygen, is characterized by elements requiring two additional valence electrons to complete their outermost shells. These elements therefore tend to be fairly electronegative and to form −2 anions, but they can also participate in covalent bonds, preferring to have two shared electron pairs and two nonbonded pairs.

Halogens

The halogens, **Group VIIA**, are highly reactive nonmetals with one valence electron less than the closest noble gas. Halogens therefore commonly form -1 anions. Halogens are otherwise highly variable in their physical properties. For instance, the halogens range from gaseous (F_2 and Cl_2) to liquid (Br_2) to solid (I_2) at room temperature. Their chemical properties are more uniform: The electronegativities of halogens are very high, and they are particularly reactive toward alkali metals and alkaline earths, which "want" to donate electrons to the halogens to form stable ionic crystals. Fluorine (F) has the highest electronegativity of all the elements.

Noble Gases

The noble gases, also called the **inert gases**, are found in **Group VIIIA** (also called Group 0). For the purposes of the test, they are completely nonreactive because they each have a complete valence shell, which is an energetically favored arrangement. This gives them no tendency to gain or lose electrons, high ionization energies, and no electronegativities. They possess low boiling points and are gases at room temperature.

Transition Elements

The transition elements, **Groups IB to VIIIB**, are all considered metals; hence, they are also called the **transition metals**. These elements are very hard and have high melting points and boiling points. From left to right across a period, the five d orbitals become progressively more filled. The d electrons are held only loosely by the nucleus and are relatively mobile, contributing to the malleability and high electrical conductivity of these elements. Chemically, transition elements have low ionization energies and may exist in a variety of positively charged forms or **oxidation states**. This is because transition elements are capable of losing various numbers of electrons from the s and d orbitals of their valence shells. Theoretically, the transition metals in Group VIIIB could have eight different oxidation states, from $+1$ to $+8$; however, they typically do not exhibit so many. For instance, copper (Cu), in Group IB, can exist in either the $+1$ or the $+2$ oxidation state, and manganese (Mn), in Group VIIB, occurs in the $+2, +3, +4, +6,$ or $+7$ state. Because of this ability to attain positive oxidation states, transition metals form many different ionic and partially ionic compounds. The dissolved ions can form **complex ions** either with molecules of water (**hydration complexes**) or with nonmetals, forming highly colored solutions and compounds (e.g., $CuSO_4 \bullet 5H_2O$, chalcanthite). This complexation may also enhance the relatively low solubility of certain compounds (e.g., AgCl is insoluble in water but quite soluble in aqueous ammonia due to the formation of the complex ion $[Ag(NH_3)_2]^+$). The formation of complexes causes the d orbitals to be split into two energy sublevels. This enables many of the complexes to absorb certain frequencies of light—those containing the precise amount of energy required to raise electrons from the lower to the higher d sublevel. The frequencies not absorbed—known as the **subtraction frequencies**—give the complexes their characteristic colors.

REVIEW PROBLEMS

1. Elements in a given period have the same

 A. atomic weight.
 B. maximum azimuthal quantum number.
 C. maximum principal quantum number.
 D. valence electron structure.
 E. ionic radius.

2. Arrange the following species in terms of increasing atomic (or ionic) radius: Sr, P, Mg, Mg^{2+}.

3. The Ca^{2+} species is electronically similar to the elements in

 A. Group IIA.
 B. Group IA.
 C. Group IVB.
 D. Group 0.
 E. Group IIIB.

4. What is the electron configuration for the outermost electrons of elements found in Group IVB?

 A. $s^2 p^6 d^4$
 B. $s^2 d^2$
 C. $s^2 d^4$
 D. $s^2 p^4$
 E. $s^2 p^2$

5. Which of the following elements has the lowest electronegativity?

 A. Cesium
 B. Strontium
 C. Calcium
 D. Barium
 E. Potassium

6. Arrange the following calcium species in terms of increasing size: Ca, Ca^+, Ca^{2+}, Ca^{3+}, Ca^-, Ca^{2-}.

7. The order of the elements in the periodic table is based on the

 A. number of neutrons.
 B. radius of the atom.
 C. atomic number.
 D. atomic weight.
 E. number of electrons.

8. The elements within each column of the periodic table
 A. have similar valence electron configurations.
 B. have similar atomic radii.
 C. have the same principal quantum number.
 D. will react to form stable elements.
 E. have the same electronegativity.

9. Discuss the properties of nonmetals and give four examples of nonmetallic elements.

10. Arrange the following elements in terms of increasing first ionization energy: Ga, Ba, Ru, F, N.

11. Explain why the Group 0 elements are so unreactive.

12. Arrange the following elements in terms of decreasing electronegativity: Ca, Cl, Fr, P, Zn.

13. Which group contains an element with an electron configuration of $1s^2\ 2s^2\ 2p^6\ 3s^2\ 3p^6\ 4s^2\ 3d^{10}\ 4p^6\ 4d^5\ 5s^2$?
 A. VA
 B. VIIA
 C. VB
 D. VIIB
 E. VIA

14. Discuss the trends in the atomic radii of different elements. How does the atomic number affect the atomic radius of an element?

15. Which element has the greatest electronegativity?
 A. Chlorine
 B. Oxygen
 C. Sulfur
 D. Fluorine
 E. Phosphorus

16. The change in energy that occurs when an electron is added to an atom is known as the
 A. electronegativity.
 B. metallic character.
 C. electron affinity.
 D. ionization energy.
 E. atomic radius.

17. Discuss the properties of metalloids and give three examples of elements exhibiting metalloid behavior.

18. Which of the following elements is most electronegative?

 A. S
 B. Cl
 C. Na
 D. Mg
 E. P

19. Transition metal compounds generally exhibit bright colors because the

 A. electrons in the partially filled *d* orbitals are easily promoted to excited states.
 B. metals become complexed in water.
 C. metals conduct electricity, producing colored light.
 D. electrons in the *d* orbitals emit energy as they relax.
 E. compounds are highly reactive and produce colors when they react.

20. Discuss the properties of metals and give four examples of metallic elements.

21. Identify the following elements as metal, nonmetal, or semimetal.

 A. Fr
 B. Pd
 C. I
 D. B
 E. Sc
 F. Si
 G. S

SOLUTIONS TO REVIEW PROBLEMS

1. **C** Discussed in the introduction to this chapter.

2. $$\mathbf{Mg^{2+} < P < Mg < Sr}$$

 The trends in atomic radii are as follows. Going from left to right across a period, the atomic radii decrease because the atomic number increases. The increasing number of protons in the nucleus will have a stronger attraction for the outermost electrons, causing them to be held closer and more tightly to the nucleus. Going down a group, the atomic radius will increase because more filled principal energy levels separate the nucleus and the outermost electrons, shielding the attractive force between them. P has a small radius because it lies far to the right and high in a group. The magnesium species will have smaller radii than the strontium species because they are higher in Group IIA. Finally, positive ions have smaller atomic radii than the corresponding neutral molecules because the loss of electrons leads to a decrease in electron-electron repulsion within the atom, which in turn allows the electrons to move in closer to the nucleus. Therefore, Mg^{2+} will be smaller than Mg. Mg^{2+} has a smaller radius than P because Mg^{2+} has no electrons in orbitals of the third principal energy level.

3. **D** The Ca^{2+} ion is electronically similar to atoms in Group 0 because its outermost valence shell is a complete octet. It is isoelectronic to argon.

4. **B** The electron configuration of the different groups can be written as long as a few basic rules are applied. First, the Roman numeral represents the number of electrons that will lie outside of the noble gas core configuration. Second, the letters A and B tell whether the atom is a representative or a nonrepresentative element. Representative elements will successively fill the s and p orbitals, while the nonrepresentative elements will successively fill the s, d, and maybe f orbitals. Elements in Group IVB are nonrepresentative elements and will have four electrons outside their respective rare gas cores. The correct standard electron configuration for Group IVB elements is thus $s^2 d^2$.

 Using G to represent any noble gas, the full electron configuration of a nonspecified group IVB element can be abbreviated as $[G](n-1)d^2 ns^2$, where n is the principal quantum number.

5. **A** The least electronegative elements are located at the bottom left of the periodic table. Cesium has the lowest ionization energy, so it is the least electronegative. Note that francium (Fr) would be lower still, but it is not a stable, naturally occurring element.

6. $$\mathbf{Ca^{3+}, Ca^{2+}, Ca^{+}, Ca, Ca^{-}, Ca^{2-}}$$

 Positive ions will have smaller radii than the corresponding neutral atoms, and, the greater the positive charge, the smaller the ionic radius. Negative ions will have larger radii than the corresponding neutral atoms, and the greater the negative charge, the larger the ionic radius (see answer to Question 2, above).

7. **C** Discussed in the introduction to this chapter.

8. **A** Discussed in the introduction to this chapter.



9. Nonmetals are brittle, lusterless elements possessing high ionization energies and high electronegativities. They tend to gain electrons to form negative ions. They are poor conductors of heat and electricity. The nonmetals are located on the upper right side of the periodic table.

10. **Ba < Ru < Ga < N < F**

Two common trends should be remembered when ordering atoms according to their ionization energies. First, the ionization energy increases toward the right across a period because the elements are less willing to give up an electron as the attractive pull (Z_{eff}) of the nucleus increases. Second, the ionization energy decreases down a group because the distance separating the valence electrons from the nucleus increases. Therefore, to order the elements according to their first ionization energy, it is necessary to go from the bottom left of the periodic table, where the lowest values are, across to the top right of the periodic table, where the highest values are.

11. Group 0 elements are also known as the noble, rare, or inert gases. They are very unreactive because their outermost shells contain complete, stable formations. There is no reason for these elements to attempt to gain or lose electrons to other atoms because they are electronically stable on their own.

12. **Cl > P > Zn > Ca > Fr**

The two trends to remember with electronegativity are that it increases across a period and decreases down a group. Therefore, chlorine, which is farthest to the top and right, will have the highest value. Francium lies farthest to the left and bottom, so it will have the lowest electronegativity.

13. **D** This element has seven electrons in its outermost shell, so its Roman numeral designation is VII; because the *d* orbital is being filled, it is a nonrepresentative, or B, element. Thus, it is found in Group VIIB.

14. There are two major trends concerning the atomic radii of elements. The first of these is that the atomic radius decreases across a period. This can be explained by the fact that the atomic number (i.e., the number of protons within the nucleus) increases. Thus, the electrostatic force between the valence electrons and the nucleus increases, and the outermost electrons will be pulled closer to the nucleus, making the atom smaller. The second trend concerning atomic radii is that the atomic radius increases down a group. This can be explained by the fact that with every subsequent element down a group, a filled principal energy level has been added. This increases the distance between the nucleus and the valence electrons because orbital size increases with increasing principal quantum number.

15. **D** The most electronegative elements are located at the top right of the periodic table.

16. **C** Discussed in the section on periodic properties in this chapter.

17. Metalloids are elements that possess characteristics of both metals and nonmetals. Their electronic characteristics, such as ionization energies and electronegativities, lie between those of the metals and nonmetals. When undergoing reactions, the metalloids may act as either

metals or nonmetals, depending upon the species with which they are reacting. The elements classified as metalloids are boron, silicon, germanium, arsenic, antimony, and tellurium.

18. **B** Chlorine has the greatest electronegativity because, out of all the choices, it lies farthest to the right and top of the periodic table. Chlorine has a great attraction for electrons in a chemical bond because it needs only one more electron to complete a stable octet formation. Therefore, it has a high electronegativity.

19. **A** The closely spaced *d* orbitals allow for relatively low energy transitions; these transitions often occur in the visible region of the electromagnetic spectrum, as do other electronic transitions from the transition metal *d* subshell to other nearby, empty subshells.

20. Metals are shiny, lustrous solids that have high melting points and densities. The ease with which metals lose electrons contributes to their high thermal and electrical conductivities, their malleability and ductility, and the ease with which they form compounds with reactive nonmetals. All of the elements on the left side of the periodic table (except H) and all of the transition elements are metals.

21. **A** Fr: metal

 B Pd: metal

 C I: nonmetal

 D B: semimetal

 E Sc: metal

 F Si: semimetal

 G S: nonmetal

CHAPTER TWENTY-SIX

Chemical Bonding

LEARNING OBJECTIVES

After this chapter, you will be able to:

- Explain the different types of chemical bonds
- Calculate the formal charge of Lewis dot structures
- Compare and contrast the molecular and electronic geometry of a molecule
- Contrast the different intermolecular forces

The atoms of many elements can combine to form **molecules**. The atoms in most molecules are held together by attractive forces called **chemical bonds**. These bonds are formed via the interaction of the valence electrons of the combining atoms. Strong chemical bonds known as **intramolecular bonds** hold atoms together as molecules and include ionic and covalent bonds. The chemical and physical properties of the resulting molecules are often very different from those of their constituent elements. In addition to the very strong forces within a molecule, there are weaker **intermolecular forces** between molecules. Intermolecular forces, although weaker than the intramolecular chemical bonds, are of considerable importance in understanding the physical properties of many substances.

BONDING

Many molecules contain atoms bonded according to the **octet rule**, which states that an atom tends to bond with other atoms until it has eight electrons in its outermost shell, thereby forming a stable electron configuration similar to that of the noble gas neon. Exceptions to this rule are as follows: hydrogen (H) and helium (He), which can have only two valence electrons; lithium (Li) and beryllium (Be), which bond to attain two and four valence electrons, respectively; boron (B), which bonds to attain six; and elements beyond the second row, such as phosphorus (P) and sulfur (S), which can expand their octets to include more than eight electrons by incorporating d orbitals.

When classifying strong chemical bonds, it is helpful to introduce two distinct types: ionic bonds and covalent bonds. In **ionic bonding**, one or more electrons from an atom with a smaller ionization energy are transferred to an atom with a greater electron affinity, and the resulting ions are held together by electrostatic forces. In **covalent bonding**, an electron pair is shared between two atoms. In many cases, the bond is partially covalent and partially ionic; we call such bonds **polar covalent bonds**.

IONIC BONDS

When two atoms with large differences in electronegativity react, there is a complete transfer of electrons from the less electronegative atom to the more electronegative atom. The atom that

loses electrons becomes a positively charged ion, or **cation**, and the atom that gains electrons becomes a negatively charged ion, or **anion**. For this transfer to occur, the difference in electronegativity must be greater than 1.7 on the Pauling scale (see Chapter 25). In general, the elements of Groups IA and IIA (low electronegativities) bond ionically to elements of Group VIIA (high electronegativities). Elements of Groups IA and IIA give up their electrons to achieve a noble gas configuration, while Group VIIA elements gain an electron to achieve a noble gas configuration. For example, Na^+ $Cl \rightarrow Na^+Cl^-$ (sodium chloride). The electrostatic force of attraction between the charged ions is called an **ionic bond**.

Ionic compounds have characteristic physical properties. They form crystal lattices consisting of arrays of positive and negative ions in which the attractive forces between ions of opposite charge are maximized, while the repulsive forces between ions of like charge are minimized. They therefore have high melting and boiling points due to the strong electrostatic forces between the ions. They also can conduct electricity in the liquid and aqueous states, though not in the solid state.

COVALENT BONDS

When two or more atoms with similar electronegativities interact, the energy required to form ions is greater than the energy that would be released upon the formation of an ionic bond (i.e., the process is not energetically favorable). Since a complete transfer of electrons cannot occur, such atoms achieve a noble gas electron configuration by **sharing** electrons in a covalent bond. The binding force between the two atoms results from the attraction that each electron of the shared pair has for the two positive nuclei.

Covalent compounds generally contain discrete molecular units with weak intermolecular forces. Consequently, they have low melting points and do not conduct electricity in the liquid or aqueous states.

Properties of Covalent Bonds

Atoms can share more than one pair of electrons. Two atoms sharing one, two, or three electron pairs are said to be joined by a **single**, **double**, or **triple covalent bond**, respectively. The number of shared electron pairs between two atoms is called the **bond order**; hence, a single bond has a bond order of one, a double bond has a bond order of two, and a triple bond has a bond order of three.

Two key features characterize covalent bonds: bond length and bond energy.

Bond length

Bond length is the average distance between the two nuclei of the atoms involved in the bond. As the number of shared electron pairs increases, the two atoms are pulled closer together, leading to a decrease in bond length. Thus, for a given pair of atoms, a triple bond is shorter than a double bond, which is shorter than a single bond.

Bond energy

Bond energy is the energy required to separate two bonded atoms. For a given pair of atoms, the strength of a bond (and therefore the bond energy) increases as the number of shared electron pairs increases.

Covalent Bond Notation

The shared valence electrons of a covalent bond are called the **bonding electrons**. The valence electrons not involved in the covalent bond are called **nonbonding electrons**. These unshared electron pairs can also be called **lone electron pairs**. A convenient notation, called a **Lewis structure**, is used to represent the bonding and nonbonding electrons in a molecule, facilitating chemical "bookkeeping." The number of valence electrons attributed to a particular atom in the Lewis structure of a molecule is not necessarily the same as the number would be in the isolated atom, and the difference accounts for what is referred to as the **formal charge** of that atom. Often, more than one Lewis structure can be drawn for a molecule; this phenomenon is called **resonance**. Lewis structures, formal charges, and resonance are discussed in detail below.

Lewis structures

When different atoms interact to form a bond, only their outermost regions come in contact. Hence, only the valence electrons are involved. One of the easiest ways to follow the valence electrons in a chemical reaction is with **Lewis dot symbols**. A Lewis dot symbol contains the symbol of an element and one "dot" for each valence electron in an atom. Magnesium, for example, belongs to Group IIA and has two valence electrons (:Mg). Note that, because the transitional metals, lanthanides, and actinides all have incompletely filled inner shells, Lewis dot symbols are not written for these elements.

·Li	Lithium		\ddot{N}	Nitrogen
·Be·	Beryllium		·\ddot{O}:	Oxygen
·\dot{B}·	Boron		·\ddot{F}:	Fluorine
·\dot{C}·	Carbon		:\ddot{Ne}·	Neon

Just as a Lewis symbol is used to represent the distribution of valence electrons in an atom, one can also be used to represent the distribution of valence electrons in a molecule. For example, the Lewis symbol of an F ion is : \ddot{F} :⁻; the Lewis structure of an F_2 molecule is :\ddot{F}——\ddot{F}:

Certain steps must be followed in assigning a Lewis structure to a molecule. These steps are outlined below, using hydrogen cyanide (HCN) as an example:

1. Count all the valence electrons of the atoms. The number of valence electrons of the molecule is the sum of the valence electrons of all atoms present:

> H has 1 valence electron;
> C has 4 valence electrons;
> N has 5 valence electrons; therefore,
> HCN has a total of 10 valence electrons.

2. Write the skeletal structure of the compound (i.e., the arrangement of atoms). In general, the least electronegative atom is the central atom. Hydrogen (always) and the halogens F, Cl, Br, and I (usually)

GC

occupy the end positions. Draw single bonds between the central atom and the atoms surrounding it, placing an electron pair in each bond (bonding electron pair).

In HCN, H must occupy a terminal position. Of the remaining two atoms, C is the less electronegative and therefore occupies the central position. The skeletal structure is as follows:

$$H:C:N$$

Each bond has 2 electrons, so $10 - 4 = 6$ valence electrons remain.

3. Complete the octets (8 valence electrons) of all atoms bonded to the central atom, using the remaining valence electrons still to be assigned. (Recall that H is an exception to the octet rule since it can have only 2 valence electrons.) In this example H already has 2 valence electrons in its bond with C.

$$H:C:\ddot{N}:$$

4. Place any extra electrons on the central atom. If the central atom has less than an octet, try to write double or triple bonds between the central and surrounding atoms using the nonbonding, unshared lone electron pairs. The HCN structure above does not satisfy the octet rule for C because C possesses only 4 valence electrons. Therefore, 2 lone electron pairs from the N atom must be moved to form two more bonds with C, creating a triple bond between C and N.

$$H:C:::N:$$

5. Finally, bonds are drawn as lines rather than pairs of dots.

$$H - C \equiv N$$

Now, the octet rule is satisfied for all three atoms because C and N have 8 valence electrons and H has 2 valence electrons.

Formal charges

The number of electrons officially assigned to an atom in a Lewis structure does not always equal the number of valence electrons of the free atom. The difference between these two numbers is the **formal charge** of the atom. Formal charge has many uses in chemistry, including predicting which of several possible Lewis structures is the most likely. Specifically, the structure with the lowest formal charges tends to best represent the molecule. Formal charge can be calculated using the following formula:

$$\text{Formal charge} = V - \frac{1}{2}N_{\text{bonding}} - N_{\text{nonbonding}}$$

where V is the number of valence electrons in the free atom, N_{bonding} is the number of bonding electrons, and $N_{\text{nonbonding}}$ is the number of nonbonding electrons. Using a Lewis dot structure, where 2 bonding electrons are represented by a stick and each nonbonding electron is represented with a dot, the formal charge is also represented by:

$$\text{Formal charge} = V - (\# \text{ of sticks} + \# \text{ of dots})$$

The formal charge of an ion or molecule is equal to the sum of the formal charges of the individual atoms comprising it.

Example: Calculate the formal charge on the central N atom of $[NH_4]^+$.

Solution: The Lewis structure of $[NH_4]^+$ is

$$\left[\begin{array}{c} H \\ | \\ H-N-H \\ | \\ H \end{array}\right]^+$$

Nitrogen is in Group VA; thus, it has 5 valence electrons. In $[NH_4]^+$, N has 4 bonds (i.e., 8 bonding electrons and no nonbonding electrons).

So $V = 5$; $N_{bonding} = 8$; $N_{nonbonding} = 0$

$$\text{Formal charge} = 5 - \frac{1}{2}(8) - 0 = +1$$

Likewise, there are 4 "sticks" and 0 "dots" in the Lewis structure, so formal charge (FC) could be calculated like this too:

$$\text{FC} = V - (\text{\# of sticks} + \text{\# of dots})$$
$$\text{FC} = 5 - (4 + 0) = 1$$

Thus, the formal charge on the N atom in $[NH_4]^+$ is +1.

Resonance

For some molecules, two or more non-identical Lewis structures can be drawn; these arrangements are called **resonance structures**. A resonance structure is one of two or more Lewis structures for a single molecule unable to be described fully with only one Lewis structure. The molecule doesn't actually exist as either one of the resonance structures but is rather a composite, or hybrid, of the two.

For example, SO_2 has three resonance structures, two of which are minor: O=S–O and O–S=O. The actual molecule is a hybrid of these three structures (spectral data indicate that the two S–O bonds are identical). This phenomenon is known as resonance, and the actual structure of the molecule is called the **resonance hybrid**. Resonance structures are expressed with a double-headed arrow between them:

$$\ddot{O}=\ddot{S}=\ddot{O} \longleftrightarrow \ddot{O}=\overset{+}{\ddot{S}}-\overset{-}{\ddot{O}:} \longleftrightarrow :\overset{-}{\ddot{O}}-\overset{+}{\ddot{S}}=\ddot{O}$$

The last two resonance structures of sulfur dioxide (shown above) have equivalent energy or stability. Often, nonequivalent resonance structures may be written for a molecule. In these cases, the more stable the structure, the more that structure contributes to the character of the resonance hybrid. Conversely, the less stable the resonance structure, the less that structure contributes to the resonance hybrid. The structure on the left of the diagram is the most stable. In this case, the most stable structure has no formal charge on any of the component atoms. Sulfur has more than 8 valence electrons (10 in this case), but that is acceptable because sulfur has a d subshell that can serve to expand the octet. More exceptions to the octet rule are discussed below.

Formal charges are often useful for qualitatively assessing the stability of a particular resonance structure, and the following guidelines should be used:

- A Lewis structure with small or no formal charges is preferred over a Lewis structure with large formal charges.
- A Lewis structure in which negative formal charges are placed on more electronegative atoms is more stable than one in which the negative formal charges are placed on less electronegative atoms.

Example: Write the resonance structures for the cyanate anion (which contains one nitrogen atom, one oxygen atom, one carbon atom, and an overall charge of negative one).

Solution: First, tally the total number of valence electrons:

N has 5 valence electrons;

C has 4 valence electrons;

O has 6 valence electrons; and the species itself has one negative charge (meaning one additional electron).

Total valence electrons $= 5 + 4 + 6 + 1 = 16$

C is the least electronegative of the three given atoms, N, C, and O. Therefore, the C atom occupies the central position in the skeletal structure of $[NCO]^-$. Draw single bonds between the central C atom and the surrounding atoms, N and O, and place a pair of electrons in each bond.

$$N:C:O$$

Complete the octets of N and O with the remaining $(16 - 4) = 12$ electrons.

$$:\ddot{\ddot{N}}:C:\ddot{\ddot{O}}:$$

The C octet is incomplete. There are three ways in which double and triple bonds can be formed to complete the C octet. Two lone pairs from the O atom can be used to form a triple bond between the C and O atoms:

$$:\ddot{N}-C\equiv O:$$

Or one lone electron pair can be taken from both the O and the N atoms to form two double bonds, one between N and C and the other between O and C:

$$:\ddot{N}=C=\ddot{O}:$$

Or two lone electron pairs can be taken from the N atom to form a triple bond between the C and N atoms:

$$:N\equiv C-\ddot{\ddot{O}}:$$

These three are all resonance structures of $[NCO]^-$.

Assign formal charges to each atom of each resonance structure: In the first structure, the N has a formal charge of -2, and the O has a charge of $+1$. In the second structure, the N has a formal charge of -1, and in the third structure the O has a charge of -1.

The most stable structure is therefore:

$$:N{\equiv}C{-}\ddot{\underset{\cdot\cdot}{O}}:$$

since the negative formal charge is on the most electronegative atom, O.

Exceptions to the octet rule

Atoms found in or beyond the third period can have more than eight valence electrons, since some of the valence electrons may occupy d orbitals. These atoms can be assigned more than four bonds in Lewis structures.

The Lewis structure of the sulfate ion, SO_4^{2-}, for example, can be drawn in six resonance forms by alternating the placement of pi electrons. Giving the sulfur 12 valence electrons permits three of the five atoms to be assigned a formal charge of zero, which is most favorable energetically.

$$\left[\begin{array}{c} O^{-1} \\ | \\ O^{-1}{-}S^{2+}{-}O^{-1} \\ | \\ O^{-1} \end{array}\right]^{2-} \quad \left[\begin{array}{c} O^{-1} \\ | \\ O{=}S{=}O \\ | \\ O^{-1} \end{array}\right]^{2-}$$

Figure 26.1

Types of Covalent Bonding

The nature of a covalent bond depends on the relative electronegativities of the atoms sharing the electron pairs. Covalent bonds are considered to be polar or nonpolar depending on the difference in electronegativities between the atoms.

Polar covalent bond

Polar covalent bonding occurs between atoms with small differences in electronegativity, generally in the range of 0.4 to 1.7 Pauling units. The bonding electron pair is not shared equally but is pulled more toward the element with the higher electronegativity. As a result, the more electronegative atom acquires a partial negative charge, δ-, and the less electronegative atom acquires a partial positive charge, δ+, giving the molecule a partially ionic character. For instance, the covalent bond in HCl is polar because the two atoms have a small difference in electronegativity (approx. 0.9). Chlorine, the more electronegative atom, attains a partial negative charge, and hydrogen attains a partial positive charge. This difference in charge between the atoms is indicated by an arrow crossed (like a plus sign) at the positive end and pointing to the negative end, as shown below.

Figure 26.2

A molecule that has such a separation of positive and negative charges is called a **polar molecule**. The **dipole moment** is a measure of the polarity of a molecule. It is a vector quantity μ, measured in **Debye** units (coulomb-meters) and defined as the product of the charge magnitude (q) and the distance between the two partial charges (r):

$$\mu = qr$$

Nonpolar covalent bond

Nonpolar covalent bonding occurs between atoms that have the same electronegativities. The bonding electron pair is shared equally such that there is no separation of charge across the bond. Nonpolar covalent bonds occur in diatomic molecules such as H_2, Cl_2, O_2, and N_2.

Coordinate covalent bond

In a coordinate covalent bond, the shared electron pair comes from the lone pair of one of the atoms in the molecule. Once such a bond forms, it is indistinguishable from any other covalent bond, so identifying such a bond is useful only in keeping track of the valence electrons and formal charges.

Coordinate bonds are typically found in Lewis acid-base compounds (see Chapter 36). A **Lewis acid** is a compound that can accept an electron pair to form a covalent bond; a **Lewis base** is a compound that can donate an electron pair to form a covalent bond. For example, in the reaction between boron trifluoride (BF_3) and ammonia (NH_3):

Figure 26.3

NH_3 donates a pair of electrons to form a coordinate covalent bond; thus, it acts as a Lewis base. BF_3 accepts this pair of electrons to form the coordinate covalent bond; thus, it acts as a Lewis acid.

Geometry and Polarity of Covalent Molecules

Molecular geometry

The **valence shell electron-pair repulsion (VSEPR)** theory uses Lewis structures to predict the molecular geometry of covalently bonded molecules. It states that the three-dimensional arrangement of atoms surrounding a central atom is determined by the repulsions between the bonding and the nonbonding electron pairs in the valence shell of the central atom. These electron pairs arrange themselves as far apart as possible, thereby minimizing repulsion.

The following steps are used to predict the geometric structure of a molecule using the VSEPR theory:

1. Draw the Lewis structure of the molecule.
2. Count the total number of bonding and nonbonding electron pairs in the valence shell of the central atom.
3. Arrange the electron pairs around the central atom so that they are as far apart from each other as possible.

4. Determine the bond angle, accounting for the additional repulsion due to nonbonding electrons, which pushes any bonding pairs slightly closer together.

For example, the compound AX_2 has the Lewis structure (X : A : X). A has two bonding electron pairs in its valence shell. To make these electron pairs as far apart as possible, their geometric structure should be linear:

$$X - A - X$$

Valence electron arrangements are summarized in the following table:

Electron Pairs	Nonbonding Pairs	Example	Geometric Arrangement	Shape	Angles
2	0	$BeCl_2$	X —— A —— X	Linear	180°
3	0	BH_3		Trigonal Planar	120°
4	0	CH_4		Tetrahedral	109.5°
4	1	NH_3		Trigonal Pyramidal	107°
4	2	H_2O		Bent	104.5°
5	0	PCl_5		Trigonal Bipyramidal	90°, 120°, 180°
6	0	SF_6		Octahedral	90°, 180°

Table 26.1

Example: Predict the geometry of NH_3.

Solution: The Lewis structure of NH_3 is:

$$H-\underset{\cdot\cdot}{N}-H$$

The central atom, N, has three bonding electron pairs and one nonbonding electron pair for a total of four electron pairs.

The four electron pairs will be farthest apart when they occupy the corners of a tetrahedron. Since one of the four electron pairs is a lone pair, the observed geometry is trigonal pyramidal.

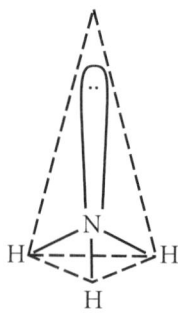

Figure 26.4

In describing the shape of a molecule, only the arrangement of atoms (not electrons) is considered. Even though the electron pairs are arranged in a tetrahedron, the shape of NH_3 is pyramidal. It is not trigonal planar because the lone pair repels the three bonding electron pairs, causing them to move as far away as possible.

Example: Predict the geometry of CO_2.

Solution: The Lewis structure of CO_2 is $\ddot{O}::C::\ddot{O}$.

The double bond behaves just like a single bond for purposes of predicting molecular shape. This compound has two groups of electrons around the carbon. According to the VSEPR theory, the two sets of electrons will orient themselves 180° apart, on opposite sides of the carbon atom, to minimize electron repulsion. Therefore, the molecular structure of CO_2 is linear.

Polarity of molecules

A molecule with a net dipole moment is called polar, as previously mentioned, because it has positive and negative poles. The overall polarity of a molecule depends on the polarity of the constituent bonds and on the shape of the molecule. A molecule with nonpolar bonds is always nonpolar; a molecule with polar bonds may be polar or nonpolar depending on the orientation of the bond dipoles.

A molecule of two atoms bound by a polar bond must have a net dipole moment and therefore be polar. The two equal and opposite partial charges are localized at the ends of the molecule on the two atoms. A molecule consisting of more than two atoms bound with polar bonds may be either polar

or nonpolar since the overall dipole moment of a molecule is the vector sum of the individual bond dipole moments. If the molecule has a particular shape such that the bond dipole moments cancel each other (i.e., if the vector sum is zero), then the result is a nonpolar molecule. For instance, CCl_4 has four polar C−Cl bonds. According to the VSEPR theory, the shape of CCl_4 is tetrahedral. The four bond dipoles point to the vertices of the tetrahedron and cancel each other, resulting in a nonpolar molecule:

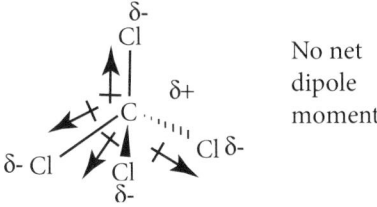

Figure 26.5

However, if the orientation of the bond dipoles are such that they do not cancel out, the molecules will have a net dipole moment and therefore be polar. For instance, H_2O has two polar O−H bonds. According to the VSEPR model, its shape is angular. The two dipoles add together to give a net dipole moment to the molecule, making the H_2O molecule polar:

Figure 26.6

Atomic and Molecular Orbitals

A description of the quantum numbers has already been given in Chapter 24, Atomic and Molecular Structure. The azimuthal quantum number (ℓ) describes the orbitals of each n shell. The shapes of these orbitals represent the probability of finding an electron at any given instant. $\ell = 0$ represents an s orbital, and s orbitals are spherically symmetric. The $1s$ orbital ($n = 1$, $\ell = 0$) is plotted below.

s orbital

Figure 26.7

When $\ell = 1$ there are three possible orbitals (since the magnetic quantum number, m_ℓ, may equal -1, 0, or $+1$). These are called p orbitals and have dumbbell shapes. The three p orbitals, designated p_x, p_y, and p_z, are oriented at right angles to each other; the p_x orbital is plotted below.

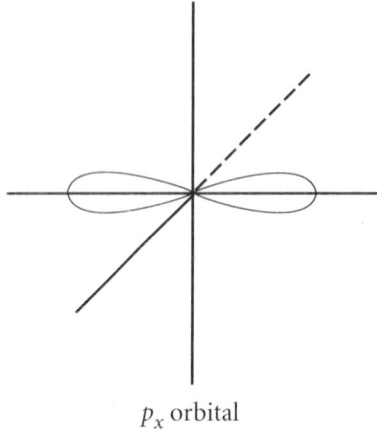

p_x orbital

Figure 26.8

The shapes of the five d orbitals ($\ell = 2$, $m_\ell = -2, -1, 0, 1, 2$) and the seven f orbitals ($\ell = 3$, $m_\ell = -3$, $-2, -1, 0, 1, 2, 3$) are more complex and need not be memorized for the exam.

When two atoms bond to form a molecule, the atomic orbitals interact to form a molecular orbital that describes the probability of finding the bonding electrons. Formally, molecular orbitals are obtained by adding the wave functions of the atomic orbitals. Qualitatively, this is described by the overlap of two atomic orbitals. If the two atomic orbitals are in phase with each other, a **bonding orbital** is formed. If the two atomic orbitals are completely out of phase with each other, an **antibonding orbital** is formed. When two orbitals of different atoms overlap head-to-head, the resulting bond is called a **sigma (σ) bond**. When parallel p orbitals interact, a **pi (π) bond** is formed.

THE INTERMOLECULAR FORCES

The attractive forces that exist between molecules are collectively known as intermolecular forces. These include **dipole-ion interactions**, **hydrogen bonding**, **dipole-dipole interactions**, and **London dispersion forces (LDF)**. In order of decreasing strength, these are as follows:

dipole-ion > hydrogen bonding > dipole-dipole > LDF

Those forces not due to the interactions of ions or hydrogen bonding (i.e., dipole-dipole and LDF) are also collectively referred to as **van der Waals forces**.

Evaluating intermolecular forces is most important on the exam for determining melting and boiling points. Stronger intermolecular forces hold molecules together more tightly, so more energy (generally represented by higher temperatures) is required to weaken those bonds to allow for phase changes.

Dipole-Dipole Interactions

Polar molecules tend to orient themselves such that the positive region of one molecule is close to the negative region of another molecule. This arrangement is energetically favorable because an attractive dipole force is formed between the two molecules.

Dipole-dipole interactions are present in the solid and liquid phases but become negligible in the gas phase because the molecules are generally much farther apart. Polar species tend to have higher boiling points than nonpolar species of comparable molecular weight.

Hydrogen Bonding

Hydrogen bonding is a specific, particularly strong form of dipole-dipole interaction. When hydrogen is bound to either fluorine, oxygen, or nitrogen, the hydrogen atom carries little of the electron density of the covalent bond. This positively charged hydrogen atom interacts with the partial negative charge located on the electronegative atoms of nearby molecules. This interaction between the δ^+ on the H and the δ^- on the nearby molecule is the hydrogen bond. On the exam, a hydrogen can only hydrogen bond to adjacent molecules if that H is covalently bound to either F, O, or N. Substances that display hydrogen bonding tend to have unusually high boiling points compared with compounds of similar molecular weight that do not hydrogen bond. Hydrogen bonding is particularly important in the behavior of water, alcohols, amines, and carboxylic acids.

> **MNEMONIC**
>
> Hydrogen bonds: Pick up the **FON** (phone):
> Hydrogen bonds exist in molecules containing a hydrogen bonded to **F**luorine, **O**xygen, or **N**itrogen.

Dispersion Forces

The bonding electrons in covalent bonds may appear to be shared equally between two atoms, but, at any particular point in time, they will be located randomly throughout the orbital. This permits unequal sharing of electrons, causing rapid polarization and counterpolarization of the electron cloud and formation of short-lived dipoles. These dipoles interact with the electron clouds of neighboring molecules, inducing the formation of more dipoles. The attractive interactions of these short-lived dipoles are called London dispersion forces (LDF).

Dispersion forces are generally weaker than other intermolecular forces. They do not extend over long distances and are therefore most important when molecules are close together. The strength of these interactions within a given substance depends directly on how easily the electrons in the molecules can move (i.e., be polarized). Large molecules in which the electrons are far from the nucleus are relatively easy to polarize and therefore possess greater dispersion forces. If not for dispersion forces, the noble gases would not liquefy at any temperature since no other intermolecular forces exist between the noble gas atoms. The low temperature at which the noble gases liquefy is to some extent indicative of the magnitude of dispersion forces between the atoms.

Carbon-Carbon Bonding

Carbon-carbon bonds can be categorized based on length and energy level as well as hybridization. In Chapter 39, Nomenclature, we will review the hybridization of carbon-carbon bonds. The table below compares the bond length and energy levels of the different carbon-carbon bonds.

	Bond Length	Bond Energy
C—C	longest	lowest
C=C	middle	middle
C≡C	shortest	highest

Table 26.2

REVIEW PROBLEMS

1. Is Cl^- an anion or a cation?

2. Consider the following reaction:

 $$H_2 \, (g) + F_2 \, (g) \longrightarrow HF \, (g)$$

 Is the HF bond more or less polar than an H—H bond?

3. Arrange the following compounds in terms of increasing polarity:

 $$HCN, \, NaCl, \, Cl_2$$

4. **(A)** Which has a greater C—C bond distance, C_2H_4 or C_2H_2?

 (B) Which has a greater C—C bond energy?

5. Which of the following compounds would you expect to be weakly drawn into a magnetic field?

 $$H_2, \, NaCl, \, NO, \, NO_2, \, BF_3, \, PCl_5, \, SO_2$$

6. Which represents the proper Lewis structure of:

 A. $CHCl_3$?

 1.

 2.

 3.

 4.

 B. N_2?

 1. N≡N

 2. N̈≡N̈

 3. :N̈=N̈:

 4. Ṅ≡Ṅ

C. $[ClO_4]^-$?

1.
$$\left[\begin{array}{c} :\ddot{O}: \\ | \\ \ddot{O}\!=\!Cl\!-\!\ddot{O}: \\ | \\ :\ddot{O}: \end{array} \right]^{-}$$

2.
$$\left[\begin{array}{c} :\ddot{O}: \\ | \\ \ddot{O}\!=\!Cl\!-\!\ddot{O}: \\ || \\ :O: \end{array} \right]^{-}$$

3.
$$\left[\begin{array}{c} :O: \\ || \\ \ddot{O}\!=\!Cl\!-\!\ddot{O}: \\ || \\ :O: \end{array} \right]^{-}$$

4.
$$\left[\begin{array}{c} :\ddot{O}: \\ | \\ :\ddot{O}\!-\!Cl\!-\!\ddot{O}: \\ | \\ :\ddot{O}: \end{array} \right]^{-}$$

7. Which is not a resonance form of:

A.
$$\left(\begin{array}{c} :\ddot{O}: \\ | \\ \ddot{O}\!=\!N\!-\!\ddot{O}: \end{array} \right)^{-} ?$$

1.
$$\left(\begin{array}{c} :\ddot{O}: \\ | \\ :\ddot{O}\!-\!N\!=\!\ddot{O} \end{array} \right)^{-}$$

2.
$$\left(:\ddot{O}\!-\!\ddot{O}\!-\!N\!=\!\ddot{O} \right)^{-}$$

3. $\left(\begin{array}{c} :\ddot{O}: \\ \| \\ :\ddot{O}-N-\ddot{O}: \end{array} \right)^{-}$

B. $\left(\ddot{N}\equiv N-\ddot{N}: \right)^{-}$?

1. $\left(:\ddot{N}-N\equiv\ddot{N} \right)^{-}$

2. $\left(:N \overset{N}{\underset{}{\diagdown}} \overset{\lll}{\underset{}{\longrightarrow}} N \right)^{-}$

3. $\left(:\ddot{N}=N=\ddot{N}: \right)^{-}$

8. Using formal charges, predict which is the most likely resonance structure for N_2O.

 A. $:N\equiv O\equiv N:$

 B. $:\ddot{N}=O=\ddot{N}:$

 C. $:\ddot{N}=N=\ddot{O}:$

 D. $:N\equiv N-\ddot{O}:$

 E. $:N\equiv O\equiv N:$

9. Draw Lewis structures of the most likely ions of the elements from Na to Ca (atomic numbers 11 to 20).

10. Draw Lewis structures for each of the following:
 A. Nitrate ion ($[NO_3]^{-}$)
 B. Phosphoric acid (H_3PO_4)
 C. Aluminum chloride ($AlCl_3$)
 D. Sodium phosphate (Na_3PO_4)

11. A hydride is a compound containing the hydride ion, H^{-}. Predict two elements whose hydrides would contain incomplete octets.

12. Which of the following sets of molecules contains only nonpolar species?
 A. BH_3, NH_3, AlH_3
 B. NO_2, CO_2, ClO_2
 C. HCl, HNO_2, $HClO_3$
 D. BeH_2, BH_3, CH_4
 E. H_2O, SO_3, BCl_3

13. Arrange the following compounds in order of increasing boiling point: C_2H_6, CH_3OH, LiF, HCl.

SOLUTIONS TO REVIEW PROBLEMS

1. Cl^- is an anion. Negative ions are called anions, and positive ions are called cations.

2. The HF bond is more polar than an H–H bond. *Polar* denotes unequal sharing of electrons; H–H must have equal sharing because the two atoms are the same. H and F are different atoms with different electronegativities, and so the electrons are unequally shared.

3. **$Cl_2 < HCN < NaCl$**

 Cl_2 is the least polar because it contains two identical atoms that must share electrons equally. HCN is a linear molecule with a triple bond between C and N; it has a dipole moment pointing from the relatively electropositive H atom toward the rather electronegative N atom. Still, we should expect HCN to be less polar than NaCl; the bond between Na and Cl, a metal and a nonmetal whose electronegativities differ greatly, is completely ionic.

4. **A** C_2H_4 has greater bond distance because it is a double bond and is therefore held less closely than C_2H_2, which is a triple bond.

 B C_2H_2 has a greater bond energy because it is a triple bond and more energy is needed to break it.

5. NO and NO_2 would be weakly drawn into a magnetic field because they are paramagnetic. All paramagnetic molecules are weakly drawn into a magnetic field, and any compound with an odd number of valence electrons is paramagnetic. Thus:

 H_2: H has 1 valence electron; $1 + 1 = 2$, so H_2 is not paramagnetic.

 NaCl: Na has 1 valence electron, Cl has 7; $1 + 7 = 8$, so NaCl is not paramagnetic.

 NO: N has 5 valence electrons, O has 6; $6 + 5 = 11$, so NO is paramagnetic.

 NO_2: $5 + (2)(6) = 17$, so NO_2 is paramagnetic.

 BF_3: B has 3 valence electrons, F has 7; $3 + 3(7) = 24$, so BF_3 is not paramagnetic.

 PCl_5: P has 5 valence electrons, Cl has 7; $5 + 5(7) = 40$, so PCl_5 is not paramagnetic.

 SO_2: S has 6 valence electrons, O has 6; $6 + 2(6) = 18$, so SO_2 is not paramagnetic.

6. **A 4**

 Choice 4 is correct. Choice 1 is incorrect because covalent bonds are not marked with lines. Choice 2 has an impossible configuration; H can never be double-bonded to anything since the maximum number of electrons it may possess is 2. Choice 3 is also impossible since having four bonds around H would imply 8 electrons are present, which again would mean that H would have more than its maximum of 2 electrons.

 B 2

 Choices 1 and 3 must be incorrect because, although they satisfy the octet rule, they have the wrong total number of electrons; choice 1 has 8 valence electrons, whereas choice 3 has 12. Given two N atoms, there can be only $(2)(5) = 10$ valence electrons, as in correct choice 2. (Choice 1 is also incorrect because quadruple bonding is impossible due to orbital geometries.) Choice 4 is doubly incorrect because, in addition to only having 8 total electrons, the octet rule is not satisfied as each nucleus has 7, not 8, valence electrons.

C 3

Choice 3 is the preferred structure because four of the five atoms have a formal charge of zero. Since Cl is in the third period, its number of valence electrons can exceed 8.

7. **A 2**

In resonance forms, only the electrons change place; atoms are not rearranged. Choices 1 and 3 are both resonance structures. Choice 2 requires rearrangement of the atoms.

B 2

By the same reasoning as above.

8. **D** There is no formal charge on the structure of choice A or E; therefore, either of these structures could be the most likely resonance structure. However, the expanded octects of N and O make both impossible since both are in period 2, and $n = 2$ and does not have d orbitals. Choice C is incorrect because the negative formal charge is on N, which is not the most electronegative atom. Choice B is incorrect because O, which is the most electronegative atom, has a formal charge of $+2$. Choice D is most likely because the negative formal charge is on O, the more electronegative element.

9. Na^+ Mg^{2+} Al^{3+} Si^{4+} $:\ddot{P}:^{3-}$ $:\ddot{S}:^{2-}$ $:\ddot{Cl}:^{-}$ **(Ar has none)**

K^+ Ca^{2+}

Note that a correct ionic Lewis structure must always show the charge on the ion.

10. **A** $[NO_3]^-$

	has	needs
charge:	1 electron	
N:	5 electrons	8 electrons
3 O:	18 electrons	24 electrons
	24 electrons	32 electrons

$(32 - 24)$ electrons $= 8$ electrons $= 4$ bonds

Place N at the center:

(N and O both have a formal charge.)

They cannot be reduced because the N octet cannot be expanded. However, since resonance will be present, a better version might be:

$$\left(\begin{array}{c} \ddot{O}\diagdown\diagup\ddot{O} \\ N \\ \| \\ :\ddot{O}: \end{array} \right)^{-}$$

B H_3PO_4

	has	needs
3 H	3 electrons	$3(2) = 6$ electrons
P	5 electrons	8 electrons (at least)
4 O	24 electrons	32 electrons
	32 electrons	46 electrons

$(46 - 32)$ electrons $= 14$ electrons $= 7$ bonds (at least).

Place the P at the center, the 4 O around it, and H on 3 of the O with single bonds between them; this will use all 7 bonds.

Now check the formal charges:

$$\begin{array}{c} H{-}\ddot{O}\diagdown \underset{+}{} \diagup \ddot{O}{-}H \\ P \\ \diagup \diagdown \\ H{-}\ddot{O} \quad \ddot{O}:{-} \end{array}$$

The P has a formal charge of $+1$, and the O has a formal charge of -1. These can be eliminated by moving a pair of electrons around from the O into a double bond:

$$\begin{array}{c} H{-}\ddot{O}\diagdown \diagup \ddot{O}{-}H \\ P \\ \diagup \diagdown\diagdown \\ H{-}\ddot{O} \quad \ddot{O} \end{array}$$

C Both aluminum chloride and sodium phosphate are ionic.

$AlCl_3$

$$\left(:\ddot{C}l:\right)^{-}$$

$$Al^{+3} \qquad \left(:\ddot{C}l:\right)^{-}$$

$$\left(:\ddot{C}l:\right)^{-}$$

 D Na_3PO_4

$$O = \overset{\overset{\displaystyle Na^+}{\overset{\displaystyle O^-}{|}}}{\underset{\underset{\displaystyle Na^+}{\overset{\displaystyle O^-}{|}}}{P}} - O^- Na^+$$

11. Be and B, because they can join to only two or three H, respectively, since they have fewer than 4 valence electrons. The elements Mg and Al may also do this, as could Na, Ca, and the other active metals of Groups IA and IIA.

12. **D**

 A. NH_3 is polar (positive end at base of pyramid, negative end at N).

 B. NO_2 and ClO_2 are both angular molecules; therefore, they are polar.

 C. All three are polar.

 D. H_2O is polar because it is a bent molecule.

13. $C_2H_6 < HCl < CH_3OH < LiF$

 For each compound, the following intermolecular forces are present:

 C_2H_6: London dispersion forces

 HCl: dipole-dipole

 CH_3OH: H-bonding

 LiF: ionic

CHAPTER TWENTY-SEVEN

Stoichiometry

LEARNING OBJECTIVES

After this chapter, you will be able to:

- Determine molecular mass, moles, and gram equivalent weight of an element
- Calculate percent composition using empirical and molecular formulas
- Determine the coefficients necessary to balance a chemical equation
- Calculate the limiting reagent and yield using a balanced equation

A **compound** is a pure substance composed of two or more elements in a fixed proportion. Compounds can be broken down chemically to produce their constituent elements or other compounds. All elements, except for some of the noble gases, can react with other elements or compounds to form new compounds. These new compounds can react further to form yet different compounds.

MOLECULES AND MOLES

A molecule is a combination of two or more atoms held together by covalent bonds and is the smallest unit of a compound that still displays the properties of that compound. Molecules may contain two atoms of the same element, as in N_2 and O_2, or may be comprised of two or more different atoms, as in CO_2 and $SOCl_2$. Molecules are usually discussed in terms of **molecular mass** and **moles**.

Ionic compounds do not form true molecules. In the solid state, they can be considered to be an extensive three-dimensional array of the charged particles of which the compound is composed. Because no actual molecule exists, molecular mass becomes meaningless, and the term **formula mass** is used in its place.

Molecular Mass

Like atoms, molecules can be characterized by their mass. The molecular mass (also known as **molecular weight**) is the sum of the atomic masses of the atoms in the molecule. Similarly, the formula mass of an ionic compound is found by adding up the atomic masses of each constituent atom according to the empirical formula of the substance.

Example: What is the molecular mass of $SOCl_2$?

Solution: To find the molecular mass of $SOCl_2$, add together the atomic masses of each of the atoms:

$$1 \text{ S} = 1 \times 32 \text{ amu} = 32 \text{ amu}$$
$$1 \text{ O} = 1 \times 16 \text{ amu} = 16 \text{ amu}$$
$$2 \text{ Cl} = 2 \times 35.5 \text{ amu} = \underline{71 \text{ amu}}$$
$$\text{molecular mass} = 119 \text{ amu}$$

Mole

To work with the enormous numbers of molecules and atoms in reactions, chemists use a quantity called a **mole**. Similar to how we use "dozen" to describe a group of twelve items, mole is used to describe a specific number of atoms or molecules. A mole is defined as the amount of a substance that contains the same number of particles found in a 12 g sample of carbon-12. This quantity, **Avogadro's number,** is equal to 6.022×10^{23}. One mole of a compound has a mass in grams equal to the molecular mass of that compound in amu and contains 6.022×10^{23} molecules of the compound. For example, 62 g of H_2CO_3 represents one mole of carbonic acid and contains 6.022×10^{23} H_2CO_3 molecules. The mass of one mole of a compound is called its **molar mass** or **molar weight** and is usually expressed as g/mol. Therefore, the molar mass of H_2CO_3 is 62 g/mol.

The following formula is used to determine the number of moles present in a sample:

$$\text{mol} = \frac{\text{Weight of Sample (g)}}{\text{Molar Weight (g/mol)}}$$

Example: How many moles are in 9.52 g of $MgCl_2$?

Solution: First find the molar mass of $MgCl_2$:

$$1(24.31 \text{ g/mol}) + 2(35.45 \text{ g/mol}) = 95.21 \text{ g/mol}$$

Now solve for the number of moles:

$$\frac{9.52 \text{ g}}{95.21 \text{ g/mol}} = 0.10 \text{ mol of } MgCl_2$$

Gram Equivalents

For some substances it is useful to define a measure of reactive capacity. This expresses the fact that some molecules are more potent than others in performing certain reactions. An example of this is the ability of different acids to donate protons (H^+ ions) in solution (see Chapter 36). For instance, one mole of HCl can donate one mole of hydrogen ions, while one mole of H_2SO_4 can donate two moles of hydrogen ions. This difference is expressed using the term **equivalent**: one mole of HCl contains one equivalent of hydrogen ions, while one mole of H_2SO_4 contains two equivalents of hydrogen ions. To determine the number of equivalents a compound contains, a new measure of weight, called **gram-equivalent weight (GEW)**, was developed such that:

$$\text{equivalents} = \frac{\text{weight of compound}}{\text{gram equivalent weight}}$$

and

$$\text{gram equivalent weight} = \frac{\text{molar mass}}{n}$$

where n is the number of equivalents per mole of the substance. The number of equivalents is usually either the number of **hydrogen** ions an Arrhenius or Brønsted-Lowry acid could donate per molecule or the number of **hydroxyl groups** an Arrhenius base could donate (or number of hydrogen ions a Brønsted-Lowry base could accept) in a reaction. Gram equivalent weight is dependent on reaction conditions and is determined experimentally; however, on the exam, gram equivalent weight can be estimated from the molecular structure. By using equivalents, it is possible to say one equivalent of acid will neutralize one equivalent of base, a statement that is not necessarily true when dealing in moles.

REPRESENTATION OF COMPOUNDS

Law of Constant Composition

The law of constant composition states that all samples of a given compound will contain the same elements in identical mass ratios. For instance, every sample of H_2O will contain two atoms of hydrogen for every atom of oxygen and therefore one gram of hydrogen for every eight grams of oxygen.

Empirical and Molecular Formulas

There are two ways to express a formula for a compound. The **empirical formula** gives the simplest whole number ratio of the elements in the compound. The **molecular formula** gives the exact number of atoms of each element in the compound and is a multiple of the empirical formula. For example, the empirical formula for benzene is CH, whereas the molecular formula is C_6H_6. For some compounds the empirical and molecular formulas are the same, as in the case of H_2O. An ionic compound, such as NaCl or $CaCO_3$, will have only an empirical formula.

Note that, given a molecular formula, the empirical formula for that molecule can be calculated by simplifying the ratio of the subscripts next to each component. However, given only an empirical formula, the molecular formula of a specific molecule cannot be determined without more information since several different molecules could share the same empirical formula. For example, the empirical formula CH_2 is shared by ethylene (C_2H_4), butane (C_4H_8), and cyclohexane (C_6H_{12}).

Percent Composition

The percent composition by mass of an element is the mass percent of the element in a specific compound. To determine the percent composition of an element X in a compound, the following formula is used:

$$\% \text{ composition} = \frac{\text{Mass of X in Formula}}{\text{Formula Weight of Compound}} \times 100\%$$

The percent composition of an element may be determined using either the empirical or molecular formula. If the percent compositions are known, the empirical formula can be derived. It is possible to determine the molecular formula if both the percent compositions and molecular mass of the compound are known.

Example: What is the percent composition of chromium in $K_2Cr_2O_7$ (potassium's molecular mass is 39 g/mol, chromium's is 52 g/mol, and oxygen's is 16 g/mol)?

Solution: The formula mass of $K_2Cr_2O_7$ is: $2(39\ g/mol) + 2(52\ g/mol) + 7(16\ g/mol) = 294$ g/mol

$$\%\ composition\ of\ Cr = \frac{2(52g/mol)}{294\ g/mol} \times 100\%$$

$$= 0.354 \times 100\%$$

$$= 35.4\%$$

Example: What are the empirical and molecular formulas of a compound that contains 40.9% carbon, 4.58% hydrogen, and 54.52% oxygen by mass and has a molecular mass of 264 g/mol (carbon's molar mass is 12 g/mol, hydrogen's is 1 g/mol, and oxygen's is 16 g/mol)?

Method One: First, determine the number of moles of each element in the compound by assuming a 100 g sample; this converts the percentage of each element present directly into grams of that element. Then convert grams to moles:

$$\#\ mol\ of\ C = \frac{40.9\ g}{12\ g/mol} = 3.41\ mol$$

$$\#\ mol\ of\ H = \frac{4.58\ g}{1\ g/mol} = 4.58\ mol$$

$$\#\ mol\ of\ O = \frac{54.52\ g}{16\ g/mol} = 3.41\ mol$$

Next, find the simplest whole number ratio of the elements by dividing the number of moles of each element by the smallest number obtained in the previous step:

$$C: \frac{3.41}{3.41} = 1.0 \qquad H: \frac{4.58}{3.41} = 1.3 \qquad O: \frac{3.41}{3.41} = 1.0$$

Finally, the empirical formula is obtained by converting the numbers obtained into whole numbers (multiplying them by an integer value).

$$C_1H_{1.3}O_1 \times 3 = C_3H_4O_3$$

Multiplying all the subscripts by 3 to obtain all whole numbers for the subscripts shows that $C_3H_4O_3$ is the empirical formula.

To determine the molecular formula, divide the molecular mass by the mass represented by the empirical formula. The resulting value is the number of empirical formula units in the molecular formula.

The empirical formula mass of $C_3H_4O_3$ is:

$3(12 \text{ g/mol}) + 4(1 \text{ g/mol}) + 3(16 \text{ g/mol}) = 88 \text{ g/mol}$

$$\frac{264 \text{ g/mol}}{88 \text{ g/mol}} = 3$$

$C_3H_4O_3 \times 3 = C_9H_{12}O_9$ is the molecular formula.

Method Two: When the molecular mass is given, it can be faster to find the molecular formula first. This is accomplished by multiplying the molecular mass by the given percentages to find the grams of each element present in one mole of compound, then dividing by the respective atomic masses to find the mole ratio of the elements:

$$\# \text{ mol of C} = \frac{(0.409)(264 \text{ g})}{12 \text{ g/mol}} = 9 \text{ mol}$$

$$\# \text{ mol of H} = \frac{(0.0458)(264 \text{ g})}{1 \text{ g/mol}} = 12 \text{ mol}$$

$$\# \text{ mol of O} = \frac{(0.5452)(264 \text{ g})}{16 \text{ g/mol}} = 9 \text{ mol}$$

Thus, the molecular formula, $C_9H_{12}O_9$, is the direct result.
The empirical formula can now be found by reducing the subscript ratio to the simplest integral values.

BALANCING EQUATIONS

Chemical equations express how much and what type of reactants must be used to obtain a given quantity of product. From the **law of conservation of mass**, the mass of the reactants in a reaction must be equal to the mass of the products. More specifically, chemical equations must be balanced so that there are the same number of atoms of each element in the products as there are in the reactants. **Stoichiometric coefficients** are used to indicate the number of moles of a given species involved in the reaction. For example, the reaction for the formation of water is:

$$2 \text{ H}_2 \text{ (g)} + \text{O}_2 \text{ (g)} \rightarrow 2 \text{ H}_2\text{O (g)}$$

The coefficients indicate that two moles of H_2 gas react with one mole of O_2 gas to produce two moles of water. Stoichiometric coefficients are usually given as whole numbers.

Example: Balance the following reaction:

$$C_4H_{10} \, (l) + O_2 \, (g) \rightarrow CO_2 \, (g) + H_2O \, (l)$$

Solution: First, balance the carbon in reactants and products.

$$C_4H_{10} + O_2 \rightarrow 4 \, CO_2 + H_2O$$

Second, balance the hydrogen in reactants and products.
$$C_4H_{10} + O_2 \rightarrow 4 \, CO_2 + 5 \, H_2O$$

Third, balance the oxygen in reactants and products.
$$C_4H_{10} + 6.5 \, O_2 \rightarrow 4 \, CO_2 + 5 \, H_2O$$

Stoichiometric coefficients are typically written as integers, so double everything to remove the decimal.
$$2 \, C_4H_{10} + 13 \, O_2 \rightarrow 8 \, CO_2 + 10 \, H_2O$$

Finally, check that all of the elements and the total charge are balanced correctly. If there is a difference in total charge between the reactants and products, then the charge will also have to be balanced. Instructions for balancing charge are found in Chapter 29 in the context of redox reactions.

Applications of Stoichiometry

Once an equation has been balanced, the ratio of moles of reactant to moles of products is known, and that information can be used to solve many types of stoichiometry problems. It is important to pay attention to units when solving such problems. In these calculations, the units should cancel out such that the units obtained in the answer represent those asked for in the problem.

Example: How many grams of calcium chloride are needed to prepare 72 g of silver chloride according to the following equation (calcium's molar mass is 40 g/mol, chlorine's is 35.5 g/mol, and silver's is 108 g/mol)?

$$CaCl_2 \, (aq) + 2 \, AgNO_3 \, (aq) \rightarrow Ca(NO_3)_2 \, (aq) + 2 \, AgCl \, (s)$$

Solution: First, note that the equation is balanced. Then, identify that one mole of $CaCl_2$ yields two moles of AgCl when reacted with two moles of $AgNO_3$. The molar mass of $CaCl_2$ is 110 g/mol, and the molar mass of AgCl is approximately 144 g/mol. Starting with the goal mass of AgCl, convert to moles, find the number of moles of $CaCl_2$ required, and then convert into g of $CaCl_2$ (as grams are the units that the question specifies).

$$72 \text{ g AgCl} \times \frac{1 \text{ mol AgCl}}{144 \text{ g AgCl}} \times \frac{1 \text{ mol CaCl}_2}{2 \text{ mol AgCl}} \times \frac{110 \text{ g CaCl}_2}{1 \text{ mol CaCl}_2} = 27.5 \text{ g of CaCl}_2$$

Thus, 27.5 g of $CaCl_2$ are needed to produce 72 g of AgCl.

Limiting reactant

When reactants are mixed, they are seldom added in the exact stoichiometric proportions as shown in the balanced equation. Therefore, in most reactions, one of the reactants will be consumed first. This reactant is known as the limiting reactant or **limiting reagent** because it limits the amount of product that can be formed in the reaction. The reactant(s) that remains after all of the limiting reactant is used up is called the **excess reactant**.

Example: If 28 g of Fe are reacted with 24 g of S to produce FeS, what is the limiting reactant? How many grams of excess reactant are present in the vessel at the end of the reaction?

The balanced equation is: $Fe + S \xrightarrow{\Delta} FeS$

Solution: First, the number of moles for each reactant must be determined.

$$28 \text{ g Fe} \times \frac{1 \text{ mol Fe}}{56 \text{ g}} = 0.5 \text{ mol Fe}$$

$$24 \text{ g S} \times \frac{1 \text{ mol S}}{32 \text{ g}} = 0.75 \text{ mol S}$$

Since one mole of Fe is needed to react with one mole of S, and there are 0.5 moles of Fe for every 0.75 moles of S, the limiting reagent is Fe. Thus, 0.5 moles of Fe will react with 0.5 moles of S, leaving an excess of 0.25 moles of S in the vessel. The mass of the excess reactant will be:

$$\text{mass of S} = (0.25 \text{ mol S})\frac{32 \text{ g}}{1 \text{ mol S}} = 8 \text{ g of S}$$

Yields

The yield of a reaction, which is the amount of product predicted or obtained when the reaction is carried out, can be predicted from the balanced equation. There are three distinct ways of reporting yields. The **theoretical yield** is the amount of product that can be predicted from a balanced equation, assuming that all of the limiting reagent has been used, no competing side reactions have occurred, and all of the product has been collected. However, the theoretical yield is seldom obtained in real-world conditions; therefore, chemists speak of the **actual yield,** which is the amount of product isolated from the reaction experimentally. There are a variety of reasons why the actual yield is less than the theoretical yield. For example, many reactions are **reversible** (i.e., do not proceed 100 percent from left to right) or use reactants that interact with one another to produce additional end products.

The term **percent yield** is used to express the relationship between the actual yield and the theoretical yield and is given by the following equation:

$$\text{Percent yield} = \frac{\text{Actual yield}}{\text{Theoretical yield}} \times 100\%$$

Example: What is the percent yield for a reaction in which 27 g of Cu is produced by reacting 32.5 g of Zn in excess $CuSO_4$ solution (copper's molar mass is 63.5 g/mol, zinc's is 65 g/mol, sulfur's is 32 g/mol, and oxygen's is 16 g/mol)?

Solution: The balanced equation is as follows:

$$Zn\ (s) + CuSO_4\ (aq) \rightarrow Cu\ (s) + ZnSO_4\ (aq)$$

Calculate the theoretical yield for Cu.

$$32.5\ g\ Zn \times \frac{1\ mol\ Zn}{65\ g} = 0.5\ mol\ Zn$$

$$0.5\ mol\ Zn \times \frac{1\ mol\ Cu}{1\ mol\ Zn} = 0.5\ mol\ Cu$$

$$0.5\ mol\ Cu \times \frac{64g}{1\ mol\ Cu} = 32\ g\ Cu\ (theoretical\ yield)$$

Finally, determine the percent yield.

$$Percent\ yield = \frac{Actual\ yield}{Theoretical\ yield} \times 100\% = \frac{27\ g}{32\ g} \times 100\% = 84\%$$

REVIEW PROBLEMS

1. What is the sum of the coefficients of the following equation when it is balanced?

 $$C_6H_{12}O_6 + O_2 \rightarrow CO_2 + H_2O$$

 A. 19
 B. 20
 C. 21
 D. 38
 E. 40

2. Determine the molecular formula and calculate the percent composition of each element present in nicotine, which has an empirical formula of C_5H_7N and a molecular mass of 162 g/mol.

3. Acetylene, used as a fuel in welding torches, is produced in a reaction between calcium carbide and water:

 $$CaC_2 + 2\ H_2O \rightarrow Ca(OH)_2 + C_2H_2$$

 How many grams of C_2H_2 are formed from 0.400 moles of CaC_2?

 A. 0.400
 B. 0.800
 C. 4.00
 D. 5.20
 E. 10.4

4. Aspirin ($C_9H_8O_4$) is prepared by reacting salicylic acid ($C_7H_6O_3$) and acetic anhydride ($C_4H_6O_3$).

 $$C_7H_6O_3 + C_4H_6O_3 \rightarrow C_9H_8O_4 + C_2H_4O_2$$

 How many moles of salicylic acid should be used to prepare six 5-grain aspirin tablets? (1 g = 15.5 grains)

 A. 0.01
 B. 0.10
 C. 1.00
 D. 1.94
 E. 2.01

5. The percent composition of an unknown element X in CH_3X is 32 percent. Which of the following is element X?

 A. H
 B. F
 C. Cl
 D. Li
 E. N

6. Twenty-seven grams of silver were reacted with excess sulfur, according to the following equation:

$$2\,Ag + S \rightarrow Ag_2S$$

Twenty-five grams of silver sulfide were collected. What are the theoretical yield, actual yield, and percent yield?

7. What is the mass in grams of a single chlorine atom? Of a single molecule of O_2?

The following reaction will be used to answer questions 8–10.

$$Ag(NH_3)_2{}^+ \rightarrow Ag^+ + 2\,NH_3$$

8. How many moles of $Ag(NH_3)_2{}^+$ are required for the production of 11 moles of ammonia?

9. If 5.80 g of $Ag(NH_3)_2{}^+$ yields 1.40 g of ammonia, how many moles of silver are produced?
 A. 0.041
 B. 0.054
 C. 2.20
 D. 4.40
 E. 5.80

10. What are the percent compositions of Ag, N, and H in $Ag(NH_3)_2{}^+$?

11. A hydrocarbon (which by definition contains only C and H atoms) is heated in an excess of oxygen to produce 58.67 g of CO_2 and 27 g of H_2O. What is the empirical formula of the hydrocarbon?

12. Balance the following reaction:

$$NF_3 + H_2O \rightarrow HF + NO + NO_2$$

How many grams of HF are expected to form if 1.5 kg of a 5.2% NF_3 sample is used?

13. Balance the following reactions:
 A. $I_2 + Cl_2 + H_2O \rightarrow HIO_3 + HCl$
 B. $MnO_2 + HCl \rightarrow H_2O + MnCl_2 + Cl_2$
 C. $BCl_3 + P_4 + H_2 \rightarrow BP + HCl$
 D. $C_3H_5(NO_3)_3 \rightarrow CO_2 + H_2O + N_2 + O_2$
 E. $HCl + Ba(OH)_2 \rightarrow BaCl_2 + H_2O$

SOLUTIONS TO REVIEW PROBLEMS

1. **A** To answer this question, the equation must first be balanced. Starting with carbon, it can be seen that there are 6 carbons on the reactant side and only one on the product side, so a coefficient of 6 should be placed in front of the carbon dioxide. For the hydrogen, there are 12 atoms on the left and only 2 on the right; thus, a coefficient of 6 should go in front of water. Now, for oxygen, there are 8 atoms on the left and 18 on the right. To balance the oxygen, 10 more atoms of oxygen must be added to the left side. The best way to do this is to put a coefficient of 6 in front of oxygen, since putting a stoichiometric coefficient in front of the glucose molecule would unbalance the equation in terms of carbon and hydrogen. Therefore, the final balanced equation is:

$$C_6H_{12}O_6 + 6\ O_2 \rightarrow 6\ CO_2 + 6\ H_2O$$

Remember that $C_6H_{12}O_6$ has a coefficient of 1, and this must be added to the total number. So $1 + 6 + 6 + 6 = 19$.

2. $C_{10}H_{14}N_2$; 74.1% C, 8.6% H, 17.3% N

To determine the molecular formula of nicotine, the empirical mass of the compound must be calculated.

5(C) + 7(H) + 1(N) = empirical mass

5(12 g/mol) + 7(1 g/mol) + 14 g/mol = 81 g/mol

The empirical mass (81 g/mol) is then divided into the molecular mass (162 g/mol) to determine the number by which each subscript in the empirical formula must be multiplied to obtain the molecular formula.

$$\frac{162\,\text{g/mol}}{81\,\text{g/mol}} = 2$$

$2(C_5H_7N) = C_{10}H_{14}N_2$ = molecular formula

To find the percent composition of each element, divide the molar mass of each element by the molecular mass of nicotine:

$$\%\ C = \frac{120}{162} \times 100\% = 74.1\%$$

$$\%\ H = \frac{14}{162} \times 100\% = 8.6\%$$

$$\%\ N = \frac{28}{162} \times 100\% = 17.3\%$$

The same percentages would be obtained if we used the empirical formula for this calculation.

3. **E** According to the balanced equation, one mole of CaC_2 yields one mole of C_2H_2. Therefore, if 0.400 mol of CaC2 were used, 0.400 mol of C_2H_2 would be produced. Now the number of moles must be converted to grams using the following formula:

$$mol = \frac{\text{Weight in g}}{\text{Molecular weight}}$$

The molecular mass of C_2H_2 is
$2(12 \text{ g/mol}) + 2(1 \text{ g/mol}) = 26 \text{ g/mol}$

Substituting into the above equation:

$$0.400 \text{ mol} = \frac{x}{26 \text{g/mol}}$$
$$x = 10.4 \text{ g}$$

4. **A** According to the balanced equation, one mole of salicylic acid will yield one mole of aspirin. Therefore, to solve this question, the number of moles of aspirin in six 5-grain tablets, or 30 grains of aspirin, must be determined using the following relationship.

$$\frac{1 \text{ g}}{15.5 \text{ grains}} = \frac{x}{30 \text{ grains}}$$
$$x \approx 2 \text{ g}$$

Therefore, the mass of the aspirin produced is about 2 grams, which must be converted to moles. The molecular mass of aspirin is:
$9(C) + 8(H) + 4(O) = 9(12 \text{ g/mol}) + 8(1 \text{ g/mol}) + 4(16 \text{ g/mol}) = 180 \text{ g/mol}$
Then, the number of moles in two grams of aspirin is calculated.

$$\frac{2 \text{ g}}{180 \text{g/mol}} = 0.01 \text{ mol}$$

5. **D** The easiest way to solve this problem, short of trying every choice, is to work through the problem with slightly backward logic. Because we know that element X comprises 32% of the compound, CH_3 must comprise 68% (100% – 32%). We must calculate the formula mass of CH_3 (12 + 3 = 15 g). The fact that 15 g = 68% of the total mass can be restated as the equation 15 g = 0.68 × total mass; we can solve this to show that the total molecular mass must be 22 g. The mass of X = total mass – 15 g = 7 g. Choice (D), Li, has an atomic mass of 7 g/mol.

6. **31 g, 25 g, 81%**

 According to the balanced equation, two moles of silver react with one mole of sulfur to form one mole of silver sulfide. The theoretical yield is the amount of product that would be collected if all of the limiting reagent reacts. Using a stoichiometric calculation, the theoretical yield of silver sulfide if 27 g of silver is used would be as follows:

 $$27 \text{ g Ag} \times \frac{1 \text{ mol Ag}}{108 \text{ g Ag}} \times \frac{1 \text{ mol Ag}_2\text{S}}{2 \text{ mol Ag}} \times \frac{248 \text{ g Ag}_2\text{S}}{1 \text{ mol Ag}_2\text{S}} = 31 \text{ g Ag}_2\text{S}$$

 The actual yield is the amount of product that is obtained from the experiment. It is usually less than the theoretical yield since the reagents may not react completely and the product may be difficult to collect. In this experiment, the actual yield is given to be 25 g

of silver sulfide. The percent yield represents the percentage of product actually collected in reference to the theoretical yield. Thus, the percent yield for this experiment would be:

$$\frac{25 \text{ g}}{31 \text{ g}} \times 100\% = 81\%$$

7. **5.81×10^{-23} g/atom Cl; 5.31×10^{-23} g/molecule O_2**

The mass of a single atom is determined by dividing the atomic mass by Avogadro's number. Therefore, the mass of a chlorine atom is

$$\frac{35.5 \text{ g/mol}}{6.022 \times 10^{23} \text{ atoms/mol}} = 5.89 \times 10^{-23} \text{ g/atom}$$

The mass of an oxygen molecule (O_2) is similarly determined by dividing the molecular mass of oxygen by Avogadro's number.

$$\frac{32 \text{ g/mol}}{6.022 \times 10^{23} \text{ molecules/mol}} = 5.31 \times 10^{-23} \text{ g/molecule}$$

8. **5.5 mol**

From the balanced equation, it can be seen that the ratio between $Ag(NH_3)_2^+$ and NH_3 is 1:2. Thus, to form 11 mol of ammonia, the following calculation must be performed.

$$\frac{1 \text{ mol Ag(NH}_3)_2^+}{2 \text{ mol NH}_3} = \frac{x \text{ mol Ag(NH}_3)_2^+}{11 \text{ mol NH}_3}$$

$$x = 5.5 \text{ mol Ag(NH}_3)_2^+$$

9. **A** To answer this question, the law of conservation of mass, which says that the mass of the products must be equal to the mass of the reactants, is used. Therefore, if 5.8 g of $Ag(NH_3)_2^+$ are allowed to dissociate to form 1.4 g of ammonia, 5.8 g − 1.4 g = 4.4 g of silver must be formed. The following calculation is used to determine the number of moles of silver formed.

$$x \text{ mol} = \frac{4.4 \text{ g}}{108 \text{ g/mol}}$$

$$x = 0.041 \text{ mol}$$

10. **76.1% Ag, 19.7% N, 4.2% H**

The percent composition of elements in a compound or formula is determined by dividing the mass of the element by the total formula mass of the compound. Therefore, in the complex ion $Ag(NH_3)_2^+$, which has a formula mass of 142 g/mol, the percent compositions of Ag, N, and H are as follows:

$$\%Ag = \frac{108 \text{ g/mol}}{142 \text{ g/mol}} \times 100\% = 76.1\%$$

$$\%N = \frac{2(14 \text{ g/mol})}{142 \text{ g/mol}} \times 100\% = 19.7\%$$

$$\%H = \frac{6(1 \text{ g/mol})}{142 \text{ g/mol}} \times 100\% = 4.2\%$$

11. **C$_4$H$_9$**

To answer this problem, several calculations must be performed. First, the number of moles of carbon and hydrogen present in the hydrocarbon must be determined using the assumption that the number of moles of atoms on the reactant side is equal to the number of moles of atoms on the product side. From this information, the empirical formula can be determined.

First, the moles of carbon and hydrogen are calculated.

$$\frac{58.67 \text{ g CO}_2}{44 \text{ g/mol}} = 1.33 \text{ mol CO}_2$$

Since each mole of CO_2 contains 1 mole of carbon, 1.33 moles of CO_2 contains 1.33 moles of carbon. Therefore, the hydrocarbon contains 1.33 moles of carbon.

$$\frac{27 \text{ g H}_2\text{O}}{18\text{g/mol H}_2\text{O}} = 1.5 \text{ mol H}_2\text{O}$$

Since one mole of H_2O contains 2 moles of hydrogen atoms, 1.5 moles of H_2O contains 3.0 moles of hydrogen. Therefore, the hydrocarbon contains 3 moles of hydrogen.

Using these calculations, the simplest formula that can be written is $C_{1.33}H_3$. However, molecular formulas are not expressed with decimals or fractions, so these coefficients should be multiplied by 3 to give an empirical formula of C_4H_9.

12. **66 g**

The balanced equation will be:

$$2 \text{ NF}_3 + 3 \text{ H}_2\text{O} \rightarrow 6 \text{ HF} + \text{NO} + \text{NO}_2$$

According to the balanced equation, 2 moles of NF_3 is needed to produce 6 moles of HF. To determine the number of grams of HF that will be formed, the amount of NF_3 used must first be calculated.

$$1,500 \text{ g} \times 0.052 = 78 \text{ g NF}_3 \text{ used}$$

Then a stoichiometric calculation can be set up to see what the theoretical yield of HF would be.

$$78 \text{ g NF}_3 \times \frac{1 \text{ mol NF}_3}{71 \text{ g NF}_3} \times \frac{6 \text{ mol HF}}{2 \text{ mol NF}_3} \times \frac{20 \text{ g HF}}{1 \text{ mol HF}} = 66 \text{ g HF}$$

Thus, 66 g of HF would be produced.

13. The following are the correct balanced equations:

A. $I_2 + 5 \text{ Cl}_2 + 6 \text{ H}_2\text{O} \rightarrow 2 \text{ HIO}_3 + 10 \text{ HCl}$
B. $MnO_2 + 4 \text{ HCl} \rightarrow 2 \text{ H}_2\text{O} + \text{MnCl}_2 + \text{Cl}_2$
C. $4 \text{ BCl}_3 + P_4 + 6 \text{ H}_2 \rightarrow 4 \text{ BP} + 12 \text{ HCl}$
D. $4 \text{ C}_3\text{H}_5(\text{NO}_3)_3 \rightarrow 12 \text{ CO}_2 + 10 \text{ H}_2\text{O} + 6 \text{ N}_2 + \text{O}_2$
E. $2 \text{ HCl} + \text{Ba(OH)}_2 \rightarrow \text{BaCl}_2 + 2 \text{ H}_2\text{O}$

CHAPTER TWENTY-EIGHT

Solutions

LEARNING OBJECTIVES

After this chapter, you will be able to:

- Calculate the concentration of a solution
- Define terms used to describe solvation, solubility, and solutions
- Relate factors that affect the solubility of a compound

Solutions are **homogeneous** (uniform in composition) mixtures of substances that combine to form a single phase, generally the liquid phase. Many important chemical reactions, both in the laboratory and in nature, take place in solution.

NATURE OF SOLUTIONS

A solution consists of a solute (e.g., NaCl, NH_3, or $C_{12}H_{22}O_{11}$) dispersed (**dissolved**) in a solvent (e.g., H_2O or benzene). The solvent is the component of the solution whose phase remains the same after mixing. If the two substances are already in the same phase, the solvent is the component present in greater quantity. Solute molecules move about freely in the solvent and can interact with other molecules or ions; consequently, chemical reactions occur easily in solution.

Solvation

The interaction between solute and solvent molecules is known as solvation or **dissolution**. Solvation is possible when the attractive forces between solute and solvent are stronger than those between the solvent particles. For example, when NaCl dissolves in water, its component ions dissociate from one another and become surrounded by water molecules. Because water is polar, ion-dipole interactions can occur between the Na^+ and Cl^- ions and the water molecules, which are stronger and more favorable than the hydrogen-bonding found between H_2O molecules in pure water. For nonionic solutes, solvation involves van der Waals forces between the solute and solvent molecules. The general rule is that like dissolves like: ionic and polar solutes are soluble in polar solvents, and nonpolar solutes are soluble in nonpolar solvents. The summation of energy associated with separating solute particles and solvent particles and combining solute with solvent particles is the energy of solvation, which if positive describes an endothermic process and if negative, an exothermic process.

Solubility

The solubility of a solute is measured in terms of the maximum amount of that solute that can be dissolved in a particular solvent at a particular temperature. When this maximum amount of solute has been added, the solution is saturated; if more solute is added, it will not dissolve. For example, at 18°C, a maximum of 83 g of glucose ($C_6H_{12}O_6$) will dissolve in 100 mL of H_2O. Thus,

the solubility of glucose is 83 g/100 mL. If more glucose is added, the excess glucose will come out of solution and form a **precipitate** at the bottom of the container. Similarly, when a dissolved solute comes out of solution and forms crystals, this process is known as **crystallization**.

The solubility of a substance varies depending on the temperature of the solution, the solvent, and, in the case of a gas-phase solute, the pressure. Typically, the solubility of liquids or solids will increase with increasing temperature and the solubility of gas will increase with decreasing temperature and increasing pressure. Solubility is also affected by the addition of other substances to the solution.

It is also important to note that some substances can form **supersaturated** solutions, which are solutions that contain more solute than found in a saturated solution. Supersaturated solutions are formed by manipulating temperature or pressure. In a supersaturated solution, the addition of more solute will cause the excess solute in the supersaturated solution to separate, and a saturated solution with a precipitate will subsequently form.

CONCENTRATION

Units of Concentration

Concentration denotes the amount of solute dissolved in a solvent. A solution in which the proportion of solute to solvent is small is said to be **dilute,** and one in which the proportion is large is said to be **concentrated**. The concentration of a solution is most commonly expressed as **percent composition by mass, mole fraction (X), molarity (M), molality (m),** or **normality (N).**

Percent composition by mass

The percent composition by mass (%) of a solute is the mass of the solute divided by the mass of the solution (solute plus solvent) and multiplied by 100.

Example: What is the percent composition by mass of NaCl of a saltwater solution if 100 g of the solution contains 20 g of NaCl?

Solution: $\dfrac{20 \text{ g NaCl}}{100 \text{ g}} \times 100\% = 20\%$ NaCl solution

Mole fraction

The mole fraction (X) of a compound is equal to the number of moles of the compound divided by the total number of moles of all species within the system. The sum of all the mole fractions in a system will always equal 1.

The mole fraction can be calculated with the following equation:

$$X_B = \frac{\text{moles of B}}{\text{sum of moles of all components}}$$

where X_B is the mole fraction of component B.

Example: If 92 g of glycerol is mixed with 90 g of water, what will be the mole fractions of the two components (the molecular mass of H_2O = 18 g/mol and the molecular mass of $C_3H_8O_3$ = 92 g/mol)?

Solution:

$$90 \text{ g water} = 90 \text{ g} \times \frac{1 \text{ mol}}{18 \text{ g}} = 5 \text{ mol}$$

$$92 \text{ g glycerol} = 92 \text{ g} \times \frac{1 \text{ mol}}{92 \text{ g}} = 1 \text{ mol}$$

$$\text{Total mol} = 5 + 1 = 6 \text{ mol}$$

$$X_{water} = \frac{5 \text{ mol}}{6 \text{ mol}} = 0.833$$

$$X_{glycerol} = \frac{1 \text{ mol}}{6 \text{ mol}} = 0.167$$

As a check, note that the sum of X_{water} and $X_{glycerol}$ is 1:

$$X_{water} + X_{glycerol} = 0.833 + 0.167 = 1.000$$

Molarity

The molarity (M) of a solution is the number of moles of solute per liter of solution. Solution concentrations are usually expressed in terms of molarity. Molarity depends on the total volume of the solution, not on the volume of solvent used to prepare the solution.

Example: If enough water is added to 11 g of $CaCl_2$ to make 100 mL of solution, what is the molarity of the solution (the molecular mass of $CaCl_2$ is 110 g/mol)?

Solution:

$$\frac{11 \text{ g } CaCl_2}{110 \text{ g/mol } CaCl_2} = 0.10 \text{ mol } CaCl_2$$

$$100 \text{ mL} \times \frac{1 \text{ L}}{1,000 \text{ mL}} = 0.10 \text{ L}$$

$$\text{Molarity} = \frac{\text{mol solute}}{\text{L solution}} = \frac{0.10 \text{ mol } CaCl_2}{0.10 \text{ L solution}} = 1.0 \text{ M } CaCl_2$$

Molality

The molality (m) of a solution is the number of moles of solute per kilogram of solvent. For dilute aqueous solutions at 25°C, the molality is approximately equal to the molarity because the density of water at this temperature is 1 kilogram per liter, but note that this is an approximation and true only for dilute aqueous solutions.

Example: If 10 g of NaOH are dissolved in 500 g of water, what is the molality of the solution (the molecular mass of NaOH is 40 g/mol)?

Solution:

$$\frac{10 \text{ g NaOH}}{40 \text{ g/mol NaOH}} = 0.25 \text{ mol NaOH}$$

$$500 \text{ g H}_2\text{O} \times \frac{1 \text{ kg}}{1,000 \text{ g}} = 0.50 \text{ kg H}_2\text{O}$$

$$\text{Molality} = \frac{\text{mol solute}}{\text{kg solvent}} = \frac{0.25 \text{ mol NaOH}}{0.50 \text{ kg H}_2\text{O}} = 0.50 \text{ m NaOH}$$

Normality

The normality (N) of a solution is equal to the number of gram equivalent weights of solute per liter of solution. A gram equivalent weight, or **equivalent**, is a measure of the reactive capacity of a molecule (see Chapter 27).

To calculate the normality of a solution, we must know for what purpose the solution is being used because it is the concentration of the reactive species with which we are concerned. Normality is unique among concentration units in that it is reaction dependent. For example, each mole of sulfuric acid contributes two equivalents for acid-base reactions (because each mole of sulfuric acid provides two moles of H^+ ions) but contributes only one equivalent for a sulfate precipitation reaction (because each mole of sulfuric acid provides only one mole of sulfate ions). You can calculate normality by multiplying the molarity (M) of a solution by the number of equivalents per mol:

$$N = \text{Molarity} \times \frac{\text{equivalents}}{\text{mol}} = \frac{\text{mol}}{\text{L}} \times \frac{\text{equivalents}}{\text{mol}} = \frac{\text{equivalents}}{\text{L}}$$

Therefore, a 3 M solution of H_2SO_4 would be 6 N in acid-base reactions (3 M × 2 equivalents/mol = 6 N) and 3 N in sulfate precipitation reactions (3 M × 1 equivalents/mol = 3 N).

Dilution

A solution is **diluted** when solvent is added to a solution of higher concentration to produce a solution of lower concentration. The concentration of a solution after dilution can be conveniently determined using the equation below:

$$M_iV_i = M_fV_f$$

where M is molarity, V is volume, and the subscripts i and f refer to initial and final values, respectively.

Example: How many mL of a 5.5 M NaOH solution must be used to prepare 300 mL of a 1.2 M NaOH solution?

Solution:

$$5.5 \text{ M} \times V_i = 1.2 \text{ M} \times 300 \text{ mL}$$

$$V_i = \frac{1.2 \text{ M} \times 300 \text{ mL}}{5.5 \text{ M}}$$

$$V_i = 65 \text{ mL}$$

Aqueous Solutions

When water is the solvent, the dissolving process is called hydration, and the resulting solution is known as an aqueous solution. These are the most common solutions you will encounter on Test Day. The aqueous state is denoted by the symbol (*aq*). When discussing the chemistry of aqueous solutions and answering questions on the exam, it is useful to know how soluble various salts are in water; this information is given by the solubility rules below:

Soluble salts (with exceptions):

- All salts of alkali metal ions (e.g., Li^+, Na^+, K^+, Rb^+, Cs^+, Fr^+) are water soluble.
- All salts of the ammonium ion (NH_4^+) are water soluble.
- All salts with chloride (Cl^-), bromide (Br^-), and iodide (I^-) ions are water soluble, with the exception of salts containing Ag^+, Pb^{2+}, and Hg_2^{2+}.
- All salts of the sulfate ion (SO_4^{2-}) are water soluble, with the exception of those containing Ca^{2+}, Sr^{2+}, Ba^{2+}, and Pb^{2+}.

Insoluble salts (with exceptions):

- All metal oxides (a metal combined with oxygen) are insoluble, with the exception of alkali metal oxides and CaO, SrO, and BaO, all of which hydrolyze to form solutions of the corresponding metal hydroxides.
- All hydroxides (containing OH^-) are insoluble, with the exception of the alkali metal hydroxides and $Ca(OH)_2$, $Sr(OH)_2$, and $Ba(OH)_2$.
- All salts with carbonates (CO_3^{2-}), phosphates (PO_4^{3-}), sulfides (S^{2-}), and sulfites (SO_3^{2-}) are insoluble, with the exception of those that contain alkali metals or ammonium.

Electrolytes

The electrical conductivity of aqueous solutions is governed by the presence and concentration of ions in solution. Therefore, pure water does not conduct an electrical current well, since the concentrations of hydrogen and hydroxide ions are very small. Solutes that make conductive solutions are called electrolytes. A solute is considered a strong electrolyte if it dissociates completely into its constituent ions. Examples of **strong electrolytes** include ionic compounds, such as NaCl and KI, and molecular compounds with highly polar covalent bonds that dissociate into ions when dissolved, such as HCl in water. A **weak electrolyte**, on the other hand, ionizes or hydrolyzes incompletely in aqueous solution, and only some of the solute is present in ionic form. Examples include acetic acid and other weak acids, ammonia and other weak bases, and $HgCl_2$. Many compounds do not ionize at all in aqueous solution, retaining their molecular structure in solution, which usually limits their solubility. These compounds are called **nonelectrolytes** and include many nonpolar gases and organic compounds, such as oxygen and sugar.

REVIEW PROBLEMS

1. Which of the following choices correctly describes the solubility behavior of potassium chloride (KCl)?

 A. Solubility in CCl_4 > Solubility in CH_3CH_2OH > Solubility in H_2O

 B. Solubility in H_2O > Solubility in CH_3CH_2OH > Solubility in CCl_4

 C. Solubility in CH_3CH_2OH > Solubility in CCl_4 > Solubility in H_2O

 D. Solubility in H_2O > Solubility in CCl_4 > Solubility in CH_3CH_2OH

 E. Solubility in CH_3CH_2OH > Solubility in H_2O > Solubility in CCl_4

2. A simple cake icing can be made by dissolving a large quantity of sugar (sucrose) in boiling water, cooling the solution, and applying it to the cake before it reaches room temperature. The icing appears to harden as it cools in part because the

 A. sugar molecules freeze from liquid to solid.

 B. common ion effect limits the dissolution of sucrose.

 C. K_{sp} of sucrose increases as the solution cools.

 D. sugar concentration increases as water boils off, and the solubility of sugar in water decreases as the solution cools.

 E. sucrose molecules dissociate to form fructose and glucose, which are insoluble in water.

3. How much NaOH must be added to 200 mL of water to make a 1.0 M NaOH solution?

 A. 8.0 g

 B. 16 g

 C. 40 g

 D. 56 g

 E. 80 g

4. To what volume must 10.0 mL of 5.00 M of HCl be diluted to make a 0.500 M HCl solution?

 A. 1.00 mL

 B. 50.0 mL

 C. 100 mL

 D. 250 mL

 E. 500 mL

5. What is the normality of a 2.0 M solution of phosphoric acid, H_3PO_4, for an acid-base titration?

 A. 0.67

 B. 2.0

 C. 3.0

 D. 4.0

 E. 6.0

6. Given that the molecular mass of ethyl alcohol, CH_3CH_2OH, is 46 g/mol and that of water is 18 g/mol, how many grams of ethyl alcohol must be mixed with 100 mL of water for the mole fraction (X) of ethyl alcohol to be 0.2?

7. Name the following ionic compounds:
 A. $NaClO_4$
 B. $NaClO$
 C. $NaNO_3$
 D. KNO_2
 E. Li_2SO_4
 F. $MgSO_3$

8. Which of the following will be the most electrically conductive?
 A. Sugar dissolved in water
 B. Saltwater
 C. Salt dissolved in an organic solvent
 D. An oil and water mixture
 E. Pure water

SOLUTIONS TO REVIEW PROBLEMS

1. **B** KCl is an ionic salt and, therefore, is soluble in polar solvents and insoluble in nonpolar solvents. Water, H_2O, is a highly polar liquid. The carbon atom in carbon tetrachloride, CCl_4, is bonded to four atoms, so the molecule is tetrahedral. This geometry means that the individual dipole moments of the bonds cancel and CCl_4 is nonpolar. Ethanol (CH_3CH_2OH) has two carbon atoms in tetrahedral arrangements; most of the dipole moments associated with the bonds are the same, but the C−C and C−OH bonds are different, so ethanol is somewhat polar. Thus, the polarities of the three solvents decrease in the following sequence: $H_2O > CH_3CH_2OH > CCl_4$, with the solubility of KCl decreasing along that sequence as well.

2. **D** The sugar-water solution hardens because it becomes supersaturated as it cools, since the solubility (K_{sp}) of sucrose in water decreases significantly with temperature. Evaporation of water during boiling also contributes to the solution's supersaturated state by reducing the amount of solvent present, which is the opposite of choice (C). Choice (A) is incorrect: in this example the sugar is dissolved, not melted (sucrose melts at 185°C, well above the boiling point of even sucrose-saturated water). Since there are no other sources of sucrose present, choice (B) is not relevant. Choice (E) is also incorrect; although sucrose is made from fructose and glucose, all are soluble in water.

3. **A** To answer this question, first find the formula mass of NaOH from the periodic table. Rounding to whole numbers, the atomic mass of Na is 23 g/mol, the atomic mass of O is 16 g/mol, and the atomic mass of H is 1 g/mol, so the formula mass of NaOH is 40 g/mol. Thus, 40 g of NaOH is 1 mol, and 40 g of NaOH dissolved in 1 L of water is a 1 M solution of NaOH. To determine how much of the solute is needed to make 200 mL of such a solution, set up the following ratio:

$$\frac{x}{200 \text{ mL}} = \frac{40 \text{ g}}{1 \text{ L}} \times \frac{1 \text{ L}}{1,000 \text{ mL}}$$

$$\frac{x}{200 \text{ mL}} = \frac{40 \text{ g}}{1,000 \text{ mL}}$$

$$x = \frac{(40 \text{ g})(200 \text{ mL})}{1,000 \text{ mL}} = 8 \text{ g}$$

4. **C** When a solution is diluted, more solvent is added, yet the number of moles of solute remains the same. To solve a dilution problem, the following equation is used:

$$M_i V_i = M_f V_f$$

where i represents the initial conditions and f represents the final conditions. Therefore, the calculation to solve for the final volume is:

$$(5.0 \text{ M})(10 \text{ mL}) = (0.50 \text{ M})(V_f)$$

$$V_f = 100 \text{ mL}$$

and the correct answer is (C).

5. **E** Each mole of H_3PO_4 contains three moles of hydrogen and (since this is an acid) three mole equivalents. A 2 M solution of this acid is thus:

$$2\,M \times \frac{3\,N}{1\,M} = 6\,N$$

6. **64.4 g**

The number of moles of water is found by estimating the density of water to be 1 g/mL.

$$\text{mol } H_2O = \frac{(100\,\text{mL } H_2O)(1\,\text{g/mL})}{18\,\text{g/mol}} = 5.6\,\text{mol}$$

If the mole fraction of ethyl alcohol is to be 0.2, then the mole fraction of water must be 0.8. If n equals the total number of moles:

$$5.6\,\text{mol} = 0.8n$$
$$n = 7\,\text{mol}$$

Then:

mol ethyl alcohol = $(0.2)(7\,\text{mol})$ = 1.4 mol

and:

grams ethyl alcohol = (1.4 mol ethyl alcohol)(46 g/mol) = 64.4 g ethyl alcohol.

7. (Oxidation numbers—discussed in detail in Chapter 29, Reaction Types—have been placed in parentheses for additional practice.)
 A Sodium perchlorate (Cl: +7)
 B Sodium hypochlorite (Cl: +1)
 C Sodium nitrate (N: +5)
 D Potassium nitrite (N: +3)
 E Lithium sulfate (S: +6)
 F Magnesium sulfite (S: +4)

8. **B** Only ionic compounds (electrolytes) dissolved in polar solvents will conduct electricity. Sugar is a covalent solid and therefore is not an electrolyte even when dissolved in water. Answers (C) and (D) are incorrect because salt will not dissolve appreciably in an organic solvent and oil and water are immiscible. Answer (E) is incorrect because, while pure water is a polar solvent, no electrolyte is present to conduct electricity. NaCl is an ionic compound, so (B) is correct.

CHAPTER TWENTY-NINE

Reaction Types

LEARNING OBJECTIVES

After this chapter, you will be able to:

- Recall the five categories of chemical reactions
- Calculate coefficients necessary to balance a redox reaction

TYPES OF CHEMICAL REACTIONS

Elements and compounds can react to form other species in many ways, and memorizing every reaction would be impossible as well as unnecessary. However, nearly every inorganic reaction can be classified into at least one of five general categories.

Combination Reactions

Combination reactions are reactions in which two or more **reactants** form one **product**. This can occur when elements react to form compounds, such as during the formation of sulfur dioxide by burning sulfur:

$$S\ (s) + O_2\ (g) \rightarrow SO_2\ (g)$$

Combination reactions can also occur when two compounds react to form a new compound. For example, in the equation below, gaseous ammonia is reacted with gaseous hydrogen chloride and forms ammonium chloride:

$$NH_3\ (g) + HCl\ (g) \rightarrow NH_4Cl\ (s)$$

Decomposition Reactions

A decomposition reaction is defined as one in which a compound breaks down into two or more substances, usually as a result of heating or electrolysis. For example, when compounds that contain oxygen are heated, most will decompose to form molecular oxygen. **Electrolysis** is a specific process that causes the decomposition of a compound by passing an electric current through the reactant. Another example of a decomposition reaction is the breakdown of mercury (II) oxide (the sign Δ represents the addition of heat):

$$2\ HgO\ (s) \xrightarrow{\Delta} 2\ Hg\ (l) + O_2\ (g)$$

Single-Displacement Reactions

Single-displacement reactions occur when an atom (or ion) of one compound is replaced by an atom of another element. For example, zinc metal will displace copper ions in a copper sulfate solution to form zinc sulfate:

$$Zn \ (s) + CuSO_4 \ (aq) \rightarrow Cu \ (s) + ZnSO_4 \ (aq)$$

Single-displacement reactions are often further classified as **redox** reactions, discussed below.

Net ionic equations

Because many reactions, including some displacements, involve ions in solution, their net equations can also be written in ionic form. In the example where zinc is reacted with copper sulfate, the **ionic equation** is:

$$Zn \ (s) + Cu^{2+} \ (aq) + SO_4^{2-} \ (aq) \rightarrow Cu \ (s) + Zn^{2+} \ (aq) + SO_4^{2-} \ (aq)$$

When displacement reactions occur, there are usually **spectator ions** that do not take part in the overall reaction but simply remain in solution throughout. The spectator ion in the equation above is sulfate, which does not undergo any transformation during the reaction. A **net ionic reaction** can be written showing only the species that actually participate in the reaction:

$$Zn \ (s) + Cu^{2+} \ (aq) \rightarrow Cu \ (s) + Zn^{2+} \ (aq)$$

Net ionic equations are important for demonstrating the actual reaction that occurs during a displacement reaction.

Double-Displacement Reactions

In double-displacement reactions, also called **metathesis reactions**, elements from two different compounds displace each other to form two new compounds. This type of reaction occurs when one of the products is removed from the solution as a precipitate or gas, or when two of the original species combine to form a weak electrolyte that remains undissociated in solution. For example, when solutions of calcium chloride and silver nitrate are combined, insoluble silver chloride forms in a solution of calcium nitrate:

$$CaCl_2 \ (aq) + 2 \ AgNO_3 \ (aq) \rightarrow Ca(NO_3)_2 \ (aq) + 2 \ AgCl \ (s)$$

Neutralization reactions

Neutralization reactions are a specific type of double displacement that occurs when an acid reacts with a base to produce a solution of a salt and water. For example, hydrochloric acid and sodium hydroxide will react to form sodium chloride and water:

$$HCl \ (aq) + NaOH \ (aq) \rightarrow NaCl \ (aq) + H_2O \ (l)$$

This type of reaction will be discussed further in Chapter 36.

Oxidation-Reduction Reactions

A reaction that involves the transfer of electrons from one species to another is an oxidation-reduction (redox) reaction. This type of reaction can be divided into two half-reactions, **oxidation** (loss of electrons) and **reduction** (gain of electrons). The law of conservation of charge states that an electrical charge can be neither created nor destroyed. Thus, an isolated loss or gain of electrons cannot occur; oxidation and reduction must occur simultaneously, resulting in an electron transfer called a **redox reaction**. An **oxidizing agent**, or oxidant, causes another atom in a redox reaction to undergo oxidation and is itself reduced. A **reducing agent**, or reductant, causes the other atom to be reduced and is itself oxidized.

Assigning oxidation numbers

It is important, of course, to know which atom is oxidized and which is reduced. **Oxidation numbers** are assigned to atoms to keep track of the redistribution of electrons during a chemical reaction. From the oxidation numbers of the reactants and products, it is possible to determine how many electrons are gained or lost by each atom.

The oxidation number is the number of charges an atom would have in a molecule if electrons were completely transferred in the direction indicated by the difference in electronegativity. Along the same lines, an element is said to be oxidized (loses electrons) if its oxidation number increases in a given reaction, and an element is said to be reduced (gains electrons) if the oxidation number of the element decreases in a given reaction. The oxidation number of an atom in a compound is assigned according to the following rules:

- The oxidation number of a free element (an element in its elemental state) is zero, irrespective of how complex the molecule is.
- The oxidation number for a monatomic ion is equal to the charge of the ion. For example, the oxidation numbers for Na^+, Cu^{2+}, Fe^{3+}, Cl^-, and N^{3-} are $+1$, $+2$, $+3$, -1, and -3, respectively.
- The oxidation number of each Group IA element in a compound is $+1$. The oxidation number of each Group IIA element in a compound is $+2$.
- The oxidation number of each Group VIIA element in a compound is -1, except when combined with an element of higher electronegativity. For example, in HCl, the oxidation number of Cl is -1; in HOCl, however, the oxidation number of Cl is $+1$ because oxygen is more electronegative and has an oxidation state of -2 (oxygen is discussed further below).
- The oxidation number of hydrogen is generally $+1$. However, the oxidation number can be -1 when H is placed with less electronegative elements (Groups IA and IIA). Examples of hydrogen's oxidation state being -1 occur with NaH and CaH_2. Nevertheless, the most common oxidation number of hydrogen is $+1$.
- In most compounds, the oxidation number of oxygen is -2. This is not the case, however, in molecules such as OF_2. Here, because F is more electronegative and has an oxidation state of -1, the oxidation number of oxygen is $+2$. Also, in peroxides such as BaO_2, the oxidation number of O is -1 instead of -2 because of the structure of the peroxide ion, $[O-O]^{2-}$ (for confirmation, note that Ba, a Group IIA element, cannot be a $+4$ cation).

- The sum of the oxidation numbers of all the atoms present in a neutral compound is zero. The sum of the oxidation numbers of the atoms present in a polyatomic ion is equal to the charge of the ion. Thus, for SO_4^{2-}, the sum of the oxidation numbers must be -2.
- Fluorine has an oxidation number of -1 in all compounds because it has the highest electronegativity of all the elements.
- Metallic elements have only positive oxidation numbers; however, nonmetallic elements may have a positive or negative oxidation number.

Example: Assign oxidation numbers to the atoms in the following reaction to determine the oxidized and reduced species and the oxidizing and reducing agents:

$$SnCl_2 + PbCl_4 \rightarrow SnCl_4 + PbCl_2$$

Solution: All these species are neutral, so the oxidation numbers of each compound must add up to zero. In $SnCl_2$, since there are two chlorines present and chlorine has an oxidation number of -1, Sn must have an oxidation number of $+2$. Similarly, the oxidation number of Sn in $SnCl_4$ is $+4$; the oxidation number of Pb is $+4$ in $PbCl_4$ and $+2$ in $PbCl_2$. Notice that the oxidation number of Sn increases from $+2$ to $+4$; it loses electrons and thus is oxidized, making it the reducing agent. Since the oxidation number of Pb has decreased from $+4$ to $+2$, it has gained electrons and been reduced. Pb is the oxidizing agent. The sum of the charges on both sides of the reaction is equal to zero, so charge has been conserved.

Balancing redox reactions

Balancing any reaction requires not only stoichiometric balance but also charge balance. Because redox reactions involve the transfer of electrons (and therefore of charge) between different elements, balancing redox reactions introduces an additional level of complexity. However, with a straightforward, stepwise method, balancing chemical reactions on the test becomes more manageable.

By assigning oxidation numbers to the reactants and products, one can determine how many moles of each species are required for conservation of charge and mass, which is necessary to balance the equation. To balance a redox reaction, both the net charge and the number of atoms must be equal on both sides of the equation. The most common method for balancing redox equations is the **half-reaction method**, also known as the **ion-electron method**, in which the equation is separated into two half-reactions—the oxidation part and the reduction part. Each half-reaction is balanced separately, and they are then added to give a balanced overall reaction:

Example: Balance the redox reaction between MnO_4 and I in an acidic solution:

$$MnO_4^- + I^- \rightarrow I_2 + Mn^{2+}$$

Solution: Note how the oxidation numbers for I and Mn change (I changes from an oxidation state of -1 to 0, and Mn changes from $+7$ to $+2$) and that the reaction is not balanced. So, use the following five-step method to balance redox reactions:

Step 1: *Separate the two half-reactions.*

$$I^- \rightarrow I_2$$
$$MnO_4^- \rightarrow Mn^{2+}$$

Step 2: *Balance the atoms of each half-reaction.* First, balance all atoms except H and O. Next, add H_2O to balance the O atoms and then add H^+ to balance the H atoms.

To balance the iodine atoms, place a coefficient of two before the I^- ion:

$$2\,I^- \rightarrow I_2$$

For the permanganate half-reaction, Mn is already balanced. Balance the oxygen atoms by adding $4\,H_2O$ to the right side:

$$MnO_4^- \rightarrow Mn^{2+} + 4\,H_2O$$

Finally, add H^+ to the left side to balance the $4\,H_2O$s. These two half-reactions are now balanced:

$$MnO_4^- + 8\,H^+ \rightarrow Mn^{2+} + 4\,H_2O$$

Step 3: *Balance the electrons of each half-reaction.* Each half-reaction must have the same net charge on the left and right sides, and the only species that can be used to balance charges are electrons, each with a -1 charge. Additionally, the reduction half-reaction must consume the same number of electrons as supplied by the oxidation half.

For the oxidation reaction, the left side has a charge of -2, and the right side has a charge of 0. Add two electrons to the right side of the reaction to balance both sides to be -2:

$$2\,I^- \rightarrow I_2 + 2\,e^-$$

For the reduction reaction, there is a charge of $+7$ on the left and $+2$ on the right. By adding five electrons to the left side, the charges on both sides become $+2$, balancing the half-reaction:

$$MnO_4^- + 8\,H^+ + 5\,e^- \rightarrow Mn^{2+} + 4\,H_2O$$

Next, both half-reactions must have the same number of electrons so that, when the half-reactions are combined, the electrons cancel. Therefore, multiply the oxidation half by five and the reduction half by two.

$$5(2\,I^- \rightarrow I_2 + 2\,e^-)$$
$$2(MnO_4^- + 8\,H^+ + 5\,e^- \rightarrow Mn^{2+} + 4\,H_2O)$$

Step 4: *Combine the half-reactions.*

$$10\,I^- \rightarrow 5\,I_2 + 10\,e^-$$
$$2\,MnO_4^- + 10\,e^- + 16\,H^+ \rightarrow 2\,Mn^{2+} + 8\,H_2O$$

The sum of the two equations is:

$$10\,I^- + 10\,e^- + 16\,H^+ + 2\,MnO_4^- \rightarrow 5\,I_2 + 10\,e^- + 2\,Mn^{2+} + 8\,H_2O$$

To find the final equation, cancel out the electrons and anything that appears on both sides of the equation:

$$10\,I^- + 16\,H^+ + 2\,MnO_4^- \rightarrow 5\,I_2 + 2\,Mn^{2+} + 8\,H_2O$$

Step 5: *Confirm that mass and charge are balanced.* Here, there is a $+4$ net charge on each side of the reaction equation, and the atoms are stoichiometrically balanced.

For redox reactions in a basic (instead of acidic) solution, an additional step is required because H^+ will not be readily available and should not appear as a reactant. Use the same initial steps 1–4, but

then add enough hydroxide (OH^-) to both sides to completely combine with the free H^+, forming water. Then, remove any species that appears on both sides and complete step 5 as usual to confirm everything is still balanced.

For example, in order to balance the same redox reaction of MnO_4 and I in a basic solution (instead of acidic), start by completing the same steps 1–3. Recall that during step 4, you combined the half-reactions:

Step 4: *Combine the half-reactions in basic solution.*

$$10\ I^- + 10\ e^- + 16\ H^+ + 2\ MnO_4^- \rightarrow 5\ I_2 + 10\ e^- + 2\ Mn^{2+} + 8\ H_2O$$

Then, add 16 OH^- to both sides to neutralize the H^+:

$$10\ I^- + 10\ e^- + 16\ H^+ + 16\ OH^- + 2\ MnO_4^- \rightarrow 5\ I_2 + 10\ e^- + 2\ Mn^{2+} + 8\ H_2O + 16\ OH^-$$

Combine the H^+ and OH^- into water:

$$10\ I^- + 10\ e^- + 16\ H_2O + 2\ MnO_4^- \rightarrow 5\ I_2 + 10\ e^- + 2\ Mn^{2+} + 8\ H_2O + 16\ OH^-$$

Cancel out any species (here, e^- and H_2O) that appear on both sides to find the balanced redox reaction in a basic solution:

$$10\ I^- + 8\ H_2O + 2\ MnO_4^- \rightarrow 5\ I_2 + 2\ Mn^{2+} + 16\ OH^-$$

Step 5: Finally, confirm that mass and charge are balanced. Here, there is a -12 net charge on each side of the reaction equation, and the atoms are stoichiometrically balanced.

Redox reaction examples

Redox reactions can occur as variations of the major types of reactions above: combination, decomposition, and displacement.

1. **Combination reactions**: These types of reactions occur with two or more substances.

Example:	Equation	$N_2\ (g)$	$+\ 3\ H_2\ (g)$	$\rightarrow 2\ NH_3\ (g)$
	Oxidation #s	0	0	$-3\ +1$

2. **Decomposition reactions**: These types of reactions lead to the production of two or more substances.

Example:	Equation	$2\ H_2O\ (l)$	$\rightarrow H_2\ (g)$	$+\ O_2\ (g)$
	Oxidation #s	$+1\ -2$	0	0

3. **Displacement reactions**: In this type of reaction, an atom or molecule is displaced from a given compound by a different atom or molecule.

Example:	Equation	$2\ Na\ (s)$	$+\ 2\ H_2O\ (l)$	$\rightarrow 2\ NaOH$	$+\ H_2\ (g)$
	Oxidation #s	0	$+1\ -2$	$+1\ -2\ +1$	0

REVIEW PROBLEMS

1. The reaction below is best classified as which type of reaction?

$$CH_3CO_2Na + HClO_4 \rightarrow CH_3CO_2H + NaClO_4$$

 A. Double-displacement reaction

 B. Combination reaction

 C. Decomposition reaction

 D. Single-displacement and decomposition reaction

 E. Single-displacement reaction

2. Which of the following represents the net ionic equation for the reaction given?

$$AgNO_3\ (aq) + Cu\ (s) \rightarrow CuNO_3\ (aq) + Ag\ (s)$$

 A. $AgNO_3\ (aq) + Cu\ (s) \rightarrow CuNO_3\ (aq) + Ag\ (s)$

 B. $Ag^+\ (aq) + Cu\ (s) \rightarrow Cu^+\ (aq) + Ag\ (s)$

 C. $AgNO_3\ (aq) + Cu\ (s) \rightarrow Cu^+\ (aq) + NO_3^-\ (aq) + Ag\ (s)$

 D. $Ag^+\ (aq) + NO_3^-\ (aq) + Cu\ (s) \rightarrow CuNO_3\ (aq) + Ag\ (s)$

 E. $Ag\ (aq) + NO_3\ (aq) + Cu\ (s) \rightarrow Cu\ (aq) + NO_3\ (aq) + Ag\ (s)$

3. Assign oxidation numbers to each atom of the following reaction equation:

$$2\ Fe\ (s) + O_2\ (g) + 2\ H_2O\ (l) \rightarrow 2\ Fe(OH)_2\ (s)$$

4. Using the ion-electron method, balance the following equation of a reaction taking place in an acidic solution:

$$ClO_3^- + AsO_2^- \rightarrow AsO_4^{3-} + Cl^-$$

Section III: General Chemistry

SOLUTIONS TO REVIEW PROBLEMS

1. **A** Because the only change is that the Na from CH_3CO_2Na exchanges with the H from $HClO_4$, this is a double-displacement reaction. Alternately, this reaction could be classified as a neutralization, since it is a reaction between an acid and a base.

2. **B** In displacement reactions, there are often ionic species that do not play a role in the overall reaction. Instead, they remain in solution throughout the entire reaction. Thus, displacement reactions can be written in terms of net ionic equations, which express the reactions of the participating species. In the reaction between aqueous silver nitrate and copper metal to form aqueous copper (I) nitrate and metallic silver, the nitrate ion does not participate in the reaction; thus, it is a spectator ion. Therefore, the only species that are involved in the reaction are copper metal and the Ag^+ ion, which react to form the Cu^+ ion and silver metal.

3. **Fe (s): Fe 0;**

 O_2 (g): O 0;

 H_2O (l): H +1, O −2;

 $Fe(OH)_2$ (s): Fe +2, O −2, H +1

 To assign oxidation numbers, use the rules given in the text. Fe (s) and O_2 (g) have oxidation numbers of zero because they are free elements. Hydrogen in H_2O (l) has an oxidation number of +1 because oxygen is more electronegative than hydrogen; likewise, oxygen in H_2O (l) has an oxidation number of −2. Oxygen and hydrogen in $Fe(OH)_2$ (s) have the same oxidation numbers as in H_2O (l). Each OH group contributes a charge of −1 to $Fe(OH)_2$, and since there are 2 OH groups, their overall contribution to the compound is −2. Since $Fe(OH)_2$ (s) is a neutral compound and thus has no overall charge, the sum of all the oxidation numbers of the atoms in this compound is zero. Consequently, the Fe in $Fe(OH)_2$ (s) must possess a charge of +2 to make the overall charge on the compound zero.

4. The balanced equation is:

$$ClO_3^- + 3\ H_2O + 3\ AsO_2^- \rightarrow 3\ AsO_4^{3-} + Cl^- + 6\ H^+$$

GC

Electrochemistry

Electrochemistry is the study of the relationships between chemical reactions and electrical energy. **Electrochemical reactions** include spontaneous reactions that produce electrical energy and nonspontaneous reactions that use electrical energy to produce a chemical change. Both types of reactions always involve a transfer of electrons through the processes of oxidation and reduction, and like other chemical reactions they result in conservation of charge and mass.

ELECTROCHEMICAL CELLS

Electrochemical cells are contained systems in which a redox reaction occurs, either to provide electrical energy or to use electrical energy for a useful purpose. There are two types of electrochemical cells: galvanic cells (also known as voltaic cells) and electrolytic cells. Spontaneous reactions occur in galvanic cells, and nonspontaneous reactions in electrolytic cells. Both types contain electrical conductors known as **electrodes,** where oxidation and reduction occur. For all electrochemical cells, the electrode where oxidation occurs is called the **anode**, and the electrode where reduction occurs is called the **cathode**.

MNEMONIC

Electrodes in an electrochemical cell:

AN OX and a **RED CAT**. The **AN**ode is the site of **OX**idation; **RED**uction occurs at the **CAT**hode.

Galvanic Cells

A redox reaction occurring in a **galvanic cell** has a negative ΔG and is therefore a **spontaneous reaction.** Galvanic cell reactions supply energy and, therefore, are used to do work. This energy is harnessed by placing the oxidation and reduction half-reactions in separate containers called half-cells. The half-cells are then connected by an apparatus that allows the flow of electrons between the half-cells, creating a circuit.

A common example of a galvanic cell is the Daniell cell shown in Figure 30.1.

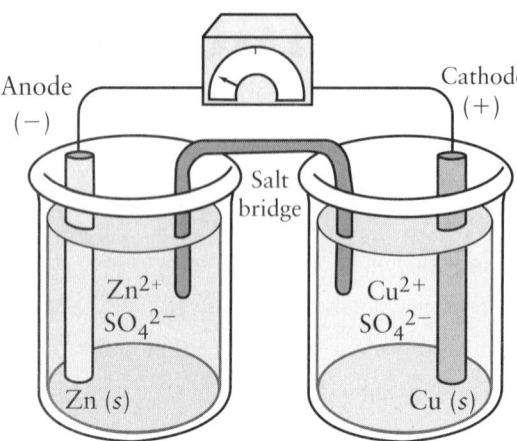

Figure 30.1

In the Daniell cell, a zinc bar is placed in an aqueous $ZnSO_4$ solution, and a copper bar is placed in an aqueous $CuSO_4$ solution. The anode of this cell is the zinc bar, where Zn (s) is oxidized to Zn^{2+} (aq). The cathode is the copper bar and is the site of the reduction of Cu^{2+} (aq) to Cu (s). The half-cell reactions are written as follows:

$$Zn\ (s) \rightarrow Zn^{2+}\ (aq) + 2\ e^-\ (anode)$$

$$Cu^{2+}\ (aq) + 2\ e \rightarrow Cu\ (s)\ (cathode)$$

If the two half-cells were not separated, the Cu^{2+} ions would react directly with the zinc bar, and no useful electrical work would be obtained. However, to complete the circuit, the two solutions must be connected somehow; without connection, the electrons from the zinc oxidation half-reaction would not be able to get to the copper ions, and no reaction would occur. Thus, a wire or other conductor is necessary.

Because of the flow of electrons away from the anode and toward the cathode, negative charge can begin to build up in the solution surrounding the cathode, and positive charge can begin to build up in the solution surrounding the anode. If enough charge were to build up, the reaction would become unfavorable and cease. However, this charge gradient can be dissipated by the presence of an additional component that permits the exchange of cations and anions between the two cells, such as a salt bridge or semipermeable membrane. A salt bridge contains an inert electrolyte, usually KCl or NH_4NO_3, whose ions will not react directly with the electrodes or the ions in solution.

In the previous example with a KCl salt bridge, the inert anions (Cl^-) flow from the salt bridge toward the anode to balance the new Zn^{2+} ions being created, and the inert cations (K^+) flow toward the cathode to balance the Cu^{2+} being deposited onto the cathode. This flow depletes the salt bridge and, along with the finite quantity of Cu^{2+} in the solution, accounts for the relatively short lifetime of the cell. Note that the *cat*ions from the salt bridge flow to the *cat*hode, and the *an*ions flow to the *an*ode; this is where the electrodes get their names from!

A cell diagram is a shorthand notation representing the reactions in an electrochemical cell. A cell diagram for the Daniell cell is as follows:

$$\text{Zn } (s) \mid \text{Zn}^{2+}(x \text{ M SO}_4{}^{2-}) \ (aq) \parallel \text{Cu}^{2+}(y \text{ M SO}_4{}^{2-}) \ (aq) \mid \text{Cu } (s)$$

The following rules are used in constructing a cell diagram:

1. The reactants and products are always listed from left to right in the form:

 anode | anode solution || cathode solution | cathode

2. A single vertical line indicates a phase boundary.

3. A double vertical line indicates the presence of a salt bridge or some other type of barrier.

Electrolytic Cells

A redox reaction occurring in an **electrolytic cell** has a positive ΔG and is therefore **nonspontaneous**. In **electrolysis**, electrical energy is required to induce reaction. Since the reaction is nonspontaneous, the oxidation and reduction half-reactions can be placed in the same container, and no salt bridge is required.

An example of an electrolytic cell, in which molten NaCl is electrolyzed to form Cl_2 (g) and Na (l), is given in Figure 30.2. An electrolytic cell is most easily recognized by the presence of a battery or power source used to drive the nonspontaneous redox reaction.

Figure 30.2

In this cell, Na^+ ions migrate toward the cathode, where they are reduced to Na (l) according to the reaction $\text{Na}^+ + \text{e}^- \rightarrow \text{Na } (l)$. Similarly, Cl^- ions migrate toward the anode, where they are oxidized to Cl_2 (g) by the reaction $2 \text{ Cl}^- \rightarrow \text{Cl}_2$ $(g) + 2 \text{ e}^-$. The electrons liberated at the anode travel through the wire to provide the electrons used at the cathode.

Electrode Charge Designations

The anode of an **electrolytic cell** is considered **positive** because it is attached to the positive pole of the battery. Just like any anode, it attracts anions from the solution. The anode of a **galvanic cell,** on the other hand, is considered **negative** because the spontaneous oxidation reaction that takes place at the galvanic cell's anode is the original source of that cell's negative charge (i.e., is the source of electrons). In spite of this difference in designating charge, oxidation always takes place at the anode in both types of cells, reduction always takes place at the cathode in both types of cells, and electrons always flow through the wire from the anode to the cathode.

In a galvanic cell, charge is spontaneously created as electrons are released by the oxidizing species at the anode. Since this is the source of electrons, the anode of a galvanic cell is considered the negative electrode.

In an electrolytic cell, electrons are forced through the cathode, where they encounter the oxidizing agent. The cathode is providing electrons, and thus the cathode of an electrolytic cell is considered the negative electrode. You can also think of the cathode as the electrode attached to the negative pole of the battery (or other power source) used for the electrolysis. Like in any cell, the cathode attracts cations.

One common topic area in which this distinction arises is electrophoresis, a technique often used to separate amino acids based on their isoelectric points, or pIs (see Chapter 51). The positively charged amino acid cations (i.e., those that are protonated at the pH of the solution) will migrate toward the cathode; negatively charged amino acid anions (i.e., those that are deprotonated at the solution pH) migrate instead toward the anode. Electrophoresis can also be used to separate proteins, nucleic acids, and other biomolecules based on their size and charge.

MNEMONIC

Electron flow in an electrochemical cell: **FAT CAT** **E**lectrons flow **F**rom **A**node **T**o **CAT**hode in all types of electrochemical cells.

MNEMONIC

The a**N**ode of a galva**N**ic cell is always **N**egative.

Quantitative Electrochemistry

The number of moles exchanged in an electrochemical cell can be determined from the balanced reaction for that cell. For a half-reaction that involves the transfer of n electrons per atom, one mole of M (s) will be produced if n moles of electrons are supplied.

$$M^{n+} + n\,e^- \rightarrow M$$

One electron carries a charge of 1.6×10^{-19} coulombs (C). The charge carried by one mole of electrons can be calculated by multiplying this number by Avogadro's number:

$$(1.6 \times 10^{-19})(6.022 \times 10^{23}) = 96{,}487 \text{ C/mol e}^-$$

This number is called the **Faraday constant**, and one **farad (F)** is equivalent to the amount of charge contained in one mole of electrons (1 F = 96,487 coulombs, or J/V, but can be rounded to 10^5 coulombs). This can be used to determine the number of moles of electrons transferred by an electrochemical cell according to the equation:

$$i \times t = n \times F$$

where i = current in amperes, t = time in seconds, n = number of moles of electrons, and F = the Faraday constant.

Example: How many moles of solid copper are produced during a redox reaction that generates 4 A of current for three seconds according to the reaction:

$$Zn\ (s) + Cu^{2+}\ (aq) \rightarrow Zn^{2+}\ (aq) + Cu\ (s)$$

Solution: First, determine the number of moles of electrons transferred using:

$$i \times t = n \times F$$

$$n = \frac{it}{F} = (4)(3)/10^5 = 12 \times 10^{-5} = 1.2 \times 10^{-4} \text{ moles of electrons}$$

Next, determine how many moles of electrons are transferred in the reaction. Copper is reduced from Cu^{2+} to Cu (s), which requires two electrons:

$$Cu^{2+}\ (aq) + 2\ e^- \rightarrow Cu\ (s)$$

Thus, one mole of Cu will be produced for every two electrons transferred, and you can use this final conversion to calculate the number of moles of solid copper produced:

$$1.2 \times 10^{-4} \text{ mol e}^- \times \frac{1 \text{ mol Cu}}{2 \text{ mol e}^-} = 0.6 \times 10^{-4} \text{ mol Cu} = 6 \times 10^{-5} \text{ mol Cu}$$

REDUCTION POTENTIALS AND THE ELECTROMOTIVE FORCE

Reduction Potentials

The species in a redox reaction that will be oxidized or reduced can be determined from the **reduction potential** of each species, defined as the tendency of a species to acquire electrons and be reduced. Each chemical species has its own intrinsic reduction potential; the more positive the potential, the greater the tendency to be reduced.

A reduction potential is measured in volts (V) and is defined relative to the **standard hydrogen electrode (SHE)**, which is arbitrarily given a potential of 0.00 volts and is based on the half-reaction $2\ H^+\ (aq) + 2\ e^- \rightarrow H_2\ (g)$. **Standard reduction potential**, $(E°)$, is measured under **standard conditions**: 25°C, a 1 M concentration for each ion participating in the reaction, a partial pressure of 1 atm for each gas that is part of the reaction, and metals in their pure state. A higher $E°$ means a greater tendency for reduction to occur, while a lower $E°$ means a greater tendency for oxidation to occur. When two half-reactions occur in the same system, only one can be a reduction; the half-reaction with the lower reduction potential will occur in reverse as an oxidation.

Example: Given the following half-reactions and $E°$ values, determine which species would be oxidized and which would be reduced.

$$Ag^+\ (aq) + e^- \rightarrow Ag\ (s) \qquad\qquad E° = +0.80 \text{ V}$$

$$Tl^+\ (aq) + e^- \rightarrow Tl\ (s) \qquad\qquad E° = -0.34 \text{ V}$$

Solution: $Ag^+\ (aq)$ would be reduced to Ag (s), and Tl (s) would be oxidized to $Tl^+\ (aq)$, because $Ag^+\ (aq)$ has the higher $E°$. Therefore, the net redox reaction equation would be:

$$Ag^+\ (aq) + Tl\ (s) \rightarrow Tl^+\ (aq) + Ag\ (s)$$

which is the sum of the two spontaneous half-reactions.

Since reduction and oxidation are opposite processes, the half-reaction and the sign of the reduction potential are both reversed for the oxidation half-reaction. For instance, from the example above, the oxidation half-reaction and oxidation potential of Tl (s) are as follows:

$$\text{Tl } (s) \rightarrow \text{Tl}^+ \ (aq) + e^- \qquad\qquad E° = +0.34 \text{ V}$$

Electromotive Force

Standard reduction potentials are also used to calculate the **standard electromotive force (emf or $E°_{cell}$)** of a reaction, the difference in potential between two half-cells. Note that electromotive force is NOT a force in the physical sense but is rather an electrical potential. The $E°_{cell}$ of a reaction is determined by adding the standard reduction potential of the reduced species and the standard oxidation potential of the oxidized species. When adding standard potentials, do *not* multiply by the number of moles oxidized or reduced.

$$E°_{cell} = E°_{red} + E°_{ox}$$

The standard $E°_{cell}$ of a galvanic cell is positive, while the standard $E°_{cell}$ of an electrolytic cell is negative.

Example: Given that the standard reduction potentials for Sm^{3+} and $[RhCl_6]^{3-}$ are -2.41 V and $+0.44$ V, respectively, calculate the $E°_{cell}$ of the following reaction:

$$Sm^{3+} \ (aq) + \text{Rh } (s) + 6 \text{ Cl}^- \ (aq) \rightarrow [RhCl_6]^{3-} \ (aq) + Sm \ (s)$$

Solution: First, determine the oxidation and reduction half-reactions. As written, the Rh is oxidized, and the Sm^{3+} is reduced. Thus, the Sm^{3+} reduction potential is used as is, while the reverse reaction for Rh, $[RhCl_6]^{3-} \rightarrow \text{Rh} + 6 \text{ Cl}^-$, applies, and the oxidation potential of $[RhCl_6]^{3-}$ must be used. Then, using $E°_{cell} = E°_{red} + E°_{ox}$, the $E°_{cell}$ can be calculated to be $(-2.41 \text{ V}) + (-0.44 \text{ V}) = -2.85$ V. The cell is thus electrolytic as written because $E°_{cell}$ is negative. This means that the reaction would proceed spontaneously to the left, in which case Sm would be oxidized, while $[RhCl_6]^{3-}$ would be reduced. The $E°_{cell}$ would then be $+2.85$ V.

THERMODYNAMICS OF REDOX REACTIONS

E_{cell} and Gibbs Free Energy

The thermodynamic criterion for determining the spontaneity of a reaction is ΔG, Gibbs free energy, a measure of the maximum amount of useful work produced by a chemical reaction. In an electrochemical cell, the work done is dependent on the number of coulombs and the energy available. Thus, when standard conditions (25°C, 1 atm pressure, and all solutions at 1 M concentration) are present, ΔG and E_{cell} are related as follows:

$$\Delta G = -nFE_{cell}$$

where n is the number of moles of electrons exchanged, and F is the Faraday constant, 10^5 coulombs per mole. Keep in mind that if the Faraday constant is expressed in coulombs (J/V), ΔG must be expressed in J, not kJ.

K

The relationship demonstrates that the signs of ΔG and E°_{cell} are opposite. A galvanic cell has a negative ΔG and a positive E°_{cell}, whereas an electrolytic cell has a positive ΔG and negative E°_{cell}.

In addition, as Chapter 32 demonstrates:

$$\Delta G^\circ = -RT \ln K_{eq}$$

This relates ΔG to K_{eq}. When $K_{eq} > 1$, products are favored over reactants, the forward reaction is spontaneous, and $\Delta G < 0$. When $K_{eq} < 1$, reactants are favored, the reverse reaction is preferred, and $\Delta G > 0$. Combining the different equations for ΔG gives:

$$nFE^\circ_{cell} = RT \ln K_{eq}$$

This relationship shows that when $K_{eq} > 1$, $\ln K_{eq} > 0$, and E°_{cell} is positive; thus, the reaction goes forward. When $K_{eq} < 1$, $\ln K_{eq} < 0$, and E°_{cell} is negative; thus, the reaction goes in the reverse direction.

Effect of Concentration

The above equations assume standard conditions, which require 1 M concentrations for all the ionic species present and for all gases to be at a pressure of 1 atm. However, concentration does have an effect on the E_{cell}, which varies with the changing concentrations of the species involved. This can be determined by using the **Nernst equation**:

$$E_{cell} = E^\circ_{cell} - \left(\frac{RT}{nF}\right)(\ln Q)$$

Q is the reaction quotient for a given reaction and gives the concentrations of reactants and products when the reaction is not at equilibrium. For example, in this reaction:

$$aA + bB \rightarrow cC + dD$$

the reaction quotient would be:

$$Q = \frac{[C]^c\ [D]^d}{[A]^a\ [B]^b}$$

This allows the actual E_{cell} to be determined based on the E°_{cell} and reagent concentrations.

Note that the Nernst equation can be rewritten as:

$$E_{cell} = E^\circ_{cell} - \left(\frac{RT}{nF}\right)(\ln Q) = \left(\frac{RT}{nF}\right)(\ln K_{eq}) - \left(\frac{RT}{nF}\right)(\ln Q)$$

If $Q = 1$, as under standard conditions, when all concentrations are 1 M, then $\ln Q = 0$, and the entire last term of the equation disappears. This again confirms the relationship between ΔG, K_{eq}, and E_{cell}.

REVIEW PROBLEMS

1. If one farad is equivalent to 96,487 C/mol e⁻, what is the charge of an individual electron?

 A. 6.0×10^{-19} C
 B. 1.6×10^{-19} C
 C. 1.6×10^{19} C
 D. 5.8×10^{23} C
 E. 6.0×10^{28} C

2. If one farad is equivalent to 96,487 C/mol e⁻, how many farad are required for the reduction of one mole of Ni^{2+} (aq) to Ni (s)?

 A. 0.5 F
 B. 1 F
 C. 2 F
 D. 96,487 F
 E. 6.022×10^{23} F

3. If the gold-plating process occurs according to the following half-reaction, how many coulombs would be required to plate 0.600 g of Au onto a metal?

 $$Au^{3+} (aq) + 3 \text{ e}^- \rightarrow Au (s)$$

 A. 299 C
 B. 600 C
 C. 868 C
 D. 2,990 C
 E. 8,680 C

4. When the half-reactions below are combined in a galvanic cell, which species will be reduced, and which will be oxidized?

 $$F_2 (g) + 2 \text{ e}^- \rightarrow 2 \text{ F}^- (aq) \qquad\qquad E° = +2.87 \text{ V}$$
 $$Ca^{2+} (aq) + 2 \text{ e}^- \rightarrow Ca (s) \qquad\qquad E° = -2.76 \text{ V}$$

 A. F⁻ (aq) will be oxidized, and Ca^{2+} (aq) will be reduced.
 B. Ca^{2+} (aq) will be oxidized, and F_2 (g) will be reduced.
 C. Ca (s) will be oxidized, and F_2 (g) will be reduced.
 D. F_2 (g) will be oxidized, and Ca (s) will be reduced.
 E. Ca (s) will be oxidized, and F⁻ (aq) will be reduced.

5. What is the standard emf if the following half-reactions are combined in a galvanic cell?

 $Co^{3+} (aq) + e^- \rightarrow Co^{2+} (aq)$ $E° = +1.82$

 $Na^+ (aq) + e^- \rightarrow Na (s)$ $E° = -2.71$

 A. -4.53 V
 B. -0.89 V
 C. $+0.89$ V
 D. $+4.53$ V
 E. $+6.31$ V

6. What is the $E°_{cell}$ for a reaction in which $\Delta G° = -553.91$ kJ and two electrons are transferred?

 A. -2.87 V
 B. -2.87×10^{-3} V
 C. 2.87×10^{-3} V
 D. 2.87 V
 E. 2.87×10^3 V

SOLUTIONS TO REVIEW PROBLEMS

1. **B** The Avogadro constant (6×10^{23} mol^{-1}) defines the numbers of particles present in one mole of any substance, including electrons, and the Faraday constant (10^5 C·(mol e$^-$)$^{-1}$) defines the charge per mole of electrons. Therefore:

$$1\,\text{mol}\,e^- \times \frac{\text{mol}\,e^-}{6 \times 10^{23}\,e^-} \times \frac{10^5\,\text{C}}{\text{mol}\,e^-} = 1.67 \times 10^{-19}\,\text{C}$$

The only answer choice that is close is (B), which is the correct answer. Note that you may have already memorized this value as e, the elementary charge, in which case you could have quickly selected that answer and moved on to the next question.

2. **C** The reduction of one mole of Ni^{2+} (aq) to one mole of Ni (s) requires two moles of electrons. The transfer of one mole of electrons is equivalent to the transfer of 1F of charge. Therefore, transferring two moles of electrons requires 2 F of charge.

3. **C** In order to solve this problem, first determine the number of moles of Au present in 0.6 g of Au.

$$0.6\,\text{g Au} \times \frac{\text{mol Au}}{197.0\,\text{g}} = 0.003\,\text{mol Au}$$

Next, determine the number of moles of electrons used to reduce Au^{3+} (aq) to 0.0030 mol of Au (s). From the given reduction half-reaction of Au, you can see that, for every mole of Au^{3+} reacted, three moles of electrons are consumed. Therefore:

$$0.003\,\text{mol Au} \times \frac{3\,\text{mol}\,e^-}{\text{mol Au}} = 0.009\,\text{mol}\,e^-$$

Finally, convert 0.009 mol e$^-$ to C using 10^5 as an approximation of the Faraday constant:

$$0.009\,\text{mol}\,e^- \times \frac{10^5\,\text{C}}{\text{mol}\,e^-} = 9 \times 10^3\,\text{C}$$

The closest answer choice is (C), which is correct.

4. **C** The half-reaction with the greater reduction potential will proceed forward as written, while the half-reaction with the smaller reduction potential will proceed in the opposite direction. The reaction with F$_2$ has the greater standard reduction potential, so it will process in the forward direction, and F$_2$ (g) will be reduced. The other reaction will proceed in the opposite direction, meaning that Ca (s) will be oxidized.

5. **D** A galvanic cell always has a positive standard electrical potential, which means that (A) and (B) can be eliminated right away. To achieve the maximum, most favorable cell potential with the two provided half-reactions, cobalt will be reduced and sodium will be oxidized. The total emf of the combined reaction can be calculated by adding together the reduction potential of cobalt and the oxidation potential of sodium (which has the opposite sign of its reduction potential). Therefore:

$$\text{emf} = 1.82\,\text{V} + 2.71\,\text{V} = 4.53\,\text{V}$$

6. **D** Based on the question stem and your outside knowledge of F, you know that $\Delta G° = -553.91 \approx -6 \times 10^2$ kJ, $n = 2$ mol e^-, and $F = 10^5$ C/mol e^-, and are asked to calculate the voltage, which is equivalent to J/C. Since the units do not match, you must convert $\Delta G°$ to J such that $\Delta G° \approx -6 \times 10^5$ J. That being done, you can rearrange the relationship $\Delta G° = -nFE°$ to calculate $E°$:

$$E° = -\frac{G°}{nF}$$

$$E° = -\frac{(-6 \times 10^5)}{(2 \times 10^5)}$$

$$E° = 3 \text{ V}$$

The closest answer choice is (D), which is correct.

CHAPTER THIRTY-ONE

Chemical Kinetics

LEARNING OBJECTIVES

After this chapter, you will be able to:

- Explain the importance of reaction mechanisms to overall chemical reactions
- Calculate the rate of a reaction
- Distinguish between zeroeth-, first-, second-, and mixed-order reactions
- Describe factors that can affect reaction rate

When studying a chemical reaction, it is important to consider not only the chemical properties of the reactants but also the **conditions** under which the reaction occurs, the **mechanism** by which it takes place, the **rate** at which it occurs, and the **equilibrium** toward which it proceeds.

REACTION MECHANISMS

The **mechanism** of a chemical reaction is the actual series of steps through which it occurs. Knowing the accepted mechanism of a reaction often helps to explain the reaction's rate, position of equilibrium, and thermodynamic characteristics. Consider the reaction below:

$$A_2 + 2\,B \rightarrow 2\,AB$$

This equation seems to imply a mechanism in which two molecules of B collide with one molecule of A_2 to form two molecules of AB. But suppose instead that the reaction actually takes place in two steps.

Step 1:	$A_2 + B \rightarrow A_2B$	(slow)
Step 2:	$A_2B + B \rightarrow 2\,AB$	(fast)

Note that these two steps add up to the overall (net) reaction. A_2B, which does not appear in the overall reaction because it is neither a reactant nor a product, is called an **intermediate**. Reaction intermediates are often difficult to detect, but a proposed mechanism can be supported through experiments.

The slowest step in a proposed mechanism is called the **rate-determining step**, because the overall reaction cannot proceed faster than that step.

REACTION RATES

Chemical kinetics is the study of the rates (or speed) of reactions. The **reaction rate** is the change of concentration of reactant or finished product with respect to time. Any given chemical reaction can be represented by the following equation:

$$\text{Reactants} \rightarrow \text{Products}$$

This equation indicates that reactant molecules are being consumed (concentration decreases) and the product molecules are being formed (concentration increases). The process of chemical kinetics is concerned with how "fast" the reactants are being transformed into products.

Definition of Rate

Consider a reaction $2A + B \rightarrow C$, in which one mole of C is produced from every two moles of A and one mole of B. The rate of this reaction may be described in terms of either the disappearance of reactants over time or the appearance of products over time.

$$\text{rate} = \frac{\text{decrease in concentration of reactants}}{\text{time}} = \frac{\text{increase in concentration of products}}{\text{time}}$$

Because the concentration of a reactant decreases during the reaction, a minus sign is placed before a rate that is expressed in terms of reactants. For the reaction above, the rate of reaction with respect to A is $-\frac{\Delta[A]}{\Delta t}$, with respect to B is $-\frac{\Delta[B]}{\Delta t}$, and with respect to C is $\frac{\Delta[C]}{\Delta t}$.

Rate is expressed in the units of moles per liter per second (mol/[L × s]) or molarity per second (molarity/s).

Rate Law

For nearly all forward, irreversible reactions, the rate is proportional to the product of the concentrations of the reactants, each raised to some power. For the general reaction:

$$aA + bB \rightarrow cC + dD$$

the rate is proportional to $[A]^x[B]^y$, that is:

$$\text{rate} = k[A]^x[B]^y$$

This expression is the **rate law** for the general reaction above, where k is the **rate constant**. The rate constant is defined as a constant of proportionality between the chemical reaction rate and the concentration of the reactants. Multiplying the units of k by the concentration factors raised to the appropriate powers gives the rate in units of concentration/time. The exponents x and y are called the **orders of reaction**; x is the order with respect to A, and y is the order with respect to B. These exponents may be integers (including zero) or fractions and must be determined experimentally.

It is important to note that the exponents of the rate law are **not** necessarily equal to the stoichiometric coefficients in the overall reaction equation. The exponents **are** equal to the stoichiometric coefficients of the rate-determining step. If one of the reactants or products in the rate-determining step is an intermediate not included in the overall reaction, then calculating the rate law in terms of the original reactants is more complex.

The **overall order of a reaction** (or the **reaction order**) is defined as the sum of the exponents, here equal to $x + y$.

Experimental determination of rate law

The values of k, x, and y in the rate law equation (rate $= k[A]^x[B]^y$) must be determined experimentally for a given reaction at a given temperature. The rate is usually measured as a function of the initial concentrations of the reactants, A and B.

Example: Given the data below, find the rate law for the following reaction at 300 K:

$$A + B \rightarrow C + D$$

Trial	$[A]_{initial}$ (M)	$[B]_{initial}$ (M)	$r_{initial}$ (M/s)
1	1.00	1.00	2.0
2	1.00	2.00	8.1
3	2.00	2.00	15.9

Solution: First, look in the given table for two trials in which the concentrations of all but one of the substances are held constant.

a) In trials 1 and 2, the concentration of A is kept constant while the concentration of B is doubled. The rate increases by a factor of 8.1/2.0, or approximately 4. Write down the rate expression for each of the two trials.

Trial 1: $\qquad r_1 = k[A]^x[B]^y = k(1.00)^x(1.00)^y$

Trial 2: $\qquad r_2 = k[A]^x[B]^y = k(1.00)^x(2.00)^y$

Divide the second equation by the first:

$$\frac{r_2}{r_1} = \frac{8.1}{2.0} = \frac{k(1.00)^x(2.00)^y}{k(1.00)^x(1.00)^y} = (2.00)^y$$

$$4 = (2.00)^y$$

$$y = 2$$

b) In trials 2 and 3, the concentration of B is kept constant while the concentration of A is doubled; the rate is increased by a factor of 15.9/8.1, or approximately 2. The rate expressions of the two trials are:

Trial 2: $\qquad r_2 = k(1.00)^x(2.00)^y$

Trial 3: $\qquad r_3 = k(2.00)^x(2.00)^y$

Divide the second equation by the first:

$$\frac{r_3}{r_2} = \frac{15.9}{8.1} = \frac{k(2.00)^x(2.00)^y}{k(1.00)^x(2.00)^y} = (2.00)^x$$
$$2 = (2.00)^x$$
$$x = 1$$

So $r = k[\text{A}][\text{B}]^2$.

The order of the reaction with respect to A is 1 and with respect to B is 2; the overall reaction order is $1 + 2 = 3$.

To calculate k, substitute the values from any one of the above trials into the rate law. For example:

$$2.0 \text{ M/s} = k \times 1.00 \text{ M} \times (1.00 \text{ M})^2$$
$$k = 2.0 \text{ M}^{-2}\cdot\text{s}^{-1}$$

Therefore, the rate law is $r = (2.0 \text{ M}^{-2}\cdot\text{s}^{-1})\,[\text{A}][\text{B}]^2$.

Reaction Orders

Chemical reactions are often classified on the basis of kinetics as zero-order, first-order, second-order, mixed-order, or higher-order reactions. The general reaction $a\text{A} + b\text{B} \rightarrow c\text{C} + d\text{D}$ will be used in the following discussion.

Zero-order reactions

A zero-order reaction has a constant rate, which is independent of the reactants' concentrations. Thus, the rate law is:

$$\text{rate} = k, \text{ where } k \text{ has units of M}\cdot\text{s}^{-1}$$

First-order reactions

A first-order reaction (order $= 1$) has a rate proportional to the concentration of one reactant.

$$\text{rate} = k[\text{A}] \text{ or rate} = k[\text{B}]$$

First-order rate constants have units of s^{-1}.

Second-order reactions

A second-order reaction (order $= 2$) has a rate proportional to the product of the concentration of two reactants or to the square of the concentration of a single reactant. For example, rate $= k[\text{A}]^2$, rate $= k[\text{B}]^2$, or rate $= k[\text{A}][\text{B}]$. The units of second-order rate constants are $\text{M}^{-1}\cdot\text{s}^{-1}$.

Higher-order reactions

A higher-order reaction has an order greater than two. These can be calculated the same way as lower-order reactions, but more possible combinations must be considered.

Mixed-order reactions

A mixed-order reaction has a fractional order; e.g., rate $= k[A]^{1/3}$. These are unlikely to appear on Test Day and describe relationships involving radicals, such as square roots.

Energetics of Reactions

Collision theory of chemical kinetics

For a reaction to occur, molecules must collide with each other. The collision theory of chemical kinetics states that the rate of a reaction is proportional to the **number of collisions per second** between the reacting molecules. It is important to note that reaction rates almost always increase with increasing temperatures. On the other hand, reaction rates decrease with decreasing temperatures.

Not all collisions, however, result in a chemical reaction. An **effective collision** (one that leads to the formation of products) occurs only if the molecules collide with the correct orientation and sufficient force to break the existing bonds and form new ones. The minimum energy of collision necessary for a reaction to take place is called the **activation energy**, E_a, or the **energy barrier**. Only a fraction of colliding particles have enough kinetic energy to exceed the activation energy. This means that only a fraction of all collisions are effective.

Transition state theory

When molecules collide with sufficient energy and in the correct orientation, they form a **transition state** in which the old bonds are weakened and the new bonds are beginning to form. The transition state then dissociates into products, and the new bonds are fully formed. For a reaction $A_2 + B_2 \rightarrow 2AB$, the change along the **reaction coordinate** (a measure of the extent to which the reaction has progressed from reactants to products; see below) can be represented as follows:

Figure 31.1

The **transition state**, also called the **activated complex**, has greater energy than either the reactants or the products and is denoted by the symbol ‡. The activation energy is required to bring the reactants to this particular energy level. Once an activated complex is formed, it can either dissociate into the products or revert to reactants without any additional energy input. Transition states are distinguished from intermediates in that, existing as they do at energy maxima, transition states do not have a finite lifetime.

A **potential energy diagram** illustrates the relationship between the activation energy, the heats of reaction, and the potential energy of the system before and after the reaction. The most important factors in such diagrams are the relative energies of the products and reactants. The **enthalpy change** of the reaction (ΔH) is the difference between the potential energy of the products and the potential energy of the reactants. A negative enthalpy change indicates an **exothermic reaction** (where heat is given off), and a positive enthalpy change indicates an **endothermic reaction** (where heat is absorbed).

The activated complex exists at the top of the energy barrier. The difference in potential energies between the activated complex and the reactants is the activation energy of the forward reaction; the difference in potential energies between the activated complex and the products is the activation energy of the reverse reaction.

For example, consider the formation of HCl from H_2 and Cl_2:

$$H_2 + Cl_2 \rightleftharpoons 2\,HCl$$

The following figure gives the energy profile of the reaction. It shows that the reaction is exothermic. The potential energy of the products is less than the potential energy of the reactants; heat is evolved, and the heat of reaction is negative.

Figure 31.2

Factors Affecting Reaction Rate

The rate of a chemical reaction depends on the individual species undergoing reaction and on the reaction environment. The rate of reaction will increase if there is an increase in the number of effective collisions or a stabilization of the activated complex compared to the reactants.

Reactant concentrations

The greater the concentrations of the reactants (the more particles per unit volume), the greater the number of effective collisions per unit time, so the reaction rate will increase as reactant concentrations increase for all but zero-order reactions. For reactions occurring in the gaseous state, the partial pressures of the reactants can serve as measures of concentration.

Temperature

For nearly all reactions, the reaction rate will increase as the temperature of the system increases. Since the temperature of a substance is a measure of the particles' average kinetic energy, increasing the temperature increases the average kinetic energy of the molecules. Consequently, the proportion of molecules having energies greater than E_a (and thus capable of undergoing reaction) increases with higher temperature.

Medium

The rate of a reaction may also be affected by the medium in which it takes place. Due to differences in intermolecular forces and other stabilizing factors, certain reactions proceed more rapidly in aqueous solution, whereas other reactions proceed more rapidly in nonpolar solvents. The state of the medium (liquid, solid, or gas) can also have a significant effect.

Catalysts

Catalysts are substances that increase reaction rate without themselves being consumed; they do this by lowering the activation energy. Catalysts are important in biological systems and in industrial chemistry; **enzymes** are biological catalysts. Catalysts may increase the frequency of collision between the reactants, change the relative orientation of the reactants to make a higher percentage of collisions effective, donate electron density to the reactants, or reduce intramolecular bonding within reactant molecules. The following figure compares the energy profiles of catalyzed and uncatalyzed reactions.

Figure 31.3

The energy barrier for the catalyzed reaction is much lower than the energy barrier for the uncatalyzed reaction. Note that the rates of both the forward and the reverse reactions are increased by the catalyst, since E_a of the forward and reverse reactions are lowered by the same amount. Therefore, the presence of a catalyst causes the reaction to proceed more quickly toward equilibrium.

 Section III: General Chemistry

REVIEW PROBLEMS

1. All of the following are true statements concerning reaction orders EXCEPT
 A. The rate of a zero-order reaction is constant.
 B. After three half-lives, a sample will have one-ninth of its original activity.
 C. The units for the rate constant for first-order reactions are s^{-1}.
 D. Higher-order reactions are those with an order greater than two.
 E. The decrease in concentration of reactants equals the increase in concentration of the products as a function of time.

2. Consider the following hypothetical reaction and experimental data:

 $$A + B \rightarrow C + D \qquad\qquad T = 273 \text{ K}$$

	$[A]_o \ (mol\cdot L^{-1})$	$[B]_o \ (mol\cdot L^{-1})$	rate $(mol\cdot L^{-1}\cdot s^{-1})$
Exp 1	0.10	1	0.035
Exp 2	0.10	4	0.070
Exp 3	0.20	1	0.140
Exp 4	0.10	16	0.140

 A. What is the order with respect to A?
 B. What is the order with respect to B?
 C. What is the rate equation?
 D. What is the overall order of the reaction?
 E. Calculate the rate constant.

3. Consider the following chemical reaction and experimental data:

 $$A \ (aq) \rightarrow B \ (aq) + C \ (g)$$

Trial 1		**Trial 2**	
[A] (mol/L)	rate (M/s)	[A] (mol/L)	rate (M/s)
0.10	0.6	0.10	0.9
0.20	0.6	0.20	0.9
0.30	0.6	0.30	0.9
0.40	0.6	0.40	0.9

 A. What is the rate expression for trial 1?
 B. What is the rate constant for trial 1?
 C. What is the most likely reason for the increased rate in trial 2?

4. Consider the following reaction and experimental data:

 $$SO_3 + H_2O \rightarrow H_2SO_4$$

	$[SO_3] \ (mol\cdot L^{-1})$	$[H_2O] \ (mol\cdot L^{-1})$	rate $(mol\cdot L^{-1}\cdot s^{-1})$
Trial 1	0.1	0.01	0.013
Trial 2	0.2	0.01	0.052
Trial 3	X	0.02	0.234
Trial 4	0.1	0.03	0.039

A. What is the value of X?

B. What is the order of the reaction?

C. What is the rate constant?

D. What would be the rate if $[SO_3]$ in trial 4 were raised to 0.2 mol/L?

5. In the following diagram, which labeled arrow represents the activation energy for the reverse reaction?

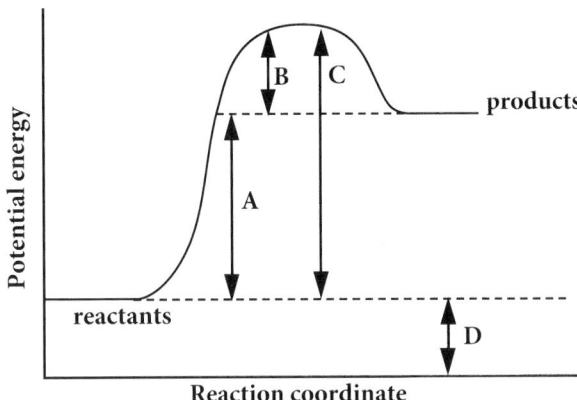

A. A

B. B

C. C

D. D

E. The sum of B and D

6. The activation energy for a reaction in the forward direction is 78 kJ. The activation energy for the same reaction in reverse is 300 kJ. If the energy of the products is 25 kJ, then:

A. What is the energy of the reactants?

B. Is the forward reaction endothermic or exothermic?

C. Is the reverse reaction endothermic or exothermic?

D. What is the enthalpy change for the forward reaction?

7. According to chemical kinetic theory, a reaction can occur

A. if the reactants collide with the proper orientation.

B. if the reactants possess sufficient energy of collision.

C. if the reactants are able to form a correct transition state.

D. for all of the above.

E. for none of the above.

GC

8. The number of undecayed nuclei in a sample of bromine-87 decreased by a factor of four over a period of 112 s. What is the decay constant for bromine-87?

A. 6.19×10^{-3} s^{-1}

B. 1.24×10^{-2} s^{-1}

C. 6.93×10^{-1} s^{-1}

D. 28 s^{-1}

E. 56 s^{-1}

9. Which of the following is most likely to increase the rate of a reaction?

A. Decreasing the temperature

B. Increasing the volume of the reaction vessel

C. Reducing the activation energy

D. Decreasing the concentration of the reactant in the reaction vessel

E. Decreasing the pressure in the reaction vessel

10. All of the following are true statements concerning catalysts EXCEPT

A. a catalyst will speed the rate-determining step.

B. a catalyst will be used up in a reaction.

C. a catalyst may induce steric strain in a molecule.

D. a catalyst will lower the activation energy of a reaction.

E. a catalyst will speed up the rates of both the forward and the reverse reactions.

SOLUTIONS TO REVIEW PROBLEMS

1. **B** Discussed in the section on reaction orders in this chapter.

2. First, the general rate equation must be written out. It is:

 rate $= k[A]^x[B]^y$

 where:

 k = the rate constant

 x = the order with respect to reactant A

 y = the order with respect to reactant B

 A $x = 2$

 To solve for x, it is necessary to find two trials in which B is held constant; here, experiments 1 and 3. The data shows that if the concentration of A is doubled, the rate increases by a factor of 4. Thus, the rate varies as the square of the concentration of A. The order with respect to A, x, is therefore equal to 2.

 B $y = 0.5$

 To solve for y, follow the steps as in x. In experiments 1 and 2 (and 2 and 4) A is held constant, the concentration of B quadruples, and the rate doubles. The rate, therefore, varies as the square root of the concentration of B. The order, y, is therefore equal to 0.5.

 C rate $= k[A]^2[B]^{0.5}$

 D order $= 2.5$

 The overall order is equal to $x + y = 2.5$.

 E 3.5

 Given the rate expression, the rate constant can easily be calculated by substituting the rate and concentrations for any of the four trials into the rate expression; the rate constant will work out to 3.5 in each case.

 Trial 1: $0.035 = k[0.10]^2[1]^{0.5}$; $k = 3.5$ $M^{-1.5} \cdot s^{-1}$

 Trial 2: $0.070 = k[0.10]^2[4]^{0.5}$; $k = 3.5$ $M^{-1.5} \cdot s^{-1}$

 Trial 3: $0.140 = k[0.20]^2[1]^{0.5}$; $k = 3.5$ $M^{-1.5} \cdot s^{-1}$

 Trial 4: $0.140 = k[0.10]^2[16]^{0.5}$; $k = 3.5$ $M^{-1.5} \cdot s^{-1}$

3. **A** rate $= k[A]^0 = k$

 This reaction has only one reactant. It is evident from the data that the rate of the reaction is not affected by reactant concentration. This is a zero-order reaction, and the rate is equal to its rate constant, k.

 B $k = 0.6$

 C The most likely reason for the increased rate in trial 2 is a change in temperature. We know that in a zero-order reaction, changing the concentration of the reactant will not cause a change in rate; the factor most likely to affect the rate is temperature.

4. **A** **$X = 0.3$**

 To calculate X, first write the rate expression for this reaction. From the data, the rate expression is calculated as:

 $$\text{rate} = k[SO_3]^2[H_2O]$$

 The order with respect to SO_3 is 2, since the rate quadruples when the concentration of SO_3 doubles (with the concentration of H_2O remaining constant) between trials 1 and 2. The order with respect to H_2O is 1, as the rate triples as the concentration of H_2O triples (with the concentration of SO_3 remaining constant) between trials 1 and 4.

 X can be calculated by plugging the values from trial 3 into the rate expression. First, however, calculate the rate constant, k, by plugging in the known values from trial 1, 2, or 4. For instance:

 Trial 4: $0.039 = k[0.1]^2[0.03]$; $k = 130\ \text{M}^{-2}\cdot\text{s}^{-1}$

 To calculate X, plug in the values of rate and $[H_2O]$ for trial 3, using $k = 130\ \text{M}^{-2}\cdot\text{s}^{-1}$.

 $0.234 = 130[X]^2[0.02]$

 $X = 0.3\ \text{M}$

 B **3**

 The order of the reaction is the sum of the exponents in the rate expression: in this case, $(2 + 1) = 3$.

 C **$130\ \text{M}^{-2}\cdot\text{s}^{-1}$**

 For calculations see solution to part A.

 D **0.156 units**

 Substitute 0.2 M instead of 0.1 M for $[SO_3]$:

 $\text{rate} = (130)(0.2)^2(0.03) = 0.156\ \text{M/s}$

5. **B** The activation energy is the minimum amount of energy needed for a reaction to proceed. The activation energy for the reverse reaction is the change in potential energy between the products and the transition state indicated by arrow B.

6. **A** **247 kJ**

 The best way to visualize the solution to this set of problems is to draw a diagram.

$$\Delta H = \text{Activation Energy}_{\text{forward}} - \text{Activation Energy}_{\text{reverse}}$$
$$= 78 \text{ kJ} - 300 \text{ kJ} = -222 \text{ kJ}$$

And because $\Delta H = \text{Energy}_{\text{products}} - \text{Energy}_{\text{reactants:}}$
$$-222 \text{ kJ} = 25 \text{ kJ} - X$$
$$X = 247 \text{ kJ} = \text{energy of reactants}$$

B The forward reaction is exothermic because ΔH is negative.

C The reverse reaction is endothermic.

D The enthalpy change, ΔH, of the reaction is -222 kJ.

7. **D** Discussed in the section on the efficiency of reactions in this chapter.

8. **B** If the number of nuclei decaying in a sample has decreased by a factor of 4, the sample has been through two half-lives, and the half-life will be

$$\frac{112 \text{ s}}{2} = 56 \text{ s} = t_{1/2}$$

The equation to determine the decay constant for the first-order reaction is

$$t_{1/2} = \frac{0.693}{k}$$

Thus, given that the half-life is 56 s, the decay constant will be

$$56 \text{ s} = \frac{0.693}{k}$$
$$k = 0.0124 \text{ s}^{-1}$$

9. **C** Various conditions can affect the rate of reaction: increased temperature, increased concentration of reactants, decreased volume or increased pressure (if any reactants are gases), or addition of a suitable catalyst. The effect of a catalyst is to decrease the activation energy; therefore, choice (C) is correct.

10. **B** Discussed in the section on factors affecting reaction rate in this chapter.

CHAPTER THIRTY-TWO

Thermochemistry

LEARNING OBJECTIVES

After this chapter, you will be able to:

- Describe thermodynamic systems and the state functions
- Calculate the thermodynamic values for a system
- Determine if a reaction is spontaneous

Thermodynamics is the branch of physics that deals with the relationship between all forms of energy. The application of thermodynamics to chemical reactions is called **thermochemistry**. All chemical reactions are accompanied by energy changes, which determine whether reactions can occur and how easily they will do so.

The **law of conservation of energy**, the first law of thermodynamics, states that the total energy in the universe remains constant. Energy can be neither created nor destroyed but can only be transformed from one form to another. Thus, thermal, chemical, potential, and kinetic energies are all interconvertible, as they must obey the law of conservation of energy.

A thermodynamic **system** is the particular part of the universe being studied; everything outside the system is considered the **surroundings** or **environment**. A system may be:

Isolated: It cannot exchange energy or matter with the surroundings, as with an insulated bomb reactor.

Closed: It can exchange energy but not matter with the surroundings, as with a steam radiator.

Open: It can exchange both matter and energy with the surroundings, as with a pot of boiling water.

STATE FUNCTIONS

The state of a system is described by the properties of the system; when the state of a system changes, the values of the properties also change. Properties whose magnitude depends only on the initial and final states of the system and not on the path of the change are known as **state functions**. Examples include temperature (T), pressure (P), and volume (V), internal energy (E or U), enthalpy (H), entropy (S), and free energy (G). Although independent of path, state functions are not necessarily independent of one another.

A set of **standard conditions** (298 K, 1 atm, and 1 M concentrations) is normally used for measuring the enthalpy, entropy, and free energy of a reaction. A substance in its most stable form

under standard conditions is said to be in its **standard state**. Examples of substances in their standard states include hydrogen as H_2 (g), water as H_2O (l), and salt as NaCl (s). The changes in enthalpy, entropy, and free energy that occur when a reaction takes place under standard conditions are called the **standard enthalpy**, **standard entropy**, and **standard free energy** changes, respectively, and are symbolized by $\Delta H°$, $\Delta S°$, and $\Delta G°$. Note that standard conditions are not the same as the conditions for standard temperature and pressure (STP), which are 273 K and 1 atm, used for gas law calculations.

INTERNAL ENERGY

Internal energy, E, includes the sum of the kinetic, potential, and chemical energies of a system and is constant in the universe:

$$\Delta E_{univ} = \Delta E_{sys} + \Delta E_{surr} = 0$$

Internal energy can also be defined as the sum of the **heat (q)** gained or lost by the system and the **work (W)** done by or on the system:

$$\Delta E_{sys} = q + W$$

Heat, measured in calories (cal) or joules (J) and often expressed in kcal or kJ (1 cal = 4.184 J), is the most common energy change in chemical processes. Heat is a form of energy that can easily transfer to or from a system due to a temperature difference between the system and its surroundings; this transfer will occur spontaneously from a warmer system to a cooler system.

Reactions that absorb heat energy are said to be **endothermic**, while those that release heat energy are said to be **exothermic**. The heat absorbed or released in a given process is calculated from this equation:

$$q = mc\Delta T$$

where m is the mass, c is the **specific heat capacity**, and ΔT is the change in temperature. Specific heat is a property of a material that describes how much energy it takes to raise its temperature.

According to convention, heat absorbed by a system (from its surroundings) or work done on the system (by its surroundings) is considered positive (increases internal energy). Conversely, heat lost by a system (to its surroundings) or work done by the system (on the surroundings) is considered negative (decreases internal energy).

ENTHALPY

The change in **enthalpy (ΔH)** of a process is equal to the heat absorbed or given off by the system at constant pressure. The enthalpy of a process depends only on the enthalpies of the initial and final states, *not* on the path. Thus, to find the enthalpy change of a reaction, ΔH_{rxn}, subtract the enthalpy of the reactants from the enthalpy of the products:

$$\Delta H_{rxn} = H_{products} - H_{reactants}$$

A positive ΔH corresponds to an endothermic process in which enthalpy is added to the system, and a negative ΔH corresponds to an exothermic process in which the system gives off enthalpy.

Figure 32.1 shows the reaction coordinate diagrams for an exothermic reaction with $\Delta H_{rxn} < 0$ and an endothermic reaction with $\Delta H_{rxn} > 0$. Note that the transition state for each reaction gives an indirect path from starting to final state, but the overall enthalpy change is determined only by the beginning and ending enthalpy values.

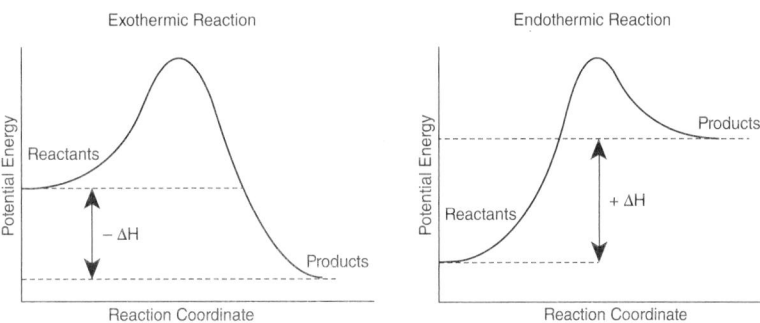

Figure 32.1

The following describe the relationships between heat, internal energy, and enthalpy of a system during a chemical reaction when one of its properties is constant.

- Isobaric processes occur in systems at constant pressure ($\Delta P = 0$). Heat given off or absorbed equals the change in enthalpy of the system.

- Isochoric processes occur at constant volume ($\Delta V = 0$). Heat given off or absorbed equals the change in internal energy of the system and also equals the change in enthalpy of the system.

- Isothermal processes occur when systems do not change temperature ($\Delta T = 0$). The change in internal energy, as well as enthalpy, equals zero (only for an ideal gas) but heat does not equal 0.

- Adiabatic processes occur when there is no heat exchanged between systems and their surroundings ($\Delta q = 0$). The change in internal energy is equal to work.

Several different enthalpy calculations can be done for reactions depending on the type of information provided: standard enthalpies of formation, standard enthalpies of reaction, or bond dissociation enthalpies.

STANDARD ENTHALPY OF FORMATION

The enthalpy of formation of a compound, $\Delta H°_f$, is the enthalpy change that occurs if one mole of a compound is formed directly from its elements in their standard states. Note that the $\Delta H°_f$ of an element in its standard state is defined as zero, so the heat of formation of a compound gives its increase or decrease in enthalpy from zero.

For example, the $\Delta H°_f$ for water is the change in enthalpy when H_2 gas and O_2 gas are combined to form one mole of water vapor:

$$H_2\ (g) + \frac{1}{2}\ O_2\ (g) \rightarrow H_2O\ (g) \qquad\qquad \Delta H°_f = -241.8 \text{ kJ/mol}$$

Note that the equation must be balanced for one mole of the product because $\Delta H°_f$ is defined for one mole of a substance.

STANDARD ENTHALPY OF REACTION

The standard enthalpy, or standard heat, of a reaction, $\Delta H°_{rxn}$, is the enthalpy change that occurs when the reaction is carried out under standard conditions (298 K, 1 atm, and 1 M concentrations). The equation for standard enthalpy of reaction demonstrates the same concept as the reaction coordinate diagrams in Figure 32.1:

$$\Delta H°_{rxn} = (\text{sum of } \Delta H°_f \text{ of products}) - (\text{sum of } \Delta H°_f \text{ of reactants})$$

One specific type of enthalpy of reaction is the standard heat of combustion, $\Delta H°_{comb}$. Combustion of hydrocarbons follows the general unbalanced reaction:

$$\text{Hydrocarbon} + O_2 \rightarrow CO_2 + H_2O$$

Example: What is the $\Delta H°_{rxn}$ of the combustion of glucose according to the following reaction ($\Delta H°_f$ for liquid water is −285.8 kJ/mole, $\Delta H°_f$ for CO_2 (g) is −393.5 kJ/mole, and the $\Delta H°_f$ for glucose is −1271 kJ/mole)?

$$C_6H_{12}O_6 \ (s) + 6 \ O_2 \ (g) \rightarrow 6 \ CO_2 \ (g) + 6 \ H_2O \ (l\)$$

Solution: The $\Delta H°_f$ for each compound in the reaction must be multiplied by its stoichiometric coefficient and then combined according to the equation:

$$\Delta H°_{rxn} = (\text{sum of } \Delta H°_f \text{ of products}) - (\text{sum of } \Delta H°_f \text{ of reactants})$$
$$\Delta H°_{rxn} = [(6 \ \Delta H°_f \text{ for } CO_2) + (6 \ \Delta H°_f \text{ for } H_2O)] -$$
$$[(\Delta H°_f \text{ for glucose}) + (6 \ \Delta H°_f \text{ for } O_2)]$$
$$\Delta H°_{rxn} = [6(-393.5) + 6(-285.8)] - (-1271 + 0)$$
$$\Delta H°_{rxn} = -2361 + -1714.8 + 1271 = -2,804.8 \text{ kJ/mole}$$

HESS'S LAW

Hess's Law states that enthalpies of reactions are additive; if a reaction is broken down into individual steps, the overall enthalpy of the reaction is the sum of enthalpies for each step.

Example: Given the following thermochemical equations, calculate ΔH_d:

a) $C_3H_8 \ (g) + 5 \ O_2 \ (g) \rightarrow 3 \ CO_2 \ (g) + 4 \ H_2O \ (l)$ $\Delta H_a = -2{,}220.1 \text{ kJ}$

b) $C \ (graphite) + O_2 \ (g) \rightarrow CO_2 \ (g)$ $\Delta H_b = -393.5 \text{ kJ}$

c) $H_2 \ (g) + \dfrac{1}{2} O_2 \ (g) \rightarrow H_2O \ (l)$ $\Delta H_c = -285.8 \text{ kJ}$

d) $3 \ C \ (graphite) + 4 \ H_2 \ (g) \rightarrow C_3H_8 \ (g)$ $\Delta H_d = ?$

Solution: Equations (a), (b), and (c) must be combined to obtain equation (d), similar to the combination of several algebraic equations. Since equation (d) contains only C, H_2, and C_3H_8, we must eliminate O_2, CO_2, and H_2O from the first three equations. Equation (a) is reversed to move C_3H_8 to the product side in order to match the net

K

equation, giving equation (e). Because the direction of the equation is reversed, the sign of the ΔH for the reaction must also be reversed:

e) $3\ CO_2\ (g) + 4\ H_2O\ (l) \rightarrow C_3H_8\ (g) + 5\ O_2\ (g)$ $\qquad \Delta H_e = 2{,}220.1\ kJ$

Next, the other two equations must be multiplied by the appropriate integer to match the stoichiometric coefficients in the net equation. Equation (b) is multiplied by three, giving equation (f), and equation (c) is multiplied by four, giving equation (g). The ΔH values for each equation must also be multiplied by the same integer values. Finally, the three equations are added, terms on either side are cancelled to reach the net reaction, and the ΔH values are added to calculate the net ΔH_{rxn}.

e) $3\ CO_2\ (g) + 4\ H_2O\ (l) \rightarrow C_3H_8\ (g) + 5\ O_2\ (g)$ $\qquad \Delta H_e = 2{,}220.1\ kJ$

f) $3 \times [C\ (graphite) + O_2\ (g) \rightarrow CO_2\ (g)]$ $\qquad \Delta H_f = 3 \times -393.5\ kJ$

g) $4 \times [H_2\ (g) + \dfrac{1}{2}\ O_2\ (g) \rightarrow H_2O\ (l)]$ $\qquad \Delta H_g = 4 \times -285.8\ kJ$

$3\ C\ (graphite) + 4\ H_2\ (g) \rightarrow C_3H_8\ (g)$ $\qquad \Delta H_d = -103.6\ kJ$

where $\Delta H_d = \Delta H_e + \Delta H_f + \Delta H_g$.

Note that the reactions used in enthalpy calculations for $C_3H_8\ (g)$ are combustion reactions, and the corresponding values ΔH_a, ΔH_b, and ΔH_c are thus heats of combustion.

BOND DISSOCIATION ENERGY

Heats of reaction can also be determined by the energy required for the breakdown and formation of chemical bonds. **Bond dissociation energy** is the energy required to break a specific chemical bond in one mole of gaseous molecules. Since it takes energy to pull two atoms apart, bond breaking is always endothermic and bond formation is always exothermic.

For example, the reaction below shows that a molecule of H_2 gas is cleaved to produce two gaseous, unassociated hydrogen atoms. For each mole of H_2 gas cleaved, 436 kJ of energy is required, and the reaction is therefore endothermic.

$$H_2\ (g) \rightarrow 2\ H\ (g) \qquad \Delta H = 436\ kJ$$

Bond energies can be used to calculate enthalpies of reactions. Using the convention that bond dissociation enthalpies are always positive, whether for bond breaking or bond formation, the enthalpy change of a reaction is given by:

$$\Delta H_{rxn} = (\Delta H\ \text{of bonds broken}) - (\Delta H\ \text{of bonds formed})$$
$$= \text{total energy input} - \text{total energy released}$$

Example: Calculate the enthalpy change for the following reaction:

$$C \, (graphite) + 2 \, H_2 \, (g) \rightarrow CH_4 \, (g) \qquad \Delta H = ?$$

The bond dissociation energies of H–H and C–H bonds are 436 kJ/mol and 415 kJ/mol, respectively. $\Delta H°_f$ of C (g) = 715 kJ/mol.

Solution: CH_4 is formed from free elements in their standard states (C as solid graphite and H_2 as a gas). The C–C bonds of C $(graphite)$ must be broken and thus form C (g), the H–H bonds of two molecules of H_2 (g) must be broken, and four C–H bonds must be formed to create CH_4 (g). Because all of the enthalpies are provided as bond dissociation energies, they are all positive; thus, bonds that are broken are added, and bonds that are formed are subtracted:

$$\Delta H_{rxn} = (\Delta H \text{ of bonds broken}) - (\Delta H \text{ of bonds formed})$$

$$\Delta H_{rxn} = [(\Delta H_{bond} \text{ for C–C}) + 2(\Delta H_{bond} \text{ for H–H})] - [4(\Delta H_{bond} \text{ for C–H})]$$

$$\Delta H_{rxn} = [715 + 2(436)] - [4(415)] = -73 \text{ kJ/mol}$$

ENTROPY

Entropy (S) is a measure of the disorder, or randomness, of a system. The units of entropy are energy/temperature, commonly J/K or cal/K. The greater the order in a system, the lower the entropy; the greater the disorder or randomness, the higher the entropy.

At any given temperature, a solid will have lower entropy than a liquid, and a liquid will have lower entropy than a gas. Individual molecules in the gaseous state are moving randomly, whereas molecules in a liquid are less able to move freely, and molecules in a solid are constrained in place. Relative entropy changes accompanying phase changes can be estimated.

For example, freezing is accompanied by a decrease in entropy, as the relatively disordered liquid becomes a well-ordered solid. The third law of thermodynamics states that the entropy of a perfectly crystalline substance at absolute zero (0 K) is zero. Meanwhile, boiling is accompanied by a large increase in entropy, as the liquid becomes a much more highly disordered gas. For any substance, sublimation will be the phase transition with the greatest entropy change.

The second law of thermodynamics states that all spontaneous processes proceed such that the entropy of the system plus its surroundings (i.e., the entropy of the universe) increases:

$$\Delta S_{universe} = \Delta S_{system} + \Delta S_{surroundings} > 0$$

However, it is possible for entropy to decrease in a localized part of the system, as long as there is an accompanying increase in entropy elsewhere in the system. For example, water can turn to ice inside a freezer, thus lowering the entropy of the water. However, the entropy of the air surrounding the freezer will increase as the heat pumped out the back of the freezer coils increases the randomness of movement of air molecules.

A system reaches its maximum entropy at **equilibrium**, a state in which no observable change takes place as time goes on. Entropy cannot increase since it is at its maximum and cannot decrease because this would violate the second law of thermodynamics. For a reversible process, $\Delta S_{universe}$ is zero:

$$\Delta S_{universe} = \Delta S_{system} + \Delta S_{surroundings} = 0$$

A system will spontaneously tend toward an equilibrium state if left alone.

STANDARD ENTROPY

Entropy is a state function, so a change in entropy depends only on the initial and final states:

$$\Delta S = S_{final} - S_{initial}$$

A standard entropy change for a reaction, $\Delta S°rxn$, is calculated using the standard entropies of reactants and products:

$$\Delta S°_{rxn} = (\text{sum of } S°_{products}) - (\text{sum of } S°_{reactants})$$

GIBBS FREE ENERGY

The thermodynamic state function G, known as **Gibbs free energy**, provides information on how both enthalpy and entropy changes affect a reaction. The change in the free energy of a system, ΔG, represents the maximum amount of energy released (i.e., work done) in a chemical reaction at constant temperature and pressure. ΔG is defined by the equation:

$$\Delta G = \Delta H - T\Delta S$$

where T is the absolute temperature in kelvin.

In the equilibrium state, free energy is at a minimum. A process can occur spontaneously if the Gibbs function decreases (i.e., $\Delta G < 0$).

1. If ΔG is negative, the reaction is spontaneous and proceeds forward.

2. If ΔG is positive, the reaction is not spontaneous, and the reverse reaction occurs.

3. If ΔG is zero, the system is in a state of equilibrium; thus, $\Delta G = 0$ and $\Delta H = T\Delta S$.

It is important to note that the **rate** of a reaction depends on the **activation energy,** not on ΔG. Spontaneity indicates whether or not a reaction will occur but not the rate of the reaction. For example, conversion of C (*diamond*) to C (*graphite*) is spontaneous under standard conditions. However, its rate is so slow that the reaction is never practically observed.

Enthalpy and entropy may act together to drive a reaction forward or backward, or they may oppose each other. In the latter case, the temperature will determine whether entropy or enthalpy has a greater effect on the spontaneity of a reaction, and the reaction is considered to be **temperature-dependent**.

The effects of the signs of ΔH and ΔS and the effect of temperature on spontaneity can be summarized as follows, keeping in mind that temperature is always positive because it is on the kelvin scale:

ΔH	ΔS	Outcome
$-$	$+$	spontaneous at all temperatures (temperature-independent)
$+$	$-$	nonspontaneous at all temperatures (temperature-independent)
$+$	$+$	spontaneous only at high temperatures (temperature-dependent)
$-$	$-$	spontaneous only at low temperatures (temperature-dependent)

STANDARD FREE ENERGY

Standard free energies are similar to standard enthalpies and are calculated by similar formulas. The standard free energy of formation of a compound, $\Delta G°_f$, is the free energy change that occurs when 1 mol of a compound in its standard state is formed from its elements in their standard states under standard conditions. The standard free energy of formation of any element in its most stable, standard state is defined as zero. The standard free energy of a reaction, $\Delta G°_{rxn}$, is the free energy change that occurs when that reaction is carried out under standard state conditions.

$$\Delta G°_{rxn} = (\text{sum of } \Delta G°_f \text{ of products}) - (\text{sum of } \Delta G°_f \text{ of reactants})$$

EXAMPLES

Vaporization of water at one atmosphere pressure

$$H_2O\ (l) + \text{heat} \rightarrow H_2O\ (g)$$

When water boils, hydrogen bonds are broken (see Chapter 26, Chemical Bonding). Energy is absorbed, so the reaction is endothermic, and ΔH is positive. Entropy increases as the closely packed molecules of the liquid become the more randomly moving molecules of a gas; thus, $T\Delta S$ is also positive. Since ΔH and $T\Delta S$ are each positive, the reaction will proceed spontaneously only if $T\Delta S > \Delta H$ such that $\Delta G < 0$. This is true only at temperatures above 373 K (100°C). Below 373 K, ΔG is positive, and the water remains a liquid. At 373 K, $\Delta H = T\Delta S$ and $\Delta G = 0$, so an equilibrium is established between water and water vapor. The opposite is true when water vapor condenses. H-bonds are formed, and energy is released; the reaction is exothermic, so ΔH is negative. Entropy decreases, since a liquid is forming from a gas and $T\Delta S$ is negative. Condensation will be spontaneous only if $\Delta H < T\Delta S$. This is the case at temperatures below 373 K. Above 373 K, $T\Delta S$ is more negative than ΔH, ΔG is positive, and condensation is not spontaneous.

The combustion of C_6H_6 (benzene)

$$2\ C_6H_6\ (l) + 15\ O_2\ (g) \rightarrow 12\ CO_2\ (g) + 6\ H_2O\ (g) + \text{heat}$$

In this reaction, heat is released, and thus ΔH is negative as the benzene combusts. The entropy is increased ($T\Delta S$ is positive) because two gases (18 moles total) have greater entropy than a gas and a liquid (15 moles gas and 2 liquid). Overall, ΔG is negative, and the reaction is spontaneous.

REVIEW PROBLEMS

1. A process involving no heat exchange is known as

 A. isothermal.

 B. isobaric.

 C. adiabatic.

 D. isometric.

 E. isochoric.

2. What is the heat capacity of a 10.0 g sample that has absorbed 100 calories over a temperature change of 30.0°C?

 A. 0.333 cal/(g·°C)

 B. 0.667 cal/(g·°C)

 C. 3.00 cal/(g·°C)

 D. 67 cal/(g·°C)

 E. 300 cal/(g·°C)

3. What is the enthalpy of formation of N (g) in the following reaction?

$$N_2 \, (g) \rightarrow 2 \, N \, (g) \qquad\qquad \Delta H_{rxn} = 945.2 \text{ kJ}$$

 A. −945.2 kJ/mol

 B. −472.6 kJ/mol

 C. 0.0 kJ/mol

 D. 472.6 kJ/mol

 E. 945.2 kJ/mol

4. A 50 g sample of metal was heated to 100°C and then dropped into a beaker containing 50 g of water at 25°C. If the specific heat capacity of the metal is 0.25 cal/(g·°C), what is the final temperature of the water?

 A. 27°C

 B. 40°C

 C. 50°C

 D. 60°C

 E. 86°C

5. What is the maximum amount of work than can be done by the following reaction at 30°C if $\Delta H = -125$ kJ and $\Delta S = -200$ J/K?

 A. 64.4 kJ

 B. 119 kJ

 C. 2,250 kJ

 D. 5,880 kJ

 E. 60,500 kJ

SOLUTIONS TO REVIEW PROBLEMS

1. **C** Discussed at the beginning of this chapter.

2. **A** In calorimetry, the amount of heat absorbed in a given process is calculated using the equation $q = mc\Delta T$. Knowing that the heat absorbed is 100 cal, the mass is 10 g, and the temperature change is 30°C, you can calculate the specific heat capacity as follows:

$$q = mc\Delta T$$
$$100 \text{ cal} = 10(c)(30)$$
$$c = 0.333 \text{ cal/(g°·C)}$$

3. **D** This problem requires the equation:

$$\Delta H_{rxn} = \Delta H_{products} - \Delta H_{reactants}$$

The equation for the enthalpy of formation of N is:

$$945.2 \text{ kJ} = 2(\Delta H_N) - (\Delta H_{N_2})$$

The ΔH of N_2 is 0 kJ because the heat of formation of any element in its elemental state is zero. Use that to solve for the enthalpy of formation of N:

$$\Delta H_N = \frac{945.2 \text{ kJ}}{2 \text{ mol}} = 472.6 \text{ kJ/mol}$$

4. **B** This problem uses the concept of conservation of energy. When the metal is put in the water, the metal will lose heat, which is transferred to the water. The amount of heat released by the metal is the same as the amount of heat absorbed by the water. The equation for heat transfer, $q = mc\Delta T$, can be used to show that the expressions for the heat released and absorbed by the metal and water, respectively, are:

$$q_m = 50(0.25)(x - 100)$$
$$q_w = 50(1.0)(x - 25)$$

Since heat is lost by the metal, it has a negative value $(-q_m)$; therefore, we can set $-q_m = q_w$, and these equations can be combined to solve for x:

$$-50(0.25)(x - 100) = 50(1.0)(x - 25)$$
$$-(0.25)(x - 100) = (1.0)(x - 25)$$
$$25 - 0.25x = x - 25$$
$$1.25x = 50$$
$$x = 40°C$$

5. **A** The maximum amount of work that can be done by a spontaneous reaction is the absolute value of its Gibbs free energy change, which can be calculated according to $\Delta G = \Delta H - T\Delta S$. Substituting the values from the question (being sure to use units consistently) gives:

$$\Delta G = -125 - (30 + 273)(-0.2)$$
$$\Delta G = -125 - (303)(-0.2)$$
$$\Delta G = -125 + 60.6 = -64.4 \text{ kJ}$$

GC

CHAPTER THIRTY-THREE

Chemical Equilibria

LEARNING OBJECTIVES

After this chapter, you will be able to:

- Apply the law of mass action to determine the K_{eq} expression of a reaction
- Recall properties of the equilibrium constant
- Predict the impact of changes within a system using Le Châtlier's principle
- Calculate solubility product constant for a solution in equilibrium

Often, reactions are discussed under the assumption that they are **irreversible** (i.e., only proceed in one direction) and that they proceed to completion. However, a **reversible** reaction often does not proceed to completion because (by definition) the products can react to reform the reactants. This is particularly true of reactions occurring in closed systems, where products are not allowed to escape. When there is no **net** change in the concentrations of the products and reactants during a reversible chemical reaction, equilibrium exists. This is not to say that a reaction in equilibrium is static; change continues to occur in both the forward and reverse directions. Equilibrium can be thought of as a balance between the two reaction directions.

Consider the following reaction:

$$A \rightleftharpoons B$$

At equilibrium, the concentrations of A and B are constant, yet the reactions $A \rightarrow B$ and $B \rightarrow A$ continue to occur at equal rates.

LAW OF MASS ACTION

Consider the following **one-step** reaction:

$$2A \rightleftharpoons B + C$$

Since the reaction occurs in one step, the rates of the forward (rate_f) and reverse (rate_r) reactions are given by:

$$\text{rate}_f = k_f[A]^2 \text{ and } \text{rate}_r = k_r[B][C]$$

When $\text{rate}_f = \text{rate}_r$, equilibrium is achieved. Since the rates are equal, it can be stated that

$$k_f[A]^2 = k_r[B][C] \text{ or } \frac{k_f}{k_r} = \frac{[B][C]}{[A]^2}$$

Since k_f and k_r are both constants, this equation may be rewritten as:

$$K_c = \frac{[B][C]}{[A]^2}$$

where K_c is called the **equilibrium constant**, and the subscript c indicates that it is in terms of concentration. When dealing with gases the equilibrium constant is referred to as K_p, and the subscript p indicates that it is in terms of partial pressure. For dilute solutions, K_c and K_{eq} are used interchangeably.

While the forward and reverse reaction rates are equal at equilibrium, the **molar concentrations** of the reactants and products usually are not equal. This means that the forward and reverse rate constants, k_f and k_r, respectively, are also usually unequal. For the one-step reaction described above:

$$k_f[A]^2 = k_r[B][C]$$

$$k_f = k_r\left(\frac{[B][C]}{[A]^2}\right)$$

In a reaction of more than one step, the equilibrium constant for the overall reaction is found by multiplying together the equilibrium constants for each step of the reaction. When this is done, the equilibrium constant for the overall reaction is equal to the concentrations of products divided by reactants in the overall reaction, each raised to its stoichiometric coefficient. For example, for the reaction

$$aA + bB \rightleftharpoons cC + dD,$$

the equilibrium constant equation will be

$$K_{eq} = \frac{[C]^c[D]^d}{[A]^a[B]^b}$$

This expression is known as the **law of mass action**.

Example: What is the expression for the equilibrium constant for the following reaction?

$$3\,H_2\,(g) + N_2\,(g) \rightleftharpoons 2\,NH_3\,(g)$$

Solution:

$$K_{eq} = \frac{[NH_3]^2}{[H_2]^3[N_2]}$$

PROPERTIES OF THE EQUILIBRIUM CONSTANT

The equilibrium constant, K_{eq}, has the following characteristics:

- Pure solids and liquids do not appear in the equilibrium constant expression.
- K_{eq} is characteristic of a given system at a given temperature.
- If the value of K_{eq} is much larger than 1, an equilibrium mixture of reactants and products will contain very little of the reactants compared to the products.
- If the value of K_{eq} is much smaller than 1 (i.e., less than 0.1), an equilibrium mixture of reactants and products will contain very little of the products compared to the reactants.
- If the value of K_{eq} is close to 1, an equilibrium mixture of products and reactants will contain approximately equal amounts of reactants and products.

Reaction Quotient

The law of mass action defines the position of equilibrium; however, equilibrium is a state that is only achieved through time. Depending on the actual rates of the forward and reverse reactions, equilibrium might be achieved in microseconds or millennia. What can serve as a "timer" to indicate how far the reaction has proceeded toward equilibrium? This role is served by the **reaction quotient**, **Q**. At any point in time during a reaction, we can measure the concentrations of all of the reactants and products and calculate the reaction quotient according to the following equation:

$$Q = \frac{[C]^c[D]^d}{[A]^a[B]^b}$$

This equation looks identical to the equation for K_{eq}. It is the same form, but the information it provides is quite different. While the concentrations used for the law of mass action are equilibrium (constant) concentrations, the concentrations of the reactants and products are not constant when calculating a value for Q of a reaction. Thus, the utility of Q is not the value itself but rather the comparison that can be made between Q at any given moment in the reaction to the known K_{eq} for the reaction at a particular temperature. Le Châtelier's principle, which will be elaborated upon shortly, will then guide the reaction. For any reaction, if:

- $Q < K_{eq}$, then the forward reaction has not yet reached equilibrium.
 - There is a greater concentration of reactants (and smaller concentration of products) than at equilibrium.
 - The forward rate of reaction is increased to restore equilibrium.
- $Q = K_{eq}$, then the reaction is in dynamic equilibrium.
 - The reactants and products are present in equilibrium proportions.
 - The forward and reverse rates of reaction are equal.
- $Q > K_{eq}$, then the forward reaction has exceeded equilibrium.
 - There is a greater concentration of products (and smaller concentration of reactants) than at equilibrium.
 - The reverse rate of reaction is increased to restore equilibrium.

Any reaction that has not yet reached the equilibrium state, as indicated by $Q < K_{eq}$, will continue spontaneously in the forward direction (consuming reactants to form products) until the equilibrium ratio of reactants and products is reached. Any reaction in the equilibrium state will continue to react

KEY CONCEPT

- $Q < K_{eq}$: $\Delta G < 0$, reaction proceeds in forward direction
- $Q = K_{eq}$: $\Delta G = 0$, reaction is in dynamic equilibrium
- $Q > K_{eq}$, $\Delta G > 0$: reaction proceeds in reverse direction

in the forward and reverse directions, but the reaction rates for the forward and reverse reactions will be equal, and the concentrations of the reactants and products will be constant, such that $Q = K_{eq}$. A reaction that is beyond the equilibrium state, as indicated by $Q > K_{eq}$, will proceed in the reverse direction (consuming products to form reactants) until the equilibrium ratio of reactants and products is reached again. Once a reaction is at equilibrium, any further movement in either the forward direction (resulting in an increase in products) or in the reverse direction (resulting in the reformation of reactants) will be nonspontaneous.

LE CHÂTELIER'S PRINCIPLE

The French chemist Henry Louis Le Châtelier indicated that, if an external stress is applied to a system currently at equilibrium, the system will attempt to adjust itself to partially offset the stress. This rule, known as Le Châtelier's principle, is used to determine the direction in which a reaction at equilibrium will proceed when subjected to a stress, such as a change in concentration, pressure, temperature, or volume.

Changes in Concentration

Increasing the concentration of a species will tend to shift the equilibrium in the direction that will reestablish the equilibrium concentration of the species that is added, and decreasing its concentration will shift the equilibrium in the opposite direction. For example, in the reaction:

$$A + B \rightleftharpoons C + D$$

if the concentration of A and/or B is increased, the equilibrium will shift toward (or favor production of) C and D. Conversely, if the concentration of C and/or D is increased, the equilibrium will shift away from the production of C and D, favoring production of A and B. Similarly, decreasing the concentration of a species will tend to shift the equilibrium toward the production of that species. For example, if A and/or B is removed from the above reaction, the equilibrium will shift so as to favor increasing the concentrations of A and B.

This effect is often used in industry to increase the yield of a useful product or drive a reaction to completion. If D were constantly removed from the above reaction, the net reaction would produce more D and concurrently more C. Likewise, using an excess of the least expensive reactant helps to drive the reaction forward.

Change in Pressure or Volume

In a system at constant temperature, a change in pressure causes a change in volume, and vice versa. Since liquids and solids are practically incompressible, a change in the pressure or volume of systems involving only these phases has little or no effect on their equilibrium. Reactions involving gases, however, may be greatly affected by changes in pressure or volume; since gases are highly compressible, changing the volume of a container effectively changes the concentration of the gases it contains.

Pressure and volume are inversely related. An increase in the pressure of a system will shift the equilibrium so as to decrease the number of moles of gas present. This reduces the volume of the system and relieves the stress of the increased pressure. Consider the following reaction:

$$N_2 (g) + 3 H_2 (g) \rightleftharpoons 2 NH_3 (g)$$

The left side of the reaction has four moles of gaseous molecules, whereas the right side has only two moles. When the pressure of this system is increased, the equilibrium will shift so that the side of the reaction producing fewer moles is favored. Since there are fewer moles on the right, the equilibrium will shift toward the right. Conversely, if the volume of the same system is increased, its pressure immediately decreases, which, according to Le Châtelier's principle, leads to a shift in the equilibrium to the left.

Change in Temperature

Changes in temperature also affect equilibrium. To predict this effect, heat may be considered as a product in an exothermic $(\Delta H < 0)$ reaction and as a reactant in an endothermic reaction $(\Delta H > 0)$. Consider the following exothermic reaction:

$$A \rightleftharpoons B + heat$$

If this system were placed in an ice bath, its temperature would decrease, driving the reaction to the right to replace the heat lost. Conversely, if the system were placed in a boiling-water bath, the reaction equilibrium would shift to the left due to the increased "concentration" of heat.

Not only does a temperature change alter the position of the equilibrium, it also alters the numerical value of the equilibrium constant. Therefore, temperature is the only thing that will affect the value of K. In contrast, changes in the concentration of a species in the reaction, in the pressure, or in the volume alter the position of the reaction quotient without changing the numerical value of the equilibrium constant itself.

SOLUTION EQUILIBRIA

The process of solvation, like other reversible chemical and physical changes, tends toward equilibrium. Immediately after a solute has been introduced into a solvent, most of the change taking place is dissociation because no dissolved solute is initially present. However, according to Le Châtelier's principle, as solute dissociates, the reverse reaction (precipitation of the solute) also begins to occur. Eventually, equilibrium is reached and the rate of solute dissociation is equal to the rate of precipitation. At equilibrium, the net concentration of the dissociated solute remains unchanged regardless of the amount of solute added.

An ionic solid introduced into a polar solvent dissociates into its component ions. The dissociation of such a solute in solution may be represented by:

$$A_m B_n (s) \rightleftharpoons mA (aq) + nB (aq)$$

For example: $$CaCl_2 (s) \rightleftharpoons Ca^{2+} (aq) + 2 Cl^- (aq)$$

The Solubility Product Constant

A slightly soluble ionic solid exists in equilibrium with its saturated solution. In the case of AgCl, for example, the solution equilibrium is as follows:

$$AgCl (s) \rightleftharpoons Ag^+ (aq) + Cl^- (aq)$$

The **ion product** (Q_{sp}) of a compound in solution is defined as follows (note that solids and pure

liquids are not included in the calculations for Q or K):

$$Q_{sp} = [A]^m[B]^n$$

The same expression for a saturated solution at equilibrium defines the **solubility product constant** (K_{sp}).

$$K_{sp} = [A]^m[B]^n \text{ in a saturated solution}$$

However, Q_{sp} is defined with respect to initial concentrations and does not necessarily represent either an equilibrium or a saturated solution, while K_{sp} does. Q_{sp}, like the reaction quotient, indicates where the dissolution is with respect to equilibrium.

Each salt has its own distinct K_{sp} at a given temperature. If at a given temperature a salt's Q_{sp} is equal to its K_{sp}, the solution is saturated, and the rate at which the salt dissolves equals the rate at which it precipitates out of solution. If a salt's Q_{sp} exceeds its K_{sp}, the solution is supersaturated (holding more salt than it should be able to at a given temperature) and unstable. Consequently, the reverse reaction will be favored. If the supersaturated solution is disturbed by adding more salt, other solid particles, or jarring the solution by a sudden decrease in temperature, the solid salt will precipitate until Q_{sp} equals the K_{sp}. If Q_{sp} is less than K_{sp}, the solution is unsaturated and no precipitate will form, and the forward reaction will be preferred.

Example: The solubility of $Fe(OH)_3$ in an aqueous solution was determined to be 4.5×10^{-10} mol/L. What is the value of the K_{sp} for $Fe(OH)_3$?

Solution: The molar solubility (the solubility of the compound in mol/L) is given as 4.5×10^{-10} M. The equilibrium concentration of each ion can be determined from the molar solubility and the balanced dissociation reaction of $Fe(OH)_3$. The dissociation reaction is:

$$Fe(OH)_3 \ (s) \rightleftarrows Fe^{3+} \ (aq) + 3 \ OH^- \ (aq)$$

Thus, for every mole of $Fe(OH)_3$ that dissociates, one mole of Fe^{3+} and three moles of OH^- are produced. Since the solubility is 4.5×10^{-10} M, the K_{sp} can be determined as follows:

$$K_{sp} = [Fe^{3+}][OH^-]^3$$

$$[OH^-] = 3[Fe^{3+}]; \quad [Fe^{3+}] = 4.5 \times 10^{-10} \text{ M}$$

$$K_{sp} = [Fe^{3+}](3[Fe^{3+}])^3 = 27[Fe^{3+}]^4$$

$$K_{sp} = 27(4.5 \times 10^{-10})^4 = 27(410 \times 10^{-40}) = 11{,}070 \times 10^{-40}$$

$$K_{sp} = 1.1 \times 10^{-36}$$

Example: What are the concentrations of each of the ions in a saturated solution of $PbBr_2$, given that the K_{sp} of $PbBr_2$ is 2.1×10^{-6}? If 5 g of $PbBr_2$ are dissolved in water to make 1 L of solution at 25°C, would the solution be saturated, unsaturated, or supersaturated?

Solution: The first step is to write out the dissociation reaction:

$$PbBr_2 \ (s) \rightleftarrows Pb^{2+} \ (aq) + 2 \ Br^- \ (aq)$$

$$K_{sp} = [Pb^{2+}][Br^-]^2$$

If x equals the concentration of Pb^{2+}, then $2x$ equals the concentration of Br^- in the saturated solution at equilibrium (since $[Br^-]$ is twice as large as $[Pb^{2+}]$).

$$K_{sp} = [x][2x]^2 = 4x^3$$

$$2.1 \times 10^{-6} = 4x^3$$

Solving for x, the concentration of Pb^{2+} in a saturated solution is 8.07×10^{-3} M, and the concentration of Br^- ($2x$) is 1.61×10^{-2} M.

To solve the second part of the question, convert 5 g of $PbBr_2$ into moles:

$$5\,g \times \frac{1\,mol\ PbBr_2}{367\,g} = 1.36 \times 10^{-2}\,mol$$

1.36×10^{-2} mol of $PbBr_2$ is dissolved in 1 L of solution, so the concentration of the solution is 1.36×10^{-2} M. Since this is higher than the concentration of a saturated solution of $PbBr_2$ (8.07×10^{-3} M), this solution would be supersaturated.

Factors Affecting Solubility

The quantity of a salt that can be dissolved is considerably reduced when it is dissolved in a solution that already contains one of its ions rather than in a pure solvent. This reduction in solubility, called the **common ion effect,** is another example of Le Châtelier's principle. The common ion effect will not change K_{sp}, but it will change the molar solubility (the concentrations of the individual ions, or x, in the solution).

Example: The K_{sp} of AgI in aqueous solution is 1×10^{-16} mol/L. If a 1×10^{-5} M solution of $AgNO_3$ is saturated with AgI, what will be the final concentration of the iodide ion?

Solution: The concentration of Ag^+ in the original $AgNO_3$ solution will be 1×10^{-5} mol/L. After AgI is added to saturation, the iodide concentration can be found with the K_{sp} equation:

$$AgI\ (s) \rightleftarrows Ag^+\ (aq) + I^-\ (aq)$$

$$K_{sp} = [Ag^+][I^-]$$

$$1 \times 10^{-16} = [Ag^+][I^-]$$

$1 \times 10^{-16} = [1 \times 10^{-5} + Ag^+][I^-]$ As a result of the common ion effect, the amount Ag^+ that will dissolve will be negligible.

$$1 \times 10^{-16} = [1 \times 10^{-5}][I^-]$$

$$[I^-] = 1 \times 10^{-11}\ mol/L$$

If the AgI had been dissolved in pure water, the concentration of both Ag^+ and I^- would have been 1×10^{-8} mol/L. The presence of the common ion, Ag^+, at a concentration 1,000 times higher than what it would be in a solution of just water and silver iodide has reduced the iodide concentration to one-thousandth of what it would have been otherwise. An additional 1×10^{-11} mol/L of silver will dissolve in solution along with the iodide ion, but this will not significantly affect the final silver concentration, which is one million times greater.

REVIEW PROBLEMS

1. The equilibrium constant, K_{eq}, of a certain single-reactant reaction is 0.16. Suppose an appropriate catalyst is added in twice the concentration of the reactant.

 A. What will be the equilibrium constant?

 B. Will the activation energy increase or decrease?

2. At equilibrium

 A. the forward reaction will continue.

 B. a change in reaction conditions will shift the equilibrium.

 C. the reverse reaction will not continue.

 D. the forward reaction will not continue.

 E. both A and B will occur.

3. What is the general equation for K_{eq} for the following reaction?

$$2 \, NO_2 \, (g) + 2 \, H_2 \, (g) \rightleftharpoons N_2 \, (g) + 2 \, H_2O \, (g)$$

4. If $K_{eq} > 1$,

 A. the equilibrium mixture will contain more product than reactant.

 B. the equilibrium mixture will contain more reactant than product.

 C. the equilibrium amounts of reactants and products are equal.

 D. the reaction is irreversible.

 E. the reaction will not occur spontaneously.

5. Answer the following questions using the reaction given below.

$$CH_3OH \, (l) + H_2 \, (g) \rightleftharpoons CH_4 \, (g) + H_2O \, (l) \qquad \Delta H = -30 \, kcal$$

 A. In which direction would the reaction be shifted if the temperature were increased?

 B. In which direction would the reaction be shifted if the volume were doubled?

 C. In which direction would the reaction be shifted if methane (CH_4) were removed from the reaction vessel?

6. What is the concentration of the Ag+ ion in a saturated solution of AgCl? (K_{sp} for AgCl = 1.7×10^{-10})

$$AgCl \, (s) \rightleftharpoons Ag^+ \, (aq) + Cl^- \, (aq)$$

 A. $1.7 \times 10^{-10} \, M$

 B. $3.4 \times 10^{-10} \, M$

 C. $1.3 \times 10^{-5} \, M$

 D. $2.6 \times 10^{-5} \, M$

 E. $5.8 \times 10^{-4} \, M$

7. Explain the common ion effect in terms of K_{sp}.

SOLUTIONS TO REVIEW PROBLEMS

1. **A** K_{eq} remains constant at 0.16. Catalysts do not affect equilibrium position.

 B Addition of a catalyst decreases the activation energy.

2. **E** At equilibrium, both the forward and reverse reactions are proceeding. Any change in the equilibrium conditions will shift the equilibrium to alleviate the stress on the reaction.

3. $$K_{eq} = \frac{[N_2][H_2O]^2}{[NO_2]^2[H_2]^2}$$

 K_{eq} can also be written in terms of partial pressures as:

 $$K_{eq} = \frac{\left(P_{N_2} \times P_{H_2O}^2\right)}{\left(P_{NO_2}^2 \times P_{H_2}^2\right)}$$

4. **A** Discussed in the section on the equilibrium constant in this chapter.

5. **A** The reaction shifts to the left. This is an exothermic reaction, as seen by the negative ΔH, and any increase in temperature will favor the reverse reaction.

 B The reaction will remain unchanged. Changing the volume constraints on a reaction that involves gases will affect the equilibrium only when one side of the reaction has a greater number of moles of gas than the other.

 C The reaction would shift to the right. By removing methane gas from the reaction vessel, the reactant concentrations are effectively increased relative to the product concentrations, and the reaction will go to the right to correct for this.

6. **C** $K_{sp} = [Ag^+][Cl^-]$

 Let $x = [Ag^+]$

 Since $[Ag^+] = [Cl^-]$: $1.7 \times 10^{-10} = x^2$

 $x = 1.3 \times 10^{-5}$ M

7. Consider as an example a dilute solution of AgCl. The K_{sp} of AgCl at 25°C is 1.7×10^{-10}. If the original concentration of AgCl is 1×10^{-6} M, then $Q_{sp} = (1 \times 10^{-6})^2 = 1 \times 10^{-12}$, which is less than the K_{sp}; thus, all the salt is dissolved.

 Now suppose NaCl is added to this solution until the NaCl concentration is 1×10^{-2}. $[Cl^-]$ will now be the sum of $[Cl^-]$ due to AgCl and $[Cl^-]$ due to NaCl; $[Cl^-] = 1 \times 10^{-2} + 1 \times 10^{-6} = 1.0001 \times 10^{-2}$, or approximately 1×10^{-2}.

 Thus, the Q_{sp} for AgCl is $(1 \times 10^{-6})(1 \times 10^{-2}) = 1 \times 10^{-8}$, which is greater than the K_{sp}. AgCl will therefore precipitate until Q_{sp} is reduced to the K_{sp}. Because of the high concentration of Cl^-, the final concentration of Ag^+ will be lower than it would have been otherwise.

CHAPTER THIRTY-FOUR

Liquids and Solids

LEARNING OBJECTIVES

After this chapter, you will be able to:

- Contrast the three phases of matter
- Identify phase equilibria and regions on a phase diagram
- Calculate changes in solutions due to colligative properties

Matter can exist in three different physical forms called **phases** or **states**: gas, liquid, and solid. The primary difference between the three phases is how tightly the constituent pieces are held together. When the attractive forces between gaseous molecules overcome the kinetic energy that keeps them apart, the molecules move closer together such that they can no longer move about freely, entering the **liquid** or **solid** phase. Because of their smaller volume relative to gases, liquids and solids are also referred to as **condensed phases**.

The table below contrasts the general properties of each phase.

Phase	Volume and Shape	Motion Principles	Density	Ability to be Compressed
Gas	Conforms to the volume and shape of the container it is in	Continual motion	Low	Easily compressed to smaller volume
Liquid	Conforms to the shape of the container; however, has definite volume	Sliding motion of particles past one another	Moderate	Small ability to be compressed (considered incompressible on the exam)
Solid	Defined volume and shape	Particles in a fixed position	High	Difficult to compress (considered incompressible on the exam)

Table 34.1

GASES

Gases display similar behavior and follow similar laws regardless of their identity. The atoms or molecules in a gaseous sample move rapidly and are far apart from each other. In addition,

only very weak intermolecular forces exist between gas particles; this results in certain characteristic physical properties, such as the ability to expand to fill any volume, to take on the shape of a container, and to flow as fluids. Furthermore, gases are easily, though not infinitely, compressible. This chapter will mainly focus on principles of liquids and solids, but gases will be discussed more in Chapter 35.

LIQUIDS

In a liquid, atoms or molecules are held close together with little space between them. As a result, liquids have definite volumes and cannot easily be expanded or compressed. However, the molecules can still move around and are in a state of relative disorder. Consequently, the liquid can change shape to fit its container, and its molecules are able to **diffuse** and **evaporate**. The movement of a liquid can be defined as viscosity. **Viscosity** is a measure of a fluid's resistance to flow. In other words, it describes the internal friciton of a moving fluid. For example, honey has a high viscosity because it flows slowly whereas water has a lower viscosity. There are several factors that determines a fluid's viscosity such as temperature, composition, and even pressure.

One of the most important properties of liquids is their ability to mix, both with each other and with other phases, to form **solutions** (see Chapter 28). The degree to which two liquids can mix is called their **miscibility**. Oil and water are almost completely **immiscible**; that is, their molecules tend to repel each other due to their polarity difference. Oil and water normally form separate layers when mixed, with oil on top because it is less dense. Under extreme conditions, such as violent shaking, two immiscible liquids can form a fairly homogeneous mixture called an **emulsion**. Although they look like solutions, emulsions are actually mixtures of discrete particles too small to be seen distinctly.

SOLIDS

In a solid, the attractive forces between atoms, ions, or molecules are strong enough to hold them rigidly together. Thus, the particles' only motion is vibration about fixed positions, and the kinetic energy of solids is predominantly **vibrational energy**. As a result, solids have definite shapes and volumes.

A solid may be **crystalline** or **amorphous**. A crystalline solid, such as NaCl, possesses an ordered structure; its atoms exist in a specific, three-dimensional geometric arrangement with repeating patterns of atoms, ions, or molecules. An amorphous solid, such as glass, has no ordered three-dimensional arrangement, although the molecules are also fixed in place.

Most solids are crystalline in structure. The two most common forms of crystals are **metallic** and **ionic** crystals.

Ionic solids are aggregates of positively and negatively charged ions; there are no discrete molecules. The physical properties of ionic solids include high melting points, high boiling points, and poor electrical conductivity in the solid phase. These properties are due to the compounds' strong electrostatic interactions, which also cause the ions to be relatively immobile. Ionic structures are given by empirical formulas that describe the ratio of atoms in the lowest possible whole numbers. For example, the empirical formula $BaCl_2$ gives the ratio of barium to chloride within the crystal.

Metallic solids consist of metal atoms packed together as closely as possible. These solids have high melting and boiling points as a result of their strong covalent attractions. Pure metallic structures (consisting of a single element) are usually described as layers of spheres of roughly similar radii.

Crystals (both ionic and metallic) are defined by their **unit cells**, which represent the smallest repeating units that compose the larger crystalline structure. Although there are many types of unit cells, the cubic unit cells are the most important: **simple cubic**, **body-centered cubic**, and **face-centered cubic**.

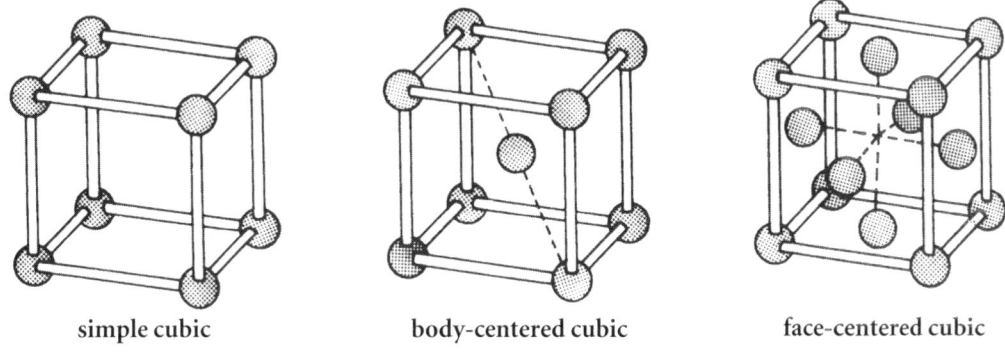

<div align="center">

simple cubic body-centered cubic face-centered cubic

Figure 34.1

</div>

Each point in a unit cell diagram represents the exact same atom or ion. Additional atoms or ions of other elements may also be present, but these are not included in the unit cell diagram. For example, the ions of cesium chloride (CsCl) arrange in simple cubic units such that each of the eight corners of the cube are occupied by Cl^- ions. The center of the cube is occupied by one Cs^+ ion (creating a final structure similar to the body-centered cubic diagram), but the Cs^+ ion is not represented in the simple cubic diagram since Cs^+ is not the same ion as the corners, which are Cl^-.

ENERGY OF PHASE CHANGES

Phase changes between solids, liquids, and gases involve the exchange of heat. First, the substance's temperature must reach the correct temperature for the phase change to occur. Then, heat must be transferred to or from the material in order for it to go through a phase change. Units of heat are either the calorie (cal) or the joule (J); one calorie is equal to 4.184 J.

Specific Heat

The heat Q gained or lost by a substance when the temperature of that substance is changed by T is given by:

$$Q = mc\Delta T = mc(T_f - T_i)$$

where m is the mass of the object and c is a constant called the specific heat. The specific heat is defined as the amount of heat required to raise a unit mass of a substance 1 K or 1°C and depends solely on the material of the object. For water, specific heat is often given as $c = 1 \text{ cal·g}^{-1}\text{·K}^{-1} = 1 \text{ cal·g}^{-1}\text{·}°C^{-1} = 4.184 \text{ J·g}^{-1}\text{·K}^{-1}$. Figure 34.3 shows the heating curve for water; the formula $Q = mc\Delta T$ applies to the angled portions of the curve.

Figure 34.2

Heat of Transformation

The $Q = mc\Delta T$ equation applies only when there is no conversion between gas, liquid, or solid phases. During a phase change the temperature of the substance remains constant and the heat gained or lost is related to the amount of material that changes phase. The amount of heat needed to change the phase of 1 kg of a substance is the latent heat of transformation H_L. The total amount of heat gained or lost by a substance during a phase change is given by:

$$Q = mH_L$$

where Q is the heat gained or lost, m is the mass of the substance, and H_L is the latent heat of transformation of the substance.

The phase change from liquid to solid, or solid to liquid, occurs at the melting-point temperature. The corresponding heat of transformation is often referred to as the heat of fusion and is written as ΔH_f. On the other hand, the phase change from liquid to gas, or gas to liquid, occurs at the boiling-point temperature. Here the heat of transformation is often referred to as the heat of vaporization and is written as ΔH_v. In Figure 34.3 the flat portions of the curve represent the phase changes, with no change in temperature occurring as water changes from either solid to liquid or liquid to gas.

Example: How much heat must be added to bring 20 g of ice at 0°C to water vapor at 100°C? (The heat of fusion of ice is 80 cal/g. The heat of vaporization of water is 540 cal/g.)

Solution: The different parts of the heating curve must be calculated separately. Start with melting the ice at 0°C:

$$Q_{melting} = mH_f = 20\text{g} \times 80 \text{ cal/g} = 1{,}600 \text{ cal}$$

Next, calculate the heat needed to raise the water temperature from 0°C to 100°C:

$$Q = mc\Delta T = 20 \text{ g} \times 1 \text{ cal·g}^{-1}\cdot{}^{\circ}\text{C}^{-1} \times (100 - 0{}^{\circ}\text{C}) = 2{,}000 \text{ cal}$$

Now calculate the heat needed to turn the water from liquid to vapor:

$$Q_{vaporization} = mH_v = 20 \text{ g} \times 540 \text{ cal/g} = 10{,}800 \text{ cal}$$

Finally, add together the three quantities from the three sections of the heating curve:

$$Q_{total} = 1{,}600 + 2{,}000 + 10{,}800 = 14{,}400 \text{ cal}$$

PHASE EQUILIBRIA

In an isolated system, phase changes (solid to liquid to gas) are reversible, and an equilibrium exists between phases. For example, at 1 atm and 0°C in an isolated system, an ice cube floating in water is in equilibrium. Some of the ice may absorb heat and melt, but an equal amount of water will release heat and freeze. Thus, the relative amounts of ice and water remain constant.

Gas-Liquid Equilibrium

The temperature of a liquid is related to the average kinetic energy of the liquid molecules; however, the kinetic energy of the molecules will vary. A few molecules near the surface of the liquid may have enough energy to leave the liquid phase and escape into the gaseous phase. This process is known as **evaporation** or **vaporization**. Each time the liquid loses a high-energy particle, the temperature of the remaining liquid decreases; thus, evaporation is a cooling process. Nevertheless, given enough kinetic energy, the liquid will completely evaporate.

If a cover is placed on a beaker of liquid, the escaping molecules are trapped above the solution. These molecules exert a countering pressure, which forces some of the gas back into the liquid phase; this process is called **condensation**. Atmospheric pressure acts on a liquid in a similar fashion as a solid lid. As evaporation and condensation proceed, an equilibrium is reached in which the rates of the two processes become equal. Once this equilibrium is reached, the pressure that the gas exerts over the liquid is called the **vapor pressure** of the liquid. Vapor pressure increases as temperature increases, since more molecules have sufficient kinetic energy to escape into the gas phase. The temperature at which the vapor pressure of the liquid equals the external pressure is called the **boiling point**.

Liquid-Solid Equilibrium

The liquid and solid phases can also coexist in equilibrium (e.g., the ice water mixture discussed above). Even though the atoms or molecules of a solid are confined to definite locations, each atom or molecule can undergo motions about some equilibrium position. These motions (vibrations) increase when heat is applied. If atoms or molecules in the solid phase absorb enough energy in this fashion, the solid's three-dimensional structure breaks down, and the liquid phase begins. The transition from solid to liquid is called **fusion** or **melting**. The reverse process, from liquid to solid, is called **solidification**, **crystallization**, or **freezing**. The temperature at which these processes occur is called the **melting point** or **freezing point**, depending on the direction of the transition. Whereas pure crystals have distinct melting points, amorphous solids, such as glass, tend to melt over a larger range of temperatures due to their less-ordered molecular distribution.

Gas-Solid Equilibrium

A third type of phase equilibrium is that between a gas and a solid. When a solid goes directly into the gas phase, the process is called **sublimation**. Dry ice (solid CO_2) sublimes at room temperature, becoming CO_2 (g); the absence of the liquid phase makes it a convenient refrigerant. The reverse transition, from the gaseous to the solid phase, is called **deposition**.

The Gibbs Function

The thermodynamic criterion for each of the above equilibria is that the change in Gibbs free energy must equal zero, meaning no net energy is required for or released from the forward or reverse reaction. For an equilibrium between a gas and a solid:

$$\Delta G = G\,(g) - G\,(s)$$

$$\text{so } G\,(g) = G\,(s) \text{ at equilibrium}$$

The same is true of the Gibbs functions for the other two equilibria.

PHASE DIAGRAMS

Single Component

A standard **phase diagram** depicts the phases and phase equilibria of a substance at defined temperatures and pressures. In general, the gas phase is found at high temperature and low pressure; the solid phase is found at low temperature and high pressure; and the liquid phase is found at high temperature and high pressure. A typical phase diagram is shown below:

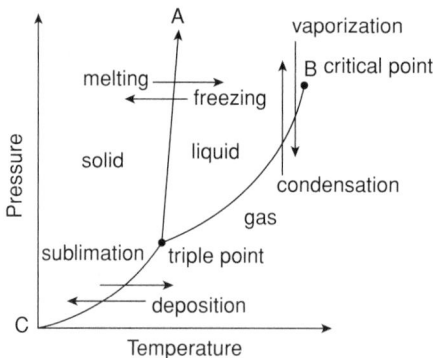

Figure 34.3

The three phases are demarcated by lines indicating the temperatures and pressures at which two phases are in equilibrium. Line A represents freezing/melting, line B vaporization/condensation, and line C sublimation/deposition. The intersection of the three lines is called the **triple point**. At this temperature and pressure, unique for a given substance, all three phases are in equilibrium. The point at B is known as the **critical point**, the temperature and pressure above which the liquid and gas phases are not possible and supercritical fluids exist instead.

Multiple Components

The phase diagram for a mixture of two or more components is complicated by the requirement that the composition of the mixture, as well as the temperature and pressure, must be specified. Consider a solution of two liquids, A and B. The vapor above the solution is a mixture of the vapors of A and B. The pressures exerted by vapor A and vapor B on the solution are the vapor pressures that each exerts above its individual liquid phase. **Raoult's law** (described below) enables one to determine the relationship between the vapor pressure of vapor A and the concentration of liquid A in the solution.

Vapor-Pressure Lowering (Raoult's Law)

When solute B is added to pure solvent A, the vapor pressure of A above the solvent decreases. If the vapor pressure of A above pure solvent A is designated by P°_A and the vapor pressure of A above the solution containing B is P_A, the vapor pressure decreases as follows:

$$\Delta P = P^{\circ}_A - P_A$$

In the late 1800s, the French chemist François Marie Raoult determined that this vapor pressure decrease is also equivalent to:

$$\Delta P = X_B P^{\circ}_A$$

where X_B is the mole fraction of the solute B in solvent A (mol B/total moles). Because $X_B = 1 - X_A$ and $\Delta P = P^{\circ}_A - P_A$, substitution into the above equation leads to the common form of Raoult's law:

$$P_A = X_A P^{\circ}_A$$

Similarly, the expression for the vapor pressure of the solute in solution (assuming it is volatile) is given by:

$$P_B = X_B P^{\circ}_B$$

Raoult's law holds only when the attraction between molecules of the different components of the mixture is equal to the attraction between the molecules of any one component in its pure state. When this condition does not hold, the relationship between mole fraction and vapor pressure will deviate from Raoult's law. Solutions that obey Raoult's law are called ideal solutions.

COLLIGATIVE PROPERTIES

Colligative properties are physical properties derived solely from the number of particles present, not the nature of those particles. These properties are usually associated with dilute solutions.

Freezing-Point Depression

Pure water (H_2O) freezes at 0°C; however, for every mole of solute particles dissolved in 1 L of water, the freezing point is lowered by 1.86°C. This is because the solute particles interfere with the process of crystal formation that occurs during freezing; the solute particles lower the temperature at which the molecules can align themselves into a crystalline structure.

The formula for calculating this freezing-point depression is:

$$\Delta T_f = iK_f m$$

where ΔT_f is the freezing-point depression, K_f is a proportionality constant characteristic of a particular solvent, m is the molality of the solution (mol solute/kg solvent), and i is the van't Hoff factor, which accounts for the number of particles that dissociate from the original molecule. For example, NaCl dissociates into two ions in water, Na^+ and Cl^-, so its $i = 2$ to represent that 1 mol NaCl becomes 2 mol solute particles.

One of the best examples of this principle is when salt is sprinkled on roads to make ice melt. This thawing occurs because the salt depresses the freezing point of the water.

Boiling-Point Elevation

A liquid boils when its vapor pressure equals the atmospheric pressure. If the vapor pressure of a solution is lower than that of the pure solvent, more energy (and consequently a higher temperature) will be required before its vapor pressure equals atmospheric pressure. The extent to which the boiling point of a solution is raised relative to that of the pure solvent is given by the following formula:

$$\Delta T_b = iK_b m$$

where ΔT_b is the boiling-point elevation, K_b is a proportionality constant characteristic of a particular solvent, m is the molality of the solution, and i is the van't Hoff factor.

One commonly misunderstood example of this principle is the addition of salt (NaCl) to a boiling pot of water on the stove, such as before cooking pasta, supposedly to speed cooking by raising the temperature of the water. Although adding Na^+ and Cl^- ions does increase the boiling point, the molality of salt normally added only results in an increase in boiling point of approximately 0.1°C (in fact, the main values of adding salt are to decrease sticking and add flavor).

Osmotic Pressure

Consider a container separated into two compartments by a semipermeable membrane (which, by definition, selectively permits the passage of only certain molecules). One compartment contains pure water, while the other contains water with dissolved solute. The membrane allows water but not solute to pass through. Because substances tend to flow, or **diffuse**, from higher to lower concentrations (which increases entropy), water will diffuse from the compartment containing pure water to the compartment containing the water-solute mixture. This net flow will cause the water level in the compartment containing the solution to rise above the level in the compartment containing pure water.

However, the pressure exerted by the water level in the solute-containing compartment due to gravity will eventually oppose the influx of water due to diffusion, and the water will stop flowing once this point is reached. This pressure is defined as the **osmotic pressure** (Π) of the solution and is given by the formula:

$$\Pi = iMRT$$

where M is the molarity of the solution, R is the ideal gas constant, T is the temperature on the Kelvin scale, and i is the van't Hoff factor. This equation shows that molarity and osmotic pressure are directly proportional (i.e., as the concentration of the solution increases, the osmotic pressure also increases). Thus, the osmotic pressure depends only on the amount of solute, not its identity.

REVIEW PROBLEMS

1. Which of the following indicates the relative randomness of molecules in the three states of matter?

 A. solid > liquid > gas
 B. liquid < solid < gas
 C. liquid > gas > solid
 D. gas > liquid > solid
 E. gas < solid < liquid

2. What factor determines whether or not two liquids are miscible?

 A. Molecular size
 B. Molecular polarity
 C. Density
 D. Both B and C
 E. Both A and C

3. Discuss the physical properties of ionic crystals.

4. Alloys are mixtures of pure metals in either the liquid or solid phase. Which of the following is usually true of alloys?

 A. The melting/freezing point of an alloy will be lower than that of either of the component metals because the new bonds are stronger.
 B. The melting/freezing point of an alloy will be lower than that of either of the component metals because the new bonds are weaker.
 C. The melting/freezing point of an alloy will be greater than that of either of the component metals because the new bonds are weaker.
 D. The melting/freezing point of an alloy will be greater than that of either of the component metals because the new bonds are stronger.
 E. None of the above.

Refer to the phase diagram below for questions 5–8.

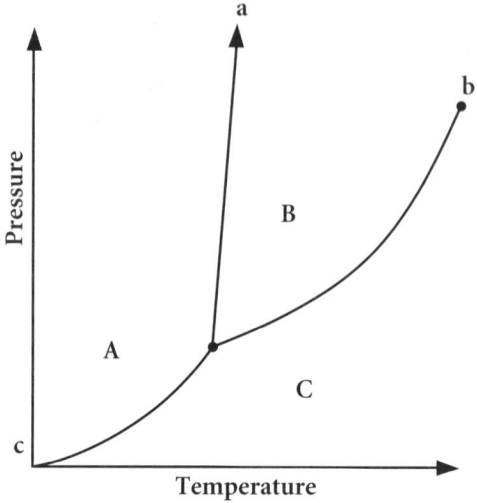

5. What is the typical form of a substance in state B?

 A. Pure crystalline solid

 B. Amorphous solid

 C. Gas

 D. Liquid

 E. Supercooled liquid

6. What is the typical form of a substance in state C?

 A. Pure crystalline solid

 B. Amorphous solid

 C. Gas

 D. Liquid

 E. Supercooled liquid

7. If line a was instead a band covering a range of temperatures, what would state A be?

 A. Pure crystalline solid

 B. Amorphous solid

 C. Gas

 D. Liquid

 E. Supercooled liquid

8. What is the triple point?

9. A semipermeable membrane separates a container of fresh water from one of salt water. If the volume of fresh water decreases significantly, what must be true of the semipermeable membrane? Assume that evaporation is negligible.

10. Once equilibrium is reached, if the temperature in Question 9 is suddenly increased, the osmotic pressure

 A. will decrease.
 B. will increase.
 C. will remain the same.
 D. will decrease and then increase.
 E. cannot be determined.

11. What is the freezing point of a solution containing 0.5 mol of glucose dissolved in 200 g of H_2O? (The K_f for water is 1.86°C·m^{-1}.)

12. The osmotic pressure at STP of a solution in which 1 L of solution contains 117 g of NaCl is

 A. 44.8 atm.
 B. 48.9 atm.
 C. 89.54 atm.
 D. 97.7 atm.
 E. 117 atm.

13. At 18°C and 1 atm, the vapor pressure of pure water is 0.02 atm, and the vapor pressure of pure ethyl alcohol (MW = 46 g/mol) is 0.50 atm. For a water-alcohol mixture with the alcohol present in a mole fraction of 0.2, find the vapor pressure due to the alcohol and the vapor pressure due to the water.

SOLUTIONS TO REVIEW PROBLEMS

1. **D** Because gas molecules have the greatest freedom to move around, gases have the greatest disorder. Liquids are denser than gases, and therefore the molecules are less free to move around. The arrangement of molecules in solids is the least random. Thus, melting and boiling are accompanied by an increase in entropy (i.e., $\Delta S > 0$).

2. **B** The miscibility of two liquids strongly depends on their polarities. In general, polar and nonpolar liquids are not miscible, while a polar liquid can usually be mixed with another polar liquid and a nonpolar liquid with another nonpolar liquid. Choice (A), molecular size, and choice (C), the density of a liquid, do not directly affect the miscibility. However, (C) should remind you that two immiscible liquids will form separate layers, with the denser liquid on the bottom. Thus, (B) is the only correct choice.

3. Ionic crystals contain repeating units of cations and anions. Because of the strong electrostatic attraction between the ions, these crystals have high melting points. Since the charges in these crystals are tightly fixed in the lattice, ionic solids are poor conductors of electricity. In the liquid or solution phase, the charged particles can move around, and thus liquid ionic compounds will conduct electricity, as will solutions of such salts.

4. **B** The bonds between different metal atoms in an alloy are much weaker than those between the atoms in pure metals. Therefore, breaking these bonds requires less energy than breaking the bonds in pure metals. Since melting and freezing points are inversely proportional to the stability of bonds, they tend to be lower for alloys than for pure metals. Alternately, an alloy can be looked at as a solid solution; adding impurities is similar to adding solutes in that it results in melting point depression.

5. **D** Discussed in the section on phase diagrams in this chapter.

6. **C** Discussed in the section on phase diagrams in this chapter.

7. **B** Discussed in the section on phase diagrams in this chapter.

8. The unique combination of temperature and pressure at which the solid, liquid, and gas phases coexist at equilibrium.

9. The membrane must be permeable to water but not to salt. If it were permeable to salt, the salt would diffuse across the membrane into the fresh water container (down its concentration gradient) until the molarities of the two containers were the same. However, the volume of the salt water container increased, indicating that fresh water diffused across the membrane from a region of low solute concentration to one of high solute concentration. The water level rose until it exerted enough pressure to counterbalance the tendency to diffuse; this pressure is known as the osmotic pressure.

10. **B** Using the formula $\Pi = iMRT$, we see that osmotic pressure and temperature are directly proportional (i.e., if temperature increases, osmotic pressure will also increase). Thus, (B) is the correct answer.

11. **−4.65°C**

This question applies the concept of freezing-point depression. If 0.5 mol of a nonelectrolyte solute such as glucose is dissolved in 200 g of H_2O, then the molality of the solution is:

$$\frac{0.5\,mol}{0.200\,kg\ H_2O} = 2.5\ mol\ solute/kg\ H_2O\ =\ 2.5\ m$$

Using the equation $\Delta T_f = iK_f m$, the freezing point depression is $1 \times 2.5\ m \times 1.86°C\cdot m^{-1} =$ 4.65°C ($i = 1$ for glucose because it does not dissociate in solution). The new freezing point is 0°C − 4.65°C = −4.65°C. Note that ΔT_f is the change in freezing point and not the freezing point itself.

12. C The osmotic pressure (Π) of a solution is given by $\Pi = iMRT$. At STP, $T = 273$ K; R, the ideal gas constant, equals 8.2×10^{-2} L·atm/(K·mol). To determine the molarity, find the formula weight of NaCl from the periodic table; FW = 58.5 g/mol. The number of moles in the solution described is:

$$\frac{117\,g/L}{58.5\,g/mol} = 2\ mol\ undissociated = NaCl/L$$

But since NaCl is a strong electrolyte, it dissociates in aqueous solution into two particles, so i is 2, and there are actually four moles of particles per liter of solution (two moles of Na^+ and two moles of Cl^-). Thus:

$$\Pi = (2)(2\ mol/L)(8.2 \times 10^{-2}\ L\cdot atm/(K\cdot mol))(273\ K)$$
$$= 89.54\ atm$$

Remember that colligative properties depend on the number of particles, not their identity.

13. Use Raoult's law to answer this question, with A = H_2O and B = ethyl alcohol.
$$P_A = X_A P°_A$$
$$P_B = X_B P°_B$$
Because we are given that $X_B = 0.2$, then $X_A = 1 − X_B = 1 − 0.2 = 0.8$.
$$P°_A = 0.02\ atm$$
$$P°_B = 0.50\ atm$$
$$P_A = (0.8)(0.02\ atm) = 0.016\ atm$$
$$P_B = (0.2)(0.50\ atm) = 0.10\ atm$$
Thus, the vapor pressure due to water is 0.016 atm, and the vapor pressure due to alcohol is 0.10 atm.

CHAPTER THIRTY-FIVE

Gases

LEARNING OBJECTIVES

After this chapter, you will be able to:

- Describe the traits of and relationships between variables in an ideal gas
- Predict deviations from ideal behavior in real gases
- Calculate the partial pressure of gases using Dalton's law
- Calculate average molecular speed and rates of diffusion or effusion

Gases, as defined in Chapter 34, are unique in that their molecules have very weak intermolecular forces, allowing gases both to flow and to change volume to fill and take the shape of their containers. The state of a gaseous sample is generally defined by four variables: **pressure (P)**, **volume (V)**, **temperature (T)**, and **number of moles (n)**. Pressure describes force per area, such as the force per area an enclosed gas exerts on the walls of its container. The SI unit of pressure is the pascal (Pa), but pressure is also often expressed in units of atmospheres (atm) or millimeters of mercury (mm Hg or torr), which are related as follows:

$$1 \text{ atm} = 10^5 \text{ Pa} = 760 \text{ mm Hg} = 760 \text{ torr}$$

Volume is generally expressed in liters (L) or milliliters (mL). The temperature of a gas is usually given in Kelvin (K, not °K). Gases are also often discussed in terms of **standard temperature and pressure (STP)**, which refers to conditions of 273.15 K (0°C) and 1 atm. It is important not to confuse STP with **standard conditions**—the two standards involve different temperatures and are used for different purposes. STP (0°C or 273 K) is generally used for gas law calculations; standard conditions (25°C or 298 K) are used when measuring standard enthalpy, entropy, Gibbs free energy, or voltage.

IDEAL GASES

When examining the behavior of gases under varying conditions of temperature and pressure, scientists speak of ideal gases. An ideal gas represents a hypothetical gas whose molecules have no intermolecular forces and occupy no volume. Although gases actually deviate from this idealized behavior, under conditions of relatively low pressure (i.e., atmospheric pressure) and high temperature, many gases behave in a nearly ideal fashion. Therefore, the assumptions used for ideal gases can be applied to real gases with reasonable accuracy.

Boyle's Law

Experimental studies performed by Robert Boyle in 1660 led to the formulation of Boyle's law. His work showed that, for a given gaseous sample held at a constant temperature (isothermal conditions), the product of pressure and volume is constant: $PV = k$. Another way to think about this mathematical relationship is that pressure and volume are inversely proportional.

It is important to note that the individual values of pressure and volume can vary greatly for a given sample of gas. However, as long as the temperature remains constant and the amount of gas does not change, the product of both P and V will equal the same constant (k). Subsequently, for a given sample of gas under two sets of conditions, the following equation can be derived:

$$P_1V_1 = k_1 = P_2V_2 \quad \text{or simply} \quad P_1V_1 = P_2V_2$$

where k is a proportionality constant and the subscripts 1 and 2 represent two different sets of conditions. A plot of pressure versus volume for a gas is shown below.

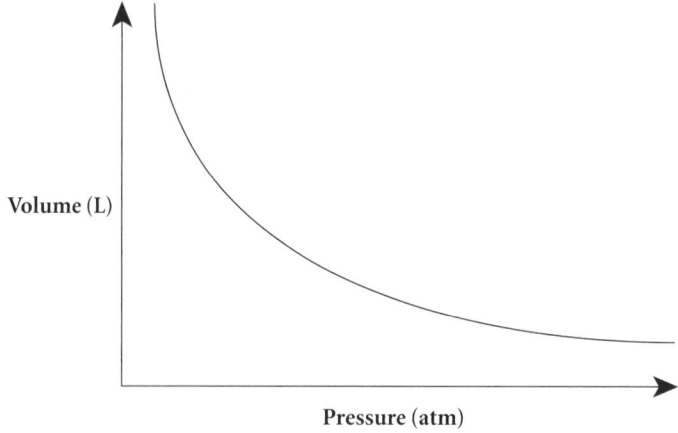

Figure 35.1

Example: Under isothermal conditions, what would be the volume of a 1 L sample of helium after its pressure is changed from 12 atm to 4 atm?

Solution:

$$P_1 = 12 \text{ atm} \qquad P_2 = 4 \text{ atm}$$
$$V_1 = 1 \text{ L} \qquad V_2 = ?$$

$$P_1V_1 = P_2V_2$$
$$12 \text{ atm } (1 \text{ L}) = 4 \text{ atm}(V_2)$$
$$\frac{12 \text{ atm}}{4 \text{ atm}} \times 1 \text{ L} = V_2$$
$$V_2 = 3 \text{ L}$$

Charles's Law

The law of volumes, also known as Charles's law, was developed at the turn of the 19th century. The law states that, at constant pressure, the quotient of the volume and temperature of gas is constant. Or, put another way, the volume of a gas is directly proportional to its absolute temperature

$$\frac{V}{T} = k \quad \text{or} \quad \frac{V_1}{T_1} = \frac{V_2}{T_2}$$

where k is a constant and the subscripts 1 and 2 represent two different sets of conditions. The absolute temperature (T) is the temperature expressed in kelvins, which can be calculated from the expression $T_K = T_{\circ C} + 273.15$. It is important to note that the temperature $-273.15°C$ is the

theoretical lowest attainable temperature, known as **absolute zero**. Below is a summary to help understand this principle:

absolute zero	0 K	−273.15°C
water freezes	273.15 K	0°C
water boils	373.15 K	100°C

A plot of temperature versus volume is shown below.

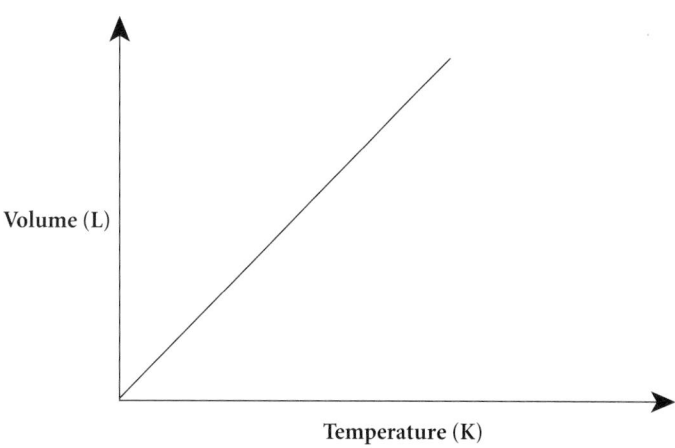

Volume (L)

Temperature (K)

Figure 35.2

Example: If the absolute temperature of 2 L of gas at constant pressure is changed from 283.15 K to 566.30 K, what would be the final volume?

Solution:

$$T_1 = 283.15 \text{ K} \qquad V_1 = 2 \text{ L}$$
$$T_2 = 566.30 \text{ K} \qquad V_2 = ?$$

$$\frac{V_1}{T_1} = \frac{V_2}{T_2}$$

$$\frac{2 \text{ L}}{283.15 \text{ K}} = \frac{V_2}{566.30 \text{ K}}$$

$$V_2 = \frac{2 \text{ L} \,(566.30 \text{ K})}{283.15 \text{ K}}$$

$$V_2 = 4 \text{ L}$$

Avogadro's Principle

In 1811, Amedeo Avogadro proposed that, for all gases at a constant temperature and pressure, the volume of the gas will be directly proportional to the number of moles of gas present; therefore, all gases have the same number of moles in the same volume.

$$\frac{n}{V} = k \quad \text{or} \quad \frac{n_1}{V_1} = \frac{n_2}{V_2}$$

The subscripts 1 and 2 once again apply to two different sets of conditions with the same temperature and pressure.

Ideal Gas Law

A theoretical gas whose volume-pressure-temperature behavior can be completely understood by the ideal gas equation is known as an "ideal gas." The ideal gas law combines the relationships outlined in Boyle's law, Charles's law, and Avogadro's principle to yield an expression that can be used to predict the behavior of a gas and is represented by the equation

$$PV = nRT$$

The constant R is known as the **gas constant**. Under STP conditions (273.15 K and 1 atmosphere), one mole of ideal gas has a volume of 22.4 L. Substituting these values into the ideal gas equation gives $R = 0.0821$ L·atm/(mol·K). The gas constant may also be expressed in many other units; another common value is 8.314 J/(K·mol), which is derived when the SI units of pascals (for pressure) and cubic meters (for volume) are substituted into the ideal gas law. When carrying out calculations based on the ideal gas law, it is important to choose a value of R that matches the units of the variables.

Example: What volume would 12 g of helium occupy at 20°C and a pressure of 380 mm Hg?

Solution: The ideal gas law can be used, but first all the variables must be converted to yield units that correspond to the expression of the gas constant as 0.0821 L·atm/(mol·K):

$$P = 380 \, \text{mm Hg} \times \frac{1 \, \text{atm}}{760 \, \text{mm Hg}} = 0.5 \, \text{atm}$$
$$T = 20°C + 273.15 = 293.15 \, \text{K}$$

$$n = 12 \, \text{g He} \times \frac{1 \, \text{mol He}}{4.0 \, \text{g}} = 3 \, \text{mol He}$$

Substituting into the ideal gas equation:
$$PV = nRT$$
$$(0.5 \, \text{atm})(V) = (3 \, \text{mol})(0.0821 \, \text{L} \cdot \text{atm/(mol} \cdot \text{K)})(293.15 \, \text{K})$$
$$V = 144.4 \, \text{L}$$

Sometimes, it is advantageous to compare gases under different conditions. To do this quickly, divide the ideal gas law from one condition by another condition:

$$\frac{P_1 V_1}{P_2 V_2} = \frac{n_1 R T_1}{n_2 R T_2}$$

One great advantage of this approach is that the ideal gas constant (R) cancels out, leaving:

$$\frac{P_1 V_1}{P_2 V_2} = \frac{n_1 T_1}{n_2 T_2}$$

And from this point, some straightforward algebra can find pressure, volume, moles, or temperature under either condition. Removing R from the equation can certainly help with mental math, but not all ideal gas questions compare gases under two separate conditions. However, by remembering that 1 mole of gas at STP (1 atm and 273.15K) occupies 22.4 L, one can use the comparative ideal gas equation and still remove the ideal gas constant from the solution (as long as all the units align!):

$$\frac{PV}{P_{STP} V_{STP}} = \frac{nT}{n_{STP} T_{STP}}$$

Using the above simplification as a guide, let's go through the previous example again:

Example: What volume would 12 g of helium occupy at 20°C and a pressure of 380 mm Hg?

Solution: Convert the given information on mass, temperature, and pressure to units that match the STP information (mol, atm, K, and L):

12 g of He is 3 mol

20°C is 293.15 K

380 mm Hg is 0.5 atm

Then, rearrange the simplification to solve for V and plug in the values given:

$$\frac{PV}{P_{STP} V_{STP}} = \frac{nT}{n_{STP} T_{STP}}$$

$$V = \frac{V_{STP} P_{STP} nT}{P n_{STP} T_{STP}} = (22.4\ \text{L})\left(\frac{1\ \text{atm}}{0.5\ \text{atm}}\right)\left(\frac{3\ \text{mol}}{1\ \text{mol}}\right)\left(\frac{293.15\ \text{K}}{273.15\ \text{K}}\right)$$

$$= (22.4\ \text{L})\left(\frac{3}{0.5}\right)\left(\frac{293.15\ \text{K}}{273.15\ \text{K}}\right) \approx (22\ \text{L})(6)(1.1)$$

$$V = 145\ \text{L (actual volume} = 144.4\ \text{L)}$$

Density

In addition to standard calculations to determine the pressure, volume, or temperature of a gas, the ideal gas law may also be used to determine the **density** and **molar mass** of a gas. Density is defined as the mass per unit volume (m/V) of a substance and, for gases, is usually expressed in units of g/L. By rearrangement, the ideal gas equation can be used to calculate the density of a gas:

$$PV = nRT$$

where:

$$n = \frac{m}{MM} \frac{\text{(mass in g)}}{\text{(molar mass)}}$$

therefore:

$$PV = \frac{m}{MM} RT$$

and:

$$\frac{P(MM)}{RT} = \frac{m}{V} = d$$

Another way to find the density of a gas is to start with the volume of a mole of gas at STP, 22.4 L, calculate the effect of pressure and temperature on the volume, and finally calculate the density by dividing the mass by the new volume.

Example: What is the density of HCl gas at 2 atm and 45°C? (The molar mass of H is 1 g/mol and Cl is 35.5 g/mol).

Solution: At STP, a mole of gas occupies 22.4 liters. Since the increase in pressure to 2 atm decreases volume, 22.4 L must be multiplied by $\left(\frac{1\,\text{atm}}{2\,\text{atm}}\right)$. Since the increase in temperature increases volume, the temperature factor will be $\left(\frac{318\,\text{K}}{273\,\text{K}}\right)$. Given the molar mass information in the question, the mass of 1 mol of HCl is 36.5 g. Plugging that into the ideal gas law comparing different conditions gives the following:

$$V = \frac{V_{STP} P_{STP} nT}{Pn_{STP} T_{STP}} = (22.4\ \text{L})\left(\frac{1\ \text{atm}}{2\ \text{atm}}\right)\left(\frac{1\ \text{mol}}{1\ \text{mol}}\right)\left(\frac{318\ \text{K}}{273\ \text{K}}\right) = (22\ \text{L})\left(\frac{1}{2}\right)(1.2) = 13\ \text{L}$$

$$d = \left(\frac{36.5\ \text{g}}{13\ \text{L}}\right) = 2.8\ \text{g/L} \quad \text{(actual value is 2.77 g/L)}$$

Molar mass

Sometimes the identity of a gas is unknown, and the molar mass must be determined to identify it. Using the concept of density, the molar mass of a gas can be determined experimentally using the ideal gas law.

Example: What is the molar mass of an 8 g sample of gas that occupies 2 L at a temperature of 15°C and a pressure of 1.5 atm?

Solution: The mass of the gas (8 g) and therefore the moles of gas are constant regardless of the volume, temperature, or pressure. To find the molar mass (g/mol), calculate how many moles (mol) of gas are present in the 2 L sample at 15°C and 1.5 atm:

$$\frac{PV}{P_{STP}V_{STP}} = \frac{nT}{n_{STP}T_{STP}}$$

$$n = n_{STP}\frac{PVT_{STP}}{P_{STP}V_{STP}T} = (1\text{ mol})\left(\frac{1.5\text{ atm}}{1\text{ atm}}\right)\left(\frac{2\text{ L}}{22.4\text{ L}}\right)\left(\frac{273.15\text{ K}}{288.15\text{ K}}\right)$$

$$= \left(\frac{3}{22.4}\right)\left(\frac{273.15\text{ K}}{288.15\text{ K}}\right) \approx \left(\frac{6}{45}\right)(0.95)$$

$$n = \frac{6}{45} = \frac{2}{15}\text{ mol}$$

Therefore, the molar mass of the unknown substance is:

$$MM = \left(\frac{m}{n}\right) = \left(\frac{8}{2\big/15}\right) = \frac{8\times15}{2} = 4\times15$$

$$MM = 60\text{ g/mol (actual value} = 63.1\text{ g/mol)}$$

REAL GASES

In general, the ideal gas law is a good approximation of the behavior of real gases, but all real gases deviate from ideal gas behavior to some extent, particularly when the gas atoms or molecules are forced into close proximity under high pressure and at low temperature so that molecular volume and intermolecular attractions become significant.

Deviations Due to Pressure

As the pressure of a gas increases, the particles are pushed closer and closer together. As the condensation pressure for a given temperature is approached, intermolecular attraction forces become more and more significant until the gas condenses into the liquid state (see Chapter 34).

At moderately high pressure (a few hundred atm) the volume of a gas is less than would be predicted by the ideal gas law; this is due to intermolecular attraction. At extremely high pressure the size of the particles becomes relatively large compared to the distance between them, and this causes the gas to take up a larger volume than would be predicted by the ideal gas law.

Deviations Due to Temperature

As the temperature of a gas is decreased, the average velocity of the gas molecules decreases and the attractive intermolecular forces become increasingly significant. As the condensation temperature (which is the same as the boiling point) is approached for a given pressure, intermolecular attractions eventually cause the gas to condense to a liquid state, and the increasing intermolecular attractions cause the gas to have a smaller volume than would be predicted by the ideal gas law. The closer the temperature of a gas is to its boiling point, the less ideal is its behavior.

Van der Waals Equation

In conditions where the Ideal Gas Law does not apply, the van der Waals equation can be used for more accurate calculations.

$$\left[P + a\left(\frac{n}{V}\right)^2\right]\left[\frac{V}{n} - b\right] = RT$$

In this equation P is the measured pressure, a is the correction factor to account for intermolecular forces, n is the number of moles of gas present, V is the measured volume, and b is a correction factor to account for the finite size of the molecules. The values of a and b vary depending on the gas being considered and will be provided if calculation is necessary.

DALTON'S LAW OF PARTIAL PRESSURES

When two or more gases are found in one vessel without chemical interaction, each gas will behave independently of the other(s). Therefore, the pressure exerted by each gas in the mixture will be equal to the pressure that gas would exert if it were the only one in the container. The pressure exerted by each individual gas is called the **partial pressure** of that gas. In 1801, John Dalton derived an expression, now known as Dalton's law of partial pressures, which states that the total pressure of a gaseous mixture is equal to the sum of the partial pressures of the individual components. The equation is:

$$P_T = P_A + P_B + P_C + \cdots$$

The partial pressure of a gas is related to its mole fraction and can be determined using the following equations:

$$P_A = P_T X_A$$

$$X_A = \frac{n_A \ (\text{moles of A})}{n_T \ (\text{total moles})}$$

Example: A vessel contains 0.75 mol of nitrogen, 0.20 mol of hydrogen, and 0.05 mol of fluorine at a total pressure of 2.5 atm. What is the partial pressure of each gas?

Solution: First, calculate the mole fraction of each gas.

$$X_{N_2} = \frac{0.75 \text{ mol}}{1.0 \text{ mol}} = 0.75 \qquad X_{H_2} = \frac{0.20 \text{ mol}}{1.0 \text{ mol}} = 0.20 \qquad X_{F_2} = \frac{0.05 \text{ mol}}{1.0 \text{ mol}} = 0.05$$

Then, calculate the partial pressures.

$$P_A = X_A P_T$$

$$P_{N_2} = (0.75)(2.5 \text{ atm}) \qquad P_{H_2} = (0.20)(2.5 \text{ atm}) \qquad P_{F_2} = (0.05)(2.5 \text{ atm})$$

$$= 1.875 \text{ atm} \qquad\qquad = 0.5 \text{ atm} \qquad\qquad = 0.125 \text{ atm}$$

KINETIC MOLECULAR THEORY OF GASES

As indicated by the gas laws, all gases show similar physical characteristics and behavior. A theoretical model to explain the behavior of gases was developed during the second half of the 19th century. The combined efforts of Boltzmann, Maxwell, and others led to a simple explanation of gaseous molecular behavior based on the motion of individual molecules. This model is called the kinetic molecular theory of gases. Like the gas laws, this theory was developed in reference to ideal gases, but it can be applied with reasonable accuracy to real gases as well.

Assumptions of the Kinetic Molecular Theory

- Gases are made up of particles whose volumes are negligible compared to the container volume.
- Gas atoms or molecules are inert and exhibit no intermolecular attractions or repulsions.
- Gas particles are in continuous, random motion, undergoing collisions with other particles and the container walls.
- Collisions between any two gas particles are elastic, meaning that there is no overall gain or loss of energy.
- The average kinetic energy of gas particles is proportional to the absolute temperature of the gas and is the same for all gases at a given temperature.

Applications of the Kinetic Molecular Theory of Gases

Average molecular speeds

According to the kinetic molecular theory of gases, the average kinetic energy (and therefore average velocity) of a gas particle is proportional to the absolute temperature of the gas:

$$KE = \frac{1}{2}mv^2 = \frac{3}{2}kT$$

where k is the Boltzmann constant. In other words, the average speed of all gas particles can be related to temperature. At a given temperature, all gases will have the same kinetic energy, but this does not mean those gases are behaving identically. For example, for two gases at the same temperature, a gas made up of molecules that have larger molecular masses will move more slowly than a comparable gas with a smaller molecular mass. This also fits with intuition: the "heavier" the gas, the slower it will move.

A **Maxwell-Boltzmann distribution curve** shows the distribution of speeds of gas particles at a given temperature. The curve below shows a distribution curve of molecular speeds at two temperatures, T_1 and T_2, where $T_2 > T_1$. Notice that the bell-shaped curve flattens and shifts to the right as the temperature increases, indicating that, at higher temperatures, more molecules are moving at high speeds.

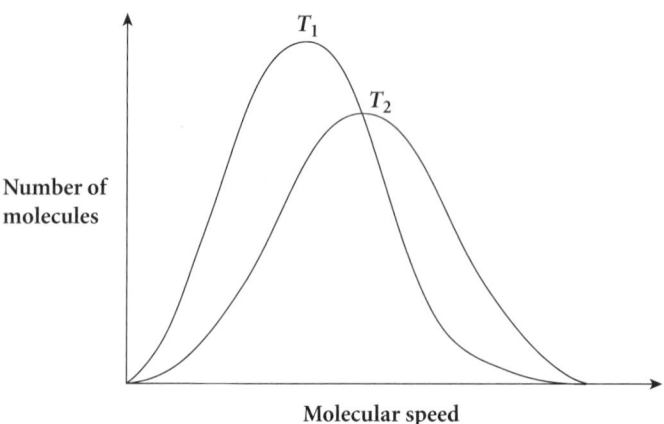

T_1

T_2

Number of molecules

Molecular speed

Figure 35.3

Graham's law of diffusion and effusion

Diffusion of gases can provide a demonstration of random motion when the molecules of these gases mix with one another by virtue of their individual kinetic properties. This process occurs when gas molecules move through a mixture and accounts for such phenomena as the fact that an open bottle of perfume can quickly be smelled across a room. The kinetic molecular theory of gases predicts that heavier gas molecules diffuse more slowly than lighter ones because of their differing average molecular speeds. In 1832, Thomas Graham showed mathematically that, under isothermal and isobaric (constant pressure) conditions, the rates at which two gases diffuse are inversely proportional to the square root of their molar masses. Thus:

$$\frac{r_1}{r_2} = \left(\frac{MM_2}{MM_1}\right)^{\frac{1}{2}} = \sqrt{\frac{MM_2}{MM_1}}$$

where r_1 and MM_1 represent the diffusion rate and molar mass of gas 1, respectively, and r_2 and MM_2 represent the diffusion rate and molar mass of gas 2.

Effusion is the flow of gas particles under pressure from one compartment to another through a small opening. Graham used the kinetic molecular theory of gases to show that for two gases at the same temperature, the rates of effusion are proportional to the average speeds. He then expressed the rates of effusion in terms of molar mass and found that the relationship is the same as that for diffusion.

REVIEW PROBLEMS

1. Boyle's law can be used for which of the following?

 A. Predicting the expected volumes of two party balloons
 B. Predicting the relative pressures inside a hot air balloon
 C. Predicting the change in volume of an inflatable toy from summer to winter
 D. Predicting the change in volume of a party balloon inside a bell jar as a vacuum is being drawn
 E. Predicting the change in pressure inside a hot air balloon as it rises into cooler air

2. The word *kinetic* appears in the kinetic molecular theory of gases because

 A. the properties of a gas are dependent primarily on the motion of its component particles.
 B. gases only possess kinetic energy in closed systems.
 C. gases possess more kinetic than potential energy.
 D. collisions in real gases do not dissipate kinetic energy.
 E. potential energy depends upon kinetic energy.

3. A sample of argon occupies 50 L at standard temperature. Assuming constant pressure, what volume will the gas occupy if the temperature is doubled?

 A. 25 L
 B. 50 L
 C. 100 L
 D. 200 L
 E. 250 mL

4. What is the molecular weight of an unknown gas if 2.5 g of it occupies 2 L at 630 torr and a temperature of 600 K?

5. Explain the conditions under which real gases follow ideal gas behavior.

6. If a 360 mL sample of helium contains 0.25 mol of the gas, how many molecules of chlorine gas would occupy the same volume at the same temperature and pressure?

 A. 1.51×10^{23}
 B. 3.01×10^{23}
 C. 6.022×10^{23}
 D. 1.2×10^{24}
 E. 2.4×10^{24}

7. In the kinetic molecular theory of gases, the speed of molecules is most often discussed in terms of the average speed. Which of the following statements concerning average speeds is true?

 A. Most of the molecules are moving faster than the average speed, but a few outliers skew the average.
 B. The average speed is independent of pressure and volume in a closed system.
 C. When the temperature increases, more of the molecules will move at the new average speed.
 D. When the temperature increases, fewer molecules will move at the new average speed.
 E. The average speed is independent of temperature in a closed system.

8. What is the density of a gas at 76.0 torr and 37.0°C (MM = 25.0 g/mol)?

 A. 0.098 g/L
 B. 0.800 g/L
 C. 22.4 g/L
 D. 75.0 g/L
 E. 107 g/L

9. The following reaction represents the production of hydrogen chloride gas:

 $$H_2 + Cl_2 \rightarrow 2\,HCl$$

 How many grams of chlorine gas are needed to produce 3 L of HCl gas at a pressure of 2 atm and a temperature of 19°C?

10. Dalton's law of partial pressures says that the total pressure of all the gases in a system

 A. is less than the sum of the partial pressures of the gases.
 B. is more than the sum of the partial pressures of the gases.
 C. is equal to the sum of the partial pressures of the gases.
 D. is not related to the partial pressures of the gases.
 E. is equal to the product of the partial pressures of the gases.

11. A student performing an experiment has a bulb containing 14 g of N_2, 64 g of O_2, 8 g of He, and 35 g of Cl_2 at a total pressure of 380 torr. What are the partial pressures of each gas?

12. A 1.74 g sample of gas is found to occupy 1 L at 10°C and 2 atm. What is the molar mass of the gas?

13. All of the following assumptions underlie the kinetic molecular theory of gases EXCEPT that:

 A. gas molecules have no intermolecular forces.
 B. gas particles are in random motion.
 C. the collisions between gas particles are elastic.
 D. the average kinetic energy is directly proportional to the number of moles present of a gas.
 E. gas particles have a volume negligible compared to that of their container.

14. What will be the final pressure of a gas that expands from 1 L at 10°C to 10 L at 100°C if the original pressure was 3 atm?

15. In the reaction $N_2 + 2\,O_2 \rightarrow 2\,NO_2$, what volume of NO_2 is produced from 7 g of nitrogen gas at 27°C and 0.9 atm?

SOLUTIONS TO REVIEW PROBLEMS

1. **D** Boyle's law states that, when a gas is held at constant temperature, its pressure and volume are inversely proportional. This means that, as the pressure increases, the volume decreases, and vice versa. Of the answer choices, the only one that involves both pressure and volume—in addition to a controlled variation of one of the variables—is (D). When a balloon is placed in a bell jar, the volume of the balloon will increase as a vacuum is being drawn in the jar. Boyle's law can be used to predict this behavior.

2. **A** In developing the kinetic molecular theory of gases, it was found that the properties of a gas sample, such as pressure, volume, and temperature, can be explained in terms of the motion of the individual gas molecules. Because *kinetic* is defined as "relating to motion," this theory of gases was called the kinetic molecular theory.

3. **C** This question is an application of Charles's law, which states that, at constant pressure, the volume and temperature of a gas will vary in direct proportion to each other. If a 50 L volume of gas is heated from standard temperature, which is 273 K, to two times standard temperature, 546 K, the volume will double as well. Therefore, the volume of the gas will increase from 50 L to 100 L. The answer can also be calculated using proportions.

$$\frac{V_1}{V_2} = \frac{T_1}{T_2}$$

$$\frac{50 \text{ L}}{x} = \frac{273 \text{ K}}{546 \text{ K}}$$

$$x = (2)(50 \text{ L})$$

$$x = 100 \text{ L}$$

4. **74.1 g/mol**
 The molecular weight of a gas is the number of grams that occupy 22.4 L at STP. At 630 torr and 600 K, the density of this gas is 2.5 g per 2 L. First, find the volume at STP:

$$V = (2 \text{ L}) \left(\frac{630 \text{ Torr}}{760 \text{ Torr}} \right) \left(\frac{273 \text{K}}{600 \text{K}} \right) = 0.754 \text{ L}$$

 Next, find the density at STP:

$$d = \frac{2.5 \text{g}}{0.754 \text{ L}} = \frac{3.31 \text{ g}}{\text{L}}$$

 Finally, find the gram molecular weight of 22.4 L of gas at STP:

$$MM = d(V \text{ for 1 mol gas at STP}) = (3.31 \text{ g/L})(22.4 \text{ L/mol}) = 74.1 \text{ g/mol}$$

5. The conditions that define an ideal gas are low pressure and high temperature. Under these conditions, the gas molecules are assumed to have no intermolecular forces and to occupy no volume. Therefore, it is possible to predict their behavior.

6. **A** This question is an application of Avogadro's principle, which states that, at a constant temperature and pressure, all gases will have the same number of moles in the same volume. This is true regardless of the identity of the gas. Thus, to answer the question, the number of particles in 0.25 mol of helium must be calculated; that value will represent the number of molecules of chlorine gas in the same volume. The number of helium atoms is $(0.25 \text{ mol})(6.022 \times 10^{23} \text{ atoms/mol}) = 1.51 \times 10^{23}$ atoms.

7. **D** The average speed of a gas is defined as the mathematical average of all the speeds of the gas particles in a sample. To answer this question, you must understand the Maxwell-Boltzmann distribution curve, which shows the distribution of speeds of all the gas particles in a sample at a given temperature. The distribution curve is a bell-shaped curve that flattens and shifts to the right as the temperature increases. The flattening of the curve means that gas particles within the sample are traveling at a greater range of speeds. As a result, a smaller proportion of the molecules will move at exactly the new average speed.

8. **A** A gas weighing 25 g/mol will have a density of 25 g per 22.4 L at STP. The density at 76 torr and 37°C is found by calculating the change in volume of a mole of gas under these conditions:

$$\frac{P_1V_1}{T_1} = \frac{P_2V_2}{T_2}$$

$$V_2 = \frac{P_1V_1T_2}{T_1P_2}$$

$$V_2 = \frac{(760 \text{ torr})(22.4 \text{ L})(310 \text{ K})}{(273 \text{ K})(76 \text{ torr})} = 254 \text{ L/mol}$$

$$d = \frac{25 \text{ g/mol}}{254 \text{ L/mol}} = 0.098 \text{ g/L}$$

9. **8.88 g**
 First, let's find out how many moles of HCl would occupy 3 L at the pressure and temperature given.

$$n = \frac{(2 \text{ atm})(3 \text{ L})}{(0.0821 \text{ Latm/molK})(293 \text{ K})} = 0.25 \text{ mol}$$

Because 2 mol of HCl are produced from each mol of Cl_2, 0.25 mol HCl would be produced from 0.125 mol of Cl_2. The molecular weight of Cl_2 is 71 g/mol, so the answer is $(71 \text{ g } Cl_2/\text{mol}) (0.125 \text{ mol}) = 8.88 \text{ g } Cl_2$.

10. **C** Discussed in the section on Dalton's law of partial pressures in this chapter.

11. **N_2: 38 torr, O_2: 152 torr, He: 152 torr, Cl_2: 38 torr**
 According to Dalton's law of partial pressures, the sum of the partial pressures of the gases in a mixture is equal to the total pressure of the mixture. Therefore, the partial pressures of nitrogen, oxygen, helium, and chlorine will add up to 380 torr. The partial pressure of a gas is calculated as follows:

$$P_p = XP_T$$

where X is the mole fraction of the gas. Thus, the mole fractions of each of the gases must be determined.

$$X = \frac{n}{n_T}$$

$$X_{N_2} = \frac{0.5 \text{ mol}}{5 \text{ mol}} = 0.1$$

$$X_{O_2} = \frac{2 \text{ mol}}{5 \text{ mol}} = 0.4$$

$$X_{He} = \frac{2 \text{ mol}}{5 \text{ mol}} = 0.4$$

$$X_{Cl_2} = \frac{0.5 \text{ mol}}{5 \text{ mol}} = 0.1$$

Now the partial pressures may be calculated.

$P_{N_2} = (380 \text{ torr})(0.1) = 38 \text{ torr}$
$P_{O_2} = (380 \text{ torr})(0.4) = 152 \text{ torr}$
$P_{He} = (380 \text{ torr})(0.4) = 152 \text{ torr}$
$P_{Cl_2} = (380 \text{ torr})(0.1) = 38 \text{ torr}$

12. **20.2 g/mol**

Convert the density given to the density at STP.

$$(1 \text{ L})\left(\frac{273 \text{ K}}{283 \text{ K}}\right)\left(\frac{2 \text{ atm}}{1 \text{ atm}}\right) = 1.93 \text{ L at STP}$$

$$\frac{1.74 \text{ g}}{1.93 \text{ L}} = 0.902 \text{ g/L at STP}$$

Now find the molar mass by multiplying by 22.4.

$MM = (0.902 \text{ g/L})(22.4 \text{ L/mol}) = 20.2 \text{ g/mol}$

13. **D** Kinetic energy is proportional to temperature, not number of moles. In an isolated system, increasing the number of moles of a gas while maintaining constant temperature and pressure will cause a decrease in temperature and therefore kinetic energy, indicating an inverse relationship.

14. **0.4 atm**

This question is different from the previous ones in that the new volume is given and you are looking for the final pressure. Rearranging the equation

$$\frac{P_1 V_1}{T_1} = \frac{P_2 V_2}{T_2}$$

gives

$$P_2 = \frac{P_1 V_1 T_2}{T_1 V_2}$$

$$P_2 = \frac{(3\text{ atm})(1\text{ L})(373\text{ K})}{(283\text{ K})(10\text{ L})}$$

$$P_2 = 0.4\text{ atm}$$

15. **13.7 L**

$$\frac{7\text{ g N}_2}{28\text{ g N}_2/\text{mol}} = 0.25\text{ mol N}_2$$

From the balanced reaction equation, 2 mol of NO_2 are produced from each mol of N_2, so 0.50 mol of NO_2 will be produced from 0.25 mol of N_2. Therefore, the volume at STP will be (0.5 mol NO_2) (22.4 L/mol at STP) = 11.2 L NO_2.

Now find the volume under the conditions given.

$$V = (11.2\text{ L})\left(\frac{1\text{ atm}}{0.9\text{ atm}}\right)\left(\frac{300\text{ K}}{273\text{ K}}\right) = 13.7\text{ L}$$

CHAPTER THIRTY-SIX

Acids and Bases

Many important reactions in chemical and biological systems involve **acids** and **bases** (defined below). Acids and bases cause color changes in certain compounds called **indicators**, which may be in solution or on paper. A particularly common indicator is **litmus paper**, which turns red in acidic solutions and blue in basic solutions. A more extensive discussion of the chemical properties of acids and bases is outlined below.

Acids	Bases
• Have a sour taste.	• Have a bitter taste.
• Aqueous solutions can conduct electricity.	• Aqueous solutions can conduct electricity.
• React with bases to form water and a salt.	• React with acids to form water and a salt.
• Nonoxidizing acids react with metals to produce hydrogen gas.	• Feel slippery to the touch.
• Cause color changes in plant dyes—turn litmus paper red.	• Cause color changes in plant dyes—turn litmus paper blue

Table 36.1

DEFINITIONS

Arrhenius Definition

The first definitions of acids and bases were formulated by Svante Arrhenius toward the end of the 19th century. Arrhenius defined an acid as a species that produces H^+ (a proton) in an aqueous solution and a base as a species that produces OH^- (a hydroxide ion) in an aqueous solution. These definitions, though useful, fail to describe acidic and basic behavior in nonaqueous media.

An example of an Arrhenius acid (HCl), base (NaOH), and acid-base reaction, respectively, are as follows:

$$\text{HCl}\,(aq) \rightarrow \text{H}^+\,(aq) + \text{Cl}^-\,(aq)$$
$$\text{NaOH}\,(aq) \rightarrow \text{Na}^+\,(aq) + \text{OH}^-\,(aq)$$
$$\text{HCl}\,(aq) + \text{NaOH}\,(aq) \rightarrow \text{NaCl}\,(aq) + \text{H}_2\text{O}\,(l)$$

Brønsted-Lowry Definition

A more general definition of acids and bases was proposed independently by Johannes Brønsted and Thomas Lowry in 1923. A Brønsted-Lowry acid is a species that donates protons, while a Brønsted-Lowry base is a species that accepts protons. For example, $\text{NH}_3\,(g)$ is a Brønsted-Lowry base because it can accept a proton. However, it cannot be called an Arrhenius base since it is not in an aqueous solution.

Brønsted-Lowry acids and bases always occur in pairs, called **conjugate acid-base pairs**. A **conjugate acid** is defined as the acid formed when a base gains a proton. Similarly, a **conjugate base** is formed when an acid loses a proton. The two members of a conjugate pair are related by the transfer of a proton. For example, H_3O^+ is the conjugate acid of the base H_2O, and NO_2^- is the conjugate base of HNO_2:

$$\text{H}_3\text{O}^+\,(aq) \rightarrow \text{H}_2\text{O}\,(aq) + \text{H}^+\,(aq)$$
$$\text{HNO}_2\,(aq) \rightarrow \text{NO}_2^-\,(aq) + \text{H}^+\,(aq)$$

Lewis Definition

At approximately the same time as Brønsted and Lowry, Gilbert Lewis also proposed definitions of acids and bases. Lewis defined an acid as an electron-pair acceptor and a base as an electron-pair donor. Lewis's are the most inclusive definitions. Just as every Arrhenius acid is a Brønsted-Lowry acid, every Brønsted-Lowry acid is also a Lewis acid (and likewise for bases). However, the Lewis definition encompasses some species not included within the Brønsted-Lowry definition. For example, BCl_3 and AlCl_3 can each accept an electron pair and are therefore Lewis acids, despite their inability to donate protons. Lewis bases (and occasionally acids) are sometimes referred to as ligands.

NOMENCLATURE OF ARRHENIUS ACIDS

The name of an acid is related to the name of the parent anion (the anion that combines with H^+ to form the acid). Acids formed from anions whose names end in -**ide** have the prefix **hydro-** and the ending -**ic**.

F^-	Fluoride	HF	Hydrofluoric acid
Br^-	Bromide	HBr	Hydrobromic acid

Acids formed from oxyanions are called **oxyacids**. If the anion ends in -**ite** (less oxygen), then the acid will end with -**ous acid**. If the anion ends in -**ate** (more oxygen), then the acid will end with -**ic acid**. Prefixes in the names of the anions are retained. Some examples:

ClO^-	Hypochlorite	HClO	Hypochlorous acid
ClO_2^-	Chlorite	HClO_2	Chlorous acid
ClO_3^-	Chlorate	HClO_3	Chloric acid
ClO_4^-	Perchlorate	HClO_4	Perchloric acid
NO_2^-	Nitrite	HNO_2	Nitrous acid
NO_3^-	Nitrate	HNO_3	Nitric acid

PROPERTIES OF ACIDS AND BASES

Hydrogen Ion Equilibria (pH and pOH)

Hydrogen ion concentration, $[H^+]$, is generally measured as **pH**, where:

$$pH = -\log[H^+]$$

Likewise, hydroxide ion concentration, $[OH^-]$, is measured as **pOH** where:

$$pOH = -\log[OH^-]$$

In any aqueous solution, the H_2O solvent dissociates slightly in a process called autoionization:

$$H_2O\ (l) \leftrightharpoons H^+\ (aq) + OH^-\ (aq)$$

This dissociation is an equilibrium reaction and is therefore described by a constant, K_w, the water dissociation constant:

$$K_w = [H^+][OH^-] = 10^{-14}$$

Rewriting this equation in logarithmic form gives:

$$pH + pOH = 14$$

In pure H_2O, $[H^+]$ is equal to $[OH^-]$ because, for every mole of H_2O that dissociates, one mole of H^+ and one mole of OH^- are formed. At STP, a solution with equal concentrations of H^+ and OH^- is neutral and has a pH of 7 ($-\log (10^{-7}) = 7$). A pH below 7 indicates a relative excess of H^+ ions and, therefore, an acidic solution; a pH above 7 indicates a relative excess of OH^- ions and, therefore, a basic solution.

Math note: estimating p-scale values

A useful skill for various problems involving acids and bases, as well as their corresponding buffer solutions, is the ability to quickly convert pH, pOH, pK_a, and pK_b into nonlogarithmic form and vice versa (pK_a and pK_b are acid and base dissociation constants, discussed below).

When the original value is a power of 10, the operation is relatively simple; changing the sign on the exponent gives the corresponding p-scale value directly. For example:

If $[H^+] = 0.001$, or 10^{-3}, then pH = 3.

If $K_b = 1.0 \times 10^{-7}$, then $pK_b = 7$.

More difficulty arises when the original value is not an exact power of 10; exact calculation would be onerous without a calculator, but a simple method of approximation exists. If the nonlogarithmic value is written in proper scientific notation, it will look like $n \times 10^{-m}$, where n is a number between 1 and 10. The log of this product can be written as $\log(n \times 10^{-m}) = -m + \log n$, and the negative log is thus $m - \log n$. Now, since n is a number between 1 and 10, its logarithm is a fraction between 0 and 1; thus, $m - \log n$ is between $m - 1$ and m. Furthermore, the larger the n, the larger the $\log n$, and therefore the closer the answer is to $m - 1$.

Example: If $K_a = 1.8 \times 10^{-5}$, then $pK_a = 5 - \log 1.8$. Because 1.8 is small, its log will be small, and the answer will be closer to 5 than to 4. (The actual answer is 4.74.)

Relative Strengths of Acids and Bases

The strength of an acid or base is determined by its ability to ionize in aqueous solution. The more an acid or base dissociates in the presence of water molecules, the stronger it is.

The strength of an acid is inherently tied to the strength of its conjugate base. Most acids are neutral molecules that upon deprotonation leave a conjugate base that is an anion. Those conjugate bases that cannot stabilize the negative charge well quickly capture a proton to reform the acid molecule; thus, there are less dissociated acid molecules in solution and it is a weaker acid. Acids that have a conjugate base capable of stabilizing the negative charge, such as through resonance or induction, will have a greater degree of ionization.

Strong Acids and Bases

For incredibly strong acids and bases (near complete dissociation), the conjugate is so weak that it is practically inert. For the purposes of the test, you allowed to assume that strong acids and bases completely dissociate into their component ions in aqueous solution. For example, when NaOH is added to water, it dissociates into:

$$\text{NaOH } (s) + \text{excess } H_2O \ (l) \rightarrow \text{Na}^+ \ (aq) + \text{OH}^- \ (aq)$$

Hence, in a 1 M solution of NaOH, complete dissociation gives one mole of OH^- ions per liter of solution.

$$\text{pH} = 14 - (-\log[\text{OH}^-]) = 14 + \log[1] = 14$$

Because NaOH is a strong base, virtually no undissociated NaOH remains. Note that the $[OH^-]$ contributed by the autoionization of H_2O is considered to be negligible in this case. In fact, the contribution of OH^- and H^+ ions from the dissociation of H_2O can always be neglected if the concentration of the acid or base is significantly greater than 10^{-7} M.

As a counterexample, consider the pH of a 1×10^{-8} M HCl solution. HCl is a strong acid and will dissociate completely, so the $[H^+] = 1 \times 10^{-8}$ M. At first glance, the pH of the solution might appear to be 8 because $-\log (1 \times 10^{-8}) = 8$. However, a pH of 8 is in the basic pH range, and an HCl solution should be acidic (pH < 7), not basic. This discrepancy arises from the fact that, at low HCl concentrations, H^+ from the dissociation of water contributes significantly to the total $[H^+]$.

The total concentration of H^+ can be calculated from:

$$K_w = [\text{H}^+][\text{OH}^-]$$
$$1.0 \times 10^{-14} = [x + 1 \times 10^{-8}][x]$$

(note the H^+ from water and HCl are added together due to the common ion effect)

Solving for x gives $x = 9.5 \times 10^{-8}$ M, so $[\text{H}^+]_{\text{total}} = [\text{H}^+ \text{ from HCl} + \text{H}^+ \text{ from water}] = (9.5 \times 10^{-8} + 1 \times 10^{-8})$ M $= 1.05 \times 10^{-7}$ M, and pH $= -\log (1.05 \times 10^{-7}) = 6.98$. The pH is slightly less than 7, as should be expected for a very dilute yet acidic solution.

Strong acids and bases commonly encountered on the exam include the following:

Acids	Bases
$HClO_4$ (perchloric acid)	NaOH (sodium hydroxide)
HNO_3 (nitric acid)	KOH (potassium hydroxide)
H_2SO_4 (sulfuric acid)	$Ca(OH)_2$ (calcium hydroxide)
HCl (hydrochloric acid)	other soluble hydroxides of Group IA and IIA metals

Table 36.2

Calculation of the pH and pOH of strong acids and bases assumes complete dissociation of the acid or base in solution: $[H^+]$ = normality of strong acid, and $[OH^-]$ = normality of strong base.

Weak Acids and Bases

Weak acids and bases are those that only partially dissociate in aqueous solution. A weak, monoprotic acid (HA) in aqueous solution will achieve the following equilibrium after dissociation (H_3O^+ is equivalent to H^+ in aqueous solution):

$$HA\ (aq) + H_2O\ (l) \leftrightharpoons H_3O^+\ (aq) + A^-\ (aq)$$

The **acid dissociation constant, K_a,** is a specific type of K_{eq} (see Chapter 33) that measures the degree to which an acid dissociates by showing the ratio of concentrations of the products (the conjugate base and the H^+ donated) to that of the reactant (the original acid).

$$K_a = \frac{[H_3O^+][A^-]}{[HA]}$$

The weaker the acid, the smaller the K_a. The strong *vs.* weak acid designation is based on this value; strong acids have a $K_a > 1$ while weak acids have a $K_a < 1$.

KEY CONCEPT

K_a and K_b are calculated the same way as K_{eq}. See Chapter 33 for a discussion on K_{eq}.

A weak monovalent base (BOH) undergoes dissociation to give B^+ and OH^-. The **base dissociation constant, K_b,** is a measure of the degree to which a base dissociates. The weaker the base, the smaller its K_b. Strong bases have a $K_b > 1$ while weak bases have a $K_b < 1$. For a monovalent base, K_b is defined as follows:

$$K_b = \frac{[B^+][OH^-]}{[BOH]}$$

The K_a and K_b values of a conjugate acid-base pair are inherently tied together. For example, in the HCO_3^-/CO_3^{2-} conjugate acid/base pair, CO_3^{2-} is the conjugate base, and HCO_3^- is the conjugate acid:

$$HCO_3^-\ (aq) \leftrightharpoons H^+\ (aq) + CO_3^{2-}\ (aq)$$

To find the K_a of the conjugate acid HCO_3^-, the reaction with water must be considered:

$$HCO_3^- \ (aq) + H_2O \ (l) \leftrightharpoons H_3O^+ \ (aq) + CO_3^{2-} \ (aq)$$

Likewise, for the K_b of CO_3^{2-}:

$$CO_3^{2-} \ (aq) + H_2O \ (l) \leftrightharpoons HCO_3^- \ (aq) + OH^- \ (aq)$$

The equilibrium constants for these reactions are as follows:

$$K_a = \frac{[H^+][CO_3^{2-}]}{[HCO_3^-]} \quad \text{and} \quad K_b = \frac{[HCO_3^-][OH^-]}{[CO_3^{2-}]}$$

Adding the two reactions shows that the net reaction is simply the dissociation of water:

$$HCO_3^- \ (aq) + H_2O \ (l) \leftrightharpoons H_3O^+ \ (aq) + CO_3^{2-} \ (aq)$$
$$+ \quad CO_3^{2-} \ (aq) + H_2O \ (l) \leftrightharpoons HCO_3^- \ (aq) + OH^- \ (aq)$$
$$2 H_2O \ (l) \leftrightharpoons H_3O^+ \ (aq) + OH^- \ (aq)$$

The equilibrium constant for this net reaction is $K_w = [H^+][OH^-]$, which is the product of K_a and K_b. Thus, if the **dissociation constant** either for an acid or for its conjugate base is known, then the dissociation constant for the other can be determined using the equation:

$$K_a \times K_b = K_w = 1 \times 10^{-14}$$

Thus, K_a and K_b are inversely related. In other words, the larger the K_a (the stronger the acid), the smaller the conjugate's K_b (the weaker the base), and vice versa. For strong acids and bases, the K_a and K_b are significantly larger than 1. For example, the K_a of HCl is 1.3×10^6. Because the K_a is large, the K_b is expected to be small. Keeping in mind that $K_a \times K_b = 1 \times 10^{-14}$, $K_b = 8.3 \times 10^{-21}$. As expected, the conjugate base (Cl^-) is weak; in fact, 8.3×10^{-21} is such a very small number that Cl^- can, practically speaking, be considered inert.

Applications of K_a and K_b

To calculate the concentration of H^+ in a 2.0 M aqueous solution of acetic acid, CH_3COOH ($K_a = 1.8 \times 10^{-5}$), first write the equilibrium reaction:

$$CH_3COOH \ (aq) \leftrightharpoons H^+ \ (aq) + CH_3COO^- \ (aq)$$

Next, write the expression for the acid dissociation constant:

$$K_a = \frac{[H^+][CH_3COO^-]}{[CH_3COOH]} = 1.8 \times 10^{-5}$$

Because acetic acid is a weak acid, the concentration of CH_3COOH at equilibrium is equal to its initial concentration, 2.0 M, less the amount dissociated, x. Likewise $[H^+] = [CH_3COO^-] = x$, since each molecule of CH_3COOH dissociates into one H^+ ion and one CH_3COO^- ion. Thus, the equation can be rewritten as follows:

$$K_a = \frac{[x][x]}{[2.0 - x]} = 1.8 \times 10^{-5}$$

We can approximate that $2.0 - x \approx 2.0$ since acetic acid is a weak acid that only slightly dissociates in water, and x will be small. Multiplying or dividing by small numbers can have large effects, but adding or subtracting small numbers is not statistically significant. On the exam, the math can be made much simpler be ignoring x values that are added or subtracted from (comparably) large numbers:

$$K_a = \frac{[x][x]}{[2.0]}$$
$$1.8 \times 10^{-5} = \frac{x^2}{2}$$
$$3.6 \times 10^{-5} = x^2$$
$$x = 6 \times 10^{-3}\,M$$

The fact that x is so much less than the initial concentration of acetic acid (2.0 M) validates the approximation; otherwise, it would have been necessary to solve for x using the quadratic formula. (A rule of thumb is that the approximation is valid as long as x is less than 5 percent of the initial concentration.)

SALT FORMATION

Acids and bases may react with one another, forming a salt and (often, but not always) water in what is termed a **neutralization reaction**. For example:

$$HA + BOH \rightarrow BA + H_2O$$

The salt may precipitate out or remain ionized in solution depending on its solubility and the amount produced. Neutralization reactions generally go to completion. The reverse reaction, in which the salt ions react with water to give back the acid or base, is known as **hydrolysis**.

Four combinations of strong and weak acids and bases are possible:

1. strong acid + strong base: e.g., $HCl + NaOH \rightarrow NaCl + H_2O$
2. strong acid + weak base: e.g., $HCl + NH_3 \rightarrow NH_4Cl$
3. weak acid + strong base: e.g., $HClO + NaOH \rightarrow NaClO + H_2O$
4. weak acid + weak base: e.g., $HClO + NH_3 \leftrightarrows NH_4ClO$

KEY CONCEPT

Weak acids have weak conjugate bases and vice versa. Strong acids have conjugate bases so weak that they are inert.

The products of a reaction between equal concentrations of a strong acid and a strong base are a salt and water. The conjugate acids and bases (Na^+ and Cl^- from combination 1, above) are so very weak that they are inert and will not contribute to the pH of the solution. The only other remaining product is water, meaning the resulting solution is neutral (pH = 7).

The product of a reaction between a strong acid and a weak base is also a salt, but usually no water is formed since weak bases are usually not hydroxides. In this case, the cation of the salt is the conjugate acid of a weak base, which will not be inert and will contribute to the pH. Instead of a neutral salt and water (as in the strong acid and strong base reaction), an inert anion and a weak acid cation (Cl^- and $NH4^+$ from combination 2 above, respectively) are formed, meaning the solution will be slightly acidic (pH < 7).

Another way to consider this reaction is that the weak-acid cation will react with the water solvent, reforming the weak base. This reaction constitutes hydrolysis. Revisiting combination 2:

$$HCl\,(aq) + NH_3\,(aq) \leftrightarrows NH_4^+\,(aq) + Cl^-\,(aq) \qquad \text{Reaction I}$$
$$NH_4^+\,(aq) + H_2O\,(aq) \leftrightarrows NH_3\,(aq) + H_3O^+\,(aq) \qquad \text{Reaction II}$$

By increasing the amount of H_3O^+, the pH of the strong acid/weak base reaction product will be slightly acidic (pH < 7).

On the other hand, when a weak acid reacts with a strong base, the opposite occurs. The cation product is practically inert, and the anion product is a weak base (Na^+ and ClO^- from combination 3 above, respectively). The presence of the weak base anion will cause the water solvent to become slightly alkaline (pH > 7); the weak base anion (ClO^- in our example) will react with the H_2O solvent, which leaves OH^- to raise the pH.

The pH of a solution containing a weak acid and a weak base depends on the relative strengths of the reactants. For example, the acid HClO has a $K_a = 3.2 \times 10^{-8}$, and the base NH_3 has a $K_b = 1.8 \times 10^{-5}$. Thus, an aqueous solution of HClO and NH_3 is basic, since the K_a for HClO is smaller than the K_b for NH_3, and therefore NH_3 is the stronger reactant.

POLYVALENCE AND NORMALITY

The relative acidity or basicity of an aqueous solution is determined by the relative concentrations of **acid** and **base equivalents**. An acid equivalent is equal to one mole of H^+ (or H_3O^+) ions; a base equivalent is equal to one mole of OH^- ions. Some acids and bases are polyvalent, that is, each mole of the acid or base liberates more than one acid or base equivalent. For example, the diprotic acid H_2SO_4 undergoes the following dissociation in water:

$$H_2SO_4\,(aq) \rightarrow H^+\,(aq) + HSO_4^-\,(aq)$$
$$HSO_4^-\,(aq) \leftrightarrows H^+\,(aq) + SO_4^{2-}\,(aq)$$

One mole of H_2SO_4 can thus produce two acid equivalents (two moles of H^+). The acidity or basicity of a solution depends upon the concentration of acidic or basic equivalents that can be liberated. The quantity of acidic or basic capacity is directly indicated by the solution's normality (N) where $N = \text{Molarity} \times \dfrac{\text{equivalents}}{\text{mol}}$ (see Chapter 28). Because each mole of H_3PO_4 can liberate three moles (equivalents) of H^+, a 2 M H_3PO_4 solution would be 6 N (6 normal).

Another useful measurement is **equivalent weight**. The equivalent weight is calculated by taking the molecular weight and dividing by the number of equivalents per mole. For example, the gram molecular weight of H_2SO_4 is 98 g/mol. Because each mole liberates two acid equivalents, the gram equivalent weight of H_2SO_4 would be $\frac{98}{2} = 49$ g; that is, the dissociation of 49 g of H_2SO_4 would release one acid equivalent. Common polyvalent acids include H_2SO_4, H_3PO_4, and H_2CO_3.

AMPHOTERIC SPECIES

An amphoteric, or **amphiprotic,** species is one that can act either as an acid or a base, depending on its chemical environment. In the Brønsted–Lowry sense, an amphoteric species can either gain or lose a proton. Water is the most common example. When water reacts with a base, it behaves as an acid:

$$H_2O + B^- \rightleftharpoons HB + OH^-$$

When water reacts with an acid, it behaves as a base:

$$HA + H_2O \rightleftharpoons H_3O^+ + A^-$$

The partially dissociated conjugate base of a polyprotic acid is usually amphoteric (e.g., HSO_4^- can either gain an H^+ to form H_2SO_4 or lose an H^+ to form SO_4^{2-}). The hydroxides of certain metals (e.g., Al, Zn, Pb, and Cr) are also amphoteric. Furthermore, species that can act as either oxidizing or reducing agents (see Chapter 29) are considered to be amphoteric as well, since by accepting or donating electron pairs, they act as Lewis acids or bases, respectively.

TITRATION AND BUFFERS

Titration is a procedure used to determine the molarity of an acid or base. This is accomplished by reacting a known volume of a solution of unknown concentration with a known volume of a solution of known concentration. When the number of acid equivalents equals the number of base equivalents added, or vice versa, the **equivalence point** is reached. It is important to emphasize that, while a strong acid/strong base titration will have an equivalence point at pH 7, the equivalence point need *not* always occur at pH 7. Also, when titrating polyprotic acids or bases, there are several equivalence points, as each acidic or basic species is titrated separately (see Polyprotic Acids and Bases later in this chapter).

The equivalence point in a titration is estimated in two common ways: either by plotting the pH (measured with a **pH meter**) of the solution as a function of added titrant on a graph or by watching for a color change of an added **indicator**. Indicators are weak organic acids or bases that have different colors in their undissociated and dissociated states. Indicators are used in low concentrations and therefore do not significantly alter the equivalence point. The point at which the indicator actually changes color is not the equivalence point but is called the **end point**; this point is not significant mathematically but rather is a practical way to ensure the reaction has gone to completion. If the titration is performed well, the volume difference (and therefore the error) between the end point and the equivalence point is small and may be corrected for or ignored.

Strong Acid and Strong Base

Consider the titration of 10 mL of a 0.1 N solution of HCl with a 0.1 N solution of NaOH. Plotting the pH of the reaction solution versus the quantity of NaOH added gives the curve shown in Figure 36.1. Because HCl is a strong acid and NaOH is a strong base, the equivalence point of the titration will be at pH 7, and the solution will be neutral.

Figure 36.1

In the early part of the curve (when little base has been added), the acidic species predominates, so the addition of small amounts of base will not appreciably change either the [OH⁻] or the pH. Similarly, in the last part of the titration curve (when an excess of base has been added), the addition of small amounts of base will not change the [OH⁻] significantly, and the pH remains relatively constant. The addition of base most alters the concentrations of H^+ and OH^- near the equivalence point, and thus the pH changes most drastically in that region.

Weak Acid and Strong Base

Titration of a weak acid, HA, with a strong base produces the titration curve shown in Figure 36.2.

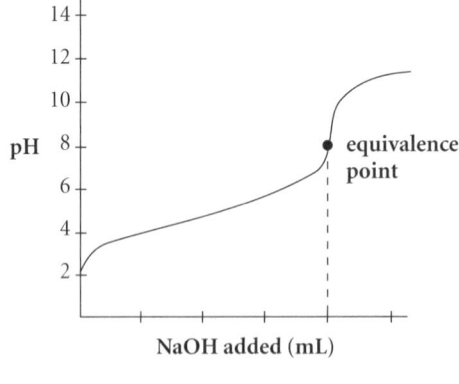

Figure 36.2

Comparing Figure 36.2 with Figure 36.1 shows that the initial pH of the weak acid solution is greater than the initial pH of the strong acid solution. The pH changes most significantly early on in the titration, and the equivalence point is in the basic range. Although the original weak acid and strong base are completely neutralized at the equivalence point (forming water with pH = 7), the side

product of weak conjugate base from the original weak acid will be able to react with water in solution, consuming H^+, thereby lowering $[H^+]$ and raising pH.

Buffers

A **buffer solution** consists of a mixture of a weak acid and its salt (which consists of its conjugate base and a cation) or a mixture of a weak base and its salt (which consists of its conjugate acid and an anion). Two examples of buffers are a solution of acetic acid (CH_3COOH) and its salt, sodium acetate (CH_3COONa), and a solution of ammonia (NH_3) and its salt, ammonium chloride (NH_4Cl). Buffer solutions have the useful property of resisting changes in pH when small amounts of acid or base are added.

Consider a buffer solution of acetic acid and sodium acetate:

$$CH_3COOH \leftrightharpoons H^+ + CH_3COO^-$$

$$CH_3COONa \leftrightharpoons Na^+ + CH_3COO^-$$

When a small amount of NaOH is added to the buffer, the OH^- ions from the NaOH react with the acetic acid in the buffer solution such that:

$$CH_3COOH + NaOH \leftrightharpoons H_2O + CH_3COO^- + Na^+$$

Subsequently, the solution contains less acetic acid and more acetate ion. Instead of a strong base (OH^-) in solution, there is now a weak base (CH_3COO^-). Though the strong base may have considerably changed the pH, the substitution by a weak base does not appreciably change pH. Likewise, when a small amount of HCl is added to the buffer, the acid will react with the acetate ion (CH_3COO^-):

$$CH_3COONa + HCl \leftrightharpoons NaCl + CH_3COOH$$

Instead of the addition of a strong acid (HCl), there is now a weak acid present (CH_3COOH). Just as with the strong base, the pH shift will be quite small.

The **Henderson-Hasselbalch equation** is used to estimate the pH of a solution in the buffer region where the concentrations of the species and its conjugate are present in approximately equal concentrations. For a weak acid buffer solution:

$$pH = pK_a + \log\frac{[\text{conjugate base}]}{[\text{weak acid}]}$$

Note that when [conjugate base] = [weak acid] (in a titration, halfway to the equivalent point), the $pH = pK_a$ because $\log 1 = 0$. Likewise, for a weak base buffer solution:

$$pOH = pK_b + \log\frac{[\text{conjugate acid}]}{[\text{weak base}]}$$

$pOH = pK_b$ when [conjugate acid] = [weak base].

Polyprotic Acids and Bases

The titration curve for a polyprotic acid or base looks different from that for a monoprotic acid or base. Figure 36.3 shows the titration of Na_2CO_3 with HCl in which the polyprotic acid H_2CO_3 is the ultimate product.

Figure 36.3

In the region between I and II, little acid has been added, and the predominant species is CO_3^{2-}. Point II represents the half-equivalence point where $[CO_3^{2-}]$ and $[HCO_3^-]$ are equal. Around this point the pH remains relatively constant at pH = 10.3; this is the first buffer region, and the pH corresponds to the pK_a of HCO_3^-.

In the region between II and III, HCO_3^- begins to predominate until point III, the first equivalence point, where all of the original CO_3^- has been consumed, leaving only HCO_3^-.

The same pattern occurs again as HCO_3^- reacts to form H_2CO_3. Point IV represents the second half-equivalence point (with a pH of 6.4 to correspond with the pK_a of H_2CO_3), and point V represents the second equivalence point where no original HCO_3^- remains, leaving only H_2CO_3.

REVIEW PROBLEMS

1. A certain aqueous solution has $[OH^-] = 6.2 \times 10^{-5}$ M.
 A. Calculate $[H^+]$.
 B. Calculate the pH of the solution.
 C. Is the solution acidic or basic?

2. What is the ratio of $[H^+]$ of a solution of pH = 4 to the $[H^+]$ of a solution of pH = 7?

3. Write equations expressing what happens to each of the following bases in aqueous solutions:
 A. LiOH
 B. $Ba(OH)_2$
 C. NH_3
 D. NO_2^-

4. What volume of a 3 M solution of NaOH is required to titrate 0.05 L of a 4 M solution of HCl to the equivalence point?

5. If 10 mL of 1 M NaOH is titrated with 1 M of HCl to a pH of 2, what volume of HCl was added?

6. Identify the conjugate acids and bases in the following equation:
$$NH_3 + H_2O \leftrightharpoons NH_4^+ + OH^-$$

7. Identify each of the following as an Arrhenius acid or base, Brønsted-Lowry acid or base, or Lewis acid or base.
 A. NaOH, in $NaOH \rightarrow Na^+ + OH^-$
 B. HCl, in $HCl \rightarrow H^+ + Cl^-$
 C. NH_3, in $NH_3 + H^+ \rightarrow NH_4^+$
 D. NH_4^+, in $NH_4^+ \rightarrow NH_3 + H^+$
 E. $(CH_3)_3N:$, in $(CH_3)_3N: + BF_3 \rightarrow (CH_3)_3N:BF_3$
 F. BF_3 in the above equation

8. At equilibrium, a certain acid, HA, in solution yields $[HA] = 0.94$ M and $[A^-] = 0.060$ M.
 A. Calculate K_a.
 B. Is this acid stronger or weaker than sulfurous acid ($K_a = 1.7 \times 10^{-2}$)?
 C. Calculate K_b.
 D. Calculate pH.
 E. Calculate the pK_a.

9. For each of the following pairs, choose which one describes the weaker acid:
 A. $K_a = x$, $K_a = 3x$
 B. $[H^+] = x$, $[H^+] = 3x$
 C. $pK_a = x$, $pK_a = 3x$
 D. $pH = x$, $pH = 3x$

10. For a certain acid HA, $K_b(A^-) = 2.22 \times 10^{-11}$. Calculate the pH of a 0.5 M solution of HA.

11. Which of the following sets of materials would make the best buffer solution?
 A. H_2O, 1 M NaOH, 1 M H_2SO_4
 B. H_2O, 1 M $HC_2H_3O_2$, 1 M $NaC_2H_3O_2$
 C. H_2O, 1 M $HC_2H_3O_2$, 6 M $NaC_2H_3O_2$
 D. H_2O, 1 M $HC_2H_3O_2$, 1 M NaOH
 E. H_2O, 1 M NaOH, 1 M HCl

12. A certain buffer solution is 3 M in HF and 2 M in NaF. Calculate the pH of this buffer given that the K_a of HF $= 7.0 \times 10^{-4}$.

13. Which of the following combinations would produce a buffer solution of pH $= 4$?
 (K_a $HNO_2 = 4.5 \times 10^{-4}$)
 A. 0.30 M HNO_2, 0.22 M $NaNO_2$
 B. 0.22 M HNO_2, 0.30 M $NaNO_2$
 C. 0.11 M HNO_2, 0.50 M $NaNO_2$
 D. 0.50 M HNO_2, 0.11 M $NaNO_2$
 E. 0.22 M HNO_2, 0.80 M $NaNO_2$

14. Write chemical equations describing the buffer activity that prevents drastic pH changes when (A) a strong acid and (B) a strong base is added.

SOLUTIONS TO REVIEW PROBLEMS

1. **A** 1.6×10^{-10} **M**

 Water is composed of hydronium and hydroxide ions, and the dissociation constant of water, K_w, is defined as $[H^+][OH^-] = 1.0 \times 10^{-14}$ M. If $[OH^-] = 6.2 \times 10^{-5}$, then:

 $$[H^+] = \frac{K_w}{[OH^-]} = \frac{1.0 \times 10^{-14}}{6.2 \times 10^{-5}} = 1.6 \times 10^{-10} \text{ M}.$$

 B **9.79**

 The pH of a solution is a logarithmic measurement of $[H^+]$, which expresses the degree of acidity.

 pH is defined as $-\log[H^+]$. In this case, pH $= -\log(1.6 \times 10^{-10}) = 9.79$.

 C **Basic**

 A pH of 9.79 indicates a basic solution, as does any $[OH^-] > 1.0 \times 10^{-7}$ M.

2. **1,000:1**

 This problem can be solved by calculating the $[H^+]$ of the pH $= 4$ solution and the $[H^+]$ of the pH $= 7$ solution. Then divide the former by the latter: because pH $= -\log[H^+]$, $[H^+]$ = antilog $(-pH)$. For pH $= 4$, antilog $(-4) = 1.0 \times 10^{-4}$. For pH $= 7$, antilog $(-7) = 1.0 \times 10^{-7}$. $1 \times 10^{-4} : 1 \times 10^{-7} = 1,000:1$. Alternately, we could subtract the pHs first, and then find the antilog: $7 - 4 = 3$ implies 10^3, or 1,000:1.

3. **A** $LiOH \rightarrow Li^+ + OH^-$

 B $Ba(OH)_2 \rightarrow Ba^{2+} + 2\,OH^-$

 C $NH_3 + H_2O \rightarrow NH_4^+ + OH^-$

 D $NO_2^- + H_2O \rightarrow HNO_2 + OH^-$

4. **0.067 L**

 At the equivalence point,

 $(\text{Normality})_{acid}(\text{Volume})_{acid} = (\text{Normality})_{base}(\text{Volume})_{base}$

 4 M HCl $=$ 4 N HCl

 3 M NaOH $=$ 3 N NaOH

 Plugging into the formula,

 $(4)(0.05) = (3)(V_B)$

 $V_B = 0.067$ L

5. **10.2 mL**

 First, add enough HCl to neutralize the solution. Because both the acid and the base are 1 M, 10 mL of HCl will neutralize 10 mL of NaOH, from $N_A V_A = N_B V_B$. This produces 20 mL of 0.5 M NaCl solution.

 Next calculate how much more HCl must be added to produce a $[H^+]$ of 1×10^{-2}. Let x be the amount of HCl to be added. The total volume of the solution will be $(20 + x)$ mL. Since this is now a dilution problem, the amount of HCl to be added can be found by using the formula:

GC

$$M_1V_1 = M_2V_2$$
$$(1 \text{ M})(x \text{ mL}) = (0.01 \text{ M})[(20 + x) \text{ mL}]$$

When this equation is solved, x is found to have an approximate value of 0.2 mL, so a total of 10.2 mL of HCl was added to the original NaOH solution.

6. NH_4^+ is the conjugate acid of the weak base, NH_3; OH^- is the conjugate base of the weak acid, H_2O.

 The reaction in question is:

 $$NH_3 + H_2O \leftrightarrows NH_4^+ + OH^-$$

 According to the Brønsted-Lowry theory of acids and bases, an acid releases a proton, whereas a base accepts a proton. In the case of weak acids and bases, an equilibrium is established whereby a weak acid, in this case H_2O, dissociates partially, donating a proton to a weak base, which is NH_3. The weak acid, H_2O, loses a proton and becomes a relatively stronger conjugate base, OH^-. This is one conjugate acid-base pair (H_2O, OH^-). Meanwhile, the weak base, NH_3, picks up a proton to become a relatively stronger conjugate acid, NH_4^+. This is the second conjugate acid-base pair (NH_4^+, NH_3).

7. **A** NaOH is an Arrhenius base.

 B HCl is an Arrhenius acid and a Brønsted-Lowry acid.

 C NH_3 is a Brønsted-Lowry base and a Lewis base.

 D NH_4^+ is an Arrhenius acid and a Brønsted-Lowry acid.

 E $(CH_3)_3N$: acts only as a Lewis base.

 F BF_3 acts only as a Lewis acid.

8. **A** 3.8×10^{-3}

 K_a is the equilibrium constant for an acid, also called the dissociation constant for the particular equilibrium state that is achieved by the dissociation of an acid. We are told that at equilibrium [HA] is 0.94 M, whereas [A$^-$] is 0.060 M. The dissociation of HA can be written as follows:

 $$HA \rightarrow H^+ + A^-$$

 The molar ratio of A$^-$ to H$^+$ is 1:1, so [H$^+$] must also be 0.060 M at equilibrium. It follows, then, that:

 $$K_a = \frac{[A^-][H^+]}{[HA]} = \frac{(0.060)(0.060)}{0.94} = 3.8 \times 10^{-3}$$

 B Weaker

 K_a is a measure of the strength of an acid. An acid with a high K_a is a strong acid because its equilibrium position lies farther to the right (more product increases the numerator of the equilibrium expression and makes K_a larger), meaning that dissociation is more complete. Greater dissociation means a stronger acid. The K_a of sulfurous acid is 1.7×10^{-2} and the K_a of HA is 3.8×10^{-3}. The K_a of HA is less than that of sulfurous acid; therefore, HA is a weaker acid.

 C 2.6×10^{-12}

 Just as K_a is the dissociation constant for an acid, K_b is the dissociation constant of a base. Whereas K_a measures the degree to which H$^+$ is liberated, K_b measures the degree to which

OH⁻ is liberated. Because H^+ and OH^- are related by $K_w = 1.0 \times 10^{-14}$, K_b can be easily calculated. In this case,

$$K_b = \frac{1.0 \times 10^{-14}}{3.8 \times 10^{-3}} = 2.6 \times 10^{-12}$$

D 1.22

$$pH = -\log\,[H^+] = -\log\,(0.060) = 1.22$$

E 2.42

$$pK_a = -\log K_a = -\log\,(3.8 \times 10^{-3}) = 2.42$$

9. A $K_a = x$

K_a is a measure of the dissociation of an acid and, therefore, the strength of an acid. A higher K_a indicates a stronger acid; a lower K_a indicates a weaker acid. x is one-third the value of $3x$ and, therefore, a weaker acid.

B $[H^+] = x$

$[H^+]$ is a direct measure of the strength of an acid. The greater the concentration of H^+ in solution, the stronger the acid. An acid that liberates x moles of H^+ per liter is weaker, therefore, than an acid that liberates $3x$ moles of H^+ per liter.

C $pK_a = 3x$

$pK_a = -\log K_a$; therefore, a pK_a of $3x$ corresponds to a K_a lower in value than that of a pK_a of x. A lower K_a means a weaker acid, and a lower pK_a means a stronger acid. $3x$ is greater than x, so the acid whose pK_a is $3x$ is weaker than the acid whose pK_a is x.

D $pH = 3x$

The acid with a pH of $3x$ is the weaker acid, using the same reasoning as for part (C).

10. 1.82

If $K_b = 2.22 \times 10^{-11}$, then

$$K_a = \frac{K_w}{K_b} = \frac{1.0 \times 10^{-14}}{2.22 \times 10^{-11}}$$

$$K_a = 4.5 \times 10^{-4}$$

If HA dissociates according to the following expression,

$HA \rightleftharpoons H^+ + A^-$,

then the equilibrium expression for this dissociation is:

$$K_a = \frac{[H^+][A^-]}{[HA]}$$

We can let $[H^+] = x$ at equilibrium and, since $[H^+]:[A^-] = 1:1$, $[A^-] = x$.

If the original [HA] was 0.5 M, and x mol/L are dissociated, then at equilibrium, $[HA] = 0.5 - x$.

Thus the equilibrium expression becomes:

$$4.5\times10^{-4} = \frac{[x][x]}{(0.5-x)}$$

We can approximate that $0.5 - x \approx 0.5$ since HA has a small K_a, which indicates it is a weak acid.

$$4.5\times10^{-4} \approx \frac{x^2}{0.5}$$
$$x^2 = 2.25\times10^{-4}$$
$$x = 0.015 = [H^+]$$

$$pH = -\log[H^+] = -\log[0.015] = 1.82$$

11. **B** A buffer solution is prepared from a weak acid and its conjugate base, preferably in near-equal quantities. Choices (A), (D), and (E) are incorrect because they do not show conjugate acid/base pairs. (C) is incorrect because it shows a weak acid and its conjugate base, where the concentrations of the acid and the base are quite different. Thus, the best buffer solution would be that prepared from (B), which shows a conjugate acid/base pair, both present in 1 M concentrations.

12. **2.98**

$$K_a = \frac{[H^+][F^-]}{[HF]}$$
$$7\times10^{-4} = \frac{[H^+](2)}{3}$$
$$[H^+] = 1.05\times10^{-3}$$
$$pH = -\log[H^+] = 2.98$$

Another way to solve this problem is by using the Henderson-Hasselbalch equation:

$$pH = pK_a + \log\frac{[\text{conjugate base}]}{[\text{weak acid}]}$$

Using the Henderson-Hasselbalch equation for this problem:

$$pH = -\log K_a + \log\frac{[F^-]}{[HF]}$$
$$pH = -\log(7.0\times10^{-4}) + \log\left(\frac{2}{3}\right)$$
$$pH = 3.155 - 0.176 = 2.98$$

13. **C** The Henderson-Hasselbalch equation may again be used here:

$$pH = pK_a + \log\frac{[A^-]}{[HA]}$$

$$4 = 3.35 + \log\frac{[A^-]}{[HA]}$$

$$0.65 = \log\frac{[A^-]}{[HA]}$$

$$\frac{[A^-]}{[HA]} = 4.5$$

Only choice (C) fulfills this criterion, as $\frac{0.50}{0.11} = 4.5$.

14. **A** Strong acid:

Salt in buffer dissociates completely:

$NaX \leftrightharpoons Na^+ + X^-$

Added strong acid dissociates completely:

$HCl \leftrightharpoons H^+ + Cl^-$

Protons from the acid are absorbed by the strong conjugate base of the salt:

$H^+ + X^- \leftrightharpoons HX$

B Strong base:

Weak acid in buffer hardly dissociates:

$HX \leftrightharpoons HX$

Added strong base dissociates completely:

$NaOH \leftrightharpoons Na^+ + OH^-$

OH^- is a strong base, which attracts protons from the weak acid:

$OH^- + HX \leftrightharpoons H_2O + X^-$

CHAPTER THIRTY-SEVEN

Nuclear Reactions

LEARNING OBJECTIVES

After this chapter, you will be able to:

- Recall the traits of nuclei and nuclear reactions
- Contrast nuclear and chemical reactions
- Predict the products of nuclear reactions and radioactive decay
- Calculate half-life of an isotope

Nuclear phenomena describe interactions with and changes to nuclei, which is distinctly different from many other topics in general chemistry focused on the behavior of electrons outside the nucleus. Therefore, to begin, it is important to understand the standard terminology used in nuclear chemistry and physics. Briefly, an amount of energy, called the **binding energy**, is required to break up a given nucleus into its constituent protons and neutrons. That energy is converted to mass via Einstein's $E = mc^2$ equation, resulting in a larger mass for the constituent protons and neutrons than that of the original nucleus; this difference is called the **mass defect**. The remainder of the chapter is concerned with a brief discussion of nuclear reactions (**fission** and **fusion**) and an extended treatment of radioactive decay, which itself is presented in two distinct parts. The first deals with the four different types of **radioactive decay** and a discussion of the reaction equations that describe them. The second covers the general problem of determining the number of nuclei that have not decayed as a function of time along with the associated concept of the half-life of a decay process.

NUCLEI

At the center of an atom lies its nucleus, consisting of one or more **nucleons** (protons or neutrons) held together with considerably more energy than the energy needed to hold electrons in orbit around the nucleus. The radius of the nucleus is about 100,000 times smaller than the radius of the atom. As described in Chapter 24, Atomic and Molecular Structure, the atomic number (Z) of an element describes the number of protons, whereas the mass number (A) describes the number of protons + neutrons. Z is used as a presubscript and A is used as a presuperscript to the chemical symbol in **isotopic notation**. The number of protons determines the identity (name) of an element, and varying numbers of neutrons determine different isotopes of that same element. The term **radionucleotide** is another generic name used to refer to any radioactive isotope, especially those used in nuclear medicine.

Nuclear versus Chemical Reactions

All nuclei of atoms, with the exception of hydrogen, contain protons and neutrons. When the nucleus of an atom is unstable, it may spontaneously emit particles or electromagnetic radiation (otherwise known as **radioactivity**). Nuclei may also change composition when nuclear

transmutation occurs. This process involves the bombardment of the nucleus by electrons, neutrons, or other nuclei. These are all specific types of nuclear reactions, which involve changes to nuclei rather than solely electrons. Below is a summary of the major differences between nuclear and chemical reactions.

Nuclear Reactions	Chemical Reactions
• Elements or isotopes are changed from one to another.	• Atoms can be rearranged by the formation or breaking of chemical bonds.
• Reactions result in the release or absorption of large amounts of energy.	• Reactions generally result in the release or absorption of small amounts of energy.
• Reaction rates are generally not affected by catalysts, temperature, or pressure.	• Reaction rates are generally affected by catalysts, temperature, or pressure.
• Protons, neutrons, or electrons can be involved.	• Only electrons in the affected orbital of the atom are involved in the formation and breaking of bonds.

Table 37.1

Nuclear Binding Energy and Mass Defect

Every nucleus (other than $_1^1\text{H}$) has a smaller mass than the combined mass of its constituent protons and neutrons. This difference is called the **mass defect**. Scientists had difficulty explaining why this mass defect occurred until Einstein discovered the equivalence of matter and energy, embodied by the equation $E = mc^2$. The mass defect is a result of matter that has been converted to energy. This energy, called **binding energy**, holds the nucleons together in the nucleus.

Note: The binding energy per nucleon peaks at iron, which implies that iron is the most stable atom. In general, intermediate-sized nuclei are more stable than large and small nuclei.

The mass defect and binding energy of ^4He are calculated in the following example.

Example: Measurements of the atomic mass of a neutron and a proton yield these results:

proton $= 1.00728$ amu

neutron $= 1.00867$ amu

A measurement of the atomic mass of a ^4He nucleus yields:

$^4\text{He} = 4.00260$ amu

^4He consists of two protons and two neutrons, which should theoretically give a ^4He mass of:

$Z(m_\text{p}) + N(m_\text{n}) = 2(1.00728) + 2(1.00867)$

$= 4.03190$ amu

What is the mass defect and binding energy of this nucleus?

Solution: The difference $4.03190 - 4.00260 = 0.02930$ amu is the mass defect for ^4He and is interpreted as the conversion of mass into the binding energy of the nucleus. The rest energy (the energy equivalent of a given mass times the speed of light squared) of

1 amu is 932 MeV, so using $E = mc^2$, we find that $c^2 = 932$ MeV/amu. Therefore, the binding energy (BE) of ^4He is:

$$\text{BE} = \Delta mc^2$$
$$= (0.02930 \text{ amu})(932 \text{ MeV/amu})$$
$$= 27.3 \text{ MeV}$$

NUCLEAR REACTIONS AND DECAY

Nuclear reactions such as fusion, fission, and radioactive decay involve either combining or splitting the nuclei of atoms. Since the binding energy per nucleon is greatest for intermediate-sized atoms, when small atoms combine or large atoms split, a great amount of energy is released.

Fusion

Fusion occurs when small nuclei combine into a larger nucleus. As an example, many stars, including the sun, power themselves by fusing four hydrogen nuclei to make one helium nucleus. By this method, the sun produces 4×10^{26} J every second. Here on Earth, researchers are trying to find ways to use fusion as an alternative energy source. Since these fusion reactions can only take place at extremely high temperatures and pressures, they are generally referred to as **thermonuclear reactions**.

Fission

Fission is a process in which a large, heavy (mass number >200) atom splits to form smaller, more stable nuclei (especially noble gases) and one or more neutrons. It is important to note that, because the original large nucleus is more unstable than its products, there is the release of a large amount of energy. Spontaneous fission rarely occurs. However, by the absorption of a low-energy neutron, fission can be induced in certain nuclei. Of special interest are those fission reactions that release more neutrons since those other neutrons will cause other atoms to undergo fission. This in turn releases more neutrons, creating a **chain reaction**. By bombarding large, unstable nuclei with neutrons, scientists can use fission reactions to power commercial nuclear electric-generating plants.

Example: A fission reaction occurs when uranium-235 (U-235) absorbs a low-energy neutron, briefly forming an excited state of U-236, which then splits into xenon-140, strontium-94, and x more neutrons. In isotopic notation form the reactions are:

$$^{235}_{92}\text{U} + {}^{1}_{0}\text{n} \rightarrow {}^{236}_{92}\text{U} \rightarrow {}^{140}_{54}\text{Xe} + {}^{94}_{38}\text{Sr} + x{}^{1}_{0}\text{n}$$

How many neutrons are produced in the last reaction?

Solution: The question is asking "What is x?" By treating each arrow as an equal sign, the problem is simply asking you to balance the last "equation." The mass numbers (A) on either side of each arrow must be equal. This is an application of **nucleon** or **baryon number conservation,** which says that the total number of neutrons plus protons remains the same, even if neutrons are converted to protons and vice versa, as they are in some decays. Because $235 + 1 = 236$, the first arrow is indeed balanced. To find the number of neutrons, solve for x in the last equation (arrow):

$$236 = 140 + 94 + x$$
$$x = 236 - 140 - 94$$
$$x = 2$$

So two neutrons are produced in this reaction. These neutrons are free to go on and be absorbed by more ^{235}U and cause more fission, and the process continues in a chain reaction. Note that it really was not necessary to know that the intermediate state $^{236}_{92}$U was formed.

Some radioactive nuclei may be induced to fission via more than one **decay channel** or **decay mode**. For example, a different fission reaction may occur when uranium-235 absorbs a slow neutron and then immediately splits into barium-139, krypton-94, and three more neutrons with no intermediate state:

$$^{235}_{92}U + {}^{1}_{0}n \rightarrow {}^{139}_{56}Ba + {}^{94}_{36}Kr + 3{}^{1}_{0}n$$

Radioactive Decay

Radioactive decay is a naturally occurring spontaneous decay of certain nuclei accompanied by the emission of specific particles. It could be classified as a certain type of fission. Radioactive decay problems are of three general types:

1. The integer arithmetic of particle and isotope species
2. Radioactive half-life problems
3. The use of exponential decay curves and decay constants

Isotope decay arithmetic and nucleon conservation

Let the letters X and Y represent nuclear isotopes such that the **parent isotope** $^{A}_{Z}X$ decays into a **daughter isotope** $^{A'}_{Z'}Y$ as in:

$$^{A}_{Z}X \rightarrow {}^{A'}_{Z'}Y + \text{emitted decay particle}$$

Alpha decay

Alpha decay is the emission of an α-particle, which is a $^{4}_{2}$He nucleus that consists of two protons and two neutrons. The alpha particle is very massive (compared to a beta particle) and doubly charged (since it contains two protons and has a +2 charge). Alpha particles interact with matter very easily; hence, they do not penetrate shielding (such as lead sheets) very far.

The emission of an α-particle means that the daughter's atomic number (Z') will be two less than the parent's atomic number, and the daughter's mass number (A$'$) will be four less than the parent's mass number. This can be expressed in two equations:

$$Z_{\text{daughter}} = Z_{\text{parent}} - 2$$
$$A_{\text{daughter}} = A_{\text{parent}} - 4$$

The generic alpha decay reaction is then:

$$^{A}_{Z}X \rightarrow {}^{A-4}_{Z-2}Y + {}^{4}_{2}\alpha$$

Note that alpha decay and fission are the only radioactive processes on the exam during which the mass number (A$'$) changes.

Example: Suppose a parent X alpha decays into a daughter Y such that:

$$^{238}_{92}X \rightarrow {}^{A'}_{Z'}Y + \alpha$$

What are the mass number (A') and atomic number (Z') of the daughter isotope Y?

Solution: Since $\alpha = {}^4_2He$, balancing the mass numbers and atomic numbers is all that needs to be done:

$238 = A' + 4$

$A' = 234$

$92 = Z' + 2$

$Z' = 90$

So $A' = 234$ and $Z' = 90$. Note that it was not necessary to know the chemical species of the isotopes to do this problem. However, the periodic table does show that $Z = 92$ means X is uranium-238 $\left({}^{238}_{92}U\right)$ and that $Z = 90$ means Y is thorium-234 $\left({}^{234}_{90}Th\right)$.

Beta decay

Beta decay is the emission of a β-particle, which could be either β^- (electron) or β^+ (positron), from the nucleus. A **positron** (e^+) is similar to an electron (so has minimal mass) but has a positive charge. Electrons and positrons do not normally reside in the nucleus but are emitted when a proton or neutron in the nucleus decays. This is because protons and neutrons are composed of elementary particles called quarks, which can recombine to form different particles. Specifically, in β^- decay, a neutron decays into a proton and a β^- particle (and an antineutrino), whereas, in β^+ decay, a proton decays into a neutron and a β^+ particle (and a neutrino). Note that neither of these reactions is concerned with electrons in orbitals outside the nucleus, which are generally ignored during radioactive decay.

β^- decay means that a neutron is consumed and a proton takes its place. Hence, the parent's mass number is unchanged, and the parent's atomic number is increased by one. In other words, the daughter's A is the same as the parent's, and the daughter's Z is one more than the parent's.

$$Z_{daughter} = Z_{parent} + 1$$
$$A_{daughter} = A_{parent}$$

In β^+ decay, a proton is consumed and a neutron takes its place. Therefore, β^+ decay means that the parent's mass number is unchanged, and the parent's atomic number is decreased by one. In other words, the daughter's A is the same as the parent's, and the daughter's Z is one less than the parent's.

$$Z_{daughter} = Z_{parent} - 1$$
$$A_{daughter} = A_{parent}$$

The generic negative beta-minus decay reaction is:

$$^A_ZX \rightarrow {}^A_{Z+1}Y + \beta^-$$

Note that β^- decay is the only radioactive decay on the test where the atomic number (Z') increases. The generic beta-plus decay reaction is:

$$_{Z}^{A}X \rightarrow _{Z-1}^{A}Y + \beta^+$$

Since β particles are singly charged and about 1,836 times lighter than protons, the beta radiation from radioactive decay is more penetrating than alpha radiation.

Example: Suppose a cobalt-60 nucleus undergoes beta-minus decay such that:

$$_{27}^{60}Co \rightarrow _{Z+1}^{A}Y + \beta^-$$

What are the A' and Z' of the daughter isotope?

Solution: Balance mass numbers:

$60 = A' + 0$

$A' = 60$

Now balance the atomic numbers, taking into account that cobalt has 27 protons (the Z value, or presubscript, given in the question) and that there is one more proton on the right-hand side:

$Z' = Z + 1$

$Z' = 27 + 1$

$Z' = 28$

The answer is an element with 28 protons and 60 nucleons. Although the question does not ask for the identity of the daughter, the periodic table shows that it is:

$Y = _{28}^{60}Ni$

Gamma decay

Gamma decay is the emission of γ-particles, which are high-energy photons. Gamma decay usually follows another type of nuclear decay and is a way for the nucleus to shed excess energy (similar to how an electron in an excited state emits a photon to shed energy). Gamma particles carry no charge and simply lower the energy of the emitting (parent) nucleus without changing the mass number or the atomic number. In other words, the daughter's A is the same as the parent's, and the daughter's Z is the same as the parent's.

$$Z_{parent} = Z_{daughter}$$
$$A_{parent} = A_{daughter}$$

The generic gamma decay reaction is thus:

$$_{Z}^{A}X^* \rightarrow _{Z}^{A}X + \gamma$$

Example: Suppose a parent isotope $^{A}_{Z}X$ emits a β^+ and turns into an excited state of the isotope $^{A'}_{Z'}Y^*$, which then γ-decays to $^{A''}_{Z''}Y$, which in turn α-decays to $^{A'''}_{Z'''}W$. If W is ^{60}Fe (Z = 26), what is $^{A}_{Z}X$?

Solution: Since the final daughter in this chain of decay is given, it will be necessary to work backward through the reactions. First, work backward from the α-decay, then use that answer to work backward from the β^+-decay. Note that the γ-decay simply releases energy from the nucleus but does not alter the atomic number or the mass number of the parent and so can be disregarded for these calculations.

First, the α-decay:

$$^{A''}_{Z''}Y \rightarrow ^{60}_{26}Fe + ^{4}_{2}He^{2+}$$

By balancing the atomic numbers you find:
$$Z'' = 26 + 2 = 28$$

A balancing of the mass numbers implies:
$$A'' = 60 + 4 = 64$$

So the γ-decay was:

$$^{64}_{28}Y^* \rightarrow ^{64}_{28}Y + \gamma$$

The first reaction was a β^+-decay that must have looked like:

$$^{A}_{Z}X \rightarrow ^{64}_{28}Y^* + \beta^+$$

Again, balance the atomic numbers:
$$Z = 28 + 1 = 29$$

Since A remains unchanged during β^+-decay, $A' = A = 64$.

While the question did not ask for it, it is possible again to look at the periodic table to find that the total chain of decays can be written as:

$$^{64}_{29}Cu \rightarrow ^{64}_{28}Ni^* + \beta^+$$
$$^{64}_{28}Ni^* \rightarrow ^{64}_{28}Ni + \gamma$$
$$^{64}_{28}Ni \rightarrow ^{60}_{26}Fe + \alpha$$

Electron capture

Certain unstable radionuclides are capable of capturing an inner electron that combines with a proton to form a neutron. The atomic number is now one less than the original, but the mass number remains the same. Electron capture is a rare process best thought of as an inverse β^- decay, following the exact same process as beta-minus decay but in reverse.

$$^{A}_{Z}X + e^- \rightarrow ^{A}_{Z-1}Y$$

Radioactive decay half-life

In a collection of a great many identical radioactive isotopes, the **half-life** $(t_{1/2})$ of the sample is the time it takes for half of the sample to decay by any of the above processes. After n half-lives, $\left(\frac{1}{2}\right)^n$ of the original sample will remain, whereas $1 - \left(\frac{1}{2}\right)^n$ will have decayed.

Example: If the half-life of a certain isotope is 4 years, what fraction of a sample of that isotope will remain after 12 years?

Solution: If 4 years is one half-life, then 12 years is three half-lives and $n = 3$. During the first half-life—the first 4 years—half of the sample will have decayed. During the second half-life (years 4 to 8), half of the remaining half will decay, leaving one-fourth of the original. During the third and final period (years 8 to 12), half of the remaining fourth will decay, leaving one-eighth of the original sample. Thus the fraction remaining after 3 half-lives is $\left(\frac{1}{2}\right)^3$ or $\frac{1}{8}$.

Exponential decay

Let N be the number of radioactive nuclei that have not yet decayed in a sample. It turns out that the **rate** at which the nuclei decay $\left(\frac{\Delta N}{\Delta t}\right)$ is proportional to the number that remain (N). This suggests the equation:

$$\frac{\Delta N}{\Delta t} = -\lambda N$$

where λ is known as the **decay constant.** The solution of this equation tells us how the number of radioactive nuclei changes with time, which is known as **exponential decay:**

$$N = N_0 e^{-\lambda t}$$

where N_0 is the number of undecayed nuclei at time $t = 0$. (The decay constant is related to the half-life by $\lambda = \frac{\ln{(2)}}{t_{1/2}} = \frac{0.693}{t_{1/2}}$.)

Example: If at time $t = 0$ there is a two-mole sample of radioactive isotopes of decay constant 2 $(\text{hour})^{-1}$, how many nuclei remain after 45 minutes?

Solution: Because 45 minutes is three-fourths of an hour, the exponent $(-\lambda t)$ is

$$-\lambda t = -2\left(\frac{3}{4}\right) = -\frac{6}{4} = -\frac{3}{2}$$

The exponential factor will be a number smaller than 1:

$$e^{-\lambda t} = e^{-3/2} = 0.22$$

So only 0.22 or 22% of the original two-mole sample will remain. To find N_0, multiply the number of moles by the number of particles per mole (Avogadro's number):

$$N_0 = 2(6.02 \times 10^{23}) = 1.2 \times 10^{24}$$

From the equation that describes exponential decay, you can calculate the number of nuclei that remain after 45 minutes:

$$N = N_0 e^{-\lambda t}$$
$$= (1.2 \times 10^{24})(0.22)$$
$$= 2.6 \times 10^{23} \text{ particles}$$

GC

REVIEW PROBLEMS

1. Element $^{102}_{20}\text{S}$ is formed as a result of 3 α and 2 β^- decays. Which of the following is the parent element?

 A. $^{90}_{16}\Gamma$

 B. $^{114}_{24}\Phi$

 C. $^{114}_{28}\Theta$

 D. $^{12}_{8}\Delta + ^{90}_{12}\vartheta$

 E. $^{114}_{25}\Lambda$

2. Element X is radioactive and decays via α-decay with a half-life of four days. If 12.5% of an original sample of element X remains after t days, then determine t.

3. A patient undergoing treatment for thyroid cancer receives a dose of radioactive iodine (^{131}I), which has a half-life of 8.05 days. If the original dose contained 12 mg of ^{131}I, what mass of ^{131}I remains after 16.1 days?

4. In an exponential decay, if the natural logarithm of the ratio of intact nuclei (N) at time t to the intact nuclei at time $t = 0$ (N_0) is plotted against time, what does the slope of the graph correspond to?

5. The half-life of radioactive sodium is 15 hours. How many hours would it take for a 64 g sample to decay to one-eighth of its original activity?

 A. 3
 B. 15
 C. 30
 D. 45
 E. 60

SOLUTIONS TO REVIEW PROBLEMS

1. **B** Emission of three alpha particles by the (as yet unknown) parent results in the following changes:

 Mass number: decreases by 3×4 or 12 units

 Atomic number: decreases by 3×2 or 6 units

 Emission of two negative betas results in the following changes:

 Mass number: no change

 Atomic number: increases by 2×1 or 2 units

 So the net change is: mass number decreases by 12 units; atomic number decreases by 4 units. Therefore, the mass number of the parent is 12 greater than 102, or 114; the atomic number of the parent is 4 greater than 20, or 24. The only choice given with these numbers is (B).

2. $t = 12$ **days**

 Because the half-life of element X is 4 days, 50% of an original sample remains after 4 days, 25% of an original sample remains after 8 days, and 12.5% of an original sample remains after 12 days. Thus, $t = 12$ days. A different approach is to set $\left(\frac{1}{2}\right)^{n} = 0.125$, where n is the number of half-lives that have elapsed. Solving for n gives $n = 3$. Thus, 3 half-lives have elapsed, and given the half-life is 4 days, $t = 12$ days.

3. **3 mg**

 Given that the half-life of ^{131}I is 8.05 days, we know that two half-lives have elapsed after 16.1 days, which means that 25% of the original amount of ^{131}I is still present. Thus, only 25% of the original number of ^{131}I nuclei remain, which also means that only 25% of the original mass of ^{131}I remain. Because the original dose contained 12 mg of ^{131}I, only 3 mg remain after 16.1 days.

4. $-\lambda$

 The expression $N = N_{0}e^{-\lambda t}$ is equivalent to $\frac{N}{N_{0}} = e^{-\lambda t}$. Taking the natural logarithm of both sides of the latter expression you find:

 $$\ln\left(\frac{N}{N_{0}}\right) = -\lambda t$$

 From this expression it is clear that plotting $\ln\left(\frac{N}{N_{0}}\right)$ versus t will give a straight line of slope $-\lambda$.

5. **D** For a 64 g sample to decay to one-eighth of its original activity, or 8 g, the sample would have to go through three half-lives. Therefore, the amount of time needed for the decay is 3 half-lives \times 15 hours per half-life $= 45$ hours.

ORGANIC CHEMISTRY

SECTION GOALS

Organic Chemistry is the final section in the Survey of Natural Sciences section of the DAT. The organic chemistry strategies, terminology, reaction mechanisms, and practice presented within this section are designed to help you to accomplish the following goals:

- Recall functional group structure, nomenclature, and reactivity trends
- Predict reaction mechanisms of novel compounds
- Distinguish key differences in compounds with similar structures
- Apply known reagents to new reaction schema
- Predict answers to DAT Organic Chemistry questions efficiently

CONTENT OVERVIEW

Nomenclature**	Chapter 39: Nomenclature
Stereochemistry	Chapter 40: Isomers
Aromatics and Bonding	Chapter 41: Bonding Chapter 44: Aromatic Compounds
Reactions, Reaction Mechanisms	Chapter 42: Alkanes Chapter 43: Alkenes and Alkynes Chapter 45: Alcohols and Ethers Chapter 46: Aldehydes and Ketones Chapter 47: Carboxylic Acids* Chapter 48: Carboxylic Acid Derivatives* Chapter 49: Amines
Acid-Base Chemistry	Chapter 47: Carboxylic Acids* Chapter 48: Carboxylic Acid Derivatives*
Chemical and Physical Properties of Molecules**	Chapter 50: Spectroscopy Chapter 51: Separation

*Chapters 47 and 48 are required for Reactions, Reaction Mechanisms, and Acid-Base Chemistry
**These test areas require both the listed chapters, and understanding of Chapters 42–49.

KEY STUDY STRATEGIES

The organic chemistry in this section is best studied in order. After an initial review, the content should be used for spot checks on content and reactions. As noted in the table above, there is extensive overlap of the topics within this section. Each chapter is designed to build on knowledge from prior chapters, so if a particular chapter is giving you trouble, refer back to previous readings. Later chapters should be used after thoroughly working through the previous chapters and their practice questions. Within each chapter, extra focus should be placed on the boldface terms, as well as the recurring reaction schema. The same simple steps within reaction mechanisms will be repeated throughout the Organic Chemistry section, making comfort with this content a key DAT skill. When solving the practice problems at the end of each chapter, attempt to do so without referring back to the associated chapter in order to demonstrate mastery of the content.

CHAPTER THIRTY-EIGHT

Organic Chemistry Strategies

LEARNING OBJECTIVES

After this chapter, you will be able to:

- Apply Kaplan's question strategies to the Organic Chemistry section
- Use Kaplan's proven techniques to study DAT Organic Chemistry content effectively

The final subtest of the Survey of Natural Sciences is Organic Chemistry. Questions 71–100 will assess your knowledge of reaction mechanisms, properties of molecules, stereochemistry, nomenclature, reactions, acids and bases, and aromatics.

ORGANIC CHEMISTRY QUESTION STRATEGY

Organic Chemistry questions should always be approached using Kaplan's Stop-Think-Predict-Match question strategy. In particular, making good use of the *Think* and *Predict* steps will allow you to quickly eliminate impossible answer choices, such as those that don't use correct Lewis structures or don't reflect the key change caused by a reaction. In this way, a general, well-thought-out prediction may be sufficient for narrowing down the choices to the correct answer without requiring you to ever draw out an entire reaction or complex molecule. This does vary, though: Some questions will be fact-based or require only a simple mental assessment, but others will necessitate writing out complex reactions or drawing molecules based on their IUPAC names. On average, expect each question to take you 60 seconds, but plan for this to fluctuate from question to question. Answering all the straightforward (and therefore less time-consuming) questions first will give you more time on the more complex questions. Note that if you did not follow the Kaplan timing guidelines for the first two subtests of the Survey of Natural Sciences, you may have less time per Organic Chemistry question. This isn't an ideal situation and might mean that your time will elapse before you are able to attempt every question. Complete enough timed practice to ensure you stay on time throughout this and every other section on Test Day. For more details about how to apply the question and timing strategies to any question in the Survey of Natural Sciences, see Chapter 4.

STUDYING ORGANIC CHEMISTRY CONTENT

Initially, the Organic Chemistry content on the DAT may appear quite dissimilar to what you studied in your previous courses. The DAT is a multiple-choice test, so you can't be asked to draw out complicated molecules, deduce elaborate reaction mechanisms, or synthesize specific products based on memory alone. If the test makers ask you to determine the reactant required

for a certain reaction or the identity of an unknown molecule based on its IR absorption spectrum, the answer must be one of five choices in front of you. The nature of the test dictates that the focus be more on generalizations, patterns, and critical thinking rather than straight memorization, which may seem more difficult at first but is actually easier for most students to learn in the long term!

To that end, study concepts rather than memorizing a long list of specific reactions. Although it won't hurt you to know the mechanisms for the Wittig reaction, the Newman-Kwart rearrangement, and the Takai olefination, a basic understanding of the properties of a carbonyl and the kinds of reactions it can take part in (the carbonyl carbon is partially positive and will react with nucleophiles, and the carbonyl oxygen is partially negative and will act as a base; see Chapter 46) will be much more beneficial for Test Day.

The chapters in this section are arranged by functional group to help you pay attention to these kinds of general properties. While reading, don't attempt to memorize every reaction initially but instead focus on the general types of reactions each functional group can undergo. Only a fraction of the Organic Chemistry subtest is about individual reactions, and the named reactions make up only a small fraction of those questions. Much more of the subtest is devoted to broader topics, such as nomenclature, physical properties, stability, and stereochemistry. Even questions that do require analyzing reactions can often be answered correctly using critical thinking based on a strong fundamental understanding of why reactions take place and a solid knowledge of General Chemistry. Learn the basics first by reading the following chapters and analyzing the reactions from the study sheets at the end of this book. Only focus on memorizing specific reactions once you feel comfortable with the concepts, which yield more points on Test Day and make memorizing the specifics easier, too.

Finally, with that understanding, don't panic if you see a reaction or molecule that you don't recognize on Test Day. Instead, examine the reactants and products for components you do recognize. If you see that xylitol (pentane-1,2,3,4,5-pentol) is a reactant for a reaction-based question, you might not initially know its structure or how it behaves. However, you can identify that it's an alcohol right away based on its name alone, which means you know it's likely to be a water-soluble weak acid that can undergo deprotonation. If only one of the five answer choices shows the transfer of a hydrogen, then you have a very good chance of getting that question right; no further knowledge is required. Once you have the concepts down and put them into practice using the Kaplan strategies, you'll be ready to think like this on Test Day and correctly answer even the questions that seem difficult to you now.

CHAPTER THIRTY-NINE

Nomenclature

LEARNING OBJECTIVES

After this chapter, you will be able to:

- Recall the commonly tested functional groups and their nomenclature
- Apply nomenclature rules to organic chemistry molecules
- Predict the structures of compounds given their names

Nomenclature, the set of accepted conventions for naming compounds, is crucial to a discussion of organic chemistry. Nomenclature represents the basic language of organic chemistry; if you don't know it, you may feel like you're taking a test in a foreign language! Note that the rules of nomenclature presented in this chapter are for general cases only. More specific examples will be discussed in the chapters dealing with particular types of compounds.

ALKANES

Alkanes are the simplest organic molecules, consisting only of carbon and hydrogen atoms held together by single bonds.

Straight-Chain Alkanes

The names of the four simplest alkanes are:

$$CH_4 \qquad CH_3CH_3 \qquad CH_3CH_2CH_3 \qquad CH_3CH_2CH_2CH_3$$
methane **eth**ane **prop**ane **but**ane

The names of the longer-chain alkanes consist of prefixes derived from the Greek root for the number of carbon atoms with the ending **-ane.**

$C_5H_{12} =$ **pent**ane $C_9H_{20} =$ **non**ane

$C_6H_{14} =$ **hex**ane $C_{10}H_{22} =$ **dec**ane

$C_7H_{16} =$ **hept**ane $C_{11}H_{24} =$ **undec**ane

$C_8H_{18} =$ **oct**ane $C_{12}H_{26} =$ **dodec**ane

These prefixes are applicable to more complex organic molecules, too, and should be memorized.

OC

Branched-Chain Alkanes

The International Union of Pure and Applied Chemistry (IUPAC) has established a set of simple rules for naming complex molecules. This basic system can be used to name all classes of organic compounds. Throughout these notes, the IUPAC names will be listed as the primary name, and common names will appear in parentheses.

1. **Find the longest chain in the compound.**

The longest continuous carbon chain within the compound is taken as the backbone. If two or more chains are of equal length, the most highly substituted chain (the one with the greatest number of other groups attached) takes precedence. The longest chain may not be as obvious from the structural formula as when it is drawn. For example, the backbone shown below is an octane (it contains eight carbon atoms).

$$C\!-\!C\!-\!C\!-\!C\!-\!C\!-\!C\!-\!C\!-\!C$$

Figure 39.1

2. **Number the chain.**

Number the chain from one end in such a way that the lowest set of numbers is obtained for the substituents (which in alkanes are carbon groups not part of the main carbon chain).

Figure 39.2

3. **Name the substituents.**

Substituents are named according to their appropriate prefix with the ending **-yl**. For example:

CH_3-	CH_3CH_2-	$CH_3CH_2CH_2-$
methyl	ethyl	n-propyl

The prefix n- in the above example indicates an unbranched ("normal") compound. There are special names for some common branched alkanes (see Figure 39.3), and these are usually used in the naming of substituents.

tert—butyl neopentyl isopropyl

sec—butyl isobutyl

Figure 39.3

If two or more equivalent groups are present, the prefixes **di-**, **tri-**, **tetra-**, etc. are used.

4. Assign a number to each substituent.
Each substituent is assigned a number to identify its point of attachment to the principal chain. If the prefixes **di-**, **tri-**, **tetra-**, etc., are used, a number is still necessary for each individual group.

5. Complete the name.
List the substituents in alphabetical order with their corresponding numbers. Prefixes such as di-, tri-, etc., as well as the hyphenated prefixes (*tert-* [or *t-*], *sec-*, *n-*), are ignored in alphabetizing. In contrast, **cyclo-**, **iso-**, and **neo-** are considered part of the group name and are alphabetized. Commas should be placed between numbers, and hyphens should be placed between numbers and words. For example:

4-ethyl-5-isopropyl-3,3-dimethyl octane

Figure 39.4

You may also need to indicate the isomer you are describing—e.g., *cis* or *trans*, *R* or *S*, etc. Isomers are discussed in detail in Chapter 40.

Cycloalkanes

Alkanes can also form rings rather than straight chains. These are named according to the number of carbon atoms in the ring with the prefix **cyclo-.**

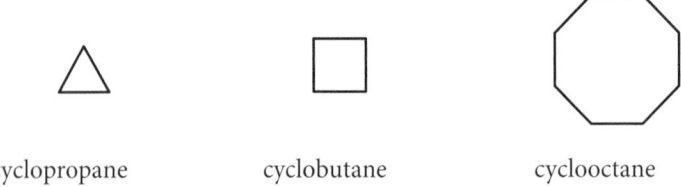

cyclopropane cyclobutane cyclooctane

Figure 39.5

Substituted cycloalkanes are named as derivatives of the parent cycloalkane. The substituents are named, and the carbon atoms are numbered around the ring *starting from the point of greatest substitution.* Again, the goal is to provide the lowest series of numbers, as in rule number 2 for naming complex molecules.

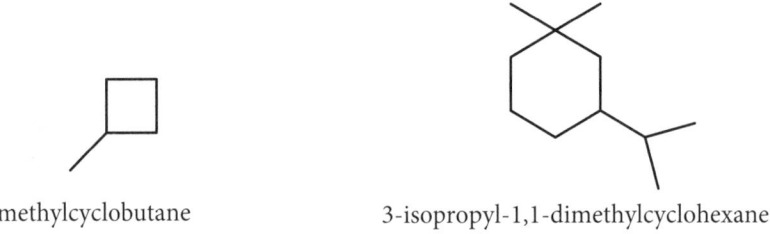

methylcyclobutane 3-isopropyl-1,1-dimethylcyclohexane

Figure 39.6

MULTIPLE BONDS

Organic molecules more complicated than simple alkanes can also be named using the 5-step process but with a few additional considerations.

Alkenes

Alkenes (or **olefins**) are compounds containing carbon-carbon double bonds. The nomenclature rules are essentially the same as for alkanes except that the ending **-ene** is used rather than **-ane**. Note the exceptions of the common names *ethylene* and *propylene,* which are used preferentially over the IUPAC names *ethene* and *propene.*

When identifying the carbon backbone, select the longest chain that contains the double bond (or the greatest number of double bonds if more than one is present).

Figure 39.7

Number the backbone so the double bond receives the lowest number possible. Remember that multiple double bonds must be named using the prefixes di-, tri-, etc. and that each must receive a number. Also, you may need to name the configurational isomer (*cis/trans*, *Z/E*). This topic will be discussed further in Chapter 40.

Substituents are named as they are for alkanes, and their positions are specified by the number of the backbone carbon atom to which they are attached.

Frequently, an alkene group must be named as a substituent. In these cases, the systematic names may be used, but common names are more popular. **Vinyl-** derivatives are monosubstituted ethylenes (**ethenyl-**), and **allyl-** derivatives are propylenes substituted at the C–3 position (**2-propenyl-**). **Methylene** refers to the –CH$_2$ group.

chloroethene 3-bromo-1-propene methylene cyclohexane

(vinyl chloride) (allyl bromide)

Figure 39.8

Cycloalkenes

Cycloalkenes are named like cycloalkanes but with the suffix **-ene** rather than -**ane**. If the molecule has only one double bond and no other substituents, a number is not necessary.

cyclohexene

Figure 39.9

Alkynes

Alkynes are compounds that possess carbon-carbon triple bonds. The suffix **-yne** replaces *-ane* in the parent alkane. The position of the triple bond is indicated by a number when necessary. The common name for ethyne is **acetylene,** and this name is used almost exclusively.

$HC\equiv CH$

ethyne
(acetylene)

4-methyl-2-hexyne

cyclohexyne

Figure 39.10

SUBSTITUTED ALKANES

Haloalkanes

Compounds containing a halogen substituent are named following similar rules as those above while including the halogen as a substituent. If the halogen is the highest priority substituent, ensure it has the lower number when deciding from which end of the carbon chain to start counting. For example:

2-chloro-3-iodopentane

1-chloro-2-methylcyclohexane

Figure 39.11

Alternatively, the haloalkane may be named as an **alkyl halide.** In this system, chloroethane is called **ethyl chloride**. Other examples are:

2-bromo-2-methylpropane

(*t*-butyl bromide)

2-iodopropane

(isopropyl iodide)

Figure 39.12

Alcohols

In the IUPAC system, **alcohols** are named by replacing the *-e* of the corresponding alkane with **-ol**. The chain is numbered such that the carbon attached to the hydroxyl group (–OH) receives the lowest number possible.

In compounds that possess a multiple bond and a hydroxyl group, numerical priority is given to the carbon attached to the –OH.

ethanol

5-methyl-2-heptanol

hept-6-en-1-ol

Figure 39.13

A common system of nomenclature exists for alcohols in which the name of the alkyl group is combined with the word *alcohol*. These common names are used for simple alcohols. For example, methanol may be named "methyl alcohol," while 2-propanol may also be named "isopropyl alcohol."

Molecules with two hydroxyl groups are called **diols** (or **glycols**) and are named with the suffix **-diol**. Two numbers are necessary to locate the two functional groups. Diols with hydroxyl groups on adjacent carbons are referred to as **vicinal**, and diols with hydroxyl groups on the same carbon are **geminal**. These terms apply for any two functional groups. Geminal diols (also called **carbonyl hydrates**) are not commonly observed because they spontaneously lose water (**dehydrate**) to produce carbonyl compounds (containing C=O; see Chapter 44).

Ethers

In the IUPAC system, **ethers** are named as derivatives of alkanes, and the larger alkyl group is chosen as the backbone. The ether functionality is specified as an **alkoxy-** prefix, indicating the presence of an ether (*oxy-*), and the corresponding smaller alkyl group (*alk-*). The chain is numbered to give the ether the lowest position. Common names for ethers are frequently used. They are derived by naming

the two alkyl groups in alphabetical order and adding the word *ether*. The generic term "ether" refers to diethyl ether, a commonly used solvent.

For **cyclic ethers**, numbering of the ring begins at the oxygen and proceeds to provide the lowest numbers for the substituents. Three-membered rings are termed **oxiranes** by IUPAC. The simplest of these are commonly called **epoxides**.

methoxyethane
(ethyl methyl ether)

1-isopropoxyhexane
(*n*-hexyl isopropyl ether)

oxirane
(ethylene oxide)

2-methyloxirane
(propylene oxide)

tetrahydrofuran
(THF)

Figure 39.14

Aldehydes and Ketones

Aldehydes are named according to the longest chain containing the aldehyde functional group. The suffix -**al** replaces the -*e* of the corresponding alkane. The carbonyl carbon receives the lowest number, although numbers are not always necessary since by definition an aldehyde is terminal and receives the number (1).

n-butanal

5,5-dimethylhexanal

Figure 39.15

The common names *formaldehyde*, *acetaldehyde*, and *propionaldehyde* are used almost exclusively instead of the IUPAC names *methanal*, *ethanal*, and *propanal*, respectively.

methanal
(formaldehyde)

ethanal
(acetaldehyde)

propanal
(propionaldehyde)

Figure 39.16

Ketones are named analogously with aldehydes but with **-one** as a suffix. If highest priority, the carbonyl group must be assigned the lowest possible number. In complex molecules, the carbonyl group can be named as a prefix with the term **oxo-**. Alternatively, the individual alkyl groups may be listed in alphabetical order and followed by the word **ketone**.

2-pentanone

3-(5-oxohexyl)cyclohexanone

2-propanone
(dimethyl ketone)
(acetone)

3-butene-2-one
(methyl vinyl ketone)

Figure 39.17

A commonly used alternative to the numerical designation of substituents is to term the carbon atom adjacent to the carbonyl carbon as α and the carbon atoms successively along the chain as β, γ, δ, etc. This system is encountered with dicarbonyl compounds and halocarbonyl compounds.

Carboxylic Acids

Carboxylic acids are named with the ending **-oic acid** replacing the *-e* ending of the corresponding alkane. Carboxylic acids are terminal functional groups and, like aldehydes, are numbered one (1).

The common names *formic acid* (methanoic acid), *acetic acid* (ethanoic acid), and *propionic acid* (propanoic acid) are used almost exclusively.

methanoic acid

(formic acid)

ethanoic acid

(acetic acid)

propanoic acid

(propionic acid)

Figure 39.18

Amines

The longest chain attached to the nitrogen atom is taken as the backbone. For simple compounds, name the alkane and replace the final -*e* with -**amine**. More complex molecules are often named using the prefix **amino-**.

ethanamine

4-aminohept-2-en-1-ol

Figure 39.19

The prefix N- is used to specify the location of an additional alkyl group attached to the nitrogen:

N-ethylpentanamine

(ethylpentylamine)

Figure 39.20

SUMMARY OF FUNCTIONAL GROUPS

Table 39.1 lists the major functional groups you need to know.

Functional Group	Structure	IUPAC Prefix	IUPAC Suffix
Carboxylic acid	$R-\overset{\displaystyle O}{\underset{\displaystyle OH}{C}}$	carboxy-	-oic acid
Ester	$R-\overset{\displaystyle O}{\underset{\displaystyle OR}{C}}$	alkoxycarbonyl-	-oate
Acyl halide	$R-\overset{\displaystyle O}{\underset{\displaystyle X}{C}}$	halocarbonyl-	-oyl halide
Amide	$R-\overset{\displaystyle O}{\underset{\displaystyle NH_2}{C}}$	amido-	-amide
Nitrile	$RC{\equiv}N$	cyano-	-nitrile
Aldehyde	$R-\overset{\displaystyle O}{\underset{\displaystyle H}{C}}$	oxo-	-al
Ketone	$R-\overset{\displaystyle O}{\underset{\displaystyle R}{C}}$	oxo-	-one
Alcohol	ROH	hydroxy-	-ol
Thiol	RSH	sulfhydryl-	-thiol
Amine	RNH_2	amino-	-amine
Imine	$R_2C{=}NR'$	imino-	-imine
Ether	ROR	alkoxy-	-ether
Sulfide	R_2S	alkylthio-	
Halide	-I, -Br, -Cl, -F	halo-	
Nitro	RNO_2	nitro-	
Azide	RN_3	azido-	
Diazo	RN_2^+	diazo-	

Table 39.1

REVIEW PROBLEMS

1. What is the IUPAC name of the following compound?

 A. 2,5-dimethylheptane
 B. 2-ethyl-5-methylhexane
 C. 3,6-dimethylheptane
 D. 5-ethyl-2-methylhexane
 E. 3,5-dimethylhexane

2. What is the structure of 5-ethyl-2,2-dimethyloctane?

3. What is the name of the following compound?

 A. 1-ethyl-3,4-dimethylcycloheptane
 B. 2-ethyl-4,5-dimethylcyclohexane
 C. 1-ethyl-3,4-dimethylcyclohexane
 D. 4-ethyl-1,2-dimethylcyclohexane
 E. 4-ethyl-1,3-dimethylcyclohexane

4. What is the name of the following compound?

 A. 2-bromo-5-butyl-4,4-dichloro-3-iodo-3-methyloctane
 B. 7-bromo-4-butyl-5,5-dichloro-6-iodo-6-methyloctane
 C. 2-bromo-4,4-dichloro-3-iodo-3-methyl-5-propylnonane
 D. 2-bromo-5-butyl-4,4-dichloro-3-iodo-3-methylnonane
 E. 7-bromo-4-butyl-5,5-dichloro-4-iodo-3-methylnonane

5. What is the name of the following compound?

 A. *trans*-3-ethyl-4-hexen-2-ol
 B. *trans*-4-ethyl-2-hexen-5-ol
 C. *trans*-3-ethanol-2-hexene
 D. *trans*-4-ethanol-2-hexene
 E. *trans*-2-ethyl-3-hexen-4-ol

6. Indicate the α, β, γ, and δ carbons in the following compound.

7. An alkane can be synthesized from its corresponding alkene by a reaction with hydrogen in the presence of a platinum catalyst. If 5-methenyl-3-methyloctane (shown below) were treated with hydrogen in the presence of a platinum catalyst, what would be the name and structure of the alkane that would be produced?

8. What is the correct structure for *cis*-1-ethoxy-2-methoxycyclopentane?

 A.

 B.

 C.

 D.

 E. None of the above

9. Do the following structures show the same compound or different compounds? Give a name for each structure.

A.

B.

10. Match each name with the correct structure below.

 A. *t*-butyl
 B. diene
 C. β-keto acid
 D. cyclohexanol
 E. *sec*-butyl

 1. R⌒⌒⌒R

 2. ⬡—OH

 3. CH_3—CH—
 |
 C_2H_5

 4. $(CH_3)_3C$—

 5. R—C(=O)—CH₂—C(=O)—OH

11. Which of the following are always considered terminal functional groups?

 A. Aldehydes
 B. Ketones
 C. Carboxylic acids
 D. Alkenes
 E. Both A and C

SOLUTIONS TO REVIEW PROBLEMS

1. **A** The first task in naming alkanes is identifying the longest chain. In this case, the longest chain has seven carbons, so the parent alkane is heptane. Choices (B) and (D) can be eliminated. The next step is to identify the substituents on the alkane chain. This compound has two methyl groups at carbons 2 and 5, so the correct IUPAC name is 2,5-dimethylheptane. Choice (C) is incorrect because the position numbers of the substituents are not minimized.

2. The structure of 5-ethyl-2,2-dimethyloctane is shown below.

3. **D** Substituted cycloalkanes are named as derivatives of their parent cycloalkane, which in this case is cyclohexane. Thus, choice (A) can be ruled out immediately. Then, the substituents are listed in alphabetical order, and the carbons are numbered so as to give the lowest sum of substituent numbers. This cyclohexane has an ethyl and two methyl substituents; it is therefore an ethyl dimethyl cyclohexane. All the remaining answer choices recognize this; they only differ in the numbers assigned. In order to give the lowest sum of substituent numbers, the two methyl substituents must be numbered 1 and 2, and the ethyl substituent must be numbered 4. The correct name for this compound is thus 4-ethyl-1,2-dimethylcyclohexane.

4. **C** This question requires the application of the same set of rules laid out in Question 1. The longest backbone has nine carbons, so the compound is a nonane. Thus, choices (A) and (B) can be ruled out immediately. The substituent groups are, in alphabetical order: bromo, chloro, iodo, methyl, and propyl; these substituents must be given the lowest possible number on the hydrocarbon backbone. The resulting name is 2-bromo-4,4-dichloro-3-iodo-3-methyl-5-propylnonane.

5. **A** The first step is to locate the longest carbon chain containing the functional groups (C=C and OH). The backbone has six carbons (hex-). Since the alcohol group has higher priority than the double bond, it dictates the ending (-ol) and is given the lower position (2). The alkene is named according to the position of the double bond followed by -ene (4-hexene). Thus, the chain is called 4-hexene-2-ol. The substituents on the backbone are an ethyl group and an alkene group on C–3 and C–4, respectively. Since these constituents lie on opposite sides of the double bond, the molecule is *trans*. Therefore, this compound is called *trans*-3-ethyl-4-hexen-2-ol.

6. Numbering the carbons on the backbone from left to right, C–2 and C–4 are α carbons, C–1 and C–5 are β carbons, C–6 is a γ carbon, and C–7 is a δ carbon. This nomenclature is used to specify how far a given carbon in the backbone is from a reactive center, usually a carbonyl carbon.

7. Treating this alkene with hydrogen in the presence of a platinum catalyst will cause hydrogen atoms to be added across the double bond. The product will be 3,5-dimethyloctane, shown below.

8. **B** A cyclopentane is a cyclic alkane with five carbons. A *cis* cyclic compound has both of its substituents on the same side of the ring. Only choices (B) and (C) have two substituents, so (A) and (D) can be ruled out. In fact, choice (C) is a *trans* compound, so the correct answer must be (B). Ethoxy and methoxy represent ether substituents, and they must be on adjacent carbons on the same side of the molecule. Thus, the structure of *cis*-1-ethoxy-2-methoxycyclopentane is given in choice (B).

9. These structures both represent the same compound, 5-ethyl-3,5-dimethylnonane. The best way to see this is to name each one; this forces you to determine both the backbone and the substituents.

10. A. 4

 B. 1

 C. 5

 D. 2

 E. 3

11. **E** Both aldehyde and carboxylic acid functional groups are located on the terminal ends of carbon backbones. As a result, the carbon to which they are attached is named C–1, and choice (E) is correct. Ketones are always internal to the carbon chain, and alkenes can be internal or terminal so are not *always* terminal.

CHAPTER FORTY

Isomers

Isomers are chemical compounds that have the same molecular formula but differ in structure—that is, in their atomic connectivity or the spatial orientation of their atoms. Isomers may be similar, sharing most or all of their physical and chemical properties, or they may be very different.

Stereoisomers

Most
Different

Most
Similar

Structural
Isomers

Diastereomers
and
Geometric Isomers

Enantiomers

Conformational
Isomers

Figure 40.1

STRUCTURAL ISOMERISM

Structural isomers, also known as constitutional isomers, are compounds that share only a molecular formula. Structural isomers differ in where and how atoms are connected to each other and thus often have very different chemical and physical properties (such as melting point, boiling point, and solubility). For example, five different structures exist for compounds with the formula C_6H_{14}.

n-hexane 2-methylpentane

3-methylpentane 2,3-dimethylbutane 2,2-dimethylbutane

Figure 40.2

All the above compounds have the same formula, but they differ in their carbon framework and in the number and type of atoms bonded to one another.

STEREOISOMERISM

Stereoisomers are compounds that have the same connectivity between their atoms and differ from each other only in the way that their atoms are oriented in space. *Cis-trans* isomers, enantiomers, diastereomers, *meso* compounds, and conformational isomers are all types of stereoisomers.

Cis-Trans Isomers

Cis-trans isomers, formerly known as **geometric isomers**, are compounds that differ in the position of substituents attached to the two carbons that form a double bond. Because a double bond cannot rotate, the substituents are fixed relative to one another and to the bond. If the substituents on the carbons are both above the double bond, they are on the same side, and the double bond is called *cis*. If one is above and one below, they are on opposite sides, and it is called a *trans* double bond.

For compounds with more than one substituent on either carbon of the double bond, an alternative method of naming applies. The highest priority substituent attached to each double bonded carbon has to be determined. The following prioritization is the Cahn-Ingold-Prelog system, which is also used in R/S configurations for chiral centers. There are three rules for determining priority under this system:

1. From the carbon of interest, determine the atomic weight of the first *atom* encountered along each bond. The group with the highest atomic weight atom has the highest priority.

2. If two atoms are the same, look at the next atom attached to each; the group that has the second atom with higher molecular weight is higher priority.

3. If two atoms are the same, a double bond takes priority over a single bond. This is a tie-breaker only; higher atomic weight will always take priority over a double bond.

The alkene is called (Z) (from German *zusammen*, meaning together) if the two highest priority substituents on each carbon are both above or both below the double bond, or (E) (from German *entgegen*, meaning opposite) if they are on opposite sides.

MNEMONIC

Z = "Z"ame side

E = "E"pposite side

(Z)-2-chloro-2-pentene (E)-2-bromo-3-t-butyl-2-heptene

Figure 40.3

Enantiomers and Chirality

A molecule that is not superimposable upon its mirror image is called **chiral**. Your right and left hands are illustrations of chirality. Although essentially identical, your hands differ in their ability to fit into a right-handed glove. They are mirror images of each other yet cannot be superimposed. **Achiral** molecules are mirror images that can be superimposed; for example, the letter A is identical to its mirror image and therefore is achiral.

Figure 40.4

Carbon atoms are chiral only if they have four different substituents. Such a carbon atom is called **asymmetric** because it lacks a plane or point of symmetry. For example, the C−1 carbon atom in 1-bromo-1-chloroethane has four different substituents. The molecule is chiral because it is not superimposable on its mirror image. Pairs of chiral molecules that are nonsuperimposable mirror images are called **enantiomers** and are a specific type of stereoisomer discussed later in this chapter.

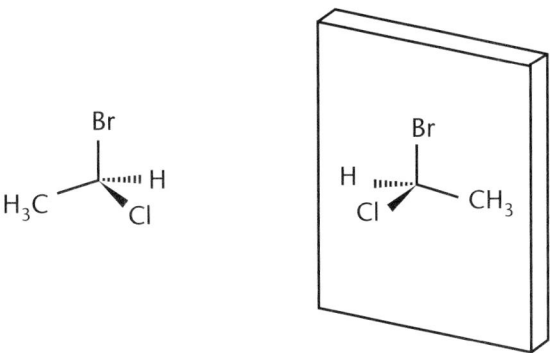

Figure 40.5

A carbon atom with only three different substituents, such as 1,1-dibromoethane, has a plane of symmetry and is therefore achiral. A simple 180° rotation along the *y*-axis allows the compound to be superimposed upon its mirror image, as shown in Figure 40.6.

Figure 40.6

Fischer projections

A three-dimensional molecule can be conveniently represented in two dimensions in a **Fischer projection**. In this system, horizontal lines indicate bonds that project out from the plane of the page, while vertical lines indicate bonds behind the plane of the page. The point of intersection of the lines represents a carbon atom. The Fischer projection of a molecule can be manipulated by interchanging any two pairs of substituents or by rotating the projection in the plane of the page by 180°, and it will keep the same absolute configuration. Thus, all Fischer projections in Figure 40.7 represent the same molecule. If only one pair of substituents is interchanged or if the molecule is rotated by 90°, the mirror image and thus the opposite enantiomer of the original compound is obtained.

Figure 40.7

Fischer projections allow straightforward determination of the configuration at a chiral center, discussed next.

Relative and absolute configuration

A **configuration** describes the spatial arrangement of the atoms or functional groups of a stereoisomer. The **relative configuration** of a chiral molecule is its configuration in relation to another chiral molecule.

The **absolute configuration** of a chiral molecule describes the spatial arrangement of these atoms or groups within the molecule relative to each other. Absolute configuration is determined using the *R/S* naming convention, and relative configuration is compared between the *R* and the *S* enantiomers.

Figure 40.8

The set sequence to determine the absolute configuration of a molecule at a single chiral center is as follows:

Step 1:

Assign priority to the four substituents using the same rules (the Cahn-Ingold-Prelog priority rules) as for *E/Z* isomers:

1. From the carbon of interest, determine the atomic weight of the first *atom* encountered along each bond. The group with the highest atomic weight atom has the highest priority.
2. If two atoms are the same, look at the next atom attached to each; the group that has the second atom with higher molecular weight is higher priority.
3. If two atoms are the same, a double bond takes priority over a single bond. This is a tie-breaker only; higher atomic weight will always take priority over a double bond.

For example:

$$\begin{array}{c} {}^{2}\,CH_2CH_3 \\ {}^{4}H \cdots\!\!\overset{|}{\underset{{}^{3}CH_3}{\diagup}}\!\!\cdots Cl\;{}^{1} \end{array}$$

Figure 40.9

Step 2:

Proceeding from highest priority (1st) to second lowest (3rd), determine the order of substituents around the wheel as either clockwise or counterclockwise by drawing a loop that connects 1st to 2nd to 3rd priority, ignoring the 4th group. If the order is clockwise, the chiral center temporarily is called

R (from Latin *rectus,* meaning right). If it is counterclockwise, it is temporarily called *S* (from Latin *sinister,* meaning left).

Step 3:

Finally, look at the lowest (4th) priority group. If group 4 is on the vertical line in a Fischer projection or otherwise is going into the page, the molecule is oriented correctly, and the designation remains the same. If group 4 is on the horizontal line or otherwise coming out of the page, the molecule is in the opposite orientation that it should be, so the temporary designation is swapped to the opposite designation (i.e., if the designation obtained in Step 2 was *R* but the 4th priority group is coming out of the page, the actual absolute configuration is *S*).

To provide a full name for a stereoisomer with a chiral center, the terms *R* and *S* are put in parentheses and separated from the rest of the name by a dash. If more than one asymmetric carbon is present, the location is specified by a number preceding the *R* or *S* within the parentheses and without a dash.

Note that in the traditional approach to determining chirality, the molecule initially must be rotated to place the lowest priority group pointing toward the back. However, this can be problematic as it is easy to lose track of the relative positions of the substituents during this step. The simpler Kaplan strategy, as described above, recognizes that if the lowest priority group is coming out of the page, it will appear the opposite of its true configuration, which avoids the difficult work of mentally rearranging the molecule.

Optical activity

Pairs of enantiomers (with opposite *R* and *S* designations) have identical chemical and physical properties with one exception: **optical activity**. A compound is optically active if it has the ability to rotate plane-polarized light. Ordinary light is unpolarized. It consists of waves vibrating in all possible planes perpendicular to its direction of motion. A polarizing filter allows light waves oscillating only in a particular direction to pass, producing plane-polarized light.

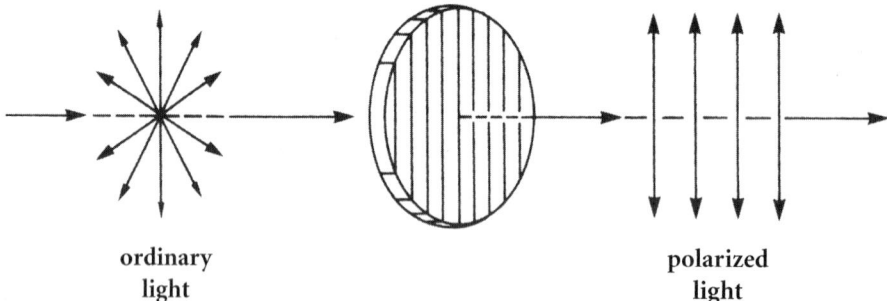

ordinary
light

polarized
light

Figure 40.10

If plane-polarized light is passed through a solution of an optically active compound, the molecule rotates the orientation of the polarized light by an angle α. The enantiomer of this compound will rotate light by the same amount, but in the opposite direction. A compound that rotates the plane-polarized light to the right, or clockwise (from the point of view of an observer seeing the light approach), is **dextrorotatory** and is indicated by (+). A compound that rotates light toward the left, or counterclockwise, is **levorotatory** and is labeled (−). The direction of rotation cannot be determined from the structure of a molecule and is not related to its *R* or *S* designation. Instead, it must be determined experimentally.

The amount of rotation depends on the number of molecules that a light wave encounters. This depends on two factors: the concentration of the optically active compound and the length of the tube through which the light passes. Chemists have set standard conditions of 1 g/mL for concentration and 1 dm for length in order to compare the optical activities of different compounds. Rotations measured at different concentrations and tube lengths can be converted to a standardized **specific rotation** (α) using the following equation:

$$\text{specific rotation} = \frac{\text{observed rotation}(\alpha)}{\text{concentration(g/ml)} \times \text{length(dm)}}$$

Observed rotation refers to the value obtained in an experiment with varying concentrations or tube lengths. **Specific rotation** accounts for these various laboratory conditions and therefore can be used to compare the rotation of polarized light between different compounds. A racemic mixture, or racemate, is a mixture of equal concentrations of both the (+) and (−) enantiomers. The rotations cancel each other, and no optical activity is observed.

Diastereomers

Many compounds have more than one chiral center, and thus multiple forms of stereoisomers exist for them. For any molecule with n chiral centers, there are 2^n possible stereoisomers. Thus, if a compound has two chiral carbon atoms, it has four possible stereoisomers (see Figure 40.11).

Figure 40.11

Compounds I and II are mirror images of each other and are therefore enantiomers. Similarly, compounds III and IV are enantiomers. However, compounds I and III are not. They are stereoisomers that are not mirror images, and so they are called diastereomers. Notice that other combinations of non–mirror image stereoisomers are also possible, and form diastereomer pairs. Hence compounds I and IV, compounds II and III, compounds I and III, and compounds II and IV are all pairs of diastereomers.

Diastereomers that differ at only one carbon make up special pairs called epimers, which are particularly important in the chemistry of carbohydrates.

Meso Compounds

Meso compounds are molecules with multiple chiral centers that also have an internal plane of symmetry. One half of the molecule has an *S* enantiomer, and the other half has its matching *R* enantiomer. If such a plane of symmetry exists, the molecule is not optically active, because the rotation of light by one chiral center is matched by the opposite rotation by the other chiral center. For example:

COOH	COOH	COOH
H——OH	H——OH --- Line of	HO——H
HO——H	H——OH Symmetry	H——OH
COOH	COOH	COOH
L-tartaric acid	*Meso*-tartaric acid	D-tartaric acid

Figure 40.12

D- and L-tartaric acid are both optically active, but *meso*-tartaric acid has a plane of symmetry and is not optically active. Although *meso*-tartaric acid has two chiral carbon atoms, the lack of optical activity is a function of the molecule as a whole.

Conformational Isomers

Conformational isomers are compounds that differ only by rotation about one or more single bonds. These isomers represent the same compound in a slightly different position—analogous to a person who may be either standing up or sitting down. These different conformations can be seen when the molecule is depicted in a **Newman projection**, in which the line of sight extends along a carbon-carbon bond axis. Because the view of the second carbon atom is blocked by the first, the second carbon is depicted as a large circle at the back, and the first carbon is depicted as the intersection of its three other bonds in front. The different conformations are encountered as the molecule is rotated about the axis between the two carbons. The classic example for demonstrating conformational isomerism in a straight chain molecule is *n*-butane. In a Newman projection, the line of sight extends through the C—2-C—3 bond axis.

Figure 40.13

Straight-chain conformations

The most stable conformation of *n*-butane is found when the two methyl groups (C–1 and C–4) are oriented 180° from each other. There is no overlap of atoms along the line of sight (besides C–2 and C–3), so the molecule is said to be in a **staggered** conformation. Specifically, it is called the *anti* conformation, because the two methyl groups are antiperiplanar to each other. This particular orientation is very stable and thus represents an energy minimum because all atoms are far apart, minimizing repulsive steric interactions.

The other type of staggered conformation, called *gauche*, occurs when the two methyl groups are 60° apart. In order to convert from the *anti* to the *gauche* conformation, the molecule must pass through an eclipsed conformation, in which the two methyl groups are 120° apart and overlap with the H atoms on the adjacent carbon. When the two methyl groups overlap with each other, the molecule is said to be totally eclipsed and is in its highest energy state.

gauche eclipsed totally eclipsed

Figure 40.14

A plot of potential energy versus the degree of rotation about the C–2-C–3 bond shows the relative minima and maxima the molecule encounters throughout its various conformations.

Figure 40.15

It is important to note that these barriers are rather small (3–4 kcal/mol) and are easily overcome at room temperature, when the molecule is rotating freely. Very low temperatures will slow conformational interconversion. If the molecules do not possess sufficient energy to cross the energy barrier, they may not rotate at all.

Cyclic conformations

In cycloalkanes, ring strain arises from three factors: angle strain, torsional strain, and nonbonded strain. Angle strain results when bond angles deviate from their ideal values (109.5° for sp³ hybridized carbons); torsional strain results when cyclic molecules must assume conformations that have eclipsed interactions; and nonbonded strain (van der Waals repulsion) results when atoms or groups compete for the same space. In order to alleviate these three types of strain, cycloalkanes attempt to adopt nonplanar conformations. Cyclobutane puckers into a slight V shape, cyclopentane adopts what is called the **envelope** conformation, and cyclohexane exists mainly in three conformations called the **chair,** the **boat,** and the **twist** or **skew-boat.**

| puckered
cyclobutane | envelope
cyclopentane | chair
cyclohexane | boat
cyclohexane | twist/skew-boat
cyclohexane |

Figure 40.16

Cyclohexane

Unsubstituted

The most stable conformation of cyclohexane is the chair conformation. In this conformation, all three types of strain are eliminated. The hydrogen atoms that are perpendicular to the plane of the ring are called axial, and those parallel to the plane of the ring are called equatorial. The axial-equatorial orientations alternate around the ring.

The chair conformation has two forms that can be thought of as "left facing" and "right facing." The boat conformation is adopted when the chair "flips" and converts to the other chair conformation. When this happens, hydrogen atoms that were equatorial become axial, and vice versa, in the new chair.

In the boat conformation, all of the atoms are eclipsed, creating a high-energy state. To avoid this strain, the boat can twist into a slightly more stable form called the twist or skew-boat conformation. In the chair form, the atoms are in the staggered gauche conformation, thus contributing to the greater stability compared to the boat form.

Monosubstituted

The interconversion between the two chairs can be slowed or even prevented if a sterically bulky group is attached to the ring. The equatorial position is favored over the axial position because of

steric repulsion with other axial substituents. Thus, a large group such as *t*-butyl can essentially lock the molecule in one conformation.

equatorial axial

Figure 40.17

Disubstituted

Different isomers can exist for disubstituted cycloalkanes. If both substituents are located on the same side of the ring, the molecule is called **cis**; if the two groups are on opposite sides of the ring, it is called **trans**.

cis-1,2-dimethylcyclohexane trans-1,2-dimethylcyclohexane

Figure 40.18

Note that the chair form shows that equatorial constituents can be either above or below the plane of the ring, shown by the "slant" of the bond connecting them to their ring carbons. For example, in *trans*-1,4-dimethylcyclohexane, both of the methyl groups are equatorial in one chair conformation and axial in the other, but in either case they point in opposite directions relative to the plane of the ring.

trans-1,4-dimethylcyclohexane

Figure 40.19

REVIEW PROBLEMS

1. Categorize the following pairs as enantiomers, diastereomers, structural isomers, molecules of the same compound, or different compounds.

 A. dimethyl ether and ethanol

 B.

 C. D.

2. Which of the following does NOT show optical activity?

 A. (R)-2-butanol

 B. (S)-2-butanol

 C. A solution containing 1 M (R)-2-butanol and 2 M (S)-2-butanol

 D. A solution containing 2 M (R)-2-butanol and 2 M (S)-2-butanol

 E. A solution containing 3 M (R)-2-butanol and 3 M (S)-2-methanol

3. How many stereoisomers exist for the following aldehyde?

 A. 2

 B. 4

 C. 8

 D. 16

 E. 32

4. Which of the following compounds is optically inactive?

A.

$$\begin{array}{c} CH_3 \\ H\text{---}\!\!\!\!-Cl \\ Cl\text{---}\!\!\!\!-H \\ CH_3 \end{array}$$

B.

$$\begin{array}{c} CH_3 \\ Cl\text{---}\!\!\!\!-H \\ H\text{---}\!\!\!\!-Cl \\ CH_3 \end{array}$$

C.

$$\begin{array}{c} CH_3 \\ H\text{---}\!\!\!\!-Cl \\ H\text{---}\!\!\!\!-Cl \\ CH_3 \end{array}$$

D.

$$\begin{array}{c} CH_2Cl \\ H\text{---}\!\!\!\!-Cl \\ H\text{---}\!\!\!\!-H \\ CH_3 \end{array}$$

E. None of the above

5. Which isomer of 2-pentene is more stable, the *cis* isomer or the *trans* isomer?

6. Assign (R) and (S) designations to the following compounds:

A.

$$\begin{array}{c} Cl \\ H\text{---}\!\!\!\!-Cl \\ CH_3\text{---}\!\!\!\!-H \\ Br \end{array}$$

B.

$$\begin{array}{c} O \\ \| \\ C\text{---}H \\ H\text{---}\!\!\!\!-OH \\ CH_2OH \end{array}$$

7. Cholesterol, shown below, contains how many chiral centers?

A. 5
B. 7
C. 8
D. 9
E. 10

8. Which isomer of the following compound is the most stable?

A.

B.

C.

D. They are all equally stable.

E. A and B are equally stable and more stable than C.

9. Designate the following compounds as (R) or (S):

A. Cl—C—H with CH₃ above and OH below the central carbon

B. HO₂C—C—CH₂CH₃ with H above and CH₃ below the central carbon

C. HO—C—Cl with Br above and F below the central carbon

D. H—C—CH₂CH₃ with HC≡CH₂ above and C(CH₃)₃ below the central carbon

E. H—C—CH₃ with C≡CH above and Br below the central carbon

F. H—C—CH₂OH with CH₃ above and CH₂CH₃ below the central carbon

G. H—C—CH₂Cl with CH₃ above and CH₂CH₃ below the central carbon

H. Br—C—Cl with F above and I below the central carbon

I. H₃C—C—Br with NH₂ above and OH below the central carbon

10. The following reaction results in:

H—O⬛⬛⬛H (with CH₃ dashed above, CH₂CH₃ below) + CH₃CCl (C=O) ⟶ HCl + CO (C=O, CH₃)⬛⬛⬛H (with CH₃ dashed above, CH₂CH₃ below)

A. retention of relative configuration and a change in the absolute configuration.
B. a change in the relative and absolute configurations.
C. retention of the relative and absolute configurations.
D. retention of the absolute configuration and a change in the relative configuration.
E. retention of the relative configuration and a change in the absolute configuration.

11. The following structures are:

I II

 A. enantiomers.
 B. diastereomers.
 C. *meso* compounds.
 D. structural isomers.
 E. *cis-trans* isomers.

12. MSG ([S]-monosodium glutamate) is a compound widely used as a flavor enhancer. MSG has the following structure:

(S)-MSG

This enantiomer of MSG has a specific rotation of +24°. In a racemic mixture of MSG, what would be the specific rotation? What is the specific rotation of (R)-monosodium glutamate?

SOLUTIONS TO REVIEW PROBLEMS

1. **A Structural isomers and different compounds**

 The two compounds, CH_3CH_2OH and CH_3OCH_3, have the same molecular formula, C_2H_6O, but differ in how the atoms are connected to each other. For instance, the oxygen atom of ethanol is bonded to a carbon atom on one side and to a hydrogen atom on the other, whereas the oxygen atom of dimethyl ether is bonded to carbon atoms on both sides.

 B Molecules of the same compound

 The two structures are achiral. Rotating one gives the other.

 Also note that, in order for a compound to be chiral, at least one of its carbons must be bonded to four different substituents. In both of these compounds, all the carbons are attached to two identical groups, so the compounds are achiral.

 C Enantiomers

 These two compounds look alike, but the Cl and the Br have been interchanged. You may remember that one exchange of two substituents produces the mirror image of the original compound. Thus, these two molecules are enantiomers.

 Another way to solve this problem is to remember that, according to the rules governing Fischer projections, interchanging two pairs of substituents in a compound will give the

original compound. Interchanging two pairs of substituents in the compound on the right in pair (C), as shown below, allows you to see that the two compounds of pair (C) are mirror images of each other; hence, they are enantiomers.

$$
\underset{\substack{\text{original} \\ \text{compound}}}{\overset{CH_3}{\underset{Br}{H{-}\!\!\!-\!\!\!-Cl}}}
\xrightarrow{\substack{\text{1st} \\ \text{trade}}}
\underset{\substack{\text{its enantiomer}}}{\overset{CH_3}{\underset{Br}{Cl{-}\!\!\!-\!\!\!-H}}}
\xrightarrow{\substack{\text{2nd} \\ \text{trade}}}
\underset{\substack{\text{starting} \\ \text{compound}}}{\overset{CH_3}{\underset{Cl}{Br{-}\!\!\!-\!\!\!-H}}}
$$

$$
\overset{CH_3}{\underset{Cl}{H{-}\!\!\!-\!\!\!-Br}}
\qquad\bigg|\qquad
\overset{CH_3}{\underset{Cl}{Br{-}\!\!\!-\!\!\!-H}}
$$

D Diastereomers

Rotate the second compound in the plane of the paper by 180°. The two compounds now are:

$$
\overset{C_2H_5}{\underset{C_2H_5}{\underset{\displaystyle HO{-}\!\!\!-\!\!\!-Cl}{HO{-}\!\!\!-\!\!\!-Br}}}
\qquad\qquad
\overset{C_2H_5}{\underset{Cl}{\underset{\displaystyle H_5C_2{-}\!\!\!-\!\!\!-OH}{Br{-}\!\!\!-\!\!\!-OH}}}
$$

Assign (R) and (S) designations to the compounds:

$$
\overset{C_2H_5}{\underset{C_2H_5}{\underset{\displaystyle HO\overset{R}{-}\!\!\!-\!\!\!-Cl}{HO\overset{S}{-}\!\!\!-\!\!\!-Br}}}
\qquad\qquad
\overset{C_2H_5}{\underset{Cl}{\underset{\displaystyle H_5C_2\overset{R}{-}\!\!\!-\!\!\!-OH}{Br\overset{R}{-}\!\!\!-\!\!\!-OH}}}
$$

The above figure shows that one compound is an S, R stereoisomer and the other is an R, R stereoisomer; hence, they are diastereomers.

2. **D** A racemic mixture of 2-butanol consists of equimolar amounts of (R)-2-butanol and (S)-2-butanol. The (R)-2-butanol molecule rotates the plane of polarized light in one direction, and the (S)-2-butanol molecule rotates it by the same angle but in the opposite direction. If for every one (R)-2-butanol molecule there is one (S)-2 butanol molecule, exact cancellation of all rotation occurs, and no net rotation of polarized light is observed. Hence, the correct answer is (D).

 Choice (A) is incorrect because all the molecules of the (R)-2-butanol solution rotate the plane of light in the same direction, so rotations do not cancel, and optical activity is observed. In the same way, the (S)-2-butanol solution also shows optical activity. Thus, choices (A) and (B) are incorrect. Choice (C) has more (S)-2-butanol molecules than (R)-2-butanol molecules. All the rotation produced by the (R)-2-butanol molecules is canceled by half of the (S)-2-butanol molecules; the rotation produced by the other half of (S)-2-molecules contributes to the optical activity observed in this solution. Thus, choice (C) is incorrect. Finally, choice (E) shows two different molecules; although one is (R) and the other (S), the two won't perfectly cancel one another out, and (E) is incorrect.

3. **C** The maximum number of stereoisomers of a compound equals 2^n, where n is the number of chiral carbons in the compound. Here, there are three chiral carbon atoms ($n = 3$) marked by asterisks in the following figure:

$$
\begin{array}{c}
\overset{\displaystyle O}{\overset{\displaystyle \parallel}{C}}\text{—H} \\[2pt]
\text{HO—}\overset{*}{C}\text{—H} \\[2pt]
\text{HO—}\overset{*}{C}\text{—H} \\[2pt]
\text{HO—}\overset{*}{C}\text{—H} \\[2pt]
\text{HO—C—H} \\[2pt]
\text{H}
\end{array}
$$

 So the number of stereoisomers it can form is $2^n = 2^3 = 8$. Hence, the correct choice is (C).

4. **C** The correct answer choice is an example of a *meso* compound: a compound that contains chiral centers but is superimposable on its mirror image. A *meso* compound can also be recognized by the fact that one half of the compound is the mirror image of the other half:

$$
\begin{array}{c}
\text{CH}_3 \\
\text{H}\!\!-\!\!\!\rule[0.5ex]{1.5em}{0.4pt}\!\!\!-\!\!\text{Cl} \\
\text{- - - -}\!\mid\!\text{- - - - plane of} \\
\text{H}\!\!-\!\!\!\rule[0.5ex]{1.5em}{0.4pt}\!\!\!-\!\!\text{Cl} \quad \text{symmetry} \\
\text{CH}_3
\end{array}
$$

As a result of this internal plane of symmetry, the molecule is achiral and hence optically inactive. Choices (A) and (B) are enantiomers of each other and will certainly show optical activity on their own. Choice (D), since it contains a chiral carbon, is optically active as well.

5. The *trans* isomer of 2-pentene is the most stable. When you draw out this isomer, you can see that one side of the double bond has a methyl group and a hydrogen, and the other side has an ethyl group and a hydrogen. In this configuration, the van der Waals repulsion (nonbonding interaction) between the methyl and the ethyl groups is minimized. If these groups were oriented *cis* to each other (on the same side of the double bond), the van der Waals repulsion would be maximized.

trans *cis*

6. **A** **(R)-2-bromo-1,1-dichloropropane**

In the above compound, C–1 is not chiral because it has two C-1 atoms bound to it. Only C–2 is chiral, so the molecule is designated as (R) or (S) with respect to only C–2. Assign priority numbers to the atoms connected directly to C–2. The atom with the highest atomic number is given priority 1, followed by the atom with next highest atomic number, which is given the priority number 2, and so on. In this compound, Br has the highest atomic number and so is assigned priority 1. Next come two carbon atoms connected to the chiral carbon. Since these have the same atomic number, you must consider their substituents. C–1 has two Cl atoms and one hydrogen, whereas C–3 has three hydrogen. Since chlorine has a higher atomic number than hydrogen, C–1 is the higher priority. Thus, C–1 is 2 and C–3 is 3. The hydrogen is the lowest priority, 4.

Draw a curved arrow from 1 → 2 → 3. The direction of the arrow is counterclockwise, so the molecule is temporarily designated (S). Finally, check the orientation of group 4, which in this case is coming out of the page, which is the opposite way it should be; thus the (S) should be swapped to the (R) designation.

B **(R)-2,3-dihydroxypropanal**

For the purposes of prioritization, double- or triple-bonded atoms are considered to be linked by multiple single bonds. For instance, in −C=O, C would be considered to have two single bonds with O, and O would be considered to have two single bonds with carbon. In this question, −OH is assigned the highest priority, 1; −C=O (here considered to be two −C−O) is assigned the next priority, 2; −CH₂OH is assigned priority 3; and hydrogen, with the lowest atomic number, is assigned the lowest priority, 4. The direction of the curved arrow from 1 → 2 → 3 is clockwise, and the molecule is designated (R).

7. **C** To be a chiral center, a carbon must have four different substituents. There are eight stereocenters in this molecule, marked below with asterisks.

The other carbons are not chiral, for various reasons. Many are bonded to two hydrogen; others participate in double bonds, which count as two bonds to the same thing (another C atom).

8. **B** This is a chair conformation in which the two equatorial methyl groups are *trans* to each other. Since the methyl hydrogens do not compete for the same space as the (unshown) hydrogens attached to the ring, this conformation ensures the least amount of steric strain. Choice (A) would be more unstable than choice (B) since the diaxial methyl group hydrogens are closer to the hydrogens on the ring, causing greater steric strain. Choice (C) is incorrect because it is in the more unstable boat conformation. Choices (D) and (E) are incorrect because these are all different structures with different stabilities.

9.

10. **C** The relative configuration is retained because the bonds between the chiral carbon and its substituents are not broken. The bond that is cleaved is one between a substituent of the chiral carbon (the O atom) and another atom attached to the substituent (the H attached to the O). The absolute configuration is also retained because the (R)/(S) designation is the same for the reactant and the product.

11. **A** Compared side by side, the two structures are mirror images of each other. Rotating one of the structures by 180° (structure III) shows that structures I and III are nonsuperimposable.

Choice (B) is incorrect because diastereomers are stereoisomers that are not mirror images of each other. Choice (C) is incorrect because, in order for a compound to be designated as a *meso* compound, it must have a plane of symmetry, which neither of these structures contains. Choice (D) is incorrect because structural isomers are compounds with the same molecular formula but different connectivity. These compounds do have the same connectivity. The only difference is that they do not have the same spatial arrangement of atoms. As a result, they are stereoisomers, not structural isomers.

12. The specific rotation of a racemic mixture of MSG, or any other racemic mixture, is zero. A racemic mixture by definition is a mixture that contains equal amounts of the (+) and (−) enantiomers, which cancel each other's optical rotations. The specific rotation of (*R*)-monosodium glutamate is −24°. An enantiomer of a chiral compound rotates plane-polarized light by the same amount but in the opposite direction.

CHAPTER FORTY-ONE

Bonding

LEARNING OBJECTIVES

After this chapter, you will be able to:

- Relate the connections between atomic orbitals, molecular orbitals, and hybridization
- Describe the molecular orbitals of single, double, and triple bonds
- Predict hybridization of a given atom
- Count sigma and pi bonds within a molecule

As discussed in general chemistry, there are two types of chemical bonds: **ionic**, in which an electron is transferred from one atom to another, and **covalent**, in which pairs of electrons are shared between two atoms. In organic chemistry, it is important to understand the details of covalent bonding, specifically hybridization theory, as these reveal the shapes and orientation of bonds, that play a crucial role in organic reactions.

ATOMIC ORBITALS

The first three quantum numbers, n, l, and m, describe the size, shape, and number of the atomic orbitals an element possesses. The quantum number n corresponds to the energy levels in an atom and is essentially a measure of size (see Chapter 24). Within each electron shell, there can be several types of orbitals (s, p, d, and f, corresponding to the quantum numbers $l = 0, 1, 2, 3$, and 4). Each type of atomic orbital has a specific shape. An s orbital is spherical and symmetrical, centered around the nucleus. A p orbital is composed of two lobes located symmetrically about the nucleus and contains a **node** (an area where the probability of finding an electron is zero). A d orbital is composed of four symmetrical lobes and contains two nodes. Both d and f orbitals are complex in shape and are rarely encountered in organic chemistry.

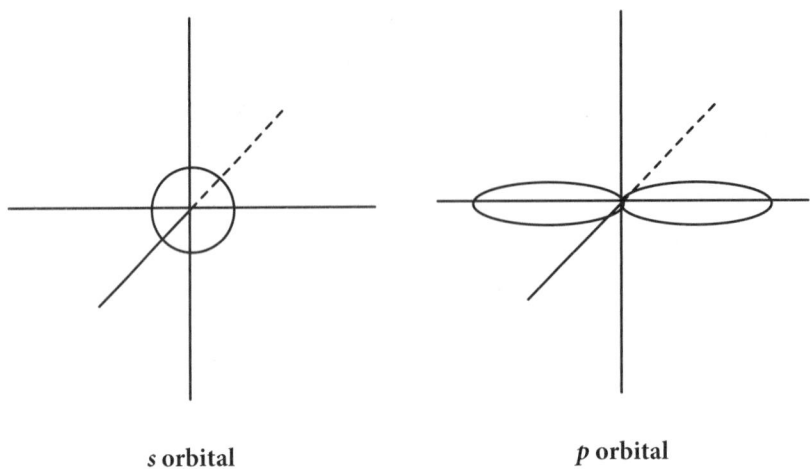

s orbital *p* orbital

Figure 41.1

MOLECULAR ORBITALS

Single Bonds

Two atomic orbitals can be combined to form a **molecular orbital** (MO). Molecular orbitals are obtained mathematically by adding the wave functions of the atomic orbitals. If the signs of the wave functions are the same, a lower-energy **bonding orbital** is produced. If the signs are different, a higher-energy **antibonding orbital** is produced. Figure 41.2 below shows examples of combining two *s* orbitals in both bonding and antibonding orbitals as well as the bonding orbitals formed from an *s* orbital and *p* orbital and from two *p* orbitals.

Figure 41.2

When a molecular orbital is formed by head-to-head overlap, the resulting bond is called a **sigma (σ) bond**. All single bonds are sigma bonds and contain two electrons. Shorter single bonds are stronger than longer single bonds.

Double and Triple Bonds

When two p orbitals overlap in a parallel fashion, a bonding MO is formed, called a **pi (π) bond**. When both a sigma and a pi bond exist between two atoms, a **double bond** is formed. When a sigma bond and two pi bonds exist, a **triple bond** is formed. As can be seen in Figure 41.3, the overlap of the p orbitals involved in a pi bond prevents rotation about double and triple bonds. Pi bonds contain two electrons each.

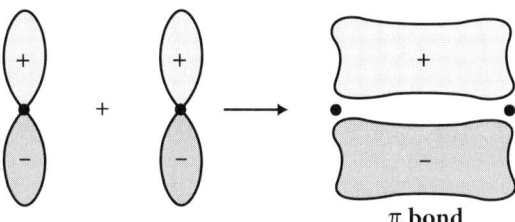

π bond

Figure 41.3

A pi bond cannot exist independently of a sigma bond. The formation of the sigma bond between two atoms orients their p orbitals to overlap from side to side, allowing the pi bond to form. In general, pi bonds are weaker than sigma bonds. It is possible to break the pi bond of a double bond but leave the sigma bond intact; however, the sigma bond cannot be broken unless the pi bond is broken first.

HYBRIDIZATION

Carbon has the electronic configuration $1s^2 2s^2 2p^2$ with 4 valence electrons; it therefore needs four additional electrons to complete its octet. A typical carbon-containing molecule is methane, CH_4. Experimentation shows that the four sigma bonds in methane are equal. This is inconsistent with the asymmetrical distribution of valence electrons predicted using the electronic configuration: two electrons in the $2s$ orbital, one in the p_x orbital, one in the p_y orbital, and none in the p_z orbital. The theory of **orbital hybridization** was developed to account for this discrepancy.

sp^3

Hybrid orbitals are formed by mixing different types of atomic orbitals. If one s orbital and three p orbitals are mathematically combined, the result is four identical sp^3 hybrid orbitals that have a new shape.

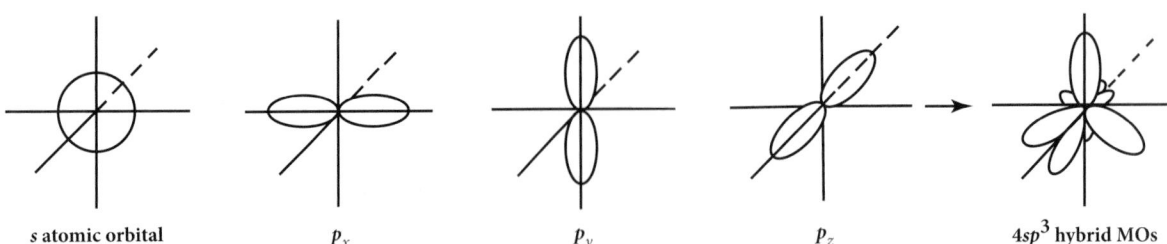

s atomic orbital p_x p_y p_z $4sp^3$ hybrid MOs

Figure 41.4

These four orbitals will point toward the vertices of a tetrahedron, minimizing repulsion. This explains the preferred tetrahedral geometry adopted by carbon when it has four single bonds to other atoms.

The hybridization is accomplished by promoting one of the $2s$ electrons into the $2p_z$ orbital (see Figure 41.5). This produces four valence orbitals, each with one electron, which can be mathematically mixed to create the hybrids. These four hybridized orbitals explain the four symmetrical CH found in methane.

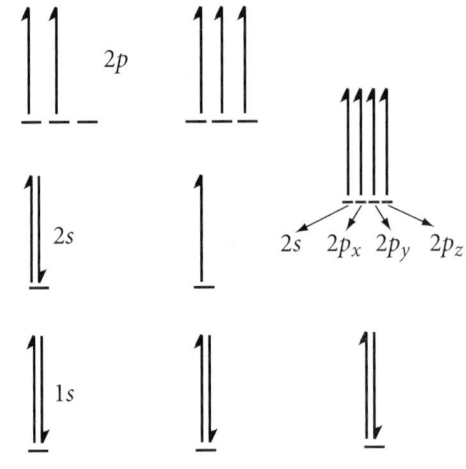

unhybridized **unhybridized** **hybridized**
ground state **excited state** **ground state**

Figure 41.5

sp^2

Although carbon is often found bonded to four other atoms with sp^3 hybridization, there are other possibilities. If one *s* orbital and two *p* orbitals are mixed, three identical sp^2 hybrid orbitals are obtained.

 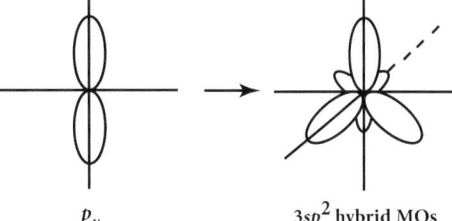

s p_x p_y $3sp^2$ hybrid MOs

Figure 41.6

For example, this occurs in ethylene ($H_2C=CH_2$). The third p orbital of each carbon atom is left unhybridized and participates in the pi bond. The three sp^2 orbitals are 120° apart, allowing maximum separation. These orbitals participate in the formation of the C=C and C−H sigma bonds.

sp

If two p orbitals are used to form the pi bonds of a triple bond and the remaining p orbital is mixed with an s orbital, two identical sp hybrid orbitals are obtained. The remaining two p orbitals of each carbon atom are left unhybridized and participate in creating two pi bonds, resulting in a triple bond. The two sp hybrid orbitals are oriented 180° apart, explaining the linear structure of molecules such as acetylene (HC≡CH).

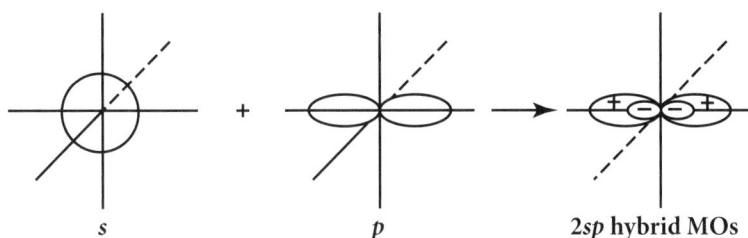

s p $2sp$ hybrid MOs

Figure 41.7

BONDING SUMMARY

The following table summarizes the major features of bonding orbitals in organic molecules.

Bond Order	Component Bonds	Hybridization	Angles	Examples
single	sigma	sp^3	109.5°	C−C; C−H
double	sigma pi	sp^2	120°	C=C; C=O
triple	sigma pi pi	sp	180°	C≡C; C≡N

Table 41.1

REVIEW PROBLEMS

1. Within one principal quantum level of a many-electron atom, which orbital has the minimum energy?

 A. s
 B. p
 C. d
 D. f
 E. g

2. Which of the following compounds possesses at least one σ bond?

 A. CH_4
 B. C_2H_2
 C. C_2H_4
 D. CH_2O
 E. All of the above

3. In a double-bonded carbon atom

 A. hybridization between the s orbital and one p orbital occurs.
 B. hybridization between the s orbital and two p orbitals occurs.
 C. hybridization between the s orbital and three p orbitals occurs.
 D. hybridization between the two s orbitals and one p orbital occurs.
 E. no hybridization between s and p orbitals occurs.

4. The hybridizations of the carbon atom and the nitrogen atom in the ion CN^- are

 A. sp^3 and sp^3, respectively.
 B. sp^3 and sp, respectively.
 C. sp and sp^3, respectively.
 D. sp and sp, respectively.
 E. sp^2 and sp^2, respectively.

5. Which of the following hybridizations does the Be atom in BeH_2 assume?

 A. sp
 B. sp^2
 C. sp^3
 D. sp^4
 E. No hybridization occurs.

6. Two atomic orbitals combine to form:

 I. a bonding molecular orbital.
 II. an antibonding molecular orbital.
 III. new atomic orbitals.

 A. I
 B. I, II, and III
 C. III
 D. I and II
 E. II and III

7. Molecular orbitals can contain a maximum of
 A. 1 electron.
 B. 2 electrons.
 C. 4 electrons.
 D. 6 electrons.
 E. $2n^2$ electrons, where n is the principal quantum number.

8. π bonds are formed by which of the following orbitals?
 A. Two s orbitals
 B. Two p orbitals
 C. One s and one p orbital
 D. One s and one f orbital
 E. One p and one f orbital

9. How many σ bonds and π bonds are present in the following compound?

 A. 6 σ bonds and 1 π bond
 B. 6 σ bonds and 2 π bonds
 C. 7 σ bonds and 1 π bond
 D. 7 σ bonds and 2 π bonds
 E. 7 σ bonds and no π bonds

10. The four C–H bonds of CH_4 point toward the vertices of a tetrahedron. This indicates that the hybridization of a carbon atom is
 A. sp.
 B. sp^2.
 C. sp^3.
 D. sp^4.
 E. none of the above.

SOLUTIONS TO REVIEW PROBLEMS

1. **A** In a many-electron atom, the energy of the orbitals within the principal quantum numbers is as follows: $2s < 2p$; $3s < 3p < 3d$; $4s < 4p < 4d < 4f$. For any given principal quantum level, the s orbital is always the lowest in energy; thus, the correct choice is (A).

2. **E** σ bonds are formed when orbitals overlap end-to-end. All single bonds are σ bonds; double and triple bonds contain one σ bond each. The compounds CH_4, C_2H_2, C_2H_4, and CH_2O all contain at least one single bond, so the correct choice is (E).

3. **B** In a double-bonded carbon, sp^2 hybridization occurs, i.e., one s orbital hybridizes with two p orbitals to form three sp^2 hybrid orbitals. Therefore, the correct choice is (B). Note that the sp^2 orbitals take part in σ bond formation, making choice (D) incorrect. The third p orbital of the carbon atom remains unhybridized and takes part in the formation of the pi bond of the double bond.

4. **D** The carbon atom and the nitrogen atoms are connected by a triple bond in CN^-.

$$:N \equiv C:^-$$

 A triple-bonded atom is sp hybridized; one s orbital hybridizes with one p orbital to form two sp hybridized orbitals. The two remaining unhybridized p orbitals take part in the formation of two π bonds. The correct choice, therefore, is (D).

5. **A** BeH_2 is a linear molecule, which means that the angle between the two Be—H bonds is 180°. Since the sp orbitals are oriented at an angle of 180°, the Be atom is sp hybridized. Therefore, the correct choice is (A). Note that sp^2 orbitals are oriented at an angle of 120°, and sp^3 orbitals are oriented at an angle of 109.5°.

6. **D** When atomic orbitals combine to form molecular orbitals, the number of molecular orbitals obtained equals the number of atomic orbitals that take part in the process. Half of the molecular orbitals formed are bonding molecular orbitals, and the other half are antibonding molecular orbitals. In this case, therefore, two atomic orbitals combine to form one low-energy bonding molecular orbital and one high-energy antibonding molecular orbital. New atomic orbitals do not form, but the bonding molecular orbital will have a corresponding antibonding molecular orbital. The correct choice is (D).

7. **B** Each molecular orbital, like an atomic orbital, can contain a maximum of two electrons with opposite spins.

8. **B** Pi bonds are formed by the parallel overlap of unhybridized p orbitals. The electron density is concentrated above and below the bonding axis. A sigma bond can be formed by the head-to-head overlap of two s orbitals, two p orbitals, or one s and one p orbital. In a σ bond, the density of the electrons is concentrated between the two nuclei of the bonding atoms.

9. **A** Each single bond has 1 σ bond, and each double bond has one σ and one π bond. In this question, there are five single bonds (5 σ bonds) and one double bond (one σ bond and one π bond), which gives a total of six σ bonds and one π bond. Thus, the correct choice is (A).

10. **C** The four bonds point to the vertices of a tetrahedron, which means that the angle between two bonds is 109.5°. sp^3 orbitals have an angle of 109.5° between them. Hence, the carbon atom of CH_4 is sp^3 hybridized. The correct choice, therefore, is (C).

CHAPTER FORTY-TWO

Alkanes

LEARNING OBJECTIVES

After this chapter, you will be able to:

- Apply nomenclature rules to recall physical properties of alkanes
- Compare and contrast S_N1 and S_N2 reactions
- Explain the mechanism for free radical substitution reactions
- Predict the products of S_N1, S_N2, combustion, and pyrolysis reactions in alkanes

Alkanes are hydrocarbons that have the maximum possible number of hydrogen atoms attached to each carbon, and thus are said to be saturated. These compounds consist only of hydrogen and carbon atoms joined by single bonds and their general formula is C_nH_{2n+2}. However, alkanes can be modified with additional functional groups as well, such as alcohols, halogens, or amines.

A brief overview of nomenclature and properties of alkanes will be followed by a discussion of substitution reactions and then additional types of reactions.

NOMENCLATURE

Alkanes are named for their longest, straight carbon chain. The names of the four simplest alkanes are:

$$CH_4 \qquad CH_3CH_3 \qquad CH_3CH_2CH_3 \qquad CH_3CH_2CH_2CH_3$$

methane **eth**ane **prop**ane **but**ane

The names of the longer-chain alkanes consist of prefixes derived from the Greek root for the number of carbon atoms with the ending **-ane**.

$C_5H_{12} =$ **pent**ane $C_9H_{20} =$ **non**ane

$C_6H_{14} =$ **hex**ane $C_{10}H_{22} =$ **dec**ane

$C_7H_{16} =$ **hept**ane $C_{11}H_{24} =$ **undec**ane

$C_8H_{18} =$ **oct**ane $C_{12}H_{26} =$ **dodec**ane

For detailed information on naming branched chain alkanes and alkanes with substituent groups, refer to Chapter 39.

Carbon atoms can be characterized by the number of other carbon atoms to which they are directly bonded. A **primary** carbon atom (written as **1°**) is bonded to only one other carbon atom. A **secondary (2°)** carbon is bonded to two; a **tertiary (3°)** to three, and a **quaternary (4°)** to four

other carbon atoms. In addition, hydrogen atoms and other functional groups attached to 1°, 2°, or 3° carbon atoms are referred to as 1°, 2°, or 3°, respectively.

Figure 42.1

PHYSICAL PROPERTIES

Most of the physical properties of alkanes vary in a predictable manner. In general, as the molecular weight of a straight chain alkane increases, the melting point, boiling point, and density also increase. At room temperature, the straight-chain compounds C_1H_4 through C_4H_{10} are gases, C_5H_{12} through $C_{16}H_{34}$ are liquids, and the longer-chain compounds are waxes and harder solids.

Branched molecules have slightly lower boiling and melting points than their straight-chain isomers. Greater branching reduces the surface area of a molecule, decreasing the weak intermolecular attractive forces (London dispersion forces). The molecules are held together less tightly, thus lowering the boiling point. In addition, branched molecules are more difficult to pack into a tight, three-dimensional structure, which is reflected in the lower melting points of branched alkanes.

SUBSTITUTION REACTIONS OF ALKANES

Alkyl halides and other substituted carbon molecules can take part in reactions known as *nucleophilic substitutions*. Substitution reactions involve removing an atom or a functional group from a molecule and replacing it with another. Substitution reactions can occur in many different types of molecules; however, this chapter will specifically discuss substitution reactions of alkanes. In all substitution reactions, identifying the nucleophile and the leaving group are critical to an understanding of the mechanism.

Nucleophiles

Nucleophiles are molecules that are attracted to positive charge, as seen by their name: nucleophile means "nucleus lover." Nucleophiles are electron-rich species that are often but not always negatively charged. Nucleophiles are attracted to atoms with partial or full positive charges.

Basicity

If a group of nucleophiles are based on the same atom (for example, oxygen) then nucleophilicity is roughly correlated to basicity. In other words, the stronger the base, the stronger the nucleophile. This is because bases act as electron donors, and stronger nucleophiles are also better electron donors. For example, nucleophilic strength decreases in the order:

$$RO^- > HO^- > RCO_2^- > ROH > H_2O$$

Size and polarizability

If a series of nucleophiles is based on different atoms, nucleophilic ability doesn't necessarily correlate to basicity. In a protic solvent (a solvent that is able to form hydrogen bonds), large atoms or ions tend to be better nucleophiles. Larger ions more easily shed their solvent molecules and are more polarizable. Hence, nucleophilic strength decreases in the order:

$$CN^- > I^- > RO^- > HO^- > Br^- > Cl^- > F^- > H_2O$$

In contrast, in an aprotic solvent (a solvent that cannot form hydrogen bonds) the nucleophiles are not solvated. In this case, nucleophilic strength is directly related to basicity. For example, in DMSO (an aprotic solvent), the order of nucleophilic strength is the same as base strength:

$$F^- > Cl^- > Br^- > I^-$$

Leaving Groups

The ease with which nucleophilic substitution takes place is dependent on the nature of the leaving group. The best leaving groups are those that are weak bases, as these can accept a negative charge and dissociate to form a stable ion in solution. In the case of the halogens, therefore, this is the opposite of base strength:

$$I^- > Br^- > Cl^- > F^-$$

Other leaving groups besides halogens can be used for substitution reactions. For example, an $-OH$ group that is a poor leaving group can be protonated to form $-H_2O^+$, which leaves as a water molecule.

S_N1 Reactions

S_N1 designates a **unimolecular nucleophilic substitution** reaction. It is unimolecular because the rate of the reaction is dependent upon only one molecule in the reaction; in other words, the rate expression is first order. The rate-determining step of an S_N1 reaction is the dissociation of the substrate (the starting molecule) to form a stable, positively charged ion called a **carbocation.** The formation and stabilization of the carbocation determine all other aspects of S_N1 reactions.

Mechanism

S_N1 reactions involve two steps: the dissociation of a substrate molecule into a carbocation and a leaving group, followed by the combination of the carbocation with a nucleophile to form the substituted product.

Figure 42.2

In the first step, a carbocation intermediate is formed. Carbocations are stabilized by polar solvents that have lone electron pairs available to donate (e.g., water or ethyl alcohol). Carbocations are also stabilized by charge delocalization throughout the molecule. More highly substituted carbocations are more stable, because hydrocarbon substituent groups donate electron density toward the positive charge. The order of stability for carbocations is:

tertiary > secondary > primary > methyl

To drive the reaction forward, the original leaving group should be a weaker nucleophile than the replacement nucleophile. The second step, in which the nucleophile combines with the carbocation, occurs very rapidly compared to the first step, and is essentially irreversible.

Rate

The rate at which a reaction occurs can never be greater than the rate of its slowest step. Such a step is termed the **rate-limiting** or **rate-determining step** of the reaction (see Chapter 31). In an S_N1 reaction, the slowest step is the dissociation of the molecule to form a carbocation intermediate, a step that is energetically unfavorable. The formation of a carbocation is therefore the rate-limiting step of an S_N1 reaction. The only reactant in this step is the original substrate molecule, and so the rate of the entire reaction depends only on the concentration of the substrate (a so-called *first-order reaction*): rate = k[substrate]. The rate is *not* dependent on the concentration or the nature of the nucleophile, because it plays no part in the rate-limiting step.

The rate of an S_N1 reaction can be increased by anything that promotes the formation and stability of the carbocation. The most important factors are as follows:

a. Structural factors: Highly substituted alkanes allow for distribution of the positive charge over a greater number of carbon and hydrogen atoms, and thus form the most stable carbocations. The order of reactivity of substrates for S_N1 reactions is tertiary > secondary > primary > methyl; in general, primary and methyl substrates do not react by the S_N1 mechanism.

b. Solvent effects: Highly polar solvents are better at surrounding and isolating ions than are less polar solvents. Polar protic solvents such as water or alcohols work best for two reasons. Protic solvents can form hydrogen bonds with the leaving group, solvating it and preventing it from returning to the carbocation. Also, lone electron pairs on oxygen or nitrogen atoms in the solvent molecule can stabilize the carbocation intermediate.

c. Nature of the leaving group: Weak bases dissociate more easily from the alkyl chain and thus make better leaving groups, increasing the rate of carbocation formation.

d. Nature of the nucleophile: S_N1 reactions do not require a strong nucleophile. S_N1 reactions run equally well with either strong (fully charged) or weak (electron-rich but uncharged) nucleophiles.

Stereochemistry

S_N1 reactions involve carbocation intermediates, which are sp^2 hybridized and have trigonal planar geometry. The attacking nucleophile can approach the carbocation from either above or below with equal probability, and thus create either the (R) or (S) enantiomer with equal probability.

Figure 42.3

If the original compound is optically active because of the presence of a chiral center, then a racemic mixture will be produced. In some cases, the nucleophile may react so rapidly that it approaches the carbocation from the opposite side of the leaving group with greater frequency; in this case, the product will be characterized as a partial racemate.

S_N2 Reactions

S_N2 designates a **bimolecular nucleophilic substitution** reaction. S_N2 reactions involve a nucleophile pushing its way into a compound while simultaneously displacing the leaving group. Its rate-determining and only step involves two molecules: the substrate and the nucleophile.

Figure 42.4

Mechanism

S_N2 reactions are **concerted** reactions, meaning that the entire mechanism occurs in single coordinated process. The nucleophile attacks the reactant from the backside of the leaving group, forming a trigonal bipyramidal **transition state**. As the reaction progresses, the bond to the nucleophile

523

strengthens while the bond to the leaving group weakens. The leaving group is displaced as the bond to the nucleophile becomes complete.

Rate

The single step of an S_N2 reaction involves *two* reacting species: the substrate and the nucleophile. The concentrations of both therefore play a role in determining the rate of an S_N2 reaction; the two species must "meet" in solution in the appropriate orientation, and raising the concentration of either will make such a meeting more likely. Since the rate of the S_N2 reaction depends on the concentration of two reactants, it follows **second-order kinetics**. The rate expression for an S_N2 reaction is: rate = k[substrate][nucleophile].

Other factors that can affect the rate of S_N2 reactions include:

- Structural factors: The nucleophile must have unhindered access to the reacting carbon of the substrate. Therefore S_N2 reactions occur most readily with substrates with little branching in order to minimize steric hindrance. The order of reactivity of substrates for S_N2 is methyl > primary > secondary > tertiary; in general, tertiary substrates do not react by the S_N2 mechanism.

- Solvent effects: S_N2 reactions occur most readily in polar aprotic solvents, meaning solvents that are unable to form hydrogen bonds. Typical polar aprotic solvents include acetone and DMSO (dimethylsulfoxide). Because these solvents cannot form hydrogen bonds, they do not create a solvation shell around the nucleophile and thus do not interfere with its attack on the substrate.

- Nature of the leaving group: Weak bases dissociate more easily from the alkyl chain and thus make better leaving groups, increasing the ease of displacement by the nucleophile.

- Nature of the nucleophile: Because the nucleophile must attack a neutral molecule and displace the leaving group, it must be strongly nucleophilic. This typically means that the nucleophile is a negatively charged ionic species, and can be either a strong or weak base.

Stereochemistry

The single step of an S_N2 reaction involves a chiral transition state. Since the nucleophile attacks from one side of the central carbon and the leaving group departs from the opposite side, the reaction "flips" the bonds attached to the carbon.

Figure 42.5

If the reactant is chiral, optical activity will be retained, but will invert between (*R*) and (*S*) as long as the nucleophile and leaving group have the same priority relative to the other groups in the substrate.

If the nucleophile and leaving group have different priorities compared to the rest of the molecule, however, the absolute configuration must be determined for the substituted product.

S_N1 versus S_N2

Certain reaction conditions favor one substitution mechanism over the other, and provide distinctive "fingerprints" that allow the determination of whether S_N1 or S_N2 will proceed. Sterics, nucleophilic strength, leaving group ability, reaction conditions, and solvent effects are all important in determining which reaction will occur.

	S_N1	S_N2
Substrate reactivity	$3° > 2° > 1° > CH_3$	$CH_3 > 1° > 2° > 3°$
Leaving group	Cl^-, Br^-, I^-, weak bases $-OH$ if protonated to form OH_2^+	Cl^-, Br^-, I^-, weak bases
Nucleophile	Any nucleophile	Strong (charged) nucleophile
Solvent	Polar protic	Polar aprotic
Reaction mechanism	2-step: carbocation, then nucleophilic attack	Concerted 1-step
Rate law	1st order: rate $= k$[substrate]	2nd order: rate $= k$[substrate][nucleophile]
Stereochemistry	Chiral \rightarrow racemic mix	Often inversion of R/S

Table 42.1

Free Radical Substitution Reactions

Alkanes can react by a **free radical substitution mechanism** in which one or more hydrogen atoms are replaced by Cl, Br, or I atoms. These reactions involve three steps:

1. **Initiation:** Diatomic halogens are cleaved by either UV light (shown as UV or hv) or peroxide (H-O-O-H or R-O-O-H), resulting in the formation of free radicals (heat can also be used, but is not specific for radical formation). Free radicals are uncharged species with unpaired electrons (such as Cl• or R_3C•). They are extremely reactive and readily attack alkanes.

$$\text{Initiation: } X_2 \xrightarrow{\text{hv}} 2X\bullet$$

2. **Propagation**—A propagation step is one in which a radical produces another radical that can continue the reaction. A free radical reacts with an alkane, removing a hydrogen atom to form HX, and creating an alkyl radical. The alkyl radical can then react with X_2 to form an alkyl halide (the substiuted product) and generate another X•, thus propagating the radical.

$$\text{Propagation: } \quad X\bullet + RH \longrightarrow HX + R\bullet$$
$$R\bullet + X_2 \longrightarrow RX + X\bullet$$

3. **Termination**—Two free radicals combine with one another to form a stable molecule.

$$\text{Termination:} \quad X\cdot + X\cdot \longrightarrow X_2$$
$$X\cdot + R\cdot \longrightarrow RX$$
$$R\cdot + R\cdot \longrightarrow R_2$$

A single free radical can initiate many reactions before the reaction chain is terminated.

Larger alkanes have many hydrogens that the free radical can attack. Bromine radicals react fairly slowly, and primarily attack the hydrogens on the carbon atom that can form the most stable free radical, i.e., the most substituted carbon atom.

$$\cdot CR_3 > \cdot CR_2H > \cdot CRH_2 > \cdot CH_3$$
$$3° > 2° > 1° > \text{methyl}$$

Thus, a tertiary radical is the most likely to be formed in a free-radical bromination reaction. As a result, the substitution product will have the bromine on the most highly substituted carbon. Note the same pattern of stability and the same resulting product compared to a carbocation-based mechanism.

Figure 42.6

Free-radical chlorination is a more rapid process and depends on both the stability of the intermediate and on the number of hydrogens present. Free-radical chlorination reactions are likely to replace primary hydrogens that are found abundantly in most molecules, despite the relative instability of primary radicals. As a result, free-radical chlorination reactions produce mixtures of products, and are useful only when a single type of hydrogen is present.

ADDITIONAL REACTIONS OF ALKANES

Combustion

The reaction of alkanes with molecular oxygen to form carbon dioxide, water, and heat is a process of great practical importance. It is an unusual reaction because heat, not a chemical species, is generally the desired product. The reaction mechanism is very complex and is believed to proceed through a radical process. As an example, the equation for the complete **combustion** of propane is:

$$C_3H_8 + 5\,O_2 \longrightarrow 3\,CO_2 + 4\,H_2O + \text{heat}$$

All combustion reactions take this basic form, with different hydrocarbons used as the starting molecule, and each reaction must be balanced appropriately for the number of carbons, hydrogens,

and oxygens present. Combustion is often incomplete, producing significant quantities of carbon monoxide instead of carbon dioxide. This frequently occurs, for example, in the burning of gasoline in an internal combustion engine.

Pyrolysis

Pyrolysis occurs when a molecule is broken down by heat in the absence of oxygen. Pyrolysis, also called **cracking,** is most commonly used to reduce the average molecular weight of heavy oils and to increase the production of more desirable volatile compounds. In the pyrolysis of alkanes, the $C-C$ bonds are cleaved, producing smaller-chain alkyl radicals. These radicals can recombine to form a variety of alkanes:

$$CH_3CH_2CH_3 \xrightarrow{\Delta} CH_3\cdot + \cdot CH_2CH_3$$

$$2\ CH_3\cdot \longrightarrow CH_3CH_3$$

$$2\ \cdot CH_2CH_3 \longrightarrow CH_3CH_2CH_2CH_3$$

Figure 42.7

Alternatively, in a process called **disproportionation,** a radical transfers a hydrogen atom to another radical, producing an alkane and an alkene:

$$\cdot CH_3 + \cdot CH_2CH_3 \longrightarrow CH_4 + H_2C{=}CH_2$$

Figure 42.8

REVIEW PROBLEMS

1. Under the following conditions,

 1-bromo-4-methylpentane will most probably react via

 A. S_N1.
 B. S_N2.
 C. both S_N1 and S_N2.
 D. E1.
 E. both E1 and E2.

2. The following molecule can be classified as having

 A. 4 primary, 2 secondary, 4 tertiary, and 3 quaternary carbon atoms.
 B. 3 methyl groups, 2 ethyl groups, and 4 secondary carbon atoms.
 C. 4 primary, 6 secondary, 2 tertiary, and 1 quaternary carbon atoms.
 D. 3 primary, 3 secondary, 4 tertiary, and 3 quaternary carbon atoms.
 E. 3 primary, 2 secondary, 5 tertiary, and 1 quaternary carbon atoms.

3. The following reactions are part of a free-radical halogenation sequence:

		ΔH (kcal/mol)
A.	$Cl_2 \rightarrow 2\ Cl\bullet$	+58
B.	$Cl\bullet + CH_4 \rightarrow \bullet CH_3 + HCl$	+1
C.	$\bullet CH_3 + Cl_2 \rightarrow CH_3Cl + Cl\bullet$	−26
D.	$\bullet CH_3 + Cl\bullet \rightarrow CH_3Cl$	−84

 Identify the initiation, propagation, and termination steps.

4. S_N1 reactions show first-order kinetics because

 A. the rate-limiting step is the first step to occur in the reaction.
 B. the rate-limiting step involves only one molecule.
 C. there is only one rate-limiting step.
 D. the reaction involves only one molecule.
 E. the reaction only involves one step.

5. The following reaction sequence is typical of S_N1 reactions. Which is the rate-limiting step(s)?

Step 1: $(CH_3)_3C-Cl \longrightarrow (CH_3)_3C^+ + Cl^-$

Step 2: $(CH_3)_3C^+ \xrightarrow{CH_3CH_2OH} (CH_3)_3C-\overset{+}{\underset{H}{O}}-CH_2CH_3$

Step 3: $(CH_3)_3C-\overset{+}{\underset{H}{O}}-CH_2CH_3 \longrightarrow (CH_3)_3C-O-CH_2CH_3 + H^+$

 A. Step 1
 B. Step 2
 C. Step 3
 D. Steps 1 and 2
 E. Steps 1 and 3

6. Which of the following would be the best solvent for an S_N2 reaction?
 A. H_2O
 B. CH_3CH_2OH
 C. CH_3SOCH_3
 D. $CH_3CH_2CH_2CH_2CH_2CH_3$
 E. NH_3

7. What choices for X and Y would most favor the following reaction?

$$R_3C-X \xrightarrow{-X^-} R_3C^+ \xrightarrow{+Y^-} R_3C-Y$$

 A. $X = I^-$, $Y = Cl^-$
 B. $X = EtO^-$, $Y =$ tosylate $(CH_3C_6H_4SO_2)$
 C. $X =$ tosylate, $Y = H_3O^-$
 D. $X = OH^-$, $Y = H_2O$
 E. $X = EtO^-$, $Y = CN^-$

8. What would be the major product of the following reaction?

$$CH_3CH_2CH_3 + Br_2 \xrightarrow{h\nu}$$

 A. $CH_3CH_2CH_2Br$
 B. $CH_3CH_2CH_2CH_2CH_2CH_3$
 C. $H_3CCHBrCH_3$
 D. CH_3CH_2Br
 E. CH_2CHBr

9. Treatment of (S)-2-bromobutane with sodium hydroxide results in the production of a compound with an (R) configuration. The reaction has most likely taken place through

 A. an S_N1 mechanism.
 B. an S_N2 mechanism.
 C. both an S_N1 and S_N2 reaction.
 D. an elimination reaction.
 E. an addition reaction.

10. What is the correct decreasing order of the boiling points of the following compounds?

 I. *n*-hexane
 II. 2-methylpentane
 III. 2,2-dimethylbutane
 IV. *n*-heptane

 A. I > IV > II > III
 B. IV > III > II > I
 C. IV > I > II > III
 D. I > II > III > IV
 E. I > II > IV > III

11. The reaction of isobutane with an unknown halogen is catalyzed by light. The two major products obtained are:

 What is the unknown halogen?

 A. Cl_2
 B. Br_2
 C. I_2
 D. F_2
 E. At

12. Place the following species in order of increasing stability.

 A. (i) $CH_3CH_2CH_2^{\bullet}$ (ii) $(CH_3)_2\overset{\displaystyle|}{\underset{\displaystyle H}{C}}{}^{\bullet}$ (iii) CH_3^{\bullet} (iv) $(CH_3)_3C^{\bullet}$

 B. (i) $R_2\overset{\displaystyle|}{\underset{\displaystyle H}{C}}{}^{+}$ (ii) R_3C^{+} (iii) H_3C^{+} (iv) $H_2\overset{\displaystyle|}{\underset{\displaystyle R}{C}}{}^{+}$

SOLUTIONS TO REVIEW PROBLEMS

1. **B** In this question, a primary alkyl halide is treated with cyanide, which is a good nucleophile. Primary alkyl halides are not sterically hindered and are readily displaced in S_N2 reactions. Cyanide will displace the bromide to produce 5-methylheptanenitrile in good yield. The correct answer is therefore choice (B). An S_N1 reaction will probably not occur because formation of a primary carbocation, which would result from the loss of bromide, is highly unfavorable. Elimination reactions would form a product with a double bond instead.

2. **C** The molecule shown in question 2 is 2-ethyl-1-neopentylcyclohexane. A primary carbon atom is one that is bonded to only one other carbon atom, a secondary carbon atom is bonded to two, a tertiary to three, and a quaternary to four. Thus, this molecule has four primary, six secondary, two tertiary, and one quaternary carbon atoms, so choice (C) is correct.

3. Step (A) is an initiation step because a nonradical species forms two radicals. Both steps (B) and (C) are propagation steps in which one radical species reacts to form another radical species. Step (D) is a termination step in which two radicals form a nonradical species.

4. **B** An S_N1 reaction is a first-order nucleophilic substitution reaction. It is called first-order because the rate-limiting step involves only one molecule; thus the correct answer is choice (B). Choice (A) is incorrect because the rate-limiting step is not necessarily the first step to occur in a reaction. It is simply the slowest step. Choice (C) is a true statement, but is incorrect because it is irrelevant to the term "first-order." Choice (D) is incorrect because it is the rate-limiting step, not the reaction, that involves only one molecule. Finally, (E) is false: S_N1 reactions involve two steps.

5. **A** The formation of a carbocation is the rate-limiting step. This step is the slowest to occur and its rate determines the rate of the reaction. Step 2 is a nucleophilic attack on the carbocation by ethanol. In step 3 a proton is lost from the protonated ether. Both steps 2 and 3 occur very rapidly in solution and are not rate-limiting steps. Choices (D) and (E) are incorrect because there can be only one rate-limiting step.

6. **C** The correct answer is choice (C), dimethyl sulfoxide. S_N2 reactions give the best results if a polar aprotic solvent is used. S_N2 reactions occur via a one-step mechanism in which a nucleophile attacks a substrate. Polar aprotic solvents accelerate this reaction by allowing the nucleophile to be "naked," i.e., not surrounded by hydrogen-bonded solvation spheres. The nucleophile therefore has easy access to the substrate. In addition, the solvent should be polar to dissolve the reactants. Choice (A), water; choice (B), ethanol; and choice (E), ammonia, are incorrect because, although these are polar, they are also protic and would diminish the power of the nucleophile. Choice (D) is hexane and is incorrect because it is a nonpolar solvent.

7. **C** This reaction is S_N1 and therefore must have a good leaving group and a nucleophile that is not too reactive as highly reactive nucleophiles will favor S_N2 reactions. In choice (C), X is a tosylate ion, an excellent leaving group, and Y is a methoxide ion, a nucleophile that is not too strong. Therefore, choice (C) is the correct answer. Choice (A) is incorrect; even though iodide is a good leaving group (favoring the forward reaction), it is also a good nucleophile (favoring the reverse reaction) because the solvent will be polar protic and it is an S_N1 reaction. Choices (B) and (E) are incorrect because ethoxide is a poor leaving group

(and tosylate is a weak nucleophile). Finally, choice (D) is incorrect because hydroxide is a poor leaving group and water is a poor nucleophile.

8. **C** This question concerns the free-radical bromination of an alkane. The bromination reaction occurs in such a way as to produce the most stable alkyl radical. This is because bromine radicals are very selective, as opposed to chlorine radicals, which react indiscriminately. In this question, the most stable radical is a secondary radical, which further reacts to form 2-bromopropane, choice (C), the correct answer. Choice (A) is incorrect because 1-bromopropane results from reaction of a primary radical, and although this may occur to an extent, the major product will be 2-bromopropane. Choice (B) would result from the combination of two primary radicals and is expected to be a very minor product. Choice (D) is incorrect because a carbon atom is lost in the reaction, and this does not occur in free-radical bromination. Finally, choice (E) is incorrect because it is an alkene, and bromination is a substitution or addition reaction, not an elimination.

9. **B** Inversion of configuration is a trademark of the S_N2 reaction, whereas racemization is typical of S_N1 reactions. When (S)-2-bromobutane is treated with hydroxide, a compound with an R configuration is obtained. The most likely occurrence is a substitution reaction, and the fact that the absolute configuration has changed suggests an S_N2 reaction. If the reaction proceeded by S_N1, the products would have both R and S configurations because the hydroxide ion could attack the planar carbocation from either side and would form a racemic mix. There is only one configuration in this case, and therefore the correct answer is S_N2.

10. **C** The correct answer is choice (C), IV > I > II > III, corresponding to: n-heptane > n-hexane > 2-methylpentane > 2,2-dimethylbutane. As the chain length of a straight-chain alkane is increased, the boiling point also increases, approximately 25–30°C for each additional carbon atom. Therefore, n-heptane is expected to boil at a higher temperature than n-hexane. Isomeric alkanes follow a typical trend: as branching increases, boiling point decreases. Compounds I, II, and III are isomeric hexanes, listed in increasing order of branching. Therefore, n-hexane boils at a higher temperature than 2-methylpentane, which boils at a higher temperature than 2,2-dimethylbutane.

11. **A** Free-radical halogenation reactions are practical only for bromine and chlorine; iodine, fluorine, and astatine do not react efficiently, and can therefore be eliminated. Bromine radicals react slowly in comparison to chlorine radicals, and are therefore more likely to react in a manner that forms the most stable alkyl radical, i.e., the most substituted radical. This leads to the production of one major bromination product. Chlorine radicals, on the other hand, react so quickly that they become rather indiscriminate, and generally produce several different products. In this particular reaction, two different products are isolated in comparable yields.

12. **A** **iii < i < ii < iv**

 The order of stability of free radicals follows this sequence: $CH_3 < 1° < 2° < 3°$. Stability is enhanced by an increase in the number of alkyl substituents bonded directly to the radical carbon atom. These substituents allow the extra electron density to be spread out or delocalized throughout the molecule.

 B **iii < iv < i < ii**

 The stability of carbocations is increased when the positive charge can be distributed over more than one carbon atom. This means that tertiary carbocations are more stable than secondary, and so on.

CHAPTER FORTY-THREE

Alkenes and Alkynes

LEARNING OBJECTIVES

After this chapter, you will be able to:

- Describe the nomenclature, physical properties, and synthesis of alkenes and alkynes
- Predict the products of reactions with alkenes and alkynes
- Describe the major types of reactions involving alkenes and alkynes

Alkenes and alkynes are hydrocarbons that contain double and triple bonds between carbons. They are called unsaturated because they contain fewer than the maximum possible number of hydrogens. Double and triple bonds are considered functional groups, and alkenes and alkynes are more reactive than the corresponding alkanes. The double and triple bonds of alkenes and alkynes are made from first forming a single sigma bond, and then by forming one or two additional pi bonds (see Chapter 41).

For both alkenes and alkynes, a brief overview of nomenclature and properties will be followed by a discussion of their synthesis and then of their reactions.

ALKENES

Alkenes are hydrocarbons that contain carbon-carbon double bonds. The general formula for a straight-chain alkene with one double bond is C_nH_{2n}. The degree of unsaturation (the number N of double bonds or rings) of a compound of molecular formula C_nH_m can be determined according to the equation:

$$N = \frac{1}{2}(2n + 2 - m)$$

The carbons at either end of a double bond are sp² hybridized and both form planar bonds with bond angles of 120°. Alkenes are not able to rotate around their double bond and thus are constrained to unique configurations.

NOMENCLATURE OF ALKENES

Alkenes, also called olefins, may be described by the terms *cis, trans, E,* and *Z* to distinguish the configuration of functional groups around the double bond. The common names *ethylene, propylene,* and *isobutylene* are often used over the IUPAC names ethene, propene, and 2-methyl-1-propene, respectively. For a review of *cis-trans* isomers, see Chapter 40; to review nomenclature, see Chapter 39.

$$CH_2\!=\!CH_2$$

ethene
(ethylene)

$$CH_3CH\!=\!CH_2$$

propene
(propylene)

2-methyl-1-propene
(isobutylene)

trans-2 butene

(Z)-3-methyl-3-heptene

Figure 43.1

PHYSICAL PROPERTIES OF ALKENES

The physical properties of alkenes are similar to those of alkanes. For example, their melting and boiling points increase with increasing molecular weight and are similar in value to those of the corresponding alkanes. Terminal alkenes (or 1-alkenes) usually boil at a lower temperature than internal alkenes. *Trans*-alkenes generally have higher melting points than *cis*-alkenes because their higher symmetry allows better packing in the solid state. They also tend to have lower boiling points than *cis*-alkenes because they are less polar.

Polarity is a property that results from the asymmetrical distribution of electrons in a particular molecule. In alkenes, this distribution creates dipole moments that are oriented from the electropositive alkyl groups toward the electronegative alkene. In *trans*-2-butene, the two dipole moments are oriented in opposite directions and cancel each other. The compound possesses no net dipole moment and is not polar. On the other hand, *cis*-2-butene has a net dipole moment, resulting from addition of the two smaller dipoles. The compound is polar, and the additional intermolecular forces raise the boiling point.

(nonpolar) (polar)

Figure 43.2

SYNTHESIS OF ALKENES

Alkenes can be synthesized in a number of different ways. The most common method involves elimination reactions of either alcohols or alkyl halides. In these reactions the molecule loses either HX (where X is a halide) or a molecule of water from two adjacent carbons to form a double bond:

Figure 43.3

Elimination occurs by two distinct mechanisms, unimolecular and bimolecular, which are referred to as E1 and E2, respectively.

Unimolecular Elimination

Unimolecular elimination, abbreviated **E1**, is a two-step process proceeding through a carbocation intermediate. The rate of reaction is dependent on the concentration of only the substrate. The elimination of a leaving group and a proton results in the production of a double bond. In the first step, the leaving group departs, producing a carbocation. In the second step, a proton is removed by a base and the double bond forms.

Because both involve the formation of a carbocation intermediate, E1 is favored by the same factors that favor S_N1: protic solvents, highly branched carbon chains, good leaving groups, and weak nucleophiles in low concentration. After the identical first step, the reaction can proceed by either the E1 or S_N1 pathway. E1 and S_N1 are therefore competitive, and occur simultaneously under the same conditions. In fact, E1 and S_N1 have exactly the same rate law, given by rate = k[substrate], including having the same value of k. Directing a reaction toward either E1 or S_N1 alone is difficult, although high temperatures tend to favor E1; this means that a mixture of both E1 and S_N1 products will always be present.

Bimolecular Elimination

Bimolecular elimination, termed **E2**, occurs in one step. Its rate is dependent on the concentration of two species, the substrate and the base. A strong base such as the ethoxide ion ($C_2H_5O^-$) removes a proton, while simultaneously a halide ion *anti* to the proton leaves, resulting in the formation of a double bond.

Figure 43.4

Often there are two possible hydrogens that can be removed from carbons on either side of the leaving group, resulting in two different products. In such cases, the more substituted double bond is formed preferentially; this is known as Zaitsev's rule.

Controlling E2 vs. S_N2 is easier than controlling E1 vs. S_N1:

1. Steric hindrance does not greatly affect E2 reactions. Therefore, highly substituted carbon chains, which form the most stable alkenes, undergo E2 easily and S_N2 rarely.

2. A strong, bulky base such as t-butoxide favors E2 over S_N2. S_N2 is favored over E2 by strong nucleophiles that are weak bases, such as CN^- or I^-.

In general, heat and basic conditions will result in an E2 mechanism; heat and acidic conditions will result in E1 combined with S_N1.

REACTIONS OF ALKENES

Alkenes undergo several types of reactions, including:

- reduction by hydrogen
- addition by electrophiles and free radicals
- hydroboration
- a variety of oxidations
- polymerization

Reduction

Catalytic hydrogenation is the reductive process of adding molecular hydrogen (H_2) to a double bond with the aid of a metal catalyst. Typical catalysts are platinum, palladium, and nickel (usually Raney nickel, a special powdered form), but on rare occasions rhodium, iridium, or ruthenium are used.

The reaction takes place on the surface of the metal. One face of the double bond is coordinated to the metal surface, and thus the two hydrogen atoms are added to the same face of the double bond. This type of addition is called *syn* addition and results in a *meso* compound if the starting molecule was symmetrical (see Chapter 40).

Figure 43.5

Electrophilic Additions

The π bond is somewhat weaker than the σ bond, and can therefore be broken without breaking the σ bond. As a result, compounds can *add* to double bonds while leaving the carbon skeleton intact. Although many different addition reactions exist, most operate via the same essential mechanism.

The electrons of the π bond are particularly exposed and are thus easily attacked by molecules that seek to accept an electron pair (Lewis acids). Because these groups are electron-seeking, they are known as electrophiles (literally, "lovers of electrons").

Addition of HX

The electrons of the double bond act as a Lewis base and react with electrophilic HX (hydrogen halide) molecules. The first step yields a carbocation intermediate after the double bond reacts with a proton. In the second step, the halide ion combines with the carbocation to give an alkyl halide. In cases where the alkene is asymmetrical, the initial protonation creates the *most stable carbocation*. The proton will add to the less substituted carbon atom (the carbon atom with the most hydrogens), and the positive charge of the carbocation will reside on the more substituted carbon. The halogen will then add to the carbocation, and thus create the product with the halide on the most substituted carbon. This phenomenon is called Markovnikov's rule. An example is:

Figure 43.6

Addition of X₂

The addition of halogens to a double bond is a rapid process. The addition of bromine and resulting change in color of the solution is frequently used as a diagnostic tool to test for the presence of double bonds. In the example shown, the double bond acts as a nucleophile and attacks a Br_2 molecule, displacing Br^-. The Br^+ attaches to the double bond and a cyclic bronomium ion is formed. This is attacked by Br^-, giving the dibromo compound. Note that this addition is *anti* because the Br^- attacks the cyclic bronomium ion in a standard S_N2 displacement from the opposite side.

Anti-addition

Figure 43.7

If the reaction is carried out in a nucleophilic solvent, the solvent molecules can compete in the displacement step, producing, for example, a bromo alcohol rather than the dibromo compound.

Section IV: Organic Chemistry

Addition of H₂O

Addition of H₂O

Water can be added to alkenes under acidic conditions. The double bond is protonated according to Markovnikov's rule, forming the most stable carbocation. This carbocation reacts with water, forming a protonated alcohol, which then loses a proton to yield the alcohol. The reaction is performed at low temperature because the reverse reaction is an acid-catalyzed dehydration favored by high temperatures.

Figure 43.8

Direct addition of water is generally not useful in the laboratory because yields vary greatly with reaction conditions; therefore, this reaction is generally carried out indirectly using mercuric acetate, $Hg(CH_3COO)_2$.

Free Radical Additions

An alternate mechanism exists for the addition of HX (hydrogen halide) to alkenes, which proceeds through free-radical intermediates, and occurs when peroxides, oxygen, or other impurities are present. Free-radical additions are called anti-Markovnikov because X• adds first to the double bond, producing the most stable free radical on the most substituted carbon. The hydrogen then adds to the free radical, resulting in the less substituted product. The reaction is useful for HBr but is not practical for HCl or HI because the energies are unfavorable.

Figure 43.9

Hydroboration

Diborane (B_2H_6) adds readily to double bonds. The boron atom is a Lewis acid and attaches to the less sterically hindered carbon atom. The second step is an oxidation-hydrolysis with peroxide and aqueous base, producing the alcohol with overall anti-Markovnikov, *syn* orientation.

538

R =

Figure 43.10

Oxidation

Potassium permanganate

Alkenes can be oxidized with $KMnO_4$ to provide different types of products, depending upon the reaction conditions. Cold, dilute, aqueous $KMnO_4$ reacts to produce 1,2 diols (vicinal diols), which are also called glycols, with *syn* orientation:

Figure 43.11

Under acidic conditions, manganate ions (MnO_4^{2-}) are reduced to manganese ions (Mn^{2+}), and this reaction can be coupled to the complete cleavage of a double bond. If a hot, basic solution of potassium permanganate is added to the alkene and then acidified, the product will be determined by the nature of the alkene substrate. Nonterminal alkenes are cleaved to form two molar equivalents of carboxylic acid, and terminal alkenes are cleaved to form a carboxylic acid and carbon dioxide. If the nonterminal double bonded carbon is disubstituted, however, a ketone will be formed:

Figure 43.12

Ozonolysis

Treatment of alkenes with ozone followed by reduction with zinc and water is a milder reaction. This treatment results in cleavage of the double bond to produce two aldehyde molecules as shown (or ketones if the double bond is substituted with alkyl groups):

Figure 43.13

If the reaction mixture is reduced with sodium borohydride, $NaBH_4$, the corresponding alcohols are produced:

Figure 43.14

Peroxycarboxylic acids

Alkenes can be oxidized with peroxycarboxylic acids. Peroxyacetic acid (CH_3CO_3H) and *m*-chloroperoxybenzoic acid (mCPBA) are commonly used. The products formed are oxiranes (also called epoxides) and are highly reactive. This makes them ideal for further nucleophilic reactions such as substitutions and the formation of alcohols, glycols, and amines:

Figure 43.15

Polymerization

Polymerization is the creation of long, high molecular weight chains (polymers), composed of repeating subunits (called monomers). Polymerization usually occurs through a radical mechanism, although anionic and even cationic polymerizations are commonly observed. A typical example is the formation of polyethylene from ethylene (ethene) that requires high temperatures and pressures:

$$CH_2 = CH_2 \xrightarrow[\text{high pressure}]{R\bullet, \text{ heat}} RCH_2CH_2(CH_2CH_2)_nCH_2CH_2R$$

Figure 43.16

ALKYNES

Alkynes are hydrocarbon compounds that possess one or more carbon-carbon triple bonds. The general formula for a straight-chain alkyne with one triple bond is C_nH_{2n-2}. Triple bonds are sp hybridized and are therefore linear, imparting unique characteristics to molecules that contain them.

NOMENCLATURE OF ALKYNES

The suffix **-yne** is used to designate an alkyne, and the position of the triple bond is specified when necessary. A common exception to the IUPAC rules is ethyne, which is called *acetylene*. Frequently, compounds are named as derivatives of acetylene.

$$CH_3CH_2CH_2CHC\equiv CCH_3 \quad\quad CH\equiv CH \quad\quad CH_3C\equiv CH$$
$$\overset{\displaystyle |}{Cl}$$

4-chloro-2-heptyne ethyne propyne

(acetylene) (methylacetylene)

Figure 43.17

PHYSICAL PROPERTIES OF ALKYNES

The physical properties of the alkynes are similar to those of their analogous alkenes and alkanes. In general, the shorter-chain compounds are gases, boiling at somewhat higher temperatures than the corresponding alkenes. Internal alkynes, like alkenes, boil at higher temperatures than terminal alkynes.

Asymmetrical distribution of electron density causes alkynes to have dipole moments that are larger than those of alkenes, but still small in magnitude. Thus, solutions of alkynes can be slightly polar.

Terminal alkynes are relatively acidic, having pK_a values of approximately 25. This property is exploited in some of the reactions of alkynes, which will be discussed later.

SYNTHESIS OF ALKYNES

Triple bonds can be made by the elimination of two molecules of HX from a geminal or vicinal dihalide:

$$CH_3C\equiv CCH_3 \quad + \quad 2\,HBr$$

Figure 43.18

This reaction is not always practical and requires high temperatures and a strong base. A more useful method adds an already existing triple bond onto a particular carbon skeleton. A terminal triple bond is converted to a nucleophile by removing the acidic proton with strong base, producing an acetylide ion. This ion will perform nucleophilic displacements on alkyl halides at room temperature using an S_N2 mechanism:

$$CH\equiv CH \xrightarrow{n\text{-BuLi}} CH\equiv C^-Li \quad + \quad \xrightarrow{CH_3Cl} \quad CH\equiv CCH_3$$

Figure 43.19

REACTIONS OF ALKYNES

Alkynes undergo several types of reactions, most of which are closely related to the reactions of alkenes:

- a variety of reduction mechanisms by hydrogen and catalysts
- addition by electrophiles and free radicals
- hydroboration
- oxidation

Reduction

Alkynes, just like alkenes, can be hydrogenated with a metal catalyst to produce alkanes in a reaction that goes to completion:

$$CH_3\text{-}C{=}C\text{-}CH_3 \rightarrow CH_3CH_2CH_2CH_3 \text{ in the presence of Pt, Pd, or Ni}$$

A more useful reaction stops the reduction after addition of just one equivalent of H_2, producing alkenes. This partial hydrogenation can take place in two different ways. The first uses Lindlar's catalyst, which is palladium on barium sulfate ($BaSO_4$) with quinoline, a poison that stops the reaction at the alkene stage. Because the reaction occurs on a metal surface, the product alkene is the *cis* isomer. The other method uses sodium in liquid ammonia below $-33°C$ (the boiling point of ammonia), and produces the *trans* isomer of the alkene via a free radical mechanism:

$$CH_3C\equiv CCH_3 \xrightarrow[\substack{\text{Quinoline}\\ \text{(Lindlar's catalyst)}}]{H_2,\ Pd/BaSO_4}$$

2-butyne

cis-2-butene

$$CH_3C\equiv CCH_3 \xrightarrow{Na,\ NH_3(l)}$$

2-butyne

trans-2-butene

Figure 43.20

Addition

Electrophilic

Electrophilic addition to alkynes occurs in the same manner as it does to alkenes, with the reaction following Markovnikov's rule. The addition can generally be stopped at the intermediate alkene stage, or carried further:

$$CH_3C\equiv CH \xrightarrow{HBr}$$

$$CH_3C\equiv CH \xrightarrow{Br_2}$$

$$CH_3C\equiv CH \xrightarrow{2Br_2} CH_3CBr_2CBr_2H$$

Figure 43.21

Free radical

Radicals add to triple bonds as they do to double bonds—with anti-Markovnikov placement of the halogen. The reaction product is usually the *trans* isomer, because the intermediate vinyl radical can isomerize to its more stable form as shown:

Figure 43.22

Hydroboration

Addition of boron to triple bonds occurs by the same method as addition of boron to double bonds. Addition is *syn*, and the boron atom adds first. The boron atom can be replaced with a proton from acetic acid, to produce a *cis* alkene:

Figure 43.23

With terminal alkynes, a disubstituted borane is used to prevent further boration of the vinylic intermediate to an alkane. The vinylic borane intermediate can be oxidatively cleaved with hydrogen peroxide (H_2O_2), creating an intermediate vinyl alcohol, which rearranges to the more stable carbonyl compound via keto-enol tautomerism (see Chapter 46).

Figure 43.24

Oxidation

Alkynes can be oxidatively cleaved with either basic potassium permanganate (followed by acidification) or ozone. In both instances shown, carboxylic acids are produced, but treatment of a terminal alkyne with basic permanganate will produce carbon dioxide.

1) $KMnO_4$, OH^-

2) H^+

Figure 43.25

1) O_3, CCl_4

2) H_2O

+ CO_2

Figure 43.26

REVIEW PROBLEMS

1. The major product of the reaction below is

 A. 3-methyl-1-butene.
 B. 2-methyl-3-butene.
 C. 3-methyl-2-butene.
 D. 2-methyl-2-butene.
 E. 3-methyl-3-butene.

2. The below reaction takes place mostly by which of the following mechanisms?

 A. S_N1
 B. S_N2
 C. E1
 D. E2
 E. None of the above

3. Which of the following products will be formed if 2-methyl-2-butene is reacted with hot basic KMnO$_4$?

 A. 1 mole of acetic acid and 1 mole of propanoic acid
 B. 2 moles of pentanoic acid
 C. 1 mole of acetic acid and 1 mole of acetone
 D. 2 moles of acetic acid and 1 mole of CO$_2$
 E. 1 mole of pentanoic acid

4. Which of the following is true about E2 reactions?

 A. They are greatly affected by steric hindrance.
 B. They need a strong base to abstract the proton.
 C. They are favored over S_N2 by weak Lewis bases.
 D. They are favored over S_N1 and E1 by polar solvents.
 E. They don't need a strong leaving group.

5. What is the product of the following reaction?

A. (structure) —OH + (formaldehyde) H—C(=O)—H **B.** (acetone structure) + CH₃OH

C. (acetone structure) + CO₂ **D.** (formaldehyde) H—C(=O)—H + (acetone structure)

E. None of the above

6. What is the product of the following reaction?

$$CH_3-C\equiv C-\underset{\underset{CH_3}{|}}{\overset{\overset{CH_3}{|}}{CH}} \quad \xrightarrow[\text{2) H}^+]{\text{1) hot KMnO}_4\text{, OH}^-} \quad ?$$

A. (acetaldehyde) CH₃—C(=O)—H + (isobutyraldehyde) H—C(=O)—CH(CH₃)₂ **B.** (acetaldehyde) CH₃—C(=O)—H + (isobutyric acid) HO—C(=O)—CH(CH₃)₂

C. (acetic acid) CH₃—C(=O)—OH + (isobutyric acid) HO—C(=O)—CH(CH₃)₂ **D.** (diol structure with two OH groups)

E. None of the above

7. What is the product of the following reaction?

(propene) $\xrightarrow[\text{peroxides}]{\text{HBr}}$?

A. (1-bromopropane with Br) **B.** (propene, no Br)

C. (2-bromopropane, Br on central carbon) **D.** (2-bromopropene, Br on central carbon with double bond)

E. None of the above

SOLUTIONS TO REVIEW PROBLEMS

1. **D** Heating an alcohol generally leads to loss of a water molecule and the formation of a double bond. Two products can be obtained depending on which H atom is used by the OH group to form water; either

OR

The most stable alkene, which is the most substituted one, is formed. Of the two alkenes, 2-methyl-2-butene is more stable, and the correct choice is (D).

2. **D** Since tertiary butyl chloride has been converted to an alkene, this is an elimination reaction. This particular compound, formally named 2-chloro-2-methylpropane, can react through either E1 or E2 depending on the conditions: reaction with strong bases leads to E2, and reaction with weak bases leads to E1. Since methoxide is a strong base, elimination occurs by the E2 mechanism. Choice (D) is the correct response.

3. **C** The double bond of 2-methyl-2-butene is cleaved by hot, basic potassium permanganate to form acetone and acetic acid. If the double-bonded carbon is a monosubstituted carbon as seen on the right side of the molecule, a carboxylic acid is obtained; if it is a disubstituted carbon as seen on the left side, a ketone is obtained. Thus, the correct choice is (C).

acetone acetic acid

4. **B** Answer choice (A) is incorrect; E2 reactions are not affected by steric hindrance. Answer choice (C) is also incorrect, as S$_N$2 reactions are favored over E2 by weak Lewis bases. Answer choice (D) is a distortion, as all four substitution and elimination mechanisms require polar solvents to keep the polar reactants and products in solution. The correct answer choice is (B), as E2 requires a strong base to remove a proton at the same time that the leaving group departs on the opposite side of the molecule.

5. **D** Ozonolysis of an alkene and subsequent treatment with zinc and water produces carbonyl compounds. The double bond is broken and a disubstituted double-bonded carbon is converted to a ketone, whereas a monosubstituted double-bonded carbon is converted to an aldehyde. In this reaction, C−1 is a monosubstituted carbon and C−2 is a disubstituted carbon, and thus the products obtained are a ketone and an aldehyde.

6. **C** Treating alkynes with hot basic KMnO$_4$ leads to the cleavage of the triple bond and the formation of carboxylic acids.

7. **A** In the presence of peroxides, the addition of HBr to the double bond takes place in an anti-Markovnikov manner in a series of free-radical reactions initiated by peroxides.

 1. $ROOR \rightarrow 2RO\bullet$
 2. $HBr + RO\bullet \rightarrow ROH + Br\bullet$
 3. $CH_3CH{=}CH_2 + Br\bullet \rightarrow CH_3{-}CH_2Br$
 4. $CH_3{-}CH_2Br + HBr \rightarrow CH_3{-}CH_2{-}CH_2Br + Br\bullet$

 In step 3, $CH_3{-}CH_2Br$ is formed instead of $CH_3{-}CHBr^-$, since the more substituted free-radical is more stable than the less substituted one. Thus, the correct choice is (A). Note that in the absence of peroxides, HBr adds to the double bond in a Markovnikov manner.

OC

CHAPTER FORTY-FOUR

Aromatic Compounds

LEARNING OBJECTIVES

After this chapter, you will be able to:

- Recall the nomenclature, physical properties, and reactions of aromatic compounds
- Predict the effects of substituents on electrophilic aromatic substitutions

The terms **aromatic** and **aliphatic,** meaning "fragrant" and "fatty," respectively, were used originally to distinguish types of organic compounds. The terms are still used by organic chemists but with new definitions. "Aromatic" now describes an unusually stable ring system with several unique characteristics. Aromatic compounds are cyclic, conjugated molecules that possess $4n + 2$ pi electrons and adopt planar conformations to allow maximum overlap of the conjugated pi orbitals. Aliphatic describes all compounds that are not aromatic.

All aromatic compounds are conjugated, but not all conjugated molecules are aromatic. A conjugated system consists of alternating single and double bonds, creating a delocalized pi electron network. This allows one or more resonance structures to exist; resonance indicates stability, which is a key characteristic of aromatics. Because every other bond is a double bond, every carbon in the conjugated system is sp^2 hybridized, and thus is trigonal planar in shape. When confined to a ring system, all of the sp^2 hybridized carbons must lie flat relative to each other, giving another characteristic of aromatics: they are cyclic and planar.

The criterion of possessing $4n + 2$ pi electrons is known as **Hückel's rule**, and is an important indicator of aromaticity. If a cyclic conjugated molecule follows Hückel's rule, then it is an aromatic compound. The integer n can be any nonnegative whole number, including 0, and thus $4n + 2$ can be 2, 6, 10, 14, 18, etc. It is often easier to remember and recognize these allowable values for Hückel's rule than to calculate them. To determine the number of pi electrons, determine the number of pi bonds and multiply by two. Unbonded p orbitals that contain lone pairs of electrons sometimes take part in the conjugation of an aromatic compound. Resonance forms are possible that include these electrons and usually have formal charges; when this is possible, the lone pairs are counted toward Hückel's rule.

Neutral compounds, anions, and cations may all be aromatic, and many compounds must be in their ionic form in order to be aromatic. Some typical aromatic compounds and ions are:

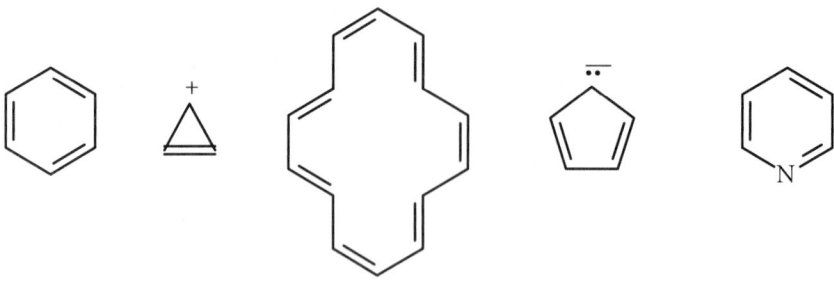

Figure 44.1

A cyclic, conjugated molecule that possesses 4*n* pi electrons is said to be **anti-aromatic** (a cyclic, conjugated molecule that is unstable and highly reactive). Some typical anti-aromatic compounds are:

Figure 44.2

NOMENCLATURE

Aromatic compounds are referred to as **aryl** compounds, or **arenes**, and are represented by the symbol **Ar**. Aliphatic compounds are called **alkyl** and are represented by the symbol **R**. Common names exist for many mono- and disubstituted aromatic compounds.

Figure 44.3

The benzene group is called a **phenyl** group (**Ph**) when named as a substituent. The term **benzyl** refers to a toluene molecule substituted at the methyl position.

methyl phenyl ketone

benzyl chloride

Figure 44.4

Substituted benzene rings are named as alkyl benzenes, with the substituents numbered to produce the lowest sequence. A 1,2-disubstituted compound is called **ortho-** or **o-**; a 1,3-disubstituted compound is called **meta-** or **m-**; and a 1,4-disubstituted compound is called **para-** or **p-**.

2,4,6-trinitrotoluene
(TNT)

o-nitrotoluene

m-dichlorobenzene

p-methylbenzoic acid

Figure 44.5

There are many polycyclic and heterocyclic aromatic compounds, many of which have common names:

| Naphthalene | Anthracene | Pyridine | Pyrrole |

Figure 44.6

PROPERTIES

The physical properties of aromatic compounds are generally similar to those of other hydrocarbons. In contrast, chemical properties are significantly affected by aromaticity. The characteristic planar shape of benzene permits the ring's six pi orbitals to overlap, delocalizing the electron density. All six carbon atoms are sp^2 hybridized, and each of the six orbitals overlaps equally with its two neighbors. As a result, the delocalized electrons form two pi electron clouds, one above and one below the plane of the ring. This delocalization stabilizes the molecule, making it fairly unreactive: in particular, benzene does not undergo addition reactions as alkenes do. The same stability holds true for other aromatic compounds, since the definition of an aromatic compound includes the presence of a delocalized pi electron system.

REACTIONS

Electrophilic Aromatic Substitution

The most important reaction of aromatic compounds is electrophilic aromatic substitution. In this reaction an electrophile replaces a proton on an aromatic ring, producing a substituted aromatic compound. Because benzene is nonreactive, a form of acidic catalyst is required for the substitution reaction to proceed. The most common examples of substitution reactions are halogenation, sulfonation, nitration, and acylation.

Halogenation

Aromatic rings react with bromine or chlorine in the presence of a Lewis acid, such as $FeCl_3$, $FeBr_3$, or $AlCl_3$, to produce monosubstituted products in good yield. Reaction of fluorine and iodine with aromatic rings is less useful, as fluorine tends to produce multisubstituted products, and iodine's lack of reactivity requires special conditions for the reaction to proceed.

Figure 44.7

Sulfonation

Aromatic rings react with fuming sulfuric acid (a mixture of sulfuric acid and sulfur trioxide) to form sulfonic acids.

Figure 44.8

Nitration

The nitration of aromatic rings is another synthetically useful reaction. A mixture of nitric and sulfuric acids is used to create the nitronium ion, NO_2^+, a strong electrophile. This reacts with aromatic rings to produce nitro compounds.

Figure 44.9

Acylation (Friedel-Crafts reactions)

In a Friedel-Crafts acylation reaction, a carbocation electrophile, usually an acyl group, is incorporated into the aromatic ring. These reactions are usually catalyzed by Lewis acids such as $AlCl_3$. This reaction can also be used to add alkyl groups, but the reaction is difficult to control and can lead to multiple products.

Figure 44.10

Substituent effects

The first substituent on an aromatic ring strongly influences the susceptibility of the ring to further electrophilic aromatic substitution, and also strongly affects what position on the ring another electrophile is most likely to attack. Substituents can be grouped into three different classes according to whether they are activating or deactivating, and where on the ring the next reaction is likely to take

place. Activators cause the next reaction to occur more quickly and more easily; deactivators cause the next reaction to occur more slowly and with greater difficulty. These effects depend on whether the group tends to donate or withdraw electron density.

The three classes of substituents, each in decreasing strength of effect, are:

a. Activating, *ortho/para*-directing substituents (electron-donating): $NH_2 > NR_2 > OH > NHCOR > OR > OCOR > R$

b. Deactivating, *ortho/para*-directing substituents (weakly electron-withdrawing): $F > Cl > Br > I$

c. Deactivating, *meta*-directing substituents (electron-withdrawing): $NO_2 > SO_3H >$ carbonyl compounds, including COOH, COOR, COR, and CHO

Example: When toluene undergoes electrophilic aromatic substitution, the methyl group directs substitution to occur primarily at the *ortho* and *para* positions:

63% 34% 3%

Figure 44.11

Reduction

Catalytic Reduction

Benzene rings can be reduced by catalytic hydrogenation under vigorous conditions (elevated temperature and pressure) to yield cyclohexane. Ruthenium or rhodium on carbon are the most common catalysts; platinum or palladium may also be used.

Figure 44.12

REVIEW PROBLEMS

1. Predict aromatic, anti-aromatic, or nonaromatic behavior for each of the following compounds.

A.

B.

C.

D.

E.

2. Which of the following represents the correct structure for *para*-nitrotoluene?

A. CH_2NH_2

B. NO_2 ... CH_3

C. NO_2 ... H_3C

D. NH_2 ... H_3C

E. None of the above

3. What would be the major product of the following reaction?

$$\text{—CH}_3 \quad + \quad C_2H_5COCl \quad \xrightarrow{\text{AlCl}_3} \quad ?$$

A.

B.

C.

D.

E. None of the above

4. Nitration of benzene at 30°C leads to a 95 percent yield of nitrobenzene. When the temperature is increased to 100°C, dinitrobenzene is produced. Which of the following is the predominant product?

A. NO_2, NO_2

B. NO_2, NO_2

C. NO_2, NO_2

D. NO_2

E. None of the above

5. What is the major product of the nitration reaction below?

NO$_2$
Br

NO$_2$

$\dfrac{H_2SO_4}{HNO_3}$ → ?

A.
NO$_2$
Br
O$_2$N
NO$_2$

B.
NO$_2$
Br
NO$_2$
Br

C.
O$_2$N
NO$_2$
Br
NO$_2$

D.
Br
NO$_2$
O$_2$N
Br

E. None of the above

6. Which represents the predominant product(s) of the reaction below?

NO$_2$

$\dfrac{Br_2}{FeBr_3}$ → ?

A.
NO$_2$
Br

B.
NO$_2$
Br

C.
NO$_2$
Br

D.
Br
O$_2$N

E. None of the above

7. Which sequence of reaction conditions should be used to produce the compound below from benzene?

A. $AlCl_3/Cl_2$; H_2/Pt
B. Cl_2/UV light; H_2/Pt
C. H_2/Pt; $AlCl_3/Cl_2$
D. HCl; H_2/Pt
E. Cl_2/UV light; $AlCl_3/Cl_2$

SOLUTIONS TO REVIEW PROBLEMS

1. **A** Nonaromatic. This compound has $4n + 2 = 6$ pi electrons ($n = 1$), and is a conjugated system; however, it is not cyclic.

 B Nonaromatic. This compound has $4n + 2 = 6$ pi electrons ($n = 1$) and is cyclic. However, there is no conjugation of the double bonds.

 C Aromatic. This compound (naphthalene) is cyclic, has $4n +2 = 8$ pi electrons ($n = 2$), and has a conjugated system of double bonds.

 D Anti-aromatic. This compound is cyclic and conjugated. However, it has only $4n = 4$ pi electrons ($n = 1$).

 E Aromatic. This class of compounds (alkyl anilinium ions) has $4n + 2 = 6$ pi electrons ($n = 1$), is cyclic, and has conjugated double bond systems.

2. **C** Toluene is the common name for methylbenzene: a methyl group attached to a benzene ring. In *para*-nitrotoluene, the nitro group (NO_2) is attached to the ring directly across from the methyl group. Choice (C) is the correct response. Choice (B) is incorrect because the nitro group is *meta*, not *para* substituted. Choices (A) and (D) can be eliminated since nitro groups are not present in these compounds.

3. **B** The reaction shown, a Friedel-Crafts acylation of toluene, will yield a product containing a $-CH_3$ substituent and a $-C=O$ substituent. Chlorination of the ring also uses $AlCl_3$ as a reagent, but the second reagent would have to be Cl_2, not C_2H_5COCl; thus, choices (C) and (D) (both chlorotoluenes) can be eliminated. Since CH_3 is an activating, *ortho/para*-directing group, the *meta* isomer, choice (A), would be a minor product at best. Choice (B), the *para* isomer, would be favored by the substituent effect of the methyl group, and along with the *ortho* isomer (which is not among these choices) would be the major product.

4. **C** *meta*-dinitrobenzene is the predominant product since $-NO_2$ is a *meta*-directing group.

5. **A** All three substituents of 2-bromo-1,3-dinitrobenzene direct reaction to C−5, which is *meta* to both nitro groups and *para* to the bromine atom, so choice (A) will be the major product. Since all three groups are deactivating, the reaction will be slow and require elevated temperatures to proceed.

6. **B** This reaction shows the bromination of nitrobenzene. Choices (A) and (D) are actually different views of the same compound. Since aromatic rings are planar, rings that are mirror images are identical (although alkyl substituents of benzene rings may still have chiral centers, and molecules containing such groups may be chiral). Choice (B) shows *meta*-bromonitrobenzene, which is the favored product of this reaction since the nitro substituent is *meta*-directing. Choices (A) and (D) show the *para* isomer, while (C) shows the *ortho* isomer, both of which are less favored in this reaction.

7. **A** In order to produce chlorocyclohexane, two different procedures must be carried out: the benzene ring must be chlorinated and then hydrogenated. A suitable way to chlorinate the ring is to use Cl_2 and the Lewis acid $AlCl_3$, which is choice (A). Using chlorine in the

presence of UV light will not be effective, so choices (B) and (E) are incorrect. Choice (D) is incorrect because HCl will not chlorinate the ring. Now for the second step: hydrogenation. Hydrogenation of the benzene ring can be accomplished by using hydrogen in the presence of a platinum catalyst, so choice (A) is the correct answer. If the procedure were carried out according to choice (C), reduction would occur, forming cyclohexane, but chlorination would not, since cyclohexane is unreactive towards chlorine and the Lewis acid catalyst.

CHAPTER FORTY-FIVE

Alcohols and Ethers

LEARNING OBJECTIVES

After this chapter, you will be able to:

- Recall nomenclature, physical properties, and key reaction mechanisms for alcohols and ethers
- Explain the methods of alcohol and ether synthesis
- Predict the products of reactions of alcohols and ethers

Alcohols are compounds with the general formula **ROH**. The functional group –**OH** is called the **hydroxyl** group. An alcohol can be thought of as a substituted water molecule, with an alkyl group R replacing one **H** atom.

An ether is a compound with two alkyl or aryl groups bonded to a single oxygen atom. The general formula for an ether is R-O-R, and ethers can be thought of as disubstituted water molecules.

The nomenclature, properties, synthesis, and reactions of alcohols will be discussed in the following sections; subsequently the same topics will be reviewed for ethers.

NOMENCLATURE OF ALCOHOLS

Alcohols are named in the IUPAC system by replacing the **-e** ending of the root alkane with the ending **-ol**. The —OH group has high priority for naming; the carbon atom attached to the hydroxyl group usually must be included in the longest chain and receive the lowest possible number. Some examples are:

2-propanol 4,5-dimethyl-2-hexanol

Figure 45.1

The common names for alcohols are given by naming the alkyl group as a derivative, followed by the word *alcohol*.

ethyl alcohol isobutyl alcohol

Figure 45.2

Compounds of the general formula ArOH, with a hydroxyl group attached to an aromatic ring, are called **phenols**.

phenol p-nitrophenol m-cresol o-bromophenol
 (m-methylphenol)

Figure 45.3

PHYSICAL PROPERTIES OF ALCOHOLS

Alcohols have a hydrogen attached directly to an oxygen, and thus are able to form **hydrogen bonds**. As a result of these strong intermolecular attractions, the boiling points of alcohols are significantly higher than those of their analogous hydrocarbons.

Figure 45.4

Molecules with more than one hydroxyl group show greater degrees of hydrogen bonding, as shown by the following boiling points:

| Boiling Point (°C) | − 42.1 | 97.4 | 189.0 | 290.0 |

Figure 45.5

The hydrogen atom of the hydroxyl group is weakly acidic, and alcohols can dissociate into protons and alkoxy ions just as water dissociates into protons and hydroxide ions. pK_a values of several compounds are listed below. The presence of electron withdrawing groups such as fluorine stabilize the negatively charged conjugate base of the alcohol, thus decreasing the pK_a. Conversely, alkyl groups destabilize the anionic form because of their electron donating properties, thereby increasing the pK_a. Note that as pK_a decreases, acidity increases; acids and pK_a values are discussed in Chapter 36, Acids and Bases.

	Dissociation	pK_a
H_2O	\rightleftharpoons $HO^- + H^+$	15.7
CH_3OH	\rightleftharpoons $CH_3O^- + H^+$	15.5
C_2H_5OH	\rightleftharpoons $C_2H_5O^- + H^+$	15.9
$i\text{-PrOH}$	\rightleftharpoons $i\text{-PrO}^- + H^+$	17.1
$t\text{-BuOH}$	\rightleftharpoons $t\text{-BuO}^- + H^+$	18.0
CF_3CH_2OH	\rightleftharpoons $CF_3CH_2O^- + H^+$	12.4
$PhOH$	\rightleftharpoons $PhO^- + H+$	≈ 10.0

Table 45.1

Phenols are more acidic than aliphatic alcohols, due to resonance structures that distribute the negative charge of the conjugate base throughout the ring, thus stabilizing the anion. This acidity allows phenols to readily form salts with inorganic bases such as NaOH. Phenols readily form intermolecular hydrogen bonds and have relatively high melting and boiling points. However, phenol and many of its derivatives are only slightly soluble in water due to the conflicting effects of the hydrophobicity of the phenyl ring and the ability of the −OH group to hydrogen bond. The presence of other substituents on the ring has significant effects on the acidity, boiling point, and melting point of phenols. As with other aromatic compounds, electron-withdrawing substituents increase acidity by stabilizing the negatively charged conjugate base, and electron-donating groups decrease acidity.

OVERVIEW OF ALCOHOLS

Key Reaction Mechanisms for Alcohols

Several basic reaction mechanisms occur over and over in the chemistry of alcohols (and ethers in many cases as well). These reactions provide a framework for understanding and learning how the alcohols behave, and specific examples will be shown in the sections on both synthesis and reactions of alcohols that follow.

1. S_N1 and S_N2 nucleophilic substitution to create alcohols. Conversely, protonation of an alcohol allows it act as a leaving group in these reactions. See Chapter 42 for a review of S_N1 and S_N2 reaction mechanisms.

2. Electrophilic addition of water to a double bond to create an alcohol. Conversely, elimination reactions (E1, E2) remove hydroxyls to create a double bond. Addition and elimination reactions are discussed in Chapter 43.

3. Nucleophilic addition to a carbonyl to create an alcohol. This reaction type is discussed further in Chapters 44–46.

4. Oxidation and reduction: Alcohols are at the most reduced end of the oxidation-reduction continuum (shown in Table 45.2 below), as they have only single bonds to oxygen. Carbonyl-containing compounds are more oxidized, as demonstrated by the larger number of bonds to oxygen from a single carbon. Additional discussion of alcohols relative to aldehydes, ketones, and carboxylic acids is found in Chapters 46 and 47.

Oxidation ⟶

1° alcohols ⟷ aldehydes ⟷ carboxylic acids

2° alcohols ⟷ ketones

⟵ *Reduction*

Table 45.2

SYNTHESIS OF ALCOHOLS

Alcohols can be prepared from a variety of different types of compounds. Methanol, also called wood alcohol, is obtained from the destructive distillation of wood. It is toxic and can cause blindness if ingested. Ethanol, or grain alcohol, is produced from the fermentation of sugars and can be metabolized by the body; however, in large enough quantities, it too is toxic.

Addition Reactions

Alcohols can be prepared via several reactions that involve addition of water to double bonds (see Chapter 41).

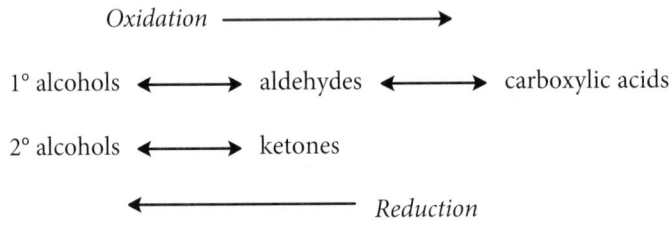

Figure 45.6

Alcohols can also be prepared from the addition of organometallic compounds (Grignard reagents) to carbonyl groups (see Chapter 46).

CH_3MgBr +

Figure 45.7

Substitution Reactions

Both S_N1 and S_N2 reactions can be used to produce alcohols under the appropriate reaction conditions (see Chapter 42). For example:

$$CH_3Br + OH^- \rightarrow CH_3OH + Br^-$$

Reduction Reactions

Alcohols can be prepared from the reduction of aldehydes, ketones, carboxylic acids, or esters. Lithium aluminum hydride ($LiAlH_4$, or LAH) and sodium borohydride ($NaBH_4$) are the two most frequently used reducing reagents. LAH is stronger and less specific, whereas $NaBH_4$ is milder and more selective. For example, LAH will reduce carboxylic acids and esters to alcohols, while $NaBH_4$ will not. Both LAH and $NaBH_4$, however, will reduce aldehydes and ketones to alcohols.

Figure 45.8

Phenol Synthesis

Phenols may be synthesized from arylsulfonic acids with heat and NaOH. However, this reaction is useful only for phenol or its alkylated derivatives, as most functional groups are destroyed by the harsh reaction conditions.

A more versatile method of synthesizing phenols proceeds using hydrolysis of diazonium salts.

Figure 45.9

REACTIONS OF ALCOHOLS

Elimination Reactions

Alcohols can be **dehydrated** in strongly acidic solution (usually H_2SO_4) to produce alkenes. The mechanism of this dehydration reaction is E1, and proceeds by first protonating the alcohol and then removing a water molecule to form the double bond.

minor

major

Figure 45.10

Notice that two products are obtained, with the more stable alkene being the major product. This occurs via movement of a proton to produce the more stable 2° carbocation. This type of rearrangement is commonly encountered with carbocations.

Substitution Reactions

The direct displacement of hydroxyl groups in substitution reactions is rare because the hydroxide ion is a poor leaving group. However, the hydroxyl group can be converted to a good leaving group using two different approaches. Protonating the alcohol makes water the leaving group, which works well for S_N1 reactions. Alternatively, the alcohol can be converted into a tosylate (*p*-toluenesulfonate) group, which is an excellent leaving group for S_N2 reactions (see Figures 45.11a and 45.11b).

Figure 45.11a

Figure 45.11b

Another substitution reaction that serves as a common method of converting alcohols into alkyl halides is through the formation of inorganic esters, which then readily undergo S_N2 reactions. Alcohols react with thionyl chloride to produce a chlorosulfite intermediate and HCl. The chloride ion of HCl then displaces SO_2 and regenerates Cl^-, forming the desired alkyl chloride.

Figure 45.12

An analogous reaction in which the alcohol is treated with PBr_3 instead of thionyl chloride produces alkyl bromides.

Phenols readily undergo electrophilic aromatic substitution reactions. Because the $-OH$ group of phenol has lone pairs that can be donated to the ring, the $-OH$ is a strongly activating, *ortho/ para*-directing ring substituent (see Chapter 44).

Oxidation Reactions

The oxidation of alcohols generally involves a metal oxidizing agent such as chromium or manganese. For example, some form of chromium (VI) is reduced to chromium (III) during the reaction. PCC (pyridinium chlorochromate, $C_5H_6NCrO_3Cl$) is commonly used as a mild oxidant. It converts primary alcohols to aldehydes but does not continue the oxidation to the carboxylic acid. PCC can also be used to convert a secondary alcohol to a ketone.

Figure 45.13

Potassium permanganate ($KMnO_4$) is a very strong oxidizing agent that will react with a primary alcohol to create a carboxylic acid or with a secondary alcohol to create a ketone. Another reagent used to oxidize primary or secondary alcohols is alkali (either sodium or potassium) dichromate salt.

Figure 45.14

A stronger oxidant is chromium trioxide, CrO_3. This is often dissolved with dilute sulfuric acid in acetone; the mixture is called Jones reagent. It oxidizes primary alcohols to carboxylic acids and secondary alcohols to ketones.

Figure 45.15

Tertiary alcohols cannot be oxidized as the carbon-carbon bonds are resistant to oxidizing agents, and therefore no second bond to the oxygen can be created.

Treatment of phenols with oxidizing reagents produces compounds called quinones (2,5-cyclo-hexadiene-1, 4-diones).

1,4-Benzenediol *p*-Benzoquinone

Figure 45.16

ETHERS

An ether is a compound with two alkyl (or aryl) groups bonded to an oxygen atom. The general formula for an ether is **ROR**. Ethers can be thought of as disubstituted water molecules. The most familiar ether is diethyl ether, once used as a medical anesthetic. The following sections describe the nomenclature, properties, synthesis, and reactions of ethers.

NOMENCLATURE OF ETHERS

Ethers are named according to IUPAC rules as **alkoxyalkanes,** with the smaller chain as the prefix and the larger chain as the suffix. There is a common system of nomenclature in which ethers are named as alkyl alkyl ethers. In this system, methoxyethane would be named ethyl methyl ether. The alkyl substituents are alphabetized.

methoxyethane

(ethyl methyl ether)

ethoxybenzene

(ethyl phenyl ether)

Figure 45.17

Exceptions to these rules occur for cyclic ethers, also known as oxiranes, for which many common names also exist.

oxirane

(epoxide)

oxyethane

oxacyclopentane

(tetrahydrofuran)

Figure 45.18

PHYSICAL PROPERTIES

Ethers do not undergo hydrogen bonding because they have no hydrogen atoms bonded to the ether oxygen atoms. Ethers therefore boil at relatively low temperatures compared to alcohols; in fact, they boil at approximately the same temperatures as alkanes of comparable molecular weight.

Ethers are only slightly polar and therefore only slightly soluble in water. They are relatively inert to most organic reagents and are frequently used as solvents. However, ethers can form highly reactive peroxides (see Reactions of Ethers), requiring careful storage and handling.

SYNTHESIS OF ETHERS

Ethers are readily synthesized by the condensation of two molecules of an alcohol in the presence of acid, producing a symmetrical ether and water in a substitution reaction:

Figure 45.19

The Williamson ether synthesis produces asymmetrical ethers from the reaction of metal alkoxide ions with primary alkyl halides or tosylates. The alkoxides behave as nucleophiles and displace the halide or tosylate in an S_N2 reaction, producing an ether.

Figure 45.20

Because this is an S_N2 mechanism, alkoxides will attack only nonhindered halides. Thus, to synthesize a methyl ether, an alkoxide must attack a methyl halide; the reaction cannot be accomplished with the methoxide ion attacking a highly substituted alkyl halide substrate.

The Williamson ether synthesis can also be applied to phenols. Relatively mild reaction conditions are sufficient, due to the acidity of phenols.

Figure 45.21

Cyclic ethers, also known as oxiranes, are prepared in a number of ways. Oxiranes can be synthesized by means of an internal S_N2 displacement. Since the nucleophile and substrate are part of the same molecule, they are in close proximity, facilitating the reaction.

Figure 45.22

Oxidation of an alkene with a **peroxy acid** (general formula RCOOOH) such as mCPBA (*m*-chloroperoxybenzoic acid) will also produce an oxirane.

Figure 45.23

REACTIONS

Peroxide Formation

Ethers react with the oxygen in air to form highly explosive compounds called **peroxides** (general formula ROOR). For this reason, ethers are typically stored at low temperature and away from light.

Cleavage

Cleavage of straight-chain ethers will take place only under vigorous conditions: usually at high temperatures in the presence of HBr or HI. Cleavage is initiated by protonation of the ether oxygen. The reaction then proceeds by an S_N1 or S_N2 mechanism, depending on the conditions and the structure of the ether (note the difference in substitution of the substrates in Figure 45.24). Although not shown below, the alcohol products usually react with a second molecule of hydrogen halide to produce a second alkyl halide.

Figure 45.24

The same basic principles and reaction mechanisms of substitution reactions apply to epoxides. Since epoxides are highly strained cyclic ethers, they are susceptible to S_N2 reactions. Unlike straight-chain ethers, these reactions can be catalyzed by acids or bases. In symmetrical epoxides, either carbon can be attacked by a nucleophile; however, in asymmetrical epoxides, the most substituted carbon is attacked by the nucleophile in the presence of acid, and the least substituted carbon is attacked in the presence of base:

Figure 45.25

Reactions of epoxides provide additional insight into S_N1 and S_N2 reaction mechanisms. Base-catalyzed cleavage of epoxides has the most S_N2 character, so it occurs at the least hindered (least substituted) carbon. The basic environment provides the strong nucleophile required for S_N2 reactions.

In contrast, acid-catalyzed cleavage is thought to have some S_N1 character as well as some S_N2 character. The epoxide oxygen can be protonated, making it a better leaving group. This gives the carbons partial positive charges. Since substitution stabilizes this charge (3° carbons provide the most stable carbocations), the more substituted C becomes a good target for nucleophilic attack.

REVIEW PROBLEMS

1. Provide IUPAC names for the following alcohols and classify them as primary, secondary, or tertiary.

2. Alcohols have higher boiling points than their analogous ethers and hydrocarbons because

 A. the oxygen atoms in alcohols have shorter bond lengths.
 B. hydrogen bonding is present in alcohols.
 C. alcohols are more acidic than their analogous ethers or hydrocarbons.
 D. alcohols are lighter than their analogous ethers or hydrocarbons.
 E. ether and hydrocarbons are more electronegative than alcohols.

3. Why are alcohols of lower molecular weight more soluble in water than those of higher molecular weight?

4. Tertiary alcohols are oxidized with difficulty because

 A. there is no hydrogen attached to the carbon with the hydroxyl group.
 B. there is no hydrogen attached to the α-carbon.
 C. they contain hydroxyl groups with no polarization.
 D. they are relatively inert.
 E. they don't contain any oxygen atoms.

5. Which of the following reagents should be used to convert $CH_3(CH_2)_3CH_2OH$ into $CH_3(CH_2)_3CHO$?

 A. $KMnO_4$
 B. Jones reagent
 C. PCC
 D. $LiAlH_4$
 E. H_2/Pd

6. The reaction of 1 mole of diethyl ether with excess hydrobromic acid results in the production of

 A. 2 moles of ethyl bromide.
 B. 2 moles of ethanol.
 C. 1 mole of ethylbromide and 1 mole of ethanol.
 D. 1 mole of methylbromide and 1 mole of propanol.
 E. 1 mole of methylbromide only.

7. Which of the following reagents should be used to oxidize the steroid hormone testosterone to 4-androsterone-3,17-dione?

testosterone 4-androsterone-3,17-dione

 A. Dilute $KMnO_4$
 B. O_3/CH_2Cl_2; Zn/H_2O
 C. PCC
 D. $LiAlH_4$
 E. H_2/Pd

SOLUTIONS TO REVIEW PROBLEMS

1. **A 3-methyl-1-heptanol**

 A primary alcohol

 B 2-methyl-2-propanol, commonly called *t*-butyl alcohol or *t*-butanol

 A tertiary alcohol

 C 2-methyl-1-propanol, commonly called isobutyl alcohol

 A primary alcohol

 D cyclohexanol

 A secondary alcohol

 E *cis*-2-methylcyclopentanol

 A secondary alcohol

 F 5-methyl-3-propyl-1-hexanol

 A primary alcohol

2. **B** Alcohols have higher boiling points than their analogous ethers and hydrocarbons because alcohols have a polarized O−H bond in which the oxygen is partially negative and the hydrogen is partially positive. This enables the oxygen atoms of other alcohol molecules to be attracted to the hydrogen to form a hydrogen bond. These hydrogen bonds make it difficult for the alcohol to vaporize, thereby increasing the boiling point. The analogous hydrocarbons and ethers do not form hydrogen bonds and therefore vaporize at lower temperatures. Choice (A) is a nonsense choice. The bond length of the oxygen is not a factor in determining the boiling point of a substance. Choice (C) is incorrect because, although alcohols are more acidic than their analogous ethers or hydrocarbons, this property does not affect the boiling point of a substance. Choices (D) and (E) are not always true and even if so would promote lower boiling points rather than higher since either would result in the alcohols having relatively weaker intermolecular forces.

3. Alcohols of lower molecular weight are more soluble in water than larger alcohols because the hydrophilic hydroxyl group can form hydrogen bonds with water. The nonpolar hydrocarbon chain is not solvated by the water because the alkyl group is hydrophobic. As the molecular weight of an alcohol increases, so does the length of the hydrocarbon chain, making the alcohol more hydrophobic. As the molecule becomes more hydrophobic, the alcohol becomes less soluble in water.

4. **A** Tertiary alcohols can be oxidized only under extreme conditions because they do not have a hydrogen attached to the carbon with the hydroxyl group. Alcohol oxidation involves the removal of such a hydrogen; if none is present, a carbon-carbon bond must be cleaved instead. This requires a great deal of energy and will therefore occur only under extreme conditions. Choice (B) is incorrect because the number of hydrogens attached to the α-carbon is irrelevant to the mechanism of alcohol oxidation. Choices (C), (D), and (E) are false statements.

5. **C** The best way to prepare aldehydes from primary alcohols is to use PCC (pyridinium chlorochromate, $C_5H_6NCrO_3Cl$), which is choice (C). $KMnO_4$, choice (A), is a strong oxidizing agent and converts a primary alcohol to a carboxylic acid. Jones reagent, choice (B), also converts a primary alcohol into a carboxylic acid. $LiAlH_4$, choice (D), and H_2/Pd, choice (E), are a reducing agents so would not add more bonds to oxygen.

6. **A** When 1 mole of an ether reacts with excess HBr, the initial products are 1 mole alcohol and 1 mole alkyl bromide, choice (C). However, under these acidic conditions, Br displaces H_2O, resulting ultimately in 1 mole each of two alkyl bromides. In this case, since the ether is symmetric, the product is 2 moles ethyl bromide, choice (A). Choice (B) is incorrect because under these conditions, the alcohol is protonated, and H_2O (a good leaving group) is replaced by Br to form ethyl bromide. Choice (D) is incorrect because the ether molecule is split at the oxygen atom; it does not rearrange, as would be required to produce a 3-carbon and a 1-carbon fragment. Choice (E) is incorrect because it does not account for all of the carbons of the original reactants.

7. **C** The best way to oxidize this 2° alcohol to a ketone is with PCC, choice (C). $KMnO_4$, choice (A), would oxidize the double bond to a diol, while $LiAlH_4$, choice (D), and H_2/Pd, choice (E), are reducing agents, not oxidizing agents. Choice (B) is incorrect because ozone would cleave the double bond in testosterone.

CHAPTER FORTY-SIX

Aldehydes and Ketones

LEARNING OBJECTIVES

After this chapter, you will be able to:

- Recall nomenclature, physical properties, and key reaction mechanisms for aldehydes and ketones
- Explain methods of aldehyde and ketone synthesis
- Predict the products of reactions of aldehydes and ketones

Aldehydes and **ketones** are compounds that contain the **carbonyl group, C=O**, a double bond between a carbon atom and an oxygen atom. A ketone has two alkyl or aryl groups bonded to the carbonyl, placing the carbonyl group in the middle of the molecule. An aldehyde has one alkyl group and one hydrogen (or, in the case of formaldehyde, two hydrogens) bonded to the carbonyl; thus, an aldehyde is always found at the end of a molecule. Functional groups found at the end of a molecule are often called **terminal groups**.

The carbonyl group is one of the most important functional groups in organic chemistry in large part because it possesses a dipole moment: the carbon carries a partial positive charge, and the oxygen carries a partial negative charge. In addition to its presence in aldehydes and ketones, it is also found in carboxylic acids, esters, amides, and more complicated compounds. These additional carbonyl compounds are discussed in Chapters 47 and 48.

NOMENCLATURE

Because of their high degree of oxidation, aldehydes and ketones are usually the priority group in naming compounds. Note that the shorthand for an aldehyde group is always written –CHO; this should not be confused with the shorthand for an alcohol, which is C–OH.

In the IUPAC system, molecules containing an aldehyde as the most oxidized group are named with the suffix **-al**. The position of such an aldehyde group does not need to be specified: it must occupy the terminal (C–1) position. Common names exist for the first five aldehydes: formaldehyde, acetaldehyde, propionaldehyde, butyraldehyde, and valeraldehyde.

 Section IV: Organic Chemistry

methanal
(formaldehyde)

ethanal
(acetaldehyde)

propanal
(propionaldehyde)

butanal
(butyraldehyde)

pentanal
(valeraldehyde)

Figure 46.1

In more complicated molecules, the suffix -**carbaldehyde** can be used. In addition, the aldehyde can be named as a functional group with the prefix **formyl-** when combined in a molecule with an even higher priority carboxylic acid group.

cyclopentanecarbaldehyde

m-formylbenzoic acid

Figure 46.2

Ketones are named with the suffix -**one**. The location of the carbonyl group must be specified with a number, except in cyclic ketones, where it is assumed to occupy the number 1 position. The common system of naming ketones lists the two alkyl groups followed by the word *ketone*. When it is necessary to name the carbonyl as a substituent, the prefix **oxo-** is used.

2-propanone
(dimethyl ketone)
(acetone)

2-butanone
(ethyl methyl ketone)

3-oxobutanoic acid

cyclopentanone

Figure 46.3

PHYSICAL PROPERTIES

The physical properties of aldehydes and ketones are governed by the presence of the carbonyl group and its strong dipole moment. Due to differences in electronegativity, the carbon carries a strong partial positive charge, and the oxygen carries a strong partial negative charge. The dipole moments associated with the polar carbonyl groups of nearby molecules align, causing an elevation in boiling point of aldehydes and ketones relative to similar alkanes. However, aldehydes and ketones show lower boiling points than comparable alcohols because –OH groups can form hydrogen bonds, but carbonyls cannot.

Figure 46.4

OVERVIEW OF ALDEHYDES AND KETONES

Aldehydes and ketones are midway along the oxidation-reduction continuum (shown below). The carbonyl carbon has two bonds to oxygen, placing it between the single C–O bond of alcohols and the three carbon-oxygen bonds of the carboxyl group.

Table 46.1

There are numerous methods of preparing aldehydes and ketones, but three are of particular interest: oxidation of alcohols, oxidative cleavage of alkenes, and Friedel-Crafts acylation of benzenes. These three mechanisms are important to study both as synthetic pathways of aldehydes and ketones and also as reaction pathways for other compounds.

The reactions of aldehydes and ketones are likewise interrelated with those of other compounds and are often driven by the dipole moment of the carbon-oxygen double bond. Aldehydes and ketones can be oxidized or reduced to form carboxylic acids or alcohols, respectively. They can act as either the nucleophile or substrate in S_N1 and S_N2-type reactions. They can serve as the substrate for nucleophilic attack on the carbonyl to produce alcohols, ethers, amides, and related compounds. They can condense to form larger molecules and to create double bonds.

Although the variety of aldehyde and ketone reaction pathways can appear overwhelming, studying them in the context of other organic molecules allows a greater understanding of the overall mechanisms involved.

SYNTHESIS OF ALDEHYDES AND KETONES

Oxidation of Alcohols

An aldehyde can be obtained from the oxidation of a primary alcohol; a ketone can be obtained from a secondary alcohol. These reactions are usually performed with PCC (one of the only options to create an aldehyde), potassium permanganate, sodium or potassium dichromate, or chromium trioxide (Jones reagent). These reactions are discussed in Chapter 45.

Figure 46.5

Figure 46.6

Oxidative Cleavage of Alkenes

Double bonds can be oxidatively cleaved with ozone to yield aldehydes and/or ketones (see Chapter 43).

Figure 46.7

Ketones can also be synthesized by the cleavage of disubstituted alkenes with potassium permanganate:

Figure 46.8

Friedel-Crafts Acylation

This reaction, discussed in Chapter 44, produces ketones of the form R–CO–Ar from benzene and an acyl halide in the presence of a Lewis acid such as $AlCl_3$.

Figure 46.9

REACTIONS OF ALDEHYDES AND KETONES

Oxidation and Reduction

Aldehydes and ketones occupy the middle of the oxidation-reduction continuum. They are more oxidized than alcohols but less oxidized than carboxylic acids.

Aldehydes can be oxidized with a number of different reagents, such as $KMnO_4$, $K_2Cr_2O_7$, CrO_3, Ag_2O (Tollen's reagent), or H_2O_2. The product of oxidation of an aldehyde is a carboxylic acid. Ketones cannot undergo further oxidation unless extraordinarily harsh conditions are used to break C–C bonds.

Figure 46.10

A number of different reagents will reduce aldehydes and ketones to alcohols. The two most common are lithium aluminum hydride (LAH), which is a stronger reducing agent, and sodium borohydride ($NaBH_4$), which is milder; both, however, are effective on aldehydes and ketones.

Figure 46.11

Aldehydes and ketones can be completely reduced to alkanes by two common methods. In the **Wolff-Kishner** reduction, the carbonyl is first converted to a hydrazone, which then releases molecular nitrogen (N_2) when heated and forms an alkane. The Wolff-Kishner reaction is performed in basic solution and therefore is only useful when the product is stable under basic conditions.

Figure 46.12

An alternative reduction to the alkane is the **Clemmensen reduction**, where an aldehyde or ketone is heated with amalgamated zinc in hydrochloric acid.

Figure 46.13

Enolization and Reactions of Enols

Aldehydes and ketones can act as nucleophiles when they undergo rearrangement to a slightly different form. Protons alpha to carbonyl groups (one carbon away) are relatively acidic ($pK_a \approx$ 20), due to resonance stabilization of the conjugate base. A hydrogen atom that detaches itself from the alpha carbon has a finite probability of reattaching itself to the oxygen instead of the carbon. Therefore, aldehydes and ketones exist in solution as a mixture of two structural isomers, the familiar **keto** form and the **enol** form, representing the unsaturated alcohol (**ene** = the double bond, **ol** = the alcohol, so **ene** + **ol** = **enol**). The two isomers, which differ only in the placement of a proton, are called **tautomers**. The equilibrium between the tautomers lies far to the keto side. The process of interconverting from the keto to the enol tautomer is called **enolization**.

Figure 46.14

Enols are the necessary intermediates in many reactions in which aldehydes and ketones act as nucleophiles. The enolate carbanion can be created with a strong base such as lithium diisopropyl amide (LDA) or potassium hydride, KH, either of which remove the proton from the –OH group. The resulting nucleophilic carbanion will react with an α,β-unsaturated carbonyl compound in a reaction called a **Michael addition** (see Figure 46.15).

Figure 46.15

Addition Reactions

General reaction mechanism: nucleophilic addition to a carbonyl

A key property of aldehydes and ketones is the dipole created by the partially positive carbonyl carbon and the partially negative oxygen. The partial positive charge on the carbon creates a site for attack by a wide variety of electron-rich nucleophiles. Nucleophilic attack creates a tetrahedral intermediate in which the carbon-oxygen bond is reduced to a single bond and the oxygen carries a full negative charge. Because there is no good leaving group present in an aldehyde or a ketone, the carbonyl cannot re-form and an alcohol will be the end product after protonation. This general mechanism is the basis for many reactions of aldehydes and ketones that appear to be different but actually follow the same principles.

Figure 46.16

Hydration

In the presence of water, aldehydes and ketones react to form **geminal diols** (1,1-diols or *gem* diols). In this case, water acts as the nucleophile attacking at the carbonyl carbon. This hydration reaction proceeds slowly; the rate may be increased by the addition of a small amount of acid or base.

Figure 46.17

Acetal and ketal formation

A reaction similar to hydration occurs when aldehydes and ketones are treated with alcohols. When one equivalent of alcohol (the nucleophile in this reaction) is added to an aldehyde or ketone, the product is a **hemiacetal** or a **hemiketal,** respectively. When two equivalents of alcohol are added, the product is an **acetal** or a **ketal,** respectively. The reaction mechanism is the same as for hydration and is catalyzed by anhydrous acid. Acetals and ketals, which are comparatively inert, are frequently used as protecting groups for carbonyl functionalities. They can easily be converted back to the carbonyl with aqueous acid.

aldehyde hemiacetal

Figure 46.18

The aldehyde–hemiacetal–acetal and ketone–hemiketal–ketal reaction schemes with ROH.

aldehyde → hemiacetal → acetal

ketone → hemiketal → ketal

Figure 46.19

Reaction with hydrogen cyanide

Aldehydes and ketones react with HCN (hydrogen cyanide) to produce stable compounds called **cyanohydrins.** HCN dissociates and the strongly nucleophilic cyanide anion attacks the carbonyl carbon atom. Protonation of the oxygen produces the cyanohydrin. The cyanohydrin gains its stability from the newly formed C–C bond (in contrast, when a carbonyl reacts with HCl, a weak C–Cl bond is formed, and the resulting chlorohydrin is unstable).

$$H^+ + CN^- + \text{(ketone)} \longrightarrow H^+ + \text{(alkoxide with CN)} \longrightarrow \text{(cyanohydrin OH, CN)}$$

Figure 46.20

Condensations with ammonia derivatives

Ammonia and some of its derivatives are nucleophiles and can add to carbonyl compounds, but a different final product is created than in other nucleophilic attacks. In the net reaction, the C=O bond is replaced by a C=N bond. In the simplest case, ammonia adds to the carbon atom and the –OH group is protonated and lost as a molecule of water. This reaction produces an **imine,** a compound with a nitrogen atom double-bonded to a carbon atom. (A reaction in which water is lost between two molecules is called a **condensation reaction.**)

Figure 46.21

Some common ammonia derivatives that react with aldehydes and ketones are hydroxylamine (H_2NOH), hydrazine (H_2NNH_2), and semicarbazide ($H_2NNHCONH_2$); these form oximes, hydrazones, and semicarbazones, respectively.

Figure 46.22

The Aldol Condensation

The aldol condensation is an important reaction that follows the same mechanism of nucleophilic addition to a carbonyl. In this case, an aldehyde acts both as nucleophile (enol form) and target (keto form).

For example, when acetaldehyde is treated with base, an enolate ion is produced. The nucleophilic enolate ion will attack the carbonyl group of another acetaldehyde molecule. The product is 3-hydroxybutanal, which contains both an alcohol and an aldehyde group. This type of compound is called an **aldol,** from **ald**ehyde and alcoh**ol.**

3-hydroxybutanal
(an aldol)

Figure 46.23a

When heated, this molecule can undergo elimination and lose H_2O to form a double bond, producing an α,β-unsaturated aldehyde. This type of condensation reaction is known as the **aldol condensation**.

Figure 46.23b

The aldol condensation is most useful when only one type of aldehyde or ketone is present, since mixed condensations usually result in a mixture of products.

The Wittig Reaction

The **Wittig reaction** is a method of forming carbon-carbon double bonds by converting aldehydes and ketones into alkenes; in other words, the C=O bond ultimately becomes a C=C bond. The first step involves the formation of the necessary reactant: a phosphonium salt from the S_N2 reaction of an alkyl halide with the nucleophile triphenylphosphine, $(C_6H_5)_3P$. The phosphonium salt is then deprotonated (losing the proton α to the phosphorus) with a strong base, yielding a neutral compound called an **ylide** (pronounced "ill-ide") or **phosphorane**.

$$(C_6H_5)_3P + CH_3Br \longrightarrow (C_6H_5)_3\overset{+}{P}CH_3 + Br^-$$

$$\underset{\text{phosphonium salt}}{(C_6H_5)_3\overset{+}{P}{-}CH_3} \xrightarrow{\text{Base}} (C_6H_5)_3P{=}CH_2 \longleftrightarrow \underset{\text{ylide}}{(C_6H_5)_3\overset{+}{P}{-}\overset{-}{C}H_2}$$

Figure 46.24

Notice that an ylide is a type of carbanion and has nucleophilic properties. When combined with an aldehyde or ketone, an ylide attacks the carbonyl carbon, giving an intermediate called a *betaine*, which forms a four-membered ring intermediate called an oxaphosphetane. This decomposes to yield an alkene and triphenylphosphine oxide.

Figure 46.25

The decomposition reaction is driven by the strength of the phosphorus-oxygen bond that is formed. Although the overall mechanism has many complex steps, the net reaction is simply the substitution of a C=C bond for the original C=O bond of the cyclic ketone.

REVIEW PROBLEMS

1. The product of the reaction below is

 O=CH—CH₃ + HO—CH₂CH₂CH₃ → ?

 A.

 B. (OH)

 C. (O)

 D. (OH)

 E. None of the above

2. The major product of the reaction below is

 $$H_3C—C(=O)—C_2H_5 \quad + \quad CH_3CH_2OH \quad \rightarrow \quad ?$$

 A. H₃C—C(OCH₃)(OC₂H₅)—CH₃

 B. (OCH₃)(OH)CH—CH₃

 C. H₃C—C(OH)(OC₂H₅)—C₂H₅

 D. CH₃—C(=O)—C₂H₅

 E. None of the above

3. The product of the reaction below is

A. B.

C. D.

E. None of the above

4. All of the following properties are responsible for the reactivity of the carbonyl bond in propanone EXCEPT the fact that
 A. the carbonyl carbon is electrophilic.
 B. the carbonyl oxygen is electron-withdrawing.
 C. a resonance structure of the compound places a positive charge on the carbonyl carbon.
 D. the π electrons are mobile and pulled toward the carbonyl carbon.
 E. the molecule is polar.

5. The reaction below is an example of

keto enol

 A. esterification.
 B. tautomerization.
 C. elimination.
 D. dehydration.
 E. neutralization.

6. Which of the following reactions produces the compound below?

 A. $CH_3CHO + CH_3CH_2CH_2CHO$
 B. $CH_3COCH_3 + CH_3CH_2CH_2CHO$
 C. $CH_3CH_2COCH_3 + CH_3CHO$
 D. $CH_3CH_2CHO + CH_3CH_2CHO$
 E. $CH_3COCH_3 + CH_3CHO$

7. The product of the reaction below is

 $\xrightarrow{KMnO_4}$?

 A. C_3H_7OH
 B. C_2H_5COOH
 C. C_3H_7CHO
 D. CH_3COOH
 E. C_5H_7COH

8. Heating an aldehyde with Zn in HCl produces

 A. a ketone.
 B. an alkane.
 C. an alcohol.
 D. a carboxylic acid.
 E. an ester.

9. Which hydrogen atom in the compound below is the most acidic?

 A. a
 B. b
 C. c
 D. d
 E. All exhibit the same acidity.

OC

K 593

10. The product obtained in the reaction below is

LiAlH₄ → ?

A.

+

OH

B.

OH

C.

D.

OH

OH

E. None of the above

11. Draw the following compounds.
 A. 3-Methyl-2-pentanone
 B. 3-Hydroxypentanal
 C. Benzyl phenyl ketone
 D. Cyclohexane carboaldehyde

12. The product of the reaction between benzaldehyde and an excess of ethanol (C_2H_5OH) in the presence of anhydrous HCl is

A.

OC₂H₅
OH

B.

OC₂H₅
OC₂H₅

C.

OC₂H₅
OH
H

D.

OC₂H₅
OC₂H₅
H

E. None of the above

SOLUTIONS TO REVIEW PROBLEMS

1. **D** One mole of aldehyde reacts with one mole of alcohol via a nucleophilic addition reaction to form a product called a *hemiacetal*. In a hemiacetal, an –OH group, an –OR group, a H atom, and a –R group are attached to the same carbon atom.

2. **C** The reaction between one molecule of a ketone and one molecule of an alcohol produces a compound analogous to a hemiacetal called a *hemiketal*. This has an –OH group, an –OR group, and two –R groups attached to the same carbon atom. Of the given choices, only choice (C) represents a hemiketal. Choice (A) has two –OR groups and two –R groups attached to the same carbon atom; this compound is called a *ketal*. Choice (B) is a hemiacetal since it has an –OH group, an –OR group, a H atom, and a –R group attached to the same carbon atom. Choice (D) is a ketone. The correct choice, therefore, is (C). Note that a hemiketal is a very unstable compound; it reacts rapidly with a second molecule of alcohol to form a ketal.

3. **A** Aldehydes and ketones react with ammonia and primary amines to form imines (also called *Schiff bases*), compounds with a double bond between a carbon atom and a nitrogen atom.
$$(CH_3)_2C{=}O + H_2N - C_2H_5 \rightarrow (CH_3)_2C{=}NCH_2CH_3 + H_2O$$

4. **D** The reactivity of the carbonyl bond in propanone, and in aldehydes and ketones in general, is due to the difference in electronegativity between the carbon and oxygen atoms. The oxygen atom has higher electronegativity and is therefore electron-withdrawing. Thus, the carbonyl carbon is electrophilic and the carbonyl oxygen is nucleophilic. The π electrons of the carbonyl bond are pulled toward the more electronegative element, which is oxygen, not carbon; thus, choice (D) is a false statement and the correct answer choice. That means the other choices are all true.

5. **B**

Esterification, choice (A), is the formation of esters from carboxylic acids and alcohols. Tautomerization, choice (B), is the interconversion of keto and enol forms of a compound. An elimination reaction, choice (C), is a reaction in which a substituent is lost and a

double bond is introduced. A dehydration reaction, choice (D), is one in which a molecule of water is eliminated. A neutralization reaction, choice (E), involves an acid and a base. The reaction in the question stem involves an interconversion of keto and enol forms of ethanal. The correct choice is therefore (B). Note that equilibrium lies to the left in the reaction since the keto form is more stable.

6. **D**

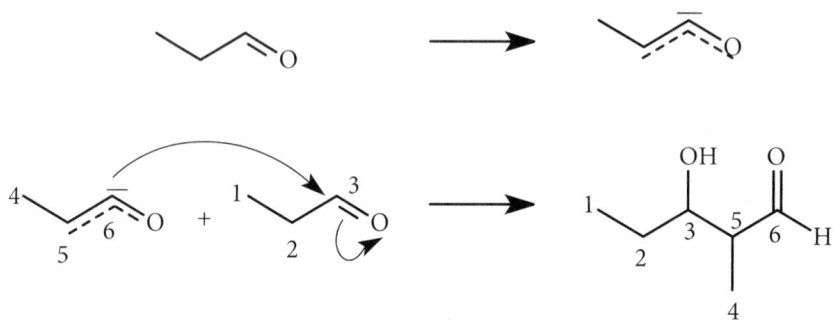

The above reaction is an example of aldol condensation. In the presence of a base, the alpha H is removed from an aldehyde, forming an enolate ion, CH_3CH^-CHO. The enolate ion then attacks the carbonyl group of another aldehyde molecule, CH_3CH_2CHO, forming the above aldol.

7. **B** Aldehydes are easily oxidized to the corresponding carboxylic acids by $KMnO_4$. The –CHO group is converted to –COOH. In this reaction, therefore, C_2H_5CHO is oxidized to C_2H_5COOH, which is choice (B). In choices (A) and (E), the aldehyde has been reduced to an alcohol. In choice (C), a $–CH_2$ group has been added. In choice (D), the –CHO group has been oxidized to –COOH, but a $–CH_2$ group has been deleted.

8. **B** Heating an aldehyde or a ketone with amalgamated Zn/HCl converts it to the corresponding alkane; this reaction is called the Clemmensen reduction. Note that aldehydes and ketones can also be converted to alkanes under basic conditions by reaction with hydrazine (the Wolff-Kishner reduction).

9. **B** The hydrogen alpha to the carbonyl group is the most acidic, since its resultant carbanion is resonance-stabilized:

10. **B** $LiAlH_4$ reduces carboxylic acids, esters, and aldehydes to primary alcohols, and ketones to secondary alcohols. In this reaction, therefore, the ketone is converted to a secondary alcohol. Thus, the correct answer is choice (B), $C_6H_5CH(CH_3)CHOHCH_2CH_3$, a secondary alcohol.

11.

A.

B.

C.

D.

12. **D** This product of this reaction is an acetal: two ethoxy groups bonded to the same carbon, represented by choice (D). This question states that an excess of ethanol is present, so benzaldehyde will first be converted to a hemiacetal, having an ethoxy and a hydroxy group bonded to the same carbon. Then the hemiacetal will be converted to the acetal by another equivalent of ethanol. Choices (A) and (B) are incorrect because they show the presence of two benzene rings in the final product. Choice (C) is incorrect since this is the hemiacetal that is formed initially, which then goes on to react with excess ethanol to produce the acetal.

CHAPTER FORTY-SEVEN

Carboxylic Acids

LEARNING OBJECTIVES

After this chapter, you will be able to:

● Recall nomenclature, physical properties, and key reaction mechanisms for carboxylic acids

● Predict the products of reactions involving carboxylic acids

Carboxylic acids contain a hydroxyl group (–OH) attached to a carbonyl carbon (C=O), represented by the formula –COOH. This functionality is known as a **carboxyl group,** which is always a terminal group on a molecule. Carboxylic acids are the most highly oxidized organic compounds (other than carbon dioxide). The carbonyl carbon of a carboxylic acid has three bonds to oxygen, two within the carbonyl C=O and the other to the oxygen of the –OH group.

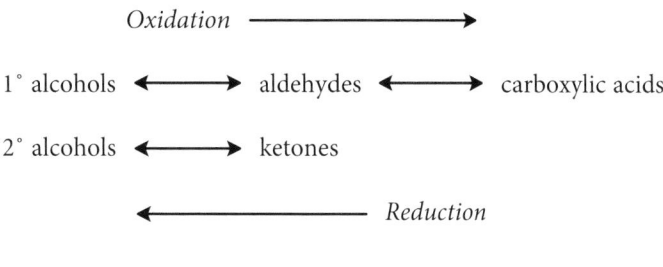

Table 47.1

The hydrogen atoms of the –OH group are highly acidic with pK_a values in the general range of 3 to 6. As with other carbonyl compounds, the C=O group is polarized with a partial positive charge on the carbon and a partial negative charge on the oxygen. Carboxylic acids occur widely in nature and are synthesized by many living organisms.

There are numerous methods of preparing carboxylic acids, but three are of particular interest: oxidation of alcohols and alkenes, carbonation with Grignard reagents, and hydrolysis of nitriles. These three mechanisms are important to study both as synthetic pathways of carboxylic acids and also as reaction pathways of other compounds.

The reactions of carboxylic acids are likewise interrelated with those of other compounds and are often driven by the dipole moment of the carbon-oxygen double bond. Carboxylic acids can be reduced to form alcohols. They can serve as the substrate for nucleophilic attack and substitution to form acyl halides, anhydrides, esters, and amides. They can decarboxylate to produce CO_2, and long-chain carboxylic acids can form soaps and micelles.

NOMENCLATURE

In the IUPAC system of nomenclature, carboxylic acids are named by adding the suffix **-oic acid** to the alkyl root. Since carboxylic acids are highly oxidized, they have very high priority in naming, and the chain is numbered so that the carboxyl group receives the lowest possible number.

2-methylpentanoic acid 4-isopropyl-5-oxohexanoic acid

Figure 47.1

Carboxylic acids were among the first organic compounds discovered. Their original names continue today in the common system of nomenclature. For example, formic acid (from Latin *formica*, meaning ant) was found in ants and butyric acid (from Latin *butyrum*, meaning butter) in rancid butter. The common and IUPAC names of the first three carboxylic acids are listed in Figure 47.2.

methanoic acid ethanoic acid propanoic acid
(formic acid) (acetic acid) (propionic acid)

Figure 47.2

Cyclic carboxylic acids are usually named as cycloalkane carboxylic acids. The carbon atom to which the carboxyl group is attached is numbered 1 because of the group's high priority. When a carboxylic acid is deprotonated, its name is changed to end in the suffix **-ate**. Thus, acetic acid becomes acetate when ionized and is called sodium acetate when in its sodium salt form. Typical examples are:

1-chloro-2-methylcyclo- sodium hexanoate
pentane carboxylic acid

Figure 47.3

Dicarboxylic acids—compounds with two carboxyl groups—are common in biological systems. The first six straight-chain terminal dicarboxylic acids are oxalic, malonic, succinic, glutaric, adipic, and pimelic acids. Their IUPAC names are ethanedioic acid, propanedioic acid, butanedioic acid, pentanedioic acid, hexanedioic acid, and heptanedioic acid.

PHYSICAL PROPERTIES

Hydrogen Bonding

Carboxylic acids are polar and form hydrogen bonds between the –OH group of one molecule and the lone pairs of electrons on the oxygen of another molecule. As a result, carboxylic acids can form dimers: pairs of molecules connected by hydrogen bonds. The boiling points of carboxylic acids are therefore even higher than those of the corresponding alcohols. The boiling points follow the usual trend of increasing with molecular weight.

Acidity

The acidity of carboxylic acids is due to the resonance stabilization of the carboxylate anion (the conjugate base). When the hydroxyl proton dissociates from the acid, the negative charge left on the carboxylate group is delocalized and shared by both oxygen atoms.

Figure 47.4

Substituents on carbon atoms adjacent to a carboxyl group can influence acidity. Electron-withdrawing groups such as –Cl or –NO$_2$ further delocalize the negative charge and increase acidity. Electron-donating groups such as –NH$_2$ or –OCH$_3$ destabilize the negative charge, making the compound less acidic.

In dicarboxylic acids, one –COOH group (which is electron-withdrawing) influences the other, making the first carboxyl group more acidic than the analogous monocarboxylic acid. The second carboxyl group is then influenced by the carboxylate anion. Ionization of the second group will create a doubly charged species, in which the two negative charges repel each other. Since this is unfavorable, the second proton is less acidic than that of a monocarboxylic acid.

β-dicarboxylic acids are notable for the high acidity of the α-hydrogens located between the two carboxyl groups (pK_a ~ 10). Loss of this acidic hydrogen atom produces a carbanion that is stabilized by the electron-withdrawing effect of the two carboxyl groups.

Figure 47.5

The same effect is also seen in β-ketoacids, $RC{=}OCH_2{-}COOH$. The resonance structures of the representative β-ketoacid below demonstrate the additional stability due to delocalization of the electrons from the carbonyl groups:

β-ketoacid

$- H^+$

Figure 47.6

SYNTHESIS

Oxidation Reactions

Carboxylic acids can be prepared via oxidation of aldehydes, primary alcohols, and certain alkylbenzenes. Any strong oxidizing agent, including $KMnO_4$, $K_2Cr_2O_7$, and CrO_3, will create a carboxylic acid, as in Figure 47.7. A primary alcohol can also be oxidized first with PCC to create an aldehyde and then further oxidized with Tollen's reagent to create the carboxylic acid.

$KMnO_4$

Figure 47.7

Carboxylic acids can also be prepared by the oxidative cleavage of alkenes:

$$\text{alkene} \xrightarrow[\text{2) H}^+]{\text{1) KMnO}_4,\ \text{OH}^-,\ \text{heat}} \text{carboxylic acid} + \text{carboxylic acid}$$

Figure 47.8

Carbonation of Organometallic Reagents

Organometallic reagents, such as Grignard reagents, react with carbon dioxide (CO_2) to form carboxylic acids. This reaction is useful for the conversion of tertiary alkyl halides into carboxylic acids, which cannot be accomplished through other methods. Note that this reaction adds one carbon atom to the chain.

$$\text{Br} \xrightarrow[\text{ether}]{\text{Mg}} \text{MgBr} \xrightarrow[\text{2) H}^+,\ \text{H}_2\text{O}]{\text{1) CO}_2\ \text{gas}} \text{COOH}$$

Figure 47.9

Hydrolysis of Nitriles

Nitriles, also called cyanides, are compounds containing the functional group $-C\equiv N$. The cyanide anion CN^- is a strong nucleophile and will displace primary and secondary halides in typical S_N2 fashion.

Nitriles can be hydrolyzed under either acidic or basic conditions. The products are carboxylic acids and ammonia (or ammonium salts).

$$CH_3Cl \longrightarrow CH_3CN \longrightarrow CH_3\overset{\displaystyle O}{\overset{\displaystyle \|}{C}}OH + NH_4^+$$

Figure 47.10

This allows the conversion of alkyl halides into carboxylic acids. As in the carbonation reaction, an additional carbon atom is introduced to the carbon chain. For instance, if the desired product is acetic acid, a possible starting material would be methyl iodide.

REACTIONS

Nucleophilic Substitution

Many of the reactions of carboxylic acids can be explained by a single mechanism: nucleophilic substitution. This mechanism is very similar to nucleophilic addition to a carbonyl, discussed in Chapter 46, Aldehydes and Ketones. The key difference between the two is that nucleophilic substitution concludes with re-formation of the C=O double bond and elimination of a leaving group.

Figure 47.11

Reduction

Carboxylic acids occupy the most oxidized position of the oxidation-reduction continuum. Carboxylic acids can be reduced with lithium aluminum hydride (LAH) to their corresponding primary alcohols. Note that this reaction will not occur when the milder reducing agent $NaBH_4$ is used. Aldehyde intermediates that may be formed in the course of the reaction with LAH are also reduced to the primary alcohol. The reaction occurs by nucleophilic addition of hydride (the H^- ion) to the carbonyl group and elimination of water as a leaving group.

Figure 47.12

Ester formation

Carboxylic acids react with alcohols under acidic conditions to form esters and water. In acidic solution, the oxygen on the carbonyl group can become protonated. This increases the polarity of the carbon-oxygen bond, putting even more positive charge on the carbon and making it even more susceptible to nucleophilic attack. Again, water is eliminated as a leaving group, and the carbonyl re-forms. This condensation reaction occurs most rapidly with primary alcohols. Esters are discussed in more detail in Chapter 48.

Figure 47.13

Acyl halide formation

Acyl halides, also called acid halides, are compounds with carbonyl groups bonded to halides. Several different reagents can accomplish this transformation; thionyl chloride, $SOCl_2$, is the most common.

Figure 47.14

Acid chlorides are very reactive, as the greater electron-withdrawing power of the Cl^- makes the carbonyl carbon more susceptible to nucleophilic attack than the carbonyl carbon of a carboxylic acid. Also, chlorine is an excellent leaving group, making acid chlorides highly reactive. They are frequently used as intermediates in the conversion of carboxylic acids to esters and amides. Acyl halides, esters, and amides are discussed further in Chapter 48.

Decarboxylation

Carboxylic acids can undergo decarboxylation reactions, resulting in the loss of carbon dioxide and thus loss of the entire carboxyl group.

1,3-dicarboxylic acids and other β-keto acids may spontaneously decarboxylate when heated. The carboxyl group is lost and replaced with a hydrogen. The reaction proceeds through a six-membered ring transition state. The enol initially formed tautomerizes to the more stable keto form as the final product.

Figure 47.15

Soap Formation

When long-chain hydrocarbon carboxylic acids react with sodium or potassium hydroxide, they form salts. These salts, called soaps, are able to solubilize nonpolar organic compounds in aqueous solutions because they possess both a nonpolar "tail" and a polar carboxylate "head."

Figure 47.16

When placed in aqueous solution, soap molecules arrange themselves into spherical structures called **micelles**. The polar heads face outward, where they can be solvated by water molecules, and the nonpolar hydrocarbon chains are inside the sphere, protected from the solvent. Nonpolar molecules such as grease can dissolve in the hydrocarbon interior of the spherical micelle, while the micelle as a whole is soluble in water because of its polar shell.

Figure 47.17

 Section IV: Organic Chemistry

REVIEW PROBLEMS

1. Which compound in each of the following pairs is more acidic?

 A. CH_3COOH or $CH_2ClCOOH$

 B. $HOOCCH_2COOH$ or $HOOCCH_2COO^-$

 C. NH_2CH_2COOH or NO_2CH_2COOH

2. Which of the following molecules could be classified as a soap?

 A. $CH_3(CH_2)_{17}CH_2COOH$

 B. CH_3COOH

 C. $CH_3(CH_2)_{19}CH_2COO^-Na^+$

 D. $CH_3COO^-Na^+$

 E. CH_3CH_2OH

3. Which of the following compounds would be expected to decarboxylate when heated?

 A.

 B.

 C.

 D.

 E. None of the above.

4. Oxidation of which of the following compounds is most likely to yield a carboxylic acid?

 A. Acetone

 B. Cyclohexanone

 C. 2-Propanol

 D. Methanol

 E. 2-Methyl-2-propanol

5. Give the IUPAC name for each of the following carboxylic acids:

A.

B.

C. HO

D. Br—⟨ ⟩—COOH

6. Draw the structures of the following carboxylic acids:

A. 2,3-Dimethylpentanoic acid
B. 3-Butenoic acid
C. *p*-Hydroxybenzoic acid
D. 4-Bromohexanoic acid

7. Carboxylic acids have higher boiling points than the corresponding alcohols because

A. the molecular weight of a carboyxlic acid is less than that of its corresponding alcohol.
B. the pH of a carboxlyic acid is lower than that of its corresponding alcohol.
C. acid salts are soluble in water.
D. hydrogen bonding is much stronger among carboxylic acids than among alcohols.
E. the average kinetic energy of a carboxylic acid is much lower than that of its corresponding alcohol at the same temperature.

8. Which of the following carboxylic acids will be the most acidic?

A. $CH_3CHClCH_2COOH$
B. $CH_3CH_2CCl_2COOH$
C. $CH_3CH_2CHClCOOH$
D. $CH_3CH_2CH_2COOH$
E. CH_3CH_2COOH

9. Which of the following substituted benzoic acid compounds will be the least acidic?

A. O ⟨ ⟩—NO₂ HO

B. O ⟨ ⟩—Cl HO

C. O ⟨ ⟩—OH HO

D. O ⟨ ⟩—H HO

E. All of the above compounds are equally acidic.

10. Rank the following compounds in order of increasing acidity.

A.

COOH	COOH	COOH
H	CH_2CH_3	Br
I	II	III

B.

COOH	COOH	COOH
NO_2	H	CH_3
I	II	III

11. Predict the final product of the following reaction:

$$CH_3(CH_2)_4CH_2OH \xrightarrow[\text{acetone}]{CrO_3,\ H_2SO_4}$$

 A. $CH_3(CH_2)_4CHO$
 B. $CH_3(CH_2)_4COOH$
 C. $CH_3(CH_2)_4CH_3$
 D. $HOOC(CH_2)_4COOH$
 E. $CH_3(CH_2)_4CH_2Cr$

12. The reduction of a carboxylic acid by lithium aluminum hydride will yield what final product?
 A. An aldehyde
 B. An ester
 C. A ketone
 D. An alcohol
 E. A sulfide

OC

SOLUTIONS TO REVIEW PROBLEMS

1. A **CH₂ClCOOH**

 Acetic acid is a fairly acidic compound and has a pK_a of 4.8. However, chloroacetic acid is more acidic because the chlorine atom is electron-withdrawing. This withdrawing effect stabilizes the carboxylate anion by delocalizing the charge more than the carboxyl group alone and thus facilitating the acid's dissociation.

 B **HOOCCH₂COOH**

 The maleate anion is less acidic than maleic acid because formation of a second negative charge is hindered by the presence of the first negative charge.

 C **NO₂CH₂COOH**

 Nitroacetic acid is more acidic than aminoacetic acid because the nitro group is electron-withdrawing while the amino group is electron-donating. The withdrawing effect delocalizes the negative charge on the anion, making it more stable. In contrast, the donating effect of the amino group concentrates the negative charge on the carboxylate group, creating a higher-energy state and destabilizing the anion.

2. C A soap is a long-chain hydrocarbon with a highly polar end. Generally, this polar end or head is a salt of a carboxylic acid. Choice (C) fits these criteria and is the correct answer. The remaining choices all fail one or both of the criteria and are therefore wrong. Choices (A), (B), and (E) are not salts. Choice (D) is sodium acetate, which is a salt but does not have a long hydrocarbon chain.

3. D Choice (D) is a β-keto acid: a keto group β-bonded to a carboxyl group. Decarboxylation occurs with β-keto acids and 1,3-diacids because they can form a cyclic transition state that permits simultaneous transfer of a hydrogen and loss of carbon dioxide. Choice (B) is a diketone, and this will definitely not decarboxylate. Choices (A) and (C) are 1,4- and 1,5-diacids, respectively, and will decarboxylate but with more difficulty. The correct answer is choice (D).

4. D Oxidation of methanol, choice (D), will yield first formaldehyde and then formic acid; this is the correct answer. Acetone, choice (A), cannot be oxidized further unless extremely harsh conditions are used. This is because the carbonyl carbon is bonded to two alkyl groups, and further oxidation would necessitate cleavage of a carbon-carbon bond. Choice (B), cyclohexanone, is likewise limited in its options for further oxidation. Choice (C), 2-propanol, can be oxidized to acetone but no further without harsh conditions. Choice (E), also known as *tert*-butyl alcohol, is similar but is even more resistant to oxidation because it is a tertiary alcohol and would also require cleavage of a carbon-carbon bond to undergo oxidation.

5. A **Hexanoic acid**

 B **3-Methylpentanoic acid**

 C **5-Ethyl-2-propylhexanedioic acid**

 D **4-Bromocyclohexanecarboxylic acid**

6.

A.

B.

C. HO—⟨benzene ring⟩—C(=O)OH

D. (structure with Br substituent)

7. **D** The boiling points of compounds depend on the strength of the attractive forces between molecules. In both alcohols and carboxylic acids, the major form of intermolecular attraction is hydrogen bonding; however, the hydrogen bonds of carboxylic acids are much stronger than those of alcohols since the acids are much more polar than the alcohols. This makes the boiling points of carboxylic acids higher than those of the corresponding alcohols, so choice (D) is correct. Boiling points are also dependent on molecular weight, choice (A), but in this case the influence of the small difference in molecular weight is negligible compared with the effect of hydrogen bonding, and in fact carboxylic acids are generally heavier than alcohols. Therefore, choice (A) is incorrect. Choice (B) describes the behavior of acids in solution; although this is also dependent on intermolecular forces, it is not otherwise related to the behavior of the pure acid, so choice (B) is incorrect. Choice (C) discusses the behavior of an acid's salt in solution, which is incorrect for the same reason. Finally, choice (E) is a false statement since having the same temperature means having the same average kinetic energy.

8. **B** The acidity of carboxylic acids is significantly increased by the substitution of highly electronegative halogens onto the carbon chain. Their electron-withdrawing effect upon the carboxyl group increases the stability of the carboxylate anion, favoring the dissociation of the proton. This effect is especially strong for α-halogenated carboxylic acids. Choices (D) and (E) are unsubstituted and therefore must have the lowest acidity. Choice (A) is β-halogenated, while choices (B) and (C) are α-halogenated, so (A) may be rejected. Finally, choice (B) contains two α-halogens and choice (C) includes only one, so the electron-withdrawing effect in choice (B) is stronger; thus, (B) is the correct answer.

9. **C** The effects of different substituents on the acidity of benzoic acid compounds is correlated with their effects on the reactivity of the benzene ring (see Chapter 44). Activating substituents donate electron density into the benzene ring, and the ring in turn donates electron density to the carboxyl group, destabilizing the benzoate ion formed and therefore decreasing a compound's acidity. Deactivating substituents have the opposite effect: they withdraw electrons from the ring, which in turn withdraws negative charge from the carboxyl group, thus stabilizing the carboxylate anion and increasing the compound's acidity. Choice (A) contains a nitro group attached to the ring, and choice (B) has a chloride; both of these substituents have deactivating effects, so these choices may be rejected.

Choice (D) is an unsubstituted benzoic acid, while choice (C) has a strongly activating hydroxyl substituent. Thus, choice (C) will be the least acidic and is the correct answer.

10. **A** II < I < III

An ethyl substituent has an activating and therefore electron-donating effect on the benzene ring; thus, the acidity of compound II is very low. The bromine substituent, on the other hand, has a deactivating and electron-withdrawing effect on the benzene ring, which makes compound III highly acidic. The acidity of unsubstituted benzoic acid (compound I) is somewhere in the middle. Therefore the order of increasing acidity is II, I, III.

B III < II < I

In this case, compound I is the strongest acid because the nitro group is a powerful deactivating and therefore electron-withdrawing substituent. On the other hand, II is a stronger acid than III because the methyl group in compound III donates electron density to the carboxyl group, decreasing the acidity of III. Here the order of increasing acidity is III, II, I.

11. **B** Jones reagent (chromium trioxide in aqueous sulfuric acid) oxidizes primary alcohols directly to monocarboxylic acids, so choice (B) is correct. This oxidizer is too strong to give an aldehyde as the final product (aldehyde will be formed but will immediately be oxidized further), so choice (A) is incorrect. Choice (D), a dicarboxylic acid, cannot form because there is no functional group "handle" on the other end of the molecule for the reagent to attack, and it cannot attack the inert alkane. Nor will it produce an alkane such as choice (C), so this is also incorrect. Finally, (E) represents a substitution reaction with the chromium, but the chromium from Jones reagent will enter solution a relatively stable Cr^{3+} ion rather than reacting.

12. **D** Lithium aluminum hydride is a very strong reducing agent. Its reaction with carboxylic acids yields alcohols, choice (D). Aldehydes are intermediate products of this reaction and will be further reduced to alcohols; therefore, choice (A) is incorrect. Esters are formed from carboxylic acids by reaction with alcohols, so choice (B) is incorrect. Ketones are formed by the Friedel-Crafts acylation of the acyl chloride derivatives of acids, so choice (C) is incorrect. Sulfides (E) are S^{2-} ions and are not directly related to carboxylic acids.

OC

Carboxylic Acid Derivatives

Carboxylic acids can be converted into several types of derivatives: **acyl halides**, **anhydrides**, **amides**, and **esters**. These are compounds in which the –OH of the carboxyl group has been replaced with **–X, –OCOR, –NH$_2$**, or **–OR**, respectively:

• Acyl halide: R-CO-X
• Anhydride: R-CO-O-CO-R
• Ester: R-CO-OR′
• Amide: R-CO-NH$_2$ or R-CO-NR$_2$

Carboxylic acid derivatives all have the highly polarized C=O group in which the carbon carries a partial positive charge and the oxygen has a partial negative charge. As a result, these compounds readily undergo nucleophilic substitution reactions, including hydrolysis (with H$_2$O as the nucleophile). They also undergo other additions and substitutions, including various interconversions between different acid derivatives. In general, the acyl halides are the most reactive of the carboxylic acid derivatives, followed by the anhydrides, the esters, and the amides.

Each of these types of carboxylic acid derivatives will be discussed in turn. Although the variety of reaction pathways can appear overwhelming, they are all closely interwoven and should be studied in relation to each other. To aid your studies, a summary of the different reactions of carboxylic acid derivatives is included at the end of this chapter.

ACYL HALIDES

Nomenclature of Acyl Halides

Acyl halides are also called **acid** or **alkanoyl halides**. The acyl group is written RCO–, and with the halide attached it is written as RCOX. Acyl halides are the most reactive of the carboxylic acid derivatives. They are named in the IUPAC system by changing the *-ic acid* ending of the

carboxylic acid to -**yl halide**. Some typical examples are ethanoyl chloride (also called acetyl chloride), benzoyl chloride, and *n*-butanoyl bromide.

ethanoyl chloride

(acetyl chloride)

benzoyl chloride

n-butanoyl bromide

Figure 48.1

Properties of Acyl Halides

Because the –OH of the carboxyl group has been replaced by a halogen, an acyl halide is not able to form hydrogen bonds. Acyl halides are therefore less polar than comparable carboxylic acids, and demonstrate significantly lower melting and boiling points. For example, acetyl chloride boils at 51°C, compared to acetic acid which boils at 118°C.

Synthesis of Acyl Halides

The most common acyl halides are the acid chlorides, although acid bromides and iodides are occasionally encountered. Acyl chlorides are prepared by reaction of a carboxylic acid with thionyl chloride, $SOCl_2$, producing SO_2 and HCl as side products. Alternatively, PCl_3 or PCl_5 (or PBr_3, to make an acid bromide) can be used for this synthesis.

Figure 48.2

Reactions of Acyl Halides

Nucleophilic acyl substitution

Acyl halides are very reactive, as the greater electron-withdrawing power of the halogen makes the carbonyl carbon more susceptible to nucleophilic attack than the carbonyl carbon of a carboxylic acid. Because halides are excellent leaving groups, nucleophilic attack will always be followed by re-formation of the carbonyl. As a result, acyl halides readily undergo nucleophilic substitution reactions, including hydrolysis (with H_2O as the nucleophile), which produces the original carboxylic acid. Acyl halides are also frequently used as intermediates in the conversion of carboxylic acids to anhydrides, esters, and amides.

Hydrolysis

The simplest reaction of acid halides is their conversion back to carboxylic acids by classic nucleophilic attack. Acyl halides react very rapidly with water to form the corresponding acid, along with HCl, which is responsible for their irritating odor.

Figure 48.3

Conversion into anhydrides

Reaction of an acyl chloride with a carboxylate salt will produce an anhydride through nucleophilic attack and re-formation of the carbonyl:

Figure 48.4

Conversion into esters

Acyl halides can be converted into esters by reaction with alcohols. The same type of nucleophilic attack found in hydrolysis leads to the formation of a tetrahedral intermediate, with the hydroxyl oxygen of the alcohol acting as the nucleophile. Chloride is displaced as the carbonyl re-forms, and HCl is released as a side-product.

Figure 48.5

Conversion into amides

Acyl halides can be converted into amides (compounds of the general formula $RCONR_2$) by nucleophilic substitution with amines. An amine, such as ammonia, attacks the carbonyl group, displacing chloride. The side product is ammonium chloride, formed from excess ammonia and HCl. Primary and secondary amines can also be used as the nucleophile to create N-substituted amides.

Figure 48.6

Other Reactions of Acyl Halides

Friedel-Crafts acylation

Aromatic rings can be acylated in a Friedel-Crafts reaction, as discussed in Chapter 44. The mechanism is electrophilic aromatic substitution, and the attacking reagent is an acylium ion, formed by reaction of an acid chloride with $AlCl_3$ or another Lewis acid. The product is an alkyl aryl ketone.

Figure 48.7

Reduction

Acid halides can be reduced to alcohols with a strong reducing agent such as LAH. They can also be selectively reduced to the intermediate aldehydes by catalytic hydrogenation in the presence of a "poison" such as quinoline, also called Lindlar's catalyst. These reaction conditions are also discussed in Chapter 43.

Figure 48.8

ANHYDRIDES

Nomenclature of Anhydrides

Anhydrides, also called **acid anhydrides**, are the condensation dimers of carboxylic acids, with the general formula RCOOCOR. They are named by substituting the word **anhydride** for the word *acid* in a carboxylic acid. Most anhydrides are symmetrical, although asymmetrical anhydrides exist and can be important in biological systems. The most common and important anhydride is acetic anhydride, the dimer of acetic acid. Other common anhydrides, such as succinic, maleic, and phthalic anhydrides, are **cyclic anhydrides** arising from intramolecular condensation or dehydration of diacids (see Figure 48.9).

acetic anhydride

(ethanoic anhydride)

phthalic anhydride

succinic anhydride

Figure 48.9

Properties of Anhydrides

Since acid anhydrides no longer have an –OH group, they do not have the ability to form hydrogen bonds. Anhydrides therefore are less polar and demonstrate lower melting and boiling points than comparable carboxylic acids of the same molecular weight (MW). For example, ethanoic anhydride and pentanoic acid are approximately the same MW, but the anhydride boils at 140°C and the carboxylic acid at 186°C.

However, because anhydrides are often formed from the condensation of two other molecules, the product will have a higher melting or boiling point due to its larger size compared to the starting materials. For example, acetic anhydride ($CH_3CO-O-COCH_3$) boils at 140°C, compared to acetic acid (CH_3COOH), which boils at 118°C. In this case, the much larger MW of the anhydride is more influential than the effect of hydrogen bonding for the carboxylic acid.

Although anhydrides are polar, they are not considered to be soluble in water because they immediately decompose in aqueous conditions to form carboxylic acids.

Synthesis of Anhydrides

The synthesis pathways of anhydrides all involve some form of nucleophilic attack on a carboxylic acid, followed by the release of a leaving group and re-formation of the carbonyl.

Acyl chloride reaction

Anhydrides can be readily synthesized by reaction of an acyl chloride with a carboxylate salt. This is the most efficient and most commonly used method of anhydride synthesis.

Figure 48.10

Cyclic anhydride self-condensation

Certain cyclic anhydrides can be formed simply by heating carboxylic acids. The reaction is driven by the increased stability of the newly formed ring; hence, only five- and six-membered ring anhydrides are easily made. In this case, the hydroxyl of one –COOH group acts as a nucleophile, attacking the carbonyl on the other –COOH group and releasing water.

o-phthalic acid phthalic anhydride

Figure 48.11

Condensation of two carboxylic acids

Two carboxylic acid molecules can condense to form an anhydride in a reaction releasing water; however, this reaction requires anhydrous conditions. Therefore a dehydrating reagent that will remove the water produced in the reaction is needed to prevent immediate conversion back to

the carboxylic acids. Reagents such as acetic anhydride, trifluoroacetic anhydride, phosphorus pentachloride, or dicyclohexylcarbodiimide (DCC) can be used for this purpose.

Figure 48.12

Reactions of Anhydrides

Anhydrides react under the same conditions as acid chlorides, but since anhydrides are somewhat more stable, they are less reactive. Nucleophilic attack on an anhydride is slower and produces a carboxylic acid as the side product instead of HCl. Cyclic anhydrides are also subject to these reactions, which cause ring opening at the anhydride group along with formation of the new functional groups.

Hydrolysis

Anhydrides are converted into carboxylic acids when exposed to water. Note that in this reaction, the leaving group is actually a carboxylic acid; because the anhydride is symmetrical, it produces two molecules of the same carboxylic acid.

Figure 48.13

Conversion into amides

Anhydrides are cleaved by ammonia, producing an amide and a carboxylic acid. The carboxylic acid then further reacts with ammonia to form an ammonium carboxylate.

Then:

Figure 48.14

Conversion into esters and carboxylic acids

Anhydrides react with alcohols to form esters; a single anhydride molecule will produce one ester and also one molecule of carboxylic acid.

Figure 48.15

Acylation

Friedel-Crafts acylation occurs readily with anhydrides in the presence of $AlCl_3$ or other Lewis acid catalysts. This reaction produces an aryl ketone and a carboxylic acid.

Figure 48.16

ESTERS

Nomenclature of Esters

Esters are the dehydration products of carboxylic acids and alcohols. They are commonly found in many fruits and perfumes. They are named in the IUPAC system as **alkyl** or **aryl alkanoates**. The alkyl chain attached to the non-carbonyl oxygen is named as a functional group; the carboxylic acid suffix *-oic acid* is replaced by **-oate** while retaining the carbon chain from the acid. For example, propyl acetate, derived from the condensation of acetic acid and propanol, has the structure $CH_3COO–CH_2CH_2CH_3$ and is called propyl ethanoate according to IUPAC nomenclature.

ethyl
ethanoate

isopropyl
butanoate

Figure 48.17

Properties of Esters

Since esters do not have an –OH group, they do not have the same ability to form hydrogen bonds. Esters, therefore, are less polar and demonstrate lower melting and boiling points than comparable carboxylic acids of the same size. For example, ethyl acetate ($CH_3COOCH_2CH_3$) and butanoic acid ($CH_3CH_2CH_2COOH$) are approximately the same molecular weight, but the ester boils at 77°C and the carboxylic acid boils at 164°C.

The water solubility of esters depends on the length of the hydrocarbon chain on the ester oxygen. Smaller esters have good water solubility, but as the chain becomes longer, water solubility decreases. This becomes important for very long chain esters that make up fats and oils.

Synthesis of Esters

Conversion of acyl chlorides into esters

Esters can be readily obtained from the reaction of acid chlorides with alcohols under anhydrous conditions. Phenolic (aromatic) esters are produced in the same way, although the aromatic acid chlorides are less reactive than aliphatic acid chlorides, requiring base to be added as a catalyst.

Figure 48.18

Conversion of anhydrides into esters and carboxylic acids

Anhydrides react with alcohols to form esters; a single anhydride molecule will produce one ester and also one molecule of carboxylic acid.

Figure 48.19

Condensation of carboxylic acids and alcohols

Mixtures of carboxylic acids and alcohols will condense into esters under anhydrous conditions, liberating water. Use of sulfuric acid as a catalyst and dehydrating reagent will drive the reaction forward:

Figure 48.20

Reactions of Esters

Esters react with nucleophiles at the carbonyl carbon, although they are less reactive than acyl halides or anhydrides. Almost all reactions of esters can be recognized as nucleophilic substitutions (in which the carbonyl is retained) or nucleophilic additions (in which the carbonyl is lost).

Hydrolysis

Esters, like the other derivatives of carboxylic acids, can be hydrolyzed, yielding carboxylic acids and alcohols. Hydrolysis can take place under either acidic or basic conditions. Under acidic conditions, the first step is protonation of the carbonyl oxygen, followed by water attacking the carbonyl carbon:

Figure 48.21

Under basic conditions, the nucleophile is OH⁻, which directly attacks the carbonyl carbon. **Triacylglycerols,** also called fats or triglycerides, are esters of long-chain carboxylic acids, often called fatty acids, and glycerol (1,2,3-propanetriol). **Saponification** is the process whereby fats are hydrolyzed under basic conditions to produce soaps.

Triacylglycerol Soap Glycerol

Figure 48.22

Conversion into amides

Nitrogen bases, such as ammonia, act as a nucleophile and attack the electrophilic carbonyl carbon atom, displacing the ester functional group to yield an amide and an alcohol side-product:

Figure 48.23

Transesterification

Alcohols can act as nucleophiles and displace the alkoxy groups on esters. This process, which transforms one ester into another, is called **transesterification**.

Figure 48.24

Grignard addition

Grignard reagents add to the carbonyl groups of esters to form ketones; however, these ketones are more reactive than the initial esters and are readily attacked by more Grignard reagent. Two equivalents of Grignard reagent can thus be used to produce tertiary alcohols with good yield. The intermediate ketone can be isolated only if the alkyl groups are sufficiently bulky to prevent further attack. This reaction proceeds via nucleophilic substitution followed by nucleophilic addition.

Figure 48.25

Condensation Reactions

An important reaction of esters is the **Claisen condensation**. In the simplest case, two moles of ethyl acetate react under basic conditions to produce a β-keto ester, ethyl 3-oxobutanoate, which is also known by its common name, acetoacetic ester. (The Claisen condensation is also called the **acetoacetic ester condensation**.) The reaction proceeds by addition of an enolate anion to the carbonyl group of another ester, followed by displacement of ethoxide ion (the formation of enolate ions is discussed in Chapter 46). This mechanism is analogous to that of the aldol condensation (also covered in Chapter 46).

Figure 48.26

Reduction

Esters may be reduced to primary alcohols with LAH, but not with $NaBH_4$. This allows for selective reduction in molecules with multiple functional groups. Note that different alcohols are produced from the ester alkoxy functional group and the carbonyl-containing carbon chain.

Figure 48.27

Phosphate Esters

While phosphoric acid derivatives are not carboxylic acid derivatives, they form esters with many similar properties and reactivities.

where R = H or hydrocarbon

phosphoric acid phosphoric ester

Figure 48.28

Phosphoric acid and the mono- and diesters are acidic (more so than carboxylic acids) and usually exist as anions. Like carboxylic acid esters, under acidic conditions they can be cleaved into the parent acid (here, H_3PO_4) and alcohols.

Phosphate esters are found in living systems in the form of **phospholipids** (phosphoglycerides), in which glycerol is attached to two carboxylic acids and one phosphoric acid.

phosphatidic acid
diacylglycerol phosphate
(a phosphoglyceride)

Figure 48.29

Phospholipids are the main component of cell membranes, and phosphate/carbohydrate polymers form the backbone of nucleic acids, the hereditary material of life. The nucleic acid derivative **adenosine triphosphate (ATP)** can give up and regain one or more phosphate groups. ATP facilitates many biological reactions by releasing phosphate groups to other compounds, thereby increasing their reactivities.

AMIDES

Nomenclature of Amides

Amides are compounds with the general formula $RCONR_2$, in which the R group can be either a hydrocarbon, a hydrogen, or one of each. Amides are particularly important in biological systems, as the peptide bonds that link amino acids into proteins are actually amide bonds. Amides are named by replacing the **-oic** acid ending with **-amide**. Alkyl substituents on the nitrogen atom are listed as prefixes, and their location is specified with the letter *N*. For example, *N*-methylpropanamide has a methyl and a hydrogen as the substituents on the nitrogen and a 3-carbon chain, including the carbonyl:

N-methylpropanamide

Figure 48.30

Properties of Amides

Although amides do not have an –OH group, those that have hydrogens as substituents on the amide nitrogen have the ability to form hydrogen bonds. In fact, when two hydrogens are present on the amide nitrogen, it has the ability to form twice as many hydrogen bonds as the corresponding carboxylic acid. As a result, amides have very high melting and boiling points, and good water solubility (with the exception of tertiary amides that have two alkyl groups on the amide nitrogen). For example, acetamide (CH_3CONH_2) boils at 221°C, while acetic acid boils at 118°C.

Synthesis of Amides

Amides are generally synthesized by the reaction of acid chlorides with amines or by the reaction of acid anhydrides with ammonia.

Conversion of acyl halides to amides

Acyl halides can be readily converted into amides by nucleophilic substitution with amines. An amine such as ammonia attacks the carbonyl group, displacing chloride. The side product is ammonium

chloride, formed from excess ammonia and HCl. Primary and secondary amines can also be used as the nucleophile to create substituted amides; tertiary amines are not able to lose a hydrogen and thus cannot participate in this reaction.

Figure 48.31

Conversion of anhydrides into amides

Anhydrides are cleaved by ammonia, producing an amide and a carboxylic acid. The carboxylic acid then further reacts with ammonia to form ammonium carboxylate.

Then:

Figure 48.32

Conversion of esters into amides

Nitrogen bases such as ammonia act as nucleophiles and will attack the electrophilic carbonyl carbon atom, displacing the ester functional group to yield an amide and an alcohol side-product.

Figure 48.33

Reactions

Amides are the least reactive of the carboxylic acid derivatives but are still susceptible to nucleophilic attack as well as rearrangements and reductions.

Hydrolysis

Amides can be hydrolyzed under acidic conditions, via nucleophilic substitution, to produce carboxylic acids. Under basic conditions amides react to form carboxylates.

Figure 48.34

Hofmann rearrangement

The **Hofmann rearrangement** converts amides to primary amines with the loss of the carbonyl carbon as a molecule of CO_2. The mechanism involves the formation of a **nitrene**, the nitrogen analog of a carbene. The nitrene is attached to the carbonyl group and rearranges to form an **isocyanate**, which under aqueous reaction conditions is hydrolyzed to the amine.

nitrene isocyanate

Figure 48.35

Reduction

Amides can be reduced with LAH to the corresponding amine. Notice that this differs from the product of the Hofmann rearrangement in that no carbon atom is lost. Note that, unlike with a carboxylic acid reduction with LAH, the oxygen atom is completely removed:

Figure 48.36

SUMMARY OF REACTIONS

- The most important derivatives of carboxylic acids are acyl halides, anhydrides, esters, and amides. These are listed in order from most reactive (least stable) to least reactive (most stable).

ACYL HALIDES:

- can be formed by adding $RCOOH + SOCl_2$, PCl_3 or PCl_5, or PBr_3
- undergo many different nucleophilic substitutions; H_2O yields carboxylic acid, while ROH yields an ester and NH_3 yields an amide
- can participate in Friedel-Crafts acylation to form an alkyl aryl ketone
- can be reduced to alcohols or, selectively, to aldehydes

ANHYDRIDES:

- can be formed by $RCOO^- + RCOCl$ (substitution) or by $RCOOH + RCOOH$ (condensation)
- undergo many nucleophilic substitution reactions, forming products that include carboxylic acids, amides, and esters
- can participate in Friedel-Crafts acylation

ESTERS:

- formed by acid chlorides or anhydrides + ROH or by $RCOOH + ROH$
- hydrolyze to yield acids + alcohols; adding ammonia yields an amide
- undergo transesterification with alcohol to exchange alkoxy functional group
- react with Grignard reagent (2 moles) to produce a tertiary alcohol
- can be formed by the Claisen condensation, analogous to the aldol condensation, which combines two molecules of ester acting both as nucleophile and target
- are very important in biological processes, particularly phosphate esters, which can be found in membranes, nucleic acids, and metabolic reactions

AMIDES:

- can be formed by acid chlorides + amines, acid anhydrides + ammonia, or ester + ammonia
- can hydrolyze, yielding carboxylic acids or carboxylate anions
- can be transformed to primary amines via Hofmann rearrangement or reduction
- are very important in formation of proteins because all amino acids are linked by amide bonds known as peptide bonds

REVIEW PROBLEMS

1. Name each of the following compounds according to the IUPAC system.

A. B.

C. D.

E.

2. What would be the product of the following reaction?

 $\xrightarrow{\text{SOCl}_2}$?

A. B.

C. D.

E.

3. During the hydrolysis of an acid chloride, pyridine (a base) is usually added to the reaction vessel. This is done because

 A. the reaction leads to the production of hydroxide ions.
 B. the acyl chloride is unreactive.
 C. the hydrolysis reaction leads to the formation of HCl.
 D. the pyridine reacts in a side-reaction with the carboxylic acid product.
 E. the oxidation leads to the formation of an ester.

4. What would be the primary product of the following reaction?

OH

+

O
Cl

⟶ ?

A.

B.

C.

D.

E. None of the above

5. In order to produce a primary amide, an acid chloride should be treated with

 A. ammonia.

 B. an alcohol.

 C. a primary amine.

 D. a tertiary amine.

 E. a sulfide.

6. Which of the following would be the best method of producing methyl propanoate?
 A. Reacting propanoic acid with methanol in the presence of a mineral acid
 B. Reacting propanyl chloride with ethanol in the presence of a base
 C. Reacting propanoyl chloride alone with an aqueous base
 D. Reacting propanoic acid with ethanol in the presence of a mineral acid
 E. Reacting propanoic acid with methanol in the presence of a base

7. What would be the product(s) of the following reaction?

A.

B. 2

C.

D.

E. None of the above

8. Which of the following correctly shows the intermediates and products of the reaction below?

A.

 I II III

B.

 I II III

C.

 I II III

D.

 I II III

E. None of the above

9. Prepare the following compounds from pentanoic acid. Give all reactants and reaction conditions.

 A. 1-Pentanol

 B. Pentanoyl bromide

 C. *N*-Methylpentanamide

 D. Ethyl pentanoate

 E. Pentanoic anhydride

10. What is saponification?

SOLUTIONS TO REVIEW PROBLEMS

1. A **N-methyl-3-butenamide**

 B **Propanoyl bromide**

 C **Pentanamide**

 D **Propyl propanoate**

 E **Ethanoic anhydride** (common name: acetic anhydride)

2. **D** Treating a carboxylic acid with thionyl chloride results in the production of an acyl chloride. In this reaction, butanoic acid is converted to butanoyl chloride, which is choice (D). Since none of the other choices are acyl chlorides, they can be eliminated.

3. **C** Hydrolysis of an acid chloride results in the formation of a carboxylic acid and HCl. Since pyridine can act as a base, it serves to neutralize the HCl that is formed. The reaction does not result in the formation of hydroxide ions, so choice (A) is incorrect. Pyridine does not react with the carboxylic acid product, it reacts with the HCl, so choice (D) is incorrect. Finally, choice (B) is incorrect because the acyl chloride is very reactive. The correct answer is choice (C).

4. **B** In this question, an acid chloride is treated with an alcohol, and the product will be an ester. However, the esterification process is affected by the presence of bulky side-chains on either reactant. It is easier to esterify an unhindered alcohol than a hindered one. In this reaction, the primary hydroxyl group is less hindered and will react with benzoyl chloride more rapidly, so choice (B) is correct. Choice (A) is incorrect because the hydroxyl group is a hindered secondary hydroxyl, and the reaction rate will be slower. Choice (C) is incorrect because it is not an ester. Choice (D) is incorrect because steric hindrance would prevent this product from being formed.

5. **A** Acid chlorides react with ammonia or other amines to form amides. Since the amine is replacing the hydroxyl group of the carbonyl, there must be at least one hydrogen on the amine. Therefore, only ammonia and primary or secondary amines can undergo this reaction. In order to obtain a primary amide, ammonia, choice (A), must be used. The reaction of an alcohol with an acid chloride produces an ester, so choice (B) is incorrect. A primary amine reacting with an acid chloride would give an N-substituted amide; thus, choice (C) is incorrect. Choice (D) is incorrect because tertiary amines will not react with acid chlorides.

6. **A** Methyl propanoate is an ester, which can be synthesized by reacting a carboxylic acid with an alcohol in the presence of acid: choice (A). Choice (E) is close, but adding both acid and base at the same time will cause a neutralization reaction and severely diminish yields. Reacting ethanol with propanoyl chloride, choice (B), will also result in the formation of an ester, but because ethanol is used, ethyl propanoate will be formed, not methyl propanoate. This is also the case for choice (D), since ethanol is used here as well. Therefore, choices (B) and (D) are incorrect. Choice (C) is incorrect because propanoyl chloride will not form an ester in the presence of base alone. Therefore, choice (A) is the correct response.

7. **D** This question asks for the products when ammonia reacts with acetic anhydride. Recall from the text that an amide and an ammonium carboxylate will be formed. The only choice showing such a pair is (D), acetamide and ammonium acetate.

8. C This question gives a reaction scheme for the interconversion of propanoic acid to various derivatives, and asks what intermediate products are formed. The first reaction involves the formation of an acid chloride using thionyl chloride. Acid chlorides are made by replacing the hydroxyl group with chlorine. Thus, choices (A) and (B), which depict intact hydroxyl groups, can be eliminated. The second reaction is nucleophilic attack by ammonia on propanoyl chloride. The product should be propanamide, since ammonia will replace the chloride on the carbonyl carbon, which is correctly shown in both answer choices (C) and (D). The final reaction involves amide hydrolysis in the presence of base; therefore, the resulting carboxylic acid will exist in solution as a carboxylate salt. Thus, choice (C) is the correct answer, since it has sodium propanoate as the product of the third reaction.

9. This question asks about preparation of pentanoic acid derivatives. Where there is more than one way to make the products, the most efficient method will be given.

A 1-Pentanol

Carboxylic acids are easily reduced by LAH to produce the corresponding primary alcohol.

B Pentanoyl bromide

To form pentanoyl bromide, pentanoic acid is reacted with PBr_3. The bromide replaces the hydroxyl on the carbonyl carbon.

C N-Methylpentanamide

N-Methylpentanamide can be prepared by first producing the acid chloride using thionyl chloride, and then reacting it with methylamine to yield the amide.

D Ethyl pentanoate

The ethyl ester of pentanoic acid can be formed by reacting it directly with ethanol in the presence of hydrochloric acid.

E Pentanoic anhydride

The most common method of preparing anhydrides is the reaction between an acid chloride and a carboxylate anion. To form pentanoic anhydride, one mole of pentanoic acid must be treated with thionyl chloride to yield pentanoyl chloride. This reacts with one mole of sodium pentanoate to form pentanoic anhydride.

10. Saponification is the process whereby fats are hydrolyzed under basic conditions to produce soaps.

CHAPTER FORTY-NINE

Amines

LEARNING OBJECTIVES

After this chapter, you will be able to:

- Recall nomenclature, physical properties, and methods of synthesis for amines
- Predict the products of reactions of amines
- Compare and contrast the methods of synthesis for amines

Amines are nitrogen-containing compounds of the general formula NR_3, with R representing either hydrogens, alkyl groups, or a combination of both. One of the most important features of amines is the lone pair of electrons on the nitrogen, which determines many of the chemical and physical properties of these compounds. Other nitrogen-containing compounds are similar to amines, including those with double or triple bonds between a carbon and a nitrogen (imines and nitriles), compounds with two or three nitrogens (diazides and azides), and compounds with both nitrogen and oxygen (amides, isocyanates, and nitrates).

Amines have a great deal of biological significance since they are part of amino acids, nucleic acids, and many other biomolecules. They are also important in medicine. Many nitrogen-containing compounds act as relaxants, including nitroglycerin and nitrous oxide. Nitroglycerin is given either sublingually or transdermally to relieve coronary artery spasms and angina (chest pain). Nitrous oxide is also known as laughing gas and is used as a dental anesthetic. Nitroglycerin and trinitrotoluene (TNT) also have nonmedical significance as explosives due to their high reactivities.

NOMENCLATURE OF AMINES

Amines are classified according to the number of alkyl (or aryl) groups to which the nitrogen is bound. A **primary** (**1°**) amine is attached to one alkyl group and can be written as RNH_2; a **secondary** (**2°**) amine is bound to two alkyl groups and can be written as R_2NH; and a **tertiary** (**3°**) amine is bound to three alkyl groups and is written as R_3N. A nitrogen atom attached to four alkyl groups is called a **quaternary ammonium compound** and is written as R_4N^+; the nitrogen carries a positive charge, and these compounds generally exist as salts.

In the common naming system, amines are generally named as alkylamines. The groups are designated individually or by using the prefixes di- or tri- if they are the same. In the IUPAC system, amines are named by substituting the suffix -**amine** for the final -*e* of the name of the alkane to which the nitrogen is attached. *N* is used to label substituents attached to the nitrogen in secondary or tertiary amines. The prefix **amino-** is used for naming compounds containing a higher priority OH or a CO_2H group. Aromatic amines are named as derivatives of aniline ($C_6H_5NH_2$), the IUPAC name for which is benzenamine. Table 49.1 gives three examples of compounds named by both the common and IUPAC system:

Formula:	$CH_3CH_2NH_2$	$CH_3CH_2N(CH_3)_2$	$H_2NCH_2CH_2OH$
IUPAC Name:	Ethanamine	*N,N*-Dimethylethanamine	2-Aminoethanol
Common Name:	Ethylamine	Dimethylethylamine	2-Aminoethanol

Table 49.1

Many other nitrogen-containing organic compounds are listed in Table 49.2 with their key characteristics, and Figure 49.1 gives several example structures.

Class of Compound	Characteristics
Amides	$RCONR_2$ Discussed in Chapter 48
Carbamates (urethanes)	RNHC(O)OR′ Form polymers called **polyurethanes** Derived from isocyanates + alcohol
Isocyanates	RNCO Combine with alcohols to create carbamates
Enamines	$C=CH\text{-}NR_2$ Analogous to enols
Imines	C=NR
Nitriles (Cyanides)	C≡N Named as either cyano- or -nitrile
Nitro compounds	$-NO_2$
Diazo compounds	$-N_2$ Lose N_2 to form carbenes R-(C:)-R′ or R=C:
Azides	$-N_3$ Readily lose N_2 to form nitrenes
Nitrenes	R-N: Nitrogen analog of carbenes Formed from azides upon loss of N_2 Highly unstable; usually a reaction intermediate

Table 49.2

Amide Carbamate Imine Enamine

Azide Nitrile Isocyanate

Figure 49.1

PROPERTIES OF AMINES

The boiling points of amines are between those of alkanes and alcohols. For example, methylamine (CH_3NH_2, MW = 31 g/mol) boils at −6°C, whereas ethane (CH_3CH_3, MW = 30 g/mol) boils at −89°C and methanol (CH_3OH, MW = 32 g/mol) boils at 64.5°C. Ammonia and primary and secondary amines can form hydrogen bonds, while tertiary amines cannot; therefore, tertiary amines have lower boiling points. Since nitrogen is not as electronegative as oxygen, the hydrogen bonds of amines are not as strong as those of alcohols.

The nitrogen atom in an amine is sp^3 hybridized. Nitrogen bonds to only three substituents in order to complete its octet; a lone pair occupies the last sp^3 orbital. This lone pair is very important to the chemistry of amines; it is associated with their basic and nucleophilic properties.

Nitrogen atoms bonded to three different substituents are chiral because of the geometry of the orbitals. However, these enantiomers cannot be isolated, because they interconvert rapidly in a process called **nitrogen inversion**: an inversion of the sp^3 orbital occupied by the lone pair. The activation energy for this process is only 6 kcal/mol, and only at very low temperatures is it significantly slowed or stopped.

Figure 49.2

Amines are Brønsted-Lowry bases and readily accept protons to form ammonium ions; they are also classified as Lewis bases because of their ability to donate electrons (for a review of acids and bases, see Chapter 36). The pK_b values of alkyl amines are around 4, making them slightly more basic than ammonia (pK_b = 4.76). Aromatic amines such as aniline (pK_b = 9.42) are far less basic than aliphatic amines, because the electron-withdrawing effect of the ring reduces the electron-donating ability

of the amino group. The presence of other substituents on the ring alters the basicity of anilines: electron-donating groups (such as $-OH$, $-CH_3$, and $-NH_2$) increase basicity, while electron-withdrawing groups (such as $-NO_2$) reduce basicity.

Amines also function as very weak acids. The pK_a values of amines are around 35, and a very strong base is required for deprotonation. For example, the proton of diisopropylamine may be removed with butyllithium, forming the sterically hindered base lithium diisopropylamide, LDA.

Figure 49.3

SYNTHESIS OF AMINES

Alkylation of Ammonia

Direct alkylation

Alkyl halides react with ammonia to produce alkylammonium halide salts. Ammonia functions as a nucleophile and displaces the halide atom. When the salt is treated with base, the alkylamine product is formed.

$$CH_3Br + NH_3 \longrightarrow CH_3\overset{+}{N}H_3 Br^- \xrightarrow{NaOH} CH_3NH_2 + NaBr + H_2O$$

Figure 49.4

This reaction often leads to side products, because the alkylamine formed is more nucleophilic than ammonia. The alkylamine product therefore reacts with the alkyl halide faster than ammonia, leading to increasingly complex products. The final result will be a mixture of primary, secondary, tertiary and sometimes quaternary amines:

$$NH_3 + R-X \longrightarrow RNH_2 \ (1°)$$

$$RNH_2 + R-X \longrightarrow R_2NH \ (2°)$$

$$R_2NH + R-X \longrightarrow R_3N \ (3°)$$

$$R_3N + R-X \longrightarrow R_4N^+ \ (4°)$$

Gabriel synthesis

The preferred method for synthesizing amines is the **Gabriel synthesis.** This pathway converts a primary alkyl halide to a primary amine without the uncontrolled additional reactions seen in the direct alkylation of amines. The first step is the creation of phthalimide, a nitrogen source based on ammonia, but with more controlled reactivity:

o-phthalic acid phthalimide

good nucleophile

Figure 49.5

Phthalimide, the condensation product of phthalic acid and ammonia, acts as a good nucleophile when deprotonated. It displaces halide ions, forming N-alkylphthalimides, which do not further react with other alkyl halides. When the reaction is complete, the N-alkylphthalimide can be hydrolyzed with aqueous base to produce the alkylamine.

Figure 49.6

Reduction

Amines can be obtained from other nitrogen-containing functionalities through reduction reactions using typical reducing agents.

From nitro compounds

Nitro compounds are easily reduced to primary amines. The most common reducing agent is iron or zinc and dilute hydrochloric acid, although many other reagents can be used. This reaction is especially useful for aromatic compounds, because aromatic rings are readily nitrated and thus provide an efficient route for amine synthesis.

Figure 49.7

From nitriles

Nitriles can be reduced with hydrogen and a catalyst, or with lithium aluminum hydride (LAH), to produce primary amines.

$$CH_3CH_2C\equiv N \xrightarrow{\text{LAH}} CH_3CH_2CH_2NH_2$$

Figure 49.8

From imines

Amines can be synthesized by **reductive amination**: a process in which an aldehyde or ketone is reacted with ammonia, a primary amine, or a secondary amine to form a primary, secondary, or tertiary amine, respectively. When the amine reacts with the aldehyde or the ketone, an imine intermediate is produced. Similar to a carbonyl, the imine can then undergo hydride reduction. When the imine is reduced with hydrogen in the presence of a catalyst, an amine is produced.

acetone | imine isopropylimine | amine isopropylamine (aminoisopropane)

Figure 49.9

From amides

Amides can be reduced with LAH to form amines (see Chapter 48 to review amides).

Figure 49.10

REACTIONS OF AMINES

Exhaustive Methylation

Exhaustive methylation is also known as **Hofmann elimination**. In this process, an amine is converted to a quaternary ammonium iodide salt by reacting with excess methyl iodide. Treatment with silver oxide and water converts this to the ammonium hydroxide, which, when heated, undergoes elimination to form an alkene and an amine. The predominant alkene formed is the least substituted, in contrast with normal elimination reactions, where the predominant alkene product is the most substituted.

Figure 49.11

REVIEW PROBLEMS

1. A compound with the general formula $R_4N^+X^-$ is classified as a
 A. secondary amine.
 B. quaternary ammonium salt.
 C. tertiary amine.
 D. primary amine.
 E. tertiary ammonium salt.

2. A compound with the structural formula $C_6H_5N^-N^+\equiv N$ is called
 A. a urethane.
 B. a diazo compound.
 C. an azide.
 D. a nitrile.
 E. an amide.

3. Amines have lower boiling points than the corresponding alcohols because
 A. amines have higher molecular masses.
 B. amines form much stronger hydrogen bonds.
 C. amines form weaker hydrogen bonds.
 D. amines are less dense.
 E. amines contain fewer total atoms per molecule.

4. Which of the following would be formed if methyl bromide was reacted with phthalimide and then hydrolyzed with aqueous base?
 A. $C_2H_5NH_2$
 B. CH_3NH_2
 C. $(C_2H_5)_3N$
 D. $(CH_3)_4N^+Br^-$
 E. CH_4

5. The reaction of benzamide with $LiAlH_4$ yields which of the following compounds?
 A. Benzoic acid
 B. Benzonitrile
 C. Benzylamine
 D. Ammonium benzoate
 E. Benzopyrene

6. Suggest a method of converting RCOOH to RNH_2.

7. Which of the following amines has the highest boiling point?
 A. CH_3NH_2
 B. $CH_3(CH_2)_6NH_2$
 C. $CH_3(CH_2)_3NH_2$
 D. $(CH_3)_3CNH_2$
 E. $CH_3CH_2NH_2$

8. If 2-amino-3-methylbutane were treated with excess methyl iodide, silver oxide, and water, what would be the major reaction products?

 A. Ammonia and 2-methyl-2-butene

 B. Trimethylamine and 3-methyl-1-butene

 C. Trimethylamine and 2-methyl-2-butene

 D. Ammonia and 3-methyl-1-butene

 E. Ammonia alone

9. Nylon, a polyamide, is produced from hexanediamine and a substance X. This substance X is most probably

 A. an amine.

 B. a carboxylic acid.

 C. a nitrile.

 D. an alcohol.

 E. a sulfide.

10. A researcher wants to prepare a primary amine (RNH_2). He uses an alkyl halide (RX) and ammonia to produce an alkyl ammonium halide salt ($RNH_3^+X^-$), which he then treats with sodium hydroxide to produce the primary amine. He finds that the product is always contaminated with a secondary amine (R_2NH) and a tertiary amine (R_3N). What has he done wrong and how can he produce only the primary amine he desires?

SOLUTIONS TO REVIEW PROBLEMS

1. **B** A quaternary ammonium salt has four substituents attached to the nitrogen, resulting in a positive charge on this atom. As a result, this compound forms a salt, where X⁻ is usually a halide. Primary amines have the general formula RNH_2, secondary amines have the general formula R_2NH, and tertiary amines have the general formula R_3N.

2. **C** This is an azide, which is unstable and readily loses nitrogen to yield a nitrene. A urethane, choice (A), has the formula RNHCOOR'. A diazo compound, choice (B), has the formula $R-N \equiv N$. A nitrile, choice (D), also called a *cyanide*, has the formula $R-C \equiv N$. An amide does contain nitrogen but also has a carbonyl.

3. **C** Amines form weaker hydrogen bonds than alcohols, since nitrogen has a lower electronegativity than oxygen. The molecules are not held together as tightly and are therefore more volatile. Density and number of atoms may indicate other properties but do not affect intermolecular forces or boiling point directly.

4. **B** The reaction between methyl bromide and phthalimide results in the formation of methyl phthalimide. Subsequent hydrolysis then yields methylamine, so answer choice (B) is the correct response. The overall reaction is the conversion of a primary alkyl halide into a primary amine. Choice (A) is incorrect because this contains an ethyl group, not a methyl group. In order to form this compound, the initial reactant would need to be ethyl bromide. Choices (C) and (D) are incorrect as these are tertiary and quaternary nitrogen compounds, respectively, and the reaction only converts primary alkyl halides into primary amines. Choice (E) is methane, which does not take into account the nitrogen from phthalimide.

5. **C** Lithium aluminum hydride is a good reducing agent and is used to reduce amides to amines. Reduction of benzamide will result in the formation of benzylamine, choice (C). Hydrolysis of benzamide would result in the formation of benzoic acid, so choice (A) is incorrect. Benzonitrile would be formed by the dehydration of amides, so choice (B) is also incorrect. To form ammonium benzoate, choice (D), benzamide would first have to be hydrolyzed and then reacted with ammonia, so this answer choice is also incorrect. Choice (E), benzopyrene, is a structure composed of five different rings and has the formula $C_{20}H_{12}$. This structure has a complex synthesis that could not be achieved with the given reactants alone, especially not in a 1:1 ratio as implied.

6. One method is transformation of the carboxylic acid to an acid chloride, followed by reaction with ammonia and then reduction with LAH (see Chapter 48).

Another approach is the Curtius rearrangement:

1.

$$\underset{R}{\overset{O}{\|}}{-}OH \xrightarrow{SOCl_2} \underset{R}{\overset{O}{\|}}{-}Cl$$

2.

$$\underset{R}{\overset{O}{\|}}{-}Cl \xrightarrow{NaN_3} \underset{R}{\overset{O}{\|}}{-}N{-}\overset{+}{N}{\equiv}N \xrightarrow{-N_2} O{=}C{=}N{-}R$$

Curtius rearrangement

3. $O{=}C{=}N{-}R \xrightarrow[-CO_2]{H_2O} \underset{H}{\overset{H}{\diagdown}}N{-}R$

7. **B** As the molecular masses of comparable amines having the same degree of substitution increase, so do their boiling points. Of the choices given, choice (B), heptylamine, has the highest molecular mass (115 g/mol) and therefore the highest boiling point, 142−144°C. Choice (A), methylamine, has a mass of 31 g/mol and a boiling point of −6.3°C. Butylamine, choice (C), has a boiling point of 77.5°C, and *t*-butylamine, choice (D), has a boiling point of 44.4°C. Butylamine and *t*-butylamine have the same mass (73 g/mol), demonstrating the effect branching has on decreasing the boiling point. Finally, choice (E), ethylamine, has a mass of 45 g/mol and a boiling point of 16.6°C.

8. **B** Treatment of an amine with excess methyl iodide, silver oxide, and water is called exhaustive methylation or Hofmann elimination. The products formed are a trisubstituted amine and an alkene. Since 2-amino-3-methylbutane is a primary amine, it will take up three methyl groups; the trisubstituted amine produced will be trimethylamine. The predominant alkene product will be the least substituted alkene, because removal of a secondary hydrogen is sterically hindered. Therefore, this reaction will produce 3-methyl-1-butene, plus trimethylamine, choice (B). Choices (A) and (D) are incorrect; ammonia cannot be a product of this reaction since the mechanism involves the addition of methyl groups. Choice (C) is incorrect because 2-methyl-2-butene, the more substituted alkene, would not be the predominant product.

9. **B** An amide is formed from an amine and a carboxyl group or its acyl derivatives. In this question, an amine is already given; the compound to be identified must be an acyl compound. The only acyl compound among the choices given is a carboxylic acid, choice (B).

10. The researcher gets a contaminated product because he is using a direct alkylation process, which does not stop cleanly after the first alkylation. The primary amine produced by

direct alkylation is an excellent nucleophile and will react with other alkyl halides to produce secondary and tertiary amines.

$$NH_3 + R-X \longrightarrow RNH_2 \quad (1°)$$
$$RNH_2 + R-X \longrightarrow R_2NH \quad (2°)$$
$$R_2NH + R-X \longrightarrow R_3N \quad (3°)$$

Instead he should use the Gabriel synthesis, which converts an alkyl halide to a primary amine without unwanted side products. In this reaction, an imide, not ammonia, is used as the nucleophile. The product is an *N*-alkylimide, which cannot react further with alkyl halides. After the reaction is complete, the *N*-alkylimide is hydrolyzed with base to produce the primary alkylamine.

Spectroscopy

LEARNING OBJECTIVES

After this chapter, you will be able to:

- Identify the functional groups in a compound using IR spectroscopy
- Predict the structure of a compound using 1H NMR or 13C NMR spectroscopy
- Describe UV-vis and mass spectrometry

When an organic compound has been synthesized or separated from a mixture, it often must be characterized and identified. **Spectroscopy** is the process of measuring the frequencies of electromagnetic radiation (light) absorbed and emitted by a molecule. The frequencies of light that are absorbed and emitted are related to the energy levels of the molecule and different types of motion, including rotation, vibration of bonds, and electron movement. Different types of spectroscopy measure these different types of motion, allowing identification of specific functional groups and how they are connected within a molecule.

INFRARED SPECTROSCOPY

Basic Theory

Infrared (IR) spectroscopy measures molecular vibrations. The infrared spectrum of a sample is determined by passing infrared light through the sample and recording the frequencies at which the light is absorbed. These absorption frequencies correspond to the vibrations of the molecule, including **stretching**, **bending**, and **rotation**. The useful absorptions of infrared light occur in the frequency range from $4{,}000{-}400$ cm^{-1} (called **wavenumbers**), which can be split into a functional group region and a fingerprint region. In the functional group region, the wavenumber of the absorption is typically related to the stretching vibrations of specific functional groups in a molecule and can be used to identify these functional groups. In the fingerprint region, the spectra, which usually consists of bending vibrations within a molecule, is complex and unique (like a fingerprint) for each compound.

Bond stretching is observed in the region of $4{,}000{-}1{,}500$ cm^{-1}, and bending vibrations are observed in the region of $1{,}500{-}400$ cm^{-1}. Four different types of vibration that can occur are shown in Figure 50.1.

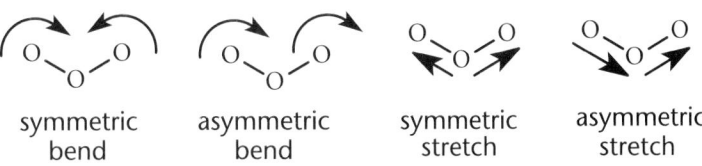

symmetric
bend

asymmetric
bend

symmetric
stretch

asymmetric
stretch

Figure 50.1

In order for IR light to be absorbed, the vibration of the molecule must result in a change in a bond dipole moment. Symmetrical molecules do not have a dipole moment and therefore do not absorb IR light. For example, O_2 and Br_2 do not absorb IR light, but HCl and CO do. The more complicated a molecule, the more peaks observed in its IR spectrum.

Characteristic IR Absorptions

Specific functional groups absorb at well-defined frequencies. For example, carbon-carbon single bonds absorb at around 1,200 cm^{-1}, double bonds around 1,600 cm^{-1}, and triple bonds around 2,200 cm^{-1}. Table 50.1 lists the specific absorptions of key functional groups and the vibrations that occur at those frequencies.

Functional Group	Frequency (cm^{-1})	Vibration
Alkanes	2800–3000	C—H
	1200	C—C
Alkenes	3080–3140	=C—H
	1645	C=C
Alkynes	3300	≡C—H
	2200	C≡C
Aromatic	2900–3100	C—H
	1475–1625	C—C
Alcohols	3100–3500	O—H (broad)
Ethers	1050–1150	C—O
Aldehydes	2700–2900	(O)C—H
	1725–1750	C=O
Ketones	1700–1750	C=O
Acids	2900–3300	O—H (broad)
	1700–1750	C=O
Amines	3100–3500	N—H (sharp)

Table 50.1

Some of the most useful information in an IR spectrum can often be quickly and easily determined by reviewing two key areas of absorption—from 1,700–1,750 and 3,100–3,500 cm^{-1}—to determine the presence of oxygen and nitrogen functional groups:

Functional Group	1,700–1,750 cm^{-1}	3,100–3,500 cm^{-1}
Alcohol	No	Broad peak
Aldehyde or Ketone	Yes	No
Carboxylic Acid	Yes	Broad peak
Amine	No	Sharp peak

Table 50.2

Application

A great deal of information can be obtained from an IR spectrum. Percent transmission, the inverse of absorbance, is plotted versus frequency; this gives areas of absorption the appearance of valleys on the spectrum.

Figure 50.2 shows the IR spectrum of an aliphatic alcohol. The broad peak at 3,300 cm^{-1} is due to the hydroxyl group, while the peak at 3,000 cm^{-1} is created by the large number of C–H bonds in the molecule.

Figure 50.2

Summary of IR Spectroscopy

1. IR spectroscopy is based on the vibrations of molecules, including bending and stretching.

2. IR absorption is measured in the frequency range of 4,000–400 cm^{-1}, and is plotted as transmittance vs. wave number, with absorption appearing as "valleys" in the spectrum.

3. Different functional groups show IR absorption at different wave numbers. Some of the most useful absorption ranges to note are at 1,700 cm^{-1} (C=O bond) and at 3,100–3,500 cm^{-1} (O–H if broad, N–H if narrow). However, other absorption frequencies can also be important.

NUCLEAR MAGNETIC RESONANCE

Basic Theory

Nuclear magnetic resonance (**NMR**) spectroscopy is one of the most widely used spectroscopic tools in organic chemistry. Certain nuclei have magnetic moments that are normally oriented at random. When such nuclei are placed in a magnetic field, their magnetic moments tend to align either with or against the direction of the field. Nuclei whose magnetic moments are aligned with the field are said to be in the **α-state** (lower energy), while those whose moments are aligned against the field are said to be in the **β-state** (higher energy).

If the nuclei are then exposed to electromagnetic radiation, some in the lower energy α-state will be excited into the β-state; this transition is known as **resonating.** The absorption corresponding to this excitation occurs at different frequencies depending on the atom's environment. Other nearby atoms in the same molecule (or sometimes in the solvent) can shift the frequency at which an atom transitions between the α- and β-states. A compound may contain many nuclei that resonate at different frequencies, producing a very complex spectrum.

Since different NMR spectrometers operate at different magnetic field strengths, a standardized method of plotting the NMR spectrum has been adopted. A variable called **chemical shift**, represented by the symbol δ and with units of **parts per million** (**ppm**), is plotted on the *x*-axis. Chemical shift is compared to the standard organic molecule tetramethylsilane (TMS). TMS is always shown by a peak at 0 ppm, and the peaks of interest always appear to the left of TMS. A peak further to the left is said to be **shifted downfield**.

NMR is most commonly used to study ^1H nuclei (protons) and ^{13}C nuclei, although any atom possessing a nuclear spin (any nucleus with an odd atomic number or odd mass number) can be studied, such as ^{19}F, ^{17}O, ^{14}N, ^{15}N, or ^{31}P.

^1H NMR (Proton NMR)

Peak location

Most ^1H nuclei come into resonance between 0 and 10 δ downfield from TMS. Each distinct set of nuclei gives rise to a separate peak. The compound dichloromethyl methyl ether ($Cl_2HC-O-CH_3$) has two distinct sets of ^1H nuclei. The single proton attached to the dichloromethyl group is in a different magnetic environment compared to the three protons on the methyl group, and the two types of protons resonate at different frequencies. The three protons on the methyl group are magnetically equivalent, due to rotation about the oxygen-carbon single bond, and resonate at the same frequency. Thus, two separate peaks are seen, as shown in Figure 50.3.

Figure 50.3

The peak at 6 ppm corresponds to the single dichloromethyl proton and the peak at 3 ppm to the three methyl protons. The size of the peaks is also significant; if the areas under the peaks are integrated, the ratio between them is 3:1, corresponding to the number of protons producing each peak. This can be roughly approximated as the relative heights of the peaks when quickly evaluating an NMR spectrum.

The single proton comes into resonance downfield from (to the left of) the methyl protons. This shift downfield is due to the electron-withdrawing effect of the chlorine atoms. The electron cloud that surrounds the 1H nucleus ordinarily screens the nucleus from the magnetic field. The chlorine atoms pull the electron cloud away and **deshield** the nucleus, moving its resonance to the left. Conversely, electron-donating atoms **shield** the 1H nuclei, causing them to appear further to the right. Different bonds also have different affinities for electrons. As a result, different functional groups can deshield protons in predictable ways, as shown in Table 50.3:

Type of Proton	Approximate Shift δ (ppm)
RCH_3	0.9
R_2CH_2	1.25
R_3CH	1.5
$-CH=CH$	4.6–6.0
$-C\equiv CH$	2.0–3.0
Ar–H	6.0–8.5
–CHX	2.0–4.5
–CHOH / –CHOR	3.4–4.0
RCHO	9.0–10.0
RCHCO–	2.0–2.5
–CHCOOH / –CHCOOR	2.0–2.6
–CHOH / –CH$_2$OH	1.0–5.5
ArOH	4.0–12
–COOH	10.5–12.0
$-NH_2$	1.0–5.0

Table 50.3

Peak splitting

If two magnetically different protons are within three bonds of each other, a phenomenon known as **coupling** or **splitting** occurs. Consider two protons, H_a and H_b, on the molecule 1,1-dibromo-2,2-dichloroethane (see Figure 50.4).

Figure 50.4

At any given time, H_a can experience two different magnetic environments, since H_b can be in either the α or the β state. These different states of H_b influence nucleus H_a, causing slight upfield and downfield shifts. Since there is a 50 percent chance that H_b will be in either state, this results in a **doublet**, two peaks of equal intensity equally spaced around the true chemical shift of H_a. H_b experiences the two different states of H_a and is likewise split into a doublet. In 1,1-dibromo-2-chloroethane (see Figure 50.5), the H_a nucleus is affected by two nearby H_b nuclei, which, taken together, can be in four different states: αα, αβ, βα, or ββ.

Figure 50.5

The αβ and βα states have the same net effect on the H_a nucleus, and the resonances occur at the same frequency. The αα and ββ states resonate at frequencies different from each other and from the αβ / βα frequency. The result is three peaks centered around the true chemical shift, with an area ratio of 1:2:1. The number of peaks that will appear when splitting occurs can be determined as follows: n hydrogen atoms couple to give $n + 1$ peaks, whose area ratios are given by Pascal's triangle, shown in Table 50.4.

Number of Adjacent Hydrogens	Total Number of Peaks	Area Ratios
0	1	1
1	2	1:1
2	3	1:2:1
3	4	1:3:3:1
4	5	1:4:6:4:1
5	6	1:5:10:10:5:1
6	7	1:6:15:20:15:6:1
7	8	1:7:21:35:35:21:7:1

Table 50.4

^{13}C NMR (Carbon NMR)

^{13}C NMR is very similar to ^1H NMR. Most ^{13}C NMR signals, however, occur $0-200$ δ downfield from the carbon peak of TMS, so a spectrum for ^{13}C NMR is easily recognized by the larger scale of the x-axis. Another significant difference is that only 1.1 percent of carbon atoms are ^{13}C atoms. This has two effects: First, a much larger sample is needed to run a ^{13}C spectrum (about 50 mg compared with 1 mg for ^1H NMR), and second, coupling between carbon atoms is generally not observed.

Coupling *is* observed, however, between carbon atoms and the protons directly attached to them. For example, if a carbon atom is attached to two protons, it can experience four different states of those protons (αα, αβ, βα, and ββ), and the carbon signal is split into a triplet with the area ratio 1:2:1.

An additional feature of ^{13}C NMR is the ability to record a spectrum *without* the coupling of adjacent protons. This is called **spin decoupling**, and produces a spectrum of **singlets**, each corresponding to a separate magnetically equivalent carbon atom. For example, compare the following two spectra, both of 1,1,2-trichloropropane. One (Figure 50.6) is a typical **spin-decoupled spectrum**, and the other (Figure 50.7) is spin-coupled.

Figure 50.6

Figure 50.7

Summary of NMR Spectroscopy

1. NMR spectroscopy is based on the magnetic moment of nuclei, which resonate between two states.

2. In general, NMR spectroscopy provides information about the carbon and hydrogen skeleton of a molecule along with some suggestion of its functional groups.

3. Each peak (single resonance) in an H-NMR spectrum represents a single proton or a group of equivalent protons. The size of each peak represents the number of equivalent protons in a group.

4. The number of nonequivalent nuclei is determined from the number of peaks (different resonances).

5. The relative number of nuclei is determined by integrating the peak areas.

6. The magnetic environment of a nucleus is determined by the chemical shift.

7. The position of the peak (distance downfield, or to the left) is determined by the shielding or deshielding effects of other functional groups nearby.

8. The splitting of a peak is determined by the number of adjacent protons n, and the number of peaks is given by $n + 1$ (except for 13C in the spin-decoupled mode).

ULTRAVIOLET-VISIBLE SPECTROSCOPY

Basic Theory

Ultraviolet-visible (UV-vis) spectra are obtained by passing ultraviolet (200 – 400 nm) or visible (400 – 800 nm) light through a chemical sample (usually dissolved in an inert, non-absorbing solvent) and plotting absorbance versus wavelength. Higher in energy than infrared light, UV-visible light causes electronic excitations in which an electron is excited from the highest occupied molecular orbital (HOMO) to the lowest unoccupied molecular orbital (LUMO). Molecules that have more conjugation have a smaller HOMO-LUMO gap, and therefore can absorb longer wavelengths. Additionally, the higher the concentration of the compound in solution, the greater the absorbance.

Since the wavelength of absorption depends on functional groups of the molecule, UV-vis spectra are often used to simply identify the presence or absence of a compound by measuring the absorbance at a characteristic wavelength for that molecule. For example, to follow the progress of an oxidation reaction using $K_2Cr_2O_7$, the absorbance of the solution at 350 nm is monitored. When large amounts of $K_2Cr_2O_7$ are present, high absorbance is recorded; when the reaction has gone to completion and the $K_2Cr_2O_7$ is no longer present, the absorption peak disappears.

Atomic absorption and emission spectra related to the energy levels of electrons are measured in the UV-vis range, and provide information on the quantum states of atoms. Atomic spectra are discussed in more detail in Chapter 24.

Summary of Ultraviolet-visible Spectroscopy

1. UV-vis spectroscopy measures light absorption of molecules across ultraviolet (200–400 nm) or visible (400–800 nm) wavelengths.

2. Absorption of UV-vis causes molecules to undergo electronic transitions such as the excitation of electrons from lower to higher energy levels.

3. The wavelength of light absorbed varies from compound to compound and depends on the functional groups of the molecule.

MASS SPECTROMETRY

Basic Theory

Mass spectrometry is a means of determining the molecular weight and structure of a molecule based on how it ionizes and decomposes under specific conditions. Mass spectrometry differs from other spectroscopic methods in two ways: No absorption of electromagnetic radiation is involved, and it is a destructive technique that does not allow the sample to be recovered and reused.

Mass spectrometers ionize the sample in a high-speed beam of electrons. The ionized sample then enters a magnetic field that deflects the ionic fragments into a detector. The net charge and mass of each particle is determined, along with the number of each type of particle (known as the **abundance**). The first ion formed is the +1 cation (M^+) resulting from the removal of a single electron. This unstable ion usually decomposes rapidly into more cationic fragments. A typical mass spectrum is composed of many lines, each corresponding to a fragment with a specific **mass to charge ratio**

(*m/e,* also written as *m/z*). The spectrum itself plots mass/charge on the horizontal axis and relative abundance of the various cationic fragments on the vertical axis (see Fig. 50.8).

Characteristics

The tallest peak, belonging to the most common ion, is called the **base peak**, and is assigned the relative abundance value of 100 percent; thus the amount of any other ion is a percent of the base peak. The peak with the highest *m/e* ratio (see Figure 50.8) is almost always the **molecular ion peak** (**parent ion peak**), **M⁺**, from which the molecular weight, M, can be obtained. The charge value is usually 1; hence the *m/e* ratio can usually be read as the mass of the fragment.

Application

Fragmentation patterns often provide information that helps identify the compound's structure. For example, while IR spectroscopy would be of little use in distinguishing between propionaldehyde and butyraldehyde, a mass spectrum would assist in identification.

Figure 50.8 shows the mass spectrum of butyraldehyde. The peak at *m/e* = 72 corresponds to the molecular cation-radical, M⁺. Additional peaks represent a variety of fragments derived from the loss of groups of carbons and hydrogens.

Figure 50.8

Summary of Mass Spectrometry

1. Mass spectrometry is based on the mass to charge (*m/e*) ratio of fragments of the molecule of interest.

2. Each peak in a mass spectrum corresponds to one fragment, and its height gives the relative abundance (amount) of that fragment.

3. The original molecule can be identified as the highest mass/charge ratio peak in the spectrum, as it is the +1 cation of the original compound.

4. The fragmentation pattern can give additional information about the structure of the compound.

REVIEW PROBLEMS

1. IR spectroscopy is most useful for distinguishing
 - A. double and triple bonds.
 - B. C−H bonds.
 - C. chirality of molecules.
 - D. composition of racemic mixtures.
 - E. electronegativity.

2. Oxygen (O_2) does not exhibit an IR spectrum because
 - A. it has no molecular motions.
 - B. it is not possible to record IR spectra of a gaseous molecule.
 - C. molecular vibrations do not result in a change in the dipole moment of the molecules.
 - D. it has a molar mass less than 20 g/mol.
 - E. it reacts too quickly to be measured.

3. If IR spectroscopy were employed to monitor the oxidation of benzyl alcohol to benzaldehyde, which of the following would provide the best evidence that the reaction was proceeding as planned?
 - A. Comparing the fingerprint region of the spectra of starting material and product.
 - B. Noting the change in intensity of the peaks corresponding to the phenyl ring.
 - C. Noting the appearance of a broad absorption peak in the region of 3,100–3,500 cm^{-1}.
 - D. Noting the appearance of a strong absorption peak in the region of 1,700 cm^{-1}.
 - E. Noting the appearance of a sharp absorption peak in the region of 675–870 cm^{-1}.

4. Which of the following chemical shifts would correspond to an aldehyde proton signal in a 1H NMR spectrum?
 - A. 1.2 ppm
 - B. 2.6 ppm
 - C. 4.8 ppm
 - D. 7.0 ppm
 - E. 9.5 ppm

5. The isotope ^{12}C is not useful for NMR because
 - A. it is not abundant in nature.
 - B. its resonances are not sensitive to the presence of neighboring atoms.
 - C. it has no magnetic moment.
 - D. the signal-to-noise ratio in the spectrum is too low.
 - E. its density is too high to be affected by magnetic fields.

6. The NMR spectra of ethanol in the presence and absence of water are shown below.

NMR spectrum of ethanol

δ(ppm)

NMR spectrum of anhydrous ethanol

δ(ppm)

Which of the following explains the differences between the two spectra?

A. Water also resonates, doubling the number of peaks.

B. Carbon atoms do not couple in the presence of water.

C. The hydroxyl proton of ethanol exchanges with protons from water, preventing it from coupling.

D. Anhydrous ethanol forms dimers, causing the signal to split.

E. The solvent is not as effective at dissolving anhydrous ethanol, so more must be added.

7. In ^{13}C NMR, splitting of spectral lines is due to

 A. coupling between a carbon atom and protons attached to that carbon atom.
 B. coupling between a carbon atom and protons attached to adjacent carbon atoms.
 C. coupling between adjacent carbon atoms.
 D. coupling between two adjacent protons.
 E. coupling between a carbon atom, a proton directly attached, and an adjacent proton.

8. In the ^{13}C NMR spectrum of methyl phenyl ketone, which carbon atom will appear the farthest downfield?

 A. The methyl carbon
 B. The carbon at the first position of the phenyl ring
 C. The carbon at the *para* position of the phenyl ring
 D. The carbonyl carbon
 E. The carbon at the *meta* position of the phenyl ring

9. UV spectroscopy is most useful for detecting

 A. aldehydes and ketones.
 B. unconjugated alkenes.
 C. conjugated alkenes.
 D. aliphatic acids and amines.
 E. alkanes.

10. Mass spectroscopy results in the separation of fragments according to

 A. atomic mass.
 B. mass-to-charge ratio.
 C. viscosity.
 D. absorption wavelength.
 E. principal quantum number.

SOLUTIONS TO REVIEW PROBLEMS

1. **A** IR is most useful for distinguishing between different functional groups. Almost all organic compounds have C–H bonds (B), so that except for "fingerprinting" a compound, these absorptions are not useful. Very little information about the optical properties of a compound, such as choices (C) and (D), can be obtained by IR spectroscopy. Electronegativity (E) can be determined from the periodic table and does not require spectroscopy.

2. **C** Since molecular oxygen is a diatomic molecule with no initial net dipole, there is no net change in its dipole moment during vibration or rotation. Diatomic nitrogen and chlorine exhibit similar behavior. IR spectroscopy is based on the principle that when the molecule vibrates or rotates, there is a change in dipole moment; therefore, choice (C) is the correct answer. Choice (A) is incorrect because oxygen does have molecular motions. Choice (B) is incorrect because it is possible to record the IR of a gaseous molecule as long as it shows a change in its dipole moment when it vibrates. Choices (D) and (E) are false statements.

3. **D** In this reaction, the functional group is changing from a hydroxyl to an aldehyde. This means that a sharp peak will appear at around 1700 cm^{-1}, which corresponds to the carbonyl functionality. Therefore, choice (D) is the correct response. Choice (C) is incorrect because the reaction will be characterized by the disappearance of a peak at 3,100–3,500 cm^{-1}, not the appearance of one (this peak corresponds to the hydroxyl functionality). Choice (A) is possible, but the complexity of the information makes it a poor choice compared to (D). Choices (B) and (E) are the least useful, as the IR absorbance of the phenyl ring, which is in the 675–870 cm^{-1} band, will not change in this reaction.

4. **E** The peak at 9.5 ppm corresponds to an aldehyde proton. This signal lies relatively far downfield because the carbonyl oxygen is strongly electron-withdrawing and deshields the proton. The other peaks are too upfield and represent more shielded molecules.

5. **C** This isotope has no magnetic moment and will therefore not exhibit resonance. Nuclei that possess a magnetic moment are those with odd-numbered masses (^{1}H, ^{11}B, ^{13}C, ^{15}N, ^{19}F, etc.) or those with an even mass but an odd atomic number (^{2}H, ^{10}B).

6. **C** The normal spectrum of CH_3CH_2OH has a CH_3 group split into a triplet by the CH_2 group protons, a CH_2 group split into a quartet by the CH_3 group protons, and a hydroxyl proton singlet. This proton exchanges rapidly with the protons of water and is not able to participate in splitting. Under anhydrous conditions, this proton can couple, and it splits the neighboring quartet into a doublet such that an octet is observed. The –OH signal itself appears as a triplet due to splitting by the protons of the neighboring CH_2 group. Answer choice (A) is incorrect because it is opposite of what is true: The peaks are split in the absence of water, not its presence. Choice (B) is incorrect because the spectra are for ^{1}H NMR, not ^{13}C NMR. Answer choice (D) is incorrect because ethanol does not form dimers in solution. Choice (E) is a false statement since the presence or absence of water doesn't affect solubility.

7. **A** Coupling between adjacent carbon atoms, choice (C), is rarely seen due to the low abundance of ^{13}C. Coupling between carbon and protons on the adjacent carbon, choices (B) and (E), is never observed. Since proton coupling is only relevant to ^{1}H NMR, choice (D) is incorrect.

8. **D** The carbonyl carbon atom will be furthest downfield because of the electron-withdrawing ability of the oxygen atom. ^{13}C NMR follows the same rules of chemical shift as ^{1}H NMR. Choices (A), (B), and (E) are farther from the oxygen than the carbonyl carbon and thus will not be shifted as far downfield. Choice (C), the carbon at the *para* position of the phenyl ring, is the furthest from the oxygen and will therefore be shifted downfield the least. Choice (D), the carbonyl carbon, is closest to the oxygen and therefore will experience the greatest shift and is the correct answer.

9. **C** Most conjugated alkenes, choice (C), give an intense UV absorption and are therefore most readily detected by UV spectroscopy. Aldehydes, ketones, acids, and amines, choices (A) and (D), all absorb in the UV, but other forms of spectroscopy (mainly IR and NMR) are more useful for their precise identification. Isolated alkanes and alkenes, choices (B) and (E), can rarely be identified by UV.

10. **B** In mass spectrometry, a molecule is broken down into smaller charged fragments. These fragments are passed through a magnetic field and are identified according to their mass-to-charge ratios; therefore, choice (B) is the correct answer. Choice (D) is the basis for IR and NMR, not mass spectrometry, so this is incorrect. Viscosity, choice (C), doesn't form the basis for any of the spectroscopic techniques discussed, so it is also incorrect. Choice (A) is incorrect because the separation of fragments does not depend solely on mass but on charge as well, and the fragments are mostly polyatomic. Choice (E), principal quantum number, indicates the distance electrons are from the nucleus and isn't directly indicated by mass spectroscopy.

CHAPTER FIFTY-ONE

Separation

Much of organic chemistry is concerned with the isolation and purification of the desired reaction product. A reaction itself may be completed in a matter of minutes, but separating the product from the reaction mixture is often a difficult and time-consuming process. Many techniques have been developed to accomplish the objective of obtaining a pure compound separated from solvents, reagents, and other products.

BASIC TECHNIQUES

Extraction

One way of separating out a desired product is through extraction, the transfer of a dissolved compound from one solvent into another in which the product is more soluble. Most impurities will be left behind in the first solvent. The two solvents should be immiscible (form two layers that do not permanently mix because of mutual insolubility). The two layers are temporarily mixed together, by shaking the container and venting any gas formed, so the solute can pass from one layer to the other. Extraction separates substances based on differential solubility in aqueous versus organic solvents.

For example, isobutyric acid in solution with diethyl ether can be extracted with water; isobutyric acid is more soluble in water than in ether, so isobutyric acid transfers to the water phase when the two solvents are placed together. The water (**aqueous**) and ether (**organic**) phases are separated in a specialized piece of glassware called a separatory funnel (see Figure 51.1). Once separated, the isobutyric acid can be isolated from the aqueous phase in pure form. Some isobutyric acid will remain dissolved in the ether phase, so the extraction should be repeated several times with fresh solvent (water). More product can be obtained with successive extractions (e.g., it is more effective to perform three successive extractions of 10 mL each than to perform one extraction of 30 mL). Once the compound has been isolated in its purified form in a solvent, it can then be obtained by evaporation of the solvent.

Extraction depends on the basic rule of solubility: "like dissolves like." This rule can be observed by comparing the types of intermolecular forces the solute forms, such as in the following examples:

1. Hydrogen bonding: Compounds that can do this, such as alcohols or acids, will move most easily into the aqueous layer, which also can form hydrogen bonds.

2. Dipole–dipole interactions: Compounds with these interactions are less likely to move into the aqueous layer because doing so requires breaking the hydrogen bonds of the solvent and replacing them with weaker dipole–dipole bonds.

3. London dispersion forces: Compounds with only these interactions are least likely to move into the aqueous layer because breaking the hydrogen bonds of the solvent without replacing them with any significant bonds takes large amounts of energy.

The properties of acids and bases also can be used to advantage in extraction:

$$HA + base \rightarrow A^- + Base: H^+$$

When the acid dissociates, the anion formed will be more soluble in the aqueous layer than the original form. This is because the charged anions will form ion–dipole bonds with the solvent, which are even stronger than the hydrogen bonds they are displacing. Thus, adding a *base* will help extract an acid into an aqueous layer.

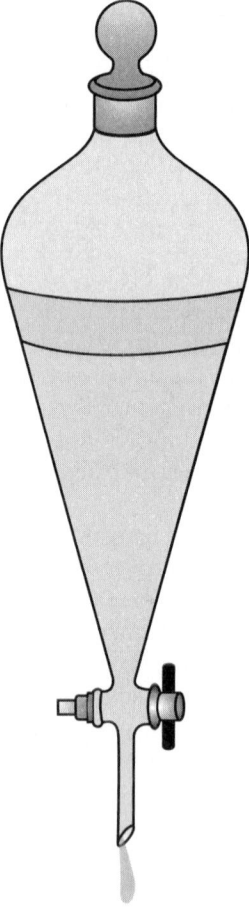

Figure 51.1

An extraction carried out to remove unwanted impurities rather than to isolate a pure product is called a **wash**.

Filtration

Filtration is used to isolate a suspended solid from a liquid. In this technique, a liquid/solid mixture is poured onto a paper filter that allows only the solvent to pass through. The result of this process is the separation of the solid (the **residue**) from the liquid (the **filtrate**). The two basic types of filtration are gravity filtration and vacuum filtration.

In **gravity filtration**, the solvent's own weight pulls it through the filter. Frequently, however, the pores of the filter become clogged with solid, slowing the rate of filtration. For this reason, in gravity filtration it is generally desirable for the substance of interest to be in solution (dissolved in the solvent), while impurities remain undissolved and can be filtered out. This allows the desired product to flow more easily and rapidly through the apparatus. To ensure the product remains dissolved, gravity filtration is usually carried out with hot solvent, since increasing heat generally increases K_{sp}. The solvent is later evaporated.

In **vacuum filtration** (see Figure 51.2), the solvent is forced through the filter by a vacuum on the other side. Vacuum filtration is used to isolate relatively large quantities of solid, usually when the solid is the desired product.

residue
filter paper

to vacuum trap

clean filter flask

filtrate

Figure 51.2

Recrystallization

Recrystallization is a process in which impure crystals are dissolved in a minimum amount of hot solvent. As the solvent is cooled, the crystals re-form, leaving the impurities in solution. For recrystallization to be effective, the solvent must be chosen carefully. It must dissolve the solid while hot but not while cold. In addition, it must dissolve the impurities at both temperatures so they remain in solution even after being cooled. In this way, recrystallization separates solids based on differential solubility at a given temperature.

Solvent choice is usually a matter of trial and error, although some generalizations can be made. Ideally, the desired product should have solubility that depends on temperature—it should be more soluble at high temperature and less so at low. In contrast, impurities should be equally soluble at various temperatures. An estimate of polarity is useful since polar solvents dissolve polar compounds, whereas nonpolar solvents dissolve nonpolar compounds. A solvent with intermediate polarity is generally desirable in recrystallization. In addition, the solvent should have a low enough freezing point that the solution may be sufficiently cooled without turning to a solid.

In some instances, a mixed solvent system may be used. Here, the crude compound is dissolved in a solvent in which it is highly soluble. Another solvent in which the compound is less soluble is then added in drops until the solid just begins to precipitate. The solution is heated a bit more to redissolve the precipitate and then slowly cooled to induce crystal formation.

Sublimation

Sublimation occurs when a heated solid turns directly into a gas without an intervening liquid stage. It is used as a method of purification because the impurities found in most reaction mixtures will not sublimate easily and separates solids based on their ability to sublimate. The vapors are made to condense on a **cold finger**, a piece of glassware packed with dry ice or with cold water running through it (see Figure 51.4). Most sublimations are performed under vacuum because at higher pressures more compounds will pass through a liquid phase rather than subliming. Low pressure also reduces the temperature required for sublimation and thus the danger that the compound will decompose. The optimal conditions depend on the compound to be purified since each compound has a different phase diagram.

Figure 51.3

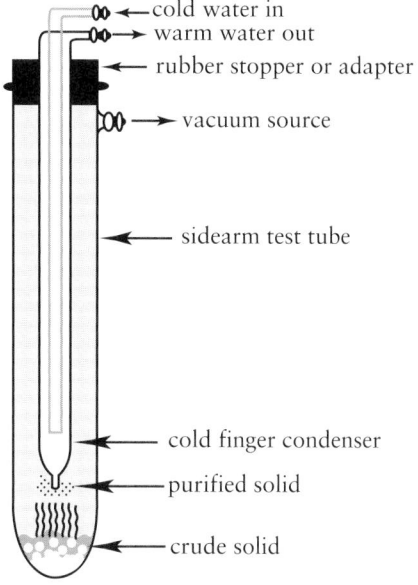

cold water in
warm water out
rubber stopper or adapter
vacuum source
sidearm test tube
cold finger condenser
purified solid
crude solid

Figure 51.4

Centrifugation

Particles in a solution settle, or **sediment**, at different rates depending upon their mass, density, and shape. Sedimentation can be accelerated by **centrifuging** the solution. A centrifuge is an apparatus in which test tubes containing the solution are spun at high speed. This subjects them to centrifugal force (see Figure 51.5). Compounds of greater mass and density settle toward the bottom of the test tube, while lighter compounds remain near the top. This method of separation is effective for many different types of compounds and is frequently used in biochemistry to separate cells, organelles, and biological macromolecules.

MNEMONIC

Sedimentation depends on **S**ize (mass) and **D**ensity.

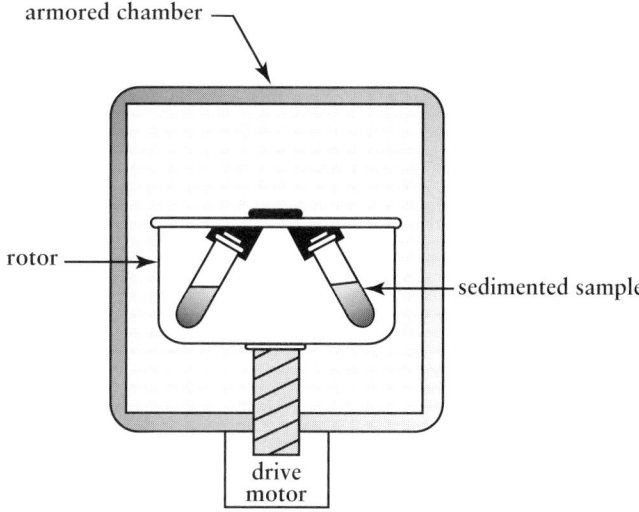

armored chamber
rotor
sedimented sample
drive motor

Figure 51.5

DISTILLATION

Distillation is the separation of one liquid from another through vaporization and condensation. A mixture of two or more miscible liquids is slowly heated. The compound with the lowest boiling point is preferentially vaporized, condensed on a water-cooled distillation column, and separated from the other, higher-boiling-point compound(s). Note that immiscible liquids can be separated in a separatory funnel and thus do not require distillation.

Boiling point is strongly affected by intermolecular forces, with stronger intermolecular forces requiring more energy (higher temperature) to break. This is why H_2O (with hydrogen bonds) has such a high boiling point and why longer molecules (with more London dispersion forces) tend to have higher boiling points than shorter ones.

Simple distillation

Simple distillation is used to separate liquids that have boiling points that are *below* 150°C and that are at least 25°C apart from one another. The apparatus consists of a distilling flask containing the two liquids, a distillation column consisting of a thermometer and a condenser, and a receiving flask to collect the distillate.

Vacuum distillation

Vacuum distillation is used to separate liquids that have boiling points *above* 150°C and that are at least 25°C apart (see Figure 51.6). The entire system is operated under reduced pressure, lowering the boiling points of the liquids and preventing their decomposition due to excessive temperature.

Figure 51.6

Fractional distillation

Fractional distillation is used to separate liquids that have boiling points that are less than 25°C apart (see Figure 51.7). A fractionating column is used to connect the distilling flask to the distillation column. It is filled with inert objects, such as glass beads, that have a large surface area. The vapors condense on these surfaces, re-evaporate, and then condense further up the column. Each time the liquid evaporates, the vapors contain a greater proportion of the lower-boiling-point component. Eventually, the vapor near the top of the fractionating column is composed solely of one component, which condenses on the distillation column and collects in the receiving flask.

Figure 51.7

CHROMATOGRAPHY

Chromatography is a technique that allows the separation and identification of individual compounds from a complex mixture based on their differing chemical properties. Chromatography separates compounds based on how strongly they adhere to a stationary phase versus a mobile phase.

First, the sample is loaded onto the stationary phase, which is a solid medium also called the **adsorbent**. Then, the **mobile phase**, which is a fluid, is run through the stationary phase to displace (or **elute**) adhered substances. Different compounds will adhere to the stationary phase with different strengths and therefore migrate with different speeds. This causes separation of the compounds within the stationary phase, allowing each compound to be isolated.

How quickly a compound travels through the stationary phase depends on a variety of factors. Several forms of media are used as the stationary phase in order to separate compounds based on different chemical properties. Chromatography is often done with silica gel as the adsorbent because it is very polar and hydrophilic. The mobile phase, usually an organic solvent of weak to moderate polarity, is then used to run the sample through the gel. In this situation, nonpolar compounds move very quickly because they dissolve well in the nonpolar mobile phase, whereas polar molecules stick tightly to the polar stationary phase.

Reverse-phase chromatography is just the opposite. In this process, the stationary phase is very nonpolar, so polar molecules run very quickly, while nonpolar molecules stick more tightly.

Size or charge may also play a role, as in column chromatography. Newer techniques, such as affinity chromatography, take advantage of unique properties of a substance, such as its ability to bind to a specific antibody, receptor, or ligand, in order to bind it to the stationary phase.

Compounds can be distinguished from each other because they travel across the stationary phase (adsorbent) at different rates. In practice, a substance can be identified based on how far it travels in a given amount of time (as in thin-layer chromatography) or how rapidly it travels a given distance (e.g., how quickly it elutes off the column in gas or column chromatography).

The four most commonly used types of chromatography are thin-layer chromatography, column chromatography, gas chromatography, and high-performance liquid chromatography.

Thin-Layer Chromatography

The adsorbent, or plate, in **thin-layer chromatography** (TLC) is either a piece of paper or a thin layer of silica gel or alumina on a plastic or glass sheet (see Figure 51.8). The mixture to be separated is placed on the adsorbent; this is called **spotting** because a small, well-defined spot is desirable. The TLC plate is then **developed**—placed upright in a developing chamber (usually a wide-mouthed jar or a beaker with a lid) containing **eluent** (solvent) approximately one-fourth of an inch deep (this value depends on the size of the plate). It is imperative that the initial spots on the plate be above the level of the solvent, or else they will simply elute off the plate into the solvent rather than moving up the plate itself. The solvent creeps up the plate by capillary action, with different compounds moving at different rates depending on their affinity for the plate versus the solvent. When the **solvent front** nears the top of the plate, the plate is removed from the chamber and allowed to dry.

The spots of individual compounds are not usually visible on the white TLC plate. They are instead **visualized** by placing the TLC plate under UV light, which shows any compounds that are UV-sensitive, or by allowing iodine to stain the spots. Other chemical staining agents include phosphomolybdic acid and vanillin. Note that these compounds destroy the product, and it cannot be recovered for further study.

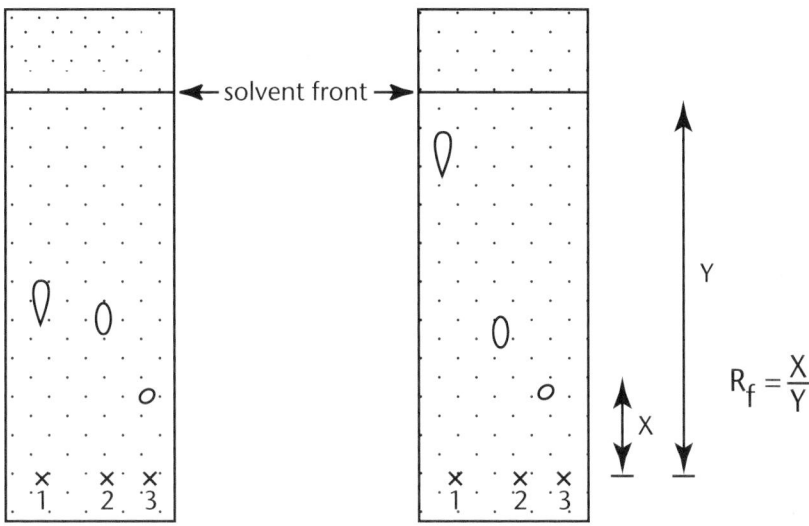

Figure 51.8

The distance a compound travels divided by the distance the solvent travels is called the **Rf value**. This value is relatively constant for each unique compound in a particular solvent and can therefore be used for identification.

TLC is most frequently used for qualitative identification (i.e., determining the identity of a compound) rather than separation. Nevertheless, it can also be used on a larger scale as a means of purification. **Preparative** or **prep TLC** uses a large TLC plate upon which a sizeable streak of a mixture is placed. As the plate develops, the streak splits into bands of individual compounds, which can then be scraped off. Rinsing with a polar solvent will recover the pure compounds from the silica.

Column Chromatography

The principle behind **column chromatography** is the same as for TLC. Column chromatography, however, uses silica gel or alumina as an adsorbent (not paper), and this adsorbent is in the form of a poured or packed column, which allows much more separation (see Figure 51.9). In TLC, the solvent and compounds move up the plate due to capillary action, whereas in column chromatography they move down the column due to the force of gravity. Sometimes the solvent is forced through the column with nitrogen gas; this is called **flash column chromatography**.

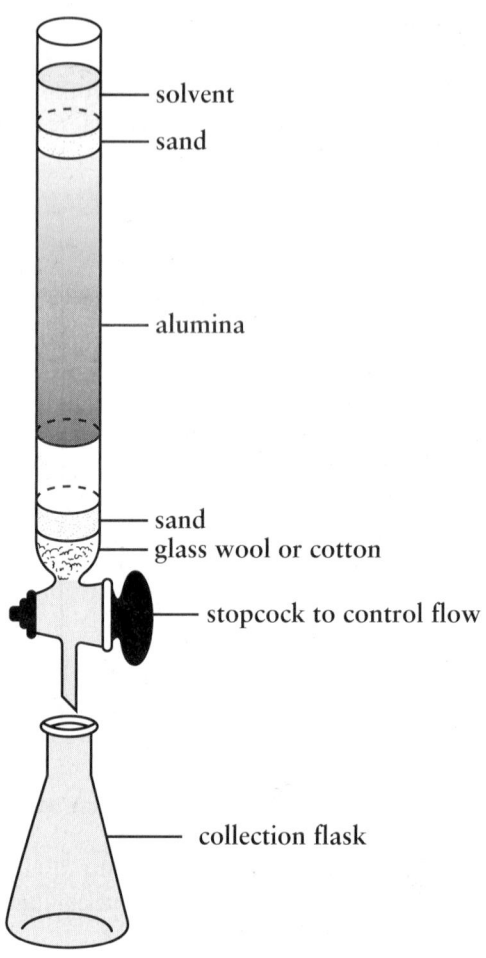

Figure 51.9

The solvent drips out of the end of the column, and fractions are collected in flasks or test tubes. These fractions contain bands corresponding to the different compounds. When the solvents are evaporated, the compounds can be isolated. In column chromatography, the silica/alumina packing is highly polar. Hence, the nonpolar fraction will be collected in the collection flasks.

Column chromatography is particularly useful in biochemistry because it can be used to separate macromolecules, such as proteins or nucleic acids.

Several specialized techniques exist:

1. In *ion exchange chromatography*, the beads in the column are coated with charged substances so they will attract or bind compounds with an opposing charge. For instance, a positively charged column will attract and hold negative substances while letting those with positive charge pass through.

2. In *size-exclusion chromatography*, the column contains beads with many tiny pores. Very small molecules can enter the beads, which slows down their progress, while large molecules move around the beads and thus travel through the column faster.

3. In *affinity chromatography*, columns can be customized to bind a substance of interest. For example, to purify substance A, a scientist might use a column of beads coated with something that binds A very tightly, such as a receptor for A, A's biological target, or even a specific antibody. This will cause substance A to bind to the column very tightly. Substance A can later be eluted by washing with free receptor (or target or antibody), which will compete with the bead-bound receptor and ultimately free substance A from the column.

Gas Chromatography

Gas chromatography (GC) is another method of qualitative separation. In gas chromatography, also called **vapor-phase chromatography** (VPC), the eluent that passes through the adsorbent is a gas, usually helium or nitrogen. The adsorbent is inside a 30-foot column that is coiled and kept inside an oven to control its temperature (see Figure 51.10). The mixture to be separated is injected into the column and vaporized. The gaseous compounds travel through the column at different rates because they adhere to the adsorbent to different degrees and will separate by the time they reach the end of the column. At this point, they are registered by a detector, which records the presence of a compound as a peak. To identify a compound or distinguish between two different compounds, the **retention times** (how long it took for each to travel through the column) are compared.

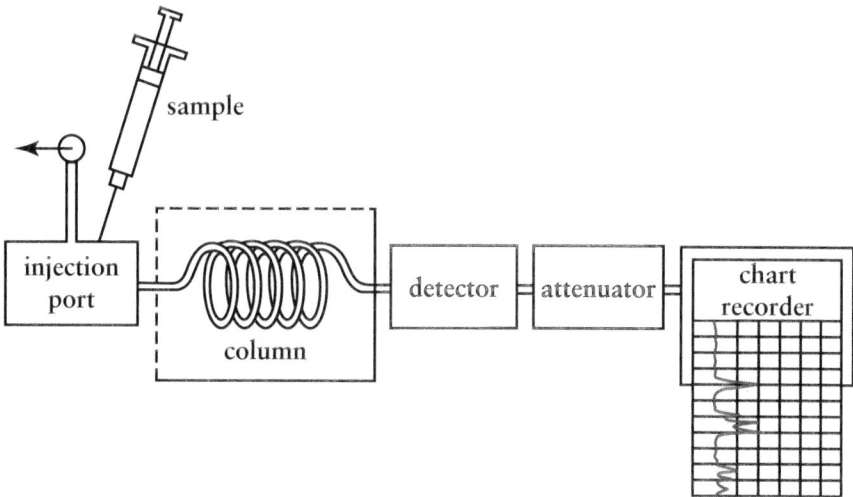

Figure 51.10

GC can be used on a larger scale for quantitative separation; it is then called preparative, or prep, GC. However, this is very tedious and difficult to perform and is rarely done.

HPLC

HPLC stands for either **high-pressure** or **high-performance liquid chromatography**. The eluent is a liquid that travels through a column similar to a GC column, but it is under pressure. In the past, very high pressures were used. Now much lower pressures can be used, hence the change from high *pressure* to high *performance*.

In HPLC, a sample is injected into the column, and separation occurs as it is pumped through. The compounds pass through a detector and are collected as the solvent flows out of the end of the apparatus. The eluent may vary, as in thin-layer or column chromatography.

The additional pressure allows for the separation of even very small samples and an increased resolving power, making HPLC a good choice when fine detail is needed, as in medical applications.

ELECTROPHORESIS

When a molecule is placed in an electric field, it will move toward either the cathode or the anode, depending on its size and charge. **Electrophoresis** employs this phenomenon to separate macromolecules, such as proteins or DNA. The migration velocity, v, of a molecule is directly proportional to the electric field strength, E, and to the net charge on the molecule, z, and is inversely proportional to a frictional coefficient, f, which depends on the mass and shape of the migrating molecules. Therefore, in a constant electric field, highly charged, small molecules will move most rapidly. Note that, in most forms of electrophoresis, the size of a macromolecule is the most important factor—small molecules move faster, whereas large ones move more slowly and may in fact take hours to leave the well.

Agarose Gel Electrophoresis

Agarose gel electrophoresis is used by molecular biologists to separate pieces of **nucleic acid** (usually **deoxyribonucleic acid**, but sometimes **ribonucleic acid** as well). Agarose is an organic gel derived from seaweed that is nontoxic and easy to manipulate. Since every piece of nucleic acid is highly negatively charged, nucleic acids can be separated effectively on the basis of size without any additional treatment to create or manage charge.

Agarose gels are stained with a compound called ethidium bromide, which binds to nucleic acids and is visualized by its fluorescence under ultraviolet light. Agarose gel electrophoresis can also be used preparatively by cutting the desired band out of the gel and eluting out the nucleic acid.

SDS-Polyacrylamide Gel Electrophoresis

SDS-polyacrylamide gel electrophoresis separates proteins on the basis of mass, not charge. Polyacrylamide gel (PAGE) is the standard medium for electrophoresis. SDS is sodium dodecyl sulfate, which disrupts noncovalent interactions. SDS binds to proteins and creates large negative net charges, overriding the protein's original net charge. Therefore, as proteins move through the gel, the only variable affecting their velocity is f, the frictional coefficient, which is dependent on mass. After separation, the gel is stained so the protein bands can be visualized.

Isoelectric Focusing

A protein may be characterized by its **isoelectric point,** pI, which is the pH at which the sum of the charges on all of its component amino acids (its net charge) is zero. Since amino acids and proteins are organic molecules, the fundamental principles of acid-base chemistry apply to them as well.

At a low pH, [H⁺] is relatively high. Thus, at a pH < pI, proteins will tend to be protonated and, as a result, positively charged. At a relatively high (basic) pH, [H⁺] is fairly low and proteins will tend to be deprotonated, thus carrying a negative charge.

If a mixture of proteins is placed in an electric field in a gel with a pH gradient, the proteins will move until they reach the point at which the pH is equal to their pI. At this location, the protein will be uncharged and will no longer move in the field. Molecules differing by as little as one charge can be separated in this manner, which is called **isoelectric focusing**.

Blotting

Blotting is a technique used to separate biological macromolecules. The sample (proteins, DNA, or RNA) are transferred onto a substrate, usually nitrocellulose. This technique often follows the electrophoresis steps above. After the blotting, a visualization stain is used to help isolate the sample. Southern blots are used to visualize DNA, northern blots are used for RNA, and western blots are used for proteins.

REVIEW PROBLEMS

1. Fractional distillation would be best used to separate which of the following compounds?
 A. Methylene chloride (b.p. 41°C) and water (b.p. 100°C)
 B. Ethyl acetate (b.p. 77°C) and ethanol (b.p. 80°C)
 C. Aniline (b.p. 184°C) and benzyl alcohol (b.p. 22°C)
 D. Aniline (b.p. 184°C) and water (b.p. 100°C)
 E. Ethyl acetate (b.p. 77°C) and aniline (b.p. 184°C)

2. Which of the following compounds would be the most effective in extracting benzoic acid from a diethyl ether solution?
 A. Tetrahydrofuran
 B. Aqueous hydrochloric acid
 C. Aqueous sodium hydroxide
 D. Aqueous acetic acid
 E. Water

3. Which of the following techniques should be used to separate red blood cells from blood plasma?
 A. Gel electrophoresis
 B. Fractional distillation
 C. Isoelectric focusing
 D. HPLC
 E. Centrifugation

Questions 4 and 5 refer to the following table.

	pI	Molecular Weight
Protein A	4.5	25,000
Protein B	6.0	10,000
Protein C	9.5	12,000

4. At which pH can the above proteins be separated by isoelectric focusing?
 A. 4.5
 B. 6.0
 C. 7.0
 D. 8.0
 E. 9.5

5. The above proteins were treated with SDS and separated by gel electrophoresis. Predict the order of migration toward the anode.

SOLUTIONS TO REVIEW PROBLEMS

1. **B** Fractional distillation is the most effective procedure for separating two liquids having boiling points that are less than 25 degrees Celsius from each another. Ethyl acetate and ethanol boil within three degrees of each other and would be good candidates for fractional distillation. In the other answer choices, the compounds have widely separated boiling points; fractional distillation could be used but is not needed since simple or vacuum distillation, which are easier to perform, would be effective.

2. **C** Benzoic acid is not soluble in cold water or acidic solutions because of its large, nonpolar ring. However, sodium hydroxide (a base) will react with benzoic acid (an acid) to produce a soluble salt, sodium benzoate. Sodium benzoate, unlike its acid counterpart, will dissolve in an aqueous solution because of the charge created by deprotonating the benzoic acid. Diethyl is a non-polar solvent that will still remain in the organic layer, which allows for the two to be separated when a basic solvent is added.

3. **E** With centrifugation, the dense blood cells would be forced to the bottom of the tube, and the less dense plasma would stay at the top, allowing for separation. Distillation (B) and high-performance liquid chromatography likely would not work; distillation would degrade the cells and proteins found in solution, whereas HPLC, which is designed for small quantities, would not be able to handle the size of the sample. Electrophoresis, (A) and (C), could separate the cells if set up correctly but is not necessary if centrifugation, which is a much simpler technique, is available.

4. **B** The three proteins may be separated when the isoelectric point of one protein is equal to the pH of the solution. Protein B has the intermediate pI at 6.0, so a good pH to choose is 6.0. At that pH, B will be neutral and will remain stationary, even in the presence of a potential difference. Since protein A is neutral at pH = 4.5, it becomes basic (negatively charged) at the relatively more basic pH of 6. Thus, at this pH, protein A migrates to the anode. On the other hand, protein C is neutral at pH = 9.6; therefore, it becomes acidic (positively charged) at the relatively more acidic pH of 6.0 and migrates to the cathode. Thus, the three proteins become separated.

5. **B > C > A**

 The order of migration in SDS-polyacrylamide gel electrophoresis is inversely proportional to the molecular weight. B, which is lightest, will move most quickly, whereas C, which is heaviest, will move most slowly.

Section V

READING COMPREHENSION

SECTION GOALS

The Reading Comprehension (RC) section of the DAT is designed to test your critical thinking skills. The higher-order components of this skill set are relatively undeveloped in most test takers, and generally require substantial practice for mastery. After completing this section of the book, you will be able to accomplish the following goals:

- Identify different question types common to DAT Reading Comprehension
- Determine the location of relevant information within the passage using a passage map
- Recognize important keywords within passages, question stems, and answer choices
- Distinguish the key characteristics of the wrong answer types common to RC questions
- Analyze arguments presented within passages and questions in the RC section

CONTENT OVERVIEW

Section Specific Strategy	Chapter 52: Reading Critically Chapter 53: Question Types
Practice Problems	Chapter 54: Reading Comprehension Practice

KEY STUDY STRATEGIES

The Reading Comprehension section of the DAT does not require any previous knowledge of the topics presented in the passages. In fact, in this section, the reader is expected to ignore any outside knowledge of the topic and rely solely on passage information. As such, the following section of this book focuses on the critical thinking and strategy skills required to perform well on RC questions. Read Chapters 52 and 53 before completing any RC practice. After these chapters have been read and understood, use Chapter 54 to practice the strategies and skills. Following completion of the practice in Chapter 54, review the questions thoroughly, ensuring that your approach was consistent with the strategies outlined in Chapters 52 and 53. If your approach differed, develop short reminders such as "Don't rely on memory for detail questions" or "Stay in scope." Build a list of these reminders and review the list before your next practice session. For best results, complete the practice in Chapter 54 prior to any additional practice in RC. Return to the strategy chapters whenever struggling with specific question or wrong answer types.

CHAPTER FIFTY-TWO

Reading Critically

To do well on Reading Comprehension on Test Day, you need to read critically and understand why the author presents certain information. Preparing for this section, therefore, is an interesting task. You won't see any lengthy calculations, and you don't need to memorize complex science concepts. Instead, the best ways to study involve learning strategies, applying them to the reading you do from now until Test Day, and completing practice passages.

THE READING COMPREHENSION PASSAGE

The Reading Comprehension portion of the exam contains three passages consisting of 9–14 paragraphs each. Each passage will pertain to a scientific topic. The intent of the author may be to inform, persuade, or speculate, but usually the author's tone remains roughly neutral due to the nature of the content. Subtle clues may indicate an author is for or against certain ideas, but these opinions will rarely be extreme.

Outside knowledge of each field is not required to answer questions correctly in this section, and the passages are meant to cover material you do not already know. Nevertheless, rough familiarity with the general vocabulary and writing style used in each field can build your confidence and speed you up on Test Day. Reading through recent editions of journals, such as the *Journal of the American Dental Association* and *Science*, and magazines, such as *National Geographic* and *Scientific American*, will increase your familiarity with this type of material. These publications tend to have articles of a similar style to those seen on the DAT. Regardless of whether you're reading DAT passages or any other material, reading more often helps improve both your reading speed and comprehension.

Each of the three passages will be accompanied by 16–18 questions for a total of 50 questions per section. Because you will have 60 minutes total to complete this section, allot 20 minutes per passage: up to 8 minutes for reading the passage and at least 12 minutes for answering the questions. This will give you approximately 40–45 seconds per question. Neither every passage nor every question should take the same amount of time due to varying difficulty and length, so use these numbers as guidelines rather than hard rules.

DAT READING

Reading Comprehension questions are *always* about the corresponding passage. You are not necessarily looking for the answer choices that are the most factual but rather those that correspond best with the author and the passage. If you do have prior knowledge in a field, you must be careful not to apply that to the questions and instead only answer based on the information in the passage. Therefore, before you can tackle a Reading Comprehension question, you must read at least some of the corresponding passage.

There are four things you really need to know about Reading Comprehension:

First, you're not reading to learn anything. This is not information you need to carry with you for years, months, weeks, or even hours. You just need to use it in the next few minutes, and you will even be able to refer back to the passage when you need it.

Second, you're not reading to remember anything. If you try to remember what you read, you'll rely on memory—which is notoriously faulty—and your mind will be taken up with what you're trying to remember. That's not helpful. Your mind needs to be open and focused on the really important parts of the DAT: the questions. Anything you think is important enough to remember will go on your passage map, which is discussed later in this chapter.

Third, you don't need any outside knowledge or your own leaps of logic to read the passage well. All the correct answers are supported in the passage. As stated previously, if you use what you already know, you'll be tempted to answer questions based on your own knowledge and not on the passage. That's a classic way to choose wrong answers.

Finally, keep in mind that you're not reading to understand everything. After all, if there's no question on the part you didn't understand, it doesn't matter anyway. So you're not going to read and reread; you're just going to keep moving ahead and let the questions determine what you need to reread.

Considering all these points together shows that reading on the DAT is quite different from reading almost anything else. Therefore, how you approach the passages in the Reading Comprehension section should be different from how you read anything else. Don't fall into the easy trap of approaching the passages as you would a novel or even a textbook; instead, read critically to set yourself up for success when you get to the questions. After all, answering those questions correctly is your primary goal on Test Day, so everything you do should directly serve that goal, including how you read.

Reading Critically

Ordinarily, people read for one or both of two reasons: to learn something or to pass the time pleasantly. Neither of these reasons has anything to do with the DAT. So what do you really need to get from reading a DAT passage that's different from everyday reading? Broadly stated, there are two primary goals in reading a passage: reading for purpose—the *why* of the text and *what* the author wants you to learn from the passage—and reading for structure—the *how* of the text and the way in which the author presents the ideas. Every Reading Comprehension question type fundamentally hinges on your ability to step back from the text and analyze *what* the author is stating, *why* the author is writing in the first place, and *how* the author puts the text together.

Notice the theme here: it's all about the author. You'll get questions about the author's ideas, her purpose, what can be inferred from what she writes in the passage, and how she puts it all together.

If you understand little more than the author's intent, you'll still have enough to get started with the questions, so your focus as you read must always be on the author. Therefore, pay attention not only to what details are present and where they are but also why they are there. Details are the *what* of a passage, and they never exist in a vacuum; they always support an idea.

Since the majority of the Reading Comprehension question types require only these big-picture ideas, don't get caught up in the details themselves as you read. Instead, skim over details quickly, then reread them more closely only when a question demands it. In fact, if you follow this strategy, you won't ever need to read or understand most of the details in a passage. If you spent a significant portion of your time poring over the passage to learn and memorize all the information contained within it, you would have wasted the majority of your time. Rather than spend your time on a task not directly earning you points, quickly read through the passage for main ideas and only return to specific details when necessary.

Nevertheless, although reading all the content carefully is a waste of time, don't take that too far. There's no payoff in getting through a passage with zero comprehension. Instead, know what is important in a passage and what is not. The author's ideas are important; the details can always be researched if there are questions regarding them (all it takes to find a detail in that case is for you to shift your eyes over to view the passage, which will always be on the screen next to each of its questions). Remember that the DAT is a timed test; use your time wisely and focus on the author when reading the first time through, saving the details for a second, targeted look if a question demands it.

Using Keywords

To help you read quickly without missing important information, pay special attention to keywords, the specific words or phrases that provide structure to text. By training your eye to notice these essential words, you will be able to skim through much of each passage, slowing down to read more thoroughly only when you know an important idea is coming next. As you review the following types of keywords, add your own words to watch out for on Test Day.

Continuation keywords announce that more of the same is about to come up. Some of the most common Continuation words and phrases include:

also	*furthermore*	*in addition*	*as well as*
moreover	*plus*	*at the same time*	*equally*

Also (there's a keyword for you), the colon often does the same job: It tells you that what follows expands upon what came before, as do commas, semicolons, and dashes. When you see a Continuation keyword of any type, you can generally keep skimming if you understood what came before it since no new ideas are likely to follow.

Sequence keywords tell you there's an order to the author's ideas. Some examples are:

second (and third, fourth, etc.)	*next*
finally	*recently*

Similar to Continuation keywords, Sequence keywords show you more of the same is coming, so keep skimming.

Illustration keywords signal that an example is about to arrive. *For example* and *for instance* are very common. But think about these:

in the words of Hannah Arendt	*according to* these experts
as Maya Angelou *says*	*for* historians
to Proust	Toynbee *claims* that

In each case, what's about to follow is an example of that person's thinking. Illustration keywords also indicate you can keep skimming, but you may want to take note of any vocabulary terms or other important words that follow so you know where to return should you be required to answer a question about that detail.

Evidence keywords tell you that the author is about to provide support for a point. Here are the four most common evidence keywords:

because	*for*	*since*	*the reason is*

Although evidence keywords do show you the same point is continued, they also indicate that the author's underlying logic is coming next. If you don't have a strong grasp of the *why* behind an argument yet, you may need to pay more attention here. Otherwise, keep moving.

Contrast keywords signal an opposition or shift. There are lots of these words:

but	*however*	*although*	*not*
nevertheless	*despite*	*alternatively*	*unless*
though	*by contrast*	*yet*	*still*
otherwise	*while*	*notwithstanding*	

Contrast keywords are among the most significant in Reading Comprehension because so many passages are based on contrast or opposition. Almost certainly, something important is happening when a Contrast keyword shows up, so slow down here to ensure you follow where the argument is going next. If you are an advanced reader, you may be able to anticipate what's coming next, saving you the time of slowing down, but verify that you anticipated correctly before continuing.

Emphasis keywords may be the most welcome. Since you are reading for the author's point of view, there are no better sections to pay attention to than those where the author announces that he finds something to be important. Note these well:

above all	*most of all*	*primarily*	*in large measure*
essentially	*especially*	*particularly*	*indeed*

These words serve as great hints that the information will show up on a question, so definitely read what follows.

Conclusion keywords signal the author is about to sum up or announce the thesis. The most common is *therefore*, together with the following:

thus	*consequently*	*hence*	*in conclusion*
it can be seen	*so*	*we conclude*	*in summary*

Because these keywords have to do with the author's logic, they are especially crucial for Reading Comprehension, especially when determining the overall purpose of the passage. Slow down and read these.

THE PASSAGE MAP

To make the most of your limited reading time, take quick notes on your noteboard as you finish reading each paragraph. These notes will make up your roadmap, a literal map of the passage that shows you where to look when you need to go back and find a specific detail. Forming a roadmap also helps guide your thought processes during your first pass. You can feel confident reading quickly and focusing on the big picture ideas while ignoring most of the details because you will know exactly where to look should the need for one of those details arise.

Every passage map has four major components:

Topic: the author's basic, broad subject matter, such as *antibiotics* or *volcanoes*. The passages on the DAT will be titled according to their Topics, so you should be able to ascertain this within the first five seconds of reading.

Scope: the specific aspect of the topic that is the focus of an individual paragraph. The scope shifts throughout the passage but always relates back to the topic. For example, if the topic of a passage is *antibiotics*, an individual paragraph might have a scope of *penicillins and cephalosporins, mechanisms,* or *side effects*.

Purpose: the reason why the author wrote the passage or how he is trying to change your mind. The purpose is always a verb, such as to *explain, evaluate, argue,* or *compare*.

Tone: the author's attitude toward the material at hand. Since the passages are related to science topics, most authors attempt to maintain relatively neutral stances, but subtle clues can indicate if an author is *positive, negative,* or truly *neutral* toward the subject matter.

Figure 52.1

Each passage map component can convey extensive meanings, but your actual notes only need to contain enough information to help you remember the broader ideas. Make use of your own shorthand to ensure your notes for each item average approximately two to three words each. When you've finished your passage map, you should have written one overall topic, purpose, and tone for the entire passage and one scope for each individual paragraph, such as in Figure 52.1, above.

DISSECTING AN ARGUMENT

Some Reading Comprehension questions ask about the structure of a passage and the function of specific words, sentences, or paragraphs. Being able to characterize each component of the passage into categories—such as supporting evidence or refutation, analogy or example, detail or inference, and fact or opinion—means you not only will be able to answer questions that ask for exactly that, but you will also have a deeper understanding of the passage as a whole, which is helpful for any question.

Parts of an Argument

An **argument**, in literary terms, is a set of reasons an author uses to convince you of some point. Sometimes an author is attempting to persuade you into supporting (or dismissing) a theory; other times, he is simply teaching you new information. Either way, the author wants you to believe his main idea or **conclusion**. The evidence, examples, and logic the author uses to support that conclusion and prove he is correct are the **evidence**.

When the author directly states these ideas in the passage, they can be called **explicit**. However, sometimes the author doesn't include either the conclusion or all the evidence plainly in his writing and instead requires you to determine some of them on your own because the ideas are only **implied**.

If the author sets up all the evidence but forces you to realize his conclusion yourself, then you are making an **inference**. This can be a strong literary technique; if you come to a conclusion on your own rather than being told, you often are more likely to believe it. However, this does require some (minimal) work on your part, so the test makers use Inferences as one of their question types.

Assumptions, or implied (unstated) evidence, are tested much less often. Not all possible types of evidence qualify as assumptions; instead, only the pieces of evidence required for the argument to make sense logically are classified as assumptions.

Consider the example of this statement: *Doberman Pinschers have bitten children, so no one should own any dogs.* The conclusion the speaker wants you to believe is that *no one should own any dogs;* the evidence is that *Doberman Pinschers have bitten children.* Since the conclusion is stated explicitly, you don't need to make an inference. However, several assumptions that the speaker believes to be obvious must be true for the logic to make sense: Doberman Pinschers must be representative of all dogs; otherwise, the evidence does not connect to the conclusion of *any* dog. Additionally, children being bitten must be unfavorable; if the listener actually wants children to be bitten, then the conclusion once again does not align with the evidence.

Facts and Opinions

The evidence of an argument can be further classified as fact or opinion. A **fact** is an unbiased observation or something that is irrefutable. An **opinion** interjects the author's feelings on or evaluation of a subject. To identify each, watch for the specific phrasing the author uses. Words like *should* and *seems* and phrases like *in my opinion* and *I believe* are good clues that the author is describing an opinion, but sometimes the clues are more subtle. When you need to differentiate between fact and opinion, such as in the following exercise, consider whether everyone would agree given the same data (fact) or if there could be multiple interpretations (opinion).

Practice exercise

Directions: Determine whether each statement is a fact or the author's opinion.

1. To assert that the ideal of democratic rule began with the Magna Carta is to misunderstand that the document was actually the product of a power struggle between two factions—the throne and the nobility—that were completely unconcerned about the rights of the common man.

2. Frank Lloyd Wright's designs are still held in very high regard by both the architectural community and the general public.

3. The federal government has claimed for years that reforms to make the income tax system more progressive will soon be enacted, but this seems very unlikely in light of the government's disinterest in easing the burden on low- and middle-income wage earners.

4. Some scientists believe that a layer of iridium in the Earth's crust proves a comet struck the planet, wiping out the dinosaurs; others argue that this layer was formed as the result of volcanic activity.

5. Astronomers long ago established that nebulae—clouds of interstellar gas and dust—are regions of space that give birth to new stars.

6. Literary critics have rightly concluded that the interest in "ethnic inheritance" displayed by George Eliot in her novels was sparked by her inability to feel comfortable in her own surroundings.

Solutions to practice exercise

1. **Opinion:** the statement refutes a *misunderstanding* of the Magna Carta held by others.

2. **Fact:** the statement repeats a generally acknowledged truth about Frank Lloyd Wright.

3. **Opinion:** the statement takes issue with the government's claim about taxes that *seems* unlikely.

4. **Fact:** the statement describes two different views about the origins of the iridium layer.

5. **Fact:** the statement repeats a scientific observation about the birth of stars.

6. **Opinion:** the statement describes a generally accepted interpretation of George Eliot's work as *right*.

CHAPTER FIFTY-THREE

Question Types

LEARNING OBJECTIVES

After this chapter, you will be able to:

- Identify DAT Reading Comprehension questions based on their question type
- Prioritize Reading Comprehension questions based on the level of personal challenge they present
- Apply wrong answer pathologies to eliminate wrong answers in Reading Comprehension questions

The test makers use the same types of questions in every Reading Comprehension section. You'll see some **comprehension** questions that test about basic facts from the passage, but you also can expect other questions that test a deeper understanding of the ideas through **analysis** and **evaluation**, so it's important to be prepared for various levels of critical thinking. Although you won't earn any points directly by identifying what type each question is on Test Day, identifying question types will help you make efficient predictions and avoid wrong answers.

QUESTION TYPES

Global

Global questions test how well you understand the passage as a whole and ask for the main idea, conclusion, or thesis of a passage or paragraph. If you follow Kaplan's passage mapping strategy (see Chapter 52), then you will already have determined the overall topic and purpose of the passage as well as the scope of each paragraph before reading any of the questions. When you do reach a Global question, all you need to do is predict the answer based on your Purpose sentence. You can identify Global questions by their use of phrases such as *main purpose, title,* or *overall point.* Although each passage generally does not have more than one Global question, these can be quick points on Test Day.

Detail

Detail questions are by far the most common question type and ask about statements found explicitly in the passage. These questions are often preceded by the phrase *according to the passage.* Detail questions are *not* asking about your own logic or opinions but merely about a statement directly from the passage. The best strategy for these questions is to use your notes as a literal map to show you where in the passage you should go to research the answer. You should be able to find phrasing in the passage that exactly or nearly exactly matches the correct answer choice. A common version of a Detail question includes one or two statements and asks you to determine if

those statements are from the passage. If you find yourself frequently missing Detail questions, ensure you are spending enough time researching; one hint is to not let yourself select the correct answer until you can point to the place in the passage that directly supports the answer choice you believe is correct.

Detail EXCEPT

Many questions ask you to choose the one answer that is true based on the passage. Detail EXCEPT questions reverse this and ask you to choose the one answer that is FALSE. These questions have phrasing similar to *the author mentions all of these items EXCEPT*. Four of the answer choices will appear in the passage, and one won't, so using the process of elimination is useful for these questions. Note, however, that finding four separate facts from a passage can be a slow process, so consider making quick educated guesses and saving thorough evaluation of these questions for last if you are running out of time in a section.

Function

Function questions require you to evaluate the way the author constructed his argument. A limited knowledge of rhetorical strategies is helpful in answering these kinds of questions. Authors might use rhetorical questions, analogies, counterexamples, or other techniques that can be asked about in Function questions. There are three subtypes of Function questions: Structure, Evaluation, and Relationship. As with other question types, you will want to refer back to the passage and to your map to identify the correct answers.

Structure

Structure questions are types of Function questions that ask about how the author organized the passage or a part of the passage. For example, a Structure question might ask about the flow of the passage, requiring you to identify where the author's conclusion is within the passage and how other paragraphs relate to the author's main point. Your roadmap will be especially helpful in these kinds of questions because you'll already have an idea of how the passage was put together and can use that as your prediction. Other questions might be about specific sentences and require you to determine if the author is stating a fact or offering an opinion. When answering questions about fact versus opinion, refer back to the passage to check the context of the clause referred to in the question stem. These questions rely heavily on your ability to recognize keywords in the passage, which will frequently be sufficient to clue you in to the answer.

Evaluation

An Evaluation question takes the task in the Structure subtype one step further. Not only do you need to recognize how the author constructed the argument using rhetorical techniques, but you need to be able to consider *why* the author did something in the passage. Evaluation questions will ask you something like *Why did the author include X phrase?* or *What function does X serve in the passage?* To answer this kind of question, start by determining in which paragraph the detail occurred, then evaluate how that sentence or clause relates to the paragraph's scope, which should already be in your roadmap. If the relationship is unclear, you can find more clues by going back to the passage and looking at the surrounding sentences to identify more of the context. Consider what effect the phrase has on the rest of the paragraph or overall argument. Often these questions can be answered by identifying whether a statement is the author's conclusion or supporting evidence.

Some Evaluation questions might ask about the purpose of one paragraph and how it fits in with the rest of the passage. The question stems are usually very straightforward in these instances, asking things like *What was the purpose of paragraph X?* For this style of question, check how the paragraph's scope relates to the entire passage's purpose, both of which should already be in your roadmap. You'll likely find that these questions are fairly quick to answer.

Relationship

Relationship questions present you with two pieces of information, a conclusion and a piece of evidence, and ask you to determine what relationships exist. Specifically, you must evaluate both the relationship between the conclusion and evidence as well as the relationship between these two pieces of information and the passage as a whole. The answer choices for these types of questions will always be the same:

> A. Both the statement and the reason are correct and related.
>
> B. Both the statement and the reason are correct but NOT related.
>
> C. The statement is correct, but the reason is NOT.
>
> D. The statement is NOT correct, but the reason is correct.
>
> E. NEITHER the statement NOR the reason is correct.

Due to the formulaic nature of the answer choices for these questions, you can quickly make predictions and eliminate wrong answers. Note that, based on the answer choices, if either conclusion (statement), evidence (reason), or both are incorrect, then you do not have to evaluate the relationship of the statements to the passage. If, however, both the conclusion and evidence are correct, you must determine if, based on the information in the passage, the evidence and conclusion are actually related to one another. In this case, related specifically means that the evidence given is used in the passage to support the conclusion given. This is a common place to see evidence given that is from a different part of the passage than the conclusion. If you must determine relationship, use your passage map to determine what paragraph each piece of information originates from and if the evidence in the question is used to directly support the conclusion in the question stem.

Inference

Inference questions test your ability to use the information in the passage to draw conclusions. They may be worded in a variety of ways, such as *it can be inferred from the passage* or *the phrase X implies*. Inference questions ask you to read between the lines and find the relationships between ideas. The correct answer will be a small step from what is said directly in the passage—but only a small step. Most Inference questions have strong clues in the passage, such as a specific detail, word choice, or tone, that will help you determine just what the author is trying to convey. Although the correct answer may not be stated explicitly in the passage, you can still determine it by restating something that was said or by combining ideas from two different sentences in the passage. Stick to the evidence in the text and avoid any answer choices that seem far-fetched.

A specific type of inference question you may see on Test Day is a Definition-In-Context question. These questions will present you a word or phrase from the text and ask you to infer what that word most nearly means. Specifically, you must identify the meaning intended by the author given the

context in which it was used. A common wrong answer for these types of questions is a commonly used definition of the word or phrase. To effectively answer these questions and avoid those traps, your prediction should involve paraphrasing the definition of the word or phrase as used in the passage.

Other

The final question type tends to be the least common and includes two fairly unique question types: Strengthen/Weaken and Tone.

Strengthen/Weaken

These questions may ask you to find the statement among the answer choices that most strengthens or weakens an argument, such as, "Which of the following best supports the author's contention that X?" Other Strengthen/Weaken questions may give you new information in the question stem and ask you to determine whether it strengthens, weakens, or has no effect on a position from the passage. In either format, your task is to determine how the new information fits with what the author has already written. As when attempting the other question types, beware of applying too much of your own reasoning or outside knowledge. Instead, treat these as matching exercises. For each piece of new information, you generally will be able to find a statement in the passage that almost exactly matches (meaning the new information strengthens that argument) or that is almost exactly the opposite (meaning the new information weakens that argument). If you can't find a match, that usually means a statement has no relevant effect on what's in the passage. Sticking with the mindset that you need to find a match will allow you to quickly answer these questions and avoid the trap statements that sound good but really don't directly affect what the author is actually saying.

Tone

The author's tone or bias is rarely stated directly in a passage but is often heavily implied. Although the author of a passage may not say "I love penguins" verbatim, he may use words to describe them that indicate his opinion, such as fascinating, remarkable, interesting, and superior, to make his bias clear. Looking for these types of Opinion keywords while initially reading makes answering Tone questions straightforward, and a good prediction is one based on the overall tone of positive, negative, or neutral from your passage map. Tone questions tend to include clear indicators of their type, such as the words tone, bias, or feels.

TRIAGING

Another benefit of identifying question types is that some types are answered in less time than others. The order of the question types listed above is an approximate order of difficulty. Typically, Global questions can be answered fairly quickly by referring to your map. Most Detail questions direct you to a specific place in the passage and require that you simply recognize or comprehend the detail in question. However, remember that Detail EXCEPT questions may be more time-consuming since they can require the process of elimination, which is slower than prediction. Function, Inference, and Other questions all require higher level skills, so you may find them more challenging and slightly more time-consuming. Answer the lower-level questions first and then tackle the higher-level questions when working on a passage. Often, a lower-level question will help you answer a more challenging question, saving you time and earning you even more points on Test Day.

WRONG ANSWER PATHOLOGIES

Although identifying question types can help with making clear predictions of the correct answer choices, it can sometimes be just as important to know what makes an answer choice wrong as what makes one right. Wrong answer choices fall into predictable categories, and analyzing those categories allows you to get inside the mind of the test writers, which is key to maximizing your score. By identifying the common traps the test makers use, you can quickly avoid them and more easily match your predictions.

Note that many wrong answer choices correspond with multiple wrong answer pathologies. It's not important to definitively identify what makes an answer choice most wrong. Instead, as soon as you realize an answer choice is incorrect for any reason, eliminate it and keep moving. Likewise, if you have found the correct answer, don't spend time evaluating why each wrong answer choice is incorrect; in fact, evaluating all of the choices is one of the most common reasons for running out of time during a section. Instead, only use the wrong answer pathologies to aid in quickly making matches and process of elimination when unsure of the correct answer.

Although recognizing these wrong answer pathologies is most useful in the Reading Comprehension section, the test makers use the same patterns in the other sections as well, so feel free to apply these ideas throughout the entire test!

Faulty Use of Detail

A Faulty Use of Detail is when an answer choice comes directly from the passage but does not answer the question being asked. These incorrect choices can come from a different paragraph than the one being asked about or describe ideas that are too narrow or too broad to answer the given question.

For example, Faulty Uses of Detail often are used with Global questions asking for the main idea of an entire passage. Such questions are looking for the overall topic and purpose, so any answer choices that describe only one specific scope or focus too much on only one example are incorrect. Although these specific Faulty Uses of Detail may accurately describe what is in the passage, they don't accurately reflect the main idea so are incorrect. To avoid these kinds of traps, always paraphrase and think about every question stem before tackling it to ensure you don't miss what's being asked.

Opposite

Opposite choices tend to be entirely correct except for one word, such as *not, false,* or *except,* that completely changes their meanings. Although Opposite choices are completely false as written, it can be easy to overlook that one important word in the question stem or answer choice. To avoid Opposite choices, slow down to ensure you carefully read the entire question stem and the answer you have chosen.

Distortion

Some answer choices contain parts that are correct alongside parts that are not. These often come in the form of Distortions, in which information is taken from the passage but then slightly changed to be incorrect. Similar to Opposite choices, Distortions can be wrong because of just one word, but for Distortions that word often ascribes an opinion that wasn't expressed in the passage, such as *more, better, worse,* or *preferred.*

One very common form of Distortion is the Extreme answer choice, which takes those ideas even further. An Extreme choice uses an idea from the passage but then adds an absolute word, such as *always, must, all, cannot,* or *never.* This tends to make a reasonable statement, such as "Most mammals bear live young," into an incorrect statement, such as "All mammals bear live young" (which is incorrect because monotremes, such as the playtpus and echidna, are mammals that lay eggs).

To avoid Distortions, ensure you have read every word of the answer choice you have chosen as correct, paraphrasing that choice to ensure it is completely right.

Out of Scope

Sometimes, an answer choice for a Reading Comprehension question describes a true statement, but that statement is not supported by information from the passage. Other times, an answer choice will seem perfectly logical but, again, is not mentioned in the passage. These are examples of Out of Scope answer choices. In the Reading Comprehension section, every correct answer must be directly supported by the passage, so using outside knowledge or even excessive reasoning can lead to choosing an incorrect answer choice. Since Out of Scope answer choices make logical sense, the best way to avoid falling into this trap is to make a strong prediction based on the passage before reading the answer choices, allowing you to bypass most choices completely since they will not match with that kind of clear prediction.

CHAPTER FIFTY-FOUR

Reading Comprehension Practice

LEARNING OBJECTIVES

After this chapter, you will be able to:

- Apply reading, passage mapping, question, and wrong answer choice pathology strategies to Critical Reading passages and questions

60 minutes—50 questions

DIRECTIONS: The following test consists of several reading passages and questions that test your comprehension of the passages. Read each passage carefully, and when you believe you have sufficient comprehension of the passage, go on to the questions. You may look back at a passage as often as you wish. Each question item consists of a question or an unfinished sentence followed by possible answers or completions. After reading a question, decide which choice is best and mark your answer.

Growth of Mammalian Teeth

The growth and development of mammalian teeth is the result of a complex series of tissue interactions that occurs during the embryonic and post-natal periods. The permanent tooth and its associated structures are composed of a wide variety of tissue types, including bone, epithelium, connective tissue, nerves, and blood vessels. Its anatomic structure is based upon a central pulp cavity containing the neural and vascular supply. This is surrounded by a layer of dentin, a yellowish material that is somewhat harder than bone. Finally, the dentin is covered by a layer of mineralized enamel, the hardest substance in the body. The dentin and enamel are each produced by highly specialized cells known as odontoblasts and ameloblasts, respectively.

The nerves responsible for pain sensation in the teeth are the superior and inferior alveolar nerves, which are derived from the fifth cranial (trigeminal) nerve. These are the sole sensory nerves for the teeth. The autonomic nervous system also innervates the teeth through the parasympathetic vasodilator fibers of the otic ganglion of the ninth cranial (glossopharyngeal) nerve and the fibers of the cervical sympathetic chain.

The blood supply to the upper jaw is provided by the superior alveolar arteries, which arise from the infraorbital and maxillary arteries. Blood to the lower jaw is carried by the inferior alveolar artery, another branch of the maxillary artery. These arteries are controlled by the vasoconstrictor fibers of the cervical sympathetic system, which stimulates contraction of the arterial smooth muscle fibers. All of the blood to the teeth comes originally from the right and left common carotid arteries, which supply the entire head and face.

The rate of tooth eruption in mammals has been studied for over 150 years. Early observations in 1823 led Oudet to conclude that rat incisors were capable of persistent growth, even in mature animals. Although it was long suspected that innervation might be responsible for control of this growth, it was not until 1919 that Moral and Hosemann were the first to measure tooth growth after cutting the inferior alveolar nerve. In 1927, Leist reported increased growth of guinea pig incisors after cutting the inferior alveolar nerve and the cervical sympathetic chain. However, he believed that the observed increase may have been due to secondary hyperemia of the pulp following the cervical sympathectomy.

This belief shifted attention, at least temporarily, away from the nervous system and toward the circulatory system. Despite the wide range of possible explanations for the control of tooth growth, the most commonly accepted theory was that first proposed by Leist—that blood supply was the important regulatory influence. it was not until the work of Butcher and Taylor in 1951 that any significant change in thought evolved.

The two investigators, working at New York University, studied five factors—blood supply, innervation, the shape of the tooth, physical stress, and the consistency of the diet—and their influence upon tooth growth rates. They explained that rat incisors were capable of two processes, eruption and attrition. The former refers to extrusion of a tooth into the oral cavity, while the latter results in a shortening of the tooth due to breakage or grinding, usually the result of normal feeding activity. Changes in tooth length were measured by initially cutting a notch in the tooth at the gingival crest. Eruption was quantified by measuring the distance between the notch and the gingival crest after a period of a few days, during which the tooth was allowed to grow. Attrition was measured as the decrease in distance from the notch to the incisal edge after breaking or grinding had occurred.

Studying the blood supply, Butcher and Taylor found that unilateral ligation of the common carotid artery decreased blood supply to teeth on the corresponding side but also produced bilateral fluctuation in eruption rate, although there was no clear decrease in tooth growth. Further, they showed that ligation of the inferior alveolar artery, while decreasing blood flow considerably, had no

effect on rate of eruption. However, when all blood flow to a tooth was stopped by applying retroactive tension to the tooth, eruption ceased. Thus, the demonstration that only complete ischemia, or total lack of blood, would drastically reduce tooth growth led Butcher and Taylor to conclude that circulation was not the most important regulatory factor.

Considering innervation, they discovered that cutting the inferior alveolar nerve resulted in an average increase in growth rate of 26 to 30 percent. Teeth so denervated appeared microscopically normal, except for a decrease in nerve fibers in the periodontal tissue and pulp cavity. Sympathetic denervation in the rats had no effect on tooth growth, despite contrary results observed in guinea pigs. Likewise, removal of the rat's otic ganglion had no effect upon the rate of growth. Thus, Butcher and Taylor surmised that the role of the inferior alveolar nerve was due to its sensory fibers, since the autonomic system had no apparent influence. They hypothesized that the phenomenon was due to sensory impulses conducted from the tooth by the inferior alveolar nerve whenever the tooth met its antagonist in occlusion. This suggested the presence of a feedback system where lack of sensory impulse served as a stimulus to additional growth and presence of sensory impulse served to inhibit additional growth. A loss of the sensory nerve, then, would render the animal unable to detect normal occlusion of the tooth or injury to the tooth.

This hypothesis was tested by artificially altering the physical stress upon a tooth by adjusting its shape. When all occlusal stress was relieved by repeated fracture of the incisor, eruption rate was accelerated. Extrusion rate was increased in every case of relieved functional pressure, and the increase reached a maximum of 200 percent above normal with prolonged repeated fracture. This was considered to be the maximum growth potential of the tooth. When the tooth was allowed to resume normal contact with its antagonist, there was an immediate return of growth rate to the normal levels. Rapidly erupting teeth were found to be abnormal in cross-sectional appearance, with decreased content of dentin and enamel and a widely dilated pulp cavity. Individual odontoblasts and ameloblasts, however, were found to be normal.

Finally, the consistency of the diet and its relation to functional stress were considered, and the results further supported the sensory feedback hypothesis. The standard consistency diet of all experiments was Purina Dog Chow. To prevent fracture and grinding, a soft consistency diet of cornmeal was used; to promote fracture and grinding, a hard consistency diet of whole kernel corn was used. When animals were placed on the soft consistency diet, eruption rate decreased 20 percent from the normal value of 0.5 mm/day. The rate gradually returned to normal when the animals were returned to the dog chow.

Similarly, eruption rate increased when the rats were fed whole kernel corn, a food that caused increased fracture and grinding. The overall difference in eruption rate from the hard to soft consistency diets was 35 percent.

Thus, the work of Butcher and Taylor shifted the focus of attention from the circulatory system to the nervous system and was largely responsible for the direction and emphasis of future research. To date, no major evidence in opposition to the theory of Butcher and Taylor has been found.

1. Vasodilator nerve fibers that innervate teeth in mammals are found in

 A. the trigeminal nerve.
 B. the otic ganglion.
 C. the cervical sympathetic chain.
 D. the inferior alveolar nerve.
 E. the superior alveolar nerves.

2. Since the work of Butcher and Taylor, the accepted theory for control of tooth eruption rate has been based upon

 A. sensory nerve feedback.
 B. blood supply.
 C. the role of odontoblasts.
 D. the role of ameloblasts.
 E. None of the above

3. In the experiment described in the passage, when a rat on a soft diet was returned to the standard consistency diet, its tooth growth rate

 A. remained depressed.
 B. immediately returned to normal.
 C. gradually returned to normal.
 D. remained elevated.
 E. decreased even further.

4. Which of the following statements correctly summarizes the sensory feedback hypothesis of Butcher and Taylor?

 A. Lack of sensory impulse causes increased blood flow to the tooth.
 B. Lack of sensory impulse causes decreased tooth growth rate.
 C. Lack of sensory impulse causes gradual pulp ischemia.
 D. Lack of sensory impulse causes increased tooth growth rate.
 E. The absence of a feedback system allows for an increased tooth growth rate.

5. Teeth that are denervated by cutting the inferior alveolar nerve show

 A. an average decrease in growth rate of 30 percent.
 B. no change in normal growth rate.
 C. an average increase in growth rate of 45 percent.
 D. no change in microscopic appearance except for a proliferation of capillaries.
 E. no change in microscopic appearance except for a decrease in nerve fibers.

6. Removal of the otic ganglion in rats

 A. caused an immediate increase in growth rate.
 B. caused an immediate decrease in growth rate.
 C. caused a delayed decrease in growth rate.
 D. caused a delayed increase in growth rate.
 E. had no effect on growth rate.

7. Before 1951, tooth growth was commonly thought to be regulated by

 A. diet.
 B. physical stress.
 C. blood supply.
 D. innervation.
 E. both (C) and (D).

8. Butcher and Taylor concluded that circulation was not the primary regulator of tooth growth because only a partial reduction of blood flow dramatically reduced tooth growth.

 A. Both the statements and the reason are correct and related.
 B. Both the statement and the reason are correct but NOT related.
 C. The statement is correct, but the reason is NOT.
 D. The statement is NOT correct, but the reason is correct.
 E. NEITHER the statement NOR the reason is correct.

9. Based on information in the passage, which of the following statements best defines the term *antagonistic teeth*?

 A. Two adjacent teeth on the upper jaw

 B. Two adjacent teeth on the lower jaw

 C. Two teeth with opposite functional properties

 D. One tooth on the upper jaw, one on the lower

 E. Upper and lower teeth that meet in normal biting

10. According to the author, odontoblasts are responsible for the production of

 A. enamel.

 B. dentin.

 C. pulp.

 D. gingival tissue.

 E. dentin and enamel.

11. Which of the following statements is the author most likely to agree with?

 A. Leist's theory that blood flow was the primary regulator of tooth growth was a detriment to the understanding of tooth eruption.

 B. Butcher and Taylor's work is scientifically flawed.

 C. Persistent growth of mammalian teeth is likely to occur.

 D. Butcher and Taylor's work was essential to the current direction of research in mammalian tooth growth.

 E. Eruption of teeth is more important than attrition of teeth in mammals.

12. The greatest increase in eruption rate was achieved by

 A. altering the consistency of the diet.

 B. relieving the tooth of all functional stress.

 C. ligating the common carotid artery.

 D. removing the otic ganglion.

 E. returning the tooth to normal contact with its antagonist.

13. The central structure of the adult tooth is composed of

 A. epithelium.

 B. mineralized enamel.

 C. cementum.

 D. nerves and blood vessels.

 E. bone.

14. To destroy pain sensation in the teeth, which of the following nerves must be cut?

 A. The ninth cranial nerve

 B. The cervical sympathetic fibers

 C. The otic ganglion

 D. The glossopharyngeal nerve

 E. The inferior alveolar nerve

15. What observation was made about rat teeth that were permitted to grow at their maximum potential rate?

 A. They were more prone to fracture.

 B. They were lacking in nerve fibers.

 C. They had decreased amounts of dentin and enamel.

 D. They had unusually small pulp cavities.

 E. They appeared normal at the microscopic level.

16. Which of the following may be concluded from the observation of Butcher and Taylor?

 A. Teeth are more likely to fracture in older mammals.

 B. Occlusal stress may account for suppression of the maximum tooth growth rate.

 C. Mammals fed a "soft" diet will exhibit an increased number of ameloblasts.

 D. Occlusion involves only antagonistic teeth.

 E. Circulation plays a critical role in the regulation of tooth growth.

17. Butcher and Taylor's findings on the effects of dietary consistency upon tooth growth rate

 A. are inconsistent with the hypothesis of a sensory feedback system.

 B. show that consistency of the diet has little effect on rate of tooth eruption in rats, even if the diet consists solely of Purina Dog Chow.

 C. suggest that a mechanism other than sensory feedback affects tooth growth rate.

 D. are irrelevant, since rats would never duplicate the experimental diet under normal circumstances.

 E. indicate that tooth growth rate is affected by more than one factor.

Population Estimates

Since estimates of future population growth are based on projections regarding complex and changeable social factors, it is not surprising to find that the estimates are often markedly inaccurate. For several decades following World War II, unprecedented population growth in the United States exceeded all projections. A 1947 Census Bureau prediction of the U.S. population in 1970, for example, underestimated the actual 1970 population by 65 million, falling far short of the count of 205 million that year. Today, predicting population growth is still an inexact science, but discrepancies often stem from overestimation rather than underestimation. Only a few years ago, demographers projected that our national population would reach the 300 million mark in the year 2000, but even after the turn of the century, the nation's population has not reached that mark. Such discrepancies stem from the fact that population predictions involve a certain amount of guesswork. The complexity and variability of social and economic factors involved in predicting population make the enterprise one of educated speculation.

Population predictions are based primarily upon studies of the "total fertility rate" of a country, defined as the average number of births a woman is expected to have over the course of her reproductive life. This rate is related to the "replacement level," a constant that describes the fertility rate at which a population neither grows nor declines. Today, the U.S. fertility rate is 1.7, considerably less than the replacement level of 2.1, so our population is expected to decrease. While demographers differ on exactly why and to what extent this diminution will occur, many agree that the decline in fertility is related to changes in the status and expectations of women.

Radical and rapid changes in attitudes toward marriage and family partly explain recent unanticipated declines in the rate of U.S. population growth. In the past few decades, there has been a considerable decline in the number of women who marry young. In 1960, only 29 percent of women under 24 had never married; by 1978, that percentage had jumped to 48 percent. This seems related to the tendency for unmarried couples to postpone marriage and live together, an arrangement that has become increasingly popular in recent years. Whether cohabitation is a likely prelude to marriage or an indication of a basic change in attitudes toward that institution, it is clear that cohabitation results in lower fertility than does marriage. Growing instability of marital relationships also affects fertility rates: As marriage rates have declined, divorce rates have increased, with half of all American marriages ending in divorce.

The shifting economic role that women play in society also effects childbearing. The relationship between fertility and the growing participation of women in the workplace is complex. A few demographers actually suggest that there is a positive correlation between women's working and fertility; this school of thought speculates that because increased prosperity positively affects fertility, women's economic gains will result in boosted fertility rates. But most demographers agree that work and fertility are negatively correlated in women. Some believe that women will have fewer children in order to facilitate their ability to join the workforce and gain financial stability. Others claim that, at the same time as increasingly effective methods of contraception have given women greater control over their own childbearing, the growing financial independence of women has weakened the economic rationale for marriage. This theory suggests that marriage offers women financial security in return for their childbearing and housekeeping services. Thus, if women no longer need to "barter" for economic support, childbearing becomes less of an automatic and expected social response.

RC

In addition to the changing attitudes and status of women, even larger, more sweeping processes are at work in declining birthrates. Broad societal trends, including increasing urbanization and decreasing religiosity, are playing a significant role in lowering fertility rates. Migration to urban areas, for instance, has stripped away a powerful economic incentive for childbearing. In agrarian economies, there is a need for large families, as children play an important role in agricultural production. But in industrial economies, children are—in an economic sense—burdens, as they consume limited resources without producing much in return.

Similarly, declining subscription to traditional religious values weakens the emphasis formerly placed upon, and reduces attachment to, family and childbearing. Some demographers have argued that the spread of evangelical religious movements, with their strong emphasis on traditional values, may eventually reverse this trend, but this seems doubtful. While these movements are certainly attracting an increasing number of followers, they appeal mainly to rural elements of the population. Put differently, evangelical movements tend to attract people who are already very religious, so it is unlikely that their ultimate impact on demographic trends will be significant.

Hence, most demographers now agree that a declining birthrate is a long-term feature of U.S. society, especially since there does not appear to be any sense of urgency about altering the status quo. Indeed, the general belief about desirable population levels in this country was best summed up by the Commission on Population Growth and the American Future, which concluded that declining fertility was a positive development, since it may—in sheer terms of numbers—help to alleviate many of our most pressing social and economic problems.

Consequently, the United States has expressed no interest in pronatalist policies. In contrast, many nations in both Eastern and Western Europe have instituted a wide variety of pronatalist measures. In most instances, national security was cited as the reason for their introduction—demographic projections for many of these nations predicted rapid falls in population by the 21st century. Whatever the case, pronatalist polices led to an almost immediate rise in European birthrates. In former East Germany, for example, the birthrate went from 10.6 per 1,000 inhabitants in 1975 to 13.3 in 1977. Most of these countries have thus far restricted themselves mainly to liberal economic measures, such as family cash allowances, generous tax relief, subsidized child care services, and improved housing.

Should the U.S. government ever decide that the declining birthrate has become a threat to the nation's well-being, it may very well take steps to encourage population growth similar to those adopted by European countries. If that were to occur, once again demographers would have to drastically revise today's population predictions.

18. According to the passage, in 1947 the Census Bureau estimated that the 1970 U.S. population would be

 A. 205 million.
 B. 65 million.
 C. 283 million.
 D. 140 million.
 E. 270 million.

19. Which of the following statements best expresses the author's opinion about the relationship between marriage and the economic status of women?

 A. Lower economic status generally results in reduced fertility.
 B. Working women give birth to fewer children than do nonworking women.
 C. The effect of women's economic position on fertility has not yet been determined.
 D. Women who receive economic support tend to exhibit lower fertility rates.
 E. Urban women of lower economic status have higher birth rates than do rural women of lower economic status.

20. The "replacement level" is defined as

 A. the number of births the average woman has over her lifetime.
 B. the difference between a nation's birth and death rates.
 C. the birthrate necessary to ensure population growth.
 D. the number of deaths that must occur in order to keep the population from increasing.
 E. the birthrate at which a nation's population will remain stable.

21. Which of the following "total fertility rates" would most probably signal an increase in U.S. population?

 A. 2.0
 B. 1.7
 C. 1.8
 D. 2.1
 E. 2.4

22. The author mentions the increasingly popular trend of cohabitation in order to

 A. make a generalization about shifting moral values.
 B. support the claim that marriage is losing its economic rationale.
 C. provide an example of a social factor that contributes to lower fertility rates.
 D. underscore the relationship between cohabitation and increased divorce rates.
 E. recommend it as a guarantor of increased fertility.

23. Which of the following would most demographers probably NOT consider a factor in decreasing fertility rates?

 A. Increasingly effective methods of birth control
 B. Greater societal acceptance of childless marriages
 C. Growing demand for women in the workplace
 D. Liberalized attitudes toward unwed motherhood
 E. An increasing divorce rate

24. It can be inferred from the author's discussion of the economic rationale for marriage that

 A. the institution of marriage has generally lost its romantic veneer.
 B. women seek financial security when choosing husbands.
 C. romantic illusions often mask exploitive financial relationships.
 D. marriage is an idyllic state of shared responsibility.
 E. some demographers consider marriage primarily an economic relationship.

25. Which of the following is the most appropriate alternative title for the passage?

 A. Decline in Birthrate Illustrates New Social Realities

 B. Growth Rate Falls as Women's Economic Status Improves

 C. Demographers Admit Futility of Population Prediction

 D. Shifting Social Values Lessen Nation's Social and Economic Ills

 E. New Women's Attitudes and National Birthrate Trends

26. According to the passage, the Commission on Population Growth and the American Future concluded that declining fertility will

 A. harm our national security.

 B. improve our quality of life.

 C. make our political problems more severe.

 D. convince our government to adopt pronatalist policies.

 E. escalate the divorce rate.

27. Which of the following is NOT mentioned in the passage as a pronatalist measure?

 A. Tax relief

 B. Cash allowances

 C. Subsidized child care

 D. Land grants

 E. Improved housing

28. According to most demographers, the U.S. birthrate will

 A. decline for a few more years but then increase.

 B. decline steadily for the indefinite future.

 C. increase over the next decade but then decline.

 D. increase drastically over the next couple of centuries.

 E. remain stable, without decline or increase.

29. The primary purpose of the first paragraph is to

 A. suggest that demographers are poor statisticians.

 B. argue that predicting population is difficult.

 C. prove that Census Bureau figures are highly accurate.

 D. discuss the social and economic factors that affect population estimates.

 E. analyze the Census Bureau's prediction of the U.S. population in 1970.

30. Many European nations have adopted pronatalist measures because

 A. their immigrant populations are expanding at alarming rates.

 B. they want to encourage long-term economic growth.

 C. they wish to reflect American pronatalist policies.

 D. their populations are heavily influenced by traditional religious values.

 E. they believe that population levels affect national security.

31. Rural families tend to be larger than their urban counterparts. The passage implies that this is because

 A. children are important as productive members of agrarian economies.

 B. rural couples are more likely to be traditional and religious.

 C. women are less likely to pursue careers in an agrarian environment.

 D. rural couples experience less difficulty conceiving than urban couples.

 E. urban couples are better educated about the use of contraception.

32. The author believes that the growth of evangelical religious movements will

 A. eventually lead to an upswing in the U.S. birthrate.
 B. cause an immediate drop in the U.S. birthrate.
 C. have no real impact on the U.S. birthrate.
 D. cause an upswing in the U.S. birthrate initially but a drop in the long run.
 E. cause an eventual decline in the U.S. birthrate.

33. The United States and Europe have opposite strategies for dealing with fertility rates. All demographers agree that the increased ability of women to join the workforce has negatively affected fertility rates.

 A. Both statements are true.
 B. Both statements are false.
 C. The first statement is true, the second is false.
 D. The first statement is false, the second is true.

34. The author suggests that current population predictions

 A. are extremely accurate.
 B. overestimate the actual population.
 C. underestimate the actual population.
 D. ignore the growth of illegal immigrant populations.
 E. are anomalous in their inaccuracy.

RC

Nutrition

Adequate nutrition is essential to the development, growth, and sustenance of the human organism. A good diet must supply the body with sufficient energy to power all life support activities. Amino acids play an important role in this dietary process.

The amino acid molecule is composed of an amino group (-NH$_2$), a carboxyl group (-COOH), a hydrogen atom (-H), and a unique R group (or side chain), all bonded to a central alpha carbon atom (C). Although amino acids occur in two stereoisomeric forms, *D*- (dextrorotary) and *L*- (levorotary), only the *L*-form is nutritionally active in the human body. There are twenty *L*-amino acids in total, each identifiable by its side chains, which differ in terms of size, shape, charge, hydrogen-bonding capacity, and chemical reactivity.

The primary role of *L*-amino acids is to provide the biologically active building blocks for proteins. Proteins are formed when groups of amino acids become linked in polypeptide chains. Peptide bonds are formed between the alpha-carboxyl group of one amino acid and the alpha-amino group of the next. These polypeptide chains link in turn to become proteins—in certain cells, they become the precursors of neurotransmitters, skin pigments, or hormones. All twenty amino acids must be present for the complete range of body proteins to be synthesized. The human body is capable of synthesizing several amino acids, such as alanine, glutamate, and proline, and these are classified as nonessential in dietary terms. Others, however, designated essential amino acids, must be supplied in the diet. The absence of any single amino acid disrupts protein synthesis and can result in a negative nitrogen balance within the body. When this occurs, protein degradation exceeds protein synthesis, and the body excretes a greater quantity of nitrogen than it ingests to replace it.

The body obtains essential amino acids by extracting them from food proteins in the digestive process, which begins in the stomach. Firstly, the oxyntic (parietal) cells of the fundic gastric glands lower the pH level of the stomach by secreting 0.15 M HCl into the stomach. Zymogenic (chief) cells secrete quantities of pepsin, the first proteolytic enzyme to break down the ingested proteins, as well as rennin, an enzyme that curdles milk. The pepsin is secreted in an inactive form (pepsinogen) and is converted to the active enzymatic form by the acid. In this state, it catalyzes the hydrolysis of the peptide bonds between amino acids within the proteins.

The majority of protein degradation and absorption occurs in the small intestine. The two primary proteolytic enzymes of the small intestine are trypsin and chymotrypsin. Trypsin breaks polypeptide chains on the carboxyl side of arginine and lysine residues. Chymotrypsin, on the other hand, cleaves preferentially on the carboxyl side of aromatic and other bulky, nonpolar amino acids.

The major end products of digestion are *L*-amino acids, which are absorbed by the intestinal mucosa cells through a complex transport mechanism. First, a basolateral membrane Na$^+$-K$^+$-ATPase pump (powered by cellular ATP) sets up a favorable concentration gradient, where the concentration of sodium ions is greater outside the cell than inside. Then, as sodium ions diffuse into the cell, *L*-amino acids are transported simultaneously with sodium ions across the cell membrane.

The intestinal mucosal cells are also capable of absorbing dipeptides and tripeptides; their microvillus membranes contain enzymes that specifically split off dipeptides from the amino terminal end of protein polypeptide chains prior to absorption. All of the amino acids absorbed from the lumen of the intestine are then transported by the mucosal cells into the blood, where they proceed to the liver via the hepatic portal system. Any excess of absorbed amino acids, above that required for protein synthesis, is not stored in the body and is much too valuable to be excreted. Instead, surplus amino acids are degraded in the liver and utilized as metabolic fuel.

Amino acid degradation primarily involves conversion of the alpha-amino group to urea. This group is transferred to the molecule alpha-ketoglutarate to form glutamate, which is subsequently oxidatively deaminated to the ammonium ion (NH_4^+) by the enzyme glutamate dehydrogenase, then converted via the enzymes of the urea cycle into the excretion product.

A special class of enzymes called transaminases catalyzes the transfer of the amino group from an alpha-amino acid to an alpha-keto acid, such as alpha-ketoglutarate. These transaminases require a prosthetic group (or coenzyme) called pyridoxal phosphate, which is derived from pyridoxine (vitamin B6) to become active. The transaminase enzyme has a terminal lysine residue at its active site that combines with the aldehyde group of pyridoxal phosphate in a covalent Schiff-base linkage prior to the binding of the amino acid substrate. The transaminases form a new covalent Schiff-base intermediate with the alpha-amino group of the amino acid, which displaces an epsilon-amino group of the enzyme's active site lysine. As a result of this reaction, the pyridoxal phosphate is converted to pyridoxamine phosphate, and the alpha-amino becomes an alpha-keto acid. The pyridoxamine phosphate-enzyme complex subsequently combines with alpha-ketoglutarate to yield glutamates and a regenerated pyridoxal phosphate enzyme. Other pyridoxal phosphate enzymes can catalyze decarboxylations, deaminations, racemizations, and aldol cleavages of amino acid substrates.

The main benefits of the transamination process are that it enables the glutamate formed to be oxidatively deaminated by glutamate dehydrogenase to regenerate alpha-ketoglutarate and thus form ammonium ions for the urea cycle. In this particular process, either NAD^+ or $NADP^+$ are energized with electrons to form NADH or NADPH respectively, and both can be used as electron carriers. NADH is an active electron carrier in oxidative phosphorylation, which generates cellular ATP, whereas NADPH is more active in reductive biosynthesis.

The process of energy production is controlled by the enzyme glutamate dehydrogenase and pre-existing cellular energy levels. It is an allosterically regulated enzyme (i.e., it is only active when low-energy precursors are present, such as ADP and GDP). Conversely, it is inhibited when high-energy molecules are in abundance, such as ATP and GTP. Thus, under low-energy states, surplus amino acids can generate high-energy molecules and raise the caloric content in the body. In contrast, amino acid carbon skeletons are transformed into acetyl-CoA, pyruvate, or one of the intermediates of the citric acid cycle. The citric acid cycle is the final common route of oxidation of fuel molecules such as carbohydrates, fatty acids, and amino acids. The reactions of this cycle occur within the cells' mitochondria, and most fuel molecules enter as acetyl-CoA. However, some amino acids enter the cycle in the form of intermediates. Phenylalanine (derived from phenylpyruvate) is degraded to tyrosine by phenylalanine hydroxylase, and tyrosine is further transaminated back to p-hydroxyphenylpyruvate (the precursor of tyrosine), which is in turn oxidized to homogentisate. Homogentisate oxidase then converts homogentisate to 4-maleylacetoacetate, which is subsequently isomerized and hydrolyzed to become acetoacetate and fumarate, a cycle intermediate.

Those amino acids that are degraded to acetyl-CoA or acetoacetyl-CoA are called ketogenic and ultimately may also give rise to the ketone bodies acetone, D-3-hydroxybutyrate, and acetoacetate, which is a preferred fuel of heart muscle and renal cortex cells. Other amino acids are called glucogenic because they are degraded to pyruvate and fumarate or oxaloacetate. Of all the twenty acids, only leucine is purely ketogenic, while isoleucine, lysine, phenylalanine, tryptophan, and tyrosine are both ketogenic and glucogenic. The remaining fourteen amino acids are purely glucogenic.

35. Negative nitrogen balance is a state in the body in which
 A. essential amino acids are absent.
 B. protein synthesis exceeds protein degradation.
 C. protein degradation exceeds protein synthesis.
 D. the body ingests too much nitrogen.
 E. both (A) and (C) are correct.

36. When the alpha-carboxyl group of one amino acid is bonded to the alpha-amino group of the subsequent amino acid, this is called
 A. a hydrogen bond.
 B. a polar covalent.
 C. a nonpolar covalent bond.
 D. a peptide bond.
 E. an ionic bond.

37. The low pH of the stomach is provided by the
 A. secretion of 0.25 M HCl by chief cells.
 B. secretion of 0.15 M HCl by parietal cells.
 C. secretion of 0.15 M phosphoric acid by oxyntic cells.
 D. secretion of 10 M HCl by oxyntic cells.
 E. secretion of 0.15 M HCl by zymogenic cells.

38. In the process of absorption, an L-amino acid is cotransported with
 A. a K^+ ion.
 B. a Cl^- ion.
 C. a Na^+ ion.
 D. a Na^+ and a Cl^- ion simultaneously.
 E. a glucose molecule.

39. Transamination is the enzymatic process
 A. of transferring the alpha-amino group of an alpha-amino acid to an alpha-keto acid.
 B. of transferring the alpha-amino group of an alpha-keto acid to an alpha-amino acid.
 C. of transferring the carboxyl group of an alpha-amino acid to a lysine residue.
 D. used to split and transfer a carboxyl group from an alpha-amino acid to an alpha-keto acid.
 E. used to create pyridoxine.

40. Which of the following amino acids is NOT glucogenic?
 A. Tyrosine
 B. Phenylalanine
 C. Leucine
 D. Isoleucine
 E. Tryptophan

41. Ketone bodies are
 A. D-3-hydroxybutyrate molecules.
 B. acetone molecules.
 C. used by renal and heart cells as fuel.
 D. products of degradation.
 E. All of the above

42. Pyridoxal phosphate enzymes
 A. can only catalyze transaminations.
 B. catalyze aldol cleavages of amino acids.
 C. catalyze carboxylations of amino acids.
 D. All of the above
 E. None of the above

43. The bond formed by a transaminase and its coenzyme
 A. is a covalent Schiff-base reaction.
 B. is a noncovalent Schiff-base reaction.
 C. occurs between a lysine residue of the enzyme and an aldehyde group of the coenzyme.
 D. occurs between a tyrosine residue of the enzyme and a carboxyl group of the coenzyme.
 E. Both (A) and (C) are correct

44. The main benefit of transamination is the
 A. conversion of coenzyme to NH_4^+.
 B. decrease in the caloric content of the body.
 C. generation of GDP and ADP.
 D. generation of NADH to participate in oxidative phosphorylation.
 E. catabolism of ammonium ions.

45. The main site of amino acid degradation in the body is
 A. the pancreas.
 B. the stomach.
 C. the small intestine.
 D. the liver.
 E. the gall bladder.

46. Side chains of amino acids differ in regard to which of the following?
 A. Size
 B. Hydrogen-binding capacity
 C. Shape
 D. Charge
 E. All of the above

47. The enzyme glutamate dehydrogenase is allosterically regulated, such that
 A. an increase in GTP and ATP levels activates the enzyme.
 B. an increase in UTP and GTP levels activates the enzyme.
 C. an increase in GDP and ADP levels activates the enzyme.
 D. only an increase in UTP activates the enzyme.
 E. only a decrease in UTP activates the enzyme.

48. Trypsin and chymotrypsin cleave protein polypeptide chains at or between
 A. the same site.
 B. different sites.
 C. arginine and lysine residues for trypsin and aromatic residues for chymotrypsin.
 D. (A), (B), and (C) are correct
 E. Both (B) and (C) are correct

49. Amino acid degradation involves
 A. transamination.
 B. change of amino acids to acetyl-CoA and acetoacetyl-CoA.
 C. change of amino acids to pyruvate and fumarate.
 D. conversion of the alpha-amino group to urea.
 E. All of the above

50. Which of the following can be concluded based on the author's discussion of amino acid metabolism?
 A. *D*-amino acids are toxic to humans.
 B. Essential amino acids are the only amino acids required by humans.
 C. Nonessential amino acids are required for normal development, growth, and sustenance of the human organism.
 D. Chymotrypsin and trypsin play a crucial role in obtaining nonessential amino acids.
 E. All *L*-amino acids can be converted to either acetone, *D*-3-hydroxybutyrate, and acetoacetate for use by the heart and renal cortex.

RC

K 715

ANSWERS AND EXPLANATIONS

Answer Key

1.	B	26.	B
2.	A	27.	D
3.	C	28.	B
4.	D	29.	B
5.	E	30.	E
6.	E	31.	A
7.	C	32.	C
8.	C	33.	C
9.	E	34.	B
10.	B	35.	E
11.	D	36.	D
12.	B	37.	B
13.	D	38.	C
14.	E	39.	A
15.	C	40.	C
16.	B	41.	E
17.	E	42.	B
18.	D	43.	E
19.	B	44.	D
20.	E	45.	D
21.	E	46.	E
22.	C	47.	C
23.	D	48.	E
24.	E	49.	E
25.	A	50.	C

EXPLANATIONS

1. B (Detail)

The passage states that the vasodilator nerve fibers are parasympathetic fibers found in the otic ganglion of the glossopharyngeal nerve, making choice (B) correct. They are not found in the inferior alveolar nerve, the superior alveolar nerve, a branch of the trigeminal nerve, or the cervical sympathetic chain. Thus, answer choices (A), (C), (D), and (E) are all incorrect.

2. A (Detail)

Each of the five factors (blood supply, innervation, shape of the tooth, physical stress, and the consistency of the diet) that Butcher and Taylor examined pointed to sensory nerve feedback, choice (A), as the predominant controller of the rate of tooth growth. While the blood supply was thought at one point in time to be important in tooth eruption, Taylor and Butcher concluded that it was not the most important regulatory factor. In addition, the accepted theory for control of tooth eruption rate since Butcher and Taylor has not been based in the roles of odontoblasts or of ameloblasts.

3. C (Detail)

Although animals that were placed on a soft consistency diet experienced decreases of tooth eruption rate of up to 20 percent from the normal value of 0.5 mm/day, the passage states that the animals' eruption rates gradually returned to normal when the animals returned to the dog chow (the standard consistency diet).

4. D (Detail)

The passage states that Butcher and Taylor surmised that the sensory fibers of the inferior alveolar nerve would provide a feedback system where a lack of sensory impulse would serve as a stimulus for a tooth to grow—choice (D)—and, conversely, the presence of a sensory impulse would serve to inhibit a tooth's growth. The sensory feedback hypothesis did not address the lack of sensory impulses and their relation to blood flow or ischemia.

5. E (Detail)

After cutting the inferior alveolar nerve, Butcher and Taylor discovered that teeth demonstrated an average increase in growth rate of 26–30 percent, not 45 percent as in choice (C). When examined microscopically, these teeth were normal except for a decrease in nerve fibers. Therefore, choice (D) is incorrect.

6. E (Detail)

In contrast to the question above, denervation of the otic ganglion had no effect on growth rate. Butcher and Taylor surmised that this was due to the presence of sensory fibers in the inferior alveolar nerve that were not present in the autonomic nerves.

7. C (Detail)

The passage states that prior to 1951 and subsequent to 1927, the most commonly accepted theory of tooth growth was the one proposed by Leist—that blood supply was the important regulatory influence. Although innervation was considered at one time, it is not the optimal answer because in the years previous to 1951, blood supply was more highly considered. Physical stress and diet were never thought to be extremely important regulators of tooth growth.

8. C (Inference)

In paragraph 7, the author discusses Butcher and Taylor's investigations into how blood supply affects tooth growth. The author states that "only complete ischemia, or total lack of blood, would drastically reduce tooth growth," as the reason for Butcher and Taylor's conclusion that blood supply was not the primary regulator. Since the evidence given is incorrect (partial blood flow reduction had no effect), but the conclusion is correct, the correct answer must be (C).

9. E (Inference)

The use of the word *antagonist* in the passage refers to a tooth that makes normal contact with another. Therefore, answer choice (E) is most correct. While the word *antagonists* might conjure up images of teeth with opposite functional properties—choice (C)—it was not used in this context in the passage. Clearly, answer choices (A) and (B) are incorrect; they are not mentioned as valid choices in the passage. Finally, answer choice (D) is too vague—choice (E) is far more accurate.

10. B (Detail)

The author states that odontoblasts are responsible for the production of dentin and that ameloblasts are responsible for the production of enamel. The pulp is littered with neural and vascular supply, and the author does not mention the origin of gingival tissue.

11. D (Other)

The author of this passage remains fairly neutral and academic throughout. This academic tone helps to quickly eliminate answer choices (A), (B), and (C). All three of these choices contain strong language that the author did not use in this passage. Specifically, while Leist's theory (A) was disputed by Butcher and Taylor, the author never implies that Leist's work was detrimental. The author also never discusses the validity of Butcher and Taylor's work (B), but says in the final paragraph that no major evidence has been found in opposition to their theory and thus it is likely not significantly flawed. In paragraph 4, Oudet's theory that rat incisors are capable of persistent growth is mentioned, but in paragraph 9 Butcher and Taylor showed that there is a maximum growth rate so the author is unlikely to agree that persistent growth is likely (C). The author never suggests that either eruption or attrition is more important (E), but states that they are antagonistic processes. In paragraph 9, the author does say that Butch and Taylor's work was the basis upon which future research determined its direction and emphasis, so (D) is the correct answer.

12. B (Detail)

The passage states that ligating the common carotid artery or removing the otic ganglion did nothing to affect the eruption rate. Altering the consistency of the diet, while affecting the eruption rate slightly, could not compare to relieving the tooth of all functional stress (which was shown to increase eruption by 200 percent). Finally, returning the tooth to normal contact with its antagonist reinstituted normal growth rates.

13. D (Detail)

The passage specifically states that the central pulp cavity of a tooth contains the neural and vascular supply. The mineralized enamel is a layer that covers the dentin, which in turn surrounds the central pulp cavity. No mention is made of cementum or bone in the composition of the central structure of the adult tooth.

14. E (Detail)

The inferior alveolar nerve carries sensory nerve fibers that the cervical sympathetic fibers and the otic ganglion do not. While the glossopharyngeal nerve does have sensory fibers, this nerve does not innervate the teeth. Therefore, the inferior alveolar nerve is the most correct answer.

15. C (Detail)

The passage states that Butcher and Taylor found that rapidly erupting teeth were abnormal in cross-sectional appearance (thus, answer choice (E) is not correct). They possessed decreased contents of dentin and enamel—choice (C)—and a widely dilated pulp cavity (therefore, choice (D) is not correct). No mention was made of their propensity for fracture or their abundance of nerve fibers; therefore, these answers—choices (A) and (B)—are incorrect.

16. B (Inference)

According to the sensory feedback hypothesis proposed by Butcher and Taylor, it is the absence of sensory influences that causes an increase in the growth rate of teeth. No mention is made of tooth fracture and older mammals, or of the occlusive ability of nonantagonistic teeth. Mammals fed on a "soft" diet exhibit a decrease in the eruption rate, indicating—if anything—a decrease in the number of ameloblasts.

17. E (Inference)

Butcher and Taylor's experiments revealed that both occlusal stress and diet consistency affected tooth eruption. This corresponds to many other findings in science, namely that they are multifactorial. The fact that dietary consistency affected tooth growth rate does not obviate the hypothesis of a sensory feedback system, nor does it suggest that a sole mechanism other than sensory feedback affects tooth growth rate. These diet consistency experiment results are relevant and should be examined from a multifactorial perspective.

18. D (Detail)

The passage states that the census count for the year 1970 was 205 million people and that the 1947 Census Bureau prediction was 65 million short of that. Therefore, 140 million was the predicted number.

19. B (Detail)

Although the author concedes that some demographers believe that there is a positive correlation between women's working and fertility, he argues that most demographers agree that work and fertility are negatively correlated in women. He also believes that higher economic status of women generally results in reduced fertility and that women who receive economic support (i.e., are dependent upon it) tend to exhibit higher fertility rates. Finally, although the author states that higher economic status is associated with lower fertility, he never compares the fertility rates of women of lower economic status in rural and urban areas. One factor that immediately undermines this supposition is the indication that urbanization provides fewer incentives for childbearing and has thus played a role in lowering fertility rates.

20. E (Detail)

The passage defines "replacement level" as a birthrate at which a nation's population will remain stable (will neither decline nor grow). Note that the question stem refers to "replacement," which implies a need for production to fill a void (or births to fill the population void caused by deaths). Thus, one could automatically eliminate choice (D), which only focuses on deaths, and choice (C), which refers to actual growth, not just replacement. Choice (A) is incorrect, as well, as it refers to "total fertility rate" as defined in the passage, and choice (B) is incorrect as it refers to a measurement of a status quo, not of a determined "level."

21. E (Inference)

The total fertility rate of a country is defined as the average number of births a woman is expected to have over the course of her reproductive life. This rate is related to the replacement level (the fertility rate at which population remains stable), which is defined as 2.1 in the passage. As the total fertility rate must exceed the replacement rate for population growth to occur, the answer choice must be greater than 2.1. Choice (E) satisfies this requirement.

22. C (Function)

The author cites cohabitation as an example of a social factor that contributes to lower fertility rates. She makes little judgment about shifting moral values; she does not support the claim that marriage is losing its economic rationale. In addition, the author never correlates cohabitation with increased divorce rates. Finally, cohabitation is anything but a guarantor of fertility, as the author indicates that it is more clearly associated with lower fertility rates than is marriage.

23. D (Detail)

The author cites several factors that demographers believe to be important in decreasing fertility rates. They include contraception, more women working, increased societal acceptance of childless marriages, and increased divorce rates. However, the author does not address the role of liberalized attitudes toward unwed motherhood, implying that it is not a factor.

24. E (Inference)

The passage discusses the rationale behind marriage in strictly economic terms and indicates that many demographers regard marriage in this way. While it might be argued that choice (B) is also correct, it is not, since it makes an assumption about all women's reasons for marriage—an inference that is too drastic. Note that choice (E) makes a less inclusive conclusion by referring to "some demographers." Finally, answers (A), (C), and (D) are poor choices because they are not addressed in the passage.

25. A (Global)

Whether the author talks about urbanization, contraception, or cohabitation, it is clear that she is referring to the relationship of new social realities and decline in birthrate. While answer choice (B) is factually correct, it is a limited title because it does not include other causes of declining birthrates. The author does not deem population prediction futile; she only admits that it is an "enterprise of educated speculation." In addition, the author never correlates shifting social values with a lessening of the nation's social and economic ills. Finally, national birthrate trends are related not just to women's new attitudes but to other issues such as divorce, cohabitation, and contraception (all of which might involve men's attitudes, as well).

26. B (Detail)

The passage states that the Commission on Population Growth and the American Future concluded that declining fertility was a positive development because it may help to alleviate many of our most pressing social and economic problems.

27. D (Detail)

The passage mentions that European pronatalist policies included family cash allowances, generous tax relief, subsidized child-care services, and improved housing. There is no mention in the passage of land grants, choice (D).

28. B (Detail)

The passage states that most demographers now agree that the present declining birthrate is a long-term feature of U.S. society, especially since there does not appear to be any sense of urgency about altering the status quo.

29. B (Function)

The purpose of the first paragraph can be identified in its last sentence, which states, "The complexity and variability of social and economic factors involved in predicting population make the enterprise one of educated speculation." In other words, it is difficult. The paragraph never states that demographers are poor statisticians. Rather, it says population growth prediction is an inexact science. And, on the contrary, it reveals the inaccuracy of Census Bureau figures. Finally, while the paragraph mentions social and economic factors, as well as the Census Bureau's prediction of the 1970 U.S. population, it does not focus on any of these points as its central purpose.

30. E (Detail)

The passage states that in most instances, European pronatalist policies have been introduced for reasons of national security. Thus, choice (E) is the most directly applicable choice.

31. A (Inference)

The author states that rural families have higher fertility rates than urban families. This is, she argues, because in agrarian (i.e., more rural) economies, children play an important role in agricultural production and are thus necessities of life. While it may be that rural couples are more likely to be traditional and religious, this cannot be argued from the passage. Further, the passage provides no indication that women are less likely to pursue careers in rural areas, that rural couples experience less difficulty conceiving than urban couples, or that urban couples are better educated about contraception.

32. C (Detail)

The author does correlate a decline in subscription to religious values with a reduced attachment to childbearing, which would imply that an extension of religious values through evangelism would potentially increase birthrates. However, the author specifically indicates that "evangelical movements tend to attract people who are already very religious," or who already embrace values of family and childbearing. Thus, evangelism, according to the passage, causes neither an increase nor decline in the birthrate.

33. C (Detail)

First, evaluate statement 1. In paragraph 8, the author states that the United States has no interest in pronatalist policies, whereas Europe has specifically designed a number of pronatalist policies. Thus, statement 1 is true. Eliminate (B) and (D). Now, evaluate statement 2. In paragraph 4, the author mentions that most demographers believe that women's increasing involvement in the workforce negatively impacts fertility rates, but says that "A few demographers actually suggest that there is a positive correlation between women working and fertility." Thus, statement 2 is not true and (C) must be the correct answer.

34. B (Inference)

The first paragraph of the passage states that discrepancies in current population predictions for the year 2000 reflect an overestimation rather than an underestimation. Thus, choices (A) and (C) are automatically eliminated as possibilities. In terms of choice (D), the author never indicates that current population predictions fail to account for the growth of illegal immigrant populations. Finally, the author's description of the 1947 underestimation of the population for 1970 indicates that present inaccuracies in prediction are not anomalous.

35. E (Detail)

The passage defines negative nitrogen balance as a process in which protein degradation exceeds protein synthesis, so the body excretes a greater quantity of nitrogen than it ingests to replace it. In this state, essential amino acids are absent. Therefore, choice (E) is the correct answer.

36. D (Detail)

The passage states that peptide bonds are formed between the alpha-carboxyl group of one amino acid and the alpha-amino group of another. Therefore, choice (D) is the correct answer.

37. B (Detail)

The passage states that the first process in gastric digestion of food is the secretion of 0.15 M HCl from the oxyntic, or parietal, cells of the fundus of the stomach. Therefore, choice (B) is the correct answer.

38. C (Detail)

The passage states that end products of digestion—*L*-amino acids—are absorbed by the intestinal mucosal cells via a complex transport mechanism that involves cotransport of sodium ion. It makes no mention of the simultaneous transport of chloride ions. Therefore, choice (C) is the correct answer.

39. A (Detail)

Transamination, mediated by enzymes called transaminases, catalyzes the transfer of amino groups from alpha amino acids to alpha-keto acids (e.g., alpha-ketoglutarate).

40. C (Detail Except)

In paragraph 12, the passage states that isoleucine, lysine, phenylalanine, tryptophan, and tyrosine are all both ketogenic and glucogenic, but that only leucine is purely ketogenic. Thus, leucine is not glucogenic and (C) is the correct answer.

41. E (Detail)

All of the answer choices work. Amino acids that are degraded to acetyl-CoA or acetoacetyl-CoA are considered ketogenic. They may give rise to *D*-3-hydroxybutyrate, acetone molecules, and acetoacetate. They are the preferred fuel of cardiac muscle and renal cortical cells; thus, choice (E) is correct.

42. B (Detail)

Pyridoxal phosphate enzymes may cause transamination, decarboxylation deamination, racemization, and aldol cleavage of amino acids. Therefore, choice (B) is correct.

43. E (Detail)

The bond between pyridoxal phosphate and a transaminase occurs at a terminal lysine residue. The bond is a Schiff-base linkage, which is covalent in property. Therefore, choice (E) is correct.

44. D (Detail)

According to the passage, the main benefit of the transamination process is that it enables the glutamate formed to be oxidatively deaminated (by glutamate dehydrogenase) to regenerate alpha-ketoglutarate. This results in the formation of ammonium ions (from the glutamate, not the coenzyme pyridoxal phosphate) for the urea cycle and the regeneration of NADH and NADPH (involved in oxidative phosphorylation and reductive biosynthesis, respectively). Therefore, answer choice (D) is correct.

45. D (Detail)

The passage states that the main degradation site of amino acids is in the liver, although the main absorption site is the small intestine. Therefore, choice (D) is correct.

46. E (Detail)

The passage states the differences in amino acids are in their side chains, which themselves differ in size, shape, charge, hydrogen bonding capacity, and chemical reactivity. The passage does not indicate that side chains differ in carbon-binding capacity or number. Therefore, choice (E) is correct.

47. C (Detail)

The passage states that glutamate dehydrogenase is an allosterically regulated enzyme that is active only when low-energy precursors are present, such as ADP and GDP. In contrast, the activity of glutamate dehydrogenase is low when ATP and GTP are present. Therefore, choice (C) is correct.

48. E (Detail)

The passage states that trypsin breaks polypeptide chains on the carboxyl side of arginine and lysine residues, while chymotrypsin cleaves preferentially on the carboxyl side of aromatic and other bulky, nonpolar amino acids. Therefore, choice (E) is correct.

49. E (Detail)

The passage states that amino acid degradation involves primarily the conversion of an alpha-amino group to urea. The alpha-amino group is initially transferred to the molecule alpha-ketoglutarate to form glutamate, which is oxidatively deaminated to form NH_4^+. The ammonium ion is then converted to an excretion product and launched into the urea cycle. Amino acid skeletons may be converted to acetyl-CoA, pyruvate, or one of the intermediates of the citric acid cycle (e.g., fumarate). Alternatively, for ketogenic amino acids, degradation may involve the formation of acetyl-CoA or acetoacetyl-Coa and may give rise to ketone bodies, such as acetone, D-3-hydroxybutyrate, and acetoacetate. Therefore, choice (E) is correct.

50. C (Inference)

Again, use of wrong answer pathologies can help you quickly eliminate wrong answer choices. (A), (B), and (E) all contain extreme language that make them unlikely to be true. Specifically, in paragraph 2, the passage states the L-amino acids are the nutritionally active forms of amino acids, but does not say that D-amino acids are toxic (A). Paragraph 3 states that all 20 amino acids must be present for normal body function, eliminating (B). Paragraph 12 states that 14 amino acids are purely glucogenic, thus these 14 amino acids would not be converted to ketone bodies (E). Chymotrypsin and trypsin are found in the small intestine and used to degrade amino acids obtained from the diet; nonessential amino acids are those amino acids that can be synthesized by the body. Thus, these enzymes do not necessarily have a necessary function in obtaining nonessential amino acids (D). Since all 20 amino acids must be present for normal function, (C) is the correct answer.

Section VI

QUANTITATIVE REASONING

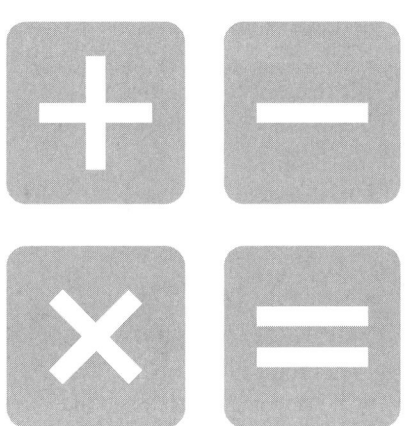

SECTION GOALS

The Quantitative Reasoning section of the DAT requires considerable outside knowledge, proficient test-taking skills, and strategic use of the calculator. The following section provides the content and guidance necessary for Test Day success. The section is designed to help you achieve the following goals:

- Recall key mathematical concepts likely to show up on Test Day
- Utilize non-traditional strategies effectively
- Identify when and how to use the on-screen calculator
- Predict answers to Quantitative Reasoning questions accurately and quickly, using the Kaplan methods

CONTENT OVERVIEW

Applied Mathematics**	Chapter 55: Quantitative Strategies
	Chapter 56: Quantitative Comparison
	Chapter 57: Data Sufficiency
	Chapter 58: Data Interpretation
Fundamentals of Calculation	Chapter 59: Fundamentals of Calculation*
Conversions	Chapter 59: Fundamentals of Calculation*
Algebra	Chapter 60: Algebra
Probability and Statistics	Chapter 61: Probability and Statistics
Geometry	Chapter 62: Geometry
Trigonometry	Chapter 63: Trigonometry

*Chapter 59 contains materials relevant to Fundamentals of Calculation and to Conversions
**Applied Mathematics problems are heavily dependent on strategy, but can contain math from any chapter.

KEY STUDY STRATEGIES

The Quantitative Reasoning section is the only section of the DAT which allows the use of a calculator. However, the calculator tends to be fairly time consuming. As such, its value tends to be overestimated. To avoid this trap, start your review with Chapter 55, which discusses strategies relevant to all Quantitative Reasoning questions as well as specific tips for certain question types. Following review of Chapter 55, prioritize the chapters that cover the test materials you have the most trouble with. Consider making flashcards for any rules or equations you have trouble with, as these are important materials to recall when solving DAT Quantitative Reasoning problems. Note that the number of chapters devoted to a topic is not correlated to the importance of that topic on the DAT. As you work through the associated practice problems, practice with the calculator on your computer, but make sure to use only the functionalities available on the actual DAT calculator. Try to complete the practice problems at the end of the chapter without referring back to the chapter, as you will not have access to a formula sheet on Test Day.

CHAPTER FIFTY-FIVE

Quantitative Strategies

The Quantitative Reasoning section of the DAT is designed to test the math skills required in dental school. The section contains 40 multiple-choice questions, and you will have 45 minutes to complete it. A basic on-screen calculator similar to the one below will be available only in this section. It can be opened by clicking the "Calculator" button at the bottom of the screen. The calculator can add, subtract, multiply, and divide as well as take square roots, percentages, and reciprocals.

Note that the calculator *cannot* perform the complex functions of a scientific or graphing calculator. You also cannot input to the calculator by typing and instead will need to click every number and operation you want to perform, which can be quite time consuming and lead to making mistakes. For these reasons, avoid using the calculator as much as possible and instead use mental math and quick scratch-work calculations, saving the calculator for the rare questions with difficult multiplication or long division. Developing your ability to complete calculations without a calculator will also be helpful for the Survey of Natural Sciences, since you won't have access to a calculator during any of that section.

Scored items in the Quantitative Reasoning section directly test your abilities with Fundamentals of Calculation, Conversions, Algebra, Probability and Statistics, Geometry, and Trigonometry. On Test Day you will also see word problems that require applying one or more topics to a story problem.

This chapter will introduce you to the most common Kaplan strategies that you will use for calculations on the DAT. Although these strategies are most useful for the Quantitative Reasoning section, you may find them helpful throughout the test, especially in the Chemistry section. Additionally, remember that you can skip questions within a section and come back to them if you have time. Use this ability to your advantage by tackling questions you know you can answer with relative ease and skipping questions you know will take longer to answer.

PICKING NUMBERS

Picking Numbers is a powerful alternative to solving problems by brute force. Rather than working with unknown variables, you can pick concrete values for those variables or unknowns. In essence, you're transforming algebra or abstract math rules into basic arithmetic, giving yourself a much simpler task.

To successfully use Picking Numbers, follow these rules:

- Pick **permissible** numbers. Some problems have explicit rules such as "x is odd." Other problems have implicit rules. For example, if a word problem says, "Betty is five years older than Tim," don't pick $b = -2$ and $t = -7$; these numbers wouldn't work in the problem.
- Pick **manageable** numbers. Some numbers are simply easier to work with than others. $d = 2$ will probably be a more successful choice than $d = 492\sqrt{\pi}$, for example. The problems themselves will tell you what's manageable. For instance, $d = 2$ wouldn't be a great pick if an answer choice were $\frac{d}{12}$. (The number 12, 24, or even 120 would be much better in that case, since each is divisible by 12.)
- Once you've picked numbers to substitute for unknowns, approach the problem as basic arithmetic instead of algebra or number properties.
- Test every answer choice—sometimes certain numbers will yield a "false positive" in which a wrong answer looks right. If you get more than one "right answer," just pick a new set of numbers. The truly correct answer must work for all permissible numbers.

There are four signals that Picking Numbers will be a possible approach to the problem:

1. Variables in the answer choices
2. Percents in the answer choices
3. Answers that are fractions of an unknown value
4. Number property questions

These aren't in any particular order. You'll see many instances of each case on Test Day, so become familiar with all of them to ensure you recognize all your options on Test Day.

Picking Numbers with Variables in the Answer Choices

Whenever the answer choices contain variables, you should consider Picking Numbers. The correct answer choice is the one that yields the result that you got when you plugged the same number(s) into the question stem. Make sure that you test each answer choice, just in case more than one answer choice produces the desired result. In such a case, you will need to pick a new set of numbers and repeat the process only for the answer choices that worked out the first time.

Example: If $a > 1$, which of the following is equal to $\dfrac{2a + 6}{a^2 + 2a - 3}$?

 A. a

 B. $a + 3$

 C. $\dfrac{2}{a - 1}$

 D. $\dfrac{2a}{a - 3}$

 E. $a - 6$

Solution: The question says that $a > 1$, so the most manageable permissible number is 2.

 Then $\dfrac{2(2) + 6}{2^2 + 2(2) - 3} = \dfrac{4 + 6}{4 + 4 - 3} = \dfrac{10}{5} = 2.$

 Now substitute 2 for a in each answer choice, looking for choices that equal 2 (the answer you just solved for) when $a = 2$. Eliminate choices that do not equal 2 when $a = 2$.

 A. $a = 2$. Choice (A) is possibly correct.

 B. $a + 3 = 2 + 3 = 5$. This is not 2. Discard.

 C. $\dfrac{2}{a - 1} = \dfrac{2}{2 - 1} = \dfrac{2}{1} = 2.$ Possibly correct.

 D. $\dfrac{2a}{a - 3} = \dfrac{2(2)}{2 - 3} = \dfrac{4}{-1} = -4.$ This is not 2. Discard.

 E. $a - 6 = 2 - 6 = -4$. This is not 2. Discard.

 You're down to (A) and (C). When more than one answer choice remains, you must

 pick another number. Try $a = 3$. Then $\dfrac{2(3) + 6}{3^2 + 2(3) - 3} = \dfrac{6 + 6}{9 + 6 - 3} = \dfrac{12}{12} = 1.$

 Now work with the remaining answer choices.

 Choice (A): $a = 3$. This is not 1. Discard.

 Now that all four incorrect answer choices have been eliminated, you know that (C) must be correct. On Test Day, you should select (C) and move on, but just to verify right now, check to see whether (C) equals 1 when $a = 3$:

 $\dfrac{2}{a - 1} = \dfrac{2}{3 - 1} = \dfrac{2}{2} = 1.$ Choice (C) does equal 1 when $a = 3$.

This approach to Picking Numbers also applies to many confusing word problems. Picking Numbers can resolve a lot of that confusion. The key to Picking Numbers in word problems is to reread the question stem after you've picked numbers, substituting the numbers in place of the variables.

Example: A car rental company charges for mileage as follows: x dollars per mile for the first n miles and $x + 1$ dollars per mile for each mile over n miles. How much will the mileage charge be, in dollars, for a journey of d miles, where $d > n$?

 A. $d(x + 1) - n$
 B. $xn + d$
 C. $xn + d(x + 1)$
 D. $x(n + d) - d$
 E. $xd + n$

Solution: Suppose you pick $x = 4$, $n = 3$, and $d = 5$. Now the problem would read like this:

A car rental company charges for mileage as follows: $4 per mile for each of the first 3 miles and $5 per mile for each mile over 3 miles. How much will the mileage charge be, in dollars, for a journey of 5 miles?

All of a sudden, the problem has become much more straightforward. The first 3 miles are charged at $4/mile. So that's $4 + $4 + $4, or $12. There are 2 miles remaining, and each one costs $5. So that's $5 + $5, for a total of $10. If the first 3 miles cost $12 and the next 2 cost $10, then the total charge is $12 + $10, which is $22.

Plugging $x = 4$, $n = 3$, and $d = 5$ into the answer choices, you get:

 A. $d(x + 1) - n = 5(4 + 1) - 3 = 22$
 B. $xn + d = 4 \times 3 + 5 = 17$
 C. $xn + d(x + 1) = 4 \times 3 + 5(4 + 1) = 37$
 D. $x(n + d) - d = 4(3 + 5) - 5 = 27$
 E. $xd + n = 4 \times 5 + 3 = 23$

Only (A) yields the same number you calculated when you plugged these numbers into the question stem, so (A) is the answer. There's no need for complex algebra at all.

Picking Numbers with Percents in the Answer Choices

Picking Numbers also works well on Problem Solving questions for which the answer choices are given in percents. When the answers are in percents, 100 will almost always be the most manageable number to pick. Using 100 not only makes your calculations easier, but it also simplifies the task of expressing the final value as a percent of the original.

Example: The manufacturer of Sleep-EZ mattresses is offering a 10% discount on the price of its king-size mattress. Some retailers are offering additional discounts. If a retailer offers an additional 20% discount, then what is the total discount available at that retailer?

 A. 10%
 B. 25%
 C. 28%
 D. 30%
 E. 32%

Solution: Since the answers are in percents, pick $100 as the original price of the mattress. (Remember, realism is irrelevant—only permissibility and manageability matter.) The manufacturer offers a 10% discount: 10% of $100 is $10. So now the mattress costs $90.

Then the retailer offers an additional 20% discount. Since the price has fallen to $90, that 20% is taken off the $90 price. A 20% discount is now a reduction of $18. The final price of the mattress is $90 − $18, or $72.

The mattress has been reduced to $72 from an original price of $100. That's a $28 reduction. Since you started with $100, you can easily calculate that $28 is 28% of the original price. Choice (C) is correct.

Notice that choice (D) commits the error of simply adding the two percents given in the question stem. An answer choice like (D) will never be correct on a question that gives you information about multiple percent changes.

Picking Numbers with Answers That Are Fractions of an Unknown

Similar to when a question asks for a percent, when a question asks about any fraction of an unknown, pick numbers to represent the unknown(s) in the question stem and walk through the arithmetic of the problem using those. Look in the question stem and the answer choices for clues about what the most manageable numbers might be.

Example: Carol spends $\frac{1}{4}$ of her savings on a stereo, and then she spends $\frac{1}{3}$ less than she spent on the stereo for a television. What fraction of her savings did she spend on the stereo and television together?

 A. $\frac{1}{4}$

 B. $\frac{2}{7}$

 C. $\frac{5}{12}$

 D. $\frac{7}{12}$

 E. $\frac{3}{4}$

Solution: Lowest common denominators of fractions in the question stem are good choices for numbers to pick. So are numbers that appear frequently as denominators in the answer choices. In this case, the common denominator of the fractions in the stem is 12, so let the number 12 represent Carol's total savings (12 dollars).

That means she spends $\frac{1}{4} \times 12$ dollars, or 3 dollars, on her stereo, and $\frac{2}{3} \times 3$ dollars, or 2 dollars, on her television. That comes out to be $3 + 2 = 5$ dollars; that's how much she spent on the stereo and television combined. You're asked what *fraction* of her savings she spent. Because her total savings was 12 dollars, she spent $\frac{5}{12}$ of her savings; (C) is correct. Notice how picking a common denominator for the variable (Carol's savings) made it easy to convert each of the fractions $\left(\frac{1}{4} \text{ and } \frac{2}{3} \times \frac{1}{4} \text{ of her savings} \right)$ to a simple integer.

A tricky part of this question is understanding how to determine the price of the television. The television does not cost $\frac{1}{3}$ of her savings. It costs $\frac{1}{3}$ *less* than the stereo; that is, it costs $\frac{2}{3}$ as much as the stereo.

By the way, some of these answers could have been eliminated quickly using basic logic. Choice (A) is too small; the stereo alone costs $\frac{1}{4}$ of her savings. Choices (D) and (E) are too large; the television costs *less* than the stereo, so the two together must cost less than $2 \times \frac{1}{4}$, or half, of Carol's savings. Although you may not be used to approaching questions using this type of broad, logical approach, you can save significant time during any section of the test by looking for these kinds of patterns!

Picking Numbers with Number Property Questions

Number properties questions deal with categorizing numbers and explaining the expected behavior of numbers based on certain rules. The most common topics you will encounter include integers/non-integers, odds/evens, positives/negatives, factors/multiples, remainders, and primes. When you see a question that asks about any of these topics and that includes any unknown values, you should immediately consider the Picking Numbers strategy. As always, remember to select permissible and manageable numbers for yourself when you pick numbers to make the math as easy as possible.

Example: If 2 is the remainder when m is divided by 5, what is the remainder when $3m$ is divided by 5?

 A. 0
 B. 1
 C. 2
 D. 3
 E. 4

Solution: This question tests your ability to think critically about the characteristics of remainders in division. You are told that some number, m, has a remainder of 2 when divided by 5. Pick simple, permissible numbers and apply them to the problem in the question stem.

Since m has a remainder of 2 when divided by 5, m could be any number that is 2 greater than a multiple of 5. The simplest number to substitute for m is 7. You know that 5 goes into 7 one time with a remainder of 2. Now, apply 7 to the rest of the question stem: $3m$ divided by 5. Multiplying 3 and 7 gives you 21, and 21 divided by 5 leaves a remainder of 1. Thus, answer choice (B) is correct; no more work is required!

BACKSOLVING

Backsolving is just like Picking Numbers except, instead of coming up with the number yourself, you use the numbers in the answer choices. You'll literally work backward through the problem, looking for the answer choice that agrees with the information in the question stem. This is a good approach whenever the task of plugging a choice into the question would allow you to confirm its details in a straightforward way.

You want to Backsolve systematically, not randomly. Start with either choice (B) or (D), depending on whether you anticipate the correct answer being closer to one or the other. If the choice you pick isn't correct, you'll often be able to figure out whether you need to try a number that's larger or one that's smaller. Since numerical answer choices will always be in ascending or descending order, you'll be able to use that information to eliminate several choices at once.

For example, you might choose to start with (B). If (B) works, then choose it as the correct answer and move to the next question. If (B) is too large, then (A) must be the correct answer since it is the only choice that is smaller. If (B) is too small, then eliminate both (A) and (B) and try (D) next. (D) will be correct, or too large, in which case (C) is the correct answer, or too small, in which case (E) is the correct answer.

Using this strategy, you'll only need to check two answer choices at most, which makes Backsolving a quick and efficient method to use for many questions. It is also an exceptional choice when you don't know how to begin a question using traditional math.

Example: Ron begins reading a book at 4:30 p.m. and reads at a steady pace of 30 pages per hour. Michelle begins reading a copy of the same book at 6:00 p.m. If Michelle started 5 pages behind the page that Ron started on and reads at an average pace of 50 pages per hour, at what time would Ron and Michelle be reading the same page?

 A. 7:00 p.m.
 B. 7:30 p.m.
 C. 8:00 p.m.
 D. 8:30 p.m.
 E. 9:00 p.m.

Solution: You could perhaps set up a complex system of equations to solve this problem, but even if you knew exactly what those equations would be and how to solve them, that's not a very efficient use of your time. Backsolving would work better here. Pick an answer choice and see whether Michelle and Ron are on the same page at that time. There's no compelling reason to prefer one choice to another, so just quickly choose (B) or (D).

Let's say you choose (B). On what page is Ron at 7:30 p.m.? He started reading at 4:30 p.m., so he has been reading for 3 hours. His pace is 30 pages per hour. So he has read 30×3, or 90 pages. Since Michelle started 5 pages behind Ron, she would need to read 95 pages to be at the same place. She has been reading since 6:00 p.m., so she has read for 1.5 hours. At 50 pages per hour, she has read 75 pages. That's 20 short of what she needs. So (B) is not the right answer.

Since Michelle is reading faster than Ron, she'll catch up to him with more time. Therefore, they will be on the same page sometime later than 7:30 p.m., so eliminate (A) as well and try (D).

At 8:30 p.m. Ron has read for 4 hours. At a pace of 30 pages per hour he's read $30 \times 4 = 120$ pages. Since Michelle started 5 pages behind, she'd need to read 125 pages to be at the same place. She's been reading for 2.5 hours at this point; at 50 pages per hour, she's read 125 pages. That's exactly what you're looking for—choice (D) must be correct.

As happened with this question, sometimes you may have to test more than one choice. But as you saw above, you should never have to test more than two answer choices. Stick to (B) or (D), and you'll save valuable time.

STRATEGIC GUESSING AND ESTIMATION

A well-placed guess can sometimes be the best tool you can use for a problem. Because of the severe time constraints, you need to stay on a steady pace. If you fall behind, it's a good idea to guess on the hardest problems and mark them for later rather than completing the full calculations right away. That way you'll get back lost time instead of falling further behind. And while you shouldn't be afraid to guess, you should be afraid to rush! The test makers write problems in complicated ways, and rushing almost always leads to misperception of questions (not to mention errors in arithmetic). This is a problem because the test makers base many wrong answers on the most common misperceptions. Rushing through a problem almost always guarantees a wrong answer. It's far better to guess as needed, skipping some questions and taking the time you need on others, than to rush through an entire section.

Even if you are ahead of schedule during a section, sometimes you simply will have no idea how to approach a problem. Instead of throwing away three or four minutes becoming frustrated, make a guess. If you don't know how to approach a problem, you aren't likely to choose the right answer anyway, and you can use the time you save to solve other problems that you stand a better chance of answering correctly.

Estimation can also be useful when answering questions as it can save you time and help you avoid mistakes when working through lengthy arithmetic calculations. You should consider estimation on questions that involve difficult or lengthy calculations and have answer choices that are spread fairly far apart. Once you decide to estimate, you'll want to follow a couple of general rules.

First, use scientific notation and fractions to simplify calculations. Although mastering both may take practice, you'll find the arithmetic required for either to be much simpler than leaving the number as a regular decimal. Review the rules in Chapter 59 if you don't feel comfortable with manipulating fractions yet; you'll need to know them to do well on certain questions anyway, so becoming adept at them now will allow you to master content and strategies at the same time.

Second, feel free to round numbers or only use powers of 10 when the answer choices vary widely. When you add or multiply numbers, round one number up and the other number down. When you subtract or divide numbers, round both numbers in the same direction. By doing so, you'll minimize the effect of rounding and arrive at a closer answer than you would if rounding randomly.

REVIEW PROBLEMS

1. Each writer for the local newspaper is paid as follows: a dollars for each of the first n stories each month and $a + b$ dollars for each story thereafter, where $a > b$. How many more dollars will a writer who submits $n + a$ stories in a month earn than a writer who submits $n + b$ stories?

 A. $(a - b)(a + b + n)$
 B. $a - b$
 C. $a^2 - b^2$
 D. $n(a - b)$
 E. $n(a + b)$

2. A crate of apples contains 1 bruised apple for every 30 apples in the crate. Three out of every four bruised apples are considered not fit to sell, and every apple that is not fit to sell is bruised. If there are 12 apples not fit to sell in the crate, then how many total apples are there in the crate?

 A. 270
 B. 360
 C. 480
 D. 600
 E. 720

3. Company Z spent $\frac{1}{4}$ of its revenues last year on marketing and $\frac{1}{7}$ of the remainder on maintenance of its facilities. What fraction of last year's original revenues did company Z have left after its marketing and maintenance expenditures?

 A. $\frac{5}{14}$

 B. $\frac{1}{2}$

 C. $\frac{17}{28}$

 D. $\frac{9}{14}$

 E. $\frac{41}{56}$

4. The positive difference between Sam and Lucy's ages is a, and the sum of their ages is z. If Lucy is older than Sam, then which of the following represents Lucy's age?

 A. $\frac{z - a}{2}$

 B. $\frac{z + a}{2}$

 C. $a - \frac{z}{2}$

 D. $\frac{a - z}{2}$

 E. $\frac{a + 2z}{2}$

5. If a bicyclist in motion increases his speed by 30 percent and then increases this speed by 10 percent, what percent of the original speed is the total increase in speed?

 A. 40%

 B. 43%

 C. 64%

 D. 140%

 E. 180%

6. If p, q, and r are positive integers such that q is a factor of r and r is a multiple of p, which of the following must be an integer?

 A. $\dfrac{p+q}{r}$

 B. $\dfrac{p}{q}$

 C. $\dfrac{r(p+q)}{pq}$

 D. $\dfrac{r+p}{q}$

 E. $\dfrac{rp+q}{p}$

SOLUTIONS TO THE REVIEW PROBLEMS

1. **C** You are given information about the number of dollars reporters are paid to write newspaper stories. They are paid at one rate for each of a certain number of stories and another rate for each remaining story after that. You are also given information about two specific writers and the number of stories that they write. Although it is possible to complete this question using traditional math, the set up would be quite difficult. Since there are variables in the question stem and the answer choices, this is a good question to use Picking Numbers instead.

 The only permissibility rule given in the question is that $a > b$, so you could pick $a = 3$ and $b = 2$. The remaining variable is n; there are no constraints on this number, so pick a number that is easy to work with, such as 10.

 Once you have chosen your numbers, reread the question stem but mentally substitute your new numbers for the variables as this can help the problem make more sense. You want to know how much more a writer who writes $n + a = 10 + 3 = 13$ stories will make than will a writer who writes $n + b = 10 + 2 = 12$ stories.

 Start with the writer who writes 13 stories. She makes \$3 for each of the first 10 stories or \$30 total for the first ten stories. Then, she makes $a + b = 3 + 2 = \$5$ for each story after that. She wrote 3 more stories, so she earned \$15 more for the additional stories. In total, the writer earned \$45.

 Next, look at the writer who wrote 12 stories. He too will make \$3 for each of the first 10 stories or \$30 total. Then he will make \$5 for each of the remaining 2 stories, another \$10. In total, the second writer earns \$40. Therefore, the difference between the two writers' earnings is \$5. Now, plug your variables into the answer choices to find one that equals \$5:

 A. $(3 - 2)(3 + 2 + 10) = (1)(15) = 15$. Eliminate.

 B. $3 - 2 = 1$. Eliminate.

 C. $3^2 - 2^2 = 9 - 4 = 5$. This could be the correct answer, but keep checking to ensure no other answer choices also calculate to 5.

 D. $10(3 - 2) = 10(1) = 10$. Eliminate.

 E. $10(3 + 2) = 10(5) = 50$. Eliminate.

 Since only one answer choice yields the number 5, pick choice (C) and move on.

2. **C** This is another difficult-sounding question. Since the answer choices are all numbers, Backsolving is a great approach to use instead of traditional math. Start with choice (B). Suppose that there are 360 apples in the crate. Then $\frac{360}{30}$ apples, or 12 apples, are bruised. Then, $\frac{3}{4}$ of those 12 apples, or 9 apples, are unsellable. This is too few unsellable apples, so (B) is too small. The answer must be larger than 360, so eliminate choices (A) and (B). Try choice (D) next. Suppose that there are 600 apples in the crate. Then $\frac{600}{30}$ apples, or 20 apples, are bruised. Of those 20, $\frac{3}{4}$ or 15, are unsalable. That's too many, so choice (C) must be correct.

3. **D** Company Z spends portions of its revenues on two things. It is important to note that the answer choices are fractions and represent the fraction of last year's revenues that company Z had left after the expenses. Notice that you are given absolutely no way to know how much revenue company Z received last year, so you can use Picking Numbers to determine the total revenue. Since you must take $\frac{1}{4}$ and $\frac{1}{7}$ of the revenue, a number divisible by both 4 and 7 will be most manageable. Make the calculations as easy as possible by picking the lowest common multiple of 4 and 7: 28.

Now, "Company Z spent $\frac{1}{4}$ of its revenues last year on marketing," becomes "Company Z spent \$7 last year on marketing." The next sentence mentions "the remainder," so you need to know what that is. Since \$28 − \$7 = \$21, "Company Z spent $\frac{1}{7}$ of the remainder on maintenance," means "Company Z spent \$3 on maintenance."

What's left from \$28 after company Z spent \$7 and then \$3 is \$18. So the answer is $\frac{18}{28}$. A common factor of 2 can be canceled from both the numerator and the denominator, leaving $\frac{9}{14}$. Choice (D) is correct.

4. **B** There are two people—Sam and Lucy—whose ages are related in some way. While you could set up an algebraic equation here, notice that the answer choices all contain variables and thus allow for Picking Numbers. You are solving for Lucy's age, so be careful not to answer with Sam's age because that's likely to be one of the wrong answers.

It's easy enough to pick two numbers for a and z. But then you would still have to backtrack from those to calculate the two ages. If this happens, consider reevaluating your approach. Are there other variables you could pick first that would make things easier?

If you pick numbers for Lucy's and Sam's ages, then all you need to do to figure out the values of a and z is basic arithmetic. You might pick that Lucy is 5 years old and Sam is 3 years old. That makes a, their difference, equal to 2. And z, their sum, is equal to 8.

Plug in $a = 2$ and $z = 8$ to see which choices yield Lucy's age of 5.

 A. is $\frac{8-2}{2} = \frac{6}{2} = 3$. Eliminate.

 B. is $\frac{8+2}{2} = \frac{10}{2} = 5$. Possibly right.

 C. is $2 - \frac{8}{2} = 2 - 4 = -2$. Eliminate.

 D. is $\frac{2-8}{2} = \frac{-6}{2} = -3$. Eliminate.

 E. is $\frac{2+8(2)}{2} = \frac{18}{2} = 9$. Eliminate.

Since it is the only choice that matches, (B) is correct.

5. **B** The question gives you information about two increases to the speed of a bicyclist and asks for the total percent increase in the cyclist's speed. When you encounter a percentage problem with an unknown value in the question and percentages in the answer choices, you should use the strategy of Picking Numbers and pick 100.

If the bicyclist initially rides at 100 (the units aren't mentioned in this problem, and in any case, the numbers don't need to be realistic, just permissible and manageable) and then increases his speed by 30%, he now rides at 130. He then increases this speed by 10%, so find 10% of 130, which is 13, and add it to 130. That makes his final speed 143. That is an increase of 43 over his original speed of 100. Recalling that 100 was the number you initially picked shows that 43 is 43% (or $\frac{43}{100}$) of the original speed. Answer choice (B) is correct.

6. C This question gives information about three variables and how they relate to each other. Since q is a factor of r, r is a multiple of q. The question stem also says r is a multiple of p. Thus, r is a multiple of both p and q. This question is very abstract and relies on your knowledge of number properties, so picking numbers that are permissible will help you make quick work of the answer choices.

Pick numbers for p, q, and r and apply them to the answer choices. Since you know r is a multiple of both p and q, start with p and q. You might pick that $p = 2$ and $q = 3$. From there, you can pick a value for r; such as $r = 6$. Now plug these values into the answer choices and eliminate any choice that does not yield an integer.

A. is $\frac{2+3}{6} = \frac{5}{6}$. Eliminate.

B. is $\frac{2}{3}$. Eliminate.

C. is $\frac{6(2+3)}{2(3)} = \frac{6(5)}{6} = 5$. Possibly correct.

D. is $\frac{6+2}{3} = \frac{8}{3}$. Eliminate.

E. is $\frac{(6 \times 2) + 3}{2} = 7.5$. Eliminate.

As the only choice that fit, (C) is correct.

CHAPTER FIFTY-SIX

Quantitative Comparison

INTRODUCTION TO QUANTITATIVE COMPARISON

In each Quantitative Comparison question, you'll see two mathematical expressions. One is Quantity A, and the other is Quantity B. You will be asked to compare them. Some questions include additional centered information. This centered information applies to both quantities and is essential to making the comparison. Since this type of question is about the relationship between the two quantities, you won't always need to calculate a specific value for either quantity. Therefore, you do not want to rely exclusively on the onscreen calculator to answer these questions.

Quantitative Comparison questions will look like this:

[Optional Centered Information]

Quantity A	Quantity B
Value A	Value B

- **A.** Quantity A is greater.
- **B.** Quantity B is greater.
- **C.** The two quantities are equal.
- **D.** The relationship cannot be determined from the information given.

THE KAPLAN METHOD FOR QUANTITATIVE COMPARISON

STOP: Analyze the centered information and the quantities.

Notice whether the quantities contain numbers, variables, or both. If there is centered information, decide how it affects the information given in the quantities. Note that a variable has the same value each time it appears within a question.

THINK, PREDICT, and MATCH: Approach strategically.

Think about a strategy you could use to compare the quantities now that you've determined the information you have and the information you need. There are a variety of approaches to solving a Quantitative Comparison question, and the practice examples will take you through several of these.

How to Apply the Kaplan Method for Quantitative Comparison

Now let's apply the Kaplan Method to a Quantitative Comparison question:

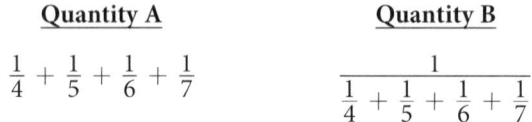

Quantity A	Quantity B
$\frac{1}{4} + \frac{1}{5} + \frac{1}{6} + \frac{1}{7}$	$\dfrac{1}{\frac{1}{4} + \frac{1}{5} + \frac{1}{6} + \frac{1}{7}}$

- **A.** Quantity A is greater.
- **B.** Quantity B is greater.
- **C.** The two quantities are equal.
- **D.** The relationship cannot be determined from the information given.

STOP: Analyze the centered information and the columns.

This problem would be a nightmare to calculate under timed conditions. But the only thing you need to figure out is whether one quantity is greater than the other. One thing you might notice is that choice **(D)** is not an option here. Because both quantities contain only numbers, there is a definite value for each quantity, and a relationship can be determined. Answer choice **(D)** is never correct when the quantities contain only numbers.

Note that the quantity on the left is the same as the quantity in the denominator of the fraction on the right. You can think about this problem as a comparison of x and $\frac{1}{x}$ (or the reciprocal of x), where x has a definite value. Your job now is to figure out just how to compare them.

THINK, PREDICT, and MATCH: Approach strategically.

Before you start to do a long calculation, think about what you already know. While you may not know the sum of the four fractions, you do know two things: $\frac{1}{4} + \frac{1}{4} + \frac{1}{4} + \frac{1}{4} = 1$, and $\frac{1}{5}, \frac{1}{6}$, and $\frac{1}{7}$ are each less than $\frac{1}{4}$. Because the reciprocal of any number between 0 and 1 is greater than 1, and Quantity A is a positive number less than 1, its reciprocal in Quantity B is greater than 1. So choice **(B)** is correct. Quantitative Comparisons rarely, if ever, ask for exact values, so don't waste time calculating them.

Now let's apply the Kaplan Method to a second Quantitative Comparison question:

$$w > x > 0 > y > z$$

Quantity A **Quantity B**

$w + y$ $x + z$

A. Quantity A is greater.
B. Quantity B is greater.
C. The two quantities are equal.
D. The relationship cannot be determined from the information given.

STOP: Analyze the centered information and the quantities.

In this problem, there are four variables: w, x, y, and z. You are asked to compare the values of the sums of pairs of variables. You know the relative values of the different variables, but you don't know the actual amounts. You do know that two of the variables (w and x) must be positive and two of the variables (y and z) must be negative numbers.

THINK, PREDICT, and MATCH: Approach strategically.

In this case, think about the different sums as pieces of the whole. If every "piece" in one quantity is greater than a corresponding "piece" in the other quantity, and if the only operation involved is addition, then the quantity with the greater individual values will have the greater total value. From the given information, we know the following:

- $w > x$
- $y > z$

The first term, w, in Quantity A is greater than the first term, x, in Quantity B. Similarly, the second term, y, in Quantity A is greater than the second term, z, in Quantity B. Because each piece in Quantity A is greater than the corresponding piece in Quantity B, Quantity A must be greater; the answer is **(A)**.

Now let's apply the Kaplan Method to a third Quantitative Comparison question:

The diameter of circle O is d, and the area is a.

Quantity A **Quantity B**

$\dfrac{\pi d^2}{2}$ a

A. Quantity A is greater.
B. Quantity B is greater.
C. The two quantities are equal.
D. The relationship cannot be determined from the information given.

STOP: Analyze the centered information and the quantities.

In this problem, you are given additional information: the sentence that tells you the diameter of circle O is d and the area is a. This is important information because it gives you a key to unlocking this question. Given that information, you can tell that you are comparing the area, a, of circle O and a quantity that includes the diameter of the same circle. If you're thinking about the formula for calculating area given the diameter, you're thinking right!

THINK, PREDICT, and MATCH: Approach strategically.

Make Quantity B look more like Quantity A by rewriting a, the area of the circle, in terms of the diameter, d. The area of any circle equals πr^2, where r is the radius. Because the radius is half the diameter, you can substitute $\frac{d}{2}$ for r in the area formula to get $a = \pi r^2 = \pi\left(\frac{d}{2}\right)^2$ in Quantity B. Simplifying, you get $\frac{\pi d^2}{4}$

Because both quantities contain π, we could compare $\frac{d^2}{2}$ to $\frac{d^2}{4}$. But let's take it one step further. You know that d is a distance and must be a positive number. That makes it possible to divide both quantities, $\frac{d^2}{2}$ and $\frac{d^2}{4}$, by d^2 and then just compare $\frac{1}{2}$ to $\frac{1}{4}$. This makes it easy to see that Quantity A is always greater because $\frac{1}{2} > \frac{1}{4}$. Choice (**A**) is correct.

ADDITIONAL QUANTIATIVE COMPARISON STRATEGIES

Memorize the answer choices

It is a good idea to memorize the Quantitative Comparison answer choice options. This is not as difficult as it sounds. The choices are always the same. The wording and the order never vary. As you work through practice problems, the choices will become second nature to you, and you will get used to reacting to the questions without reading the four answer choices, thus saving you lots of time on Test Day.

When there is at least one variable in a problem, try to demonstrate two different relationships between quantities

Here's why demonstrating two different relationships between the quantities is an important strategy: if you can demonstrate two different relationships, then choice (**D**) is correct. There is no need to examine the question further.

But how can this demonstration be done efficiently? A good suggestion is to look at the expression(s) containing a variable and notice the possible values of the variable given the mathematical operation involved. For example, if x can be any real number and you need to compare $(x + 1)^2$ to $(x + 1)$, pick a value for x that will make $(x + 1)$ a fraction between 0 and 1 and then pick a value for x that will make $(x + 1)$ greater than 1. By choosing values for x in this way, you are basing your number choices on mathematical properties you already know: a positive fraction less than 1 becomes smaller when squared, but a number greater than 1 grows larger when squared.

Compare quantities piece by piece

Compare the value of each "piece" in each quantity. If every "piece" in one quantity is greater than a corresponding "piece" in the other quantity, and the operation involved is either addition or multiplication, then the quantity with the greater individual values will have the greater total value.

Make one quantity look like the other

When the Quantities A and B are expressed differently, you can often make the comparison easier by changing the format of one quantity so that it looks like the other. This is a great approach when the quantities look so different that you can't compare them directly.

Do the same thing to both quantities

If the quantities you are given seem too complex to compare immediately, look closely to see if there is an addition, subtraction, multiplication, or division operation you can perform on both quantities to make them simpler—provided you do not multiply or divide by zero or a negative number. For example, suppose you have the task of comparing $1 + \dfrac{w}{1 + w}$ to $1 + \dfrac{1}{1 + w}$, where w is greater than 0. To get to the heart of the comparison, subtract 1 from both quantities and you have $\dfrac{w}{1 + w}$ compared to $\dfrac{1}{1 + w}$. To simplify even further, multiply both quantities by $(1 + w)$, and then you can compare w to 1.

Don't be tricked by misleading information

To avoid Quantitative Comparison traps, stay alert and don't assume anything. If you are using a diagram to answer a question, use only information that is given or information that you know must be true based on properties or theorems. For instance, don't assume angles are equal or lines are parallel unless it is stated or can be deduced from other information given.

A common mistake is to assume that variables represent only positive integers. As you saw when using the Picking Numbers strategy, fractions or negative numbers often show a different relationship between the quantities.

Don't forget to consider other possibilities

If an answer looks obvious, it may very well be a trap. Consider this situation: a question requires you to think of two integers whose product is 6. If you jump to the conclusion that 2 and 3 are the integers, you will miss several other possibilities. Not only are 1 and 6 possibilities, but there are also pairs of negative integers to consider: -2 and -3, -1 and -6.

Don't fall for look-alikes

Even if two expressions look similar, they may be mathematically different. Be especially careful with expressions involving parentheses or radicals. If you were asked to compare $\sqrt{5x} + \sqrt{5x}$ to $\sqrt{10x}$, you would not want to fall into the trap of saying the two expressions were equal. Although time is an important factor in taking the DAT, don't rush to the extent that you do not apply your skills correctly. In this case, $\sqrt{5x} + \sqrt{5x} = 2\sqrt{5x}$, which is not the same as $\sqrt{10x}$ unless $x = 0$.

REVIEW PROBLEMS

1.

Quantity A	Quantity B
$x^2 + 2x - 2$	$x^2 + 2x - 1$

 A. Quantity A is greater.
 B. Quantity B is greater.
 C. The two quantities are equal.
 D. The relationship cannot be determined from the information given.

2.

$x = 2y$; y is a positive integer.

Quantity A	Quantity B
4^{2y}	2^x

 A. Quantity A is greater.
 B. Quantity B is greater.
 C. The two quantities are equal.
 D. The relationship cannot be determined from the information given.

3.

q, r, and s are positive numbers; $qrs > 12$.

Quantity A	Quantity B
$\dfrac{qr}{5}$	$\dfrac{3}{s}$

 A. Quantity A is greater.
 B. Quantity B is greater.
 C. The two quantities are equal.
 D. The relationship cannot be determined from the information given.

4. In triangle XYZ not given, the measure of angle X equals the measure of angle Y.

Quantity A	Quantity B
The degree measure of angle Z	The degree measure of angle X plus the degree measure of angle Y

A. Quantity A is greater.
B. Quantity B is greater.
C. The two quantities are equal.
D. The relationship cannot be determined from the information given.

5.

square A

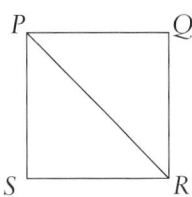

square B

Quantity A	Quantity B
$\dfrac{\text{Perimeter of square } A}{\text{Perimeter of square } B}$	$\dfrac{\text{Length of } WY}{\text{Length of } PR}$

A. Quantity A is greater.
B. Quantity B is greater.
C. The two quantities are equal.
D. The relationship cannot be determined from the information given.

6. Set A consists of 35 consecutive integers.

Quantity A	Quantity B
The probability of selecting an even number less than the median from set A	The probability of selecting an odd number greater than the median from set A

A. Quantity A is greater.
B. Quantity B is greater.
C. The two quantities are equal.
D. The relationship cannot be determined from the information given.

QR

7.

For all shows except those on Sunday afternoons, a local theater sells tickets at one price for adults and a reduced price for children. On Sunday afternoons, all tickets are sold at a discount of 20%.

Quantity A	**Quantity B**
The amount of money collected for 120 adults and 100 children on a Saturday night	The amount of money collected for 150 adults and 120 children on a Sunday afternoon

A. Quantity A is greater.
B. Quantity B is greater.
C. The two quantities are equal.
D. The relationship cannot be determined from the information given.

8.

Quantity A	**Quantity B**
$(x + 2)(x - 2)$	$\dfrac{-5(x^2 - 25)(x - 1)}{(x + 5)(x^2 - 6x + 5)}$

A. Quantity A is greater.
B. Quantity B is greater.
C. The two quantities are equal.
D. The relationship cannot be determined from the information given.

9.

An apartment building has apartments numbered 2 through 85, consecutively.

Quantity A	**Quantity B**
The probability that the apartment number of a randomly selected tenant contains a 4	$\dfrac{3}{14}$

A. Quantity A is greater.
B. Quantity B is greater.
C. The two quantities are equal.
D. The relationship cannot be determined from the information given.

10.

A car begins at Point A traveling 30 miles per hour. The car decreases its speed by 5 miles per hour every 10 minutes until the car comes to a complete stop.

Quantity A	**Quantity B**
The total number of miles traveled between Point A and the final stopping point	The average speed of the car in miles per hour between Point A and the final stopping point

A. Quantity A is greater.
B. Quantity B is greater.
C. The two quantities are equal.
D. The relationship cannot be determined from the information given.

SOLUTIONS TO REVIEW PROBLEMS

1. **B** Comparing the two quantities piece by piece, you find that the only difference is the third piece: -2 in Quantity A and -1 in Quantity B. You don't know the value of x, but whatever it is, x^2 in Quantity A must have the same value as x^2 in Quantity B, and $2x$ in Quantity A must have the same value as $2x$ in Quantity B. Because any quantity minus 2 must be less than that quantity minus 1, Quantity B is greater than Quantity A. **(B)** is the correct answer.

2. **A** Replacing the exponent x in Quantity B with the equivalent value given in the centered information, you're comparing 4^{2y} with 2^{2y}. Because y is a positive integer, raising 4 to the exponent $2y$ will result in a greater value than raising 2 to the exponent $2y$. The correct answer is **(A)**.

3. **D** Do the same thing to both quantities to make them look like the centered information. When you multiply both quantities by $5s$, you get qrs in Quantity A and 15 in Quantity B. Because qrs could be any integer greater than 12, qrs could be greater than, equal to, or less than 15. **(D)** is correct.

4. **D** Because angle X = angle Y, at least two sides of the triangle are equal. You can draw two diagrams with X and Y as the base angles of a triangle. In one diagram, make the triangle tall and narrow so that angle X and angle Y are very large and angle Z is very small. In this case, Quantity B is greater. In the second diagram, make the triangle short and wide so that angle Z is much larger than angle X and angle Y. In this case, Quantity A is greater. Because more than one relationship between the quantities is possible, the correct answer is **(D)**.

5. **C** You don't know the exact relationship between square A and square B, but it doesn't matter. The problem is actually just comparing the ratios of corresponding parts of two squares. The relationship between the specific side lengths of both squares will also exist between them for any other corresponding length. If a side of one square is twice the length of a side of the second square, the diagonal will also be twice as long. The ratio of the perimeters of the two squares is the same as the ratio of the diagonals.

You can make this abstract relationship concrete by Picking Numbers for the sides of the two squares. Say, for example, that each side of square A is 2 and each side of square B is 3. Then the ratio of the perimeters is 8:12 or 2:3, and the ratio of the diagonals is $2\sqrt{2} : 3\sqrt{2}$ or 2:3. The quantities are equal, so **(C)** is correct.

6. **D** In a set of 35 consecutive integers, the median will be the number in the middle. Of the remaining 34 values, 17 will be less than the median and 17 will be greater.

 If the first integer is odd, there will be 9 odd numbers and 8 even numbers below the median. The median will be even. Then, there will be another 9 odd numbers and 8 even numbers above the median. If the first integer is even, the results are reversed. There will be 9 even numbers and 8 odd numbers below the median, the median will be odd, and there will be 9 even numbers and 8 odd numbers above the median.

 So, if the first integer is odd, there's an 8 in 35 chance of picking an even number less than the median and a 9 in 35 chance of picking an odd number greater than the median. Quantity B would be greater than Quantity A. However, if the first integer is odd, the odds are reversed, with a 9 in 35 chance of picking an even number less than the median and an 8 in 35 chance of picking an odd number greater than the median. That would make Quantity A greater than Quantity B. Because more than one relationship is possible, **(D)** is the correct answer.

7. **A** The stimulus provides no actual prices for the different tickets, so use A to represent the regular price of an adult's ticket and C to represent the regular price of a child's ticket. The tickets are full price on Saturday, so Quantity A could be calculated as: $120A + 100C$.

 On Sunday afternoon, there's a 20% discount on all tickets. That means the tickets will be 80% of their original price. Quantity B would thus be calculated as:

 $$150(.8A) + 120(.8C) = 120A + 96C$$

 Comparing the two results, both quantities have an equal total in sales from adults, but Quantity A has $100C$ while Quantity B has $96C$. That means Quantity A is larger, making **(A)** the correct answer.

8. **A** Using FOIL, Quantity A can be rewritten as $x^2 - 4$. Quantity B needs to be simplified. In the numerator, $x^2 - 25$ can be factored into $(x + 5)(x - 5)$. In the denominator, $x^2 - 6x + 5$ can be factored into $(x - 5)(x - 1)$. The fraction can then be simplified by canceling out common factors in the numerator and denominator:

 $$\frac{-5(x^2 - 25)(x - 1)}{(x + 5)(x^2 - 6x + 5)} = \frac{-5(x + 5)(x - 5)(x - 1)}{(x + 5)(x - 5)(x - 1)} = \frac{-5}{1} = -5$$

 So, Quantity B is equal to -5. Without knowing what x is, it might seem that Quantity A and Quantity B cannot be compared. However, when x is squared, the result cannot be negative. The smallest value it could have is 0. Subtracting 4, the smallest possible value of Quantity A is -4. That means Quantity A must be greater than or equal to -4. Any such

number will always be greater than -5, so Quantity A will always be greater than Quantity B, no matter what x is. That makes **(A)** the correct answer.

9. **D** It may be tempting to jump straight into the probability formula here, $Probability = \dfrac{Number\ of\ desired\ outcomes}{Number\ of\ total\ outcomes}$. Counting each apartment with a 4 in it (those starting with 4 as well as ending in 4) and the number of total apartments would give $\dfrac{18}{84}$,

which, when simplified, equals Quantity B. However, notice that the centered information gives information about apartments, while Quantity A is based on selecting a random *tenant*. There's no information on how many tenants are in each apartment. The above math works if each apartment has an equal number of tenants. However, if each apartment with a 4 in the number has three tenants while other apartments only have one, it would be more likely that a randomly selected tenant lives in an apartment with a 4 in the number. Since more than one relationship is possible, the correct answer is **(D)**.

10. **C** It's important to realize that the total distance need not be calculated to compare the two quantities. For this question, let d represent the total distance, in miles, traveled. Quantity A will thus be equal to d.

Quantity B is the average speed for the entire trip. The average speed, in miles per hour, is calculated by taking the total mileage (d) and dividing that by the total number of hours. The car starts at 30 miles per hour and slows down 5 miles per hour every 10 minutes. That means it will travel first at 30 miles per hour, then 25 miles per hour, then 20, then 15, then 10, then 5. After that, it will stop. It will travel for 10 minutes at each of those 6 speeds, for a total of 60 minutes, which is 1 hour. That means the average speed will be equal to $\dfrac{d}{1} = d$. Regardless of the value of d (which could be calculated, but would only take up valuable time for this question), the two quantities are equal. That makes **(C)** the correct answer.

CHAPTER FIFTY-SEVEN

Data Sufficiency

LEARNING OBJECTIVE

After this chapter, you will be able to:

- Apply Kaplan's strategies to answer Data Sufficiency questions

Below is a typical Data Sufficiency question. In this chapter, we'll look at how to apply the Kaplan Method to this question, discuss how to tackle this question type, and go over the basic principles and strategies that you want to keep in mind on every Data Sufficiency question. But before you move on, take a minute to review the overall question structure, think about what makes this question type a unique challenge, and answer some questions about how you think it works:

Is the product of x, y, and z equal to 1?

(1) $x + y + z = 3$
(2) x, y, and z are each greater than 0.

A. Statement (1) ALONE is sufficient, but statement (2) is not sufficient.
B. Statement (2) ALONE is sufficient, but statement (1) is not sufficient.
C. BOTH statements TOGETHER are sufficient, but NEITHER statement ALONE is sufficient.
D. EACH statement ALONE is sufficient.
E. Statements (1) and (2) TOGETHER are NOT sufficient.

Figure 57.1

- How is the structure of this question different from that of a typical "math" question?
- What mathematical concepts are tested in this question?
- How can you use the answer choices to your advantage?

PREVIEWING DATA SUFFICIENCY

Data Sufficiency questions are quite different from the other questions you'll see on the Quantitative Reasoning test. Figure 57.1 shows the standard structure of this question type. Notice that the question stem only asks if the product of x, y, and z is equal to 1. It does not ask you to solve for the values of the given variables. The question also provides two pieces of information in two separate statements. No other information is given. This is a key feature of Data Sufficiency questions: you must use the statements, not just the question stem, to determine whether the data in the statements are enough (sufficient) to answer the question.

Another distinct feature of Data Sufficiency questions is the format of the answer choices. Like we saw in Quantitative Comparison questions, all of the answer choices will be exactly the same in every question. In this case, each answer choice focuses on the "sufficiency" or "insufficiency" of the statements. In other words, does one, both, or neither of the statements provide enough information to answer the question? Since these answer choices will never change, the Kaplan Method includes an easy way to analyze the answer choices for strategic elimination.

Although these questions may seem strange at first, once you are familiar with their structure and associated tasks, they can be straightforward questions. Data Sufficiency questions are only asking you to assess whether or not you have enough information to answer the question; you don't need to solve for specific values. As such, many Data Sufficiency questions can be solved without any arithmetic. Instead, you can rely solely on critical thinking, as these questions are focused on testing your ability to assess presented data and make deductions from that information.

While data sufficiency questions appear to test you on basic arithmetic concepts like multiplication, addition, and inequalities, they often require your knowledge of less explicitly mentioned topics, such as number properties. For example, in Figure 57.1, it is easy to assume that x, y, and z are integers. However, the question does not provide any information to prove this assumption. *Never* assume that variables are integers or even positive numbers unless explicitly stated. Training your mind to think in this way requires practice, but using the Kaplan Method for Data Sufficiency will help you correctly and efficiently answer even the most challenging Data Sufficiency questions.

These questions may seem confusing at first, but they become far simpler with practice. Let's walk through a simple example:

What is the length of segment AC?

(1) B is the midpoint of AC.
(2) $AB = 5$

A. Statement (1) ALONE is sufficient, but statement (2) is not sufficient.
B. Statement (2) ALONE is sufficient, but statement (1) is not sufficient.
C. BOTH statements TOGETHER are sufficient, but NEITHER statement ALONE is sufficient.
D. EACH statement ALONE is sufficient.
E. Statements (1) and (2) TOGETHER are NOT sufficient.

The diagram tells you that there is a line segment AC with point B somewhere between A and C. You're asked to figure out the length of AC.

Statement (1) tells you that B is the midpoint of AC, so $AB = BC$ and $AC = 2AB = 2BC$. Since Statement (1) does not give an actual value for AB or BC, you cannot answer the question using Statement (1) alone.

Statement (2) says that $AB = 5$. Since Statement (2) does not give you any information about BC, the question cannot be answered using Statement (2) alone.

Using both of the statements together, you can find a value for both *AB* and *BC*; therefore you can solve for the length of *AC*, and the answer to the question is choice (**C**).

THE KAPLAN METHOD FOR DATA SUFFICIENCY

This Method is the essential systematic approach to mastering Data Sufficiency. Use this approach for every Data Sufficiency question. It will allow you to answer questions quickly and will guarantee that you avoid the common Data Sufficiency mistake of subconsciously combining the statements instead of considering them separately at first.

STOP: Analyze the Question Stem

There are three things you should aim to accomplish when initially evaluating DS questions:

- **Determine Value or Yes/No.** Which type of Data Sufficiency question is this? Depending on whether the question is a Value question or a Yes/No question, the rules for sufficiency are a little different. If you treat the two types the same way, you probably won't get the right answer. Later in this chapter, you'll learn the critical differences between these two types.
- **Simplify.** If the given information is an equation that can be simplified, you should do so up front. Likewise, any word problems should be translated into math or otherwise paraphrased in your scratchwork. When a question asks for the value of a specific variable and gives you a multi-variable equation, isolate the variable being asked for so you can more clearly see what kind of information you need in order to solve.
- **Identify What Is Needed to Answer the Question.** What kind of information would get you the answer to the question? The more you think up front about what information would be sufficient, the better you'll be able to evaluate the statements.

Don't rush through this step, even for seemingly simple questions. The more you glean from the question stem, the easier it will be to find the right answer.

THINK, PREDICT, and MATCH: Evaluate the Statements Using 12TEN

Since the answer choices depend on considering each statement alone, don't let the information you learn from one statement carry over into your analysis of the other. Consider each statement separately, in conjunction with the question stem. Remember that each statement is always true. Don't waste time verifying the statements; just evaluate whether this information lets you answer the question.

On Test Day, you don't want to spend even a second reading the answer choices or thinking about which answer choice is which. They will never change, so you will save yourself much time and confusion by memorizing what the answer choices mean and working with them until you've fully internalized them.

A helpful way to remember how the answer choices are structured is to use the acronym **12TEN**.

1 Only Statement (**1**) is sufficient.

2 Only Statement (**2**) is sufficient.

T You must put the statements **together** for them to be sufficient.

E **Either** statement alone is sufficient.

N **Neither** separately nor together are the statements sufficient.

In fact, it's so important to memorize the answer choices that after this initial sample question, we will no longer print the choices along with the questions. For each practice question, you should follow the routine you will use on Test Day: write 12TEN in your scratchwork for each question and cross out the incorrect answer choices as you eliminate them. We'll teach you patterns for eliminating answer choices later in this chapter.

Now, let's apply the Kaplan Method for Data Sufficiency to the question you saw at the beginning of this chapter:

Is the product of x, y, and z equal to 1?

(1) $x + y + z = 3$

(2) x, y, and z are each greater than 0.

A. Statement (1) ALONE is sufficient, but statement (2) is not sufficient.

B. Statement (2) ALONE is sufficient, but statement (1) is not sufficient.

C. BOTH statements TOGETHER are sufficient, but NEITHER statement ALONE is sufficient.

D. EACH statement ALONE is sufficient.

E. Statements (1) and (2) TOGETHER are NOT sufficient.

STOP: Analyze the Question Stem

This is a Yes/No question. If $xyz = 1$, then the answer is "yes." If $xyz \neq 1$, then the answer is "no." Either answer—"yes" or "no"—would be sufficient. There's nothing that needs to be simplified in this step; all variables are in their simplest terms, and there are no common variables to combine. It's often worth thinking about how you could get the "yes" or "no" that you're looking for. For instance, if x, y, and z all equal 1, you would get an answer of "yes." But is this the only way? This question is short but definitely not simple, since there may be many other possibilities to consider.

THINK, PREDICT, and MATCH: Evaluate the Statements Using 12TEN

Picking Numbers for Statement (1), you can readily see how to get a "yes": $x = 1$, $y = 1$, and $z = 1$. Can you Pick Numbers in such a way that the sum is 3 but the product is not 1? Not if you only consider positive integers. But if you consider different kinds of numbers, you can easily find some. Zero doesn't alter a sum, but it forces a product to be 0. So $x = 3$, $y = 0$, and $z = 0$, while they follow the restrictions given in Statement (1), will give you an answer of "no" to the original question. Since you can get both a "yes" and a "no," Statement (1) is insufficient. Eliminate **(A)** and **(D)**—or choices "1" and "E," if you've written 12TEN in your scratchwork.

Now that you've reached a verdict on Statement (1) on its own, completely put Statement (1) out of your mind as you evaluate Statement (2) independently. Statement (2) rules out the possibility of using 0 but not the possibility of using fractions or decimals. So $x = 1$, $y = 1$, and $z = 1$ is also permissible here, but so is something like $x = 100$, $y = 100$, and $z = 100$. So xyz could equal 1, but it could also equal 1,000,000. So you can get both a "yes" and a "no" here, as well. Statement (2) is also insufficient, so you can eliminate **(B)**—which is the "2" of 12TEN.

Since each statement is insufficient on its own, you need to consider them together. Can you pick numbers that add to 3 and are all positive? Again, $x = 1$, $y = 1$, and $z = 1$ makes the cut and answers the question with a "yes." Can you think of numbers that *don't* multiply to 1 that also are consistent

with both statements? Once again, you have to expand your thinking to include other types of numbers besides positive integers. Fractions and decimals make things bigger when added but smaller when multiplied. For example, $x = 2.8$, $y = 0.1$, and $z = 0.1$ fit the bill. They are all positive and sum to 3. Their product is $2.8(0.1)(0.1) = 0.028$; this answers the question with a "no." Since you can get both a "yes" and a "no" answer, the statements are insufficient to answer the question even when combined. The answer is **(E)**—which corresponds to the "N" of 12TEN.

Don't worry if Data Sufficiency questions are challenging at first; you're only getting started working with this unique question type. For now, do not concentrate on speed—or even on getting the correct answer in the end—but rather on building your technique for approaching Data Sufficiency questions systematically using the Method. For practice, go and work questions 1-3 at the end of this chapter now.

THE BASIC PRINCIPLES OF DATA SUFFICIENCY

Especially because this question type is more abstract than Problem Solving, it's essential to have a strategic approach to every Data Sufficiency question. Don't waste time or mental energy doing unnecessary calculations. A systematic approach will ensure that you find the most efficient solution to the problem and that you make as few careless and avoidable errors as possible. Here are some ways you can optimize your Data Sufficiency performance by using the Kaplan Method.

Know How to Eliminate Data Sufficiency Answer Choices

As you've already learned, the directions and answer choices for Data Sufficiency questions never change, so it's to your advantage to memorize them. But you can take this approach one step further by learning how to eliminate answer choices as you work through Data Sufficiency problems.

As you evaluate the two statements, use your noteboard to keep track of which answer choices you have ruled out as incorrect. Use the following patterns to guide your elimination:

> If Statement (1) is sufficient, the answer could only be **(A)** or **(D)**. *Eliminate* **(B)**, **(C)**, *and* **(E)**.
>
> If Statement (1) is insufficient, the answer could only be **(B)**, **(C)**, or **(E)**. *Eliminate* **(A)** *and* **(D)**.
>
> If Statement (2) is sufficient, the answer could only be **(B)** or **(D)**. *Eliminate* **(A)**, **(C)**, *and* **(E)**.
>
> If Statement (2) is insufficient, the answer could only be **(A)**, **(C)**, or **(E)**. *Eliminate* **(B)** *and* **(D)**.

Using the mnemonic device 12TEN will help you keep track of these answer choices, allowing you to attack the question more efficiently and avoid considering an answer choice you've already ruled out.

You also want to avoid a common mistake on Data Sufficiency: choosing **(C)** when the answer is actually **(A)**, **(B)**, or **(D)**. Remember: if either statement *by itself* is sufficient, then of course the two statements *together* will also be sufficient, since the statements are always true and never contradict each other. But **(C)** can be correct *only* when each statement alone is insufficient and combining the statements is necessary to obtain sufficiency.

You should consider the statements together only if each is insufficient on its own. When you evaluate the statements together, keep in mind that each statement is true. So if you're Picking Numbers to evaluate the statements combined, you must choose values that are permitted by *both* statements.

Know the Two Types of Data Sufficiency Questions

There are two broad types of Data Sufficiency questions, and they play by slightly different rules. The two types are Value questions and Yes/No questions. During Step 1 of the Kaplan Method for Data Sufficiency, you need to determine which type of question you're dealing with, since this will determine your approach.

Value Questions

A Value question will ask you for the exact value of something. If a statement narrows the possibilities down to exactly one number, then it is sufficient. Otherwise, it is not. Of the Data Sufficiency questions you'll see on Test Day, approximately two-thirds will be Value questions.

Let's take a closer look at how this question type functions using a sample question:

Example:

What is the value of x?

(1) $x^2 - 7x + 6 = 0$
(2) $5x = 30$

STOP: Analyze the Question Stem

This is a Value question, meaning you need to find the value of x to obtain sufficiency. There's nothing that needs to be simplified in this step, since there's just one variable: x. Before you evaluate the statements, remember that sufficiency is obtained when you can identify one, and *only* one, possible value for x.

THINK, PREDICT, and MATCH: Evaluate the Statements Using 12TEN

Statement (1) can be reverse-FOILed to $(x - 1)(x - 6) = 0$, which means that there are two possible values for x, either 1 or 6. But you don't even need to calculate these two values; once you know there is more than one possible value, you know that Statement (1) must be insufficient.

Statement (2) is a linear equation, containing a single variable. Therefore, there can only be one possible result (in this case, $x = 6$), and it is sufficient.

Since Statement (1) is insufficient and Statement (2) is sufficient by itself, the answer is **(B)**.

For additional practice with Value questions, tackle questions 4 and 5 at the end of this chapter.

Yes/No Questions

Yes/No questions are, simply put, questions that call for a "yes" or a "no" answer. A key difference between Value questions and Yes/No questions is that a range of values can establish sufficiency for Yes/No questions. For example, if a question asks "Is $x > 10$?" a statement saying $x < 9$ will be sufficient.

Note that in this example, the answer to the question in the stem is, "No, x is never greater than 10." Don't confuse a "yes" to the question "Is Statement (1) sufficient?" with a "yes" to the question in the stem; they are not the same. This mistake is the most common pitfall test takers face on Yes/No questions. You can avoid this pitfall by remembering that any answer of "ALWAYS yes" or "ALWAYS no" is sufficient; only "sometimes yes, sometimes no" answers are insufficient. The definitiveness of your answer to the stem question is more important in determining sufficiency than whether the answer itself happens to be "yes" or "no."

Sometimes Yes/No questions don't appear to call for a "yes" or "no" answer. Suppose a Data Sufficiency question asks which employee, Jane or Sam, earned more in 2009. Ask yourself, "Do I absolutely need to know the specific values for Jane and Sam?" As it turns out, you don't. You should handle this question the same way as you would a Yes/No question that asked, "Did Jane earn more than Sam last year?" In both cases you have sufficient information when you determine that only one answer is possible—Jane or Sam—even if you don't know a precise value for either Jane's earnings or Sam's earnings. Again, you can determine sufficiency knowing only ranges of values (for example, it's sufficient to know that Jane earned more than $20,000 and that Sam earned less than $16,000).

Let's take a closer look at how this question type functions using a sample question:

Example:

> If x is an integer, and $0 < x < 4$, is x prime?
>
> (1) $x > 1$
> (2) x is even.

STOP: Analyze the Question Stem

This is a Yes/No question, meaning you need to determine whether x is prime or not. According to the question stem, x could be 1, 2, or 3. You know that 2 and 3 are prime but 1 is not. In order to attain a definite "yes" answer, x must be either 2 or 3, and to obtain a definite "no" answer, x must be equal to 1. In other words, you could restate the question as "Does x equal 2 or 3?"

THINK, PREDICT, and MATCH: Evaluate the Statements Using 12TEN

Start with Statement (1). Knowing that x is greater than 1 rules out 1, leaving only 2 and 3 as possible values of x. Since both 2 and 3 are prime, you have an answer: definitely "yes." This statement is sufficient. Notice that you don't know which of those two values x equals, but for a Yes/No question, knowing a precise value is irrelevant; you can still have sufficiency as long as you know the answer is "always yes" or "always no." Eliminate choices **(B)**, **(C)**, and **(E)**.

Now set aside Statement (1) and move on to Statement (2). Of the possible values of x—1, 2, and 3—only one of them is even. You've determined that x must be 2. Because 2 is prime, the statement gives you a definite "yes." Statement (2) is also sufficient, so the answer is **(D)**.

For additional practice with Yes/No questions, tackle questions 6 and 7 at the end of this chapter.

The Statements Are Always True

The statements are new pieces of data that apply to the problem and are always true. Don't waste time trying to verify a statement.

The fact that the statements are always true has an important corollary that will help you catch careless errors: the statements will never contradict each other. Although they won't always be sufficient to answer the question, they'll never be mutually exclusive. If it appears that two statements are in disagreement with each other, you should recheck your work, because you have made an error.

Example:

What is the value of t?

(1) $t^2 = t$
(2) $t + 6 = 6$

This is a straightforward Value question for which you need a value of t. Let's say that you made an error in your analysis of Statement (1) and thought that t had to equal 1. You'd think that Statement (1) was sufficient.

Then you'd look at Statement (2). Simplifying, you'd learn that t equals 0. That's also sufficient. So you'd think that the answer would be **(D)**. However, according to your analysis, the statements contradict each other:

(1) $t = 1$
(2) $t = 0$

That isn't possible. So you'd know to go back and recheck your work. Statement (2) pretty obviously says that $t = 0$, so you would recheck your work on Statement (1). Is 1 the only number that equals itself when squared? Substitute the 0 from Statement (2) and you get $0^2 = 0 \times 0 = 0$. So Statement (1) actually permits *two* values and is therefore insufficient.

(1) $t = 0$ or 1
(2) $t = 0$

The correct answer is **(B)**, not **(D)**.

It's All About the Question Stem

On Data Sufficiency questions, if you rush past the question and dive into the statements, you risk doing a whole bunch of unnecessary—and possibly misleading—math. It's essential that you understand the question stem before you analyze the statements. For one thing, there's a huge difference between a Value question and a Yes/No question. Consider this identical pair of statements:

(1) $x^3 = x$ (1) $x^3 = x$
(2) $x^2 = x$ (2) $x^2 = x$

Here's how they evaluate:

(1) $x = -1, 0,$ or 1 (1) $x = -1, 0,$ or 1
(2) $x = 0$ or 1 (2) $x = 0$ or 1

But you still have no idea what the answers are without seeing the question stems:

What is the value of x? Is $x < -1$?

(1) $x = -1, 0,$ or 1 (1) $x = -1, 0,$ or 1
(2) $x = 0$ or 1 (2) $x = 0$ or 1

For the question on the left, a Value question, Statement (1) is insufficient because there are three possible values of x. Statement (2) is also insufficient because it permits two possible values. Even when the statements are considered together, x could be either 0 or 1. That's two values, which is insufficient for a Value question. The answer is **(E)**.

But the question on the right is a Yes/No question, so you will need to evaluate it differently. This question asks whether x is less than -1. First, look at Statement (1). Is $-1 < -1$? No. Is $0 < -1$? No. Is $1 < -1$? No. Always "no": this statement is sufficient. The same for Statement (2): Both values answer the question with a "no," so it's sufficient, as well. The answer is **(D)**.

That's as different as two Data Sufficiency answers can be, and it had *nothing* to do with the statements, which were identical. It's all about the question stem.

But during Step 1 of the Kaplan Method, you want to look for more than just whether the question is a Value or a Yes/No question. You saw how Problem Solving questions get much easier with some analysis and simplification before an approach is chosen. So too with Data Sufficiency.

Example:

If $w \neq x, w \neq z,$ and $x \neq y$, is $\dfrac{(x-y)^3(w-z)^3}{(w-z)^2(x-y)(w-x)^2} > 0$?

(1) $x > y$
(2) $w > z$

This is a Yes/No question that asks about a fraction containing multiple variable expressions as factors. At first glance, this may look like a scary question stem. But take a closer look at that fraction. There are a lot of shared terms in the numerator and the denominator. Using the laws of exponents, you can cancel the $(w-z)^2$ and the $(x-y)$ in the denominator:

If $w \neq x, w \neq z,$ and $x \neq y$, is $\dfrac{(x-y)^{\cancel{3}^2}(w-z)^{\cancel{3}^1}}{\cancel{(w-z)^2}\,\cancel{(x-y)}(w-x)^2} > 0$?

That simplifies the question to this:

If $w \neq x, w \neq z,$ and $x \neq y$, is $\dfrac{(x-y)^2(w-z)}{(w-x)^2} > 0$?

This is looking better already. You can simplify even further by thinking logically about the question. You aren't asked for the value of anything, just whether this complicated fraction is positive. Without

knowing anything about the values of w, x, y, and z, what can you already know about the answer to this question stem? Well, for one thing, you know that a squared term cannot be negative. So there's no way that $(x - y)^2$ or $(w - x)^2$ is negative. In fact, since $w \neq x$ and $x \neq y$, they can't be zero, either. So those two terms are both positive, which is the only thing that matters to the question. You can simplify the question even further, to this:

$$\text{Is } \frac{(\text{Positive})(w-z)}{(\text{Positive})} > 0 ?$$

Since multiplying and/or dividing $(w - z)$ by anything positive will not change its sign, you have this:

Is $w - z > 0$?

Now *that's* a much simpler question. Look at how much easier the statements have become to evaluate:

(1) $x > y$
(2) $w > z$

Statement (1) is totally irrelevant to whether $w - z > 0$. This statement is insufficient.

Statement (2) tells you that w is bigger than z, so $w - z$ must be positive. (Subtract z from both sides of the inequality, and you get $w - z > 0$.) That's a definite "yes." This is sufficient, so the answer is **(B)**.

The more analysis and simplification you do with the question stem, the easier dealing with the statements will become.

Think About Sufficiency, Not Calculation

Get into the habit of thinking about what's needed for *sufficiency*, rather than doing arithmetic calculations. One of the ways that the test can make a Data Sufficiency question harder is to make the numbers scarier. But if you aren't worrying about arithmetic, you won't be fazed by this. Let's take a look at two important math concepts that can help you avoid number crunching in Data Sufficiency.

The "N-Variables, N-Equations" Rule

Perhaps one of the most powerful tools to evaluate sufficiency is the *n*-variables, *n*-equations rule. If you have at least as many distinct, linear equations as you have variables, you will be able to solve for the unique numerical values of all the variables. If there are two variables, you need at least two equations to solve for all the values. If you have three variables, you need at least three equations. If you have four variables, you need at least four equations, and so on.

Note that when you apply the *n*-variables, *n*-equations rule, you must be alert to the exact definition of the word "distinct": each equation must provide new, different information. For instance, even though the equations $x + 3y = 5$ and $2x + 6y = 10$ look different, they are not in fact distinct—the second equation is merely the first equation multiplied by 2. Another example is the following system of equations: $x + 2y - 3z = 8$; $2y + 6z = 2$; and $x + 4y + 3z = 10$. These may also initially seem to be distinct, but a closer look reveals that the third equation is merely the sum of the first two. It therefore adds no new information, so this system of equations cannot be solved for unique numerical values for each variable.

Example:

A souvenir shop made $2,400 in revenue selling postcards. If a large postcard costs twice as much as a small postcard, the shop sold 950 large postcards, and it sold no other type of postcard besides these two sizes, then how many small postcards did it sell?

(1) A large postcard costs $2.

(2) If the shop had sold 20% fewer small postcards, its revenue would have been reduced by $4\frac{1}{6}$ %.

There are four factors that affect the outcome of this problem: (1) the price of a small postcard, (2) the price of a large postcard, (3) the number of small postcards sold, and (4) the number of large postcards sold. That's four variables, so four distinct, linear equations would enable you to solve for any of the variables. How many equations do you have already? Well, something-or-other equals $2,400 (that's one), there's a relationship between the prices (that's two), and you get the number of large postcards (that's three). With three equations for four variables, *any new equation* will be sufficient, as long as it is distinct and it doesn't introduce a new variable.

Statement (1) is a new equation and is therefore sufficient. Statement (2) is a more complicated equation, and it would likely be time-consuming to calculate. But it is still a new, distinct equation, and it is therefore sufficient. The answer is **(D)**.

Imagine how much time it would take to work through these equations. Using the *n*-variables, *n*-equations rule, it need take no longer than a minute.

One word of caution, though: having the same number of distinct, linear equations guarantees sufficiency, but having fewer does *not* guarantee insufficiency. The test will set up equations so that you can sometimes solve for what's asked even though you can't solve for every variable individually.

Example:

A fruit stand sells apples, pears, and oranges. If oranges cost $0.50 each, then what is the cost of 5 oranges, 4 apples, and 3 pears?

(1) The cost of 1 apple is $0.30.

(2) The cost of 8 apples and 6 pears is $3.90.

There are three variables in this problem (the cost of an orange, the cost of an apple, and the cost of a pear), so three distinct equations could solve for everything. You're given only one (the exact price of an orange). So two additional distinct equations will guarantee sufficiency. But you should keep your eyes open for a way to answer your question with fewer. Since you already know the price of an orange, the only thing you'd need to answer your question is the price of 4 apples and 3 pears.

Statement (1) is insufficient, as you still do not know anything about the price of a pear. Statement (2) is only one equation, but if you divided it by 2, you'd get the cost of 4 apples and 3 pears, which is exactly what you need. This statement is sufficient, so the correct answer is **(B)**.

Proportions

Another common way that the test allows you to get sufficiency without knowing all the individual values is to ask questions based on proportions (ratios, percents, averages, rates/speed, etc.). The goal of the following exercise is to get you to think about what kind of information can be sufficient to answer a question, even though you can't calculate the exact value of every variable involved. Read the question stem and each of the following statements, asking yourself whether it gives you enough information to answer. Don't waste time trying to come up with the actual value.

What was the percent increase in profits for Company X between 1991 and 1993?

Do the following statements provide sufficient information?

(1) The company earned 20 percent less profit in 1991 than in 1993.
(2) The average annual profit from 1991 to 1993 was 12.5% higher than the profit in 1991.
(3) The average of the annual profits of 1991 and 1993 was 12.5% higher than the profit in 1991.
(4) In 1991, the profit was $4.5 million less than in 1993.

Let's evaluate each statement on its own:

Statement (1) is sufficient. You could "reverse" the math and figure out percent increase from the given decrease. Let the 1993 profit equal P_{1993} and the 1991 profit equal P_{1991}. The statement can be translated to $P_{1991} = 0.8 (P_{1993})$, which is $P_{1991} = \frac{4}{5} (P_{1993})$. That means $P_{1993} = \frac{5}{4} P_{1991} = 1.25 (P_{1991})$. That's 125% of 1991, or a 25% increase.

Statement (2) is insufficient because you don't know anything about the profit in 1992, and this information would be necessary to set up the calculation.

Statement (3) is sufficient because you are given a proportional relationship between the two years' profits: $\left(\frac{P_{1991} + P_{1993}}{2} = 1.125(P_{1991}) \right)$. The question asks you for a proportional relationship, so this is exactly what you need.

Statement (4) is insufficient because you aren't given the total; you don't know what percentage a $4.5 million difference represents.

TAKEAWAYS: THE BASIC PRINCIPLES OF DATA SUFFICIENCY

The basic principles of Data Sufficiency are the following:

- Know the Data Sufficiency answer choices cold.
- Know the two types of Data Sufficiency questions.
- The statements are always true.
- It's all about the question stem.
- Think about sufficiency, not calculation.

DATA SUFFICIENCY STRATEGY

Now that you're familiar with how Data Sufficiency questions are constructed, let's look at two important strategic approaches to these questions. The first you're already familiar with from the Problem Solving chapter: we'll start by looking at how to effectively utilize the Picking Numbers strategy. After that, we'll discuss in greater detail how to most effectively combine statements.

Picking Numbers in Data Sufficiency

You've already seen the power of the Kaplan strategy of Picking Numbers for Problem Solving questions. You can also use this strategy for many Data Sufficiency questions that contain variables, unknown quantities, or percents of an unknown whole. When using this strategy, you always pick at least two different sets of numbers, trying to prove that the statements are *insufficient* by producing two different results. It's usually easier to prove insufficiency than sufficiency. As you practice, you will become adept at recognizing the types of numbers that can produce different results: positives vs. negatives, fractions vs. integers, odds vs. evens, and so on. Also, don't hesitate to use the numbers 0 and 1, as they have unique properties that make them great candidates for the Picking Numbers strategy in Data Sufficiency questions.

Applying the Kaplan Method: Picking Numbers in Data Sufficiency

Now let's use the Kaplan Method on a Data Sufficiency question that involves Picking Numbers:

If $a + b = 20$, then what is the value of $c - d$?

 (1) $ac - bd + bc - ad = 60$
 (2) $d = 4$

STOP: Analyze the Question Stem

Here's a Value question, so you need one, and *only* one, value for the expression $c - d$. There's nothing much to simplify here, but keep in mind that you are given a value for another expression, $a + b$. To obtain sufficiency, you'll need values for both c and d or a way to relate the equation $a + b = 20$ to the expression $c - d$.

THINK, PREDICT, and MATCH: Evaluate the Statements Using 12TEN

As always, think strategically. Since the statements are not presented in any particular order, it's sometimes wise to start by evaluating Statement (2) if it looks easier to evaluate than Statement (1). Here, Statement (2) gives you a value for d but not for c. There's also no way to relate the equation $a + b = 20$ to the expression $c - d$. Eliminate **(B)** and **(D)**. Notice that you've eliminated 50 percent of the wrong answer choices very quickly.

Now let's tackle Statement (1), remembering to use the information it provides in conjunction with the question stem. You're given $a + b = 20$, so let's use Picking Numbers here. Pick $a = 10$ and $b = 10$.

Now, Statement (1) reads: $10c - 10d + 10c - 10d = 60$

Combine the like terms: $20c - 20d = 60$

Factor out the 20:	$20(c - d) = 60$
Divide out the 20:	$c - d = 3$

So, the expression $c - d$ can equal 3. But you're not finished yet. You have to pick a different set of numbers to see whether you can produce a different answer.

What permissible numbers might be likely to produce a different answer? Since Statement (1) involves subtraction, try negative numbers. Try $a = 25$ and $b = -5$.

Now Statement (1) reads:	$25c - (-5)d + (-5)c - 25d = 60$
Move the common terms next to each other:	$25c + (-5)c - (-5)d - 25d = 60$
Simplify the positive and negative signs:	$25c - 5c + 5d - 25d = 60$
Combine like terms:	$20c - 20d = 60$
Factor out the 20:	$20(c - d) = 60$
Divide out the 20:	$c - d = 3$

After picking two sets of numbers that have different properties and receiving the same result, you can say with reasonable confidence that Statement (1) is sufficient. Eliminate **(C)** and **(E)**. The correct answer is **(A)**.

> **TAKEAWAYS: PICKING NUMBERS IN DATA SUFFICIENCY**
> - To evaluate a statement (or the statements combined), you must pick at least two sets of numbers.
> - When picking the second set of numbers, try to produce a different answer than that given by the first set.

Combining Statements

If—and *only* if—each statement on its own is insufficient, you must then consider the statements together. The best way to do this is to think of the statements as one long sentence. At this stage, you can essentially approach the question as you would a Problem Solving question, using all the information you're given to answer the question. The main difference is that, since this is still Data Sufficiency, you will stop solving as soon as you know that you *can* solve. The time saved by avoiding unnecessary calculations is better spent on questions later in the section.

As you've learned earlier in this chapter, information is always consistent between the statements. The statements never contradict each other. For example, you'll never see a question in which Statement (1) says that x must be negative and Statement (2) says that x is positive. You might, however, learn from Statement (1) that x is greater than -5 and learn from Statement (2) that it's positive. Learning to recognize how one statement does or does not limit the information in the other is the key in deciding between choices **(C)** and **(E)**.

Combining statements exercise

The following exercise contains a single question stem—"What is the value of x?"— and many sets of sample statements, which have already been simplified and evaluated for you. Imagine that you had analyzed the statements and gotten the possible values for x listed below: Which statements, either separately or combined, are sufficient to answer the question? Choose the appropriate Data Sufficiency answer choice—(A), (B), (C), (D), or (E)—for each pair of statements.

What is the value of x?

1. (1) $x = -1, 0, 1$ 4. (1) $x = -1, 1$ 7. (1) $x = -1, 1$

 (2) $x = 0, 1$ (2) $x = 1, 2$ (2) $x = -1$

2. (1) $x < 3$ 5. (1) $x < 4$ 8. (1) $x \geq 2$

 (2) $x > 1$ (2) $x < 2$ (2) $x \leq 2$

3. (1) $x = -1, 0$ 6. (1) $x = -1, 0$ 9. (1) x is even.

 (2) $x < 0$ (2) $x = -1, 0$ (2) x is prime.

Combining statements exercise: answers

1. (E); x could be 0 or 1.

2. (E); x could be any number between (but not including) 1 and 3. Don't assume that variables are integers.

3. (C); $x = -1$.

4. (C); $x = 1$.

5. (E); x could be any number smaller than 2.

6. (E); x could be 0 or -1. Statements that give redundant information are never sufficient when combined.

7. (B); Statement (2) is sufficient. Note that you would never combine statements in this case.

8. (C); $x = 2$.

9. (C); $x = 2$.

Applying the Kaplan Method: Combining Statements

Now let's use the Kaplan Method on a Data Sufficiency question that involves Picking Numbers:

> If x and y are positive integers, is $\frac{2x}{y}$ an integer?
>
> (1) Some factors of y are also factors of x.
>
> (2) All distinct prime factors of y are also prime factors of x.

STOP: Analyze the Question Stem

First, this is a Yes/No question. Any statement that gives you a "sometimes yes; sometimes no" answer is insufficient. Now, how can you paraphrase the question in the stem? You can say either, "Is $2x$ a multiple of y?" or "Does $2x$ divide evenly by y?"

THINK, PREDICT, and MATCH: Evaluate the Statements Using 12TEN

Use the Kaplan strategy of Picking Numbers. Pick permissible, manageable numbers. If you pick $x = 5$ and $y = 5$, that will give you a "yes" to the original question, since $2x$, or 10, divided by y, or 5, will yield an integer. But if you pick a different set of numbers, say $x = 2$ and $y = 42$, that will yield a fraction. Statement (1) is insufficient; eliminate **(A)** and **(D)**.

Pick numbers for Statement (2), making sure they're permissible. For example, 36 and 6 have the same distinct prime factors: 2 and 3. Picking the numbers $x = 36$ and $y = 6$ gives you an integer; choosing $x = 6$ and $y = 36$, on the other hand, gives you a fraction. Therefore, Statement (2) is insufficient; eliminate **(B)**.

Now, combining the statements, you will notice something interesting. Statement (2) is more restrictive than Statement (1). So as you combine the statements, ask yourself, "Will any numbers that satisfy Statement (2) also satisfy Statement (1)?" Yes, they will. For instance, $x = 36$ and $y = 6$, which you picked for Statement (2), also works for Statement (1): these numbers will again yield a "yes" answer. And $x = 6$ and $y = 36$ also works for Statement (1), yielding a "no" answer. Since combining the statements didn't add any new information and the information presented was insufficient, the answer must be **(E)**. Even combined, you get a "sometimes yes, sometimes no" answer to the question in the stem.

TAKEAWAYS: COMBINING STATEMENTS

- Each data statement is true. Therefore, when combining statements, look for values that are permitted by both statements.
- Treat combined statements as one long statement.
- Never combine statements unless each statement is insufficient on its own.

Strategic Guessing

When you run into a very complicated question, like the following, don't forget to use a sound Data Sufficiency guessing strategy. That means perhaps skipping a statement that looks too daunting and trying to eliminate some answer choices by looking at the easier statement. Try your hand at the difficult question below. Don't try to solve it; instead, see if you can narrow down the possibilities quickly.

Example:

What was the maximum temperature in City A on Saturday, May 14?

(1) The average (arithmetic mean) of the maximum daily temperatures in City A from Sunday, May 8, to Saturday, May 14, was 72 degrees, which was 2 degrees less than the average (arithmetic mean) of the maximum daily temperatures in City A from Monday, May 9, to Friday, May 13.

(2) The maximum temperature in City A on Saturday, May 14, was 5 degrees greater than the maximum temperature in City A on Sunday, May 8.

STOP: Analyze the Question Stem

This is a Value question. To obtain sufficiency, you need an exact maximum temperature.

THINK, PREDICT, and MATCH: Evaluate the Statements Using 12TEN

Statement (1) is long and complicated. Skip it and go straight to Statement (2); it's much easier.

Statement (2) tells you that the value you're looking for is 5 degrees more than the temperature on some other day. Without knowing the temperature on that other day, you don't have the information you need. This statement is insufficient. You can eliminate **(B)** and **(D)** and give yourself a one-in-three chance to get the right answer without even evaluating Statement (1).

Perhaps you feel comfortable evaluating Statement (1). Perhaps you don't. But let's pretend for a moment that you aren't sure how to evaluate Statement (1). Keep in mind that complicated or hard-to-evaluate statements are more likely to be sufficient than insufficient. For this reason, you should avoid **(E)** and lean toward **(A)**, unless you have a logical reason to suspect that Statement (1) alone is insufficient. Of course, this doesn't guarantee you a correct answer, but if you're falling behind on time, it will help you move through the these questions most efficiently. Remember, no one particular question will make or break your score, but spending too much time on one question and having to rush through several others just to make up for the lost time will hurt your score. As it turns out, **(C)** is the right answer to this particular problem.

Fortunately, you're unlikely to run into anything as complicated as Statement (1) on Test Day. The point of this exercise is to show you that even if you do encounter something this difficult, you're still in control. If you work the odds and look for the strategic approach, you will increase your likelihood of picking up the points even for questions you're not sure how to solve.

For the record, let's analyze Statement (1). If the average maximum temperature from May 8 to May 14 was 72 degrees, then the sum of the maximum temperatures of those days is $7 \times 72 = 504$ degrees. If the average maximum temperature from May 9 to May 13 was $72 + 2$, or 74 degrees, then the sum of the maximum temperatures of those days was $5 \times 74 = 370$ degrees.

The difference between those two sums is simply the sum of the maximum temperature on May 8, which you can call x, and the maximum temperature on May 14, which you can call y (since these two days were left out of the second time period). So $x + y = 504 - 370 = 134$. Statement (1) by itself is insufficient. But Statement (2) tells you that $y - x = 5$. You have the two distinct linear equations, $x + y = 134$ and $y - x = 5$. These equations can be solved for a single value for y, so the statements taken together are sufficient: choice (**C**).

This example demonstrates how guessing can be a good alternative approach for certain questions. By looking at only one statement, you can narrow down the possibilities to two or three choices. This can be a great help, particularly on difficult or time-consuming problems for which you think you might have to guess. But you must be sure you know the rules for eliminating answer choices absolutely cold by Test Day.

REVIEW PROBLEMS

1. If $x > 0$, what is the value of x?

 (1) $x > 5$

 (2) $40 - x^2 = 4$

2. If $a > 0$, $b > 0$, and $2c = \sqrt{\dfrac{a}{b}}$, what is the value of b?

 (1) $a = 8$ and $c = 2$

 (2) $\dfrac{c^2}{a} = \dfrac{1}{2}$

3. A certain company produces exactly three products: X, Y, and Z. In 1990, what was the total income for the company from the sale of its products?

 (1) In 1990, the company sold 8,000 units of product X, 10,000 units of product Y, and 16,000 units of product Z.

 (2) In 1990, the company charged $28 per unit for product X and twice as much for product Z.

4. What is the value of $\dfrac{st}{u}$?

 (1) $s = \dfrac{3t}{4}$ and $u = 2t$.

 (2) $s = u - 10$ and $u = s + t + 2$.

5. What is the value of the integer p?

 (1) p is a prime number.

 (2) $88 \le p \le 95$

6. Is $4 + \dfrac{n}{6}$ an integer?

 (1) n is a multiple of 3.

 (2) n divided by 6 has a remainder of 0.

7. If $y > 0$, is x less than 0?

 (1) $xy = 16$

 (2) $x - y = 6$

8. If x is an integer with n distinct prime factors, is n greater than or equal to 3?

 (1) x is divisible by 6.

 (2) x is divisible by 10.

9. If $x^3 < x$, is $x > x^2$?

 (1) $x > -5$

 (2) $x < -2$

10. What is the value of x?

 (1) $x^2 - 9 = 16$

 (2) $3x(x - 5) = 0$

11. If a coffee shop sold 600 cups of coffee, some of which were large cups and the remainder of which were small cups, what was the revenue that the coffee shop earned from the sale of coffee?

 (1) The number of large cups sold was $\frac{3}{5}$ the total number of small cups sold.

 (2) The price of a small cup of coffee was $1.50.

SOLUTIONS TO REVIEW PROBLEMS

1. **B** If $x > 0$, what is the value of x?

 (1) $x > 5$
 (2) $40 - x^2 = 4$

 STOP: Analyze the Question Stem

 In this Value question, sufficiency means finding one and only one value for x. We are told that x must be greater than 0.

 THINK, PREDICT, and MATCH: Evaluate the Statements Using 12TEN

 Statement (1) tells us that $x > 5$. While that certainly narrows down the options for x, there is no way to figure out one and only one value for x from that information alone, so this statement is insufficient. Eliminate **(A)** and **(D)**.

 Statement (2) provides an equation that allows us to determine the value of x^2. Every positive number has two square roots, one positive and one negative, so this statement narrows the options down to two values for x. This would normally not be sufficient. However, the question stem states that $x > 0$, which eliminates the negative square root, leaving one and only one value for x. Statement (2) alone is sufficient, so **(B)** is correct.

2. **D** If $a > 0$, $b > 0$, and $2c = \sqrt{\dfrac{a}{b}}$, what is the value of b?

 (1) $a = 8$ and $c = 2$

 (2) $\dfrac{c^2}{a} = \dfrac{1}{2}$

 STOP: Analyze the Question Stem

 In this Value question, sufficiency means finding one and only one value for b. We are told that a and b are both positive and are given an equation. Let's simplify the equation before proceeding to the statements.

 $$(2c)^2 = \left(\sqrt{\dfrac{a}{b}}\right)^2$$
 $$4c^2 = \dfrac{a}{b}$$
 $$4c^2 b = a$$
 $$b = \dfrac{a}{4c^2}$$

 Solving for b means having either the values for both a and c or the value of $\dfrac{a}{4c^2}$.

THINK, PREDICT, and MATCH: Evaluate the Statements Using 12TEN

Statement (1) provides the values of a and c. By plugging these provided values into the expression $\frac{a}{4c^2}$, we can solve for b, so Statement (1) is sufficient. Eliminate (B), (C), and (E).

Statement (2) may not look sufficient at first glance, but we can actually change the left side of the equation to $\frac{a}{4c^2}$:

$$\frac{c^2}{a} = \frac{1}{2}$$
$$a = 2c^2$$
$$\frac{a}{c^2} = 2$$
$$\frac{a}{4c^2} = \frac{2}{4}$$
$$\frac{a}{4c^2} = \frac{1}{2}$$

Since $\frac{a}{4c^2}$ is also the value of b, this statement is sufficient. Eliminate (A).

Each statement alone is sufficient to answer the question, so (D) is the correct answer.

3. **E** A certain company produces exactly three products: X, Y, and Z. In 1990, what was the total income for the company from the sale of its products?

(1) In 1990, the company sold 8,000 units of product X, 10,000 units of product Y, and 16,000 units of product Z.

(2) In 1990, the company charged $28 per unit for product X and twice as much for product Z.

STOP: Analyze the Question Stem

In this Value question, we are told that a company makes three products and are asked to find the total income from the sale of these products. For sufficiency, we need to be able to determine the quantities and prices of all three products.

THINK, PREDICT, and MATCH: Evaluate the Statements Using 12TEN

Statement (1) gives us quantity information, by product, for each of the three products. Because it has no pricing information, the statement is insufficient. Eliminate (A) and (D).

Statement (2) gives us pricing information for one product and information to calculate the price of a second product. However, it has no quantity information and nothing about the pricing of the third product. The statement is therefore insufficient, and you can eliminate (B).

Because each of the statements is insufficient, we now combine the statements. When combined, we have quantity information for all three products but only have pricing information for two of them. Therefore, the two statements combined are insufficient to answer the question. Answer choice (E) is correct.

4. **C** What is the value of $\frac{st}{u}$?

(1) $s = \frac{3t}{4}$ and $u = 2t$.

(2) $s = u - 10$ and $u = s + t + 2$.

STOP: Analyze the Question Stem

This is a Value question. The stem for this item includes three variables. Specific values for each of the variables would be sufficient to get one value for the entire expression.

THINK, PREDICT, and MATCH: Evaluate the Statements Using 12TEN

Statement (1) gives us restatements of two of the variables—s and u—in terms of the third variable, t. If we take the expression in the stem and replace s and u with the expressions given in the statement, we can see that the variable t is not eliminated:

$$\frac{st}{u} = \frac{\left(\frac{3t}{4}\right)t}{2t} = \frac{\frac{3t^2}{4}}{2t} = \frac{3t^2}{4} \times \frac{1}{2t} = \frac{3t^2}{8t} = \frac{3}{8}t$$

Therefore, Statement (1) is insufficient, and we can eliminate **(A)** and **(D)**.

At first glance, Statement (2) appears to invite a similar conclusion to the one for Statement (1). However, further analysis of the information is worth a try. We are told that $s = u - 10$ and also that $u = s + t + 2$. Substituting $u - 10$ for s in the second equation, we find that

$$u = u - 10 + t + 2$$

$$8 = t$$

Substituting the value of 8 for t and substituting $u - 10$ for s,

$$\frac{st}{u} = \frac{(u-10)(8)}{u} = \frac{8u - 80}{u}$$

Unfortunately, this still doesn't eliminate the variable u, so Statement (2) is insufficient and we can further eliminate **(B)**.

Combining the statements, we determined from Statement (1) that the expression $\frac{st}{u} = \frac{3}{8}t$. If we substitute the value of 8 for the variable t—from Statement (2)—we see that we can get one value even without actually solving the math.

Therefore, the correct answer is **(C)**: Neither statement alone is sufficient, but the statements combined are sufficient.

5. **C** What is the value of the integer p?

(1) p is a prime number.

(2) $88 \leq p \leq 95$

STOP: Analyze the Question Stem

This is a Value question, so we'll need one exact value for p. There's nothing to simplify in the question stem, but it's worth noting that p is an integer—we won't need to consider decimal values. So what we need is very clear—one specific numeric value for p.

THINK, PREDICT, and MATCH: Evaluate the Statements Using 12TEN

Statement (1) doesn't give us one exact value, as there are many prime numbers. Eliminate **(A)** and **(D)**.

Likewise, Statement (2) doesn't give us one exact value, only a range with eight possibilities. Eliminate **(B)**.

To choose between **(C)** and **(E)**, we must consider these statements in combination. Treating (1) and (2) as one long statement, we know that p is between 88 and 95, inclusive, and that it's prime. If you happen to have all the primes through 100 memorized, then you know right away that p can only equal 89 and that the answer is **(C)**.

But what if you don't have all those primes memorized? When evaluating a reasonably short list of numbers, it's often beneficial to write out the possibilities on your noteboard. Then, instead of the abstract "$88 \leq p \leq 95$," we have $p = 88, 89, 90, 91, 92, 93, 94,$ or 95. A prime number is a number that is divisible only by 1 and itself. So any of these that are divisible by any other number can be crossed off the list. If we can cross off seven of these eight numbers, we'll know p.

Any even number is divisible by 2, so that eliminates 88, 90, 92, and 94. Any number that ends in a 0 or a 5 is divisible by 5, so that eliminates 95 (and 90, if it weren't already gone). We know that 93 is divisible by 3. (The divisibility test for 3 is to check whether the digits of a number sum to a multiple of 3; if so, that number is itself divisible by 3. The digits of 93 are 9 and 3. Since $9 + 3 = 12$ and 12 is a multiple of 3, 93 is a multiple of 3.)

Now we've narrowed the possibilities down to $p = 89$ or 91. We've checked for divisibility by the primes 2, 3, and 5. What about the next prime, 7? There is a little-known way to test divisibility by 7. But the test often rewards test takers who think about numbers in creative ways, so even if you don't know the divisibility rule, you can still try to break 91 into multiples of 7 that you know. Because 91 is also $70 + 21$, it's $7(10) + 7(3)$, or $7(10 + 3)$, or $7(13)$. So, it's definitely a multiple of 7 and can be eliminated. We have now determined that p must equal 89. The statements together are sufficient, so the answer is **(C)**.

(Incidentally, that little-known divisibility test for 7 is this: separate the units digit from the rest of the number, then multiply that units digit by 2. Subtract that from what's left of the original number. If the result is a multiple of 7, the original number is a multiple of 7. Here's how that works for 91. Separate 91 into the digits 9 and 1. Multiply 1 by 2: $1 \times 2 = 2$.

Subtract: $9 - 2 = 7$. 7 is obviously a multiple of 7, so 91 is a multiple of 7. Try it out on other multiples of 7, and you'll see that it works every time.)

6. **B** Is $4 + \frac{n}{6}$ an integer?

(1) n is a multiple of 3.

(2) n divided by 6 has a remainder of 0.

STOP: Analyze the Question Stem

This Yes/No question asks whether $4 + \frac{n}{6}$ is an integer. Sufficiency means showing that the value of the expression is definitely an integer or definitely not an integer. As 4 is an integer and will therefore have no effect on whether the entire expression is equal to an integer, we simply need to consider whether $\frac{n}{6}$ is definitely an integer.

THINK, PREDICT, and MATCH: Evaluate the Statements Using 12TEN

Statement (1) narrows the value of n to multiples of 3. Picking Numbers can illustrate for us: if $n = 6$, $\frac{n}{6}$ is an integer, but if $n = 9$, $\frac{n}{6}$ is not an integer. There is no definite "yes" or "no" outcome for the given expression, so this statement is insufficient. Eliminate **(A)** and **(D)**.

Statement (2) restricts n to values that leave a remainder of 0 when divided by 6. These are, by definition, multiples of 6, and any multiple of 6 for n will always make $\frac{n}{6}$ an integer. This statement provides a definite "yes" answer, so it is sufficient. Eliminate **(C)** and **(E)**.

Statement (2) alone is sufficient, so the correct answer is **(B)**.

7. **D** If $y > 0$, is x less than 0?

(1) $xy = 16$

(2) $x - y = 6$

STOP: Analyze the Question Stem

This is a Yes/No question. What can we learn from the stem? It tells us that y is positive and asks us whether x is negative. What would constitute sufficiency? Learning that x is definitely negative or that x is definitely not negative. (Keep in mind that the number 0 is neither positive nor negative.)

THINK, PREDICT, and MATCH: Evaluate the Statements Using 12TEN

Statement (1) tells us that $xy = 16$. To get a positive outcome when multiplying two variables, we need to have either two positive numbers or two negative numbers. Because the question stem tells us that y is positive, that means that x also has to be positive. Therefore, this statement is sufficient to answer the question with a "no" (x cannot be negative in this case), and we can eliminate **(B)**, **(C)**, and **(E)**.

Statement (2) tells us that $x - y = 6$. Adding y to both sides of this equation shows that x is 6 greater than y. Since we already know that y is positive, Statement (2) is sufficient to answer the question with a "no," and we can eliminate **(A)**.

The correct answer is **(D)**: Either statement alone is sufficient to answer the question.

8. **C** If x is an integer with n distinct prime factors, is n greater than or equal to 3?

 (1) x is divisible by 6.
 (2) x is divisible by 10.

STOP: Analyze the Question Stem

This is a Yes/No question, so we don't need to know the exact value of n, just whether $n \geq 3$.

There's nothing to simplify, but it's important to note the relationship between the variables: n is the number of distinct prime factors of x. (Every non-prime number can be rewritten as a series of prime numbers multiplied together; those are the number's prime factors.)

To answer the question, we'll need to know whether or not x has at least three distinct prime factors.

THINK, PREDICT, and MATCH: Evaluate the Statements Using 12TEN

Let's say that you weren't sure how to evaluate the statements abstractly. Picking Numbers allows you to evaluate a Data Sufficiency statement when you aren't comfortable with a more rules-based approach.

Statement (1): Let's pick the simplest number that's divisible by 6, namely $x = 6$ itself. We get $6 = 2 \times 3$. Since there are two prime factors, $n = 2$. Now test that number in the question: "Is $2 \geq 3$?" No, it isn't.

But our work on Statement (1) isn't done. We only know that Statement (1) *can* yield the answer "no." We have no idea yet whether the answer is "definitely no," because other permissible numbers might yield different results. Always test at least two sets of numbers when Picking Numbers in Data Sufficiency so that you can differentiate between the *definite* answers and the *maybe* answers.

Since we already got a "no" answer, our task is to see whether we can get a "yes," thus proving that Statement (1) does not provide one definite answer. Could we think of a value for x that has three or more prime factors? Since 2 and 3 showed up as prime factors already, we can think of a value for x that has a different prime factor: 5, perhaps. So let's pick x to be a multiple of 5 that is also divisible by 6 (otherwise it won't be permissible). $x = 30$ fits the bill: $30 = 2 \times 3 \times 5$. That's three prime factors, so $n = 3$. Put that into the question: "Is $3 \geq 3$?" Yes, it is.

Because we've found both a "yes" and a "no" answer, Statement (1) answers the question "maybe yes, maybe no." That's not a definite answer, so Statement (1) is insufficient. Eliminate **(A)** and **(D)**.

Statement (2): Now let's pick the simplest number that's divisible by 10, namely $x = 10$ itself. We get $10 = 2 \times 5$. Since there are two prime factors, $n = 2$. Now test that number in the question: "Is $2 \geq 3$?" No, it isn't. Let's see whether we can pick a number that yields a different answer. We've already seen a number that has three prime factors: 30. And it's divisible by 10, so it's permitted by Statement (2). We get $30 = 2 \times 3 \times 5$. That's three prime factors, so $n = 3$. Put that into the question: "Is $3 \geq 3$?" Yes, it is. As with Statement (1), we've produced a "maybe" answer, so Statement (2) is insufficient. Eliminate **(B)**.

(C) and **(E)** still remain, so now we have to consider the statements together. We have to pick values for x that are divisible both by 6 and by 10. Happily, we already know one from our earlier work. If $x = 30$, then the answer to our question is "yes." Can we find a number that's divisible both by 6 and by 10 but has fewer than three prime factors? Let's try $x = 6 \times 10$, or $x = 60$. We get $60 = 6 \times 10 = 2 \times 3 \times 2 \times 5 = 2^2 \times 3 \times 5$. That's also three distinct prime factors. If you weren't at this point confident that any number that's divisible both by 6 and by 10 would have to have 2, 3, and 5 as prime factors (that's at least three!), quickly testing one or two other possibilities (e.g., $x = 90$, $x = 120$) would confirm it. No matter what permissible numbers we pick, we get the same answer: "yes." So considering the statements together, the answer is "definitely yes." **(C)** is correct.

9. **B** If $x^3 < x$, is $x > x^2$?

(1) $x > -5$
(2) $x < -2$

STOP: Analyze the Question Stem

This is a Yes/No question, so we don't need to know the exact value of x, just whether x is definitely greater than x^2 or definitely *not* greater than x^2.

Is it possible to simplify the question? We're told that $x^3 < x$. When would a number be *greater* than its cube? Picking Numbers can help us understand the question. If $x = 2$, then $x^3 = 8$; 8 is not less than 2, so $x = 2$ is not a permissible number according to the question stem. Neither is $x = 1$ nor $x = 0$, as in both cases $x^3 = x$. What about other kinds of numbers, like fractions or negatives?

If $x = \frac{1}{2}$, then $x^3 = \left(\frac{1}{2}\right)^3 = \frac{1}{8}$. Because $\frac{1}{8}$ is less than $\frac{1}{2}$, x could be a fraction between 0 and 1. And if $x = -2$, then $x^3 = -8$; -8 is less than -2, so x could be a negative number less than -1.

How would these different possible values affect the question "Is $x > x^2$?" If $x = \frac{1}{2}$, then $x^2 = \left(\frac{1}{2}\right)^2 = \frac{1}{4}$; $\frac{1}{2}$ is greater than $\frac{1}{4}$. So if x is a fraction between 0 and 1, the answer to the question is "yes." And if $x = -2$, then $x^2 = 4$; -2 is not greater than 4, so if x is negative, then the answer to our question is "no."

To answer the question, we'll need to know definitely which of the two permitted types of number x is—a positive fraction or a number less than -1.

THINK, PREDICT, and MATCH: Evaluate the Statements Using 12TEN

Statement (1) permits any number greater than -5. Certainly x could be negative. And since there's no upper limit provided on x, it could also be a positive fraction. We haven't gotten a definite "yes" or "no" answer to our question, so Statement (1) is insufficient. Eliminate **(A)** and **(D)**.

Statement (2) permits only negative numbers and excludes positive fractions. So the answer to our question is "definitely no." Statement (2) is sufficient, so **(B)** is correct.

10. **C** What is the value of x?

(1) $x^2 - 9 = 16$
(2) $3x(x - 5) = 0$

STOP: Analyze the Question Stem

In this Value question, we must find one and only one value for x to have sufficiency.

THINK, PREDICT, and MATCH: Evaluate the Statements Using 12TEN

Statement (1) provides an equation that allows us to determine the value of x^2. Every positive number has two square roots, one positive and one negative, so this statement narrows things down to two values for x: 5 and -5. Without further information, we cannot determine one and only one value for x, so this statement is insufficient. Eliminate **(A)** and **(D)**.

Statement (2) provides an equation in which at least one of the expressions $3x$ or $(x - 5)$ is equal to 0. That translates into two possible values for x: 0 and 5. We need one and only one value for sufficiency, so this statement is insufficient. Eliminate **(B)**.

Combining the statements tells us that x is either 5 or -5 and either 0 or 5. The only way to satisfy both statements is for x to be 5. That is the one and only one possible value for x, so combining the statements leads to sufficiency, and the correct answer is **(C)**.

11. **E** If a coffee shop sold 600 cups of coffee, some of which were large cups and the remainder of which were small cups, what was the revenue that the coffee shop earned from the sale of coffee?

(1) The number of large cups sold was $\frac{3}{5}$ the total number of small cups sold.
(2) The price of a small cup of coffee was $1.50.

STOP: Analyze the Question Stem

This is a Value question. Simplifying a word problem essentially entails understanding the situation, allowing us to figure out what variables would need to be calculated in order to answer the question. This coffee shop sells two sizes of coffee, and we are asked to determine its revenue. To answer this question, we need to ascertain both how many cups of each size were sold and the price of each size of cup.

THINK, PREDICT, and MATCH: Evaluate the Statements Using 12TEN

Statement (1) has no pricing information at all. We can eliminate **(A)** and **(D)** as potential answers. Even though we could create an equation that, when combined with the stimulus, would tell us the number of cups of each size that were sold, doing so would be a waste of time—we already know that Statement (1) is insufficient, so there's no point in working further.

Statement (2) tells us the price of one size—small. This is insufficient because it tells us nothing about the price of the large cup or about the number of cups sold. We can now eliminate **(B)**.

Because each statement alone is insufficient, we now combine both statements to determine whether they are sufficient together. Combined, we still know nothing about the price of a large cup. A crucial piece of data is missing, so the two statements combined are insufficient to answer the question. Eliminate **(C)**. The correct answer is **(E)**.

CHAPTER FIFTY-EIGHT

Data Interpretation

INTRODUCTION TO DATA INTERPRETATION QUESTIONS

Data Interpretation questions are based on information located in tables or graphs, and they are often statistics oriented. The data may be located in one table or graph, but you might also need to extract data from two or more tables or graphs. On Test Day, you may see Data Interpretation questions present a single question or a set of questions associated with one or more charts, graphs, figures, images, or tables.

THE KAPLAN METHOD FOR DATA INTERPRETATION

Now let's discuss the Kaplan Method for Data Interpretation.

STOP: Assess the difficulty of the problem.

Quickly skim the question stem, looking for clues as to difficulty. This is similar to the STOP step for a Quantitative Reasoning question, but there are a few additional things to look for. Features to focus on include:

- **Figure Complexity**. How challenging will it be to analyze the figure or table given? Is it easy to understand?
- **Required Information Processing**. What do you have to do with the figure/table data? Will preparing for the needed calculation or question require additional steps?
- **Calculation Complexity**. Once you understand the data presentation, is a calculation required? Is the required calculation typically a time consuming one?

THINK: Analyze the tables and graphs.

Familiarize yourself with the information of any given figures before attacking the given question. Scan figures for these components:

- **Title**. Read the titles to ensure you know exactly what is being shown.
- **Scale and/or Axes**. Check the units of measurement. Does the graph measure miles per minute or hour? Missing the units can drastically change your answer.
- **Data**. Evaluate the information being conveyed. Note any major trends or differences within the data.
- **Notes**. Read any accompanying notes—you will typically be given information only if it is helpful or even critical to getting the correct answer.
- **Key**. If there are multiple bars or lines on a graph, make sure you understand the key so you can match up the correct quantities with the correct items.

PREDICT: Approach strategically.

Data Interpretation questions are designed to test both your ability to understand unique forms of data presentation and your ability to perform conversions and calculations on data sets. Taking a split second to make sure you answered the right question can make the difference between a correct answer and the "right" answer to the wrong question.

No matter how difficult graph questions appear at first glance, you can usually simplify questions by taking advantage of their answer choices. By first ensuring you understand the question, then approximating the answer rather than calculating it wherever possible, you can quickly identify the right one. Estimation can be one of the fastest ways to identify the correct answer in math problems. Data Interpretation questions benefit from this strategy, as they tend to be time-consuming questions to answer.

MATCH: Select the answer that matches your prediction.

When matching for data interpretation questions, ensure you have answered the entirety of the question asked. Select the answer choice that matches your prediction, and move on.

HOW TO APPLY THE KAPLAN METHOD FOR DATA INTERPRETATION

Now let's apply the Kaplan Method to a Data Interpretation question:

CLIMOGRAPH OF CITIES

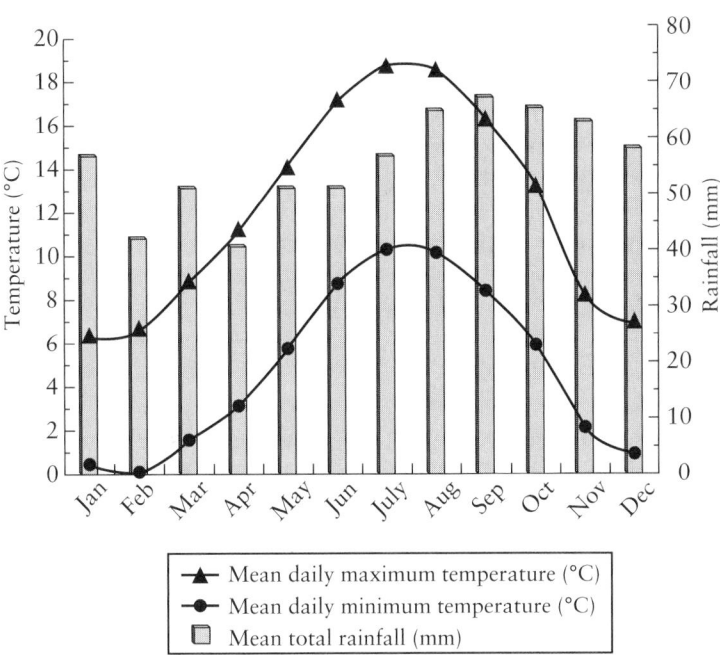

The Tourism Board of City S uses the information provided in the climograph to market the city as a tourist destination. One criterion is that the average monthly rainfall be less than 60 millimeters. What fraction of the months meet this criterion?

A. $\frac{1}{4}$

B. $\frac{1}{3}$

C. $\frac{1}{2}$

D. $\frac{2}{3}$

E. $\frac{1}{1}$

STOP: Assess the difficulty of the problem.

This figure is relatively complex, with both bar and line graph components. In order to answer, you will have to read the figure for a specific metric (rainfall below a given value) that will allow you to ignore a good portion of the graph. The answer is a simple fraction. Despite the complexity of the figure, this is likely a "Now" question.

THINK: Analyze the tables and graphs.

Take the analysis of the graph step-by-step. Start with the title of the graph to verify that the data given are for City S. Then take note of the scale for each type of information—degrees Celsius for temperature and millimeters for rainfall. There are data for each month of the year, which means you will not have to convert the units to answer the question that's being asked.

PREDICT: Approach strategically.

The question asks only about rainfall; those data are given by the bars on the graph. According to the bars, rainfall is greater than 60 mm in August, September, October, and November. That's 4 of 12 months that do not meet the criteria, so 8 of 12 months *do* meet it. This reduces to $\frac{2}{3}$ and makes **(D)** the correct answer.

MATCH: Select the answer that matches your prediction.

Select the answer choice that contains either $\frac{8}{12}$ or an equivalent fractional value, and move on.

Now let's apply the Kaplan Method to a second Data Interpretation question:

CUSTOMERS WHO SWITCHED SERVICE PROVIDERS
(IN MILLIONS OF CUSTOMERS)

COMPANY A PROFIT 2008

In 2008, Company A had a total profit of $220 million. If half of the customers who switched to Company A were responsible for half of the profit for Plan X, how much did these customers contribute per person toward Company A's profit for the year?

A. $1.10

B. $13.75

C. $20.25

D. $27.50

E. $55.00

STOP: Assess the difficulty of the problem.

There are two figures given, and the first is more complex than the second. Both will need to be analyzed in order to solve the problem, and then additional calculation will be required. This could make a good contender for a "Later" question.

THINK: Analyze the tables and graphs.

This question has information about numbers of customers switching service providers for various years. It also has information about one company's profit for the year 2008, so the data in the two graphs will be linked by the year 2008.

PREDICT: Approach strategically.

Approach the question methodically, starting with identifying the number of customers who switched to Company A. The line chart indicates that 4 million customers switched to Company A. This is the only information needed from the top graph.

The pie chart shows the breakdown of profit from the various plans offered and indicates that 25% of the profit came from Plan X.

The other information you need to get to the correct answer is given in the question stem:

- Profit of $220 million.
- Half of the customers who switched were responsible for half of Plan X's profits.

Now that your information is organized, all you need to do is the calculation. Plan X accounts for 25% of $220 million = $55 million. Half of $55 million is $27.5 million.

If 4 million people switched, then half of the people who switched would be 2 million.

The last step is to divide $27.5 by 2 (you can drop the zeroes in the millions because they will cancel out): $27.5 ÷ 2 = $13.75.

MATCH: Select the answer that matches your prediction.

The calculated value matches (**B**). Pick it and move on.

CUSTOMERS WHO SWITCHED SERVICE PROVIDERS
(IN MILLIONS OF CUSTOMERS)

COMPANY A PROFIT 2008

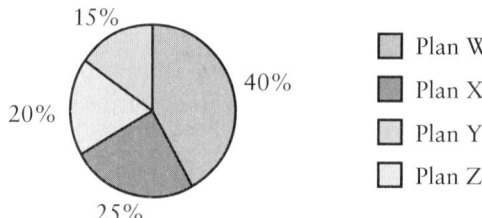

The management of Company B is most interested in the data for the years in which there were at least one million *more* customers who switched from Company A to Company B than switched from Company B to Company A. In which of the following years did this happen?

A. 2004

B. 2005

C. 2006

D. 2007

E. 2008

STOP: Assess the difficulty of the problem.

There are two figures given, and the first is more complex than the second. Only the first is necessary to solve this problem. There is no major calculation. This is a "Now" question.

THINK: Analyze the tables and graphs.

This question asks for a comparison of facts between Company A and Company B. Take time to verify which line in the top graph represents customers switching to Company A and which line represents customers switching to Company B. Confirm that the title states that the data are given in millions and then look at the scale on the line graph.

PREDICT: Approach strategically.

After examining the line graph carefully, you are ready to gather the information needed to answer the question. The years that satisfy the requirement are those years for which the line representing A to B is at least one full horizontal row above the line representing B to A.

When you are clear what to look for on the graph, start from the left and identify the years 2005 and 2009 as those in which at least one million more customers switched from A to B than switched from B to A.

MATCH: Select the answer that matches your prediction.

2005 and 2009 are both valid answers to the question, but only 2005 was given as an option. (**B**) is correct, select it and move on.

KAPLAN'S ADDITIONAL TIPS FOR DATA INTERPRETATION QUESTIONS

Slow Down

There's always a lot going on in Data Interpretation problems—both in the charts and in the questions themselves. If you slow down the first time through, you can avoid calculation errors and having to reread the questions and charts.

Pace Yourself Wisely

To ensure that you score as many points on the exam as possible, use the allotted time for a section wisely. Remember that each question type has the same value. If you must miss a few questions in a section, make them the ones that would take you the longest to answer, not the ones at the end of the section that you could have answered correctly but simply didn't get to. Data Interpretation questions are generally some of the more time-consuming ones to answer, and if answering them isn't one of your strong suits, save them for the end.

REVIEW PROBLEMS

Try the following Data Interpretation questions using the Kaplan Method for Data Interpretation. If you're up to the challenge, time yourself; on Test Day, you'll want to spend only about 67 seconds on each question.

Questions 1–4 are based on the following graphs.

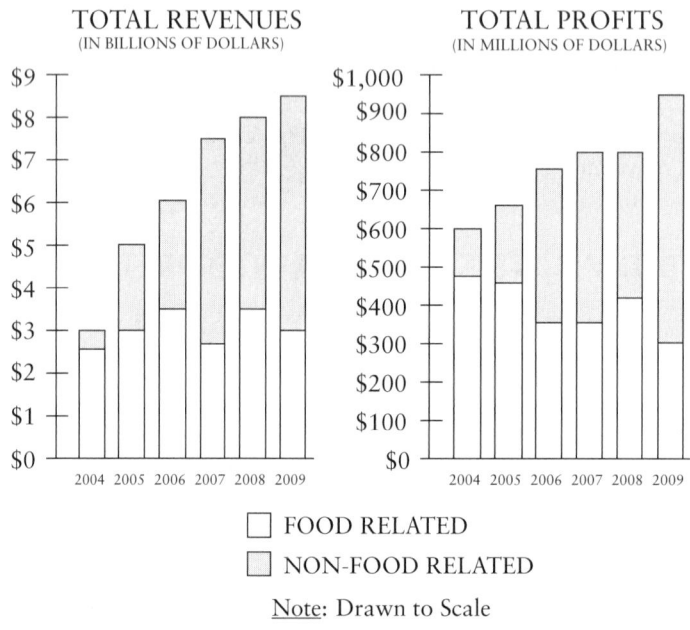

☐ FOOD RELATED

☐ NON-FOOD RELATED

Note: Drawn to Scale

PERCENT OF REVENUES FROM FOOD-RELATED
OPERATIONS IN 2009 BY CATEGORY

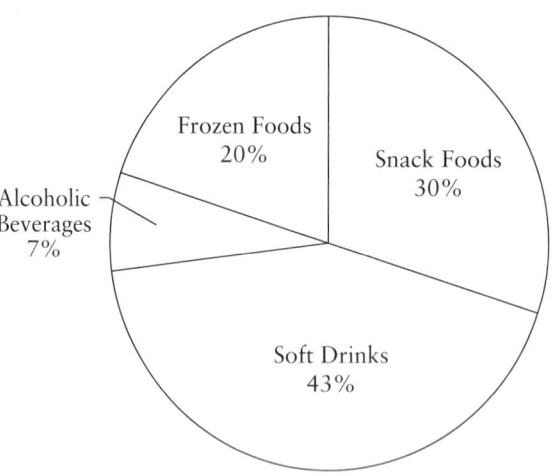

1. Approximately how much did total revenues increase from 2004 to 2007?

 A. $0.5 billion

 B. $1.5 billion

 C. $4 billion

 D. $4.5 billion

 E. $5 billion

2. For the year in which profits from food-related operations increased over the previous year, total revenues were approximately:

 A. $3.5 billion

 B. $4.5 billion

 C. $5.7 billion

 D. $6 billion

 E. $8 billion

3. In 2008, total profits represented approximately what percent of total revenues?

 A. 50%

 B. 20%

 C. 10%

 D. 5%

 E. 1%

4. For the first year in which revenues from non-food-related operations surpassed $4.5 billion, total profits were approximately:

 A. $250 million

 B. $450 million

 C. $550 million

 D. $650 million

 E. $800 million

Questions 5–9 refer to the following stimulus.

Unemployment (%) in Country X and Country Y

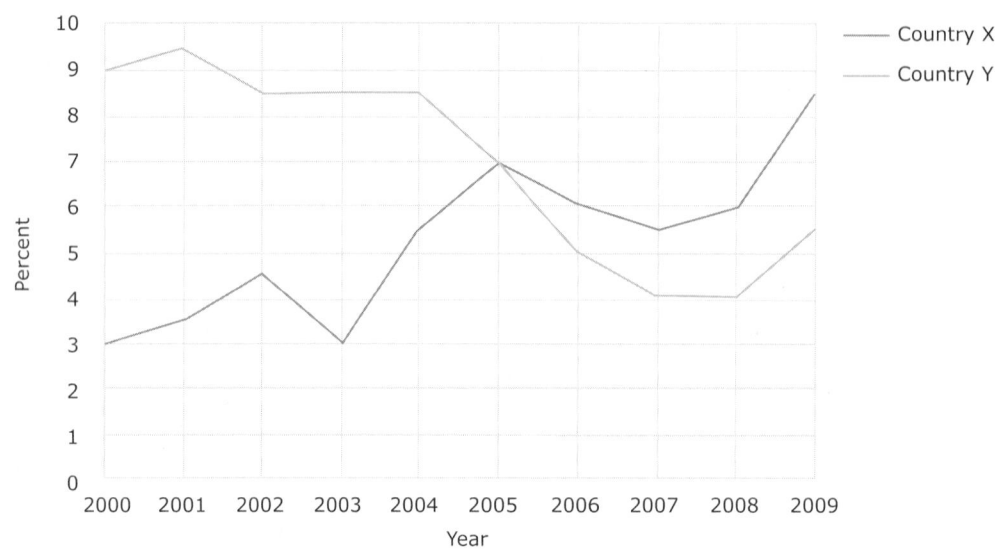

5. For which of the years was the unemployment rate in Country Y more than 5 percentage points greater than that of Country X ?

 A. 2002
 B. 2003
 C. 2004
 D. 2005
 E. 2006

6. Which of the following is closest to the average (arithmetic mean) of the 9 changes in the percentage of unemployed workers in Country X between consecutive years from 2000 to 2009?

 A. .4%
 B. .5%
 C. .6%
 D. .7%
 E. 1.3%

7. In 2006, the unemployment rate of Country X was approximately what percent of that of Country Y ?

 A. 16.7%
 B. 20%
 C. 60%
 D. 83.3%
 E. 120%

8. If it were discovered that the unemployment rate for Country Y shown for 2003 was incorrect and should have been 6% instead, then the average (arithmetic mean) unemployment rate per year for the 10 years shown would have been off by approximately how many percentage points?

 A. 0.25
 B. 0.3
 C. 2.5
 D. 3
 E. 25

9. The percent change in unemployment was greatest for which one of the following?

 A. Country X, from 2000 to 2002
 B. Country X, from 2003 to 2004
 C. Country X, from 2008 to 2009
 D. Country Y, from 2004 to 2006
 E. Country Y, from 2005 to 2007

SOLUTIONS TO REVIEW PROBLEMS

1. **D** This question asks about total revenues, so refer to the left bar graph. Total revenues are indicated by the total height of the bars in the graph. For 2004, total revenues appear to be $3 billion, and for 2007 they appear to be about $7.5 billion. So the increase is roughly $7.5 billion − $3 billion = $4.5 billion. **(D)** is correct.

2. **E** The question mentions profits and revenues, so both bar graphs will be needed. First, refer to the right bar graph to find the lone year in which food-related profits increased over the previous year. The only year in which the unshaded portion of the bar is taller than the unshaded portion of the previous year's bar is 2008. Now refer to the left bar graph to determine the total *revenues* for 2008, which appear to be about $8 billion. **(E)** is correct.

3. **C** The question deals with total profits and total revenues, so both bar graphs will be needed. Total profits and revenues are indicated by the total height of the bars. From the right bar graph, the total profits for 2008 appear to be $800 million; from the left bar graph, total revenues for that year appear to be $8 billion (i.e., $8,000 million). Now, convert the part/whole into a percent:

$$\frac{800\,\text{million}}{8\,\text{billion}} = \frac{800\,\text{million}}{8{,}000\,\text{million}} = \frac{1}{10} = 10\%$$

4. **E** First, find the year for which revenues from non-food-related operations surpassed $4.5 billion on the left bar graph. Finding the correct bar is made more difficult by the fact that non-food-related operations are represented by the shaded portion, which is at the top of the bar, not at the bottom. Comparing the shaded portions of the bars carefully to the revenues axis on the left of the graph, it becomes clear that 2007 is the first year in which the shaded portion represents more than $4.5 billion. The question asks for total *profits*, so once again refer to the right bar graph to find that the profits for 2007 were around $800 million. **(E)** is correct.

5. **B** Calculate the differences for the years 2002 through 2006:
 A: 2002: 8.5% − 4.5% = 4%. Incorrect.
 B: 2003: 8.5% − 3% = 5.5%. Correct.
 C: 2004: 8.5% − 5.5% = 3%. Incorrect.
 D: 2005: 7% − 7% = 0%. Incorrect.
 E: 2006: 6% − 5% = 1%. Incorrect.

 Note that precise calculation is not necessary for 2004 and 2005; eyeballing the difference in the graph should be sufficient for these years.

6. **C** First, find the changes from year to year. Note that downward changes must be represented by negative values; making all the values positive yields distractor choice (**E**).

 2000 to 2001: 0.5%

 2001 to 2002: 1%

 2002 to 2003: −1.5%

 2003 to 2004: 2.5%

 2004 to 2005: 1.5%

 2005 to 2006: −1%

 2006 to 2007: −0.5%

 2007 to 2008: 0.5%

 2008 to 2009: 2.5%

 Then, calculate the average of these changes:

 $$\frac{0.5 + 1 - 1.5 + 2.5 + 1.5 - 1 - 0.5 + 0.5 + 2.5}{9}$$

 $$= \frac{5.5}{9} = 0.6\bar{1}$$

 The correct answer is (**C**).

7. **E** Look up the unemployment values for 2006:

 Country X: 6%

 Country Y: 5%

 Six is 1.2 times 5, and 1.2 = 120%. Thus, the unemployment rate of Country X (6) is 120% of that of Country Y (5). Critical thinking also leads to (**E**) without having to do any calculations, as the correct answer has to be greater than 100% and the other four choices are less than 100%. Many of the trap choices hinge on a misunderstanding of the question. Five is about 16.7% smaller than 6 (**A**), and 6 is 20% greater than 5 (**B**). (**D**) is backwards, giving Y as a percent of X.

8. **A** The 2003 unemployment rate for Country Y shown in the graph is 8.5%, so 6% is a decrease of 2.5 percentage points. At this point, you could calculate both averages and compare them directly, but it's much faster to think critically. There are 10 years shown, so each year contributes one tenth of the average. Thus, a decrease of 2.5 percentage points would decrease the overall average by 2.5 ÷ 10, or 0.25 percentage points, (**A**).

9. **B** Recall the percent change formula:

$$\text{Percent Change} = \frac{\text{Change}}{\text{Original}} \times 100\%$$

Strategic elimination is much faster here than precise calculation. For Country X, comparing **(A)** and **(B)**, 2000 and 2003 had the same rate, but the rate in 2004 was higher than the rate in 2002, so **(A)** is wrong. Also for Country X, comparing **(B)** and **(C)**, the increase from 2003 to 2004 was the same as the increase from 2008 to 2009 (2.5 percentage points in both cases), but the value in 2003 was much lower, so a 2.5 percentage point change represented a more significant change in 2003 to 2004. **(C)** is wrong.

For Country Y, **(D)** and **(E)** feature decreases that are less than 50%: $\frac{3.5}{8.5}$ and $\frac{3}{7}$, respectively. **(B)** is $\frac{2.5}{3}$, which is much greater than 50% and thus the right answer.

CHAPTER FIFTY-NINE

Fundamentals of Calculation

LEARNING OBJECTIVES

After this chapter, you will be able to:

- Apply number operations to predict the answers to math problems on the DAT
- Apply the rules of fractions, ratios, decimals, and scientific notation when solving math problems
- Calculate averages, conversions, and logarithms

The test makers describe the arithmetic covered in this chapter as basic math, but that doesn't mean it's all easy to calculate, especially when you do not have access to a calculator and are under the time constraints of Test Day. Even if you once had a strong, working knowledge of number properties and how to manipulate fractions, decimals, ratios, logarithms, and means, you may find that your knowledge has deteriorated through disuse, especially if you haven't taken a math class in several years. Even if this content seems straightforward at first glance, spend some time with the practice problems and worked examples to ensure your knowledge is fresh and you won't need to waste time on Test Day recalling basic rules or formulas.

NUMBER OPERATIONS

Important terms and concepts to be familiar with for Test Day:

- **Real number:** All numbers on the number line.
- **Integers**: All numbers with no fractional or decimal parts, including negative whole numbers and zero; multiples of 1. See the number line below.
- **Operation**: A process that is performed on one or more numbers. The four basic arithmetic operations are addition, subtraction, multiplication, and division.
- **Sum**: The result of addition.
- **Difference**: The result of subtraction.
- **Product**: The result of multiplication.
- **Reciprocal**: The result of switching the numerator and denominator of a fraction. The reciprocal of $\frac{3}{5}$ is $\frac{5}{3}$. The reciprocal of 2 is $\frac{1}{2}$ because 2 can be considered to be the fraction $\frac{2}{1}$. Multiplying any number by its reciprocal will result in 1.

Numbers and the Number Line

A number line is a straight line, extending infinitely in either direction, on which real numbers are represented as points. Decimals and fractions can also be depicted on a number line, as can numbers such as $\sqrt{2}$.

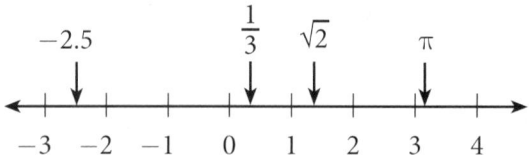

The values of numbers get larger as you move to the right along the number line. Numbers to the right of zero are **positive**; numbers to the left of zero are **negative**. **Zero** is neither positive nor negative, but it is an even integer. Any positive number is larger than any negative number. For example, 4 is larger than -300.

Laws of Operations

Commutative laws of addition and multiplication

Addition and multiplication are both **commutative**; switching the order of any two numbers being added or multiplied together does not affect the result. For example, $5 + 12 = 12 + 5$; both sums equal 17. Similarly $2 \times 6 = 6 \times 2$; both products equal 12.

$$a + b = b + a$$
$$a \times b = b \times a$$

Subtraction and division are *not* commutative; switching the order of the numbers changes the result. For instance, $3 - 2 \neq 2 - 3$; the left side yields a result of 1, whereas the right side yields a result of -1.

Similarly, $6 \div 2 \neq 2 \div 6$; the left side gives 3, whereas the right side gives $\frac{1}{3}$.

Associative laws of addition and multiplication

$$(a + b) + c = a + (b + c)$$
$$(a \times b) \times c = a \times (b \times c)$$

Addition and multiplication are both **associative**. This means that the terms can be regrouped without changing the result.

Example: $(3 + 5) + 8 = 3 + (5 + 8)$
$$8 + 8 = 3 + 13$$
$$16 = 16$$

Example: $(4 \times 5) \times 6 = 4 \times (5 \times 6)$
$$20 \times 6 = 4 \times 30$$
$$120 = 120$$

Because addition and multiplication are both commutative and associative, numbers can be added or multiplied in any order. Subtraction and division are *not* associative.

Example: $(7 - 10) - 4 = -3 - 4 = -7$, whereas $7 - (10 - 4) = 7 - 6 = 1$.

So $(7 - 10) - 4 \neq 7 - (10 - 4)$.

Example: $(24 \div 12) \div 3 = 2 \div 3 = \frac{2}{3}$, whereas $24 \div (12 \div 3) = 24 \div 4 = 6$.

So $(24 \div 12) \div 3 \neq 24 \div (12 \div 3)$.

Distributive law

The distributive law of multiplication allows you to "distribute" a factor among the terms being added or subtracted by multiplying that factor by each number in the group.

$$a(b + c) = ab + ac.$$

Example: $4(3 + 7) = (4 \times 3) + (4 \times 7)$

$4 \times 10 = 12 + 28$

$40 = 40$

Division can be distributed in a similar way, because dividing by a number is equivalent to multiplying by that number's reciprocal.

Example: $\frac{3+5}{2} = \frac{1}{2}(3 + 5) = \frac{1}{2}(3) + \frac{1}{2}(5)$

$\frac{8}{2} = \frac{3}{2} + \frac{5}{2}$

$\frac{8}{2} = \frac{3+5}{2}$

$\frac{8}{2} = \frac{8}{2}$

Don't get carried away, though. When the sum or difference is in the denominator—that is, when you're dividing by a sum or difference—no distribution is possible. $\frac{9}{4+5}$ is NOT equal to $\frac{9}{4} + \frac{9}{5}$; $\frac{9}{4+5} = \frac{9}{9} = 1$. But $\frac{9}{4}$ and $\frac{9}{5}$ are both greater than 1, so their sum can't equal 1.

Operations with signed numbers

Numbers can be treated as though they have two parts: a positive or negative sign and a number part. For example, the sign of the number -3 is negative, and the number part is 3. Numbers without any sign are understood to be positive. To add two numbers that have the same sign, add the number parts and keep the sign.

Example: What is the sum of -6 and -3?

Solution: To find $(-6) + (-3)$, add 6 and 3, and then attach the negative sign from the original numbers to the sum:

$$(-6) + (-3) = -9.$$

To add two numbers that have different signs, find the difference between the number parts and keep the sign of the number whose number part is larger.

Example: What is the sum of -7 and $+4$?

Solution: To find $(-7) + (+4)$, subtract 4 from 7 to get 3. $7 > 4$; that is, the number part of -7 is greater than the number part of $+4$, so the final sum will be negative. $(-7) + (+4) = -3$.

Subtraction is the opposite of addition. You can rephrase any subtraction problem as an addition problem by changing the operation sign from a minus to a plus and switching the sign on the second number. For instance, $8 - 5 = 8 + (-5)$. There's no real advantage to rephrasing if you are subtracting a smaller positive number from a larger positive number. But the concept comes in very handy when you are subtracting a negative number from any other number, a positive number from a negative number, or a larger positive number from a smaller positive number.

To subtract a negative number, rephrase as an addition problem and follow the rules for addition of signed numbers.

For instance, $9 - (-10) = 9 + 10 = 19$.

Here's another example: $(-5) - (-2) = (-5) + 2$. The difference between 5 and 2 is 3, and the number with the larger number part is -5, so the answer is -3.

To subtract a positive number from a negative number or from a smaller positive number, change the sign of the number that you are subtracting from positive to negative and follow the rules for addition of signed numbers.

For example, $(-4) - 1 = (-4) + (-1) = -5$.

Example: Subtract 8 from 2.

Solution: $2 - 8 = 2 + (-8)$. The difference between the number parts is 6, and the -8 has the larger number part, so the answer is -6.

Multiplying or dividing two numbers with the same sign gives a positive result.

$$(-4) \times (-7) = +28$$
$$(-50) \div (-5) = +10$$

Multiplying or dividing two numbers with different signs gives a negative result.

$$(-2) \times (+3) = -6$$
$$8 \div (-4) = -2$$

Properties of 0, 1, and -1

Properties of 0

Adding zero to or subtracting zero from a number does not change the number.

$$x + 0 = x$$
$$0 + x = x$$
$$x - 0 = x$$

Example: $5 + 0 = 5$

$0 + (-3) = -3$

$4 - 0 = 4$

Notice, however, that subtracting a number from zero switches the number's sign. It's easier to see why if you rephrase the problem as an addition problem.

Example: Subtract 5 from 0.

Solution: $0 - 5 = -5$. That's because $0 - 5 = 0 + (-5)$, and according to the properties of zero, $0 + (-5) = -5$.

The product of zero and any number is zero.

$$0 \times z = 0$$

$$z \times 0 = 0$$

Example: $0 \times 12 = 0$

Division by zero is undefined. For practical purposes, that translates as "it can't be done." Because fractions are essentially division (that is, $\frac{1}{4}$ means $1 \div 4$), any fraction with zero in the denominator is also undefined.

Properties of 1 and −1

Multiplying or dividing a number by 1 does not change the number.

$$a \times 1 = a$$

$$1 \times a = a$$

$$a \div 1 = a$$

Example: $4 \times 1 = 4$

$1 \times (-5) = -5$

$(-7) \div 1 = -7$

Multiplying or dividing a nonzero number by −1 changes the sign of the number.

$$a \times (-1) = -a$$

$$(-1) \times a = -a$$

$$a \div (-1) = -a$$

Example: $6 \times (-1) = -6$

$(-3) \times (-1) = 3$

$(-8) \div (-1) = 8$

QR

Order of Operations

Whenever you have a string of operations, be careful to perform them in the proper order. Otherwise, you will probably get the wrong answer.

The acronym PEMDAS stands for the correct order of operations:

Parentheses

Exponents

Multiplication

Division

Addition

Subtraction

Multiplication and division should be performed together in order from left to right, and then addition and subtraction should be performed together in order from left to right. If you have trouble remembering PEMDAS, you can think of the mnemonic phrase Please Excuse My Dear Aunt Sally.

Example: $66 \times (3 - 2) \div 11 = ?$

Solution: If you were to perform all the operations sequentially from left to right, without regard to the rules for the order of operations, you would arrive at the answer $\frac{196}{11}$. To do this correctly, however, perform the operation inside the parentheses first: $3 - 2 = 1$. Now you have:

$$66 \times 1 \div 11 = 66 \div 11 = 6$$

Example: $30 - 5 \times 4 + (7 - 3)^2 \div 8 = ?$

Solution: First perform any operations within parentheses. (If the expression has parentheses within parentheses, work from the innermost set out.)

$30 - 5 \times 4 + 4^2 \div 8$

Next, do the exponent.

$30 - 5 \times 4 + 16 \div 8$

Then, do all multiplication and division in order from left to right.

$30 - 20 + 2$

Last, do all addition and subtraction in order from left to right.

$10 + 2$

The answer is 12.

FRACTIONS

Basic Arithmetic with Fractions

$\dfrac{7}{8}$ \rightarrow Numerator
\rightarrow Denominator

Multiplying fractions: Multiply numerators by each other and denominators by each other.

$$\frac{3}{4} \times \frac{9}{7} = \frac{3 \times 9}{4 \times 7} = \frac{27}{28}$$

Dividing fractions: Flip the numerator and denominator of the fraction you're dividing by, then multiply.

$$\frac{1}{5} \div \frac{4}{11} = \frac{1}{5} \times \frac{11}{4} = \frac{1 \times 11}{5 \times 4} = \frac{11}{20}$$

Adding fractions: You can add fractions only when they have the same denominator. When you add, add only the numerators, NOT the denominators.

$$\frac{2}{3} + \frac{5}{3} = \frac{2 + 5}{3} = \frac{7}{3}$$

If you don't have a common denominator, you have to find one. The fastest way to get a common denominator is to multiply each fraction by a fraction whose numerator and denominator are the same as the denominator of the other fraction. (You can do this because any fraction with the same numerator and denominator is equal to 1, and multiplying any number by 1 doesn't change the value of the number.)

$$\frac{1}{3} + \frac{2}{5} = \left(\frac{1}{3} \times \frac{5}{5}\right) + \left(\frac{2}{5} \times \frac{3}{3}\right) = \frac{5}{15} + \frac{6}{15} = \frac{11}{15}$$

Subtracting fractions: This works the same way as adding fractions, except you subtract the numerators instead of adding them.

$$\frac{6}{7} - \frac{1}{2} = \left(\frac{6}{7}\right)\left(\frac{2}{2}\right) - \left(\frac{1}{2}\right)\left(\frac{7}{7}\right) = \frac{12}{14} - \frac{7}{14} = \frac{5}{14}$$

Remember, parentheses can be used to indicate multiplication instead of the "×" sign.

Reducing fractions: Whenever there is a common factor in the numerator and denominator, you can reduce the fraction by removing the factor from both parts of the fraction. You can do this because dividing the numerator and denominator by the same number doesn't change the value of the fraction as a whole. This will often make working with the fraction much easier because you'll be using smaller numbers.

$$\frac{4}{12} = \frac{1 \times 4}{3 \times 4} = \frac{1}{3} \times 1 = \frac{1}{3}$$

On Test Day, you don't actually have to write out all this math. For example, you might work like this:

$$\frac{4}{12} = \frac{1 \times 4}{3 \times 4} = \frac{1}{3}.$$

Or, even more simply, you might keep track of the multiplication operations mentally, only writing down the results. For example, if attempting to reduce $\frac{42}{28}$, you might write your work by cancelling like this:

$$\frac{{}^{6}\cancel{42}}{{}_{4}\cancel{28}} = \frac{{}^{3}\cancel{6}}{{}_{2}\cancel{4}} = \frac{3}{2}.$$

Because both 42 and 28 are divisible by 7, you can divide both the numerator (42) and the denominator (28) by 7. Thus, $\frac{42}{28}$ reduces to $\frac{6}{4}$. Because both 6 and 4 are divisible by 2, you can divide both the numerator (6) and the denominator (4) by 2. Thus, $\frac{6}{4}$ reduces to $\frac{3}{2}$.

Canceling: Whenever you have to multiply two or more fractions, you should cancel common factors before you multiply. This is a lot like reducing and has the same advantages. $\frac{1}{7} \times \frac{7}{3}$ can be canceled like this:

$$\frac{1}{7} \times \frac{\cancel{7}^{1}}{3} = \frac{1}{1} \times \frac{1}{3} = \frac{1}{3}$$

$\frac{4}{5} \times \frac{15}{12}$ can be canceled like this:

$$\frac{\cancel{4}^{1}}{\cancel{5}_{1}} \times \frac{\cancel{15}^{3}}{\cancel{12}_{3}} = \frac{1}{1} \times \frac{3}{3} = 1$$

Notice that both the 5 in the denominator of the first fraction and the 15 in the numerator of the second fraction are divisible by 5. Similarly, the 4 in the numerator of the first fraction and the 12 in the denominator of the second fraction are both divisible by 4. Simplifying fractions requires identifying these types of relationships and dividing accordingly.

Comparing Fractions

One way to compare fractions is to re-express them with a **common denominator**. $\frac{3}{4} = \frac{21}{28}$ and $\frac{5}{7} = \frac{20}{28}$. $\frac{21}{28}$ is greater than $\frac{20}{28}$ so $\frac{3}{4}$ is greater than $\frac{5}{7}$. Another way to compare fractions is to convert them both to decimals. $\frac{3}{4}$ converts to 0.75, and $\frac{5}{7}$ converts to approximately 0.714.

Mixed Numbers and Fractions

A mixed number consists of an integer and a fraction. For example, $3\frac{1}{4}$, $12\frac{2}{5}$, and $5\frac{7}{8}$ are all mixed numbers.

To convert an improper fraction (a fraction whose numerator is greater than its denominator) to a mixed number, divide the numerator by the denominator. The number of "whole" times that the denominator goes into the numerator will be the integer portion of the mixed number; the remainder will be the numerator of the fractional portion.

Example: Convert $\frac{23}{4}$ to a mixed number.

Solution: Dividing 23 by 4 gives you 5 with a remainder of 3, so $\frac{23}{4} = 5\frac{3}{4}$.

To change a mixed number to a fraction, keep the denominator of the fraction. To figure out the numerator, multiply the integer portion of the mixed number by the number in the denominator. Then add this result to the numerator of the mixed number.

Example: Convert $2\frac{3}{7}$ to a fraction.

Solution: $2\frac{3}{7} = \frac{(2\times7)+3}{7} = \frac{17}{7}$

Example: Convert $5\frac{8}{9}$ to a fraction.

Solution: $5\frac{8}{9} = \frac{(5\times9)+8}{9} = \frac{53}{9}$

Adding and Subtracting Mixed Numbers

Adding or subtracting mixed numbers whose fractional parts have the same denominator will probably be on the test.

Example: $3\frac{12}{17} + 4\frac{10}{17} = ?$

Solution: First, add the integer parts: $3 + 4 = 7$.

Next, add the fractional parts: $\frac{12}{17} + \frac{10}{17} = \frac{22}{17}$.

Now, $\frac{22}{17} = 1\frac{5}{17}$.

Therefore, $3\frac{12}{17} + 4\frac{10}{17} = 7 + 1\frac{5}{17} = 8\frac{5}{17}$.

Example: $4\frac{5}{8} - 2\frac{7}{8} = ?$

Solution: The wrinkle here is that the fractional part of the first number is smaller than the fractional part of the second number (i.e., $\frac{5}{8}$ is smaller then $\frac{7}{8}$). What you need to do, therefore, is borrow from the integer part of the first number to make the fractional part of the first number bigger. Borrow 1 from the integer part and add it to the fractional part (remembering that 1 can be rewritten as $\frac{8}{8}$).

So $4\frac{5}{8} = 3 + \frac{8}{8} + \frac{5}{8} = 3\frac{13}{8}$. So the problem of finding $4\frac{5}{8} - 2\frac{7}{8}$ has been replaced with the problem of finding $3\frac{13}{8} - 2\frac{7}{8}$, which is easier because the fractional part of the first number is greater than the fractional part of the second number.

Notice that all you need to do is replace $4\frac{5}{8}$ with $3\frac{13}{8}$, which is equal to $4\frac{5}{8}$. To find $3\frac{13}{8} - 2\frac{7}{8}$, first subtract the integer parts: $3 - 2 = 1$. Next subtract the fractional parts: $\frac{13}{8} - \frac{7}{8} = \frac{13-7}{8} = \frac{6}{8} = \frac{3}{4}$. So $4\frac{5}{8} - 2\frac{7}{8} = 1\frac{3}{4}$.

Example: $5\frac{1}{4} - 1\frac{3}{4} = ?$

Solution: $5\frac{1}{4} - 1\frac{3}{4} = 5 + \frac{1}{4} - 1\frac{3}{4} = \left(4 + \frac{4}{4}\right) + \frac{1}{4} - 1\frac{3}{4} = 4 + \left(\frac{4}{4} + \frac{1}{4}\right) - 1\frac{3}{4}$

$$= 4\frac{5}{4} - 1\frac{3}{4} = 3\frac{2}{4} = 3\frac{1}{2}$$

When you gain experience with this, you'll be able to skip some of the steps and do this type of problem more quickly.

Example: $8\frac{3}{25} - 4\frac{12}{25} = ?$

Solution: $8\frac{3}{25} - 4\frac{12}{25} = 7 + \frac{25}{25} + \frac{3}{25} - 4\frac{12}{25} = 7\frac{28}{25} - 4\frac{12}{25} = 3\frac{16}{25}$

RATIOS

Setting Up a Ratio

To find a ratio, put the number associated with the word *of* on top and the quantity associated with the word *to* on the bottom and reduce. The ratio of 20 oranges to 12 apples is $\frac{20}{12}$, which reduces to $\frac{5}{3}$.

Part-to-Part Ratios and Part-to-Whole Ratios

If the parts add up to the whole, a part-to-part ratio can be turned into two part-to-whole ratios by putting each number in the original ratio over the sum of the numbers. If the ratio of males to females is 1 to 2, then the males-to-people ratio is $\frac{1}{1+2} = \frac{1}{3}$ and the females-to-people ratio is $\frac{2}{1+2} = \frac{2}{3}$. In other words, $\frac{2}{3}$ of all the people are female.

Solving a Proportion

To solve a proportion, **cross-multiply**:

$$\frac{x}{5} = \frac{3}{4}$$

$$4x = 5 \times 3$$

$$x = \frac{15}{4} = 3.75$$

An Important Point About Ratios

Notice that if you are given a ratio, you can't determine how many there are of each item just from the ratio. For example, if you are told that the ratio of the number of pencils to the number of pens in a drawer is 5 to 4, you don't know that there are 5 pencils and 4 pens in the drawer. All you know is that for every 5 pencils, there are 4 pens. There might be 50 pencils and 40 pens, or there might be 10 pencils and 8 pens in the drawer.

Example: The ratio of dogs to cats in an apartment building is 3 to 2. If there are a total of 50 animals in the apartment building and all of the animals in the building are dogs or cats, how many dogs are in the building?

Solution: The fraction of animals that are dogs is $\frac{3}{3+2}$, or $\frac{3}{5}$. So the number of dogs in the building is $\frac{3}{5} \times 50$, or 30.

DECIMALS

There are two different ways to express numbers that are not integers: as fractions and as decimals. You've already seen fractions; now it's time to talk about decimals.

When a number is expressed in decimal form, it has two parts: the whole number part and the decimal fraction part. The two parts are separated by the decimal point (.). The whole number part is to the left of the decimal point; the decimal fraction part is the decimal point and the numbers to the right of the decimal point. For example, in 4.56, the whole number is 4, and the decimal fraction is 0.56.

You are certainly familiar with decimals from dealing with money: $12.45 is an example of a decimal. The part to the left of the decimal point is the whole number part: 12 in this case. The decimal fraction part is 0.45 in this case.

You can see how decimals work by looking at dollars and cents. What fraction of a dollar is 1 cent? That's 0.01 dollars. Well, there are 100 cents in a dollar, so 1 cent must represent $\frac{1}{100}$ of a dollar. So you know that the fraction $\frac{1}{100}$ is equivalent to the decimal 0.01.

Now, what fraction of a dollar is 10 cents, or 0.10 dollars? That's equal to a dime, and there are 10 dimes in a dollar, so 10 cents must be $\frac{1}{10}$ of a dollar. So you also know that $\frac{1}{10}$ is equivalent to the decimal 0.10.

Now notice this: the fraction $\frac{1}{10}$ is ten times as much as the fraction $\frac{1}{100}$. Similarly, the decimal 0.10 is ten times as much as the decimal 0.01. This should reassure you that you aren't changing the values of the fractions, only the way they're expressed.

You also can tell how each digit in a positive integer will lead to the value of that integer by the place value of that digit. For instance, in the number 27,465, the number 6 is in the tens place, so there will be $6 \times 10 = 60$ going towards the value of the integer 27,465. Each place is worth 10 times as much as the place to its right:

$$
\begin{aligned}
27,465 = 2 \times \ & 10,000 \\
+ 7 \times \ & 1,000 \\
+ 4 \times \ & 100 \\
+ 6 \times \ & 10 \\
+ 5 \times \ & 1
\end{aligned}
$$

Decimals work the same way. You can tell each digit in a decimal will lead to the value of that decimal by the place of that digit relative to the decimal point. The first place to the right of the decimal point is worth $\frac{1}{10}$ (thus it is called the tenths place). The second place is worth $\frac{1}{100}$ (thus it is the hundredths place). The third place is worth $\frac{1}{1,000}$ (thus it is the thousandths place). The fourth place is worth $\frac{1}{10,000}$ (thus it is the ten-thousandths place), and so on.

As before, each place is worth 10 times as much as the place to its immediate right. That's why 0.10 means $\frac{1}{10}$, and 0.01 means $\frac{1}{100}$. By the way, the decimal point is small and has a habit of getting lost (is that a decimal or a bug?); for this reason, it's best to put the 0 before the decimal. That doesn't change the value; 0.01 is the same as .01. Also, zeros to the right of the last digit of a decimal don't change its value: 0.10 is the same as 0.1; they're both $\frac{1}{10}$. Similarly, 7.59 and 7.59000 have the same value; they're both $7\frac{59}{100}$.

Changing Fractions to Decimals

To change a fraction into a decimal, divide the denominator of the fraction into the numerator.

Example: Change $\frac{415}{3,220}$ into a decimal.

Solution: First write the fraction as long division.

$$3,220\overline{)415}$$

3,220 is much bigger than 415, so add zeros to 415 to make the division work out. The only way you can do this without changing the value of 415 is by adding a decimal point after the 5. Then, change 415 to 415.00 (those zeros don't change the value of anything). Divide normally but put a decimal point in the quotient (the answer) directly above the decimal point in 415.

$$
\begin{array}{r}
.12 \\
3220\overline{)415.00} \\
322\,0 \\
\hline
93\,00 \\
64\,40 \\
\hline
28\,600 \\
\end{array}
$$

How far you should go depends on how much accuracy you need; here, you can stop at this hundredths place because you can see the answer is going to be close to 0.13.

Changing Decimals to Fractions

How do you express 0.5 as a fraction? 0.1 represents $\frac{1}{10}$, and 0.5 is five times as much as 0.1, so 0.5 must represent 5 times $\frac{1}{10}$ or $\frac{5}{10}$.

How do you express 0.55 as a fraction? Think of it in terms of dollars and cents. \$0.01 is one cent, and that's $\frac{1}{100}$ of a dollar. \$0.55 is 55 cents, and that's 55 times as much, so \$0.55 must be $\frac{55}{100}$ of a dollar. You can reduce this by dividing the top and bottom by 5, giving $\frac{11}{20}$. That's the fractional equivalent of 0.55.

Hopefully by this point you recognize a pattern:

$$0.1 = 1 \times \frac{1}{10} \text{ or } \frac{1}{10}$$

$$0.11 = 11 \times \frac{1}{100} \text{ or } \frac{11}{100}$$

$$0.111 = 111 \times \frac{1}{1,000} \text{ or } \frac{111}{1,000}$$

$$0.1111 = 1,111 \times \frac{1}{10,000} \text{ or } \frac{1,111}{10,000}$$

and so on.

To change decimals that are between 0 and 1 to fractions, put the digits to the right of the decimal point in the numerator. To figure out the denominator, put a 1 in the denominator and follow it with as many zeros as digits to the right of the decimal point.

Example: Change 0.564 to a fraction.

Solution: There are three digits to the right of the decimal point, so the denominator of the fraction will be 1,000 (a 1 followed by three zeros). The numerator of the fraction is 564.

$$0.564 = \frac{564}{1,000}$$

But notice that $\frac{564}{1,000}$ can be reduced. Because both 564 and 1,000 are divisible by 4, divide both the numerator and the denominator by 4; therefore, $\frac{564}{1,000} = \frac{564 \div 4}{1,000 \div 4} = \frac{141}{250}$.

Addition and Subtraction of Decimals

Add and subtract decimals the same way you add and subtract whole numbers, but make sure the decimal points are lined up before adding. In the answer, put the decimal point directly below the other decimal points.

$$0.456 + 1.234 = 0.456$$
$$\underline{+\ 1.234}$$
$$1.690$$

If one of the terms you are adding or subtracting is longer than another (has more digits to the right of the decimal point), add zeros to the shorter number before adding or subtracting.

$$6.97 - 3.567 = 6.970$$
$$\underline{- \ 3.567}$$
$$3.403$$

Multiplication of Decimals

As with addition and subtraction, you multiply decimals as if they were whole numbers and worry about the decimal points later. You don't need to add zeros to make the numbers the same length when you multiply, however.

$$4.5 \times 3.2 = 4.5$$
$$\underline{\times \ 3.2}$$
$$90$$
$$\underline{+ \ 1350}$$
$$1440$$

To place the decimal point in the answer, count the number of digits to the right of the decimal point in each number. Here you have 1 decimal place in 4.5, and 1 in 3.2, for a total of $1 + 1$ or 2 places. Put the decimal point 2 places from the right in the answer: 14.40.

It's a good idea when you get the answer to see whether it makes sense and to check that you put the decimal point in the right place. Here the answer should be a little bigger than 4×3 or 12. So 14.40 should be about right. If you placed the decimal point incorrectly and ended up with 144, you would know that was wrong.

Division of Decimals

It's easiest to discuss division of decimals if you express the division in fractional form.

Example: $4.15 \div 32.2 = \dfrac{4.15}{32.2}$

Solution: Make both the numerator and the denominator of the fraction whole numbers; to do this, multiply both top and bottom by a sufficient power of 10. In this example, multiply by 100; this will make the denominator 3,220 and the numerator 415, leaving:

$$\frac{4.15}{32.2} = \frac{415}{3,220}$$

Now divide 3,220 into 415. You should get approximately 0.129.

Rounding Decimals to the Nearest Place

To round a decimal to the nearest place, look at the digit immediately to the right of that place. If that digit is 5, 6, 7, 8, or 9, then round up. If the digit immediately to the right of the place you are rounding to is 0, 1, 2, 3, or 4, then don't change the digit at the place you are rounding. In either case, in the rounded-off number, there will be no digits to the right of the place you are rounding.

Example: Round 0.12763 to the nearest thousandth.

Solution: The digit in the thousandths place is 7. The digit immediately to the right of the 7 is a 6. Because 6 is among the digits that are 5 or more, round up the thousandths digit from 7 to 8. So 0.12763 rounded to the nearest thousandth is 0.128.

Example: Round 0.5827 to the nearest hundredth.

Solution: The digit in the hundredths place is 8. Immediately to the right of the 8 is a 2. Because 2 is among the digits 0 through 4, keep the digit in the hundredths place the same. So 0.5827 rounded to the nearest hundredth is 0.58.

Scientific Notation

Scientific notation is a convention for expressing numbers that simplifies computation and standardizes results. To write a nonzero number in scientific notation, write the number in the form $a \times 10^n$, where n is an integer and $1 \leq a < 10$ or $-10 < a \leq -1$.

Example: $123 = 1.23 \times 10^2$

1.23 is the **coefficient**, and 2 is the **exponent**.

Example: $0.042 = 4.2 \times 10^{-2}$

You can obtain products and quotients of numbers expressed in scientific notation. When multiplying, one simply multiplies the coefficients and adds the exponents to find the new coefficient and exponent of the answer. Some additional conversion may be necessary so that the new coefficient a is such that $1 \leq a < 10$ or $-10 < a \leq -1$, as in the example below.

Example: $(1.1 \times 10^6)(5.0 \times 10^{17}) = ?$

Solution: Multiply the coefficients 1.1 and 5.0 and add the exponents 6 and 17. The answer is 5.5×10^{23}.

The quotient of two numbers expressed in scientific notation is obtained by dividing the coefficient in the numerator by the coefficient in the denominator and subtracting the exponent in the denominator from the exponent in the numerator.

Example: $\dfrac{6.2 \times 10^5}{2.0 \times 10^{-7}} = ?$

Solution: Divide 6.2 by 2.0 and subtract -7 from 5 (note that $5 - (-7) = 5 + 7 = 12$). The answer is 3.1×10^{12}.

When a number expressed in scientific notation is raised to an exponent, the coefficient is raised to that exponent, and the original exponent is multiplied by that exponent.

Example: $(6.0 \times 10^4)^2$

Solution: Square the 6.0 and multiply the exponent by 2:

$(6.0)^2 \times 10^{4 \times 2} = 36.0 \times 10^8 = 3.6 \times 10^9$

Note that when you move the decimal point one place to the left you must increase the exponent of the 10 by one, from 8 to 9.

When adding or subtracting numbers expressed in scientific notation, they must have the same exponent; when they do not, the appropriate conversion must be made first.

Example: $3.7 \times 10^4 + 1.5 \times 10^3 = ?$

Solution: First, convert 1.5×10^3 to 0.15×10^4 so both numbers have the same exponent:

$3.7 \times 10^4 + 0.15 \times 10^4 = 3.85 \times 10^4$, which can be rounded to 3.9×10^4.

PERCENTS

Percents are a special kind of ratio. Any percent can be expressed as a fraction with a denominator of 100 (*cent* means "one hundred," so *percent* means "per one hundred"). When you see the symbol %, think of it as the factor $\frac{1}{100}$. Thus, $70\% = 70\left(\frac{1}{100}\right)$.

To convert a percent to a fraction or decimal, divide the percent by 100%. Because 100% = 1, you are dividing the percent by 1 and are not changing the value of the percent. In the case where the percent is in the form of a decimal number followed by the percent symbol %, the shortcut is to drop the percent symbol and move the decimal point in the number two places to the left.

Percent to fraction: $78\% = \frac{78\%}{100\%} = \frac{78}{100}$

Note that in going from $\frac{78\%}{100\%}$ to $\frac{78}{100}$, the percent symbol %, which represents the factor $\frac{1}{100}$, was cancelled from the numerator and denominator.

Percent to decimal: $78\% = 0.78$

$$78\% = \frac{78\%}{100\%} = \frac{78}{100} = 0.78$$

To convert any fraction or decimal to a percent, just multiply by 100%. For decimals, just move the decimal point two places to the right and add a percent sign. For fractions, remember to reduce if you can before you multiply.

Decimal to percent: $0.29 = 0.29 \times 100\% = 29\%$

$0.3 = 0.30 \times 100\% = 30\%$

$1.45 = 1.45 \times 100\% = 145\%$

Fraction to percent: $\frac{3}{5} = \frac{3}{5} \times 100\% = \frac{3(100)}{5}\% = 3(20)\% = 60\%$

Know these common conversions. They come up frequently on the test, and you can avoid errors and save time by memorizing them instead of having to calculate them on the test.

In general, a digit with a bar over it means that the digit repeats indefinitely. In the table below, $0.3\overline{3}$ means that the 3 with the bar over it repeats indefinitely. Thus, $0.3\overline{3} = 0.3333\ldots$

Fraction	Decimal	Percent
$\frac{1}{1}$	1.0	100%
$\frac{3}{4}$	0.75	75%
$\frac{2}{3}$	$0.6\overline{6}$	$66\frac{2}{3}\%$
$\frac{1}{2}$	0.5	50%
$\frac{1}{3}$	$0.3\overline{3}$	$33\frac{1}{3}\%$
$\frac{1}{4}$	0.25	25%
$\frac{1}{5}$	0.2	20%
$\frac{1}{8}$	0.125	$12\frac{1}{2}\%$
$\frac{1}{10}$	0.1	10%
$\frac{1}{20}$	0.05	5%

The Percent Formula

The percent formula is commonly expressed in two different ways that are mathematically identical. Memorize and use whichever version of the formula you prefer. Notice how easy it is to get from one formula to the other—just multiply or divide both sides of the equation by the Whole.

$$\text{Percent} = \frac{\text{Part}}{\text{Whole}}$$

$$\text{Percent} \times \text{Whole} = \text{Part}$$

If the Part is 3 and the Whole is 4, then the Percent $= \frac{3}{4} = 0.75 = 75\%$.

If the Percent is 20% and the Whole is 8, then the Part $= 20\%(8) = (0.2)(8) = 1.6$.

If the Percent is 60% and the Part is 12, then $60\% \times (\text{Whole}) = 12$. So:

$$\text{Whole} = \frac{12}{60\%} = \frac{12}{\left(\frac{6}{10}\right)} = 12\left(\frac{10}{6}\right) = 20.$$

Translating

Translating percent word problems into math is relatively easy. Whenever you see the phrase "what percent *of* . . . *is* . . .?," whatever follows the word *of* is the Whole and whatever follows the verb (often *is* or *are*) is the Part.

QR

Example: 25% of 48 is 12.

$$\frac{\text{(part)}\,12}{\text{(whole)}\,48} = 25\%$$

Example: What percent of the songbirds are cardinals?

You don't really have to know what the question is talking about to know that the Whole is the number of songbirds and the Part is the number of cardinals.

Percent Increase/Decrease

Once you understand percents, percent increase and decrease are not as difficult as they may seem.

$$\% \text{ increase} = \frac{\text{Amount of increase}}{\text{Original whole}} \times 100\%$$

$$\% \text{ decrease} = \frac{\text{Amount of decrease}}{\text{Original whole}} \times 100\%$$

$$\text{New whole} = \text{Original whole} \pm \text{Amount of change}$$

Look at the first equation above. To find a percent increase, divide the amount of increase by the original whole. Then multiply this fraction by 100%.

Example: If a number increases from 50 to 70, what is the percent increase?

Solution: The amount of increase is $70 - 50$, or 20. The original whole is 50. So the percent increase is

$$\frac{20}{50} \times 100\% = \frac{2}{5} \times 100\%.$$

What you learned about reducing fractions can help here:

$$\frac{2}{5} \times 100\% = 2 \times 20\% = 40\%$$

If the new price of an item is 130% of its previous price, then it has increased in price by 30%. If an item goes on sale at 60% of its previous price, then it has decreased in price by 40%.

QR

The percent increase or decrease is just the difference in percent from the whole (which is always equal to 100%).

The following table shows which formula to use—percent increase or percent decrease—when you come across different phrases in word problems:

Percent Increase	Percent Decrease
percent higher than	percent lower than
percent greater than	percent less than
percent gain	percent loss
percent more than	percent less than

Table 56.1

If X is n% greater than Y, then X is $(100 + n)$% of Y. For example, if X is 10% greater than Y, then X is 110% of Y.

If X is n% less than Y, then X is $(100 - n)$% of Y. For example, If X is 70% less than Y, then X is 30% of Y.

Example: If the value of a certain piece of property now is 350% of its original value when Kim purchased it, by what percent has the value of the property increased since Kim purchased it?

Solution: The percent increase is the difference from 100%. So there was a 350% − 100% = 250% increase.

AVERAGES

Formula for Computing Averages (**Mean**)

The average formula is $\text{Average} = \dfrac{\text{Sum of the terms}}{\text{Number of terms}}$

To find the mean of a set of numbers, add them up (the sum of the terms) and divide by the number of numbers (the number of terms).

Example: To find the average of the five numbers 12, 15, 23, 40, and 40, first add them: $12 + 15 + 23 + 40 + 40 = 130$. Then divide the sum by 5: $130 \div 5 = 26$.

Using the Average to Find the Sum

$\text{Sum} = (\text{Average}) \times (\text{Number of terms})$

Example: If the average of 10 numbers is 50, then they add up to 50×10, or 500.

QR

Finding the Missing Number

To find a missing number when you're given the average, use the sum.

Example: If the average of four numbers is 7, then the sum of those four numbers is 4×7, or 28. Suppose that three of the numbers are 3, 5, and 8. These three numbers add up to 16 of that 28, which leaves $28 - 16 = 12$ for the fourth number.

CONVERSIONS

Occasionally you will be asked to convert a quantity in a question. The quantity will be a number of units of something. Examples of quantities are 450 miles and 12 pounds. Converting a quantity means expressing the quantity in a different unit.

Example: If the distance between the city of New York and the city of London is approximately 3,500 miles, how many inches apart are these cities?

Solution: To convert from miles to inches, first convert miles to feet and then convert feet to inches:

3,500 miles (5,280 feet/1 mile)

= 18,480,000 feet (12 inches/1 foot)

= 221,760,000 inches.

Now 221,760,000 rounded to the nearest million is 222,000,000, which in scientific notation is 2.2×10^8.

Example: The moon revolves around the Earth at a speed of approximately 1.02 kilometers per second. How many kilometers per hour is this approximate speed?

Solution: Since the question asks for kilometers per hour, begin by converting seconds to minutes and then converting minutes to hours.

(1.02 kilometers/1 second) (60 seconds/1 minute)

= (61.2 kilometers/1 minute) (60 minutes/1 hour)

= 3,672 kilometers/hour.

LOGARITHMS

The properties of logarithms are dependent on the laws of exponents; therefore, a review of exponents is necessary before the introduction of logarithms.

In the equation:

$$b^c = x$$

b is the base

c is the exponent

x is b raised to the exponent c, where b is positive and not equal to 1.

In the equation above, the exponent c may be an integer, a fraction, or an irrational number. The value of c may be positive, negative, or 0.

In the equation $b^c = x$, the exponent c is the exponent to which b must be raised to obtain the number x. This relationship is described by the statement "The logarithm of x to the base b," which means if $b^c = x$, then the logarithm to the base b of x is c. In other words:

The logarithm to the base b of a positive number x is equal to the exponent to which b must be raised to obtain x:

$$\text{If: } \log_b (x) = c, \text{ then: } b^c = x$$

Examples: $\log_4 (16) = 2$, since $4^2 = 16$

$\log_{10} (10{,}000) = 4$, since $10^4 = 10{,}000$

$\log_{25} (5) = \frac{1}{2}$, since $25^{\frac{1}{2}} = 5$

Example: If $\log_5 (x) = 3$, then $x = ?$

Solution: The expression $\log_5 (x) = 3$ means that $5^3 = x$; therefore, $x = 125$.

Example: If $\log_b (36) = 2$, then $b = ?$

Solution: The expression $\log_b (36) = 2$ means that $b^2 = 36$; therefore, $b = 6$. If $b^2 = 36$, then $b = 6$ or $b = -6$. However, since you are working with a logarithm to the base b, b must be positive and not equal to 1. Thus, you cannot have $b = -6$. In this example, the only possible value of b is 6.

Example: If $\log_{10} (100) = c$, then $c = ?$

Solution: The expression $\log_{10} (100) = c$ means that $10^c = 100$. Now $100 = 10^2$. Thus, $10^c = 10^2$. Therefore, $c = 2$.

Properties of Logs

The logarithm of the product of two numbers equals the sum of the individual logarithms:

$$\log_b (s \times t) = \log_b (s) + \log_b (t)$$

The logarithm of a quotient of two numbers is the logarithm of the numerator minus the logarithm of the denominator:

$$\log_b \left(\frac{s}{t}\right) = \log_b(s) - \log_b(t)$$

The logarithm of a power with a positive base is equal to the exponent of the power multiplied by the logarithm of the base of that power:

$$\log_b (s^p) = p \times \log_b (s)$$

QR

817

Log Base 10

Most commonly, logs are expressed in base 10. This means that an increase of one logarithmic unit (in base 10) corresponds to a multiplication of 10 of the actual total.

$$\log_{10}(0.1) = -1, \text{ since } 10^{-1} = 0.1$$
$$\log_{10}(1) = 0, \text{ since } 10^0 = 1$$
$$\log_{10}(10) = 1, \text{ since } 10^1 = 10$$
$$\log_{10}(100) = 2, \text{ since } 10^2 = 100$$
$$\log_{10}(1{,}000) = 3, \text{ since } 10^3 = 1{,}000$$

When working with logarithms to the base of 10, $\log_{10}(x)$ is often written $\log(x)$. For example, $\log(5.3)$ means $\log_{10}(5.3)$. When working with logarithms to the base 10, the integer of the logarithm of a number is called the **characteristic** and the decimal fraction of the logarithm of the number is called the **mantissa**. For example, consider $\log(7{,}435)$ (note that $\log(7{,}435)$ means $\log_{10}(7{,}435)$.) You have that $\log(7{,}435) = 3.87128$. In this case, for $\log(7{,}435)$, the characteristic is 3 and the mantissa is 0.87128. Shifting the decimal point to the right or left in a number increases or decreases the characteristic of the logarithm of that number as seen below:

Example: $\log(4.26) = \log(1 \times 4.26) = \log(10^0) + \log(4.26) = 0 + 0.62941 = 0.62941 + 0$

$\log(0.426) = \log(0.1 \times 4.26) = \log(10^{-1}) + \log(4.26) = -1 + 0.62941 = 0.62941 - 1$

$\log(0.0426) = \log(0.01 \times 4.26) = \log(10^{-2}) + \log(4.26) = -2 + 0.62941 = 0.62941 - 2$

$\log(42.6) = \log(10 \times 4.26) = \log(10^1) + \log(4.26) = 1 + 0.62941 = 0.62941 + 1$

$\log(426) = \log(10^2 \times 4.26) = \log(10^2) + \log(4.26) = 2 + 0.62941 = 0.62941 + 2$

REVIEW PROBLEMS

1. The average of 3, 15, 18, and 8 is

 A. 5
 B. 9
 C. 11
 D. 15
 E. 18

2. Which of the following fractions is largest?

 A. $\frac{2}{5}$

 B. $\frac{1}{2}$

 C. $\frac{2}{7}$

 D. $\frac{2}{10}$

 E. $\frac{3}{9}$

3. $\frac{2}{7} + \frac{1}{4} =$

 A. $\frac{1}{11}$

 B. $\frac{3}{28}$

 C. $\frac{15}{28}$

 D. $\frac{7}{8}$

 E. $\frac{13}{11}$

4. $6\frac{1}{7} - 3\frac{4}{7} =$

 A. $2\frac{3}{7}$

 B. $2\frac{4}{7}$

 C. $3\frac{3}{7}$

 D. $3\frac{4}{7}$

 E. $3\frac{6}{7}$

5. Which of the following numbers is smallest?

 A. 0.1
 B. 0.01
 C. 0.0407
 D. 0.03995
 E. 0.043999

6. What is the value of $5\frac{1}{4} \div 7$?

 A. $\frac{7}{20}$

 B. $\frac{5}{7}$

 C. $\frac{3}{4}$

 D. $\frac{6}{7}$

 E. 3

7. $16 + 0.267 + 36.78 =$

 A. 5.347
 B. 8.26
 C. 50.036
 D. 52.047
 E. 53.047

8. What is the cost of a blouse that is priced at $50.00 with a tax of 7%?

 A. $35.00
 B. $50.35
 C. $53.50
 D. $62.75
 E. $85.00

9. If a pencil costs $0.26, what is the cost of 96 pencils?

 A. $2.49
 B. $12.00
 C. $24.00
 D. $22.96
 E. $24.96

10. What is the value of $2,886 \div 37$?

 A. 78
 B. 708
 C. 780
 D. 7,008
 E. 7.800

SOLUTIONS TO REVIEW PROBLEMS

1. **C** Average $= \dfrac{\text{Sum of the terms}}{\text{Number of terms}}$

 Here, the average is $\dfrac{3+15+18+8}{4} = \dfrac{44}{4} = 11$.

2. **B** Begin by comparing choice (A), $\dfrac{2}{5}$, and choice (B), $\dfrac{1}{2}$. $\dfrac{2}{5}$ has a numerator that is less than

 half of its denominator, so choice (A) is less than $\dfrac{1}{2}$. Choice (A) can be eliminated. Choices

 (C), (D) and (E) both have numerators that are less than half of their denominators, so

 these choices are also less than $\dfrac{1}{2}$ and can therefore also be eliminated. This means that

 choice (B), $\dfrac{1}{2}$, is the largest.

3. **C** $\dfrac{2}{7} + \dfrac{1}{4} = \left(\dfrac{2}{7} \times \dfrac{4}{4}\right) + \left(\dfrac{1}{4} \times \dfrac{7}{7}\right) = \dfrac{8}{28} + \dfrac{7}{28} = \dfrac{15}{28}$

4. **B** $6\dfrac{1}{7} - 3\dfrac{4}{7} = \left(6 + \dfrac{1}{7}\right) - 3\dfrac{4}{7} = \left(5 + \dfrac{7}{7} + \dfrac{1}{7}\right) - 3\dfrac{4}{7} = 5\dfrac{8}{7} - 3\dfrac{4}{7} = 2\dfrac{4}{7}$

5. **B** Choice (A) has a tenths digit of 1, while choices (B), (C), (D), and (E) each have a tenths
 digit of 0. So choice (A) can be eliminated. Next, look at the hundredths digit: choice (B)
 has the smallest value at 1, so (B) is the smallest number.

6. **C** When you divide one fraction by another, you invert the second fraction and multiply.

 Think of the integer 7 as the fraction $\dfrac{7}{1}$, so that you can invert it to get the fraction $\dfrac{1}{7}$.

 Rewrite $5\dfrac{1}{4}$ as an improper fraction. $5\dfrac{1}{4} = \dfrac{5 \times 4 + 1}{4} = \dfrac{20 + 1}{4} = \dfrac{21}{4}$.

 Then $5\dfrac{1}{4} \div 7 = \dfrac{21}{4} \div \dfrac{7}{1} = \dfrac{21}{4} \times \dfrac{1}{7} = \dfrac{21 \times 1}{4 \times 7} = \dfrac{21}{28} = \dfrac{3}{4}$.

7. **E** Write the numbers in a column, making sure to align the decimal points. Write 16 as
 16.000 and write 36.78 as 36.780.

 $$\begin{array}{r} 16.000 \\ 0.267 \\ +\,36.780 \\ \hline 53.047 \end{array}$$

8. **C** Add 7% of 50 to 50. 7% of 50 is $\dfrac{7}{100} \times 50 = \dfrac{7}{2} \times 1 = \dfrac{7}{2} = 3\dfrac{1}{2} = 3.5$. So the cost of the blouse
 is $50 + $3.50, or $53.50.

9. **E** Multiply the cost of one pencil by the number of pencils. The cost of all the pencils is $0.26 \times 96 = 24.96.

10. **A**
$$\begin{array}{r} 78 \\ 37\overline{)2886} \\ \underline{259} \\ 296 \\ \underline{296} \\ 0 \end{array}$$

CHAPTER SIXTY

Algebra

LEARNING OBJECTIVES

After this chapter, you will be able to:

- Map word problems to mathematical formulas
- Apply rules of exponents, simultaneous equations, and polynomial math to solve for unknown variables
- Solve for unknown variables in fractions, exponents, and quadratic equations
- Apply absolute value and inequality rules to solve for unknown variables

Algebra uses the concepts of arithmetic and number properties but adds a twist: variables. **Variables** represent unknown quantities, and many algebraic questions task you with determining what numerical values variables actually represent. Variables are often defined by the rules of **equations** and **inequalities**, statements that show the relationship between two or more expressions as equal (equations) or greater than or less than each other (inequalities).

WORD PROBLEMS

Often the most challenging aspect of algebra problems is the odd way in which information is presented. Don't get frustrated; just break down the information into small pieces and take things one step at a time. Word problems can usually be translated from left to right, but this is not always the case. Say you see this sentence: "The number of stamps in George's stamp collection is twice the number that is 5 less than the number of stamps in Bill's stamp collection." Instead of trying to translate it into math all in one step, approach it piece by piece.

Whenever possible, choose letters for the variables that make sense in the context of the problem. For example, start by calling the number of stamps in George's stamp collection G and the number of stamps in Bill's stamp collection B. Now, think about the relationship between the two amounts: G is not compared to B but to 5 less than B, or $(B - 5)$. So G is twice as large as $(B - 5)$. To set them *equal* to each other, multiply $(B - 5)$ by two. The equation is $G = 2(B - 5)$.

The hardest part of word problems is the process of taking the English sentences and extracting the math from them. The actual math in word problems tends to be the easiest part. The following translation table will help you start dealing with English-to-math translation:

Word Problems Translation Table	
English	**Math**
equals, is, was, will be, has, costs, adds up to, the same as, as much as	$=$
times, of, multiplied by, product of, twice, double, by	\times
divided by, per, out of, each, ratio	\div
plus, added to, and, sum, combined	$+$
minus, subtracted from, smaller than, less than, fewer, decreased by, difference between	$-$
a number, how much, how many, what	x, n, etc.

Table 57.1

Example: w is x less than y.

Solution: $w = y - x$

Example: Giuseppa's weight is 75 pounds more than twice Jovanna's weight.

Solution: $G = 2J + 75$

Example: In 5 years, Sandy will be 4 years younger than twice Tina's age.

Solution: $(S + 5) = 2(T + 5) - 4$

Notice here that the statement discusses the ages of Sandy and Tina *in five years*, so you must represent their ages as $(S + 5)$ and $(T + 5)$, respectively. One common mistake is to translate the right side of the equation as $2T + 5 - 4$, but that is not equivalent to $2(T + 5) - 4$.

Example: The sum of Richard's age and Cindy's age in years is 17 more than the amount by which Tim's age is greater than Kathy's age.

Solution: $R + C = (T - K) + 17$

EXPONENTS

You can't be adept at algebra unless you're completely at ease with exponents. Here's what you need to know:

Multiplying powers with the same base: To multiply powers with the same base, keep the base and add the exponents:

$$x^3 \times x^4 = x^{3+4} = x^7$$

Dividing powers with the same base: To divide powers with the same base, keep the base and subtract the exponents:

$$y^{13} \div y^8 = y^{13-8} = y^5$$

Raising a power to an exponent: To raise a power to an exponent, keep the base and multiply the exponents:

$$(x^3)^4 = x^{3 \times 4} = x^{12}$$

Multiplying powers with the same exponent: To multiply powers with the same exponent, multiply the bases and keep the exponent:

$$(3^x)(4^x) = (3 \times 4)^x = 12^x$$

Dividing powers with the same exponent: To divide powers with the same exponent, divide the bases and keep the exponent:

$$\frac{6^x}{2^x} = \left(\frac{6}{2}\right)^x = 3^x$$

Example: For all $xyz \neq 0$, $\dfrac{6x^2 y^{12} z^6}{(2x^2 yz)^3} = ?$

Solution: The first step is to eliminate the parentheses. Everything inside gets cubed:

$$\frac{6x^2 y^{12} z^6}{(2x^2 yz)^3} = \frac{6x^2 y^{12} z^6}{8x^6 y^3 z^3}$$

The next step is to look for factors common to the numerator and denominator. The 6 on the top and the 8 on the bottom reduce to 3 over 4. The x^2 on the top cancels with the x^6 on the bottom, leaving x^4 on the bottom.

You're actually subtracting the exponents: $2 - 6 = -4$. The x^{-4} on the top is the same as $\dfrac{1}{x^4}$. The y^{12} on the top cancels with the y^3 on the bottom, leaving y^9 on the top. And the z^6 on the top cancels with the z^3 on the bottom, leaving z^3 on the top:

$$\frac{6x^2 y^{12} z^6}{8x^6 y^3 z^3} = \frac{3y^9 z^3}{4x^4}$$

ADDING, SUBTRACTING, AND MULTIPLYING POLYNOMIALS

Algebra is the basic language of mathematics, and you will want to be fluent in that language. You might not get a whole lot of questions that ask explicitly about such basic algebra procedures as combining like terms, multiplying binomials, or factoring algebraic expressions, but you will do all of those things in the course of working out the answers to more advanced questions. So it's essential that you be at ease with the mechanics of algebraic manipulations.

Combining like terms: To combine like terms, keep the variable part unchanged while adding or subtracting the coefficients:

$$2a + 3a = (2 + 3)a = 5a$$

Adding or subtracting polynomials: To add or subtract polynomials, combine like terms:

$$(3x^2 + 5x - 7) - (x^2 + 12)$$
$$= 3x^2 + 5x - 7 - x^2 - 12$$
$$= (3x^2 - x^2) + 5x + (-7 - 12)$$
$$= 2x^2 + 5x - 19$$

Multiplying monomials: To multiply monomials, multiply the coefficients and the variables separately:

$$2x \times 3x = (2 \times 3)(x \times x) = 6x^2$$

Multiplying binomials: To multiply binomials, use FOIL. To multiply $(x + 3)$ by $(x + 4)$, first multiply the First terms: $x \times x = x^2$; next the Outer terms: $x \times 4 = 4x$; then the Inner terms: $3 \times x = 3x$; and finally the Last terms: $3 \times 4 = 12$. Then add and combine like terms:

$$x^2 + 4x + 3x + 12 = x^2 + 7x + 12$$

Multiplying polynomials: To multiply polynomials with more than two terms, make sure you multiply each term in the first polynomial by each term in the second. (FOIL works only when you want to multiply two binomials.)

$$(x^2 + 3x + 4)(x + 5) = x^2(x + 5) + 3x(x + 5) + 4(x + 5)$$
$$= x^3 + 5x^2 + 3x^2 + 15x + 4x + 20$$
$$= x^3 + 8x^2 + 19x + 20$$

After multiplying two polynomials together, the number of terms in your expression before simplifying should equal the number of terms in one polynomial multiplied by the number of terms in the second. In the example above, you should have $3 \times 2 = 6$ terms in the product before you simplify like terms.

DIVIDING POLYNOMIALS

To divide polynomials, you can use long division. For example, to divide $2x^3 + 13x^2 + 11x - 16$ by $x + 5$:

$$x + 5 \overline{)2x^3 + 13x^2 + 11x - 16}$$

The first term of the quotient is $2x^2$, because that's what will give you a $2x^3$ as a first term when you multiply it by $x + 5$:

$$
\begin{array}{r}
2x^2 \phantom{{}+13x^2+11x-16} \\
x + 5 \overline{)2x^3 + 13x^2 + 11x - 16} \\
2x^3 + 10x^2 \phantom{{}+11x-16}
\end{array}
$$

Subtract and continue in the same way as when dividing numbers:

$$\begin{array}{r} 2x^2 \;+\; 3x \;-\; 4 \\ x+5\overline{)2x^3 + 13x^2 + 11x - 16} \\ \underline{2x^3 + 10x^2} \\ 3x^2 + 11x \\ \underline{3x^2 + 15x} \\ -4x - 16 \\ \underline{-4x - 20} \\ 4 \end{array}$$

The result is $2x^2 + 3x - 4$ with a remainder of 4.

Example: When $2x^3 + 3x^2 - 4x + k$ is divided by $x + 2$, the remainder is 3. What is the value of k?

Solution: To answer this question, start by cranking out the long division:

$$\begin{array}{r} 2x^2 \;-\; x \;-\; 2 \\ x+2\overline{)2x^3 + 3x^2 - 4x + k} \\ \underline{2x^3 + 4x^2} \\ -x^2 - 4x \\ \underline{-x^2 - 2x} \\ -2x + k \\ \underline{-2x - 4} \\ k + 4 \end{array}$$

The question says that the remainder is 3, so whatever k is, when you add 4, you get 3:

$k + 4 = 3$

$k = -1$

FACTORING

Performing operations on polynomials is largely a matter of cranking it out. Once you know the rules, adding, subtracting, multiplying, and even dividing is automatic. Factoring algebraic expressions is a different matter. To factor successfully, you have to do more thinking and less cranking. You have to try to figure out what expressions multiplied will give you the polynomial you're looking at. Sometimes that means having a good eye for the test makers' favorite factorables:

- Factor common to all terms

- Difference of squares

- Square of a binomial

Factor common to all terms: A factor common to all the terms of a polynomial can be factored out. This is essentially the distributive property in reverse. For example, all three terms in the polynomial $3x^3 + 12x^2 - 6x$ contain a factor of $3x$. Pulling out the common factor yields $3x(x^2 + 4x - 2)$.

Difference of squares: You will want to be especially keen at spotting polynomials in the form of the difference of squares. Whenever you have two identifiable squares with a minus sign between them, you can factor the expression like this:

$$a^2 - b^2 = (a + b)(a - b)$$

$4x^2 - 9$, for example, factors to $(2x + 3)(2x - 3)$.

Squares of binomials: Learn to recognize polynomials that are squares of binomials:

$$a^2 + 2ab + b^2 = (a + b)^2$$
$$a^2 - 2ab + b^2 = (a - b)^2$$

Polynomials such as those seen above can be expressed as a product of two or more polynomials of lower positive degree. Each of these polynomials is referred to as a factor of the given polynomial. Unless stated in the question otherwise, one can assume only integer coefficients for the factors of a polynomial with integer coefficients.

For example, $4x^2 + 12x + 9$ factors to $(2x + 3)^2$, and $a^2 - 10a + 25$ factors to $(a - 5)^2$.

Sometimes you'll want to factor a polynomial that's not in any of these classic factorable forms. When that happens, factoring becomes a kind of logic exercise with some trial and error thrown in. To factor a quadratic expression, think about what binomials you could use FOIL on to get that quadratic expression. For example, to factor $x^2 - 5x + 6$, think about what First terms will produce x^2, what Last terms will produce $+6$, and what Outer and Inner terms will produce $-5x$. Some common sense—and a little trial and error—will lead you to $(x - 2)(x - 3)$.

Example: For all $x \neq \pm 3$, $\dfrac{3x^2 - 11x + 6}{9 - x^2} =$

 A. $\dfrac{2x - 3}{x + 3}$

 B. $\dfrac{2 - 3x}{x + 3}$

 C. $\dfrac{2x + 3}{x + 3}$

 D. $\dfrac{3x - 2}{x - 3}$

 E. $\dfrac{x - 3}{2x + 3}$

Solution: To reduce a fraction, you eliminate factors common to the top and the bottom. So the first step in reducing an algebraic fraction is to *factor the numerator and denominator.* Here, the denominator is the difference of squares: $9 - x^2 = (3 - x)(3 + x)$. The numerator takes some thought and some trial and error. For the first term to be $3x^2$, the first terms of the factors must be $3x$ and x. For the last term of the polynomial in the numerator to be $+6$, the last terms of the binomials must be either $+2$ and $+3$, -2 and -3, $+1$ and $+6$, or -1 and -6. After a few tries, you should come up with: $3x^2 - 11x + 6 = (3x - 2)(x - 3)$. Now the fraction looks like this:

$$\frac{3x^2 - 11x + 6}{9 - x^2} = \frac{(3x - 2)(x - 3)}{(3 - x)(3 + x)}$$

In this form there are no precisely common factors, but there is a factor in the numerator that's the opposite (negative) of a factor in the denominator: $x - 3$ and $3 - x$ are opposites. Factor -1 out of the numerator and get:

$$\frac{(3x - 2)(x - 3)}{(3 - x)(3 + x)} = \frac{(-1)(3x - 2)(3 - x)}{(3 - x)(3 + x)}$$

Now $(3 - x)$ can be eliminated from both the top and the bottom:

$$\frac{(-1)(3x - 2)(3 - x)}{(3 - x)(3 + x)} = \frac{-(3x - 2)}{3 + x} = \frac{-3x + 2}{3 + x}$$

That's the same as choice (B):

$$\frac{-3x + 2}{3 + x} = \frac{2 - 3x}{x + 3}$$

Alternative: Here's another way to answer this question. Pick a number for x, and see what happens. At least one of the answer choices, the correct answer choice, will give you the same value as the original fraction, no matter what you plug in for x. However, some of the incorrect answer choices might give you the same value as the original fraction for the value that you plug in. Pick a number that's easy to work with—like 0.

When you plug $x = 0$ into the original expression, any term with an x drops out, and you end up with $\frac{6}{9}$, or $\frac{2}{3}$. Now plug $x = 0$ into each answer choice to see which ones equal $\frac{2}{3}$. Eliminate any answer choices that do not equal $\frac{2}{3}$ when $x = 0$.

When you get to (B), it works, but you can't stop there. Sometimes one or more incorrect answer choices will work for the particular value that you choose. When you pick numbers, *look at every answer choice*. All the incorrect answer choices must be eliminated when using the method of picking numbers. Choice (D) also works for $x = 0$. At least you know one of those is the correct answer, and you can decide between them by picking another value for x.

This is not a sophisticated approach, but who cares? You don't get points for elegance. You get points for right answers.

Example: Factor the following polynomial: $8xy + 18y^2$.

Solution: You can see that $2y$ is greatest common factor of each term in the polynomial. Therefore, by the distributive law, you can factor:

$8xy + 18y^2 = 2y(4x + 9y)$

In this example, $2y$ is referred to as the greatest monomial factor of the given polynomial because it is the monomial with the greatest numerical coefficient that is a factor of each term in the polynomial and each variable of the monomial is raised to the greatest exponent that is a factor of each term of the polynomial. The other factor, $4x + 9y$, cannot be reduced to a product of factors of lower positive degree and therefore is irreducible. Moreover, the greatest monomial factor of $4x + 9y$ is 1. A polynomial is said to be completely factored when it is expressed as a product of a monomial, which may or may not be a constant, and one or more irreducible polynomials, each of which has 1 as its greatest monomial factor.

THE GOLDEN RULE OF EQUATIONS

You probably remember the basic procedure for solving algebraic equations: *do the same thing to both sides.* You can do almost anything you want to one side of an equation as long as you preserve the equality by doing the same thing to the other side. Your aim in whatever you do to both sides is to get the variable (or expression) you're solving for all by itself on one side.

Example: If $\sqrt[3]{8x+6} = -3$, what is the value of x ?

Solution: To solve this equation for x, do whatever you must to both sides of the equation to isolate x on one side. Layer by layer you want to peel away all those extra symbols and numbers around the x. First you want to get rid of that cube-root symbol. The way to undo a cube root is to cube both sides:

$$\sqrt[3]{8x+6} = -3$$
$$\left(\sqrt[3]{8x+6}\right)^3 = (-3)^3$$
$$8x + 6 = -27$$

Next, subtract 6 from both sides and divide both sides by 8:

$$8x + 6 = -27$$
$$8x = -27 - 6$$
$$8x = -33$$
$$x = -\frac{33}{8} = -4.125$$

The test makers have a few favorite equation types that you should be prepared to solve. Solving linear equations is usually straightforward. Generally, it's obvious what to do to isolate the unknown. But when the unknown is in a denominator or an exponent, how to proceed might not be so obvious.

UNKNOWN IN A DENOMINATOR

The basic procedure for solving an equation is the same even when the unknown is in a denominator: do the same thing to both sides. In this case, you multiply to undo division.

If you wanted to solve $1 + \frac{1}{x} = 2 - \frac{1}{x}$, you would multiply both sides by x:

$$1 + \frac{1}{x} = 2 - \frac{1}{x}$$
$$x\left(1 + \frac{1}{x}\right) = x\left(2 - \frac{1}{x}\right)$$
$$x + 1 = 2x - 1$$

Now you have an equation with no denominators, which is easy to solve:

$$x + 1 = 2x - 1$$
$$x - 2x = -1 - 1$$
$$-x = -2$$
$$x = 2$$

Another good way to solve an equation with the unknown in the denominator is to *cross multiply*. That's the best way to do the following example.

Example: If $\dfrac{5}{x+3} = \dfrac{1}{x} + \dfrac{1}{2x}$, what is the value of x?

Solution: Before you can cross multiply, you need to re-express the right side of the equation as a single fraction. That means giving the two fractions a common denominator and adding them. The common denominator to use is $2x$:

$$\frac{5}{x+3} = \frac{1}{x} + \frac{1}{2x}$$

$$\frac{5}{x+3} = \frac{2}{2x} + \frac{1}{2x}$$

$$\frac{5}{x+3} = \frac{3}{2x}$$

Now cross multiply:

$$\frac{5}{x+3} = \frac{3}{2x}$$
$$(5)(2x) = (x+3)(3)$$
$$10x = 3x + 9$$
$$10x - 3x = 9$$
$$7x = 9$$
$$x = \frac{9}{7}$$

UNKNOWN IN AN EXPONENT

The procedure for solving an equation when the unknown is in an exponent is a little different. What you want to do in this situation is to re-express one or both sides of the equation so that the two sides have the same base.

Example: If $8^x = 16^{x-1}$, then $x =$

 A. $\dfrac{1}{8}$

 B. $\dfrac{1}{2}$

 C. 2

 D. 4

 E. 8

QR

Solution: In this case, the base on the left is 8 and the base on the right is 16. They're both powers with bases of 2 and integer exponents, so you can re-express both sides as powers with bases of 2:

$(2^3)^x = (2^4)^{(x-1)}$

$2^{3x} = 2^{4(x-1)}$

$2^{3x} = 2^{(4x-4)}$

Thus, $2^{3x} = 2^{(4x-4)}$. When two powers have the same base, they must have equal exponents. Here, you can simply set the exponent expressions equal and solve for x:

$3x = 4x - 4$

$3x - 4x = -4$

$-x = -4$

$x = 4$

Choice (D) is correct.

Alternative: Here's another way to answer this question: Use Backsolving. Here, if you start with choice (C) and $x = 2$, you get $8^x = 8^2 = 64$ on the left side of the equation and $16^{(x-1)} = 16^{(2-1)} = 16^1 = 16$ on the right side. It's not clear whether (C) was too small or too large, so you should probably try (D) next—it's easier to work with than (B), which is a fraction (and that's also why you didn't want to start with it first). If $x = 4$, then $8^x = 8^4 = 4,096$ on the left side, and $16^{(x-1)} = 16^{(4-1)} = 16^3 = 4,096$ on the right side. No need to do any more. Choice (D) works, so it's the answer.

QUADRATIC EQUATIONS

To solve a quadratic equation, put it in the $ax^2 + bx + c = 0$ form, factor the left side (if you can), and set each factor equal to 0 separately to get the two solutions. To solve $x^2 + 12 = 7x$, first rewrite it as $x^2 - 7x + 12 = 0$. Then factor the left side:

$$x^2 - 7x + 12 = 0$$
$$(x - 3)(x - 4) = 0$$
$$x - 3 = 0 \text{ or } x - 4 = 0$$
$$x = 3 \text{ or } x = 4$$

Sometimes the left side may not be obviously factorable. You can always use the *quadratic formula*. Just plug the coefficients a, b, and c from $ax^2 + bx + c = 0$ into the formula:

$$x = \frac{-b \pm \sqrt{b^2 - 4ac}}{2a}$$

To solve $x^2 + 4x + 2 = 0$, plug $a = 1$, $b = 4$, and $c = 2$ into the formula:

$$x = \frac{-4 \pm \sqrt{4^2 - 4 \cdot 1 \cdot 2}}{2 \cdot 1}$$

$$= \frac{-4 \pm \sqrt{8}}{2} = \frac{-4 \pm 2\sqrt{2}}{2} = -2 \pm \sqrt{2}$$

For all real numbers b and c, and all nonzero real numbers a, the quadratic equation $ax^2 + bx + c = 0$ has:

- Two different real roots if $b^2 - 4ac > 0$

- One double real root if $b^2 - 4ac = 0$

- Two complex conjugate roots if $b^2 - 4ac < 0$

"In Terms Of"

So far in this chapter, solving an equation has meant finding a numerical value for the unknown. When there's more than one variable in one equation, it's generally impossible to get numerical solutions. Instead, what you do is solve for the unknown *in terms of* the other variables.

To solve an equation for one variable in terms of another means to isolate the one variable on one side of the equation, leaving an expression containing the other variable on the other side of the equation.

For example, to solve the equation $3x - 10y = -5x + 6y$ for x in terms of y, isolate x:

$$3x - 10y = -5x + 6y$$
$$3x + 5x = 6y + 10y$$
$$8x = 16y$$
$$x = 2y$$

Example: If $a = \frac{b + x}{c + x}$, what is the value of x in terms of a, b, and c?

Solution: You want to get x on one side by itself. The first thing to do is eliminate the denominator by multiplying both sides by $c + x$:

$$a = \frac{b + x}{c + x}$$

$$a(c + x) = \frac{b + x}{c + x}(c + x)$$

$$ac + ax = b + x$$

Next, move all terms with x to one side and all terms without x to the other:
$$ac + ax = b + x$$
$$ax - x = b - ac$$

Now factor x out of the left side and divide both sides by the other factor to isolate x:

$$ax - x = b - ac$$

$$x(a - 1) = b - ac$$

$$x = \frac{b - ac}{a - 1}$$

SIMULTANEOUS EQUATIONS

You can get numerical solutions for more than one unknown if you are given more than one equation. Simultaneous Equations questions take a little thought to answer. Solving simultaneous equations almost always involves combining equations, but you have to figure out the best way to combine each unique set of equations.

You can solve for two variables only if you have two distinct equations. Two forms of the same equation will not be adequate. Combine the equations in such a way that one of the variables cancels out. For example, to solve the two equations $4x + 3y = 8$ and $x + y = 3$, multiply both sides of the second equation by -3 to get $-3x - 3y = -9$. Now add the two equations; the $3y$ and the $-3y$ cancel out, leaving $x = -1$. Plug that back into either one of the original equations and you'll find that $y = 4$.

Example: If $2x - 9y = 11$ and $x + 12y = -8$, what is the value of $x + y$?

Solution: If you just plow ahead without thinking, you might try to answer this question by solving for one variable at a time. That would work, but it would take a lot more time than this question needs. As usual, the key to this Simultaneous Equations question is to combine the equations, but combining the equations doesn't necessarily mean losing a variable. Look what happens here if you just add the equations as presented:

$$2x - 9y = 11$$
$$+ \underline{(x + 12y = -8)}$$
$$3x + 3y = 3$$

Suddenly you're almost there! Just divide both sides by 3 and you get $x + y = 1$.

ABSOLUTE VALUE AND INEQUALITIES

To solve an equation that includes absolute value signs, think about the two different cases. For example, to solve the equation $|x - 12| = 3$, think of it as two equations:

$$x - 12 = 3 \text{ or } x - 12 = -3$$
$$x = 15 \text{ or } 9$$

To solve an inequality, do whatever is necessary to both sides to isolate the variable. Just remember that when you multiply or divide both sides by a negative number, you must reverse the inequality sign. To solve $-5x + 7 < -3$, subtract 7 from both sides to get $-5x < -10$. Now divide both sides by -5, remembering to reverse the inequality sign: $x > 2$.

Example: What is the solution set of $|2x - 3| < 7$?

 A. $\{-5 < x < 2\}$
 B. $\{-5 < x < 5\}$
 C. $\{-2 < x < 5\}$
 D. $\{x < -5 \text{ or } x > 2\}$
 E. $\{x < -5 \text{ or } x < 2\}$

Solution: What does it mean if $|2x - 3| < 7$? It means that if the expression between the absolute value bars is positive, it's less than $+7$, or if the expression between the bars is negative, it's greater than -7. If the expression between the absolute value bars is 0, its absolute value is less than 7. In other words, $2x - 3$ is between -7 and $+7$:

$$-7 < 2x - 3 < 7$$
$$-4 < 2x < 10$$
$$-2 < x < 5$$

Choice (C) is correct.

In fact, there's a general rule that applies here: to solve an inequality in the form $|\text{whatever}| < p$, where $p > 0$; just put that "whatever" inside the range $-p$ to p:

$|\text{anything}| < p$ means: $-p < \text{anything} < p$
For example, $|x - 5| < 14$ becomes $-14 < x - 5 < 14$.

And here's another general rule: to solve an inequality in the form $|\text{whatever}| > p$, where $p > 0$; just put that "whatever" outside the range $-p$ to p:

$|\text{anything}| > p$ means: $\text{anything} < -p$ OR $\text{anything} > p$
For example, $\left|\dfrac{3x + 9}{2}\right| > 7$ becomes $\dfrac{3x + 9}{2} < -7$ or $\dfrac{3x + 9}{2} > 7$.

GRAPHING EQUATIONS

When graphing an equation, it's best to identify a few key parameters initially to get an overall sense of the function. Doing these in order provides a repeatable way to tackle almost any equation:

1. **Determine what type of function is presented.**

 Equations can be linear, absolute value, quadratic, polynomial, radical, and piecewise. Knowing what general category the equation or function falls under gives you an idea as to what the graph should look like.

 - **Linear:** These come in one of two general forms:
 - The graph of the equation $y = mx + b$ is a straight line where m = slope and $b = y$-intercept.
 - The graph of the equation $x =$ constant is a vertical line. This is not a function.
 - **Absolute Value:** The graph of the equation $y = |ax + b|$, where a and b are constants and $a \neq 0$, has a V-shape.
 - **Quadratic:** The graph of the equation $y = ax^2 + bx + c$, where $a \neq 0$, is a parabola.
 - **Polynomial:** The graph of the equation $y = p(x)$, where $p(x)$ is a polynomial, can take on any squiggly-line shape. When $p(x) = ax^2 + bx + c$, where $a \neq 0$, $p(x)$ is a quadratic polynomial.
 - **Radical:** The radical function cannot take a negative value under the radical.
 - **Piecewise:** These have no general form because they can be continuous or discontinuous functions that may take on the characteristic shapes of other general functions over certain ranges.

2. **Identify the y-intercepts and the x-intercepts.**

 Obvious points on the graph of an equation are points where the graph in question crosses the x- and y-axes. A y-intercept is the y-coordinate of a point where the graph crosses the y-axis. An x-intercept is the x-coordinate of a point where the graph crosses the x-axis. At a y-intercept, $x = 0$. At an x-intercept, $y = 0$. You find the y-intercept or y-intercepts by letting $x = 0$ and find the x-intercept or x-intercepts by letting $y = 0$.

3. **Identify the zeros of functions.**

 Find the zeros of the function f by finding the x-intercepts of the graph of the equation $y = f(x)$.

4. **Find the domain.**

 The domain of a function defines all the values that x can have for the function.

5. **Determine the range.**

 The range of a function defines all the values that y can have for the function.

The following examples illustrate these five steps.

Example: Graph $y = 3x + 2$.

Solution: 1. This is a nonvertical straight line.

2. The y-intercept (where $x = 0$) is $y = 2$. The x-intercept (where $y = 0$) is $x = -\dfrac{2}{3}$

3. If the function is f, where $f(x) = 3x + 2$, then there are no other zeros for this function.

4. The domain is all real numbers because x can be any real number.

5. The range is all real numbers because y can be any real number.

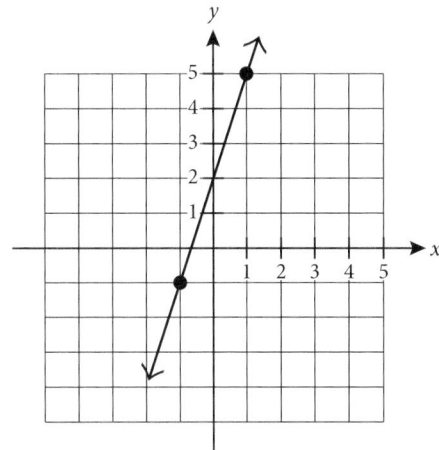

Example: Graph $y = |x + 1|$.

Solution: 1. This is an absolute value and fits in the general form of the equation $y = |ax + b|$, so it should have a V-shape.

2. The y-intercept is $y = 1$. The x-intercept is $x = -1$.

3. There are no other zeros for the function $|x + 1|$.

4. The domain is all real numbers.

5. The range is $[0, \infty)$. This means y can be any value from 0 to ∞, including 0.

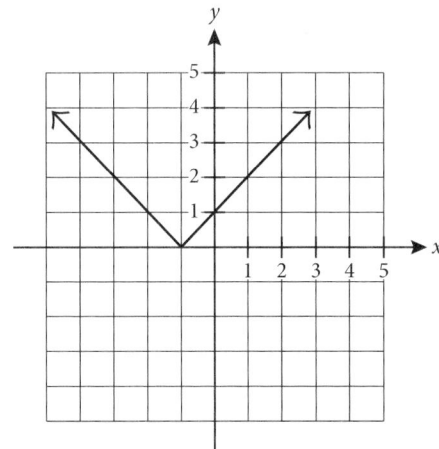

Example: Graph $y = \sqrt{2x - 5}$.

Solution: 1. This is a radical. The graph of this particular equation is part of a parabola.

2. When $x = 0$, $y = \sqrt{-5}$. That means the graph never crosses the y-axis. The x-intercept is $x = \dfrac{5}{2}$.

3. There are no other zeros for the function $f(x) = \sqrt{2x - 5}$.

4. The domain for this function is $\left[\frac{5}{2}, \infty\right)$.

5. The range for this function is $[0, \infty)$.

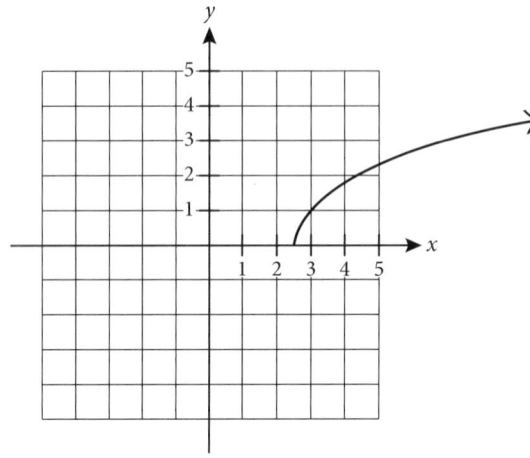

Example: Graph $y = \dfrac{2x - 6}{x^2 - 9}$ $x \leq 0, x \neq -3$

$\qquad\qquad\quad = x^2 - 6x + 5, x > 0$

Solution:

1. This fits the piecewise general form, so look at the general form of each piece.

$$\frac{2x - 6}{x^2 - 9} = \frac{2(x - 3)}{(x + 3)(x - 3)} = \frac{2}{x + 3}.$$

The first piece is $y = \dfrac{2}{x + 3}$, $x \leq 0, x \neq -3$.

The second piece takes on a quadratic general form and will be part of a parabola.

2. The only y-intercept is $y = \dfrac{2}{3}$. The x-intercepts are $x = 1$ and $x = 5$.

3. The vertical asymptote has the equation $x = -3$, and the horizontal asymptote has the equation $y = 0$.

4. The domain is $(-\infty, -3) \cup (-3, \infty)$. This means x can be any number but -3.

5. The range is all real numbers.

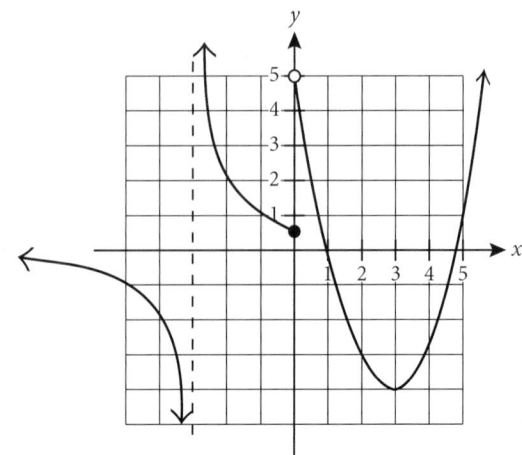

REVIEW PROBLEMS

1. If $x = 3 - y^2$ and $y = -2$, what is the value of x?

 A. -2
 B. -1
 C. 1
 D. 2
 E. 3

2. For all x, $2^x + 2^x + 2^x + 2^x =$

 A. $2^{(x+2)}$
 B. $2^{(x+4)}$
 C. 2^{3x}
 D. 2^{4x}
 E. 8^x

3. For all $x \neq \pm \frac{1}{2}$, $\dfrac{6x^2 - x - 2}{4x^2 - 1} =$

 A. $\dfrac{2 - 3x}{2x + 1}$
 B. $\dfrac{3x + 2}{2x + 1}$
 C. $\dfrac{3x + 2}{2x - 1}$
 D. $\dfrac{3x - 2}{2x - 1}$
 E. $\dfrac{2 - 3x}{2x - 1}$

4. When $3x^3 - 7x + 7$ is divided by $x + 2$, the remainder is:

 A. -5
 B. -3
 C. 1
 D. 3
 E. 5

5. If $\sqrt[4]{\dfrac{x+1}{2}} = \dfrac{1}{2}$, then $x =$

 A. -0.969
 B. -0.875
 C. 0
 D. 0.875
 E. 0.985

6. If $\dfrac{19}{5x+17} = \dfrac{19}{31}$, then $x =$

 A. 0.4
 B. 1.4
 C. 2.8
 D. 3.4
 E. 4.8

7. If $(3^{x^2})(9^x)(3) = 27$ and $x > 0$, what is the value of x?

 A. 0.27
 B. 0.41
 C. 0.73
 D. 1.41
 E. 1.92

8. If $y \neq 4a$ and $x = \dfrac{y + a^2}{y - 4a}$, what is the value of y in terms of a and x?

 A. $\dfrac{4a - 4a^2 x}{x + 1}$

 B. $\dfrac{a^2 - 4ax}{x + 1}$

 C. $\dfrac{a^2 + 4ax}{x + 1}$

 D. $\dfrac{a^2 + 4ax}{x - 1}$

 E. $\dfrac{4a - 4a^2 x}{x - 1}$

9. If $4x + ky = 15$ and $x - ky = -25$, which of the following could be the values of x and y?

 A. $x = -3$ and $y = -5$
 B. $x = -2$ and $y = 3$
 C. $x = 0$ and $y = -2$
 D. $x = 2$ and $y = 3$
 E. $x = 3$ and $y = 2$

10. How many integers are in the solution set of $|4x + 3| < 8$?

 A. None
 B. Two
 C. Three
 D. Four
 E. Five

SOLUTIONS TO REVIEW PROBLEMS

1. **B** Substitute -2 for y into the equation $x = 3 - y^2$:

$$x = 3 - y^2 = 3 - (-2)^2 = 3 - 4 = -1$$

2. **A** The sum of 4 identical quantities is 4 times one of those quantities, so the sum of the four terms 2^x is 4 times 2^x:

$$2^x + 2^x + 2^x + 2^x = 4(2^x) = 2^2(2^x) = 2^{x+2}$$

3. **D** Factor the top and the bottom and cancel the factors they have in common:

$$\frac{6x^2 - x - 2}{4x^2 - 1} = \frac{(2x+1)(3x-2)}{(2x+1)(2x-1)}$$
$$= \frac{3x-2}{2x-1}$$

4. **B** Use long division. Watch out: The expression that goes under the division sign needs a place-holding $0x^2$ term:

$$
\begin{array}{r}
3x^2 - 6x + 5 \\
x+2 \overline{\smash{\big)}\ 3x^3 + 0x^2 - 7x + 7} \\
\underline{3x^3 + 6x^2} \\
-6x^2 - 7x \\
\underline{-6x^2 - 12x} \\
5x + 7 \\
\underline{5x + 10} \\
-3
\end{array}
$$

The remainder is -3.

5. **B** To undo the fourth-root symbol, raise both sides to the exponent 4:

$$\sqrt[4]{\frac{x+1}{2}} = \frac{1}{2}$$
$$\left(\sqrt[4]{\frac{x+1}{2}}\right)^4 = \left(\frac{1}{2}\right)^4$$
$$\frac{x+1}{2} = \frac{1}{16}$$

Now cross multiply:

$$(x+1)(16) = (2)(1)$$
$$16x + 16 = 2$$
$$16x = -14$$
$$x = -\frac{14}{16} = -\frac{7}{8} = -0.875$$

6. **C** This might look at first glance like a candidate for cross multiplication, but that would just make things more complicated. Notice that the fractions on both sides have the same numerator, 19. If the two fractions are equal and they have the same numerator, then they must have the same denominator, so just write an equation that says that one denominator is equal to the other denominator:

$$\frac{19}{5x+17} = \frac{19}{31}$$

$$5x + 17 = 31$$
$$5x = 31 - 17$$
$$5x = 14$$
$$x = \frac{14}{5} = 2.8$$

7. **C** Watch what happens when you express everything as powers with a base of 3:

$$(3^{x^2})(9^x)(3) = 27$$
$$(3^{x^2})(3^2)^x(3^1) = 3^3$$

When you raise a power to an exponent, multiply the exponents, and keep the same base. So $(3^2)^x = 3^{2x}$:

$$(3^{x^2})(3^2)^x(3^1) = 3^3$$
$$(3^{x^2})(3^{2x})(3^1) = 3^3$$

The left side of the equation is the product of powers with the same base, so just add the exponents:

$$(3^{x^2})(3^{2x})(3^1) = 3^3$$
$$3^{x^2+2x+1} = 3^3$$

Now the two sides of the equation are powers with the same base, so you can just set the exponents equal:

$$x^2 + 2x + 1 = 3$$
$$(x + 1)^2 = 3$$
$$x + 1 = \pm\sqrt{3}$$
$$x = -1 \pm \sqrt{3}$$

The positive value is $-1 + \sqrt{3}$, which is approximately 0.732.

8. **D** First multiply both sides by $y - 4a$ to clear the denominator:

$$x = \frac{y + a^2}{y - 4a}$$

$$x(y - 4a) = y + a^2$$

$$xy - 4ax = y + a^2$$

Now move all terms with y to the left and all terms without y to the right:

$$xy - 4ax = y + a^2$$
$$xy - y = a^2 + 4ax$$

Now factor the left side and divide to isolate y:

$$xy - y = a^2 + 4ax$$
$$y(x - 1) = a^2 + 4ax$$

$$y = \frac{a^2 + 4ax}{x - 1}$$

9. **B** With only two equations, you won't be able to get numerical solutions for three unknowns. But apparently you can get far enough to rule out three of the four answer choices. How? Look for a way to combine the equations that leads somewhere useful. Notice that the first equation contains $+ky$ and the second equation contains $-ky$, so if you add the equations as they are, you'll lose those terms:

$$4x + ky = 15$$
$$\underline{x - ky = -25}$$
$$5x = -10$$
$$x = -2$$

There's not enough information to get numerical solutions for k or y, but you do know that $x = -2$, so the correct answer is the only choice that has an x-value of -2.

10. **D** If the absolute value of something is less than 8, then that something is between -8 and 8:

$$|4x + 3| < 8$$

$$-8 < 4x + 3 < 8$$

$$-11 < 4x < 5$$

$$-\frac{11}{4} < x < \frac{5}{4}$$

$$-2\frac{3}{4} < x < 1\frac{1}{4}$$

There are four integers in that range: $-2, -1, 0,$ and 1.

CHAPTER SIXTY-ONE

Probability and Statistics

LEARNING OBJECTIVES

After this chapter, you will be able to:

- Apply probability rules to determine the probability of a given outcome
- Calculate median, mode, range, and standard deviation of a data set
- Apply combination and permutation rules to solve grouping or ordering problems

Questions involving probability and statistics tend to be some of the most dreaded by test takers. This isn't without good reason: The equations can appear confusing, and the questions can be time-consuming. Nevertheless, these question types can be broken down into predictable formulations that appear time and again. With good understanding of the terminology and experience with the calculations, you will find these questions to be much more manageable and possibly even a source of quick points on Test Day.

PROBABILITY

Probability is the branch of mathematics concerned with calculating the likelihood that an event will occur. This likelihood is assigned a numerical value. If p is the probability that an event will occur, then you always have that $0 \leq p \leq 1$. Thus, the probability of an event is always greater than or equal to 0 and less than or equal to 1. A probability of 0 means there is *no* chance an event will occur, while a probability of 1 means the event will *definitely* occur.

Basic Terms

While you do not need to memorize the following terms verbatim, understanding what each means is important for understanding test questions. As you read through each, consider the example of a fair die with sides numbered 1, 2, 3, 4, 5, and 6 being rolled.

Experiment: When some process is conducted, it is called an experiment. An experiment could be the process of rolling the die one time.

Outcome: One of the possible results of the experiment. An example of an outcome is the rolling of a 3.

Sample space: The set of all possible outcomes. The set of possible outcomes can be considered to be the rolling of a 1, the rolling of a 2, the rolling of a 3, the rolling of a 4, the rolling of a 5, and the rolling of a 6. Thus, the sample space in this case is {1, 2, 3, 4, 5, 6}. The probability of the sample space is always 1. Therefore, if the sample space is S, then $P(S) = 1$.

Empty set: The unique set having no elements. The empty set is often represented by ϕ, so $P(\phi) = 0$.

Event: One particular set of possible outcomes. An example of an event is the rolling of a 3 or a 5. Thus, one event, which you can call event A, is $\{3, 5\}$. So $A = \{3, 5\}$.

Elementary event: An event that is a set consisting of only one outcome, such as rolling a 4. If B is the event of rolling a 4, then $B = \{4\}$. 4 is an outcome, whereas $\{4\}$ is an event. This is consistent with the definition since an event is a set of possible outcomes. Note that, as is the case with the event of rolling a 4, it is possible that the set contains just one outcome.

The sample space of an experiment can be defined in different ways, which can affect how you will need to consider outcomes and events. For example, suppose the experiment is the rolling of the die once. You can define the outcomes to be these:

One outcome is the rolling of a 1 or a 2. Define this outcome as s_1.
One outcome is the rolling of a 3. Define this outcome as s_2.
One outcome is the rolling of a 4, a 5, or a 6. Define this outcome as s_3.

In this experiment, because of how you have defined it, the only possible outcomes are s_1, s_2, and s_3. The sample space in this case is $\{s_1, s_2, s_3\}$. Under these conditions, an event could be the set consisting of s_1 and s_2. Thus, if B is the event consisting of the outcomes s_1 and s_2, then $B = \{s_1, s_2\}$.

Notation
In mathematics, the probability that event A occurs is written $P(A)$.

Describing Probability

Probability can be expressed as a percent (for example, there's a 50% chance of getting heads in a fair coin toss), as a fraction (for example, the probability of getting heads is $\frac{1}{2}$), or as a decimal (for example, there's a 0.5 chance of getting heads). What does this value mean? It's a statement of what's *likely* to happen and not a guarantee of what *will* actually happen. It's certainly possible, for example, to flip a coin 10 times and get 10 tails.

What's behind probability?
Now, how do you know that, when a fair coin is tossed, there's a 50% chance of getting heads? You figure out how many different outcomes there are for the coin toss (two: heads or tails) and then figure out how many of those outcomes give a result of heads (just 1). So one out of the two possible outcomes (or 50% of them) result in heads. That's the basic formula for probability when all the outcomes are equally likely:

$$\text{Probability} = \frac{\text{Number of desired outcomes}}{\text{Number of possible outcomes}}$$

You can see now that probability is a fraction with the number of desired outcomes on the top and the number of possible outcomes on the bottom. In other words, probability is just a way of predicting the likelihood of a specific event by figuring out what fraction of all possible outcomes have the characteristic you're looking for. Stated yet another way, probability is the fraction of all the possible outcomes that are members of the set of outcomes that is a specified event. In every

probability question, your goal is to find the total number of possible outcomes and the number of desired outcomes. Keep in mind that "desired" means only that these are the outcomes that have the characteristic you're interested in, not that you necessarily want these outcomes to happen.

Example: A bag contains 10 identical balls numbered 1 through 10 inclusive. If a ball is drawn from the bag at random, what is the probability (as a percent) that it bears a number less than 4?

Solution: If there are 10 balls in the bag, and you're picking only one ball, then there are 10 possible outcomes. So you now have the bottom of our probability fraction. What you still need to do is determine the number of desired outcomes. You're interested in numbers less than 4, and the only balls that have this characteristic are 1, 2, and 3, so 3 out of the 10 balls would give us a number less than 4. That's $\frac{3}{10}$ or 30%.

So to find a probability for a single event:

1. Figure out how many outcomes are possible overall.
2. Figure out how many of the possible outcomes have the characteristic you're looking for.
3. Plug these numbers into the probability formula.

As you can see, every probability problem starts with two basic things:

1. Total possible outcomes
2. Desired outcomes

Example: A fair six-sided die with sides numbered 1, 2, 3, 4, 5, and 6 is thrown. What is the probability it lands with an even number facing up?

Solution: Desired outcomes = 3
Total possible outcomes = 6

The regular six-sided die has six numbers (1, 2, 3, 4, 5, and 6) on its faces. That gives us a total of six possible outcomes. You're interested only in the even numbers, of which there are three (2, 4, and 6). So the number of desired outcomes is three. This gives us a probability of $\frac{3}{6}$, or $\frac{1}{2}$.

Example: Of the 1,000 employees of a company, 5 employees have the job title of accountant. If one of these employees is selected at random, what is the probability this employee has the job title of accountant?

Solution: Desired outcomes = 5
Total possible outcomes = 1,000

There are 1,000 employees that could be selected. So the total number of possible outcomes is 1,000. There are 5 employees with the job title of accountant. So the number of desired outcomes here is 5. That gives a probability of $\frac{5}{1,000}$, or $\frac{1}{200}$.

Example: A certain pet store has 13 mice in a single tank. Five of the mice are white, and 8 of the mice are brown. If the store clerk reaches into the mice's tank to select a mouse at random, what is the probability that the mouse is white?

Solution: Desired outcomes = 5
Total possible outcomes = 13

If there are 13 mice total, then the number of possible outcomes is 13. Only 5 of the mice are white, so the number of desired outcomes is 5. This gives us a probability of $\frac{5}{13}$.

Probability an Event Does Not Occur

Now that you've seen how to find the probability of a single event, consider what happens when you're interested in more than one event. Let A be an event and \overline{A} be the event that event A does not occur. Added together, these two events represent the entire sample set (with a probability of 1). Therefore, the probability event A does not occur is equal to 1 minus the probability that event A does occur: $P(\overline{A}) = 1 - P(A)$.

For example, suppose a fair sided die with sides numbered 1 through 6 is tossed. The probability that a 4 is rolled is $\frac{1}{6}$. Therefore, the probability that a 4 is not rolled is $1 - \frac{1}{6} = \frac{5}{6}$.

The event that a 4 is not rolled is the event that a 1, 2, 3, 5, or 6 is rolled. There are 5 desired outcomes and 6 possible outcomes. So the probability that a 4 is not rolled is $\frac{\text{Number of desired outcomes}}{\text{Number of possible outcomes}} = \frac{5}{6}$.

Multiple-Event Probability

When all the outcomes are equally likely, the probability for a single event is just $\frac{\text{Number of desired outcomes}}{\text{Number of possible outcomes}}$. But what if you're interested in the probability that *at least* one of two different events occurs? Or in the probability that two different events *both* occur? Or in the probability that one of two different events occurs and the other does *not*? In those cases, it's not enough just to determine the probabilities of the individual events; you must combine the probabilities somehow.

Probability at least one of two events will occur when both events cannot occur

Some probability questions test your ability to determine the probability of what are known technically as **mutually exclusive events**. Mutually exclusive events are those events for which the occurrence of one event eliminates the possibility of the occurrence of the other event (in other words, where the two events *exclude* each other). To find the probability that one *or* another of two mutually exclusive events will occur, you add the probabilities of the two events.

For example, what is the probability that a certain machine randomly fills a box with all pennies *or* with all dimes? If the box contains all pennies, then it can't contain all dimes. If it contains all dimes, it can't contain all pennies. So these two events are mutually exclusive in that the occurrence of one means the other can't happen at the same time. If you wanted to figure out the probability that a box contains either all pennies or all dimes, the first thing you'd need is the probabilities of the two events separately.

Say that the probability that the machine fills the box with all pennies is $\frac{1}{2}$ and the probability that the machine fills the box with all dimes is $\frac{1}{3}$. To calculate the probability that one or the other of these two events occurs, add their respective probabilities:

$$\frac{1}{2} + \frac{1}{3} = \frac{3}{6} + \frac{2}{6} = \frac{5}{6}$$

So the probability that the box contains all pennies *or* all dimes is $\frac{5}{6}$.

Remember, if two events A and B cannot both occur, then to calculate the probability that either event A *or* event B occurs (but not both), find the probabilities of A and B separately and then *add* them together.

Why do you need to add in such cases? Because with many repetitions, close to $\frac{1}{2}$ of the boxes can be expected to be filled with pennies, and close to $\frac{1}{3}$ of the boxes can be expected to be filled with dimes. Close to $\frac{1}{2} + \frac{1}{3}$ or $\frac{5}{6}$ of all the boxes will be filled with pennies or dimes, which is the same as saying that the probability that any given box contains all pennies or all dimes is $\frac{5}{6}$. Remember that a probability tells you how likely it is that something will occur.

Example: A bag contains 20 identical plastic tiles. Eleven of the tiles are marked with the numbers 1 through 11 inclusive. The remaining 9 tiles are marked with the letters A through I inclusive. If a single tile is drawn at random from the bag, what is the probability that it bears either an even number or a vowel?

Solution: To find the probability of getting either an even number *or* a vowel, you need to find the probability of each of these occurrences separately and then add them together. Start off with the even numbers. There are 20 tiles in the bag, so you know the number of total possible outcomes is 20. The even numbers in the bag are 2, 4, 6, 8, and 10, so there are five desired outcomes. The probability of withdrawing an even number is $\frac{5}{20}$ (don't reduce the fraction yet; you'll see why). Now for the vowels: The number of possible outcomes is still 20. There are three vowels in the bag (A, E, and I), so there are three desired outcomes. The probability of withdrawing a vowel is $\frac{3}{20}$. Therefore, the probability of withdrawing an even number *or* a vowel is $\frac{5}{20} + \frac{3}{20}$ (this is why you didn't want to reduce before), which sums to $\frac{8}{20}$, or $\frac{2}{5}$.

Probability Two Events Occur

So far, you have looked at the probability of one or another of two events happening, but what about the case in which *both* happen? In general, the probability that events A *and* B both occur is equal to the probability that event A occurs multiplied by the conditional probability that event B occurs given that event A occurs. You can also say that the probability that events A *and* B both occur is equal to the probability that event B occurs *multiplied* by the conditional probability that event A occurs, given that event B occurs.

Example: There are 4 blue disks and 12 green disks in a container. Two disks are to be removed from the container, one after the other. What is the probability that the first disk selected is blue and the second disk selected is green?

Solution: There are 4 blue disks and a total of $4 + 12 = 16$ disks in the container. The probability that the first disk selected is blue is $\frac{4}{16} = \frac{1}{4}$. Once a blue disk is removed from the container, there remain 3 blue disks and 12 green disks. So there are 12 green disks and $3 + 12 = 15$ disks in the container. The probability that the second disk selected is green given that the first disk selected is blue is $\frac{12}{15} = \frac{4}{5}$. Then the probability that the first disk selected is blue and the second disk selected is green is $\frac{1}{4} \times \frac{4}{5} = \frac{1}{5}$.

Independent events

Two events are said to be independent if one of these events has absolutely no effect on the probability of the other event occurring. For example, suppose a fair coin with heads and tails is tossed once and then a fair die with sides number 1, 2, 3, 4, 5, and 6 is rolled once. For the coin toss, you are interested in the event that a head is tossed (say that's event A), and for the die roll you are concerned with the event that a 1 or a 4 is rolled (say that's event B). The tossing of the coin has absolutely no effect on the rolling of the die. Thus, the event that a head results when a fair coin is tossed is independent of the event that a 1 or a 4 is tossed when a fair die is rolled.

In the case of independent events A and B, the probability that events A and B both occur is equal to the probability that event A occurs multiplied by the probability that event B occurs. Returning to the above situation, you can use that relationship to find the probability that both events A and B occur.

There are 2 possible outcomes when the coin is tossed, heads or tails. So the number of possible outcomes is 2. For the event that a head is tossed, you have one desirable outcome, heads. So the probability that, when a fair coin is tossed, the result is heads is $\frac{1}{2}$.

When the fair die is rolled, all the possible outcomes are 1, 2, 3, 4, 5, and 6. The number of possible outcomes is 6. For the event that a 1 or a 4 is rolled, there are 2 desired outcomes, which are 1 and 4. So the probability that, when the fair die is rolled, a 1 or 4 results is $\frac{2}{6} = \frac{1}{3}$.

Finally, the probability that both events A and B occur is $\frac{1}{2} \times \frac{1}{3} = \frac{1}{6}$.

Example: If the probability of finding a pearl in any given oyster is $\frac{1}{3}$ and the probability of any given pearl being black is $\frac{2}{5}$, what's the probability that if you crack open a randomly chosen oyster, you'll find a black pearl?

Solution: In $\frac{1}{3}$ of the cases when you crack open an oyster, you'll find a pearl. And in $\frac{2}{5}$ of the cases when you find a pearl, that pearl will be black. Therefore, you should find a black pearl in $\frac{2}{5}$ of $\frac{1}{3}$ of the times you open an oyster, which is $\frac{2}{5} \times \frac{1}{3}$ or $\frac{2}{15}$ of all the times you open an oyster. Therefore, the probability of finding a pearl *and* having the pearl be black is $\frac{2}{15}$.

Example: A bag contains ten identically shaped plastic tiles. Six of the tiles are red, three are blue, and one is black. If two tiles are drawn at random from the bag, without replacement, what is the probability that the first tile drawn is red and the second tile drawn is black?

Solution: First find the individual probabilities of drawing a red tile and then drawing the black tile. For the first tile drawn, there are 10 tiles in the bag, and 6 of them are red, so the probability of drawing a red tile first is $\frac{6}{10}$ or $\frac{3}{5}$. For the second tile, there are only 9 tiles left in the bag, and 1 of them is black, so the probability of getting a black tile on the second draw is $\frac{1}{9}$. Now you need to find the probability of getting a red tile on the first draw *AND* a black tile on the second draw. To do so, you multiply the individual probabilities: $\frac{3}{5} \times \frac{1}{9} = \frac{3}{45} = \frac{1}{15}$.

Probability at Least One of Two Events Occurs

Suppose you have two events A and B. You want to find the probability that at least one of the events A or B occurs. A picture of the events A and B would look like this:

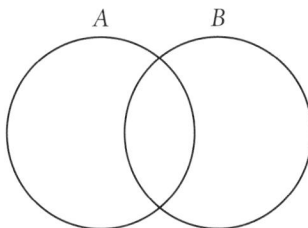

If you just add the probability that event A occurs and the probability that B occurs, the sum will include the probability of *both* events A and B occurring (the overlapping area on the Venn diagram) twice, which is included in both the probability that A occurs and the probability that B occurs. So you must subtract the probability that both events A and B occur from that sum. Remember that $P(E)$ means the probability that event E occurs. You can say that $P(A \text{ or } B) = P(A) + P(B) - P(A \text{ and } B)$.

Notice that the rule for finding the probability that at least one of events A or B occurs, $P(A \text{ or } B) = P(A) + P(B) - P(A \text{ and } B)$, also accounts for cases in which the events are mutually exclusive. If the events A and B are mutually exclusive, $P(A \text{ and } B) = 0$. So, if the events A and B are mutually exclusive, $P(A \text{ or } B) = P(A) + P(B) - P(A \text{ and } B) = P(A) + P(B) - 0 = P(A) + P(B)$.

Example: Suppose a fair coin is tossed and a fair die with sides numbered 1, 2, 3, 4, 5, and 6 is rolled. Let A be the event that the coin toss results in a head. Let B be the event that the roll of the die results in a 5. What is the probability that at least one of the events A or B occurs?

Solution: For the coin toss, $P(A) = \frac{1}{2}$. For the roll of the die, $P(B) = \frac{1}{6}$. The toss of the coin and the roll of the die are independent, so $P(A \text{ and } B) = P(A)P(B) = \frac{1}{2} \times \frac{1}{6} = \frac{1}{12}$. Then $P(A \text{ or } B) = \frac{1}{2} + \frac{1}{6} - \frac{1}{12} = \frac{6}{12} + \frac{2}{12} - \frac{1}{12} = \frac{6+2-1}{12} = \frac{7}{12}$.

QR

Summary Comparison: And/Or

You've seen two different ways to calculate probabilities for situations involving more than one event. It's essential you understand which method to use in any given probability question. To recap:

- To find the probability of event A *or* event B when the events A and B are mutually exclusive, find the probability of A and the probability of B and then *add* these two probabilities. Thus, if the events A and B are mutually exclusive, $P(A$ or $B) = P(A) + P(B)$. (The same rule applies if you're trying to figure out the probability that A *or* B *or* C occurs where the events A, B, and C are mutually exclusive, etc.)

- For any two events A and B, to find the probability that *at least one of* event A *or* event B occurs, find the probability of event A and the probability of event B, *add* these two probabilities, then *subtract* from this sum the probability that both events A and B occur. Thus, for any events A and B, $P(A$ or $B) = P(A) + P(B) - P(A$ and $B)$.

- To find the probability of event A *and* event B, find the probability that event A occurs and the conditional probability that B occurs given that event A occurs, then *multiply* the probability that event A occurs by the conditional probability that event B occurs given that event A occurs. (The same rule applies if you're trying to figure out A *and* B *and* C, etc.)

MEDIAN, MODE, RANGE, AND STANDARD DEVIATION

Probability is just one way to look at statistical patterns. Using other techniques, such as determining median, mode, range, and standard deviation, also can provide equally useful information.

Median

If a group containing an odd number of terms is arranged in numerical order, the median is the middle value.

If a group containing an even number of terms is arranged in numerical order, the median is the average, or arithmetic mean, of the two middle numbers.

Example: What is the median of 4, 5, 100, 1, and 6?

Solution: First, arrange the numbers in numerical order: 1, 4, 5, 6, and 100. The middle number (the median) is 5.

Example: What is the median value of 2, 7, 8, 16, 12, and 37?

Solution: If a set has an even number of terms, then the median is the average (arithmetic mean) of the two middle terms after the terms are arranged in numerical order. Arrange the values in numerical order: 2, 7, 8, 12, 16, 37. The two middle numbers are 8 and 12. The median is the average of 8 and 12, that is, 10.

The median can be quite different from the mean (average). For instance, in the first set of numbers above, {1, 4, 5, 6, 100}, the median is 5, but the average is $\frac{1 + 4 + 5 + 6 + 100}{5} = \frac{116}{5} = 23.2$.

Mode

The mode is the number that appears most frequently in a set. For example, in the set {1, 2, 2, 2, 3, 4, 4, 5, 6}, the mode is 2.

It is possible for a set to have more than one mode. For example, in the set {35, 42, 35, 57, 57, 19}, the two modes are 35 and 57. When more than one mode exists, do not calculate the mean of these numbers but rather report each as a separate value. It may also be worthy to note that not all sets have a mode.

Range

The range is the positive difference between the largest term in the set and the smallest term. For example, in the set {2, 4, 10, 20, 26}, the range is $26 - 2 = 24$.

Standard Deviation

Standard deviation measures the dispersion of a set of numbers around the mean. If you let σ be the standard deviation of the N values $x_1, x_2, \ldots x_N$ and let μ be the average, or arithmetic mean, of the N values $x_1, x_2, \ldots x_N$, that is, $\mu = \dfrac{x_1 + x_2 + \ldots + x_N}{N}$,

then the formula looks like this:

$$\sigma = \sqrt{\frac{1}{N}\left[\left(x_1 - \mu\right)^2 + \left(x_2 - \mu\right)^2 + \cdots + \left(x_N - \mu\right)^2\right]}$$

It can be intimidating, so it helps to break up the process into the following steps:

1. Find the arithmetic mean of the set.
2. Subtract the mean of the set from each term in that set.
3. Square each result.
4. Take the mean of those squares.
5. Calculate the positive square root of that average.

Fortunately, you will only very rarely be required to apply this formula and only on the most difficult questions. When standard deviation is tested, all you will generally need to understand is the basic concept: Standard deviation represents how close or far the terms in a set or list are from the average. Thus, standard deviation is a measure of how widely dispersed the terms of a list are, or how widely dispersed the members of a set are.

Thus, {1, 2, 3} and {101, 102, 103} have the same standard deviation since they both have one term on the mean and two terms exactly one unit away from the mean. Quickly sketching number lines can confirm this:

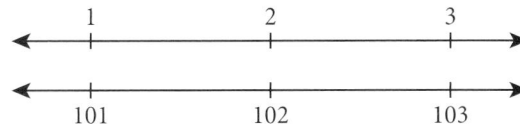

The set {1, 3, 5} will have a smaller standard deviation than {0, 3, 6}. Both sets have a mean of 3, but the first has terms 2, 0, and 2 units from the average, while the second has terms 3, 0, and 3 units from the average. Again, you can confirm this by quickly sketching number lines:

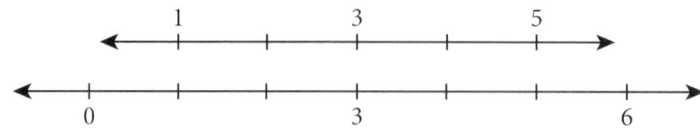

You could also calculate the standard deviation for the sets {1, 3, 5} and {0, 3, 6} to confirm:

{1,3,5}

mean $= 3$

$$\sigma = \sqrt{\frac{1}{3}\left[(1-3)^2 + (3-3)^2 + (5-3)^2\right]}$$

$$= \sqrt{\frac{1}{3}\left[(-2)^2 + 0^2 + 2^2\right]}$$

$$= \sqrt{\frac{1}{3}(8)}$$

$$= \sqrt{\frac{8}{3}}$$

{0,3,6}

mean $= 3$

$$\sigma = \sqrt{\frac{1}{3}\left[(0-3)^2 + (3-3)^2 + (6-3)^2\right]}$$

$$= \sqrt{\frac{1}{3}\left[(-3)^2 + 0^2 + 3^2\right]}$$

$$= \sqrt{\frac{1}{3}(9+0+9)}$$

$$= \sqrt{\frac{1}{3}(18)}$$

$$= \sqrt{6}$$

Since 6 is larger than $\frac{8}{3}$, the standard deviation of the second, more widely spaced set of numbers is larger than that of the first set.

Below are the key concepts to remember about median, mode, range, and standard deviation.

- When the numbers in a list with an odd number of numbers is arranged in ascending or descending order, the median is the middle number.
- When the numbers in a list with an even number of numbers is arranged in ascending or descending order, the median is the average of the two middle numbers.
- The mode of a list of terms is the term that appears most frequently. Having more than one mode, or no mode at all, is possible.
- The range is the positive difference between the largest term in the list and the smallest term.
- Standard deviation measures the dispersion of a set of numbers around the mean. You will rarely be required to apply the formula for standard deviation. Instead, use critical thinking and quick sketches of number lines to determine how close the terms in a list are from the mean.

COMBINATIONS AND PERMUTATIONS

Some questions ask you to count the number of possible ways to select a small subgroup from a larger group. If the selection is **unordered**, then it's a combination question. But if the selection is **ordered**, it is a permutation question.

For example, if a question asks you to count the possible number of different slates of officers who could be elected to positions in class government, then order matters—President Joseph and Vice President Rose is a different slate than President Rose and Vice President Joseph. You would use the permutations formula in this scenario. But if you had to count the number of possible pairs of flavors of jelly beans, you are solving a combinations question; cherry and lemon is the same pair as lemon and cherry, so order does not matter (that is, you wouldn't count those as two different pairs).

The very first thing you need to do is use critical thinking to figure out whether a given question calls for an ordered or an unordered selection; otherwise, you won't know which formula to use.

Combinations

The combinations formula is used when solving for the number of k unordered selections one can make from a group of n items where $k \leq n$. This is usually referred to as $_nC_k$, which is said as "n choose k." It is often helpful to say it this way to yourself because that's what making combinations is: an act of choosing small groups from a larger group.

Here's the formula, in which $n!$, or n-factorial, is the product of n and every positive integer smaller than n (for example, $5! = 5 \times 4 \times 3 \times 2 \times 1$), where n is a positive integer:

$$_nC_k = \frac{n!}{k!(n-k)!}$$

Example: A company is selecting 4 members of its board of directors to sit on an ethics subcommittee. If the board has 9 members, any of whom may serve on the subcommittee, how many different selections of members could the company make?

Solution: Since the order in which you select the members doesn't change the composition of the committee in any way, this is a combinations question. The size of the group from which you choose is n, and the size of the selected group is k. So $n = 9$ and $k = 4$.

$$_9C_4 = \frac{9!}{4!(9-4)!}$$

$$= \frac{9!}{4!5!}$$

$$= \frac{9 \times 8 \times 7 \times 6 \times 5 \times 4 \times 3 \times 2 \times 1}{4 \times 3 \times 2 \times 1 \times 5 \times 4 \times 3 \times 2 \times 1}$$

Save yourself some work. There's rarely a need to multiply out factorials since many of the factors can quickly be canceled.

$$_9C_4 = \frac{9 \times \cancel{8}^2 \times 7 \times \cancel{6} \times \cancel{5 \times 4 \times 3 \times 2 \times 1}}{\cancel{4} \times \cancel{3 \times 2} \times 1 \times \cancel{5 \times 4 \times 3 \times 2 \times 1}}$$

$$= 9 \times 2 \times 7 = 126$$

Sometimes the problems will be more complicated and will require multiple iterations of the formula.

Example: County X holds an annual math competition to which each county high school sends a team of 4 students. If school A has 6 boys and 7 girls whose math grades qualify them to be on their school's team, and competition rules stipulate that the team must consist of 2 boys and 2 girls, how many different teams might school A send to the competition?

QR

Solution: The order of selection doesn't matter here, so you can use the combinations formula. But be careful … if you lump all the students together in a group of 13 and calculate $_{13}C_4$, you'd wind up including some all-boy teams and all-girl teams. The question explicitly says you can only select 2 boys and 2 girls. So you aren't really choosing 4 students from 13 but rather choosing 2 boys from 6 and 2 girls from 7. Multiply the two combinations together to get the answer.

$$_6C_2 \quad \text{and} \quad _7C_2$$

$$\frac{6!}{2!4!} \times \frac{7!}{2!5!} =$$

$$\frac{6\times5\times4\times3\times2\times1}{2\times1\times4\times3\times2\times1} \times \frac{7\times6\times5\times4\times3\times2\times1}{2\times1\times5\times4\times3\times2\times1} =$$

$$\frac{\cancel{6}^3\times5\times\cancel{4\times3\times2\times1}}{\cancel{2}\times1\times\cancel{4\times3\times2\times1}} \times \frac{7\times\cancel{6}^3\times\cancel{5\times4\times3\times2\times1}}{\cancel{2}\times1\times\cancel{5\times4\times3\times2\times1}} =$$

$3 \times 5 \times 7 \times 3 = 315$ possible teams consisting of 2 boys and 2 girls.

Permutations

If the order of selection matters, use the permutation formulas instead:

Number of permutations (arrangements) of n items $= n!$

Number of permutations of k items selected from n items $= {_nP_k} = \dfrac{n!}{(n-k)!}$

Example: How many ways are there to arrange the letters in the word ASCENT?

Solution: Order matters here since ASCENT is different from TNECSA. There are 6 letters in the word, so you must calculate the permutations of 6 items:

$$6! = 6 \times 5 \times 4 \times 3 \times 2 \times 1 = 720$$

Another way to solve this question is to draw a quick sketch of the problem with blanks for the arranged items, then write in the number of possibilities for each blank in order. Finally, multiply the numbers together. Many high-difficulty permutation questions resist formulaic treatment but are easier to complete with the *draw blanks* or *slot filling* approach.

Here's how you would use this technique to solve the ASCENT problem:

ASCENT has 6 letters, so you need 6 blanks:

$$__\times__\times__\times__\times__\times__$$

There are 6 letters you might place in the first blank (A, S, C, E, N, or T):

$$\underline{6}\times__\times__\times__\times__\times__$$

No matter which letter you placed there, there will be 5 possibilities for the next blank:

$$\underline{6} \times \underline{5} \times \underline{} \times \underline{} \times \underline{} \times \underline{}$$

There will be 4 for the next, 3 thereafter, 2 after that, and just 1 letter left for the last:

$$\underline{6} \times \underline{5} \times \underline{4} \times \underline{3} \times \underline{2} \times \underline{1} = 720$$

Notice that you wind up reproducing the arrangements formula, $n!$. It's quite possible to solve most permutation problems without knowing the right formulas ahead of time, although knowing the formulas can save you time on Test Day.

Example: There are 6 children at a family reunion, 3 boys and 3 girls. They will be lined up single-file for a photo, alternating genders. How many arrangements of the children are possible for this photo?

Solution: You may not be sure how to approach this with a formula, so draw a picture. You know you'll have 6 blanks, but you don't know whether to begin with a boy or with a girl. It could be either one. So try both:

bgbgbg or *gbgbgb*

$$\underline{} \times \underline{} \times \underline{} \times \underline{} \times \underline{} \times \underline{} + \underline{} \times \underline{} \times \underline{} \times \underline{} \times \underline{} \times \underline{}$$

Any of the three boys could go in the first spot, and any of the three girls in the second:

$$\underline{3} \times \underline{3} \times \underline{} \times \underline{} \times \underline{} \times \underline{} + \underline{} \times \underline{} \times \underline{} \times \underline{} \times \underline{} \times \underline{}$$

The next spot can be filled with either of the remaining two boys; the one after by either of the two remaining girls. Then the last boy and the last girl take their places:

$$\underline{3} \times \underline{3} \times \underline{2} \times \underline{2} \times \underline{1} \times \underline{1} + \underline{} \times \underline{} \times \underline{} \times \underline{} \times \underline{}$$

That's the boy-first possibility. The same numbers of boys and girls apply to the girl-first possibility, and so you get:

$$\underline{3} \times \underline{3} \times \underline{2} \times \underline{2} \times \underline{1} \times \underline{1} + \underline{3} \times \underline{3} \times \underline{2} \times \underline{2} \times \underline{1} \times \underline{1}$$

$$9 \times 4 \times 1 + 9 \times 4 \times 1$$

There are $36 + 36 = 72$ possible arrangements of 3 boys and 3 girls, with alternating genders.

Hybrids of Combinations and Permutations

Some questions involve elements of both ordered and unordered selection.

Example: How many ways are there to arrange the letters in the word ASSETS?

Solution: Earlier you saw that the rearrangement of ASCENT was a permutation. But what about ASSETS? The order of the E, the A, the T, and the Ss matter, but the order of the three Ss themselves does not.

Think about it this way: Put a tag on the Ss … $AS_1S_2ETS_3$. If you just calculated 6! again, you'd be counting $AS_1S_2ETS_3$ and $AS_3S_1ETS_2$ as different words, even though with the tags gone, you can see they aren't (ASSETS is the same as ASSETS). So you'll need to eliminate all the redundant arrangements from the 6! total.

For each specification of the positions of the different letters A, E, and T, there are 3! ways to permute 3 distinguishable Ss, like S_1, S_2, and S_3. For each specification of the positions of the different letters A, E, and T, there is just one way to permute 3 indistinguishable Ss. So the total number of permutations, for 6 distinguishable letters, which is 6!, must be divided by 3! because of the 3 indistinguishable Ss.

So instead of 6! arrangements, as there were for ASCENT, the word ASSETS has $\frac{6!}{3!}$ arrangements.

$$\frac{6!}{3!} = \frac{6 \times 5 \times 4 \times 3 \times 2 \times 1}{3 \times 2 \times 1} = 6 \times 5 \times 4 = 120$$

The same logic would apply to the arrangements of ASSESS … $\frac{6!}{4!}$.

And if two letters repeat, you need two corrections to eliminate the counting of redundant arrangements. For instance, the number of arrangements of the letters in the word REASSESS is $\frac{8!}{4!2!}$.

Some difficult problems boil down to the same logic as this rearranging letters problem.

Example: A restaurant is hanging 7 large tiles on its wall in a single row. How many arrangements of tiles are possible if there are 3 white tiles and 4 blue tiles?

Solution: This problem essentially asks for the arrangements of *WWWBBBB*. Although there are 7 total tiles to arrange, all the white tiles are indistinguishable from one another, as are the blue tiles. Therefore, you will need to divide out the number of redundant arrangements from the 7! total arrangements:

$$\frac{7!}{3!4!} = \frac{7 \times 6 \times 5 \times 4 \times 3 \times 2 \times 1}{3 \times 2 \times 1 \times 4 \times 3 \times 2 \times 1} = 7 \times 5 = 35$$

Did you notice that $\frac{7!}{3!4!}$ is the same as $_7C_3$? This is also the same as $_7C_4$, $\frac{7!}{4!3!}$.

Whether you consider "rearrange *WWWBBBB*" to mean "choose 3 of the 7 tiles to be white (the rest will be blue)," or consider "rearrange *WWWBBBB*" to mean "choose 4 of the 7 tiles to be blue (the rest will be white)," the result is the same. As you'll soon see, many probability questions involve just this kind of calculation.

REVIEW PROBLEMS

1. A certain school has 50 students assigned to five distinct classes so that the numbers of students in the classes are consecutive and each student is assigned to only one class. What is the probability that a student selected at random from the 50 students is in one of the two largest classes?

 A. 38%

 B. 42%

 C. 46%

 D. 48%

 E. 56%

2. A certain machine produces toy cars in a repeating cycle of blue, red, green, yellow, and black. If a string of six consecutively produced cars is selected at random from all the possible strings of six consecutively produced cars, what is the probability that, in the string selected, two of the cars are red?

 A. $\frac{1}{6}$

 B. $\frac{1}{5}$

 C. $\frac{1}{3}$

 D. $\frac{2}{5}$

 E. $\frac{1}{2}$

3. A certain circular stopwatch has exactly 60 second marks and a single hand. If the hand of the watch is randomly set to one of the marks and allowed to count exactly 10 seconds, what is the probability that the hand will stop less than 10 marks on either side of the 53-second mark?

 A. $\frac{1}{6}$

 B. $\frac{19}{60}$

 C. $\frac{1}{3}$

 D. $\frac{29}{60}$

 E. $\frac{41}{60}$

4. A certain board game is played by rolling a pair of fair six-sided dice and then moving one's piece forward the number of spaces indicated by the sum showing on the dice. A player is "frozen" if her opponent's piece comes to rest in the space already occupied by her piece. If player A is about to roll and is currently six spaces behind player B, what is the probability that player B will be frozen after player A rolls?

 A. $\frac{1}{36}$

 B. $\frac{5}{36}$

 C. $\frac{1}{6}$

 D. $\frac{1}{3}$

 E. $\frac{1}{2}$

5. A machine is made up of two components, A and B. Each component either works or fails. The failure or nonfailure of one component is independent of the failure or nonfailure of the other component. The machine works if at least one of the components works. If the probability that each component works is $\frac{2}{3}$, what is the probability that the machine works?

 A. $\frac{1}{9}$

 B. $\frac{4}{9}$

 C. $\frac{1}{2}$

 D. $\frac{2}{3}$

 E. $\frac{8}{9}$

6. In the list 3, 4, 5, 5, 5, 5, 7, 11, 21, what fraction of the data is less than the mode?

 A. $\frac{2}{9}$

 B. $\frac{1}{3}$

 C. $\frac{2}{3}$

 D. $\frac{7}{9}$

 E. $\frac{8}{9}$

7. Amanda goes to the toy store to buy 1 ball and 3 different board games. If the toy store is stocked with 3 types of balls and 6 types of board games, how many different selections of the 4 items can Amanda make?

 A. 20

 B. 23

 C. 40

 D. 60

 E. 80

8. A code is to be made by arranging 7 letters. Three of the letters used will be the letter A, two of the letters used will be the letter B, one of the letters used will be the letter C, and one of the letters used will be the letter D. If there is only one way to present each letter, how many different codes are possible?

 A. 42
 B. 210
 C. 420
 D. 5,040
 E. 6,025

SOLUTIONS TO THE REVIEW PROBLEMS

1. **C** The correct answer is 46%. To find the probability, you need possible outcomes and desired outcomes. The possible outcomes here are just the total number of students you have to choose from. The desired outcomes are the number of students in the two largest classes. How can you find that, though? The key to this problem is the fact that the numbers of students in the classes are consecutive. Whenever you see *consecutive* in a math problem, it's there for a specific reason. It tells you that each number in the series is separated from the next by a fixed amount. Consecutive integers are separated by 1, consecutive even integers by 2, etc. So here you know that if you add up the numbers of students in all the classes, you'll get 50. You also know that the numbers of students in the classes are separated by 1. So let's call the number of students in the smallest class x. The next largest class would have $x + 1$ students, then $x + 2$ students, $x + 3$ students, and $x + 4$ students. If you add these up, you get $5x + 10 = 50$. Now you can solve for x: subtract 10 from both sides to get $5x = 40$, then divide both sides by 5 to get $x = 8$. So the smallest class has 8 students, and the two largest classes then will have $8 + 3$ and $8 + 4$ students respectively, which gives a total of 23 students in the two largest classes. So the probability is $\frac{23}{50} = \frac{23}{50} \times \frac{2}{2} = \frac{46}{100} = 46\%$.

2. **B** The correct answer is $\frac{1}{5}$. You need to find the number of possible and the number of desired outcomes. You're going to be randomly selecting a possible string of six consecutively produced cars, and you want to know what the probability is that the string will contain two red cars. How many different possible strings of six consecutive cars are there? You have five colors, so any one of them could be the first in the string of six that you choose. That gives five different strings of six, so 5 is the number of possible outcomes here. What about desired outcomes? You need to know how many of those five strings have two red cars. What does getting two red cars depend on? It depends on the color of the first car of the string of six. For example, if blue is the first car of the string, then you'd get blue, red, green, yellow, black, and then blue again. So, the only way to get two red cars is if the first car of the string is red because then you'd have red, green, yellow, black, blue, and then red again as the sixth car. So one out of the five strings will contain two red cars, and that's a probability of $\frac{1}{5}$.

3. **B** The correct answer is $\frac{19}{60}$. There's a watch with a single hand and 60 second marks. Say you randomly spin the hand so it points to one of those marks and then you let the watch count 10 seconds. What are the chances that the hand will end up pointing to a mark that's less than 10 marks from the 53-second mark? What would it depend on? It would depend on the mark the hand began counting from. How many marks are less than 10 marks from 53 seconds? This is a good question for scrap paper. If you jot down 53 and then count 9 in either direction (remember, you need less than 10, so you don't want to count 10), you start with 44 seconds and count all the way past 53 seconds to the mark that is 2 seconds after the minute mark, with the minute mark also being the 0-second mark. This gives 19 marks that are less than 10 marks from 53 seconds. To end up less than 10 marks from 53 seconds, you need to end on one of those 19 marks. Each one of those 19 marks corresponds to another mark that's exactly 10 seconds earlier than it, which would be marks 34–52. If the hand begins counting from any of the 19 marks that go from 34 to 52, it will end up on a mark between 44 and 02. So there are 19 marks that have the characteristic you're looking for. That's 19 out of 60, or $\frac{19}{60}$.

4. B The correct answer is $\frac{5}{36}$. In this game, a player is "frozen" whenever another player lands on the spot where the first player already has her piece. The question asks for the probability that player B will be frozen by player A, who's six spaces behind. What does it depend on? It depends on whether player A gets a roll of exactly 6 on the dice. So what's the probability of getting 6 on the dice? First, figure out the total possible outcomes for the roll. Since there are six numbers on each die, the total number of possible rolls is 6×6, or 36. So there are 36 possible rolls. How many of them would allow player A to move exactly six spots? Any roll that adds up to 6 will. So you could have (1, 5), (2, 4), and (3, 3). But since there are two dice, there are two ways to get (1, 5) and (2, 4) because either die could get the 1 or the 5, etc. So there's (1, 5), (5, 1), (2, 4), (4, 2), and (3, 3). That's five possible rolls that add up to exactly 6. So 5 out of the 36 possible rolls would allow player A to freeze player B, which gives a probability of $\frac{5}{36}$.

5. E The fastest way to do this is to find the probability that neither component works and subtract that from 1. Since the probability of a component working is $\frac{2}{3}$, the probability of a component not working is $1 - \frac{2}{3} = \frac{1}{3}$. Therefore, the probability that neither component works is $\frac{1}{3} \times \frac{1}{3} = \frac{1}{9}$, and the probability that the machine works is $1 - \frac{1}{9} = \frac{8}{9}$.

6. A This question can be answered by using the definitions of mode and fraction. Determine the mode, the total number of items in the list, and the number of items in the list less than the mode. The mode of any list of numbers is the number that appears most frequently in the list. In this case, the mode is 5. The total number of items in the list is 9. Finally, the number of items in the list less than the mode, or 5, is 2. So the final fraction is $\frac{2}{9}$.

7. D Amanda is buying 1 ball and 3 different board games from a selection of 3 balls and 6 types of board games. You need to find the number of different selections of 4 items that Amanda can make. Amanda is choosing 3 board games from a total of 6, so you can use the combination formula (since a different arrangement of the same board games is not considered a different selection) to find the number of combinations of board games:

$$_nC_k = \frac{n!}{k!(n-k)!}$$

$$_6C_3 = \frac{6!}{3!(6-3)!}$$

$$_6C_3 = \frac{6 \times 5 \times 4 \times 3!}{3! \times 3!}$$

$$_6C_3 = 20$$

Amanda has 20 ways to choose 3 board games from a total of 6. For each of those 20 ways, Amanda can choose 1 of 3 balls, so there are $20 \times 3 = 60$ different ways for Amanda to choose 1 ball and 3 games from 3 balls and 6 games.

QR

K 863

8. **C** You need to make a seven-letter code, but some of the letters are repeated. You have three *As*, two *Bs*, one *C*, and one *D*. Calculate the number of different permutations, remembering to take the repeated letters into account. To calculate the number of permutations where some of the elements are indistinguishable, divide the total number of permutations (here, 7!) by the factorial of the number of indistinguishable elements. So you have $\dfrac{7!}{3!2!} = \dfrac{(7 \times 6 \times 5 \times 4 \times 3 \times 2 \times 1)}{(3 \times 2 \times 1)(2 \times 1)} = 420$.

Geometry

The DAT may use geometry concepts to test your quantitative reasoning skills. This chapter covers the fundamentals of Plane Geometry, Solid Geometry, and Coordinate Geometry. However, it's important to note that these topics are only tested indirectly through the Quantitative Reasoning section. You may occasionally see these basic concepts come up in Data Analysis, Data Sufficiency, or Quantitative Comparison questions, but you are unlikely to see a question testing your knowledge of higher level geometry topics. Plan your studying accordingly to ensure you spend the right amount of time reviewing these topics in relation to other higher-yield subjects you'll see on Test Day.

PLANE GEOMETRY

Line Segments

One of the most fundamental skills in geometry is the ability to manipulate **line segments**, which make up the sides of **polygons**, such as triangles and rectangles. In general, the lengths of line segments can be added or subtracted just like any other numbers, but this may still require algebraic skills when one or more of the sides are unknown.

Example:

In the figure above, the length of segment PS is $2x + 12$, and the length of segment PQ is $6x - 10$. If R is the midpoint of segment QS, what is the length of segment PR?

Solution: Usually the best way to start on a plane geometry question is to draw a figure. Put as much of the information into the figure as you can. That's a good way to organize your thoughts, and that way you don't have to go back and forth between the figure and the question.

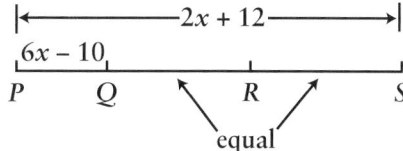

Now you can plan your attack. First, subtract PQ from the whole length PS to get QS:

$$QS = PS - PQ = (2x + 12) - (6x - 10) = 2x + 12 - 6x + 10 = -4x + 22$$

Then, because R is the midpoint of QS, you can divide QS by 2 to get QR and RS:

$$QR = RS = \frac{QS}{2} = \frac{-4x + 22}{2} = -2x + 11$$

What you're looking for is PR, so add PQ and QR:

$$PR = PQ + QR = (6x - 10) + (-2x + 11) = 4x + 1$$

Triangles

Most plane geometry questions are about **closed figures**: polygons and circles. The test makers' favorite closed figure is the three-sided polygon; that is, the **triangle**. All triangles share a number of common properties, and several types of triangles—equilateral, isosceles, and right triangles—display special characteristics.

First, let's look at the traits all triangles share:

Sum of the interior angles: The three interior angles of any triangle add up to 180°.

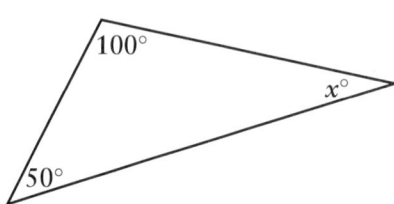

In the figure above, $x + 50 + 100 = 180$, so $x = 30$.

Measure of an exterior angle: The measure of an exterior angle of a triangle is equal to the sum of the measures of the remote interior angles.

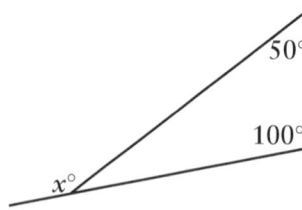

In the figure above, the measure of the exterior angle labeled $x°$ is equal to the sum of the measures of the remote interior angles: $x = 50 + 100 = 150$.

Sum of the exterior angles: The measures of the three exterior angles of any triangle add up to 360°.

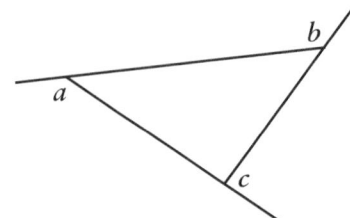

In the previous figure, $a + b + c = 360°$. In fact, the measures of the exterior angles of any polygon add up to 360°.

Area formula: The general formula for the area of a triangle is always the same:

$$\text{Area of Triangle} = \frac{1}{2}(\text{base})(\text{height})$$

The height is the perpendicular distance between the side that's chosen as the base and the opposite vertex. In the triangle shown below, 4 is the height when the 7 side is chosen as the base.

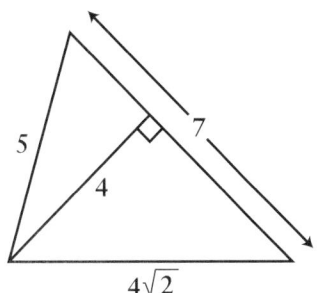

$$\text{Area of Triangle} = \frac{1}{2}(\text{base})(\text{height})$$

$$= \frac{1}{2}(7)(4) = 14$$

Triangle inequality theorem: The length of any one side of a triangle must be greater than the positive difference and less than the sum of the lengths of the other two sides. For example, if it is given that the length of one side is 3 and the length of another side is 7, then the length of the third side must be greater than $7 - 3 = 4$ and less than $7 + 3 = 10$.

Triangles summary

1. Interior angles add up to 180°
2. Exterior angle equals sum of remote interior angles
3. Exterior angles add up to 360°
4. Area of a triangle = ½ (base)(height)
5. Each side is greater than the difference and less than the sum of the other two sides

Types of triangles

Three unique triangle types deserve special attention: isosceles triangles, equilateral triangles, and right triangles. Be sure you know not just the definitions of these triangle types but, more importantly, their special characteristics: side relationships, angle relationships, and area formulas.

Isosceles triangle: An isosceles triangle is a triangle that has two equal sides. Not only are two sides equal, but the angles opposite the equal sides, called *base angles*, are also equal.

Equilateral triangle: An equilateral triangle is a triangle that has three equal sides. Since all the sides are equal, all the angles are also equal. All three angles in an equilateral triangle measure 60 degrees, regardless of the lengths of the sides.

Right triangle: A right triangle is a triangle with one right angle. The two sides that form the right angle are called **legs**, and you can use them as the base and height to find the area of a right triangle. The side opposite the right angle is called the **hypotenuse** and is always the longest of the three sides.

Pythagorean theorem: If you know any two sides of a right triangle, you can find the third side by using the Pythagorean theorem:

$$(\text{leg}_1)^2 + (\text{leg}_2)^2 = (\text{hypotenuse})^2$$

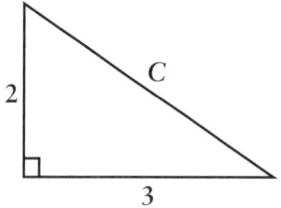

For example, if one leg is 2, and the other leg is 3, then

$$2^2 + 3^2 = c^2$$
$$c^2 = 4 + 9$$
$$c = \sqrt{13}$$

Pythagorean triplet: A Pythagorean triplet is a set of integers that fits the Pythagorean theorem. The simplest Pythagorean triplet is (3, 4, 5). In fact, any integers in a 3:4:5 ratio make up a Pythagorean triplet, including (6, 8, 10) and (9, 12, 15). There are many other Pythagorean triplets as well: (5, 12, 13); (7, 24, 25); (8, 15, 17); (9, 40, 41); all their multiples; and infinitely many more.

Pythagorean triplets are useful because, when present, you can determine the length of the third side of a right triangle with no Pythagorean theorem calculations. You simply determine what Pythagorean triplet is present and by what factor that triplet is multiplied. For example, in the right triangle shown below, one leg is 30 and the hypotenuse is 50. This is 10 times a 3-4-5 triplet. Thus, the missing side, b, must be 4 times 10, or 40.

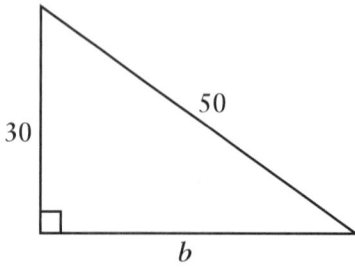

45°-45°-90° triangles: The sides of a 45°-45°-90° triangle are in a ratio of $1:1:\sqrt{2}$. If you know just one of the side lengths, you can find the other two.

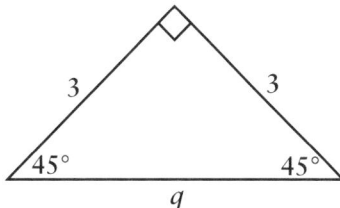

If one leg is 3, then the other leg is also 3, and the hypotenuse q is equal to a leg times $\sqrt{2}$ or $3\sqrt{2}$.

30°-60°-90° triangles: The sides of a 30°-60°-90° triangle are in a ratio of $1:\sqrt{3}:2$. Again, if you know one of the side lengths, you can find the others; you won't need to use the Pythagorean theorem.

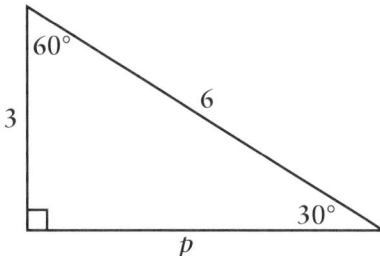

If the hypotenuse is 6, then the shorter leg is half that, or 3, and the longer leg p is equal to the short leg times $\sqrt{3}$, or $3\sqrt{3}$.

Quadrilaterals

A quadrilateral is any polygon with four sides. There are five special quadrilaterals you should be familiar with for test day. As with triangles, there is some overlap among these categories, and some figures fit into none of these categories. Just as a 45°-45°-90° triangle is both right and isosceles, a quadrilateral with four equal sides and four right angles is not only a square but also a rhombus, a rectangle, and a parallelogram. It is wise to have a basic understanding of the definitions and special characteristics of these five quadrilateral types.

Trapezoid

A trapezoid is a four-sided figure with one pair of parallel sides and one pair of nonparallel sides.

$$\text{Area of Trapezoid} = \left(\frac{\text{base}_1 + \text{base}_2}{2} \right) \times \text{height}$$

Think of this formula as the average of the bases (the two parallel sides) times the height (the length of the perpendicular altitude).

Parallelogram

A parallelogram is a four-sided figure with two pairs of parallel sides. Opposite sides are equal. Opposite angles are equal. Consecutive angles add up to 180°.

$$\text{Area of Parallelogram} = \text{base} \times \text{height}$$

As in triangles and trapezoids, the base and height must be perpendicular.

Rectangle

A rectangle is a four-sided figure with four right angles. Opposite sides are equal. Diagonals are equal. The perimeter of a rectangle is equal to the sum of the lengths of the four sides, which is equal to 2(length + width).

$$\text{Area of Rectangle} = \text{length} \times \text{width}$$

Rhombus

A rhombus is a four-sided figure with four equal sides. A rhombus is also a parallelogram, so to find the area of the rhombus, you need its height to plug into the equation area = base × height. The more a rhombus "leans over," the smaller the height and, therefore, the smaller the area.

Square

A square is a four-sided figure with four right angles and four equal sides. A square is also a rectangle, a parallelogram, and a rhombus. The perimeter of a square is equal to 4 times the length of one side.

$$\text{Area of Square} = (\text{side})^2$$

Perimeter and Area

The test makers like to write problems that combine the concepts of perimeter and area. What you need to remember is that perimeter and area are not directly related. In the following example, for instance, you have two figures with the same perimeter, but that doesn't mean they have the same area.

Example: A square and a regular hexagon have the same perimeter. If the area of the square is 2.25, what is the area of the hexagon?

Solution: The way to get started is to sketch what's described in the question. A square of area 2.25 has sides each of length $\sqrt{2.25} = 1.5$, so the perimeter of the square is $4(1.5) = 6$. Since that's also the perimeter of the regular hexagon, and a regular hexagon has six equal sides, the length of each side of the hexagon is 1.

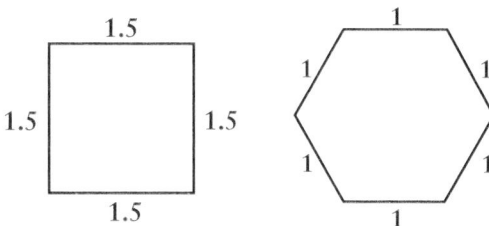

Now the problem is one of finding the area of a regular hexagon of side length 1. The fastest way to do that would be to use the formula. If the length of one side is s,

$$\text{Area of Regular Hexagon} = \frac{3s^2\sqrt{3}}{2}$$

This formula is not one the test makers expect you to know—there's always a way around it—but if you like formulas and you're good at memorizing them, it can only help. Let's proceed, however, as if we didn't know the formula.

Another way to go about finding this area is to add a line segment or two to the figure and divide it up into more familiar shapes. You could, for example, draw in three diagonals and turn the hexagon into six equilateral triangles of side 1:

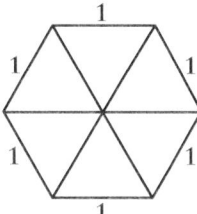

Each of those six triangles has base 1 and height $\frac{\sqrt{3}}{2}$, and therefore,

$$\text{Area of one triangle} = \frac{1}{2}(\text{base})(\text{height}) = \frac{1}{2}(1)\left(\frac{\sqrt{3}}{2}\right) = \frac{\sqrt{3}}{4}$$

The area of the hexagon is 6 times that.

$$\text{Area of Hexagon} = 6\left(\frac{\sqrt{3}}{4}\right) = \frac{3\sqrt{3}}{2} \approx 2.598.$$

Circles

Another figure you should have a basic understanding of for Test Day is the circle. Circles don't come in as many varieties as triangles do. In fact, all circles are similar—they're all the same shape. The only difference among them is size. So you don't have to learn to recognize types or remember names. All you have to know about circles is how to find four things: circumference, length of an arc, area, and area of a sector. You could think of the task as one of memorizing four formulas, but you'll be better off in the end if you have some idea of where the arc and sector formulas come from and how they are related to the circumference and area formulas.

Circumference

Circumference is a measurement of length. You could think of it as the perimeter: It's the total distance around the circle. If the radius of the circle is r,

$$\text{Circumference} = 2\pi r$$

Since the diameter is twice the radius, you can easily express the formula in terms of the diameter d:

$$\text{Circumference} = \pi d$$

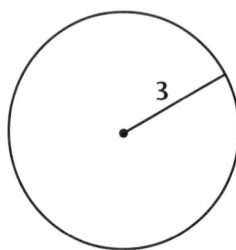

In the circle above, the radius is 3, so the circumference is $2\pi(3) = 6\pi$.

Length of an arc

An arc is a piece of the circumference. If n is the degree measure of the arc's central angle, then the formula is

$$\text{Length of an Arc} = \left(\frac{n}{360}\right)(2\pi r)$$

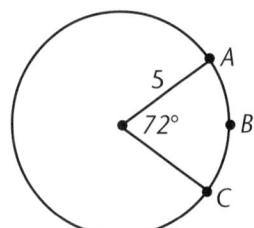

In the figure above, the radius is 5 and the measure of the central angle is 72°. The arc length is $\frac{72}{360}$ or $\frac{1}{5}$ of the circumference:

$$\left(\frac{72}{360}\right)(2\pi)(5) = \left(\frac{1}{5}\right)(10\pi) = 2\pi$$

Area

The area of a circle is found using this formula in terms of the radius r:

$$\text{Area of a Circle} = \pi r^2$$

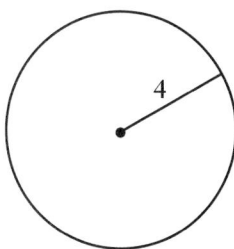

The area of the circle above is $\pi(4)^2 = 16\pi$.

Area of a sector

A sector is a piece of the area of a circle. If n is the degree measure of the sector's central angle, then the area formula is

$$\text{Area of a Sector} = \left(\frac{n}{360}\right)(\pi r^2)$$

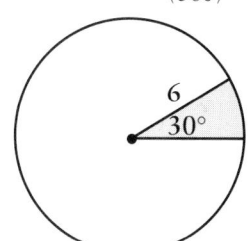

In the figure above, the radius is 6 and the measure of the sector's central angle is 30°. The sector has $\frac{30}{360}$ or $\frac{1}{12}$ of the area of the circle:

$$\left(\frac{30}{360}\right)(\pi)(6^2) = \left(\frac{1}{12}\right)(36\pi) = 3\pi$$

Circles summary

1. Circumference $= 2\pi r = \pi d$

2. Length of an arc $= \left(\dfrac{n}{360}\right)(2\pi r)$

3. Area of a circle $= \pi r^2$

4. Area of a sector $= \left(\dfrac{n}{360}\right)(\pi r^2)$

QR

873

Complex Figures

Some of the most challenging plane geometry questions are those that combine circles with other figures.

Example: In the figure below, rectangle $ABCD$ is inscribed in a circle. If the radius of the circle is 1 and $AB = 1$, what is the area of the shaded region?

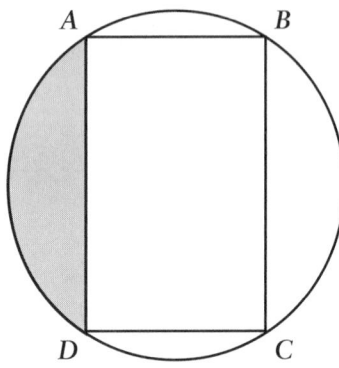

Solution: Once again, the key here is to add to the figure. And in this case, as is so often the case in a figure that includes a circle, what you should add is radii. The equilateral triangles tell you that the central angles are 60° and 120°.

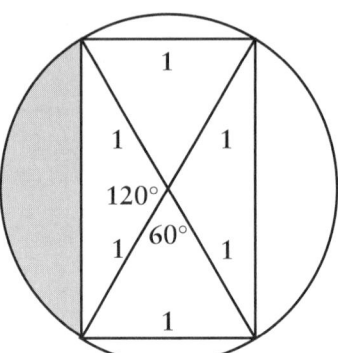

The shaded region is what's left of the 120° sector after you subtract the area of the triangle with the 120° vertex angle.

To find the area of the shaded region, you want to find the areas of the sector and triangle, then subtract. The sector is exactly one-third of the circle (because 120° is one-third of 360°), so

$$\text{Area of sector} = \frac{1}{3}\pi r^2 = \frac{1}{3}\pi(1)^2 = \frac{\pi}{3}$$

You can divide the triangle into two $30°-60°-90°$ triangles:

The area of each $30°-60°-90°$ triangle is $\frac{1}{2}\left(\frac{1}{2}\right)\left(\frac{\sqrt{3}}{2}\right)=\frac{\sqrt{3}}{8}$, so the area of the triangle with the $120°$ vertex is twice that, or $\frac{\sqrt{3}}{4}$.

The area of the shaded region is, therefore:

$$\frac{\pi}{3}-\frac{\sqrt{3}}{4}$$

SOLID GEOMETRY

Solids are three-dimensional objects with length, width, and height. **Solid geometry** takes concepts from two-dimensional plane geometry and adds another dimension such that area becomes volume. With a strong understanding of the planar shapes, you'll find that the rules for solid geometry follow the same format and are only slightly more complicated.

Uniform Solids

A **uniform solid** is what you get when you take a plane and move it, without tilting it, through space. Here are some uniform solids.

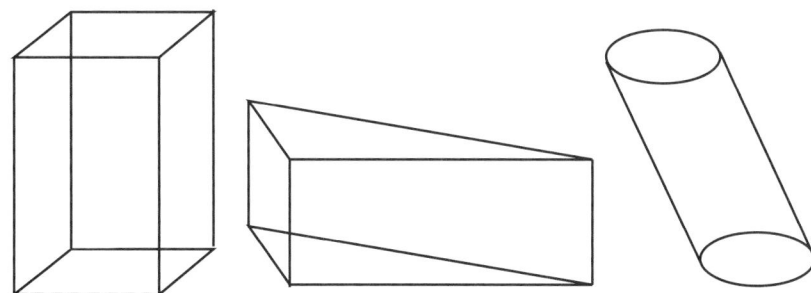

The way these solids are drawn, the top and bottom faces are parallel and congruent. These faces are called the **bases**. You can think of each of these solids as the result of sliding the base through space. The perpendicular distance through which the base slides is called the **height**.

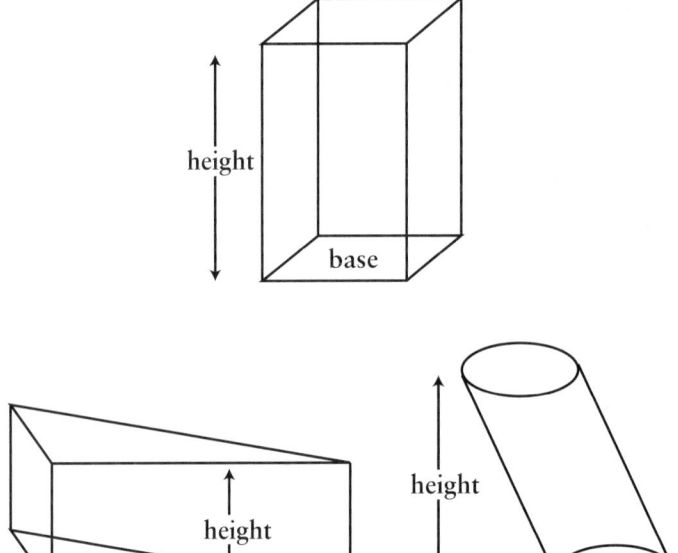

In every one of the above cases—indeed, in the case of any uniform solid—the volume is equal to the area of the base times the height. Therefore, you can say that for any uniform solid, given the area of the base B and the height h:

$$\text{Volume of a Uniform Solid} = Bh$$

Surface area can be much more time-consuming to calculate and involves adding together the areas of all the faces of a three-dimensional object, which can be calculated using the equations for finding the area of various polygons.

Example: In the figure below, the bases of the right uniform solid are triangles with sides of lengths 3, 4, and 5. If the volume of the solid is 30, what is the total surface area?

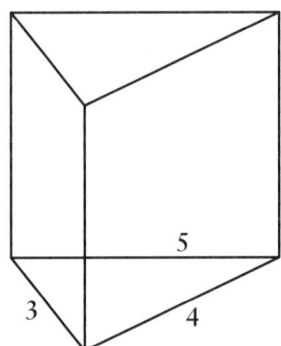

Solution: The surface area is the sum of the areas of the faces. To find the areas of the faces, you need to figure out what kinds of polygons they are so that you'll know what formulas to use. Start with the bases, which are triangles with sides of lengths 3, 4, and 5. This is a 3-4-5 triangle, which means that it's a right triangle, and you can use the legs as the base and height to find the area:

$$\text{Area of Right Triangle} = \frac{1}{2}(\text{leg}_1)(\text{leg}_2) = \frac{1}{2}(3)(4) = 6$$

That's the area of each of the bases. The other three faces are rectangles. To find their areas, you need first to determine the height of the solid. If the area of the base is 6 and the volume is 30, then

$$\text{Volume} = Bh$$
$$30 = 6h$$
$$h = 5$$

So the areas of the three rectangular faces are $3 \times 5 = 15$, $4 \times 5 = 20$, and $5 \times 5 = 25$. The total surface area, then, is $6 + 6 + 15 + 20 + 25 = 72$.

Spheres

A **sphere** is a round three-dimensional solid such that every point on its surface is equidistant from its center.

Surface area of a sphere

Given radius r:

$$\text{Surface Area of Sphere} = 4\pi r^2$$

For example, if the radius of a sphere is 2, then

$$\text{Surface Area} = 4\pi(2^2) = 16\pi$$

Volume of a sphere

Given radius r:

$$\text{Volume} = \frac{4}{3}\pi r^3$$

For example, if the radius of a sphere is 2, then

$$\text{Volume} = \frac{4}{3}\pi(2)^3 = \frac{32\pi}{3}$$

COORDINATE GEOMETRY

Midpoints and Distances

Some of the more basic coordinate geometry questions are concerned with the layout of grids, the location of points and the distances between them, midpoints, and similar concepts.

Example:

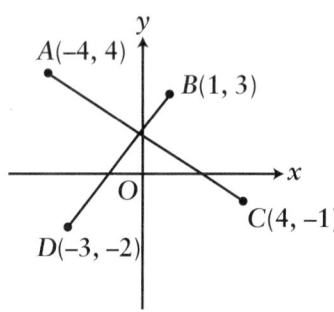

In the above figure, what is the distance from the midpoint of segment AC to the midpoint of segment BD?

Solution: To find the **midpoint** of a segment, average the x-coordinates and average the y-coordinates of the endpoints:

$$\text{midpoint of } AC = \left(\frac{-4+4}{2}, \frac{4-1}{2}\right) = (0, 1.5)$$

$$\text{midpoint of } BD = \left(\frac{-3+1}{2}, \frac{-2+3}{2}\right) = (-1, 0.5)$$

To find the distance between two points, use the distance formula:

$$\text{Distance} = \sqrt{(x_1 - x_2)^2 + (y_1 - y_2)^2}$$

The distance from $(0, 1.5)$ to $(-1, 0.5)$ is calculated as follows:

$$\text{Distance} = \sqrt{(-1 - 0)^2 + (0.5 - 1.5)^2}$$
$$= \sqrt{1 + 1}$$
$$= \sqrt{2}$$

Slope-Intercept Form

Slopes and **intercepts** are descriptions of lines and points on the grid, but the processes of finding and using slopes or intercepts are generally algebraic processes.

Example: Which of the following lines has no point of intersection with the line $y = 4x + 5$?

A. $y = \dfrac{1}{4}x - 5$

B. $y = -\dfrac{1}{4}x - 5$

C. $y = 4x + \dfrac{1}{5}$

D. $y = -4x + \dfrac{1}{5}$

E. $y = -4x - \dfrac{1}{5}$

Solution: What does "has no intersection with" mean? It means that the lines are parallel, which in turn means that the lines have the same slope. If you know the slope-intercept form, you're able to spot the correct answer instantly.

When an equation is in the form $y = mx + b$, the letter m represents the slope, and the letter b represents the y-intercept. The equation in the stem is $y = 4x + 5$. That's in slope-intercept form, so the coefficient of x is the slope.

$$y = \text{\textcircled{4}}x + 5$$
$$\text{slope} = 4$$

Now look for the answer choice with the same slope. Conveniently, all the answer choices are presented in slope-intercept form, so spotting the one with $m = 4$ is straightforward; it's (C):

$$y = \text{\textcircled{4}}x + \dfrac{1}{5}$$
$$\text{slope} = 4$$

Slope is a description of the "steepness" of a line. Lines that go uphill (from left to right) have positive slopes, and the steeper the uphill grade, the greater the slope.

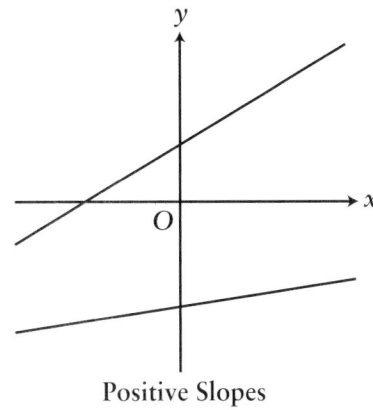

Positive Slopes

Lines that go downhill have negative slopes. The steeper the downhill grade, the less the slope:

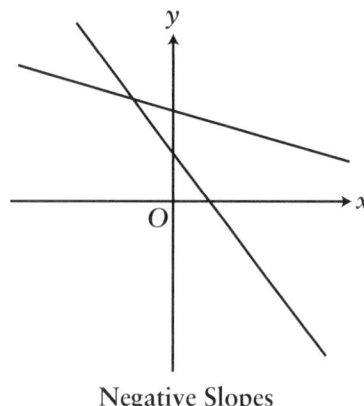

Negative Slopes

Lines parallel to the x-axis have slope $= 0$, and lines parallel to the y-axis have *undefined slopes*.

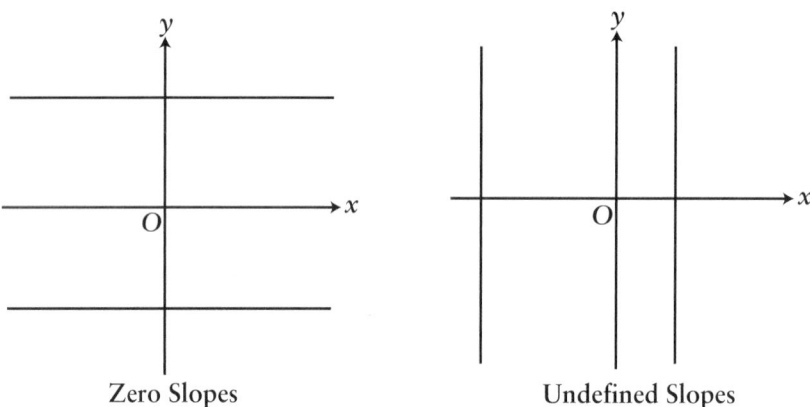

Zero Slopes Undefined Slopes

Lines that are parallel to each other have the same slope, and lines that are perpendicular to each other have negative-reciprocal slopes.

Absolute Value and Inequalities

Example: Which of the following shaded regions shows the graph of the inequality $y \leq |x + 2|$?

A.

B.

C.

D.

E.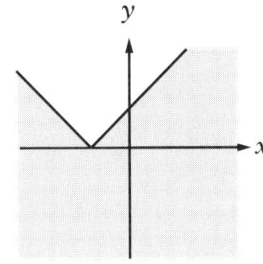

Solution: The way to handle an inequality is to think of it as an equation first, plot the line, and then figure out which side of the line to shade. This inequality is complicated by the absolute value. When you graph an equation with an absolute value, you generally get a line with a bend, as in all of the answer choices above. To find the graph of an absolute value equation, figure out where the bend is. In this case, $|x + 2|$ has a turning-point value of 0, which happens when $x = -2$. So the bend is at the point $(-2, 0)$. That narrows the choices down to (A) and (E).

Next, figure out which side gets shaded. Pick a convenient point on either side and see if that point's coordinates fit the given inequality. The point $(0, 0)$ is an easy one to work with. Do those coordinates satisfy the inequality?

$$y \leq x + 2$$
$$0 \overset{?}{\leq} 0 + 2$$
$$0 \overset{?}{\leq} 2 \quad \text{Yes.}$$

The point $(0, 0)$ must be on the shaded side of the bent line. The answer is (E).

QR

881

REVIEW PROBLEMS

1. Point *m* has coordinates $(-2, -10)$, and point *n* has coordinates $(-8, -6)$. What are the coordinates of the midpoint of the line segment that has endpoints *m* and *n*?

2. The hypotenuse of a right triangle is 17, and one of the legs is 8. What is the area of the triangle?

3. The area of a circle is 36. What is the circle's diameter?

4.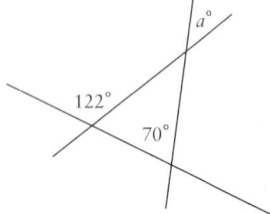

 In the diagram above, what is the value of *a*?

5.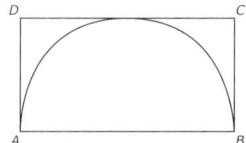

 \overline{AB} is the diameter of the semicircle above, which is tangent to \overline{CD}. If the area of the semicircle is 50π, then what is the area of rectangle *ABCD*?

6. Each side of an equilateral triangle is 12. What is the area of the triangle?

7.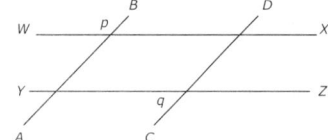

 In the diagram above, $\overline{AB} \| \overline{CD}$ and $\overline{WX} \| \overline{YZ}$. If $p = 125°$, then what does *q* equal?

8. How many times does the parabola represented by the function $f(x) = x^2 - 3x + 28$ intersect the parabola represented by the function $g(x) = 2x^2 + 7x + 53$?

9. A circle and a square have the same area. What is the ratio of the radius of the circle to the length of a side of the square?

10. Darnell leaves his house and walks 25 feet due north, then 42 feet due east, and then stops. Melanie leaves the same house and walks 86 feet due east, then walks in a straight line to where Darnell is standing. What is the area of the region enclosed by the paths Darnell and Melanie walked?

SOLUTIONS TO REVIEW PROBLEMS

1. $(-5, -8)$ The midpoint of a line segment is found by taking the average of the *x*-coordinates of the endpoints and the average of the *y*-coordinates of the endpoints. For *m* and *n*, the average of the *x*-coordinates is $[-2 + (-8)] \div 2 = (-10) \div 2 = -5$. The average of the *y*-coordinates is $(-10 + -6) \div 2 = -16 \div 2 = -8$.

2. 60 The area of a triangle equals (base)(height) \div 2. For a right triangle, the base and height are the legs. This is an 8-15-17 right triangle, so the legs are 8 and 15. Thus, the area is $(8)(15) \div 2 = 4(15) = 60$.

Recognizing the 8-15-17 right triangle pattern was helpful, but the missing leg could also have been found via the Pythagorean theorem:

$$8^2 + s^2 = 17^2$$
$$64 + s^2 = 289$$
$$s^2 = 225$$
$$s = 15$$

3. $\dfrac{12}{\sqrt{\pi}}$ The area of a circle equals πr^2. Set this equal to 36 and solve for *r*:

$$36 = \pi r^2$$
$$r^2 = \frac{36}{\pi}$$
$$r = \frac{6}{\sqrt{\pi}}$$

This is the radius. The diameter is twice that, or $\dfrac{12}{\sqrt{\pi}}$.

4. 52 Angles on one side of a straight line add up to 180°, so the interior angle of the triangle that is next to the 122° angle must equal $180° - 122°$, or 58°. The angles of a triangle add up to 180° as well, so now the final angle of the triangle must be $180° - 70° - 58° = 52°$. Angle *a* is vertical to this last angle, and vertical angles are always congruent. Thus, angle *a* is also 52°.

5. 200 If the area of half a circle is 50π, then the area of the entire circle is twice that, or 100π. For a circle, area $= \pi r^2$, so the radius of the semicircle is 10. ($100\pi = \pi r^2$, so $r^2 = 100$ and $r = 10$.) This is also the height of the rectangle. The diameter of the semicircle is twice that, or 20. This is also the width of the rectangle. The area of a rectangle is width \times height, which is $20 \times 10 = 200$.

6. $36\sqrt{3}$ In an equilateral triangle, all sides are equal and all angles are equal to 60°. The area is equal to $\frac{1}{2}bh$. The base is equal to 12, but the height needs to be calculated. Drawing a height will create two 30-60-90 triangles.

An equilateral triangle with side length $2x$. A height is drawn, creating two smaller triangles with interior angles of 30, 60, and 90 degrees.

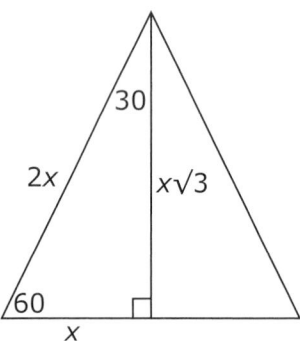

The ratio of sides in a 30-60-90 triangle is $x : x\sqrt{3} : 2x$. For each smaller triangle, the side opposite the 30° angle (x) is 6. That means the height (opposite the 60° angle) is equal to $6\sqrt{3}$. With the height determined, the area of the original equilateral triangle is equal to $\frac{1}{2}(12)(6\sqrt{3}) = 36\sqrt{3}$.

7. **55°** Because both pairs of lines are parallel, all of the acute angles are congruent and all of the obtuse angles are congruent. As a result, every obtuse angle is supplementary to every acute angle. Since p is obtuse and q is acute, it must be that $p + q = 180°$. Thus, $q = 180° - 125° = 55°$.

8. **1** To find the point(s) of intersection between two functions in the coordinate plane, set them equal to each other and solve:

$$2x^2 + 7x + 53 = x^2 - 3x + 28$$
$$x^2 + 10x + 25 = 0$$
$$(x + 5)(x + 5) = 0$$

This equation has only one solution: -5. Thus, there is only one point of intersection between the two parabolas.

9. $\dfrac{1}{\sqrt{\pi}}$ Call the radius r and the length of a side of the square s. The question asks for the ratio of r to s, or $\dfrac{r}{s}$. The area of the circle is πr^2 and the area of the square is s^2. The question states that these are equal:

$$\pi r^2 = s^2$$

Take the square root of both sides to simplify:

$$\sqrt{\pi}\,r = s$$

Finally, divide both sides by s and by $\sqrt{\pi}$ to find the ratio of r to s:

$$\frac{r}{s} = \frac{1}{\sqrt{\pi}}$$

10. **1,600** Draw a diagram to visualize the region:

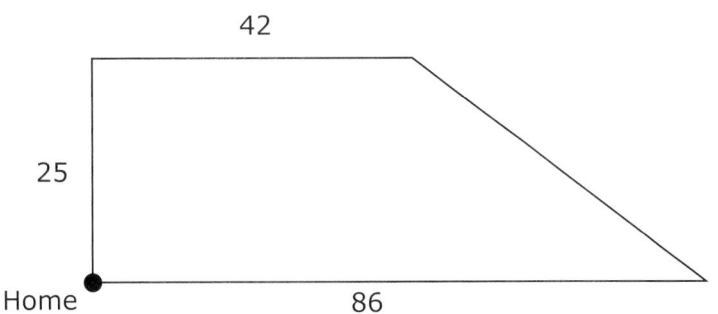

This is a trapezoid. The area of a trapezoid equals the average of the bases times the height:

$$\text{Area} = 25 \times (42 + 86) \div 2$$
$$\text{Area} = 25 \times (128) \div 2$$
$$\text{Area} = 25 \times 64 = 1{,}600$$

CHAPTER SIXTY-THREE

Trigonometry

LEARNING OBJECTIVE

After this chapter, you will be able to:

• Apply trigonometric functions to solve for angles and side length of triangles

RIGHT TRIANGLES

Trigonometry is really all about right triangles—and you're concerned not with the right angle, per se, but with one of the other angles of the triangle. The **sine** of angle θ is the length of the side opposite the angle divided by the length of the hypotenuse (the **hypotenuse** is the side opposite the right angle). The mathematical abbreviation for sine is sin, and the sine of the angle θ is written sin θ.

The **cosine** is the length of the side adjacent to angle θ (actually, there will be two sides adjacent to the angle, but one of those sides will be the hypotenuse, so by adjacent, we really mean the side adjacent to angle that is not the hypotenuse) divided by the length of the hypotenuse. The mathematical abbreviation for cosine is cos, and the cosine of the angle θ is written cos θ.

Finally, the **tangent** of an angle is the length of the opposite side over the length of the adjacent side. The mathematical abbreviation for tangent is tan, and the tangent of the angle is written tan θ.

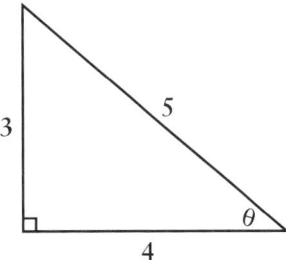

So for instance, in the figure above, the sine of angle θ, sin θ, is the length of the side opposite angle θ (3) divided by the length of the hypotenuse (5). So the sine is $\frac{3}{5} = 0.60$. That is, sin $\theta = 0.60$.

The cosine of angle θ is the length of the side adjacent to angle θ (4) divided by the length of the hypotenuse (5). So the cosine of angle θ is $\frac{4}{5} = 0.80$, or cos $\theta = 0.80$.

Finally, the tangent is the length of the side opposite angle θ (3) divided by the length of the side adjacent to angle θ (4). So the tangent of angle θ is $\frac{3}{4} = 0.75$, or tan $\theta = 0.75$. To help

you remember the definitions of sine, cosine, and tangent as they apply to right triangles, use the mnemonic **SOHCAHTOA** (the first letters of each of the words below).

$$\text{Sine} = \frac{\text{Opposite}}{\text{Hypotenuse}} \qquad \text{Cosine} = \frac{\text{Adjacent}}{\text{Hypotenuse}} \qquad \text{Tangent} = \frac{\text{Opposite}}{\text{Adjacent}}$$

We can also use this information to help us figure out the lengths of sides of triangles.

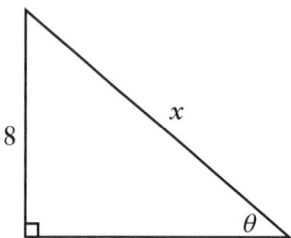

Example: In the right triangle above, if the sine of angle $\theta = 0.5$, what is the value of x?

Solution: The angle is opposite the given side, and the side you're looking for is the hypotenuse, so you can use the sine formula to find x:

$$\sin \theta = \frac{\text{Opposite}}{\text{Hypotenuse}}$$

$$0.5 = \frac{8}{x}$$

$$x = \frac{8}{0.5}$$

$$x = 16$$

There are three other trig functions you should be aware of—and each is the *reciprocal* of one of the trig functions introduced above. They are called **cotangent**, **secant**, and **cosecant**.

$$\text{Cotangent} = \frac{\text{Adjacent}}{\text{Opposite}} \qquad \text{Secant} = \frac{\text{Hypotenuse}}{\text{Adjacent}} \qquad \text{Cosecant} = \frac{\text{Hypotenuse}}{\text{Opposite}}$$

These are also equal to:

$$\text{Cotangent} = \frac{1}{\text{Tangent}} \qquad \text{Secant} = \frac{1}{\text{Cosine}} \qquad \text{Cosecant} = \frac{1}{\text{Sine}}$$

The mathematical abbreviation for cotangent is cot, and the cotangent of the angle θ is written cot θ. The mathematical abbreviation for secant is sec, and the secant of the angle θ is written sec θ. The mathematical abbreviation for cosecant is csc, and the cosecant of the angle θ is written csc θ.

DEGREES AND RADIANS

By definition, if you go all the way around a circle, you have traveled 360 degrees. The **degree** is a unit of measure for describing angles. An angle that is 1 degree is $\frac{1}{360}$ of a complete circle.

The **radian** is another measure used to describe an angle and is often used in trigonometry.

The word *radian* is related to the word *radius*. Remember that, in a circle, a **central angle** is the angle formed by two radii of the circle. This leads to the definition of a radian. If a central angle of a circle intercepts an arc of a circle with length ℓ, then the number of radians in the central angle that contains this arc is $\frac{\ell}{r}$.

For Test Day, you should remember that 2π radians is equal to 360 degrees. From this, you can convert from some other given number of degrees to the corresponding number of radians, or you can convert from the number of radians to the corresponding number of degrees. You may also remember that π radians is equal to 180 degrees and do your converting based on this, if you are more comfortable doing so.

Example: How many degrees are in $\frac{5\pi}{6}$ radians?

Solution: Let x be the number of degrees. Then:

$$\frac{x}{\left(\frac{5\pi}{6}\right)} = \frac{360}{2\pi}$$

$$x = \frac{5\pi}{6} \times \frac{360}{2\pi} = \frac{5}{6} \times \frac{360}{2} = \frac{5}{1} \times \frac{60}{2} = 5 \times 30 = 150.$$

So there are 150 degrees in $\frac{5\pi}{6}$ radians.

Example: How many radians are there in 270 degrees?

Solution: Let y be the number of radians. Then $\frac{y}{270} = \frac{2\pi}{360}$. So:

$$y = 270 \times \left(\frac{2\pi}{360}\right) = \left(\frac{270}{360}\right) \times \pi = \left(\frac{27}{36}\right) \times \pi = \frac{3\pi}{2}.$$

There are $\frac{3\pi}{2}$ radians in 270 degrees.

Notice that in the first example, we had the number of degrees in the numerator and the number of radians in the denominator, while in the second example, our equation had the number of radians in the numerator and the number of degrees in the denominator. This is just a matter of setting up an equation so it will be easier to work with, since it's generally easier to begin with the unknown in the numerator. Both are correct.

TRIGONOMETRIC FUNCTIONS OF OTHER ANGLES

To find a trigonometric function of an angle greater than or equal to 90°, sketch a circle of radius r and centered at the origin of the coordinate grid (known as the **unit circle**). Start from the point $(r, 0)$ and rotate the appropriate number of degrees θ counterclockwise.

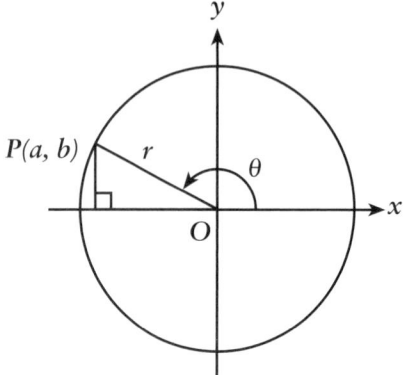

In this circle setup, the basic trigonometric functions are defined in terms of the coordinates a and b:

$$\sin \theta = \frac{b}{r}$$

$$\cos \theta = \frac{a}{r}$$

$$\tan \theta = \frac{b}{a}$$

$$\cot \theta = \frac{a}{b}$$

$$\sec \theta = \frac{r}{a}$$

$$\csc \theta = \frac{r}{b}$$

Notice that tan and sec are undefined if $a = 0$ and cot and csc are undefined if $b = 0$. Notice also that you are working with a right triangle whose hypotenuse is a radius of the circle. One of the legs of this right triangle is on the part of the x-axis that is closest to the hypotenuse (which is the rotated radius).

Example: What is sin 210°?

Solution: Sketch a 210° angle in the coordinate plane:

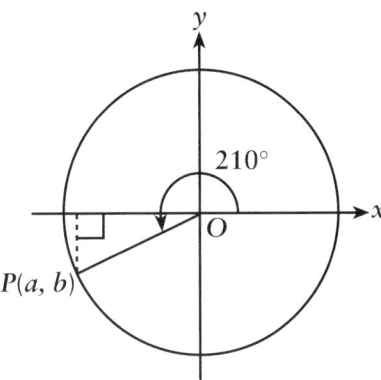

Because the triangle shown in the figure above is a 30°−60°−90° right triangle whose side lengths are in the ratio of $1:\sqrt{3}:2$, it is convenient to use a radius of 2. The coordinates of point P are $(-\sqrt{3}, -1)$.

Therefore $b = -1$, $r = 2$, and $\sin 210° = \dfrac{b}{r} = \dfrac{-1}{2} = -\dfrac{1}{2}$.

INVERSE FUNCTIONS

The inverse sine function of x, which is denoted by arcsin x, or $\sin^{-1} x$, determines the angle y such that $\sin y = x$ and $-90° \le y \le 90°$. Because $-1 \le \sin y \le 1$, the inverse sine function cannot be defined for values of x such that $x < -1$ or $x > 1$. Therefore, the inverse sine function of x is defined only for x such that $-1 \le x \le 1$.

For example, $\arcsin\left(\dfrac{1}{2}\right) = \sin^{-1}\left(\dfrac{1}{2}\right) = 30°$ because $\sin 30° = \dfrac{1}{2}$ and 30° is in the interval $-90° \le y \le 90°$.

The reason why, for a given x, the value of $\sin^{-1} x$ is defined to be in the interval $-90° \le y \le 90°$ is that there are infinitely many y such that $\sin y = x$, and a function must associate exactly one number with each number in the domain.

For example, look at $\sin^{-1}\left(\dfrac{1}{2}\right)$ again. It is true that $\sin(-570°) = \dfrac{1}{2}$, $\sin(-330°) = \dfrac{1}{2}$, $\sin(-210°) = \dfrac{1}{2}$, $\sin 30° = \dfrac{1}{2}$, $\sin 150° = \dfrac{1}{2}$, $\sin 30° = \dfrac{1}{2}$, $\sin 510° = \dfrac{1}{2}$, $\sin 750° = \dfrac{1}{2}$, and so on. To be able to assign a unique value to $\sin^{-1}\left(\dfrac{1}{2}\right)$, the requirement that the angle be in the interval $-90° \le y \le 90°$ is included.

The inverse tangent function of x, which is denoted by arctan x, or $\tan^{-1} x$, determines the angle y such that $-90° < y < 90°$ and $\tan y = x$. The inverse tangent function is defined for all real x. For example, $\arctan(-1) = \tan^{-1}(-1) = -45°$ because $-45°$ is in the interval $-90° < y < 90°$ and $\tan(-45°) = -1$.

The reason why, for any given real number x, the value of $\tan^{-1} x$ is defined to be in the interval $-90° < y < 90°$ is that there are infinitely many values of y such that $\tan y = x$, and a function must associate exactly one number with each number in the domain.

For example, look at $\tan^{-1}(-1)$ again. It is true that $\tan(-765°) = -1$, $\tan(-585°) = -1$, $\tan(-405°) = -1$, $\tan(-225°) = -1$, $\tan(-45°) = -1$, $\tan(135°) = -1$, $\tan 315° = -1$, $\tan 495° = -1$, $\tan 675° = -1$, and so on. To be able to assign a unique value to $\tan^{-1}(-1)$, the requirement that the angle be in the interval $-90° < y < 90°$ is included.

Notice that the possible values of the inverse sine function are in the interval $-90° \le y \le 90°$, while the possible values of the inverse tangent function are in the interval $-90° < y < 90°$. The values of $-90°$ and $90°$ are not possible values of the inverse tangent function because $\tan 90°$ and $\tan(-90°)$ are both undefined.

Example: Which of the following is equal to $\tan\left(\sin^{-1}\left(\dfrac{7}{\sqrt{74}}\right)\right)$?

 A. $\dfrac{\sqrt{74}}{7}$

 B. $\dfrac{5}{\sqrt{74}}$

 C. $\dfrac{5}{7}$

 D. $\dfrac{7}{\sqrt{74}}$

 E. $\dfrac{7}{5}$

Solution: You want to find the tangent of a certain angle. That angle is $\sin^{-1}\left(\dfrac{7}{\sqrt{74}}\right)$. Call $\sin^{-1}\left(\dfrac{7}{\sqrt{74}}\right)$ the angle y. Then $y = \dfrac{7}{\sqrt{74}}$. In a right triangle, the sine of an angle is equal to the length of the leg opposite that angle divided by the length of the hypotenuse. So draw a picture of a right triangle with an angle y whose sine is $\dfrac{7}{\sqrt{74}}$:

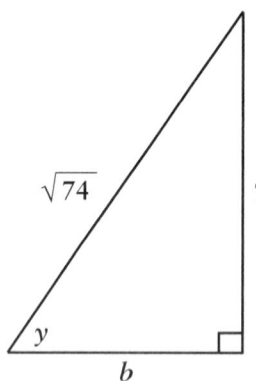

If you can find the length of b, you can find $\tan\left[\sin^{-1}\left(\dfrac{7}{\sqrt{74}}\right)\right] = \tan y$ by remembering that, in a right triangle, the tangent of an angle is equal to the length of the leg opposite that angle divided by the length of the leg adjacent to that angle. The length b of the other leg can be found by using the Pythagorean theorem, which says that the square of the hypotenuse is equal to the sum of the squares of the legs. Here,

$$7^2 + b^2 = (\sqrt{74})^2$$
$$49 + b^2 = 74$$
$$b^2 = 25$$
$$b = 5$$

Note that $b = -5$ is also a solution of the equation $b^2 = 25$, but you're concerned with lengths, and you can't have a negative length; therefore, $b = -5$ does not apply here.

So $b = 5$, and $\tan y = \tan\left[\sin^{-1}\left(\dfrac{7}{\sqrt{74}}\right)\right] = \dfrac{7}{5}$. Choice (E) is correct.

REVIEW PROBLEMS

1. In the figure below, what is the value of cos θ?

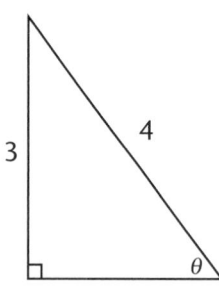

Figure 1

 A. 0.25
 B. 0.66
 C. 0.75
 D. 0.80
 E. 1.25

2. Which of the following equals $\dfrac{\cos^4 \theta - \sin^4 \theta}{\cos^2 \theta - \sin^2 \theta}$ where defined?

 A. 1
 B. 2
 C. $\cos \theta + \sin \theta$
 D. $\cos \theta - \sin \theta$
 E. $\cos^2 \theta + \sin^2 \theta$

3. If $\sin \theta = \dfrac{1}{2} \cos \theta$, and $0 < \theta < \dfrac{\pi}{2}$, the value of $\dfrac{1}{2} \sin \theta$ is

 A. 0.22
 B. 0.25
 C. 0.45
 D. 0.50
 E. 0.75

4. If θ is an acute angle for which $\tan^2 \theta = 6 \tan \theta - 9$, what is the approximate measure of θ?

 A. 30°
 B. 45°
 C. 75°
 D. 90°
 E. 105°

5. What is the y-coordinate of the point at which the graph of $y = 2 \sin x - \cos 2x$ intersects the y-axis?

 A. −2
 B. −1
 C. 0
 D. 1
 E. 2

SOLUTIONS TO REVIEW PROBLEMS

1. **B** The cosine is the ratio of the adjacent side to the hypotenuse. Use the Pythagorean theorem $a^2 + b^2 = c^2$ to find the adjacent leg, then approximate cosine based on that value and the given value of hypotenuse, which is 4:

$$\text{leg} = \sqrt{4^2 - 3^2}$$
$$= \sqrt{16 - 9}$$
$$= \sqrt{7}$$
$$\cos \theta = \frac{\text{adjacent}}{\text{hypotenuse}} = \frac{\sqrt{7}}{4} = 0.66$$

On Test Day, you could use your calculator to take the square root of seven, or you could estimate that it would be smaller than the square root of nine, meaning the final fraction would be smaller than three-fourths, and answer choice (B) is the best fit without being too small.

2. **A** The numerator is the difference of squares and so can be factored:

$$\frac{\cos^4 \theta - \sin^4 \theta}{\cos^2 \theta - \sin^2 \theta} = \frac{\left(\cos^2 \theta + \sin^2 \theta\right)\left(\cos^2 \theta - \sin^2 \theta\right)}{\cos^2 \theta - \sin^2 \theta}$$
$$= \cos^2 \theta + \sin^2 \theta$$

This is a trigonometric identity and equals one.

3. **A** Rewrite the given equation in terms of only sine by using the identity $\sin^2 \theta + \cos^2 \theta = 1$ to determine that $\cos^2 \theta = (1 - \sin^2 \theta)$, then solve for θ and divide by two:

$$\sin \theta = \frac{1}{2} \cos \theta$$
$$\sin^2 \theta = \frac{1}{4} \cos^2 \theta$$
$$\sin^2 \theta = \frac{1}{4}(1 - \sin^2 \theta)$$
$$4 \sin^2 \theta = 1 - \sin^2 \theta$$
$$5 \sin^2 \theta = 1$$
$$\sin^2 \theta = \frac{1}{5}$$

Since one-fifth is less than one-fourth, and the square root of one-fourth is one-half:

$$\sin \theta < \frac{1}{2}$$
$$\frac{1}{2} \sin \theta < \frac{1}{4}$$

Only (A) is less than (and not equal to) 0.25.

QR

4. **C** This is a quadratic equation for which the unknown is $\tan \theta$:

$$\tan^2 \theta = 6 \tan \theta - 9$$
$$\tan^2 \theta - 6 \tan \theta + 9 = 0$$
$$(\tan \theta - 3)^2 = 0$$
$$\tan \theta = 3$$
$$\theta = \arctan (3) < 75°$$

Note that the answer choices are widely separated, so you only need a rough approximation of tangent. Remembering that tangent is the ratio of sine to cosine, you can recall that $\tan 45° = 1$ because that is where sine equals cosine. A tangent larger than one occurs when sine is larger (the angle is larger than 45° and smaller than 90°), and a tangent smaller than one occurs when cosine is larger (the angle is smaller than 45° and larger than 0°). Only answer choice (C) lies in the correct range. Note that the tangent of 90° (D) is undefined since it's a fraction with a denominator of 0, and the tangent of 105° (E) would be negative since it's past 90° and in a different quadrant.

5. **B** The graph intersects the y-axis at the point where $x = 0$:

$$y = 2 \sin x - \cos x$$
$$= 2 \sin (0) - \cos (0)$$
$$= 2 (0) - 1$$
$$= -1$$

Section VII

PERCEPTUAL ABILITY

SECTION GOALS

The Perceptual Ability Test (PAT) is unique to the DAT and is designed to test spatial reasoning skills. The style of questions asked in the PAT is new to most test takers, and will require considerable practice for mastery. This section of the book is designed to help you achieve the following goals:

- Recall rule sets and strategies unique to each type of Perceptual Ability problem
- Order the subsections to make the best use of the available time
- Recognize opportunities for the application of time-saving skills
- Distinguish between similar objects and answer choices using the Kaplan PAT strategy
- Visualize relevant portions of 3D structures given 2D representations within DAT questions

CONTENT OVERVIEW

Section Specific Strategy	Chapter 64: Perceptual Ability Strategies

KEY STUDY STRATEGIES

The Perceptual Ability section of the DAT contains several subsections, including: keyholes, top front end, angle ranking, hole punching, cube counting, and pattern folding. Each subsection has its own set of rules and associated Kaplan strategies, which are discussed in Chapter 64. As you get started with your prep for this section, use Chapter 64 to learn the rules for each question type and internalize the strategies. Then, use your online resources to practice these different question types in a testlike format with interactive solutions. Your focus in practice should be the application of strategy, so review Chapter 64 as needed as you work through problems.

CHAPTER SIXTY-FOUR

Perceptual Ability Strategies

LEARNING OBJECTIVE

After this chapter, you will be able to:

- Apply Kaplan's strategies to solve Perceptual Ability questions

The Perceptual Ability Test (PAT) is the second section of the DAT and tests your spatial visualization skills, including your ability to interpret two-dimensional (2D) representations of three-dimensional (3D) objects. These skills will be very useful to you as a dentist since you will need to construct mental images of teeth from X-rays, deal with casts and fillings, and otherwise work with 2D and 3D objects.

The PAT contains a total of 90 questions that you must complete within 60 minutes. The 90 questions are divided into six categories consisting of 15 questions each: **Keyholes (apertures)**, **Top-Front-End (view recognition)**, **Angle Ranking**, **Hole Punching (paper folding)**, **Cube Counting**, and **Pattern Folding (3D form development)**. All the questions for a given subsection appear together, and the subsections always appear in the same order.

Some question types are more time-consuming than others, so pace yourself accordingly rather than only considering the average amount of time per question for the entire section. Angle Ranking and Hole Punching questions tend to be the fastest because they only involve 2D images and should take you approximately 20 seconds each. Keyhole and Top-Front-End questions require understanding of how 2D images correspond with 3D shapes and will likely take closer to 50 seconds each. Pattern Folding questions also require 2D-to-3D manipulation and tend to be some of the most challenging, so they may take up to 60 seconds each. Finally, the Cube Counting section is unique because it contains several questions associated with one figure, so it is easier to think about it as taking two minutes per figure (which corresponds to about 40 seconds per question). You may find certain subsections to be easier or more challenging for you personally, but these guidelines are a good place to start, and you can modify them based on your personal needs.

KEYHOLES

For each Keyhole question you are presented with a 3D object and must determine which of the five openings in the answer choices would allow the object to pass through with a perfect fit. The object can pass through the opening in any orientation, but it cannot be rotated *while* it is passing through. The external outline of the object is the exact size and shape of the opening without being too big or small or having extra protrusions. In the example below, the cube *could* fit through any of the apertures, but the only correct answer is the square projection of the cube that is an exact fit.

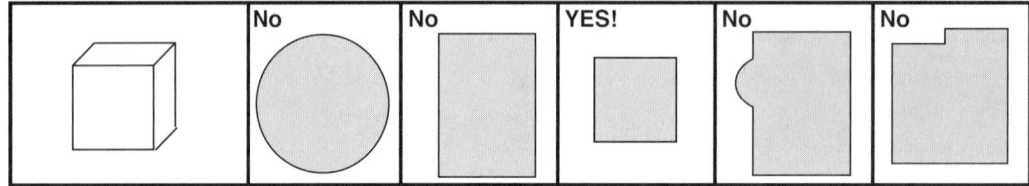

Note that none of the features present within an object, such as overlapping shapes, appear in the answer choices; instead, the focus is merely on the outline alone. Because of this, the correct opening generally corresponds with one of three **projections** (reductions of 3D images to flat, 2D images) that can be drawn for the object: the top-bottom projection, the front-back projection, or the side projection. One way to visualize these projections is to think of what shadow would be created if you were to shine a bright light on the object from one direction. Specifically, imagine the shadow created by shining a light on the top, front, or right side of the object. The resulting shadows will appear on the bottom, back, and left side of the object and represent three possible apertures you could see in the answer choices. This choice of directions is important because these are the same directions you will use in the top-front-end section of the test.

Regardless of how you visualize the projections, the most efficient way to arrive at the correct answer is to determine the three projections of the object and pick the choice that matches one of these. The following example illustrates this technique:

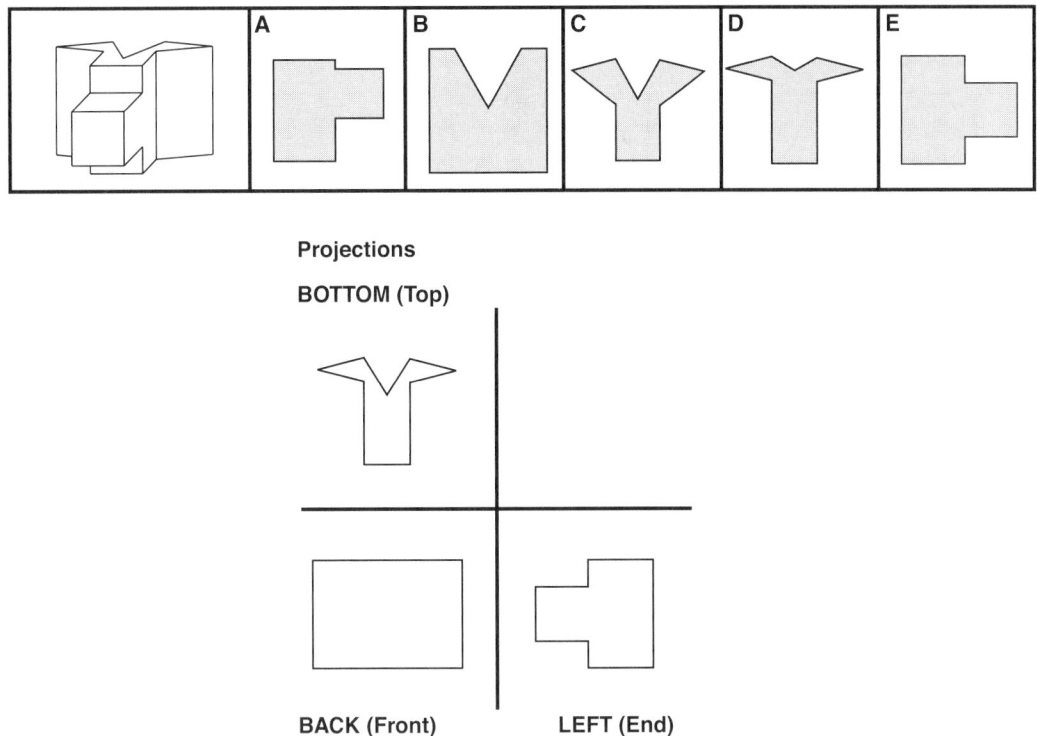

Projections

BOTTOM (Top)

BACK (Front) **LEFT (End)**

The correct choice is therefore (E). Note that choices (C) and (D) are distractors; they are similar to the top projection, however the proportionality of the sides are incorrect. This is a common PAT trap. Therefore, as you practice, pay special attention to the angles and proportions in the answer choices to ensure they match your projections.

If you have difficulty visualizing the correct projection, try to imagine what would happen if you were to flatten the object against the wall relative to the top/bottom, front/back, or left/right sides. Whichever way you crush the original object, the part that remains will represent a correct aperture for the problem. A good example of this occurs when crushing a soft drink can. If you crush it from top to bottom, you are left with a circular disc. If you crush it from left to right or from front to back, though, you are instead left with a rectangular piece. Therefore, if your original object is a circular cylinder, the correct projection would be either a rectangle or a circle.

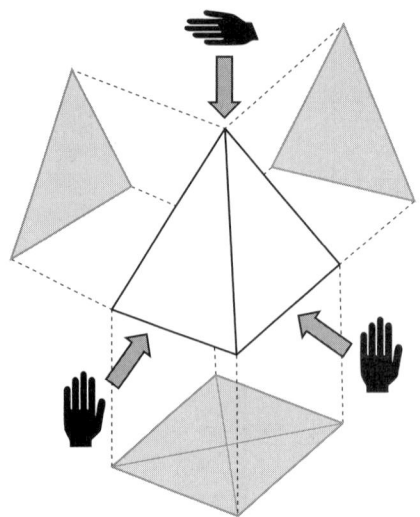

Another way to quickly eliminate wrong answer choices is through use of Kaplan's key feature and proportion strategy. Key features are easily distinguishable regions of a shape such as cut outs, shapes of comparative size, or sharp angles. By identifying these features in the object, you can then quickly eliminate answer choices that misplace or distort that feature.

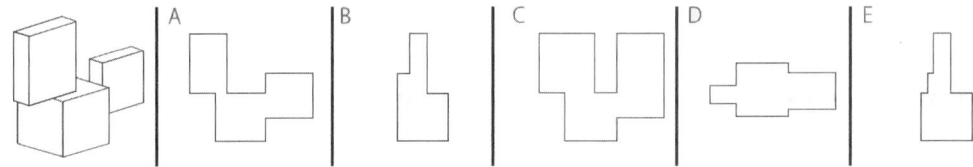

For the above question, projections or crushing can be used to predict the correct answer, but the question is often solved most quickly by using key features and proportions. Look at the parent shape, which consists of a flattened square, a cube, and a flattened rectangle. If we start by noting the relative heights and positions of the two flattened shapes, we can jump straight to (E)—but that takes practice! Let's assume that, for now, we have some difficulty with that, so we'll eliminate down. All three of these shapes appear to have similar widths, but differ in placement, height, and depth. Eliminate (A), because the object widths are not identical. In terms of heights, the flattened rectangle is the tallest part of the object. Eliminate (C). This means the front projection will not be the correct answer. Next, we can consider the positions of the two shapes on the cube as they relate in depth. The rectangle is closer to the front of the cube than the square is, and both are connected to the "body" of the cube, without touching the front or back edges. Eliminate (B), which indicates that the flat square touches the back edge of the cube. The depth of the flattened square and the flattened rectangle appears to be nearly identical. For (D) to be correct, the flattened square would need to be much "thicker." Eliminate (D). This leaves us with (E), which matches all of our observations about proportions. Note that not only was this method successful in helping us to choose the correct answer, but we avoided tempting trap answers such as (A) by considering these relative features.

With practice, focusing on the three main projections, crushes, or key features will allow you to spend no more than the recommended 12.5 minutes on the 15 questions in the Keyholes subsection, which equates to 50 seconds per question.

TOP-FRONT-END

Top-Front-End questions are closely related to Keyhole problems. You are presented with two projections of an object and are expected to determine the third. However, Top-Front-End projections are not mere outlines but also contain lines that represent where the visible and hidden edges of each figure would appear. Hidden edges of the object that *cannot* be seen when viewing it straight on are represented by dotted lines, whereas visible edges that *can* be seen when viewing it straight on are represented by solid lines. The following scenario illustrates this convention:

The top views of both of the above objects are the same. They show that the object possesses some kind of step, but it's not clear which half is higher from the top view alone. This information is conveyed in the front views. In the first case, since the front view contains a solid line, the lower step must be in front. In the second case, however, the higher step is in front, hiding the lower step from view. Hence, a dotted or dashed line is used to indicate the presence of the step; it is something that is present in the shape but not visible when looking from the direction indicated.

The actual 3D objects being represented in each case are similar, but their orientations are different. This is important because the end view is always lateral from the right. Hence, in the first case, the end view is an L-shape with the higher step on the right, while in the second case, the higher step of the L-shape is on the left. In short, unlike in Keyhole problems, orientation *does* matter here. However, if you have already been drawing keyhole projections by visualizing projections as they would appear from the top, front, and right sides, then you have already been visualizing objects from the correct orientations to answer Top-Front-End questions.

Note that on the DAT you will *not* be given the 3D object itself; instead, you are expected to be able to construct those kinds of images mentally.

The correct interpretation of solid and dashed lines can be very helpful in more challenging problems. Sometimes it can be very difficult to construct a full 3D image of the object from the two projections given; in these situations, it may be much easier to use Kaplan's key feature strategy to determine whether solid or dotted lines will be present in certain regions. The following example illustrates this point:

TOP VIEW

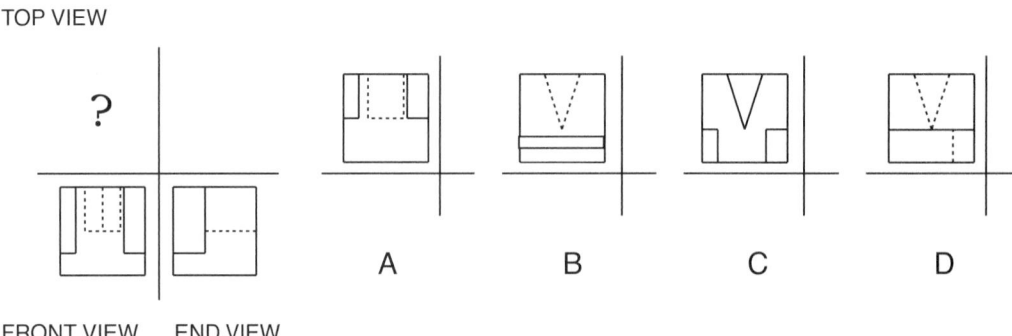

FRONT VIEW END VIEW

In this question, you are asked to select the correct top view. The 3D appearance of the object is not immediately obvious from the two given projections. However, in the front view, you can see a substructure represented by dotted lines. The dotted lines show that the substructure is present but not visible from the front view. However, since the substructure is connected to the top of the object, you *can* expect to see it in solid lines in the top view. Only choice (C), which shows a horizontally centered, visible structure, fits that prediction.

Even with a strong grasp of how Top-Front-End questions work, you may still find them to be challenging, especially when confronted with elaborate shapes. In those cases, Kaplan's **event-counting** strategy can make the questions much more manageable. The fundamental concept behind the strategy is that, although the three views may at first seem completely separate, they all share edges with one another. In fact, event-counting is not so much a strategy as an alternate way to conceptualize that the 2D views given are correlated to the sides of a 3D object. For example, the right edge of the

front view must necessarily be the same as the left edge of the end view because both represent the exact same corner of the overall figure. This is easiest to visualize if your original shape is a cube:

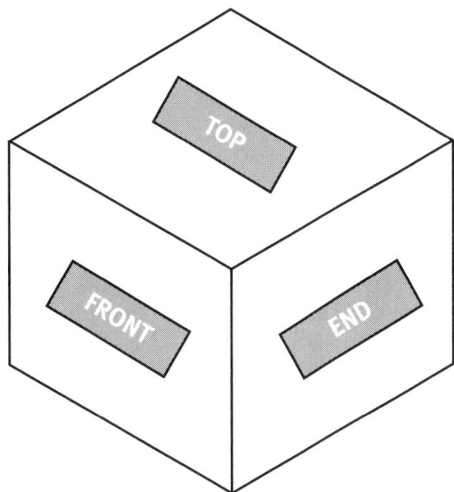

Looking at the figure this way, you also can see that the top edge of the front view matches the bottom edge of the top view, and the right edge of the top edge view matches the top edge of the end view. This may sound confusing at first, but all you really need to know is that edges from each view correspond with edges from another.

The reason why this is important is that anything that happens along the edge in one view also must be happening along the corresponding edge in another view—because any edge in a 3D object is shared by the sides that intersect at that edge. For example, consider the cube above but with a notch removed from the corner:

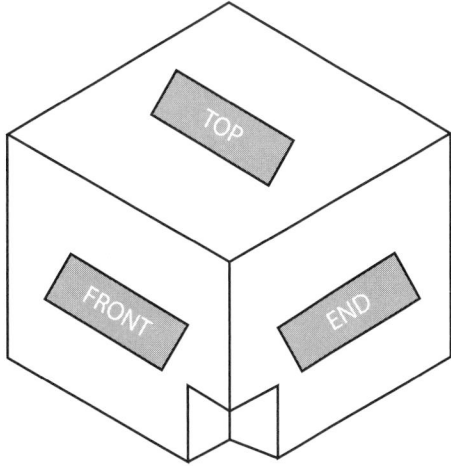

In this situation, the notch is visible from the right edge of the front view and also the left edge of the end view. If the end view was the missing view, you would know that the correct answer must have that corresponding notch. In fact, you can simplify that even further by merely realizing that

"something" (some "event") happened along that edge in the front view, so that "event" must have happened along the corresponding edge in the end view, too. By counting the number of events that occur along one edge and finding the answer choice(s) that also have the same number of events along the corresponding edge in the missing view, you will be able to quickly eliminate wrong answer choices, sometimes even narrowing down to the correct answer based on counting alone. This is the basis of event theory, and it is why event theory will always be a valid way to envision the sides of an object interacting. However, event theory is not always necessary to answer a question, and may not by itself be sufficient. In practice, you should focus on applying event theory to questions where it will help you quickly eliminate choices and find the correct answer, or on problems where you only have to consider a small number of events or events from one view. Though event theory is extremely useful in several contexts, you should not and cannot rely solely on event theory for every question.

In addition to event theory, the major consideration for TFE problems is the same as in Keyhole problems: Kaplan's key feature/proportion elimination strategy. When viewing a question, always look for opportunities to identify unique motifs on the given sides, and predict how those motifs will affect the missing side. Use this for fast elimination of wrong answer choices, and even to solve some problems outright. Most importantly, key features in conjunction with event counting will allow you to solve even the most challenging of TFE problems.

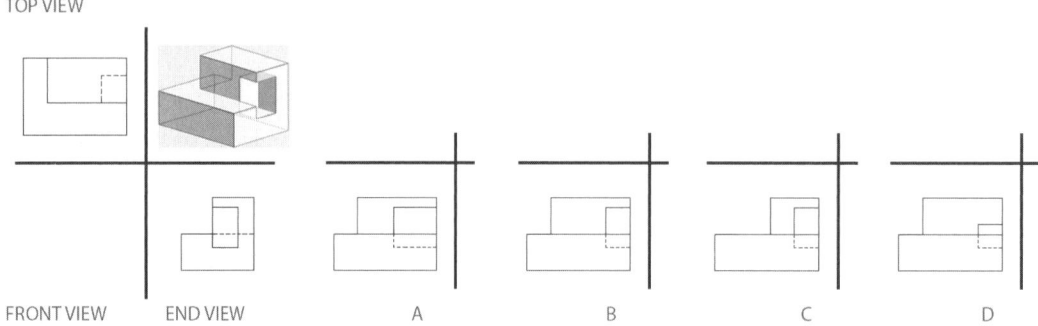

For the above question, event theory can be used, but let's try using key feature/proportion elimination. There appears to be an interesting feature in the object that falls in the center of the right edge from the top, and we can see that same feature in the center of the End view. This feature is of particular use for key feature elimination because of its proportions—we can see that it is intersected by an event that falls about $\frac{2}{3}$ of the way down whatever the feature is, and that it is taller than it is wide. Right away, we can eliminate (A) and (D). The only difference between (B) and (C) is the width of the upper half of the object. Looking at the top view, we can see that this rectangular portion takes up about $\frac{3}{4}$ of the top of the object. That indicates it should also be about $\frac{3}{4}$ of the total width of the object from the front. This matches with (B). Note that if you made the mistake of trying to trace this vertical feature of the front view to a feature on the end view, you would accidentally choose (C)! Use those relationships between top, front, and end that were outlined previously in the chapter (trace vertically from top to front, horizontally from front to end, and horizontally from the front to vertically on the end) to ensure that you are correctly interpreting the relationships between sides.

By implementing Kaplan's event counting and key feature strategies in tandem, you will be able to eliminate answer choices more quickly even if you are unable to visualize the 3D object. Armed with these strategies, expect to spend 12.5 minutes on the Top-Front-End section, which equates to 50 seconds per question.

ANGLE RANKING

For each Angle Ranking question, you are given four angles labeled 1–4 that you must rank in increasing order from smallest to largest interior angle.

Some angles may be so close in size (such as a difference of only two degrees) that assigning the order of them unambiguously is almost impossible. Further, angles can have lines of uneven length, be rotated in any direction, and the vertices of each angle may not be at the same height. However, you will be able to use the answer choices to help you eliminate based on the other angles and possibly find the correct answer without needing to identify the full ranking first. This strategy is illustrated in the following example:

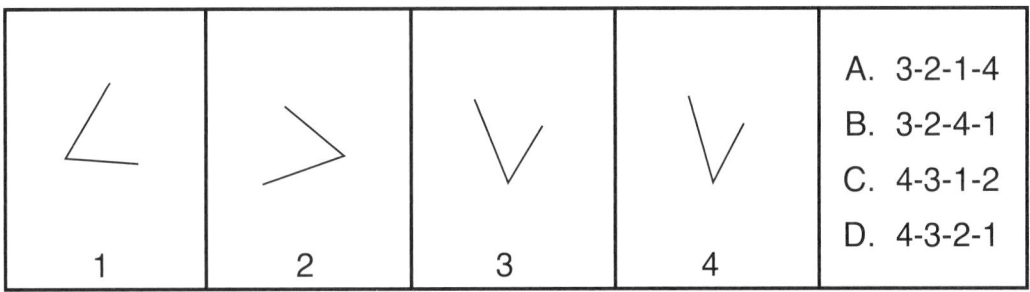

It is difficult to ascertain which angle is larger, 2 or 3. However, if you can see that 4 is the smallest angle, you can eliminate (A) and (B), and then seeing that 1 is the largest angle will confirm that (A) is incorrect and also eliminate (C). This leaves only choice (D) as the correct answer and doesn't require determining whether 2 or 3 is smaller.

Although not necessarily easier than the other PAT questions, the Angle Ranking questions don't require 3D manipulation and can be completed very quickly. Spending no more than five minutes on the 15 Angle Ranking questions at the rate of 20 seconds per question will allow you to spend longer on the more time-consuming subsections.

HOLE PUNCHING

For each Hole Punching question, a square piece of paper is folded one, two, or three times, and then one or more holes are punched at specific locations. Holes can be punched on a fold resulting in what appears to be half punches. These half punches, however, will always result in a full hole punch when the paper is unfolded. You are then asked to unfold the paper mentally and determine the final locations of the hole(s).

The paper is always folded toward the front (out of the screen and toward you) to allow you to see the final positions of paper. The edges of the paper in the new position are represented by solid lines, and the original locations where the paper used to be are represented by dashed lines. There are several possibilities for initial folds, the four most common of which are shown below:

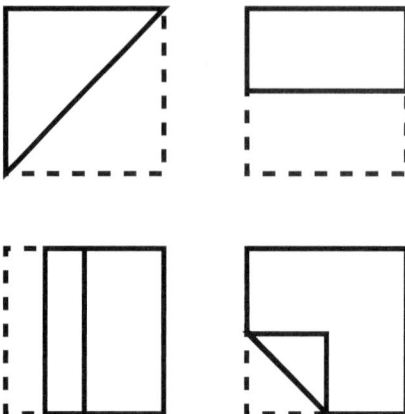

Note that each of these four first folds can occur on any edge; for example, the corner fold shown in the bottom right can be on any of the four corners, not just the bottom-left corner.

After the first fold, the paper may be folded one or more additional times. Since these occur after the first fold, a wide range of combinations exist, but all the folds still follow the same basic patterns. In the following example, you can see the paper folded diagonally in the first fold and then folded halfway down before a hole is punched.

Mentally unfolding the paper gives the following:

In the answer choices, punched holes are indicated by filled circles on a grid of 16 possible positions. These 16 positions represent the only possible final holes, and no partial holes will appear in the correct answer. Here, the correct answer includes two punched holes.

A helpful strategy for Hole Punching questions is to eliminate answer choices by looking at the symmetry of the first fold. Because the unfolding step will be the opposite of that initial fold, any position with a hole on one side of the line of symmetry created by the first fold will be mirrored by another position with the same hole.

Any answer choice that does *not* have the corresponding line of symmetry can be eliminated immediately regardless of any other factors. Note that if the first fold does not bisect the paper into two equal parts, you should only look at the overlapping portion of the paper and can ignore any other sections. For example, if the first fold is a corner fold, the line of symmetry will be diagonal across that quadrant (one-fourth) of the paper, and the other three-fourths can be ignored when evaluating the paper's symmetry:

Similar to Angle Ranking, spend only five minutes on the Hole Punching section, which means taking an average of 20 seconds per question. Note that on Test Day, you are given two sheets of laminated graph paper for your scratch work. While the graph paper can be a helpful tool, drawing each punch on your scratch paper is very time-intensive and should be reserved for the most difficult questions in this section, at most one or two questions. Be sure to set aside time in your prep to practice completing these questions both quickly and accurately.

CUBE COUNTING

In this part of the PAT, you will be presented with several stacks of cubes. Each stack is constructed by cementing together identical cubes. You are asked to imagine that the stack as a whole is painted on all sides except for the bottom (on which the stack rests). You are then asked to determine how many individual cubes have a particular number of sides painted with each figure accompanied by several questions. The following example makes the directions more concrete:

In the figure, how many cubes have two of their exposed sides painted?

- A. 5 cubes
- B. 6 cubes
- C. 7 cubes
- D. 8 cubes
- E. 9 cubes

In the figure, how many cubes have three of their exposed sides painted?

- A. 5 cubes
- B. 6 cubes
- C. 7 cubes
- D. 8 cubes
- E. 9 cubes

For this figure, the total number of sides painted for each cube in this stack is as follows:

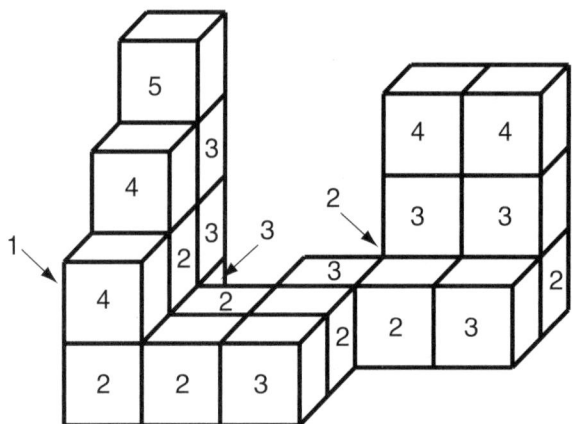

As the diagram illustrates, you cannot neglect cubes that are not clearly visible, but you also can't imagine cubes are present when they are not; requiring you to do so would make the questions unfair. The general rule devised by the test makers is that hidden cubes exist if and only if they are required to support other cubes. In this diagram, you should infer the presence of a hidden cube with one side painted on the left because without such a cube the four-sided and two-sided cubes on top of it would not be supported.

Sometimes cubes can be totally hidden within the stack and have no sides painted, as shown below:

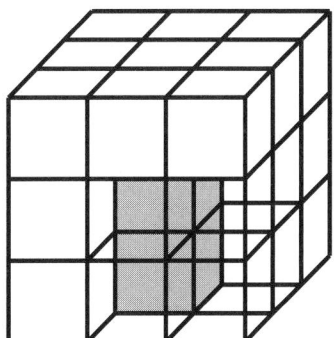

The best strategy for this section is to make a **tally** of all the cubes that make up the figure before even starting the corresponding questions. To do so, make a table on your note board with a left column of 0–5. Then, methodically go over the stack and make a tally mark next to the correct number of sides painted for each cube in the figure. After you have constructed the table, count the total number of cubes in the figure and compare it to your total number of tally marks to ensure you did not omit any cubes when tallying.

Besides allowing you to verify that you did not miss any cubes when counting, this strategy also saves you a significant amount of time per figure. Rather than approaching each question separately by repeatedly searching the figure for each type of cube being asked about, you instead are able to obtain all the answers right away and use those to very quickly select the correct choice for each question based on your tally and move right on to the next figure.

The tally table for the example shown on page 910 would look something like this:

0 side	
1 side	I
2 sides	⊬⊦⊦ III
3 sides	⊬⊦⊦ III
4 sides	IIII
5 sides	I
Total	22

The entire figure has 22 cubes, and this does in fact correspond with the 22 tallies in the table.

On Test Day, the Cube Counting section will have 15 questions corresponding to five different figures with 2–4 questions each. A good goal is to spend two minutes on each figure (including time spent answering its approximately three questions) for a total of ten minutes for the entire subsection.

PATTERN FOLDING

For Pattern Folding questions, a flat pattern is presented, and you are asked to select the 3D figure it would become when folded. The patterns in this section should always be folded away from you (into the page). Some questions require you to identify the structure only, as in the first example below, while others also present shading and patterns that you must identify, as in the second example below:

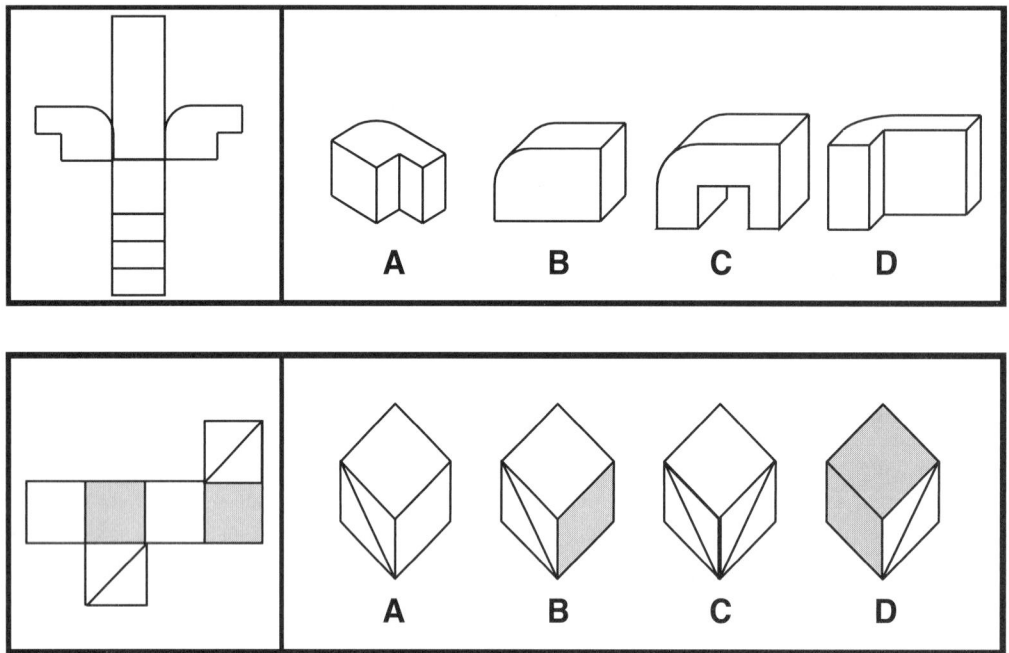

In figures that have **unique shapes**, an effective strategy is to eliminate any answer choices that do not contain the unique shape in the original pattern. For the first question above, the flat pattern shows a two-step shape with a rounded back. Choices (B) and (C) do not make the correct stair-step system, and choice (D) has the wrong proportions for the shape. Only choice (A) has the correct, unique shape, so (A) must be correct, regardless of how the rest of the figure comes together.

For figures that instead have **unique shading** as the predominant feature, the strategy is to instead focus on that shading pattern. For the second question above, the figure shows an alternating shaded-unshaded pattern. Again, elimination of answer choices is a very powerful technique here. You can eliminate choice (A) because it shows two unshaded faces together and (D) because it shows two shaded faces together, and you know the pattern should instead alternate. This leaves answer choices (B) and (C) as options.

Although identifying unique shapes and shading often allows you to eliminate down to the correct answer, sometimes more than one choice will be left, as with the second question above. In that case, the final piece to look at is a **key landmark** or point of interest in the figure. This builds on what you already identified with unique shape and shading but adds in evaluating the relationships among key pieces. For the second figure above, you already narrowed the correct answer down to either (B) or (C). Both answer choices feature the square with a diagonal line through it, so use the corresponding square toward the bottom and left of the original pattern as your key landmark. The square is attached to a shaded square, which is part of the alternating shaded-unshaded pattern you already

identified. That means all the squares that intersect your key landmark must follow that pattern as well. Therefore, (C) can be eliminated, and (B) is the correct answer.

The important takeaway for all of these strategies is to evaluate a point of interest and focus in on that rather than attempting to visualize the folding and positioning of the entire figure, which is a much more difficult task. By focusing in, you break the pattern into more reasonable pieces that tend to be much less overwhelming but that will still allow you to narrow down to the correct answer.

Because Pattern Folding questions are some of the most challenging ones in the PAT, you can spend up to 15 minutes on this subsection at the rate of 60 seconds per question.

PERCEPTUAL ABILITY PRACTICE QUESTIONS

In order to best replicate the experience of working with PAT questions on a computer, practice questions for all PAT Question Types can be found in your online assets. Use this online practice as an opportunity to practice using the strategies in Chapter 64 in solving these questions when you cannot draw on the figures. Remember, on Test Day you cannot touch the computer screen, so be sure to keep this restriction in mind as you practice.

You will learn the most from these questions by reviewing feedback immediately after completing each set rather than after attempting all of the sets at once. Strive to complete each within the appropriate amount of time. Then, spend at minimum the same amount of time reviewing all of the questions, regardless of whether you chose the correct answer for each or not, to ensure you're comfortable tackling all similar questions on Test Day.

Index

Index

Index

Index

Index

Index

Index

Index

Index

Index

Index

Index

Tear-Out, Quick Reference Study Sheets for Biology, General Chemistry, Organic Chemistry, and Perceptual Ability

The following DAT Study Sheets are your one-stop resource for the key diagrams, charts, equations, and formulas that you are sure to see on the exam. This guide is separated into four DAT subtopics: Biology, General Chemistry, Organic Chemistry, and Perceptual Ability. Each topic features the most important highlights you will want to review between study sessions and before your Test Day. Carefully tear out the pages to create a light and portable on-the-go resource you can use to study anytime, anywhere.

Periodic Table of Elements

1 H 1.0																	2 He 4.0
3 Li 6.9	4 Be 9.0											5 B 10.8	6 C 12.0	7 N 14.0	8 O 16.0	9 F 19.0	10 Ne 20.2
11 Na 23.0	12 Mg 24.3											13 Al 27.0	14 Si 28.1	15 P 31.0	16 S 32.1	17 Cl 35.5	18 Ar 39.9
19 K 39.1	20 Ca 40.1	21 Sc 45.0	22 Ti 47.9	23 V 50.9	24 Cr 52.0	25 Mn 54.9	26 Fe 55.8	27 Co 58.9	28 Ni 58.7	29 Cu 63.5	30 Zn 65.4	31 Ga 69.7	32 Ge 72.6	33 As 74.9	34 Se 79.0	35 Br 79.9	36 Kr 83.8
37 Rb 85.5	38 Sr 87.6	39 Y 88.9	40 Zr 91.2	41 Nb 92.9	42 Mo 95.9	43 Tc (98)	44 Ru 101.1	45 Rh 102.9	46 Pd 106.4	47 Ag 107.9	48 Cd 112.4	49 In 114.8	50 Sn 118.7	51 Sb 121.8	52 Te 127.6	53 I 126.9	54 Xe 131.3
55 Cs 132.9	56 Ba 137.3	57 La * 138.9	72 Hf 178.5	73 Ta 180.9	74 W 183.9	75 Re 186.2	76 Os 190.2	77 Ir 192.2	78 Pt 195.1	79 Au 197.0	80 Hg 200.6	81 Tl 204.4	82 Pb 207.2	83 Bi 209.0	84 Po (209)	85 At (210)	86 Rn (222)
87 Fr (223)	88 Ra (226)	89 Ac † (227)	104 Rf (267)	105 Db (268)	106 Sg (269)	107 Bh (270)	108 Hs (277)	109 Mt (278)	110 Ds (281)	111 Rg (282)	112 Cn (285)	113 Nh (286)	114 Fl (289)	115 Mc (289)	116 Lv (293)	117 Ts (294)	118 Og (294)

	58 Ce 140.1	59 Pr 140.9	60 Nd 144.2	61 Pm (145)	62 Sm 150.4	63 Eu 152.0	64 Gd 157.3	65 Tb 158.9	66 Dy 162.5	67 Ho 164.9	68 Er 167.3	69 Tm 168.9	70 Yb 173.0	71 Lu 175.0
*														
†	90 Th 232.0	91 Pa (231)	92 U 238.0	93 Np (237)	94 Pu (244)	95 Am (243)	96 Cm (247)	97 Bk (247)	98 Cf (251)	99 Es (252)	100 Fm (257)	101 Md (258)	102 No (259)	103 Lr (266)

THE CELL

Fluid Mosaic Model and Membrane Traffic

- Phospholipid bilayer with cholesterol and embedded proteins
- Exterior: hydrophilic, phosphoric-acid region
- Interior: hydrophobic, fatty-acid region

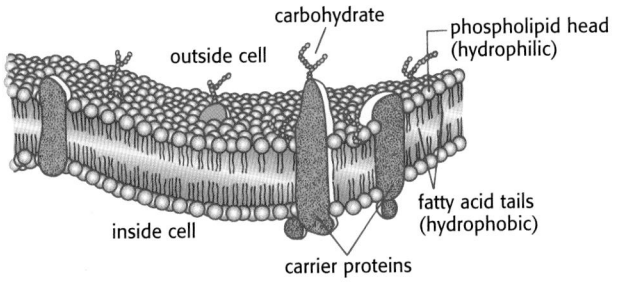

carbohydrate

outside cell

phospholipid head (hydrophilic)

fatty acid tails (hydrophobic)

inside cell

carrier proteins

HOMEOSTASIS

Hormonal Regulation

Aldosterone

- Stimulates Na^+ reabsorption and K^+ secretion, increasing water reabsorption, blood volume, and blood pressure
- Secreted from adrenal cortex
- Regulated by renin-angiotensin system

ADH

- Increases collecting duct's permeability to water to increase water reabsorption
- Secreted from posterior pituitary with high [solute] in the blood

The Liver's Roles in Homeostasis

1. Gluconeogenesis
2. Processing of nitrogenous wastes (urea)
3. Detoxification of wastes/chemicals/drugs
4. Storage of iron and vitamin B_{12}
5. Synthesis of bile and blood proteins
6. Beta-oxidation of fatty acids to ketones
7. Interconversion of carbs, fat, and amino acids

ENZYMES

Regulation

- **Allosteric**: Binding of an effector molecule at allosteric site.
- **Feedback inhibition**: End product inhibits initial enzyme pathway.
- **Reversible inhibition**: Competitive inhibitors bind to active site; noncompetitive inhibitors bind to allosteric site.

Glucose Catabolism

Glycolysis occurs in the cytoplasm: $C_6H_{12}O_6 + 2\ ADP + 2\ P_i + 2\ NAD^+ \rightarrow 2\ Pyruvate + 2\ ATP + 2\ NADH + 2\ H^+ + 2\ H_2O$.

Fermentation occurs in anaerobic conditions. Pyruvate is converted into lactic acid (in muscle) or ethanol (in yeast).

Respiration occurs in aerobic conditions.

- **Pyruvate decarboxylation**: Pyruvate converted to acetyl CoA in the mitochondrial matrix.
- **Citric acid cycle**: Acetyl CoA enters; coenzymes exit.
- **Electron transport chain**: Coenzymes are oxidized; energy is released as electrons are transferred from carrier to carrier.
- **Oxidative phosphorylation**: Electrochemical gradient caused by NADH and $FADH_2$ oxidation provides energy for ATP synthase to phosphorylate ADP into ATP.

Anaerobic

Glucose (6C)
2 ATP, 4 ADP
2 NAD+, 2Pi

You are here.

GLYCOLYSIS

Aerobic

2 Pyruvate (3C)
2 ADP, 4 ATP
2 NADH
2 H+, 2 H2O

2 ATP

Aerobic?

YES NO

Pyruvate (3C)
NADH
H+

You are here.

FERMENTATION

Ethanol (2C) (yeast) + CO2
Lactic Acid (3C) (muscle cells)
NAD+

You are here.

−2 ATP

Aerobic

2 Pyruvate (3C)
2 Coenzyme A
2 NAD+

PYRUVATE DECARBOXYLATION

2 Acetyl CoA (2C)
2 CO2
2 NADH

You are here.

2 Acetyl CoA (2C)
6 NAD+, 2 FAD
2 ADP, 4 H2O, 2 Pi

CITRIC ACID CYCLE

4 CO2
6 NADH
2 FADH2
2 ATP*, 4 H+, 2 Coenzyme A

2 ATP

You are here.

10 NADH total
2 FADH2
34 ADP
34 Pi
10 H+, 5O2

ELECTRON TRANSPORT CHAIN/ OXIDATIVE PHOSPHORYLATION

10 NAD+
2 FAD
34 ATP
(3 ATP/NADH, 2 ATP/FADH2)
10 H2O

+ 34 ATP

36 ATP Net

PHOTOSYNTHESIS

Overall Reaction

$6\ CO_2 + 6\ H_2O + \text{light energy} \rightarrow C_6H_{12}O_6 + 6\ O_2$

Light Reactions

- Chlorophyll captures light energy from the sun to generate high-energy molecules.
- $6\ H_2O + 6\ NADP^+ + 9\ ADP + 9\ P_i + \text{light energy} \rightarrow 6\ NADPH + 6\ H^+ + 9\ ATP + 3\ O_2$

Calvin Cycle (Dark Reactions)

- RuBP captures CO_2 from the environment to generate PGAL.
- $3\ CO_2 + 9\ ATP + 6\ NADPH + 6\ H^+ \rightarrow C_3H_6O_3 + 3\ H_2O + 6\ NADP^+ + 9\ ADP + 8\ P_i$

ENDOCRINE SYSTEM

Direct hormones directly stimulate organs. **Tropic** hormones stimulate other glands.

Mechanisms of hormone action: **Peptides** act via secondary messengers. **Steroids** act via a hormone/receptor binding to DNA. **Monoamines** may do either.

Hormone	Source	Action
Follicle-stimulating (FSH)	Anterior pituitary	Stimulates follicle maturation, spermatogenesis
Luteinizing (LH)		Stimulates ovulation, testosterone synthesis
Adrenocorticotropic (ACTH)		Stimulates adrenal cortex to make and secrete corticosteroids
Thyroid-stimulating (TSH)		Stimulates thyroid to produce thyroid hormones
Prolactin		Stimulates milk production and secretion
Endorphins		Inhibit the perception of pain in the brain
Growth hormone		Stimulates bone and muscle growth, lipolysis
Oxytocin	Hypothalamus; stored in posterior pituitary	Stimulates uterine contractions during labor, milk secretion during lactation
Vasopressin (ADH)		Stimulates water reabsorption in kidneys
Thyroid hormones (T_4, T_3)	Thyroid	Stimulate metabolic activity
Calcitonin		Decreases (tones down) blood calcium level
Parathyroid hormone	Parathyroid	Increases blood calcium level
Glucocorticoids	Adrenal cortex	Increase blood glucose level, decrease protein synthesis
Mineralocorticoids		Increase water reabsorption in kidneys
Epinephrine, Norepinephrine	Adrenal medulla	Increases blood glucose level, heart rate
Glucagon	Pancreas	Stimulates conversion of glycogen to glucose in the liver, increases blood glucose
Insulin		Lowers blood glucose, increases glycogen stores
Somatostatin		Suppresses secretion of glucagon and insulin
Testosterone	Testes	Maintains male secondary sexual characteristics
Estrogen	Ovary/Placenta	Maintains female secondary sexual characteristics
Progesterone		Promotes growth/maintenance of endometrium
Melatonin	Pineal	Maintains circadian rhythms
Atrial natriuretic peptide	Heart	Involved in osmoregulation and vasodilation
Thymosin	Thymus	Stimulates T lymphocyte development

REPRODUCTION

Cell Division

- **G_1:** Cell doubles its organelles and cytoplasm
- **S:** DNA replication
- **G_2:** Same as G_1
- **M:** Cell divides in two
- Mitosis = PMAT
- Meiosis = PMAT × 2

Sexual Reproduction

Meiosis I

- Two pairs of sister chromatids form tetrads during prophase I.
- Crossing over leads to genetic recombination in prophase I.

Meiosis II

- Identical to mitosis but without replication.
- Meiosis occurs in **spermatogenesis** (sperm formation) and **oogenesis** (egg formation).

Four Stages of Early Development

Cleavage: Mitotic divisions

Implantation: Embryo implants during blastulation

Gastrulation: Ectoderm, endoderm, and mesoderm form

Neurulation: Germ layers develop a nervous system

Ectoderm "Attract-o-derm"	Nervous system, epidermis, lens of eye, inner ear	Endoderm "Endernal" organs	Lining of digestive tract, lungs, liver, pancreas	Mesoderm "Means-o-derm"	Muscles, skeleton, circulatory system, gonads, kidney

DIGESTION

Carbohydrate Digestion

Enzyme	Site of Production	Site of Function	Hydrolysis Reaction
Salivary amylase (ptyalin)	Salivary glands	Mouth	Starch → maltose
Pancreatic amylase	Pancreas	Small Intestine	Starch → maltose
Maltase	Intestinal glands	Small Intestine	Maltose → 2 glucoses
Sucrase	Intestinal glands	Small Intestine	Sucrose → glucose, fructose
Lactase	Intestinal glands	Small Intestine	Lactose → glucose, galactose

Protein Digestion

Enzyme	Production Site	Function Site	Function
Pepsin	Gastric glands (chief cells)	Stomach	Hydrolyzes specific peptide bonds
Trypsin	Pancreas	Small Intestine	Hydrolyzes specific peptide bonds / Converts chymotrypsinogen to chymotrypsin
Chymotrypsin			Hydrolyzes specific peptide bonds
Carboxypeptidase			Hydrolyzes terminal peptide bond at carboxyl
Aminopeptidase	Intestinal glands		Hydrolyzes terminal peptide bond at amino
Dipeptidases			Hydrolyzes pairs of amino acids
Enterokinase			Converts trypsinogen to trypsin

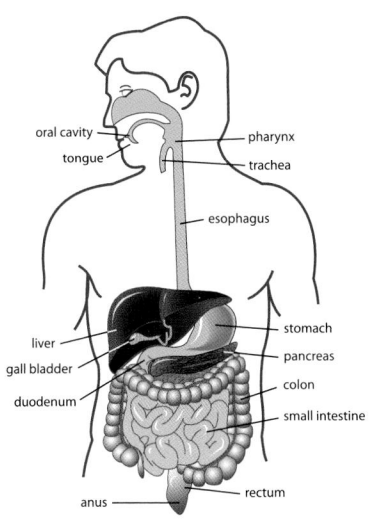

IMMUNE SYSTEM

- The body distinguishes between "self" and "nonself" (antigens).

Humoral Immunity (specific defense)

B lymphocytes

Memory cells: remember antigen, speed up secondary response

Plasma cells: make and release antibodies (IgG, IgA, IgM, IgD, IgE), which induce antigen phagocytosis

- **Active immunity:** Antibodies are produced during an immune response.
- **Passive immunity:** Antibodies produced by one organism are transferred to another organism.

Cell-Mediated Immunity

T lymphocytes

Cytotoxic T cells: destroy cells directly

Suppressor cells: regulate B and T cells to decrease anti-antigen activity

Helper T cells: activate B and T cells and macrophages by secreting lymphokines

Memory cells

Nonspecific Immune Response

Includes skin, passages lined with cilia, macrophages, inflammatory response, and interferons (proteins that help prevent the spread of a virus).

Lymphatic System

- Lymph vessels meet at the thoracic duct in the upper chest and neck, draining into the veins of the cardiovascular system.
- **Lymph nodes** are swellings along the vessels with phagocytic cells (leukocytes) that remove foreign particles from lymph.

MUSCULOSKELETAL SYSTEM

Sarcomere

- Contractile unit of the fibers in skeletal muscle.
- Contains thin actin and thick myosin filaments.

Contraction

Initiation

- Depolarization of a neuron leads to action potential.

Bone Formation and Remodeling

- **Osteoblast:** Builds bone.
- **Osteoclast:** Breaks down bone.

CIRCULATION

Blood Typing

Antigens are located on the surface of red blood cells.

Blood type	RBC antigen	Antibodies	Donates to:	Receives From:
A	A	Anti-B	A, AB	A, O
B	B	Anti-A	B, AB	B, O
AB	A, B	None	AB only	All
O	None	Anti-A, B	All	O

Blood cells with Rh factor are Rh$^+$ and produce no antibody. Rh$^-$ lack antigen and produce an antibody.

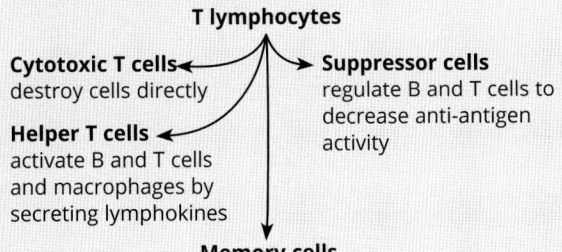

MOLECULAR GENETICS

Nucleic Acid

- Basic unit: nucleotide (sugar, nitrogenous base, phosphate)
- DNA's sugar: deoxyribose. RNA's sugar: ribose.
- 2 types of bases: double-ringed **purines** (adenine, guanine) and single-ringed **pyrimidines** (cytosine, thymine, uracil).
- **DNA double helix:** antiparallel strands joined by base pairs (AT, GC).
- RNA is usually single-stranded: A pairs with U, not T.

Transcription Regulation, Prokaryotes

Regulated by the **operon**

- **Structural genes:** have DNA that codes for protein
- **Operator gene:** repressor binding site
- **Promoter gene:** RNA polyermase's 1st binding site
- **Inducible systems:** need an inducer for transcription to occur
- **Repressible systems:** need a corepressor to inhibit transcription

Mutations

- **Point:** One nucleotide is substituted by another; they are silent if the sequence doesn't change.
- **Frameshift:** Insertions or deletions shift reading frame. Protein doesn't form or is nonfunctional.

Viruses

- Acellular structures of double- or single-stranded DNA or RNA in a protein coat.
- **Lytic cycle:** Virus kills the host.
- **Lysogenic cycle:** Virus enters host genome.

DNA Replication

- **Semiconservative:** each new helix has an intact strand from the parent helix and a newly synthesized strand.

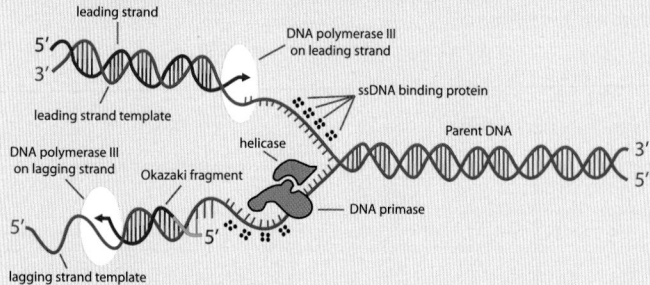

Eukaryotic Protein Synthesis

- **Transcription:** RNA polymerase synthesizes hnRNA using a DNA, "antisense strand" as a template.
- **Post-transcriptional processing:** Introns cut out of hnRNA, exons spliced to form mRNA.
- **Translation:** Occurs on ribosomes in the cytoplasm.

- **Post-translational modifications:** (e.g., disulfide bonds) made before the polypeptide becomes a functional protein.

EVOLUTION

- When frequencies are stable, the population is in Hardy-Weinberg equilibrium: no mutations, large population, random mating, no net migration, and equal reproductive success.

$$p + q = 1; \ p^2 + 2pq + q^2 = 1$$

p = freq. of dom. allele q = freq. of rec. allele

p^2 = freq. of dom homozygotes

$2pq$ = freq. of heterozygotes

q^2 = freq. of recessive homozygotes

CLASSICAL GENETICS

- If both parents are Rr, the alleles separate to give a genotypic ratio of 1:2:1 and a phenotypic ratio of 3:1.

Law of independent assortment: Alleles of unlinked genes assort independently in meiosis.

- For two traits: AaBb parents will produce AB, Ab, aB, and ab gametes.
- The phenotypic ratio for this cross is 9:3:3:1.

Statistical Calculations

- The probability of producing a genotype that requires multiple events to occur equals the *product* of the probability of each event.
- The probability of producing a genotype that can be the result of multiple events equals the *sum* of each probability.

Genetic Mapping

- Crossing over during meiosis I can unlink genes during prophase I.
- Genes are most likely unlinked when far apart.
- One map unit is 1% recombinant frequency.

Given recombination frequencies

X and Y: 8%

X and Z: 12%

Y and Z: 4%

Inherited Disorders in Pedigrees

- **Autosomal recessive:** Skips generations
- **Autosomal dominant:** Appears in every generation
- **X-linked (sex-linked):** No male-to-male transmission, more males are affected.

THE PERIODIC TABLE

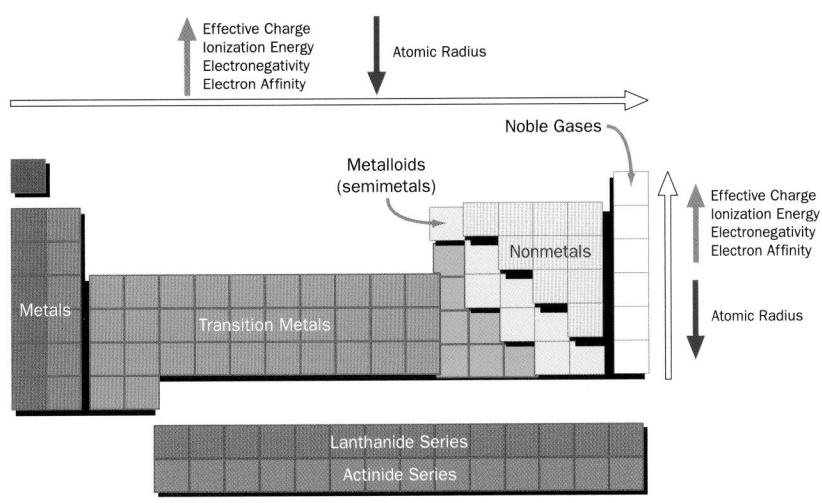

ATOMIC STRUCTURE

Atomic weight: The weight in grams of one mole (mol) of a given element and is expressed in terms of g/mol.

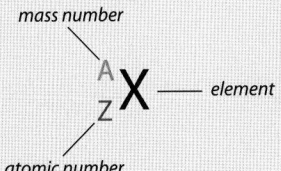

A **mole** is a unit used to count particles and is represented by **Avogadro's number**, 6×10^{23} particles.

$$\text{Moles} = \frac{\text{grams}}{\text{atomic or molecular weight}}$$

Isotopes: For a given element, multiple species of atoms with the same number of protons (same atomic number) but different numbers of neutrons (different mass numbers).

Planck's quantum theory: Energy emitted as electromagnetic radiation from matter exists in discrete bundles called quanta.

Bohr's Model of the Hydrogen Atom

Angular momentum: $\dfrac{nh}{2\eta}$

Energy of electron: $E = \dfrac{-RH}{n^2}$

Electromagnetic energy of photons: $E = \dfrac{hc}{\lambda}$

The group of hydrogen emission lines corresponding to transitions from upper levels $n > 2$ to $n = 2$ is known as the **Balmer series**. The group corresponding to transitions between upper levels $n > 1$ to $n = 1$ is known as the **Lyman series.**

Absorption spectrum: Characteristic energy bands where electrons absorb energy.

Quantum Mechanical Model of Atoms

Heisenberg uncertainty principle: It is impossible to determine with perfect accuracy the momentum and the position of an electron simultaneously.

Quantum Numbers:

#	Character	Symbol	Value
1st	Shell	n	n
2nd	Subshell	l	From zero to $n - 1$
3rd	Orbital	m_λ	Between l and $-l$
4th	Spin	m_s	½ or −½

Principal Quantum Number (n): The larger the integer value of n, the higher the energy level and radius of the electron's orbit. The maximum number of electrons in energy level n is $2n^2$.

Azimuthal Quantum Number (l): Refers to subshells, or sublevels. The four subshells corresponding to $l = 0$, 1, 2, and 3 are known as s, p, d and f, respectively. The maximum number of electrons that can exist within a subshell is given by the formula $4l+2$.

Magnetic Quantum Number (m_λ): This specifies the particular orbital within a subshell where an electron is highly likely to be found at a given point in time.

Spin Quantum Number (m_s): The spin of a particle is its intrinsic angular momentum and is a characteristic of a particle.

Electron Configuration

$1s$
$2s\ 2p$
$3s\ 3p\ 3d$
$4s\ 4p\ 4d\ 4f$
$5s\ 5p\ 5d\ 5f$
$6s\ 6p\ 6d$
$7s\ 7p$

Hund's rule: Within a given subshell, orbitals are filled such that there are a maximum number of half-filled orbitals with parallel spins.

Valence electrons: Electrons of an atom that are in its outer energy shell or that are available for bonding.

KINETICS AND EQUILIBRIUM

Experimental Determination of Rate Law: The values of k, x, and y in the rate law equation (rate = $k[A]^x[B]^y$) must be determined experimentally for a given reaction at a given temperature. The rate is usually measured as a function of the initial concentrations of the reactants, A and B.

Efficiency of Reactions

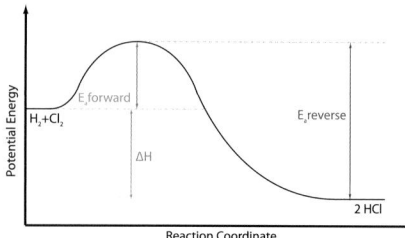

Factors affecting reaction rates: Reactant Concentrations, Temperature, Medium, Catalysts

Catalysts are unique substances that increase reaction rate without being consumed; they do this by lowering the activation energy.

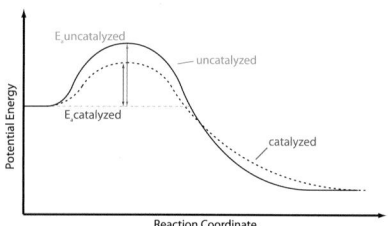

Law of Mass Action

$$aA + bB \rightleftharpoons cC + dD$$

$$K_c = \frac{[C]^c[D]^d}{[A]^a[B]^b}$$

K_c is the equilibrium constant. (c stands for concentration.)

Properties of The Equilibrium Constant

Pure solids/liquids don't appear in expression.

- K_{eq} is characteristic of a given system at a given temperature.
- If $K_{eq} > 1$, an equilibrium mixture of reactants and products will contain very little of the reactants compared to the products.
- If $K_{eq} < 1$, an equilibrium mixture of reactants and products will contain very little of the products compared to the reactants.
- If K_{eq} is close to 1, an equilibrium mixture of products and reactants will contain approximately equal amounts of the two.

$A + B \rightleftharpoons C$ + heat	
Will shift to **RIGHT**:	Will shift to **LEFT**:
1. if more A or B added	1. if more C added
2. if C taken away	2. if A or B taken away
3. if pressure applied or volume reduced (assuming A, B, and C are gases)	3. if pressure reduced or volume increased (assuming A, B, and C are gases)
4. if temperature reduced	4. if temperature increased

BONDING AND CHEMICAL INTERACTIONS

Formal Charges

Formal charge = Valence electrons $- \frac{1}{2} N_{bonding} - N_{nonbonding}$

Intermolecular Forces

1. **Hydrogen Bonding:** The partial positive charge of the hydrogen atom interacts with the partial negative charge located on the electronegative atoms (F, O, N) of nearby molecules.

2. **Dipole-Dipole Interactions:** Polar molecules orient themselves such that the positive region of one molecule is close to the negative region of another molecule.

3. **Dispersion Forces:** The bonding electrons in covalent bonds may appear to be equally shared between two atoms, but at any particular point in time they will be located randomly throughout the orbital. This permits unequal sharing of electrons, causing rapid polarization and counter-polarization of the electron clouds of neighboring molecules, inducing the formation of more dipoles.

COMPOUNDS AND STOICHIOMETRY

A **compound** is a pure substance composed of two or more elements in a fixed proportion.

A **mole** is the amount of a substance that contains the same number of particles found in a 12.0 g sample of carbon-12.

Combination Reactions: two or more reactants form one product.

$$S\ (s) + O_2\ (g) \rightarrow SO_2\ (g)$$

Decomposition Reactions: A compound breaks down into two or more substances, usually as a result of heating or electrolysis.

$$2\ HgO\ (s) \rightarrow 2\ Hg\ (l) + O_2\ (g)$$

Single-Displacement Reactions: An atom (or ion) of one compound is replaced by an atom of another element.

$$Zn\ (s) + CuSO_4\ (aq) \rightarrow Cu\ (s) + ZnSO_4\ (aq)$$

Double-Displacement Reactions: Also called metathesis reactions, elements from two different compounds displace each other to form two new compounds.

$$CaCl_2\ (aq) + 2\ AgNO_3\ (aq) \rightarrow Ca(NO_3)_2\ (aq) + 2\ AgCl\ (s)$$

Net Ionic Equations: These types of equations are written showing only the species that actually participate in the reaction. So in the following equation,

$$Zn\ (s) + Cu^{2+}\ (aq) + SO_4^{2-}\ (aq) \rightarrow Cu\ (s) + Zn^{2+}\ (aq) + SO_4^{2-}\ (aq)$$

the spectator ion (SO_4^{2-}) does not take part in the overall reaction, but simply remains in solution throughout. The net ionic equation would be:

$$Zn\ (s) + Cu^{2+}\ (aq) \rightarrow Cu\ (s) + Zn^{2+}\ (aq)$$

Neutralization Reactions: These are a specific type of double displacements that occur when an acid reacts with a base to produce a solution of a salt and water:

$$HCl\ (aq) + NaOH\ (aq) \rightarrow NaCl\ (aq) + H_2O\ (l)$$

ACIDS AND BASES

Arrhenius: An acid is a species that produces H^+ (a proton) in an aqueous solution, and a base is a species that produces OH^- (a hydroxide ion).

Brønsted-Lowry: An acid is a species that donates protons, while a base is a species that accepts protons.

Lewis: An acid is an electron-pair acceptor, and a base is an electron-pair donor.

Properties of Acids and Bases

$$pH = -\log[H^+] = \log\frac{1}{[H^+]}$$

$$pOH = -\log[OH^-] = \log\frac{1}{[OH^-]}$$

$$H_2O(l) \rightleftharpoons H^+ (aq) + OH^- (aq)$$

$$K_w = [H^+][OH^-] = 10^{-14}$$

$$pH + pOH = 14$$

Weak Acids and Bases

$$HA\ (aq) + H_2O\ (l) \rightleftharpoons H_3O^+\ (aq) + A^-\ (aq)$$

$$K_a = \frac{[H_3O^+][A^-]}{[HA]}$$

$$K_b = \frac{[B^+][OH^-]}{[BOH]}$$

Salt Formation: Acids and bases may react with each other, forming a salt and (often, but not always) water in a neutralization reaction.

$$HA + BOH \rightarrow BA + H_2O$$

Titration and Buffers

Strong Acid and Strong Base

pH vs. NaOH added (mL) — end point, equivalence point

Weak Acid and Strong Base

pH vs. NaOH added (mL) — equivalence point

Titration is a procedure used to determine the molarity of an acid or base by reacting a known volume of a solution of unknown concentration with a known volume of a solution of known concentration.

ACIDS AND BASES (continued)

Henderson-Hasselbalch equation is used to estimate the pH of a solution in the buffer region where the concentrations of the species and its conjugate are present in approximately equal concentrations.

$$pH = pK_a + \log\frac{[\text{conjugate base}]}{[\text{weak acid}]}$$

$$pOH = pK_b + \log\frac{[\text{conjugate acid}]}{[\text{weak base}]}$$

BASIC

NaOH
NH_3
HCO_3^-
F^-
Water
H_2CO_3
NH_4^+
HSO_4^-
HF
HCl

ACIDIC

THE GAS PHASE

1 atm = 760 mm Hg = 760 torr

Do not confuse STP with standard conditions—the two standards involve different temperatures and are used for different purposes. STP (0°C or 273 K) is generally used for gas law calculations; standard conditions (25°C or 298 K) is used when measuring standard enthalpy, entropy, Gibbs free energy, and voltage.

Boyle's Law

$$PV = k \text{ or } P_1V_1 = P_2V_2$$

Charles's Law

$$\frac{V}{T} = k \text{ or } \frac{V_1}{T_1} = \frac{V_2}{T_2}$$

Avagadro's Principle

$$\frac{n}{T} = k \text{ or } \frac{n_1}{T_1} = \frac{n_2}{T_2}$$

Ideal Gas Law

$$PV = nRT$$

Deviations due to Pressure: As the pressure of a gas increases, the particles are pushed closer and closer together. At moderately high pressure a gas's volume is less than would be predicted by the ideal gas law, due to intermolecular attraction.

Deviations due to Temperature: As the temperature of a gas decreases, the average velocity of the gas molecules decreases, and the attractive intermolecular forces become increasingly significant. As the temperature of a gas is reduced, intermolecular attraction causes the gas to have a smaller volume than would be predicted.

SOLUTIONS

Units of Concentration

Percent Composition by Mass: $= \frac{\text{Mass of solute}}{\text{Mass of solution}} \times 100\ (\%)$

Mole Fraction: $\frac{\text{\# of mol of compound}}{\text{total \# of moles in system}}$

Molarity: $\frac{\text{\# of mol of solute}}{\text{liter of solution}}$

Molality: $\frac{\text{\# of mol of solute}}{\text{kg of solvent}}$

Normality: $\frac{\text{\# of gram equivalent weights of solute}}{\text{liter of solution}}$

PHASES AND PHASE CHANGES

simple cubic body-centered cubic face-centered cubic

Colligative Properties: Physical properties derived solely from the number of particles present, not the nature of those particles, usually associated with dilute solutions.

Freezing Point Depression
$$\Delta T_f = K_f m$$

Boiling Point Elevation
$$\Delta T_b = K_b m$$

Osmotic Pressure
$$\Pi = MRT$$

Vapor-pressure Lowering (Raoult's Law)
$$P_A = X_A P°_A;\ P_B = X_B P°_B$$

Solutions that obey Raoult's Law are called ideal solutions.

Graham's Law of Diffusion and Effusion

Diffusion: occurs when gas molecules diffuse through a mixture.

Effusion: is the flow of gas particles under pressure from one compartment to another through a small opening.

Effusion

Both diffusion and effusion have the same formula:

$$\frac{r_1}{r_2} = \left(\frac{MM_2}{MM_1}\right)^{\frac{1}{2}}$$

REDOX REACTIONS AND ELECTROCHEMISTRY

Oxidation: Loss of electrons

Reduction: Gain of electrons

Oxidizing agent: Causes another atom to undergo oxidation, and is itself reduced

Reducing agent: Causes another atom to be reduced, and is itself oxidized

THERMOCHEMISTRY

Constant-volume and constant-pressure calorimetry: used to indicate conditions under which the heat changes are measured.

$Q = mc\Delta T$, where Q is the heat absorbed or released in a given process, m is the mass, c is the specific heat, and ΔT is the change in temperature.

States and State Functions: are described by the macroscopic properties of the system. These are properties whose magnitude depends only on the initial and final states of the system, and not on the path of the change.

Enthalpy (H): is used to express heat changes at constant pressure.

Standard Heat of Formation ($\Delta H°_f$): the enthalpy change that would occur if one mole of a compound were formed directly from its elements in their standard states.

Standard Heat of Reaction ($\Delta H°_{rxn}$): the hypothetical enthalpy change that would occur if the reaction were carried out under standard conditions.

$\Delta H°_{rxn}$ = (sum of $\Delta H°_{rxn}$ of products) − (sum of $\Delta H°_{rxn}$ of reactants)

Hess's Law: Enthalpies of reactions are additive.

The reverse of any reaction has an enthalpy of the same magnitude as that of the forward reaction, but its sign is opposite.

Bond Dissociation Energy: Average of the energy required to break a particular type of bond in one mole of gaseous molecules:

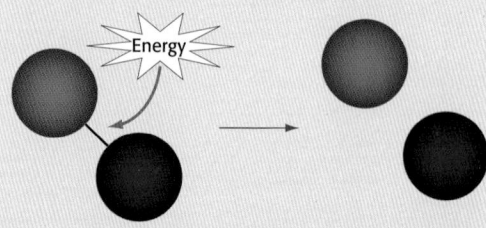

Entropy (S): Measure of the disorder, or randomness, of a system.

$$\Delta S_{universe} = \Delta S_{system} + \Delta S_{surroundings}$$

Gibbs Free Energy (G): combines the two factors that affect the spontaneity of a reaction—changes in enthalpy, ΔH, and changes in entropy, ΔS.

$$\Delta G = \Delta H - T\Delta S$$

if ΔG is negative, the rxn is spontaneous

if ΔG is positive, the rxn is not spontaneous

if ΔG is zero, the system is in a state of equilibrium; thus, $\Delta G = 0$ and $\Delta H = T\Delta S$

ΔH	ΔS	Outcome
−	+	Spontaneous at all temps.
+	−	Nonspontaneous at all temps.
+	+	Spontaneous only at high temps.
−	−	Spontaneous only at low temps.

Reaction Quotient (Q): Once a reaction commences, the standard state conditions no longer hold. For the reaction,

$$aA + bB \rightleftharpoons cC + dD$$

$$Q = \frac{[C]^c[D]^d}{[A]^a[B]^b}$$

NOMENCLATURE

1. Find the longest carbon chain containing the principle functional group (highest priority groups are generally more oxidized).
2. Number the carbon chain so the principle functional group gets lowest number (1).
3. Proceed to number the chain so the lowest set of numbers is obtained for the substituents.
4. Name the substituents and assign each a number.
5. Complete the name by listing substituents in alphabetical order; place commas between numbers and dashes between numbers and words.

t-butyl

neopentyl

isopropyl

sec-butyl

isobutyl

Functional Group	Suffix
Carboxylic Acid	-oic acid
Ester	-oate
Acyl halide	-oyl halide
Amide	-amide
Nitrile/Cyanide	-nitrile
Aldehyde	-al

Functional Group	Suffix
Ketone	-one
Thiol	-thiol
Alcohol	-ol
Amine	-amine
Imine	-imine
Ether	-ether

ISOMERS

same connectivity?

NO → STRUCTURAL
YES → STEREOISOMERS

require bond breaking to interconvert?

NO → CONFORMATIONAL
YES → CONFIGURATIONAL (OPTICAL)

GEOMETRIC ISOMERS
different configuration around a double bond

non-superimposable mirror images?

NO → DIASTEREOMERS
YES → ENANTIOMERS

180° — anti
60° — gauche
120° — eclipsed
0° — totally eclipsed

puckered cyclobutane

conformation cyclopentane

chair cyclohexane

boat cyclohexane

twist boat cyclohexane

BONDING

Bond order	single	double	triple
Bond type	sigma	sigma pi	sigma 2 pi
Hybridization	sp^3	sp^2	sp
Angles	109.5°	120°	180°
Example	C–C	C=C	C≡C

ALKANES

Free radical halogenation

- Initiation
- Propagation
- Termination

Combustion

$$C_3H_8 + 5\ O_2 \rightarrow 3\ CO_2 + 4\ H_2O + heat$$

Nucleophilicity and basicity

$$RO^- > HO^- > RCO_2^- > ROH > H_2O$$

Nucleophilicity, size, and polarity

$$CN^- > I^- > RO^- > HO^- > Br > Cl^- > F^- > H_2O$$

Leaving groups (weak bases best)

$$I^- > Br^- > Cl^- > F^-$$

S_N1	S_N2
2 steps	1 step
Favored in polar protic solvents	Favored in polar aprotic solvents
3° > 2° > 1° > Methyl	Methyl > 1° > 2° > 3°
Rate = k[RX]	Rate = k[Nu][RX]
Racemic products	Optically active and inverted products
Strong nucleophile not required	Favored with strong nucleophile

AMINO ACIDS, PEPTIDES, AND PROTEINS

Amino acids have four substituents: amine group, carboxyl group, hydrogen, and R group. Amino acids are **amphoteric**—they can act as either acids or bases and often take the form of **zwitterions** (dipolar ions).

amino acid → (neutral solution) → zwitterion

Structure

Primary: Sequence of amino acids

Secondary: α-helix, β-pleated sheet

Tertiary: Disulfide bridges, hydrophobic/hydrophilic interactions

Quaternary: Arrangement of polypeptides

Henderson–Hasselbalch Equation

$$pH = pK_a + \log\frac{[\text{conj. base}]}{[\text{conj. acid}]}$$

ALKYNES

Alkynes have a terminal hydrogen that is appreciably more acidic than hydrogens on alkanes and alkenes.

Synthesis via double elimination of geminal or vicinal dihalide

$$\xrightarrow[\text{Base}]{\text{Heat}} \quad CH_3C\equiv CCH_3 \quad + \quad 2\,HBr$$

Oxidation with $KMnO_4$, O_3

1) $KMnO_4$, OH^-
2) H^+

1) O_3, CCl_4
2) H_2O

Reduction with Lindlar's catalyst or liquid ammonia

$$CH_3C\equiv CCH_3 \xrightarrow[\substack{\text{Quinoline} \\ \text{(Lindlar's catalyst)}}]{H_2,\ Pd/BaSO_4}$$

2-butyne → *cis*-2-butene

$$CH_3C\equiv CCH_3 \xrightarrow{Na,\ NH_3(liq)}$$

2-butyne → *trans*-2-butene

Free radical addition

$$CH_3CH_2C\equiv CH + X\cdot \longrightarrow \rightleftharpoons \longrightarrow$$

Electrophilic addition (anti orientation)

$$CH_3C\equiv CH \xrightarrow{Br_2}$$

$$CH_3C\equiv CH \xrightarrow{2Br_2} CH_3CBr_2CBr_2H$$

Hydroboration (cis alkene formed)

$$3\ H_3CC\equiv CCH_3 + \tfrac{1}{2}\ B_2H_6 \longrightarrow$$

$$\xrightarrow{CH_3COOH} 3$$

ALKENES

Catalytic Reduction

$$\xrightarrow[Pd]{H_2}$$

Electrophilic Addition of HX

$$\xrightarrow{+H^+} \xrightarrow{Br^-}$$

Electrophilic Addition of X_2

anti-addition

Electrophilic Addition of H_2O

$$\xrightarrow[H_2O]{H^+} \qquad \xrightarrow{H_2O} \qquad \xrightarrow{H_2O^+} \xrightarrow{-H^+}$$

Free Radical Addition (anti-Markovnikov)

$$\xrightarrow{Br\cdot} \xrightarrow{HBr} + Br\cdot$$

most stable radical

Hydroboration (anti-Markovnikov, syn orientation)

$$R =$$

$$3 \xrightarrow{BH_3} \xrightarrow[OH^-]{H_2O_2} 3$$

Oxidation with $KMnO_4$

$$\xrightarrow[KMnO_4]{\text{cold, dilute}} + MnO_2(s)$$

Oxidation with O_3

$$\xrightarrow[2)\ Zn/H_2O]{1)\ O_3,\ CH_2Cl_2} 2$$

ALDEHYDES

The dipole moment of aldehydes causes an elevation of boiling point, but not as high as alcohols since there is no hydrogen bonding.

Synthesis

- Oxidation of primary alcohols
- Ozonolysis of alkenes
- Friedel-Crafts acylation

Reactions

Reactions of Enols (Michael additions)

$$\xrightarrow{Base} + H:Base$$

$$\xrightarrow{} + Base$$

Nucleophilic Addition to a Carbonyl

$$\xrightarrow{} \xrightarrow{H^+}$$

Aldol condensation

An aldehyde acts both as nucleophile (enol form) and target (keto form).

CARBOXYLIC ACIDS

Carboxylic acids have pK_as of around 4.5 due to resonance stabilization of the conjugate base. Electronegative atoms increase acidity with inductive effects. Boiling point is higher than alcohols because of the ability to form two hydrogen bonds.

Synthesis

Oxidation of Primary Alcohols with KMnO$_4$

Organometallic Reagents with CO$_2$ (Grignard)

1) CO$_2$ gas
2) H$^+$, H$_2$O

Hydrolysis of Nitriles

$CH_3Cl \longrightarrow CH_3CN \longrightarrow CH_3\overset{O}{C}OH + NH_4^+$

Reactions

Formation of soap by reacting carboxylic acids with NaOH; arrange in micelles.

nonpolar tail polar head

Nucleophilic Acyl Substitution

Ester formation

Acyl halide formation

Reduction to alcohols

carboxylic acid

aldehyde

alcohol

ALCOHOLS

- Higher boiling points than alkanes
- Weakly acidic hydroxyl hydrogen

Synthesis

- Addition of water to double bonds
- S$_N$1 and S$_N$2 reactions
- Reduction of carboxylic acids, aldehydes, ketones, and esters
 - Aldehydes and ketones with NaBH$_4$
 - Esters and carboxylic acids with LiAlH$_4$

Reactions

E1 dehydration reactions in strongly acidic solutions

$\frac{H_2SO_4}{\Delta}$

Hoffman product — minor

Zaitsev product — major

Substitution reactions after protonation or leaving group conversion

—OH + HBr ⟶ —OH$_2^+$ + Br$^-$

Br$^-$ + —OH$_2^+$ ⟶ —Br + H$_2$O

NaI

tosyl chloride

Oxidation

- PCC takes a primary alcohol to an aldehyde.

\xrightarrow{PCC}

- Jones's reagent, KMnO$_4$, and alkali dichromate salts will convert secondary alcohols to ketones and primary alcohols to carboxylic acids.

$\xrightarrow[H_2SO_4]{Na_2Cr_2O_7}$

- Tertiary alcohols cannot be oxidized without breaking a carbon-to-carbon bond.

Oxidation and Reduction

$CH_3\overset{O}{CH} \xrightarrow[\text{or Ag}_2O]{KMnO_4, CrO_3,} CH_3\overset{O}{C}OH$

$\xrightarrow[NaBH_4]{LAH \text{ or}}$

SEPARATIONS

- **Chromatography**: separates and allows for identification of compounds based on differing chemical properties (Thin-Layer, Column, Gas, HPLC)
- **Electrophoresis**: separates molecules based on size and charge by applying an electric field (Agarose, SDS-PAGE, Isoelectric Focusing)
- **Blotting**: separates biological macromolecules. (Southern, Northern, Western)

Acyl halides

Nucleophilic acyl substitution

Friedel–Crafts acylation

Reduction

Anhydrides

Synthesis via reaction of carboxylic acid with an acid chloride

Addition of ammonia to form amides

Friedel–Crafts acylation

Amines and Nitrogen-Containing Compounds

Amide Carbamate Imine Enamine

Azide Nitrile Isocyanate

Direct alkylation of ammonia

$$CH_3Br + NH_3 \longrightarrow CH_3\overset{+}{N}H_3Br^- \xrightarrow{NaOH} CH_3NH_2 + NaBr + H_2O$$

Reduction from nitro compounds, nitriles, imines, and amides

$$CH_3CH_2C\equiv N \xrightarrow{LAH} CH_3CH_2CH_2NH_2$$

Exhaustive methylation (Hoffman elimination)

Gabriel Synthesis

Amides

Hoffman rearrangement converts amides to primary amines

nitrene isocyanate

Reduction with LAH

Esters

Synthesis via condensation of carboxylic acids and alcohols

Conversion to amides

Claisen condensation

KEYHOLES (50 seconds per question)

The Task

A 3D object is presented, and you must determine which of the five given openings best matches the object.

The Rules

1. The object can pass through the opening in any orientation
2. The object cannot be rotated once it has started through the opening. The external outline of the object is the exact shape of the opening.
3. The object and opening are drawn to the same scale.
4. There are no irregularities in any hidden part of the object.

Strategies

1. **Projections**

 Imagine shining a light on the top, front, or right side and predict the back, bottom, and left shadows or projections. Check your predictions against the answers, eliminate, and match.

2. **Crushing**

 Visualize the object if it is crushed flat from the top, front, or right side. Check your visualization against the answers, eliminate, and match.

 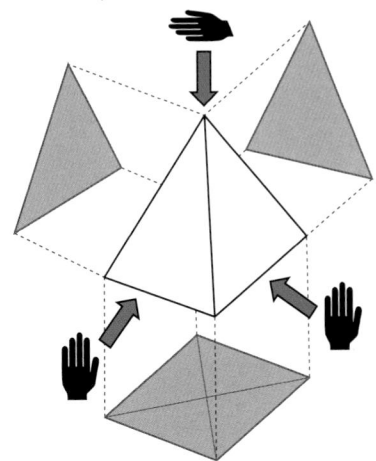

3. **Key Features**

 Identify distinct features of the object and eliminate answer choices that do not have the correct feature or contain the incorrect size, location, or spacing of that feature.

 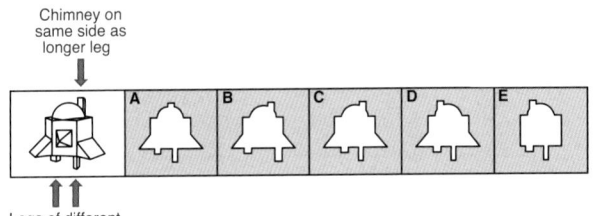

 Chimney on same side as longer leg

 Legs of different width

TOP FRONT END (50 seconds per question)

The Task

Two views of an object are presented, and you must extrapolate the third.

The Rules

1. Presented are top, front, and end views of various solid objects.
2. All views are presented without perspective. Points in the viewed surface are presented along parallel lines of sight.
3. The TOP VIEW, FRONT VIEW, and END VIEW are always presented in the same positions relative to a cross on the left of the page.
4. Edges of the object that cannot be seen are represented by DOTTED lines.
5. The END VIEW is a lateral view of the object from the right only.

Strategies

1. **Event Theory**

 Track the distinct changes common to both sides of a shared corner.

 Identify the number of events (vertical, horizontal, hidden, and visible) on the two given sides, and then eliminate answer choices that do not contain the appropriate number of events.

2. **Key Feature/Proportion Elimination**

 Identify distinct features in a given view, determine whether the feature will be visible in the answer, and eliminate answer choices that do not have the correct feature or contain the incorrect size, location, or spacing of that feature.

3. **3D Visualization**

 Use the 3D folded correlation between the given faces to solve:

 Vertical lines on the TOP are vertical lines on the FRONT.

 Horizontal lines on the FRONT are horizontal lines on the END.

 Vertical lines on the END are horizontal lines on the TOP.

 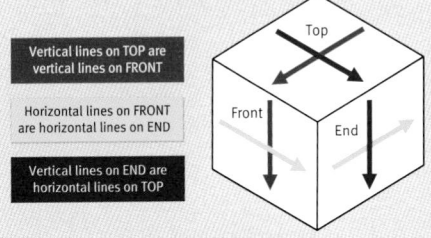

ANGLE RANKING (20 seconds per question)

The Task

Four angles are given and must be ranked in order of increasing angle.

The Rules

1. Each question contains four interior angles that are distinct from each other. There will always be at least a one to three degree difference between sequentially ranked angles.

Strategies

1. **Smallest and Largest Angles**

 Start by identifying the extremes, and then eliminate answers that don't fit your prediction.

 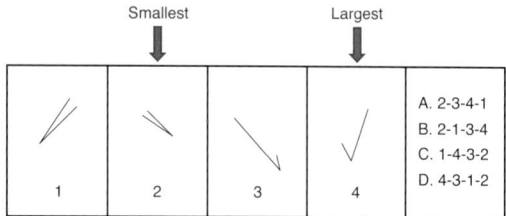

2. **Blocking**

 Mentally block extra size/length to ensure you are ranking accurately.

 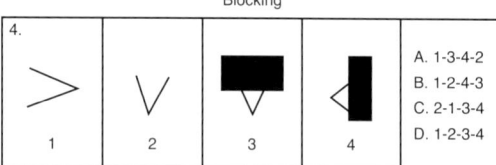

3. **Stacking**

 Imagine one angle stacking inside another to see which ones fits better. Smaller angles will fit inside of larger angles.

 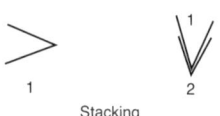

HOLE PUNCHING (20 seconds per question)

The Task

You must identify where the holes punched in a folded piece of paper will be when the piece of paper is unfolded.

The Rules

1. A flat, square piece of paper is folded one or more times. The paper is never folded under; it is always folded so the overlapping part is on top.
2. Broken lines indicate the original position of the paper, and solid lines indicate the position of the folded paper. The folded paper remains within the boundaries of the original, flat sheet. The paper is not turned or twisted.
3. There are one, two, or three folds per question.
4. After the final fold is performed, one or more holes are punched in the paper. Once the holes are punched, mentally unfold the paper and ascertain the positions of the holes on the original flat sheet.
5. The location of the hole punched is constrained by the fact that no "half" holes are generated. However, a hole may be punched along a fold so that when the paper is unfolded, a single "whole" results from the "half" punch.

Strategies

1. **First Fold Line of Symmetry**

 The first fold is particularly important for determining the symmetry of the final solution.

2. **Number of Holes**

 The number of folds determines the maximum number of holes created.

 1 fold → 2 holes

 2 folds → 4 holes

 3 folds → 8 holes

 The number of layers of paper under the punch determines the actual number of holes created.

 1 layer → 1 hole

 2 layers → 2 holes

 3 layers → 3 holes

3. **Position of Holes**

 When you can't determine the correct answer using symmetry or number of holes alone, track where holes should be by mentally "unfolding" the paper. Eliminate answer choices that have holes in the incorrect position or that do not have holes in the correct position.

4. **Scratch Paper Strategy**

 For the most difficult Hole Punching questions, you can use the grid provided on your noteboard to sketch out where each punch would be. This is time consuming, though, so use this strategy sparingly.

CUBE COUNTING (5 figures, 2 minutes each)

The Task

A stack of cubes is given. You must determine how many cubes have a particular number of exposed sides.

The Rules

1. Each figure has been constructed by cementing together identical cubes.
2. After being cemented, each figure was painted on all sides EXCEPT for the bottom (the side on which the figure rests.
3. The only hidden cubes are the ones necessary to support the other cubes in the figure.

The Six Cubes of the PAT

1. One-Sider: Usually appears on the faces of complex figures.

2. Two-Sider: Can appear on the bottoms of walls.

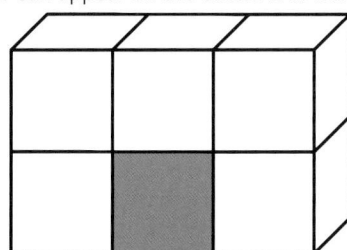

3. Three-Sider: Can appear in many places, including the edges of a wall of cubes.

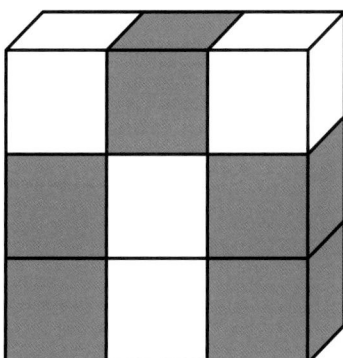

4. Four-Sider: Appears on the corners of a wall of cubes and within a column of cubes.

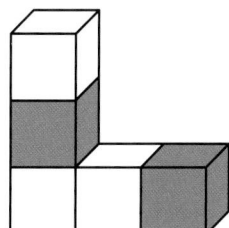

5. Five Sider: Can only appear when it sits above all immediate surrounding blocks.

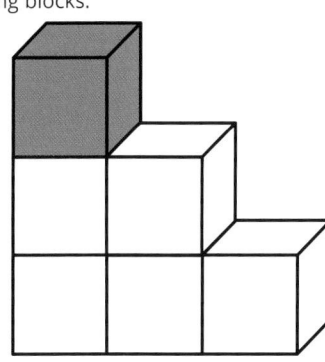

6. No-Sider: Must be completely surrounded by cubes and/or the floor.

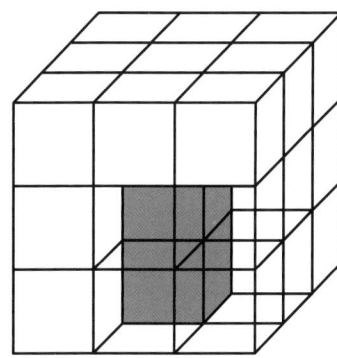

Strategies

1. **Tallying the Cubes**

 Spend some time up front counting how many of each type of cube is present in a methodical way. Work one column of cubes at a time, from top to bottom keeping tally of the type of cubes encountered.

 When finished, ensure that your total tally of cubes is the same as the total number of cubes present in the figure.

 Answering the questions should be quick and easy using your tally as a reference rather than going back to the figure for each question.

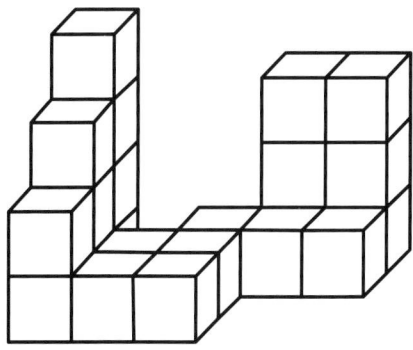

Sides	#	
0		0
1	\|	1
2	\|\|\|\|\|\|\|\|	8
3	\|\|\|\|\|\|\|\|	8
4	\|\|\|\|	4
5	\|	1
Total		22

The Task

Determine which three-dimensional shape is produced by folding a two-dimensional pattern.

The Rules

1. A flat pattern is presented at left.
2. The flat pattern represents the outside of the figure.

Strategies

1. Unique Shape

Identify distinct shapes in the flat pattern and eliminate answer choices that distort or do not have that shape.

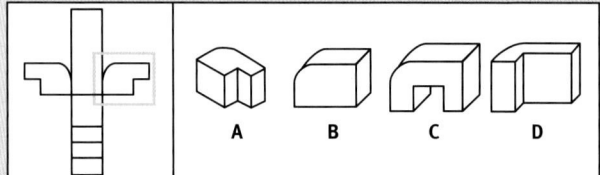

2. Unique Shading

Identify unusual shading in the flat pattern and eliminate answer choices that do not contain the proper shading in the appropriate location.

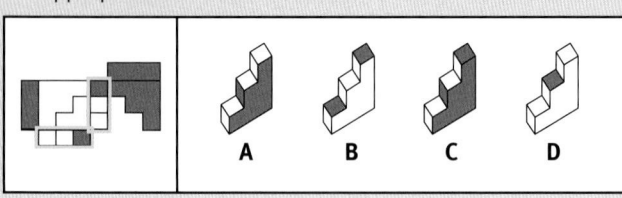

3. Key Landmark

Identify shapes or shadings that point at a specific face or edge.